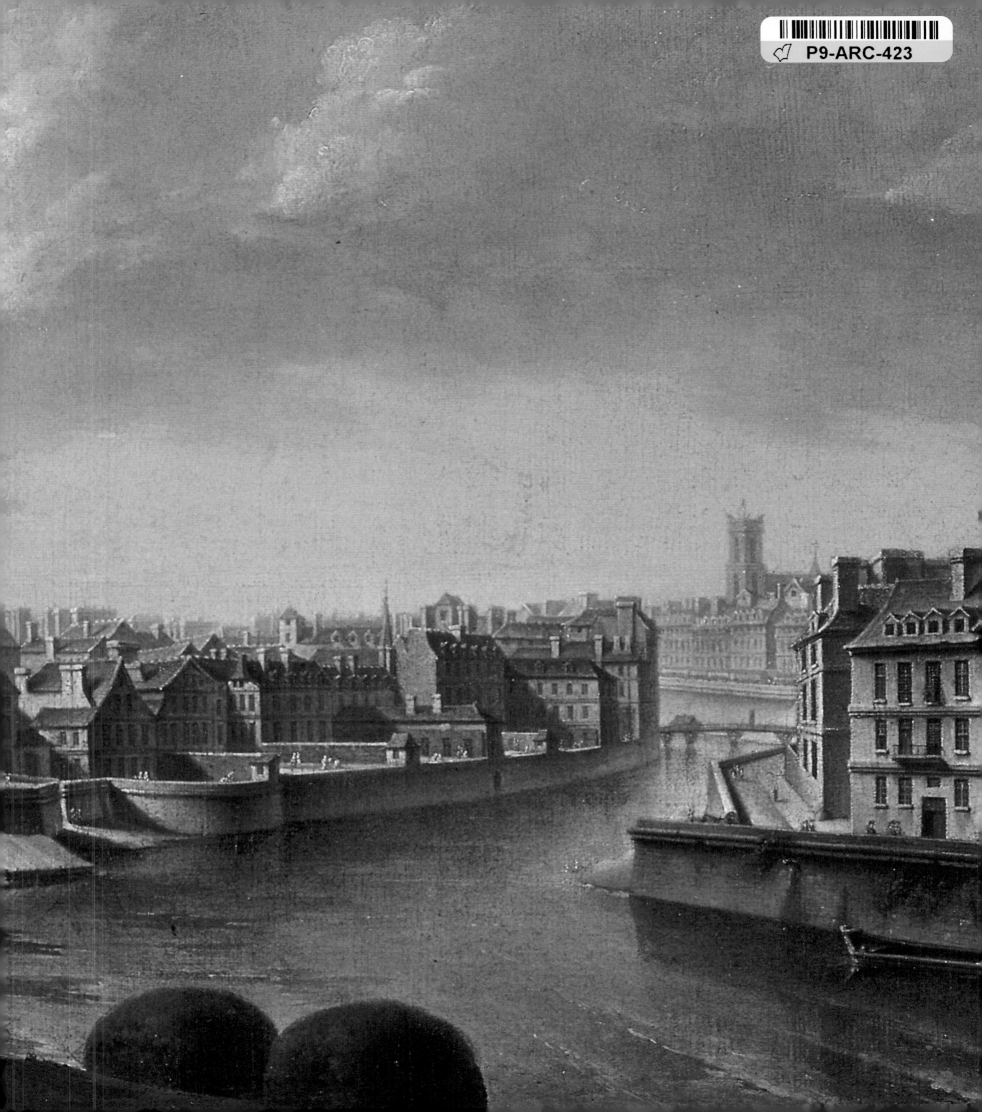

# Paris
## *City of Art*

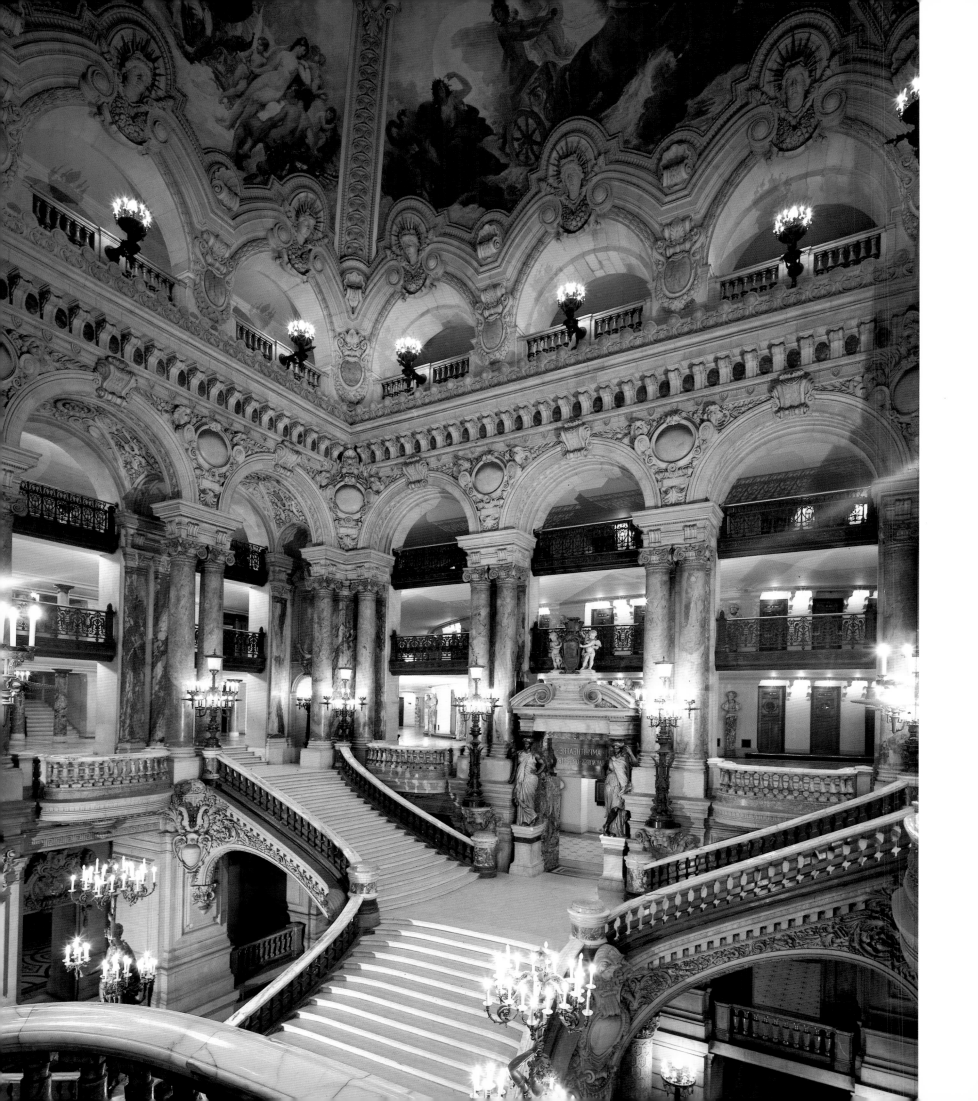

Jean-Marie Pérouse de Montclos

# Paris

## *City of Art*

VENDOME

First published in the United States of America in 2003 by
The Vendome Press
1334 York Avenue
New York, NY 10021

Originally published under the title *L'art de Paris* by Editions Mengès.

Copyright © 2000 Editions Mengès
Translation copyright © 2003 The Vendome Press

ISBN: 0-86565-226-0

Library of Congress Cataloging-in-Publication Data

Pérouse de Montclos, Jean-Marie.
        [Art de Paris. English]
        Paris, city of art / Jean-Marie Pérouse de Montclos.
            p. cm.
        Includes bibliographical references and index.
        ISBN 0-86565-226-0 (alk. paper)
            1. Art, French--France--Paris. I. Title.

        N6850.P44513 2003
        709'.44'361--dc21                                2003053498

Second printing

For the original French edition:
Editor: Agnès de Gorter
Artistic director: Nicholas d'Archimbaud
Graphic coordination: Valérie Azzaretti
Photographic research: Dalloula Haiouani
Maps and floor plans: Edigraphie, Nicolas Poussin

The biographies were edited by Marisa Basile, Hélène Florent, Egalantine Reymond, and Cristina Rognoni.

Editor's note: the two-page sections devoted to major works of architecture that are located at the end of six chapters and the biographies
were not written by the author of this book.

The author would like to thank Alfred Fierro and Luc Passion,
conservationists at the Bibliothèque Historique of the city of Paris.

For the English edition:
The translation was coordinated by Tammi Reichel and Martin Sulzer-Reichel for A-P-E International, Richmond, VA.
The translation was done by:
Denise E. Barstow-Girel
Karen S. Berrier, Ph.D.
Elizabeth I. Droppleman, Ph.D.
Cynthia T. Hahn
Isobel D. Kersting, M.A.
Michael D. Locey, Ph.D. and Lenita C. Locey, Ph.D.
Perette E. Michelli, Ph.D.
Lynn Penrod
Toni B. Wulff, Ph.D.

Front cover: a copy of Gianlorenzo Bernini's statue of Louis XIV in the courtyard of the Louvre. Photo by Cornelis van Vorthuizen.
Back cover: top left, rose window of Sainte-Chapelle; top right, François Boucher. *Portrait of Madame de Pompadour*, 1756;
bottom, gardens of Luxembourg Palace.
Spine: Edouard Manet. *A Bar at the Folies Bergère* (detail), 1881–1882.
Front flap: Edgar Degas. *Absinthe*, 1875–1876.
Page 1: The Eiffel Tower, photograph © Winnie Denker.
Page 2: Grand staircase of the Paris Opéra.
Page 6: Pierre Puvis de Chavannes. *Young Girls on the Seaside*, 1879.
Page 8: François Gérard. *Cupid and Psyche*, 1798.

Typesetting by Martin Sulzer-Reichel for A-P-E International

Jacket and frontmatter design by lync.

Printed in China

*To Brigitte, Marc-Antoine, and Romain-Louis*

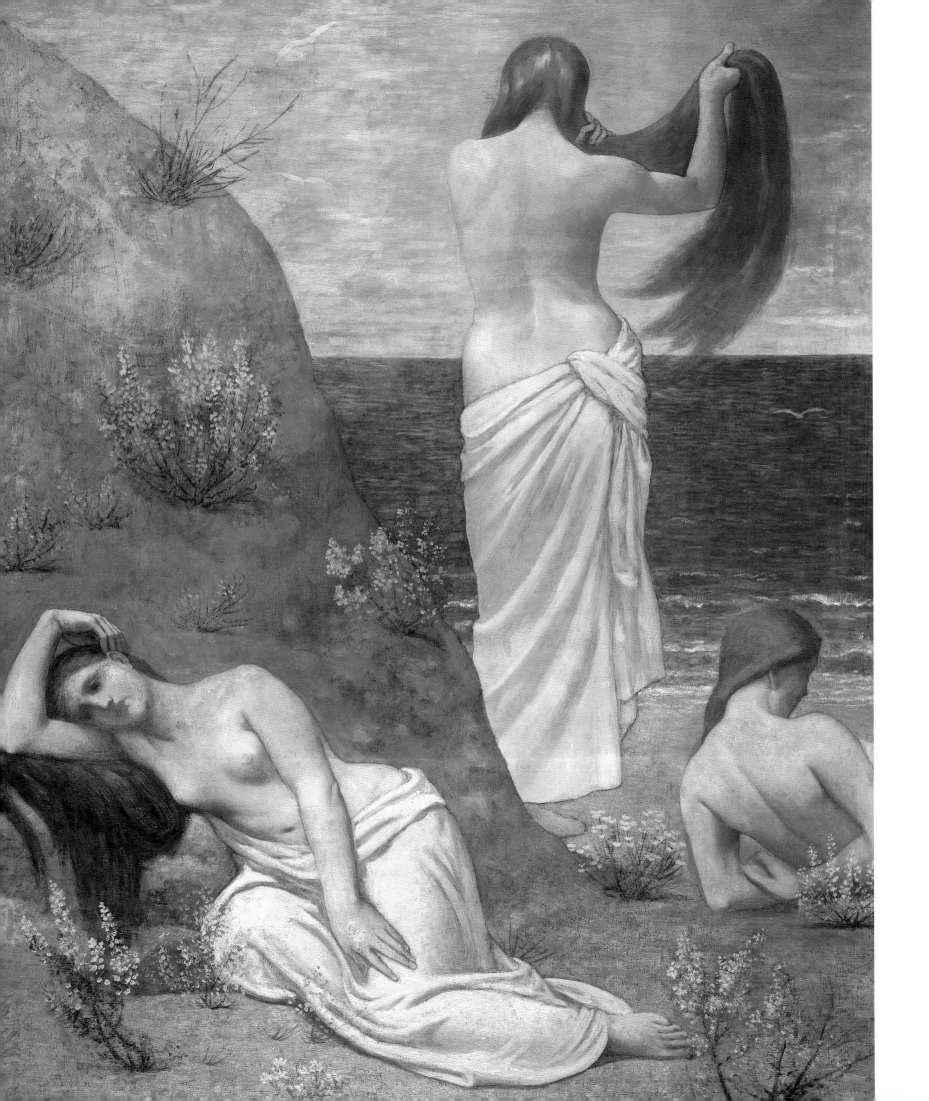

# Contents

Foreword … 9

Gifts of Nature Reflected in Art … 10

PART ONE: Antiquity and the Middle Ages … 14

Chapter I: The Layering of People, Religions, and Dynasties (Up to 1140) … 18

Saint-Germain-des-Prés … I–II

Chapter II: Early Gothic Art (1140–1220) … 36

Notre-Dame Cathedral … III–IV

Chapter III: Rayonnant Gothic Art (1220–1330) … 60

Palais de la Cité … V–VI

Chapter IV: The First Valois Kings (1330–1450) … 98

PART TWO: Modern Times … 138

Chapter V: The Renaissance (1450–1540) … 142

Hôtel de Ville … VII–VIII

Chapter VI: Atticism and Mannerism (1540–1600) … 186

The Louvre … IX–X

Chapter VII: The First Bourbons (1600–1660) … 236

Chapter VIII: The First Thirty Years of the Personal Reign of Louis XIV (1660–1690) … 316

Chapter IX: The Late Louis XIV Style and the Rococo (1690–1760) … 354

The Pantheon … XI–XII

Chapter X: Antiquity and the Revolution (1760–1800) … 406

The Palais Royal … XIII–XIV

PART THREE: The Contemporary Era … 478

Chapter XI: The Last Kings (1800–1870) … 482

Chapter XII: The Belle Epoque (1870–1914) … 568

Chapter XIII: The Turbulent Years (1914–1940) … 634

Epilogue: Late Modernity … 668

Appendix: Maps … 684

Biographies … 689

Bibliography … 698

Index … 702

Photo Credits … 706

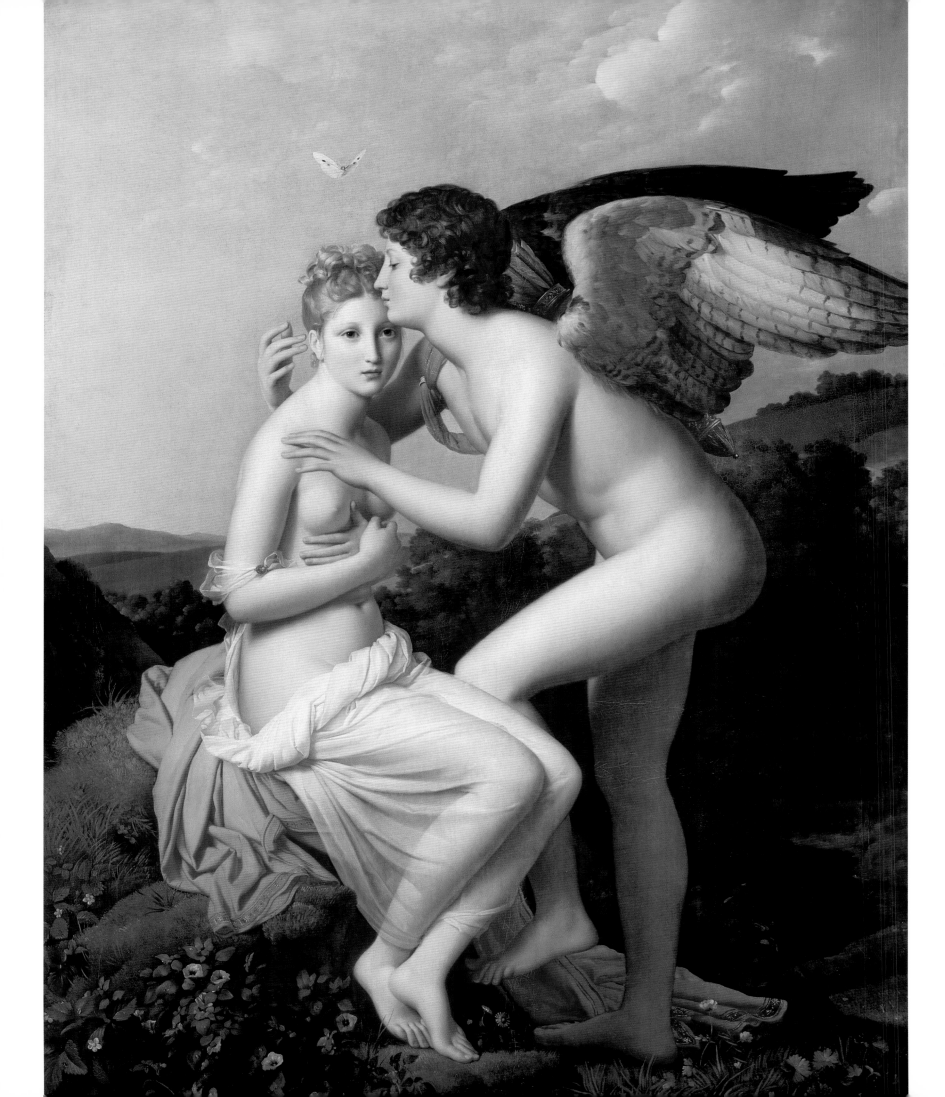

# FOREWORD

*The extraordinary destiny of the city of Paris was the product of a large, industrious population, a community that was for a long time the most populous in Europe. These inhabitants were responsible for the earliest examples of Parisian architecture, which began a long and distinguished tradition of extraordinary built environments. Paris's leading role in the plastic arts did not originate with the great sculptors and painters, whose work we have come to know so well and who in the early years of Paris's history had only a fleeting presence in the city, but rather with the activity of settled craftsmen who were masters in the arts of gold, glass, wood, and tapestry. This exceptional expertise guaranteed them the lasting patronage of princes, dukes, and other royal figures, in the city and beyond. These artisans knew only one master: taste. And it is changing tastes that have propelled the arts forward. Changing tastes instilled in Parisians an insatiable appetite for novelty, which developed their capacity for welcoming ideas and people arriving from elsewhere, and thanks to this, Paris became the European model of sociability. In Paris, and because of Paris, the boundaries of art have regularly been pushed back. Thus it is not by chance that Paris, in the first half of the twentieth century, is where modern art originated.*

*What I have attempted to write is the story of a kind of business venture: the importation of products and workers that this business called "Paris" managed to organize into a profit-making enterprise. One wonders how Paris managed to develop such a prestigious reputation attracting important clients and suppliers, and spreading its business activity to the farthest reaches of Europe. My goal was not to write the complete history of art and architecture in Paris, but merely to observe the ebbs and flows and the many influences that impacted this history. As Paul Valéry wrote in* Fonction de Paris *(Paris's Function) in 1937: "A great city needs the rest of the world, it feeds like a flame on a territory and people whose mute treasures and deep reserves it consumes and transforms into spirit, words, novelties, gestures, and works,"*

*All of the works of art gathered here, with few exceptions, were made in Paris, or for Paris, so that the true story of Paris could be told. Because of their common "birthplace," many affinities among the works will be evident. The works functioned as mirrors of sorts to each other. Writing about Paris, Walter Benjamin said: "Mirrors are the spiritual element of this city, its emblem within which the emblems of all poetic schools have been inscribed." And if indeed works of art are mirrors, they reveal many aspects of the culture that produced them. One will notice that women are frequently the subject of the work shown here; the stained-glass windows and gold reliquaries often represented other great works of art; and artists made their fellow painters and sculptors the subjects of their work on many occasions.*

*In describing the artistic genius of Paris, the question of the boundaries of a constantly growing urban area could have presented some difficulties. For the purposes of this volume, the boundaries are as follows: they include not only Saint-Germain-des-Prés and Saint-Martin-des-Champs, but also Saint-Denis and Vincennes, originally at some distance from Paris, yet inseparable from it; they exclude Fontainebleau and Versailles, which were, in fact, in competition with Paris; they join to the city the curving banks of the Seine, on which impressionism took its first steps, so rural and yet so Parisian. We have left to its country setting Barbizon, where the painters gathered when they were exhausted by the tumult of the city.*

— Jean-Marie Pérouse de Montclos

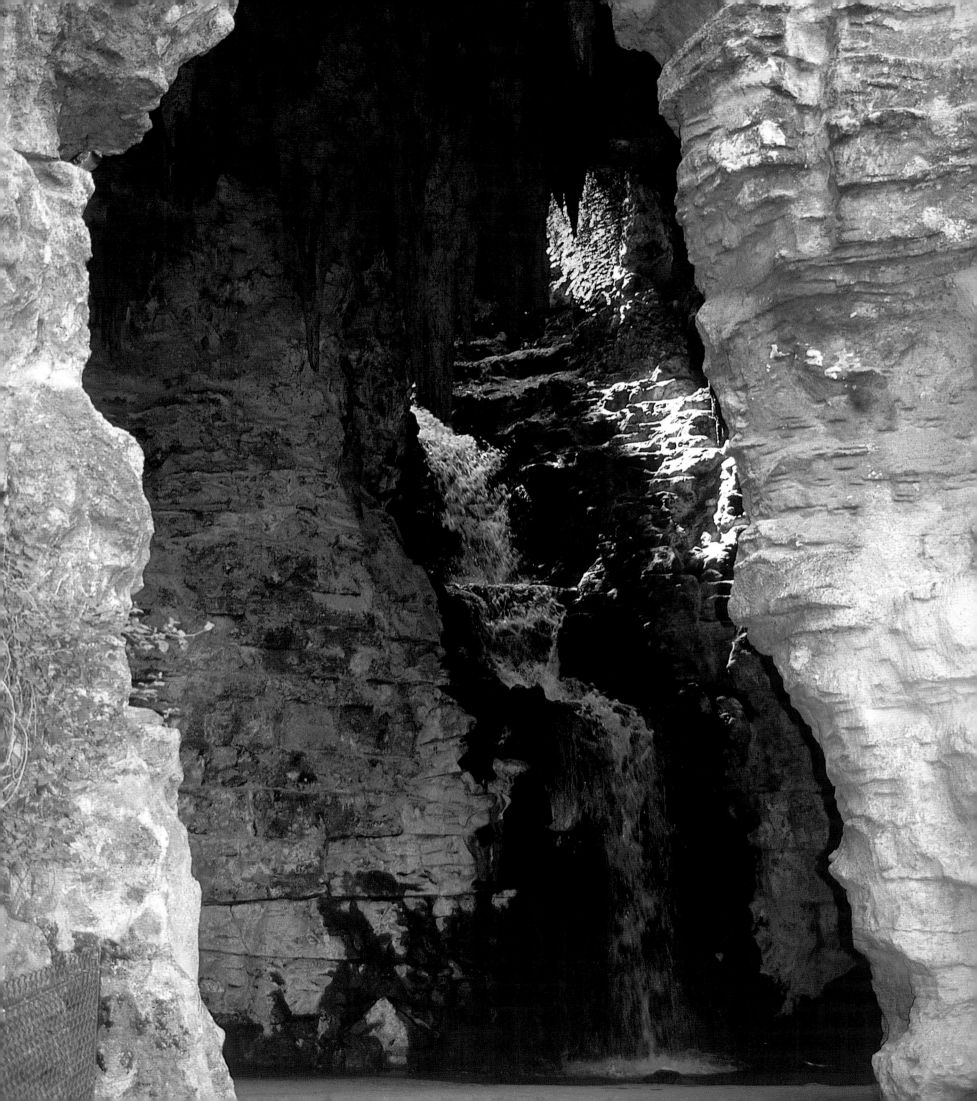

# Gifts of Nature Reflected in Art

Paris sits in the hollow of a great natural basin into which the waters of five rivers join and pass through the city, before they flow on to the sea. Two mighty rivers, the Meuse and the Loire, resisted the pull of the Paris basin. The former runs away to the north, reaching the sea through the Netherlands. The latter, briefly tempted to join the Seine at Orléans, changed its mind and flows toward the Atlantic, watering the Loire Valley. Thus it was nature that determined the location of the two centers of artistic activity, the valleys of the Meuse and the Loire, which rivaled Paris for many centuries. Paris would perhaps not have gained the advantage without the open fan of these rivers, so easily navigable, which provided deliveries of all kinds and from all points. Moreover, the Ile de la Cité, the island around which the city grew, made crossing the river easier: one of the most important trans-European routes established its passage there very early on.

Among the favors lavished on Paris by nature is the abundance of building stone found in the region. The sediments in the soils of the Ile-de-France have yielded many rocks useful in construction: clays, marls, molasses, sands, sandstones, millstones, soapstone, gypsum, and limestone. Since antiquity, Parisians have been charring the gypsum that is located in abundance beneath the city itself, under the hills of Montmartre and Belleville (fig. 1): the plaster of Paris is justly famous. The adjective "lutetian," derived from "Lutetia," the original name for Paris, has become the international designator for a geological stratum. Lutetian limestone itself exists in several varieties, each with its own proper name and particular use: *bancs francs*, which are durable and used for building exterior walls; *liais*, which are fine and hard and used for monumental sculpture; and *lambourdes* and *vergelés*, which are more fragile and used in protected locations and interior finishing. Once again, it was beneath the city itself that the material from which Paris is made was found. Until the fourteenth century Paris lived on its own resources. Parisian *liais* was even exported to Chartres and Provins, and lutetian limestone to England. But the urban quarries were not inexhaustible, and as demand increased, builders in the fifteenth century began to take their stone from the northern edge of the region, at Saint-Leu-d'Esserent on the Oise River, and by the sixteenth century from the southern edge, at Château-Landon, on the Loing.

### THE QUARRIES OF PARIS

*Paris is surrounded by quarries because the only way it was possible to build so many structures was by pulling stone from the heart of the earth. There are sizeable excavations under the surface of the avenues and neighborhoods of Paris … There is an underground city where streets, crossroads, and oddly shaped squares are to be found … When one ponders what supports the soil of much of this magnificent city, one is seized by an inner shudder and a fear of the effects of centripetal force … And one drinks, and one eats, and one sleeps in buildings which rest on this uncertain crust.*

Louis-Sébastien Mercier, Tableau de Paris
(Portrait of Paris), *1781–1790.*

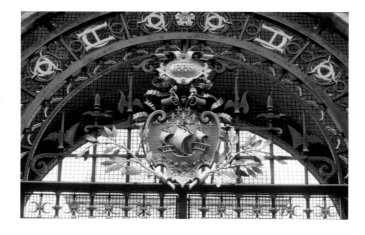

Opposite:

1. Quarries of Les Buttes-Chaumont at Belleville

2. Crest of the City of Paris
(Musée Carnavalet, Paris)

*The crest of the city of Paris was developed over the years. The boat appeared on the seal of the merchants of the Seine in the thirteenth century; the fleur-de-lis during the reign of King Charles V. The essential elements were established by the sixteenth century.*

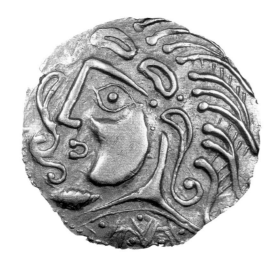

**3.** *Stater* (Gold Coin) of the Parisii (Bibliothèque Nationale de France, Cabinet des médailles, Paris)

*This coin was struck in the first half of the first century B.C. by the Parisii (the Gallic tribe from which modern Parisians are descended), representing on one side a head of Apollo or Athena and on the reverse a horse, based on the Macedonian stater.*

## THE GALLIC INSPIRATION OF PICASSO

*Picasso's inspiration for basing his "copy" of Courbet's* Maidens on the Banks of the Seine *on Gallic coins may have stemmed from an article by Georges Bataille in* Documents, 1929, *a very influential magazine in artistic circles between the wars. Comparing Greek coins with the interpretations of them done by the Gauls, Bataille adapts the eternal opposition of classic and barbarian civilizations to events of his own time. In painting his* Maidens, *Picasso was showing his opposition to the official Communist Party doctrine, which equated the Realism of Courbet with the ultimate expression of painting, an expression said to have been betrayed by modernity.*

On the other hand, it took several centuries before slate covered all of the rooftops of Paris. Slate is an imported product, and the sources of supply are, in fact, on the banks of the Loire and the Meuse, in Anjou and the Ardennes. From the beginning, flat terra-cotta tiles were the traditional roofing material in Paris, as is the case in nearly all of France. Indeed, their use persists widely in the countryside in the northern half of France. The violet-hued slate of the Ardennes came to color Parisian roofs only long after the bluish slate of Anjou. The use of slate is technically connected to the building of large, steeply pitched roofs such as those on churches, spires, and palaces' decorative peaks, the type of construction favored by most architectural styles from the late Middle Ages forward. In fact, more than just a building material, it is a concept of roof design, imported to Paris from the Loire Valley.

The last of Paris's natural assets, but not the least, is the fertility of the soil in the Ile-de-France. The boundaries of this "island of France," in which the Ile de la Cité stands out like the central device of an escutcheon, are difficult to define. The toponym "France," which today is used to designate the nation, originally referred only to a roughly diamond-shaped region northwest of Paris, bordered by the Oise, the Seine, the Marne, and the forest, and, curiously, referred to as an island owing to these watery borders; the metaphor was in wide use by the fifteenth century. At the beginning of the sixteenth century, the Ile-de-France became an administrative division, changing gradually so that Paris would be more centrally located within it. The toponym "France," referring to its original region only, has been preserved to our day; thus the Paris airport is appropriately located in the town of Roissy-en-France.

The Ile de la Cité, floating in the Seine, gave Paris its crest. A boat appeared for the first time in 1210 in the seal of the provost of the merchants of the Seine; in the seal from 1393 it is centered in a field of fleurs-de-lis. The sixteenth century gave the crest what was to be its ultimate arrangement (fig. 2) and added the motto *Fluctuat nec mergitur*: "it floats but does not sink." The boat of Paris has never sailed; it is the river that has swept away the years and the days along its shores. Some very curious phenomena of recurrent images have happened along these banks. The design on the gold *stater*—the coin of the Gallic Parisii (fig. 3)—combines lines and dots in a way that reappears in *Les Demoiselles de bord de Seine* (*Maidens on the Banks of the Seine*; fig. 5), painted by Picasso fifty years after his first stay in Paris. As Picasso scholars to date have not listed Celtic art among those primitive arts that consciously inspired the master, this resemblance must be attributed to the memory of the water. In fact Picasso's painting is based on *Les Demoiselles des bords de Seine* (*Maidens on the Banks of the Seine*; fig. 4), painted by Gustave Courbet just one century earlier. The singular x-ray view to which Picasso has subjected these poor young things, stripping them of their lovely flesh tones, was not executed in Paris, but in Vallauris, far from the original, and working from a reproduction. In this case, rather than merely being exported to the provinces and the world, the art of Paris has at last weighed anchor.

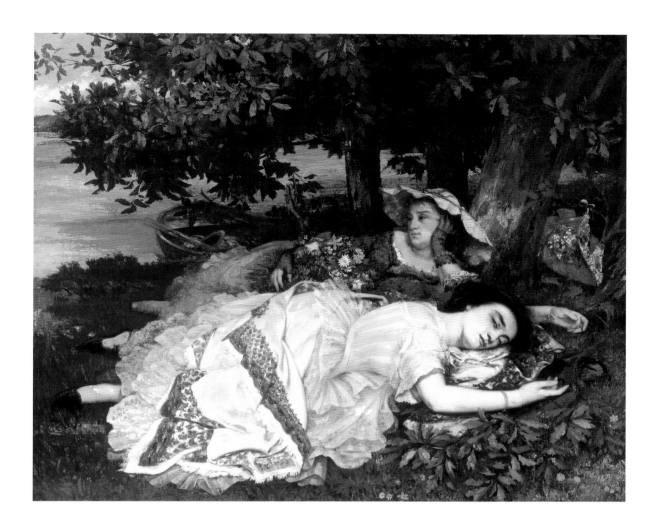

4. Gustave Courbet.
*Les Demoiselles des bords de Seine*
(*Maidens on the Banks of the Seine*),
1857. (Petit Palais, Paris)

*The painting, begun in Ornans in
1856 and finished in Paris in 1857,
represents two bathers on the banks
of the Seine near Paris.*

5. Pablo Picasso.
*Les Demoiselles de bord de Seine*
(*Maidens on the Banks of the Seine*),
1950. (Kunstmuseum, Basel)

*Picasso arrived in Paris in 1900.
Fifty years later he painted this
work, which was based on the
painting by Gustave Courbet.*

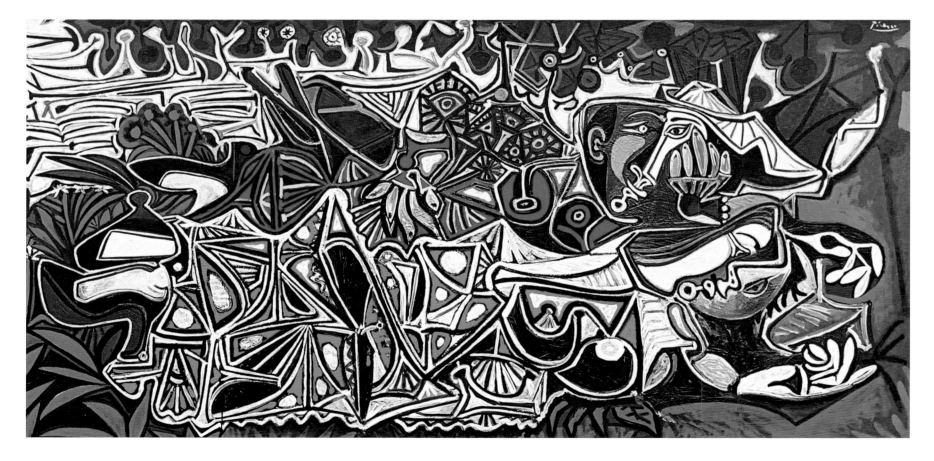

# PART ONE:

# ANTIQUITY AND THE MIDDLE AGES

# CHRONOLOGY – PART ONE

### B.C.

| | |
|---|---|
| c. 40 000 | Human presence in what is known later as Paris. |
| c. 4200 | Permanent habitat in Paris proven by the excavations of 1991 at Bercy. |
| c. 250–225 | Creation of the Gallic *oppidum* of Lutetia. |
| c. 100 | Appearance of the gold coinage of the Parisii. |
| 52 | Battle of Lutetia: victory of Labienus, lieutenant of Caesar, over the Parisii. Victory of Caesar over Vercingetorix at Alésia. |
| 50 | End of Caesar's conquest of Gaul. |

### A.D.

| | |
|---|---|
| between 14 and 37 | Under the reign of Tiberius, the Nautes erect a column in honor of Jupiter. |
| between 100 and 200 | Construction of three baths, an amphitheater, and a theater. |
| c. 250 | Martyrdom of the first bishop of Lutetia, Saint Denis. |
| c. 300 | Construction of a fortified wall to protect the Ile de la Cité from the Germanic invaders. Lutetia takes the name of Paris. |
| 313 | The Edict of Milan is issued, granting tolerance to Christianity in the Roman empire. |
| 355 | Invasion of Gaul by Franks, Alamans, and Saxons. |
| 360 | Julian is proclaimed emperor by his troops in Paris. |
| 373–397 | Saint Martin, bishop of Tours. |
| 451 | The Huns threaten Paris. Saint Geneviève dissuades the citizens from abandoning the town. |
| c. 475 | Construction of a church on the site of the tomb of Saint Denis. |
| 476 | End of the western Roman empire. |
| 481 | Clovis succeeds Childeric. |
| 486 | Saint Geneviève grants Clovis authority over Paris. |
| c. 496 | Battle of Tolbiac. Conversion of Clovis. |
| c. 502 | Interment of Saint Geneviève atop the hill which will bear her name, upon which Clovis founds the church of the Holy-Apostles, later called Sainte-Geneviève. |
| 511 | Death of Clovis. Division of his kingdom among his sons. |
| 542 | Childebert I, son of Clovis, founds the Sainte-Croix-Saint-Vincent church, future Saint-Germain-des-Prés. |
| 558 | Death of Childebert I. His brother, Clotaire I, succeeds him. |
| 561 | Death of Clotaire. Division of his kingdom among his sons. |
| 573–593 | Episcopate of Gregory of Tours. |
| 629 | Death of Clotaire II. Dagobert I succeeds him. |
| 639 | Death of Dagobert I; he is buried in the abbey of Saint-Denis. |
| 732 | Charles Martel defeats the Arabs at Poitiers. |
| 741 | Death of Charles Martel. |

| | |
|---|---|
| 751 | Pepin the Short elected king. Childeric III, last Merovingian king, deposed. |
| 768 | Death of Pepin the Short. Abbot Fulrad begins reconstruction of Saint-Denis. |
| 800 | Charlemagne crowned emperor in Rome. |
| 814 | Death of Charlemagne. Louis the Pious succeeds him. |
| 838 | Charles the Bald crowned king. |
| 840 | Death of Louis the Pious. |
| 845, 856, 861 | Raids by the Normans, who pillage and burn the city. |
| 866 | Victory of Robert the Strong over the Normans. |
| 875 | Charles the Bald crowned emperor in Rome. |
| 877 | Death of Charles the Bald. |
| 885–888 | Siege of Paris by the Normans. Odo, Count of Paris, son of Robert the Strong, resists the Normans. Emperor Charles the Fat negotiates their departure. |
| 888 | Odo proclaimed king of France over Charles the Simple. |
| 893 | Charles the Simple crowned king. |
| 911 | Treaty of Saint-Clair-sur-Epte, establishing the Normans in Normandy. |
| 915–917 | Construction of the first abbey church at Cluny. |
| 929 | Death of Charles the Simple in captivity. |
| 978 | Siege of Paris by Emperor Otto II. Hugh Capet forces him to lift the siege. |
| 987 | Election of Hugh Capet as king. Coronation at Reims. |
| 996 | Death of Hugh Capet. His son, Robert II the Pious, succeeds him. |
| 1003 | Marriage of Robert the Pious to Constance of Provence. |
| 1031 | Death of Robert the Pious. Succeeded by his son, Henry I. |
| 1060 | Death of Henry I. Succeeded by his son, Philip I. |
| 1066 | William of Normandy, king of England. |
| 1095 | Preaching of the First Crusade. |
| 1098 | Foundation of Cîteaux by Robert de Molesme. |
| 1102–1136 | Teaching of Abélard. |
| 1103 | Nomination of Guillaume de Champeaux to the head of the episcopal school of Paris. |
| 1108 | Death of Philip I. Succeeded by his son, Louis VI the Fat. |
| 1113 | Guillaume de Champeaux writes the rule of the canons of Saint-Victor of Paris. The adventure of Héloïse and Abélard. |
| 1115 | Founding of Clairvaux. |
| 1118 | Founding of the Order of the Knights Templar. |
| 1120 | Founding of the Order of the Prémontrés by Saint Norbert. |
| 1122 | Suger made abbot of Saint-Denis. |
| 1124 | Louis VI raises an army to confront the Emperor Henry V. First appearance of the Oriflamme of Saint-Denis as the battle insignia for the king of France |

and the war cry of the royal army: "Montjoye Saint-Denis!"

**1137** Death of Louis VI. Succeeded by his son, Louis VII the Young, husband of Eleanor, heiress of the duchy of Aquitaine.

**1146** Departure of Louis VII for the Second Crusade. Abbot Suger made regent of the realm.

**1151** Death of Abbot Suger.

**1160–1196** Maurice de Sully, bishop of Paris.

**1180** Death of Louis VII. Succeeded by his son, Philip II Augustus.

**1190** Before leaving for the Third Crusade, Philip Augustus orders the building of ramparts around Paris.

**1194** Following the loss of the royal archives during the battle of Fréteval, Philip Augustus decides to establish the archives in two copies, one of which must remain in Paris. This is the beginning of the establishment of Paris as the seat of the royal administration.

**1204** Conquest of Normandy and Poitou. Crusaders take Constantinople.

**1205** Conquest of Touraine and Anjou.

**1214** Victory at Bouvines with the participation of the Paris militia. Triumphal welcome of Philip Augustus on his return to Paris.

**1223** Death of Philip Augustus. Succeeded by his son, Louis VIII the Lion.

**1226** Death of Louis VIII. Succeeded by his son, Louis IX (Saint Louis). Blanche of Castile, the queen mother, is regent. The late king's other sons are given various regions: Robert is given Artois, Charles is given Anjou and Maine, and Alphonse is given Poitou.

**c. 1250** Constitution of the *Curia Regis*, or Parliament, and its first proceedings, limited to judicial matters.

**1252–1259** Saint Thomas Aquinas teaches at the university.

**1257** Founding of a college by Robert de Sorbon, the future Sorbonne.

**1267** The Florentine, Brunetto Latini, writes *The Treasure* in French.

**1268** *The Book of the Trades of Paris*, in which the Royal Provost, Etienne Boileau, lists the statutes of 132 Parisian trades.

**1270** Death of Louis IX at Tunis. Succeeded by his son, Philip III the Bold.

**1285** Death of Philip III. Succeeded by his son, Philip IV the Fair.

**1302** The first Estates General of the northern provinces convene at Notre-Dame. Philip IV convened them to get support in the struggle against Pope Boniface XIII.

**1304** Establishment of the moneychangers on the Grand-Pont, which takes the name of Pont aux Changeurs or Pont au Change. Foundation of the College of Navarre by the queen, Jeanne, who is also queen of Navarre.

**1305** Election of the pope, Clement V, who moves the Holy See to Avignon.

**1307–1314** Arrest, trial, and execution of the Templars in France.

**1314** Death of Philip IV the Fair. Succeeded by his son, Louis X the Quarrelsome.

**1316** Death of Louis X the Quarrelsome. Succeeded by his son, John I the Posthumous, then by Louis X's brother, Philip V the Tall.

**1322** Death of Philip V. Succeeded by his brother, Charles IV the Fair.

**1328** Death of Charles IV. End of the direct Capetian line. Accession of Philip VI of Valois.

**1332** Condemnation of Robert d'Artois; he leaves for the court of England.

**1333–1334** Death of the painter Jean Pucelle.

**1346** Defeat at Crécy.

**1348** Beginning of the great Black Death, which lasts two years.

**1350** Death of Philip VI. Succeeded by John II the Good.

**1354** Etienne Marcel, provost of the merchants.

**1356** Defeat at Poitiers. John the Good taken prisoner. Start of construction of new ramparts, known as the Charles V wall.

**1357** Regency of Charles, the dauphin (or crown prince).

**1358** Etienne Marcel incites Paris against the dauphin and opens the city to the English. He is killed by supporters of the dauphin, who drive the English from Paris.

**1364** Death of John the Good in London. Succeeded by his son, Charles V the Wise.

**1367** Urban V leaves Avignon for Rome.

**1380** Death of Charles V. Succeeded by his son, Charles VI.

**1392** Madness of Charles VI. His uncles take the reins of power.

**1407** Assassination of Louis d'Orléans, brother of the king, by killers hired by the duke of Burgundy, Jean-sans-Peur (John the Fearless).

**1414** Henry V, new king of England, lays claim to the Plantagenet inheritance in France.

**1415** Defeat at Agincourt.

**1420** Treaty of Troyes, giving France to the English king.

**1422** Deaths of Charles VI, king of France, and Henry V, king of England. Henceforth the kings rarely reside in Paris.

**1423** Oath of allegiance by the Parisians to the duke of Bedford, representative of the king of England.

**1429** Coronation of Charles VII, son of Charles VI, at Reims.

**1431** Joan of Arc burned at the stake in Rouen. Henry VI, young son of Henry V of England, crowned king of France at Paris.

**1436** Charles VII takes Paris.

**1450** Victory at Formigny. End of the Hundred Years War

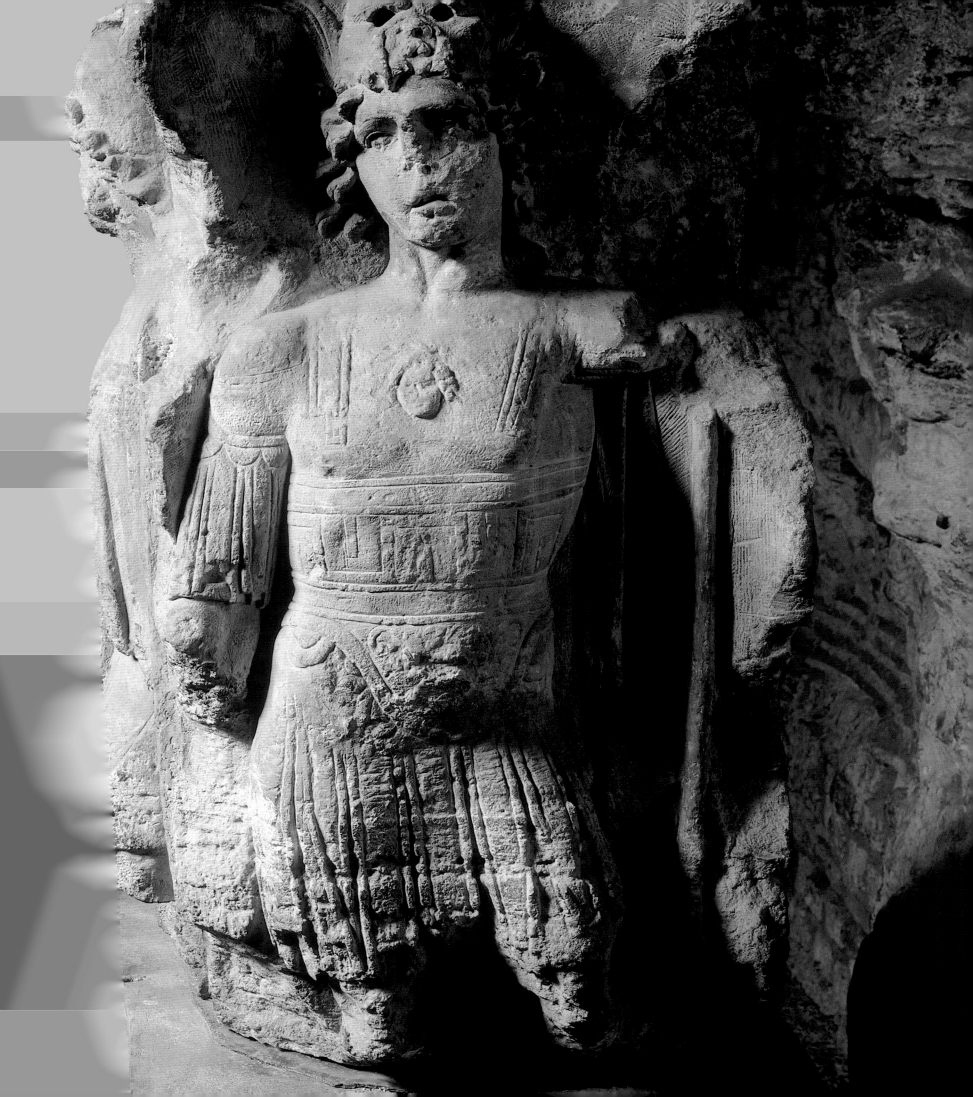

# Chapter I
# THE LAYERING
# OF PEOPLE, RELIGIONS,
# AND DYNASTIES
## (UP TO 1140)

Situated in a basin filled with geologic layers, the city of Paris itself does not appear until the most recent sedimentation: the human one. The site certainly saw human activity in the Paleolithic period. But the earliest signs of human occupation date back only as far as the Neolithic: in Bercy, flint axes, ceramics, statuettes of women, and even dugouts have been found. These waterlogged tree trunks give evidence of navigation on the Seine around 4500 B.C.

Of the Neolithic culture that was named "Seine-Oise-Marne" after the three rivers of the Ile-de-France, and illustrated by the sites of Pincevent and Etiolles (villages that lent their names to periods of prehistory), nothing remains in Paris itself, where they were doubtless erased. In spite of massive destructions, a few megaliths have been preserved in the Ile-de-France. The Rue de la Pierre-Levée ("Street of the Raised Stone") is a reminder of a menhir, those great standing stones of pre-history, discovered in the middle of Paris at the end of the eighteenth century. The enigmatic sixteenth-century painting of Geneviève, patron saint of the city, in the middle of a cromlech on the Lendit plain between Paris and Saint-Denis (fig. 10), is an example of a surprising syncretism. What meaning must the Renaissance have seen in the improbable blending of megalithism and Christianity, separated from each other by several centuries of Gallic and Roman paganism? On the whole the Paris vestiges of civilizations that preceded the arrival of the Gauls are modest: nothing to compare with the sumptuous treasure of Vix, in the high valley of the Seine (500 B.C.), made up primarily of objects of Greek manufacture.

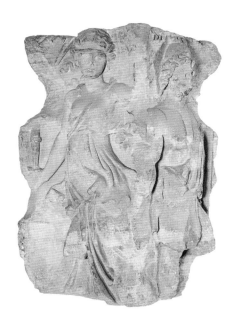

**1–2. Pillar of Saint-Landry
(Musée du Moyen Age–
Thermes de Cluny, Paris)**

*This votive pillar was found on the site of the church of Saint-Landry on the Ile de la Cité. Its bas-reliefs present three divinities, probably Venus, Mars, and Vulcan. Its style dates it from the period of Hadrian (117–138).*

In the third century B.C., the Parisii, a Celtic people, established homes on the Ile de la Cité, which, under the name of Lutetia, became their *oppidum*. Simultaneously, the name of the Parisii cropped up in Yorkshire. Lutetia, so named for the first time in Caesar's *Commentaries on the Gallic Wars*, was indeed an *oppidum*, a fortified town with walls around the edges of the island. In Latin terminology, the word *civitas* meant a territory. Through a semantic shift, examples of which abound in Gaul, the word came to mean "city," as in modern usage. At the same time, the name of the people occupying the territory was applied to the town. Thus, Lutetia became Paris, but not before the beginning of the fifth century.

The cultural unity of France, as well as the diversity of its provinces, was inherited from Gaul, from these Celts who were divided into so many tribes. In his book *French Art* (1993), André Chastel pointed out two characteristics of Gallic civilization. First, the taste for finery: Gallic warriors fought bare-chested, more adorned than armed, something that very much amazed Caesar. Fashion and the manufacture of luxurious and beautiful objects derive from this penchant for personal adornment. More subtle is what Chastel called the *interpretatio gallica*, the capacity of the inhabitants of Gaul to borrow and to interpret. Caesar recognized in the Gauls "a singular capacity for imitation." The *stater*, the Gallic coin, with a head of Apollo or Athena on one side and the horse on the other, was taken from the Macedonian *stater* or from the coins of Tarentum.

The *staters* of the Parisii were among the most beautiful, most finely minted, and most stable in terms of monetary value, testifying to the constant prosperity of Parisian commerce. *Staters* of the Parisii have been found as far away as Durham, in England. Parisian minting was active between 121 and 52 B.C. In 121 the king of the Arvernes, the powerful Gallic tribe into which Vercingetorix would be born and which had long held a sort of monopoly on coin making in Gaul, was beaten by the Romans. Minting was then scattered among various sites.

### 3–6. The Great Baths of the North or Baths of Cluny

*These baths, the largest in Lutetia, were situated on the northern edge of a city concentrated on the Left Bank of the Seine. They began to be called the Baths of Cluny when they became the property of the abbots of the famous Burgundian abbey. They were built at the end of the second century or at the beginning of the third century A.D., probably financed by the Nautes. They included a basilica, a palaestra, a tepidarium, a frigidarium, and a caldarium. The frigidarium (above), the only section where the structural members are totally preserved, is a room over sixty-five feet wide.*

In A. D. 52, Vercingetorix was defeated at Alésia, by Caesar. The Parisii had participated heavily in the war effort. The very year when Gaul, almost completely united for the first time, was defeated, Lutetia was captured by one of Caesar's lieutenants. Wars involving France have almost always been concluded in Paris.

Lutetia under Roman rule was an average city of a few thousand inhabitants; it was subordinate to Lyons, then to Sens, in the imperial administrative hierarchy. Until the seventeenth century, the diocese of Paris was under the authority of the archbishop of Sens. Lutetia played a capital role only in the defense of the empire, which was threatened as early as the third century by barbarian incursions, which sporadically reached the Seine. Two emperors campaigning on the Rhine established their winter quarters there: Julian in 358, 359, and 360; and Valentinian in 365. It was in Lutetia in 360 that Julian was proclaimed Augustus by his troops.

The Roman city spread out on the Left Bank, along the slopes of the hill, known as the Montagne Sainte-Geneviève. Like all Roman cities, Lutetia has its *cardo*, the principal axis of the Roman town plan, its forum, and its monuments. The Roman road which traversed the city and the island from north to south, and which is still visible today in the Rue Saint-Martin on the Right Bank and the Rue Saint-Jacques on the Left Bank, traces the *cardo*. The forum, the main square, bordered by the *cardo*, was on the Montagne (Rue Soufflot).

In the second century, it included a temple, a basilica, and porticoes, following a pattern that seems to have been imposed by the Roman authority on several cities of Gaul, but Lutetia's forum was among the largest.

The city had an arena, a theater, perhaps a circus, a temple at the top of Montmartre (the mountain on the Right Bank), three thermal baths, and an aqueduct bringing water from Rungis. The arena was an amphitheater with a stage (built at the end of the first century A. D.): the combination of an amphitheater for combats and a stage for theatrical productions was rather common in Gaul. Lutetia's amphitheater had a capacity only slightly smaller than that of Nimes or Arles, very important cities in the empire.

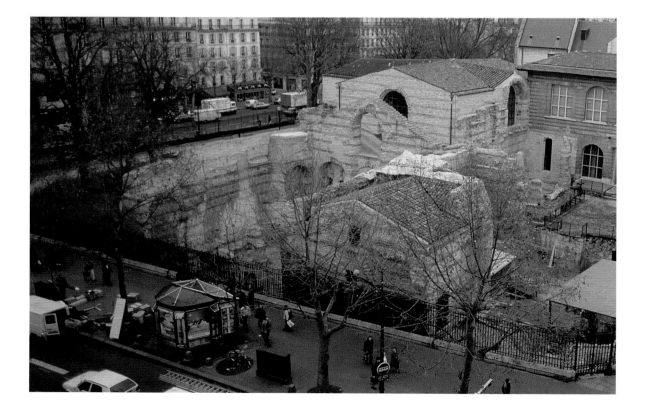

Key:

A – *Basilica with palaestra*
B – *Corridor connecting the basilicas*
C – *Tepidarium*
D – *Frigidarium*
E – *Caldarium*
F – *Chapel*

### The Great Roman Baths

The ruins of the great Roman baths, built at the foot of the Montagne Sainte-Geneviève, not far from the Seine, constitute the largest monument surviving from Roman Lutetia (figs. 3–6). For many years they were mistakenly identified as Emperor Julian's palace, but the latter was at the western tip of the island, where the royal palace of the Franks would later be established. The baths were built in the late second or early third century following the technique that was so typical of Roman construction: a field of square stone traversed by courses of brick at regular intervals. The only room of which the structural members are totally preserved is the *frigidarium*. The springings of the great groin vault, in the upper corners of the room, are decorated with prows of boats, which are presumed to commemorate the sponsors of its construction, the Nautes. These were the traders and boatmen who controlled commercial shipping on the Seine. The organization they put in place was to play the primary factor in the development of a Parisian municipal structure and middle class. The Nautes naturally practiced patronage by the elite, to which Gaul owed most of its monuments. They were the ones who built the baths.

### The Pillar of the Nautes

They also commissioned a votive column, known as the pillar of the Nautes (figs. 8–9). The four sides of the pillar are illustrated with representations of Gallic and Roman divinities, and on top was a statue of Jupiter. The design was original and would be imitated in Gaul. But the style was an unpolished version of Greco-Roman art. Five centuries after the sculptor Praxiteles, the Parisii were still relatively unskilled in monumental sculpture. It might give one second thoughts about the *interpretatio gallica*, which was nonetheless carried out so successfully by the goldsmiths; but the medium was different, and coins, a tool for commerce, were doubtless better adapted to the expression of the Celtic genius. On the other hand, the choice of gods represented demonstrates the Gaulish capacity for religious syncretism. The Gauls may have adopted Roman gods, perhaps somewhat opportunistically, but they held onto their own all the same: their religion would also survive the advent of Christianity, as evidenced by the ex-votos discovered in the springs at the sources of the Seine and dedicated to Sequana, the goddess of the river.

**7. Terra-Cotta Ring-Shaped Drinking Flask, third or fourth century. (Musée Carnavalet, Paris)**

*This drinking vessel, found in 1807 in the excavations of the Hôtel-Dieu on the Ile de la Cité, has a Latin inscription meaning: "Hostess: fill my flask with beer/Landlord, have you any peppered wine? Yes, I do. Fill this, give it here." It is most likely an imported article. Its ring shape is reminiscent of terra-cotta Corinthian aryballas and glass Roman aryballas.*

The pillar of the Nautes had a certain posthumous fame worth mentioning. Recovered in 1710 on the island, it was immediately invoked as evidence of the antiquity of the nation. And since ancestry was then considered an important cultural and political asset, this discovery was the topic of discussions in all the courts of Europe. Leibniz spoke of it in a letter to the elector Sophia of Hanover. The pillar of Saint-Landry (a votive pillar found near the church of Saint-Landry; figs. 1–2) testifies to a more complete Romanization and a greater mastery of the techniques of monumental sculpture.

Excavations have uncovered vestiges of sigillated pottery, that is, pottery stamped with makers' marks. Such stamping was usually reserved for items considered somewhat luxurious. Their presence in excavations is an excellent indicator of an active international trade. Indeed, stamped pottery is invaluable to archeologists since it is imprinted with a mark indicating the place of manufacture. Production of stamped pottery was particularly concentrated. The Gallic workshops, which rivaled those of Arezzo in Italy, were for the most part located in the center of Gaul. It would not be until several centuries later that "made in Paris" became a guarantee of prestige for consumers in markets around the world (fig. 7).

By the middle of the fourth century, most of Lutetia had retreated behind the walls that fortified the island. A new, secular basilica had been built within these ramparts. In fact, the fortification of Gallic cities at the end of the third century and in the first half of the fourth, as a reaction to barbarian incursions, was a generalized phenomenon. Squeezed into the seventeen acres of its island, Lutetia was, in terms of its total area, one of the smallest cities in Gaul. A score of cities were larger in area, some of them even much larger: two to three times bigger for Amiens, Bordeaux, Bourges, Nantes, Orléans, Reims, Rouen, Saintes, Sens, Tournai, or Troyes; quadruple for Poitiers. The biggest city in Gaul was then Metz, with over 170 acres on its peninsula between the Meuse and the Rhine.

And yet the myth kept growing. Emperor Julian, who wrote the earliest description of the city, already speaks of it tenderly, as though it were a woman, calling it his "dear little Lutetia."

**8–9. Pillar of the Nautes.
(Musée des Thermes, Paris)**

*This votive pillar, discovered in pieces, was erected by the Parisii Nautes during the reign of Tiberius (14–37): an inscription names the honoree and donors. It was probably surmounted by a statue of Jupiter, to whom it was dedicated, along with the emperor. The faces are decorated with bas-reliefs representing gods of Rome (Jupiter, Vulcan, Castor and Pollux, Mars, Mercury, Venus, and Fortune), and of Gaul (Esus, Tarvos, Trigaranus, Cernunnos, and Smertios). The pieces of this monument are conserved in the Musée des Thermes.*

Gregory, elected bishop of Tours in 573 and author of the *Historia Francorum*, attributed the Christianization of Gaul to the preaching of direct followers of the apostles, among whom he named Denis, who is considered the first bishop of Paris. The early evangelizing did indeed date from the first century, but it took place mostly in the south and in the cities along the Rhône, as far north as Lyons, the parts of Gaul most directly in contact with Rome. However, inspired by Gregory of Tours, churchmen would long intone the anthem

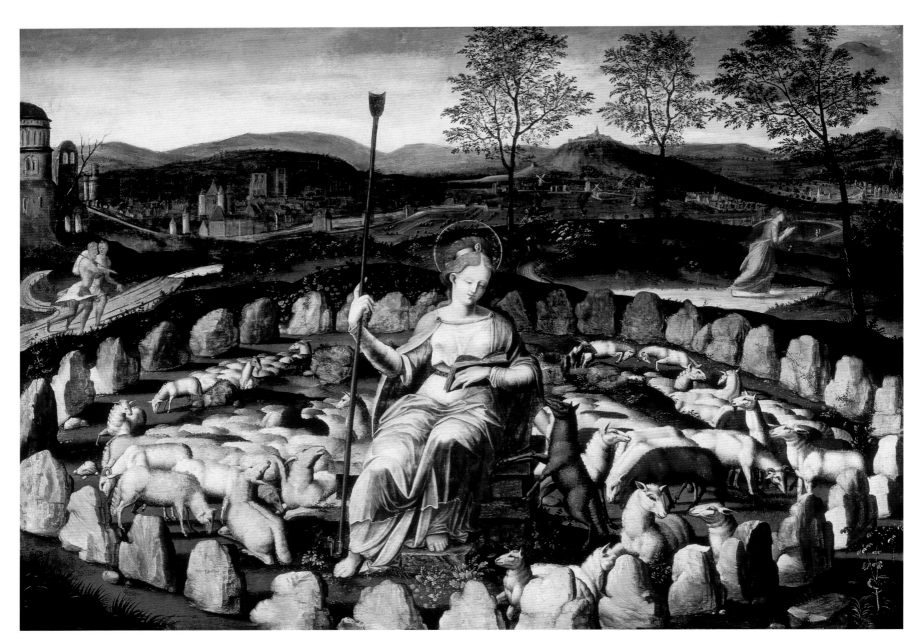

**10. Anonymous. *Saint Geneviève Watching over Her Sheep on the Lendit Plain*, second half of the sixteenth century. (Musée Carnavalet, Paris)**

*Geneviève, a farmer's daughter born in Nanterre about 422, came to live in Paris when her parents died. The spiritual influence that she exerted over the Parisians through her exemplary ascetic life made of her the initiator and leader of the victorious defense of Paris against the Huns of Attila. The oldest representations of Geneviève honor the saintly character: at the Louvre there is a monumental statue (thirteenth century) from the portal of the church of Saint-Geneviève, built over the tomb of the heroine. This painting is perhaps the first depiction of Geneviève as a shepherd, a theme which will be consecrated by classical iconography, drawing a parallel between the cults of Geneviève liberating*

*Paris and Joan of Arc liberating France. The view of Paris in the background (the Bastille, Notre-Dame Cathedral, the keep of the Temple) places the scene in the Lendit plain between Paris and Saint-Denis. Geneviève surely looked after sheep at Nanterre, east of Paris, and probably not to the north on the Saint-Denis road. But it was she who founded the first church over the tomb of Denis, apostle of Paris. Did a cromlech, a prehistoric circle of standing stones, exist on this plain, or is it an invention of the painter, who used it for its symbolic value? For no compelling reason, the painting, which is the central panel of a dismantled polyptych, is attributed to the school of Fontainebleau. It is said to be the work of one Jérôme Penne, not known otherwise: might he be a member of the Penni family, made famous by Luca Penni, who died in 1557?*

of the early conversion of Gaul to Christianity. The stimulation of the growth of Christianity was not the only benefit which flowed from the martyrs' wounds: the flowering of myth and imagery was also enriched, the hero of which, in Paris, was Saint Denis. If, in fact, Denis and his followers, Eleutherius and Rusticus, were beheaded on Montmartre, it was in the third century at the earliest (around 250). The least questionable of Denis's miracles is obviously that he picked up his head and walked all the way from the mountain of martyrs (*Mons martyrum*, or Montmartre) to the plain of Lendit, where he was buried!

The Edict of Milan (313), which granted Christians the freedom to practice their religion, is the work of Constantin the Great: the first Christian emperor, the founder of Constantinople, the reunifier of the of the empire, and the builder of churches in Rome, Constantinople, Jerusalem, Bethlehem, and Trier. Julian, who loved Lutetia so much, was his nephew; he had been born a Christian, but his renunciation of Christianity earned him the nickname the Apostate. Martin, one of Julian's soldiers, was the first proselytizer of northern Gaul. In 373, he was elected to the Episcopal seat of Tours, which Gregory would later occupy.

*The Basilica*
It is during the fourth century that Gaul saw the founding of what we now call the cathedral complexes, the buildings surrounding a bishop's residence. The cathedral complex consists of at least of two churches, parallel and oriented toward Jerusalem, one for the baptized, the other for the catechumens; a baptistery; and a *domus episcopi*, or Episcopal palace. The Parisian cathedral complex occupied the eastern end of the island, counterbalancing the imperial palace on the western end. The design of these churches has been called "basilical" because it is identical to the civil basilica, initiated by Constantin. The Christian basilica is actually just a vast hall made up of several naves (usually three), often with a transept and an apse. The Christian basilica of Lutetia, excavated under the square of the current cathedral, had five naves; the eastern portion, buried under the cathedral, could not be reconstituted. But the dependence on Constantinian models is unquestionable: there may have been an eastern apse. The naves were separated by rows of marble columns, the roof was wooden, and the walls were covered with mosaics. Its length, estimated at over 200 feet, made it one of the largest churches in Christendom, whether it dates from the fourth or the fifth century. Archeologists do not agree on its dating. For some, it was built by the Merovingians; for the others, it was too large to have been built after the collapse of the Roman empire. The Italian poet, Fortunatus, future bishop of Poitiers, who came to France to make a pilgrimage to Saint-Martin of Tours in 565, wrote a poem about Lutetia that would seem to justify the later date. About the basilica, he wrote: "If one recalls the disposition of Solomon's temple, this church is equal to it in its art, and it is more beautiful because of faith. ... A magnificent sanctuary rises on columns of marble. ... Illuminated by windows...by the agility of the artist, it has captured daylight within its walls. The light which wanders following the whims of Aurora washes over its paneling." And he adds: "Such is the immortal gift offered to his people by the pious king Childebert." So the question would seem settled. But the Merovingian Childebert I is also the founder of the church that would be called Saint-Germain-des-Prés, on the Left Bank. For this reason, it cannot be excluded that the panegyric was not addressed to the basilica on the island, that is, the first cathedral, but rather to the church on the Left Bank.

Beyond the island, both banks of the Seine were dotted with isolated funereal basilicas, around which Parisian parishes would develop.

*This tomb of Childebert, son of Clovis and founder of Sainte-Croix-Saint-Vincent Basilica (Holy Cross Saint Vincent Basilica), which later became the abbey church of Saint-Germain-des-Prés, was originally in the choir of the latter, where Childebert had been buried. But Childebert died in 558 and the*

**12. Saint-Germain-des-Prés. Statue of Childebert I, from Portal of the Refectory. (Musée du Louvre, Paris)**

*This second posthumous depiction of Childebert, the founder of the abbey, graced the central pillar of the refectory built between 1239 and 1244.*

### 3 – THE MEROVINGIANS

The barbarians swept over the empire in waves. Around 350, Franks entered Gaul, which they divided into kingdoms, which in turn were invaded by the Huns in 450. In 451, Geneviève convinced the people of Paris to resist Attila instead of buying him off with tribute. The example of Paris inspired the resistance of Gaul. In the same year, Attila was defeated by a coalition of Romans, Goths, and Franks, the latter placed under the command of their king, Merovaeus. Geneviève also opposed, albeit peacefully, the efforts of Clovis, grandson of Merovaeus, to establish his capital in Paris: Paris must have already been profoundly Christianized since Clovis was unable to enter until he converted to Christianity. It is a well-accepted fact that the conversion of Clovis

*tomb was not made until the mid-twelfth century. The technique, intentionally archaic, consists of recessing the figure into the thickness of the stone. On the other hand, the iconography is innovative: this gisant is the earliest of such reclining effigies known in northern France. Moreover, the figure is also presented as a donor: the model of the church which he carries conforms to what we know about the apse of Saint-Germain-des-Prés, constructed in the middle of the twelfth century.*

had considerable political consequences for the Merovingian dynasty as well as for the entire realm of the Franks and, in the longer term, for France. In the conquest of Gaul, Clovis was everywhere supported by the bishops, the only authorities with any effective power since the fall of the western Roman empire in 476. The conversion of Clovis on the eve of the battle of Tolbiac (around 496) was likened by Gregory of Tours to that of Constantin on the Milvius bridge. It prefigured that of Henry IV who, to enter Paris, had to do so through the church.

*The Church of Saints-Apôtres (Church of the Holy Apostles)*
The proof that Clovis took himself for a modern Constantin is his founding, in 508, of the church of Saints-Apôtres, intended to receive his remains, as well as those of his wife Clotilde and of Geneviève. He chose a site at the top of the hill which, like the church, would later be given the name of the saint. Its model was the church of

Saints-Apôtres built by Constantine in Constantinople as the mausoleum of the imperial couple. This is why it is not impossible to credit Clovis with the construction of the five-nave cathedral of the Ile de la Cité, which was as large as Saint-Peter's in the Vatican, and Saint John the Lateran, both built by Constantine himself.

The construction of the cathedral is more probably attributable to Clovis's son, Childebert I, who bore the title of king of Paris. The cities of Reims, Metz, Soissons, and Orléans were also chosen as capitals for the kingdoms resulting from Clovis's succession. The Franks considered their kingdoms as property to be divided as inheritances. This practice, which put recent conquests into doubt with each passing generation, was perpetuated until the end of the Middle Ages in the form of apanages. Throughout the Merovingian dynasty, Paris was the capital of a kingdom that, over the course of many divisions and reunifications of territories, managed to extend sporadically to the whole of Gaul.

### The Church of Sainte-Croix-Saint-Vincent

In 542 Childebert I also founded a church that he named *Sainte-Croix-Saint-Vincent*, intended to serve as the mausoleum for himself and his wife; he charged Germain, bishop of Paris, to found a monastery there. The bishop, who was buried there near the royal couple, would later be honored when the monastery was dedicated as Saint-Germain-des-Prés. According to the biography of Saint Droctoveus, first abbot of Saint-Germain-des-Prés, Childebert's church had a floor decorated with mosaics, a gold ceiling, and a bronze roof.

We can easily see the importance of these Merovingian foundations that created two famous and powerful abbeys, and perhaps also the cathedral, which was at first dedicated to Saint Stephen. It is astonishing that nothing is left of these works given the Capetians' obsession with maintaining the illusion of a seamless continuity with their ancestors (figs. 11–12).

**13–14. The Tomb of Queen Arégonde**

*Queen Arégonde (or Arnegonde), one of the wives of Clotaire I, son of Clovis, was buried at Saint-Denis in the second half of the sixth century. Vestiges uncovered by excavations have made possible the reconstitution of the princess's costume, in which jewelry (below) played an important role.*

### Arégonde's Tomb

Childebert's brother, Clotaire I, who reunified the realm (all the while keeping the title of king of Paris), would probably not be mentioned in a book about the art of Paris had it not been for excavations at Saint-Denis that led to the discovery of the tomb of one of his wives, Arégonde, who had been buried with her jewelry (figs. 13–14). These jewels have a place of honor in the history of the goldsmiths' trade in Lutetia and Paris, among the Gallic *staters* and the cross of Saint Eligius (figs. 17–18). Textile fragments found in the tomb have made possible the description of the first Parisian frock: "The deceased wore a fine woolen shift, a short dress in purple silk under a wide belt; over these she wore a long, dark red tunic, also made of silk, with sleeves embroidered in gold. On her head was a satin veil which came down to her breast. From her shoulders to her feet, she lay upon a sort of cape of light red wool. She wore thin leather slippers tied on with straps" (Michel Fleury).

*Saint-Denis*

Dagobert I was reputed to have founded the church of Saint-Denis. In fact, around 475, Saint Geneviève had already had a church built over the tomb of Denis and his two followers. A large suburban cemetery grew up there, at the edge of this "national highway" running out of Paris toward the north. Many Christians had themselves buried *ad sanctos*, that is, close to graves of martyrs. A Benedictine monastery had been established in this location before the beginning of Dagobert's reign in 628. The reason that the foundation of Saint-Denis by Dagobert was believed to be the first, as noted in the *Gesta Dagoberti* (834) and illustrated in the monastic *scriptoria* (fig. 15), is probably that Dagobert, benefactor of the abbey, had been buried there, thus establishing the first royal tomb in what was to become the cemetery of kings. Over this tomb, the Capetians raised a monument which still exists today.

**15.** *Le Songe de Dagobert* (*The Vision of Dagobert*), illumination from the *Lectionary of Saint-Germain-des-Prés*, eleventh century. (Bibliothèque Nationale de France, Paris)

*The lectionary containing this image was commissioned in the middle of the eleventh century by Adélard, abbot of Saint-Germain-des-Prés, from Ingelard, a monk of the abbey and the most talented painter of the scriptorium, or the workshop where monastic manuscripts were illustrated. This page represents the vision of Dagobert (prostrate at the bottom of the picture) in which Saint Denis and his two disciples, Rusticus and Eleutherius, appear ordering the Merovingian king to found the abbey of Saint-Denis. The vision was written about in the Gesta Dagoberti (834). The tale came two centuries after the legendary founding; the picture came four centuries after.*

Saint Eligius, patron saint of the goldsmiths, treasurer and counselor of Dagobert, was born near Limoges where he was trained in the art of enamel. He created on the Ile de la Cité a workshop for goldsmiths, which became very influential. The most famous of its works was the cross donated by Dagobert to the monastery of Saint-Denis, which is known through a painting from the early sixteenth century (figs. 17–18). Several examples of Merovingian contributions are preserved in the crypt of Saint-Denis and also on Montmartre, where the first Frankish dynasty had built a church; capitals (figs. 19–24), which are the only remains, were reused *in situ* for the church of Saint-Pierre-de-Montmartre.

**16. Founding of Saint-Martin-des-Champs, manuscript. (British Museum, London)**

*The first chapel of Saint-Martin, built in the fields along the Paris-Saint-Denis road and destroyed by the Normans, is first discussed in a charter from 709–710. This illumination, virtually contemporary with the founding of the collegiate church of Saint-Martin-des-Champs by King Henry I, is in a manuscript relating the history of this house. King Henry is represented twice. Below, the canons receive from his hands the charter of foundation. The church was dedicated in 1067 in the presence of Philip I, son of Henry I. In 1079 it became a Benedictine priory, attached to the abbey of Cluny. The eleventh-century church has been identified through excavations.*

**17–18. Master of Saint-Giles.**
*La Messe de Saint-Gilles*
*(The Mass of Saint Giles), c. 1500.*
*(National Gallery, London)*

*This painting, executed by a Flemish painter working in Paris between 1495 and 1516, was part of a polyptych devoted to the life of Saint Giles, probably given by King Louis XII to the Parisian church of Saint-Leu-Saint-Gilles. The name of the painter, called the Master of Saint-Giles, has never been discovered. The painting is first of all one of those invaluable and rare witnesses to the activity of the painters known as the "French primitives." Its real value is what it depicts: not for its subject, which is related to the hagiography of Charlemagne, but for the location it describes. An angel is bringing to Saint Giles, officiating at Saint-Denis, a parchment on which is written the unspeakable sin of Charlemagne, shown kneeling at the foot of the altar. The altarpiece was originally the front panel of an altar base donated by Charles the Bald, probably made between 865 and 877, and which later served as a reredos. The cross was made by Saint Eligius and given to the abbey by Dagobert in the years 620–630. Behind the altar one can see the miniature chapel done by Pierre Rozette, donated to the abbey by Charles VI, and upon which was placed the reliquary of the body of Saint Louis, commissioned in 1368 by Charles V from his goldsmith, Hennequin Du Vivier. This painting makes known four major pieces of*

*metalwork from the three dynasties, all of which have disappeared today. At the right, we also see the tomb designed by Saint Louis (c. 1250) for the Merovingian, Dagobert, who has been improperly identified as the founder of the abbey.*

In 751 the last descendant of Merovaeus was deposed and Pepin, son of Charles Martel, who gave his name to the new dynasty, was elected king of the Franks. In order to erase what his abbey owed to the Merovingians, Abbot Fulrad hurried to Rome to arrange the recognition of the new king by the pope. Pepin the Short renewed the alliance formed under Clovis between the church and the Frankish monarchy. He came to the aid of the papacy, which was threatened by the Lombards, re-established the authority of the episcopal hierarchy, and reformed the clergy: it was under his administration that the clerics close to the bishop were organized into chapters of canons, governed by a rule, and living in cloistered communities attached to the cathedrals.

Pepin was both crowned and buried at Saint-Denis. His sons, Carloman and Charles, financed the sumptuous reconstruction of the abbey church, begun by Fulrad in 768, at the death of Pepin, and finished in 775. This church was some forty feet longer than the cathedral on the Ile de la Cité; while it had only three naves, on the other hand it had a transept, a crossing tower, and an apse. The crypt, organized around the tomb of Saint Denis, was inspired by Roman martyrs' tombs. Fulrad had brought the plan for his church back from Rome.

The future of Saint-Denis seemed assured. Charles, known as Charlemagne, who would bear the title of emperor, had made known his intention to be buried next to his father, Pepin. But the extraordinary development of the empire incited him to transfer his capital and his tomb to Aix-la-Chapelle, between the Meuse and the Rhine. We know that Charlemagne's reign was a period of splendor for abbeys, which spread the teaching of reading and writing, an endeavor strongly encouraged by the emperor. The *scriptoria* of abbeys copied out in the new alphabet, Caroline script, the texts that the illuminators illustrated. The principal centers of Carolingian illumination were at Saint-Rémi in Reims and at Saint-Martial in Limoges. Abbeys were competitive. Reims had the advantage, since it was the city where Saint Rémi had baptized Clovis: it remained the city of coronations. But to Saint-Denis was entrusted the custodianship of the *regalia*, the insignia of royal power. New abbeys such as Centula (Saint-Riquier) in Picardy, founded and heavily endowed by Charlemagne, joined in the competition.

To gloss over the fact that it had been somewhat neglected by the most famous of the Carolingians and to heighten the prestige of its patron saint, the abbey Saint-Denis had recourse to some unusual measures. In defiance of all logic and in full awareness of what he was doing, Abbot Hilduin in his *Vita Sancti Dionysii* (c. 835) asserted that the Denis of the abbey was none other than Dionysius the Areopagite, disciple of the apostle Paul and bishop of Athens, said to have been sent by Rome to evangelize Gaul. The treasury of the abbey acquired rich and beautiful objects, fraudulently described as gifts from Charlemagne. Some of these were given only later by Charles the Bald, grandson of Charlemagne, in particular the admirable lower altar panel, which was later used as an altarpiece and is shown in the painting of the *Mass of Saint Giles* (figs. 17–18). This masterpiece had probably come out of the famous Mosan metal workshops. The center of the empire was very definitely located between the Meuse and the Rhine. But farther afield, the empire was threatened by the Normans. Charles the Bald was able to contain them only at the price of enormous tributes. Historians have shown that, of all the invasions that succeeded one another in Europe, the last ones, those of the Normans, were the most decisive for the fate of the continent. Imperial prestige, to which Clovis had aspired and which Charlemagne had restored through his affirmation of the will to restore classic civilization, gave evidence of true continuity through the perpetuation of the art of Rome, at least in its late forms, from the time of Constantin. The Corinthian capital was still the model for Merovingian and Carolingian sculpture (fig. 19). Paris, although somewhat neglected by the Carolingians, was to provide the resistance to the Normans and the continuity of royal dynasties.

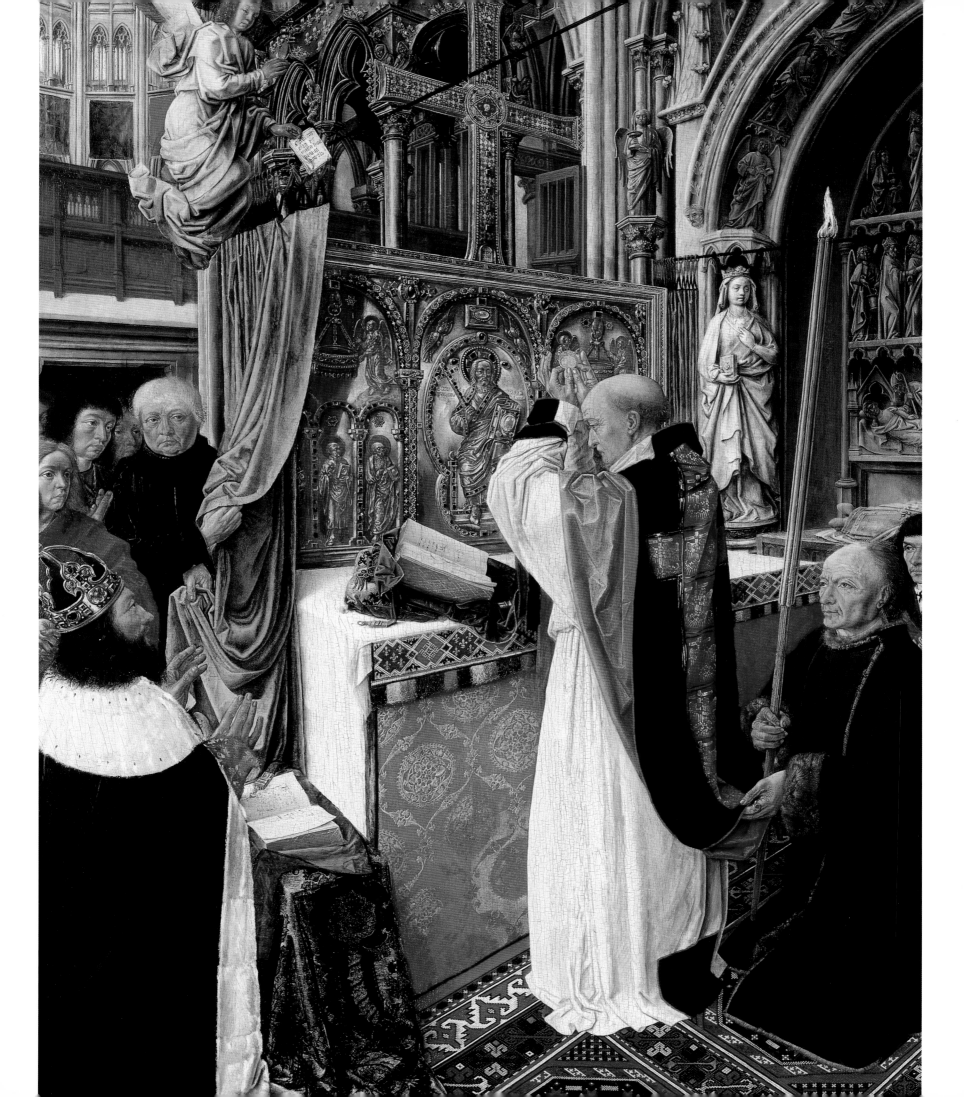

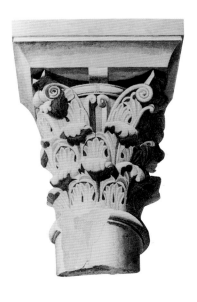

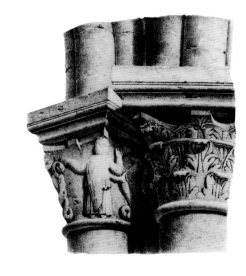

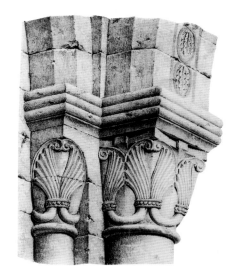

### 19–24. Saint-Pierre de Montmartre Capitals

*Marble capitals, probably originally from a church dedicated to Saint-Denis, constructed at the summit of Montmartre, at the location of the martyrdom, were reused in the church of Saint-Pierre, which was constructed in the twelfth century. These capitals, deriving from the Corinthian capital, were probably carved in Aquitaine in the fifth or sixth centuries in a Pyrenean marble. They are testimony to the persistence of classical forms, which did not disappear until the time of the Capetian kings.*

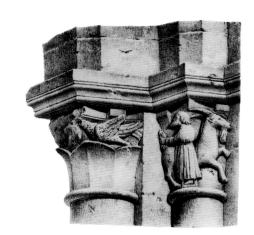

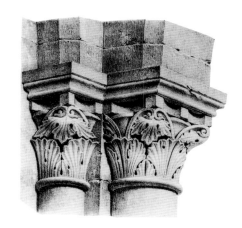

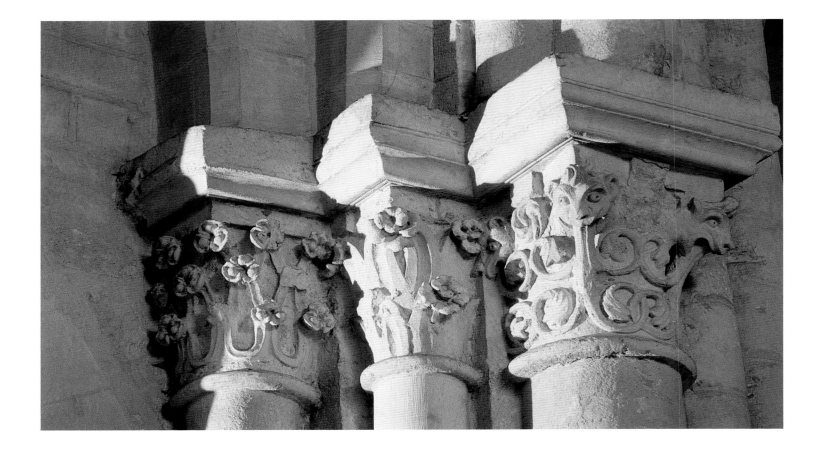

In 885, following the example of Geneviève before the Huns, Odo, son of Robert the Strong and count of Paris, resisted the Normans, who had already invaded the city several times. The siege lasted an entire year. The victorious resistance of the Parisians had consequences for all of western Francia, once known as Gaul: the thwarted Normans settled down in the province which took the name of Normandy in 911; Robertians, descendants of Robert, count of Paris and then duke of France, traded on their new-found fame to rival the last Carolingians for the crown. In 888 Odo was elected king by acclamation. Throughout the tenth century, the crown was passed from one dynasty to another until the election of Hugh Capet in 987, a Robertian and founder of the Capetian dynasty, which would reign for eight centuries.

These remarkable events symbolized the quasi-destruction of the state. Bit by bit an alternate power structure was taking hold, one based on personal relationships of authority and loyalty: feudalism. France was disintegrating into a mosaic of hierarchy and geography. The first Capetians had, in their own right, no more than a small domain extending to the north and the south on either side of Paris, with several large cities that could aspire to the title of capital: Senlis, Corbeil, Etampes, Orléans. Before they could enlarge their domain, the Capetians had to pacify it, because their authority was challenged at the very gates of Paris by a number of outlaw barons. Moreover, this domain seemed paltry compared to the powerful duchies of Normandy, Aquitaine, and Burgundy. But the Capetian was the king, the coronation confirmed him as God's chosen one, and the dukes owed him homage.

Within the confines of the domain, the policy of alliance by marriage brought the Capetians perhaps not an increase in power, but at least an air of exoticism. At the marriage of Robert the Pious and Constance of Provence in 1003, fashion, which was to play such a role for so many centuries to come, made its entry into Paris, worn by the sophisticated retinue from the southern courts, whose magnificent dress amazed the austere Capetians. Disapproval followed shortly thereafter. Guillaume de Volpiano, whom Robert had made abbot of Saint-Germain-des-Prés in order to reform it, criticized the short hair, the shaved faces, and the indecent tights. Henry I's marriage to a Russian, Anne of Kiev, seemed to forecast a policy of circumvention of the Germanic Holy Roman Empire by the east, ruled by the powerful Ottonian dynasty: in fact, it was simply an effort to choose a spouse outside the circle of cousins and so avoid the effects of consanguinity.

The empire was called Holy, and France, since the time of Pepin the Short, was considered the eldest daughter of the church, as events and foundations proved. In 910 the Benedictines were established at Cluny; in about 1074 Saint Stephen of Muret founded the order of Grandmont; and in 1084 Saint Bruno founded the order of the Carthusian monks. In 1095 Urban II, the French pope, preached about the First Crusade in Clermont-Ferrand. In 1098 Robert de Molesme founded the Cistercian order, which, under the leadership of Saint Bernard, abbot of Clairvaux, would spread throughout Europe. In 1113 Guillaume de Champeaux founded the collegiate church of Saint-Victor in Paris and gave it a rule which would serve as a model for most of the chapters of canons regular, known as Victorines. In 1120 Saint Norbert founded the Premonstratensian order.

These establishments were instrumental in the development of Romanesque art, an art which was essentially monastic and provincial, and in which Paris's role was played out within its suburban abbeys whose names evoked their rustic locations—Saint-Martin-des-Champs (Saint-Martin-of-the-Fields) and Saint-Germain-des-Prés (Saint-Germain-of-the Meadows).

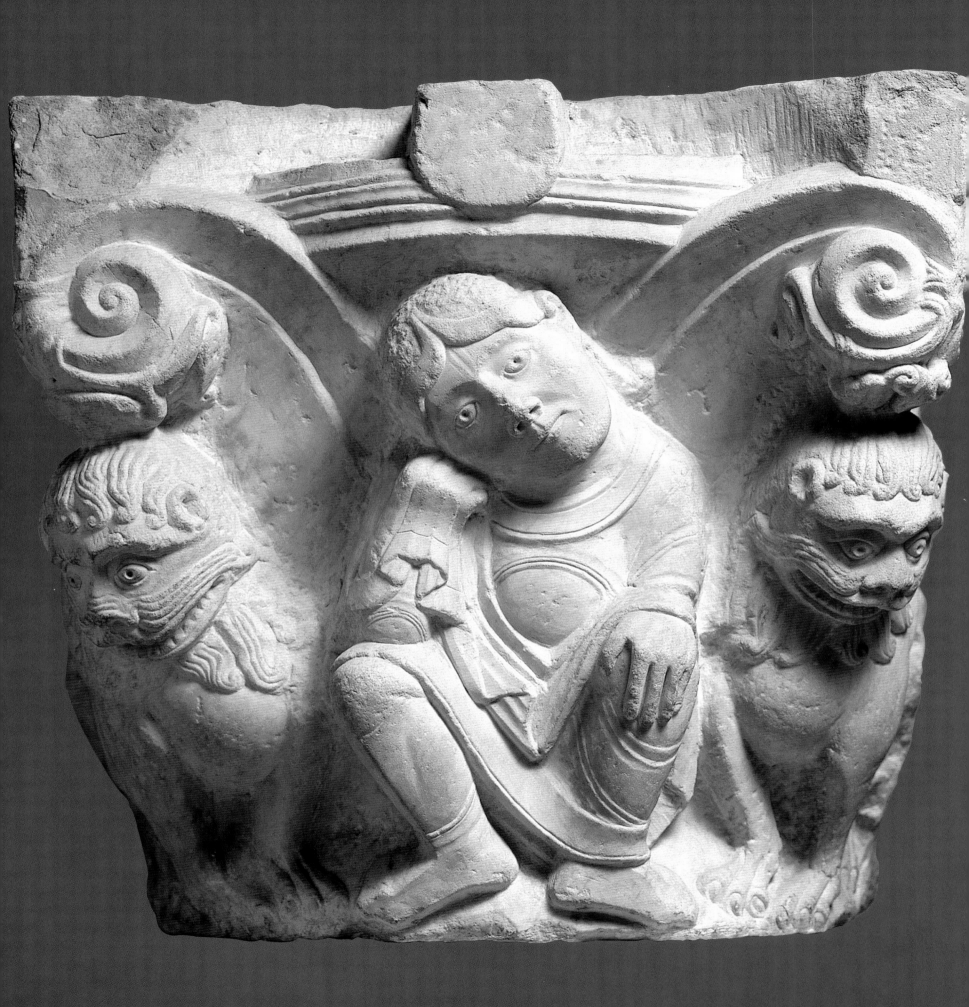

In the city itself, which had shifted almost completely to the Right Bank, few traces remain of the initiatives of this period. Of the parish church of Saint-Germain-l'Auxerrois, rebuilt thanks to the generosity of Robert the Pious, nothing remains: the oldest vestige preserved, the base of a tower flanking the choir, cannot be earlier than the first half of the twelfth century.

Lateral towers, whether on one or on both sides of the choir, are a distinctive feature of Parisian architecture, though they are not unique to it. All these towers have, at least once in their history, been razed and then either left at the foundation level or later restored. The church of Saint-Martin-des-Champs, founded by Henry I and dedicated in 1067 (fig. 16), has the base of a lateral tower dated either from this founding, or from the rebuilding of the choir in 1130–1140.

### The Church of Saint-Geneviève
There also remains from the abbey church of Saint-Geneviève, built during the reign of Philip I (late eleventh century or early twelfth century) on the site of the basilica of Saints-Apôtres built by Clovis, the base of a lateral choir tower, called the Clovis tower: the upper parts were built later. Also from this church there remains one capital (fig. 25), which is surely the most accomplished example of Romanesque sculpture from Paris. This beautiful piece, in Pyrenean marble, was probably imported or was the work of an artist from elsewhere. Indeed the capitals of the nave of Saint-Germain-des-Prés show the talent, or lack thereof, of local artists; they had made no progress since their Gallic ancestors carved the pillar of the Nautes.

### The Church of Saint-Germain-des-Prés
The narthex-tower at Saint-Germain-des-Prés, although its upper sections were built or rebuilt in the twelfth century, is a representative example of earlier churches, with an anterior tower in place of a unified facade. The most striking characteristic of this three-part nave is the structure of its pillars, on the side of which a single column rises to the top of the wall where its capital once supported the original wood roof (the vaulting is of a later date). This single ascension from floor to ceiling, no doubt inspired by Norman abbey churches, differentiates the interior elevations of Romanesque churches from those of Constantinian churches, in which the upward movement is halted at the height of the arcade, above which clerestory windows were opened in a smooth wall, decorated with mosaics or frescoes. The choir also has the foundations of two lateral towers: as at Saint-Martin-des-Champs, they are associated either with the construction in the eleventh century or with the building of the choir in the middle of the twelfth century. The abbey holds a position of importance among the great Romanesque abbeys of France, but less because of its architecture than the reputation of its *scriptorium*, distinguished during the time of Abbot Adelard (1030–1060) by an inspired monk, Ingelard, the artist of the illuminations in the *Lectionary of Saint-Germain-des-Prés* (fig. 15).

The question is whether the sister abbeys were more generously endowed or simply more adept at preserving their dower. Saint-Germain-des-Prés's *scriptorium* arose from that of Saint-Rémi of Reims. The famous illustration of the commentary on the *Apocalypse* by Beatus, the source of all Romanesque iconography, was painted in the abbey of Saint-Sever in Gascony. In the late eleventh century or early twelfth century, at Cluny, in Burgundy, the largest church in Christendom was built; the churches of Vézelay and Autun received their renowned sculpted portals. The abbey of Fleury (Saint-Benoît-sur-Loire), as notable for the sculpture of its narthex as for the illuminations from its *scriptorium*, was founded by Abbot Gauzlin, the half brother of Robert the Pious, who endowed it richly. It was at Fleury that the *Vita Roberti regis* was written, the first pages of the historiography of the kings; Henry, Robert's successor, was buried there. And once again, the Loire Valley won out over Paris.

**25. Daniel dans la fosse aux lions (Daniel in the Lions' Den). (Musée du Louvre, Paris)**

*The acanthus leaves of a Corinthian capital decorated one side of this marble block, probably intended for the basilica of Saints-Apôtres, built by Clovis as the royal mausoleum. Saint Geneviève, who was also buried there, later lent her name to the mountain on which the basilica was built and to the abbey church that succeeded the basilica. This block, re-used in the abbey church, had this Daniel carved into it at the end of the eleventh century.*

# Saint-Germain-des-Prés

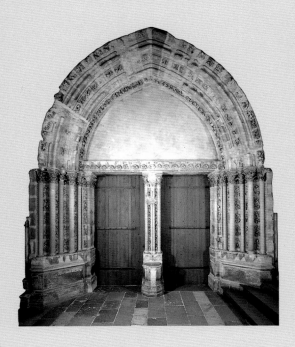

**Above and right:**

*Pierre de Montreuil. Portal of the Chapel of the Virgin, mid-thirteenth century. (Musée National du Moyen-Âge-Thermes de Cluny, Paris) There once was a statue of the Virgin and Child on the central pillar.*

*The church is located at a prominent crossroads in the Latin Quarter, at the corner of the Place Saint-Germain-des-Prés and the Boulevard Saint-Germain.*

**Opposite:**

*Shown here are an interior view of Saint-Germain-des-Prés, the Abbot's Palace (top), and the Place Furstemberg, formerly the entry court to the Abbot's Palace.*

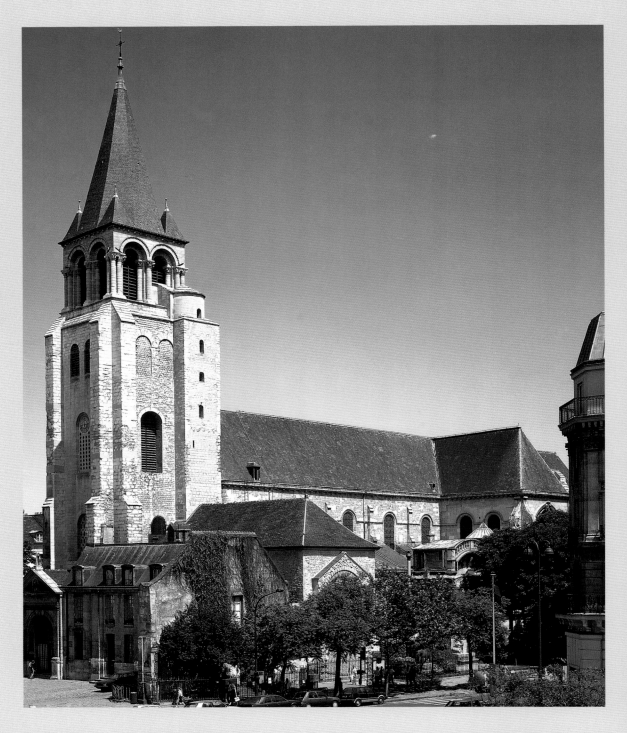

The beginnings of Saint-Germain-des-Prés were a basilica and a monastery founded by Childebert, the Merovingian king, and placed under the authority of Germain, bishop of Paris. The latter dedicated the basilica in 558 or 559, and the king was buried there. Its original consecration to the Holy Cross and Saint Vincent was replaced when the church was rededicated in honor of Saint Germain, who was also buried in the basilica. It developed into an influential Benedictine abbey there on the Left Bank, protected within its walls, outside the city.

Starting in the year 1000, the church was entirely rebuilt. The lower portions of the narthex tower and perhaps also of the two towers flanking the choir were constructed between 990 and 1014 by Abbot Morard; the nave was built between the years 1025–1030 by Guillaume de Volpiano, appointed by King Robert the Pious to reform the monastery; and the choir was constructed between 1145–1155, by Abbot Hugh of Saint-Denis. The central nave of the church was decorated in 1842–1848 with a series of paintings by Hippolyte Flandrin.

From the monastic buildings of the thirteenth century, in particular the refectory and the Chapel of the Virgin, the renowned creation of Pierre de Montreuil, only fragments have survived. But there still remains the abbot's residence, built in 1586 for the Cardinal de Bourbon, the abbot of Saint-Germain, pretender to the crown of France supported by the members of the League (in opposition to the claims of Henry de Navarre, future Henry IV): the Place Furstemberg is the former entrance court of this palace.

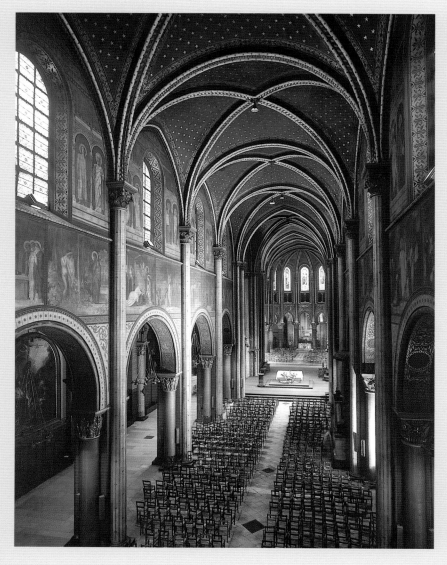

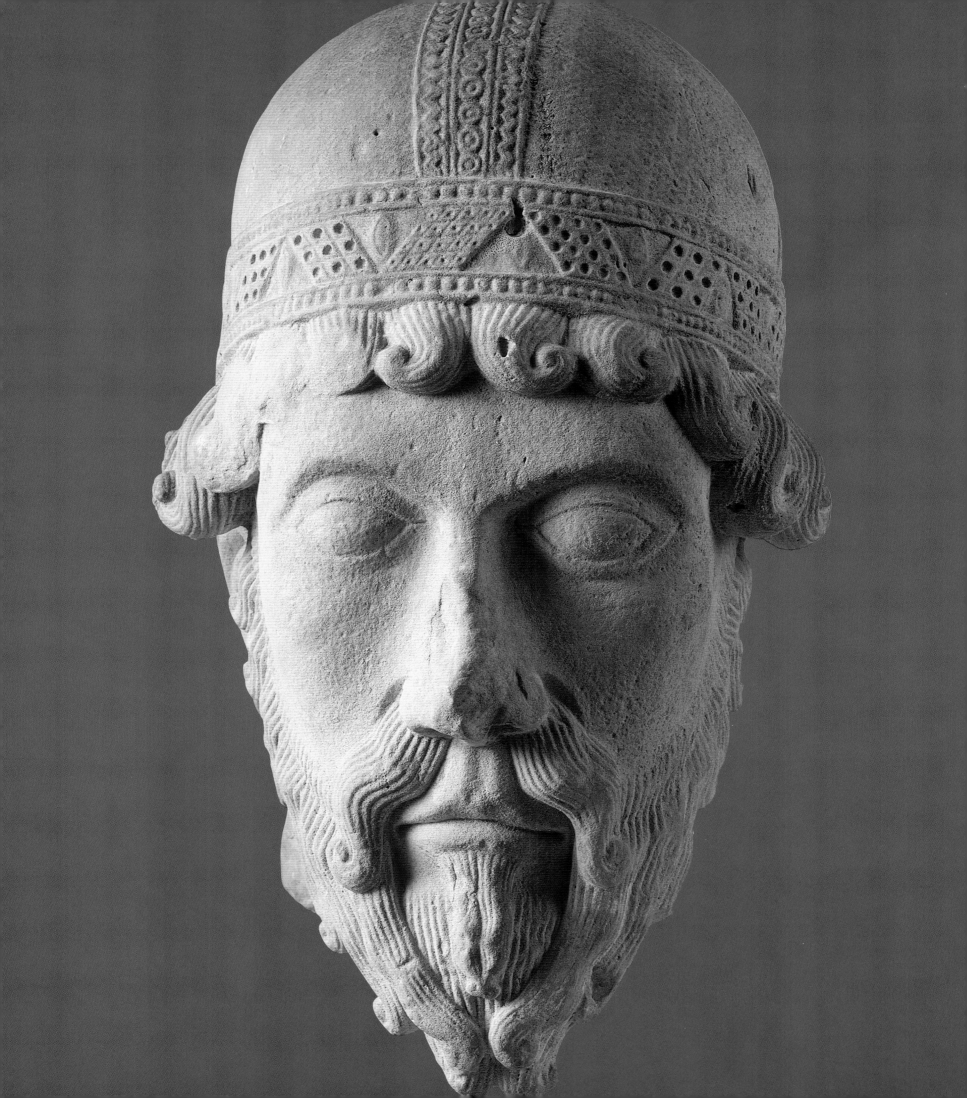

# Chapter II
# EARLY GOTHIC ART
## (1140–1220)

It was Abbot Suger (1122–1151) who reminded the kings of their debt toward Saint-Denis and established irreversible bonds between the dynasty and the abbey. The abbots' banner became the kings' flag, and "Montjoye Saint-Denis" was their war cry. "Montjoye" was the term designating the milestones that marked out the road from Paris to Saint-Denis leading royal funeral processions across the Lendit plain toward burial in proximity to the *regalia*.

At the monastery school of Saint-Denis, Suger and the future King Louis VI had been classmates. After the lengthy, inward-looking administration of his predecessor, the reign of Louis VI, the first monarch to carry the title of king of France rather than king of the Franks, gave a strong boost to Capetian power by reviving the traditional alliance with the church and its hierarchy. The royal campaign of 1124, which mobilized the high vassals against Emperor Henry V and the English king Henry I, set out from Saint-Denis where Louis VI himself raised the banner. Suger became the official historian of Louis VI, and the history of the kings would thereafter be written at Saint-Denis. And when in 1147 Louis VII, son of Louis VI, left for the Second Crusade, it was Suger who was named regent of the realm.

**1. Head of Prophet (Musée National du Moyen Âge – Thermes de Cluny, Paris)**

*This head comes from one of the column statues of the central portal of the west facade of Saint-Denis, c. 1140.*

If the influence exerted by the work of the brilliant abbot owed much to these powerful connections with the monarchy, its longevity can only be explained by the exceptional prosperity of the twelfth and thirteenth centuries, which was to spur Europe on to an unparalleled destiny and spread Gothic art across the entire continent. The economy was recruiting an urban aristocracy—the bourgeoisie—from the predominantly rural population. The king would cultivate their allegiance as a counterbalance to the power of the feudal lords. Louis VI became the champion of the first *communes*, the political personalities of the cities.

However, the prosperity initially benefited one of the royal domain's worrisome neighbors, the county of Champagne, which was growing rich from the international flow of goods and wealth through its famous fairs. Life at the court was also changing. Courtly poetry had arrived at the court of France from Aquitaine, along with the duchess Eleanor upon her marriage to King Louis VII; but it was to reach its fullest expression at the court of Champagne, presided over by the daughter of Eleanor and Louis, who became Countess Marie de Champagne. When her marriage to Louis was dissolved, and Eleanor, taking her duchy along with her, married King Henry II, the royal court of England acquired a brilliance that made the French court seem dull by comparison.

On the other hand, France, or more precisely the France north of the Loire or, more properly still, Paris and its schools, was the scene of an important event in intellectual life, the introduction of rationalism into the field of knowledge. The teachings of Pierre Abélard in Paris (1102–1136) can be considered the foundation of Scholasticism and dialectics: reasoning in the service of faith as well as science. Substituting the *ingenium* for the *usus* and the *habitus* in the interpretation of texts, as proposed by that charismatic schoolmaster, could be represented as the intellectual parallel of Suger's work. It did not, however, proceed without clashing with accepted beliefs. Abélard caused a scandal by daring to demonstrate the unlikelihood of the "Dionysian" legend equating the Parisian Denis with the Athenian Dionysius.

**2. Cross of Saint-Bertin**
**(Musée de l'Hôtel Sandelin, Saint-Omer)**

*This cross base, made in the Mosan metal workshop of Saint-Denis and intended for the abbey of Saint-Bertin in Saint-Omer, is a reduced-scale replica of the great cross created for Saint-Denis by Godefroid de Claire, a native of Huy, commissioned by Abbot Suger. The replica dates from the second half of the twelfth century: it is slightly later than the great cross. The enamels draw parallels between scenes of the Old and New Testaments; the three-dimensional figures represent the four evangelists (below) and the four elements (above).*

Suger's first act was to reform his abbey by raising its moral standards and reaffirming the practice of prayer. Although in most ways a follower of his contemporary, Saint Bernard, he differed with the strict reformer of monasticism over the importance that ought to be given to the ostentation of wealth and the utilization of the arts in service to God. From the tomb of Saint Denis, Suger caused a fountainhead of art to pour forth, carrying into all the reaches of Europe the reputation of Parisian art, the royal art, soon to be thought of as the art of the entire kingdom. Suger's art is not invention, except in the original sense of the term: discovery. It is maieutic, intended to incite the viewer to a higher reflection. A key factor in this respect is the plentiful commentaries left by Suger to explain his choices. From them emerges an articulate art, a synthesis of techniques and styles achieved by enlisting artists from many different regions with the widest possible variety of specialties. All aspects were to converge, producing "by analogy" (the term is from Suger himself) the pull of belief. Techniques exploiting light—precious metals, stained glass, painting—and architectural shapes were intended to accompany the ascending movement of one's faith. "Our poor spirit is so weak that it is only through the realities of the senses that it can rise toward the truth," wrote Suger.

The golden twenty-three-foot cross that stood on the tomb of Saint Denis, one of the masterpieces of Suger's art, is known to us today only through a scaled-down and incomplete reproduction from the period, the base of the cross of Saint-Bertin (fig. 2). It was the work of "aurifabros lotharingos," goldsmiths of Lotharingia (Lorraine), the center of activity in the Meuse Valley. At Saint-Denis the usual direction of migrations was reversed: it appears that Nicolas de Verdun, the most illustrious Mosan silversmith and creator of the masterpiece of Klosterneuburg, was trained under Godefroid de Claire, at the school of Saint-Denis.

Whereas the goldsmith's craft could point to a local tradition, stained glass, which had produced important works in the west and southwest of France (Le Mans, Angers, Vendôme, Poitiers), doesn't appear in Paris until the middle of the twelfth century, in the radiating chapels of the apse of Saint-Denis, glazed between 1140 and 1146 by master glassworkers of various nationalities. Scholars have been able to distinguish the work of three distinct workshops in this collection, which Suger himself called *mirificum opus*," now unfortunately ruined by restorations; and one of these workshops was from the Meuse Valley.

To accomplish his fusion of the arts, Suger adapted the architectural framework. The design of the choir was specially conceived to make the church glow "with the magnificent and continuous light of the very sacred windows," Suger wrote. The stained glass on the east, the sculptures on the west, the paintings in the nave, and the gold furnishing in the sanctuary all worked together according to the same principles of composition and a shared iconography. Suger used the medium of the monumental arts to put into images the rhetoric of the priest, the parallel of the Old and New Testaments. Taking literally the phrase of Saint Augustine— "The Old Testament is but the New hidden under a veil and the New Testament is but the Old unveiled"—Suger had Christ portrayed between the church and the synagogue, crowning the one and unveiling the other. The Tree of Jesse, represented for the first time at Saint-Denis (figs. 3–4) is, as we shall see, the best testimony of the exceptional fertility and durability of Sugerian iconography.

Does Suger's art deserve to stand alone in bearing the true title of "Gothic"? We shall decline to discuss such a question and take sides in the interpretations of Gothic considered sometimes as the fulfillment of Romanesque, sometimes as a radical departure from it. But no one, we think, will take issue with this observation by André Chastel in *French Art*: "Romanesque art is the great moment of provinces; Gothic is the art of the intellectual, daring, and triumphant center which is the Ile-de-France."

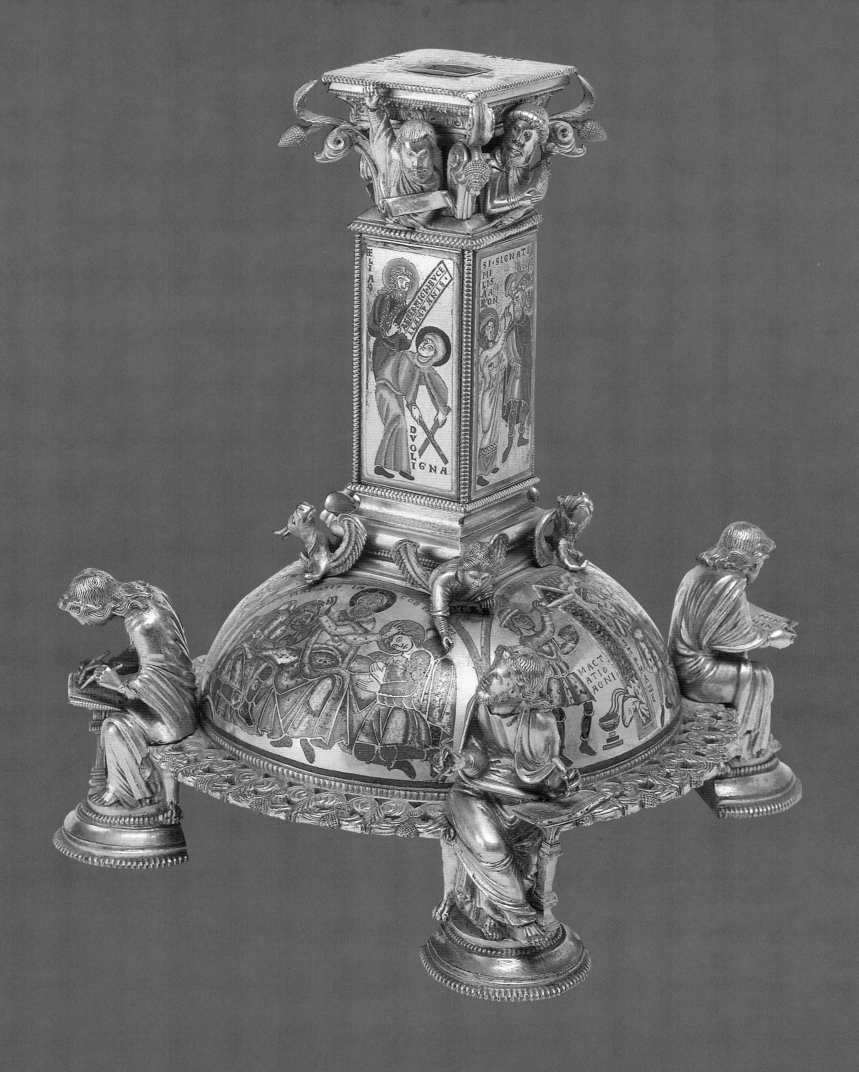

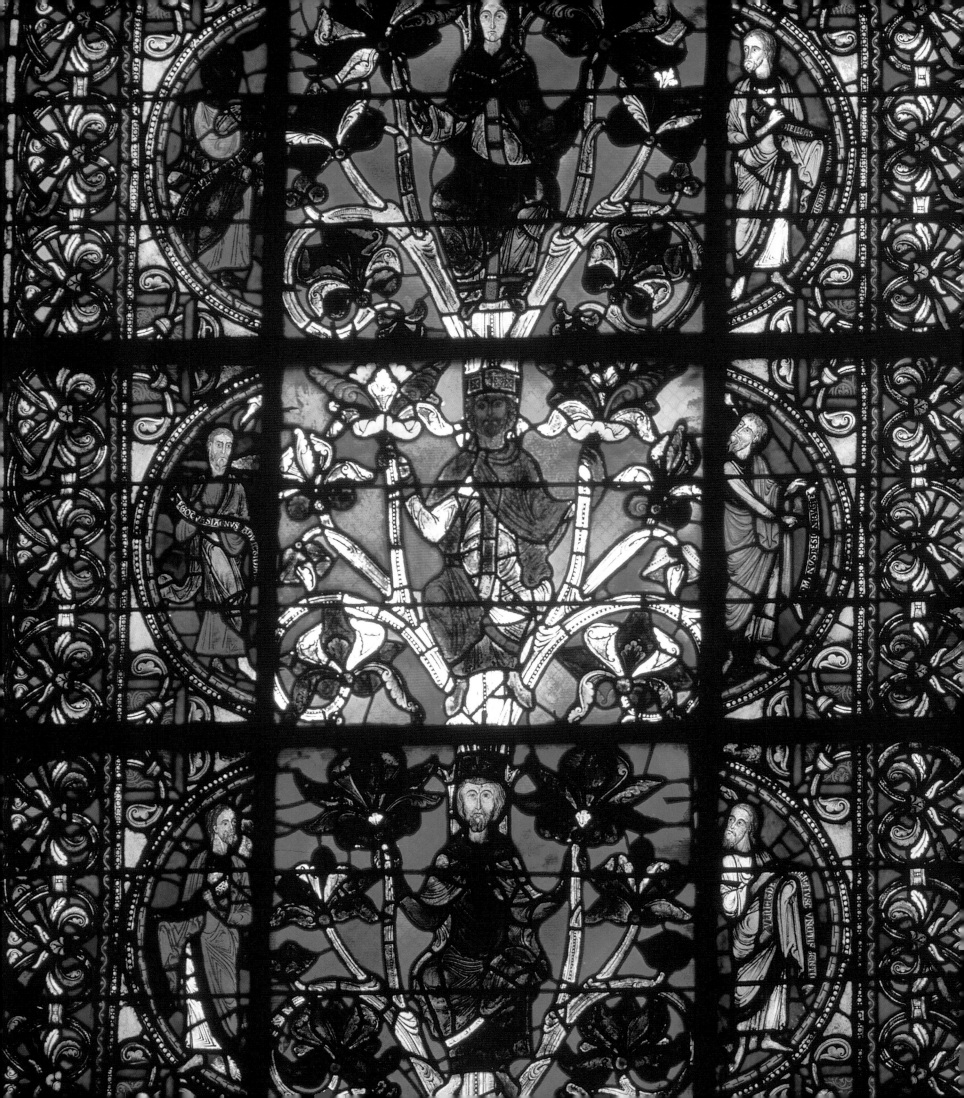

## Saint-Denis

The reconstruction undertaken by Suger at Saint-Denis (figs. 7–9) began with the west facade, which was dedicated in 1140; the choir was begun immediately thereafter and was dedicated in 1144. The boldness of the techniques used and the haste of execution compromised the stability of the upper levels of this choir, which had to be rebuilt in the thirteenth century. Suger laid the foundations for a new nave around the Carolingian church, which, for lack of time or boldness, he did not dare to touch, protected as it was by its reputation of beauty and the legend that it had been consecrated by Christ himself.

The facade of Saint-Denis is inspired by the facades of the great Norman abbeys, in particular that of Saint-Etienne of Caen. Normandy at that time was the point of reference for monumental architecture. Saint-Etienne was begun in 1063 by Duke William, three years before he conquered England, and by Abbot Lanfranc, who would later become archbishop of Canterbury. Saint-Etienne is the paragon of what art historians call the "harmonious facade," the tripartite facade with two towers, unlike anything then extant in the Ile-de-France. One feature nevertheless sets Saint-Denis apart from Saint-Etienne: the upper stories of the towers are the uninterrupted continuation of the lateral portions of the Norman facade; in Saint-Denis, these higher parts are set back and a crenellated balustrade crowns the facade, which in this way is revealed as a square. These crenellations invented by Suger are thought to be a reference to Solomon's temple, which, according to scripture and its exegesis, was crenellated. Transposing a text to a work of art is characteristic of Suger, who was considered by some contemporaries to be a modern Solomon.

The choir of Saint-Denis differs from Romanesque choirs in the peculiarities of its circulating areas. There are two concentric ambulatories; the shallow radiating chapels adjoin without walls and are covered by the ribbed vaults of the second ambulatory. Thus the chapels can be interpreted simply as the lobed wall of the latter. Furthermore, as this wall is largely glazed, light of the innumerable hues imparted by the stained glass fills the interior, exactly as Suger wished.

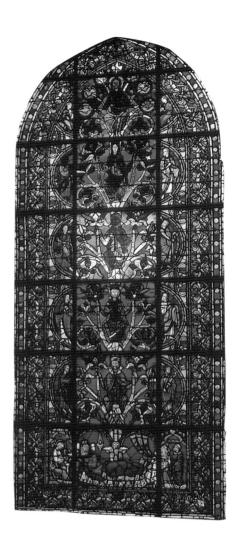

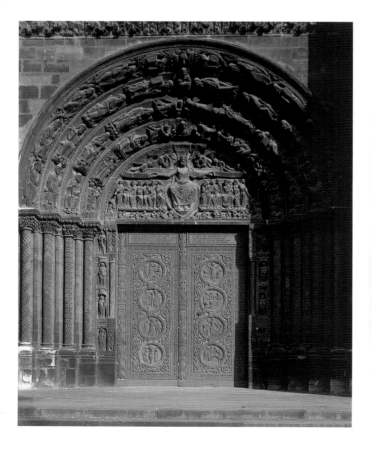

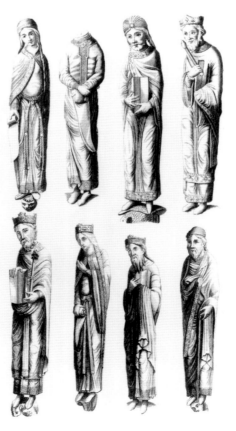

**3–4. Saint-Denis. Window of the Tree of Jesse, between 1140 and 1146.**

*This window is part of the group commissioned by Suger between 1140 and 1146 for the choir of Saint-Denis. In spite of considerable restoration in the nineteenth century (only the four central panels are original), this window is the best preserved of the series. The theme of the Tree of Jesse (the genealogy of Christ born of Jesse through the kings of David), borrowed from manuscript illuminations, is treated for the first time in monumental art with this window.*

**5–6. Saint-Denis. West Facade, Center Portal, c. 1140.**

*This portal, poorly restored in the nineteenth century, was a major work by Suger. From the tympana of the south of France, he borrowed the theme of the Last Judgment, here treated for the first time on the tympanum of a northern French church. The use of column statues decorating the splayed entrance, representing prophets and kings as precursors of Christ (figs. 32–33), is one of Suger's most important innovations: it would be adopted in most Gothic portals.*

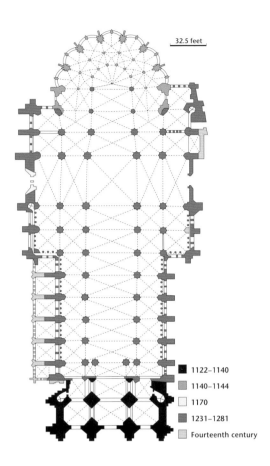

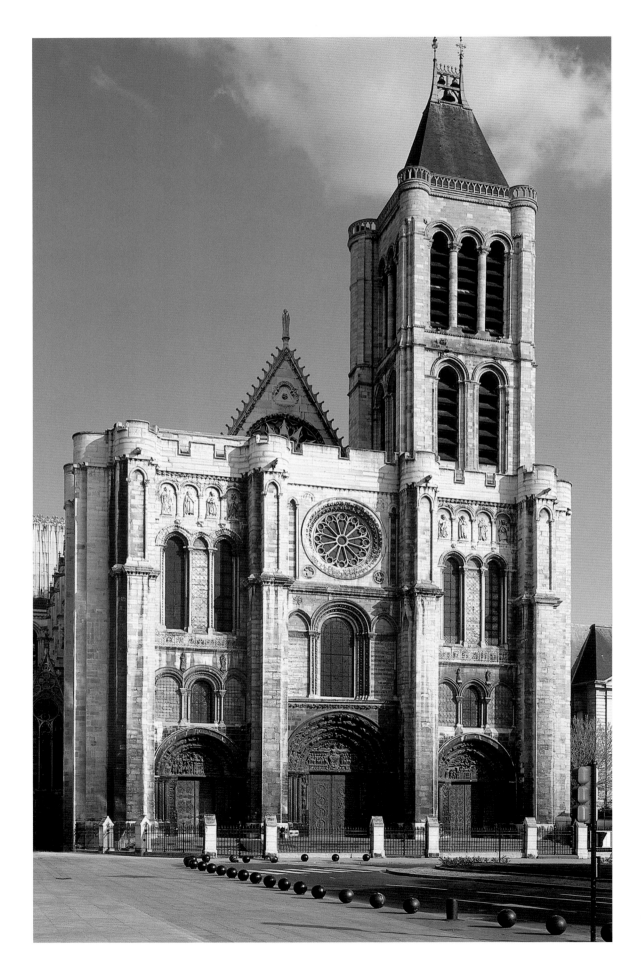

**1122–1140**
**1140–1144**
**1170**
**1231–1281**
**Fourteenth century**

32.5 feet

### 7–9. Saint-Denis. West Facade and Choir.

*In the early days of the Christian era, there was a large cemetery beside the ancient road leading north out of Paris. In about a.d. 250, Saint Denis, first bishop of Paris, martyred on Montmartre, was buried there. In about 475, Saint Geneviève had a church built over Denis's tomb. Before 625 a Benedictine monastery was founded there. Dagobert, long considered the founder of the place of worship, chose to be buried there, thus breaking the tradition by which Saint-Germain-des-Prés was the mausoleum of the Merovingians. Pepin, founder of the Carolingian dynasty, also chose to be buried there. At Pepin's death, Abbot Fulrad built the church that was dedicated in 775. In the crypt there are vestiges of these successive buildings.*

*In the present church, the west facade, dedicated in 1140, and the lower level of the choir, begun in 1140 and dedicated in 1144, are the works of Abbot Suger. The facade suffered from the restorations in the nineteenth century. It lost the steeple on the left tower, which postdated Suger's work in any case; the rose window was redrawn, the portal destroyed. The upper levels of the choir, built by Suger, were redone in the thirteenth century.*

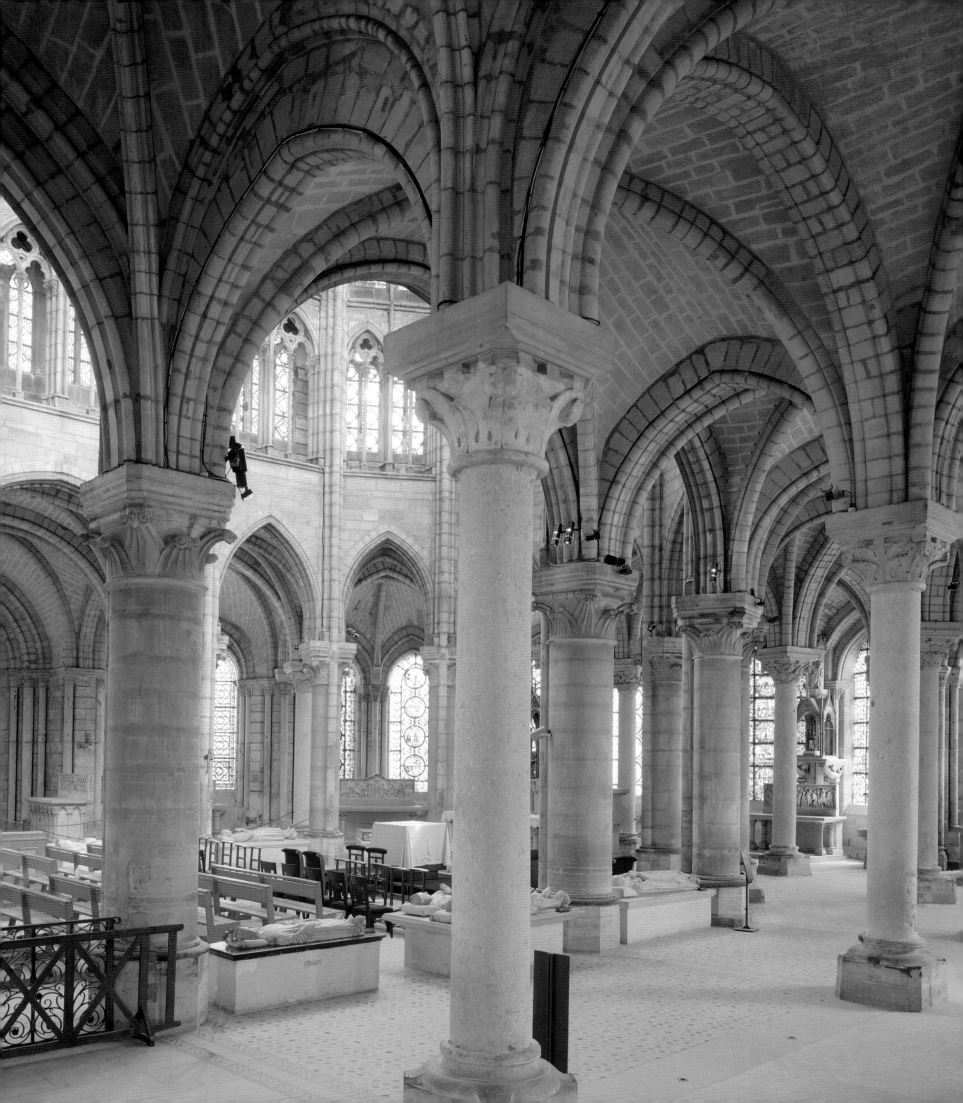

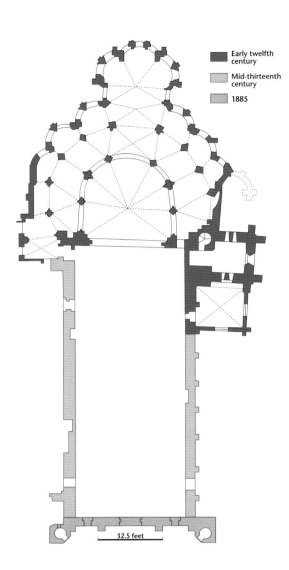

Early twelfth century

Mid-thirteenth century

1885

32.5 feet

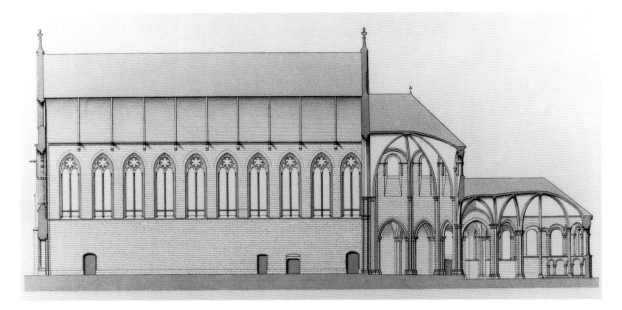

### Saint-Martin-des-Champs

The choir of Saint-Denis is remarkably original, unless inspired by the one at Saint-Martin-des-Champs (figs. 10–12). But the chronology of the two works is too imprecise for us to know whether to give the credit to the abbot of Saint-Denis or to the prior of Saint-Martin. Less regular and homogeneous, the choir of Saint-Martin gives an impression of a first attempt: ribbed groin vaults and pseudo-groin vaults are mixed, and the shapes of the bays are an affront to geometry. But after all is said and done, it may just be the more inspired: the central bay of the second ambulatory opens wide onto the axial three-lobed chapel where the statue of Notre-Dame de la Carole (fig. 36) was once displayed.

**10–12. Priory of Saint-Martin-des-Champs**

*The choir of the church in the priory of Saint-Martin-des-Champs, rebuilt by Prior Hugh (1130–1147), is one of the first examples of early Gothic art; it is contemporary with the choir of Saint-Denis—with which it shares some similarities—or, in fact, earlier than the latter. It has been preserved nearly intact, with the exception of the flanking steeple tower, which was truncated in the fourteenth century.*

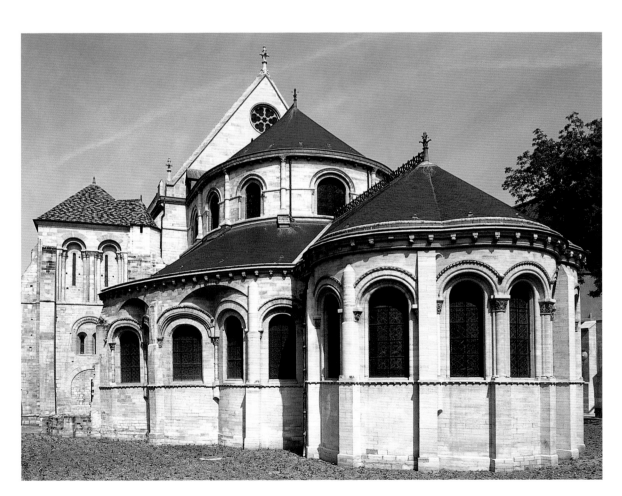

## 13. Saint-Germain-des-Prés Portal

*This portal, of which only the lintel has been saved, was probably contemporary with the choir, constructed beginning in 1145.*

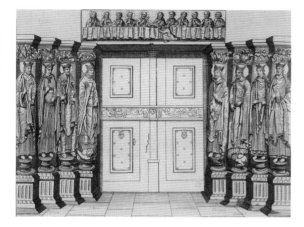

## 14. Saint-Germain-des-Prés. Capital from the Choir, c. 1145.

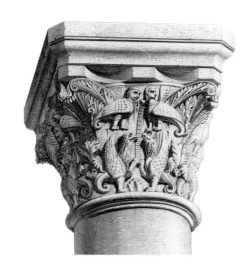

Early eleventh century
Mid-twelfth century
Mid-seventeenth century
Nineteenth century

16 feet

### Saint-Germain-des-Prés

The choir at Saint-Germain-des-Prés (figs. 15–17) was considered archaic when its dating was based on the consecration in 1163. Today it is thought to have been built by Hugh, a monk originally from Saint-Denis who was abbot of Saint-Germain from 1116 to 1146. The colonnade with round arches lining the rectangular parts may be inherited from the Romanesque church. Although not extremely innovative, the interior elevation in three levels (colonnade, triforium, clerestory) could be considered modern for the time, as could the layout of contiguous radiating chapels. This same layout is common to the three choirs; it would become commonplace afterward, but at the time it broke with the Romanesque tradition of spacing radiating chapels apart from each other so as to admit light directly into the ambulatory through windows between the chapels. In Saint-Denis as in Saint-Martin, it had been shown that ambulatories could be lit with the windows of the chapels themselves.

### 15–17. Saint-Germain-des-Prés

*The first church was founded in 542 by Childebert I as Holy Cross Saint Vincent. The Merovingian king appointed Germain, bishop of Paris, to create a monastery at the site. The dedication of the monastery church took place in 558 or 559, just after the death of Childebert, who was buried there along with the bishop-saint. The abbey was given its permanent name in honor of the latter. Destroyed by the Normans, the Merovingian church was replaced by a new one under the first Capetians. Abbot Morard built, between 990 and 1014, the tower-narthex and possibly the steeple towers flanking the choir. The nave was built between the years 1025–1030 under Abbot Guillaume de Volpiano, who was summoned by Robert the Pious to reform the monastery. Today, this*

*church is the principal example of Parisian Romanesque architecture that has survived more or less intact: the upper section of the tower-narthex and the vaults of the nave are later additions: the steeple towers of the choir have been taken down, but are shown in the drawings below. Most of the capitals of the nave were removed during the restoration in the fourteenth century (presently at the Cluny Museum). The choir, begun shortly before 1145 by Abbot Hugh and not dedicated until 1163, is an important and valuable example of early Gothic architecture. The bays of its triforium became square when, in the seventeenth century, the clerestory windows were enlarged. An example of the original triforium remains on the interior wall at the base of the towers.*

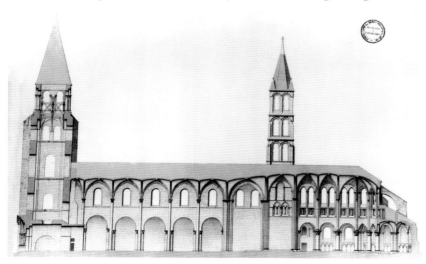

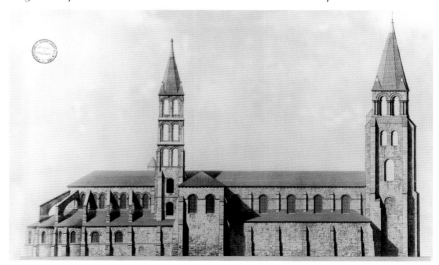

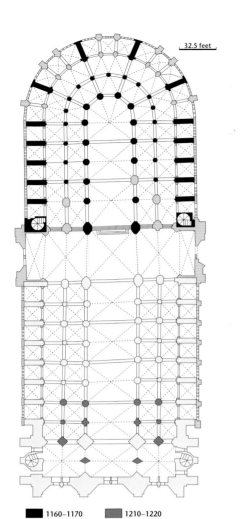

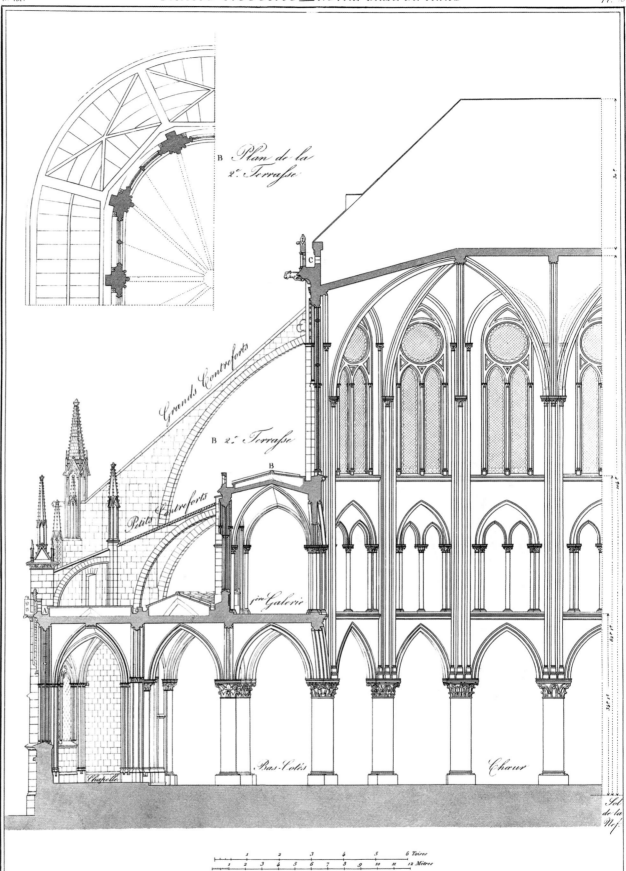

32.5 feet

■ 1160–1170   ■ 1210–1220
□ 1170–1200   ▨ Second half of thirteenth century

Plan de la 2.ᵉ Terrasse

Grands Contreforts

2.ᵉ Terrasse

Petits Contreforts

B

1.ʳᵉ Galerie

Chapelle

Bas-Côtés

Chœur

Sol de la Nef

Publié par Émile Leconte Rue Sᵗᵉ Anne, 5.

Coupe sur l'Abside.

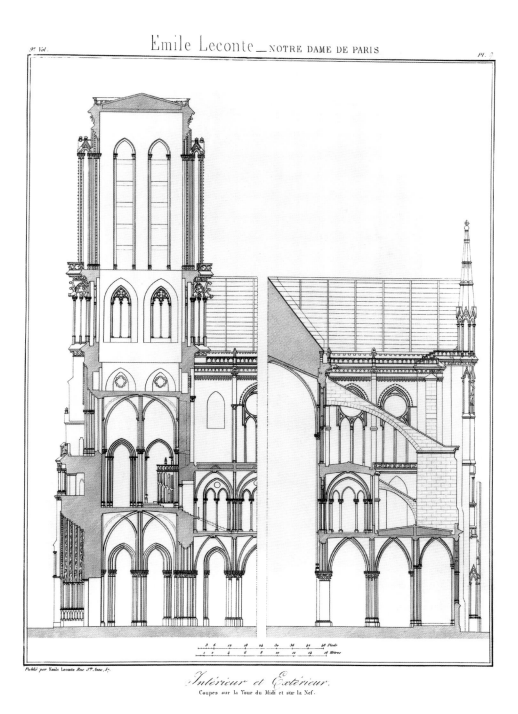

*Intérieur et Extérieur.*
Coupes sur la Tour du Midi et sur la Nef.

### 18–21. Notre-Dame Cathedral

*The first cathedral, dedicated to Saint Stephen, was a spacious building with five naves in the manner of the Constantinian basilica, dating to the fourth or fifth century. It was entirely rebuilt by Bishop Maurice de Sully. The reconstruction started about 1163 with the choir, which had no flying buttresses originally; it was finished with the west facade, which by 1225 lacked only the upper sections.*

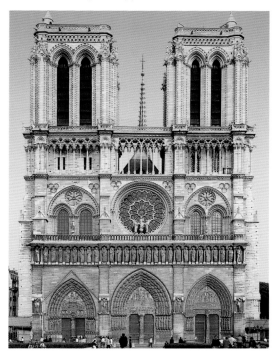

*The twelfth-century cathedral inherited the five-nave arrangement of the basilica. Its design is characteristic of early Gothic art: arcades, tribunes, clerestories, and sexpartite vaults. In this particular case, the traditional triforium had a row of oculi, later eliminated to enlarge the clerestories and partially reinstated by Viollet-le-Duc, the nineteenth-century restorer of the cathedral. The alternation of large, cylindrical piers and slender-looking piers, traditionally found in association with sexpartite vaults, here appears only in the row of pillars separating the side aisles.*

### The Cathedral

Notre-Dame of Paris is one of the most important accomplishments of the second half of the twelfth century, important because of its size, which was not surpassed for centuries (it is 422 feet long and nearly 115 feet high), and because it was the perfect and fully developed expression of the characteristic design of the first Gothic period (figs. 18–21), with alternating pillars, sexpartite vaults, and interior elevations in four levels. The treatment of this design is original. The floor plan with its five naves and the columns of the central nave are inherited from the original sanctuary. In the line of piers separating the two side aisles one again finds the alternating pillars usually associated with the use of the sexpartite vault, the vault with diagonal ribs dividing it into six sections instead of four (fig. 18). The four-level elevation includes tribunes, as in the great Romanesque churches. The third level, usually formed by the line of blind openings called a triforium, was indicated in Paris only by a series of oculi, which were later destroyed to enlarge the clerestory windows and then restored in one bay during the restorations of the nineteenth century. The double ambulatory is the logical conclusion of a

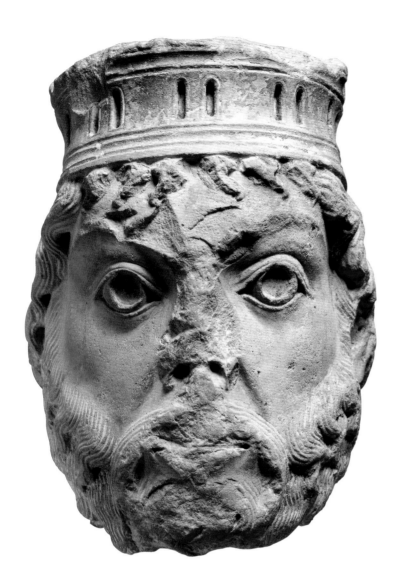

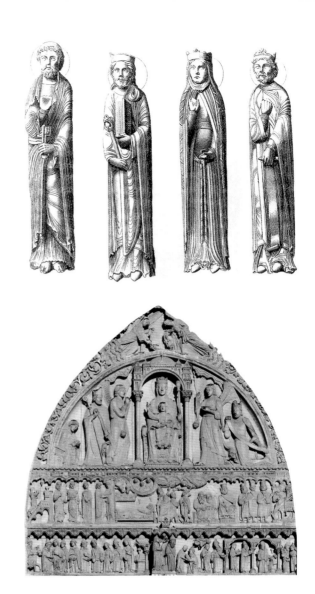

### 22–24. Notre-Dame Cathedral. West Facade, Right Portal, between 1140 and 1145.

*The original components of this portal had been commissioned by Canon Etienne de Garlande between 1140 and 1145 for a portal of the Virgin, which was to be added to the original cathedral (fourth to fifth centuries). They were placed in the facade of the present cathedral. To adapt the tympanum to the newer, wider door, voussoirs were added outside the original molding to reach the archivolts of the new opening, and the lintel was extended on both ends. Under the original lintel was added another that tells the story of the mother of the Virgin, Saint Anne, whose name has been given to this doorway. The tympanum represents the Virgin in majesty; the original lintel, the childhood of Christ; and the archivolts, the elders of the Apocalypse, kings, and prophets.*

*All the column statues were destroyed in the Revolution and redone in the nineteenth century. A statue of Saint Marcel stood at the central pillar; in the splayed jambs are Saint Peter, Saint Paul, and kings and queens of the Old Testament. The head from the original King David has been preserved (Metropolitan Museum of Art, Cloisters Collection, New York).*

plan with double side aisles; the placement of the pillars and the shapes of vaulting generated by this placement have the simplicity of an arithmetical sequence.

As with the cathedral overall, the facade, which was finished by around 1225 (assuming no spires were intended), owed much to Saint-Denis. But the obedience to the square outline and the division into three are more firmly drawn here because of the exceptional horizontality of the composition (fig. 21). The two great royal churches of Paris and Saint-Denis are sisters; they arose from identical circumstances. In the footsteps of his father, Louis VI, who had been taught at the abbey school, Louis VII had been educated at the cathedral school, where Maurice de Sully, the bishop, was one of the most eminent masters.

Facing the cathedral, Maurice de Sully opened up a square and a street that was a continuation of the cathedral's centerline, a surprising anticipation of the principles of seventeenth-century classicism. He removed the episcopal palace and the Hôtel-Dieu once again to the banks of the Seine. The second basilica of the early cathedral compound had been sacrificed to create a residential enclosure known as the cloister, for the canons, the clergy governed by the rule dating from the time of Pepin the Short. The baptistery had a circular plan.

### 25. Notre-Dame Cathedral. Side Aisles.

*Between the side aisles, on either side of the central nave, are large, layered columns alternated with smaller ones with engaged colonnettes, installed vertically and giving the impression of a bundle.*

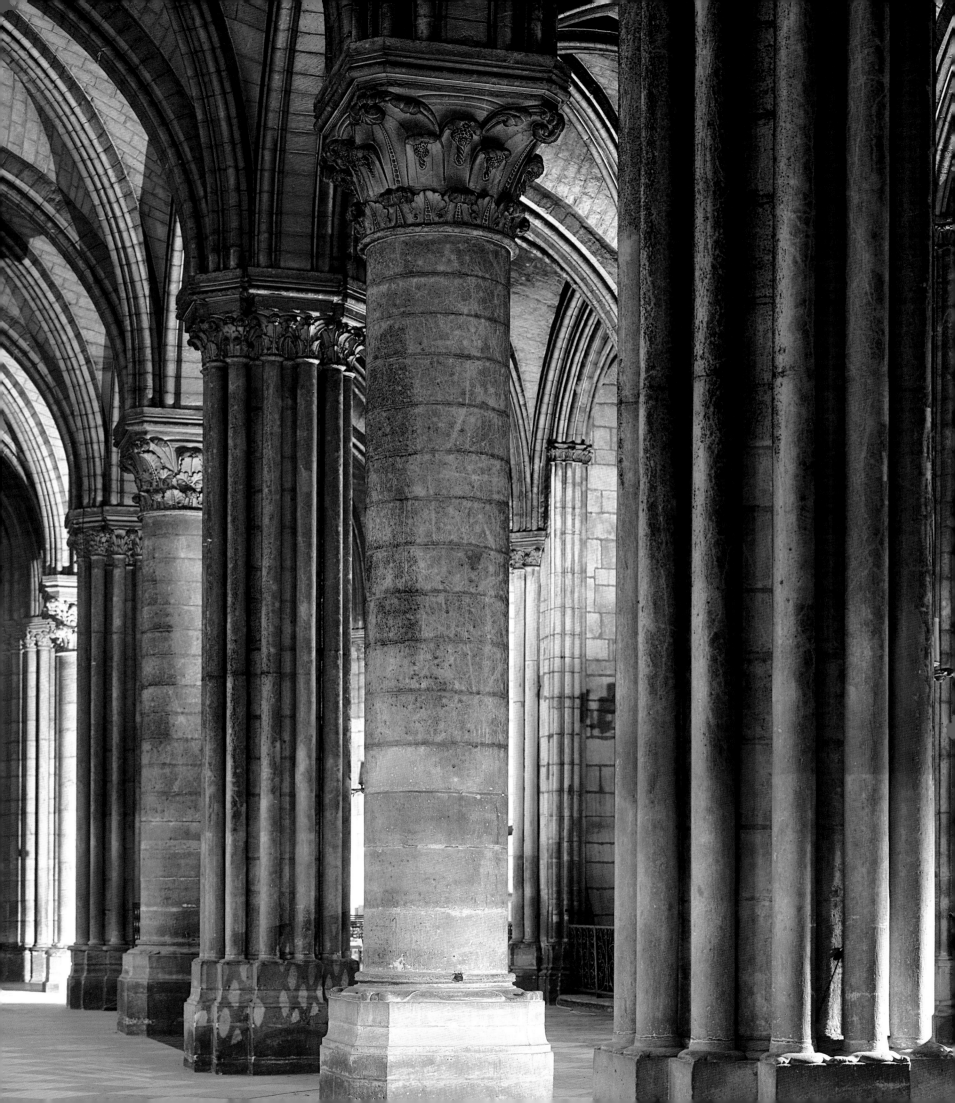

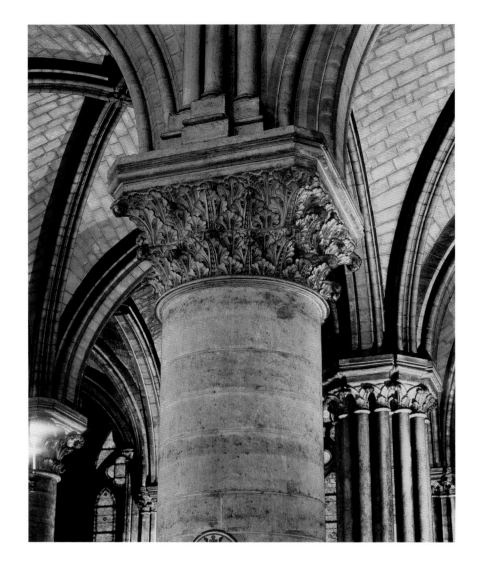

**26. Notre-Dame Cathedral**

*This capital from the choir dates from about 1160.*

**Opposite:**

**29. Notre-Dame Cathedral**

*This view looks from the central portal down the entire central axis of the nave.*

**27–28. Notre-Dame Cathedral. West Facade, Left and Center Portals.**

*Only the tympana of these two portals, designed for the cathedral begun around 1160, have survived. The other components, destroyed during the Revolution, were redone in the nineteenth century. The left portal is called the Portal of the Coronation: on the tympanum (from top to bottom) are the Coronation of the Virgin, the Dormition (burial of the Virgin), and kings and prophets. On the tympanum of the center portal, called the Portal of the Last Judgment, (from bottom to top) are: the Resurrection of the Dead (almost entirely redone), the Judgment by the Archangel Saint Michael (center part redone), Christ between two angels carrying the instruments of the Passion, and the Virgin and Saint John. Christ and the angel with the lance were not sculpted until 1230–1240.*

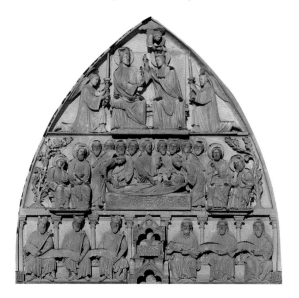
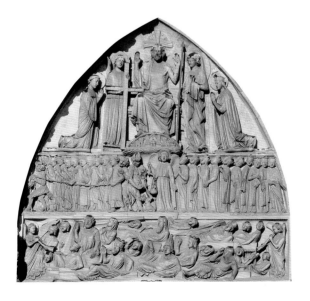

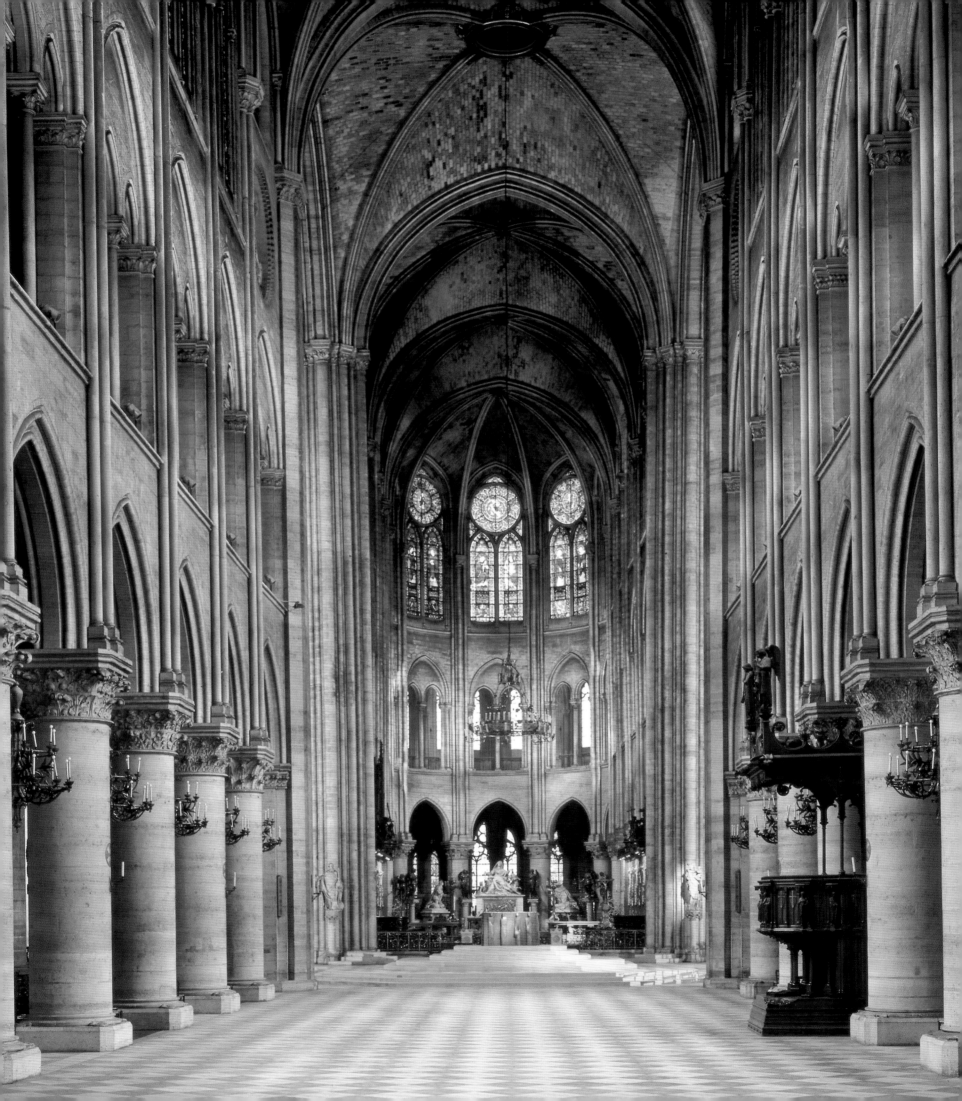

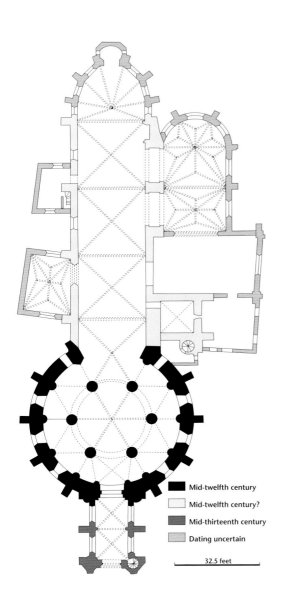

**Mid-twelfth century**

Mid-twelfth century?

**Mid-thirteenth century**

Dating uncertain

32.5 feet

*The Temple*

The most monumental rotunda of Paris was in the church of the Knights Templar, datable to the mid-twelfth century (figs. 30–31). Its interpretation is unclear. Some assert that it was originally free-standing and based on the Korbbet-es-Sakhra mosque, built in Jerusalem and turned into the church of the Knights Templar, and not, as once thought, copied from the Anastasis, the church of the Holy Sepulcher built by Constantin. This change of attribution is astonishing: apart from the fact that the reference to the tomb of Christ and to the legacy of Constantin seems more canonical, the mosque is polygonal and the Anastasis round. Furthermore, the rotunda in Paris was perhaps no more than a round nave built along with the straight choir; since nothing proves that it was added on, as is usually assumed, it could simply have been lengthened later. The French examples of Templar churches, in Laon and Metz, present these two elements. The royal abbey church of Ferrières, just outside the Ile-de-France, dedicated in 1163, probably gives a rather clear picture of what the church in Paris must have been. The church at Ferrières is not a Templar church, but its roots are certainly in Constantin's creation in Jerusalem.

### 30–31. The Church of the Temple

*The Knights Templar established their Paris seat in 1139. The Grand Master withdrew there in 1291, after the loss of Palestine. In 1312 the order was outlawed. The church (now destroyed) consisted of a round nave, a choir with an apse, a lateral steeple tower, and a narthex with a second floor. The latter, an outstanding example of rayonnant art, had obviously been added in the middle of the thirteenth century. The nave, datable to the middle of the twelfth century, was circular with a central space framed by six pillars:*

*it had been vaulted sometime after its original construction, probably at the time of the construction of the narthex and its diameter was nearly sixty feet. The steeple tower was probably contemporary with the rotunda, but originally separate from it. The choir is thought to have been added also: in fact, a second dedication was held in 1217, following an enlargement of the church. It is probable that the choir was simply lengthened and that the original church was, in fact, composed of a round nave and a rectangular choir.*

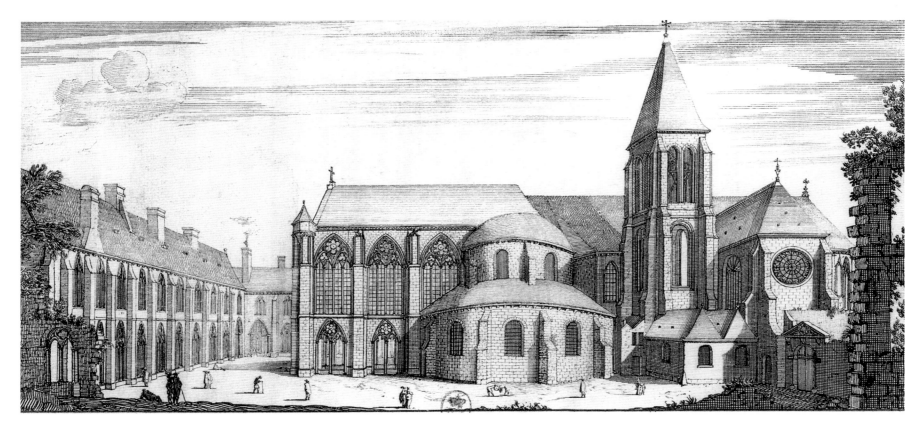

Understanding the many influences various examples of early Gothic architecture had on each other is often difficult, and every new generation of historians revises the chart of influence. For example, it was thought that the choir of Saint-Germain-des-Prés was imitated at the cathedral of Noyon, which resembles it as to floor plan, whereas today the converse is believed. The choir of the cathedral of Senlis stems apparently from that of Saint-Denis; and the plan of the cathedral of Bourges, built by the archbishop Henri de Sully, brother of Maurice de Sully, stems from the plan of the cathedral of Paris. The cathedral of Laon, contemporary with Paris, presents certain similarities with it. The cathedral of Sens inspired numerous structures, possibly the choir of Saint-Germain-des-Prés. And yet, taken as a whole, all these relationships seem to be coherent. Sens is the seat of the archdiocese with authority over the diocese of Paris; the county of Sens was annexed to the royal domain in 1055. Bourges has been part of it since 1100. Laon, the former capital of the last Carolingians, henceforth belonged to the Capetians. Laon, Bourges, and Sens bound a territory that extends well beyond the Ile-de-France. Between 1194 and 1225 the construction campaigns of all the Capetian cathedrals were begun, from Chartres to Beauvais. And this first Gothic art was already being exported: Guillaume, architect of the cathedral of Sens, was called to Canterbury in 1174 to build the cathedral there.

In the great construction sites in the Ile-de-France, one observes unprecedented innovation in construction techniques. The first flying buttresses in France and Europe were erected at Saint-Germain-des-Prés in 1140. The ribbed groin vault, or ogive, in which a self-supporting band of masonry replaces or reinforces lines of intersection in a groin vault, appeared earlier, around 1125, in the small churches of the Ile-de-France. The ribbed groin vaults at Saint-Pierre-de-Montmartre, dedicated in 1145, are contemporary with those at Saint-Denis, Saint-Martin, and Saint-Germain. But only at Saint-Germain do the flying buttress and the ribbed groin vault occur together, the combination that was to become the hallmark of Gothic architecture. At Notre-Dame, where the tribunes provided support, the flying buttresses we see today were added in the thirteenth century (fig. 19).

The thin wall is also an important innovation. The Romanesque wall consists of two masonry panels between which rubble stone is piled. The Gothic wall is formed by a single thickness of stones finished on both sides. Reducing the thickness of walls was the necessary step before replacing blind surfaces with windows, but to get the heavy cut stones to the top of the walls, hoisting machinery first had to be developed.

The use of standing stones first appears at Saint-Denis. This technique consists of laying stones, not horizontally as they occur in the quarry, but in a vertical orientation. Columns and colonnettes in the choir of Saint-Denis were in an upright position. But the piers of the ambulatory would have to be replaced in the thirteenth century by traditional columns built up in horizontal courses. This failure illuminates the work of Suger; Saint-Denis was obviously a proving ground for technical processes that Gothic architecture would make commonplace. The heavy pillars of Notre-Dame (every other one) are made using a very original bundle of small, upright stone columns (fig. 25).

**32–33. Column Statues from the Church of Notre-Dame in Corbeil. (Musée du Louvre, Paris)**

*These two statues, identified sometimes as Solomon and the queen of Sheba, sometimes as Clovis and Clotilde, belong to the family of column statues that graced Parisian portals of the early Gothic period, and that have been victims of wholesale destruction. The date of the portal of Corbeil is uncertain: 1150–1160 or 1180–1190. Corbeil, a city in the royal domain, has today been absorbed into greater Paris.*

The monumental sculpture of the first Gothic age suffered less from the vandalism—at the hands of both revolutionaries and restorers—than the stained glass, which was so often destroyed in the seventeenth century by the clergy. Hence it is in the sculpture that one still best perceives the figurative traditions of that time. Everything had to be invented: subjects, composition, and technique. How does one adapt the goldsmiths' art of carving, in relief and in the round, to the scale of architecture; how does one project the sophisticated compositions of the illuminators onto the facades? For the most part, converting the Ile-de-France to monumental sculpture would have to be a job for visiting artists, those artists whose mobility doubtless explains the similarities one observes among the statuary of the cathedrals.

In a unique occurrence, the left portal of the facade of Saint-Denis was to have been fitted with a mosaic, the only known example of this technique in the facades of the Ile-de-France, and probably chosen as a reminder of the Roman basilicas. But it is the central portal that is most noteworthy, even as badly damaged as it is (figs. 5–6). This earliest sculptured portal of the Ile-de-France is in fact a compendium of the art of the provinces: the tympanum and trumeau of Burgundy or the southwest, the sculptured archivolts of Poitou, the jamb statues of Languedoc or Provence. The Last Judgment on the tympanum, unprecedented north of the Loire, is taken from the tympanum of Beaulieu in the Limousin. But the general arrangement of the subjects and the figures, elders of the Apocalypse, wise and foolish virgins, prophets and kings of the Old Testament, was set down by Suger and this stage setting became, in its way, classic; it was reused, with some variations, in many places. The most beautiful invention of this portal, the procession of column statues on the splayed jambs, was regrettably destroyed in the Revolution.

The column statues of the portal were also destroyed, which the archdeacon Etienne de Garlande had commissioned in about 1140–1145 for the previous cathedral of Paris, and which was finally adapted to the new one, built by Maurice de Sully (figs. 22–24). For the first time in the history of monumental sculpture, the Virgin in majesty, enthroned in full frontal view, centered the tympanum; until then, the Virgin had been represented on the tympanum only in the scene of the Adoration of the Magi. The column statues of the portal of Saint-Germain-des-Prés, probably the work of the same artists as those of Garlande's portal, were likewise destroyed (fig. 13). The result is that there are no longer any examples in Paris of this Parisian creation, save for the two admirable column statues in the Louvre, which came from Corbeil (figs. 32–33).

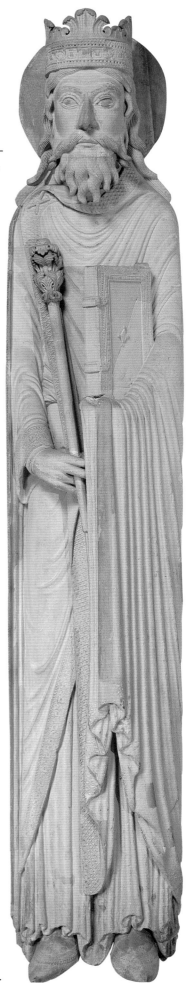

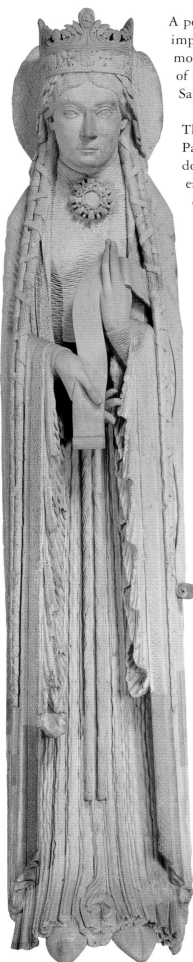

A portal of this type can still be seen virtually intact at Etampes, an important city of the royal domain in the twelfth century. But the most famous statuary group of early Gothic art is the royal portal of Chartres, which owes much to the iconographic innovations of Saint-Denis and Paris.

The central and the left portals that complete the entrance to the Parisian cathedral (figs. 27–28) are much later than Garlande's door, reused on the right. Except for some later additions and especially the brutal restoration of the nineteenth century, they can be dated to the beginning of the thirteenth century and could have been executed by a workshop from Sens. They are nonetheless derived once again from Suger's iconography, especially in the case of the Last Judgment of the central portal. The left tympanum presents a Coronation of the Virgin, a new subject, destined to have an extremely wide following. It is used three times in the cathedral itself. The idea is thought to have come from Suger, who had no occasion to put it into practice at Saint-Denis. Its first known monumental occurrence is in the tympanum of the cathedral of Senlis (1185), another important royal city in the twelfth century. Its spread would be borne by the increasing importance of the cult of Mary and by the sacralization of the royal office, which views the king as chosen by God.

The Gallery of Kings crowns, metaphorically as well as visually, the portals of Notre-Dame Cathedral. Did these hieratic statues represent kings of France, as the revolutionaries who destroyed them believed, or kings of Judah, as the scholars of the nineteenth century who restored them thought? The fact is that there is no way to know. Essentially, the theme is the same as in the Tree of Jesse; here it is a horizontal tree, above which appear the Virgin and Child. The revolutionaries, who knew something about symbolism, were not mistaken in striking out against this illustration of the dynastic principle.

The early Gothic age gathered its monumental sculptures on facades. The historiated capitals of Romanesque art, with their many human or animal figures, such as those at Sainte-Geneviève at the end of the eleventh century (chapt. I, fig. 25), bit by bit lost most of their inhabitants. The choirs of Saint-Germain-des-Prés (fig. 14) and Saint-Julien-le-Pauvre (figs. 34–35), still give shelter to a few monsters from the Romanesque bestiary in late imitations of Corinthian capitals; in the ambulatory of Notre-Dame, the last recollections of the antique capital fade and the Gothic comes into its own with the simplified capital.

The fourth of the great sites of the early Gothic age in Paris, Saint-Martin-des-Champs, left no examples of monumental sculpture, because it lacked a facade in the twelfth century. But a seated Virgin has been preserved, probably the one

known as Notre-Dame de la Carole, which was worshipped in the axial chapel of Saint-Martin for many centuries (fig. 36). The hieratic Virgin of the tympana has retained all of her majesty, but the Child is posed with relaxed naturalism. This Virgin is particularly precious in that detached statues from the early Gothic age are rare, and rarer still, any which can rival in quality the Virgin of Saint-Martin-des-Champs.

The recumbent effigy that covered the tomb of Childebert at Saint-Germain, a posthumous portrait of this king, is at home in this setting on the basis of its date, the middle of the twelfth century (chapt. I, fig. 11). The style is archaic, no doubt intentionally so, in order to make the falsification more believable: the relief is sunken into the slab, which is trapezoidal, as were the Merovingian tombs. The idea of portraying the deceased lying on the tombstone (called a "*gisant*") originated in the south at the beginning of the century; it is found for the first time north of the Loire in this tomb of Childebert, which—and this is unusual—combines the themes of the *gisant* and the donor. The king holds in his hand a model of the church that he founded. The importance of this tomb cannot be overemphasized: it provides an introduction to the art of tomb carving that, during the centuries to come, was to fill the cemetery of kings at Saint-Denis.

Like Corinthian capitals, the capitals of the early Gothic age are covered with stylized foliage, but the flora has been completely revised—indigenous species have replaced the acanthus leaf and the olive branch of the Mediterranean (fig. 26). For the first time in French art, ornamentation has a local flavor. At Saint-Denis, there are vertical calla lilies and iris; in the cathedral are bent calla lilies and ferns, water lilies and plantain, and at the end of the twelfth century, grapevines.

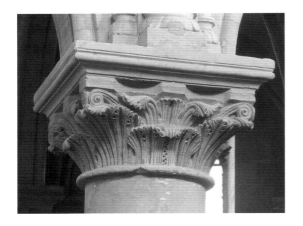

**34–35. Saint-Julien-le-Pauvre. Capitals in the Choir, between 1165–1170 and 1210–1220.**

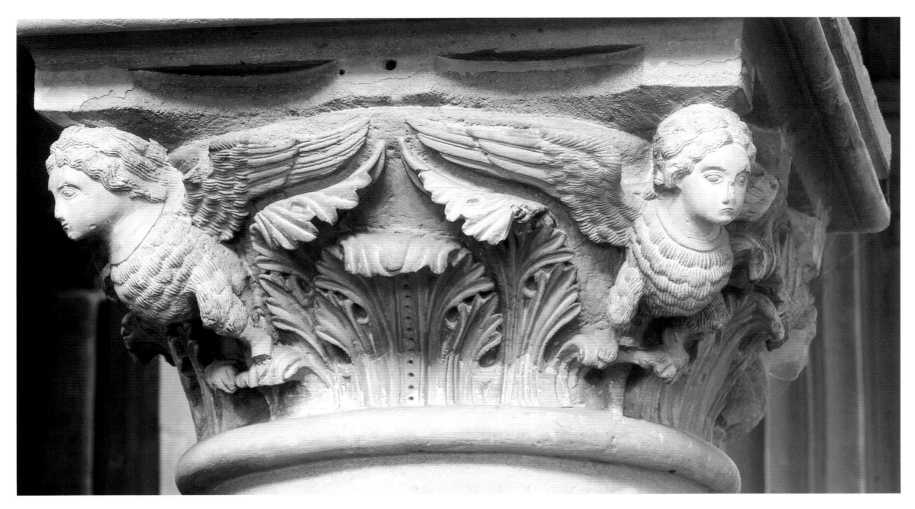

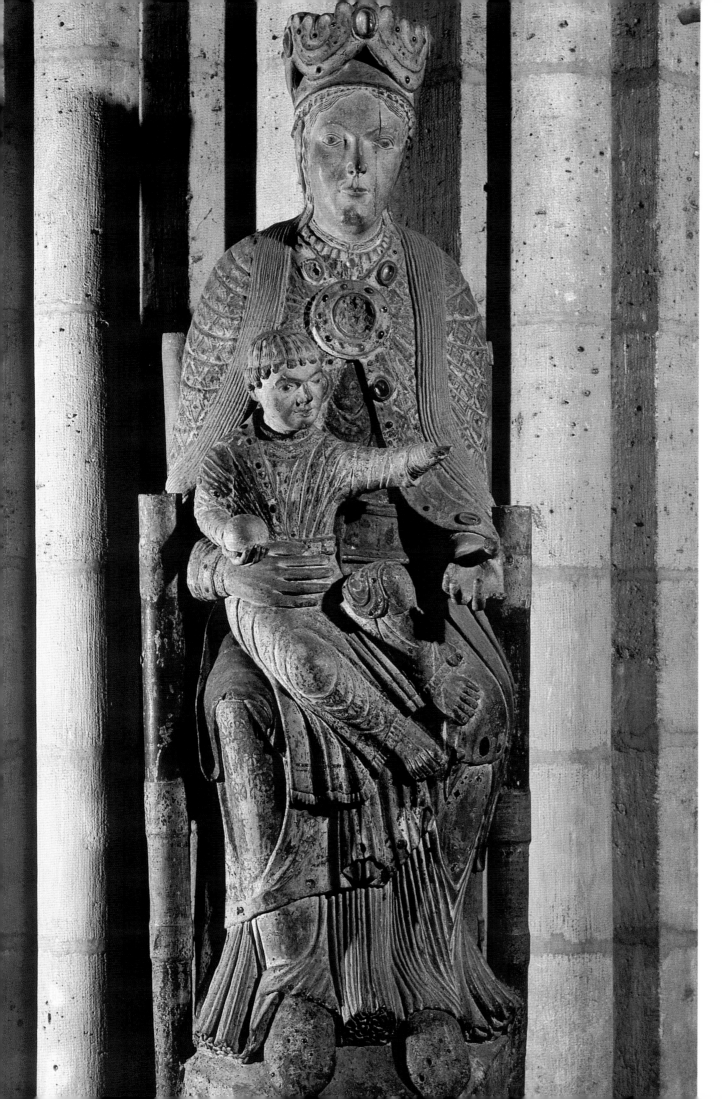

**36. Saint-Martin-des-Champs.
Vierge en majesté
(Virgin in Majesty), c. 1160.**

*Having been received by the
Musée des Monuments Français
at the Revolution, this Virgin is
today at Saint-Denis. It is
probably the same as the Notre-
Dame de la Carole that once
stood in the axial chapel open-
ing onto the ambulatory of
Saint-Martin-des-Champs.
"Carole" is an ancient synonym
for "ambulatory."*

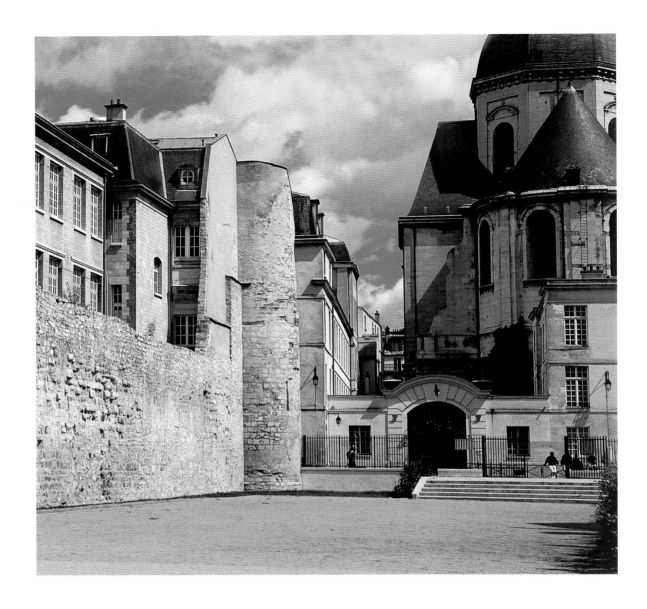

## 37. The City Walls

*This fragment of the fortified wall built by Philip Augustus is situated on the Right Bank, beside the church of Saint-Paul-Saint-Louis, the main church of the Marais, a section of Paris not yet developed at the time. This curtain wall and tower were part of the defenses on the eastern edge of the city.*

## 5 – THE FORTIFICATIONS OF PHILIP II AUGUSTUS

The west facade of Notre-Dame was completed during the reign of the seventh of the Capetian kings, Philip II. Like Julian before him, he was given the title Augustus. This term, which in the Roman religion referred to objects and places relating to the gods, had been given to the deified emperors. It, of course, no longer had the same meaning when it was conferred upon Philip II. The term was not meant to honor the victor-king so much as the rightful king, chosen by God. With Philip Augustus the consciousness of all Frenchmen resonated with the conviction that the coronation was a sacrament and the king a sacred person. After the victory at Bouvines, in 1214, Philip II, a great acquirer of territory, was also recognized as the natural leader of the nation. The victory that the king, surrounded by all his vassals and by the municipal militias (that of Paris in particular), won against a powerful coalition is considered the foundation of national unity. It entitled the victor to a triumphal entrance into Paris. Guillaume Le Breton, in the style of the epic of antiquity, described this in ten thousand Latin verses of the *Philippide*—the victory of the rightful king, the servant of the church, over the excommunicated emperor, heir of the Ottonian dynasty and adversary of the Holy See.

### The City Walls
Before embarking on the Third Crusade in 1190, Philip Augustus initiated the building of ramparts around Paris, bits of which still exist today (fig. 37). They included seventy-five

circular towers and ten gates; for the first time ever the Left Bank, the Right Bank, and the Ile de la Cité were enclosed within a single wall. In the north it enclosed the Cemetery of the Innocents and the Champeaux market. The cemetery, an ancient Merovingian burial ground, was the main Paris cemetery; and the market, established at the spot known as Les Champeaux by Louis VI and provided with a covered building by Philip Augustus, was the city's central market. In Philip Augustus's day, the only things remaining outside the wall were the Temple Close, the priory of Saint-Martin-des-Champs, and the abbeys of Saint-Germain-des-Prés and Saint-Victor, all of which possessed their own fortifications, as well as Saint-Denis in the distance.

### The Louvre

At the point where the ramparts met the river, to the west and on the Right Bank, at the place called the Louvre, he had a fortress built, which was to be the focal point for the defense of the city. This fortress included a square battlement with round towers in each corner, in the middle of the walls, and on both sides of each gate. The battlement enclosed a courtyard in the middle of which stood the keep, or the tower, as it was called then. The political and military destiny of this tower was extraordinary. It was the center of gravity of the kingdom: all the fiefs depended on it, so that its destruction under François I would mark the symbolic end of feudalism and the birth of the modern state. It was the prototype of a new art of fortification that Philip Augustus's military engineers created there at the Louvre and spread throughout the royal domain, which had expanded tremendously.

The "fat tower" or the round keep of the Palais de la Cité, often believed, without proof, to have been built by Louis VI the Fat, could also well be from the time of his grandson, Philip Augustus (chapt. III, fig. 35). A good example of fortifications in the manner of Philip Augustus survives in Dourdan, one of those cities of the original kingdom, which, like Senlis or Etampes, contained a royal residence (Hugh Capet is said to have been born there). It follows the pattern of the square or short rectangular battlement flanked by round towers and associated with a round keep. Once the engineers realized their mistake in putting the keep of the prototype in the center of the courtyard, making it crowded and dark, they placed the keep at Dourdan in a corner. The gates were equipped with a portcullis and a death-trap; the keep had archery loop-holes at all levels except in the base, which was solid. The keeps of the strongholds controlled and rebuilt by Philip Augustus could deliver an impressive "fire" power. Replications of this basic model proliferated as Philip Augustus spent enormous sums in fortifying his domain. In Chinon, for example, acquired along with Touraine, Philip Augustus strengthened the fortress left by the English by building the Coudray tower. But the basic fortress of Philip Augustus was also imitated outside his domain, even outside the realm, in the Rhône Valley, in Flanders, Lorraine, Burgundy, Auvergne, Provence, Languedoc, even as far away as English Gascony, for the king's opponents lost no time in realizing the potential of this defensive weapon. The largest of the round keeps in the style of Philip to be built in the kingdom was that of the lords of Coucy, who were not on particularly good terms with the king.

One should probably also date to the reign of Philip Augustus the "fat tower" of the Temple of Paris, also called "Caesar's tower," and maybe even attribute the initiative for its construction to him personally. Indeed, Philip Augustus had entrusted the Knights Templar with the safekeeping of the royal treasury, which was kept in this tower. Its function was very different from that of the round keep of the Louvre: it was square like the earlier keeps. Brother Hubert, who died in 1222, is thought to have been its architect.

So ends the first Gothic period, which produced works of art in Paris that, for the first time in the history of the city, cast it in the role of a trendsetter.

### IN PRAISE OF PARIS

*In this royal city...the abundance of natural spaces attracts not only those who live there but invites and entices those who are far away...It is situated in the midst of a delicious valley at the center of a crown of hills which Ceres and Bacchus outdo each other to enrich. The Seine, that majestic river which comes from the east, flows though it, full from bank to bank, and embraces with its two arms an island which is the head, the heart, the marrow, of the city itself. Two suburbs extend on the right and on the left, the lesser of which would yet make many cities envious. Each of these suburbs is connected to the island by a stone bridge: the Great Bridge, facing north, in the direction of the English sea, and the Lesser Bridge, which looks toward the Loire. The first, wide, rich, and commercial, is the scene of bubbling activity: many boats surround it, filled with goods and riches. The Lesser Bridge belongs to the dialecticians, who go strolling there as they converse. On the island, near the palace of the kings, which stands out above the entire city, is found the palace of philosophy, where studiousness reigns single and sovereign, the citadel of light and immortality.*

*Guy de Bazoches, between 1175 and 1190.*

# NOTRE-DAME CATHEDRAL

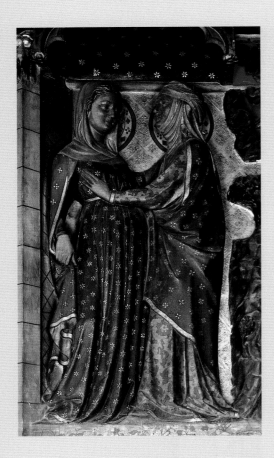

**Above:**

La Visitation (The Visitation), *a relief panel from the enclosure of the chancel; late thirteenth, early fourteenth century. Polychrome from the nineteenth century.*

**Right:**

*The spire and the top of one tower.*

**Opposite:**

*Top: The chevet of Notre-Dame on the Ile de la Cité, and the Pont de l'Archevêché linking this island to the Left Bank.*

*Bottom: Monsters inspired by the medieval gargoyles and added to the towers by Viollet-le-Duc.*

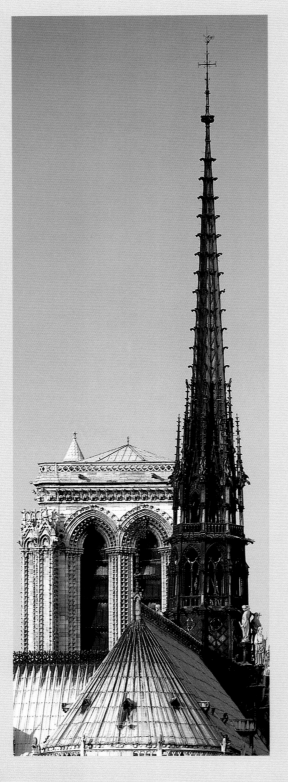

The earliest cathedral on this site was part of a bishop's complex that, in the fourth century, occupied the eastern half of the Ile de la Cité, counterbalancing the royal palace situated in the western half. The complex probably included a second sanctuary, a circular baptistery, and the bishop's residence. This complex began to disappear during the eighth century, giving way to the houses of the canons of the cathedral and the Hôtel-Dieu charity hospital. The first cathedral was a sizeable structure, comparable to the emperor Constantine's most prestigious establishments in Rome, Byzantium, and Jerusalem. Still visible in the present-day cathedral is the five-nave plan of the original cathedral. In the middle of the twelfth century, a doorway with column statues, later to be reused in the Sainte-Anne portal (on the right side of the facade), was added to the older structure.

In 1160 Bishop Maurice de Sully began a general rebuilding, which was finished at the end of the century. The building shows some characteristics common to most of the early Gothic cathedrals (sexpartite vaults, triforium passageways). In the thirteenth century, the structure was completed by the addition of flying buttresses and side chapels, the building of the arms and the facades of the transept, and decoration of the portals with sculpture. During the construction of the transept in the middle of the century the names of master masons Jean de Chelles and Pierre de Montreuil first make their appearance. Later campaigns dealt only with interior decoration and restoration. The enclosure of the chancel, made up of bas-reliefs recounting the life of Christ, was sculpted at the beginning of the fourteenth century. The goldsmiths presented a picture every year in May from 1630 to 1707, and the series known as "the Mays," which has now been dispersed (although a few paintings remain in side chapels), graced the central nave for many years. The furnishings in the chancel (1710 to 1728: high altar, choir stalls, and statues) are the work of Jules Hardouin-Mansart and Robert de Cotte, successive First Architects to the king, assisted by the sculptors Antoine Coysevox and Jules Degoullons.

With the French Revolution came the destruction of much of the monumental sculpture and the disposal of the interior furnishings, partially rescinded at the beginning of the nineteenth century. The ambitious restoration carried out by the official architect and self-styled archeologist Viollet-le-Duc, finished in 1864, endowed the crossing with a new spire and the facade with new statues.

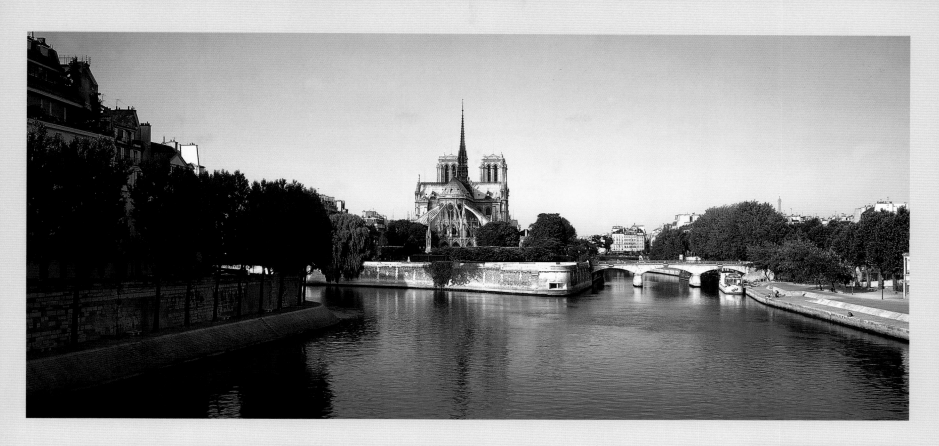

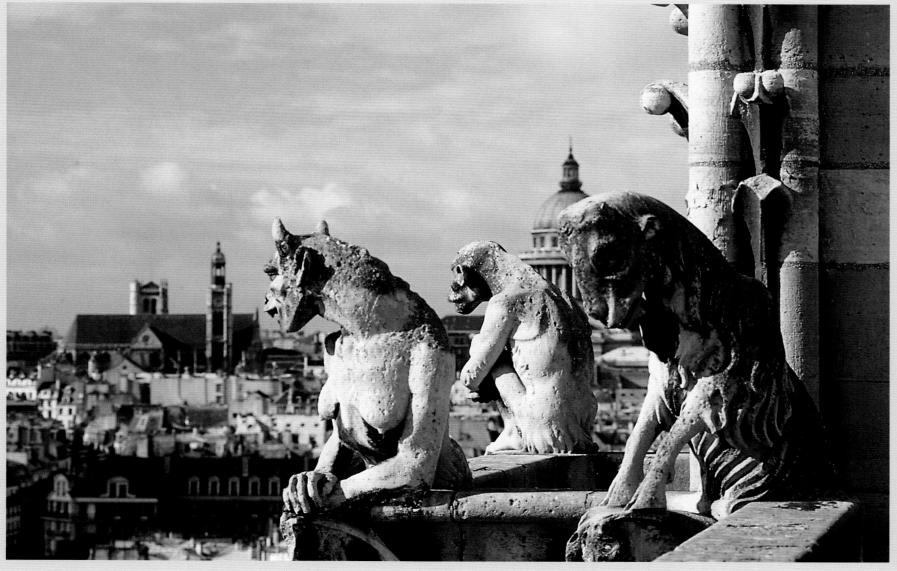

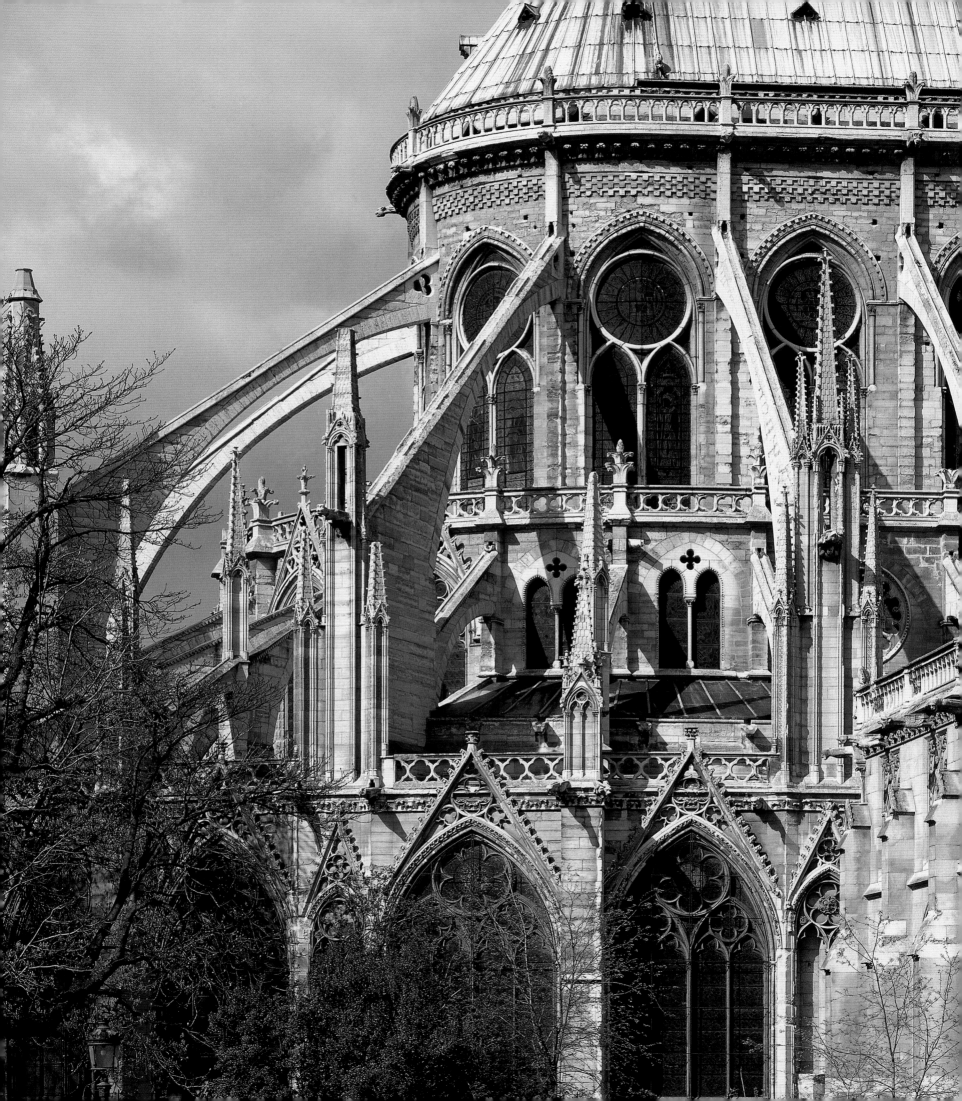

# Chapter III
# RAYONNANT GOTHIC ART
## (1220–1330)

From the death of Philip Augustus in 1223 to the last of the direct descendants of Hugh Capet in 1328, seven sovereigns passed on the crown from father to son or from brother to brother. Both by the length of their reign and by the importance of their accomplishments, two kings stand out from the others: Louis IX (Saint Louis) and Philip IV (Philip the Fair). Philip III (Philip the Bold), son of the former and father of the latter, nevertheless reigned fifteen years; but the lengths of the other reigns range between three days and six years. The three crowned sons of Philip IV died quickly one after the other, leaving the crown to their Valois cousins.

The reign of the of king-saint bequeathed to the following century the memory of a golden age, the "time of My Lord Saint Louis." And yet the record of his reign was not as good as it seemed. France had prospered, but it had let the expansion toward Flanders and Italy fritter away. In obedience to the terms of his father's will, Louis IX had had to give as appanages to his brothers some prime portions of the realm: Poitou to Alphonse, Artois to Robert, and Anjou to Charles. Alphonse had died without issue, but Robert gave rise to the house of the counts of Artois, a can of worms for the century to follow. Charles had extended Capetian control over Provence and the kingdom of Naples-Sicily, in defense of which the Valois would squander their energies. In the interest of peace in Europe, Saint Louis, on his own initiative, had restored to the king of England a part of the territory that had been captured. And what of the crusades that led first to his captivity and then to his death? This very unrealistic pursuit nevertheless lent an admirable aura to the monarch, who was sought after as an arbitrator in European affairs. The king's fame had everywhere bolstered the reputation of the art of the fleur-de-lis, the art that has since come to be called "rayonnant" based on the radiating design of the rose windows that had blossomed forth on cathedral facades throughout his reign.

Philip IV the Fair, as realistic and clever a statesman as his grandfather had been scrupulous and generous, managed to capitalize on the situation by obtaining the canonization of his forebear, which reflected an aura of sanctity on the entire royal line. But the French monarchy, for the first time in its history, came into conflict with the Holy See, as if the jurists who surrounded the king, by invoking Roman law in support of absolute royal power, had inspired in Philip IV the ambition of substituting himself for the emperor and heir of the *imperium* in opposition to the spiritual power of the popes. History tells us that the king won: in 1309 the papacy removed from Rome

**4. Page from the *Vie de saint Denis* (*Life of Saint Denis*), illuminated manuscript, 1317.**

*This biography of Saint Denis was written by Yves, a monk of Saint-Denis, commissioned by Abbot Gilles de Pontoise. It was illuminated by a workshop of four to five monks of the abbey. This manuscript is famous for its illustrations, the lower sections of which represent scenes from the daily life of Parisian tradesmen. The area formed by the schematic depiction of the bridges of Paris is the same in all the illuminations, but the figures change. These scenes are thought to be an encomium on the good government of the Capetians, the patrons of Saint-Denis. The illumination shown features Saint Denis telling Saint Saintin and Saint Antonin to write his biography.*

Since the time of Philip Augustus, the king of France was unquestionably the most powerful monarch in Europe. He derived his strength, in part, from a kingdom and a capital city that were the most populous on the continent.

## The Population

Various reports allow us to know more about the population of Paris: there is the census taken in 1328, the very year of the extinction of the direct Capetian line, and taxation rolls for *la taille* from 1292, 1296, 1298, 1299, 1300, and 1313. But the census was made by hearths, or households, and the *taille* was a direct tax that did not apply to everyone. Thus the figures obtained are not agreed upon by demographers, but the experts do generally agree about the

classification of the nine main European cities at the end of the thirteenth century. Paris tops the list with a population of 220,000 to 280,000 inhabitants; Milan, Venice, and Genoa are next with 100,000 (although perhaps twice that for Venice); then Ghent and Florence with 56,000 and 55,000; London had 40,000; Bruges had 35,000; and finally Lyons and Metz had 25,000. The people of the Parisian suburbs (*la banlieue*) were not counted, although they were Parisians, merely living outside the walls: the *banlieue* (the word originates from *ban*, "authority," and *lieue*, "league") signifies the approximately one league radius of the city's jurisdiction outside its walls. The fertile countryside of the Ile-de-France was a sizeable resource favoring Paris. The provinces also sent their contingents: Normans, Picards, residents of Lorraine, Burgundians, and especially Bretons. On the other hand, Paris had few Frenchmen from the south, which meant everything south of the Loire Valley. Paris was a capital city of northern France, or one might say, northern Europe, since in Paris one could meet the Flemish and Germans, Scots and Welsh, and the English. The Mediterranean world was represented by bankers from northern Italy, all referred to as Lombards. These traders were responsible for the circulation of a considerable number of currencies, some coming from great distances. Currency exchange was an active business; the moneychangers did business on the bridge known as the Pont au Change.

### The Political Capital

Paris gradually acquired the status of capital, which logically would only be applied to the permanent location of the authority of the state, a status incompatible with the traditional mobility of the kings and their governments. Philip Augustus, who realized through his experience in battles that it was dangerous to carry the archives and royal treasury with him, left them in Paris, the archives in the palace on the Ile de la Cité, and the treasury under the guard of the Knights Templar in their fortification north of Paris. The trial initiated by Philip IV against the Knights Templar and the confiscation of their property obviously put an end to this assignment: at the beginning of the fourteenth century, the royal accountants were well established in their chamber at the palace. The Parliament, the royal judicial body, had been meeting there since the middle of the thirteenth century. The King's Council still moved about with the king, but a select council was required to hold regular meetings, thus keeping it at the palace. The exception to this tendency away from mobility was an original and novel institution called the Estates General, that is, the assembly of the representatives of the provinces, convened by the king for the first time at the beginning of the fourteenth century. King Philip called them to Paris, but also to Toulouse, Tours, Poitiers, and Orléans. The meeting at Toulouse was a realistic response to the vastness of the realm and its division into linguistic and geographic areas: *langue d'oïl* in the north and *langue d'oc* in the south. The southerners refused to attend the meetings in the north, so it was the king who came to them. As for summoning the people of the north to cities along the Loire River, this bears witness as much to the attraction that the Loire Valley continued to exert as to the king's hesitation to put all his authority under the protection of the Parisians. This was a wise decision since as a result of the growing unity of river merchants, a sense of municipal responsibility, a collective desire for shared civic governance was developing, which, before the end of the century, would cause the monarchy many problems.

### Education

All of that was not merely a domestic concern. What made thirteenth-century Paris a European capital was the renown of its intellectuals. The minds of Paris were trained in the schools: the cathedral school of Notre-Dame was among the most prestigious. The "colleges" were private foundations, boarding institutions providing classes to poor boys, usually natives of the college founder's home region. After the founding of the first one in 1171, colleges multiplied. The most famous, the Sorbonne, was established in 1257 by Robert de Sorbon, chaplain of Saint Louis. Among the founders appear many great nobles of the realm: Jeanne de Navarre, countess of Champagne, wife of Philip IV the Fair, and Jeanne d'Evreux, widow of Charles IV the Fair. These institutions, for the most part situated on the Left Bank, caused the intellectual center of Paris to move from the Ile de la Cité to the Montagne Sainte-Geneviève, an area soon to be known as the Latin Quarter.

The university received its first articles in 1215 and its full legal status in 1231, which placed it directly under the authority of the pope. It was made up of four faculties. The Faculty of Arts was for beginning students learning philosophy. The higher-ranking faculties, with more advanced specializations, were medicine, law, and theology. There were so many students in the Faculty of Arts that they had to be divided into "nations" and "tribes." The nation of France included five properly French tribes, all from the royal domain; but one of these also was home to students from Italy and Spain! There was also a Picard nation, a Norman nation and a nation that was sometimes English and sometimes German, according to the international situation, but included islanders as well as continental Europeans. This bizarre organization highlights the magnitude of the foreign student population and the relative paucity of Mediterraneans, arbitrarily included in the nation of France.

At the university, "arts" meant "literature" only. Music was also taught, but at the cathedral school, where Pérotin the Great, who introduced important changes in the composition of polyphony, enjoyed a fame comparable to that of a renowned academic.

*Craftsmen*

The lives and activities of Parisian craftsmen and artists—the two categories were beginning to differentiate—is fairly well known owing to the tax rolls and to the famous *Book of the Trades of Paris* (1268), the collection of statutes and regulations of the Parisian corporations drawn up by Etienne Boileau, who was provost to the king in Paris. One profession stands out in particular by for its domination of the art market—the mercers. Mercers traded in and financed the production of everything having to do with artwork and apparel (even sometimes themselves producing, although their right to do so was often contested). The most modest were simple peddlers; they would soon be called "common mercers" to distinguish them from those established in permanent locations, in particular those doing business in a gallery of the Palais de la Cité, the Mercers' Gallery, which the king traversed on his way from his bedchamber to his chapel (figs. 36–37). This was an honest trade, but it has created problems for the modern perception of the artistic activity of Paris: it was so successful in promoting movement of goods among the cities of Europe that it is today impossible to verify the authenticity of Parisian makers' marks.

The surprise and admiration inspired by this industrious and creative Paris has left testimonials. For an Italian, Paris was a "true paradise on earth," a "royal city without equal." For an Englishman, "Paris receives from all parts of the world those who come to it... Wealth and goods abound there"; it is "peaceful, well aerated" and has "meadows, fields, hills where beauty abounds." Yet another effusive quote is from the *Treatise in Praise of Paris*, written in 1323 by Jean de Jandun, which is properly included in all anthologies. And this flatterer doesn't mince words: "To be in Paris is to exist in the absolute sense of the word; to be somewhere else is to exist accidentally." "Is there a man so lacking in good sense," he writes, "as to dare to put Paris alongside other cities?" The treatise is also a description, according to which the very name of Paris is said to come from Paradise: indeed, the city is situated in a "happy valley of delights toward which flow all the benefits of parts distant. The climate there is neither too warm nor too cold; the inhabitants are neither too short nor too tall. Politeness is their very nature." The author devotes chapters to the university, the churches, the royal palace, the covered market at Champeaux, even the houses. The chapter on craftsmen is famous: he writes the artisans "are crowded so densely in any given neighborhood that in casting one's eyes over the streets one could scarcely find two houses side by side that weren't filled with them."

Concordia discordantium ca
nonum ac primum de iure natu
et constitutonis

vmanu

The phenomenal growth in the production and appreciation of the luxury arts of manuscript illumination, fine metalwork, and ivory carving is a telling demonstration of the prosperity of Paris in the thirteenth century.

### Illumination

In the *Divine Comedy* (1302–1321), Dante speaks of "this art which one calls in Paris illumination," or in Italian, *alluminare*. The painting of illustrations in manuscripts obviously existed in Italy, where it was called *miniare*, from which the French made the word "miniature." This synonym is worth noting, since the increasing popularity of this genre was in part due to the passion for images on a very diminutive scale, often less than an inch high or wide (fig. 11). (Luckily, eyeglasses were just then becoming available for looking at them. This new invention is first mentioned in 1305, and eyeglasses soon became a standard attribute in the stereotype of the scholar or intellectual.) The activity of the university, the schools, and the colleges stimulated enormous activity in the handwritten duplication of texts. Of course, not all texts needed illustration and only rich collectors could order pictures in their books. These circumstances produced a certain secularization of this art: a secularization in the patronage, subject matter, and even the artists, who were now only rarely monks working in, and for, their abbey.

Saint Louis, who had learned to read using a psalter (probably not illustrated), himself commissioned the illustration of one of these devotional books, which contain prayers as well as psalms, intended for devout laypersons. The *Psautier de Saint Louis* (*Saint Louis Psalter*; fig. 7) is a meditation on the mission of the king-priest, successor to the judges and the kings of Israel. In the illustrations, flat, non-differentiated figures act out the scenes against a background of gold. The simplification of gestures is reminiscent of the figures in the famous *Album* of Villard de Honnecourt, who was either an enlightened architect or a cleric with architectural training. This contemporary of Saint Louis was an important observer of rayonnant Gothic architecture, to which the *Psautier of Saint Louis* is connected, in terms of style as well as composition.

Oddly enough, political subjects were also treated in illumination, and this is a testament to how important they were. The *Decree of Gratianus* was painted by Master Honoré, who is the earliest Parisian illuminator known by name. There is evidence that in 1300 he lived in the Rue Eremboure-de-Brie (today Rue Boutebrie), near Saint-Séverin, a neighborhood in which many illuminators lived at the time. He worked for Philip IV the Fair and, in fact, may be the model for the king teaching law to the three estates of society (fig. 5); even though the figures are still not individualized, they have been given some depth and shading. The borders, containing plant and animal motifs, was perhaps done by Robert de Verdun, son-in-law of Master Honoré, prefigure those of Jean Pucelle. How remarkable if the most characteristic feature of Pucelle, the most Parisian of illuminators, was invented by an artist from the Mosan artistic circle.

**6.** *Gesta regum Francorum (History of the Kings of France)*, early fourteenth century. (Bibliothèque Nationale de France, Paris)

*The illustrations present the genealogy of the kings of France. The first figure in the left column is Charlemagne and the last is Hugh Capet, here presented for propagandistic reasons as a direct descendant of Charlemagne. The German line of Charlemagne's descendants is represented in the right-hand column: through two women, the blood of Charlemagne is reintroduced into the French line. Hugh the Great, duke of France and father of Hugh Capet, is relegated to the single frame at the far right.*

**7.** *Psautier de Saint Louis (Saint Louis Psalter)*, c. 1260–1270. (Bibliothèque Nationale de France, Paris)

*This psalter was decorated for Louis IX by an artist working at the court of France. The illustration represents the moment when Gideon, one of the judges of Israel, has trumpets sounded in the middle of the night near the camp of the Madianites, who are so startled that they set upon and slay each other in the dark. It has all the appearances of a scene from the crusades: Gideon is seen as the pre-figuration of the reverend king.*

fomme

*Gesta regum Francorum* (*History of the Kings of France*; fig. 6), a pure product of Capetian historiography written at Saint-Denis, demonstrates that Hugh Capet descended from Charlemagne: the illumination recalls the Tree of Jesse, that genealogy of Christ that Suger had had represented in stained glass there. The treatment of the *Vie de Saint Denis* (*Life of Saint Denis*; fig. 4), another product of the Dionysian abbey, is again typical of the style practiced during the time of Saint Louis. With the intention of praising the good government of the Capetians, the lower part of the illuminations gives us the first images we have of the industrious daily life of Paris. The *Roman de Fauvel* (*Romance of Fauvel*; fig. 8) also provides amusing peeks into popular life, but with a very different intention, and a very individual mode of expression. The adventures of the horse Fauvel are the vehicle for denouncing the cynicism of the ministers of Philip IV the Fair, and to some extent that of the king himself, and lamenting the "olden days of My Lord Saint Louis." The surprisingly critical text was written by administrators close to the king.

Jean Pucelle is the first Parisian illuminator to have had a career and an influence far surpassing political and technical boundaries. He traveled to Italy, where he saw the works of Duccio and Giotto. He was active in Paris up to his death, which was either in 1333 or1334, surrounded by followers who were to continue developing his art throughout the fourteenth century. His very personal style, his signature, can be found in enamel as well as in ivory carving, monumental sculpture, and stained glass. His most important works are the *Bréviaire de Belleville* (*Breviary of Belleville*; fig. 12) and the *Heures de Jeanne d'Evreux* (*Hours of Jeanne d'Evreux*; fig. 11). The breviary was indeed for ecclesiastical use, but Pucelle's decoration made it a highly collectible object, and it quickly passed into private hands. The book of hours was commissioned by Charles IV the Fair for his wife, Jeanne d'Evreux. A book of hours was a slightly newer version of the psalter: a devotional book containing a calendar and prayers for each day and hour. With Pucelle, both realistic representation and fantastic ornamentation take a great leap forward: he coupled the perspective and depiction of volume borrowed from the Italians with the profusion of the decorative framework found in Honoré's workshop. Like the masters of the *trecento*, he places his people in architectural structures showing depth through perspective; and with a quite Parisian eloquence he creates the decorative frames with a thousand details taken from fauna or flora. He uses the technique of grisaille (from *gris*, or gray, denoting profuse use of fine lines, usually black, suggesting shading; Pucelle also used colored lines), anticipating the future decline in color used in French stained glass.

*Metal Crafts*
The most famous example of the Parisian goldsmith's art from the fourteenth century is the *Virgin and Child* offered to Saint-Denis by the dowager queen, Jeanne d'Evreux, whose long widowhood was completely dedicated to good works and beautiful art (fig. 9). It so infused with characteristics suggestive of Pucelle, who was also a goldsmith, notably in the enamels on the pedestal, that it is believed he may have been involved in the creation of the work. Also attributed to him is the Copenhagen Ewer, covered with enamels (fig. 10).

Up to the eleventh century, the great centers of enamel were in Constantinople, in northern Italy, and in Germany. Limoges took the lead only in the twelfth century, when the exploitation of the nearby natural resources (namely wood, water, and ore) was encouraged under the protection of the Plantagenet kings of England. By the 1220s, Paris was starting to take advantage of a slackening in the *opus lemovici*, or the work of Limoges, and began to borrow its techniques of champlevé (in which the metal is hollowed out to receive the enamel powder) and of cloisonné (in which each section is outlined with metal threads). But the technique of translucent *basse-taille* enameling came from Tuscany to Paris at the beginning of the fourteenth century, while Pucelle was at his most active: the Copenhagen Ewer (fig. 10) is the earliest example of it known in Paris, and Jeanne d'Evreux's *Virgin* (fig. 9), one of the most accomplished.

**8. *Roman de Fauvel* (*Romance of Fauvel*), c. 1320. (Bibliothèque Nationale de France, Paris)**

*The Roman de Fauvel is the principal work in a manuscript containing various texts relating to the royal chancellery. This "romance" is in fact a satirical poem written by Gervais du Bus, notary under Philip the Fair and his successors. Some scenes were added by Raoul de Chaillou de Pestain. The illustrations are perhaps the work of Geoffroy de Saint-Léger, a Parisian bookseller. The cynicism that marked the policies of Philip the Fair and the mendicant orders' lust for power are spoofed by the adventures of the horse, Fauvel (his name is an acronym of the first letters of the French words for Flattery, Avarice, Villainy, Vanity, Envy, and Cowardice), who manages to marry Dame Fortune. The illustration shown depicts the charivari on their wedding night. The charivari was a mass ruckus raised in front of the house of someone whose conduct was disapproved of, such as a widower who remarried.*

**9. Jeanne d'Evreux.** *Vierge à l'Enfant (Virgin and Child),* between 1324 and 1339. (Musée du Louvre, Paris)

*This statue of the Virgin was presented to Saint-Denis by Jeanne d'Evreux, widow of Charles IV the Fair. This silver gilt piece is just under twenty-seven inches tall and is decorated with gold, crystal, precious stones, pearls, and, on the base, basse-taille enamels. The fleur-de-lis in the Virgin's hand is a reliquary. The artist may be Simon de Lille, if it is not Jean Pucelle.*

**10. Copenhagen Ewer, c. 1320–1330. (Nationalmuseet, Copenhagen)**

*This silver gilt vessel, eight and two-thirds inches tall, is decorated with enamels, and bears the stamp of Paris, the fleur-de-lis. It is attributed to the circle of Pucelle, perhaps even to the master himself, who was also a goldsmith. By the fifteenth century, it was already in the possession of a merchant from Lübeck. The scenes represented are from an unidentified romance.*

**11. Jean Pucelle. *Heures de Jeanne d'Evreux (Hours of Jeanne d'Evreux),* 1325–1328. (Metropolitan Museum of Art, Cloisters Collection, New York)**

*Ordered by Charles IV the Fair for his wife, Jeanne d'Evreux, this book measures only three and a half inches by two and a third inches.*

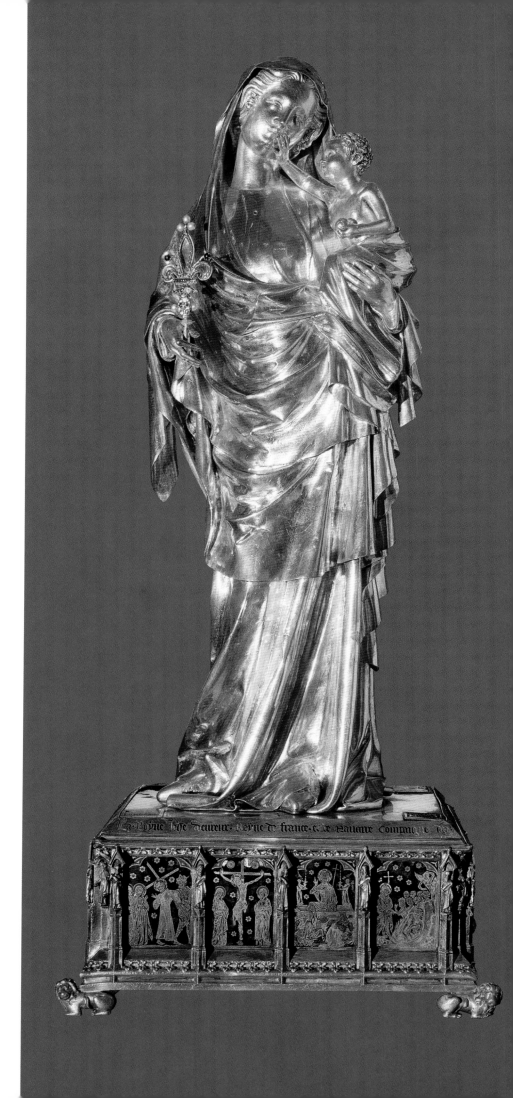

Goldsmiths and silversmiths, who are not differentiated from enamellers, were present in great numbers in Paris: there were 116 on the tax rolls of 1292 and 251 in 1300. Judging by their names, which mention their place of origin, they came from many areas (Aire, Lille, Lens, Senlis, Medan, Mantes, Toul, Besançon, Auxerre, and Montpellier). From the time of the decree by Philip III the Bold in 1275, all their artworks were to bear the stamp of Paris, the fleur-de-lis; the Copenhagen Ewer is so stamped.

*Ivory*

By the suddenness of its appearance, the rapidity of its success, and the originality of the works it produced, ivory carving is the most singular of all the Parisian luxury arts. It appeared in the middle of the thirteenth century with an unexpected surge in ivory trade and slowed little by little in the sixteenth century (figs. 13, 15–19). In the provinces and abroad, ivory had been used for book covers; Paris invented the ivory devotional artifact and personal accessory. Elephant, walrus, wild boar, and warthog tusks, sperm whale and hippopotamus teeth, whalebone, and antlers made up the raw materials. Narwhal horn was not used as it was believed to be the horn of the legendary unicorn. Traditionally, elephant tusks, which gave the particular "Gothic slouch" to Virgin and Child statuettes (fig. 16), arrived in France via the Italian ports. In the thirteenth century competing routes were opened through the Norman ports of Dieppe and Rouen and through several Flemish ports. This would explain the relative abundance of the material after a long bout when it was scarce, although this rebound is perhaps only the effect of an increasing demand from a rapidly growing city. The uniformity in ivory production and the national and international imitation of the Parisian style make the identification of the origin of objects difficult. There are ivory carvers in the important ports, Rouen and Dieppe, and almost everywhere in Europe. But it is certain that Parisian works were exported, such as the famous *Virgin and Child of Villeneuve-lès-Avignon* (fig. 16), which traveled to Avignon to bear witness to the excellence of the Parisian technique to the connoisseurs of the papal court.

Ivory was worked in Paris by artists called *"ymagiers"* (imagers), who practiced the *"mestier d'entaillerie"* (craft of carving), *"paintres et tailleurs d'ymages"* (painters and image carvers), *"ymagiers tailleurs"* (carving imagers), and by manufacturers of numerous useful objects such as combs, knives, writing tablets, lanterns, dice, tokens, chessmen, shoe buckles, rosary beads, and buttons. The first mention of an "ivory man" by name dates from 1322 and refers to Jean le Scelleur, who in 1313 had still been called a mercer; he was undoubtedly a merchant as well as a craftsman of ivory objects. Artists and artisans {that's what the French book says, but seems redundant} collected around the Rue de la Tabletterie, between the cloister of Sainte-Opportune and the Rue Saint-Denis.

**12. Jean Pucelle.** *Belleville Breviary,* **between 1323 and 1326.** (Bibliothèque Nationale de France, Paris)

*Made for a Dominican convent, this breviary once belonged to the wife of Olivier de Clisson, Jeanne de Belleville, who gave it its name. It is considered the masterpiece of Jean Pucelle and was bought by Charles V, whose famous library was the basis of the collection at the Bibliothèque Royale, now Bibliothèque Nationale de France. Seen in the illustration: top, Saul tries to kill David; lower left, Cain killing Abel; lower right, the Eucharist and Charity. The dragonfly, which was called "demoiselle," is perhaps the signature of Pucelle (whose name means "maiden").*

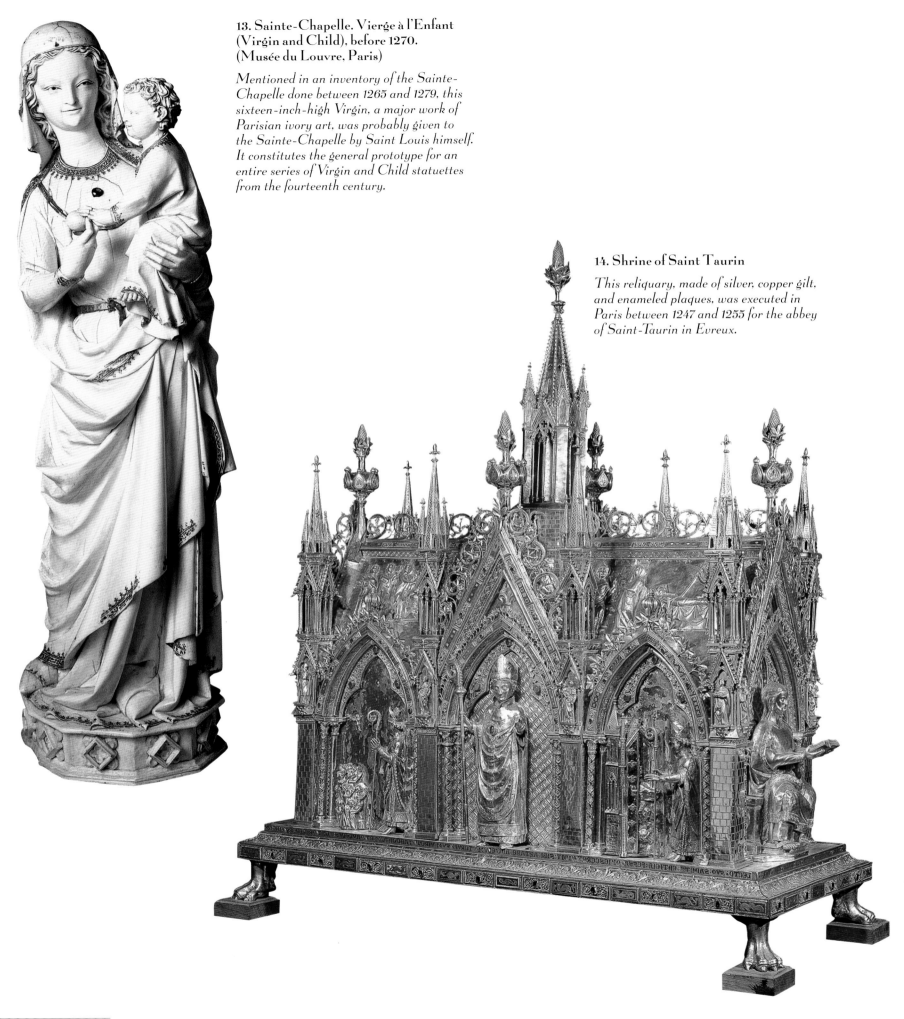

**13.** Sainte-Chapelle. Vierge à l'Enfant
(Virgin and Child), before 1270.
(Musée du Louvre, Paris)

*Mentioned in an inventory of the Sainte-
Chapelle done between 1265 and 1279, this
sixteen-inch-high Virgin, a major work of
Parisian ivory art, was probably given to
the Sainte-Chapelle by Saint Louis himself.
It constitutes the general prototype for an
entire series of Virgin and Child statuettes
from the fourteenth century.*

**14.** Shrine of Saint Taurin

*This reliquary, made of silver, copper gilt,
and enameled plaques, was executed in
Paris between 1247 and 1255 for the abbey
of Saint-Taurin in Evreux.*

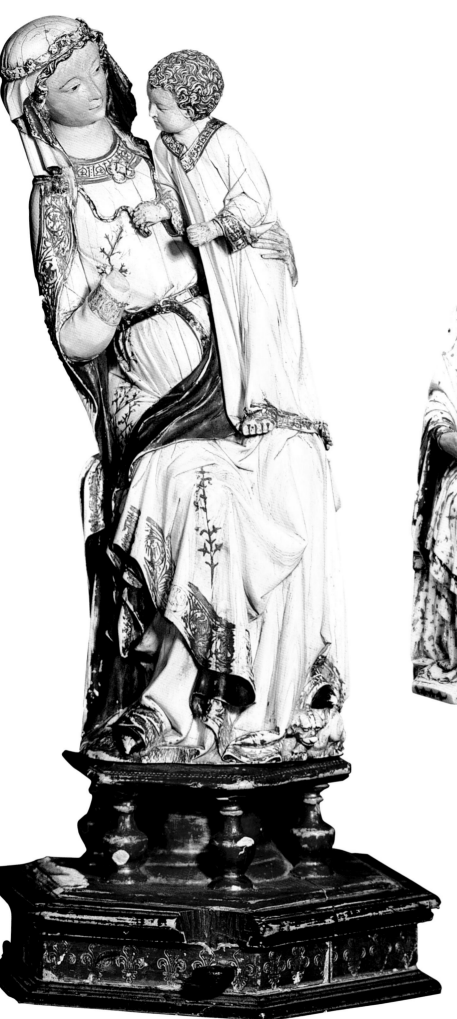

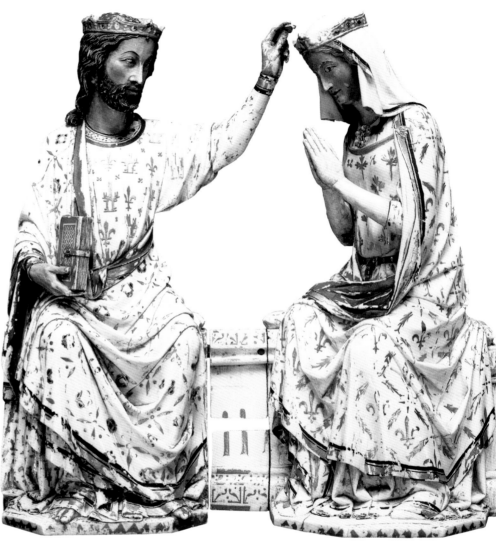

15. *Couronnement de la Vierge*
(*Coronation of the Virgin*),
third quarter of the thirteenth century.
(Musée du Louvre, Paris)

*The grouping of Christ and the Virgin (eleven inches high) was framed by two angels (also in the Louvre) and surmounted by two other angels descending from the clouds (now in the Mayer van den Bergh Museum in Antwerp). Its polychromatic paint was spoiled by restorations in the nineteenth century.*

16. *Vierge à l'Enfant de Villeneuve-lès-Avignon*
(*Virgin and Child of Villeneuve-lès-Avignon*),
c. 1310–1320. (Musée Pierre de Luxembourg,
Villeneuve-lès-Avignon)

*This exceptionally large statuette of the Virgin (nearly eighteen inches high), carved from the tip of an elephant tusk, was probably commissioned from a Parisian ivory carver by Arnaud de Via, Cardinal-Deacon of Saint-Eustache, who died in 1325. He had founded the collegiate church of Villeneuve-lès-Avignon, whose treasury included this Virgin. Its polychromatic paint was refreshed during a restoration.*

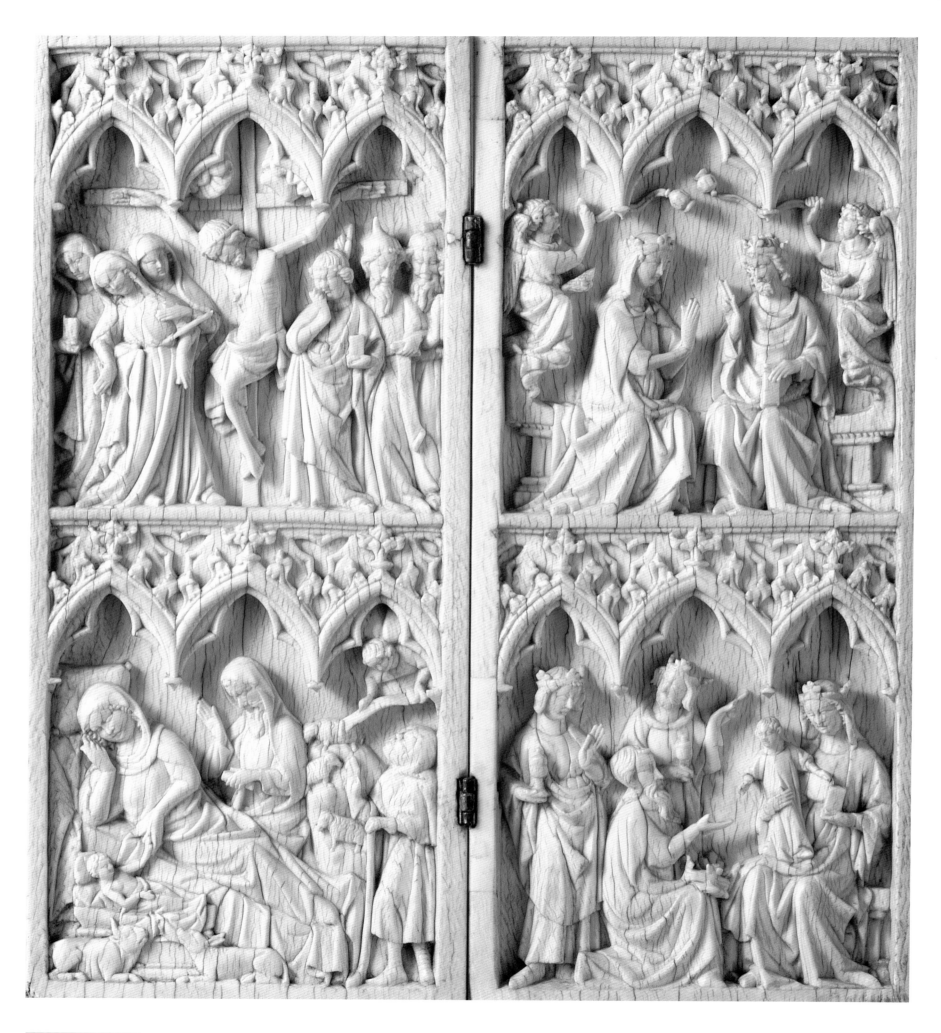

Like manuscript illumination, ivory statuettes were intended for private worship; artisans made miniature versions of monumental sculpture available for use in private chapels. Other ivory objects served daily life, personal grooming in particular, such as the mirror valves (figs. 18–19), that is, round boxes containing a polished metal mirror carried in a belt or a purse. These very luxurious objects were decorated with scenes taken from mythology, legend, or song depicting secular or courtly life.

Even the simplest grooming objects were luxurious and expensive. It is clear that the nobles, as with manuscript illumination, were the principal patrons of this work. However, it is usually impossible to determine by whom an order was placed. Furthermore, one must take into account the bourgeois clientele, growing along with the population and anxious to imitate the nobility. At the end of the thirteenth century the first sumptuary laws appeared forbidding commoners from using furs, gold, and precious stones and even wearing certain color clothes. But to no avail—Parisian fashion was not to be thwarted so easily!

**17. Scenes from the Life of the Virgin, ivory diptych, second quarter of the fourteenth century. (Musée du Louvre, Paris)**

*Shown are the Nativity and the Annunciation to the Shepherds (lower left), the Adoration of the Magi (lower right), and the Crucifixion (in the upper left one can see the fainting Virgin struck by a stream of blood from Christ's wound). In the upper right is the Coronation of the Virgin.*

**18. L'Assemblée (The Assembly), ivory mirror valve, c. 1300. (Musée National du Moyen Âge– Thermes de Cluny, Paris)**

*This ivory valve, or mirror box (five and a half inches in diameter), of unknown provenance, shows an unidentified scene called* The Assembly, *perhaps a scene from a romance, perhaps a meeting of King Solomon and the queen of Sheba.*

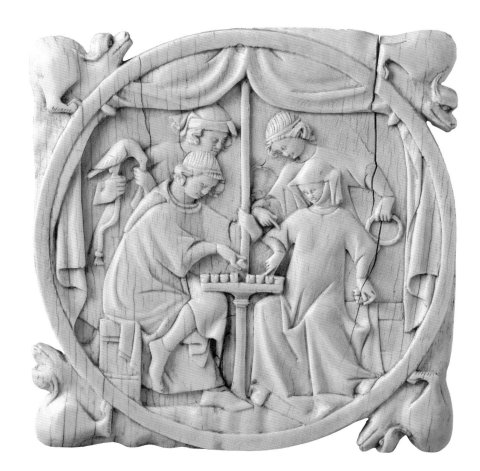

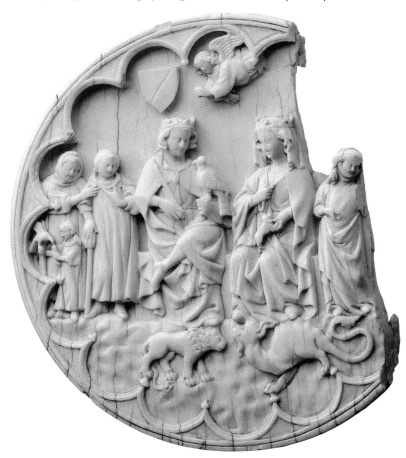

**19. Le Jeu d'échecs (The Chess Game), ivory mirror valve, first quarter of the fourteenth century. (Musée du Louvre, Paris)**

*This ivory valve, or mirror box (four and three-quarters inches in diameter), of unknown origin, shows a chess game between a couple, probably based on a scene from a romance.*

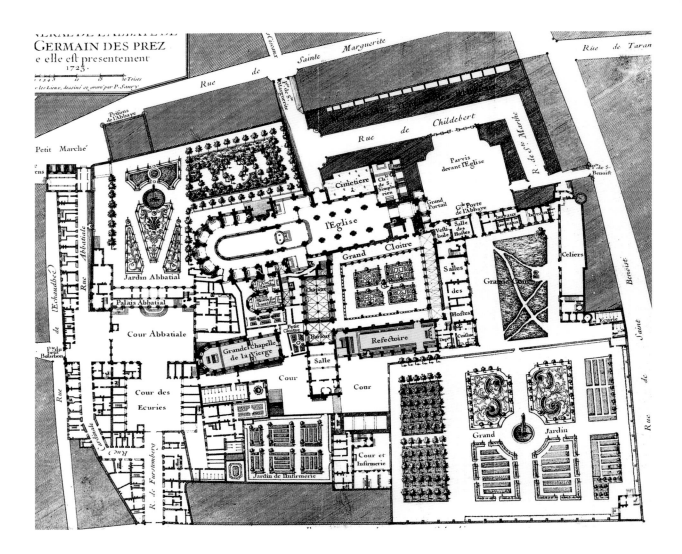

**20–21. The Abbey of Saint-Germain-des-Prés. Chapel of the Virgin and Refectory.**

*The refectory was built from 1239 to 1244 and the Chapel of the Virgin in about 1250, by Pierre de Montreuil. These masterpieces of rayonnant Gothic architecture were destroyed during the Revolution. There are a few vestiges left in the little square beside the church and in the Musée du Moyen Âge. The statue of Childebert I that decorated the refectory portal is preserved in the Louvre (chapt. I, fig. 12).*

## 3 – ARCHITECTURE

"Just as the writer who has written his book illuminates it with gold and azure, the king [Louis IX] embellished his kingdom with beautiful abbeys, and he made great numbers of charity homes and houses for preachers and friars." This comparison, written by Jean de Joinville, friend and biographer of the king, shows how important illumination had become during that period. And it is praise indeed for architecture, in spite of the difference in scale, to be compared with illumination. The fact is that building was relatively inexpensive; much less so than certain precious objects. The construction of the Sainte-Chapelle cost 40,000 *livres* (pounds of gold), whereas the reliquary that the chapel housed cost 100,000. This is without taking into account the actual relic, the crown of thorns that Saint Louis bought from the emperor of Constantinople at the price of 135,000 *livres*!

It is true that Saint Louis built much and spent a great deal, as much on his own projects as on those that he encouraged through donations. The record of these donations confirming the charitable nature of the king was piously collected by hagiographers, and through it we know that the donations were distributed to almost all of the religious buildings in the kingdom, numerous though they were. In Paris there were two hundred churches by the time of the French Revolution in 1789, nineteen of which had been founded in the Middle Ages on the Ile de la Cité alone. That can obviously give only a rough idea of the number of churches in Paris at the time of Saint Louis. What is certain is that at the end of his reign the building of the great Parisian churches was finished and that the powerful figures of Paris would undertake no new construction of comparable size for at least two centuries; in those two centuries, they would embellish, add a portal, found chapels at a college or a convent, and indeed they turned their attention to civil architecture.

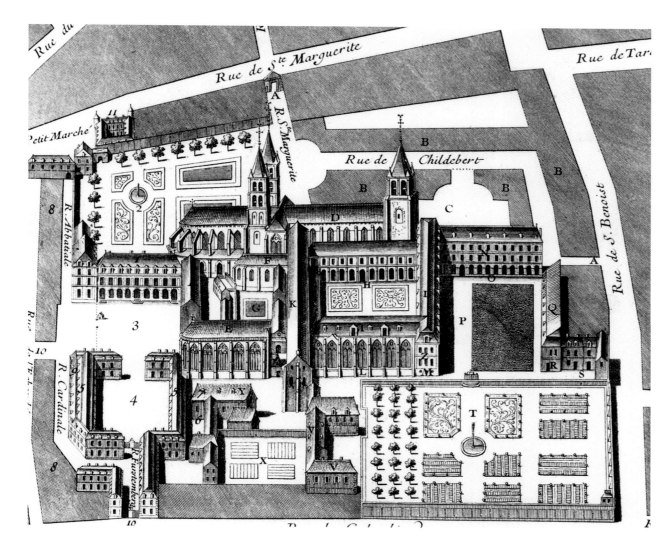

## The Saint-Louis Style

The architecture of the reign of Saint Louis is characterized by its technical innovation, which had been underway already for nearly a century. The method of distributing the weight of the ogives onto flying buttresses was being perfected, but also rivaled by the use of iron bars, either transversal tie rods hidden in attics or in the thickness of walls, or as at Sainte-Chapelle, a band encircling the entire structure. In the latter example, it is hidden behind the masonry, except where it crosses a window, where the attentive observer can spot it. Prefabrication made its appearance at the beginning of the thirteenth century, in particular in the manufacture of sash windows: in the Gothic method, the divisions of a window were no longer obtained by grouping the openings of a wall, as in the Romanesque period, but by using a large opening held up by a stone webbing called tracery. The metal-framed glass panels were inserted in the gaps in the tracery. The combination of metal sash and stone tracery allowed the wall, now no longer weight-bearing, to appear more open than solid, sometimes giving the impression of being made entirely of glass. The masonry was subjected to more rigid constraints and had to be more carefully assembled: the stones were larger and of better quality, the joints thinner. Furthermore, stones could be held together by metal fasteners, an ancient method that was revived, but here the fasteners were iron rather than bronze.

From these innovations, rayonnant architecture derived its main characteristics, and even its name, since the typical thirteenth-century rose window has a tracery pattern with radiating ("*rayonnant*" in French) segments, one of many designs made possible by the use of the sash window. The reduction of the weight-bearing function of the wall obviously allowed the expansion of the glazed parts. The rose window could occupy the full width of the facade. The formerly blind outer wall behind the triforium could be opened up. Clerestory windows and

**22. Notre-Dame Cathedral.**
*Adam*, 1260.
(Musée National du Moyen Age –
Thermes de Cluny, Paris)

*This statue is said to have come from the south arm of the transept of Notre-Dame and to date from the 1260s. It was found in storage in one of the towers of the cathedral, along with an Eve, which was beyond repair. The* Adam *underwent an aggressive restoration in the nineteenth century.*

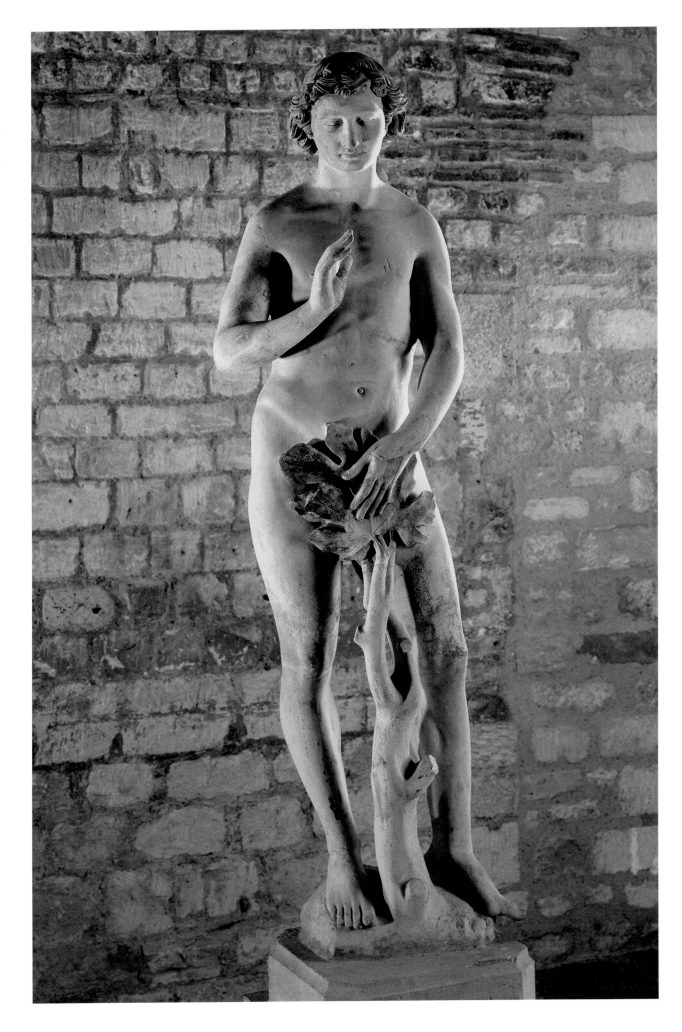

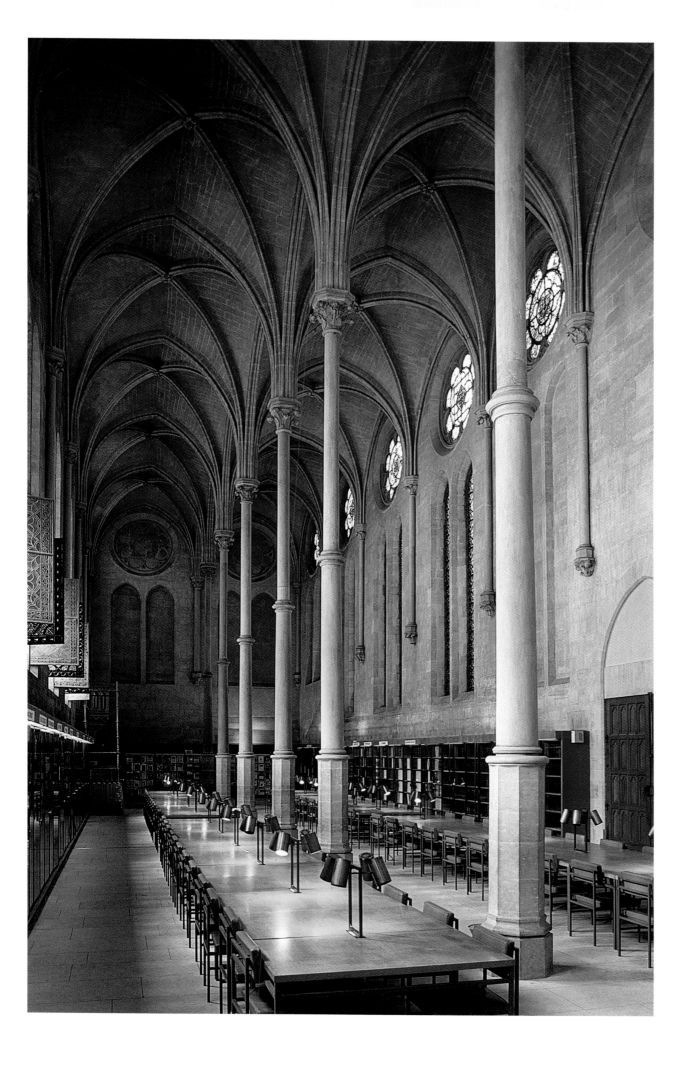

**23. Priory of Saint-Martin-des-Champs. Refectory, before 1240.**

*This architectural masterpiece is not documented: it is attributed, without proof, to Pierre de Montreuil and dated from before 1240.*

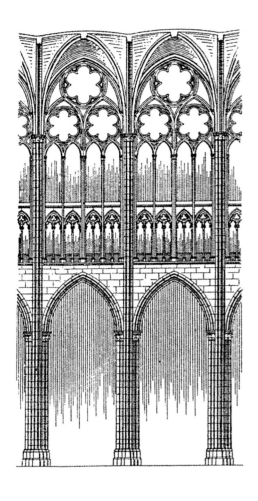

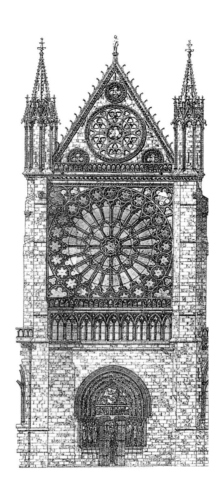

### 24–25, 27. Abbey Church of Saint-Denis. Nave, Transept, and Upper Levels of the Choir.

*The construction of the abbey church, left unfinished by Suger, was taken up again in 1231 by Abbot Odo Clément; it was halted, or at least slowed down, in 1245 when the abbot resigned. The principal structural elements were apparently finished, with the exception of the vaults in the choir. The work was not entirely finished until 1281. Built were the nave and the transept, both of which were unusually wide since they were to receive the tombs of the kings; rebuilt were the upper levels of Suger's choir. This is the first example of rayonnant Gothic art. It is attributed to an architect who has been called the Master of 1231. Beginning in 1247 the name of Pierre de Montreuil begins to appear in documents. He was formerly credited with the original design of the plans. In fact, nothing strictly precludes identifying the Master of 1231 with Pierre de Montreuil. True, there are in the details certain design changes that could be explained by the arrival of a new master mason on the site after the interruption of 1245, but an artist may recognize on his own the need to change his plan. So many works have been withdrawn from Pierre de Montreuil, under the pretense that they were not in his style, that one is hard pressed today to say exactly what that style was.*

### 26. Monts-joie

*The road from Paris to Saint-Denis was marked off with seven stone crosses, or milestones, known as* monts-joie. *The side facing the road was decorated with three kings. This series of twenty-one kings is similar to the Gallery of Kings on Notre-Dame, the Great Hall of the Palais, and the tombs of Saint-Denis. Destroyed in the French Revolution, these* monts-joie *are known today through an engraving from the seventeenth century. In it one can see initials "L" with an imperial crown. They were added during a restoration in the seventeenth century by the Bourbons. Their construction is attributed to Philip III the Bold: he is thought to have had them built in 1275 for the transport of the body of Saint Louis from Paris to Saint-Denis. The* monts-joie *are not discussed in the literature before the early fifteenth century, when a* mont-joie *was included in the scene of the Meeting of the Magi in the Très Riches Heures du duc de Berry (chapt. IV, fig. 42).*

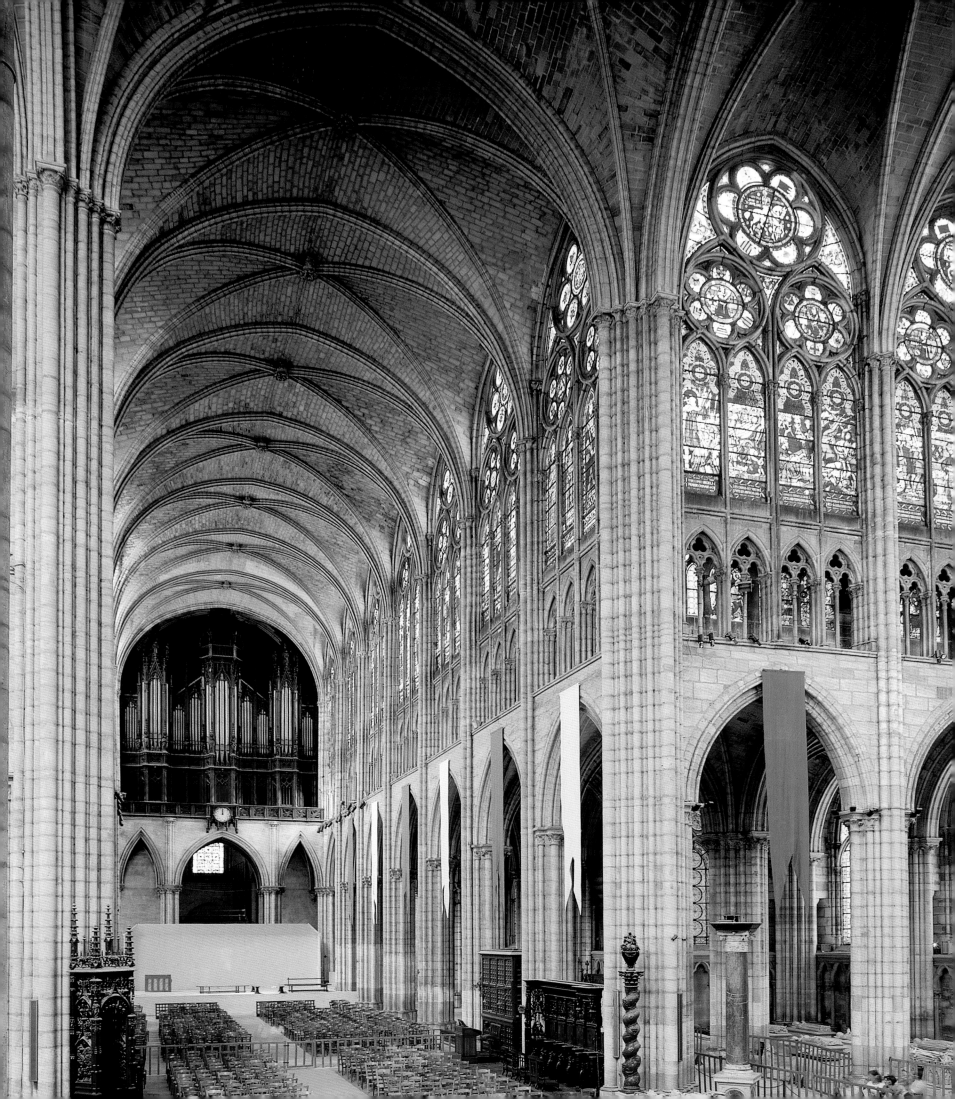

### 28–31. Sainte-Chapelle

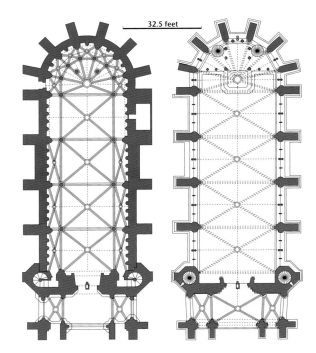

The Sainte-Chapelle was built from 1241–1248 in the middle of the Palais de la Cité, on the order of Saint Louis, to house the relics of the Passion that he had acquired, and in particular the Crown of Thorns, which he had purchased in 1237 from Baldwin II, monarch of the short-lived latin empire of Constantinople.

The chapel is double: the lower chapel was for use by the parish and the upper chapel was reserved for the king. Behind the altar of the upper chapel, a tribune (rebuilt in the nineteenth century) bore a shrine (now lost) containing the relics. The upper chapel was accessible on the same level from the king's bedchamber, on the second story of the palace; from the lower chapel it was accessible only by narrow spiral stairs, still used today. Thus, the upper chapel was, in fact, itself a reliquary, to which only the king, his close retainers, and the canons on duty could gain access. Processions on feast days, exposing the relics outside the chapel, gave the populace its only opportunity to worship the artifacts. At an undetermined date (before 1470), a wide staircase was added to the exterior, giving the public access to the second floor and the reliquary; these stairs were removed during the restorations carried out beginning in 1849 by Jean-Baptiste Lassus.

The Trésor des Chartes (Charterhouse Treasury) was connected to the chevet. It was built at the same time as Sainte-Chapelle and was itself a kind of chapel for housing the most important documents of the royal archives.

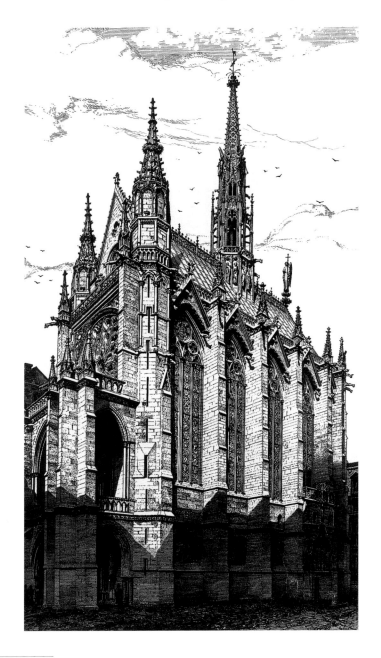

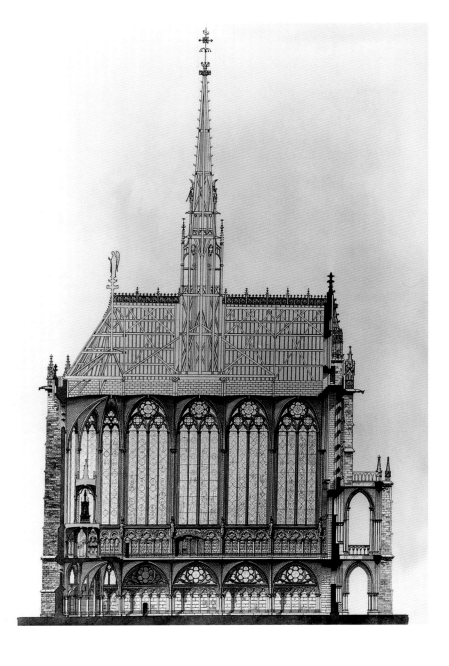

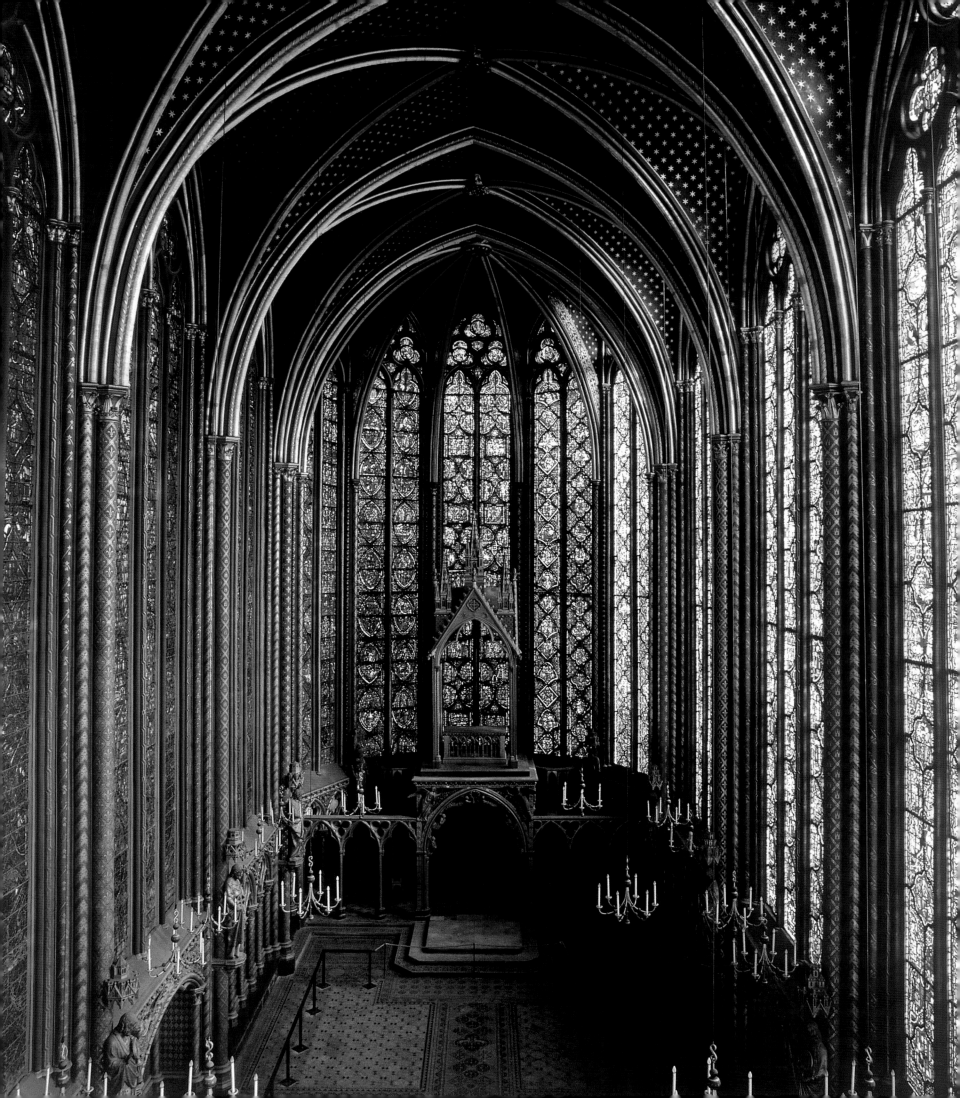

### 32–34. Sainte-Chapelle Windows

*The windows of the Sainte-Chapelle were made between 1242–1243 and 1248 by three different workshops, each one with its own individual manner. They fill the eight windows of the side walls, which are nearly fifty feet high by fifteen feet, and the seven absidial windows, which are forty-eight feet high by eleven feet wide. The theme is the priesthood of the king, illustrated with passages from the Old Testament, which are obviously to be read in the context of Saint Louis's image of royal duty and the presence in this place of the Crown of Thorns. In the last window on the left before the apse is the story of Joshua, successor to Moses (detail shown above).*

triforia seem to melt into a single luminous web. Such "magic" was nothing more than the extension of the principle of the sash window. The solid portions of the wall were themselves entirely covered with blind arcades, which extend the illusion of the network in the glass. The blending of the solid and the open parts led to the use of gables, no longer those triangular caps arching heavily over a bay, but simple ornaments repeated rhythmically one after the other, like the garlands of a crown. The slender shafts that form its lacey webs, tracery, and arcatures lend a gossamer quality to rayonnant structures, accentuating the importance of line. This is why this style was so well adapted to the luxury arts: the illuminations of the *Psautier de Saint Louis* (*Saint Louis Psalter*) are crowned with openwork gables (fig. 7). Unless, of course, it was the architects that were copying the decorative fancies of the book painters! Thus the innovation that most influenced the rayonnant style was the generalization of the use of drawing in the planning and realization of architectural projects (figs. 55–56). Previously, the master masons laid out their plans or working drawings in full scale on the ground or on a wall. The use of scale drawings on parchment transformed the perception of architecture, which was promoted to a place among the liberal arts: the architect drew in the same way that others wrote; he left behind instructions and so could respond to requests for consultations that came to him from

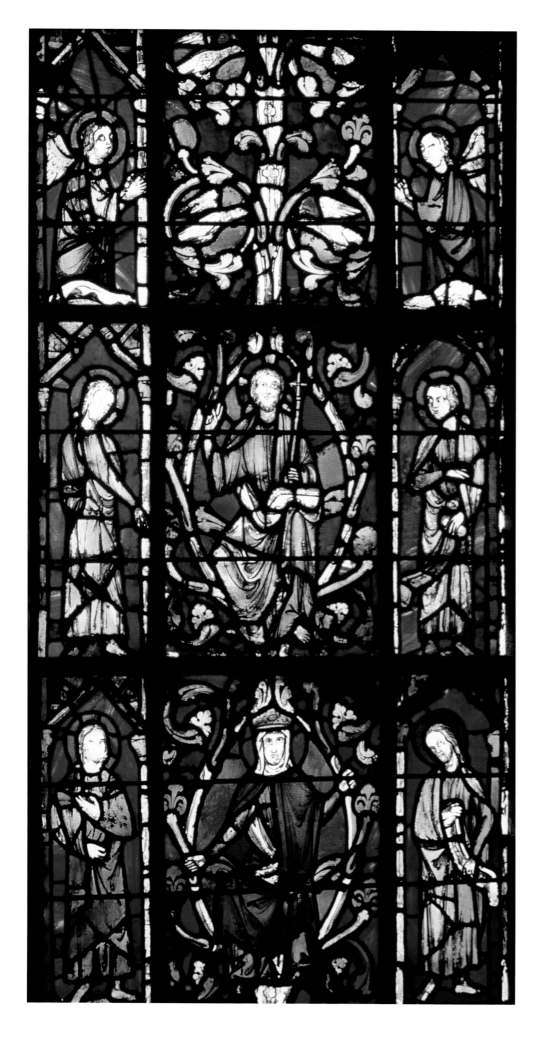

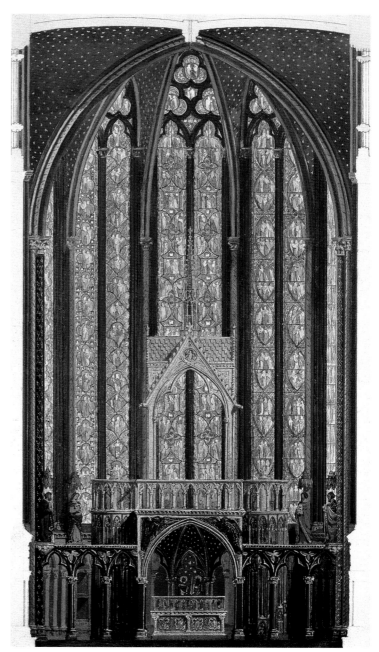

**33–34. Sainte-Chapelle Windows**

*One of the windows of the apse represents the Tree of Jesse (detail shown at left), a theme already treated by Suger at Saint-Denis.*

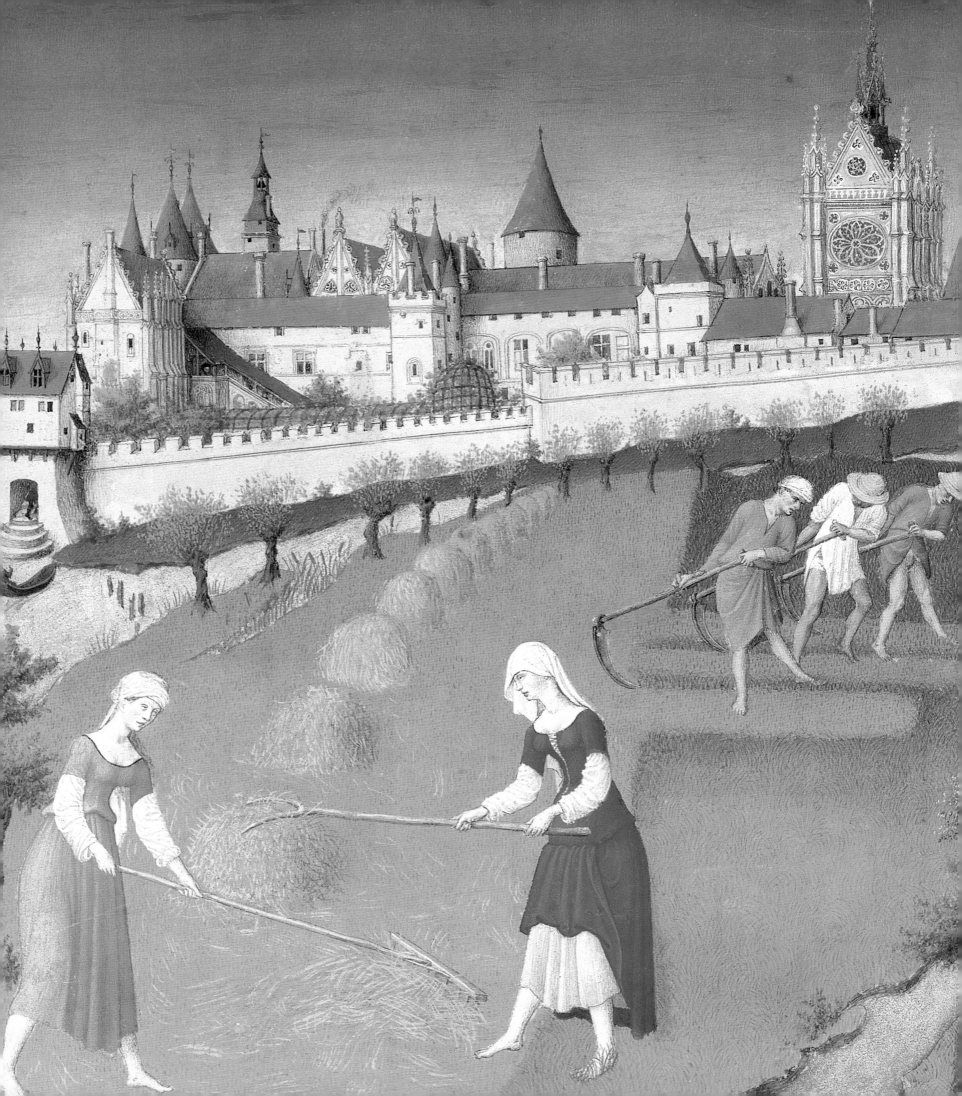

all sides. These master masons, who were anonymous in the time of Suger, now had a name that made them famous.

*Master Masons*

Paris and its immediate surroundings had a leading role in the development of this new architecture. Ranking high among famous architects is Pierre de Montreuil: or rather was, because many of the works formerly attributed to him have been reattributed, according to the dubious principle that every architect has his own style and that his touch should always be recognizable. The catalog of works by Pierre de Montreuil now contains only two important attributions: the refectory and the Chapel of the Virgin at Saint-Germain-des-Prés, two rayonnant masterpieces, attested today by a few fragments, some rudimentary renderings in engravings (figs. 20–21), and one lasting reputation. Pierre de Montreuil is also responsible for the facade of the south transept of the cathedral (fig. 43), but since this facade had been started by Jean de Chelles, it is difficult to distinguish their contributions from one another. Pierre's hand is more apparent in the construction of the lateral chapels in the choir, but these are still just secondary projects (fig. 1). Henceforth Pierre de Montreuil must not be spoken of in connection with Saint-Denis, nor Saint-Germain-en-Laye, nor the Sainte-Chapelle. He may still be the architect of the stunning refectory at Saint-Martin-des-Champs (fig. 23), but this assertation has not been proven. His only title that cannot be challenged is that of *doctor latomorum* written on his tomb, "Doctor of Stones," which makes him the equal of the erudites of the university. Pierre died four years before Saint Louis. He had been born in Montreuil, probably the Montreuil east of Paris. Odo de Montreuil, certainly a relation, called simply "master mason" and "master carpenter," was nonetheless a member of the household of King Philip IV the Fair and followed him as he moved about the kingdom. Jean and Pierre de Chelles, probably father and son, were active at the Notre-Dame site. They came from Chelles, which was famous for its royal Merovingian abbey.

Besides this group, two architects are as noteworthy as the Parisian architects: Robert de Luzarches and Hugues Libergier. They are each responsible for one of the earliest and most important examples of rayonnant art, the cathedral of Amiens and the church of Saint-Nicaise in Reims, respectively. In other words, to properly understand the origins of

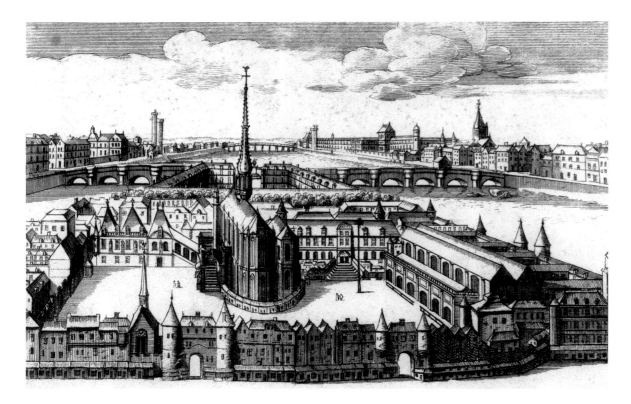

## 35–39. Palais de la Cité

*The Gallo-Roman fortress, built on the western tip of the Ile de la Cité, was used and no doubt remodeled by the Merovingian kings. Considerable work was also done on it by Robert the Pious, Louis VI the Fat, Philip Augustus, Saint Louis, and Philip IV the Fair. Little by little the palace was completely given over to administrative functions and permanently ceased to serve as a royal residence in 1417. Today it is the Palais de Justice (court building). The only remains from the time it was a residence is the Sainte-Chapelle, built by Saint Louis; the great halls and the twin towers of the Conciergerie, built by Philip IV; and the Tour de l'Horloge (Clock Tower), built by John II the Good. The earliest known picture of the palace is the illumination in the Très Riches Heures du duc de Berry, which is nearly contemporary with the final years of royal residency. Visible in it are, from right to left: the Sainte-Chapelle; the royal lodgings between the two square towers, essentially dating from Louis VI; behind that, the Grosse Tour (Big Tower), attributed to Louis VI but possibly built later by Philip Augustus; the Conciergerie, with the twin gables of the Grande Salle (Great Hall) at its rear, all built by Philip IV; the Tournelle with the tip of the pointed slate roof of the Tour Bonbec, both built by Saint Louis; the two pointed red roofs of the Tour d'Argent (Silver Tower) and the Tour de César (Caesar's Tower), built by Philip IV; behind these is the square steeple of the Tour de l'Horloge, built by John II. The three latter towers have been preserved to this day.*

### Plan of the ground floor

A – (Documented as it was in the period of Saint Louis)
B – Tour Bonbec (period of Saint Louis)
C – Tour d'Argent (period of Philip the Fair)
D – Tour de César (period of Philip the Fair)
E – Tour de l'Horloge (period of John the Good)
F – Conciergerie (period of Philip the Fair)
G – Upper Floor, Grande Chambre (documented as it was in the period of Louis XII)
H – Salle des Gardes (Guard Room; period of Philip the Fair). Upper Floor, Grande Salle (Great Hall, documented as it was in the period of Philip the Fair).
J – Royal Lodging (periods of Louis VI and Philip the Fair; no longer extant)
K – Grosse Tour or keep (period of Philip Augustus; no longer extant)
L – Galerie Mercière (Mercers' Gallery; period of Saint Louis; remodeled)
M – Trésor des Chartes (period of Saint Louis; no longer extant)
N – Sainte-Chapelle (period of Saint Louis)
P – Chambre des Comptes (Counting House, documented as it was in the period of Louis XII)

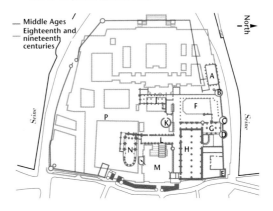

Middle Ages
Eighteenth and nineteenth centuries

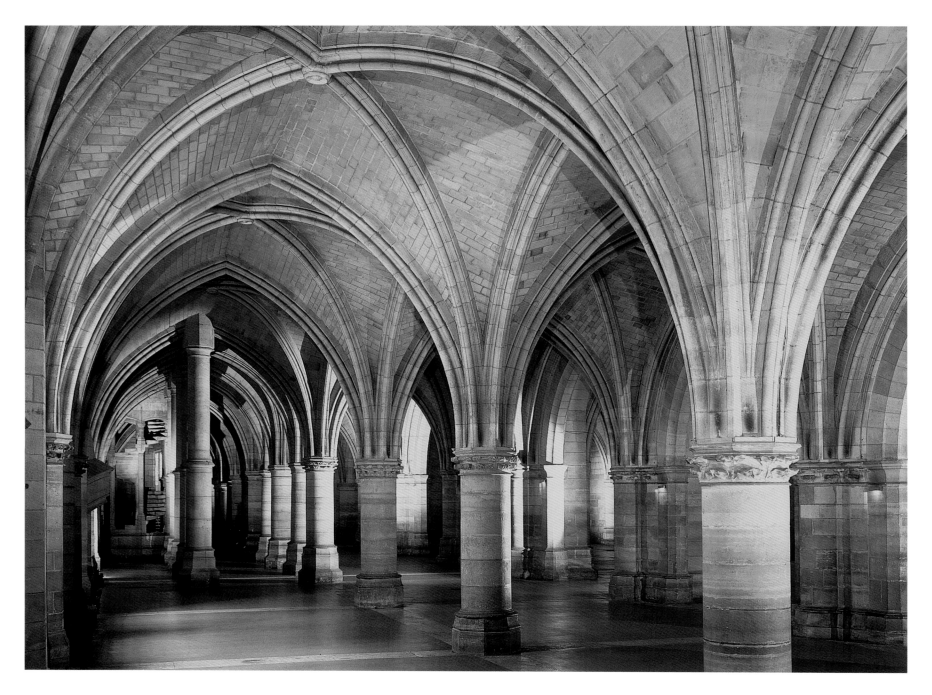

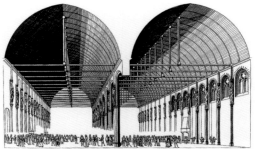

### 38–39. Palais de la Cité

*The Salle des Gardes, built by Philip the Fair, is the principal part of the royal residence that has been preserved. Above the Salle des Gardes was the Grande Salle, decorated with the statues of the kings of France now known only through an engraving by Jacques Androuet Du Cerceau from the second half of the sixteenth century.*

rayonnant Gothic architecture, one must look somewhat beyond Paris. But Luzarches is in the Ile-de-France, and Robert probably spent his formative days on the Parisian construction sites. Of Hugh Libergier, only his tombstone is known, upon which the professional architect appears for the first time in all his dignity, with cape, mason's square, compass, ruler, and scale model.

### Saint-Denis

Since Pierre de Montreuil has fallen out of favor, it is an anonymous architect who must be credited with the nave, transept, and upper parts of the choir of Saint-Denis, from between 1231 and 1245 (figs. 24–27). This is among the very first rayonnant works. The important feature is openness. The arcade rises almost high enough to touch the triforium, which is glazed on the outer wall. Thus the triforium runs between two identical series of archways, one open and facing the nave, the other one fitted with windows and facing outward. The clerestory windows rise immediately above the level of the triforium. Triforium and clerestory windows are united in the same composition by the mullions, which start at the triforium and are carried on the same plane to the top of the windows, unifying all levels into a single composition. The piers are fasciculate in appearance, that is, made up of a bundle of

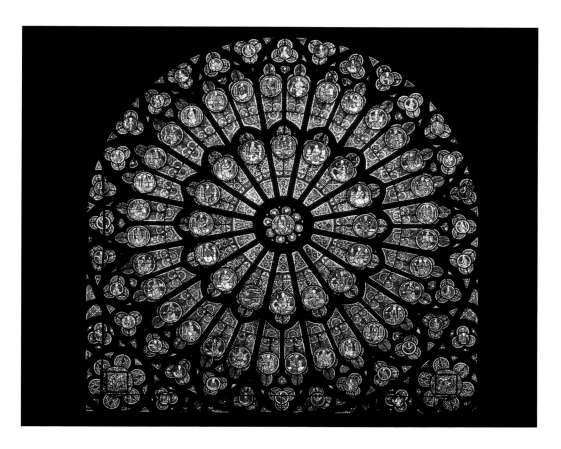

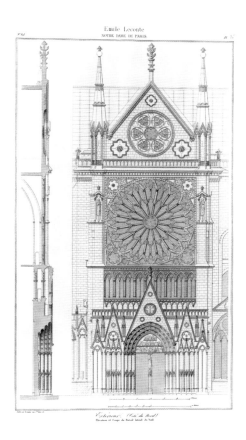

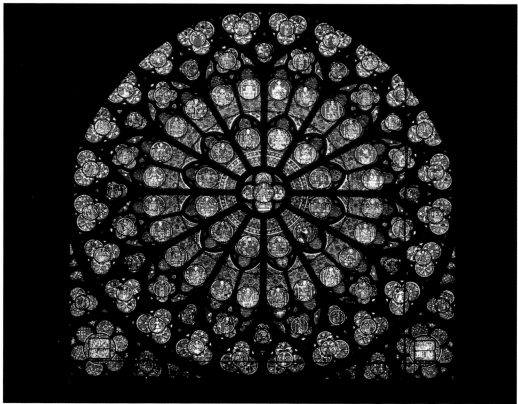

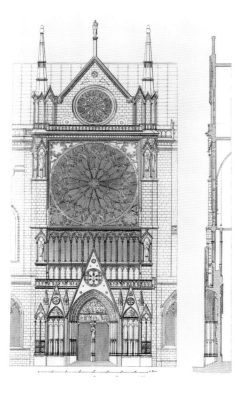

## 40–41. Notre-Dame Cathedral. Rose Windows of the Transept.

*The rose window of the north transept, from about 1255, represents characters from the Old Testament: the rose of the south arm, from about 1260, originally showed God the Father surrounded by martyrs, confessors, and saints. Both windows have been restored frequently, particularly the south rose, in which fragments from a window of the late twelfth century were re-used during a restoration in the seventeenth century. In this same window, Viollet-le-Duc, in his nineteenth-century restoration, replaced God the Father with a figure of the Christ of the Apocalypse.*

## 42–43. Notre-Dame Cathedral Transept

*From the middle of the thirteenth century to the beginning of the fourteenth, lateral chapels were built along the flanks of the cathedral, surrounding it completely. Consequently, it became necessary to lengthen the arms of the transept so that their facades would not be set back from the outer walls at the ground-floor level. The north facade (above) was rebuilt in the 1250s by Jean de Chelles, who also began the south facade.*

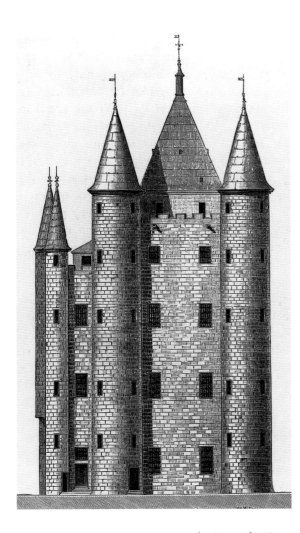

### 44–46. The Temple Keep

*Within the Temple close there was a massive tower called the Tour de César, built at the end of the twelfth century, which held the royal treasure entrusted to the Templars by Philip Augustus, and which had perhaps been built for that purpose. A second large tower, known as the Temple Keep, was added later. It appears on a seal from 1290. Its builder was Friar Jean de Tour (who died in 1310). Destroyed in the nineteenth century (after having served as a prison for the royal family during the Revolution), it was rectangular with round turrets at each corner.*

columns: to each colonnette corresponds the springing of one of the structural elements, first the arcade, then in the vaulting, the transversal ribs and the crossed groin ribs. The fasciculate pier is basic to rayonnant architecture. The principle of the sash window is applied to both the windows and the roses at the ends of the transept, which are glazed across their full width. The anonymous architect of Saint-Denis has also been credited with the construction of the chapel in the castle of Saint-Germain-en-Laye, a royal residence on the outskirts of Paris. This chapel is one of the most original structures from this period.

The connection of Saint-Denis to Paris is made more visible through the unusual demarcation of the roadside, at regular intervals, with monuments called *monts-joie*: while the royal necropolis was being finished, *monts-joie* were installed along the funeral route of the kings. The *mont-joie*, the slender stone monument originating on the Lendit plain, was the model for numerous small rayonnant structures, delicate as jewel boxes (fig. 26).

### The Sainte-Chapelle

The Sainte-Chapelle of the Palais de la Cité, like the chapel of Saint-Germain-en-Laye, was a commission from Saint Louis, surely his most famous (figs. 28–34). The upper chapel is completely glazed: the only interruption in the glass wall comes from the buttresses, which bear a part of the weight of the vault. Instead of flying buttresses the choice was made to install a reinforcing system of iron straps circling the structure and hidden in the masonry of the buttresses. This metal girdle is barely visible where it crosses the windows at mid-height, since it nearly always corresponds to a joint in the sashes. Iron also plays an essential role in the stability of the lower chapel, which is, in fact, very low, since its primary function is to raise the upper chapel just far enough to be on the same level as the noble floor of the royal residence. Some of the ribs in the lower chapel are lined with iron and stabilized by brackets, also iron. The Sainte-Chapelle is among the earliest examples of the systematic use of iron elements in construction. But it is not these technical innovations that make this masterpiece the paragon of rayonnant architecture: the blind arcades that relieve the flatness of some of the walls and the crown of gables above the windows are attributes of this style.

16.25 feet

Based on the similarity between the Sainte-Chapelle and the Chapel of the Virgin at the cathedral of Amiens, and in spite of questionable chronology, the Paris chapel has been attributed to the architects of the Amiens cathedral, Robert de Luzarches or Thomas de Cormont. The copy is doubtless the one in Amiens, so perhaps we should return to the traditional attribution of the Sainte-Chapelle to Pierre de Montreuil. What we know about the refectory and the Chapel of the Virgin at Saint-Germain-des-Prés certainly argues in his favor.

Pierre de Montreuil was also, as we have said, responsible for part of the lateral chapels and for the south transept facade of Notre-Dame (fig. 43), where all the characteristics of rayonnant architecture are present: rose windows, lace-work screens, arcades, and gables. Yet, although this facade is indebted to the transept facades of Saint-Denis and to the facade of the other transept of Notre-Dame, the work of Jean de Chelles, it nonetheless gathers these familiar elements into a composition that would become the model not only for transept facades, but for the west facades of innumerable, more modest, churches.

*Saint-Martin-des-Champs*

It is hard to believe that the nave of Saint-Martin-des-Champs, made in a single span and covered by a vaulted wooden ceiling, and devoid of all the attributes of rayonnant architecture, is in fact a work from the thirteenth century, for one of the most important establishments in Paris.

To have a clearer picture of Parisian architecture from the reigns of Saint Louis and Philip the Fair, one ought to reconstitute many massive structures, particularly convent churches. If the three great royal abbeys of Maubuisson, Royaumont, and Le Lys, founded by Saint Louis and his mother, Blanche de Castile, just beyond the urban limits of Paris, had not lost their churches, we might have been able to observe the coexistence, in the reign of Saint Louis, of a style owing little to the Parisian manner and much to Romanesque traditions.

*The Palais de la Cité*

The same could also be said about civilian architecture. The only parts of the palace that have been preserved date from the reign of Philip the Fair. At the end of the thirteenth century, he decided to transform the Palais de la Cité into a "new palace of marvelous and costly work, the most very beautiful that anyone ever saw in France" (*Grandes Chroniques de France*; figs. 35–39). The idea was to bring together royal residence and administrative functions. The work was finished by about 1324. Two rooms have survived: one is the Salle des Gardes, on the ground floor under the Great Hall, which is unfortunately destroyed, but known to us through an engraving

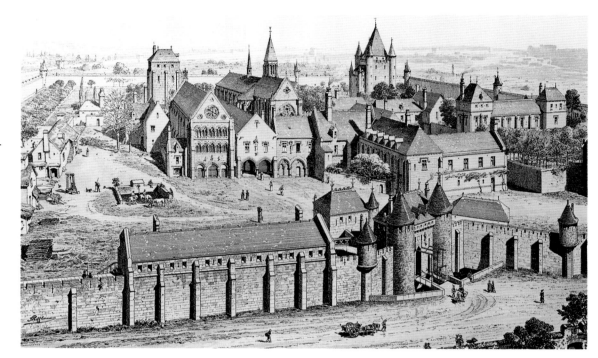

of the sixteenth century (fig. 39). Apparently nothing hinted of the rayonnant style. However, we may lack sufficient information to form an opinion.

*The Temple*

We know even less about the Grosse Tour, or keep, of the Temple, built before 1290 (figs. 44–46). The Temple compound actually had two keeps at the same time, which was not unusual, as they were built by two different kings. The Tour de César, the first of the two keeps, had probably been built by Philip Augustus to safeguard the royal treasury. Ironically, the second keep was built at about the same time that Philip the Fair had the treasury returned to the palace; perhaps the Templars felt threatened by increasing royal disapproval. The plan of this second keep, in a new design which would be widely imitated, was in the shape of a square with round towers at each corner: one of these contained a spiral staircase; the three others contained chambers accessible on each floor from the central, square room.

Until the first decades of the fourteenth century, civilian architecture remained essentially closed, massive, and defensive, in other words, completely different from rayonnant architecture. This could be easily seen at the Temple itself, by comparing the Grosse Tour to the narthex and its open-work upper level, which was added to the front of the church at about the same time and is attested by an engraving (chapt. II, fig. 31): this upper space was glassed in like a lantern.

**47. Sainte-Chapelle. Apostle, between 1245 and 1248. (Musée National du Moyen Âge – Thermes de Cluny, Paris)**

*The upper chapel of the Sainte-Chapelle (figs. 28–34) is decorated with twelve apostle statues, divided into two groups of six: a first group was carved between 1245 and the dedication in 1248; the other was finished after the dedication (perhaps as late as 1264). The first group, which includes the Saint James shown here, is more classical; the second group is more mannerist. Many of these figures have been moved to the Musée National du Moyen Âge and replaced at the site by nineteenth-century copies.*

Such a radical transformation in architecture, even limited to a few prestigious buildings, could not avoid having considerable consequences for the monumental arts.

### Mural Painting and Stained Glass

Did the reduction in flat wall surface cause a transferal of imagery from mural painting toward glass? It's impossible to tell: the history of the medieval mural in Paris has yet to be written, and if it were to be tried, this history would consist only of documentation of works that have disappeared. Texts mention in particular two cycles dedicated to the life of Saint Louis, one commissioned by Blanche, the daughter of Saint Louis, for the Franciscan convent of Lourcines in the Faubourg Saint Marcel; the other one was commissioned by Queen Jeanne d'Evreux, that tireless patron, for the Carmelite convent of the Place Maubert. Apparently, Paris still had some walls left to be decorated.

Nor is it possible to do a proper survey of stained glass from the rayonnant period limited to extant Parisian examples. Today one must go to Chartres to learn about it: the collection at Chartres, so miraculously preserved, shows what used to exist in Paris. Saint-Denis's thirteenth-century windows were destroyed; of those from the Chapel of the Virgin at Saint-Germain-des-Prés, there remain only scattered fragments; the rose windows of Notre-Dame (figs. 40–41) and the windows of the Sainte-Chapelle (figs. 32–34) were extensively redone in the nineteenth century. However, at the Sainte-Chapelle they were very carefully restored, and they remain an incomparable illustration of French stained glass in the middle of the thirteenth century: colors are darker than in the previous century, dominated by saturated blues and dark reds, and the whites are almost totally absent. Panels, now more numerous, stand out against geometrical borders in two or three colors.

## Sculpture

The evolution of monumental sculpture was similar to that of architecture, although there is no direct causal relationship between the two. Yet, what we might call the "mobilization" of sculpture is not unrelated to the opening up of the walls in the rayonnant style; three-dimensional statues tended to become separate from walls—they found new locations and acquired a certain autonomy.

The most representative examples of the style of the 1240s are once again from a tympanum and a door pier: the Christ and angel with a lance from the central tympanum of Notre-Dame (chapt. II, fig. 28) and the *Childebert* of the refectory doorway at Saint-Germain-des-Prés (chapt. I, fig. 12), probably produced in the same workshop. They are fairly typical examples of the general tendencies in sculpture at the middle of the century, tendencies that the nomenclature of styles divides somewhat unsatisfactorily between classicism and mannerism. The canon of the human body was made longer (from 1:6 to 1:7 for the proportion of head to body); its volume was no longer suggested just by the folds of clothing, but by the shape of the body itself; and faces were more refined, eyes and lips thinner, and hair was curled.

The Sainte-Chapelle once again has a starring role (fig. 47), providing the earliest example of the different use of statues, which, forsaking the jambs of portals, moved inside to pedestals on the narrow piers between the glass expanses of the nave. The twelve apostles of the Sainte-Chapelle were sculpted in two campaigns, a decade or more apart, by two different workshops: the first, more classic, the second, more mannered. The second tendency would dominate, half a century later, in another Apostolic College sculpted at Saint-Jacques-de-l'Hôpital, which closely followed the feeling of the second Sainte-Chapelle group.

This approach perhaps also inspired the decoration of the Great Hall of the Palace (fig. 39). By order of Philip IV the Fair, the pillars of the Great Hall were embellished with statues representing the kings of the three dynasties, from Pharamond, the ancestor of Clovis, on. It has been noted before that the Capetians never hesitated to commission posthumous effigies of their predecessors.

Saint Louis had set the example by gathering into the new transept of Saint-Denis, designed for that very purpose, the tombs of the kings buried in the basilica. Dagobert, the most ancient of these kings and considered the founder of the abbey, was honored with a special niche next to the high altar, which was shaped like a portal and tympanum. The other bodies were placed, Merovingians and Carolingians on one side, Capetians on the other, under a *gisant* that particular recumbent effigy made famous by the example of Saint-Denis. The *gisants* were carved from the same stone as the slab on which they lay. The treatment of figures did not take into account their position: drapery folds fell as if they were standing, eyes were open as if these kings were still alive. And their features were idealized. Kings of the Great Hall of the Palace must not have been very different.

If its placement and dating were not so uncertain, the *Adam* of the cathedral (fig. 22) would doubtless have a prominent place in the history of the nude and freestanding statuary. It is thought to be from the cathedral transept where it was balanced by a sculpture of Eve. Nothing is known of its degree of integration into the architecture. Its dating runs all the way from the 1260s to the beginning of the sixteenth century; it is true that this full-scale nude, isolated from its context, is quite suggestive of the Renaissance.

Equally "Renaissance" in its style was the equestrian statue in Notre-Dame (fig. 48). Its subject, however, was Philip IV the Fair. It is true that the famous statue of the Roman emperor Marcus Aurelius in the Forum of the Capitol in Rome, thought to represent the

**48. Equestrian Statue of Philip IV the Fair**

*This statue was an ex-voto, raised in the cathedral after the victory of Philip IV the Fair over the Flemish at Mons-en-Pévèle in 1304. Although this engraving, published in the Cosmographie by André Thevet (1575), is only from the end of the sixteenth century, and the ionic capital of the base is surprising, there seems to be little doubt about the identification and dating. Nonetheless, the horseman has sometimes been identified as Philip VI, victor over the Flemish at Mont-Cassel in 1328.*

**49. Entrance to the Collège de Navarre**

*The College, founded in 1304 on the Montagne Sainte-Geneviève by Jeanne de Navarre, wife of Philip the Fair, was the location for the first example of the portrayal of a royal couple on either side of an entranceway, a composition that was to be frequently imitated.*

Christian emperor Constantin, was reproduced on the facade of many Romanesque churches and that the mysterious horseman of Bamberg Cathedral, whose pose is similar to the Paris statue, dates from the middle of the thirteenth century.

More innovative and more influential, however, were the statues of Philip IV the Fair and Jeanne de Navarre at the entrance to the Collège de Navarre: for the first time, the royal couple was the actual subject of a portal. The representation of the queen, who founded the institution by the terms of her will, was posthumous, but the king was in fact alive at the laying of the cornerstone in 1309 (fig. 49). Might the artist have attempted a true portrait of the king? The work is no longer there to help us decide. The same uncertainty holds for the statue of Philip IV in the Great Hall of the Palace.

The question is important because it would be useful to be able to date the appearance of a portrait done from life, a genre that was to take on considerable importance in the fourteenth century. It is agreed that the famous royal statue of Mainneville castle, which belonged to Enguerrand de Marigny, a minister under Philip IV, is either a portrait of the

**50. Saint-Denis. Tomb of Isabelle d'Aragon, wife of Philip III the Bold.**

*Isabelle, daughter of King James I of Aragon and first wife of the king of France, Philip III the Bold, died in 1271. The tomb must have been begun at once (payment was made in 1275). Only the white marble gisant and the black marble slab with peripheral inscription on which it lies have survived. Lost are the polychromic paint from the gisant and the false niche (colonnettes at the side) in which the figure was presented as though standing.*

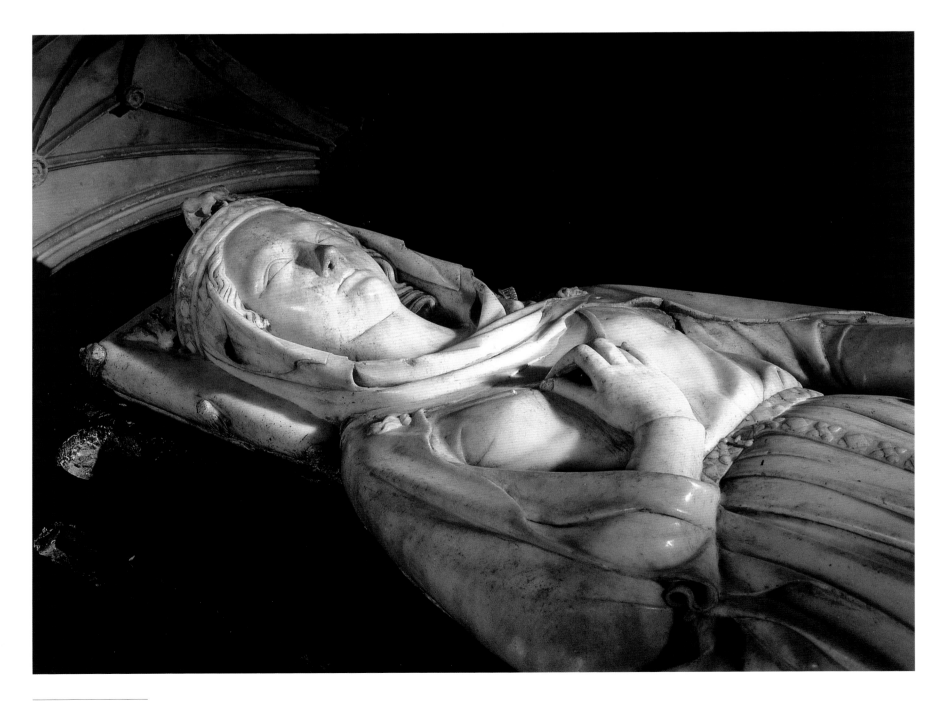

king or an effigy of Saint Louis under the features of Philip IV; the appearance of this statue, from the years 1305–1310, does indeed give the impression of an attempt at a likeness.

On the other hand, no such effort is apparent in the two tombs of Philip III the Bold's first wife, Isabelle d'Aragon, who died in 1271 at Cosenza in Calabria on her way back from the crusade. The effigy of the queen on the tomb in Cosenza shows a curious bit of damage: some say there was a defect in the stone that the sculptor was unable to overcome; others say it is evidence of a fall from a horse which disfigured the queen and from which she eventually died. In any case, there is no scar on the tomb at Saint-Denis, which nevertheless illustrates an important step in the history of funereal art (fig. 50). The tomb is not carved from a limestone of the Ile-de-France, like its predecessors, but from marble: the *gisant* is white marble; the slab (and possibly the sarcophagus that it once covered), is black marble. The folds of the garment seem crushed, but it is uncertain whether this is because of the thinness of the marble block in which the figure was sculpted, or a desire to represent these folds as they would appear on a person lying down. The first hypothesis is doubtless the more likely, because the figure is placed in a kind of niche similar to those used with standing statues at the time. Between naturalistic beauty and classical ideal, the figure of the queen does not relinquish its secret.

The recumbent effigies of Philip III (fig. 51) and of Philip IV are also posthumous, but probably created from memory. The materials are the same as those used in the tomb of Isabelle d'Aragon. We know also that the base of Philip III's tomb was decorated with figures. Archives have left us the name of one of the sculptors of this tomb: Jean d'Arras. The identity of the artist and likeness to the subject would go hand in hand in the second half of the fourteenth century.

The evolution in decoration involving plants and flowers tended in the same direction (figs. 52–54). The flora of early Gothic art included only a half-dozen very stylized species. According to botanists, the vegetation of the rayonnant period was enriched by several dozen species: blossoms of the rose, violet, and buttercup; leaves of the ranunculus, geranium, peony, and anemone; leaves of oak, fig, maple, beech, willow, and chestnut trees; and the stalks and leaves of ivy, creeper, morning glory, greater celandine, columbine, toad-flax, and euphorbia, all of which blossom in the herbarium of poets as well. This vegetation was no longer stylized, but treated with naturalism. Thus, decorative sculpture follows much the same tendency as statuary: it is in search of verisimilitude.

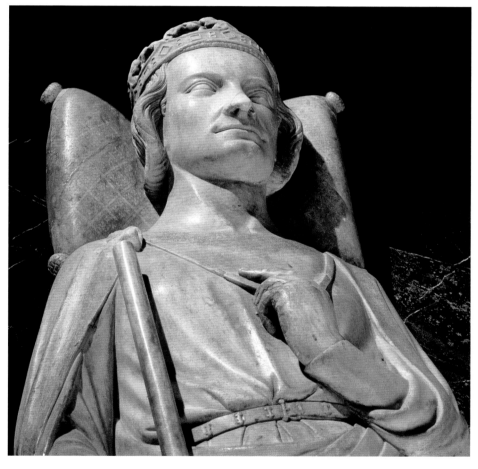

**51. Saint-Denis. Tomb of Philip III the Bold.**

*Of the tomb of Philip III the Bold, son of Saint Louis, who died in 1285, there remains only the white marble gisant. This gisant once lay on a cenotaph of black marble encircled with alabaster "ymages," or figures; it was framed with colonnettes at each side and a baldequin above its head, creating the effect not of a reclining figure, but of one standing in a niche. The monument had been placed at Saint-Denis in 1307 by Pierre de Chelles. The sculptor Jean d'Arras, mentioned in 1298–1299 but not otherwise known, participated in its creation, and it is believed today that he was the artist of the gisant. Pierre de Chelles was also apparently active as a sculptor.*

The evolution of the size and shape of sculpted surfaces favored floral ornamentation to the detriment of the figure. The multiple, smaller capitals of the fasciculated pillar, with its bundle of small columns, lend themselves more naturally to groupings in corollas or bouquets than to the telling of a story in sculpture. However, narration found a new area of expression, one that traditionally belonged to the mural. The cycle of the Life of Christ was elaborated, starting in about 1250–1260, in a series of high-relief panels all around the ambulatory of Notre-Dame, each narrating a scene. Sculpture changed positions and freed itself from the structure, but not from the architectural context.

Parisian art of the years 1220–1330 shows such a coherence that it can be gathered together under a single title, borrowed from the rose window, an architectural feature which became standard in all buildings of the period. We might just as well have chosen to speak of a Louis IX style in the same way we speak about a Louis XIV style; in both of these cases, moreover, the expression "art of the court" has also been used. The choices of these princes outlasted their reigns. The last monarchs in the direct Capetian line preserved, along with the cult of Saint Louis, an attitude of resistance to novelty, assuring rayonnant art more than a century of duration.

This art is characterized, first and foremost, by an overall coherence. Architecture still controls the monumental arts; it provides the framework for the luxury arts (fig. 7), the shape of the objects in precious metal (fig. 14). The same networks of colonnettes, arches, and medallions transform the bareness of walls, pages, and metal plates. Everything is divided as in a cloisonné enamel. The quatrefoil medallion, which could be described as a square with lobes, or with brackets for sides (figs. 2–3), is a *sine qua non* of painting on parchment or on glass, of carving in ivory or in stone. The iconography elaborates the same themes in all media: marrying religion and politics in the figure of the priest-king, such as the Gideon of the *Psautier de Saint Louis* (*Saint Louis Psalter*; fig. 7) and the Joshua of the stained glass of the Sainte-Chapelle (fig. 32); spreading both official doctrine (fig. 5) and political criticism (fig. 8); borrowing from tale and legend, the heroic and the intimate (fig. 19). The depictions of space, anatomy, the human face, and flora all tend toward greater realism.

Such coherence derives from the versatility of the artists. In 1304 Evrard d'Orléans is mentioned with the title "painter to the king": it is the earliest known reference to such a title. He is the artist of the statues of kings in the Great Hall of the Palace; he probably did not execute them, but he designed them, and that was enough for him to be recognized as their creator. The case of Jean Pucelle is even more convincing. This painter and goldsmith practiced several crafts, and he invented a style visible in works that are obviously not by him, as, for example, the series of medallions of the Life of the Virgin on the chevet of Notre-Dame (figs. 2–3).

This art developed in Paris thanks to an influx of artists coming partly from the surrounding area, like Jean and Pierre de Chelles, Pierre and Odo de Montreuil, or from the north, which sent students to the university: Jean d'Arras, who carved Philip III's tomb; Jean de Douai, mentioned on the tax roll of 1313; Pépin de Huy, from Huy near Liège, active in Paris between 1311 and 1329; and Guillaume de Nourriche and Jean de Broisselles, mentioned on the tax rolls between 1297 and 1300, who probably came from Norwich and Brussels. Is it due to this cosmopolitanism that this very Parisian art has been called the French art *par excellence*, the ultimate artistic expression of the French manner, the *opus francigenum* spoken of in manuscripts of its day?

*Diffusion Throughout France*
The expansion of this style completely justifies this designation, although once again we must be careful to distinguish between the areas of the *langue d'oïl* in the north and the *langue d'oc* in the south. The Sainte-Chapelle was imitated in Tours, Le Mans, Angers; the transept facades of Notre-Dame in Meaux, and its sanctuary enclosure in Chartres and in Reims. In northern France the relationships are so tightly knit and the influences so reciprocal that it is difficult to identify what Amiens owes to Paris and what Paris owes to Amiens.

In the south, things are clearer because the imported architecture stands out in the context of a very specific type of southern Gothic style. The historical setting there is the crusade against the Albigensians, an imposition of religious and political discipline vigorously pursued by the northerners against their brethren of the south. The reconstruction of Cathar fortresses and also the fortifications of Aigues-Mortes or Carcassonne are indeed royal enterprises, but they are unlike anything in Paris at this time. The same is not true in the case of the churches, which were built *ad modum franciae*, partly because of the mobility of artists such as Jean Deschamp, a

**52–54. Capitals**

*Sainte-Chapelle*
*Absidial chapel of Notre-Dame*
*Refectory of Saint-Martin-des-Champs*

northerner seen at several construction sites in Auvergne or Languedoc, but mostly because those responsible for commissioning this architecture were militants in the religious reconquest and fervent believers in an orthodoxy both doctrinal and architectural. They were in Toulouse, Rodez, Béziers, and Valmagne. The example of the cathedral of Carcassonne speaks for itself: it even has apostles like those of the Sainte-Chapelle. But the cathedral of Narbonne is still more explicit. The architect is Jean Deschamp, who is not the same as the one who participated in the construction of the cathedrals of Rodez, Clermont-Ferrand, Toulouse, and Limoges; but he belonged to the same family. The project was initiated by Pope Clément IV, previously the bishop of Narbonne, who gave instructions to imitate the beautiful French churches.

### Diffusion Throughout Europe

The French style was propagated throughout all of Europe, from Sweden to Castile, from Great Britain to central Europe. Charles d'Anjou, brother of Saint Louis, introduced it into his kingdoms of Naples and Sicily. Henry III of England, a contemporary of Saint Louis, recommended it in the project at Westminster; Konrad von Hochstaden, francophile archbishop of Cologne, demanded it for his cathedral. According to the chronicler Burchard von Hall, the church of Saint-Peter in Wimpfen-im-Tal was built, starting in 1269, *opere francigeno*, by a master mason from Paris. Etienne de Bonneuil, from Bonneuil near Paris, was called in 1287 by the archbishop to reconstruct the cathedral of Uppsala, Sweden, in the likeness of Notre-Dame. Clément V, another French pope and ally of Philip IV the Fair, who was responsible for moving the papacy to the banks of the Rhône, hired Jean de Louvre, from the diocese of Paris, to build a room comparable to the Great Hall of the Palais de la Cité in the new papal city of Avignon. The tomb of Robert Bruce, first king of Scotland, is said to have been sculpted in Paris. Even Italian sculptors, with all their resources, still borrowed from Paris. The Virgin and Child sculpted in 1299 by Giovanni Pisano for the cathedral of Pisa (in the treasury of the cathedral) is freely imitated from the one of the north portal of Notre-Dame. The style of Jean Pucelle in the cycle of the Life of the Virgin on the chevet of Notre-Dame (figs. 2–3) is discernable in certain works of Andrea Pisano and Lorenzo Ghiberti. It is less obvious what French art of the time borrowed from Italian art, but the connection was established. Charles d'Anjou, the brother of Saint Louis, visited the workshop of Cimabue in Florence. In 1298 Philip IV the Fair sent his painter, Etienne d'Auxerre, to Rome. Etienne brought back the painters and mosaic artists Filippo Rusuti, his son Giovanni, and Nicola dei Marzi, known as Desmarz. Francesco da Barberino, the poet, was in the court of Philip IV the Fair in 1311–1313.

### The French Language

The success of the French style is comparable, even parallel, to that of the French language, which was in the process of replacing Latin as the common language of Europe. The *Book of the Treasure* was written in northern French (*langue d'oïl*) by the Florentine Brunetto Latinii: to make himself understood he chose to use the *parlure plus commune à tous les gens* ("the speech most common to all people"). Likewise, the *Chronicle of Venice*, by Martino de Canale was also written in French *por ce que lengue franceise cort parmi le monde* ("because the French language is current throughout the world"). Those who resisted Capetian dominance are rare, but Dante is one of them. In the *Purgatory* he meets Hugh Capet, who says he was the root of the malevolent plant whose shadow harms all of Christianity. How haunting a metaphor for the dynastic family tree.

In France itself, as early as the reign of Philip IV, only a few figures recalled that the dynasty was born of usurpation, predicted its imminent end, and questioned whether the ruling king was really the legitimate son of Philip III. The display in the Great Hall had been created to proclaim the affiliation of the three dynasties; in this gallery of kings, pedestals were left empty to demonstrate that the dynasty had a future. Still, darker times loomed: contested legitimacies, disputed crowns, fratricidal wars, the misbehavior of queens and the madness of kings, the diseases of the soul and the body, the schism, and the plague.

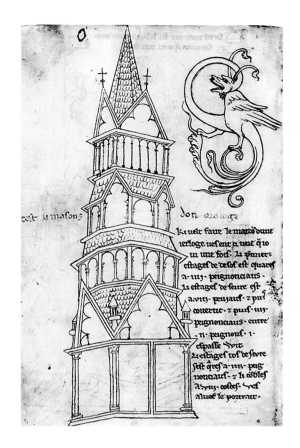

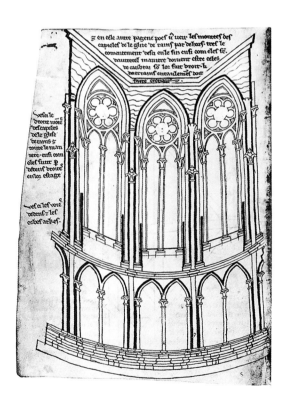

**55–56. Villard de Honnecourt. *Album*, thirteenth century.**

*Above is his rendering of a clock tower; below, the rendering of a chapel in the chevet of the cathedral of Reims.*

# The Palais de la Cité, now the Palais de Justice, and the Sainte-Chapelle

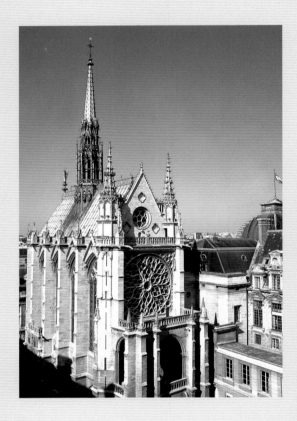

**Above:**

*The Sainte-Chapelle was built from 1241 to 1248 by commission from Saint Louis to hold the relics of the Passion, which he acquired in 1237 from Baldwin II, emperor of Constantinople. It is one of the few remaining parts of the former Palais de la Cité.*

**Right:**

*The gate to the entrance court of the Palais de Justice was built starting in 1782 by the locksmith Bigonnet and the sculptor Antoine Rascalin, from a design by Pierre Desmaisons.*

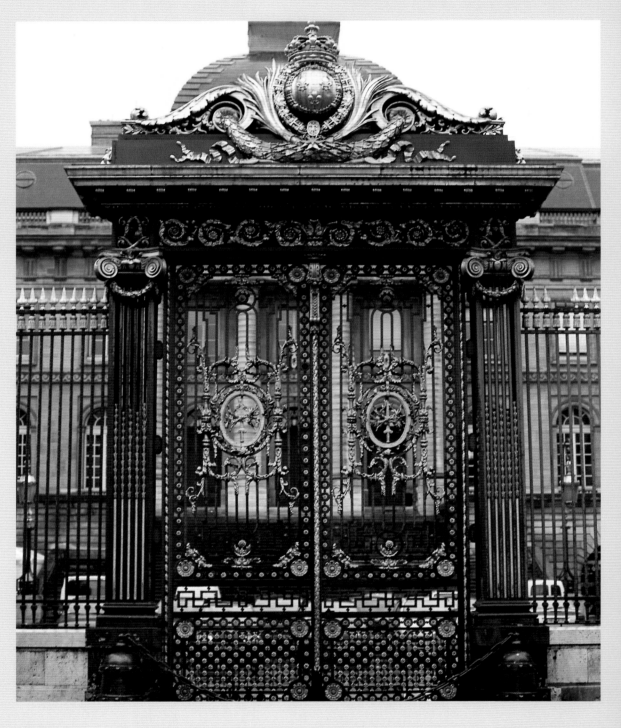

The Palais de Justice (Court Building), located in the western half of the Ile de la Cité, is the former palace: residence of the kings and home of the governmental institutions under the monarchy. When, in the second half of the fourteenth century, Charles V removed the residence to the Louvre, the institutions expanded and filled the entire palace. The principal body was the Parlement, which, in addition to its exercise of judiciary power shared with provincial parliaments, had a political role limited to recording royal decisions.

*The First Civil Chamber of the Court of Appeals was inaugurated in 1891 and has a ceiling painted by Léon Bonnat in 1901.*

Above:

*The Vestibule de Harley was inaugurated in 1869 in the wings of the Palais de Justice, built by Jean-Louis Duc and Honoré Daumet.*

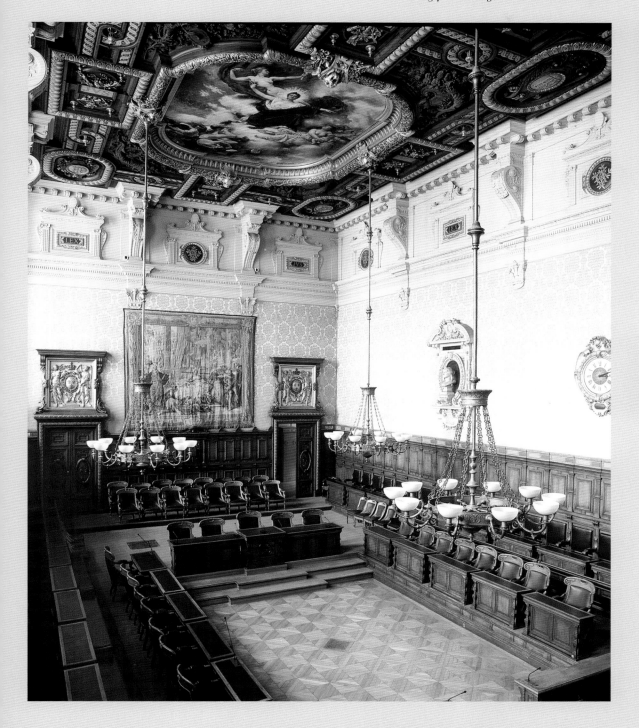

Originally, there was a Gallo-Roman fortress, which the Merovingian kings took as their residence. Of the medieval buildings there remain only the Sainte-Chapelle, built from 1241 to 1248 by Saint Louis to hold the relics of the Passion, and the rooms built by Philip the Fair, starting in 1285. Following a fire a part of the structure was rebuilt, starting in 1782. Most of the present buildings date from the nineteenth century.

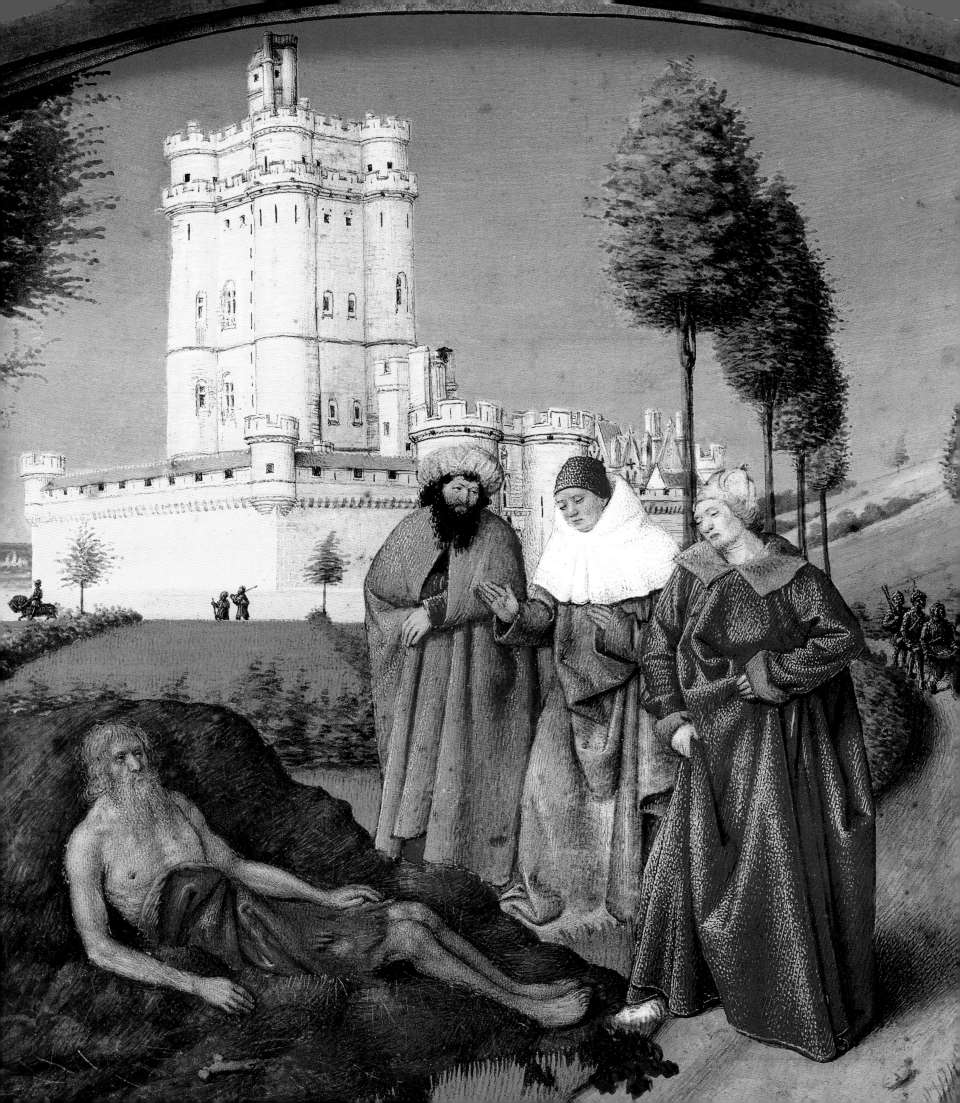

# Chapter IV
# THE FIRST VALOIS KINGS
## (1330–1450)

**1–2. Castle of Vincennes, from the *Très Riches Heures du duc de Berry***

*Vincennes was originally just a hunting lodge in the middle of a royal forest. The lodge was turned into a residence by Augustus. Its present structure dates from the reign of Charles V, who began the reconstruction when he was still only regent; he died before it was finished. The keep and the small gate-castle, which defended the entrance, were built from 1361 to 1369, and the ramparts and towers from 1372 to 1377. The illumination showing the hunt and the upper portions of the keep and towers is taken from the* Très Riches Heures du duc de Berry *and dates from the early fifteenth century (fig. 16). The illumination of the story of Job, showing the keep, is taken from the* Heures d'Etienne Chevalier (Hours of Etienne Chevalier), *painted by Jean Fouquet between 1452 and 1460 (opposite). The bird's eye view is taken from the* Plus excellents bastiments de France (Most Excellent Buildings of France), *by Jacques Androuet Du Cerceau (1576). The chapel is not shown on it: the artist was probably hindered by its being hidden behind a tower of the outer walls. The tower known as la Tour du Village (the Tower of the Village) is the only one to have survived almost intact.*

It is probably best to start with the year 1314 to chronicle one of the darkest periods in the history of France: in that year, Jacques de Molay, Grand Master of the Knights Templar, was condemned to be burned alive; the wives of the three sons of Philip the Fair, convicted of adultery or complicity in adultery, were sent to prison. Before the end of the year, fulfilling the prophecy made by the Grand Master on the stake, Philip the Fair died prematurely. To be sure, the events of year 1314 had fewer apparent consequences than did the death, in 1328, of the last of the three crowned sons of Philip the Fair, ending the direct Capetian line. But Paris is a photographic plate on which drama and scandal leave durable imprints. The western tip of the Cité, site of executions at the stake, and the Nesle Tower, which sheltered many lovers' trysts, constitute, along with the Louvre, a triangle on the three facing banks of the river in the center of the Parisian landscape. The Nesle Tower disappeared in the second half of the seventeenth century, but the memory of the crimes that were said to have been committed there lingered: the queens were accused of having thrown their lovers in the Seine after having their way with them. "Semblement où est la royne / Qui commanda que Buridan / Fust jesté en ung sac en Seine" ("And where is the Queen / Who ordered Buridan / To be thrown in the Seine in a sack"), Villon would write in his *Ballade des dames du temps jadis* (*Ballad of the Ladies of Times Past*), a century and a half after the fact, or at least what is believed to be fact. The philosopher Buridan was fourteen years old at the time and unbelievably survived this watery fate. In 1328, Philip, of the younger branch of the Valois line, inherited the crown. Edward, king of England, and Charles the Bad, king of Navarre, who also had grounds to claim it, contented themselves at first with negotiating their renunciation. In 1329, the king of England agreed to pay homage to Philip VI in return for Guienne. It was over Artois that the situation turned sour. The county of Artois, created for his brother by Saint Louis, had been given by Philip IV the Fair to Mahaut, aunt of Robert, the legitimate heir. Robert instituted lawsuits to recover his inheritance, but in the process he produced false documents, for which, in 1332, he was tried for treason and banished. The trial record is illustrated with an illumination that testifies to the importance of the event (fig. 3). Robert d'Artois, having taken refuge in London, where he was welcomed as an innocent victim, convinced the king of England to claim the crown of France by force. The defeats of Philip VI at Crécy (1346) and of John II the Good at Poitiers (1356) befitted these first two Valois kings: they were fighters, they were brave ("the Good" meant "the Brave"), they were lovers of splendor and extravagance, and devoid of political savvy, a description that would apply to a number of the kings of this dynasty, which would last for over three centuries.

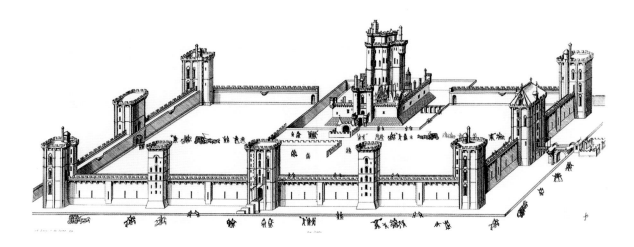

## The Reign of Charles V

An exception to this assessment of the Valois kings appears in the personality of the dauphin Charles, the future King Charles V, who, as regent, governed the kingdom in the absence of his father, John II, who was taken prisoner at Poitiers. It was he who suffered the affront by Etienne Marcel, the provost of the merchants, who invaded and bloodied the palace, opening the gates of Paris to Charles the Bad, ally of the English. The healing reign of Charles V, an enlightened and perceptive politician, began only at the death of John II in 1364. But before dying, John II had had time to split up the kingdom by giving appanages to his other sons, Charles's brothers: he gave Anjou to Louis, Berry to John, Burgundy to Philippe. The harmful effects of the three dukes would be felt only after the death of Charles V. The kingdom he inherited, moreover, had been affected by that scourge more deadly than war, the Black Death, which, within the five years following 1348, had eradicated at least a third of the French population.

The intelligence of Charles V, confirmed by his epithet, "the Wise," does not completely explain the extraordinary success of his reign. With little inclination to bear arms and to expose himself recklessly in battle as his father had done, Charles V let his commander in chief, Du Guesclin, worry about his victories. Charles the Wise saw the return of good times in the thirteenth century. The reception of the Holy Roman emperor Charles IV in Paris in 1378 (fig. 4), toward the end of his reign, is proof of the restoration of the city's international prestige. It was, nevertheless, in a sense, just a family gathering. Charles IV was the son of John of Luxemburg, king of Bohemia, who had been killed at Crécy and who had given his daughter in marriage to John II the Good, so Charles V, king of France, was the nephew of Charles of Luxemburg, king of Bohemia and emperor. Both father and son, John and Charles of Luxemburg, had been brought up in France and were promoters of French ideas and art. John had brought artisans from France to build the Bohemian convent of Zbraslav in the *modo gallico*. Charles, who had founded a university in Prague on the model of the University of Paris, imitated the French royal residence when he had the castle in his capital city rebuilt *ad instar domus regis franciae* (in the image of the French king's house).

3. *Procès de Robert d'Artois, 1332* (*Trial of Robert d'Artois, 1332*). (Bibliothèque Nationale de France, Paris)

*To assert his claim to the county of Artois, from which he had been dispossessed by his aunt, Mahaut, Robert III had furnished forged documents, for which he was tried for lese-majesty. The manuscript of the trial record was illustrated with an illumination representing the solemn session held at the palace on August 6, 1332, sentencing Robert to banishment. It shows the king, Philip VI; at his feet, King John of Luxembourg and Philip d'Evreux, king of Navarre; in the first row, the peers of the realm: laymen at left, the ecclesiastics at right; in the middle, the audience; in the foreground, counselors and lawyers. The pyramidal composition is a reflection of the hierarchy of the kingdom. The painting is in the tradition of Jean Pucelle: the figures are identifiable only by their coats of arms.*

## Charles VI's Reign

During the first thirty years of the reign of Charles VI, son of Charles V, France benefited from a respite from the punishments visited upon it. There was, to be sure, at the very beginning of the reign, the anti-tax rebellion of the *maillotins* (Parisians armed with mallets) and the regency of his uncles, the three dukes, before the king was "of age." The duke of Burgundy, Philippe-le-Hardi, particularly exploited this position of power. He incited the young king to crush the citizens of Ghent, who had revolted against their count, whose son-in-law and heir was Philippe. In 1384 Philippe-le-Hardi did, in fact, inherit the counties of Flanders and Artois, thus assembling a

powerful state, the political and artistic influence of which was considerable. At his majority in 1388, the king set aside the dukes and called back the counselors of Charles V, lesser nobles and influential bourgeois, derisively referred to as *marmousets* ("figurines"); but at the onset of the king's madness in 1392, the dukes reasserted their power and dismissed the wise *marmousets*.

Charles VI—handsome, amiable, champion of chivalrous feats of arms, and lover of pleasures— resembled his grandfather more than his father. The court made a show of lavish luxury, and the madness of the king did not stop the revelry. In 1393 *the bal des ardents* ("the Ball of the Burning Dancers") took place: the king and many of the courtiers, disguised as savages and coated with pitch, caught fire; the king nearly burned to death. Paris was then the stage of bitter rivalries between the Orléans faction and the Burgundy faction. In 1407, Louis, made the duke of Orléans by his brother the king, was killed right in the middle of Paris by murderers in the pay of Jean-sans-Peur (John the Fearless), son of Philippe-le-Hardi (Philip the Bold) and heir to the duchy of Burgundy. From then on, the capital was taken hostage by the Armagnacs on the one side (Charles d'Orléans, son of the victim of 1407, had married the daughter of Bernard d'Armagnac) and, on the other, the Burgundians, supported in Paris by the powerful corporation of the butchers, called the *cabochiens* (from the name of their leader, the animal skinner Simon Caboche).

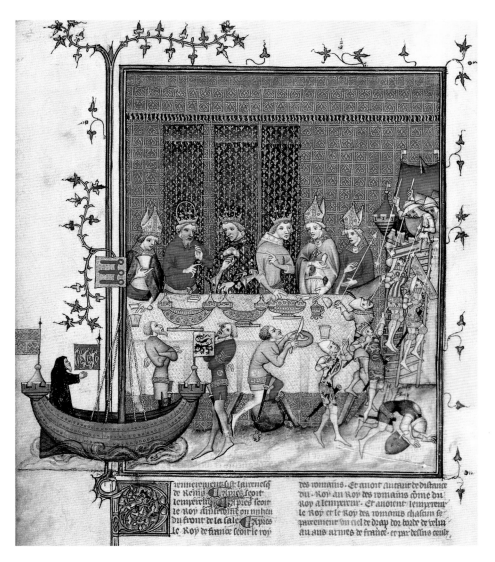

While civil war raged across France, Henry V, the new king of England, re-opened the hostilities and went to overcome the French at Agincourt in 1415. More than this battle, the murder of Jean-sans-Peur in 1419 by the men of the dauphin Charles, the future Charles VII, turned the tide of events. The alliance of the Burgundians and the English against the dauphin, legitimate son of Charles VI and Isabeau of Bavaria, forced the signing of the disastrous treaty of Troyes, which disinherited Charles in favor of the English branch. At the death of Charles VI in 1422, Henry VI, son and heir of Henry V, was proclaimed king of France and England and crowned in Paris. As the new king was a minor, the regency was confided to his uncle, the duke of Bedford.

The history of France remains so Parisian during the entire reign of Charles VI that to ignore this string of battles, rebellions, and murders would lead to a total misunderstanding of the history of the capital (fig. 49). Quite the opposite is true for what happened next. The dauphin Charles withdrew first to Bourges then to Chinon, where Joan of Arc sought him out in 1429 with the objective of having him crowned in Reims. Charles was indeed able to reach Reims, the coronation city, a feat that had been denied Henry: from then on, Charles had legitimacy on his side. And Paris paid heavily for it. The taking of Paris by Charles VII in 1436 and the end of the war in 1453 did not help matters; kings avoided Paris for an entire century from that moment onward.

**4. *Grandes Chroniques de France* (*Great Chronicles of France*), c. 1380. (Bibliothèque Nationale de France, Paris)**

*This manuscript of the Grandes Chroniques de France (Great Chronicles of France) was prepared for Charles V and illustrated in Paris about 1380. On the occasion of their visit to Paris in 1378, a banquet was held for the Holy Roman emperor Charles IV and his son, Wenceslas, king of Rome, by Charles V, king of France, the emperor's nephew. The banquet took place in the palace on the Feast of the Three Kings. This illumination shows the three kings, a reminder of the Magi: Charles V; at his right, Charles IV, with the covered imperial crown; at his left, Wenceslas. The entremets — that is, the mid-meal entertainment — is the staging of a famous episode from the crusades, the conquest of Jerusalem by Godefroy de Bouillon.*

The Treaty of Troyes of 1420 can be seen as initiating an important hiatus in the history of Paris as capital of the kingdom. In spite of the uprising and the treason of Etienne Marcel, provost of the merchants, Charles V had still declared: "Our royal town of Paris is the head of all our empire." The year following the revolt of the *maillotins*, while King Charles VI was on a lengthy voyage in Languedoc, the poet Eustache Deschamps, himself a familiar of the court, could write: "There is no worker in Paris who does not exclaim: 'When will our king return?'" What mattered for the worker was less the king than his court, the mainstay of the Parisian economy. Even in the darkest days of the rivalry between Armagnacs and Burgundians, which preceded the English occupation, the dukes maintained a lavish lifestyle. The Parisians' marked preference for the Burgundians is understandable in economic terms: the duke of Burgundy, count of Artois and of Flanders, controlled the two provinces that were Paris's most important trading partners. Normandy, so important in this respect, was in the hands of the English. The Armagnacs belonged to the south, which counted for very little. During the English occupation, Paris, the walled city, which no one could enter or leave, was forsaken by the very parties that had fought over it. Duke Philippe the Good, son of Jean-sans-Peur, was preoccupied with his beautiful land to the north and the east; the "French" were camped on the Loire; even the English had withdrawn their administrative headquarters to Rouen and at Caen had founded a university to rival the one of Paris. The hardships of the occupation and the reconciliation between Charles VII and the duke of Burgundy did much to rekindle a feeling of patriotism among Parisians. But the legitimate king did not return to the city he won back.

*Population and Economy*

And yet Paris had never ceased to be the capital in terms of population and influence. Its population had been reduced by a third during the Black Death of 1348, and still Paris did not lose its rank, since all of Europe had been stricken. But in the years 1410 to 1440, proscriptions, banishments, executions, and the flight of frightened inhabitants, in particular the richest ones, made for a serious depopulation that affected only Paris. At the end of the English occupation, the population was half as large as at the time of Philip IV the Fair. It would not regain its previous level until the end of the reign of Charles VII, who initiated policies such as exemption from taxes, aimed at promoting population growth.

The prosperity that Paris enjoyed until about 1400 was fragile because of the very particular structure of its economy. Paris had neither the industry nor the banks of its rival cities. The prosperity of the rival cities was based in large part on the development of an important textile industry, which was decaying in Paris. Paris had its moneylenders: indeed, they were the wealthiest members of its middle class; but they did only currency exchange and short-term transactions. The international banks were elsewhere. In its heyday, Paris was the city of many exceptionally diverse and skilled artisans, but they were too well protected against competition and unemployment by the guilds and their rules. The labor shortage after the Black Death of 1348 led to a certain relaxation of these rules. But overall the situation remained unchanged.

*The Bourgeoisie*

In prosperous times there were more benefits for customers than for suppliers. The bourgeoisie was flourishing, but the number of its tradesmen was shrinking in comparison to the officers, the *petits royetaux* ("petty monarchs," as the poet Christine de Pisan called them), the bourgeois appointed to offices in the royal administration. Appointment to office was more profitable than business, and moreover it gave access to that supreme consecration, ennoblement. The career of Jean Jouvenel, founder of his family's fortune, is typical: he was a lawyer in the Parliament, then the provost of the merchants; banned by the Burgundians, he ended his career in the provinces (president of the parliaments of Poitiers and Toulouse). With Jean Jouvenel, the position of provost of the merchants was held by an officer and not by a merchant. From Saint Louis to John II the Good, the growing power of Parisian aldermen was obvious. It reached its height in the

middle of the fourteenth century under the provost Etienne Marcel, who was a rich merchant with business connections to the Flemish; he was a reformer with near-revolutionary ideas, in the mold of the Artevelde family in Flanders. But by the fifteenth century, especially after the suppression of the uprising of the *maillotins*, which reduced the authority of the municipal institutions, Paris took on, bit by bit, the configuration it would keep for several centuries, that of a city of lawyers and officers—in short, bureaucrats.

## The University

The university suffered less from the war than it did from the great schism. In the beginning of the fourteenth century, with the support of Philip IV the Fair, the papacy had become established in Avignon, where popes of French nationality had served one after the other. After Urban V moved the papacy back to Rome in 1367, the French cardinals took it upon themselves to elect a French pope simultaneously with the Italian pope, in hopes of reasserting the French location of the Holy See. The University of Paris thought it its duty to side with the pope of Avignon, causing the students of the English and German nations, favorable to the pope of Rome, to withdraw. Nevertheless, the authority of the professors of the theology faculty was undiminished: the French professors played a determining role in the council of Constance (1414–1418), which ended the schism. But the long-term result was the creation of rival institutions: the universities of Dole (1423) and of Louvain (1425) were established in his states by the duke of Burgundy, Poitiers (1431) by Charles VII, and Caen (1432) by the duke of Bedford. The location of the universities is a clear reflection of the positions of the armies in the war. It was just when its monopoly was compromised that the Parisian university developed the theory of the *translatio universitatis*, a kind of transferal of the principle of the divine right of kings to the intellectual realm: Paris was the capital of learning by inheritance from Rome as Rome had been from Athens.

## Housing

The Parisian housing situation had evolved too. Bishops' and abbots' residences on the Left Bank continued to be converted into schools, accentuating the predominance of students on this side of the river. The dwellings of the upper nobility were clustered on the Right Bank around the two royal residences, the Louvre and the Hôtel Saint-Pol in the Marais, the recently developed neighborhood just inside the walls near the Bastille. Public squares were rare; the most important one was the Place de Grève, where Etienne Marcel had moved the city's administrative seat when he bought the building called the Hôtel des Piliers, the nucleus of the future city hall. On the other hand, private gardens were numerous. Housing for the people consisted of wooden houses, roofed with red tiles or even thatch, their gable end facing the street. They were no more than twenty feet wide and typically had one or two upper floors. The English occupation caused a major exodus of renters, leaving many houses in ruins and their owners destitute. The drop in the rental value of houses in the 1420s has been estimated at 90 percent. In 1425, 22 of the 65 houses on the Pont Notre-Dame were empty; in 1440, 51 of the 112 on the Pont au Change were empty as well, but, in 1450, this figure had fallen to no more than 27. It is estimated that at the end of the occupation, one house out of six had neither an owner nor an occupant. It was the proliferating class of office holders buying or rebuilding the mansions abandoned by the nobles that made the recovery possible after the liberation of Paris, in spite of the absence of a king. Jean Jouvenel lived in a residence on the Ile de la Cité, bordering the Seine; it is unknown whether it was purchased or built by him; it was a compound with a keep, similar to the one at the Temple (fig. 14).

Two poets have left very different portraits of Paris from these times. Listen to Eustache Deschamps, from the time of Charles V: "Nothing can compare with Paris / It is the city crowned above all others / Fountains and springs of wisdom and learning … All foreigners love it and will love it / Of all the arts, it is the flower, whatever one may say." And Guillebert de Metz from the time of Charles VI: "Alas! Paris, noble city / I have great pity / When I see your affliction … You have nothing left / But misery, pain, and suffering / Peace was banished from you / Look at the streets / Beaten down / The houses inside the town / Which are all fallen in / And lost / The princes have abandoned you."

**5. Map of Paris.
(Universitätsbibliothek, Basel)**

*The map of Paris printed by Truschet and Hoyau in the middle of the sixteenth century shows the importance of the triangle formed by the three points of the Hôtel de Nesle (lower right), the Louvre (on the opposite bank of the Seine), and the Palais de la Cité (tip of the island), at the apex of the triangle. The Nesle Tower, part of the ramparts built by Augustus in the thirteenth century, constituted the western end of the walls on the Left Bank of the Seine; it stood opposite the Louvre and the Tour du Coin, which constituted the western end of the walls on the Right Bank. It took its name from the Seigneur de Nesle, who had built his residence later in the thirteenth century, at the base of the tower. The house had been acquired by Philip IV the Fair in 1308. In 1380, at his accession, Charles V gave it to his brother, duke of Berry, who transformed it into one of the most beautiful buildings in Paris.*

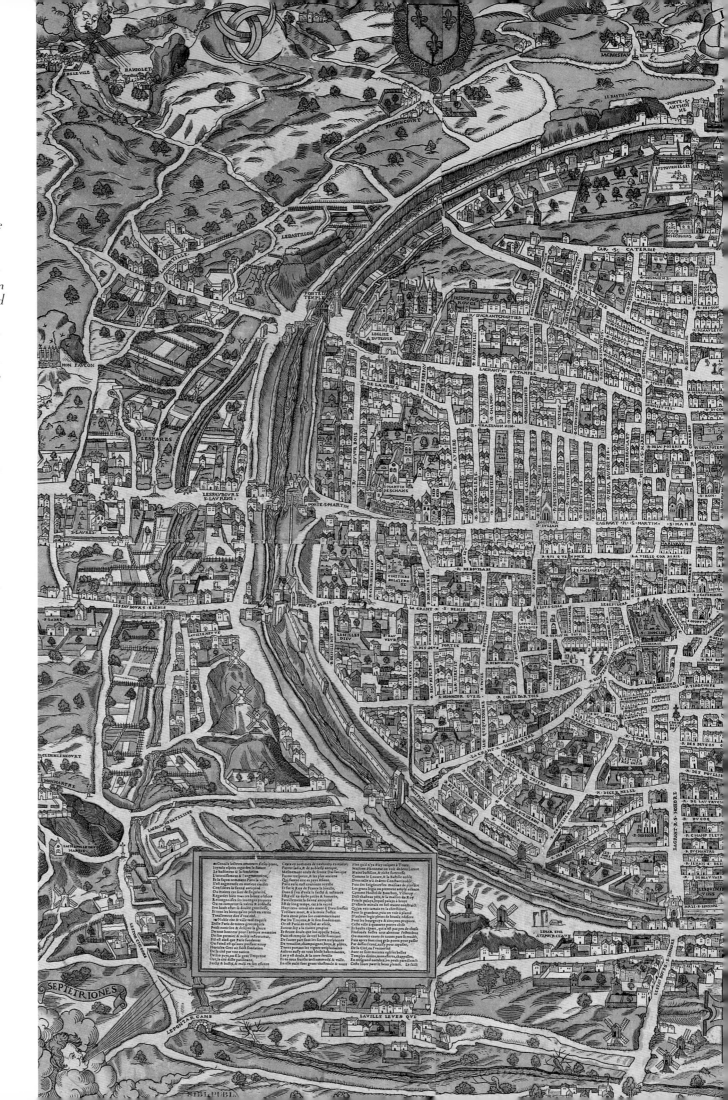

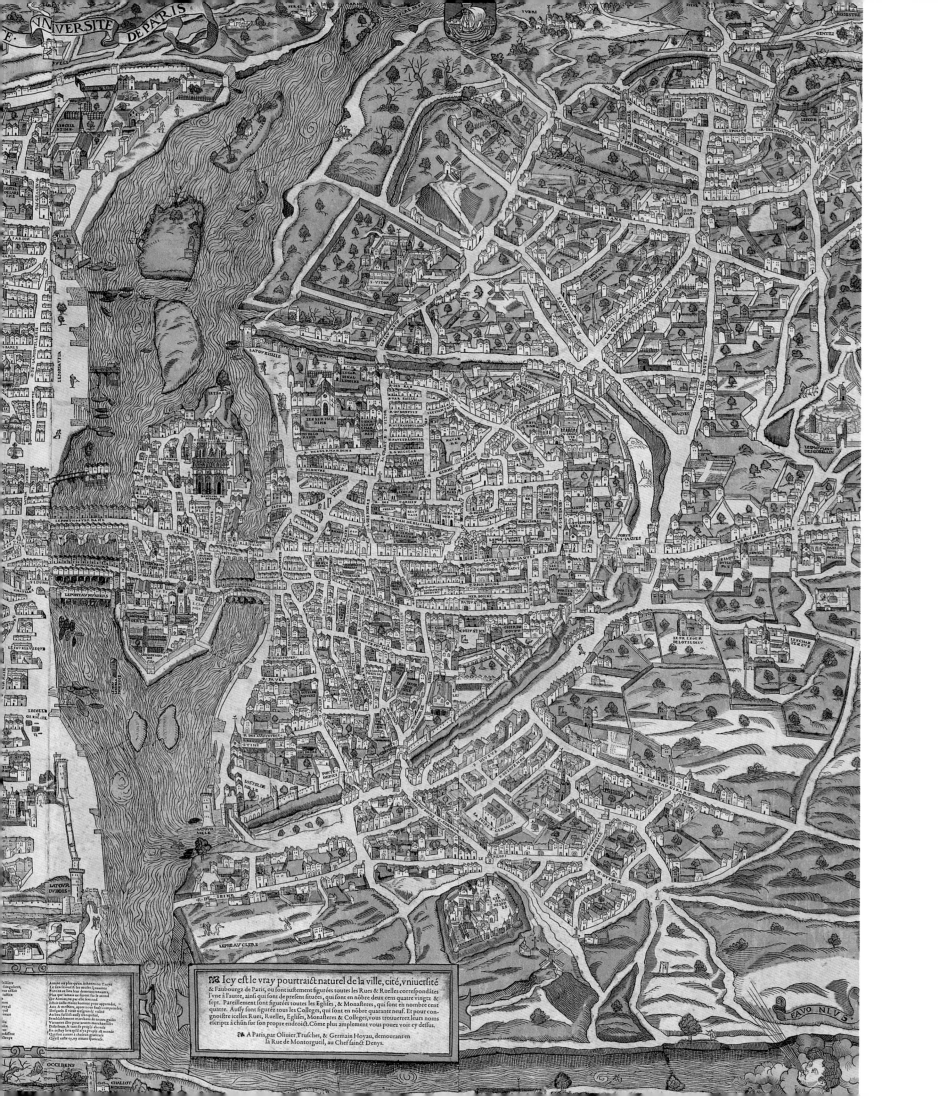

**6. *The Ramparts of Charles V,*
from *Grandes Chroniques de France*
(Great Chronicles of France).**
(Bibliothèque Nationale de France, Paris)

*This illumination from the Grandes
Chroniques de France (Great Chronicles
of France), painted by Jean Fouquet about
1460 for Charles VII, shows an event from a
hundred years before: the entry of Charles V
into Paris on May 28, 1364, as he returned
from his coronation. The scene is only a
reconstitution, but the decor is indeed the
Paris of Charles V, which was still intact
under Charles VII. The walls were started by
Etienne Marcel, the provost of the merchants,
during the captivity of John II the Good, and
enlarged and finished by the dauphin, the
future Charles V, after the death of Marcel
in 1358. Visible in the picture are, in the
foreground, the Porte Saint-Denis (in the
niche, the saint holding his severed head,
flanked by his two disciples), and in the
middle ground the Porte Saint-Martin. To
the far left is the keep of the Temple. The only
historical error is the Bastille (to the right of
the keep): it was indeed built by Charles V,
but six years after his entry of 1364.*

**7. The Bastille**

*Originally, there was the Porte Saint-Antoine,
a fortified gate in the ramparts, built starting in
1338, by the dauphin Charles, future Charles V.
This gate, defended by two round towers, gave
access to the Rue Saint-Antoine: it was the main
entrance to Paris on the east. In 1370 the corner-
stone was laid for a fortress with eight round
towers, integrating the towers of the fortified gate.
The actual city gate of Porte Saint-Antoine had
to be moved, but it was kept within range of the
fortress. On the drawing prepared by Pierre
François Palloy, the architect appointed to
demolish the Bastille in 1789, Paris is at the
bottom. One can see, in the foreground (detail
shown here), the two towers of the original gate.*

To show his humility, Saint Louis had labored as a mason on the abbeys that he founded; to suit his own inclination, Charles V oversaw the design of the houses that he created. He was what was called at the time a *deviseur*, or a designer, a writer of *devis*, descriptions of projects to be built. "Charles fut sage artiste, se démonstra vray architecte et deviseur certain et prudent ordeneur, lors-que les belles fondacions fist faire en maintes places, notables édiffices beaulx et nobles" ("Charles was a skilled artist; he showed himself to be a true architect, a harmonious designer, and careful organizer when he founded in many places notable edifices, fine and noble"), wrote Christine de

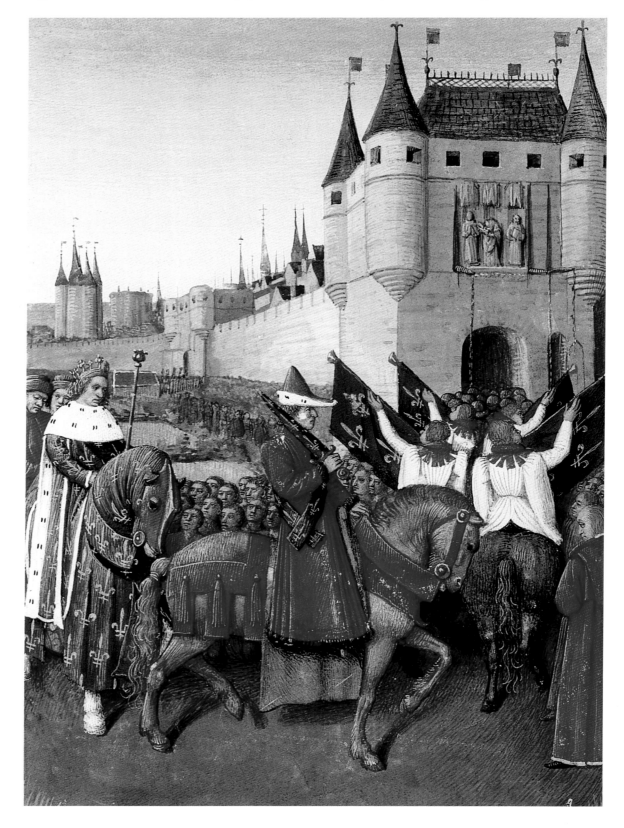

Pisan in the *Livre des faiz et bonnes mœurs du Sage roy Charles* (*The Book of the Acts and Good Conduct of Wise King Charles*). Christine de Pisan was the daughter of Thomas de Pisan, the Italian astrologer to Charles V, and a model of integration: she wrote in French as well as Eustache Deschamps, whom she met at court. If he had done nothing more important than choosing Raymond du Temple as his architect, Charles V would have ensured his place in the lineage of builder-kings.

## The Ramparts of Charles V and the Louvre

The architecture of Charles V is quintessentially Parisian. The initiative for building new walls to enclose the considerable expansion of the city on the Right Bank belonged to Etienne Marcel, who

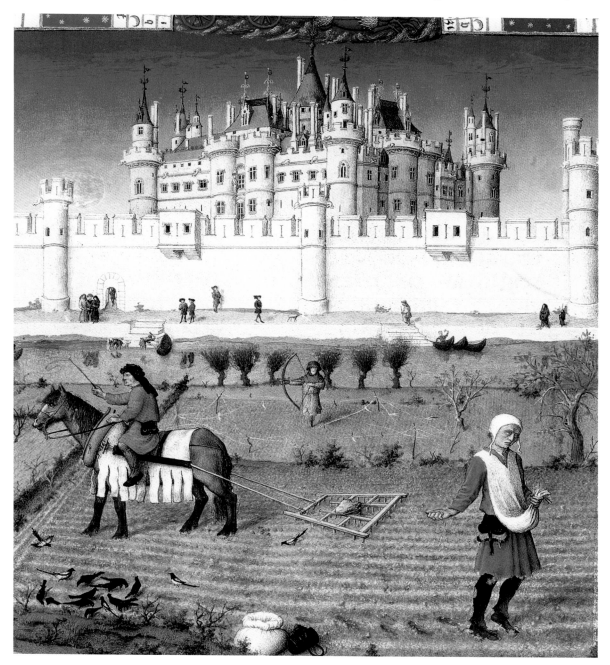

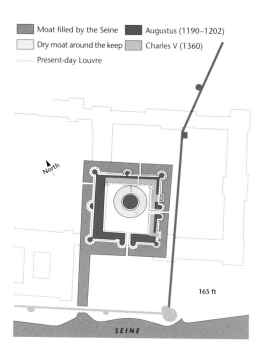

### 8–9. *The Louvre, from the Très Riches Heures du duc de Berry.* (Musée Condé, Chantilly)

*The remodeling of the Louvre by Raymond du Temple, begun in 1360, consisted primarily of building lodgings in the courtyard behind the north and east curtain walls, and of reworking the tops of the towers, to which were added two more floors. This illumination from the Très Riches Heures du duc de Berry, painted by one of the Limbourg brothers, perhaps after the death of the duke (1416), shows it as it existed fifty years after the renovation. Along the Seine is the wall built by Charles V; at the right is the Tour du Coin where it joins the ramparts of Augustus. Hidden behind the wall, the south entrance to the building, between two round towers, was decorated with statues of the king and the queen (one of them is visible on the left tower). In the background is the conical roof of the keep, built by Augustus.*

undertook it after the defeat of Poitiers; but, in the aftermath, it was finished by Charles V. It profoundly shaped the topography of the city and modified the status of the buildings attached to the ramparts of Augustus, henceforth inside the walls (figs. 8–9). Such was the case of the fortress of the Louvre that Charles V had Raymond du Temple transform into a place of residence in the 1360s (figs. 8–9). Lodgings were added on the north and east sides of the courtyard. The walls received windows, and the towers were extended by turrets capped with conical roofs. According to the famous image from the *Très Riches Heures du duc de Berry* (fig. 8), which dates from the fifteenth

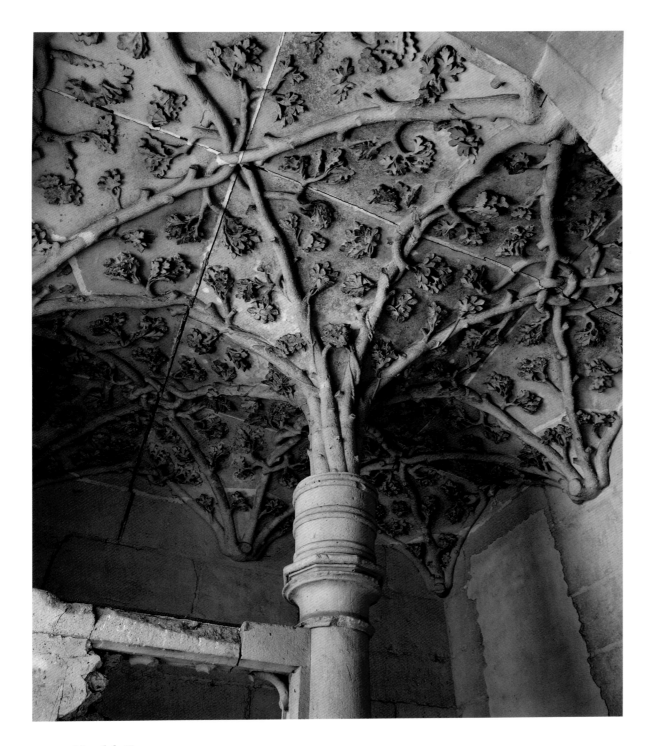

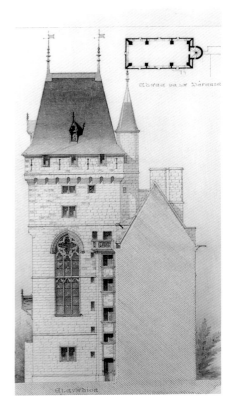

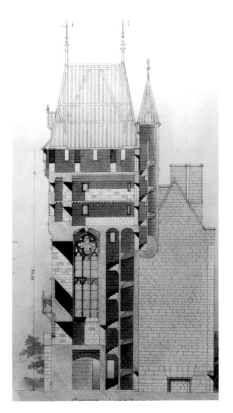

## 10–12. Hôtel de Bourgogne

*The Hôtel d'Artois, built against the ramparts of Augustus, came into the hands of the dukes of Burgundy at the marriage of the duke Philippe-le-Hardi to the heiress of the county of Artois. The part preserved (on Rue Etienne Marcel) was built from 1409 to 1412 for the duke Jean-sans-Peur by his architect Robert de Helbuterne. The building included a logis (a wing of rooms), now destroyed. All that remains is the tower that gave access to the guards' walk (unused after the construction of the Charles V ramparts) and that contained, in its upper levels, secret hiding rooms. After having the Duke Louis d'Orléans killed, Jean-sans-Peur thought it prudent to leave Paris: he came back the following year, fairly sure of impunity, owing to the support of the Parisians, the majority of whom backed the Burgundian faction.*

Opposite:

**13. The Feast of the Duke of Berry,** from the *Très Riches Heurs du duc de Berry.* (Musée Condé, Chantilly)

*The location of the scene shown in this illumination from the Très Riches Heures du duc de Berry, by the Limbourg brothers, is not known: it could be situated in any one of the many residences of the duke. In it one sees gold serving pieces on the dresser at left and on the table in front of the duke; on the wall behind is a large historical tapestry.*

century, the Louvre was then completely roofed in slate; but in the painting of the *Pietà de Saint-Germain-des-Prés* (chapt. V, fig. 6), only the towers and pavilions—that is, the tall roofs—are covered with slate; the wings still have red tiles. Slate, the more prestigious material, which would be increasingly favored, was probably used at first only on the parts built by Charles V. By embellishing the portrait of the castle in this way, the fifteenth-century illumination testified to the special meaning that was beginning to be associated with the use of slate.

Everything in the new Louvre set trends that would last until the Renaissance, especially the great circular stairway, a famous work, now destroyed like much else. Its fame came perhaps less from its size (over sixteen feet in diameter) or its rich sculptural decoration than from the fact that it completely revolutionized the thinking on spatial distribution in dwellings: this helix of steps in a single shaft, lighted by windows where it touched the facade, gave access to all the floors without having to cross any of them. To understand the importance of this invention, one must consider how stairs were dealt with before the Louvre staircase. Previously, the traffic patterns in dwellings were defined by unconnected and illogical series of staircases in different sizes and shapes buried in the thickness of walls. One had to cross through the rooms of one floor to reach the stairway to the next. For two centuries after the Louvre, the best French homes had their semidetached tower containing a circular staircase, with an entrance on each floor, the nonmechanical equivalent of the modern elevator.

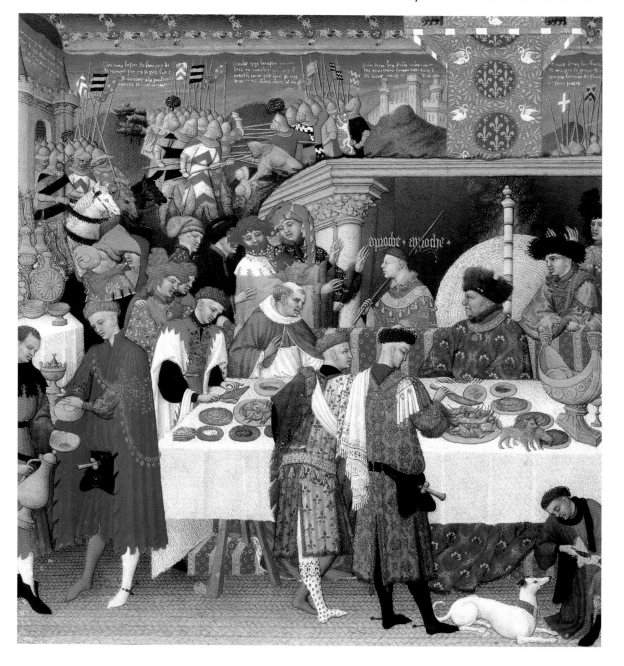

## 14. Hôtel des Ursins

*This townhouse, now gone, was located on the northern bank of the Ile de la Cité. It belonged, in the middle of the fourteenth century, to Jean Jouvenel, the provost of the merchants, who had perhaps built it. This engraving from the nineteenth century is the only evidence of what the houses of persons of standing might have been like in the reigns of Charles V and Charles VI. The arcades of the ground floor were added in the sixteenth century, perhaps by Guillaume Juvénal des Ursins, the royal chancellor.*

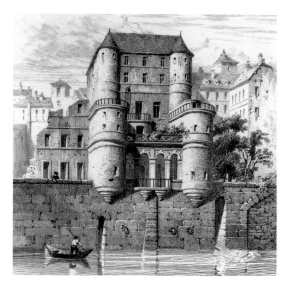

Below:

## 15. Castle of Bicêtre

*About 1400 Duke Jean de Berry was given the usufruct of the royal domain of Bicêtre. He had one of castles there renovated, probably by Drouet de Dammartin, and had it decorated by a "German" painter who has been identified as Pol de Limbourg. The portrait gallery was famous. The castle was the victim of the quarrels between the Armagnacs and the Burgundians: held by the former, it was burned in 1411 by the Parisians who supported the duke of Burgundy.*

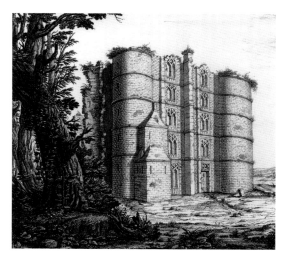

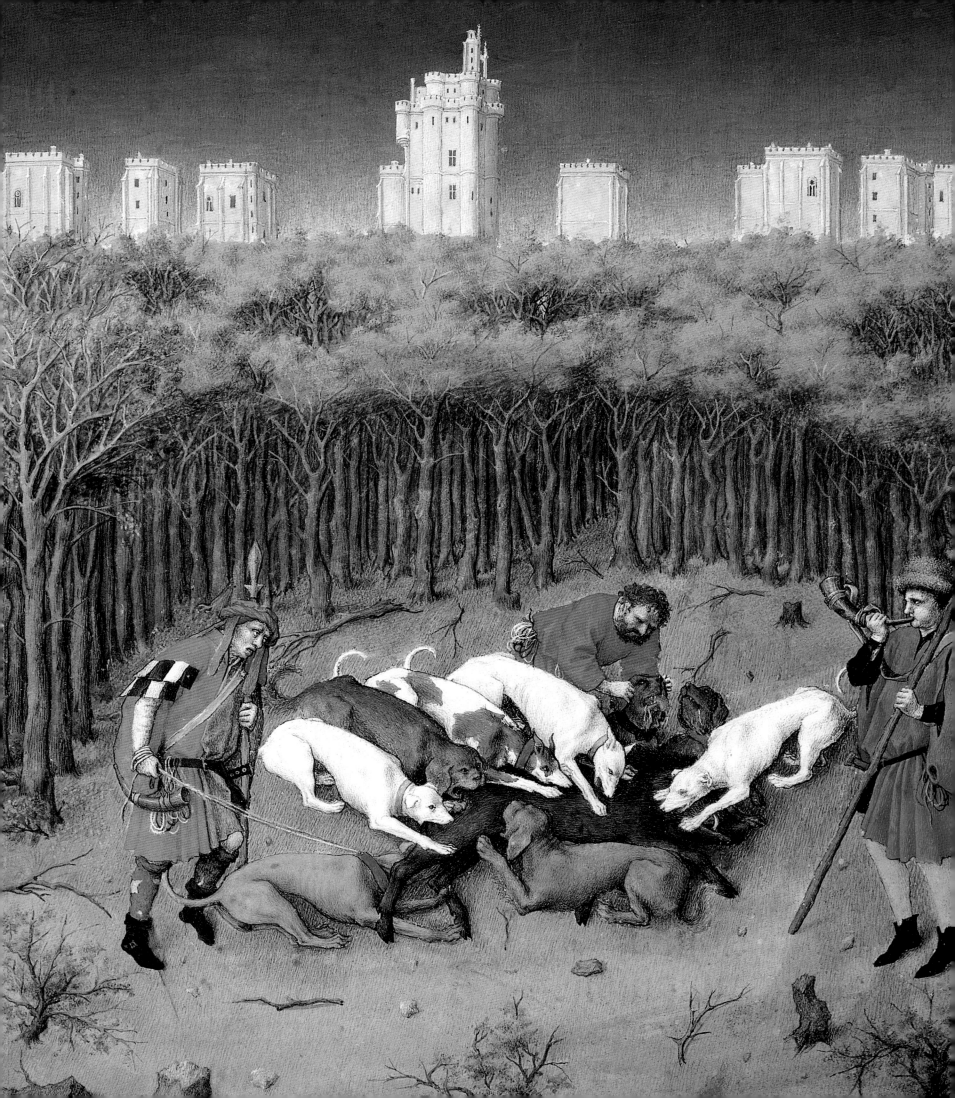

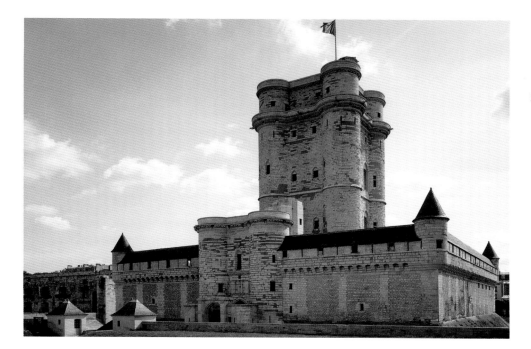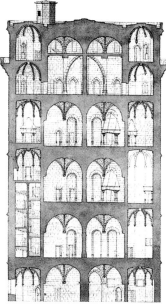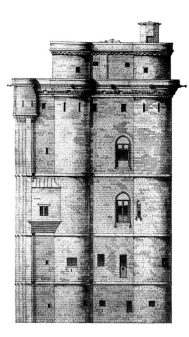

## Vincennes

The keep at Vincennes, built between 1361 and 1369 (figs. 16–19), which was situated beside a hunting lodge or forest manor house that Saint Louis made famous with his sojourns there, was perhaps another work by Raymond du Temple. At Vincennes, the ground floor housed the guards; the second contained the king's apartments; the third was perhaps the queen's apartments; the fourth, the lodgings of the dauphin; the fifth was completely devoted to defense. One of the corner towers again contained the stairway. On the king's floor there was a chapel in the second tower, a wardrobe in the third, and the fourth blended into an annex containing latrines and the king's study.

The fortified ramparts, which were put around the keep of Vincennes, must have been built between 1372 and 1377, and are thought to be by Temple: it is the most unusual aspect of what is known somewhat incorrectly as the castle of Vincennes. It is a rectangular enclosure with moat, flanked by nine square or rectangular towers. As Christine de Pisan wrote, Charles V "avoit entencion d'y faire ville fermée et là auroit establie en beaulz manoirs la demeure de plusieurs seigneurs, chevaliers et autres ses mieulx amez" ("intended there to make an enclosed city and would have installed in beautiful manors the dwellings of many lords, knights, and others of his best loved"). It does indeed consist of a fortified town, able to serve as a substitute capital for Paris during an insurrection, a sort of Versailles by anticipation.

We can probably recognize the manors intended for the king's "best loved" in the towers. They were originally entrenched; that is, each had its own complete moat just like a castle keep. The symbolic value of the castle of Vincennes impressed itself onto the French consciousness for a century. These towers are the nine champions of legend, and the keep is the key piece of this royal chessboard. (Games of chess, as well as knightly romances, were very fashionable at the court of Charles V.)

It is interesting to note the stylistic similarities between Vincennes and the design of many castles of the Loire Valley, in particular Chambord. The use of square towers, instead of the round ones of Augustus, was perhaps an intentional archaism, suggestive of the olden days of legend, but they also allowed for arranging comfortable apartments on all floors, except in the foundations and on the top levels meant for defense.

**16.** *Le Forêt et le château de Vincennes* (*The Forest and Castle of Vincennes*), from the *Très Riches Heures du duc de Berry.* (Chantilly, Musée Condé)

*This illumination showing a hunt in the forest of Vincennes and the tops of the keep and the towers is taken from the* Très Riches Heures du duc de Berry *and dates from the first part of the fifteenth century.*

**17–19. Keep of the Castle of Vincennes**

*The keep has four stories above the ground floor, which was intended for the king's guard. The upper floors, set aside for the king, the queen, the royal children, and for defense, are reached by a spiral staircase in one of the corner towers. The keep is defended by its own rampart, through which one entered by a châtelet, or fortress-gate.*

## 20–25. Chapel of the Castle of Vincennes

*This chapel was founded by Charles V and constructed beginning in 1396 (that is, under Charles VI), by Raymond du Temple. The facade was not finished until the reign of Louis XI, and the upper parts, including the vaulting and the loft, were finished under François I and Henry II.*

### The Bastille

The same concepts for spatial organization and defense were used again at the Bastille (fig. 7), the purpose of which could be understood only in the context of Vincennes. The Bastille defended the Porte Saint-Antoine, the eastern gate out of Paris by which one gained access to the safe haven of Vincennes. To a certain extent, it watched over the city and was a forerunner of the citadels that overlords would build to ensure the submission of rebellious cities. The Bastille was built with round towers, which are different from the towers of Philip Augustus by the organization of their openings. The bases, which were solid in the latter, were hollow at the Bastille, fitted with loopholes for shooting crossbows along the level of the moat. It also featured an unprecedented innovation: the walls and the towers were the same height, and the top formed a single, continuous platform for firing artillery. It was at Crécy that artillery had appeared on a battlefield for the first time. To give the greatest width to this platform, the guards' walk was corbelled out and given machicolations. Interior hoists were provided to carry artillery and munitions up to the platform. For the second time, Paris revolutionized the art of fortification. The effects of the Parisian example can be seen in many places: Tarascon and Beaucaire, Vitré and Suscinio, Foix and Montaner, and in the Saint-Nicholas tower in La Rochelle.

### The Hôtel Saint-Pol

The Bastille also defended the Hôtel Saint-Pol, which Charles V had established in 1364 inside the ramparts, to the east, near the Seine. Hôtel Saint-Pol was a sort of garden village, made up of separate lodgings—one for the king, one for the queen, and one for the royal children—all connected by colonnades. These lodgings were nothing more than former townhouses, acquired over time, and perhaps for the most part kept as they were. The main points of interest were the interior decoration, the gardens, and the menagerie and its lions (which were the main attraction).

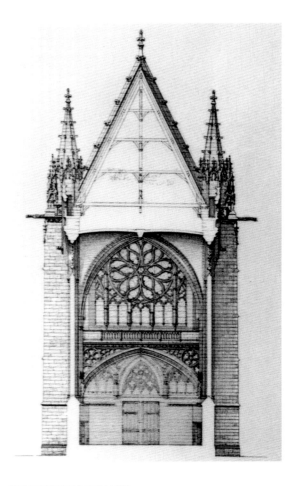

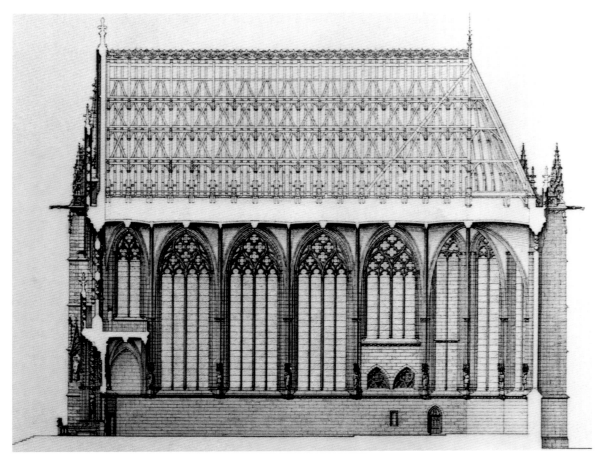

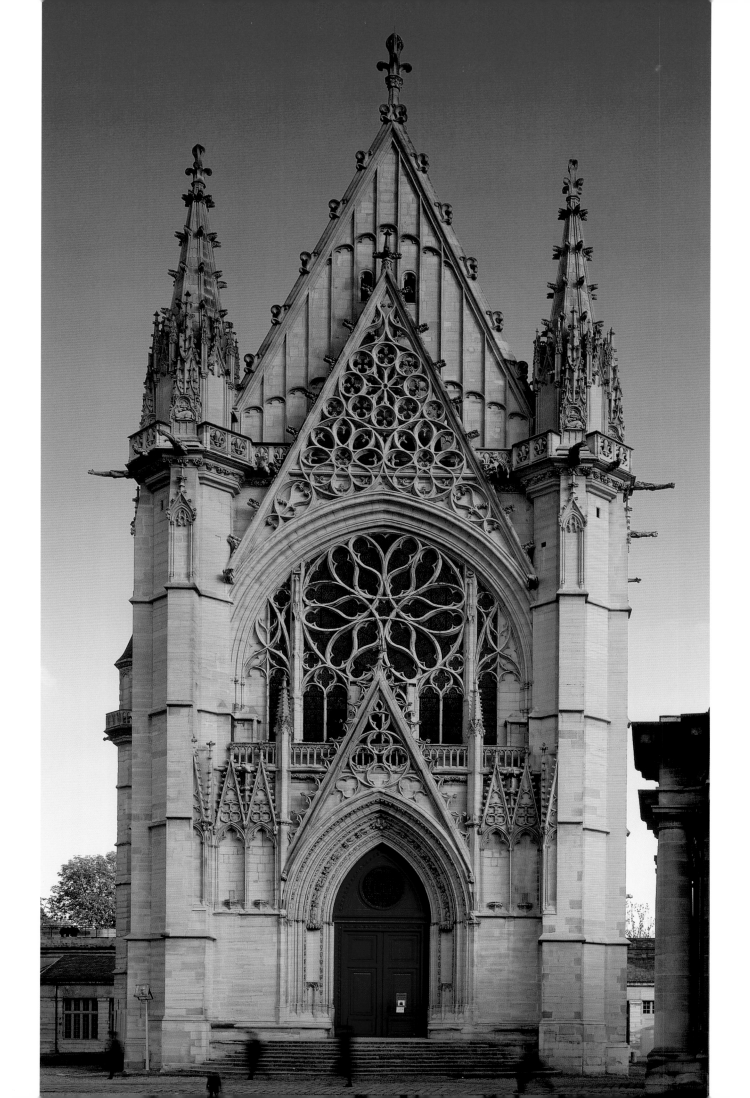

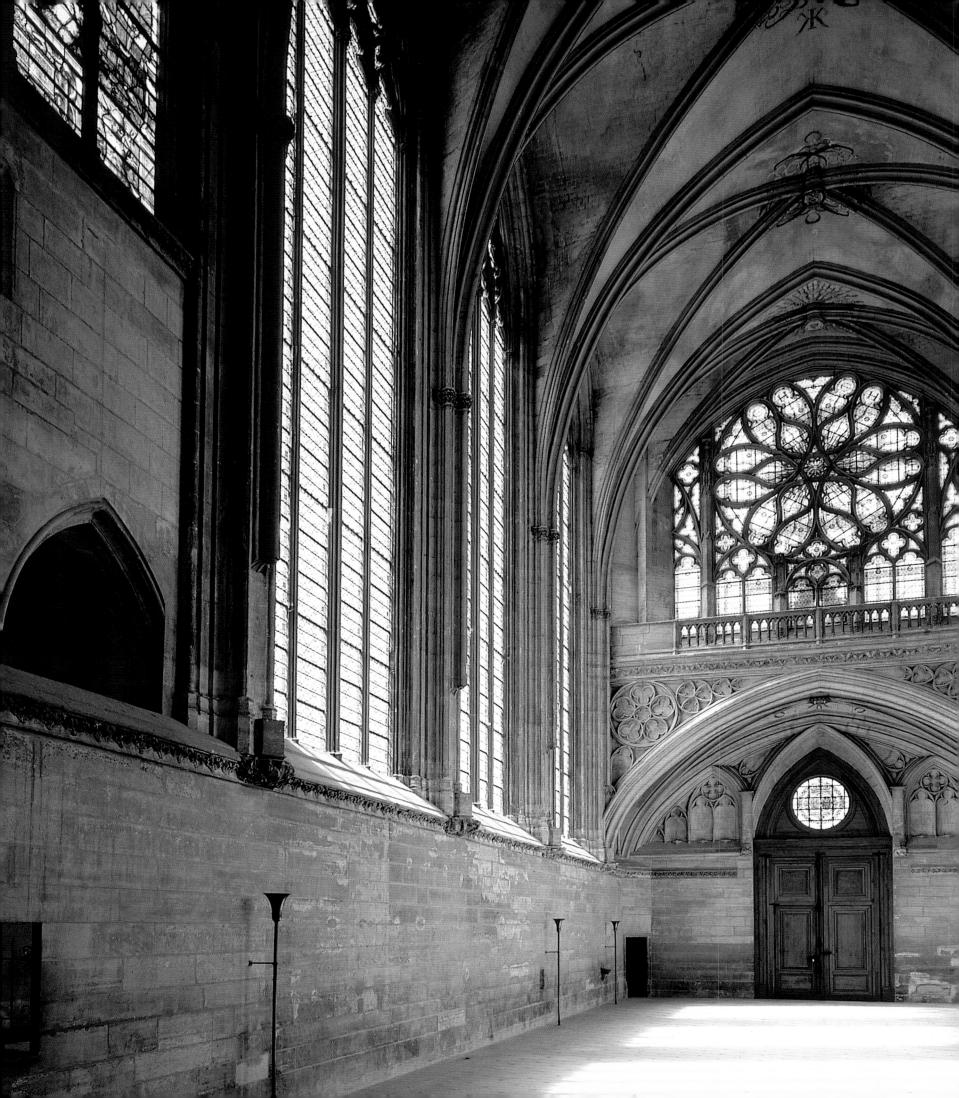

Charles V apparently built only in Paris and its immediate vicinity, according to a well-planned scheme, aligning from west to east: the Louvre, the Hôtel Saint-Pol, the Bastille, Vincennes, and farther east, in Nogent-sur-Marne, the little castle of Beauté, perhaps built by Raymond du Temple, which is virtually unknown.

### The Dukes' Houses

The dukes also built in Paris, but with a peculiar deference to the works of Charles V, which continued even after the king's death. They built only grand townhouses, or *hôtels*. Like the Louvre, their residences were connected to the unused ramparts of Augustus; or rather, again like the Louvre, their residences were enlargements and embellishments of the fortified houses, which had nestled against the ramparts when the latter were in use. Thus, spaced along roughly a quarter of the arc of the Right Bank perimeter of the old ramparts, from south to north, were the Louvre; the Hôtel de Bourbon, built between 1390 and 1413 by duke Louis II de Bourbon, brother-in-law of Charles V; the *hôtel* of the dukes of Orléans, formerly that of the kings of Bohemia; and the *hôtel* of the dukes of Burgundy, formerly that of the counts of Artois. One could move between these latter two *hôtels*, the residences of the feuding cousins, by using the guards' walk of the old ramparts. On the Left Bank, also abutting the ramparts, the Hôtel de Nesle faced the Louvre from across the river: the duke of Berry had doubled its size by adding a lodge beyond the wall, the first example of a residence that was half-rural, half-urban—in other words, suburban (fig. 5). Of all of these, there remains only the hideaway built by Jean-sans-Peur in the Hôtel de Bourgogne (figs. 10–12), as a challenge to the authority of king after he had admitted having ordered the murder of the duke of Orléans. The duke of Bedford, for his part, preferred the proximity of the Hôtel Saint-Pol. He built the first elements of what would become the royal Hôtel des Tournelles: almost nothing is known of these early projects. Farther yet to the east, Drouet de Dammartin had renovated the castle of Bicêtre for Jean de Berry (fig. 15).

### Churches and Chapels

It should be noted that our consideration here has focused on secular buildings, but these surely contained masterpieces of religious architecture. The only surviving example is the chapel in the castle of Vincennes (figs. 20–25), founded by Charles V, begun by Raymond du Temple for Charles VI, but not finished until after 1450. Dating from the reign of Charles V (also by Raymond du Temple, but founded in 1374 by a churchman, Jean de Dormans, bishop of Beauvais), the college of Dormans-Beauvais is an example of the colleges that proliferated on the Left Bank throughout the fourteenth century. Its chapel (more or less intact) shows the scale of religious buildings in that century; the previous century had been the one to splurge on grand churches. The narthex of Saint-Germain-l'Auxerrois, the only parish church project dated with certainty from the English occupation, was almost completely redone in the second half of the fifteenth century.

24–25. Chapel of the Castle of Vincennes

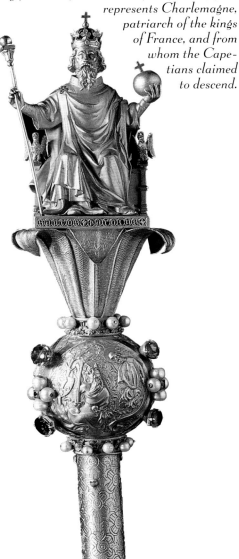

## 3 – THE LUXURY ARTS AND MONUMENTAL ARTS UNTIL THE END OF THE REIGN OF CHARLES V (1380)

Charles V was a connoisseur and collector, perhaps the first among the kings of the French dynasties. Indeed, through the accumulation of manuscripts and precious objects, Charles V was not attempting, as some of his predecessors had, to amass a treasure, a private cache of religious and royal artifacts that could be liquidated in extreme cases, but rather a collection

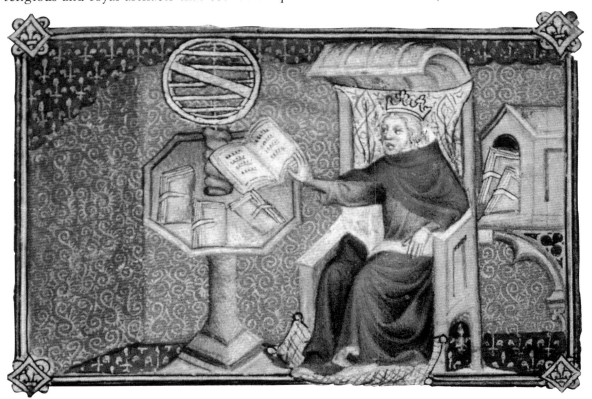

intended to reward the eyes and the mind. The incomparable libraries of the Louvre and Vincennes contained 1,150 manuscripts, all carefully catalogued, which became the core of the modern Bibliothèque Nationale. Not all of these manuscripts were illuminated, however: some concerned the sciences, which were a particular passion of Charles V, and others were about astrology. He possessed a copy of the *Traité sur la sphère* (*Treatise on the Sphere*), c. 1377, by Nicolas Oresme, the famous academician and frequent companion of the king (fig. 26), as well as treatises on the use of the astrolabe and the influence of the planets.

### Stained Glass

Until the end of the reign, the arts industry, which had flourished in the preceding century, continued to produce many good, quality objects, but clung to tried and true forms. All the arts of the thirteenth century are present in Paris in the fourteenth century, with the apparent exception of stained glass. The only surviving example known from this time is the window in the chapel of the college of Dormans-Beauvais, which showed the apostles in niches similar in conception to the statuary group of the Apostolic College in the Sainte-Chapelle; a few remains of this work have been reinstalled, but not well, in the nave of Saint-Séverin. However, there are documents attesting to the activity of master glass painters who had not disappeared from Paris. Thus, a considerable amount of destruction must be assumed. This is due not only to the misfortunes of the times, but also to technical and functional reasons. In the fourteenth century, glass was thin, spread over wider surfaces, and therefore more fragile. Moreover, glass artisans were no exception to the general movement in artistic production away from the religious and toward the secular arts. And civilian buildings (along with their windows) are the most frequent victims of modernization projects. Additionally, glass artisans were traditionally itinerant; it is an accepted fact that the masterpieces of fourteenth-century stained glass can be found in Rouen and Evreux, Carcassonne, Albi, Toulouse, Narbonne, and Limoges.

nullam causam inuenio. Exuit ego illis portans spineam coronam : et purpureum uestimentum. ¶ Sā Tiburtij mrs. euuāgł Richul optm̄. ij. xxbiij. Typhia sochx eius euuangeliū. Attendite a fermto. ij. xxxij. In vigilia assūpois be mar. Secundum lucam. N illo tr : Factum est dum loquatur illis ad turbas : extollens uocem quedam mulier de turba. dixit illi. Beatus uenter qui te portauit : et ubera que sinxisti. At ille dixit. Q̄ minimo : beati qui audiunt ubum dei : et custodiunt illud. In die euuang. ¶ Sedm lucam.

28. Evangelistary for use in Paris, c. 1345–1350. (Bibliothèque de l'Arsenal, Paris)

*This gospel book, which was once in the Sainte-Chapelle, was painted by two colleagues of Jean Pucelle, Jean Lenoir and Jaquet Maci. The latter, who did the page shown, made a specialty of this filigreed decoration, a very particular expansion of the Pucelle style.*

## Metal Crafts

The luxury arts enjoyed continued popularity: they are durable, portable, and have a good resale value, qualities appreciated in times of uncertainty. Domestic objects, tumblers, cups, ewers, salt boats, goblets, and table fountains (fig. 29), competed seriously with religious artifacts. It was a Parisian ewer that the emperor Charles IV gave to the cathedral of Prague, and that was later transformed into a reliquary. The most important commission in the precious metals by Charles V, however, was the coronation scepter (fig. 27). Reliquaries continued to be structured architecturally in shapes reminiscent of a rayonnant church. The one that Charles V offered to his brother, Louis d'Anjou, was done in the shape of a book, an unusual design.

## Illumination and Ivory

Illumination and ivory hardly evolved at all during this period. The best paintings came from Jean Lenoir and Jaquet Maci, disciples and collaborators of Jean Pucelle (fig. 28). Certain artists, however, apparently learned nothing from Pucelle's "modern" sensibility and drew flat figures on backgrounds with no depth, though with highly decorative frames. It is true that only about one hundred manuscripts that belonged to the king himself have been identified; therefore it is risky to critique the whole of the production of his reign and the choices of the king. However, it may be significant to point out that a manuscript of the highest importance, the *Grandes Chroniques de France* (*Great Chronicles of France*; fig. 32), is illustrated with illuminations that are rather archaic in style.

## Monumental Painting

As is true of stained glass, the presence of mural painting is attested to, though no longer extant. In 1320, Pierre de Broisselles (Pierre from Brussels), living in Paris, agreed to do an oil painting in Conflans based on the life of Robert II d'Artois, for a hall in the residence of Robert's daughter, Mahaut d'Artois; below the scenes in the painting there were to be "courtines ou des fenestrages à arches," which were requested by Mahaut: in other words, the lower parts of the wall would be covered with trompe l'oeil curtains or with arcades imitating those of rayonnant churches. The same artist worked for Mahaut around 1323 at her Parisian Hôtel d'Artois.

It is known that Charles V had the Great Hall of the Louvre painted with birds and other animals in a country setting; at the Hôtel Saint-Pol, he commissioned mythological, historical, and legendary subjects. There was, for example, a Charlemagne room and a Theseus room. The most remarkable room in the queen's pavilion is described by Sauval: "From the top of the wainscot up to the vault on a green background...a great forest full of trees and shrubs, apple trees, pear trees...mixed with lilies, flags, roses and other flowers,... children,...fruits." There were "branches up to the vault, painted white and azure to represent the sky and the daylight." The design must have been reminiscent (and perhaps even inspired by) the Room of the Stag at the palace of the Popes in Avignon (which was preserved, fortunately), painted in fresco in 1343 for Clément VI by a team of Italian and French painters. One would like to know who originated this kind of depiction of nature, very new at the time, with which French art was to become identified. It should be compared with the extraordinary flora of decorative sculpture and the multiplicity of plant species in the gardens of the Hôtel Saint-Pol. *Le Songe du vergier* (*The Dream of the Orchard*), the anonymous work published in 1492, but written in 1375, reveals subjects for painting that were most likely present in Paris: "Les chevaliers de nostre temps font en leurs sales paindre batailles à pié et à cheval affin que par manière de vision ils preignent aulcune délectacion en batailles ymaginatives" ("The knights in our day paint their rooms with pictures of battles, both on foot and on horseback, so that as though in a dream they may take delight in imagined battles").

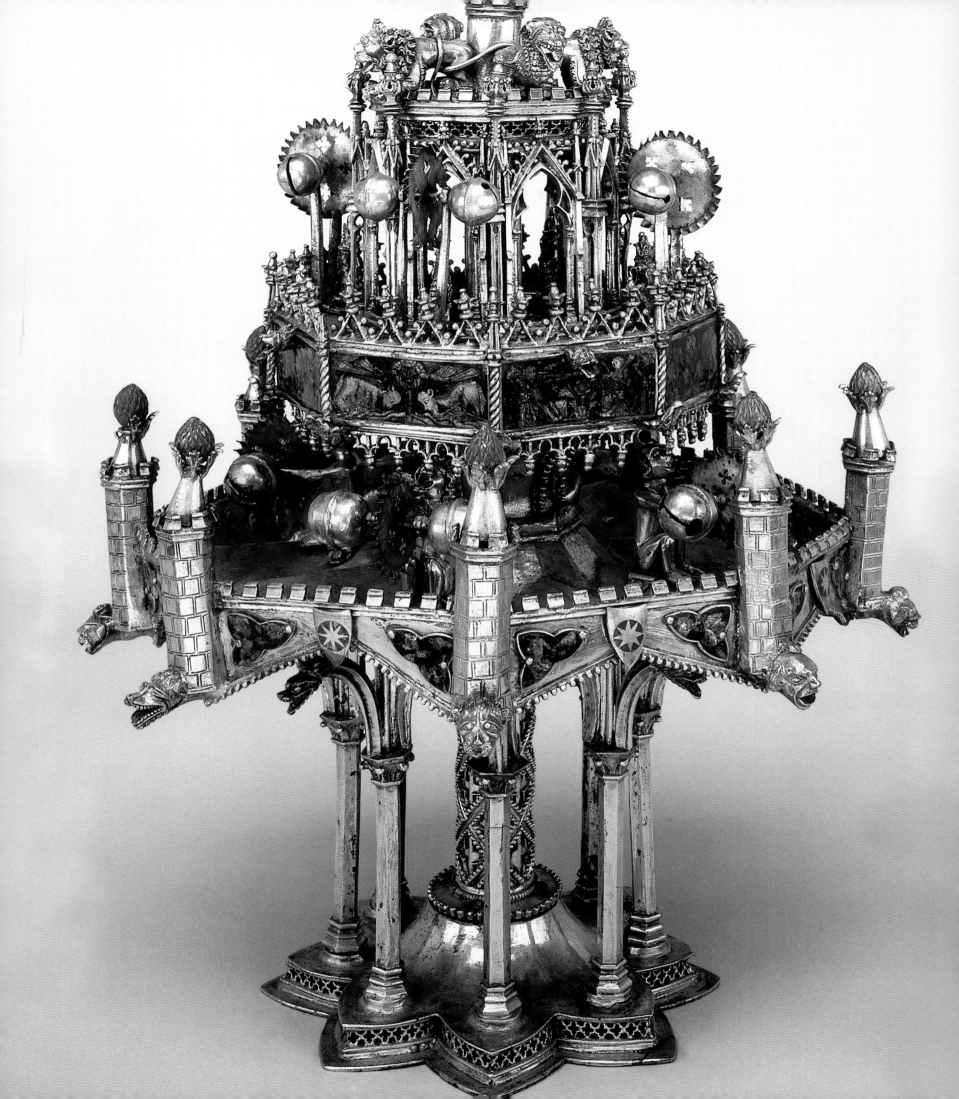

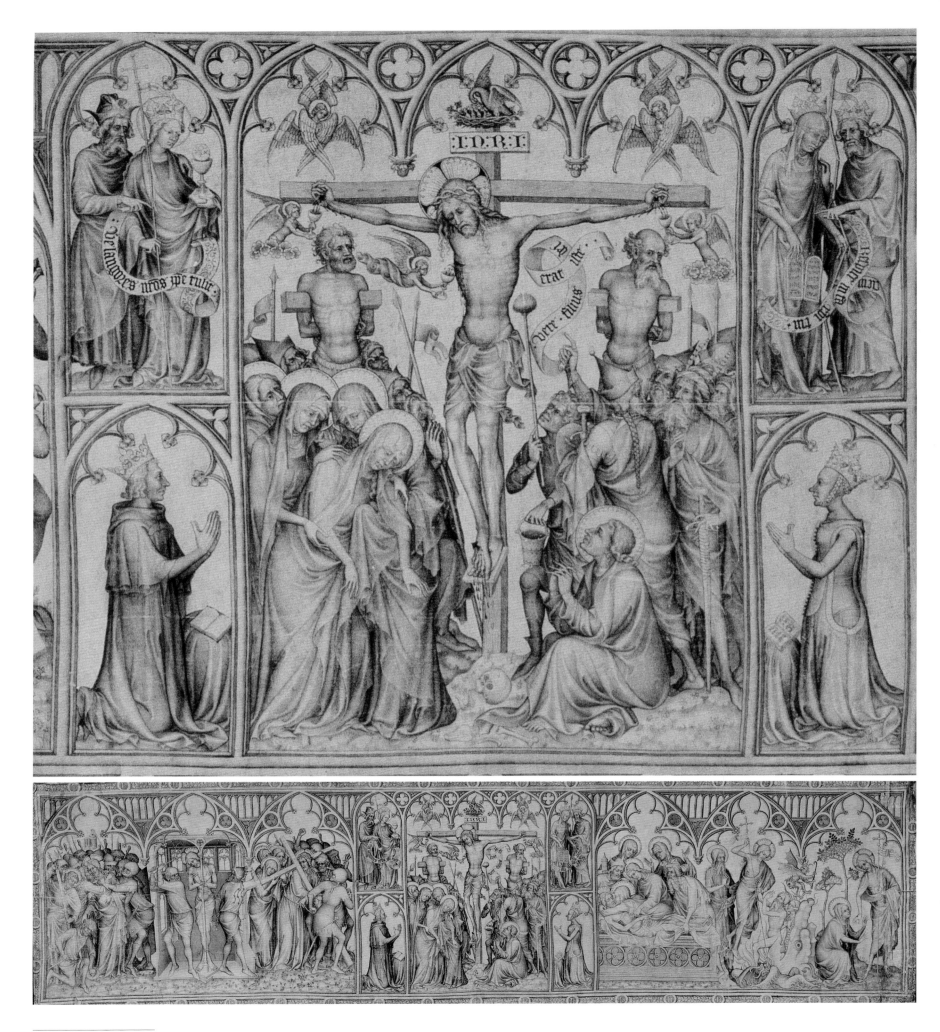

**30–31. *Parement de Narbonne***
**(*The Narbonne Altar Cloth*), c. 1375.**
**(Musée du Louvre, Paris)**

*This large piece of silk (nine feet three inches long), on which scenes from the Passion have been drawn in black ink, is dated to approximately 1375. It is an altar frontal, or parement, for a day during Lent: parements were hung over and behind the altar and could be changed each day. The royal donors, Charles V and his wife, Jeanne de Bourbon, are pictured kneeling on either side of the Crucifixion. Above the king, the church and Isaiah are shown; above the queen, the synagogue and King David. The cloth was discovered near Narbonne. It is supposed that it might have been a royal donation to the cathedral of that city. The artist is unknown, but other illuminations are attributed to him. The unusual size of the work and the technique of the artist, which is in the tradition of Pucelle but enriched with the latest developments from Italian painting (Giotto, Simone Martini), indicate a highly skilled artist, from the Parisian circle of the end of the reign of Charles V. The names of Jean d'Orléans and André Beauneveu have been suggested as the creators, though this has not been substantiated.*

**32. *Grandes Chroniques de France***
**(*Great Chronicles of France*), c. 1375–1380.**
**(Bibliothèque Nationale de France, Paris)**

*This manuscript is a copy, intended for the personal use of Charles V, containing the history of France, which was kept up to date by the monks of Saint-Denis. It was painted by an artist working in Paris in the latter years of the reign. It shows the persistence of compositional traditions already in wide use a century before in manuscript painting, ivory, and stained glass. It would seem that the artist was unaware of Pucelle's work. The page shown here tells of an episode from the Trojan War. Top row, the Greeks land and lay siege to the city; bottom row, the Trojan exiles, directed by Francus, their leader, build a city and fight the Alani. The legend of the Trojan origins of the Francs supports the parallel between Rome, founded by Aeneas, and Paris, founded by Francus. The name of the city is said to come from the name of the Trojan hero, Paris. The purpose of the Chroniques was propagandistic in nature.*

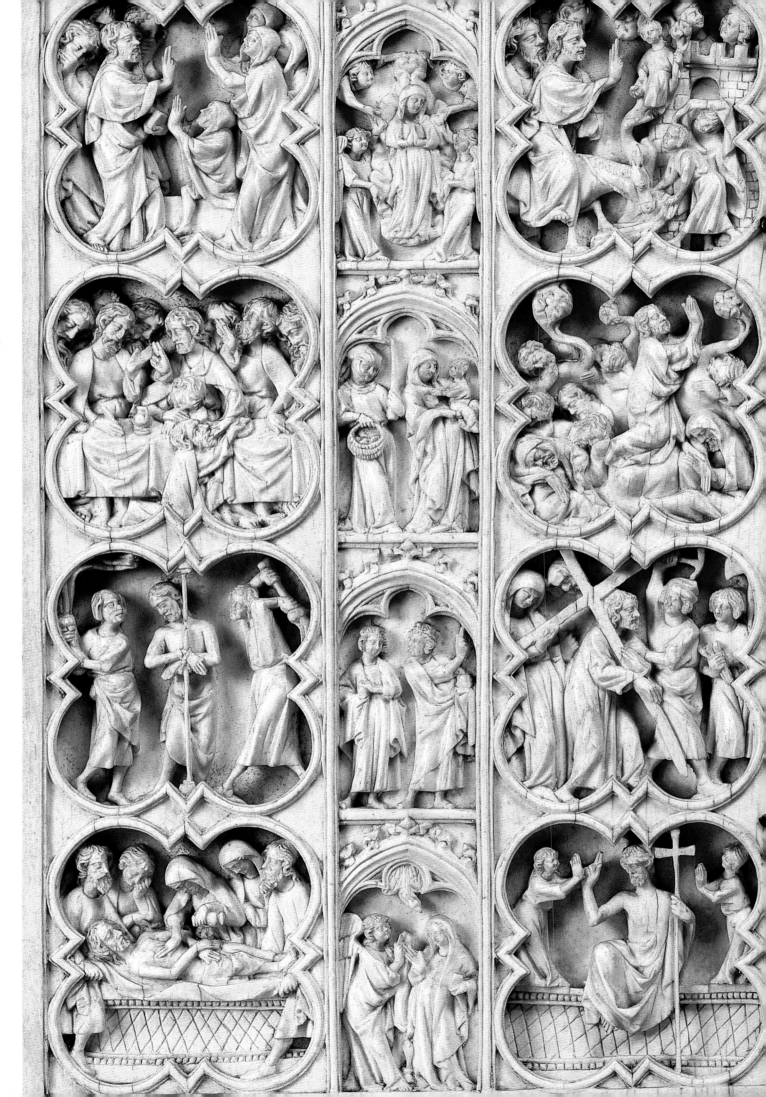

**33.** Diptych, c. 1370–1380. (Musée du Louvre, Paris)

*This ivory diptych, representing scenes from the life of the Virgin, the ministry of Christ, the Passion, and the Resurrection, is traditionally dated to the end of the reign of Charles V, particularly by comparison with the Parement de Narbonne (The Narbonne Altar Cloth; figs. 30–31). The arrangement and the framing of scenes in lobed medallions (the life of Christ, read from left to right and top to bottom, like a book) and under Gothic arches (the life of the Virgin, read in both columns simultaneously from bottom to top, like a stained-glass window) had been used in stained-glass and manuscript illumination.*

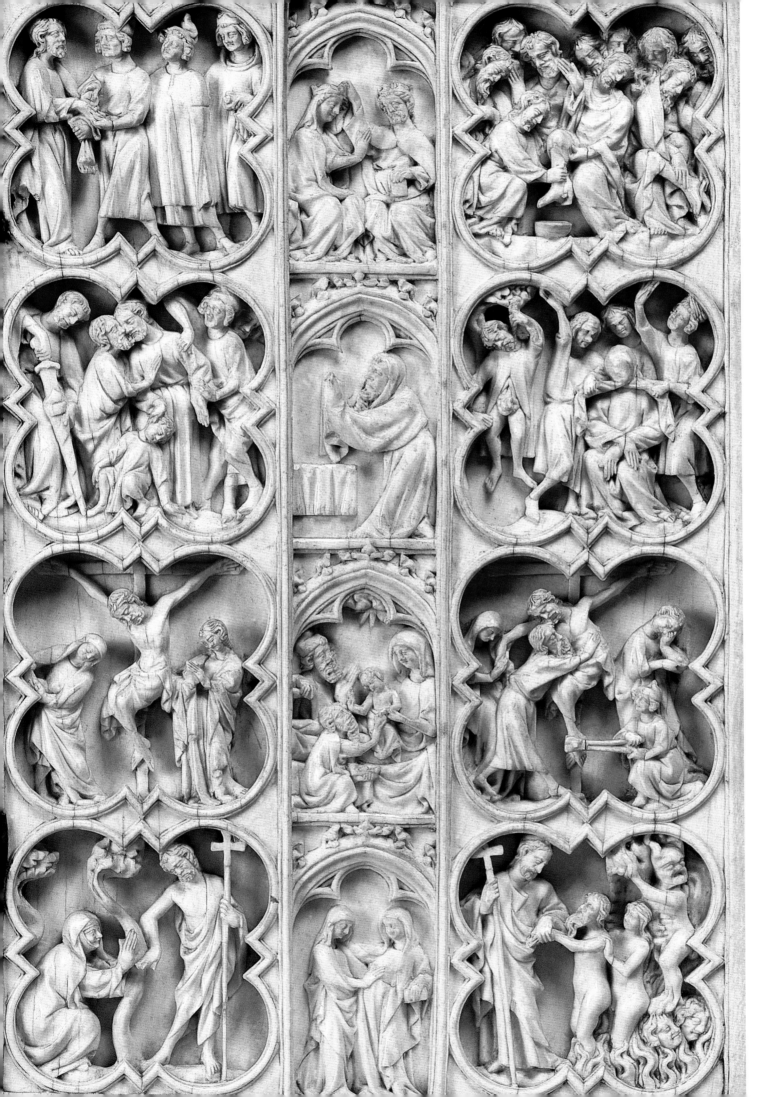

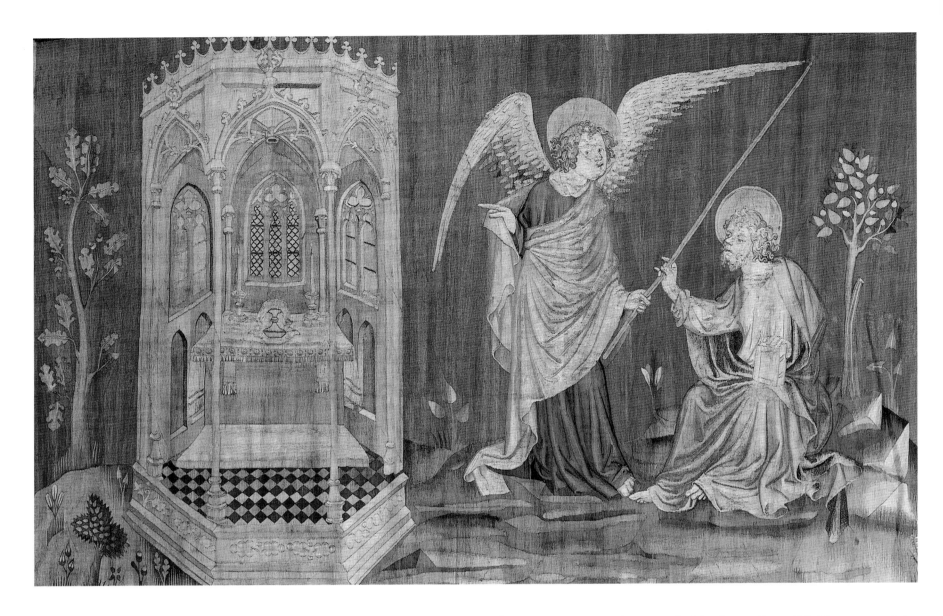

**34–35. The *Apocalypse*, tapestry, between 1373 and 1382. (Château du Roi René, Angers)**

*This series of tapestries representing scenes from the Apocalypse was commissioned by Louis I, duke of Anjou, from Nicolas Bataille, a Parisian mercer; the cartoons were by Jean Bondol. It has been suggested that they were created for hanging in the streets on high feast days, and that they might have been used for the entry of Charles VI into Paris in 1380. There are in all sixty-seven complete panels and three fragments, in two superimposed rows, with a total length of 335 feet and a height of 15 feet. Each panel is approximately 9 feet by 6 feet. One of the panels shown here represents Saint John receiving the order to measure the temple. The other one shows the locusts: a fallen angel descends from heaven in the form of a star; with the key, he opens the pit releasing the locusts, represented by crowned kings and insects that resemble dragonflies more than locusts. The mission of these insects is to torture sinners.*

A part of the decoration of the Hôtel Saint-Pol was probably due to Jean d'Orléans, one of the most active painters in Paris, royal painter to John II the Good, Charles V, and Charles VI. Jean d'Orléans was perhaps also the creator of the *Parement de Narbonne* (*The Narbonne Altar Cloth*; figs. 30–31), a unique work that, miraculously, has been saved. It is unusual because of its size, its technique, the scope of its composition, and the status of its donors, Charles V and the queen, but the style is still close to that of Pucelle.

*Painting*

During this time there appear the first mentions of panel paintings in French art. In 1328, Mahaut bought from John of Ghent, a painter living in Paris, "trois grans tabliaus et uns petiz ront à ymages, de l'ouvraige de Rome" ("three large paintings and a small round one with figures, made in Rome"). Was the painter only a merchant of paintings made in Rome? Another artist, who might himself have been of Italian origin, also worked for Mahaut in Conflans: he is known under the name of Master of the Hours of Charles III of Navarre.

A lost painting from the Sainte-Chapelle (whose existence is confirmed by a seventeenth-century drawing in the Gaignières collection) represented the future John II the Good (then duke of Normandy) in audience with the French pope Clément VI in Avignon in 1342; the painting was perhaps by Matteo Giovannetti, one of the pope's painters; remarkably, the scene represented the pope giving a religious painting to the future king.

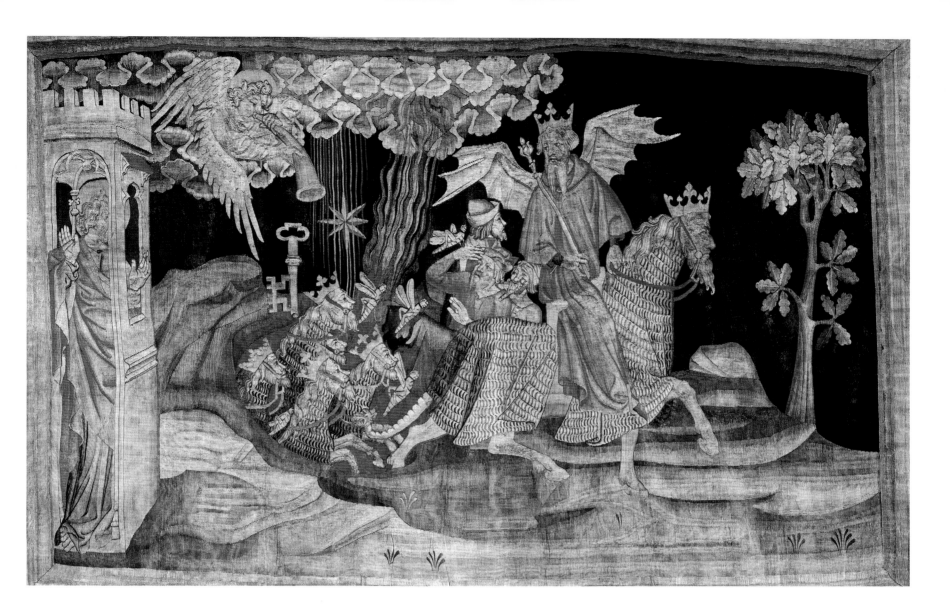

*Tapestry*

The head court painter to Charles V was Jean Bondol, known as John, or Hennequin (Little John), of Bruges, who received a lifetime appointment worth double that of Jean d'Orléans. He is primarily known as an illuminator. But Bondol's greatest work, the tapestry of the *Apocalypse* (figs. 34–35), was executed for Louis, duke of Anjou, and not for the king, who lent his painter to his brother. Charles V also lent him an illuminated manuscript of the Apocalypse; this demonstrates the close link between illumination and tapestry, in spite of the difference of scale. The commission was financed by Nicolas Bataille, the leading mercer of Paris.

The tapestry-making trade certainly existed in Paris in the thirteenth century, but *lissiers* ("tapestry weavers") are not distinguished in documents from carpet manufacturers; both are called *tapissiers*. In a 1303 addendum to the rules and regulations for Parisian tapestry making, it is stated that there exists "une autre manière de tappiciers que l'on appelle ouvriers en haute lice" ("another kind of tapestry maker, called makers of tapestry with nap"). The *Apocalypse* marks the birth (or the revival if one counts the embroidery pieces called the *Bayeux Tapestry*) of a genre destined for enormous success: the narrative tapestry. Until then tapestries had been limited to plant or heraldic motifs. Bataille, who had furnished noble households with so many wall hangings, including the *Apocalypse*, might have had the latter woven in Paris. But it could also have been made in Arras, which became a competitor of Paris starting in the fourteenth century: Mahaut d'Artois, a great patroness, is credited with having launched Arras, which was in her county, at the beginning of the century. In his castle of Beauté, Charles V had a *History of Judas Maccabaeus and Antiochus*, and they were designated "works of Arras."

*This effigy, commissioned for his own tomb by
Charles V from the sculptor André Beauneveu in
1364, is the first gisant of a king created during
his lifetime. The king is shown with the corona-
tion regalia; the crown, the scepter, and the "hand
of justice," all done in metal, have disappeared.*

The tapestry of the *Apocalypse* is not only the earliest narrative wall hanging, but also the largest to have survived. Its intended use is a mystery. No room in any castle and no nave of any church in the territories of the duke of Anjou could have held a hanging of this size. Tapestries were, however, also used to decorate the streets during festivals. They were hung, for example, at Arles for the marriage of Louis II d'Anjou and Yolande d'Aragon, and in Paris for the entry of Isabeau of Bavaria. An unusual feature of this tapestry lends credence to the theory that such was its intended purpose: it was woven in such a way as to be displayed with both sides visible—and there is no back, as with other tapestries. But for what

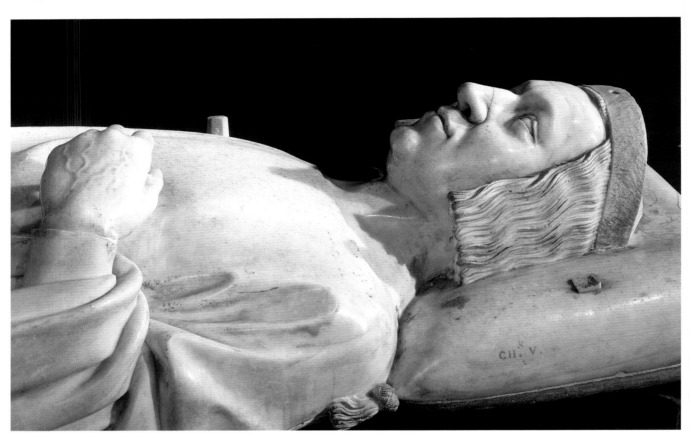

kind of open-air celebration could an Apocalypse have been meant? Might it have been the entry of Charles VI into Paris at his accession to the throne in 1380? This was one of the earliest of the official royal entry parades into the capital with full pomp, an event that would become ritual on the occasion of the accession of a new king. In 1380, in the streets of Paris, decked out in tapestries, both secular and religious events took place. These religious events were not unlike small mystery plays, the theatrical genre treating religious subjects, which first appeared in Paris at about that time. Therefore, it seems likely that the creation of this tapestry was meant for that type of event.

*Sculpture*

There are more and more painters, such as Jean d'Orléans and Bondol de Bruges, whose names are known. The same is true of sculptors. Jean Pépin de Huy, a native of Huy (near Liège) and a Paris resident, worked for Mahaut d'Artois between 1311 and 1329. Jean de Brecquessent came from Brexent in Artois, arrived in Paris in 1313, and also worked for Mahaut. We do not know where Jean de Soignolles (or de Sanholis) came from; he worked in Avignon on the tomb of Clément VI before arriving in Paris, where documents refer to him in 1358. The name of Jean (or Hennequin) de Liège is rather informative: he left Liège in 1361 for Paris, where he stayed until his death in 1381. The only preserved, intact work by this sculptor, who was considered one of the best of his time, is the posthumous effigy on the tomb of Charles IV the Fair and Jeanne d'Evreux (figs. 38–39). André Beauneveu, whose reputation equaled that of Jean de Liège, came from Valenciennes. He is mentioned in Paris in 1364 as an "imager" in the service of Charles V. In 1364 Charles V commissioned him to create his tomb (fig. 36) and those of his father and his grandparents. Only the tomb of the king was apparently executed by the man whom Charles V called "our beloved imager, Andrieu Biauneveu": it is the earliest known example of a funerary *gisant* (the recumbent figure on a tomb) made during the lifetime of the subject. André Drouet and Guy de Dammartin (there were several Dammartins in Ile-de-France), both architects, were in Paris as of 1365, at the same time as Jean de Lannoy, probably a native of the northern provinces, a possible relation of the Robert de Lannoy mentioned in the previous chapter, and Jean de

Saint-Romain, whose origin is unknown. Jean de Beaumetz, probably a native of Picardy or Artois, was in Paris in 1371. Jean de Thoiry was mentioned in Arras, in Valenciennes, and, in 1378, in Paris. Pierre de Thoiry was a bourgeois of Paris; he is known as the creator of the tombs of Charles VI and Isabeau of Bavaria (fig. 37). All of this is to say that sculpture in Paris at this time was created by artists who came from everywhere between the Ile-de-France and Flanders. Jacques de Chartres, in Paris in 1365, is the exception.

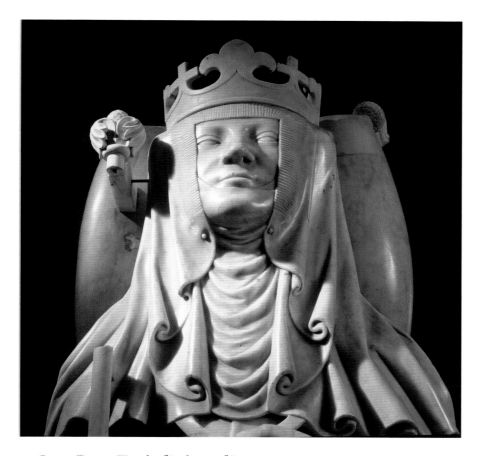

**38–39. Tomb of the Entrails of Charles IV the Fair and Jeanne d'Evreux, after 1371. (Musée du Louvre, Paris)**

*These marble gisants (the recumbent figure on a tomb) were executed by Jean de Liège according to the terms of the will of Jeanne d'Evreux, who died in 1371, forty-two years after her husband, Charles IV the Fair, the last in the direct Capetian line. A royal person could have three*

**37. Saint-Denis. Tomb of Isabeau of Bavaria, c. 1425.**

*This tomb was commissioned during her lifetime, about 1425, by Isabeau of Bavaria, widow of Charles VI, from Pierre de Thoiry. She died in 1435.*

*tombs: one for the body, one for the heart, and one for the entrails. The uniqueness of the tomb of Charles IV, intended for the royal abbey of Maubuisson, near Paris, is that the couple is represented on a small scale (the statue of the king is only three feet eight inches high). The two spouses carry their entrails in a bag. Jeanne d'Evreux was responsible for commissioning many artworks (chapt. III, figs. 9 and 11). Jean de Liège, active in Paris, was one of the leading sculptors during the reign of Charles V.*

Monumental sculpture, particularly for religious architecture, was generally installed in the very same places sculpture of the previous century had been. At Vincennes, in the keep and chapel alike (figs. 24–25), figurative decoration grew more intricate. In the chapel, in the same positions as in the Sainte-Chapelle of the palace, statues, probably of apostles, were planned but never completed (fig. 23). The Apostolic School also decorated the chapel of the royal lodging at Saint-Pol. In the chapel of the Louvre, in a novel approach, thirteen statues of prophets decorated the fireplace of the king's bedchamber. More novel yet, the fireplace of the king's bedchamber at Saint-Pol was decorated with "large stone horses." And totally innovative was the exterior decoration of the grand circular staircase at the Louvre.

As was mentioned earlier, the great circular staircase of the Louvre was pierced; that is, it was illuminated by a section of wall consisting of several levels of open tracery. This bay was decorated on either side with a series of ten statues in niches, which represented, starting from the bottom (above the two men-at-arms): King Charles V and the queen; the male children of the royal couple; duke Philippe of Orléans, the king's uncle (who should not be confused with Louis, son of the king and heir to the title of duke of Orléans); the dukes of Anjou, Burgundy, and Berry, brothers of the king; the Virgin and Saint John; and at the top was the coat of arms of France, probably on a field of fleurs-de-lis. The groin vault at the top of the stairwell was decorated with the coats of arms of the king, the queen, and their children. The structure is thought to have been begun in 1365 by a team including Jean de Liège, creator of the statues of the king and queen, Jean de Lannoy, Jean de Saint-Romain, Jacques de Chartres, and Guy de Dammartin. It was, in a sense, the Tree of the Valois, the striking assertion of the vitality of the dynasty. It is clear that the disappearance of this great circular staircase was a considerable loss in every way. One can get an idea of what it was like from the smaller version that the duke of Anjou installed in his castle at Saumur.

Like Philip IV the Fair at the Collège de Navarre, Charles V made the royal couple into guardians of doorways. They appeared everywhere: in the Louvre; in the Bastille; in Vincennes with the royal children; in the convent of the Celestines, burial ground of princes near the Hôtel Saint-Pol; and in the Quinze-Vingts, where Saint Louis and Marguerite de Provence, founders of this home for the poor, were represented with the features of Charles V and of Jeanne de Bourbon. In the collections of the Louvre there is an example of this royal couple, which came from either the Celestines or the Louvre.

*Portrait Painting*
When one speaks of portrait painting, one must start with what is presumed to be the portrait of John II the Good in the Louvre (fig. 41). This painting does have the characteristics of the genre: individualization of a character without the subject's attributes of office, distinctiveness of pose, and a neutral background. But since the identification of this person remains questionable, in spite of the inscription, and its dating uncertain, are we justified in hailing this as the first portrait painted in Europe since antiquity? What we do know is that the genre was reborn in the course of the fourteenth century, perhaps in Paris, where it would indeed become popular. There is evidence that, in 1380, the king's study at the Hôtel Saint-Pol contained a four-paneled painting with portraits of Charles IV the Fair, the last in the direct line of Capetians; Edward III, the English cousin; John II the Good; and King Charles. And at Bicêtre, Jean de Berry had an entire portrait gallery. But then what are we to make of the Italian portrait of Laura that Petrarch was already praising in two sonnets from 1336? Does this mean that the first portrait painting was actually an Italian accomplishment?

*Dress*
This same Petrarch was irritated that the whole world acquiesced to the dictates of Paris, a northern city. He was indignant that Parisian illuminators could be preferred to those of his country and that he, himself, was forced to wear clothes and leggings in the French style. What was the role played by Paris in this clothing revolution, which amounted to the adoption of short garments for men in the first half of the fourteenth century? This secularization of civilian male clothing, the long robe being left to noblemen, clerics, and women, was complete by the beginning of the reign of Charles V. Fashion, however, true fashion, she who pulls her victims into her dance, and even cavorts with death, she who plays dress-up to hide from the truth, appears only later, at the court of Charles VI, that animal farm where the great dukes, like buzzards, hovered about the person of the mad king.

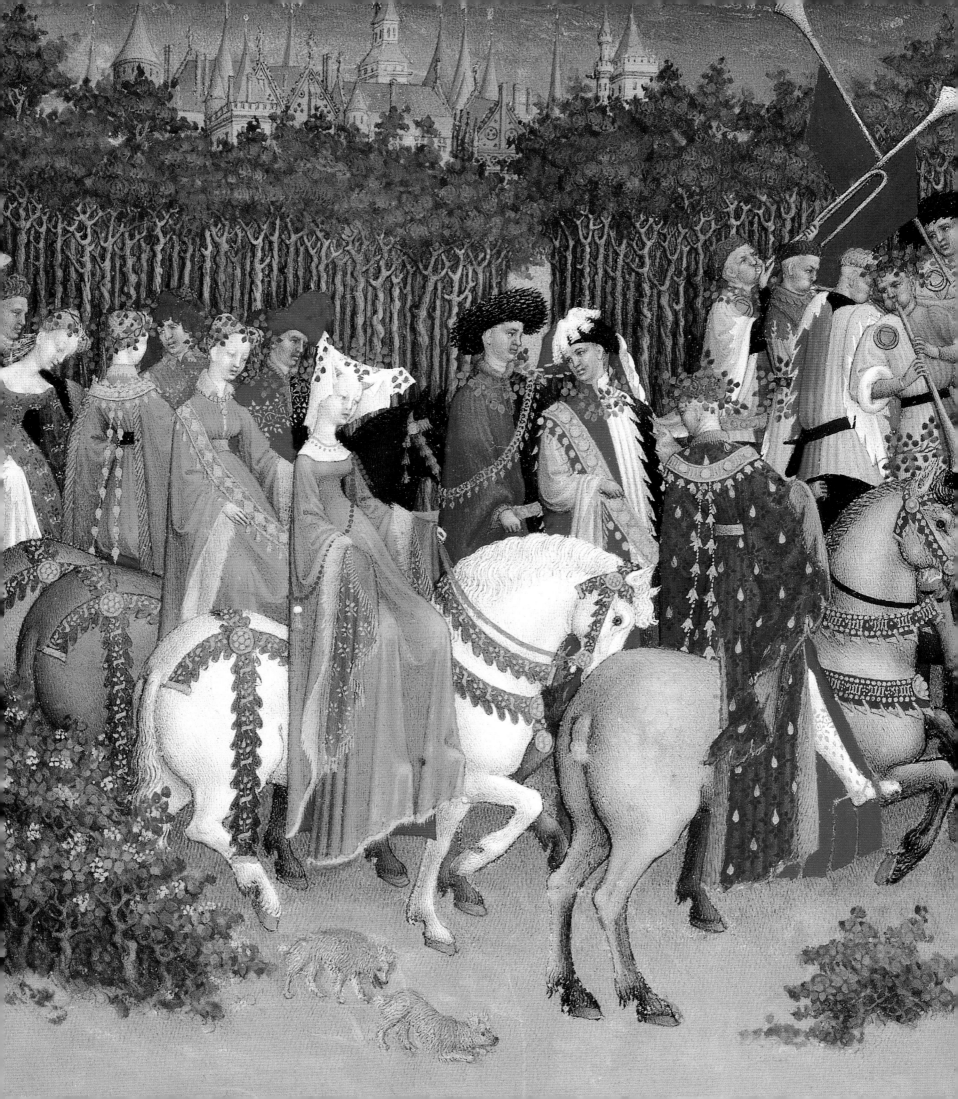

*The actual subject of this painting, the location at which it was intended to be displayed, and the name of the painter remain to be identified. Based on the inscription, the subject is "Jehan, roy de France" ("John, king of France"), but since he is not shown wearing a crown, it may be just the dauphin John, and the painting would then pre-date the accession of John II to the throne in 1350. A second identification, with the dauphin Charles, future Charles V, has also been proposed. The inscription could well have been added after the fact if, for example, it was needed to fill the spot of King John in a portrait gallery. Even though its dating is uncertain, this painting is tradi-tionally considered the earliest example of a "portable" European portrait since antiquity.*

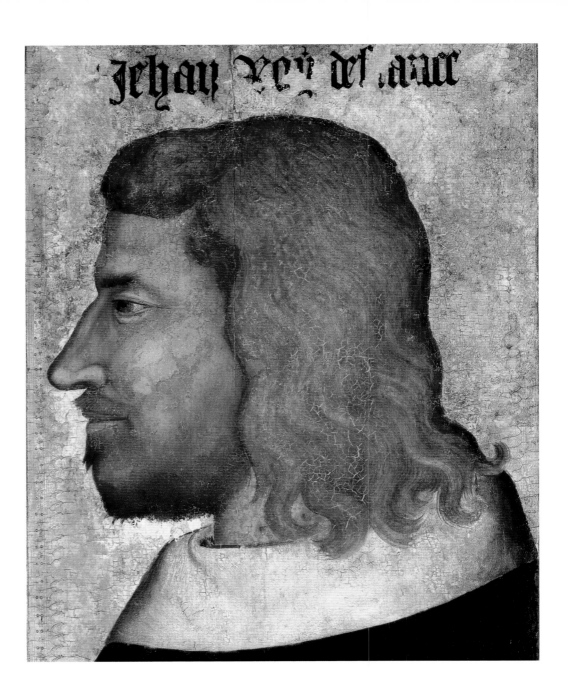

*And whatever wars, tempests, tribulations there might be, the ladies and demoiselles lived in high and excessive style, wearing marvelously high and wide horns. And on each side they had two great ears, so wide that, when they wished to pass through the door of a room, they were obliged to turn and to lower their heads or they could not have passed through.*

*Juvénal des Ursins,* Histoire de Charles VI (History of Charles VI), *written from 1380 to 1422 (first printed in 1614).*

## 4 – THE LUXURY ARTS AND MONUMENTAL ARTS AFTER THE DEATH OF CHARLES V

Illuminations made during the reign of Charles the Wise reveal that clothes were somewhat chaste (fig. 4); in that of Charles the Mad, they were flamboyant and whimsical (fig. 40): men's cloaks were scalloped so radically they seemed to have been slashed in battle; this style of "lacinations," supposedly borrowed from German fashion, may have been imported by the Bavarian queen. The dresses of the women were close-fitting and low cut at the neck. Their hats had horns, which the clergymen compared to those of the devil. Of Charles VII's mistress, Agnès Sorel, Georges Chastellain, a contemporary, wrote: "Elle portoit queues du tiers plus longues qu'oncques princesse de ce royaume, plus hauts atours qu'à demi, robes plus coûteuses, et n'étudiant qu'en vanité jour et nuit" ("She wore trains a third longer than ever any princess of this realm, collars higher by half, more expensive dresses, and she studied only vanity day and night").

Never had jewelers been more in demand than during the reign of Charles VI, both by the king himself and by the dukes. The king's goldsmith was Hennequin Du Vivier. In spite of the efforts by the duke of Bedford to maintain a court there, the English occupation was fatal to Paris. The extinction was all the more sensational because, against the dark background of the reign of Charles VI, the arts had shone more brightly than ever.

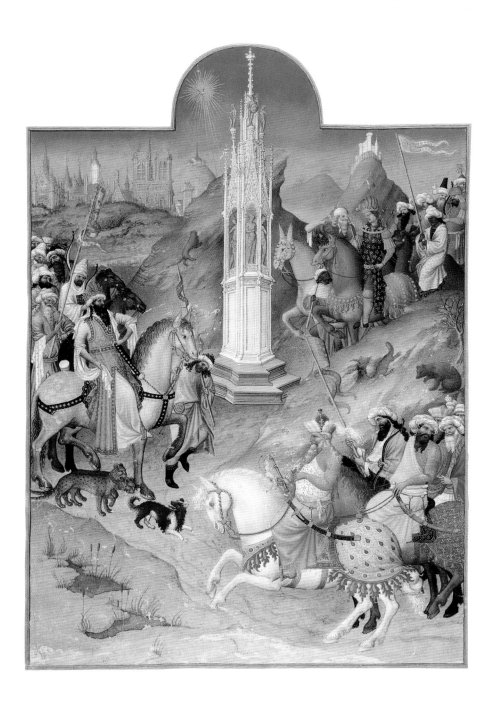

**42. *Très Riches Heures du duc de Berry*, early fifteenth century. (Musée Condé, Chantilly)**

*This book of hours was decorated for Jean de Berry, but perhaps completed after his death in 1416 at the request of King Charles VI or Louis d'Anjou. Still more additions were made later by Jean Colombe. With the exception of these additions, the hands of four painters are discernable, among them the three Limbourg brothers—Pol, Herman, and Jean—although it is impossible to attribute a particular name to any specific illustration. Most of the illuminations show Parisian monuments, indicating that, at least in part, the work was done in Paris. The month of October, with the Louvre (fig. 8), and the month of December, with Vincennes (fig. 1), are by the same hand. The month of June, with the Palais de la Cité (chapt. III, fig. 35), is by a second. The month of January, showing the duke's banquet (fig. 13), and the month of May (fig. 40), with a distant view of the Palais de la Cité, are by a third. The fourth artist created the meeting of the three Magi (opposite). The three Magi meet before a monument that can be identified as a mont-joie (group of stones; chapt. III, fig. 26) except that the statues of kings from the mont-joie have been replaced with classical figures. In the distance appear, arranged unrealistically, the Sainte-Chapelle, the cathedral, and Montmartre.*

## Illumination

Illumination, a bit uninventive under Charles V, was revived by often anonymous, but nevertheless highly skilled artists; they are named after one of their works. The Master of Boucicaut, the painter of the *Heures du maréchal de Boucicaut* (Hours of the Maréchal de Boucicaut; c. 1405–1410), is perhaps identifiable as Jacques Coene from Bruges, who spent his career in Paris; documents place him definitely in Paris between 1398 and 1404. He was also consulted about construction of the cathedral of Milan, where in 1410 they were planning to install balustrades *ad oculos franciscos*, which may mean "with openings in the French quatrefoil style." The Master of Boucicaut anticipates Van Eyck, but the complexity of the architectural spaces and the animation of the figures (fig. 43) are probably the result of his familiarity with the Italian painters of the trecento. A special mention should be made of his *Livre des merveilles* (Book of Marvels), not so much for its quality, which is very uneven (it is probably partly a studio work), as for its contents. This illustrated compilation of stories of journeys to Asia, offered to Jean de Berry by Jean-sans-Peur, contains very early illustrations of exoticism and utopia in French art. This work is approximately contemporary with the visit of "Egyptians" at Saint-Denis in 1427, gypsies that the Parisians went to look at out of curiosity, but whom they were relieved to see leave.

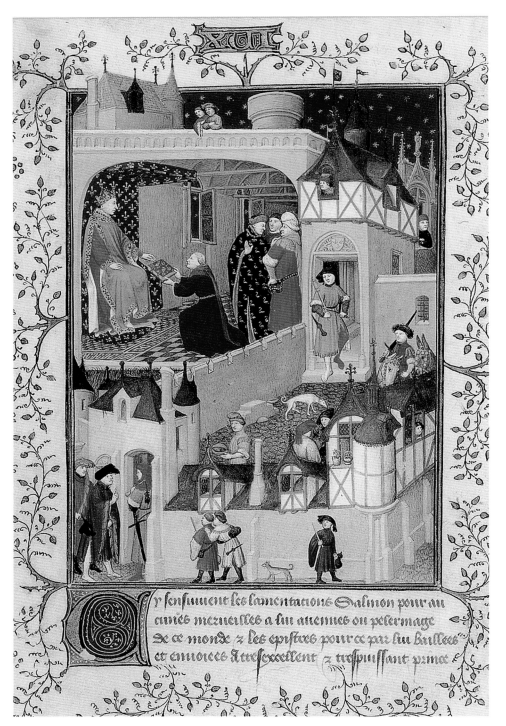

The brothers Pol, Jean, and Herman, who bore the name of their native province, Limbourg, are the artists of the majority of the illuminations of the *Très Riches Heures du duc de Berry* (fig. 42), the masterpiece begun for Jean de Berry and executed at least partially in Paris, as the Parisian monuments it depicts testify. In 1399, Herman and Jean are mentioned as being in the workshop of a Parisian goldsmith; they were hired in 1402 by Philippe-le-Hardi and in 1404 by Jean de Berry. The three brothers died the same year as the duke, in 1416.

The Master of Bedford, the painter of the *Heures du duc et de la duchesse de Bedford* (*Hours of the Duke and Duchess of Bedford*; fig. 44), is perhaps identifiable as Haincelin (Hännslein, "little John") of Haguenau (in the north of Alsace). He worked for the English between 1420 and 1435; his workshop was the most active during the occupation.

Nothing is known about the Master of Rohan, who was in Paris in the 1410s and who must have been in the same workshop as the Master of Bedford. He entered the service of the house of Anjou in about 1420. Responsible for some most striking images (fig. 45), he set himself apart from his contemporaries, who tended more toward realism, but he expressed better than any other the eschatological anguish of the final days that tormented his times.

*Mural Painting*

The mural painting of the reign of Charles VI has not survived any better than that of the reign of Charles V, but there is one major work documented by an engraving, the *Danse macabre* (*Dance of Death*) painted in the charnel house in the Cemetery of the Innocents (fig. 46). It is believed that a sermon on death by a mendicant monk, or more exactly a mimed sermon (accompanied by mimes) or an illumination, may have been the inspiration for this theme, which appeared for the first time at the Cemetery of the Innocents.

And once again, Paris fulfills its role as trendsetter. By direct or indirect transfer, the fresco at the cemetery inspired French, English, and German art.

*Sculpture*

Sixteen years before the painting of the *Danse macabre*, Jean de Berry had ordered a sculpture for the tympanum of the church at the Cemetery of the Innocents, in which he planned to be buried, depicting the *Dit des trois morts et des trois vifs* (*Story of the Three Dead Men and the Three Living Men*; figs. 47–48), a subject already illustrated in a manuscript belonging to the duke, but also in an earlier prayer book of Marie de Brabant. It is not surprising that eschatological topics would emerge so prominently in this dark period: apocalypse, the "dance of death," the discourse between dead and living. But Paris was not the only city that delighted in this subject matter; in Saint-Denis and in many Parisian convents, the *gisants* (the recumbent figure on a tomb) were becoming more and more numerous. The tomb of Charles VI and Isabeau was created by Pierre de Thoiry between 1424 and 1429, between the death of the king in 1422 and that of the queen in 1435, who had placed the order and was modeled *ad vivum* (fig. 37).

**43. *Réponses au roi Charles VI et Lamentation au roi sur son Etat (Answers to King Charles VI and Lamentation to the King About the State of His Country)*, written in 1409 by Pierre Salmon, illumination by the Master of Boucicaut. (Bibliothèque Nationale de France, Paris)**

*The text is a dialogue between Charles VI and his secretary, Pierre Le Fruitier, known as Salmon, on the government of the kingdom and Salmon's autobiographical account of missions carried out for the king. In the illumination Salmon presents the manuscript to the king. Recognizable are Duke Jean de Berry (in black) and perhaps Duke Louis d'Anjou (in red). The dukes' presence is a subtle reminder of the disastrous situation created in the kingdom by the rivalry of the dukes.*

## Stained Glass

In 1393 and 1394, the Parisian glassmaker Henri de Nivelle executed the rose window of the cathedral in Lyons. In 1397, duke Louis d'Orléans presented the convent of the Celestines in Paris with a window "which is now being made in the city of Amiens." Because of this, it is difficult to evaluate the role of Parisian glassmakers in the purely technical innovations of the century: the use of silver-yellow, grisaille, and the *"chef d'oeuvre."* Silver-yellow is applied by brush to make a gradation in color (from blue to green), or to mark a shadow or a contour. Grisaille is an enamel, black or gray, that firing fuses into the glass: it allows the creation of volumes through a gradation from total transparency to total opacity. The term *chef d'oeuvre* here refers to the inlay, in a field of one color, of a segment of a different color to highlight a detail. On the other hand, based on a comparison with painting, the art of Paris is recognizable, if not necessarily influential, in stylistic innovations in glass. The use of large figures in niches, the depiction of space through perspective, the increasing use of clear glass, and the use of grisaille for shading all have equivalents in painting: one recalls the niches with figures of the *Apocalypse* (fig. 34) or the grisaille technique of the *Parement de Narbonne* (*The Narbonne Altar Cloth*; figs. 30–31). The comparison begs the question of the interplay between different media: Would stained glass have been less in use than tapestry at the beginning of the fifteenth century?

## Tapestry

Nicolas Bataille and his successor Jacques Dourdin had supplied scores of tapestries to Isabeau of Bavaria and to the dukes. But the siege of Paris annihilated Parisian tapestry making: in 1421, there were only two weavers left in Paris. A destruction that complete, the likes of which did not occur in manuscript illumination, could only have been the result of a conscious effort to ruin Paris in favor of the duke of Burgundy's workshops in Arras and Brussels, and even in Tournai, which, although not directly under the duke, was in the middle of his territory. These cities were textile centers, and promoting tapestry and rug making there could not but help to consolidate their manufacturing base. The turning point was probably the enormous commission, in 1387, in Arras by Philippe-le-Hardi, duke of Burgundy, for tapestries entitled *Bataille de Roosebecke* (*The Battle of Roosebecke*) celebrating the rout of the citizens of Ghent by Charles VI and the duke in 1382, which gave Artois to the duke. In 1385, Dourdin delivered two tapestries with gold in the Arras style. In the inventory of the tapestries of Charles VI, there are numerous tapestries "in the fashion of Arras"; in no text is there any reference to a tapestry made in Parisian style. Even so, these designations of style do not completely resolve the questions of where they were made. Indeed, "Arras style" may mean nothing more than using Arras thread, a very fine thread that had been immediately imitated in Paris. In fact, Charles VI commissioned Bataille and Dourdin to make a tapestry of the *Jousts of Saint-Denis*, to be made in Paris, "in the thin thread of Arras."

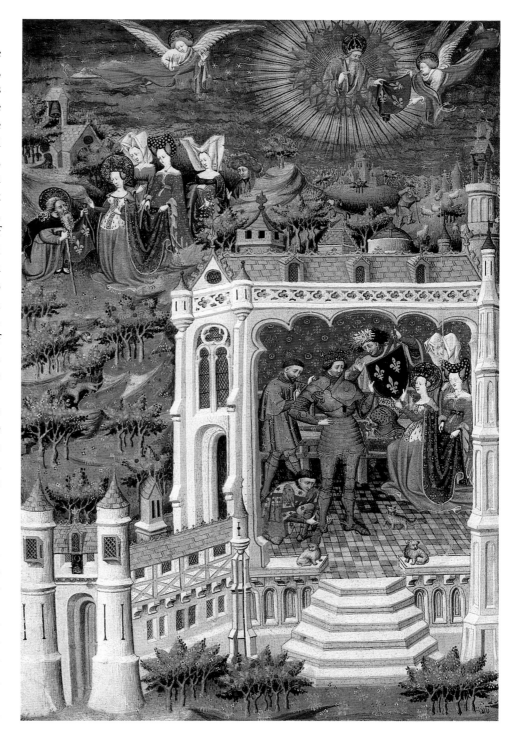

44. *Heures du duc et de la duchesse de Bedford* (*Hours of the Duke and Duchess of Bedford*), around 1429. (British Library, London)

*This book was likely begun for Philippe-le-Bon, duke of Burgundy, and given to his sister for her marriage in 1422 to John of Lancaster, duke of Bedford; it was completed by a painter working in Paris for the duke of Bedford, regent of France from 1422 until his death in 1435. The illumination reproduced here represents the legend of Clovis and the origins of the fleur-de-lis. God gives lilies to an angel, who transmits them to a saint; the saint hands them on to Saint Clotilde, and she to Clovis, dressed in knight's armor. Bedford thus appropriates one of the founding myths of the French monarchy in favor of the English king.*

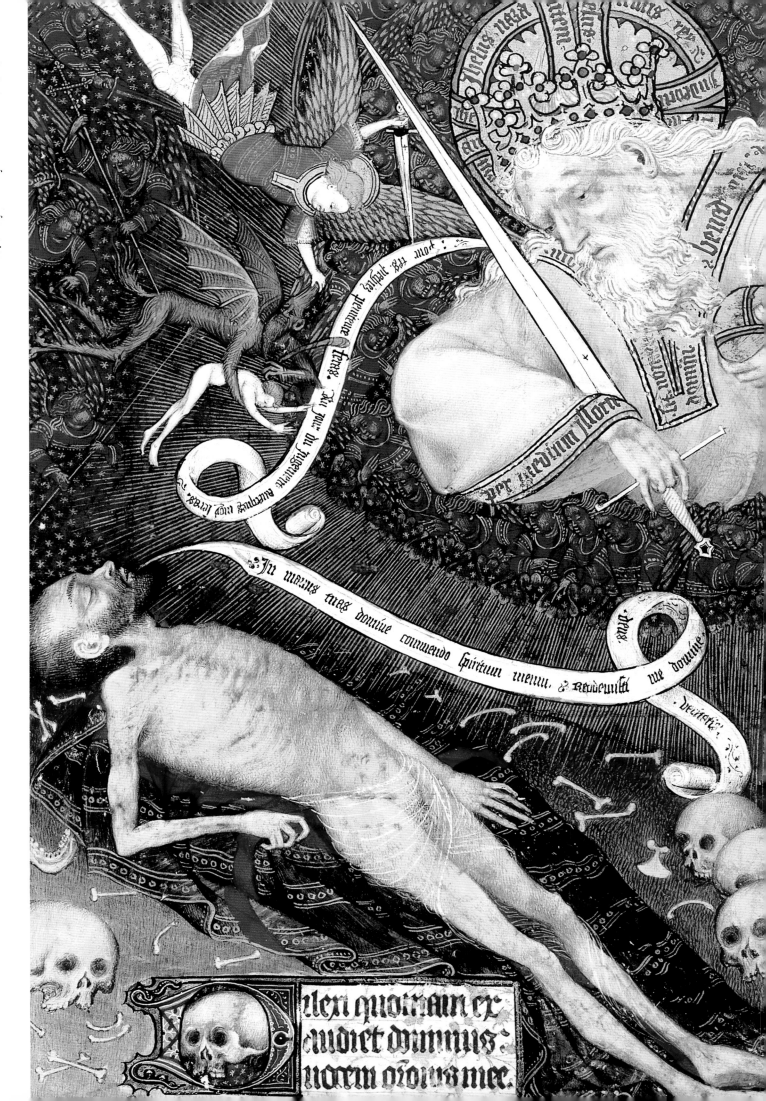

**45.** *Les Grandes Heures de Rohan* (*Great Hours of Rohan*), first quarter of the fifteenth century. (Bibliothèque Nationale de France, Paris)

*We do not know by whom or for whom this book of hours, for use in Paris, was made. The painter is known as the Master of the Grandes Heures de Rohan (Great Hours of Rohan); the coat of arms of the Rohan family that it bears was perhaps added later.*

Nonetheless, the general impression was that the primacy of Paris was eroding, and that authority was being dissipated. The most obvious symptom of this breakdown was the scattering of the royal library so fervently collected by Charles V: plundered and sold off, it was one of the victims of the war. The royal library would later be reassembled bit by bit, but not in Paris: in Amboise by Charles VIII, in Blois by Louis XII, and in Fontainebleau by François I. Such were the main stages of the royal progress, before the kings decided to settle again in Paris.

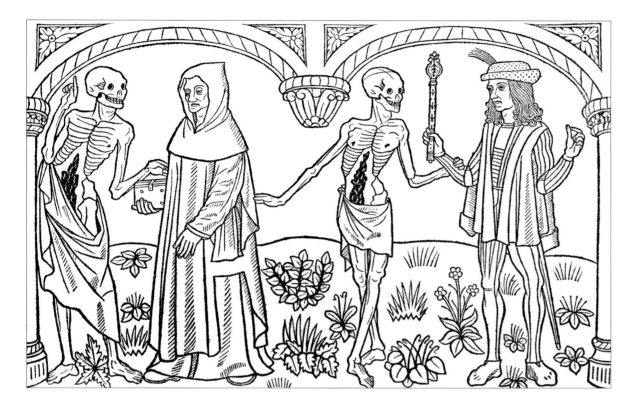

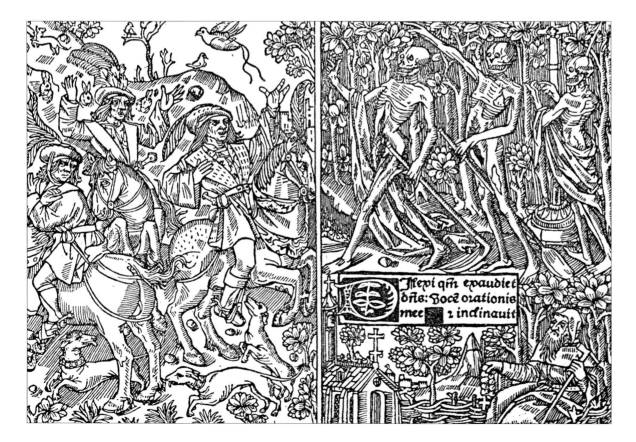

**46.** *Danse macabre (Dance of Death).* (Bibliothèque Municipale, Grenoble)

*In the charnel houses at the Cemetery of the Innocents, the principal burial grounds inside the ramparts, a Dance of Death had been painted between 1408 and 1426. It is known to us through the engravings of the Danse macabre, published in 1485, by the Parisian printer Guyot Marchand; it is known that these engravings reproduced somewhat freely the frescos of the cemetery.*

**47–48.** *Dit des trois morts et des trois vifs (The Story of the Three Dead Men and the Three Living Men),* 1408.
Bottom left: Illustration from the book of hours by Jean du Pré.
Bottom right: Miniature from a book of hours. (Bibliothèque Nationale de France, Paris)

*In 1408 Duke Jean de Berry had a sculpture of the* Story of the Three Dead Men and the Three Living Men *made for one of the doors of the church of the Cemetery of the Innocents, where he intended to be buried. The document on the left is taken from the book of hours by Jean du Pré; the miniature on the right is from a manuscript at the Bibliothèque Nationale de France.*

Thus it was that, for two and a half centuries, an art, which all of Europe identified with French art, prospered in Paris. Although the provinces had not remained inactive, the title had been seized by a single city whose demographic weight and the royal politics of unification and centralization had disproportionately favored. Still, the territory around the capital, this northern capital, so much closer to Flanders than to Guienne, was not really representative of the kingdom as a whole.

European art of the years 1380 to 1400 has been called international Gothic. Certain major cities became artistic centers capable of competing with Paris. Artists moved about, following the whims of the market; they went from one workshop to another. The result of all this was a certain generalization of their means of expression, and the disappearance of distinctive local characteristics. This interpretation is only really applicable to portable objects, those for which the place of manufacture can no longer be identified. The term *international* is appropriate only if the domains of the royal "in-laws" (Burgundy, Anjou, Flanders, etc.) are each considered as a sovereign and separate country, given that the buildings constructed in these areas do indeed seem to be related stylistically, which is not surprising because they have a common source—the projects of Charles V and even of Saint Louis. The best example is the Apostolic College of the Sainte-Chapelle in Paris: these statues of saints in niches (or later on, atop a short column) were replicated in Bourbon-l'Archambault by the duke of Bourbon in Bourges, by the duke of Berry in Châteaudun, and in Champigny by the duke of Montpensier. In present usage, the term *decentralization* would be more appropriate than *internationalization* to describe the situation in France.

Let us begin with the territories of Louis d'Orléans, where there were two magnificent castles, Pierrefonds and Ferté-Milon. They were far enough away from the capital not to be included in the Paris region, yet they were very much in its sphere of influence. Moreover, the sculptures at Ferté-Milon, outstanding examples of the transfer of monumental sculpture to the facade of a castle, inspired by Charles V, came from Paris. The dukes of Anjou built a castle in Saumur whose spiral staircase, windows, cornices, and roofs were inspired by the Louvre. Having added the county of Provence to their lands, they built the castle of Tarascon on the model of the Bastille.

The emancipation of the Burgundian domain was more radical. The painting and the sculpture there took on a distinctive style. One need only study the tomb of Philippe-le-Hardi and the Well of Moses, done by Sluter between 1385 and 1405, to conclude that the masterpieces of European art were no longer being made in Paris by the end of the fourteenth century. However, Dijon's moment of glory was fleeting; the third duke, Philippe-le-Bon, preferred Brussels. Between Anjou and Burgundy, Berry was a middle ground, in all respects. It fell to the duke to gather in the Parisian heritage and to succor the hopes of France. When the duke of Berry died without issue, the appanage returned to the dauphin Charles, who set up his court in the duke's castle in Bourges after the signing of the treaty of Troyes. While the duke was still alive, Beauneveu, the brothers Limbourg, the painter Jacquemart de Hesdin, and the brothers Dammartin (architects and sculptors and veterans of the renovation of the Louvre) had taken refuge in Bourges.

### The Flamboyant Style

It seems to have been in the regions that belonged to the duke of Berry that the French Flamboyant style was born. While there remains much to be learned about this style, several features can be described. Vaults were covered with a proliferation of ribs with no structural logic; the moldings of arcades melted into the shaft of pillars, which had lost their capitals. The counter-curve of the ogee contradicted the natural curve of gables and arches, while window tracery sprouted new shapes imitating fans, leaves, and swirls in infinite variations, some of which suggested the flames that gave the style its name.

49. *Le Quadriloge invectif* (*The Invective Quadrilogy*), by Alain Chartier, third quarter of the fifteenth century. (Bibliothèque Nationale de France, Paris)

*The Quadriloge, written by Alain Chartier at the beginning of the fifteenth century, is a poem describing the misfortunes of France. The present copy, which belonged to the Parisian abbey of Saint-Victor, was painted after the return of peacetime, which did not put an end to the exceptionally wide readership of the book. The page reproduced here highlights the exploitation of the peasants by the dukes.*

Elements of this style, such as fan vaulting and the counter-curve, came from England. But the first Flamboyant tracery was done by Guy and Drouet de Dammartin for the duke between 1380 and 1390: in the Sainte-Chapelle of Riom, in the great hall of the castle of Poitiers, or on the facade of the cathedral of Bourges. This style added new elements to the Gothic vocabulary of floral decoration: the thistle and, most important, the curly cabbage leaf, which replaced the smooth croquet of the rayonnant. Influenced by flower motifs, ribs were sometimes treated as branches. In this respect, the important decoration of the ceiling of the stairwell in the Parisian Hôtel de Bourgogne (fig. 10) is noteworthy.

However, an ornamental vocabulary may well constitute a style without really amounting to a fundamental approach applicable to all the manifestations of architecture. Thus the main phenomenon is probably the extension of the innovations of rayonnant art to civilian architecture. Stone lacework, blind arcades, and the profusion of moldings, which had been cast like nets over church walls, were all applied to castles as well. One example, which is the most convincing because it has been preserved, is the elaborate openwork created by the Dammartin brothers for the duke of Berry over the fireplaces in the palace of Poitiers. But one could also point to the castles of Bicêtre (fig. 15) and Mehun-sur-Yèvre, near Bourges, both also done by the Dammartins. These two fortresses had their facades split open to receive bays of blind arcades and tracery-crowned windows. At Mehun-sur-Yèvre, the influence of the Louvre is most apparent: the walls were opened up with windows, rectangular rather than arched, and the towers were given turrets.

Combining new functions for traditional forms and new ornamentation did in fact give birth to the Flamboyant style. But having occurred in castles that have almost all been destroyed, this birth has gone largely unappreciated, and all the more so since these first "buds" of the style were victims of a late frost, and the full blossoming occurred only in the sixteenth century.

# MODERN TIMES

# Chronology - Part Two

| | |
|---|---|
| 1483 | Death of Louis XI. Succeeded by his son, Charles VIII. |
| 1498 | Death of Charles VIII. Succeeded by Louis XII, duke of Orléans. |
| 1515 | Death of Louis XII. Succeeded by François I, of the Valois-Angoulême branch. |
| 1523 | Publication by Simon de Colines of the translation of the New Testament by Jacques Lefèvre d'Etaples. |
| 1528 | Demolition of the keep of the Louvre. |
| 1530 | Foundation by François I of the Collège des Lecteurs Royaux or Collège de France. |
| 1532 | Laying of the cornerstone of the new church of Saint-Eustache. |
| 1539 | Creation by François I of the Printers to the king for the Greek language; Claude Garamond supplies its printing fonts, the basis of the future Imprimerie Royale. |
| 1546 | The printer Etienne Dolet burned at the stake. |
| 1547 | Death of François I. Succeeded by his son, Henry II. |
| 1549 | Triumphal entry of Henry II, on which occasion the Fontaine des Innocents (Fountain of the Innocents) and temporary factories were constructed. |
| 1559 | Death of Henry II. Succeeded by his son, François II. Regency of Catherine de Médicis. |
| 1560 | Death of François II. Succeeded by his brother, Charles IX. |
| 1566 | Construction begun on a city wall to enclose the palace and the gardens of the Tuileries. |
| 1572 | Saint Bartholomew's Day massacre. |
| 1574 | Death of Charles IX. Succeeded by his brother, Henry III. |
| 1576 | Foundation of the Holy League. |
| 1588 | Day of Barricades, the insurrection against Henry III, who abandons the city to the Guise faction. The League takes over the city administration. |
| 1589 | Assassination of Henry III. Succeeded by Henry IV, of the Bourbon branch. |
| 1593 | Inauguration at the Louvre of the Estates General of the League, convoked for the purpose of offering the crown to the daughter of Philip II of Spain. The deputies refuse. Abjuration of Protestantism by Henry IV in the basilica of Saint-Denis. |
| 1594 | Triumphal entry of Henry IV. |
| 1598 | Edict of Nantes guaranteeing religious freedom to Protestants. Public Protestant worship forbidden in Paris and within five leagues of the city. |
| 1606 | Installation in the Louvre of a silk carpet factory "in the manner of Persia and Turkey," which is the precursor of the Savonnerie works. Construction of a Protestant church in Charenton. |
| 1610 | Assassination of Henry IV. Succeeded by his son, Louis XIII. Regency of Marie de Médicis. |
| 1612 | "Grand Carrousel," tournament to inaugurate the Place Royale (present-day Place des Vosges). |
| 1622 | Elevation of the diocese of Paris to archdiocese. |
| 1624 | Richelieu becomes head of the King's Council. |
| 1627 | Laying of the cornerstone of the professed house of the Jesuits, Rue Saint-Antoine. Siege of La Rochelle. |
| 1629 | Construction begun on the Palais Cardinal, the future Palais Royal, for Cardinal Richelieu. |
| 1635 | Construction begun on the church of the Sorbonne. Foundation of the Académie Française. |
| 1636 | Pierre Corneille, *Le Cid*. |
| 1637 | René Descartes, *Discours de la méthode*. |
| 1642 | Death of Richelieu. |
| 1643 | Death of Louis XIII. Succeeded by his son, Louis XIV. Regency of Anne of Austria. Mazarin becomes prime minister. Victory at Rocroy. |
| 1645 | Laying of the cornerstone of the church of the Val-de-Grâce. |
| 1648 | Foundation of the Academy of Painting and Sculpture by Charles Le Brun. Day of Barricades. Beginning of the Fronde (the "slingshot rebellion") Treaties of Westphalia. |
| 1649 | Flight of the queen mother and the king to Saint-Germain-en-Laye. |

| 1652 | Break-up of the Fronde. |
| | Triumphal entry of Louis XIV, who establishes in the Louvre. |
| 1659 | Peace of the Pyrenees. |
| 1660 | Entry of Louis XIV and his wife, Maria Theresa. |
| 1661 | Beginning of the personal reign of Louis XIV. |
| | Installation of Molière's theater troupe in the Palais Royal. |
| | Death of Mazarin. |
| 1662 | "Grand Carrousel," which leaves its name on the square located between the Louvre and the Tuileries. |
| | Purchase by the king of the factory of the Gobelins. |
| 1664 | Jean-Baptiste Colbert named Superintendent of Buildings. |
| 1665 | First exhibition of works by members of the Royal Academy of Painting, precursor of the Salons. |
| | Creation of the royal mirror works at Reuilly. |
| 1666 | Molière writes *Le Misanthrope.* |
| | Edict instituting the royal furniture factory at La Couronne. |
| 1671 | Louis XIV leaves Paris permanently for Versailles. |
| | Ordinance by City Council to replace the fortifications with boulevards. |
| | Laying of the cornerstone of Les Invalides. |
| | Foundation of the Academy of Architecture. |
| 1673 | Death of Molière. |
| 1678 | Treaty of Nijmegen. |
| 1679 | The title of "the Great" conferred upon Louis XIV by the municipality after the signing of the Treaty of Nijmegen. |
| 1683 | Death of Colbert. |
| 1685 | Edict of Fontainebleau, declaring the revocation of the Edict of Nantes. |
| | Demolition of the Protestant church in Charenton. |
| 1686 | Inauguration of the Place de la Victoire. |
| 1690 | Death of Charles Le Brun. |
| 1699 | Death of Jean Racine. |

| 1708 | Death of Jules Hardouin-Mansart. |
| 1715 | Death of Louis XIV. Succeeded by his great-grandson, Louis XV. |
| | Regency of Duke Philippe d'Orléans. |
| 1721 | Death of Antoine Watteau. |
| | Montesquieu, *Les Lettres persanes.* |
| 1730 | Marivaux, *Le Jeu de l'amour et du hasard.* |
| 1737 | Institution of the Salons. |
| 1738 | Foundation of the porcelain manufactory of Vincennes. |
| 1742 | Ange-Jacques Gabriel named First Architect to the king. |
| 1745 | Madame de Pompadour becomes official "favorite" of the king. |
| | Victory of Fontenoy. |
| 1748 | Treaty of Aix-la-Chapelle. |
| 1751 | Appearance of the first volume of the *Encyclopedia.* |
| 1755 | Death of Montesquieu. |
| 1761 | Jean-Jacques Rousseau, *La Nouvelle Héloïse.* |
| 1764 | Death of Jean-Philippe Rameau. |
| | Death of Madame de Pompadour. |
| 1766 | Annexation of Lorraine. |
| 1770 | Death of François Boucher. |
| 1774 | Death of Louis XV. Succeeded by his grandson, Louis XVI. |
| 1778 | Death of Voltaire. Death of Jean-Jacques Rousseau. |
| 1779 | Death of Jean-Baptiste-Siméon Chardin. |
| 1785 | Jacques-Louis David paints *The Oath of the Horatii.* |
| 1786 | Edict ordering the destruction of the houses built on the bridges. |
| 1789 | Opening of the Estates General. Taking of the Bastille. |
| 1791 | Transformation of the church of Sainte-Geneviève into the Pantheon. |
| | Flight of the royal family. |
| 1792 | Suspension of the king. |
| 1793 | Execution of Louis XVI. |
| 1794 | Festival of the Supreme Being. Fall of Robespierre. |
| 1797 | Treaty of Campoformio. |
| 1798 | First national exhibition of industrial products. |
| 1799 | Bonaparte abandons Egypt. |
| | Coup d'état of the 28th of Brumaire. |

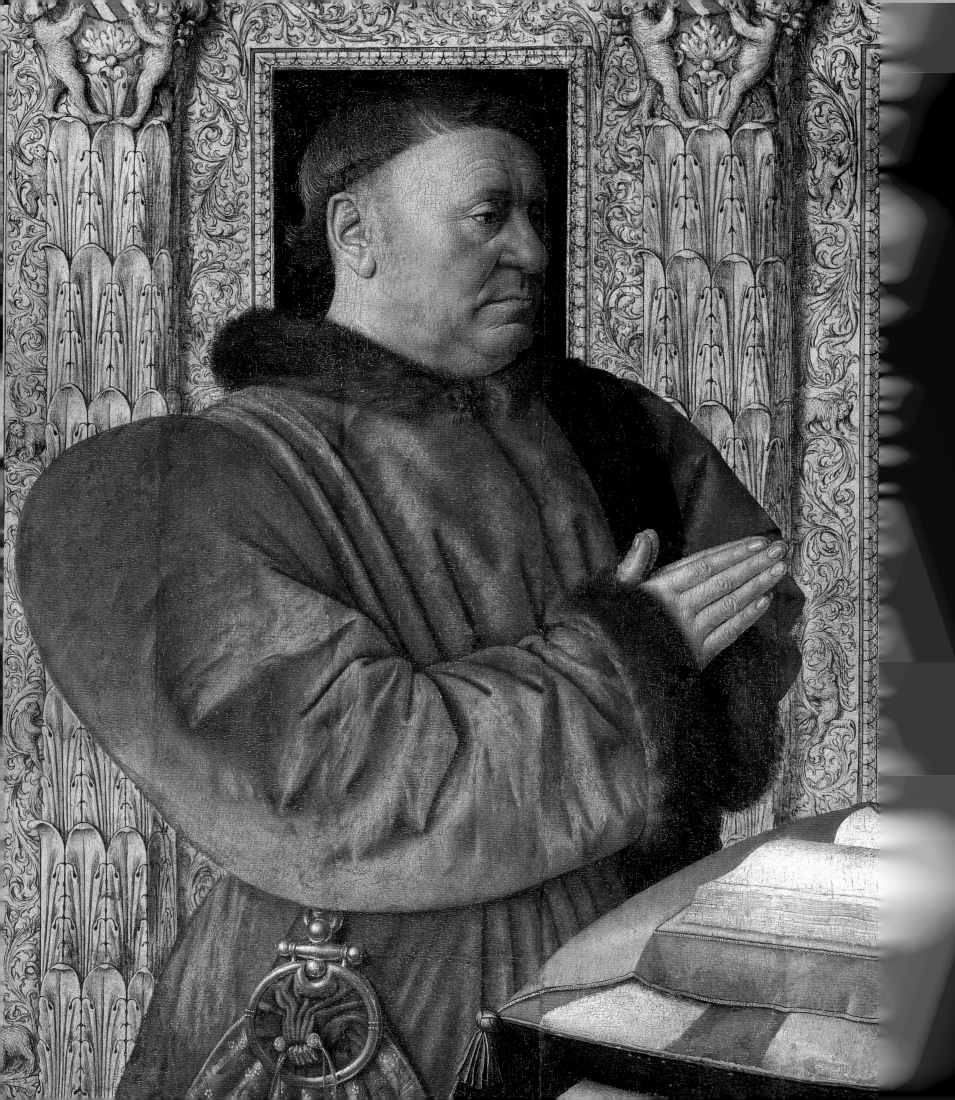

# Chapter V
# THE RENAISSANCE
## (1450–1540)

The liberation of Paris by Charles VII (1436) did not bring peace, and peace (1453) did not bring the kings back to the capital. They persisted for almost a century in lingering near the Loire, a refuge first imposed by political necessity, then prolonged out of personal inclination. No doubt they were reluctant to break the charm of what seemed almost a royal holiday, preferring castle life to city life, hunting to the crowded conditions of the street. In spite of their relatively small populations (or perhaps because of them, since the overpopulated metropolis might worry the sovereign), certain cities of the Loire Valley could aspire to the title of capital; one of them stood out in particular: Tours, whose bourgeoisie had become an important supplier of servants to the state. It has been calculated that during the administration of Louis XI, who resided in the modest castle of Plessis, just outside Tours, 56 percent of the 462 members of the king's council came from Loire Valley families with lands, houses, and castles that anchored them firmly to the territory. Certain of these families amassed the highest offices of the church and the state, such as the Amboise-Chaumont family, who had already ceded the castle of Amboise to the king but who still held Chaumont. Among the seventeen children of Pierre d'Amboise were Louis, the bishop of Albi; Jacques, the abbot of Cluny; and Georges, the close personal aide to Louis XII, archbishop of Rouen and cardinal. The buildings they built are references in the history of the Renaissance. In the year 1537, one could count no fewer than fifty members of this family thus "crosiered and mitered."

The continued existence of the appanages favored the growth of provincial capitals, and occasional bursts of feudalistic zeal further threatened the unity of the realm. The work of unification carried out by Charles VII and Louis XI collided with allegiances of powerful lords, especially with mighty Burgundy, the northerly possessions of which extended from Artois to Holland. More logical annexations to the realm were set aside in favor of the adventures in Italy, which Charles VIII undertook in 1494.

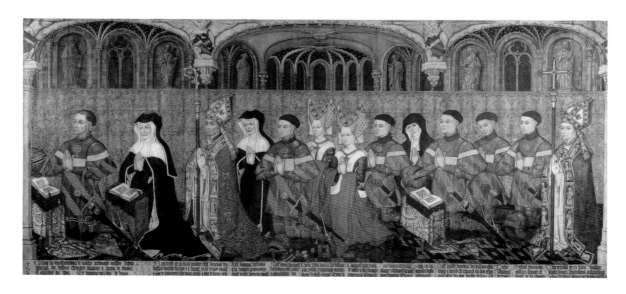

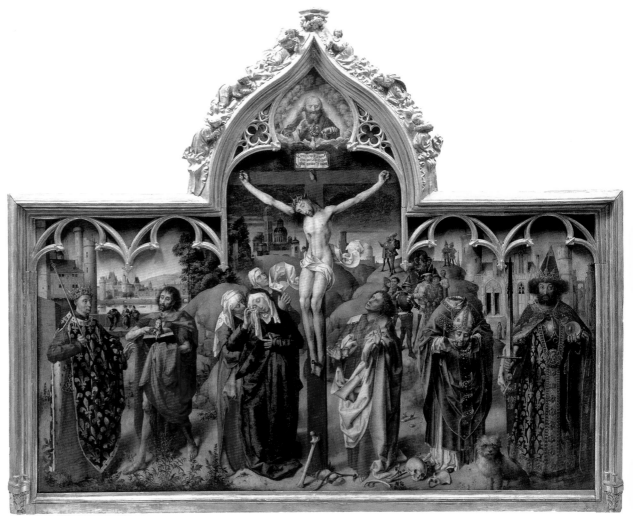

*This painting was commissioned about 1454 by
the Parliament of Paris for the Great Chamber.
The altar over which it hung was used for oaths
of office (fig. 46). At the left are Saint Louis,
with the features of Charles VII, and John the
Baptist; behind them are the Nesle Tower, the
Louvre, and the Petit Bourbon. At the right are
Saint Denis and Saint Charlemagne with, in
the background, the Palais de la Cité showing
the entrance to the Mercers' Gallery. In the
center portion, the Crucifixion is framed by the
Virgin, Mary Magdalene, and Saint John, with
Jerusalem in the background. Oaths of office
were supposed to be made before a crucifix. The
arrangement is clearly political, with its seamless
topography between Jerusalem and Paris and the
presence of Saint Louis, Saint Denis, and Saint
Charlemagne, protectors and ancestors of the
king. The reason for the inclusion of John the
Baptist, on the other hand, is less obvious, unless
his presence is intended to recall the divine anoint-
ment of the kings. It has been suggested that the
painter may have been Louis Le Duc, active in
Paris in the middle of the fifteenth century.*

## 1 – THE BOURGEOISIE AND THE KING

Paris kept its major asset: it was still the largest city in Europe, and by far. In just half a century, it had recovered the population that it boasted on the eve of the war: it had 200,000 inhabitants in 1500; it would reach its peak of 350,000 inhabitants in 1550. However, Paris did not become a powerful business center. Career opportunities were in the area of administration of the state, the various branches of which were permanently seated in the Palais de la Cité. Commerce and manufacturing were mostly centered around luxury items, particularly those having to do with personal adornment, of which Paris was Europe's leading supplier: gloves, shoes, purses, doublets, hose, belts, lingerie, and many more specialties contributed to this lively fashion accessories industry. But the master financier Jacques Coeur, *argentier* (literally, "money man") to the king, Charles VII, ran his enormous international operation from his headquarters in Bourges and Montpellier. As for Paris, it was, in the words of the ambassador from Venice in 1540, the *bottega di Francia*, the "shop of France."

The wealth of the Parisian bourgeoisie was being built up through land acquisition, official appointments, and life annuities. The war had ruined much of the property of the nobility, leaving large estates available for purchase by members of a prosperous urban middle class, who, once they themselves were ennobled, would establish (from the middle of the sixteenth century and especially in the first half of the seventeenth century) their own country seats.

A chance at such opportunities was enticing to the provincial. Parisian immigrants from the provinces formed the bulk of the clientele supporting the arts in Paris during the absence of the king. The famous tapestries of *La Dame à la licorne* (*The Lady with the Unicorn*; fig. 13) bears the crest of the Lyonnais Jean IV Le Viste, president of the Court of Aids (the customs and tax authority), living in Paris because of his duties. The Jouvenel family came from Troyes. Guillaume, who was a chancellor to Charles VII and Louis XI, was the son of Jean, who had been provost of

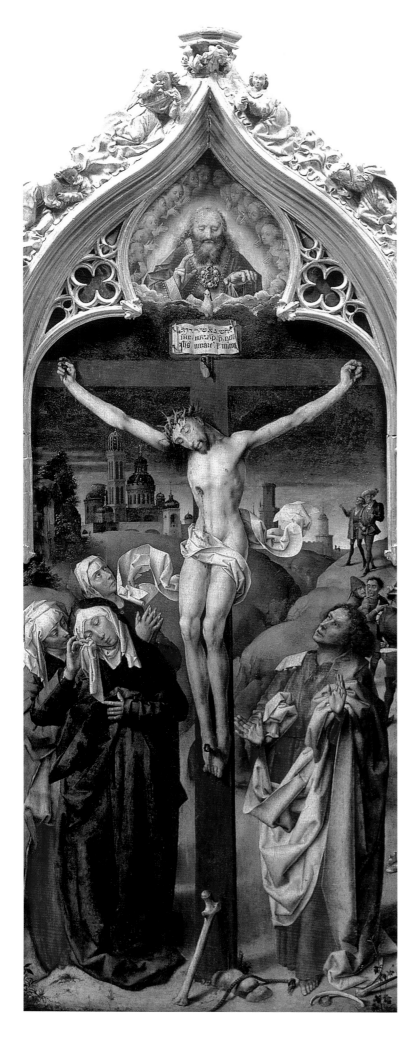

the merchants. Guillaume commissioned the collective portrait representing his family (fig. 2) that decorated the funeral chapel of the Jouvenels in the cathedral of Paris, and both kneeling statues placed atop his parents' tomb. For this same chapel, he had asked Fouquet for an altarpiece, where he, too, is shown in prayer (fig. 1). From Jouvenel, the name of the family was changed to Juvénal des Ursins because of humanist and noble pretensions: the family could thus claim to descend from the Latin poet and from the noble Roman Orsini family. The Chevalier family came from Melun. There are scores of them among the official appointees. Pierre, founder of the line, had been valet to King Charles V. His grandson, Etienne, was a notary and a royal secretary in 1442, then treasurer of France in 1452; he was the friend and patron of Fouquet; he had a townhouse on the Rue de la Verrerie and a chapel in the church of Saint-Merri. Louis Poncher, from Touraine, was notary, royal secretary, and treasurer of France in Languedoc. His brother, Etienne Poncher, archbishop of Sens, ordered a tomb for Louis and his wife in the family chapel at Saint-Germain l'Auxerrois. His wife belonged to the Legendre family, which probably came from Rouen. Jean Legendre, a fabric and wine merchant, was appointed in 1474 as king's counselor and war treasurer; in 1485, he bought an estate at Villeroy. In 1491 he lent money to the king. In 1494, he was ennobled and also became an alderman. The career of his son, Pierre Legendre, followed his father's almost exactly; Pierre built the *hôtel* (townhouse) in Paris (figs. 56–58) and married Charlotte Briçonnet, from one of the most prominent families in Touraine. For lack of a direct heir, Pierre bequeathed his possessions to his nephew Nicolas de Neufville, from a family of fishmongers in Paris's central market, Les Halles. The financial and political fortunes of the Neufville de Villeroy family were to be considerable in the seventeenth century.

The Italians who arrived in Paris at the time of the wars of Italy were from an entirely different background, compared to those of the French middle-class gentlemen and even to those of the Italians who had integrated into the Parisian community in the Middle Ages. These were noble families who had sided with the French and who, through the misfortunes of war, had been more or less permanently condemned to exile in Paris. They did not play a significant role in Paris. Nonetheless, the count of Carpi, who served at the court of François I, had a residence on the Rue Saint-Antoine and was buried in the convent of the Franciscans (fig. 12).

The Parisian schools were very early converted to a sort of prehumanism. Greek was taught in Paris starting in 1421, Hebrew in 1452. Guillaume Briçonnet of Touraine, from the same family as the aforementioned Charlotte, was elected abbot of Saint-Germain-des-Prés in 1505. He became a reformer of his abbey, introduced the teaching of Greek and Hebrew there, and welcomed Lefèvre d'Etaples. Briçonnet, who appears as donor in the *Pietà* of Saint-Germain (fig. 6), was one of the originators of the movement in favor of Bible study, known as evangelism. Named bishop at Meaux in 1516, he made of his diocese an asylum for humanists threatened by the wrath of the university, and brought there, among others, the great publisher Simon de Colines.

In the end, Paris managed fairly well without the king; that may well be what prompted him to return. Throughout five different reigns, the kings had contented themselves with making their ceremonial entry in Paris, as in most of their "good cities." The entry of Charles VII in 1437 revived the kind of spectacular entry inaugurated by Charles VI. Along the parade route, the king saw tableaux or pageants representing the seven virtues, the seven deadly sins,

the saints of the city, the nine valiant knights and nine valiant ladies, episodes from the life of Christ and scenes from the hunt, and a Last Judgment, all at the expense of the Parisians. Like the entry of Charles VI, that of Charles VII borrowed liberally from the Mysteries, which were in favor during the second half of the fifteenth century and up to the beginning of the sixteenth century. (In about 1450 the *Mystery of the Passion* was presented in Paris, a text with 30,000 verses by Arnoul Greban.) For the entry of Louis XI in 1461, classical allegory appeared for the first time, coupled with a triumph inspired by what had been done for Petrarch in Rome. Plus, in a fit of heathen daring, three nude women represented sirens. The entry of Charles VIII in 1484 still held closely to medieval traditions. In 1498, for Louis XII the program became more politicized; the city displayed nine portraits: five of the greatest Capetian kings, one of the founder of the Valois line, one of Louis d'Orléans (the murdered duke), one of Charles of Orléans (the king's grandfather and father, respectively), and one of Louis XII himself. François I in 1515 was the object of a celebration surprisingly lacking in novelty or touches of "modernity."

### The Return of the King

The return of the king to his capital had to wait until March 15, 1528. On that date, François I wrote to the aldermen of Paris: "Très chers et bien amez, pour ce que nostre intention est de doresnavant faire la plus part de nostre demeure et séjour en nostre bonne ville et cité de Paris

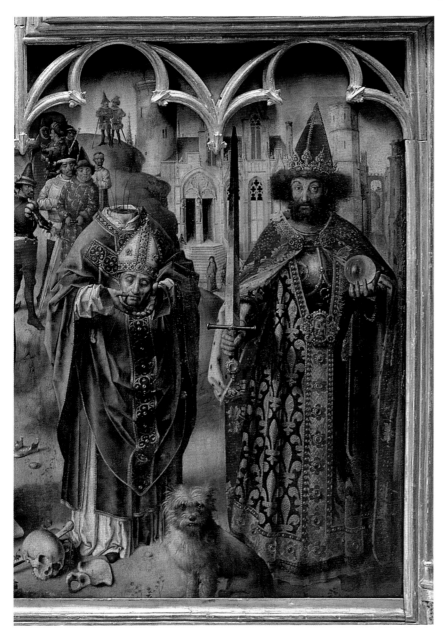

et alentour plus qu'en aultre lieu du royaulme: cognoissant nostre chastel du Louvre estre ce lieu plus commode et à propos pour nous loger; à ceste cause, avons délibéré faire réparer et mettre en ordre ledict chastel" ("Very dear and well loved, because our intention is henceforth to make the most part of our dwelling and residence in our good city of Paris and the surrounding area more than in any other place in the kingdom: knowing that our castle of the Louvre is that most comfortable and proper place for our lodgings; for this reason we have determined to repair and put in order the said castle"). This declaration, coming after the defeat of Pavia and the captivity of the king in Madrid, shows the decision of François I to cut back on his hunting outings in the valley of the Loire and henceforth to take seriously the affairs of state. And historians know that this declaration can be considered as the founding act of modern France.

Taking back control of Paris had to be done gradually. In spite of the protests of the Parliament of Paris, Charles VII had created three provincial parliaments: in Toulouse, in Bordeaux, and in Grenoble. Louis XI had created the precedent for royal intervention in the election of municipal governments. It was a question of insuring the election or the reelection of aldermen approved of by the king. The evolution of Parisian society itself brought the city leadership more and more into the king's sphere of influence: in the fifteenth century, the city government was still marked by its mercantile origins; the aldermen were metalsmiths, moneychangers, butchers, or cloth merchants. In the sixteenth century, the number of merchant aldermen was diminishing in favor of members of the parliament, notaries, and royal secretaries.

One aspect of the king's letter of 1528 was not fulfilled. François I did not take up residence in the Louvre, as he had announced: he limited himself to the demolition of the keep, symbol of feudalism. At the same time, however, he had many castles in the Ile-de-France built or remodeled for his use. Moreover, the king's calendar shows that between 1515 and 1527 he had already spent more time in the Paris region than in the Loire Valley (38 weeks to 28). It is true that the difference

is much greater in the latter period of the reign, 1528 to 1547 (112 weeks to 22). In this connection it is to be noted that the king spent 70 percent of his time traveling. Of more consequence doubtless was the quick condemnation of Semblançay to the Parisian gibbet.

Semblançay was the superintendent of finances, a member of a powerful family in Touraine, and one among many wealthy patrons of the Loire region—patrons whose fortunes collapsed, to the point that they saw their castles confiscated by the king in compensation for public money embezzled by the superintendent. The repercussions of the decision of 1528 were felt more dramatically in Tours than in Paris.

Nevertheless, nothing kept François I from putting his personal seal on the capital. He obliged the aldermen to rebuild their city hall, and the wardens of Saint-Eustache, their church. He imposed on the university the creation of the School of Royal Lectors, the future Collège de France. He reoriented Paris's urban development through measures that may not yet have exhausted their possibilities to this day. He began the building of wharves along the banks of the Seine. He finished the dismemberment of the Hôtel Saint-Pol, making room for the first aristocratic houses of the Marais. The eastward expansion favored by Charles V, with the line from the Hôtel Saint-Pol to the Bastille and the Bois de Vincennes, was replaced with a westward perspective extending from the Louvre to the Château de Madrid in the Bois de Boulogne and the castle of Saint-Germain-en-Laye.

The fondness of François I for his capital has been considered dubious by some. Nevertheless, in 1540 he extolled his city to his former enemy, Emperor Charles V. When asked by the latter which was the greatest city in his kingdom, François I answered Rouen, and, when the emperor was startled by this, the king clarified that Paris was not a city but a world: "*Non urbs, sed orbis,*" as Charles V translated. Moreover, the flatterers were at it again, and in force. Among them, Gilles Corrozet stands out. In 1532 he published *La Fleur des antiquitez, singularitez et excellences de la plus que noble et triomphante ville et cité de Paris* (*The Flower of the Antiquities, Singularities and Preeminences of the Most Noble and Triumphant City and Town of Paris*). In it we learn that Paris was founded seventy years before Troy and 498 years before Rome!

**6. The *Pietà* of Saint-Germain-des-Prés, c. 1505. (Musée du Louvre, Paris)**

*This picture was painted for the abbey of Saint-Germain-des-Prés, probably commissioned by Guillaume Briçonnet, abbot from 1503 to 1507, thought to be shown as a donor behind Christ. On the basis of its style, it is usually attributed to a German painter, a native of Cologne. Seen in the background are the abbey church (with its flanking towers, now gone), the Louvre, the Petit Bourbon, and Montmartre.*

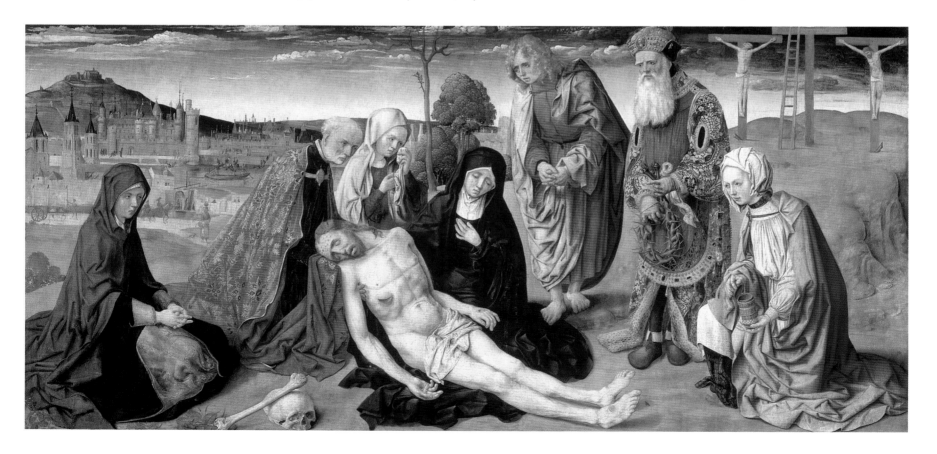

In half a century, Paris had reconstituted its population; in half a century more, it had reclaimed its king and its renown. For all that, it still had not resumed its dominant position in the field of the arts. Artists did come, but they were not the most accomplished and they tended not to stay. They went on to put their talents at the service of the dynamic artistic centers in the provinces and across Europe.

Particularly instructive is the case of those called, rather improperly, the Franco-Flemish; that is, the artists native to the north of France, the Netherlands, and the Rhine. It is difficult to follow their movements because in many cases the connection between the documentation and the rare works preserved is not evident. Anonymous masters also often have multiple identifications.

Some works have been recognized as Parisian only because they presented the sights of the city at the bottom of the composition: luckily, the panorama of the great metropolis apparently fascinated the artists of the north. After 1505 to 1510, the Franco-Flemish artists scattered, taking the art of Parisian painting with them. These masters were really only the last of the fourteenth-century influx of artists who had done so much for the reputation of the city under Charles V and Charles VI. The Franco-Flemish artists would not soon return, unless one considers Jean Clouet, the very French painter, possibly of Flemish origin. He worked in Tours and is mentioned for the first time in 1516, as painter to François I. He followed the king to Paris in 1529. In 1533, he bore the title of painter and valet to the king.

### The Franco-Flemish Painters in Paris

Louis Le Duc, probably a native of Tournai, was temporarily in Paris in the middle of the fifteenth century. He is perhaps the artist of the *Parliament Altarpiece* (figs. 3–5), which shows marked influences of the style of Tournai, epitomized by the art of Robert Campin and Rogier van der Weyden. André d'Ypres (his name shows his origin) was in Paris around 1443, but he soon moved to the Loire Valley. He is identified with the Master of Guillaume Juvénal des Ursins; he died before 1479. His son, Colin d'Amiens, was active in Amiens, in Paris in 1444, in Bourges, in Tours, and in Angers. But he settled in Paris, on the Rue Quincampoix, and became a bourgeois of the capital. Conrad and Henri de Vulcop came from Vulcop, near Utrecht. They were mentioned in 1454 to 1455, the former as the painter of Charles VII, living in Paris; the latter as the painter of the queen, Marie of Anjou, active in the Loire Valley. Afterward, Henri became the painter to Charles de France, duke of Berry and brother of Louis XI. He had a residence in Bourges in 1463 and was active there between 1470 and 1479. There would be no reason for mentioning him among Parisian painters if it weren't for the suggestion that he may be the Master of Coëtivy. The reconstituted opus of the artist called the Master of Coëtivy or the Master of the Hours of Olivier de Coëtivy includes illuminations, cartoons for tapestries (fig. 15) and stained glass (fig. 21), and drawings for sculptures. He was active in Paris in the years 1460 to 1470 and identified successively with Henri de Vulcop and with Colin d'Amiens. The artist known as the Master of the Hours of Anne of Brittany, or the Master of the Hunt of the Unicorn, or the Master of Saint John the Baptist, is considered the successor of the Master of Coëtivy. His prolific work includes illuminations, tapestries (figs. 13–14), stained glass (figs. 22–23), and engravings. He was active in Paris in the last quarter of the fifteenth century. He is also credited with the stained glass of Rouen and Evreux. There are two other masters known only by a single work: the Master of Saint-Gilles, the creator of the *Polyptych of Saint-Gilles* (chapt. I, fig. 18), trained in Bruges or in Ghent, influenced by Hugo van der Goes and Gérard David, and active in Paris between 1495 and 1510; and the Master of the Pietà of Saint-Germain-des-Prés (fig. 6), a German, possibly from Cologne, active in Paris around 1505.

*The Italians*

In the disparate band of artists and artisans whom Charles VIII brought to France in 1495 upon his return from the Neapolitan expedition "to build and create works in the fashion of Italy," there was no one identified as a painter, but then, wasn't every Italian artist capable of painting? These artists were summoned to Amboise, where they received their first wages in 1498. The best paid was the sculptor Guido Mazzoni, called Paganino, or Master Pagain. He worked at Gaillon, the castle of the cardinal Georges d'Amboise, and at Cluny's Parisian *hôtel*. His principal work was the tomb of Charles VIII (fig. 7). For the work on this project, the king gave the artist the Petit-Nesle and its tower, the eastern part of the Hôtel de Nesle, Jean de Berry's former city residence, which by then had been divided in two. The Petit-Nesle was to play an important role in the artistic history of Paris as a studio for metal-working, doubtless because of the forges that were built there. Mazzoni was also credited with the funeral chapel commissioned by Philippe de Commines, the famous chronicler, for the Paris convent of the Grands Augustins. In 1516 Mazzoni returned to Italy, perhaps after designing the proposal for the tomb of Louis XII (figs. 8–11).

On the list of wages of 1498, Giovanni da Verona, called Jehan Jocundus or Fra Giocondo or even Joconde, was named in third place, after a silversmith, and his wages were two-thirds lower than those of Mazzoni. He was, nevertheless, an important figure: a philosopher, a theologian, a Hellenist, an archeologist, an engineer, and "a designer of buildings." He had studied antiquities in Rome and prepared an edition of Vitruvius, which led him to consult certain manuscripts of certain Parisian libraries. He arrived in Paris after the death of Charles VIII in 1498, which brought about the disbanding of the Amboise workshop. In Paris he taught courses that introduced the French humanists to the work of Vitruvius. Of Fra Giocondo's work, we know only those projects relating to engineering, in particular the hydraulic works in the castles of the Loire Valley. However, he was consulted in Paris for the reconstruction of the Pont Notre-Dame (fig. 45), and he is credited without proof with the construction of the new Counting House of the Palais (fig. 47). He had left France by 1506. It was in Venice in 1508 to 1511 that he published the first critical edition of Vitruvius.

As a "maker of châteaux and a carpenter," Domenico da Cortona, born in Cortona, called Becalor or Boccador, is entered at the bottom of the list on the payroll, just before the ala-baster worker and the keeper of the parrots, but after the perfumer: doubtless this was due to his youth. He first became established at Amboise. At the death of Charles VIII, he may have gone to Tours, and certainly to Blois, the new royal construction site where Louis XII was making over the castle of the dukes of Orléans, his forebears. Becalor participated in the decorations that were raised in Paris for the entry of the young Queen Mary of England in 1514 and for the funeral of Louis XII in 1515, but he remained active in the Loire Valley. His role in the construction of the château at Chambord has been the object of much spec-ulation. In 1531, he settled in Paris: it was a direct effect of the royal declaration of 1528. Moreover, the great projects in the Loire Valley were more or less finished, or considered to be.

Girolamo della Robbia, of the famous family of Florentine sculptors, made several trips to France, including one in 1518, and then again in 1527. He became established in Paris at that time: he was in charge of the work on the Château de Madrid (figs. 59–60) at the entrance to Paris, as sculptor or perhaps even as architect. The Château de Madrid is entirely the result of the king's return to the capital. Girolamo restored himself in Florence for a part of the reign of Henry II, whose favor he did not win. But it was in the Petit-Nesle that he died in 1566.

Another effect of the king's return, but this time at Fontainebleau, where François I was having the castle completely renovated, was the arrival in 1530 of the Florentine Giovanni Battista di Jacopo, called Rosso Fiorentino, "the Florentine redhead." Even though Rosso Fiorentino was a canon of the Sainte-Chapelle and Notre-Dame, and was given the use of the Petit-Nesle, the principal part of his work was in Fontainebleau; he died prematurely in

7. Tomb of Charles VIII.
(Bibliothèque Nationale de France,
Collection Gaignières, Paris)

*This tomb, the work of Guido Mazzoni, was destroyed during the Revolution to recover the metal from the figure of the king; it was made of copper gilt, with a mantel painted, perhaps enameled, in azur. The work is not dated, but it was surely done after the death of Charles VIII in 1498; if the king had commissioned it while alive, he would not have had himself represented alone; Anne of Brittany, his widow, is on the tomb of Louis XII, her second husband.*

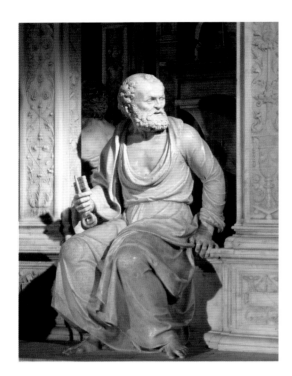

1540. From Bologna came Francesco Primaticcio, called Primaticcio, or Bologna, arriving at Fontainebleau in 1532. Other Italians gathered around him, forming what we now call the School of Fontainebleau.

*Parisians and Francilians (Those from the Ile-de-France)*
The only Frenchman whose reputation equals that of the Italians is Jean Perréal, called Jean of Paris, who was perhaps born in Paris. Perréal chose to spend his career in Lyons, the city that was on the rise, born by the success of its fairs, the vitality of its crafts, the presence of Italian banks. Lyons was the embarkation point for the wars of Italy. Perréal was in Lyons in 1483 and bore the title of valet to the king. In 1489, he staged the entry for Charles VIII into Lyons. In 1499 and 1502, he was in Italy with Louis XII. The curious thing is that we know little about his work. Several portraits in miniature are attributed to him; perhaps also the proposal for the church of Brou for Marguerite of Austria. The best of his works were undoubtedly his proposals for tombs at Brou and Nantes. He may also have designed the tomb of Louis XII and Anne of Brittany in Saint-Denis (figs. 8–11). He died either in Lyons or in Paris in 1530.

The Chambiges, however, were true Parisians. They didn't have the savoir-faire of Perréal, but they built, and a great deal more than others. Martin Chambiges, born in Paris and master planner for the city, left remarkable examples of his art in the cathedrals of Sens, Senlis, Troyes, and Beauvais. We know that he was consulted about the reconstruction of the Pont Notre-Dame in Paris, and the construction of the church of Saint-Gervais-Saint-Protais (figs. 34–37) and the Hôtel de Sens (figs. 50–51) have been attributed to him, but without proof. He died in 1532 in Beauvais. Pierre Chambiges, probably born in Paris, at first followed his father to his construction sites. In 1527, he was working on the castle of Chantilly for Anne de Montmorency; in 1540, he was working for the king at the castles of Fontainebleau and Saint-Germain-en-Laye.

The brothers Jehan and Didier de Felin were from the Ile-de-France, otherwise Parisians: they were both masons to the king and master planners for the city of Paris. Jehan was active in Melun; he built the Saint-Jacques Tower. He assisted his brother, who in 1499 was put in charge of the reconstruction of the Pont Notre-Dame. Jean Delamarre and Pierre Le Mercier

### 8–11. Saint-Denis. Tomb of Louis XII and Anne of Brittany, 1515–1531

*This tomb was made entirely in Tours starting in 1515; the marble sculptures were delivered to Saint-Denis in 1530. The design was perhaps by Jean Perréal, more probably by Guido Mazzoni. The kneeling statues and the transis (recumbent effigies of realistic corpses) are attributed to Guillaume Regnault of Tours. The seated figures (prophets and four virtues: Strength, Justice, Prudence, and Temperance) and the reliefs were done by the Juste brothers. Antonio and Giovanni di Giusto Betti, known as Antoine and Jean Juste, were Florentine sculptors, established in Tours.*

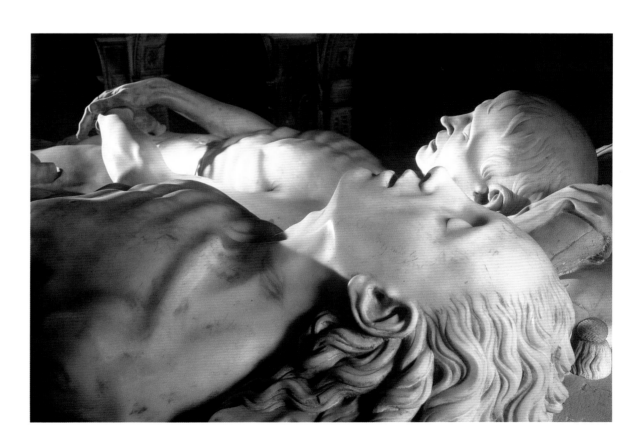

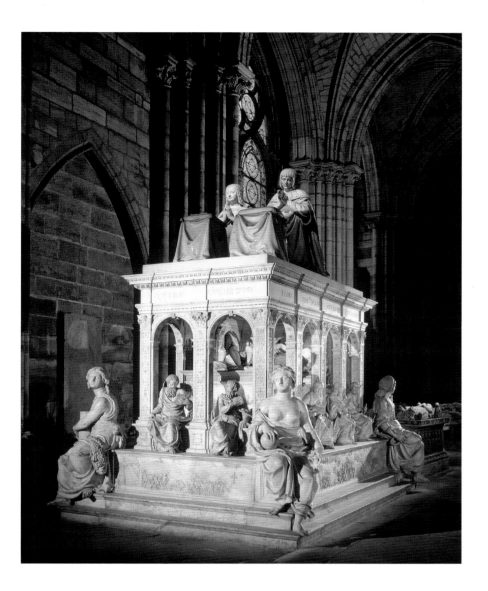

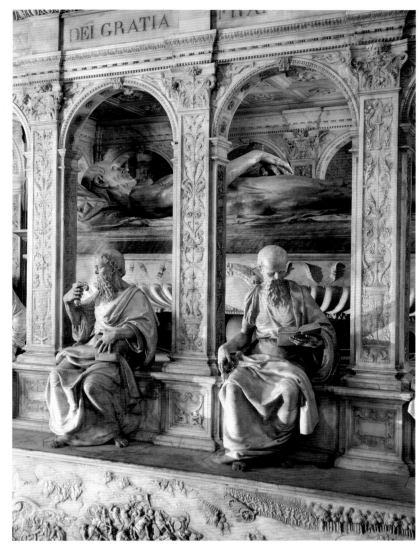

came from Pontoise, where they were active. Delamarre built the abbey church of Saint-Victor in Paris (now destroyed) and possibly also Saint-Eustache (figs. 39–44), which was also attributed to Pierre Le Mercier. Le Mercier was a founder of a line that took hold in Paris and that in the seventeenth century, gave a first architect to the king. It is to be noted that building, which is a business, a trade, a corporation, as much as it is an art, was typically the domain of local entrepreneurs. However, this observation applies more clearly to projects ordered by aldermen or churchwardens—people with ties to the locality.

### Artists in the Provinces and Abroad

Before the return of François I to Paris, Tours was unquestionably the artistic capital of France. It was there that the great sculptor Michel Colombe worked and that his disciple Guillaume Regnault executed works that he sent to Paris. It was also in Tours that Jean Fouquet, the greatest French painter of the fifteenth century, was born and spent most of his career—Paris could not keep him. However, he was probably trained in Paris and, on his return from Rome (1446), he worked in Paris, notably for Juvénal des Ursins (fig. 1) and for Etienne Chevalier (fig. 64). His famous *Hours of Etienne Chevalier* are full of views of Paris, as is his copy of the *Grandes Chroniques de France* painted for Charles V (chapt. IV, figs. 4, 32). In painting, the provincial centers were more important than Paris. Need we mention, to put Paris in proper perspective, that this period corresponded to the prime of Hans Memling, Raphael, Albrecht Dürer, even Leonardo da Vinci, who was working in Amboise at his death in 1519? Andrea del Sarto arrived in France in 1517, but he could not manage to adapt. The most important Italians were in Fontainebleau, too far from Paris to be considered a suburban workshop of Paris.

PROVINCIAL CENTERS
OF PAINTING

*In Touraine, Jean Bourdichon succeeded Fouquet and became painter to Charles VIII, Louis XII, and François I. In the north of France, Simon Marmion and Jean Bellegambe stand out; in the Bourbonnais, Jean Hey, known as the Master of Moulin; in Provence, Nicolas Froment, Enguerrand Quarton, and the Master of King René, perhaps identifiable with Berthélemy van Eyck.*

The situation of the various techniques and artistic genres in Paris in the years 1450 to 1540 is very disparate: some of these arts, native to Paris, became mired in sameness; others were still innovating; some disappeared from the city. Among the newer techniques and genres belonging to the Renaissance, some were transitory, while others took hold permanently. The "carvers of ivory images" were becoming scarcer. The statutes of 1485 forbade the sale in Paris of imported works, a protectionist measure that is telling of the precariousness of the profession. Ivory carvers were losing any originality, replicating in bulk models based on engravings. On the other hand, goldsmiths were prosperous and numerous. There were 104 forges on the Pont-au-Change alone, and provincial goldsmiths often had articles for sale in their shops stamped as made in Paris. Many artists who made a name for themselves in other domains had a background in metal crafts. Nevertheless, few contemporary pieces are noteworthy (fig. 18). In Limoges, the invention of painted enamel, around 1500, revived local production. Illumination was practiced by masters who are known to have been working in Paris, notably the Master of Coëtivy and the Master of the Hours of Anne of Brittany. Yet illumination sometimes tended toward technical brio: the *Très Petites Heures d'Anne de Bretagne* (*The Very Small Hours of Anne of Brittany*) squeezed paintings into a space about 1.75 by 2.5 inches. But the incomparable Fouquet was also practicing this art.

## Stained Glass

The same artists reappear as pattern makers for stained glass. The saints in architectural frameworks in the windows of Saint-Séverin, by the Master of Coëtivy (fig. 21), were belated examples of a design that was popular in the fourteenth century and that was going out of fashion by 1500. The wonderful rose window of the Sainte-Chapelle (figs. 19–20) and the windows depicting the life of the Virgin at both Saint-Gervais and at Saint-Etienne-du-Mont (figs. 22–23) are the work of the Master of the Hours of Anne of Brittany. Their use of engravings as the model is noticeable: it is well known how receptive French stained glass was to the distribution of the works of the great masters through engravings. The *Sagesse de Salomon* (*The Wisdom of Solomon*) of Saint-Gervais (fig. 26) is an early and excellent example of French stained glass of the Renaissance: the subject is spread across the entire width of the window without regard to the tracery divisions; the scene is presented in an architectural decor in the style of the Renaissance; the range of colors is vast and makes generous use of white; and the composition is similar to that of painting, with borrowings from Dürer, Lucas van Leyden, Jan Gossaert, and Raphael, who were known through engravings. The immediate source of the window at Saint-Gervais is a drawing by Jan de Beer. The master glassworker was Jean Chastellain, who, along with Jean de La Hamée, was among the best known: both worked for the king. The roundel with the initials of Laurens Girard (fig. 25) is doubtless the rarest piece of stained glass preserved in Paris, as much because it was made by Fouquet as because it is secular, a category abused by

**12. Tomb of Alberto Pio, count of Carpi, c. 1535. (Musée du Louvre, Paris)**

*After the count of Carpi sided with François I, his property in Italy was seized by Emperor Charles V, and he was obliged to take refuge in France, where he became a leading figure at the court of François I. When he died in 1531, he was living in Paris on the Rue Saint-Antoine; François I gave him a state funeral. He was a gifted diplomat and distinguished writer. His tomb, from the Franciscan church of Paris, was probably designed by Rosso Fiorentino and cast in the Petit-Nesle.*

the whims of fashion. A roundel is a circular or rectangular piece of stained glass, of small dimensions, intended to be inserted into a pane: in them extensive use was made of grisaille and silver-yellow, as Fouquet's roundel demonstrates.

Whatever the merits of Parisian stained glass of the period, it seems to us not to equal that of the provinces. The *Annunciation* given by Jacques Coeur to the cathedral of Bourges in the middle of the fifteenth century is one of the earliest examples of the window treated as painting and likewise the masterpiece of the genre, easily comparable to the paintings of van Eyck. The compositions in Champagne and Normandy are magnificent: it is true that some may be the work of Parisian masters, particularly those in Rouen and Elbeuf, which are attributed to the Master of the Hours of Anne of Brittany.

*Tapestry*
The popularity enjoyed by tapestry fostered much movement among the workshops. In the Loire Valley, these were mobile studios that followed the court and worked in castles. Their production was rather stilted, specializing in millefleur, tapestries without perspective. Tapestry migrated south of the Loire, also. Production at Felletin, near Aubusson, is documented by the middle of the fifteenth century. Flemish workshops went to seek their fortune in Italy, in Siena and Ferrara.

For a short period, during the last three or four decades of the fifteenth century, Parisian weavers produced masterpieces, doubtless solicited by an increasing demand from the *nouveaux riches*, who wanted to furnish their houses in the style of the nobility. Among these were such bourgeois as Guillaume Jouvenel, Etienne Chevalier, and Jean Le Viste, for whom, as mentioned above, the tapestries of *La Dame à la licorne* (*Lady with the Unicorn*; fig. 13) were made. The cartoons of this series are attributed to the Master of the Hours of Anne of Brittany, who may also have drawn those for *La Chasse à la licorne* (*The Hunt of the Unicorn*; fig. 14). The Master of Coëtivy also designed tapestries: of his work there still remain the drawings for the tapestry of the Trojan War (fig. 15), works that are exceptional less for their intrinsic worth than for having been preserved, because preparatory drawings were usually neglected, and thus lost, after the tapestries were produced.

Parisian tapestry production stopped at the beginning of the sixteenth century. The slack is not taken up by Arras, which was destroyed by the siege of 1477 (Louis XI completely emptied the city of all its inhabitants). Instead, it was replaced by Tournai, which was to be destroyed in its turn by the sieges of 1512 and 1521, and especially by Brussels, which was at its peak in the first half of the sixteenth century. The support it had received from the duke of Burgundy, Philippe-le-Bon, was prolonged by the prestigious commission of the tapestry of the *Acts of the Apostles*: the commission came from Pope Leo X; the tapestry was intended for the Sistine Chapel; the cartoons were drawn by Raphael. Tapestry was used, like engravings, as a means for making painting known to a wider audience. Brussels specialized in the production of the tapestry-picture. It was probably in Brussels that François I had the tapestry of the *Story of Scipio* executed, now known only by copies from the seventeenth century: this commission from 1532 does not belong to the art of Paris, since the tapestry was certainly intended for some great castle.

*Painting*
We know nothing, or almost nothing, of mural painting in Paris. Mazzoni's paintings in the chapel of the Hôtel de Cluny have disappeared. Mention is often made of the *Story of Hercules* from the residence thus known as the Hôtel d'Hercule on the Rue des Grands Augustins. But the authors who spoke about this lost series (Sauval, du Breuil) were speaking in the seventeenth century, using terminology that perhaps did not correspond to what had been done in the fifteenth century. The building had been painted with frescos inside as well as out by an Italian. Was that done at the time of Jean Le Viste, who was an owner of the residence in the 1470s? Or at the time of Jean de La Driesche, president of the Court of Accounts, who, after

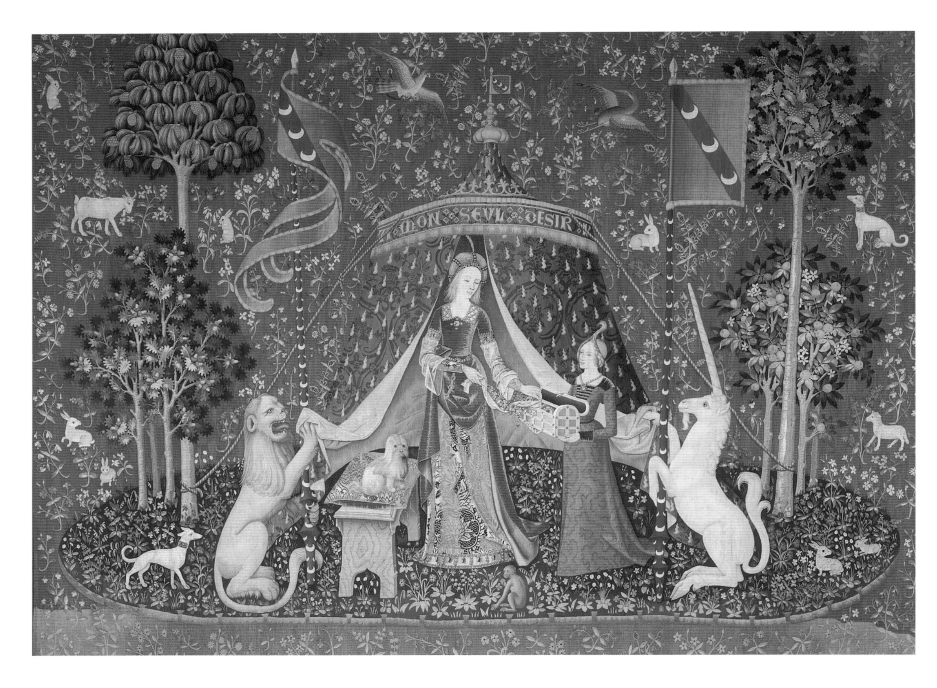

**13.** *La Dame à la licorne* (*Lady with the Unicorn*), tapestry, late fifteenth century. (Musée National du Moyen Âge-Thermes de Cluny, Paris)

*This tapestry in six panels was created for a member of the Le Viste family, whose coat of arms appears on each piece: most probably for Jean IV Le Viste, president of the Court of Aids between 1484 and 1500, for his Parisian residence. The artist remains anonymous but is known by one of his works, the* Très Petites Heures d'Anne de Bretagne (The Very Small Hours of Anne of Brittany). *He was active in Paris at the end of the fifteenth century and was probably also the artist of the tapestry of* La Chasse à la licorne (The Hunt of the Unicorn: *fig. 14). The first five panels represent the five senses; the sixth, shown here, is thought to be an allegory for the control of the senses: it is true that the lady is taking off her jewelry, but her tent bears the inscription "A mon seul désir" ("To my one desire," or "To my desire only"). The lion and the unicorn on all six panels may be allegories for the dilemma of pleasure, of physical love and chaste or mystical love. The unicorn was generally recognized as a figure of chastity or of Christ.*

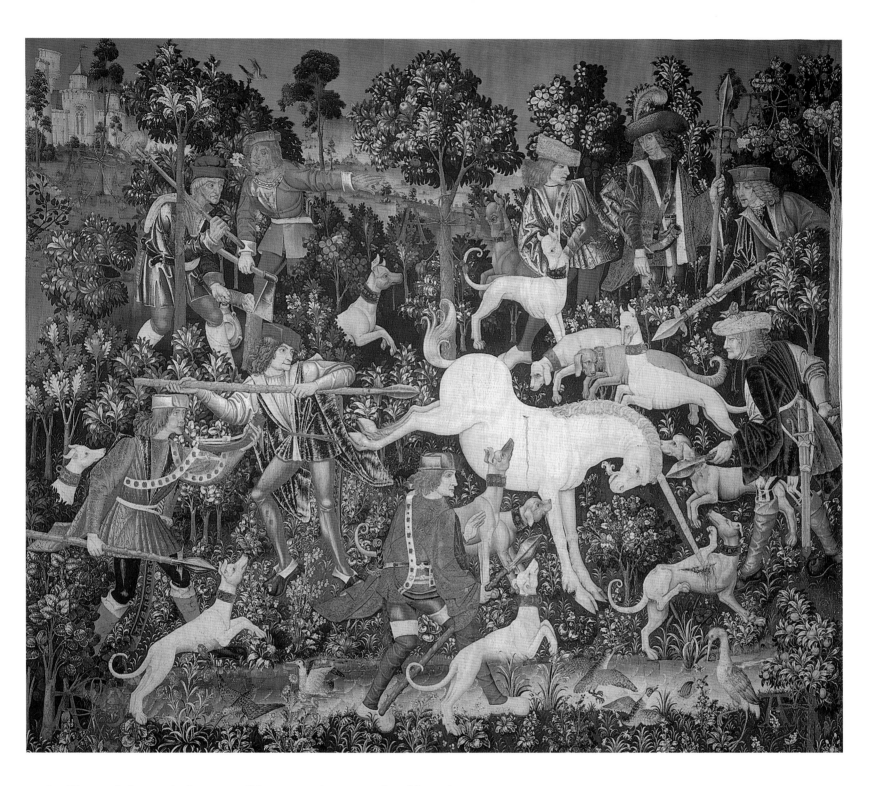

**14.** *La Chasse à la licorne* (*The Hunt of the Unicorn*), tapestry, late fifteenth century. (Metropolitan Museum of Art, The Cloisters Collection, New York)

*This series of four tapestries, plus the fragment of a fifth, is attributed to the same artist as the tapestry of* La Dame à la licorne (Lady with the Unicorn), *an anonymous artist working in Paris. Several of the panels bear the as yet unidentified monogram "AE" (in this panel, one on the collar of one of the dogs, one near each corner knotted together by a cord in the vegetation, and one on the trunk of the apple tree in the upper center). The inscription "AVE REGINA C[OELORUM]" ("Hail Queen of H[eaven]"), on the belt of the horn blower, is an invocation of the Virgin. The subject carries the same ambiguity as the tapestry of* La Dame à la licorne (Lady with the Unicorn). *The unicorn, a mythological animal, could be captured only by a virgin. The unicorn is thought to be an allegory for Christ, and hence the subject would be the incarnation. In a more secular interpretation, the unicorn is man under the sway of feminine seduction: perhaps the tapestry was a wedding present.*

**15. Cartoon for the tapestry of *La Guerre de Troie* (*The Trojan War*), between 1460 and 1470. (Musée du Louvre, Paris)**

*Eight large pen and ink drawings with touches of watercolor, now in the Louvre, are cartoons for the tapestry of* La Guerre de Troie. *They are the only examples to have survived of the paper models from which tapestries were executed. The scene reproduced here shows the capture of Troy.*

On the basis of the watermark, the paper was made in Troyes for the Paris market between 1460 and 1470. Several copies of the tapestry were woven in Tournai by Pasquier Grenin, presumably for members of the royal family, among whom the myth of the Trojan origin of the French dynasty was promoted. The artist of the cartoons is thought to be the Master of Coëtivy, who worked in Paris.

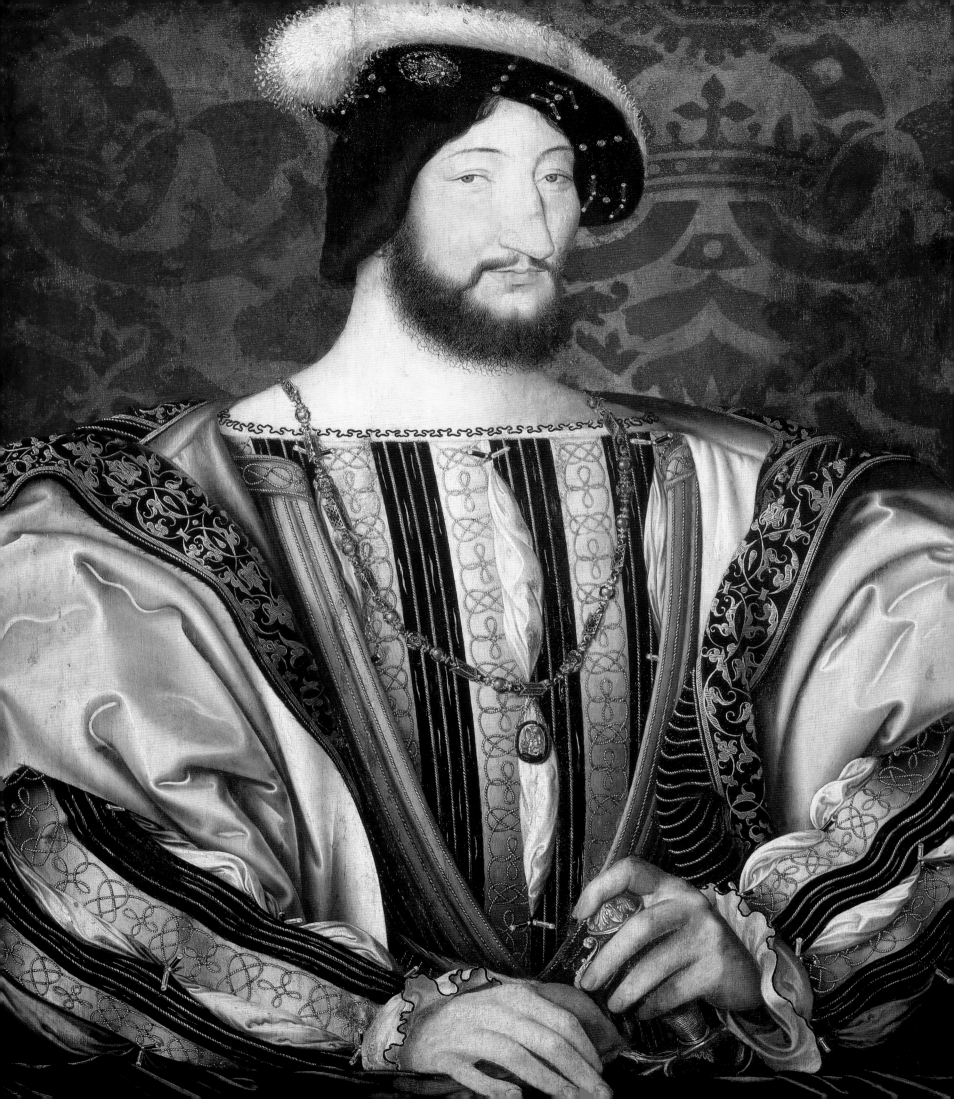

adding on to it, sold it in 1484 to Louis de Hallewin, future chamberlain of Charles VIII? Or was it painted in the time of Charles VIII, who bought it from his chamberlain in 1493? François I gave it to Chancellor Duprat. On the whole, nothing proves that these frescos pre-date 1484, which in any case would make it a very early example of Italianism.

Narrative paintings were extremely rare in Paris in the second half of the fifteenth century. They were all devotional works, painted on wood panels by northern painters: they were Parisian either by their destination or by their inclusion of views of the city. *The Parliament Altarpiece* (figs. 3–5) was intended for the Great Chamber of the Parliament (fig. 46); the polyptych of the *Life of Saint Gilles* was probably given by Louis XII to the church of Saint-Leu-Saint-Gilles (chapt. I, fig. 17); and the *Pietà* had been commissioned for Saint-Germain-des-Prés (fig. 6). At the same time, paintings in Italy and in the Netherlands can be counted by the thousands. The situation is better in the provinces than in Paris, but there is in France an overall paucity, which can only be explained by massive losses. As we will see later, competition from sculpture must also be taken into account.

To the small inventory of Parisian devotional paintings must be added the two paintings from the funeral chapel of the Jouvenel family in the cathedral. The group portrait, representing his parents, his brothers, and his sisters, must have been commissioned by Guillaume Jouvenel (fig. 2), who, although he did not hire a great master, received a work that is nonetheless

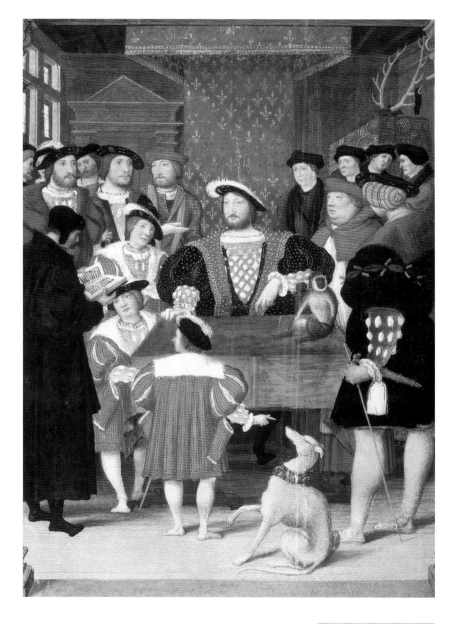

remarkable: this line of kneeling figures was obviously facing the altar or some religious image, now lost. The portrait of Guillaume by Fouquet (fig. 1) is perhaps the only surviving panel of a diptych or triptych, the center and other flanking panels of which might have been an image of the Virgin and a portrait of Guillaume's wife. However, this painting is also a masterpiece of portraiture, a genre in which the French were beginning to distinguish themselves, and illustrates the link between this genre and the tradition of the donor figure, which appears so often in French illumination and stained glass. Of Fouquet's time in Rome, we know that he painted the portrait of Pope Eugene IV. His famous portrait of Charles VII, which probably should be considered as being from Touraine rather than Paris, already presents all the characteristics that were to become standard in French portrait painting: the view of the face in half profile and the bust down to the waist with the hands gathered at the lower edge of the painting, a neutral background, and space suggested by a simple curtain. Jean Clouet's works are almost all devoted to this genre. His innumerable portraits of nearly everyone at court not only look like their subjects, they resemble each other. Since Clouet left Touraine for Paris in 1528, his portrait of François I may be considered Parisian (fig. 16).

*Sculpture*

The French favored sculpture as a means of expression. This tendency went back a long way, but it was particularly apparent in the period from 1450 to 1540 because of a relative lack of monumental painting. Paradoxically, the great theme of that time was the entombment, which produced masterpieces in provincial churches but appears in Paris only in a painting: the *Pietà* of Saint-Germain-des-Prés (fig. 6) was apparently inspired by these groups of saints, holy women, and apostles, witnesses of the Passion, in lamentation around the body of Christ; the ubiquitous donor is present here as well. The Master of Coëtivy is also said to have made a drawing for an entombment of Christ.

All, or nearly all, French sculpture of the period consists of tombs or depictions of the entombment of Christ. Even the Burgundian tombs are forgotten in the face of this impressive number of works, scattered as they are, which may be considered as a group under the classification of royal commissions. Louis XII commissioned from Mazzoni the tomb of Charles VIII, his predecessor, which was executed in Paris at the Petit-Nesle, and meant for Saint-Denis (fig. 7). He also ordered tombs of his forebears, the dukes of Orléans, executed in Genoa by Italians; they were intended for the church of the Celestines, the location of the chapel of the dukes of Orléans (today at Saint-Denis). Anne of Brittany, wife of Charles VIII, then of Louis XII, ordered the tomb of her parents for the cathedral of Nantes, and one for the children from her first marriage, who died very young, in the cathedral of Tours. The tomb at Nantes is a collaborative work by Perréal and Michel Colombe. The death of Colombe put an end to the project by the same team for Brou. The tomb of Louis XII and Anne of Brittany for Saint-Denis (figs. 8–11) was probably ordered by François I, but it may have been commissioned by Louis XII himself, during his lifetime. It was designed either by Perréal or by Mazzoni just before his final return to Italy. The execution of the sculpture was entrusted to members of the Juste family, who were probably assisted by Guillaume Regnault for the figures at prayer and perhaps the *transis*, or withering body. In any case, all of the statues were carved in Tours and shipped to Saint-Denis. Tours remained the major workshop of French sculpture until the beginning of the sixteenth century. Only bronzes, apparently, were done in Paris, because of the furnaces at the Petit-Nesle.

The tomb of Charles VIII was decorated with allegories of the virtues framed in medallions, in the Italian tradition; the king was represented at prayer, according to a more French tradition. The tomb of Louis XI, as stipulated by the king's will, was located in the church of Cléry in the Loire Valley; it also included a kneeling figure, this one designed by Fouquet. But in Paris, the grouping of the parents of Guillaume Jouvenel, shown kneeling, probably

dates to before 1450. In yet an earlier instance, in his will, Jean Phélippin of Bar-le-Duc, who died in the mid-fourteenth century, asked to be portrayed at prayer on his tomb. As in portraits, the *priants* of tombs are generally no more than kneeling donors, taken directly from illumination and stained glass.

The tomb of Louis XII (figs. 8–11) is a *tempietto*, or miniature temple, which carries the praying couple on its roof, and shelters the *transis* within. It is adorned by seated figures: prophets along the sides, the four virtues at the corners. The idea of such a novel architectural arrangement originated in Italy. The designer of this tomb, which could pass for a Milanese work, may have been inspired by Gian Galeazzo Visconti's tomb in the charterhouse of Pavia, which was very much admired by the French. Gian Galeazzo was the great-grandfather of Louis XII; it was from his grandmother Visconti that the king of France derived his claim to Milan. Moreover, the tomb is decorated with reliefs illustrating the wars of Italy. The attribution to Mazzoni, which is probably accurate, is based on comparisons with two works by this artist: the entombment at Modena and a design for the tomb of Henry VII of England. The latter, probably done in Paris, is regrettably known now only through a restoration: it was *tempietto*-type tomb with *priants* and *transis*. The *transis* was not executed by Mazzoni. The theme of the withering body perhaps grew out of depictions in the thirteenth and fourteenth centuries of bodies of the damned being devoured by beasts. Such representations were done of Guillaume de Harcigny (Laon, 1393), Cardinal Jean de Lagrange (Avignon, 1402), and Canon Etienne Yver (died 1467) in the cathedral of Paris.

The Louvre has collected the vestiges of three important Parisian tombs, unfortunately too incomplete and too questionable in their reassembly to allow for meaningful analysis: the tomb of Philippe de Commines and his wife; that of Louis Poncher and his wife (sculpted in Tours by Guillaume Regnault and intended for Saint-Germain-l'Auxerrois); and that of the count of Carpi (fig. 12). This last tomb presents, apparently for the first time in France, the subject lying on his side, a motif borrowed from Etruscan tombs. But here he is reading: one may very well suppose that the open book is a book of hours or some other pious work, but the position of the deceased does indeed suggest at first glance a humanist absorbed in his studies.

*Printing and Engraving*

As the count of Carpi was dying, the Parisian printing industry was becoming the most active in Europe; perhaps it already was. Printers from the Rhine had set up in Paris in 1470, twenty years after the release of the first incunabula from the presses of Mainz. Printing arrived in Lyons in 1473, in Albi in 1475, and in Toulouse and Angers in 1476. In the years 1480 to 1482, 156 editions were published in Venice, the capital of book production, while 35 were done in Paris, which ranked only seventh at the time. In the years 1495 to 1497, however, Paris was in second place (181 titles) behind Venice (447) but before Lyons, which was in third place (95). During the sixteenth century, Paris published 25,000 books, Venice 15,000, and Lyons 13,800. From the beginning of the century, booksellers multiplied in Paris, notably in the Latin Quarter: on the Rue Saint-Jacques alone, there were 160 of them! The Parisian publishers Chrétien Wachel, Michel de Vascosan, the Estienne family, Simon de Colines, and

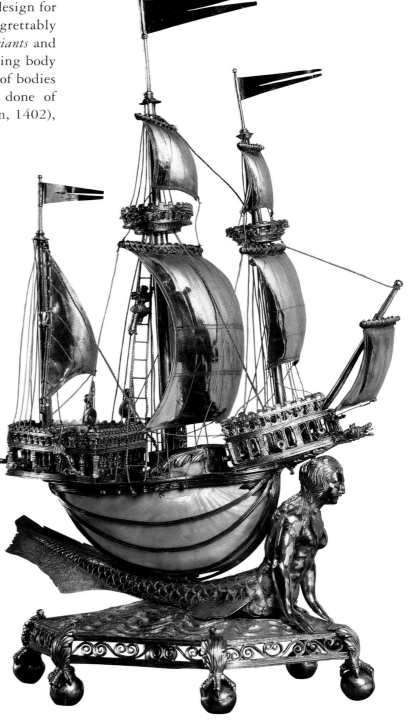

**18. Saltcellar in the shape of a ship, 1517–1518. (Victoria and Albert Museum, London)**

*This piece, in silver and silver gilt, is one of the rare preserved examples of Parisian metalwork, which was very active in this period. The dating of 1482–1483 has been corrected to 1517–1518. The craftsman has not been identified: the name of Pierre Le Flamand was linked to the earlier dating. It was probably the saltcellar of a ship owner.*

**19–20. Western Rose Window
of the Sainte-Chapelle, c. 1485**

*The rose window of the Sainte-Chapelle,
which depicted the Apocalypse, was
entirely redone on the same theme some-
time after 1485, by order of Charles VIII.
The use of silver-yellow and chef d'oeuvre
is characteristic of stained-glass tech-
nique at the end of the Middle Ages. The
anonymous artist is thought to be the
Master of the Hours of Anne of Brittany.*

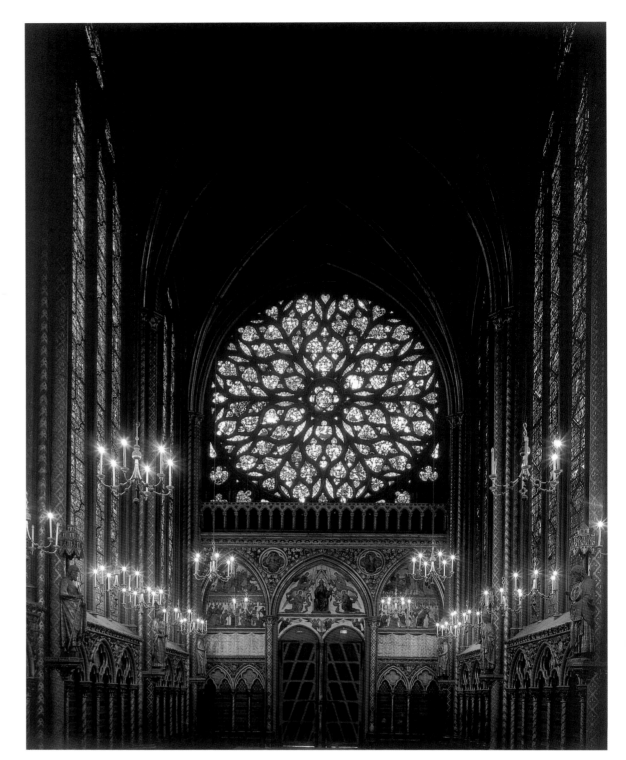

Geoffroy Tory are well known. Some of them were persecuted for their ideas and took flight, causing a drop in Parisian production toward the middle of the century, but it soon recovered.

Tory was the first of these publishers to treat the printed book as a work of art. He was a writer, typographer, and engraver. He traveled in Italy, and he taught literature and philosophy in Paris. He worked as a corrector for Henri Estienne. In 1518, he became a member of the Parisian booksellers' guild, and in 1530, printer to the king. He did ornamental woodcuts and, following the example of Aldo Manuce, the famous Venetian publisher and the inventor of italics, he designed character fonts for Simon de Colines and Robert Estienne. In 1529, he published his *Champfleury*, a treatise on calligraphy and typography, containing notes on grammar and spelling. For Tory, typography was an art, and he integrated text and images (figs. 62–63).

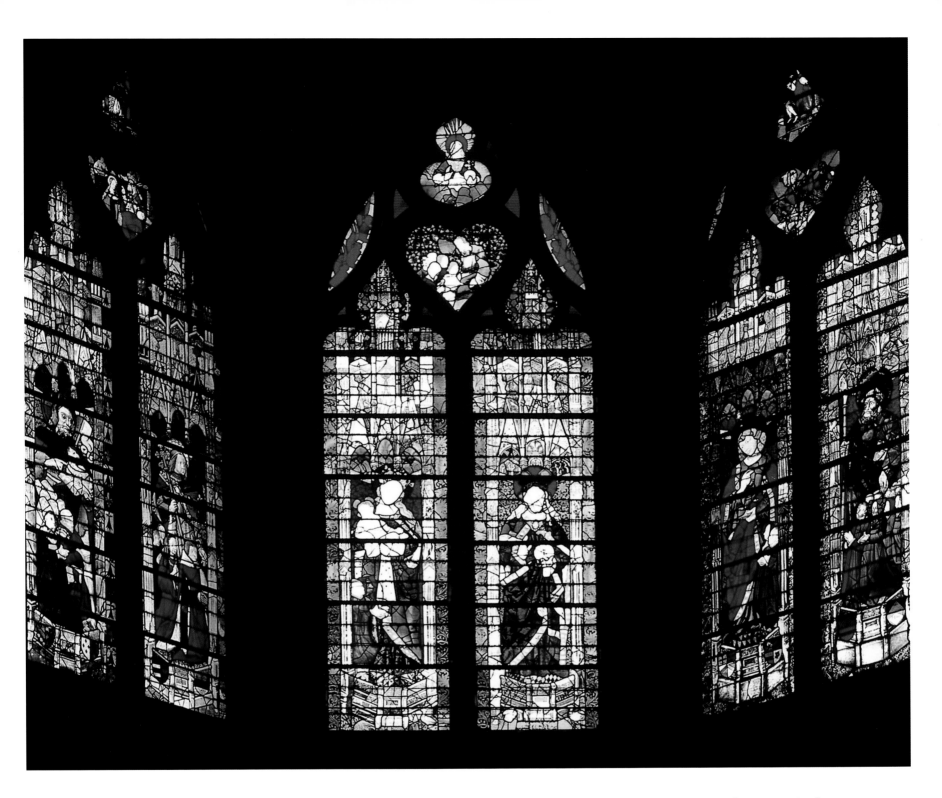

The almost simultaneous births of engraving and printing and their shared origins promoted the distribution in France of works such as those of Dürer, Lucas van Leyden, and those of Raphael engraved by Raimondi. Through engravers such as Tory, French engraving began to make a place for itself on the market: the stakes were high, because engravings became the common models for ivory carvers, glassworkers, and tapestry makers.

As for contents, the first book concerning our subject is *De artificiali perspectiva*, by Jean Pélerin, also known as Viator. This first treatise on perspective was published in Toul (1505), but the illustrative diagrams were based on Parisian monuments—the interior of the cathedral and the Great Hall of the Palais.

**21. Windows of the Church of Saint-Séverin**

*The windows in the apse, built between 1489 and 1496, were reused from a choir finished in 1470: borders were added on the sides to make the windows fit into their new location. New windows, made to resemble the old ones, were created to complete the series. The two center windows (the Virgin and the Savior) had been given in 1460 to 1470 by the Brinon family, who were members of parliament. The artist was undoubtedly the Master of Coëtivy, well known for his illuminations.*

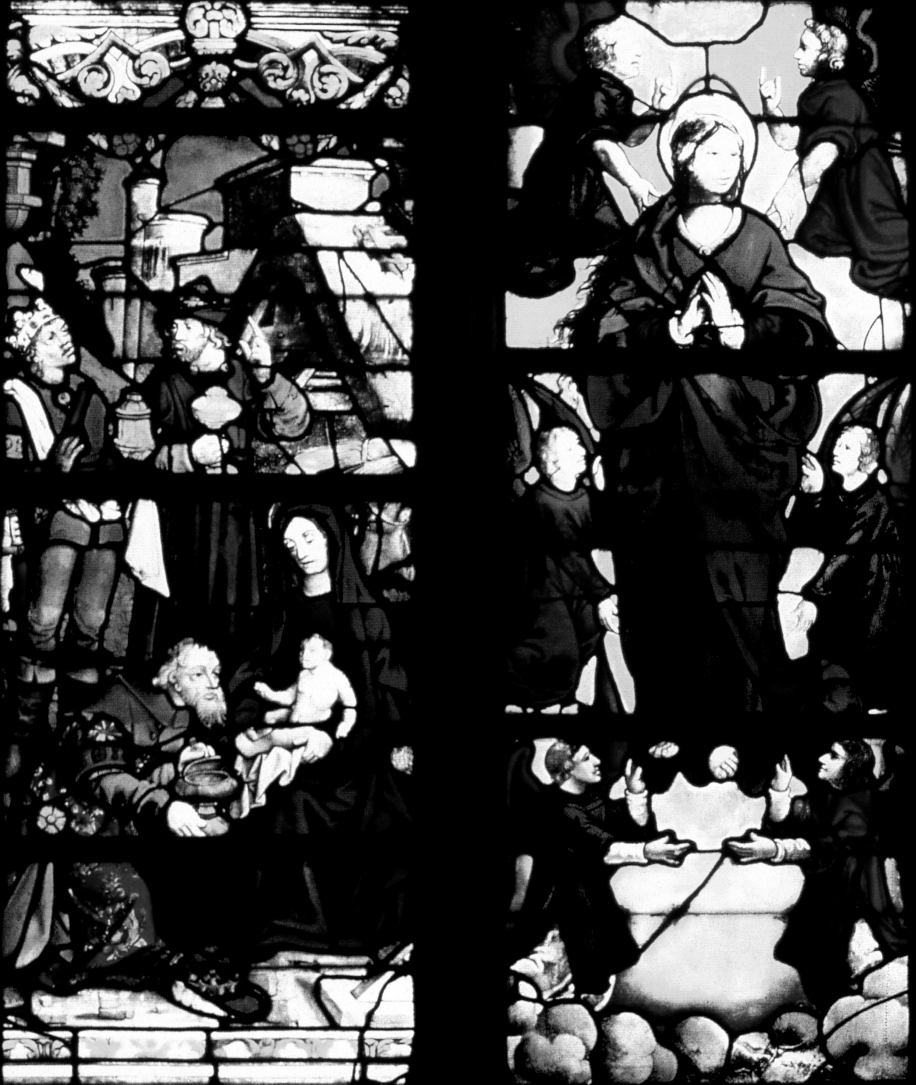

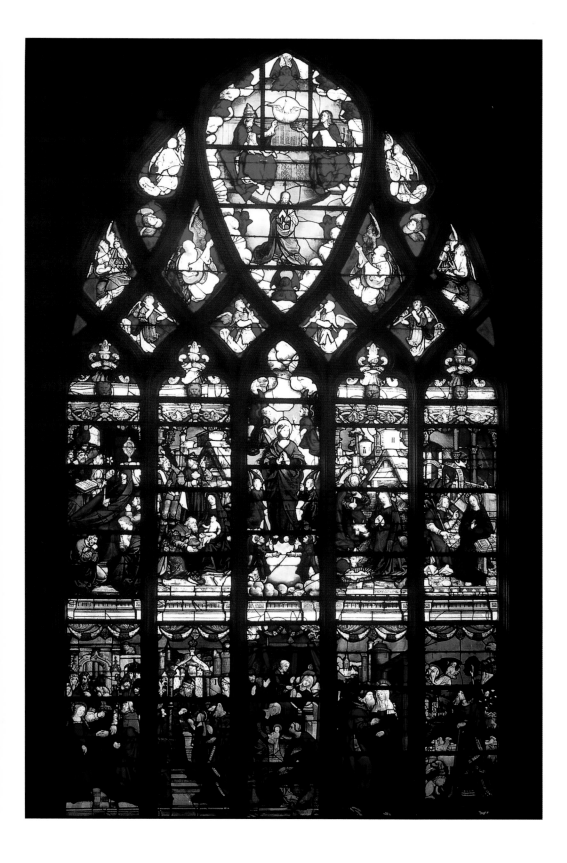

**22–23. Saint-Etienne-du-Mont.
Window of the *Vie de la Vierge*
(*Life of the Virgin*), c. 1500.**

*This window was probably designed by the Master
of the Hours of Anne of Brittany. Like so many
other windows, this one is modeled after engravings.*

**24. *Adoration des Mages* (*Adoration of the Magi*)**

*This engraving served as a model for the window
at Saint-Etienne-du-Mont. It comes from the
Heures à l'usage de Rome (Hours for the Use of
Rome), published in 1496 by Philippe Pigouchet.*

*Churches*

The example of the medieval cathedral is still fundamental, in the literal sense: its floor plan was imitated in many Parisian churches being built or enlarged in later centuries. They have its double side aisles and ambulatory, its transept, its semicircular chevet with radiating chapels, and its tripartite vaults in the turning bays. On the other hand, the walls follow an entirely different concept: the interior elevations have only two levels, the grand arcade and the clerestory windows. The simplicity of this design can be very effective when the shapes are elongated and tall, but more often than not, they are treated with economy and produce, in certain Parisian churches, an unfortunate effect of oppression. This approach, so unlike what one usually thinks of as a Flamboyant church, is nevertheless rather widespread in the churches of this period, and is especially apparent in the church of Notre-Dame in Cléry. It is unclear to what extent these Parisian churches are connected to Cléry, built by Louis XI in the Loire Valley, but Cléry is tall, as befits a royal church, while those in charge of the finances in Parisian parishes did not have the same level of resources. All the more so since the scope of the projects was a function of the damages due to the war or to years of neglect. Work was carried out on Saint-Médard and Saint-Séverin (second half of the fifteenth century; figs. 27–30), Saint-Germain-l'Auxerrois (starting in 1476; figs. 31–33), Saint-Gervais-Saint-Protais (starting in 1494; figs. 34–37), Saint-Victor (early sixteenth century, now destroyed), Saint-Jacques-de-la-Boucherie (1508–1522; fig. 38), Saint-Etienne-du-Mont and Saint-Merri (first half of the sixteenth century), Saint-Eustache (starting in 1532; figs. 39–44), and Saint-Laurent (fifteenth or sixteenth century).

25. Jean Fouquet. Roundel with the initials of Laurens Girard, c. 1450–1460. (Musée National du Moyen Age-Thermes de Cluny, Paris)

*This roundel (in grisaille and silver-yellow) with the initials of Laurens Girard, notary and royal secretary, was made by Jean Fouquet, perhaps for Girard's home on the Rue de la Verrerie. It is known that Jean Fouquet worked for Girard and for Etienne Chevalier. Girard's father-in-law.*

With their tracery containing fan and teardrop shapes, their many-ribbed vaults and hanging keystones, their ribs blending directly into the shafts of pillars without capitals, Renaissance churches in Paris are, in fact, Flamboyant in style. This is not necessarily apparent at first glance, because the facades, where this style shows to its best advantage, are missing: the parishes deferred the completion of their churches, some of the facades of which were not built until the seventeenth century. In all respects, Saint-Eustache was the exception. It is the largest church built in France during the Renaissance. Its special situation is the result of royal intervention, which forced the churchwardens to work on a larger scale. The object was to build the cathedral of the Valois line; the floor plan emulated the venerable Capetian cathedral, but it was given what was hoped to be an entirely new look. The wall treatments show superimposed levels of pilasters, in the Italian manner, perhaps borrowed from the cathedral of Pavia. There has been much speculation about the identity of the designer of the project and his nationality: French or Italian? Could it have been Domenico da Cortona, whom François I brought to Paris to build the Hôtel de Ville?

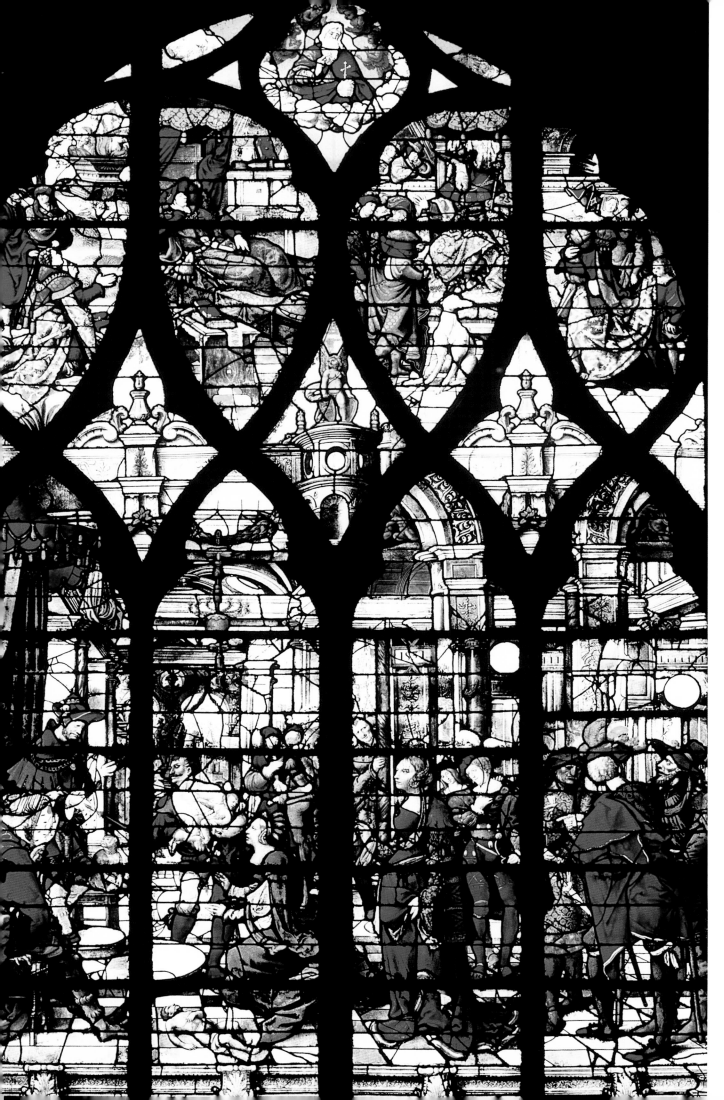

*Perhaps the work of master glassmaker Jean Chastellain, this window represents, across the lower lancets, the Judgment of Solomon, and, in the upper teardrops, the Vision of Solomon at Gibeon and Solomon and the Queen of Sheba. These three scenes represent Solomon in the three ages of life.*

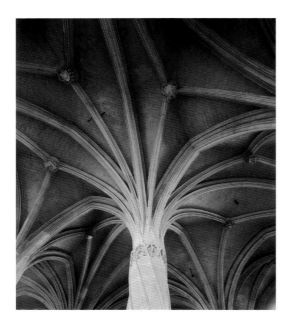

## 27–30. The Church of Saint-Séverin

*This church in a large Parisian parish was rebuilt beginning in the middle of the fifteenth century. The first bays of the central nave date from the thirteenth century; the others date from the second half of the fifteenth. The choir, with its famous spiral pillars in the ambulatory, was built between 1489 and 1495, the side chapels between 1498 and 1520.*

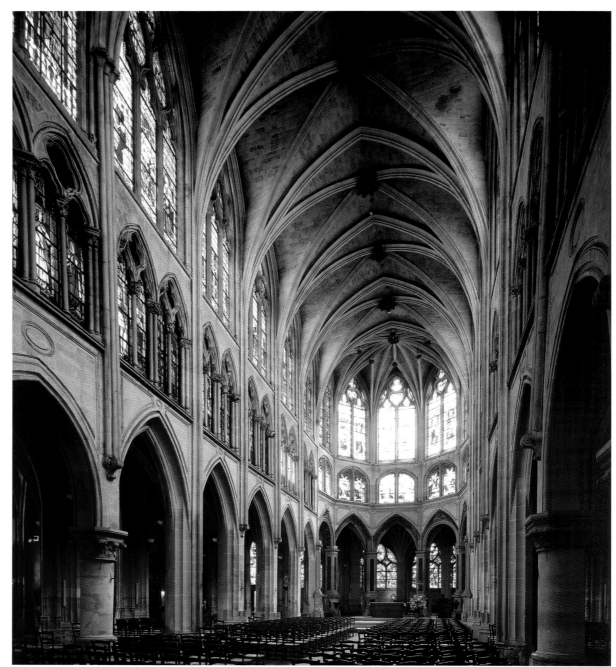

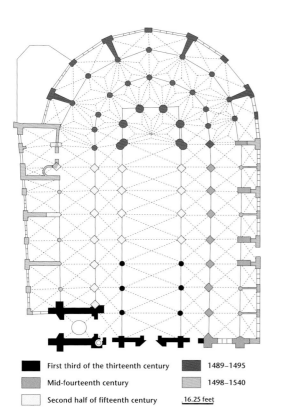

| | |
|---|---|
| ■ First third of the thirteenth century | ▨ 1489–1495 |
| ▨ Mid-fourteenth century | ▨ 1498–1540 |
| ▢ Second half of fifteenth century | 16.25 feet |

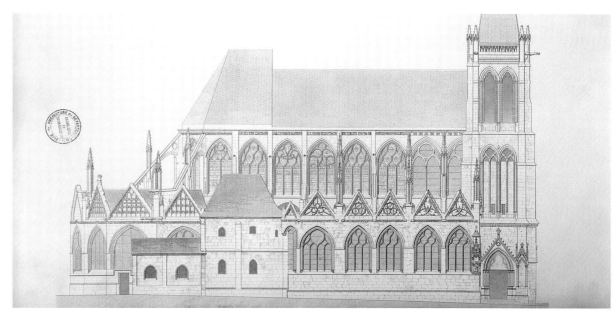

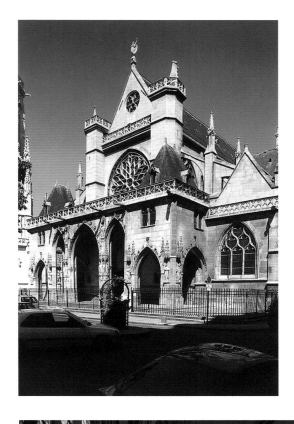

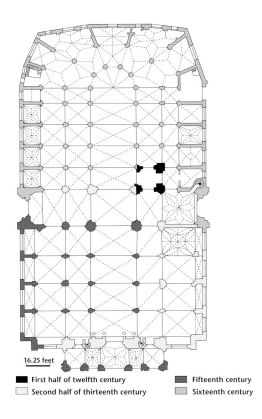

16.25 feet

■ First half of twelfth century
□ Second half of thirteenth century
■ Fifteenth century
□ Sixteenth century

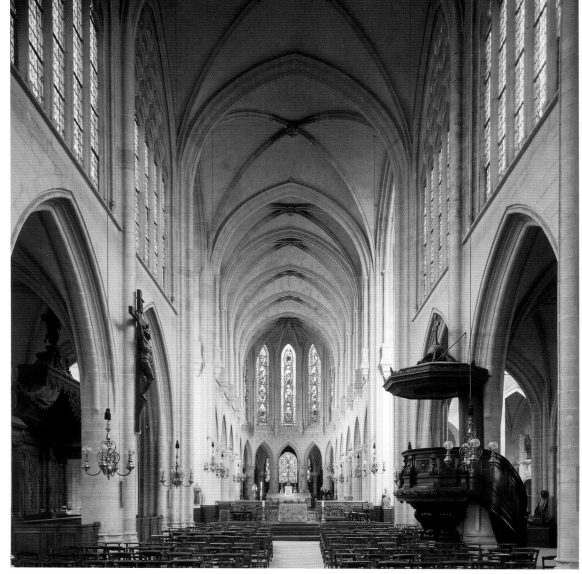

## 31–33. The Church of Saint-Germain-l'Auxerrois

*This church in one of the largest Parisian parishes replaced the church of Saint-Germain-le-Rond, which had a circular floor plan and which dated from the late seventh or early eighth century. Of the reconstruction done in the first half of the twelfth century, there remains only the base of the tower, which flanked the choir. Many parts have survived from the reconstruction done in the second half of the thirteenth century, including the right side of the nave. The latter was rebuilt yet again from 1476 to about 1488. The narthex, added by master mason Jean Gaussel in 1435–1439 and one of the very few construction projects undertaken during the English occupation of Paris, was almost entirely rebuilt just after 1488.*

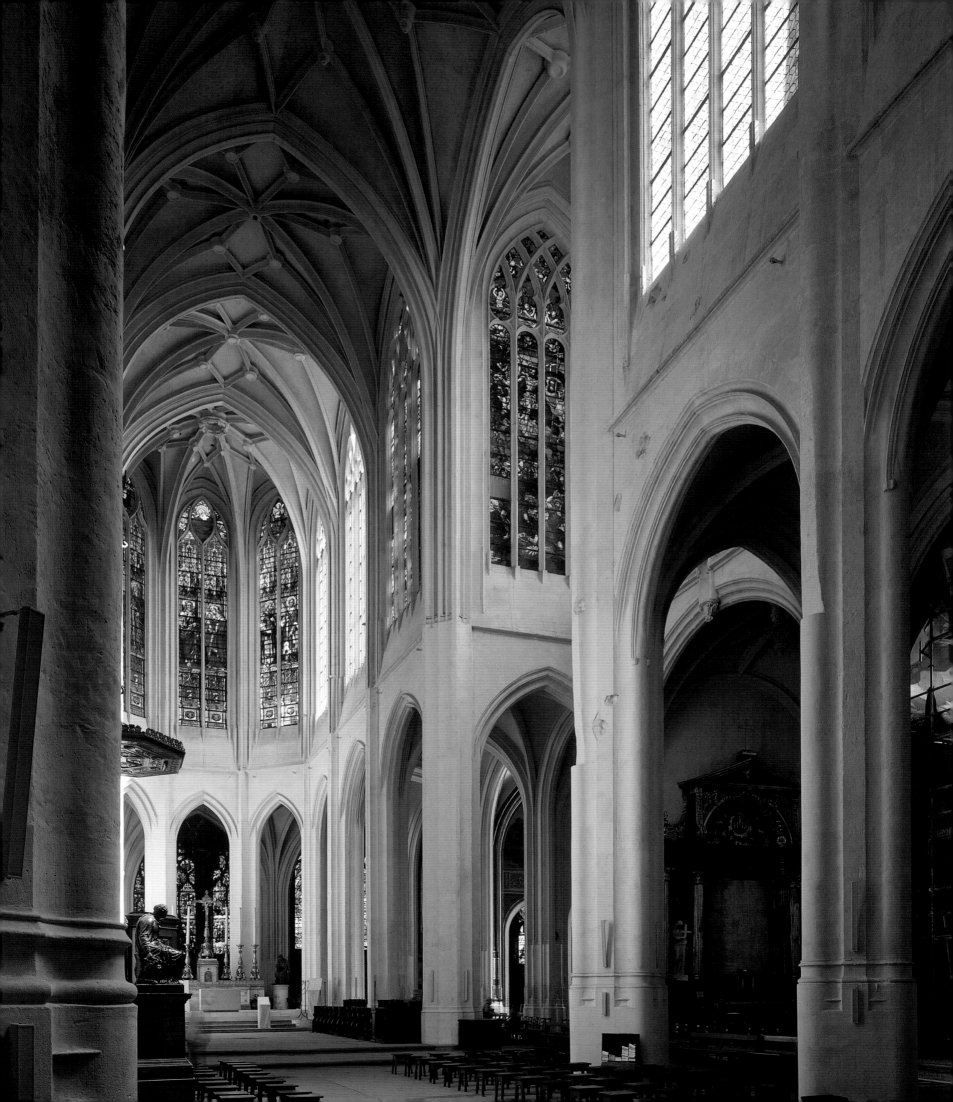

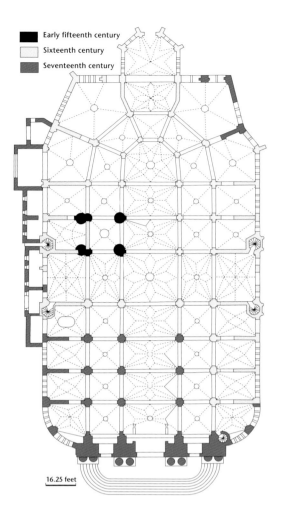

Early fifteenth century
Sixteenth century
Seventeenth century

16.25 feet

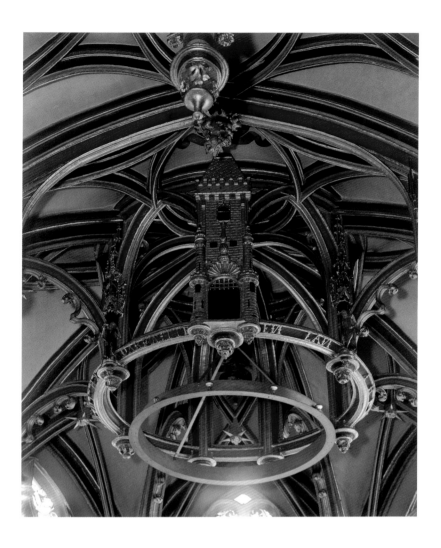

## 34–37. The Church of Saint-Gervais-Saint-Protais

*The reconstruction of this parish church was begun in 1494 and interrupted in the middle of the sixteenth century: the choir and transept were finished. The master mason was probably Martin Chambiges. Work resumed in 1574. The first bays of the nave and the facade are from the seventeenth century (chapt. VII, fig. 64).*

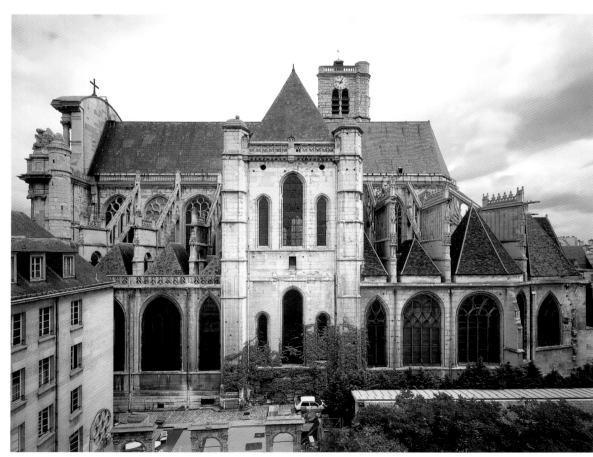

## 38. The Church of Saint-Jacques-de-la-Boucherie

*The Tour Saint-Jacques is all that remains of the church of Saint-Jacques-de-la-Boucherie, rebuilt from 1508 to 1522 by Jehan de Felin. The church, which was near the central slaughterhouse, owed its name to the powerful Parisian guild of butchers, whose chapel was in the church. In the manner of many Parisian churches, the lone tower stood along the side of the church. Of all the church towers in Paris to have survived, this is the only one in the Flamboyant style.*

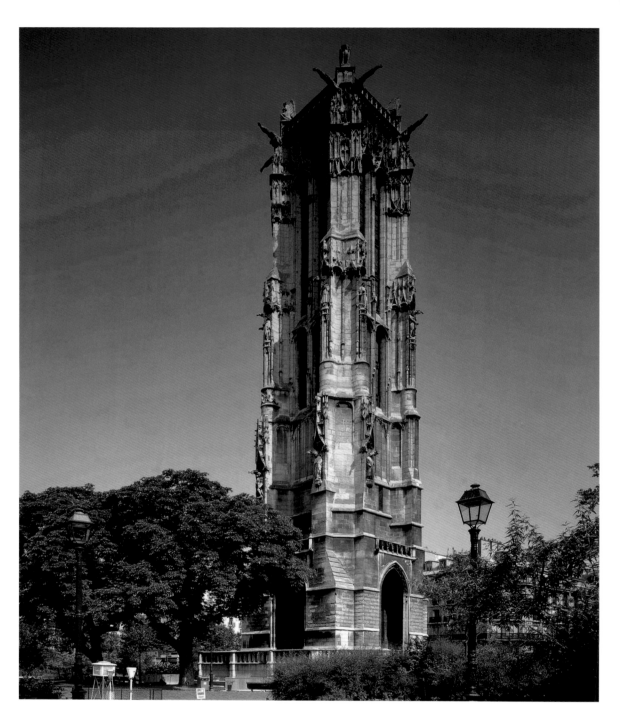

### Public Buildings

The participation by the Italians is no easier to discern in the construction or reconstruction of public buildings during the reign of Louis XII. The Great Chamber of the Parliament was entirely rebuilt (fig. 46), but all of its Italianate decoration is from a later time: the extraordinary ceiling with its hanging keys is more typical of Gothic engineering, even though their tips assume the shape of the classic capital. The new buildings of the Counting House of the Palais de la Cité (fig. 47) are in the style that Louis XII had adopted for Blois; nothing allows us to confirm Fra Giocondo's participation in this construction. On the other hand, we do know that the latter was consulted for the reconstruction of the Pont Notre-Dame (fig. 45). But he was only one of many experts who had come from many parts at the request of the aldermen, and he apparently did no more than offer engineering advice on the shape of the arches. The gabled houses, all of which were the same, must not have been much different from those built on the bridge in its reconstruction of 1413, except that they were built of stone whereas the houses of the fifteenth century were wooden. Here again innovation is first of all technical. The Pont Notre-Dame, with its *case di pietra* ("stone houses"), still inspired the admiration of the

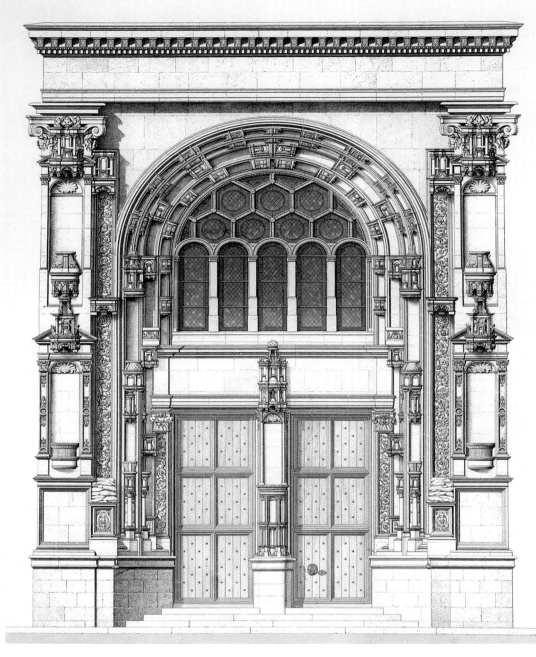

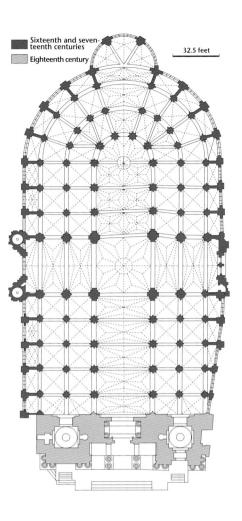

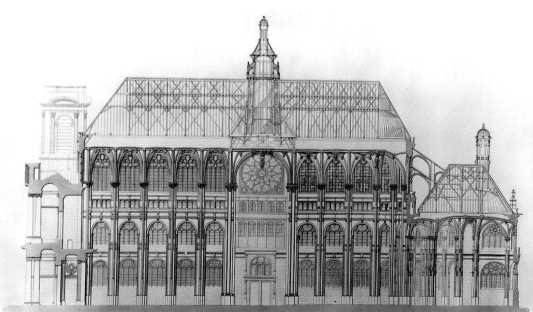

## 39–44. The Church of Saint-Eustache

*This church in one of the largest Parisian parishes was entirely rebuilt beginning in 1532. The architect who designed the project had probably worked on the church of Saint-Maclou in Pontoise; it may have been either Jean Delamare or Pierre Le Mercier. Delamare was indeed active in Paris, where he was rebuilding the abbey church of Saint-Victor. However, it was more likely Le Mercier, since members of his family are documented later at the site. It has sometimes also been speculated that it was designed by Domenico da Cortona. The chronology of the construction is unusually complex. In the 1530s and 1540s, the transept and the left side of the choir were built; in the second half of the sixteenth century, the nave; and in the early seventeenth century, a facade, itself replaced with the current one from the eighteenth century. It was not until 1624 to 1631 that the previous church, which had been kept for religious services, was destroyed and the choir built in its place. The construction site was not closed until 1640. The foundations and the lower parts of the walls were no doubt carried out according to the original design of 1532. But the upper parts (particularly at the level of the columns) may well be, in spite of their Renaissance style, additions from the 1630s meant to give the nave greater height than originally planned; that is, to lend it more nearly the proportions of a Gothic church. Without this upper level, the church would have had proportions more similar to those of an Italian church.*

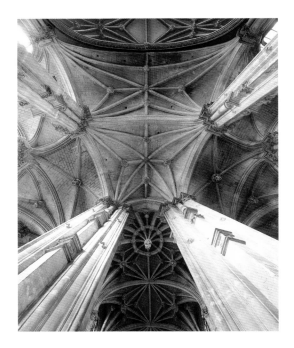

Venetian ambassador at the end of the sixteenth century: Lippomano called them "le cose più belle di tutta la Francia" ("the most beautiful things in all of France").

The only major Parisian building project definitely known to have been given to an Italian was the Hôtel de Ville, for which François I insisted on Domenico da Cortona. Domenico unveiled his design in 1532 and supervised the project until his death in 1549. The map of Paris by Truschet and Hoyau (1550; chapt. IV, fig. 5) gives a reliable idea of its appearance at the time. But we know that a new proposal was drawn up in 1549, which, like Saint-Eustache, planned to increase its height. Drawings and engravings from the end of the century and the beginning of the following one attest to this change (figs. 48–49).

*Houses*

This is the earliest period from which there have survived private dwellings sufficiently well documented or preserved to permit more than a vague suggestion of their original appearance. First of all, there are two *hôtels* of powerful prelates: the abbot of Cluny, head of the most important monastery of the kingdom, and the archbishop of Sens, to whom the bishop of Paris was suffragan. The fact that these churchmen considered it important and proper, already before 1500, to provide themselves with a modern house for their visits to Paris is proof that both political and religious activities had picked up again in the city, well before the king settled there. The Hôtel de Cluny (figs. 52–55) may have been begun in the middle of the fifteenth century, although its facades are covered with the crest and the initials of Jacques d'Amboise, abbot from 1485 to 1510. It shows certain details that were to become characteristic of the French house. The main building, one room deep between entrance court and garden, contains the reception rooms, reached by the tower, containing a circular stairway. The entry into the main building is directly through the tower. In the wing to the right are the kitchens; in the wing to the left, a portico on the ground floor with a gallery above; in the el opening onto the garden are the abbot's private apartments, with the chapel projecting from the facade like an oriel. All the windows are

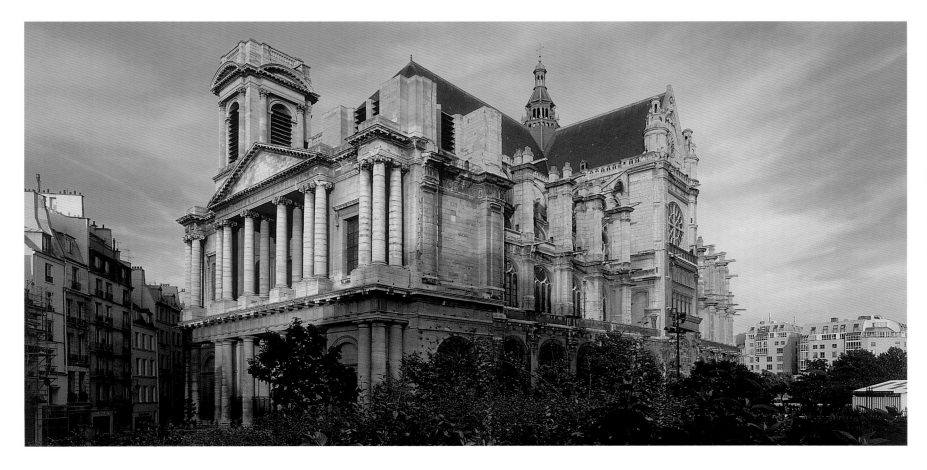

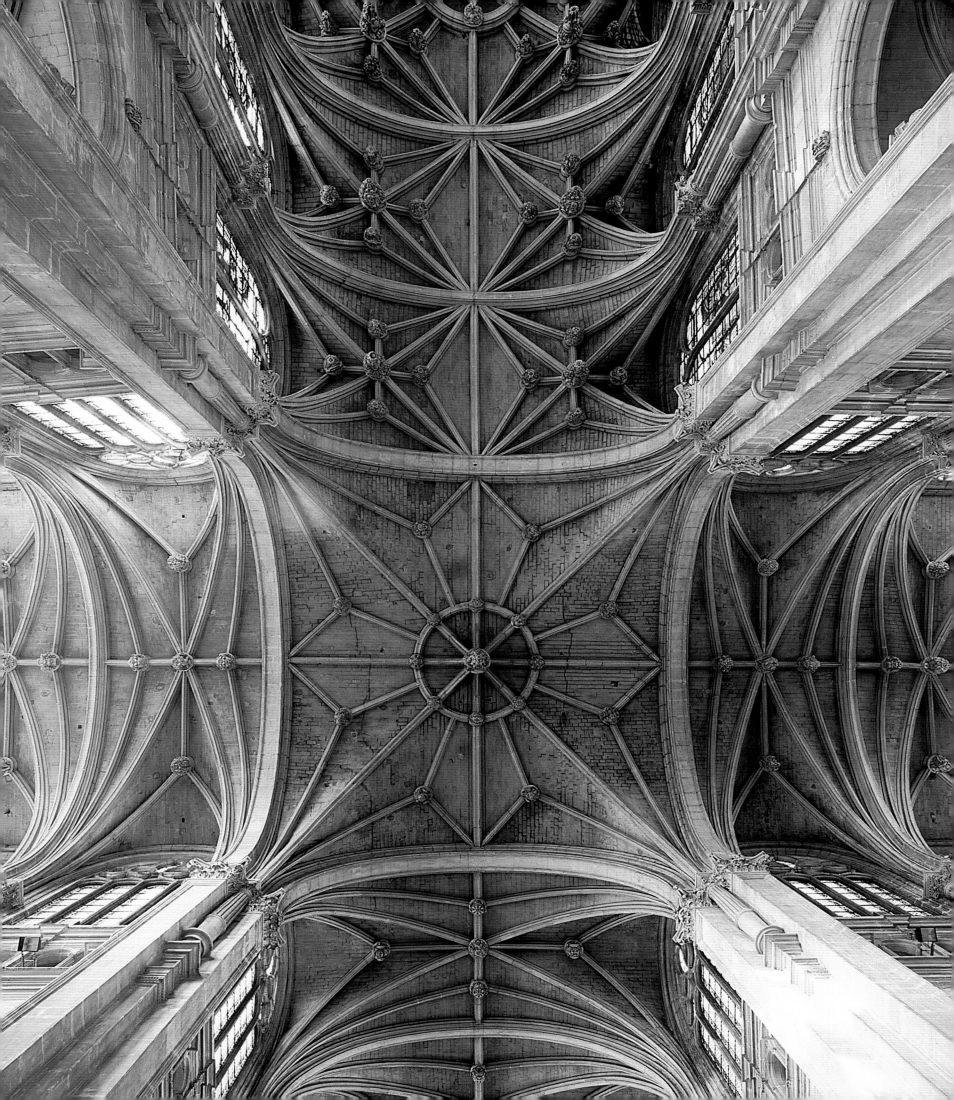

rectangular mullion windows. Under the roof are finished rooms lit by high dormer windows. The only really unusual feature is the fact that the courtyard is enclosed by a simple crenellated wall, and not by a wing of the building, as would be expected in a city where space was scarce. But it is precisely because the Hôtel de Cluny was in a special position, adjacent to the former ramparts of Philip Augustus, that there was space freed in front of the building. Of the Hôtel de Sens, built on a part of the Hôtel Saint-Pol, which had been given by the king to the archbishop, one can hardly say that it still exists, so poorly was it restored; the views from the seventeenth century are perhaps more authentic (figs. 50–51). The distribution of the volumes is totally irregular. One enters the courtyard through a portal with a carriage entrance and pedestrian door, which are opened through a wing built on the street. The main building between the courtyard and the garden is accessed through a large stair tower on one side. The chapel extends into the courtyard at the center of the main wing.

Of the *hôtel* built by Pierre Legendre, a beautiful example of a middle-class gentleman's home (figs. 56–58), there are only a few fragments preserved in the courtyard of the Ecole des Beaux-Arts, but it was carefully annotated before being destroyed. The back of the building, which was particularly large, opened onto two opposite streets, through the middle of the block. A circular stair tower in the courtyard served as the entry to the main building, between the courtyard and the garden. This courtyard was lined on either side with wings, each of which had a portico on the ground floor and a gallery above. A lateral passageway through the main building led from the courtyard to the garden and from the garden to the service courtyard, which had a door onto the side street. Like those at the Hôtel de Cluny, most of these arrangements were to become standard for France, with the exception of their relationship to the street: the large blind facade of the Hôtel Legendre is as ostentatious as the curtain wall at Cluny. Open spaces were too scarce in the city not to take advantage of the street front as a source of light.

There remain a few vestiges of, and fragmentary documents concerning, eight or nine houses constructed or remodeled during this period. But none of these exhibits a solid trend in house decoration other than several overhanging corner turrets (fig. 61) that, when taken along with those on the Counting House and the Hôtel de Sens, give an idea of the fascination for this type of embellishment, jutting forth at the corners of buildings and streets, as a sign of social prominence.

The only structure that cannot be ignored, although it too has disappeared, is the Château de Madrid, in the Bois de Boulogne (figs. 59–60). Of the several castles built by François I after the declaration of 1528, which pointedly implied that the king might prefer the surrounding countryside to the city, the Château de Madrid was the closest to the Louvre. It was nonetheless a hunting lodge: the Bois de Boulogne in those days was fenced in, like a game

## 45. Pont Notre-Dame (Notre-Dame Bridge)

*At the site of the Pont Notre-Dame originally stood the Roman bridge, which carried the main north-south axis from the Ile de la Cité to the Right Bank (Rue Saint-Martin). Abandoned for several centuries owing to a relocation of this axis toward the west (Pont-au-Change and Rue Saint-Denis), it is once again attested to in the fourteenth century. Reconstructed yet again in 1413 of wood timbers and with thirty identical exposed-beam houses, it was swept away in 1499. For its reconstruction in stone, the city brought experts from all the towns of the kingdom, including Fra Giocondo, the royal architect, who apparently gave only technical advice about the number of arches. Its construction, with its sixty-eight identical houses, was supervised by Didier de Felin, master of masonry works for the city from 1507 to 1512. From that point on, the Pont Notre-Dame replaced the Pont-au-Change in the parade route for royal entries: in 1515, it was used for the first time, for the entry of François I. The Pont Notre-Dame is known through an engraving by Androuet Du Cerceau, wrongly entitled "Pont Saint-Michel," and left unfinished (the pillars under the ground-floor arcade are missing).*

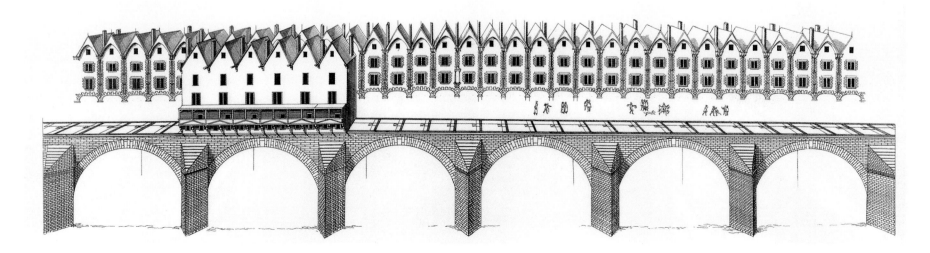

preserve. The hunting castles of François I constituted a whole genre unto themselves. Created with amusement in mind, the plan of the Château de Madrid was like a hopscotch board with its regular arrangement of rooms and bedchambers. It was also the most Italianate building within the Paris region. Curiously, it was modeled on the Casa de Campo, a country house with Italian influences that François I had seen during his captivity in Madrid, from which the name of the castle in the Bois de Boulogne was derived.

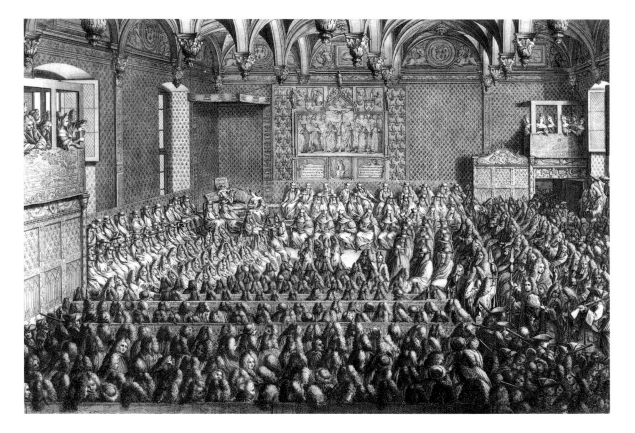

### 46–47. Palais de la Cité

*During the time of Louis XII, two important works, now known only through drawings and engravings, were built in the Palais de la Cité, by then entirely given over to royal administrative offices. The building of the Counting House is attributed to Louis XII: in fact the king only completed and refurbished, in 1505, two buildings, which had been built by Charles VII after the fire of 1450 and by Charles VIII in 1486 (an inscription commemorated this event). A drawing and an engraving, both by Israël Silvestre (seventeenth century), show the Counting House, which forms one side of the courtyard of the Sainte-Chapelle, as it appeared in the time of Louis XII. The grand staircase was famous: Rabelais's* Pantagruel *(sixteenth century) had boasted of its beauty. The facade was covered with a field of fleurs-de-lis and decorated with a statue of Louis XII framed by statues of Temperance, Prudence, Justice, and Strength. The attribution of its construction to Fra Giocondo has no basis. At about the same time, the Great Chamber of Parliament was redecorated. Proceedings resumed there at the end of 1511, after the completion of the new ceiling. This unusual ceiling, wooden panels with hanging keys, is known today only by engravings from the eighteenth century. In the background can be seen the* Parliament Altarpiece.

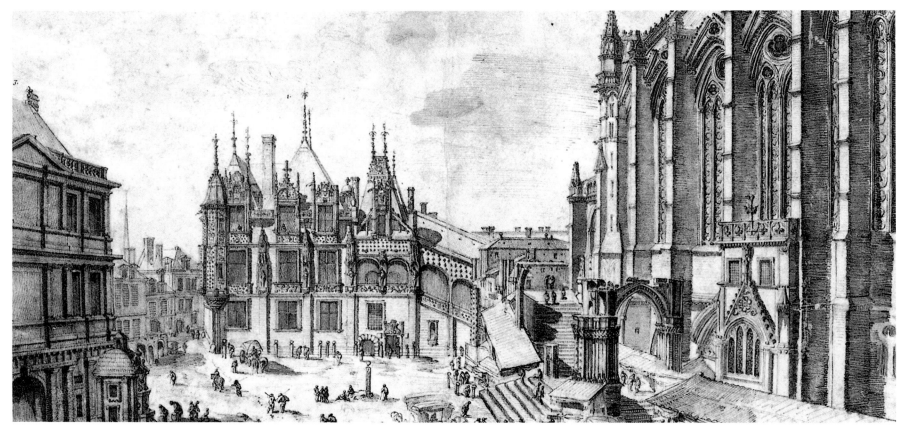

## 48–49. Hôtel de Ville

The "meeting rooms of the burghers"—that is, the city hall—had been on the Place de Grève (the present-day Place de l'Hôtel de Ville) since the provost of the merchants, Etienne Marcel, bought the building known as the "maison aux piliers" (the "house with pillars") for that purpose in 1357. In 1533 the cornerstone was laid for a new city hall, to be constructed by Pierre Chambiges from the design drawn up in 1532 by Domenico da Cortona, the architect whom François I had insisted on. Domenico watched the progress of the work until his death. According to Sauval, a new plan was made in 1549 on orders from Henry II, Domenico and Chambiges having died. Work stopped after 1551 and was not taken up again until 1606, on orders from Henry IV. This time the project was executed by Marin de la Vallée and finished in 1628. It is known that the building was completed according to the plan, but was it the plan from 1532 or from 1549? It is difficult to have a very precise notion of the original plan by Domenico da Cortona based on the meager vestiges spared by successive renovations and the fire in the nineteenth century, or on the earliest preserved representations, one of which is visible on the 1550 map of Paris by Truschet and Hoyau (chapt. IV, fig. 5), and another in the drawing by Jacques Cellier (1583–1587), below. The trapezoidal lot, with the four sides of the building around a central courtyard, faced the square on its shortest side. In order to make a more impressive facade on the square, the Italian conceived the idea of extending it on either side with the addition of an attached pavilion. This was an ingenious but fatal idea, for the city owned only the ground for the right-hand pavilion, called the Pavillon Saint-Jean, and not for the left-hand one, which was already occupied by the Hôpital du Saint-Esprit. The building's timely progress was sorely hindered until the seventeenth century, when the city came to an agreement with the hospital. Thus, only the first level of the facade and the first two levels of the Pavillon Saint-Jean can be attributed to Domenico's plan. The status attested by Cellier is assumed to be the one that existed in 1551: only the Pavillon Saint-Jean was finished. It arched the street leading to the church of Saint-Jean-en-Grève. On the left, the symmetry was impeded by the presence of the chapel of the Hôpital du Saint-Esprit. The columns along the first level are already shown on the Truschet-Hoyau map, which must be a reflection of the 1532 plan, but they are arranged very differently. Moreover, the comparison between the map and the drawing reflects the decision in 1549 to add an extra story, which is confirmed by documents stating that the Pavillon Saint-Jean, after having been roofed for the first time in 1541, was reroofed in 1551.

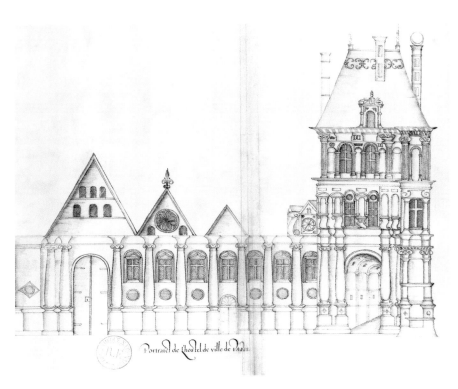

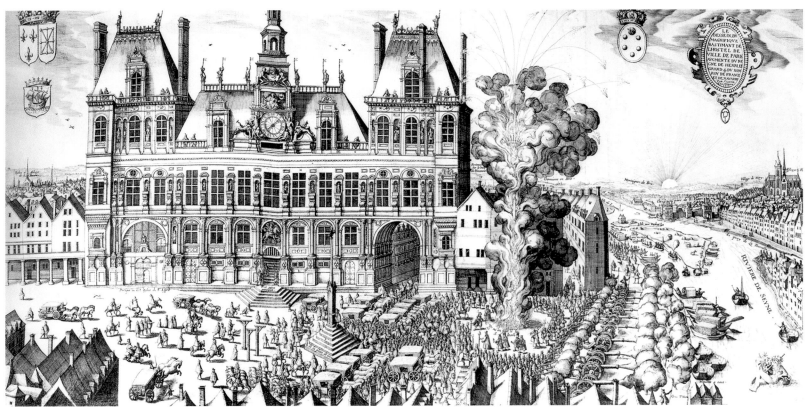

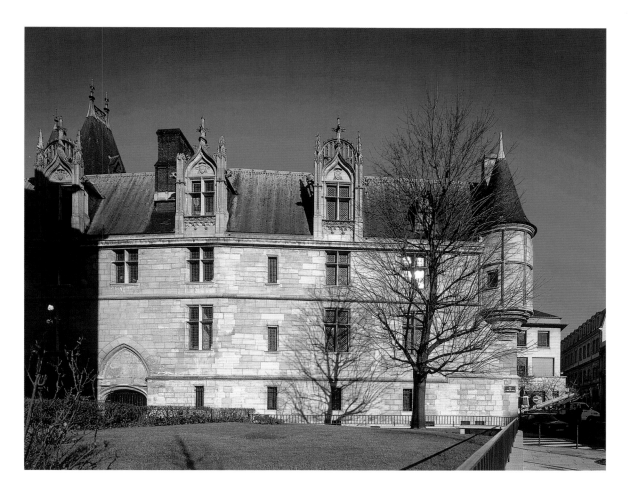

# 5 – FLAMBOYANT STYLE AND ITALIAN STYLE

In the period that we have just considered, the Renaissance in France, two styles coexisted, referred to at the time as modern and classical. It must be remembered that, for a contemporary of François I, modern style meant the traditional manner, the late-blooming Gothic that evolved out of the works of Charles V and his brothers: in other words, the Flamboyant style. As for classical art, it had all the charm of novelty, because it consisted of everything imported from Italy, considered to be the mediator of classic antiquity.

The notion of Flamboyant, as we have said, should not be too strictly confined. By considering only the decoration of churches, this style is often reduced merely to a certain tortuosity of ornamentation, an excellent example of which is the spiral pillars of Saint-Séverin (fig. 27). This style also includes a tendency toward the most gratuitous of technical tours de force: by carrying Gothic technique to the extreme, form surpasses function. The hanging key (fig. 36) is nothing more than a keystone with extra weight to counterbalance the tendency of the vault to open at the top; but it serves no purpose to give it an elaborate shape like those in the chapel of the Virgin at Saint-Gervais-Saint-Protais. The "Saint-Gilles staircases" at this church and also at Saint-Merri are exercises in pure virtuosity, which are not even expected to be seen. Based on the example at the abbey of Saint-Gilles-du-Gard, these stone staircases are enclosed in a spiraling barrel vault, the execution of which would have required considerable skill. Among other manifestations of this tendency are the affection for overhanging turrets, and large, protruding dormers, with tall, ornate gables, the upward thrust of which vies with the visual horizontality of the cornice above which they rise. To avoid reducing architecture to a collection of details, one must also include in the concept spatial and structural treatment.

Flamboyant, understood in this way, is less present in Paris than in the "backcountry": Normandy, Picardy, and Champagne. The topography is already seen elsewhere. The map of

## 50–51. Hôtel de Sens

*Originally the Parisian residence of the archbishop of Sens. now the Bibliothèque Forney (Forney Library). this hôtel was rebuilt by Archbishop Tristan de Salazar in 1474. An unfortunate restoration has irreparably disfigured the building. but the drawing in the Gaignières collection (1696) gives a more accurate picture of its original appearance (the right half of the main building and also the pattern of the garden are obviously more recent). The plan was perhaps by Martin Chambiges. whom Salazar had hired to work on the cathedral of Sens.*

Flamboyant churches and stained glass looks the same as the map of the entombment theme. Notwithstanding Tours, Vendôme, and a few other places, the Flamboyant style seems less dense, less frenetic in the Loire Valley. The most famous southern examples are derived from the north. In the cathedral of Albi, the entry porch and the rood screen were begun by a native of Touraine, Louis I d'Amboise, bishop from 1474 until 1503, counselor to Louis XI, Charles VIII, and Louis XII. At Brou, after the abandonment of the Perréal-Colombe project, Marguerite of Austria, regent of the Netherlands, commissioned the rood screen and the tombs from Flemish artists from the Brabant.

The first examples of Italian decoration are to be found in the illuminations and panels painted in Paris by Fouquet after his return from Rome in the 1460s (fig. 64); but this was an isolated appearance with no immediate consequences. The momentum was carried on in the states of King René, who held the Angevin claim to the kingdom of Naples (which Charles VIII would inherit), through the works done by Francesco Laurana in the 1470s in Marseille and Le Mans.

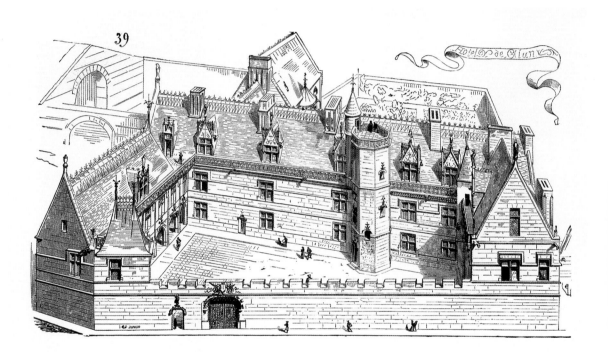

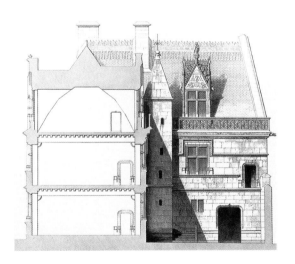

### 52–55. Hôtel de Cluny

*The abbots of Cluny, the influential Benedictine abbey in Burgundy, acquired a house beside the thermal baths of Lutetia (chapt. I, figs. 3–6) in 1334. They used it as their residence during their visits to Paris. The reconstruction of the hôtel used to be attributed to Jacques d'Amboise, abbot from 1485 to 1510, whose initials and crest appear in several places. But the construction had probably been initiated toward the middle of the century by Jean III de Bourbon, the predecessor of Jacques d'Amboise. The left wing of the courtyard, with its ground-level portico topped by a gallery, is an addition from the beginning of the sixteenth century. This hôtel is now the Musée National du Moyen Âge.*

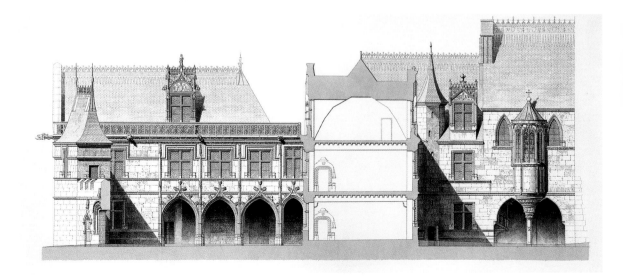

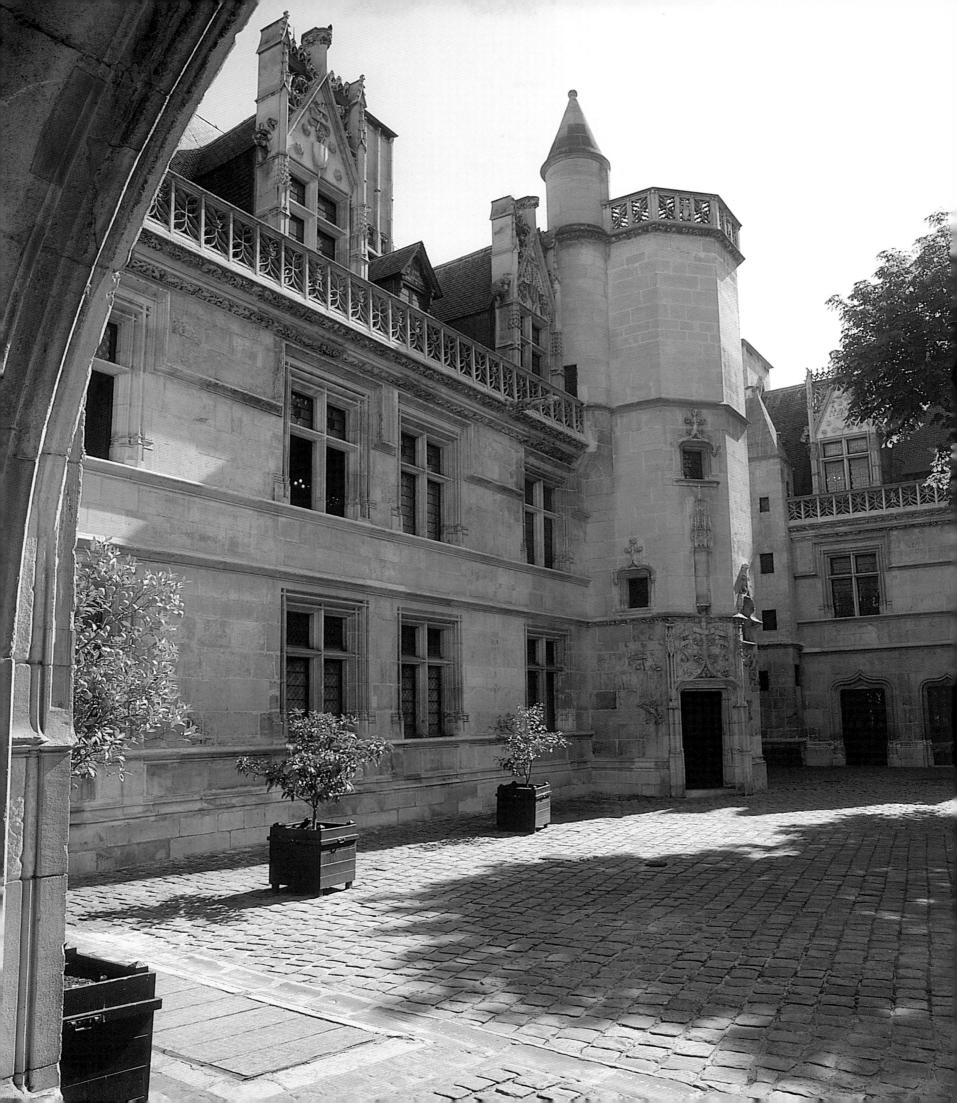

## 56–58. Hôtel Legendre

*The campaign undertaken to save this hôtel (then mistakenly thought to have belonged to La Trémoille) did not prevent its destruction in 1841, but it left us with a great many drawings. One of those was done by Viollet-le-Duc, a promoter of the campaign. This townhouse, built around 1505 for Pierre Legendre, treasurer of France, was among the largest in Paris.*

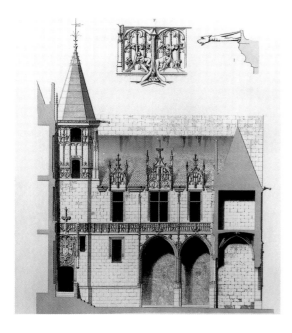

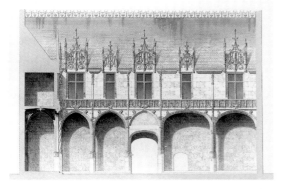

With the exception of Gaillon, the castle of the powerful cardinal Georges d'Amboise, the Italian style, which began to take hold in the first decade of the sixteenth century, did so only on a few tombs, which Italian sculptors decorated with motifs from their own country. In Paris, the most prestigious buildings, built by socially prominent families, who were aware of the latest trends, the *hôtels* of Cluny and Sens (figs. 50–55), were entirely Flamboyant. The same is true for the Hôtel Legendre, with the exception of the exterior decoration of the entranceway, perhaps derived from Gaillon.

At the same time, however, Mazzoni, master mason at Gaillon, was creating, at the chapel of Commines in Paris (1505), a fine example of the Lombard-inspired floral decorations that so charmed the French: they would be used in France up to the end of the reign of François I. It has nothing in common with the style in Italy of the same time: Bramante's *tempietto* in Rome is contemporary with Commines's chapel! Both of the major Parisian construction projects of the 1530s, the church of Saint-Eustache and the Hôtel de Ville, apparently did nothing to discourage this already somewhat outmoded style.

Because of this delay, the French Renaissance has long been described as a slow assimilation by a rustic French society of the new spirit emanating from Italy. Such was the point of view of Viollet-le-Duc, who, calling Saint-Eustache "a sort of Gothic skeleton dressed in Roman rags sewn together like the pieces of a Harlequin costume," wrote: "The Renaissance had snuffed out the last traces of the old national art...The genius which had presided over [medieval church] construction was gone and disdained. Attempts were made to apply the classical architectural forms, which were unfamiliar, to the Gothic structural system, which was scorned without being understood."

The most recent commentators on the French Renaissance (Jean Guillaume and Henri Zerner) have shown. the weaknesses of this interpretation. One style did not replace the other. The French immediately seized on those parts in Italian art that most appealed to their taste, and they took advantage of the interplay between the two manners. The proof is in Fouquet's illuminations: the Italian mode is humanism, antiquity reinvented, pagan literature; the Gothic mode is the church and the Christian faith. Three quarters of a century after Fouquet, Tory was selling in his bookshop both an antique and a Gothic version of the same book (figs. 62–63).

It was in Italy that the Renaissance was presented as a break, starting in the fourteenth century with Petrarch, who was hoping to see the beginnings of the restoration of the Italian state. The idea gained ground in France, although the situation there was quite different; Rabelais explains: "Le temps estoit encore ténébreux et sentant l'infélicité et calamité des Gothez qui avaient mis à destruction toute bonne littérature. Mais par bonté divine, la lumière et dignité a esté de mon eage rendue es lettres" ("The times were still dark and feeling the unhappiness and the disaster of the Goths, which had destroyed all good literature. But through divine kindness, light and dignity have been returned to literature in my time"). By this declaration in *Pantagruel* (1532), Rabelais was laying the groundwork for French to come into its own as the language of letters and arts, thanks to the efforts by the poets of the Pleiade in the latter years of the reign of François I.

It is only from the vantage point of the 1540s that the previous century can be seen as a long gestation. The efforts of Ronsard and the other members of the Pleiade to make of the French language the modern language of the French people cannot be fully understood without the quotation from Villon, the Parisian poet who, in the middle of the fifteenth century, wrote: "Prince, aux dames parisiennes / De beau parler donnez le prix; / Quoi qu'on die d'Italiennes / Il n'est bon bec que de Paris" (*Ballade des femmes de Paris*; "Prince, to the Parisian ladies / For speaking beautifully, please, award the prize; / Whatever one says of Italians / The only fine speech is in Paris." Indeed, it was again Paris's turn to speak.

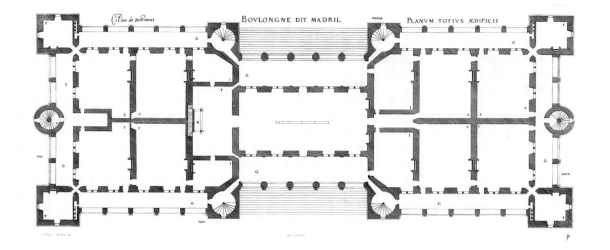

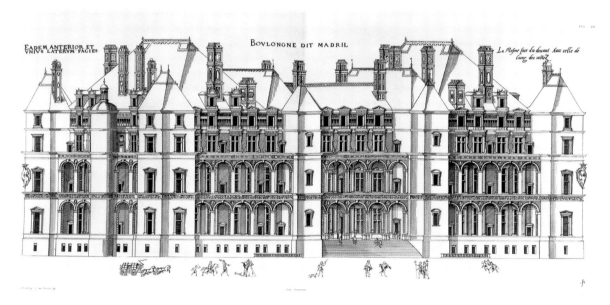

### 59–60. Château de Madrid

*Construction on this royal castle, which was located in the Bois de Boulogne, was begun at the end of 1527. The ground floor, the upper floor, and the attic were roofed in 1537. The exterior walls were covered in ceramics by the Florentine Girolamo della Robbia. Building was done under the supervision of Pierre Gadier and Gatien François, both from Touraine. The identity of the designer is unknown. Philibert De l'Orme added two upper floors, incorporating the former attic, between 1547 and 1550.*

### 61. The Maison Hérouet

*This house, located at the corner of the Rue Vieille-du-Temple and the Rue des Francs-Bourgeois, was built about 1510 to 1520 for Jean d'Hérouet, secretary to the duke of Orléans.*

### 62–63. Heures à la louange de la Vierge (Hours to the Praise of the Virgin)

*Geoffroy Tory published an "antique" (1525) and a "modern" (1527) illustration for this book of hours in praise of the Virgin. We mustn't forget that the "antique" is in Renaissance style and the "modern" is in Gothic style. The typeface for the former is roman and, for the latter, Gothic. Tory was one of the inventers of modern typography.*

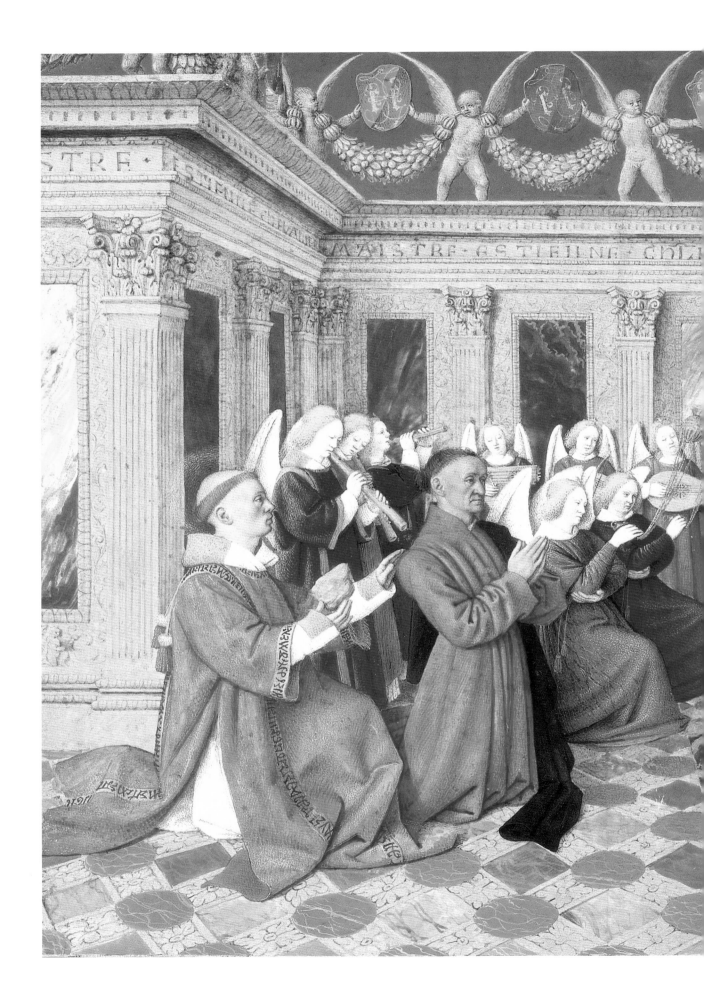

**64. Jean Fouquet.** *Heures d'Etienne Chevalier (Hours of Etienne Chevalier),* c. 1450. (Musée Condé, Chantilly)

This book of hours was painted by Jean Fouquet on his return from Italy for Etienne Chevalier, secretary and counselor to Charles VII and treasurer of France in 1452. Fouquet also painted for the same patron and at the same time the famous diptych of Melun showing Saint Stephen, Etienne Chevalier, and the Virgin. The devotional book must have been painted during the artist's time in Paris: several pages show a Parisian monument in the background (Notre-Dame, the Sainte-Chapelle, the Temple keep, the gibbet of Montfaucon, and the Châtelet). We have already shown the scene from this collection representing Job, before the keep of Vincennes (chapt. IV, figs. 1–2). The double page shown here represents Etienne Chevalier presented to the Virgin by Saint Stephen. The decor of the left-hand portion is one of the very earliest examples of the Italian style in French art: it is a rendition of elements gathered by Fouquet in Italy. It is to be noted that the Virgin is, herself, presented in an entirely Gothic setting. Fouquet here draws a parallel between "secular magnificence and the celestial world" (H. Zerner).

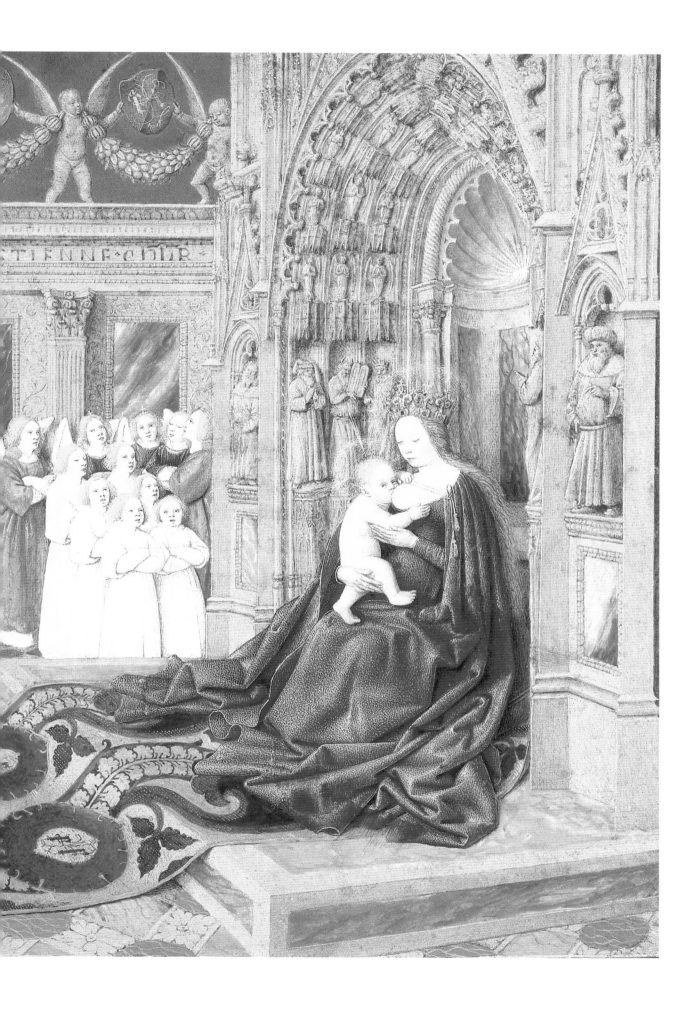

# HÔTEL DE VILLE

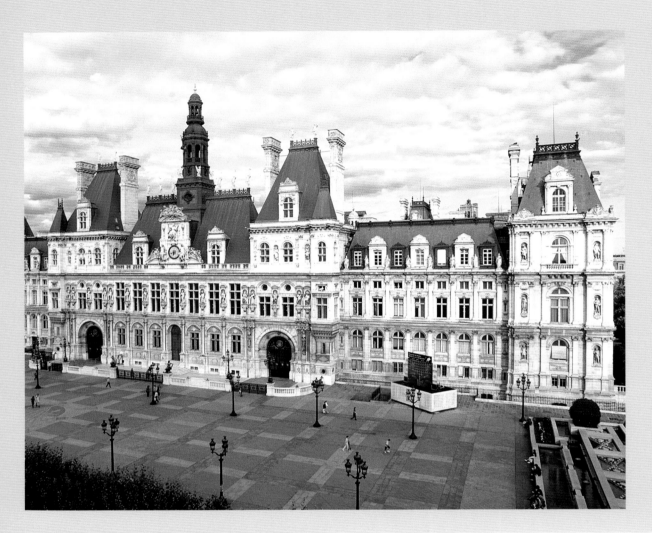

The powerful corporation of the Nautes, which controlled navigation on the Seine near Paris, formed the nucleus of early city governments, made up of aldermen with the provost of the merchants at their head. Sessions took place in the "meeting rooms of the burghers," which had several locations before establishing permanently on the Place de Grève (Place de l'Hôtel de Ville) in the building called the *"maison aux piliers"* (the "house with pillars"), acquired in 1337. In 1533 the cornerstone was laid for a new structure adjoining the *maison aux piliers*, which would be dismantled only in 1589. François I had imposed the plans by his architect, Domenico da Cortona, known as Becalor or Boccador, on the aldermen. The work was supervised by the architect Pierre Chambiges. However, on the death of both architects, the plans were modified, since the structure was hampered by the proximity of a hospital. The structure was finally finished in 1628 based on the revised plan. Between 1836 and 1850, the Hôtel de Ville was enlarged, surrounded on three sides by a separate U-shaped building, which framed the Renaissance facade on the square.

**Above:**

*Facade overlooking the Place de l'Hôtel-de-Ville.*

**Floor plan of the Hôtel de Ville**

A – *Salle des Fêtes*
B – *Salle Lobau*
C – *Salon de l'Arrivée Sud*
D – *Salon of the Sciences*
E – *Salon of the Arts*
F – *Salon of Letters*
G – *Galland Gallery*
H – *Mayor's Staircase*

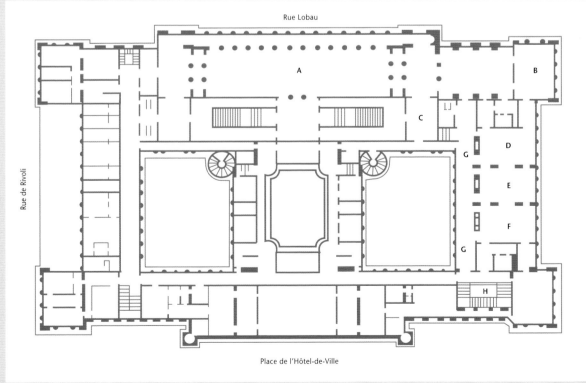

The Hôtel de Ville was burned by the Communards in 1871: the municipal archives and the masterpieces by Jean-Auguste-Dominique Ingres and Eugène Delacroix, which decorated the additions from 1836, were destroyed in the fire. Instead of saving what could be saved, it was decided to build an exact reproduction of the Renaissance facade as the central element for an even larger complex. The current building is particularly noteworthy for its interior decoration, a remarkable example of the decorative art of the Third Republic, with works by Pierre Puvis de Chavannes.

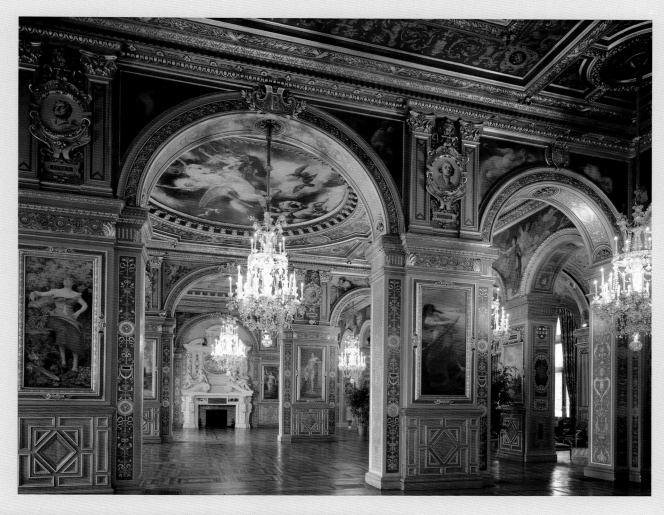

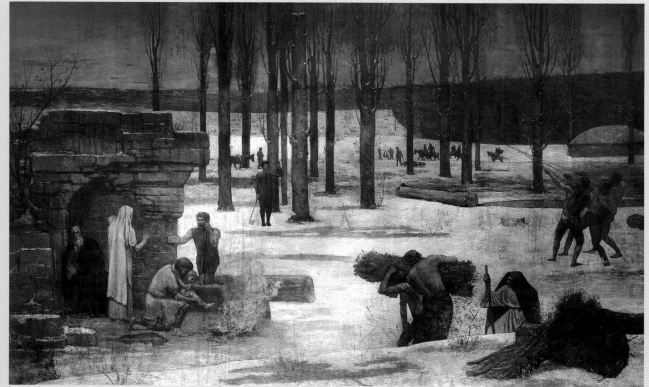

**Above:**

*Suite of Salons: Letters, Arts, and Sciences*

**Left:**

*Pierre Puvis de Chavannes. Winter. 1891–1892. (Salon de l'Arrivée Sud)*

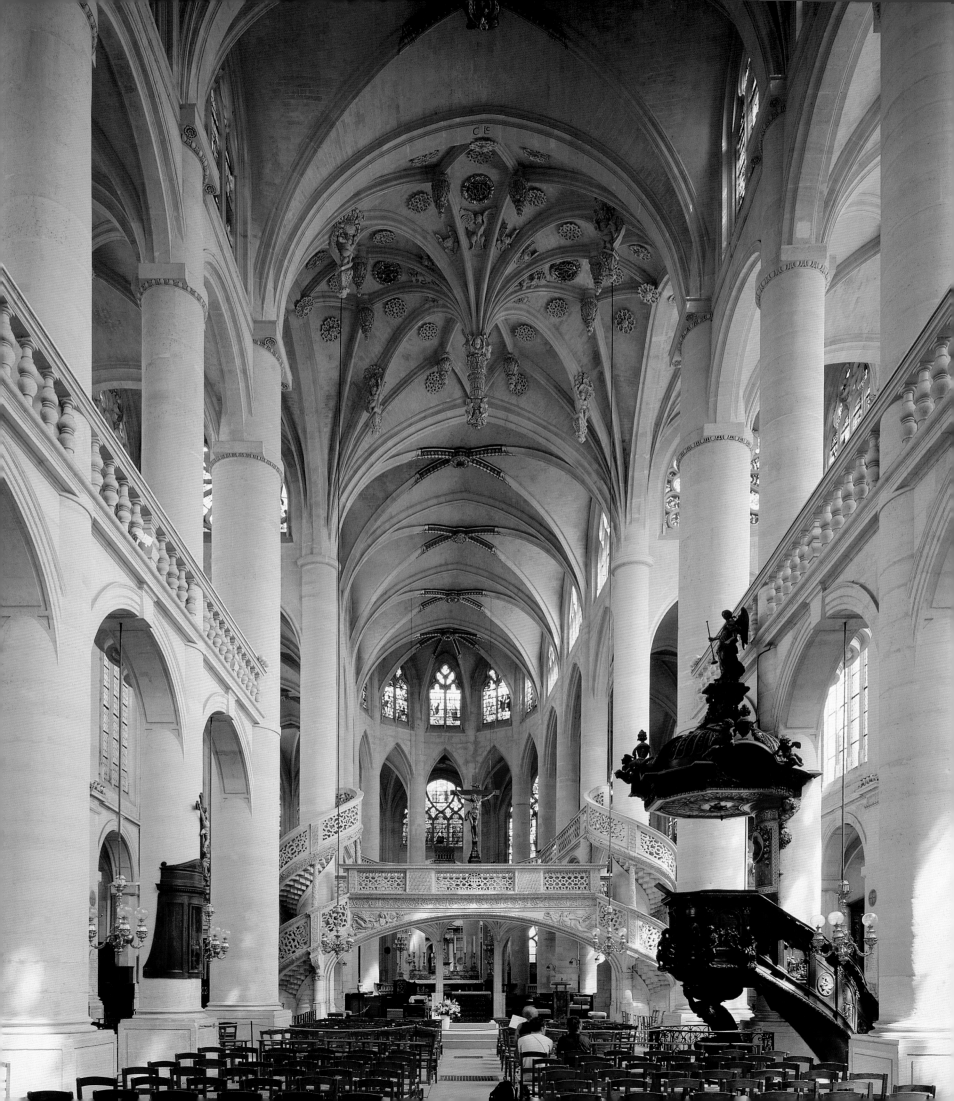

# Chapter VI
# ATTICISM AND MANNERISM
## (1540–1600)

In the 1540s, with the passing of a generation, old Lombard-Ligerian art, which remained associated with the name of François I, fell out of fashion. The king waited until the very end of his reign (he died in 1547) to entrust the renovation of the Louvre to Pierre Lescot, one of the distinguished representatives of the new generation. Yet he inaugurated the decade with an act that marks an epoch in the nation's history: the 1539 Ordinance of Villers-Cotterets, which substituted French for Latin in official written documents.

The French language was in fact the main issue in the movement organized in the 1540s, a unique issue insofar as the arts constitute a language. Writers from the Loire Valley came, attracted by the new brilliance of the capital, including Rabelais of Chinon, Ronsard of Vendome, Du Bellay of Angers, and De Baïf, who was born in Venice but with a father of Maine Angevin stock. Du Bellay, Ronsard, and De Baïf met at the Parisian college Coqueret on Mount Sainte-Geneviève, where Dorat introduced them to ancient letters. They founded the Brigade, an association dedicated to the defense of the French language. After that successful defense, it later became the Pléiade. Du Bellay set about writing the manifesto, *La Défense et illustration de la langue française* (*The Defense and Illustration of the French Language*), 1549. Having established the poorness of his native French language, Du Bellay proposed enriching it by reviving old words, diverting technical terms from their meaning, and borrowing from provincial dialects, foreign languages, and "dead" languages. Dauphin Henry's architect, Philibert De l'Orme, who would become the all-powerful architect of King Henry II, used the same formula to create the new French method of construction.

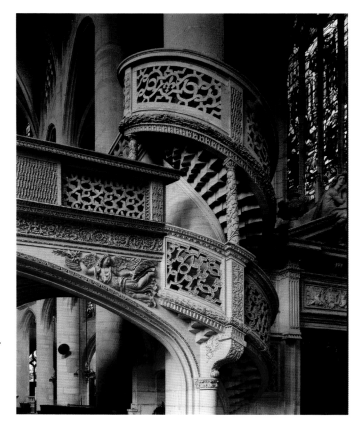

### 1–2. Saint-Etienne-du-Mont

*The reconstruction of this parish church began in 1492 with the chevet and the bell tower. In 1545 the choir was finished, with the completion of the balustered spiral staircase à l'antique, as stipulated in the contract. In 1545 the nave was begun. The nave and the transept crossing were vaulted from 1582–1586. Both the layout, which is very much like that of a cathedral, and the lateral bell tower are in the Parisian tradition. The uncommon elevation is due to a change in concept that is easily traced in the choir. The original plan called only for side aisles connected with the central nave at the first level of grand arcades. After an interruption from 1511 to 1530, work resumed according to a plan calling for side aisles almost as high as the central nave and connected to it by two levels of arches. Indeed, "hall-churches" built with several naves of the same height were fashionable at this time. The vaulting remained traditional, however: the church had ribbed vaulting with multiple ribs and a hanging keystone. The jube was begun in 1530 (lower parts and the great arch), but the bulk of the work was completed according to a plan designed between 1540 and 1545, perhaps by Pierre Lescot, but more probably by Philibert De l'Orme. It was modified first in the eighteenth century by the elimination of the central cross and probable rebuilding of the railing in the central section, and then again during the Revolution, when the features of the angels carrying instruments of the Passion were modified to make them appear victorious.*

He knew better than anyone how to apply Du Bellay's watchword: "And so, French kinsfolk, march courageously toward that superb Roman city, and with its servile remains, decorate your temples and your altars." The ancient culture of the French was mainly Latin. But Ronsard spoke Greek, as did Lescot, in his way, when he gave Jean Goujon models of the caryatids for the Grande Salle of the Louvre that he had obviously borrowed from the Erechtheum in Athens (fig. 55).

This atticism of Ronsard and Lescot, which is merely the infancy of French classicism, proscribed the Italianization that had proliferated during the time of François I. But new art had nonetheless to bow to the Italian example, promoted by Fontainebleau and updated by Sebastiano Serlio. Serlio had been summoned by François I and arrived at Fontainebleau in 1541, his trunks loaded with the two treatises on the antiquities and the orders he had had printed in Venice. And even Ronsard's and Du Bellay's action to champion living language sprang directly from Petrarch's and Giovanni Bocaccio's own efforts on behalf of the Italian language.

During the reign of Henry II (1547–1559), the art of the Pléiade, the art of the seven poets named by Ronsard in the constellation, and more generally the art of their contemporaries,

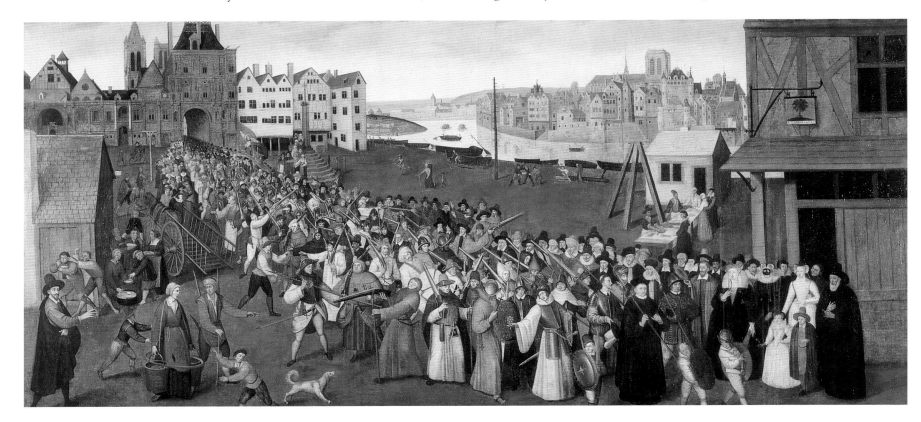

became royal art *par excellence*. It is quite difficult to discern what this officialization owed to the king's personal taste, since he was naturally inclined to set himself apart from his father by giving priority to the French. Among these French was Clément Janequin, newly arrived in Paris in 1549, author of the *Cris de Paris* (*Cries of Paris*), and named ordinary royal composer by Henry II. If the reign had lasted, it would perhaps have made the sixteenth century the Great French Century; instead it was brutally ruptured by the lance that mortally wounded the king in the Rue Saint-Antoine jousting tournament.

With the massacre of the Protestants at Wassy in 1562, a new thirty-six-year period of civil war began. The effect of the Wars of Religion on artistic activity is difficult to measure. Protestants were forced to leave Catholic Paris, including numerous artists. Jean Goujon disappeared from French building sites the very year of the Wassy massacre; he probably

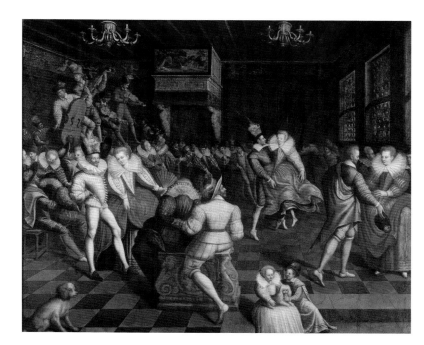

4. French-Flemish School. *Bal à la cour des Valois (Ball at the Valois Court).* c. 1580. (Musée des Beaux-Arts, Rennes)

*The scene is not identified: it recalls the wedding ball of the duke de Joyeuse in 1581 represented in a painting conserved at the Louvre.*

ended his days in Italy. Two years later Jacques Androuet Du Cerceau sought refuge at Montargis with Renée de France, duchess of Ferrare and protectress of Protestants. In 1572, the year of the Saint Bartholomew's Day Massacre, the goldsmith, engraver, and medal-maker Etienne Delaune fled. The same was true for Baptiste, son of Jacques Androuet Du Cerceau, who left the service of Henry III rather than attend mass.

Architecture is more subject to the hazards of circumstance than any other art. The closing of work sites left the field open to the imagination: projects gained in scope what they lost in credibility. And as war and peace alternated with greater frequency, people took advantage of fleeting periods of calm to attempt improbable creations. There were no fewer than eight religious wars, with two periods of calm longer than the respite between two battles: they were the period between 1564–1566 during which the queen mother created the immense palace of the Tuileries (fig. 67) and the period 1581–1585, utilized by Louis Gonzague, duke of Nevers, an Italian like the queen mother and one of the main players at the court, to undertake construction of the Hôtel de Nevers, which is second only to the Tuileries in its excessiveness. The two enterprises would remain unfinished.

The disastrous reigns of Henry II's three sons, François II, Charles IX, and Henry III, with whom the Valois dynasty ended, exacerbated the remarkable characteristics of the Pléiade's art. The customs of the court illustrated this evolution perfectly. In the time of Henry II, court dress borrowed from Spanish fashion the "stiffness" of armor and the black that inspired Diane de Poitiers's widow's veils, a color to which the royal lover committed by passion, the courtesan by constraint. Under Henry III, the "corps," a rigid, tight-fitting bodice for women, put a suggestive point in the folds of the dress front; the farthingale used hoops to keep the dress front distended. The ruff, which appeared fully starched in 1555, grew to the point where it required an iron armature (fig. 4). Fashion became eclectic: it was Spanish, Tudor, Flemish, and even Polish as a result of Henry III's brief stay on the Polish throne. In 1562 François Desprez published the 120 engravings of his *Recueil de la diversité des habits qui sont à présent un usage en pays d'Europe, d'Asie, d'Afrique* (*Compendium of the Diverse Clothing Currently Worn in European, Asian, and African Countries*), a sort of topography of costume or clothing customs.

French sociability, which we associate too quickly with the salon life of the Grand Siècle, was established during the reign of Henry II. As Madame de La Fayette, one of the most illustrious representatives of this salon society, attests: "Magnificence and gallantry have

never appeared in France with such brilliance as in the final years of the reign of Henry the Second," she wrote in *La Princesse de Clèves* (1678), the classical novel *par excellence*, which in fact takes place in the court of Henry II. The significant celebrations of Henry II's reign, preserved as memories in narration and engravings, were at once scholarly and political; they were the arrivals of the royal party in France's cities, occasions that were treated like triumphs, in the antique style (figs. 40–44). The erudition of the arches was addressed to a cultured public, the only sort capable of deciphering an homage to king and kingdom. A few subtle Greek or Latin citations sufficed to give a shine to French art. The common people, deprived of the performance of mystery plays by Parliament's 1548 decree, could only marvel at the expense, one that was not in vain since it served as proof of royal power.

Balls and ballets added spice to the mad festivities of the last three Valois kings (fig. 4). Society found entertainment in the spectacle it made of itself behind closed doors. Such spectacle elicited only sarcasm or indignation in the common people, who were aware only of its excesses. The masquerade tournament at the wedding of Marguerite de Valois, the king's sister (Queen Margot), to Henri de Bourbon, the future Henry IV, served as a preamble for the Saint Bartholomew's Day massacre (1572): in the hall at the Petit Bourbon, the Protestants led by Henry confronted the Catholics led by the king in person, over a battle formulated by Ronsard—the Protestants from Hell had to conquer Heaven, defended by the Catholics!

As odd and extravagant as they were, the celebrations of the last Valois were, like their architecture, harbingers of innovation that would not be fully exploited until the following century. Upon the occasion of the wedding of Charles IX in 1571, Louis de Gonzague had a troop of Italian actors, the Gelosi, come from his native Italy. The event was repeated for Marguerite and Henry's wedding; the troop gave its first public performance in 1577 in the hall at the Petit Bourbon. And it was thus that the Italian comedy, with its *harlequins*, made its appearance in France. *Circé ou le Ballet comique de la Royne* (*Circé*, or the *Queen's Comic Ballet*), which was performed in the Petit Bourbon for the Joyeuse wedding, announced the coming of court ballet and opera. For the first time (twenty years before Monteverdi's *Orféo*), music, dance and poetry contributed jointly to a narrative-based performance. The author, Balthazar de Beaujoyeux, an Italian with a gallicized name who was a violinist and a choreographer, arrived in France about 1555.

Bombast and excess even influenced the praises elaborated on the city and on art by the thurifers. The dithyramb reached a summit with *La Grande et Excellente Cité de Paris et choses remarquables d'icelle* (*The Great and Excellent City of Paris and the Remarkable Things about It*), 1575, published by André Thevet, a strange character whose scholarly reputation launched him at the court. According to Thevet, Paris was the "miracle of the Universe." The towers of Notre-Dame deserved to rank with the pyramids amongst the Seven Wonders of the World. The Palais de la Cité was "unique, with all due respect to all the sovereign courts of European Christian kings." The Seine was the "prince of all rivers. Its water was the best in the world for drinking, with all due respect to the Roman Tiber, the Egyptian Nile, and to Senegal's river." The locution *"n'en déplaise"* ("with all due respect") was used in writings that multiplied in order to impose the predominance of French art in Europe. The praise of Paris was but one aspect of this generous publicity campaign.

In his *Vrais Pourtraits et vie des hommes les plus illustres* (*True Portraits and Lives of Famous Men*), 1584, Thevet wrote about Eudes de Montreuil, Saint-Louis's architect: "Although the buildings constructed by this Eudes are not mausoleums or temples of Epheseus, they are not much inferior Without its Eudes, France would have lost the brilliance it has, compared to many nations, in being superb, rich, and magnificent in its constructions." As for the

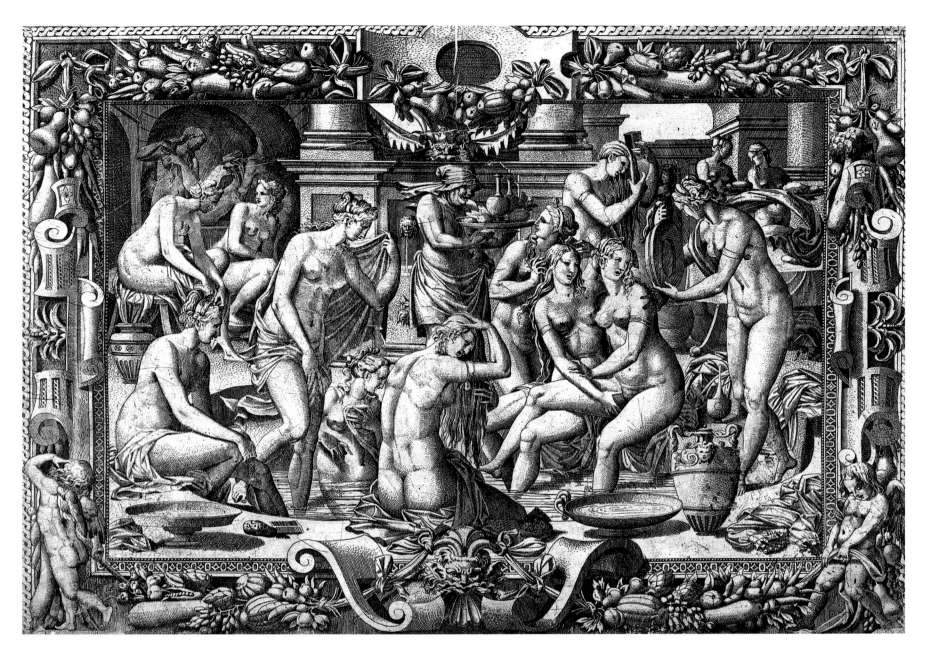

"industrious labors of Michelangelo, whoever might compare them with our Eudes would recognize that in twenty years the latter perfected more works than did the former in sixty, which is why he has acquired this honor over all architects of his time."

The paradox of these writings is that, in the pompous style of the late Valois, they express the ardent but measured discourse of the artists who in the 1540s were reducing the arts to a "French essence," as Lefèvre de La Boderie wrote in his *Galliade ou Révolution des arts et des sciences* (*Galliade or Revolution of the Arts and Sciences*), 1578. According to this author, the *primae inventiones* described by ancient authors originated in Gaul, at the time of a certain King Magus. Since then, this Gaul "that today we call France has nourished a vast troop / Of celestial Spirits, who from all directions have brought us the River of the Arts / Which in olden times spurted forth from its shady fountain."

The fusion effected in the Parisian crucible in the 1540s produced the metal that would flow into the mold of French classicism. One could fail to notice this, not because the fire was covered by the slag of the last years of the century, but because the original works were massively sacrificed to copies made later on. What is left to see of Henry II's Paris beneath that of Colbert and Baron Haussmann? What has become of the drawings of Pierre Lescot and Philibert De l'Orme, whose number and perfection ought to have merited their conservation?

5. Jean Mignon. *Bain de femmes* (*Women's Bath*; etching done according to Luca Penni), 1547–1550. (Bibliothèque Nationale de France, Paris)

*This engraving is characteristic of the art of Fontainebleau in more ways than one, including the theme of the bath; adherence to the standards of feminine beauty of the time; the ornamental program of the frame; and the frequent use of erotic allusions. But the work is Parisian.*

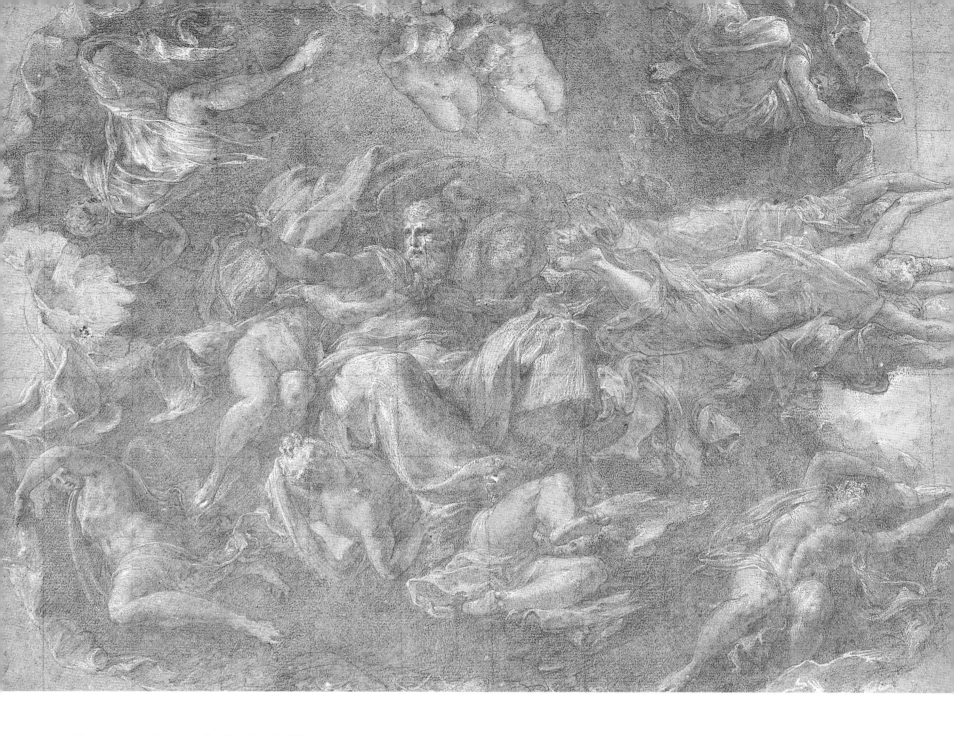

**6. Primaticcio. Drawing for the chapel of the Hôtel de Guise. (Musée du Louvre, Paris)**

*This is a study for the central motif of the vault of the chapel at the Hôtel de Guise, representing God the Father. The former Hôtel de Clisson, on the Rue du Temple, was purchased in 1553 by François de Guise, duke of Lorraine, and his wife, Anne d'Este. The paintings of the chapel, created starting in 1556 by Nicolò dell'Abate according to compositions designed by Primaticcio, represent God the Father in the vault and the Adoration of the Magi on the walls. One can recognize the principal members of the de Guise family in the kings. Since these paintings were destroyed, it is possible to know them only through Primaticcio's drawings, through facsimiles executed by Abraham van Diepenbeck in the seventeenth century, and through descriptions.*

## 1 – Drawing, Engraving, and Painting

We have no known drawing from Lescot, and one at most from De l'Orme. This is astonishing given the fact that drawing played such an important role at this time. In the creation of a work of art, drawing was the principal challenge for the artist, since execution of the work was cottage industry. In sixteenth-century French art, conception and realization were generally fairly distinct. Perhaps the dichotomy sprang from the scope of the challenge imposed on the artists at Fontainebleau. There Primaticcio did drawings for murals that others created, among them painters of great merit like Nicolò dell'Abate. Only the division of labor allowed the originator of the idea to guarantee the cohesion of the whole. But the lack of signatures on drawings is a more general phenomenon. De l'Orme gave drawings not only to glassmakers, polishers, carpenters, but even to sculptors. The Italian model, whose theory defined the work of art as a *cosa mentale*, never ceased to exercise influence. The drawing is a design: as such it can even be replaced by a specification, the description of the work to be done.

## Engraving

Can the destruction of the drawings, which did not spare anything but the works of a few masters, be explained by the extraordinary development made by engraving in the sixteenth century? Was the print understood as the ultimate, durable, and distributable version of drawing? At the very least, the print was certainly used as a means of circulation. Thanks to the print, the inventions of the school of Fontainebleau were widely known and imitated. In this respect, Paris was an essential center. The engraver Pierre Milan, who reproduced the works of Rosso Fiorentino and Primaticcio, was active in Paris between 1540 and 1557. The printing presses of Milan were able to produce a thousand or more copies. The etcher Jean Mignon specialized in the reproduction of the drawings of Luca Penni, who probably produced them to that end (fig. 5). These two artists were first active at Fontainebleau, but they quickly returned to Paris. The capital seems to have profited from the misunderstanding that broke out between the artists of Fontainebleau after 1540, at the death of Rosso Fiorentino, and especially between Primaticcio and Penni. Penni returned to Paris around 1540; Jean Mignon around 1550. The Master L. D., possibly identifiable as Léon Davent, the interpreter of Primaticcio and Penni, left Fontainebleau for Paris upon the death of François I.

## Painting

Compared to the development of engraving, the evolution of painting seems unimpressive indeed. There were fewer illuminators, but they continued to produce quality work, blending the Flemish and Fontainebleau traditions, as in the *Recueil des Roys* (*Collection of Kings*; Bibliothèque Nationale, Paris), which represents the kings of France from Clovis to François I. It was a work commissioned by the royal secretary, Jean Du Tillet, and created about 1550. It was intended for Henry II, but actually given to Charles IX by Du Tillet, and not until 1566. Paintings of monuments are mentioned more frequently and in greater detail, but we would only have descriptions, were it not for the practice of making drawings. Primaticcio's plans for the chapel of Guise's Parisian private mansion were preserved: beginning in 1556, Abate covered the chapel with paintings, guided by Primaticcio's drawings. Abate also did decorative painting at the constable of Monmorency's Parisian mansion and Jacques du Faur's (a superb sample of the architecture of this mansion, known as the Torpane, was preserved at the Ecole des Beaux-Arts, but it is not presentable in its current state.

Relatively few paintings have been conserved. However, the investigation of posthumous inventories between 1550 and 1610 documents the existence of numerous paintings during the succession, especially religious paintings and genre scenes. It is possible that certain paintings were destroyed because their content was condemned for religious, political, or moral reasons.

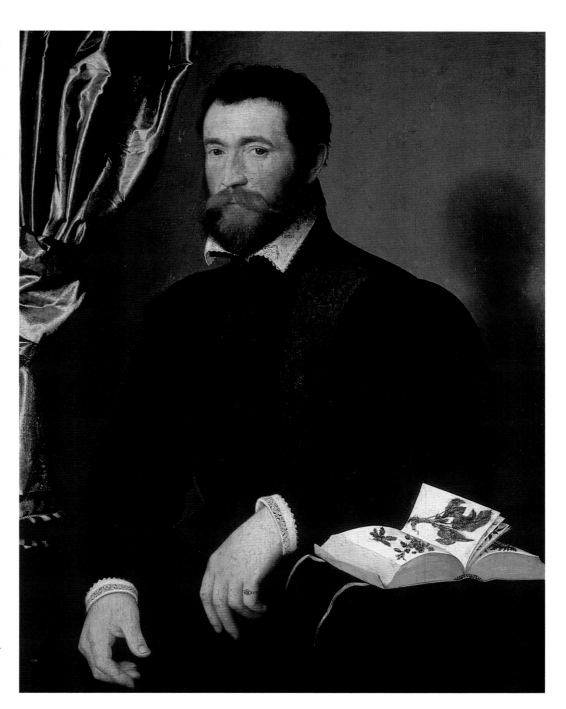

7. François Clouet. *Portrait of Pierre Quthe*, 1562. (Musée du Louvre, Paris)

*This portrait of Pierre Quthe, a Parisian apothecary and neighbor and friend of François Clouet, is the only one of the artist's portraits depicting a single individual. It shows the level of quality and innovation that Clouet could attain when he was not constrained by the conventions of court portraiture. One can still note in it, however, some of the traditional traits of the genre: the neutral background, the curtain, the three-quarter post, and the hands near each other in the foreground.*

One comes to this conclusion by what was spared: genre scenes, court scenes, and intimate scenes (fig. 5). We know that women bathing was one of the great themes of sixteenth-century French painting. In the Count of Châteauvilain's gallery, known as Adjacet, Brantôme saw "a very fine painting representing many beautiful naked women bathing, women who were mingling and touching, feeling, handling, and rubbing each other, and who, furthermore, were doing each other's hair so nicely and properly in the nude that a recluse or hermit herself would have been excited and moved." The seventeenth century had stricter mores and more refined taste, so during that period a number of paintings deemed scandalous were probably destroyed because of their mediocrity. To this author, the typical quality of surviving sixteenth-century painting does not attain that of seventeenth-century French production. Artists active in sixteenth-century Paris proved to be brilliant at drawing rather than good at painting. What would one think of Penni's talent if one judged it by the single surviving painting, *La Pseudo-justice d'Othon* (*Otho's Pseudo Justice*) at the Louvre? Lescot's painting was esteemed during his lifetime: nothing remains today. Only one of Charles Dorigny's paintings has survived, probably one of the better ones. Dorigny worked with Rosso Fiorentino at Fontainebleau and collaborated with Goujon and Cousin at the time of Henry II's entry into Paris in 1549 (fig. 8).

The work of Antoine Caron is better conserved and constitutes a remarkable record of the events of the time, represented in myth and allegory; however, it has not won the artist a place in Parnassus. This man from Beauvais worked first in Fontainebleau, but those of his paintings that have been conserved were produced after he settled in Paris. He orchestrated the celebrations of the last Valois kings, notably the weddings of Marguerite and Henri and of Joyeuse. Some of his drawings were used to create sketches for tapestry wallhangings, such as the *Fêtes des Valois* (*The Celebrations of the Valois*) and *L'Histoire d'Artémise* (*The Story of Artemis*), the queen with whom contemporaries identified as Catherine de Médicis (fig. 9).

Jean Cousin the Elder, who came from Sens to Paris in about 1538–1539, was the most famous French painter of the sixteenth century. He provided multiple models for gold and silver working (fig. 12), stained glass, tapestry, sculpture, temporary architecture for celebratory occasions (he was involved with Goujon and Dorigny in the 1549 entry), and armor. He published an important *Livre de perspective* (*Book of Perspective*) in Paris in 1560. Like Primaticcio, Cousin was much in demand as an artist and was able to cope with his numerous orders only by giving priority to drawing, in which he excelled. But his paintings, which can be counted on one hand, do not do him justice as an artist. He was the only French artist to be honored in Vasari's *Lives of the Artists* (1550). But his reputation was created in part by seventeenth-century critics who were seeking an artist capable of carrying the French banner in the face of the Italian cohort. People made a French Michelangelo of him; but it was Jean Cousin the Younger who produced the Louvre's *Jugement dernier* (*The Last Judgment*), which contemporaries did not hesitate to compare to that of the Sistine Chapel: a grandiloquent and painstaking work, perfectly adapted to the macabre piety of Henry III, for whom the painting was done.

The masterpieces of sixteenth-century painting, the Louvre's and Washington's *Dames au bain* (*Women in the Bath*) and Rouen's *Bain de Diane* (*Diane's Bath*), have been attributed to François Clouet, successor to his father (who died in 1541). He also exploited the French tradition of the portrait, but he liberated himself from the constraints of the genre in his portrait of Pierre Quthe (fig. 7), which introduces a modest Parisian apothecary to the gallery of illustrious men painted by the Raphaels and the Titians.

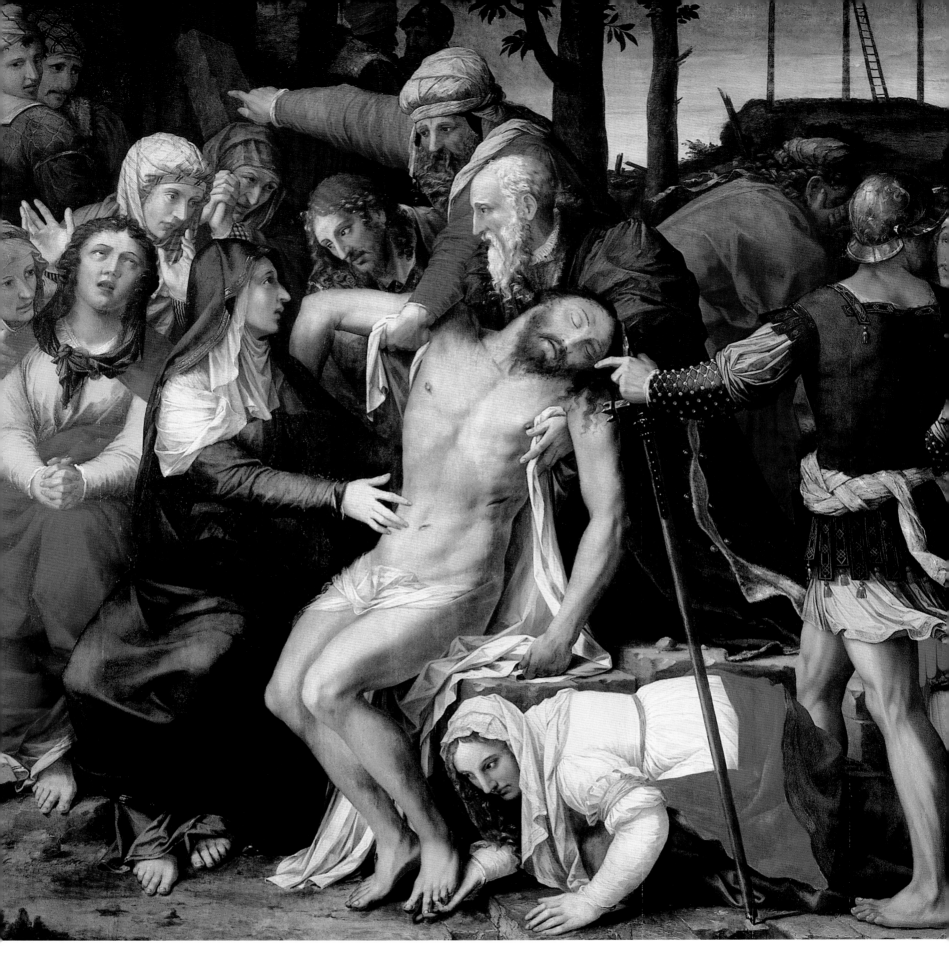

**8. Charles Dorigny.** *Le Christ descendu de la croix* (*Christ Descended from the Cross*), 1548. (Sainte-Marguerite Church, Paris)

*This painting has been identified as the one commissioned by Charles Dorigny in 1548 for the Chapelle d'Orléans in the Célestines Convent.*

**10.** *Diane demande à Jupiter le don de chasteté*
(*Diana Requests the Gift of Chastity from Jupiter*), c. 1550.
(Musée Départemental des Antiquités, Rouen)

*This tapestry representing Diana requesting the gift of chastity from Jupiter is part of the wallhanging of the History of Diana, probably commissioned by Henry II for Diane de Poitiers and intended for the decoration of the Anet Château. Until the recent destruction of the sections conserved at Anet, this wallhanging included eight sections and one fragment. The sketches were not all done by the same person: De l'Orme, Cousin the Elder, and Penni have been among the artists who are believed to have contributed. Penni was probably responsible for the sketch of this section. The tapestry must have been woven about 1550 in the Parisian workshops of la Trinité created by Henry II. The inscription on the scroll explains why Diana aspired to chastity: "So as better to give myself to the hunt/I address my prayers to Jupiter." In the border we see three intertwined crescents, a symbol of Henry II, and Diane de Poitiers' two intertwined deltas.*

**9.** Antoine Caron. *La reine Artémise devant le tombeau du roi Mausole* (*Queen Artemis before King Mausolus's Tomb*), 1562. (Bibliothèque Nationale de France, Paris)

*This drawing is one of the illustrations of Nicolas Houel's manuscript. It tells the story of Queen Artemis, the inconsolable widow of King Mausolus, for whom she had a monumental tomb, the Mausoleum, built at Halicarnassus. It was considered one of the Seven Wonders of the World. Caron's drawings were to serve as models for a tapestry wallhanging that Houel wanted to give to Catherine de Médicis, the new Artemis. In this drawing, there is evident allusion to the Valois Rotunda, built by Catherine to receive the tomb of the royal couple.*

## 2 – THE APPLIED ARTS

### Bookmaking

Among the arts utilizing particular techniques for the application of drawing is that of bookmaking, in which everything is art—illustration, typography, binding, and content. The process of wood engraving was perfected by working on books, and since these engravings were done in relief, they could either accompany the text or be integrated into it, according to the procedure initiated by Tory. Engraving promoted the emblem, a genre invented by André Alciat that closely associated an image and a maxim. Andrea Alciati taught law in Paris in about 1530. He may have inspired the iconography of the François I Gallery at Fontainebleau. He published his book of emblems, *Emblematum libellus*, in Augsbourg in 1531 and then republished it in Paris in 1534 when the first edition did not satisfy him. This second edition became a model. The original wood engravings were corrected, redone, and above all, made up into pages: at the top of the page above the image the *inscriptio*, or maxim, was placed; at the bottom under the image was the *subscriptio*, a little poem explaining the emblem. Alciat's emblems would be exploited for two or three centuries by European painting as an inexhaustible source of representation. Gilles Corrozet immediately seized upon the formula and published his *Hecatomgraphie* in 1540.

When it comes to influence, Francesco Colonna's *Discours du songe de Poliphile* (*Discourse on Poliphile's Dream*) yields to no other book. The *Discours* casts Poliphile's quest for Polia, his lover, in terms of an initiation to a reinvented antiquity; consequently, the ruins and workmanship of his illustration inspired an aesthetic of ancient times. The work was first published in Venice in 1499 under the title *Hypnerotomachia Poliphili* (*The Strife in the Dream of Poliphilus*). The illustration was totally redone by Jean Cousin or Jean Goujon for Jean Martin's French edition (1546). The *Discours's* frontispiece attracted particular attention (fig. 11), not only for its own qualities and its ample development of Fontainebleau decoration, but also as evidence of a new genre destined for a grand future; until then, title pages had not received special attention.

SIC IMMOTA · MANET

IVPITER AMBAS

EN · MESME · TEMPS · PHOEBVS · SES · ARMES · DRESSE
CONTRE · PYTHO · ET · PAR · SA · GRAND · VERTV
DE · MILLE · TRAITZ · IL · L'A · MORT · ABBATV
LE · PEVPLE · LORS · QVI · SESTŌNE · ET · COMTEPLE
VOYANT · DES · DIEVX · L'ENNEMY · COMBATTV
POVR · SON · HONNEVR · LVY · A · DRESSE · VN · TEPLE

IVPITER

11. Francesco Colonna. *Discours du songe de Poliphile* (*Discourse on Poliphile's Dream*), translated by Jean Martin, edited by Jacques Kerver, 1546. (Bibliothèque Nationale de France, Paris)

*The work was first published in Venice in 1499 under the title* Hypnerotomachia Poliphili (*The Strife in the Dream of Poliphilus*). *Poliphile's search for his beloved Polia is but an allegorical and philosophical approach to antiquity. The ruins and workmanship that make up the decoration strongly influenced the development of an aesthetic with a penchant for antiquity and ruins.*

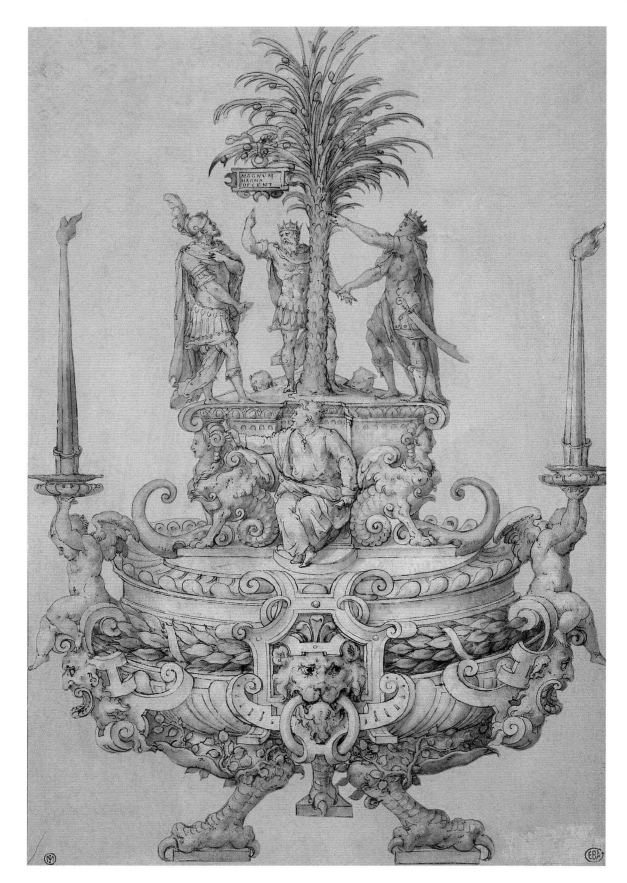

12. Gift offered by the city to Henry II upon the occasion of his entry into Paris in 1549. Drawing attributed to Jean Cousin the Elder. (Ecole Nationale Supérieure des Beaux-Arts, Paris)

*This "vessel" was created according to the drawing by Jean Cousin the Elder by goldsmiths Hans Yoncre, Thibaut Laurens, Macé Begault, and Jean Cousin, royal goldsmith, namesake of the artist and probably from the same family.*

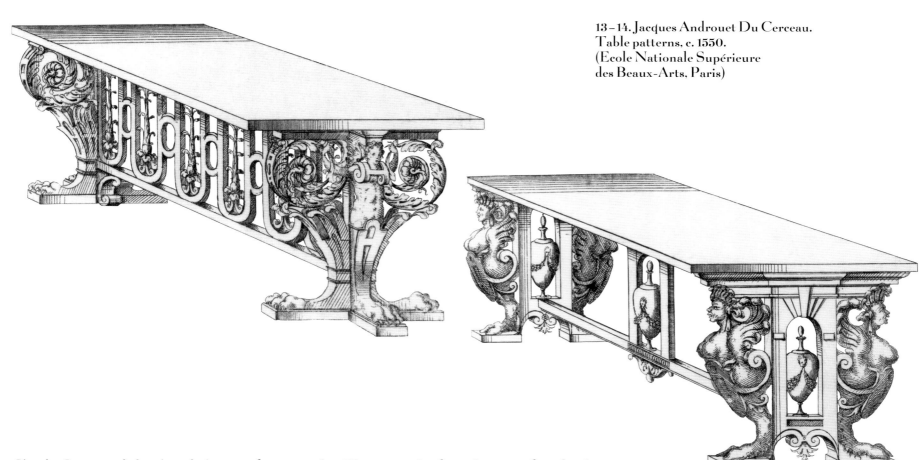

Claude Garamond developed the art of typography. He set up the first character foundry in Paris that was separate from a print shop. Beginning in 1544, he created characters for the king that bore his name and were reserved exclusively for him, namely the "king's Greeks," Greek letters commissioned by François I to publish the royal library works in Greek, roman letters inspired by Tory's own, and italic letters derived from Aldus Manutius, the famous Venetian editor. The attempt in Lyons to create "French letters" capable of rivaling the Italian was a failure.

Like the frontispiece, the art of bookbinding was a new genre (figs. 15–16). François I's commissions for the royal library gave this art tremendous impetus. In 1539, the title of "royal bookbinder" was created, to the advantage of Etienne Roffet of Paris. The royal workshop was moved to Fontainebleau, location of the royal library, and was active there from 1545 to 1552. As of 1552, it returned to Paris and was managed first by Gomar Estienne and then by Claude Picque. Once the royal orders were filled, the royal binders put themselves at the disposal of amateurs, the most outstanding of whom was Jean Grolier.

In all of its aspects—illustration, typography, and binding—the art of bookmaking reached its apogee during the reign of Henry II, himself a great bibliophile. All the resources of "Fontainebleau ornamentation" were deployed on the frontispieces and leathers of Henry II's books. Under the last Valois kings, on the other hand, quality was sacrificed to quantity: less attention was given to typography, and engravings were no longer integrated with the text.

### Tapestry

François I and Henry II tried to revive the art of tapestry in France by creating, respectively, the workshops at Fontainebleau and La Trinité in Paris. Very few works are certifiable products of the Paris workshop: *La Vie de saint Mamès* (*The Life of Saint Mamès*; Langres Cathedral), woven according to the drawings of Jean Cousin the Elder; *La Vie du Christ* (*The Life of Christ*), commissioned by construction finance committee of Saint-Merry (drawings at the Bibliothèque Nationale). *La Tenture de Diane* (*The Diana Tapestries*; fig. 10) were designed

**15–16. Bindings from the Royal Workshop. (Bibliothèque Nationale de France, Paris)**

*These bookbindings with Henry II's coat of arms were created in Paris at the royal workshop. They illustrate two styles favored in that workshop. The binding of the Histoires de Polybe (Histories of Polybus) in Moroccan citron leather was made in 1549–1550. It is a masterpiece of interlaced decoration. The binding of the Art de la guerre de Machiavel (The Art of War of Machiavelli) was created about 1554. It is one of the most remarkable examples of orientalized decoration.*

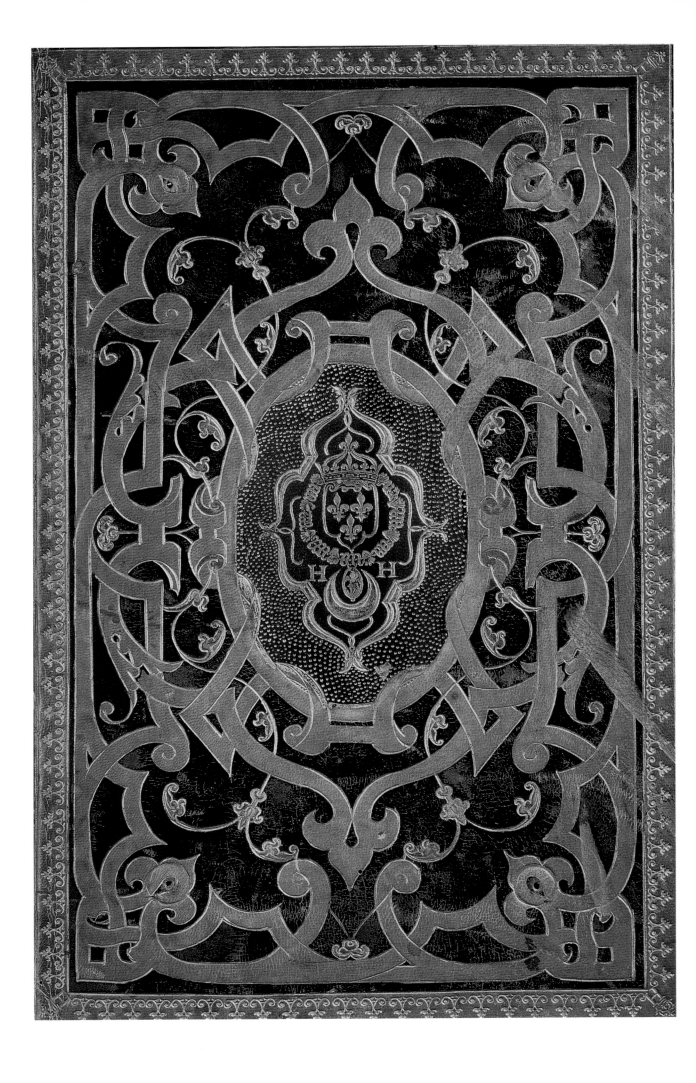

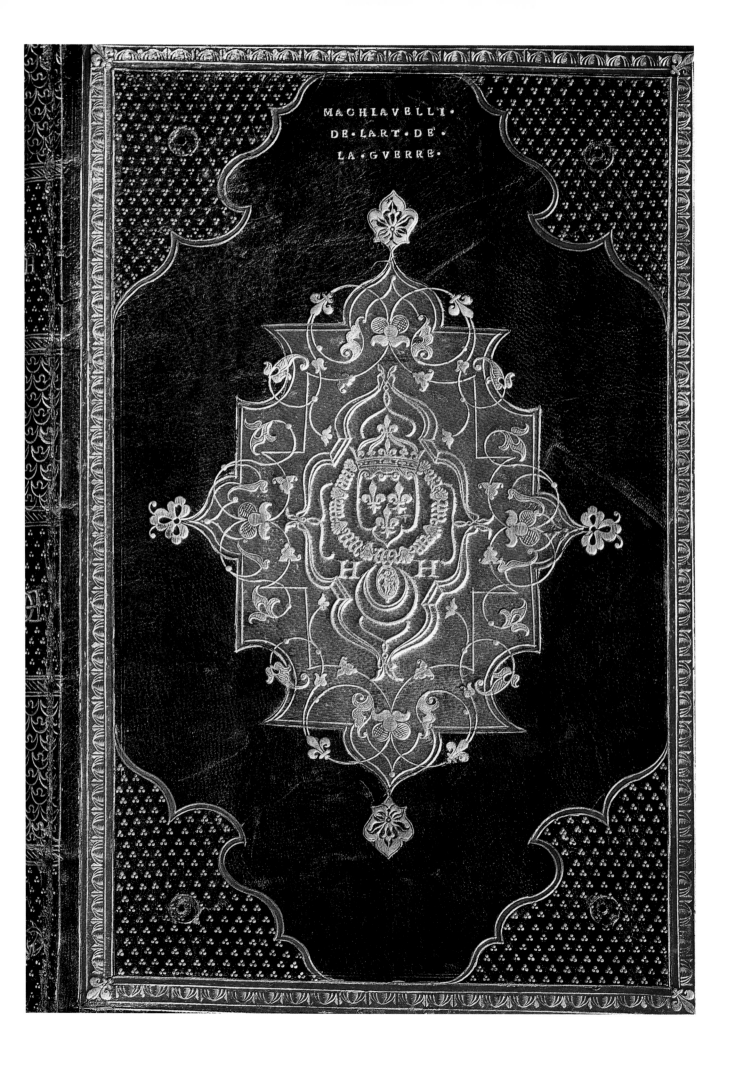

## 17–20. Vincennes Chapel Stained-Glass Windows, 1551.

*According to Henry II's orders, the Vincennes Chapel was created in Gothic style by De l'Orme, who made it the chapel of the royal order of Saint Michel. Choir stalls (no longer in existence) were sculpted by the woodworker Scibec de Carpi, and the stained-glass windows were created starting in 1551 by Nicolas Beaurain, all according to De l'Orme's drawings. There are seven stained-glass windows in all. The central range of the windows is devoted to a representation of the Apocalypse, which allowed prominent positioning of the archangel, Saint Michael, patron of the order. The top range is heraldic. The lower range represents various figures: the Virgin, saints, members of the order, François I and Henry II, Catherine de Médicis. These windows were removed, improperly restored, and badly reinstalled.*

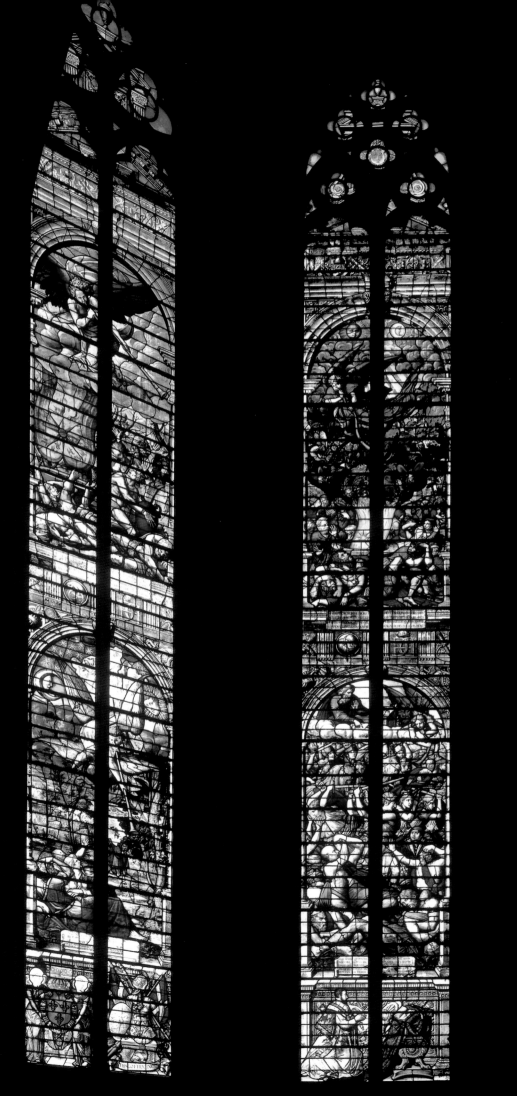

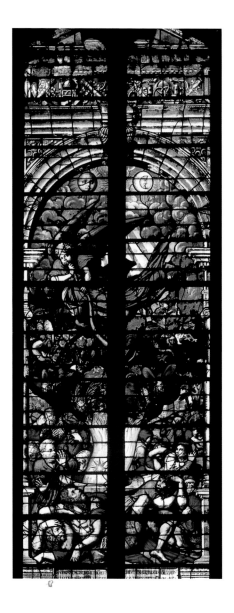

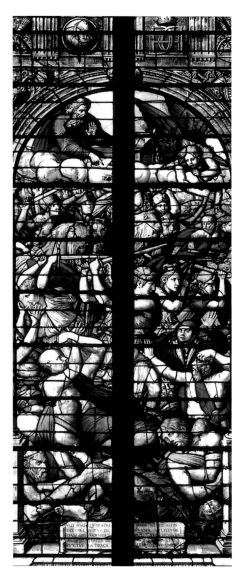

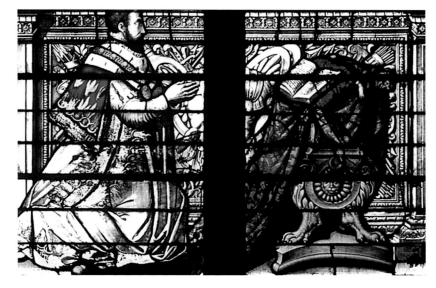

**18–20. Central Stained-Glass Window of the Vincennes Chapel**

*From left to right: the plague of grasshoppers, the exterminating angels, Henry II.*

by several masters, among them Jean Cousin the Elder, Penni, perhaps De l'Orme, and were probably commissioned by Henry II for Diane de Poitiers at the La Trinité workshop. But the tapestry of the *Fêtes des Valois* (*The Valois Celebrations*; Galleria degli Uffizi, Florence) was created based on some of Caron's drawings representing Franco-Italian scenes and was woven in Angers.

### Stained Glass

The production of the master Parisian stained-glass workers of the sixteenth century was very uneven in quality. The masterpiece is the *Apocalypse* of the Château of Vincennes Chapel (figs. 17–20); it is the work of glassworker Nicolas Beaurain, who succeeded Jean Chastellain (died in 1541) in the king's service. But it seems that Beaurain worked exclusively from drawings furnished to him by Cousin or De l'Orme. The Pinaigriers owed their reputation to Robert Pinaigrier, a mythical personage invented to highlight Italian values, according to the same line of thinking that lay behind the Cousin myth. The Pinaigriers were a Beauvais family with three glassworking brothers who settled in Paris. Nicolas, the most notable, was definitely in Paris in 1566.

### Precious Metalworking and Medals

Recent research has emphasized the importance of Parisian metalworking in the sixteenth century, although surviving objects fail to convince us on this point. The one exception is the extraordinary medal given by the city to Henry II upon the occasion of his 1549

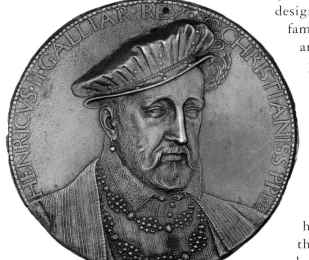

entry there. The work is known only through Jean Cousin the Elder's design (fig. 12). Several Parisian goldsmiths belonged to the painter's family, carrying his name and the title of royal goldsmith: the family arrived en masse in Paris in 1542. The most original pieces were produced in Limoges, where the technique of enameled painting on copper was perfected. The most famous enameler was Léonard Limousin. There has been some effort to attribute original portraiture activity to him, but in fact, like an engraver, he was more skilled at reproducing the drawings of Clouet, Cousin, and Abate (figs. 23–27).

Etienne Delaune, who was born in Milan and arrived in Paris in 1546, was a trained metalworker. Known primarily as an engraver, he provided designs for precious metal items and medals. He was the engraver at the Royal Mint, the Parisian workshop that produced coins and medals, and where Henry II introduced the technique of mechanized minting. It was Louis XII who imposed the royal effigy on coins, following the Italian example. As soon as he took power, Henry II took measures to standardize and improve coin production. The medal was another Italian influence; it seems Pisanello was its inventor. Germain Pilon advanced the art of medal-making significantly. He was named head of the Royal Mint in 1572 (figs. 21–22).

### Armor

Delaune also provided designs for armor. François I's armor was made in Milan. Henry II's was created in Paris, though the site of fabrication is uncertain. What is certain is that in this sphere, as in so many others, Henry II's reign distinguished itself by its perfection and originality. Henry II was a great collector of "parade" arms and armor; his breastplates display Fontainebleau's image, history, and ornamentation.

### Furniture

It is once again to Henry II's reign that we must attribute the appearance of a furniture design and style that break with the Lombard-Ligerian tradition. Jacques Androuet Du Cerceau was the innovator of the period. He was born in Paris, the son of a wine merchant. When his father died in 1546, he went to Tours, and he published his first prints in the middle of the century in Orléans. In 1551 he was the organizer of Henry II's entry into Orléans, and after that he went to Paris. He was certainly the creator of some of the "Paris-style" buffets noted in posthumous inventories.

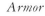

**21–22. Medals representing Henry II (Private collection) and Catherine de Médicis. (Musée du Louvre, Paris)**

*Medals molded c. 1575, probably created by Germain Pilon from portraits by François Clouet. The medal of Henry II bears the date of the king's death (1559). These medals are part of a series that also includes portraits of the late Valois kings.*

### Ceramics

Paris played no role in the popular production of ceramics like the "Italian style" pieces created by Masseot Abaquqesne in Rouen, or those made in Saint-Porchaire, which imitated Androuet Du Cerceau's models and were often known as "Henry II earthenware." It was in the Louvre's kilns that Palissy, who was educated as a master glassworker, started with very white Saint-Porchaire earthenware and attempted the alchemy of porcelain, though without success.

## 23–27. Retable of the Sainte-Chapelle, 1553.
### (Musée du Louvre, Paris)

*In 1552 Henry II commissioned two retables in glazed copper for the secondary altars adjacent to the choir enclosure constructed by De l'Orme in the upper chapel of the Sainte-Chapelle of the palace. These retables are conserved in the Louvre. They represent Calvary, with portraits of François I and Queen Eléonore (reproduced here), and the Resurrection, with its portraits of Henry II and Catherine. On each retable four angels frame the central image, carrying the instruments of the Passion. These retables were created by the enameler Léonard Limousin from various drawings, including Nicolò dell' Abate's drawings of angels that are reproduced here and preserved in the Ecole Nationale des Beaux-Arts.*

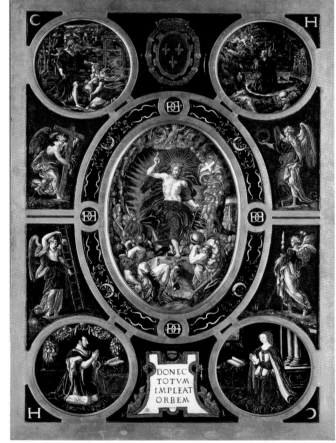

*Casa quasi simile alla passata ma al costume di francia*

## 28. Paris-Style House, according to Serlio

*Serlio's* Delle habitationi di tutti li gradi degli huomini *(About the Living Spaces of Men of All Ranks), which remained unpublished until the twentieth century, dealt exclusively with residences for people of all classes. In the book, Serlio presented two types of Paris-style houses. The more modest actually consisted of two matching houses, whereas the more grandiose type, suitable for a merchant or a wealthy urban dweller, consisted of four sections, two of them overlooking the street sharing one gable, and two overlooking a courtyard.*

## 3 – ARCHITECTURE AND MONUMENTAL SCULPTURE IN THE LAST YEARS OF FRANÇOIS I'S REIGN (1539–1547)

The new art manifested itself first through architecture, both in building form and in monumental sculpture, with the sculpture strictly subordinated to the architectural plan. Everything was accomplished at the end of François I's reign. As we have said, however, we can credit the king only with taking the initiative of summoning Serlio and Lescot. Apparently, Serlio only worked at Fontainebleau, and Lescot did not have time to complete a single significant work during François I's lifetime. The major works of the 1540s apparently owe nothing to royal directive.

### Serlio
Serlio earned recognition through his publications. In Venice he published his *Regole generali di architettura* (*General Rules of Architecture*) in 1537, sending a copy to François I, and in 1540 the *Antiquità di Roma* (*Antiquities of Rome*), dedicated to the king. All contemporary artists, from Goujon to De l'Orme, recognized their debt to Serlio: it was in these two treatises that they were initiated to the regimen and acquired or perfected their knowledge of antiquity. And yet Serlio, who arrived in France in 1541, did not find his place in the French system.

In Paris he published his books on geometry and perspective in Italian, which were translated by Jean Martin, but they were not very influential. His *Delle habitationi di tutti li gradi degli huomini* (*About the Living Spaces of Men of All Ranks*) was not published until the twentieth century, but it was known in his time. It created a genre in which the French would specialize—producing models for houses adapted to the means of people of all social conditions. Delle habitationi also communicates the nature of contemporary thinking about the specifics of Italian and French architecture. Serlio juxtaposed a French-style and an Italian-style house: the differences are obvious. The second type of urban house, characterized especially by an immense gable on the street side and an attic with several stories (fig. 28), was called *alla parisiana*, since for foreigners Paris was the French city *par excellence*. The comparison makes it clear that the two styles were incompatible, hence Serlio's failure, despite his efforts to adapt. Serlio aspired to be in charge of the Louvre construction site; but his plan (fig. 45), which was huge and characterized by abstract geometry, did not meet the king's immediate expectations, as Lescot's later would. It is not clear, however, that the Italian plan was definitively set aside; it may merely have been put on hold, in hope of achieving a better solution. In any case, it would not be forgotten and would inspire other efforts in the Tuileries and even at the Louvre, but not until the seventeenth century.

### De l'Orme's First Works
We know little about the extraordinary cloister of the Célestines Convent (fig. 29), which was probably begun in 1539 and no longer exists today. Was the king not involved with the commissioning of this first manifestation of religious order architecture from a master whose name we don't know: was it Lescot or De l'Orme? It is odd that critics of the period did not hail the creation of such an innovative work: only Sanval, the refined connoisseur of the seventeenth century, singled it out as "the best architecture in Paris." De l'Orme himself took charge of promoting his Saint-Maur Château (fig. 30), and was aided in that effort by Rabelais, companion of Cardinal Jean Du Bellay, for whom Saint-Maur was constructed. His career did not take off until Saint-Maur about 1541. Saint-Maur was a sort of Italian-style villa with an elevated first floor and no obvious roof. It was remarkable for its formal perfection and masonry, installed with expert joints (which were invisible) in the Roman style. Sadly, almost nothing remains of the château.

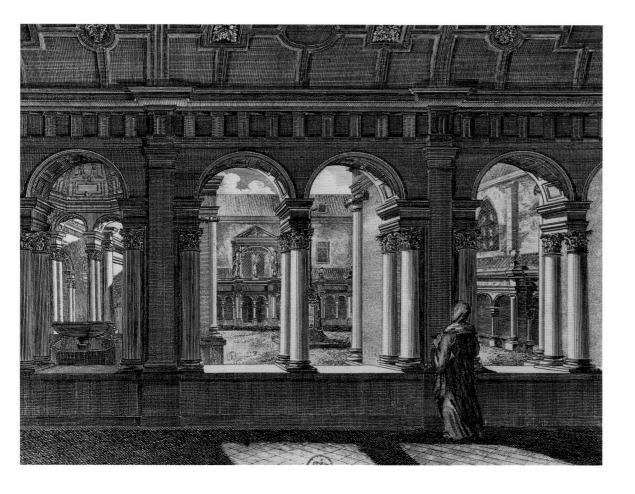

29. Testard. Célestines Convent,
engraving, 1790.

*The cloister of the Célestines Convent in the
Marais (now destroyed) was built beginning in
1539 by the master mason Pierre Hannon,
according to a plan that may be either De
l'Orme's or Lescot's. The convent itself was
founded by Charles V in a section of the
Saint-Pol mansion. Its church was full of
the tombs of royal and princely families.*

*The Jubes*

The Saint-Germain-l'Auxerrois jube, which according to Sauval was "the most admirable in
the kingdom," was also destroyed, but the best sections, sculptured by Goujon, were spared
(figs. 31–33). The plan was Lescot's, and with it he made his first appearance in the history
of French art. (It is important to remember that Saint-Germain-l'Auxerrois served as the
Louvre's church.) According to his friend Ronsard, Lescot was a precocious genius and this
first became evident in his painting. He began architecture at the age of twenty. Little more
is known about him: he was a cultured Parisian, but he may have traveled to Italy; and he
bore the titles of chaplain and advisor to the king, as well as lord of Clagny.

30. Jacques Androuet Du Cerceau. *Saint-
Maur Château*, engraving, 1579.

*The château was constructed in the early
1540s by Philibert De l'Orme for Jean Du
Bellay, Bishop of Paris, in Saint-Maur-
des-Fossés; it is no longer extant.*

For the jube's sculpture, Lescot turned first to Laurent Renaudin, an Italian from Rosso Fiorentino's entourage, who provided the drawings for the corner angels. For the first time, the winged figures of the ancient triumphal arches took flight in France.

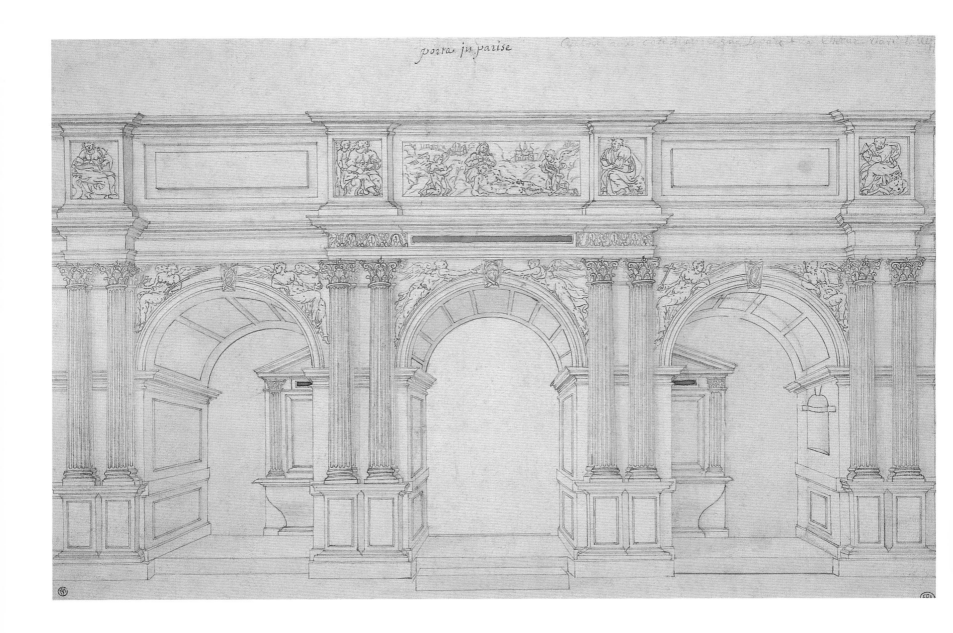

### 31–33. Saint-Germain-l'Auxerrois

*Known from an anonymous drawing of the second half of the sixteenth century, this jube was begun in 1541 according to a Lescot design. Work continued under the direction of Pierre de Saint-Quentin. The corner angels carrying instruments of the Passion were created from 1542 by Symon Le Roy according to a drawing of Laurent Renaudin. The Entombment and the Four Evangelists were begun in 1544 by Jean Goujon and are preserved in the Louvre.*

Goujon's involvement began in 1544. He was a native of Rouen, where he designed the columns of the Saint-Maclou tribune in 1541. Goujon may have developed his own style only by basing his work on Lescot's drawings. Goujon's style *without* Lescot's influence is illustrated by the engravings he did for the translation of *Vitruve* by Jean Martin (1547). And for comparison, Louis de Brézé's tomb, erected in the Rouen Cathedral, has been attributed to him. These works are beautiful, but they lack the life and vitality that characterized the Lescot-Goujon style.

According to its composition and its date (1542), the Saint-Merri retable by Pierre Berton of Saint-Quentin does indeed belong to the new art repertoire, but it reveals that the new art would not have been so prominent in French art were it not for Lescot's and De l'Orme's genius. We do not know which of the two masters was responsible for the finest part of the Saint-Etienne-du-Mont jube (figs. 1–2), i.e. the parts constructed between 1540 and 1545 on a jube begun in 1530.

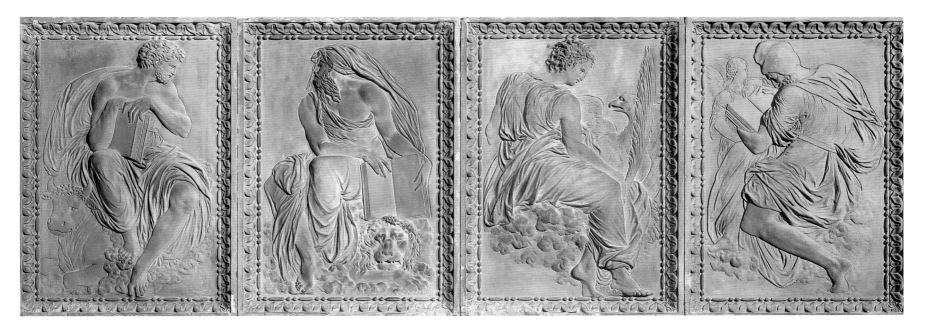

### The New Style in the Provinces

Paris's role in the blossoming of the new style is certain, but it was not the only influence, at least until Henry II's reign. La Ferté-Saint-Romain in Rouen, which dates from 1543 and is sometimes attributed to Goujon, is an architectural work in this style. The list should begin with the Saint-Lazare Fountain in Autun (1543), with certain churches in Champagne and Ile-de-France that are often given approximate dates of origin (Belloy-en-France, 1545), and the chapel of the Champigny-sur-Veude château (1545–1550). Bachelier arrived in Toulouse from Arras in 1532: the Assézat Mansion that he may have created and that bears some resemblance to Lescot's Louvre was not built before 1555.

The current state of our documentation may be definitive, given the massive destruction of works and sources, for it is impossible to reconstitute the links among works that have been dispersed.

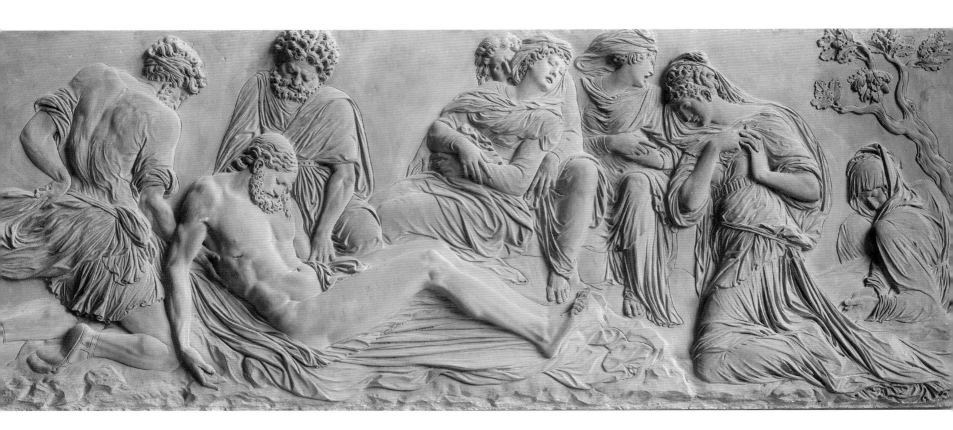

### Publications

The first compendium of publications on French-style architecture was issued during the reign of Henry II. It is not surprising that the work was contemporaneous with the *Défense et illustration de la langue française* (*Defense and Illustration of the French Language*), for it is marked by the same determination to define French style. The collection contains translations of the great Italian and ancient treatises; this was undertaken by Jean Martin, to whom we owe the translations of Serlio, Vitruvius, and Alberti, in addition to that of the *Poliphile*. All were published in Paris. In a posthumous edition of the translation of Alberti there is a significant homage to Martin: "Greece must no longer boast / of being greater in this art than learned France / The French need no longer / Seek elsewhere than in France / The spirit of intelligence and innovation / For Martin alone fills France with both."

The first publications of the prolific Jacques Androuet Du Cerceau appeared from 1549–1550: these were the volumes on arches, temples, and antiquities. Then in 1559, the important *Livre d'architecture contenant les plan...de cinquante bastimens pour instruire ceux qui désirent bastir suivant de petit, moyen et grand estat* (*Architecture Book Containing Plans for Fifty Buildings, to Instruct Those Desiring to Construct Appropriately for Lower, Middle, and Upper Classes*) was published in Paris (figs. 34–35). Continuing in the philosophy of *Delle habitationi*, Du Cerceau designed a hierarchy of models based on social hierarchies.

**34–35. Jacques Androuet Du Cerceau. Plan for four integrated private mansions, c. 1559.**

*This plan for private mansions was probably drawn for the* Livre d'architecture *published in Paris in 1559 by Androuet Du Cerceau, a work that proposes diverse groupings of houses. In this drawing, the design for each mansion is characteristic of the Parisian mansion, but the arrangement in a swastika is utopian: the back of each main building looks out on the courtyard of the neighboring building, not into a garden; the large central pavilion, whose likeness in style might make one think of Lescot's Louvre, was in fact shared in common by the four properties.*

Upon the accession of Henry II, De l'Orme, who had been the dauphin's architect, became the royal architect and took charge of all the construction sites in the kingdom except the Louvre, which was under Lescot's direction. At that point Serlio could only withdraw. He tried his luck for the last time in Lyons, where he published his *Libro straordinario*, a collection of models of portals that would be used in France. It was a posthumous homage to a man who was a great innovator, but who had the misfortune to arrive in a milieu defined by xenophobia and nationalism.

### The Entry of 1549

The manifesto of the new reign was Goujon's collected engravings, with Martin's commentary on the festivities organized by the city of Paris in honor of Henry II's official entry in 1549 (figs. 36–44). The city had turned to Martin, Goujon, Cousin, and Dorigny to erect the temporary structures that adorned the streets on this occasion.

As royal architect, De l'Orme designed the structures of the royal palaces, those for the Cîté and the Tournelles, and also one of the arches that barricaded the rue Saint-Antoine during the jousting tournaments that took place there at the end of the festivities. It is easy to identify the literary sources of these architectural constructions. The rhinoceros carrying an obelisk was inspired by the "obélifère" elephant of the *Songe de Poliphile*. The arch of the Porte Saint-Denis represents a Hercules with the features of François I amongst representatives of the orders of the nation, the bourgeois, the cleric, the warrior, and the peasant: the thread linking the king's mouth to his subjects' ears represents the royal word, forger of the kingdom's unity. That metaphor was borrowed directly from Alciat, whose treatise presents people chained by the ears to Hercules's tongue in an attempt to emphasize the prevalence of eloquence over force.

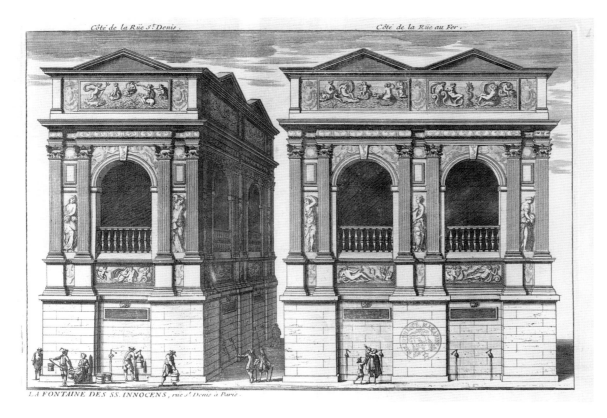

LA FONTAINE DES SS. INNOCENS, rue St Denis à Paris.

The statues of men serving as arch supports were from Vitruvius. The Fontaine des Innocents (Fountain of the Innocents; figs. 36–38), the only permanent monument created at the time of the entry (its platform served as a loge for privileged spectators), took its inspiration from a plan for a triumphal arch published by Serlio; the sculpture was inspired by ancient sculpture (Ariane of the Vatican) and from Fontainebleau (Thétis du Rosso). The sculpture was certainly Goujon's, and perhaps the architecture as well. Lescot was not named.

**36–44. Structures built for the occasion of Henry II's entry into Paris in 1549.**

*The municipality commissioned the creation of structures along the route of Henry II's entry into Paris from a team consisting of Jean Martin, Jean Cousin the Elder, Dorigny, and Jean Goujon. We know of these structures from Goujon's report, illustrated with engravings. Goujon has been credited with the arch of the Porte Saint-Denis, representing François I as Hercules, and the triumphal arch on Rue Saint-Denis near Saint-Jacques-de-l'Hôpital. Authorship is less certain concerning the Ponceau Fountain on Rue Saint-Denis, the rhinoceros in front of the church of Saint-Sépulcre, the portico Lutetia nova Pandora at Châtelet, and the two arches at the ends of the covered Notre-Dame bridge. The arch at the Palais de la Cité was probably constructed by De l'Orme. The Fontaine des Innocents (Fountain of the Innocents: above), which was constructed in stone in the Cemetery of the Innocents, was conserved but reassembled according to a plan focusing on four sides, whereas it originally had two spans on facades on Rue Saint-Denis and one perpendicular to it (the sculptor, Pajou, provided the fourth side when it was reassembled in 1786). The platform served as a tribune for witnessing the royal procession of 1549. The sculptures were by Goujon (some are preserved in the Louvre). According to certain authors, Lescot was responsible for the design of the fountain and its sculpture. After the ceremonies, Henry II lodged at the Tournelles mansion: the jousting tournaments took place in front of this building. Rue Saint-Antoine was cordoned off at the ends by an "H"-shaped structure provided by the city and by a hall built over an arcade that was financed by the king and constructed by De l'Orme.*

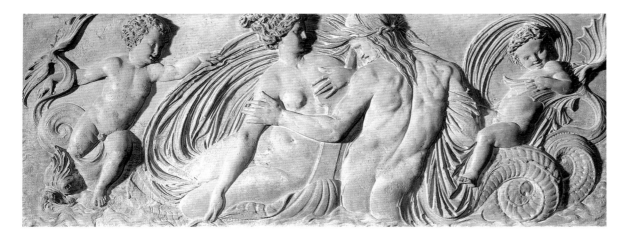

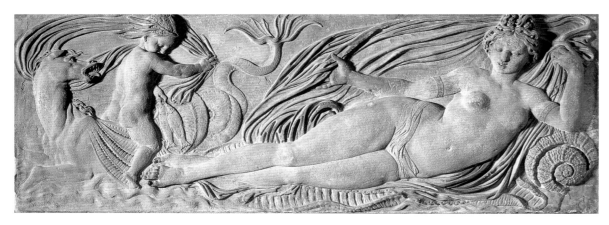

**40–44. Structures built for Henry II's entry into Paris in 1549.**

*Upper right: Arch of the Palais de la Cîté*
*Upper left: Hall over arcade on Rue Saint-Antoine*
*Lower left: Rhinoceros in front of the church of Saint-Sépulcre*
*Center: Arch of the Porte Saint-Denis*
*Lower right: Triumphal arch at the Hôpital de Saint-Jacques*

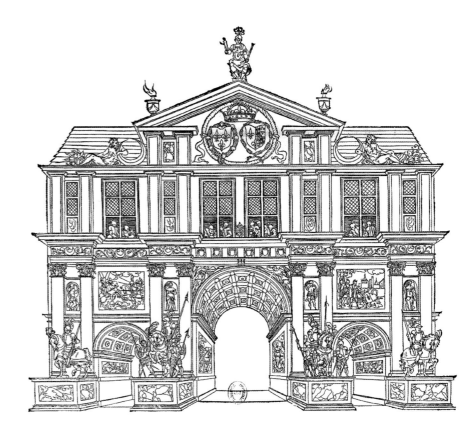

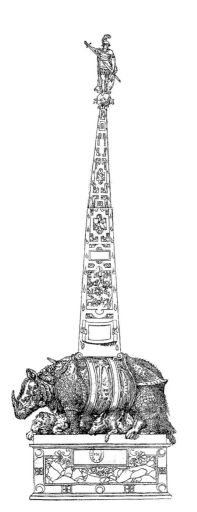

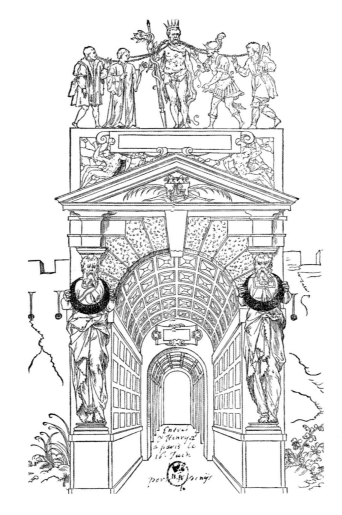

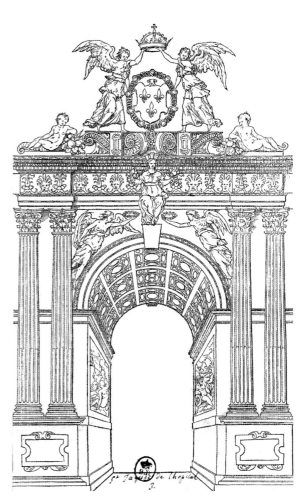

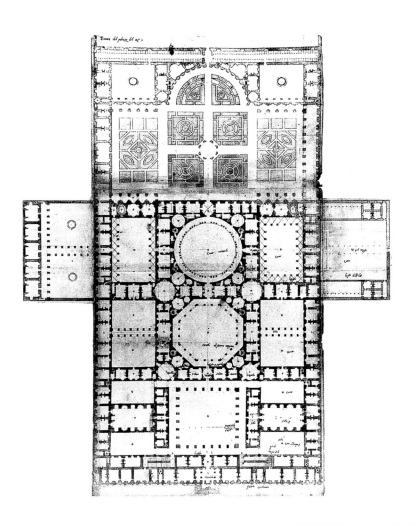

## 45–55. The Louvre

*Upon his return from captivity in 1528, François I decided to make the Louvre his Parisian residence, thereby necessitating reconstruction of the château of Philip Augustus and Charles V. Work was initially limited to destruction of the keep and some renovation. In 1541 at the earliest, he asked Serlio for a construction plan (reproduced at the left). In 1546, one year before his death, he summoned Lescot, who began to build a main building on the site of the medieval west wing. It had a staircase in the center, whose presence was reflected in the projection in the facade. We do not know Lescot's plan in its entirety: it probably included at least one enclosed courtyard similar in size to that of the medieval Louvre, in which the main building constituted the base. Just after his succession in 1549, Henry II confirmed Lescot as architect of the Louvre. He also asked him to move the staircase to the end of the building so that the ground-floor and first-floor halls could extend the full length of the building. The central projection was reproduced next to the stairway and also at the other end, for symmetry's sake.*

*In 1553 Lescot constructed an attic floor above the first floor: it seems that the original intention was to place this floor even with the projections and that the height between them would be lighted by dormer windows. The roof was "broken" à la Mansart, as they would say in the seventeenth century. In 1553 Lescot built the King's Pavilion at the end of the building on the Seine side. It contained the royal apartments on the first floor. The additional story of the main building and the construction of the pavilion were part of the same plan. Under François II and Charles IX, Lescot built the wing perpendicular to the main building on the Seine side. So when Lescot died, the new Louvre consisted of two main buildings at right angles with a pavilion in the corner: the medieval château was reconstructed only on two sides of the courtyard.*

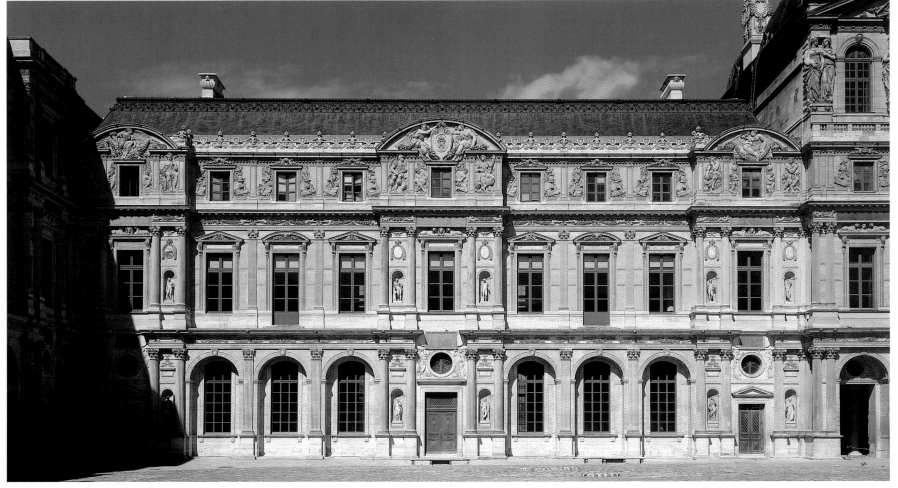

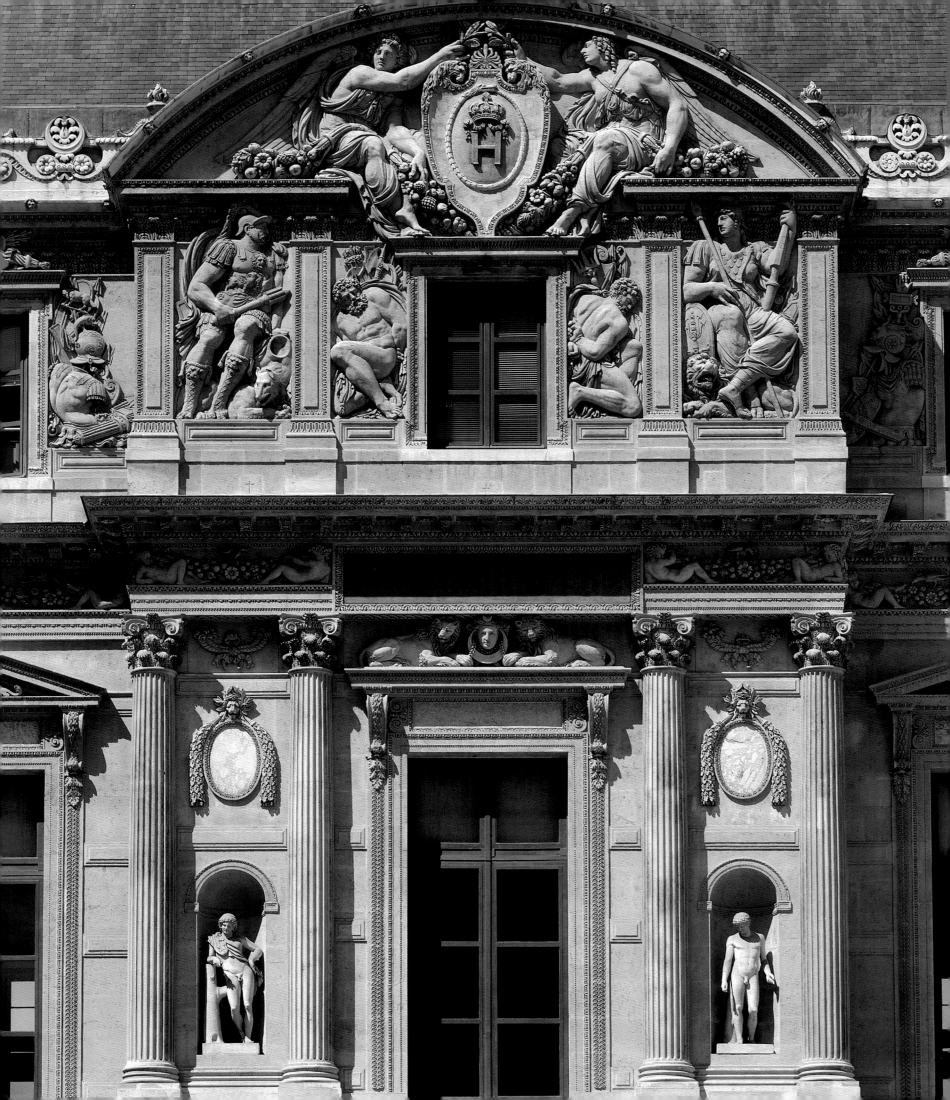

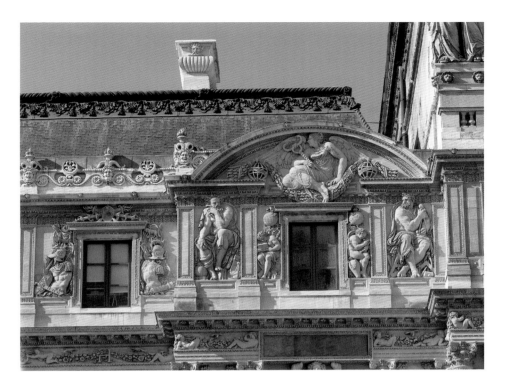

**47–49. The Lescot wing of the Louvre. Sculpture of the courtyard facade.**

*The sculpture of the courtyard facade, created by Goujon and his collaborators, illustrated the arts and arms of France, as well as the imperial pretensions of the king.*

**50–51. The Louvre. The Lescot wing and the king's pavilion.**

*Taken from Jacques Androuet Du Cerceau.*

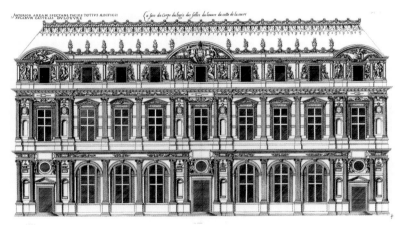

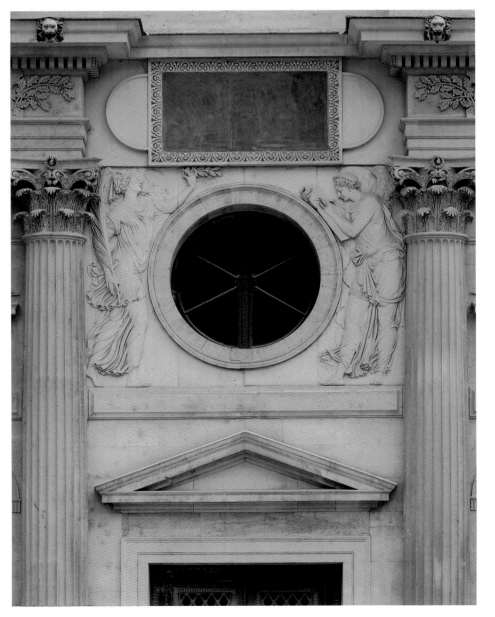

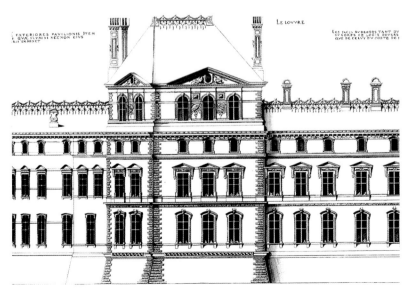

**52–55. The Louvre, Caryatids Hall.**

*The ground-floor hall of the Lescot wing, called the Caryatids Hall, was not vaulted until the seventeenth century. At one end was the musicians' tribune, with caryatids sculpted in 1550 by Goujon according to molds furnished by Lescot. At the other end was the "tribunal," or the royal tribune, which was originally elevated. Jacques Androuet's engraving (below) shows the tribune before the vaulting of the hall.*

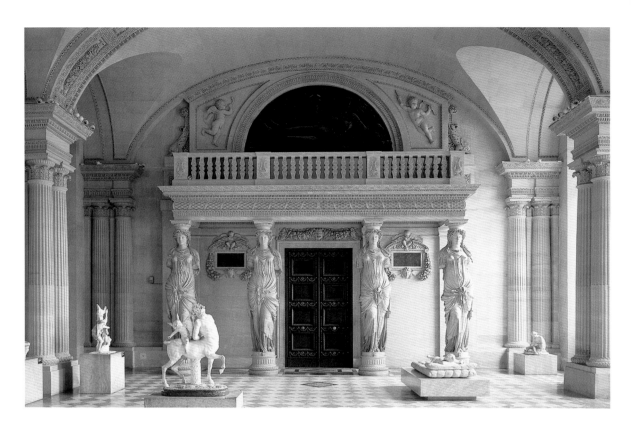

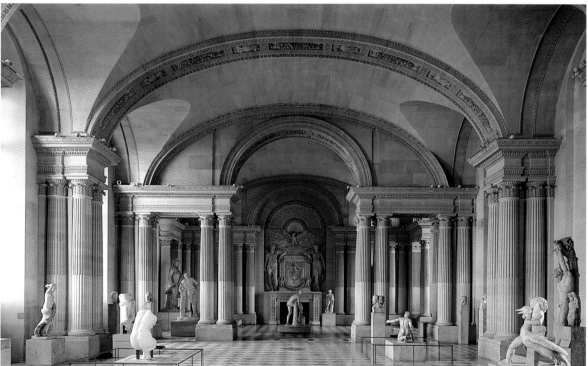

### The Louvre

The Louvre is the only example of explicit collaboration between Lescot and Goujon. Lescot was not confirmed in the position given him by François I until 1549, as if the Louvre, like the Fontaine des Innocents (Fountain of the Innocents), were a mere application of the architectural philosophy of the 1549 entry. And although we do not know the scope and details of his project, we can at least reconstitute four wings surrounding a square courtyard of the same dimensions as the medieval courtyard, and pavilions at the corners (probably at the four corners). It is not impossible that Lescot's plan was as ambitious as Serlio's, which called for sub-build-ings extending to the west into Charles V's area. Lescot's plan was also modified twice, in 1549 and 1553.

Although it was never completed, Lescot's Louvre was the model for residential dwellings of the time and the paragon of French-style architecture (figs. 45–55). All that survived of his design was the organization into wings and pavilions, not the sculpture programs of the facade, which was too costly to have resulted in imitations.

But these sculptures earned Goujon both the reputation for being the most French of the sculptors, and tributes on the facades of the Ecole des Beaux-Arts. The design calling for wings or long buildings of modest depth that contained reception rooms and pavilions that

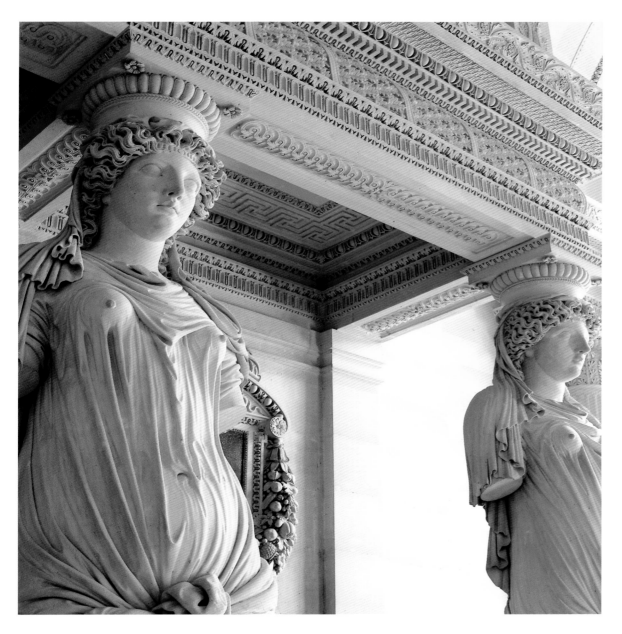

allowed grouping of rooms into royal apartments was common practice until the middle of the seventeenth century, i.e. until the time when the doubling of long buildings made the pavilion seem no longer advantageous. In the Louvre, the main building, with the Hall of the Caryatids, and the pavilion with the king's apartments contain some of the masterpieces of sculpture and French decorative art. The caryatids are particularly interesting because of the enigmatic relationship they create between France and Greece. These caryatids were created by Goujon "according to a plaster model made previously and delivered to him by the aforementioned man from Clagny," i.e. Lescot. Were these plaster models molds of Erechtheum's caryatids? Or were they created according to a Roman copy of the original Greek works or according to an archeologist's drawing, perhaps done by Lescot himself?

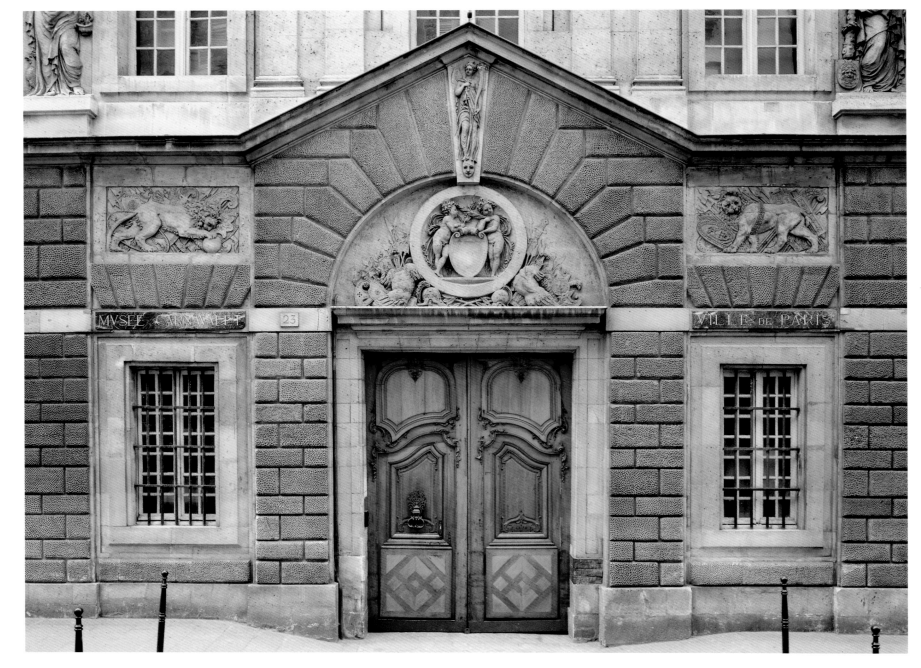

## 56–58. Hôtel des Ligneris, known as the Carnavalet

*This private mansion was begun in 1547 for Jacques des Ligneris, president of the Chamber of Petitions. While it was under construction, Ligneris represented the king of France at the Council of Trent. Construction may not have been complete when he returned in 1553. He died in 1556. The hôtel was changed at the hands of Françoise de La Baume-Montrevel, widow of François de Kernevenoy, also known as Carnavalet, who acquired the residence in 1570; and also in the mid-seventeenth century according to François Mansart's drawings. It was improperly restored in the nineteenth century, as evidenced by some engravings. The work was traditionally attributed to Lescot and Goujon (it even goes back as far as Sauval), but not with good evidence. Some of the remarkable sculpture was probably created before Goujon's disappearance from French worksites in 1562. The restitution of the mansion in 1558, after Ligneris's death, brought about the creation of a main building of modest depth between the courtyard and the garden, two pavilions overlooking the courtyard, a gallery in a wing to the left of the courtyard, a stable courtyard to the right, and a service building on the street side. The courtyard side of the main building was decorated with four reliefs representing the seasons, and they are original (next page). Though they are of high quality, they are not the work of Goujon. The masks decorating the gallery's arcades are by Ponce Jacquiot: they may not have been created during Widow Carnavalet's time. The principal artistic piece is the main building in which the entry portal was cut. This building was originally at street level. The passage opened into a courtyard through an arch decorated with two fanfares and holding the key to an unidentified allegorical figure: these reliefs could be Goujon's. On the street side, the passage also opened through an arch whose key represented Abundance and which also might be Goujon's. On the other hand, the tympanum and the lions in the passage must have been done later: their warlike iconography seems incongruous with the status of Ligneris, who was a member of Parliament. Would it have been more fitting for the widow of a military man, Madame Carnavalet? These beautiful sculptural pieces are sometimes attributed to Pilon. But could they not be Ponce Jacquiot's, whose work remains to be established? All the other sculpture dates from Mansart's work.*

A - Cabinet     D - Salon
B - Bedroom     E - Gallery
C - Master     F - Kitchen
    bedroom     G - Stables

### 59. Hôtel de Diane de France

*The private mansion on Rue des Francs-Bourgeois, known by its seventeenth-century name, Hôtel de Lamoignon, was built for Diane de France, illegitimate daughter of Henry II, starting in 1584. The architect was probably Thibaut Métezeau, royal architect and also Diane's architect. Only half of the building was complete when construction was interrupted, probably because of the siege of Paris in 1589. The second half was built from 1611. The mansion contained a main building with pavilions in the wings overlooking courtyard and garden. The entry was in the center and overlooked a winding staircase. Diane (who died in 1619) bequeathed the mansion to Charles of Valois, duke of Angoulême, illegitimate son of Charles IX. The courtyard wing connecting to one of the pavilions was probably built for him.*

The courtyard facade of the Louvre offers an impressive number of "gallicismes," that is, characteristics so widespread in France that they were ultimately considered to be typically French: the "avant-corps" (projecting section), the false gallery, the "broken" roof. The "avant-corps" was the use of projecting features that gave artistic energy to Gothic architecture. The layout with three projecting sections became the leitmotif of French architecture. The "fausse-galerie" sprang from the same artificial intent as the "avant-corps": since open galleries ran along the edges of medieval buildings, Lescot achieved the same effect by placing the upper levels of his facade slightly further back in relation to the level below. The lower level had deep window recesses, like gallery arcades, in which windows were framed so as to appear to cut through the inside walls. Originally, only the projecting sections were to have a third level, and the decision to extend it to the entire wing was not made until 1553. At the same time, Lescot constructed the first roof with two slopes on each side, commonly known thereafter as the Mansart roof. Since he designed his roofs as steep as medieval ones, he needed to modify the peak in order to avoid creating roofs as high as those in medieval times.

In the Louvre's remarkably coherent composition, then, everything tends toward interpreting the picturesque with reason, giving measure to tradition, and correcting the uneducated accent of the native language while sacrificing nothing of its essence. One of the works of the Pléiade, dedicated directly to the king, conferred upon it the status of a national model. According to Pierre de Ronsard, Jean Goujon sculpted a *renommée* (a figure of a winged woman blowing a trumpet) "specifically to represent the force of the poet's verse / which, like the wind, bore Lescot's name throughout the universe" (*Second Livre de poèmes*, 1560).

*Hôtel des Ligneris, known as the Carnavalet*
The attribution of the Hôtel des Ligneris, known as the Carnavalet, to the Lescot-Goujon team is not a certain one. Despite the transformations it has undergone, and thanks to skillful restoration of its original state, the mansion remains the prototype of this sort of Parisian private mansion (figs. 56–58): a fairly narrow main building between a courtyard and a garden, with an enclosed courtyard on the street side bordered by a gallery wing on one side and by a service courtyard on the other. The Hôtel des Ligneris belonged to the group of buildings erected on the site of the Sainte-Catherine parcel, which was part of the

60–61. Illustrations by Philibert De l'Orme.

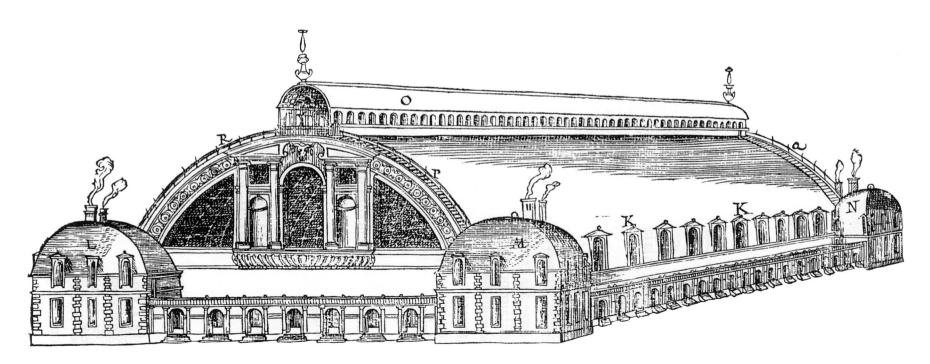

Marais. By dividing its land into lots and selling it, the Sainte-Catherine-des-Ecoliers convent was following the example of François I when he sold the Hôtel Saint Pol by lots, an act that decided the future of that aristocratic part of town.

Other projects begun during François I's reign were not completed until the following reign. This was the case for a topographical map of the city begun about 1520: the results were rapidly exploited in maps that remained poorly organized until the publication of Truschet and Hoyau's remarkable map (chapt. IV, fig. 5). It was drawn by Germain Hoyau, printed by Olivier Truschet, and published in *Les Antiquitez, histoires et singularitez de Paris, ville capitale du royaume de France* (*The Antiquities, History, and Singularities of Paris, Capital of the Kingdom of France*) by Gilles Corrozet in 1550. This revised, expanded, and organized version of *La Fleur des antiquités* (*The Flower of Antiquities*) already cited (1532) was the premier guide to monuments in the city.

### De l'Orme's Work

Although his most important work is (or rather was, since it was not preserved) outside of Paris, De l'Orme certainly participated in the beautification of the capital. Here we will mention only his work on the renovation of Les Halles (the large outdoor market building), a modernization ordered by Henry II in 1550, and especially for his plans for a dormitory for the Montmartre Benedictines and for the Royal Basilica (figs. 62–63). The gigantic dormitory in the form of a tower topped with an astronomy cupola was to have been constructed on Montmartre, dominating Paris like a lighthouse; its construction was terminated upon the death of the king, who had commissioned it from his architect. The colossal basilica or royal hall may not have been designed until the period of disgrace that descended upon De l'Orme after the death of his patron. But this extraordinary foreshadowing of the halls, stations, and warehouses of the nineteenth century dates from 1560–1561, at the latest. Its creation depended entirely on the use of a framing technique invented by De l'Orme and promoted by Henry II that involved the assembling of small boards to create longer boards than those obtainable from the tallest trees. The hall would have been 150 feet wide, and until then it had been impossible to obtain widths exceeding forty-five feet. Henry II's reign was also a time of invention, for it was then that Abel Foulon invented the automobile!

Of De l'Orme's work, time has spared only the tombs, the tomb for the heart (fig. 64) and the tomb for the body (figs. 65–66) that Henry II ordered for his father's burial. Both were created in Paris. The idea of an urn for the heart was original: the reliefs, created according to De l'Orme's drawings by Pierre Bontemps, one of his regular collaborators, showed the architect's extraordinary virtuosity in designing ornaments and figures. These are talents that are also evident in the tomb for the body, which treats the themes of the triumphal arch and of praying and deceased figures first represented in the tomb of Louis XII (chapt. V, figs. 8–11). The masterpiece has its flaws: one is the unusual collective nature of the tomb, which was intended not only for the king's spouse, but also for his mother and those of his children who died young; the other is the fact that it was never completed.

Opposite, bottom:

**62. Philibert De l'Orme. Plan for the Royal Basilica, before 1561.**

*De l'Orme published this drawing in the Nouvelles Inventions pour bien bastir et à petits fraiz (New Inventions for Good, Low-Cost Construction). It is a plan for a royal basilica, a large hall for royal celebrations. It includes pavilions and is covered with a wood roof framed according to a technique invented by De l'Orme.*

**63. Philibert De l'Orme. Plan for a dormitory for the Abbaye de Montmartre.**

*This plan was drawn at the request of Henry II and published in the Nouvelles Inventions pour bien bastir et à petits fraiz (New Inventions for Good, Low-Cost Construction), 1561.*

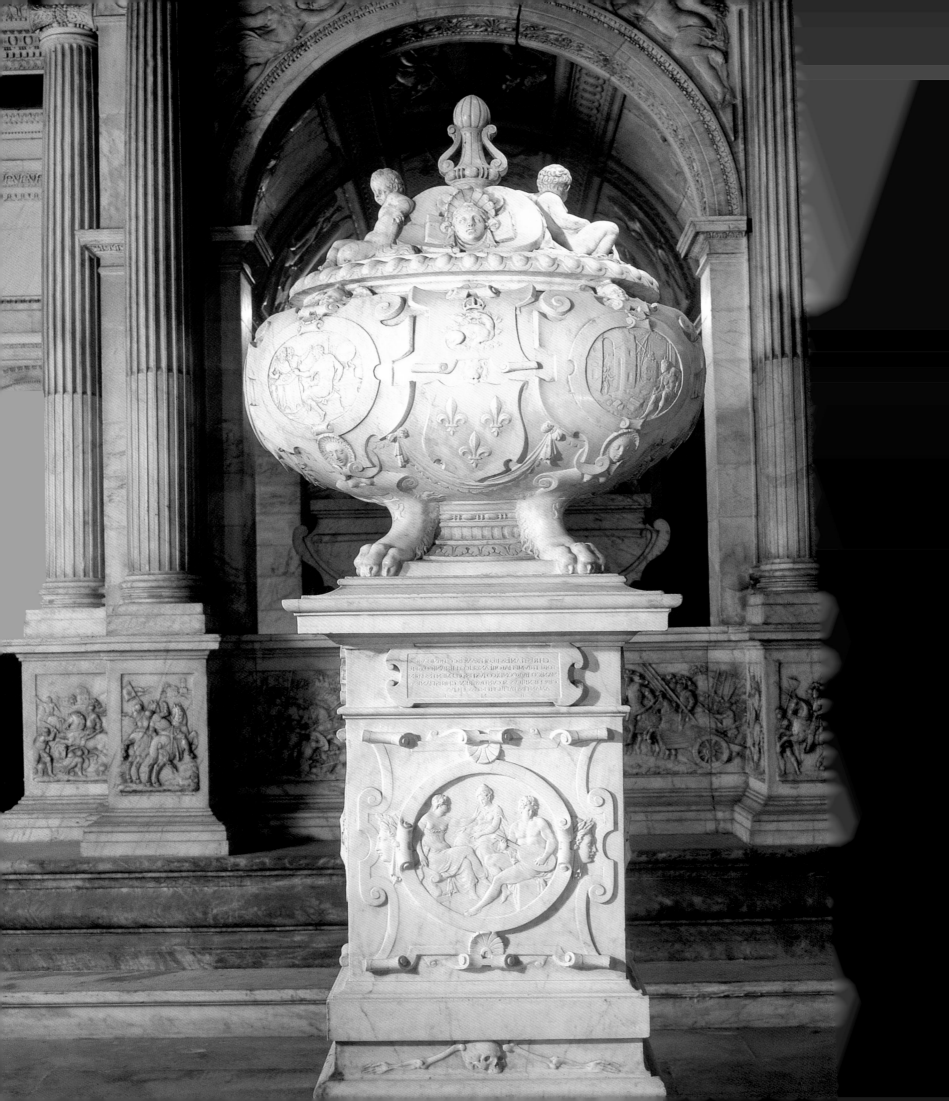

## 5 – ARCHITECTURE AND MONUMENTAL SCULPTURE UNDER THE LAST THREE VALOIS KINGS (1559–1589)

### The Valois Rotunda

The tomb of Henry II and Catherine (figs. 77–79) inspired great admiration. The concept was still that of the triumphal arch depicting praying and deceased figures. Catherine had planned to house the tomb in a mausoleum known as the Valois Rotunda (figs. 74–76). This circular mausoleum, originally set apart, with a central chamber accessible only through a narrow corridor, was inspired by ancient Roman mausoleums and plans from Peruzzi and Michelangelo familiar to De l'Orme, who is assumed to be the designer of the rotunda. For this monument Pilon created a *Résurrection* (Resurrection) and a *Vierge de douleurs* (Grieving Virgin), both of which bore traces of Michelangelo's style. There was also a *Saint François en extase* (Saint Francis in Ecstasy; foreshadowing Bernini) that may have been intended for the rotunda, but was instead created later for Henry III, patron of the Franciscans. The rotunda with its monuments and sculpture is defined by its Italian influence, especially Michelangelo's, more than any other French Renaissance work. The

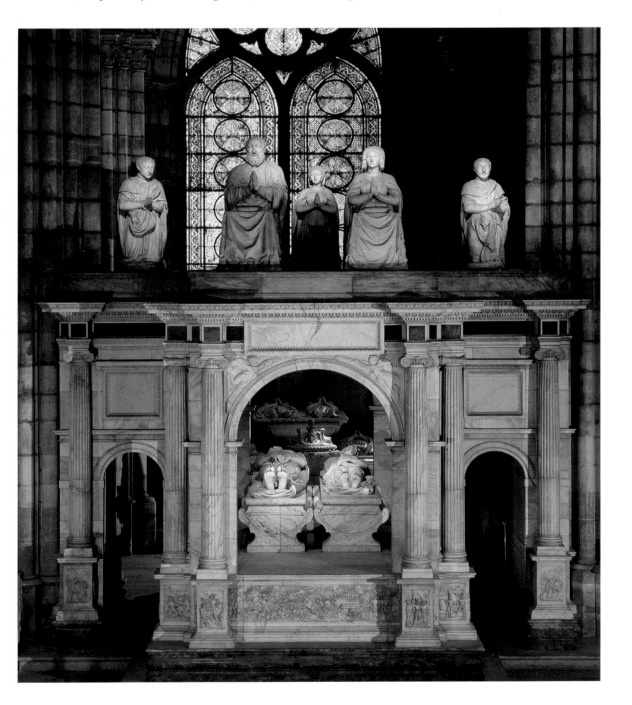

**64. Tomb for the heart of François I, 1550.**

*It was traditional to bury the king's heart in a tomb housed near the tomb for the body. Since François I died at Rambouillet, the heart tomb was created for the nearby Hautes-Bruyères Abbey. It seems that it was moved shortly thereafter to the Célestines Church in Paris, where there were already a number of tombs. After several moves, it joined the tomb of the body in Saint-Denis in 1818. It was created by the sculptor Pierre Bontemps according to Philibert De l'Orme's drawings, beginning in 1550, and probably in Paris at the Hôtel d'Etampes, which was put at the architect's disposal to create François I's tombs. The medallions represent the arts that constituted the glory of his reign.*

**65–66. Tomb for the body of François I**

*François I's tomb at Saint-Denis was commissioned by Henry II from Philibert De l'Orme, who provided the drawings and supervised construction beginning in 1548. Henry II's death in 1559 led to De l'Orme's disgrace, and the tomb was not finished. The final work was probably done by Primaticcio. The tomb shows the praying figures of François I; Queen Claude, his first wife (who died in 1524); Louise of Savoie, mother of François I (who died in 1531); and two of his sons, the first dauphin, François (who died in 1536), and Charles, duke of Orléans (who died in 1545). Some of the praying figures were probably duplicates of works prepared for the tombs of François I's parents, who died well before he did. The two reliefs represent the victories of Marignan and Cérisolles. Many sculptors collaborated on the creation of the tomb, namely François Marchand and Pierre Bontemps, who frequently worked with De l'Orme. The sculptures of the deceased royal couple were probably the work of Pierre Bontemps. Later on, De l'Orme ordered sixteen "putti" from Germain Pilon and Ponce Jacquiot, but they were never put in place. One or the other of these two sculptors deserves credit for the most beautiful works, the reliefs of the vault representing the Résurrection et Quatre Prophètes (The Resurrection and Four Prophets), which were probably created according to drawings by Primaticcio.*

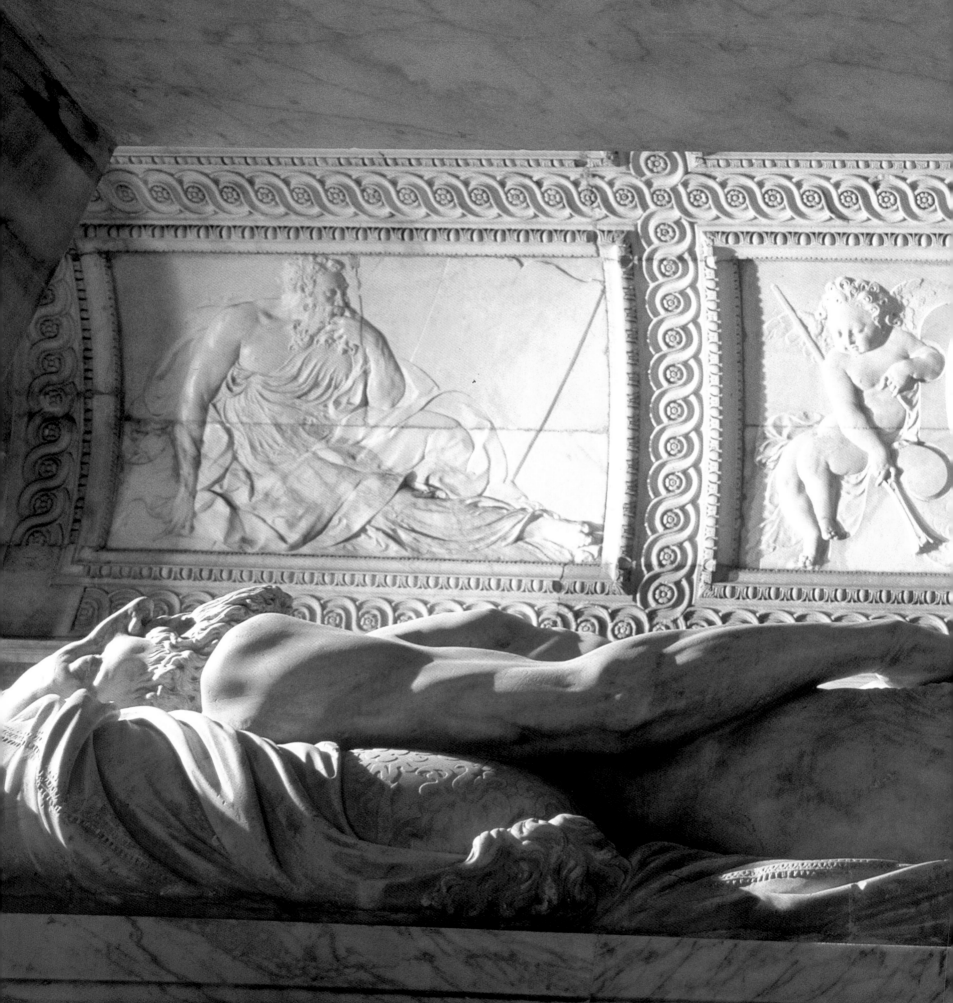

## 67–71. The Tuileries

In 1564 Philibert De l'Orme began construction on an immense palace on the site called the Tuileries in western Paris for the queen mother, Catherine of Médicis. The building plan called for three large courtyards. By the time of De l'Orme's death in 1570, only the main building between the courtyard of honor and the garden had been built, with a celebrated spiral staircase attached to the ceiling in the middle. Bullant succeeded De l'Orme and built the large pavilion to the far south of this building. But all of Catherine's attention was directed to the private mansion that she was having constructed in the city (fig. 73). The scope of the Tuileries project had been reduced to the Cour d'honneur (Courtyard of Honor), for which the lateral wings had been erected, but it was abandoned nevertheless. In 1578–1579 Henry III asked his architect Baptiste Androuet Du Cerceau to redo a master plan based on the original three-courtyard plan. De l'Orme's original plan became known through the publication Les Plus excellents bastiments de France (France's Most Superior Buildings), 1579, by Jacques Androuet Du Cerceau (drawings and structures reproduced). The drawings of Baptiste, Jacques's son, have been preserved in London. The Tuileries were also expanded and transformed in the seventeenth century. They were destroyed in 1871 by the Commune; only a few scattered remains are left.

Opposite: Remains of the Tuileries (Ecole nationale des Ponts et Chaussées)

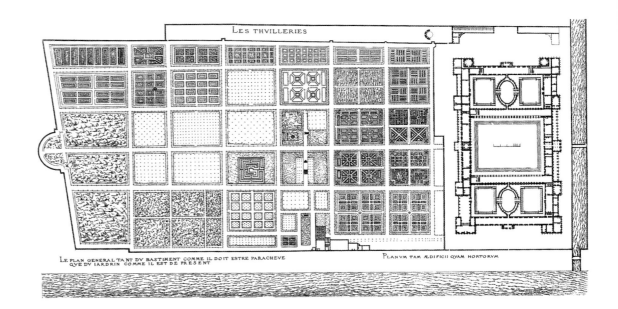

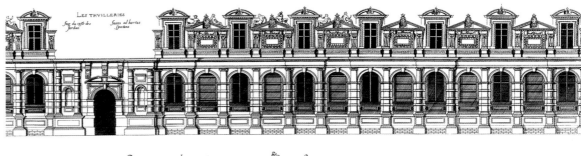

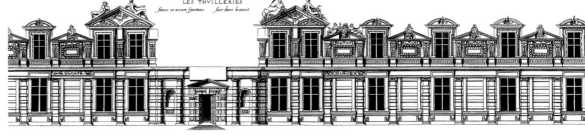

## 72. Saint-Germain-des-Prés Abbatial Palace

*This building was constructed in 1586 in the chevet of the abbatial church for Cardinal Bourbon, abbot of Saint-Germain-des-Prés, probably by Guillaume Marchand. Like the Louvre, the palace included an elongated main building and a large pavilion, but it was probably never finished. A courtyard led into it, one that was doubled at the end of the seventeenth century by a stable courtyard recalled by the Place de Furstemberg.*

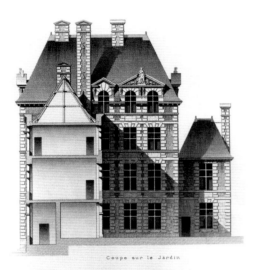

Coupe sur le Jardin

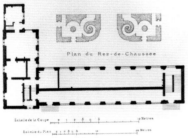

Plan du Rez-de-Chaussée

## 73. Catherine de Médicis Column

*In 1573 Catherine de Médicis ordered her architect, Jean Bullant, to build a private mansion near Saint-Eustache, inside the city walls. She had decided to give up on the Tuileries palace project, having judged the location too remote and vulnerable to the Protestants. Only one monumental column remains of this city palace (known by its seventeenth-century name, the Hôtel de Soissons). The column is usually presented as an astronomical observatory, located right next to the Bourse du Commerce: Catherine was passionate about astrology. Like the Trajan column in Rome, it is really more of a commemorative work, dedicated to Catherine's ongoing devotion to her dead husband. It was right next to the wing containing the queen's first-floor apartments, from which one could access the column's interior. The ironwork crown replaced the upper part of the staircase (inside the column) and emerged above the capital. The church of Saint-Eustache is in the background.*

queen mother requested an equestrian statue of the dead king from the most famous of his compatriots. When Michelangelo declined, the commission went to Daniel de Volterra. No one knows where Catherine intended to put the statue, for which the horse was completed (it was eventually used in the equestrian statue of Louis XIII on the Place des Vosges).

### The Tuileries

The queen mother's second great work site, the Tuileries, provided evidence of the great Florentine's inventions: the reclining figures on the pitch of the pediments and the three-tiered staircase, done in imitation of the Laurentian Library's staircase. The queen mother even imposed her taste when it came to the polychrome marble and the overabundance of ornamentation and symbols, whereas De l'Orme had made it a manifesto of French art by virtue of his beautiful use of stone in the drum and ringed columns, his plant ornamentation explicitly grounded in Gothic tradition, and especially the suspended staircase.

Without the precedent of Serlio's plan for the Louvre, De l'Orme might not have dared design this enormous Tuileries palace with three courtyards, a double palace with a courtyard for the king, one for the queen mother, and a common courtyard. It would have been inconceivable to build this structure within the constraints of the urban Louvre site, but it was feasible to do so on the Tuileries site, which was then outside the city limits. But it was precisely this location that doomed the enterprise to failure. Although it was begun at a time when the civil war seemed to be under control, construction was brought to a halt by the Saint Bartholomew's Day massacre, which revealed how vulnerable the palace would have been. An oversized project, and the realization of a more reasonable plan under Henry IV: on all counts, the history of the Tuileries is representative of the architecture of the late Valois kings.

### The Private Mansions

The abandonment of the Tuileries inspired the substitution of two other building projects: Jean Bullant's construction for the queen mother of the Paris mansion known in the eighteenth century as the Hôtel de Soissons (fig. 73); and the construction of the Petit Bourbon hall, which was the setting for several memorable events, as we have seen. Paris lacked a grand hall appropriate for hosting the most important social events. De l'Orme built temporary halls in the Hôtel des Tournelles for the entry of 1549 and the fatal jousting tournament of 1559, and he planned both the royal basilica and the enormous oval halls in the Tuileries. Thibaut Métezeau, one of his followers, created the great hall in the Hôtel de Bourbon, or Petit Bourbon, the mansion that the dukes of Burgundy owned next to the Louvre during the reign of Charles VI. He probably used De l'Orme's framing technique.

Many residences in Paris became construction sites during the reign of the late Valois kings, but it is impossible to trace the history of many of them with any accuracy. The unique decor of the Hôtel d'Hercule, on Rue des Grands-Augustins, may be from the very end of the century. The Hôtel de Diane de France in the Sainte-Catherine area (fig. 59) was undertaken by Métezeau in 1584, during the second long peaceful period; it was only half finished then, not to be completed until the seventeenth century. The chronology and results were the same for the Hôtel de Nevers that has already been mentioned. Given its late sixteenth-century condition, the palace of the abbey of Saint-Germain-des-Prés, begun in 1586, was probably never finished, although its intended occupant, the Cardinal-Abbot Charles de Bourbon, whom the league wanted to make king, no doubt had more elbow room than most in league-biased circles. Even though they were never finished, these princely dwellings nevertheless bequeathed to the next century not only the task of completing construction, but also some important innovations: the use of the colossal order in the form of tall pilasters rising to the top of facades; and especially the association of brick and stone masonry with the arrangement in wings and pavilions, a combination usually recognized as typical Louis XIII style.

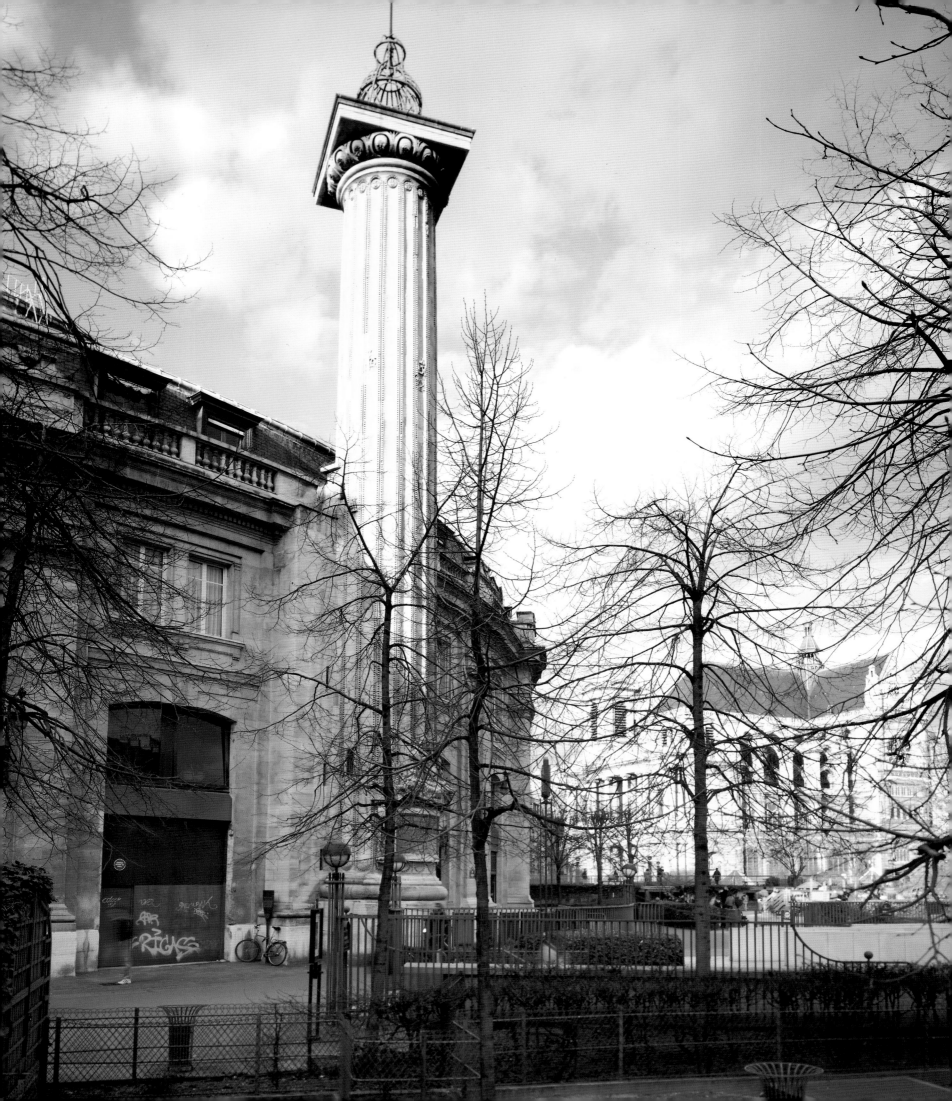

### 74–76. Valois Rotunda, Saint-Denis

This rotunda was left unfinished and was then destroyed in the eighteenth century. Our knowledge of it comes from J. Marot's and I. Silvestre's seventeenth-century prints and from those published in Dom Michel Félibien's L'Histoire de l'abbaye royale de Saint-Denis en France (History of the Royal Abbey of Saint Denis, France), 1706. The rotunda's history is uncertain and the following summary is this author's interpretation of events. Henry II may have had the idea of constructing a funerary chapel next to the abbey church of Saint-Denis, and De l'Orme may have drawn the plans. Upon Henry II's death, the project was taken on by Catherine de Médicis, who, like Queen Artemis for King Mausolus, wanted to consecrate a mausoleum to receive the royal couple's tomb. Primaticcio presented a new plan for the rotunda: in Italy in 1563 he showed it to Vasari, who spoke of it in his Lives of the Artists. But Primaticcio was replaced by De l'Orme as architect for the queen mother. Construction of a plan with eight chapels began in 1570, the year that De l'Orme, author of the plan, died. Jean Bullant had been De l'Orme's collaborator and was his successor on the queen mother's construction sites. The rotunda must have been built next to the church, but detached from it. Because of the Saint Bartholomew's Day massacre, the rotunda, which was barely begun, was attached to the church in 1572 so as to be accessible only from there. If it had been a separate building, it could have fallen victim to Protestant attack. It is strange that seventeenth-century pictures show it still separated. The number of chapels was probably reduced to six at the same time: this plan was carried out.

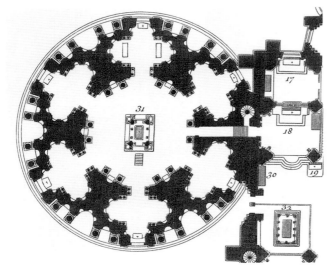

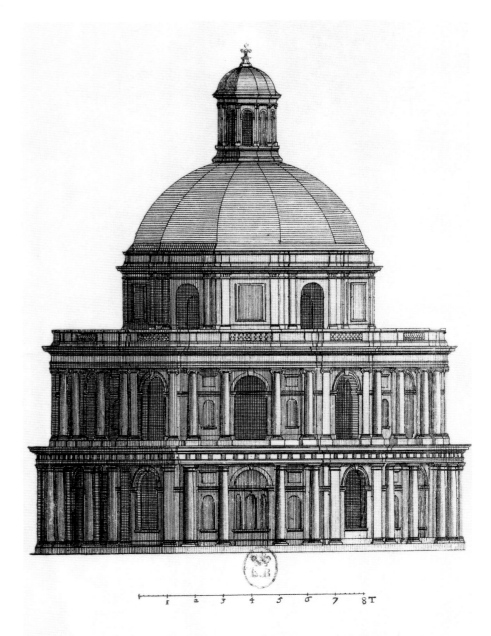

*Eleuation du dehors de la sepulture des Rois des Valois à St. Denis.*

Opposite page and the following two pages:

77–79. Tomb of Henry II and Catherine de Médicis

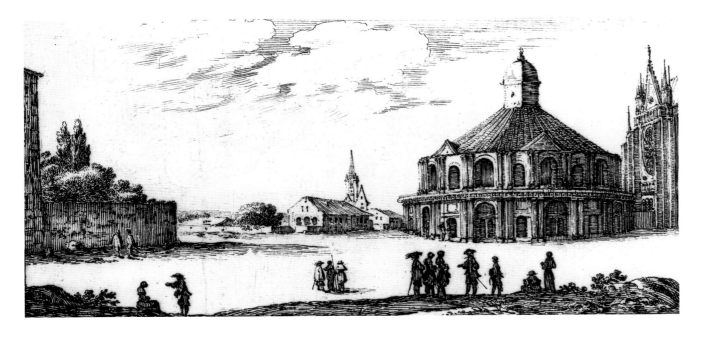

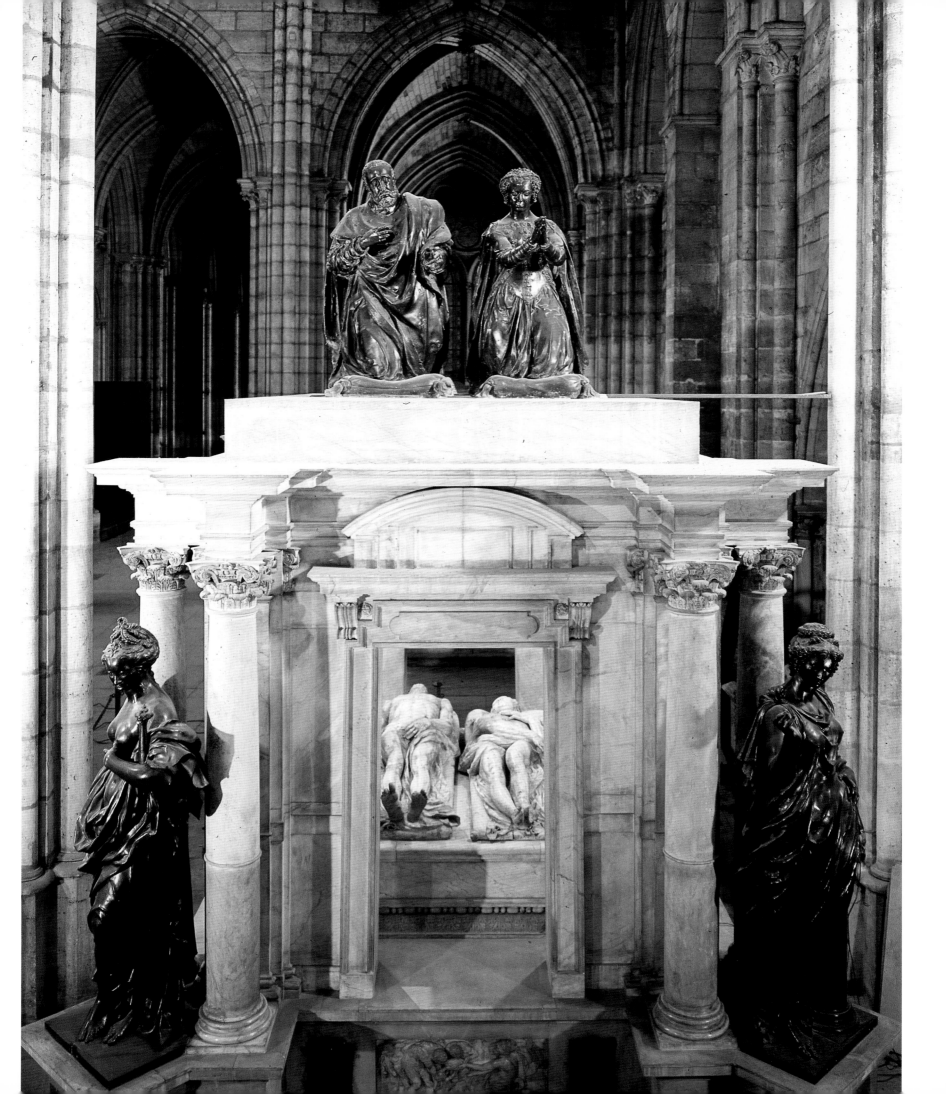

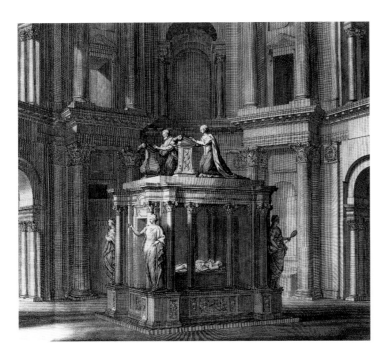

**77–79. Saint-Denis. Tomb of
Henry II and Catherine de Médicis.**

*The tomb was commissioned from Primaticcio by Catherine
de Médicis, and the sculpture was done by Germaine Pilon.
The figures of the deceased are marble; the praying figures
and the Virtues at the corners are bronze. This tomb was
intended for the center of the Valois Rotunda.*

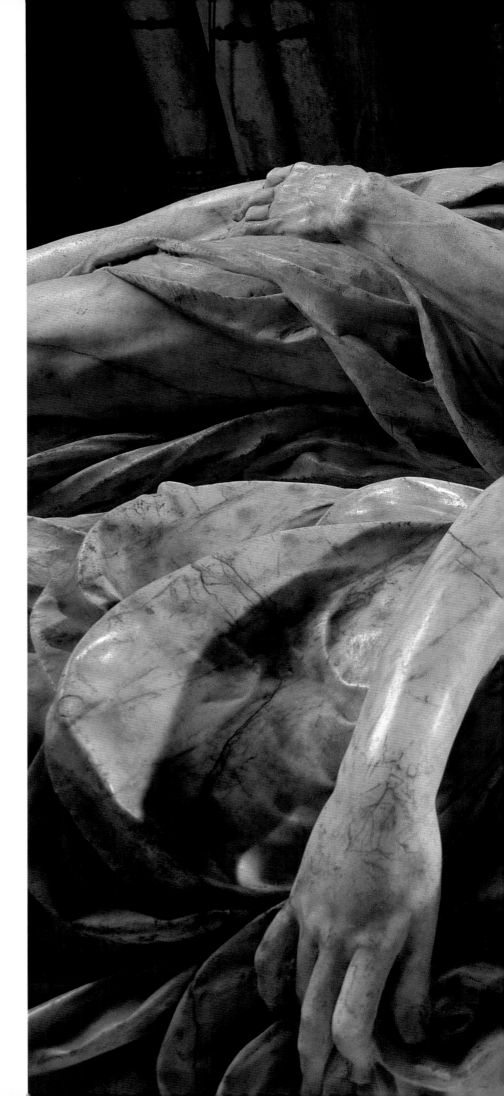

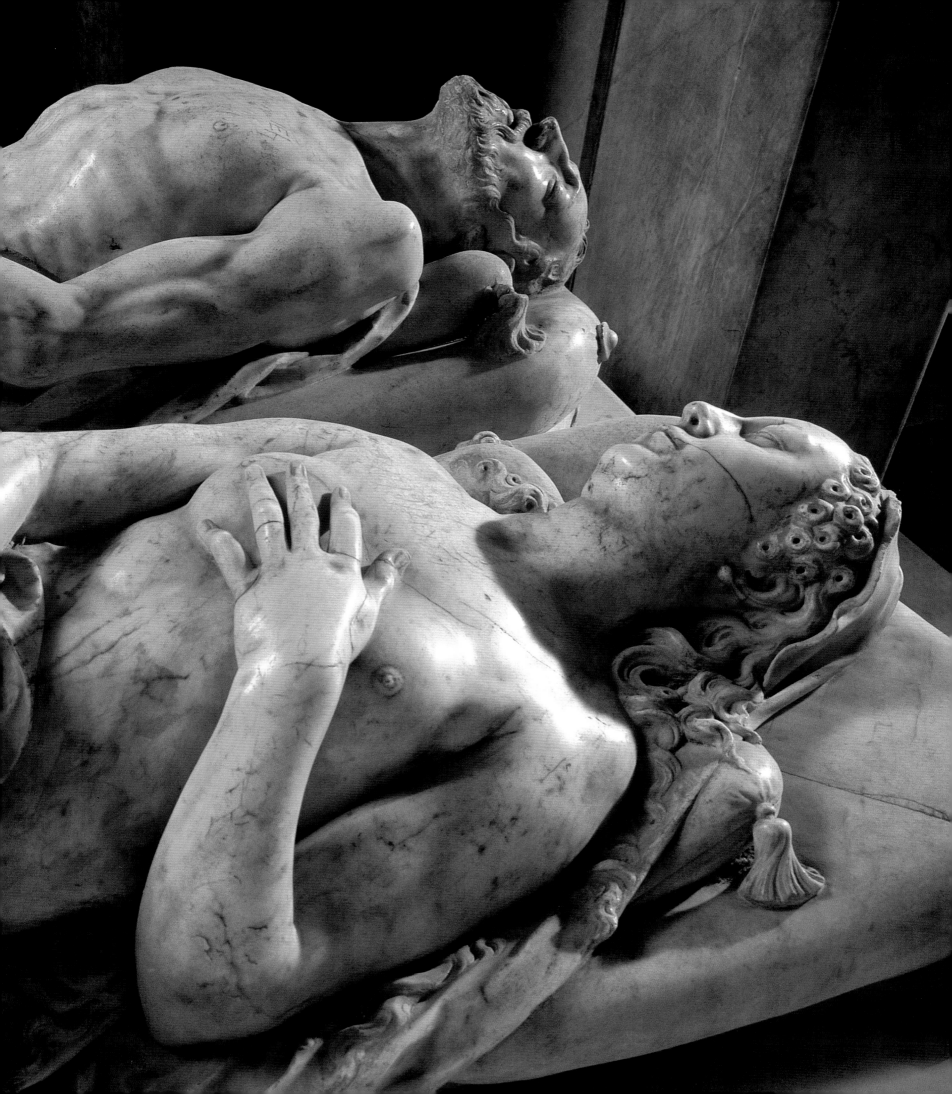

## 80–83. Birague Chapel and Tombs

*The tombs of René de Birague and his wife, Valentine Balbiani, were both put in the chapel that Birague had constructed at Sainte-Catherine-des-Écoliers, a church in the Marais that no longer exists. After his wife's death in 1572, Birague became chancellor in 1573; he entered the priesthood and became cardinal in 1578. Valentine Balbiani's tomb was commissioned from Germain Pilon in 1573; its original condition is known from a drawing from the Gaignières collection. René de Birague's tomb was commissioned from Pilon by the cardinal's heirs. The drawn plan has been conserved. It was approved by the heirs and executed with almost no change. The bronze statue of the cardinal was painted. The remains of the two tombs are conserved in the Louvre.*

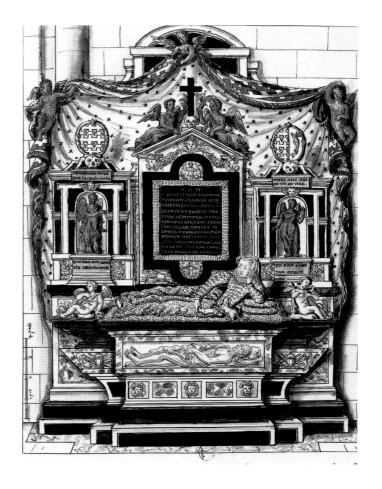

The increased number of construction sites was due to the process of escalation that obliged every successful organization, beginning with the court, to show off through ruinously high expenditure. Du Cerceau's 1559 book, with its hierarchy of models, provided descriptive advice regarding the next social level to which one should aspire. In *Discours politique et militaire* (*Political and Military Discourse*), 1586, a critical study of the situation in France by François de la Noue, the phenomenon is analyzed and vigorously condemned. In *Causes de l'extrême cherté qui est en France* (*Causes of the Extremely High Prices in France*), 1586, Bernard de Girard, Lord of Halian and historiographer of Charles IX, revealed another deviation of French architecture, noting that in the past "there was less of a tendency to pay attention to external geometrical and architectural proportions, which spoiled the internal spatial arrangements of many buildings." The creation of comfortable interiors was a constant preoccupation of French architecture. It was an art perfected during Henry II's reign, when apartments were enriched by the addition of two new rooms, the antechamber and the "cabinet." De l'Orme was partly responsible for this innovation, and he wrote: "In my opinion, the architect would do better to neglect column ornamentation, measurements, and facades than the beautiful natural laws concerning the use, convenience, and benefit of the inhabitants" (*Premier Tome de l'Architecture*, or *First Volume of Architecture*, 1567). We must assume, then, that Catherine ordered the Italian-style repetition of features and the skillful geometry *à la* Serlio of the Palais des Tuileries.

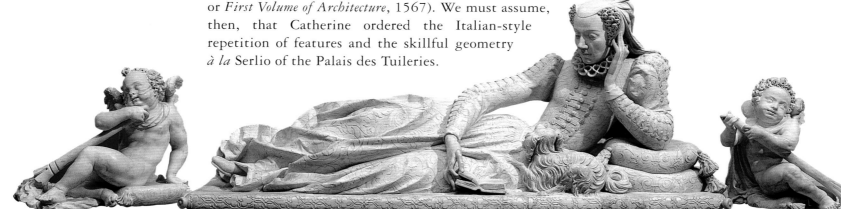

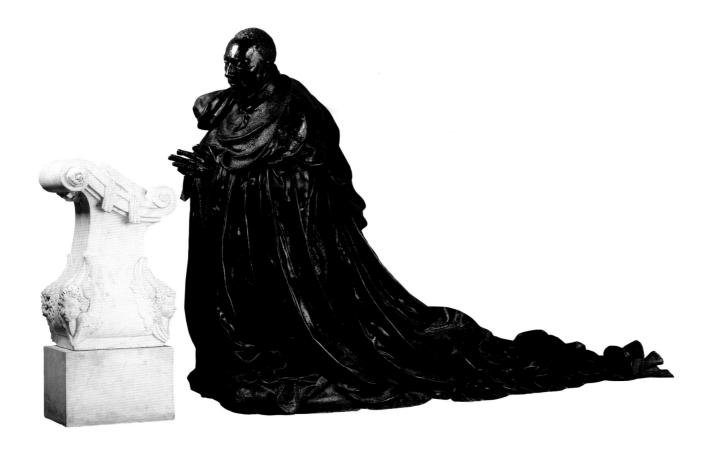

## The Birague Chapel

The Italian influence had never been stronger in France than during the time of Catherine de Médicis, and of course it is to an Italian that we owe Pilon's masterpiece. René de Birague belonged to the Birago family of the Milan group that became committed to the French and took refuge in their country. He married Valentine Balbiani of Turin. Birague had a funerary chapel built at the Sainte-Catherine-des-Ecoliers convent (which was in the Marais, near the lot on which the Hôtel des Ligneris and the Hôtel de Diane de France were built) to house the royal couple's tomb. Pilon's work on the Birague Chapel constitutes the last great French sculpture of the sixteenth century. Tradition is very evident in it, less in the ever-present iconography of the praying and reading figures than through the stylistic filiation from Goujon to Pilon: the *Déploration du Christ mort* (*Lamentation over the Dead Christ*) of the Birague Chapel recalls that of the Saint-Germain-l'Auxerrois jube (fig. 33). But the spirit of what would be called the baroque period was beginning to emerge: the large curtain of Valentine Balbiani's tomb was Bernini's style before its time—unless (since this observation was not made until the seventeenth century) it was added later.

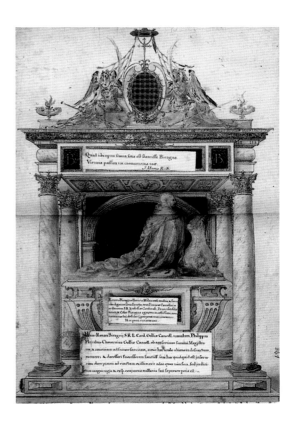

As it came to a close, then, the sixteenth century bequeathed more than failures to the seventeenth century: it also left project plans and a certain *savoir-faire*. Though they worked mainly from Lescot's and Primaticcio's designs, the Goujons and Pilons nevertheless founded a French school of sculpture that would be brilliantly famous in the following century, the "grand siècle." These were dynasties of architects, mostly from nearby provincial areas, whose descendants would serve the kings—names like Le Mercier, Métezeau, and Du Cerceau. The plans that the late Valois kings had conceived for Paris would be realized by Henry IV, particularly the creation of a new bridge, the first to have no houses on it: the Pont Neuf. And last of all, the inheritance was partly a sense of the spirit of French architecture that was implemented in the Louvre by Lescot and codified in the *Premier Tome de l'architecture* (*First Volume of Architecture*), 1567, by Philibert De l'Orme. This book was the first French treatise on architecture.

# THE LOUVRE

**Above:**

*The Flore Pavilion and the Pont Royal.*

*The pyramid in the Cour Napoléon.*

The Louvre was originally a fortress begun in 1190 to reinforce the western, Seine-bordering part of the fortified enclosure that Philip Augustus had ordered built around Paris. In the 1360s, this fortress was transformed into a royal residence for Charles V, who had a new urban enclosure built, thus placing the Louvre within Paris limits. The original Louvre covered only a quarter of the area of the present Cour Carrée (Square Courtyard). It was gradually destroyed as the sixteenth and seventeenth centuries wore on, and only fragments of it survive today, namely Philip Augustus's donjon and Charles V's spiral staircase. The Lescot wing was built under Henry II starting in 1549 by Pierre Lescot. The sculptures of the Carrée Courtyard facade were done by Goujon and his studio. The only noticeable modification in this facade was the elimination of mullions and crosspieces in the windows. The ground floor was entirely occupied by the Caryatids Hall: at one end was the musicians' tribune with caryatids sculpted by Goujon according to the models provided by Lescot in 1550; at the other end was the tribune where the king sat enthroned. It was originally elevated by five steps.

The quadrupling in size of the Cour Carrée was planned under Henry IV, begun under Louis XIII, and completed under Louis XIV. The Clock Pavilion and the Lemercier wing, imitating the Lescot wing, were constructed starting in 1624 by Lemercier, Louis XIII's first architect. The wing called the Colonnade—named as such because the the colonnade adorns its exterior on the city side—was constructed under Louis XIV according to a plan drawn up in 1667 by the "petit conseil" made up of Le Vau, Le Brun, and Claude Perrault. The plan was modified in 1668 and executed by Perrault alone. In 1667 the intention was still to locate the royal apartments on the first floor of this wing. But because it proved impossible to acquire the land needed to make enough room for the colonnade, the planners resigned themselves to keeping the royal apartments in the south wing, which was then doubled in order to enlarge the apartments. This expansion was carried out by Perrault in 1668, and it enclosed the king's pavilion, which was built in 1551–1553 by Lescot for Henry II. The first floor originally contained the show room and the king's bedroom.

The wing of the "little gallery," or the Apollo Gallery, was constructed in about 1566–1567 on the first floor, and it was covered with a flat roof; the "little gallery" interior was remodeled in 1655–1658 into a summer apartment for Queen Anne d'Autriche and decorated with Romanelli paintings and Anguier stucco. In 1594–1596, it was moved up a floor, and there it bears the monograms of Henry IV and Gabrielle d'Estrées. She was the woman Henry IV wanted to marry; she died in 1599. This floor contained the Kings' Gallery, in which the portraits of the kings and queens of France were assembled. It burned in 1661 and was reconstructed by Le Vau to house the Apollon Gallery.

The Grande Galerie (Great Gallery) wing, or waterfront gallery, was begun in the second half of the sixteenth century: the ground floor of its eastern section dates from this century. It was expanded and floors were added under Henry IV. The "nobles' floor" allowed passage from the Louvre to the Tuileries (now destroyed). The Grande Galerie in its current state dates essentially from the time of Napoleon I and was created by Percier and Fontaine. The western part of the wing was reconstructed under Napoleon III by Lefuel, who was the principal creator of almost all the buildings and facades visible in the Cour Napoléon (Napoleon Courtyard) and on the Place du Carrousel.

In the middle of the Cour Napoléon, there is a pyramid built over the main entrance of the Grand Louvre. It was designed by architect I. M. Pei. The Grand Louvre is the result of decisions made in 1982 by President François Mitterrand to affect the Louvre as a whole by altering the museum. For the most part, Mitterand's plans have been carried out.

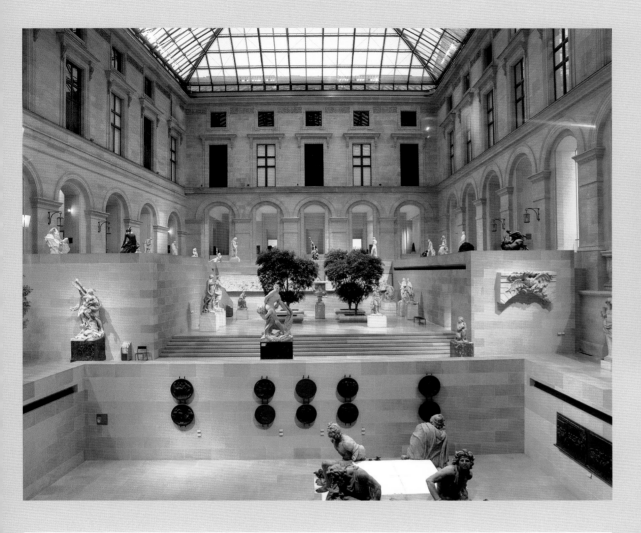

Below:

*Archeological crypt of the Cour Carrée.
Vestiges of Philip Augustus's Louvre.*

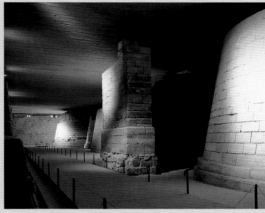

## Plan of the Louvre

1. *Lescot wing*
2. *Clock Pavilion (or Sully Pavilion)*
3. *Lemercier wing*
4. *North wing of the Cour Carrée*
5. *Colonnade wing*
6. *South wing of the Cour Carrée*
7. *King's Pavilion*
8. *Wing of the Petite Galerie (Small Gallery) or Gallery of Apollo*
9. *Pavilion of the Salon Carré*
10. *Wing of the Great Gallery*
11. *Pavillon des Etats*
12. *Flora Pavilion*
13. *Wings overlooking the Queen's Courtyard or Sphinx's Courtyard*
14. *Wing between the Lefuel and Visconti Courtyards*
15. *Denon Pavilion*
16. *Mollien Pavilion*
17. *Buildings constructed as ministries by Lefuel from 1853 to 1857*
18. *Wing built by Percier and Fontaine from 1810 to 1824*
19. *Section reconstructed by Lefuel from 1873 to 1875*

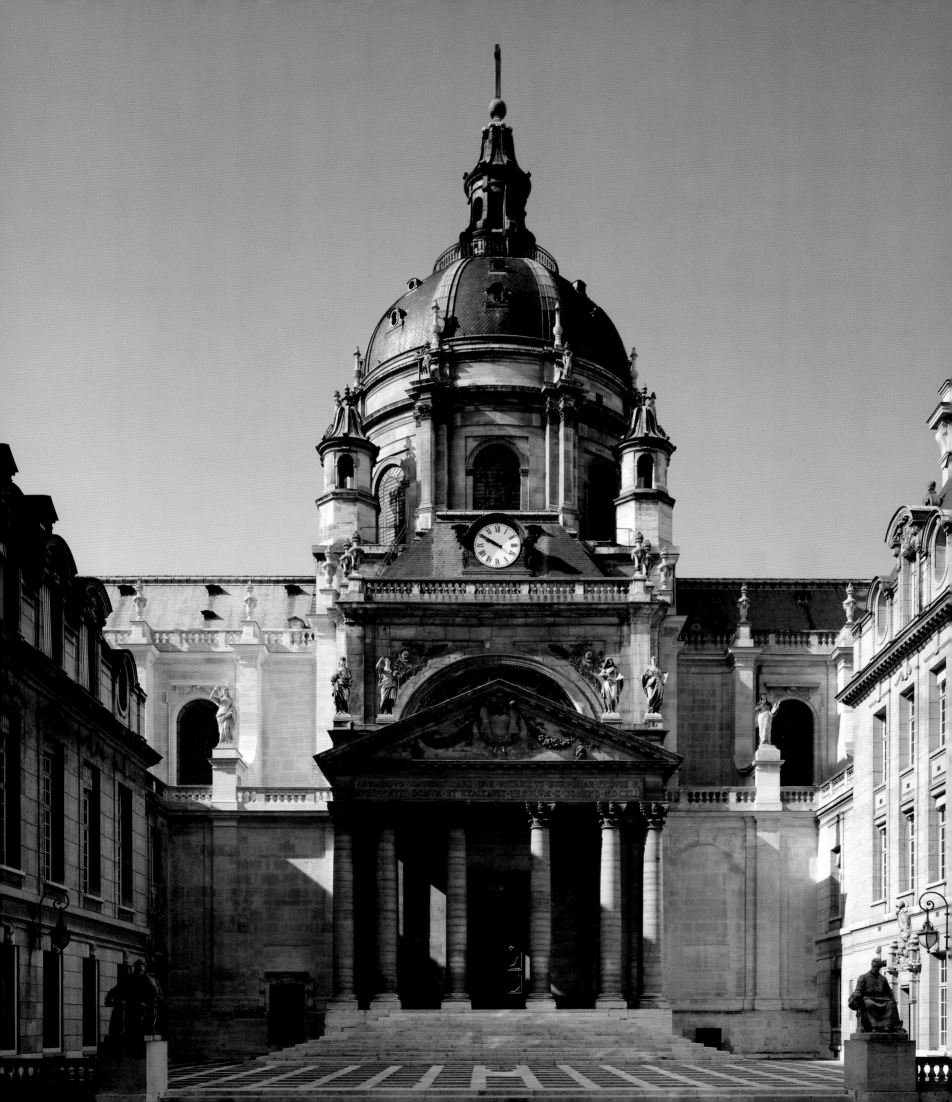

# Chapter VII
# THE FIRST BOURBONS
## (1600–1660)

**1. Chapel of the Sorbonne**

*The chapel of the Sorbonne was built at Richelieu's behest in order to receive his grave.*

The period between the crowning of Henry IV in 1589 and the death of Cardinal Mazarin in 1661 is a complex one, full of contradictions. It takes its name, *baroque*, from the Portuguese word *barocco*, which means "irregular pearl." But giving this word a stylistic meaning has not necessarily helped clarify our understanding of a period that historians already called by this name (they reserved it for the personal reign of Louis XIV). Jacques Bossuet aptly described the tensions of the first half of the century, stating that it was as if France was "in labor ready to give birth to the miraculous reign of Louis XIV."

The period seems best characterized by the word *abundance*, but *baroque* is acceptable if one understands the term refers to a loosely defined group of characteristics and influences that even includes neoclassicism. Some supporters of neoclassicism belonged to the group around Sublet de Noyers, who called themselves the Intelligents. De Noyers was superintendent of buildings during last five years of Louis XIII's reign. The theoretician of the Intelligents (the name they took for themselves) was Roland Fréart de Chambray. After Sublet fell into disgrace, de Chambray published both his *Parallèle de l'architecture antique et de la moderne* (*A Parallel of the Ancient Architecture with the Modern*), the French version was published in 1650, the English in 1664, and his translation of Palladio's treatise, *The Four Books on Architecture* (1570), which had become the de facto handbook for all practicing architects in Europe. He reiterated all the long-held beliefs: the ancients were better than the moderns, especially when these moderns are called Michelangelo or Borromini whom he deemed wonderful but undisciplined geniuses who perverted architecture). Meanwhile Palladio was lauded as the great theorist of the orders, the *palladium* (quasi-divine guardian) of good architecture. The whole doctrine of the Intelligents is set up in Fréart's translation of Palladio's treatise, in a chapter whose title he expanded to "Abuses that have been introduced into architecture." Purist disapproval is the only common thread in the baroque. As Fréart put it, "one can only deplore that building style which completely reverses in itself everything that nature teaches," that mistrusts "that pure simplicity with which we see that it [nature] produces everything."

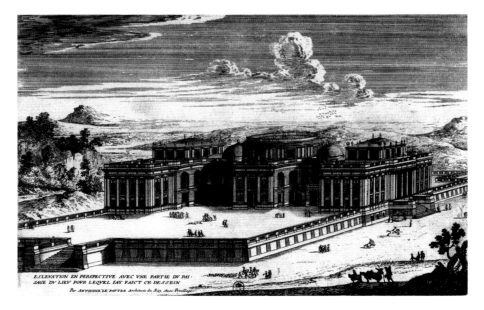

ESLEVATION EN PERSPECTIVE AVEC VNE PARTIE DV PAI-
SAGE DV LIEV POVR LEQVEL IAY FAICT CE DESSEIN
Par ANTHOINE LE PAVTRE Architecte du Roy Avec Privilege

**2. Antoine Lepautre. *Project for a Castle* from *Dessin de plusieurs palais* (*Designs for Various Palaces*), 1652.**

*This project, published by Lepautre in his collection of* Dessins de plusieurs palais, *1652, was perhaps intended for Cardinal Mazarin, as he had no living quarters that reflected his immense fortune.*

The application of such a quasi-moral condemnation to certain artistic practices created an unprecedented situation that had some link to the religious fervor sustaining the Counter-Reformation. One can sense a secret complicity between Roman virtue, Nicolas Poussin's stoicism, the harsh Jansenism of Philippe de Champaigne, and the linguistic purism of François de Malherbe or Claude Favre de Vaugelas. The language had to be purged of the ornamentation it had become burdened with during the prolific Renaissance.

The French Academy was founded by Richelieu in 1635 in order "to work with all possible care and diligence on noting the rules particular to our language and to purify it." The poet Malherbe died in 1628, the artist Poussin in 1665, and the architect François Mansart the following year. These were the founders of French classicism, and they all lived during this half century described as the baroque. It is indeed surprising that classical art should have been invented by two such tormented minds as Mansart and Poussin. The first endlessly reworked his projects (and sometimes even the buildings themselves), and the second retired from the world and continually reworked his paintings in the silence of his studio. The search for classical perfection pushed people to their limits. For the first time in the history of French architecture, an architect would present his projects as "children of his genius." Antoine Lepautre made this claim in his *Desseins de plusieurs palais* (*Designs for Various Palaces*), published in Paris in 1652 (fig. 2).

*The Reign of Henry IV*

The first five years of the reign of King Henry IV were devoted to the conquest of the kingdom, and in 1594 he peacefully took control of the united capital. One of his contemporaries noted that it was in the Louvre that "the King found the keys to the cities of his kingdom." It wasn't until the Peace of Vervins and the Edict of Nantes in 1598 that the civil war and its international continuation came to an end. But "as soon as the King became master of Paris, one saw only masons, at their labor," recalls the newspaper *Le Mercure François* in 1610, just after Henry IV had been assassinated. The last ten years of his reign, which left a sense of rebirth in the collective memory, had deeply and permanently transformed the Parisian landscape: one can still identify perfectly well today what Paris owes to Henry IV. However, either because he wished to demonstrate dynastic continuity or because he had no time to promote his ideas and new people, this first Bourbon king was generally content to put into operation the projects of his Valois predecessors. As for the painters of his reign, they became known as the "Second School of Fontainebleau," which, although it owed much to the first, did not achieve a similar acclaim.

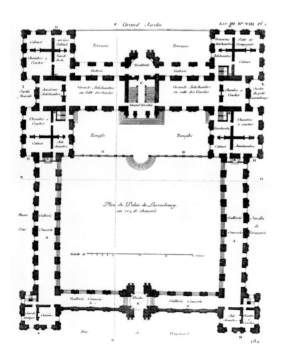

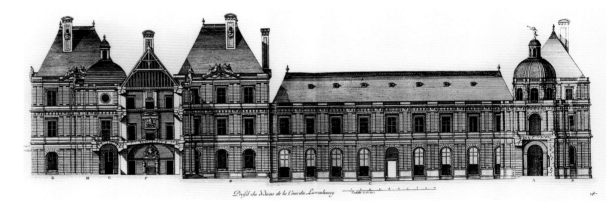

3–5. Luxembourg Palace. Engravings published in *L'Architecture française* by J.-F. Blondel, 1752–1756.

*The Luxembourg Palace was built for queen mother Marie de Médicis between 1615 and 1622 by Salomon de Brosse, who was replaced by Marin de la Vallée in 1622 after a disagreement between the architect and the queen mother with regard to payments. The grand staircase in the center of the structure (now destroyed) was by Marin de la Vallée. The chapel formed a projecting block at the center of the garden side, with a vestibule underneath. The queen had her apartment on the second floor of the pavilion to the right, and her gallery painted by Rubens in the courtyard wing (fig. 23). The left side (incomplete) should have contained an apartment for King Louis XIII, son of the queen mother, and in the wing, a gallery in which Rubens was to have painted the life of Henry IV. In the nineteenth century the palace underwent important modifications.*

*The Governments of Richelieu and Mazarin*

The reign of Louis XIII was of great importance to French art; this era would determine the artistic role played by the capital for a long time to come. And yet, the role that the monarch himself played in this is not clear. As a monarch, his stature is dwarfed by a glorious father and an even more magnificent son. The most notable Parisian developments were those of Marie de Médicis, the queen mother, at the Luxembourg Palace (figs. 3–5), and those of Richelieu at the Palais Cardinal. For twenty years, from 1624 to 1642, from the time of his entrance into the King's Council until his death, Richelieu stayed at the forefront. All the glory of the enterprises accomplished by Richelieu as the first of the ministers should go to the king, but we cannot reduce the work of the great patron to public service—even if the considerable fortune of Richelieu was constituted at the expense of the state. The homage of the beneficiaries of commissions and stipends rightly goes to the minister himself (fig. 49).

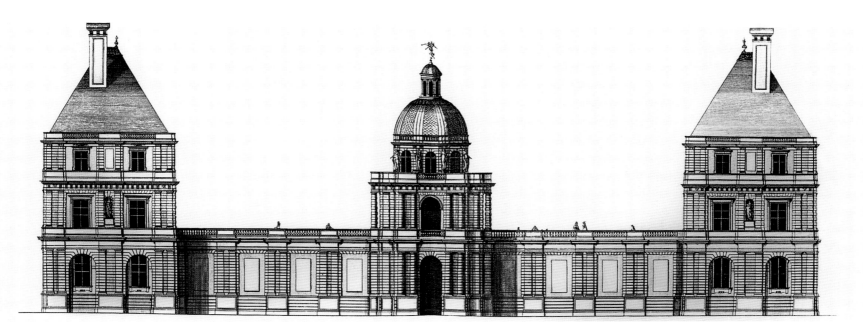

Mazarin, who governed while Louis XIV was a minor and even beyond that, benefited from the policies of Louis XIII and of Richelieu. The victory at Rocroi in 1643, which inaugurated a century of French supremacy, came the day after the death of Louis XIII, and the Treaties of Westphalia (1648) and the Pyrenees (1659) bear the signature of Mazarin. However, the Fronde, the period of revolt against the absolutism of the crown that for four years (1648–1652) targeted the minister and threatened the monarchy, prevented Mazarin's artistic policies from taking strong effect. Mazarin had the ambition of Romanizing French art. He was able to summon the painter Giovanni Francesco Romanelli, but Romans did not work on construction of the Louvre until after his death, at the invitation of Colbert, who without great conviction, would execute the last wishes of Mazarin.

*Immigration of the Artists*

Nonetheless, this immense metropolis (400,000 inhabitants)—with twice the population of the largest cities of Europe, four times larger than the main cities of France—a capital city that harbored the most powerful of monarchies and that again attracted artists and clients, owes its luster to the painters and sculptors who went to take classes in Rome. Some of them, such as Valentin and Lorrain, did not return. And Poussin, the only French painter whose international reputation equaled that of the Italians, only stayed in Paris a few months during his long Roman career.

If those from the provinces once again felt the pull of the capital, it was not so strong as to make them leave. During this entire half century, there were fine painters and fine sculptors

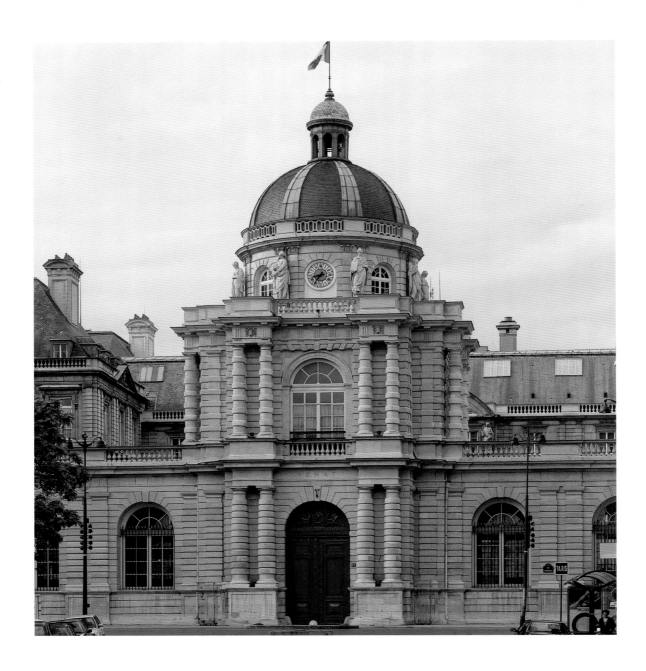

Opposite:

7. Luxembourg
Palace Gardens,
Medici Fountain,
c. 1630.

*The fountain was
constructed c. 1630
by Salomon de
Brosse, by Jacques Le
Mercier or by one of
the Francines, Thomas
or Alexandre. The
crowning figures of the
Rhône and the Seine
are copies of originals
made in 1630 by Pierre
Biard. The Acis and
Galatea in the fore-
ground is a nineteenth
century creation.*

working in Rouen, Langres, Bourges, Puy, and Toulouse. They only lacked the stimulating competition, which was fierce in Paris. Only Lorraine, which was not yet French, had a kind of school, dominated by Georges de La Tour. He was in Paris from 1638 to 1642, but the chronology of his work is too uncertain for one to identify his Parisian paintings.

We cannot define the artistic map of Europe without taking into account some collections that conferred status on the work of the greatest masters. The works of Valentin, Lorrain, and Poussin were present in Paris in royal collections in the considerable collections of the two cardinal ministers. Works by Leonardo da Vinci, Correggio, Titian, Guido Reni, and Giulio Romano figure among the hundred paintings and six thousand drawings of the banker Jabach. Parisian artists, born in Paris, such as Le Sueur and Laurent de La Hyre, could see the work of masters without even leaving the city. But the fact that they considered it unimportant to leave Paris is notable; with them, the general attitude of French-born artists toward spending time in Roman territory was changing. The relationship between the provinces and the capital also changed; in fifty years, the population of Paris, which represented only 1½ percent of the national total, surpassed 2 percent by 1650. The change was due in part to provincial immigration. This influx had a noticeable effect on architecture.

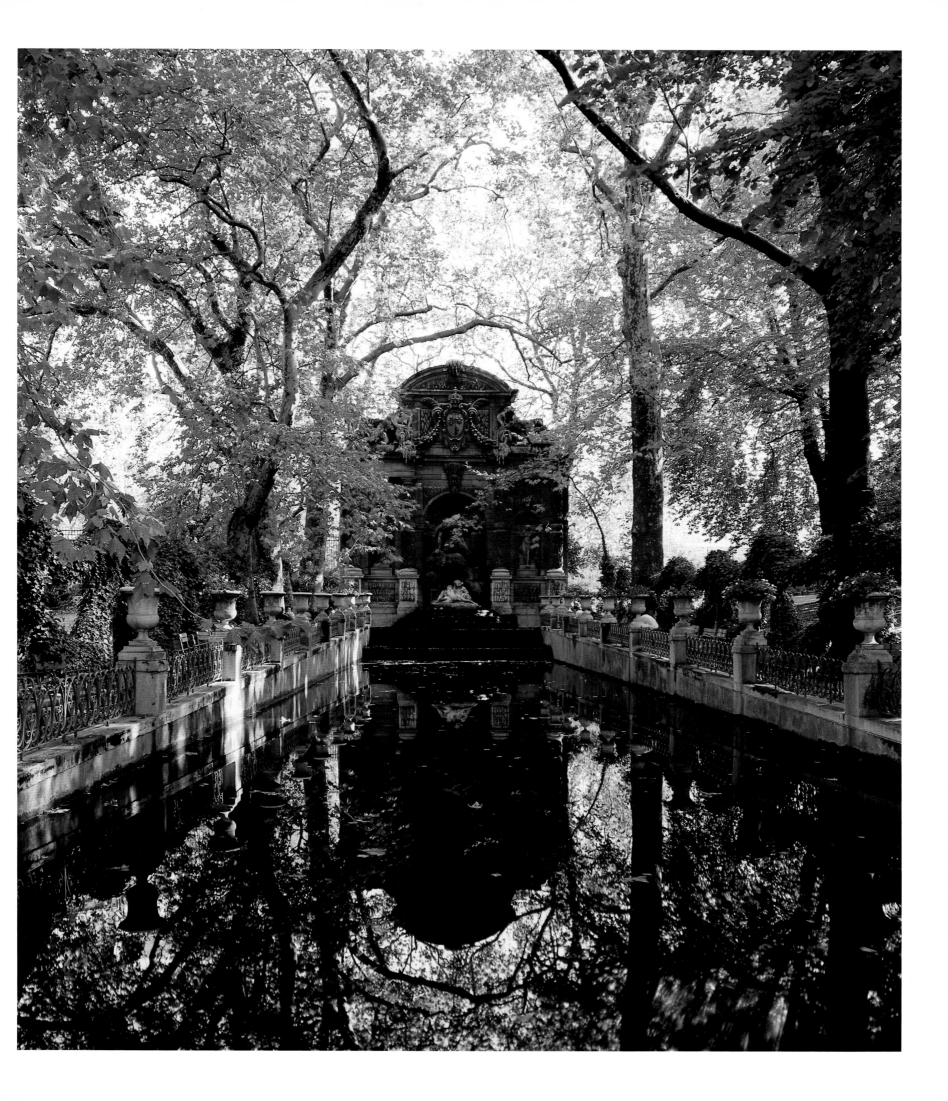

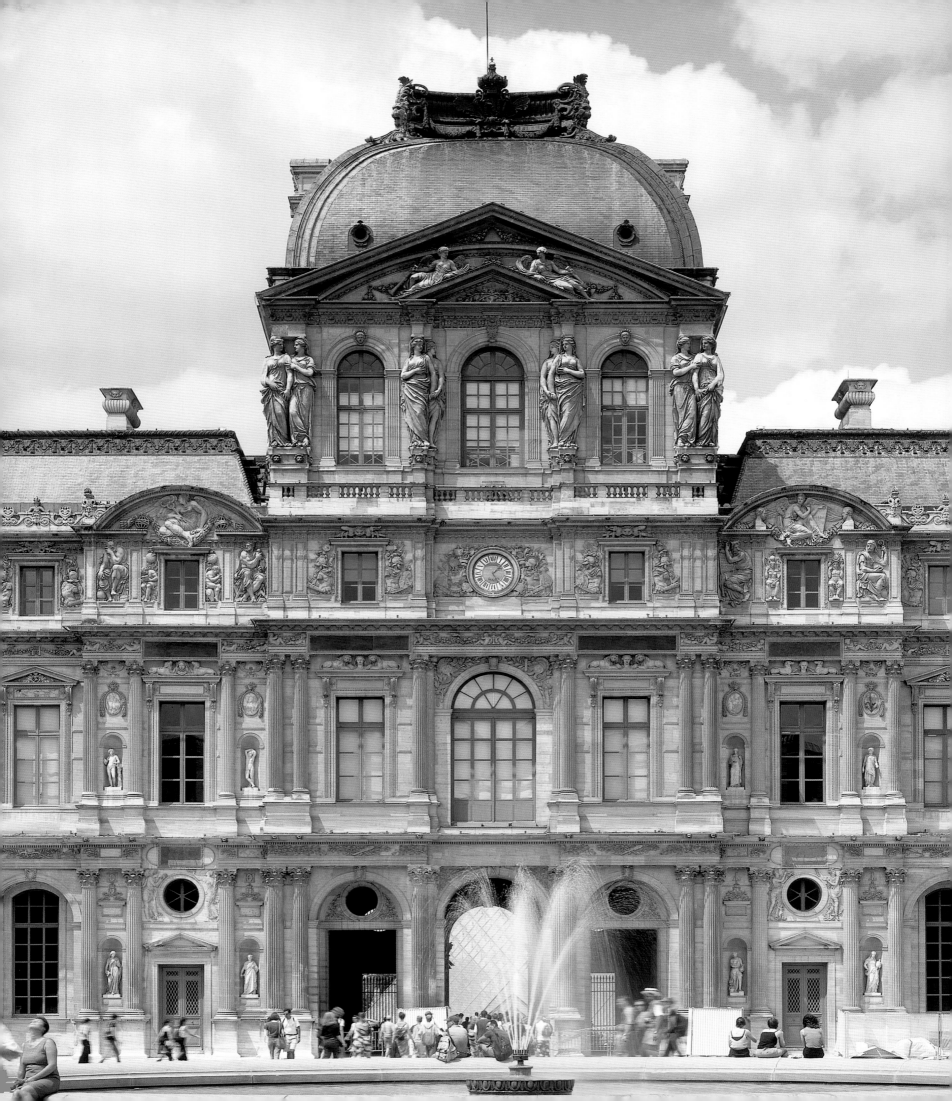

*Architects and Their Place of Origin*

With the exception of Le Muet, who arrived alone from Dijon, the architects active in Paris during the first half of the seventeenth century came from nearby provinces with their families. Salomon de Brosse was born in Verneuil-en-Halatte, where his father worked as an architect at the castle; his mother was from the Androuet Du Cerceau family. Salomon was therefore the grandson of Jacques I Androuet Du Cerceau and nephew of Baptiste, architect of Henry III, and of Jacques II, architect of Henry IV. He was the cousin of Jean, son of Baptiste, and architect of several Parisian hotels. The family of de Brosse and of Du Cerceau came from Verneuil to the north of Ile-de-France. Saloman married a sister of the architect Antoine Métivier; he was related to the Du Ry family, as well as to the De La Fond family. The Métezeaus came from Drouais, to the west of Ile-de-France. Thibaut, like his two sons Louis and Clément (all three First Architects to the king), was born in Dreux. The Le Merciers came from Pontoise, northwest of Paris. There were seven architects of this family active in Paris in the first half of the seventeenth century. Jacques, who would gain fame as First Architect to the king, left for Italy in 1607 where he stayed for seven years. His is the only certified case of a Parisian architect spending time in Italy. François Mansart, Louis Le Vau, and Antoine Lepautre, whose careers spanned beyond 1660, also contributed to building dynasties; they were native Parisians. Paris began to produce its own elites.

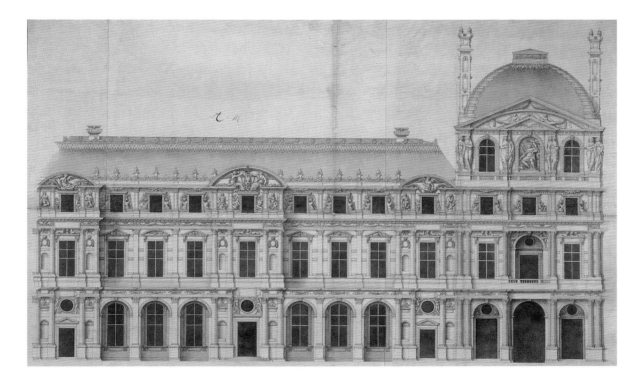

### 8–9. The Grand Design of the Louvre and the Clock Pavilion

*One can divide the Grand Design of the Louvre into three parts: the construction of the wings joining the Louvre to the Seine, and from there along the river bank to the Tuileries; the quadrupling of the Cour Carrée (Square Courtyard) of the Louvre; and the construction of a second Louvre-Tuileries link, symmetrical to the first. Together, the two wings completely isolated the area between the two palaces, which was destined to be razed. At the end of the sixteenth century, the ground floor of the first link was completed as far as the corner of Charles V's wall. Henry IV extended the riverside wing and the Tuileries buildings until they joined, and heightened the wings with a gallery floor. However, the Grande Galerie (Great Gallery) was not finished by the time of the death of Henry IV: Poussin, who came from Rome to decorate it, complained about the architecture Le Mercier had designed. Le Mercier had become the king's architect only under Louis XIII.*
*It was also Le Mercier who, upon the royal declaration of 1624, began work on the quadrupling of the Cour Carrée (Square Courtyard) by constructing the Clock Pavilion, the new middle to the courtyard sides.*
*The Pavilion was decorated with caryatids by Jacques Sarrazin. The drawing reproduced above,*
*attributed to Le Mercier, represents the Lescot wing and the Clock Pavilion.*

## 10–12. High Altar of the Church of Saint Louis of the Jesuits

*The high altar of the church at the Jesuit House of the Professed on Rue Saint-Antoine (currently the church of Saint-Paul-Saint-Louis), was designed by Father François Derand, who supervised the construction of the church as of 1629. It is known through the engravings of Edme Moreau, published by Derand in 1643 with a dedication to Sublet de Noyers. The high altar, in variegated marble, included a silver tabernacle. It was decorated with statues representing, on the first level, Saint Ignatius and Saint Francis-Xavier between Saint Louis and Charlemagne. On the second level, Saint John and Mary Magdalene are represented; on the third, under the crucifix, is the Virgin. On the top level there was the Apotheosis of Saint Louis, painted by Simon Vouet (Musée des Beaux-Arts, Rouen). In the central area were, alternating according to the feasts, the Presentation at the Temple (painted by Simon Vouet in 1641, and preserved at the Louvre), a gift of Richelieu (reproduced opposite), and a painting by Vignon and another by Champaigne.*

Up to 1620 or 1630, the Bellifontains (the School of Fontainebleau) and the artists from Antwerp and Lorraine shared the Parisian painting market, where mannerism still reigned. A stylistic hold over from the sixteenth century, mannerism is characterized by attenuated figures, affected attitudes, and acidic colors. Those from the School of Fontainebleau disappeared first: Dubreuil, who was trained by the Italians at Fontainebleau, died in 1602; Dubois died in 1614; and Fréminet in 1619. Fréminet lived in Italy from 1587 to 1602, when he was called back by Henry IV, who considered him his own Michelangelo. All three worked mostly at Fontainebleau. Jérôme Francken of Antwerp remained in Paris from 1568; he was painter to the king in 1588, and died in 1610. His compatriot Franz Pourbus was called to Paris in 1609 by Marie de Médicis; he remained painter to the queen mother and to the court until his death in 1622. He was especially sought after for his Flemish style portraits. He was also the artist of the *Cène* (*The Last Supper*) for the high altar of Saint-Leu-Saint-Gilles (today in the Louvre), which was considered a masterpiece and admired by Poussin; one can see in it the germ of the great French master's more austere classicism.

The region of Lorraine kept for itself two of its most eminent representatives, Jacques Bellange and Georges de La Tour, but as of 1601, Georges Lallemant of Lorraine established himself in Paris. He opened a workshop there that was very active, frequented notably by Poussin, Champaigne, and La Hyre. Lallemant died in 1636, one year after his illustrious compatriot Jacques Callot, the master of etchings. Callot was trained by Bellange, and he

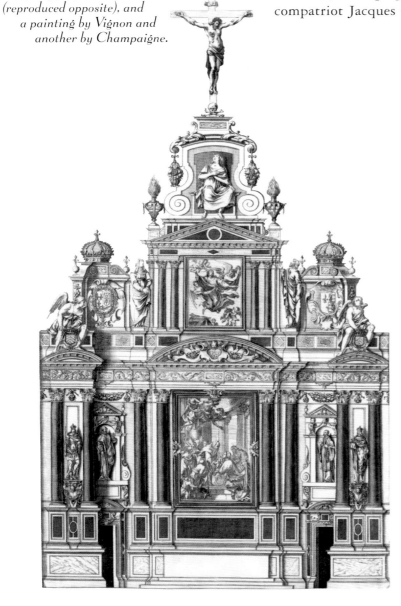

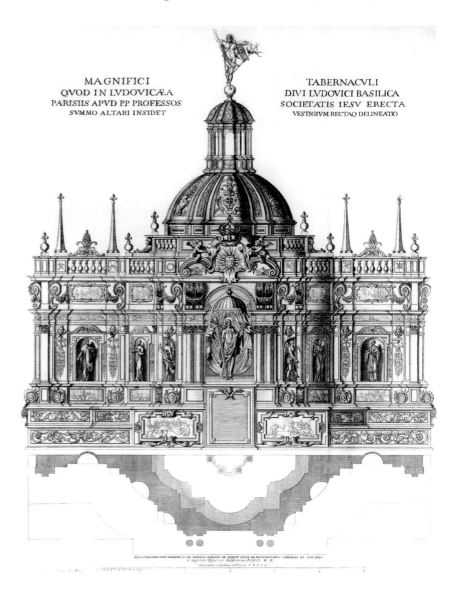

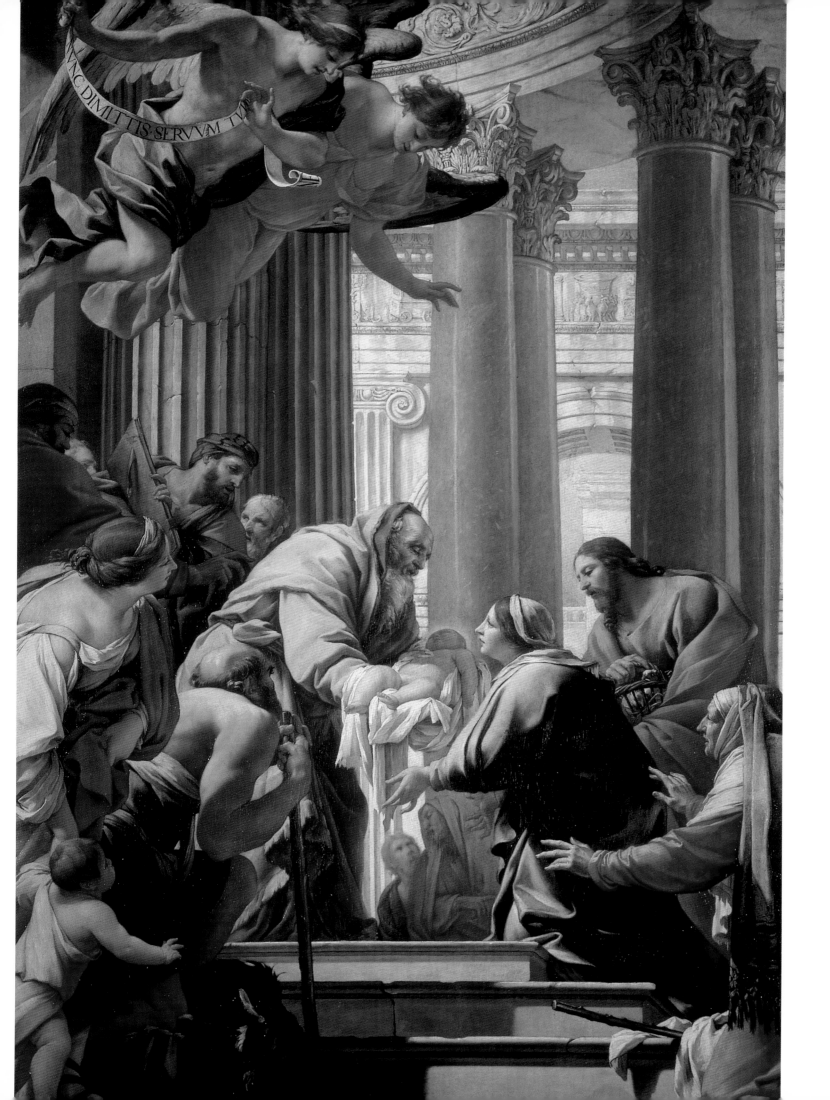

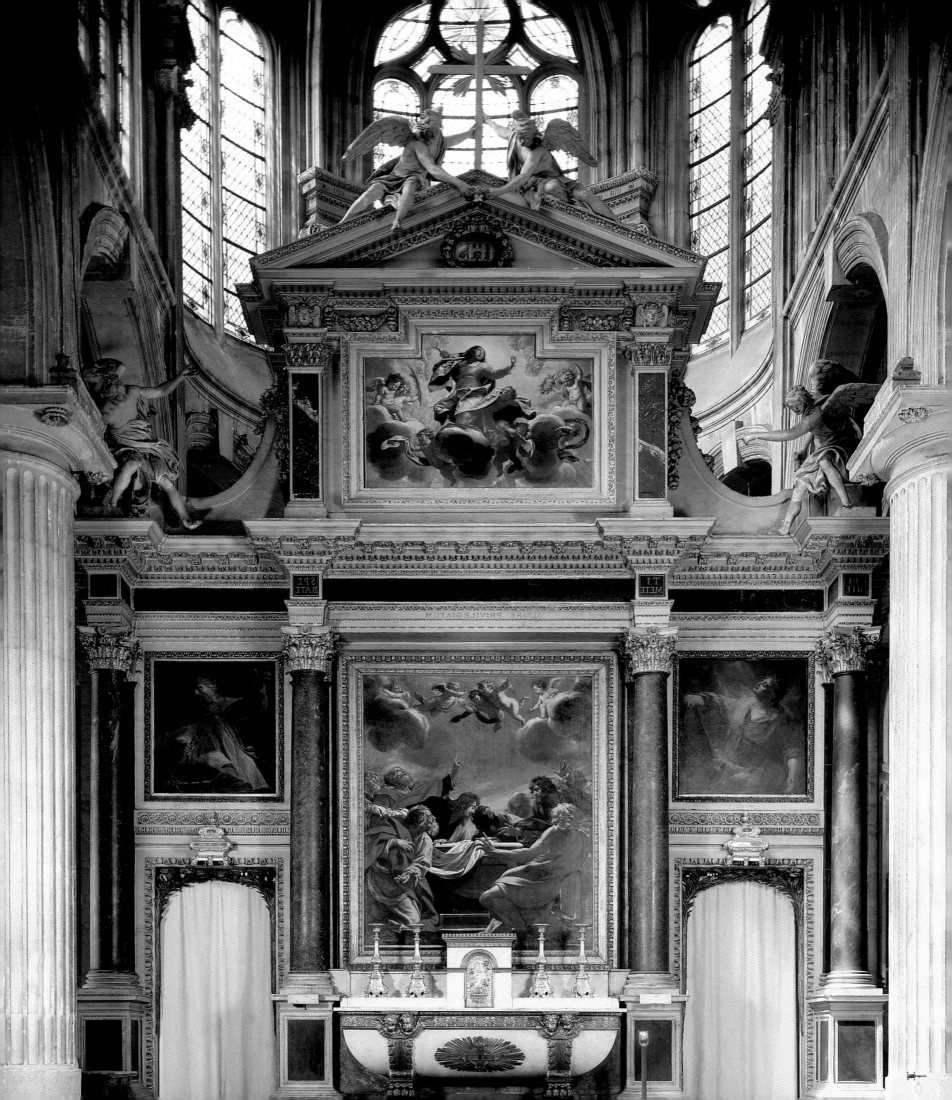

spent more than ten years in Italy. Several times between 1628 and 1631 he found himself in Paris, where he created some admirable views of the city (fig. 36). He left the sale of his engravings to another master from Lorraine, Isaac Henriet, engraver and print editor, established in Paris. Also from Lorraine, Isaac Silvestre had found refuge with Henriet and trained himself by studying the engravings of Callot. Silvestre was one of the most prolific *vedutisti* (view painters) of the century. During the period from 1645 to 1655, he turned out animated small format views of silhouettes characteristic of Callot; many of these were focused on Paris. During the reign of Louis XIV, the career as well as the prints of Silvestre would change format. Silvestre would be officially charged with representing the king's constructions in large prints.

Mannerism would have been outmoded in Paris in the 1620s without Claude Vignon, who gave it a long reprieve. Vignon, from Tourange, was trained in Paris; during a trip to Italy (1617–1623), he studied Caravaggio, Adam Elsheimer, and the Venetians. Upon his return to Paris (1623), he made paintings (fig. 29) that evoked Fontainebleau, Venice, and the memory of Caravaggio, and anticipate Rembrandt. But with his success (and it would remain constant until his death in 1670), Vignon's prolific production would often be of mediocre quality.

In addition, when Vignon returned from Italy, the focus was elsewhere. Two notable outsiders came together to decorate the Luxembourg Palace, the Tuscan Orazio Gentileschi and Peter-Paul Rubens from Antwerp. Gentileschi had the favor of the queen mother, inheritor of the Medici tradition, but he could not displace the superb Rubens. He stayed in Paris only from 1623 to 1625, just enough time to transmit his style to Philippe de Champaigne, the Le Nain brothers, and La Hyre. In every way different from that of Gentileschi, Rubens's presence produced no disciples, at least in the near term, but he did create one of the greatest painted ensembles in Europe, the *Vie de Marie de Médicis* (*Life of Marie de Médicis*), which was to decorate the right wing of the palace (fig. 23). In 1621, responding to the request of the queen mother, Rubens arrived from Antwerp, as if to take the place of his compatriot Pourbus, who died the following year. Rubens was already a celebrated master, who had toured Italy from 1600 to 1608. He only made brief appearances in Paris, just enough time to take measurements and instructions for paintings that would be realized in Antwerp. The commission also included a life of Henry IV which was to decorate the left gallery of the Luxembourg Palace; only sketches of it were completed. Then the operation ended swiftly and Rubens did not head up the French school. The failure would be due to Richelieu, who suspected Rubens of being a spy for Spain. But it was more probable that Rubens preferred Antwerp to Paris, just as, later on, Poussin preferred Rome. Such incredible talents did not need Paris to impose themselves, and Paris, which had its own ideas, was not always necessarily disposed to welcome them for any length of time.

## Philippe de Champaigne

Richelieu's preference was for Philippe de Champaigne of Brussels. En route to Italy, he had come through Paris in 1621 and, in the end, went no further. He was already an established artist, though it is not known how he learned what he knew of Caravaggio and the Carracci. He worked first at the Luxembourg Palace. In 1629, he received his *lettres de naturalité* (certificate of naturalization). In 1635 the commission for portraits and effigies for the Gallery of Fame at the Palais Cardinal sealed his reputation. Most notably, he was responsible for the portrait of Louis XIII (fig. 25) that presided over that assembly of famous statesmen, among whom Richelieu naturally found his place. It is pleasing to recognize in the Louis XIII of the Palais Cardinal one of several fine examples of Champaigne's talent in portraiture; he would succeed Pourbus in this genre. However,

**13. Simon Vouet and Jacques Sarrazin. Altarpiece of Saint-Nicolas-des-Champs, 1629.**

*The only Parisian altarpiece preserved as it was left by Simon Vouet and Jacques Sarrazin in 1629 (except the two paintings above the doors from 1775 and the altar from the early nineteenth century). Vouet painted an Assumption on two panels: below are the Apostles around the empty tomb; above is the Virgin. Sarrazin designed and made the four stucco angels.*

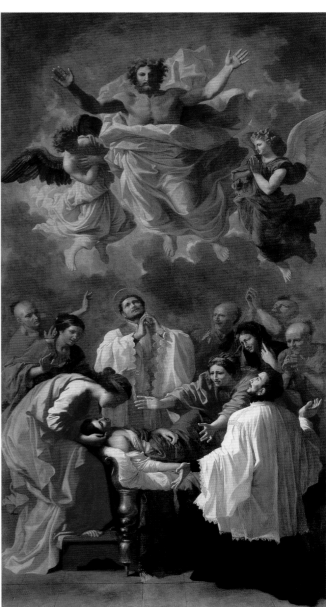

**14. Nicolas Poussin. Le Miracle de Saint François-Xavier (The Miracle of Saint Francis-Xavier), 1641. (Musée du Louvre, Paris)**

*Commissioned in 1641 by Sublet de Noyers for the high altar of the church of the Jesuit novitiate, this work was painted during Poussin's stay in Paris. At the same time, Sublet commissioned Vouet and Stella for paintings for the side altars. The scene shows the resurrection of a young Japanese woman by Francis-Xavier.*

unique in Champaigne's work, this portrait is accompanied by an allegory, that of Victory: a "piece of baroque machinery," as one art historian referred to it, and is considered an anomaly by the admirers of a master whose genius was only fully expressed in pious images such as the solemn *Voeu de Louis XIII* (*Oath of Louis XIII*; fig. 22), or scenes from the *Vie de la Vierge* (*Life of the Virgin*; fig. 17). These works are marked with the taste of northern painters for depicting intimate scenes. Around 1646 Champaigne began to come under the influence of Jansenism, the rigorous form of Christianity practiced at the abbey of Port-Royal. The commemorative plaque representing two nuns from the abbey, one of whom was Champaigne's own daughter, is a painting of sisters wearing sackcloth and ashes, brightened only by the blood-red crosses that cover the nuns' torsos. Never, without this religious influence, would classical aesthetics have attained such a high degree of asceticism.

## Simon Vouet

At this point, the principle of change demands the arrival with much pomp and fanfare of the sumptuous Vouet. This was the master Paris was waiting for. This Parisian, the king's stipendiary in Italy, brought together examples of the great Italian artists, Caravaggio and the Carracci, Guido Reni and Domenichino, Il Guercino and Paolo Veronese. In Rome, where he was appointed "prince" of the Academy of Saint Luke, he was noted as among the best when King Louis XIII made him return. For twenty years (from his return in 1627 until his death in 1649), he reigned over the French School, giving it a style and a palette that his disciples and collaborators would inherit. He was overwhelmed with commissions. He painted altarpieces for several churches in Paris, notably for the high altar of Saint-Nicolas-des-Champs, which was the first work produced upon his return (fig. 13), and that of the high altar of the Jesuit House of the Professed, Rue Saint-Antoine (fig. 12), an important focus of spiritual life in Paris where the specious notion of Jesuit style could take on a kind of meaning. Vouet's painting for the House of the Professed is in Veronese's style, but can one call it baroque? The figures are skillfully amassed under a compositional oblique; the architecture imposes its solid verticals; the angels are no longer enveloped in baroque clouds; and the palette, characteristic of the painter, is as cold as Rubens's is passionate. Vouet also painted numerous decors of Parisian *hôtels* (fig. 31). These decors, which constituted the most remarkable part of his work, were totally dispersed and in large part destroyed. It is difficult to imagine such a far-reaching catastrophe anywhere outside of France surrounding a master whose notoriety was so great! But in France, fame has a short memory. For three centuries, Vouet's name would be forgotten.

## 15–16. Tomb of the Heart of Henry de Bourbon, Prince of Condé

*Henry, prince of Condé, from a junior branch of the Bourbon family, died in 1646, three years after the victory at Rocroi, which earned his son the nickname of "the Great Condé." The tomb of his heart, set up in the church of Saint-Louis in the Jesuit House of the Professed, was commissioned from the sculptor Jacques Sarrazin in 1648. A gouache from 1683 by Pierre-Paul Sevin, shows the tomb in the mourning display that was replaced every year during a solemn mass in memory of the deceased. The tomb as such included a sculpted altar wall and a sanctuary defined by a guardwall heavy with Sarrazin's sculptures, including statues of allegorical figures representing religion, prudence, justice and piety; two children in high relief, and relief panels showing the triumphs of Renown, Eternity, Religion, and Death. These sculptures were remounted at the Musée Condé de Chantilly. Religion (shown here) holds a heart and a small box in which she carries the prince's heart.*

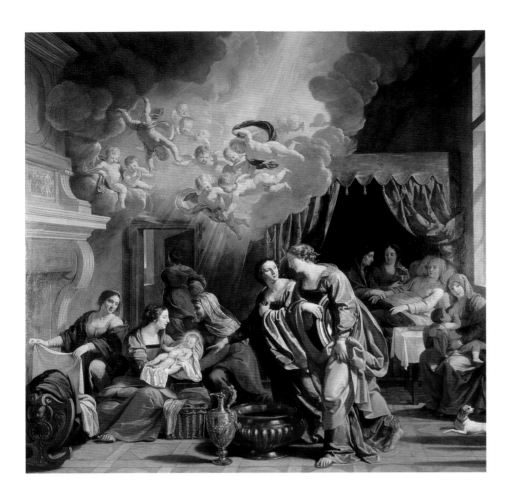

## Nicolas Poussin

If Poussin's art has never been forgotten, it is perhaps because this master made paintings for collections and not decors, which were as vulnerable as the buildings themselves, threatened by real estate speculation. In addition, Poussin had what Vouet did not: a theory of painting, which fully justified the academic canons. This was his theory of modes, taken from the ancient theory of musical modes and similar to the theory of architectural orders, or the principle of the three unities of classical tragedy. Each subject had its mode; for each sentiment, its gestures and range of expressions. Indeed, few temperaments are as dissimilar as those of Vouet and Poussin. The public commissions and spectacular works that Vouet sought were spurned by Poussin, who reserved his meditative paintings for amateur philosophers. Vouet exploited and promoted numerous collaborators; Poussin worked alone. Vouet used color and active scenes, while Poussin drew; his characters are frozen like ancient marble statues.

Poussin, who was trained in Paris, left for Rome in 1624. In 1640, Louis XIII sent two "intelligents," the brothers Fréart de Chambray and Fréart de Chantelou, to Rome with a mission to bring back Poussin. The preceding year,

**17–18.** *Vie de la Vierge* (*Life of the Virgin*) **wall covering, between 1638 and 1657.**

*This tapestry made of fourteen pieces (today in Strasbourg Cathedral) was finished for the Cathedral of Paris between 1638 and 1657. It was commissioned by Michel Le Masle, canon of the cathedral, either in his own name or on behalf of Richelieu. In 1640 the* Naissance de la Vierge (The Birth of the Virgin) *and* La Présentation au Temple (The Presentation in the Temple) *were delivered (both by Philippe de Champaigne). The painted cartoon for the Birth of the Virgin, dating from 1636, has been preserved (Musée des Beaux-Arts, Arras; reproduced above). The fabrication of the pieces was halted by the death of Richelieu and by the Fronde. In 1650 Le Mariage de la Vierge (Marriage of the Virgin) was completed; it was made in Brussels after the cartoon by Stella (Musée de Toulouse). Finally, from 1652 to 1657, the last eleven pieces were made in Paris in the workshop of Pierre Damour. Their cartoons were by Charles Poerson; among those is The Nativity, reproduced right.*

Poussin had sent his painting *La Manne* (*Manna*) to Chantelou, who had commissioned it. This celebrated work, which would promptly become part of the royal collections, represents Poussin's theories perfectly. The king and his minister, who were admirers of Champaigne, could not see Vouet as head of the French School. But, after all, it was Poussin who was "out of luck" because his commissions to decorate the Palais Cardinal and the Louvre went beyond his professional capabilities. The arch of the Great Gallery in the Louvre will never hold a great place in history. In the final analysis, the most significant work of his Parisian stay from 1640 to 1642 was without a doubt the large altarpiece for the Jesuit novitiate (fig. 14). This was a work that Sublet had sponsored and which was to be proposed as a model of good composition. Poussin in the novitiate, Vouet at the church—would the choice between classicism and baroque finally be decided? Nothing is less certain, as Poussin's composition strongly resembles that which Vouet himself had adopted for the altar at Saint-Nicolas-des-Champs (fig. 13): Poussin, who only made paintings, assembled earth and sky on the same canvas. Vouet, who had created decors, made two paintings and placed the sky in the crown of the architectural altar, which he may have designed himself.

*The Le Nain Brothers*

While Poussin was still in Paris or soon after his departure, the Le Nains painted their masterpieces, *Le Repas* (*The Meal*; fig. 32) and *La Tabagie* (*The Smoke Room*; fig. 33). The three Le Nain brothers—Antoine, Louis, and Mathieu—arrived from their native Picardy in 1629, two years after Vouet. They did not go to Italy, but knew all about the art of Caravaggio, perhaps from the work of his imitators. One can distinguish three styles in the work of the Le Nain brothers, without being able to attribute them specifically to any

**19. Simon Vouet.** *Moïse sauvé des eaux* (*Moses Saved from the Waters*), c. 1627. (Musée du Louvre, Paris)

*This piece is part of the wall hanging of the Old Testament (made in six pieces) ordered from Vouet upon his return from Rome (1627) to decorate the Louvre, and woven in the workshop of the Great Gallery. It is considered a masterpiece of French tapestry. It was reproduced by several workshops and engraved. Above is the coat of arms of France and of Navarre; below is the emblem of King Louis XIII; and on the sides are his initials.*

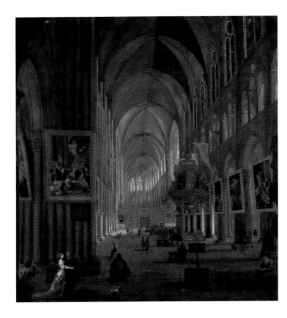

## 20–21. *Les Mays de Notre-Dame* (The "Mays" of Notre-Dame)

*Each year between 1630 and 1707 (with the exception of 1683 and 1684), the silversmith's guild of Paris offered a painting to the cathedral in the month of May. These seventy-six paintings, each over ten feet high, called "Mays," were commissioned from the greatest painters and were hung in the nave of the cathedral. The subjects were for the most part drawn from the Acts of the Apostles. An anonymous painting in the cathedral's museum shows the effect that the ensemble produced. There are today only fourteen Mays dispersed in museums or hanging in the cathedral's side chapels. The May of 1649, by Eustache Le Sueur, representing the Prédication de saint Paul à Ephèse (Saint Paul Preaching at Ephesus), reproduced here, was considered the masterpiece of the "French Raphael." The eloquence of Saint Paul is convincing the magicians to burn their books. To the right is the celebrated temple of Ephesus consecrated to Diana (Musée du Louvre, Paris).*

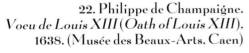

## 22. Philippe de Champaigne. *Voeu de Louis XIII (Oath of Louis XIII),* 1638. (Musée des Beaux-Arts, Caen)

*In 1638 Louis XIII devoted his kingdom to the Virgin. For this occasion, he revealed his intention to rebuild the main altar of the cathedral by placing an "image" there, representing him kneeling at the feet of the Virgin, offering her his crown and his scepter. This is the scene that Champaigne painted at the king's request. The painting was deposited in the cathedral while awaiting a remodeling of the sanctuary, which was only accomplished under Louis XIV, and did not utilize the painting (chapt. IX, fig. 5).*

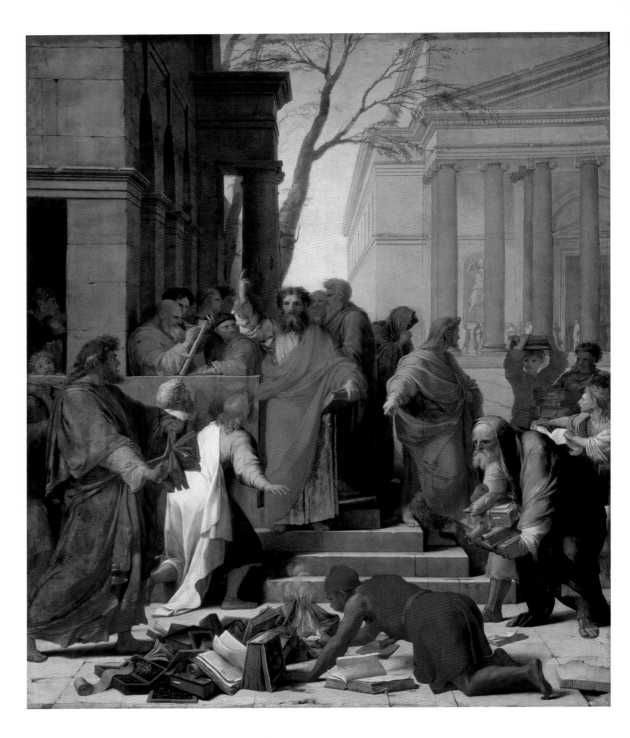

particular one of them. Certain authors attribute *Le Repas* (*The Meal*; fig. 32) to Louis and *La Tabagie* (*The Smoke Room*; fig. 33) to Mathieu. The brothers practiced all the genres successfully, but they were especially appreciated for their themes of daily life, a genre adopted at the time by Pieter van Laer (called Bamboccio in Rome) and David Téniers the Younger in Antwerp. However, the scenes painted by the Le Nains have little to do with picturesque revelrie and noisy cabaret scenes. "Silence is established between the figures and the objects, even those which are outside the order of the story ... The entire feeling of the painting is concentrated in the looks" (Jacques Thuillier). The smokers, surprised by the intrusion of an outside spectator, turn all eyes upon him. In *The Meal* (once better-known as *The Peasant Meal*), the spectator only attracts the attention of the children; that of three main characters, who have come together to break bread and drink wine, is entirely concentrated on a kind of eucharistic celebration. These three figures are perhaps not peasants, as has been noted for quite some time; in any case, they are not all of the same class as seen by their clothing. It has been suggested that the main figure could be a representative of those charitable organizations that multiplied

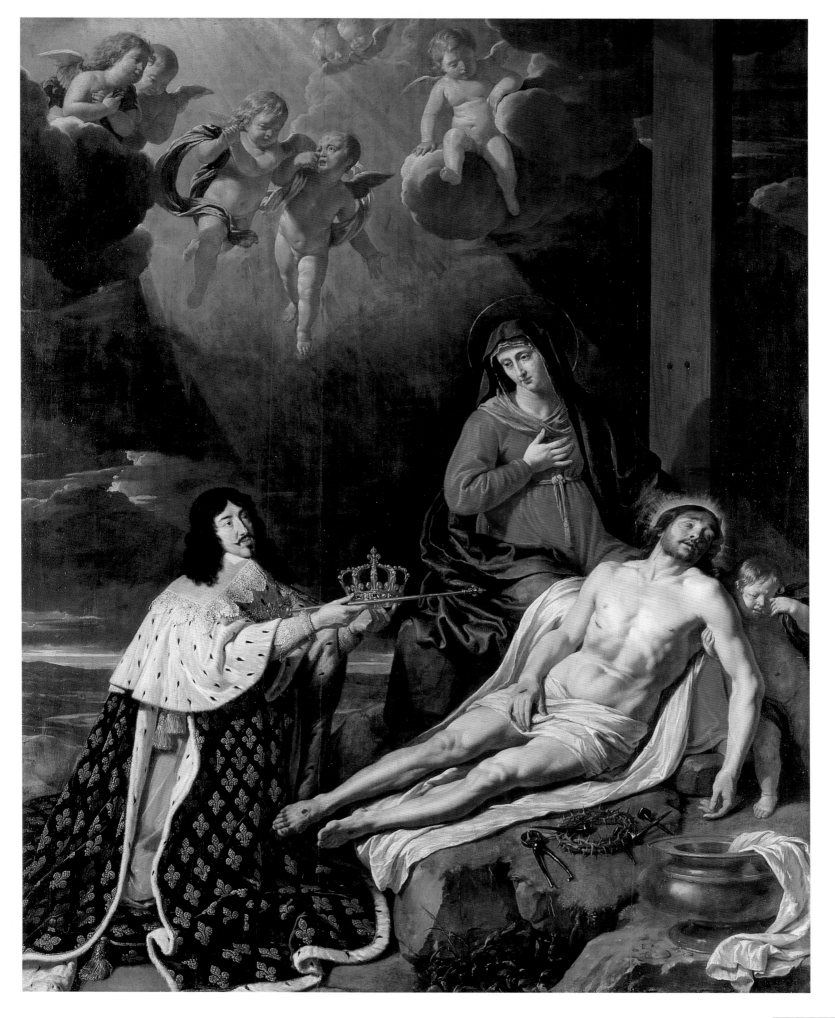

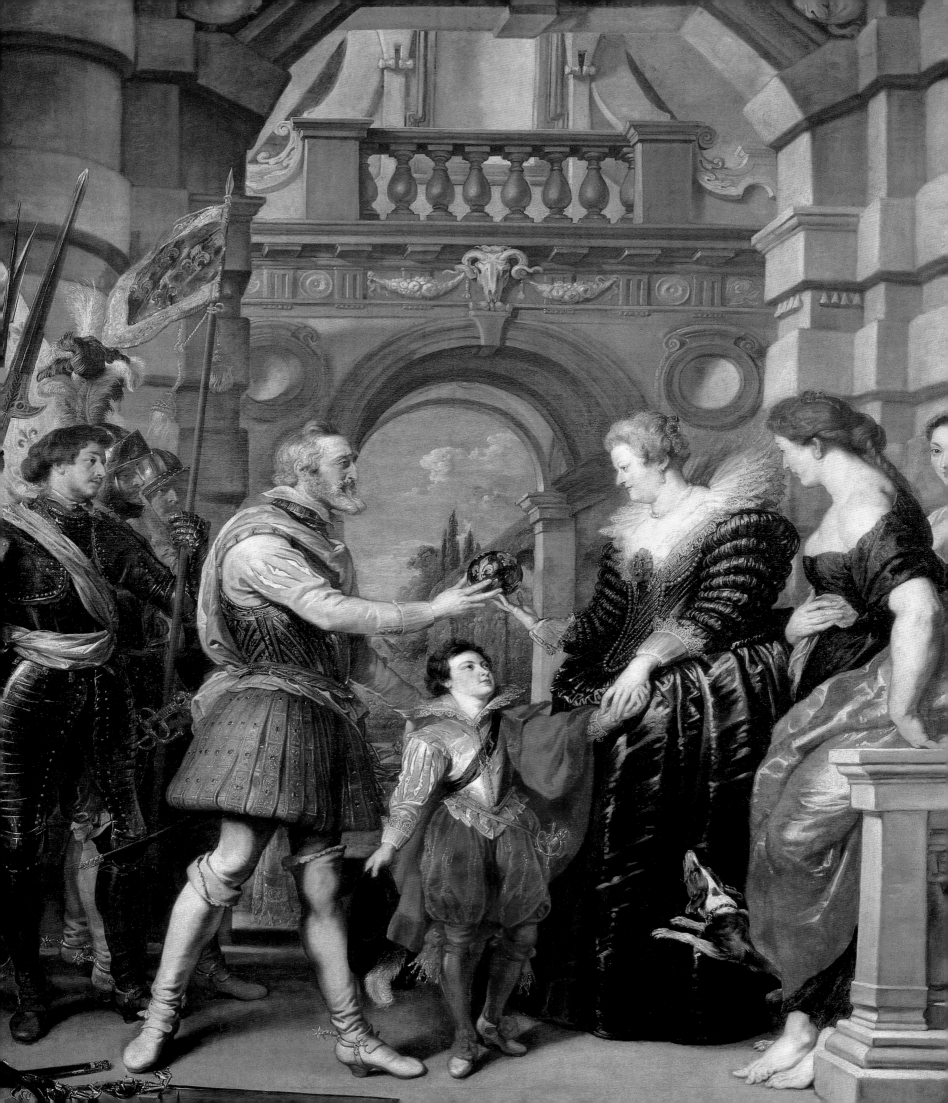

in Paris in the wave of the Counter-Reformation. Thus, the Le Nain brothers join Champaigne in the production of images sublimated by piety. We see in this one of the components of French classicism, "that recurring phenomenon in French art, a classicism which does not use the outward forms of Greek or Roman formulas, but attains to the clarity and calm which are the more fundamental qualities of this style," wrote art historian Anthony Blunt.

At the crossroads of Paris, dozens of talented painters become known as they passed through it. They came from neighboring provinces, Burgundy (Perrier), from Champagne (Pierre Mignard), from Lorraine (Charles Poerson), from Picardy (Michel Dorigny), and occasionally even from faraway Languedoc (Sébastian Bourdon). More and more numerous were the natives of Paris (such as Blanchard, La Hyre, Le Sueur, and Le Brun). Romanelli was Italian, and he was Mazarin's wild card. This disciple of Pietro da Cortona, a specialist in large decors, arrived in Paris in 1646 or 1647; soon after that he received prestigious commissions, the decoration of the gallery of the Mazarin palace (fig. 27) and that of the summer apartment of Queen Anne of Austria in the Louvre (fig. 100). The title of the premier painter of Paris was ready to be taken from an aging Vouet (he died in 1649), but Romanelli had two strong competitors. They were two of Vouet's disciples, and both were Parisians: Eustache Le Sueur, who didn't live long enough to fully take his place (he died in 1655) and especially Charles Le Brun, who continued to be a major figure in French art for a large part of the personal reign of Louis XIV, who died in 1690.

*Eustache Le Sueur*

*Venus* (fig. 30), which is among the finest of Le Sueur's known works, raises questions. How did Le Sueur, who did not leave Paris, manage to paint such an erudite work? One can see quotations from Poussin's bacchanalias and Titian's nudes; it also betrays knowledge of the *Ariadne* in the classical collections of the Vatican. How could the author of the severe *Vie de Saint Bruno* (*Life of Saint Bruno*) and of the solemn *Saint Paul Preaching* (fig. 21) imagine such sensual beauty without making of it the subject of the temptations of Saint Anthony? It was the *Life of Saint Bruno*, painted from 1645 to 1648 for the Carthusian monks in Paris, that rendered Le Sueur famous. Would the enlightened amateurs of Parisian society expose themselves to the scourging of the cenobites in order to appreciate such a radical

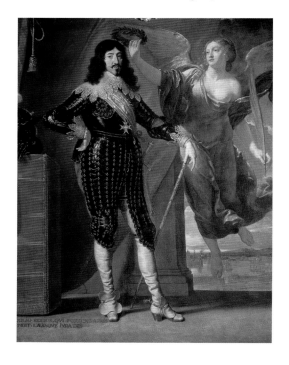

**26.** Jean de Saint-Igny.
*Le Théâtre du Palais-Cardinal*
(*The Theater of the Palais Cardinal*).
(Musée des Arts Décoratifs, Paris)

*In 1641 Richelieu received Louis XIII, the
queen, and the dauphin, future Louis XIV,
for the inauguration of the palace theater
with the performance of* Mirame. *The
outline for the play by Desmarets de Saint-
Sorlin, as well as certain passages, were
written by Richelieu. The auditorium
was constructed by Jacques Le Mercier,
the architect of the palace. The opening
scene was engraved as the frontispiece
for the publication of the play.*

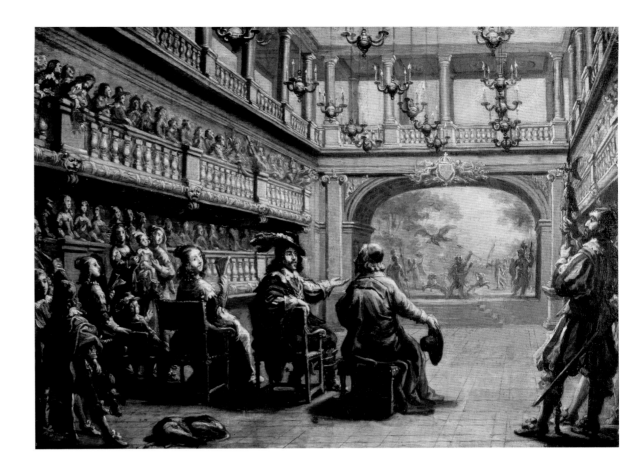

**27.** Robert Nanteuil. *La Galerie
du palais Mazarin* (*The Gallery
of the Mazarin Palace*, engraving.

*Upon becoming principal minster in 1643,
Mazarin rented a hôtel near the Palais
Cardinal that Richelieu had given to the king,
and in which, on the advice of Mazarin, the
queen mother came to live with the young
Louis XIV. From 1644 to 1645, without waiting
to become the owner, Mazarin had remodeling
done on the building by François Mansart, who
constructed, notably, on the garden side, a large
wing containing one gallery on the main floor
and one on the second floor. Mazarin had
Romanelli paint the upper gallery in which he
placed his collections. The engraving by Robert
Nanteuil, portraitist of the court and the city,
shows Mazarin in the upper gallery.*

**28.** Charles Le Brun. *Martyre de Saint
Jean l'Evangéliste à la Porte Latine*
(*Martyrdom of Saint John the
Evangelist at the Porte Latine*). (Saint-
Nicolas-du-Chardonnet Church, Paris)

*This was finished shortly before Le Brun's
departure for Rome in 1642 and given by him
to the community of painters and sculptors
for his chapel of the church of Saint-Sépulcre
(now destroyed). There is a strong influence
from Vouet in this painting by a young
artist who had not yet seen Italy.*

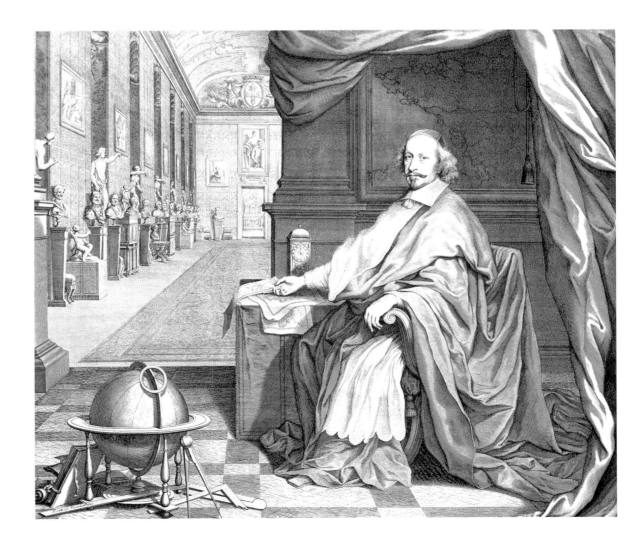

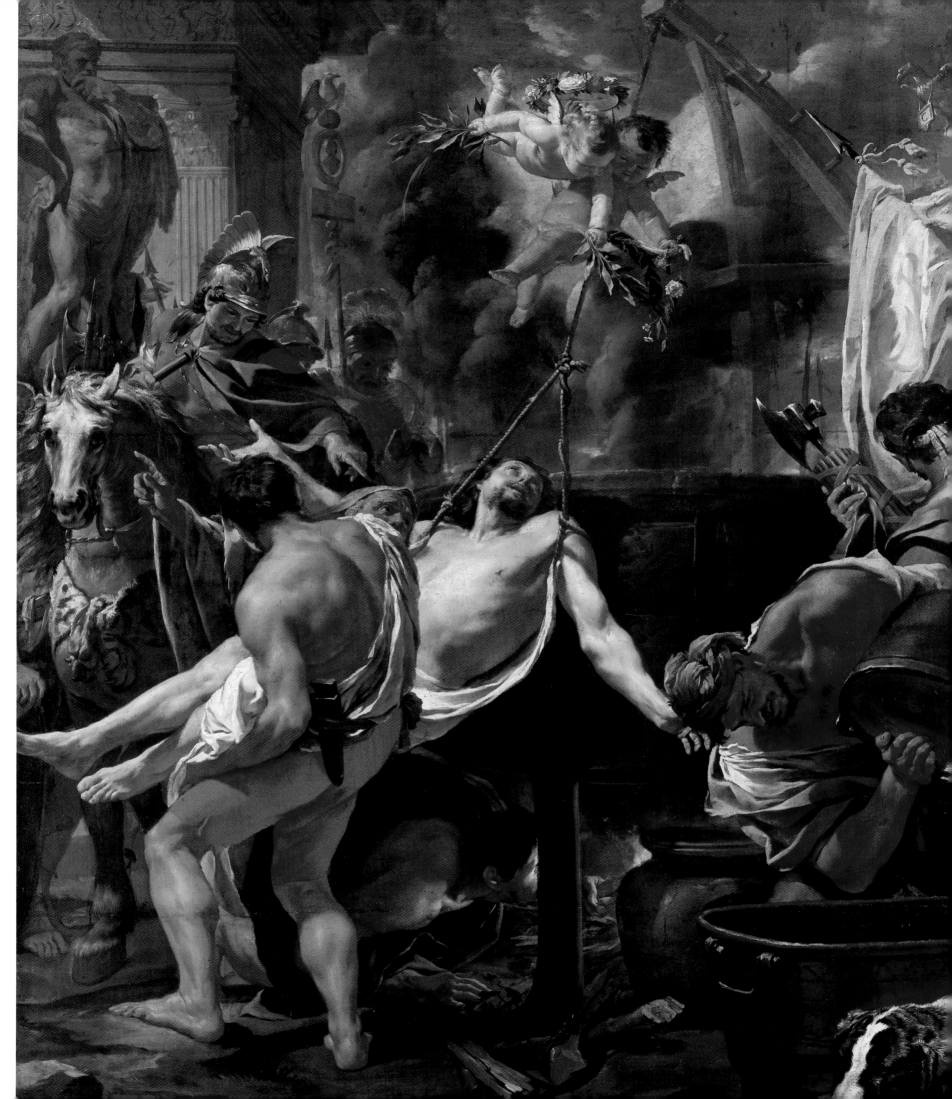

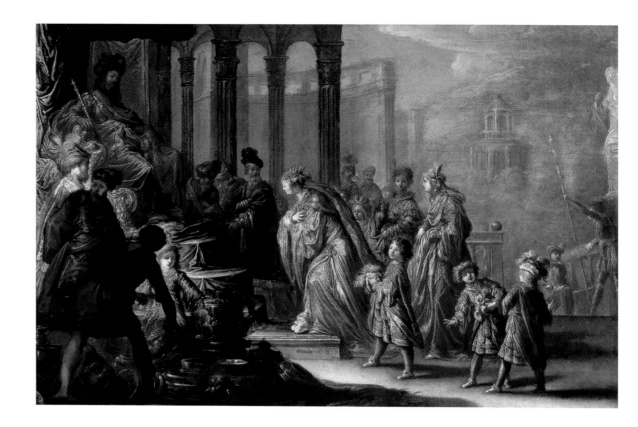

**29. Claude Vignon.**
*La Reine de Saba devant Salomon (The Queen of Sheba Before Solomon). 1624.*
(Musée du Louvre, Paris)

*This painting, in which the influence of French mannerism and Venetian painting is still visible (see the diagonal composition), already anticipates the work of Rembrandt.*

revelation of holy poverty? The *Saint Paul*, painted in 1649 for the cathedral (fig. 21), was considered a model for French painters and would earn Le Sueur the title of "French Raphael": indeed, the pyramid composition, the architectural framework, and the central figure came from Raphael. Le Sueur would also be admired in the nineteenth century: "Eustache Le Sueur, Raphael's spiritual son … without leaving Paris, would discern the beautiful and create marvels of grace and sublime simplicity," wrote Ingres, who remem-

**30. Eustache Le Sueur.**
*Vénus endormie surprise par l'Amour (Sleeping Venus surprised by Cupid). c. 1640.*
(Fine Arts Museum, San Francisco)

*Painted c. 1640, it was soon famous and engraved. The range of colors is characteristic of the artist. Venus's posture, inspired by the Ariane endormie (Sleeping Ariadne) in the Vatican, could be the origin of the Odalisques by Ingres (chapt. XI, fig. 88).*

Opposite:

**31. Simon Vouet.** *Allégorie de la Richesse (Allegory of Wealth). c. 1634.* (Musée du Louvre, Paris)

*This work was probably painted for the castle of Saint-Germain-en-Laye.*

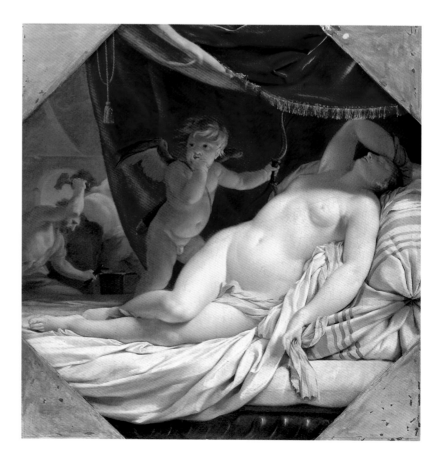

32. Le Nain. *Le Repas*
(*The Meal*), 1642.
(Musée du Louvre, Paris)

bered the *Venus* (fig. 30) when he painted his bathers and his odalisques (chapt. XI, figs. 88 and 105). One must in fact return to the *Venus* in order to understand the situation of French painting in the middle of the seventeenth century. One finds traits common to these painters who constitute the "first school of Paris": "A smoothing out, without noticeable impasto (thick paint), light colors juxtaposed with a refined audacity, sometimes with a touch of preciosity, a knowledgeable modeling"; these painters "privilege the line to the detriment of the brush stroke, avoid movement, and attach great importance to compositional rigor. Their taste for landscape and austere architecture, for beautiful bodies and beautiful drapery brings them together" (P. Rosenberg).

*Charles Le Brun*
When he started out, before founding his own "school" in Versailles, Le Brun belonged to this Parisian school. He was an adolescent prodigy who quickly learned Vouet's teachings and produced masterpieces in Vouet's style that equaled those of the master himself, notably the *Hercule* (*Hercules*) destined for Richelieu, which was painted before Le Brun's stay in Rome. Regarding the *Hercule*, Poussin said that if the painting was done by a young

33. Le Nain. *La Tabagie*
(*The Smoke Room*), 1643.
(Musée du Louvre, Paris)

man, this man would one day be counted among the greatest painters. In 1642 Le Brun left for Rome in the company of Poussin, who was returning to Italy. He rapidly took it all in, with that capacity for assimilation that had allowed him to appropriate the style of Vouet in short order. He was, in fact, in a hurry to return to Paris to move ahead of all the candidates for Vouet's position. From 1646 on, he was back. He distinguished himself with some remarkable decors in the Hôtel La Rivière (fig. 101) and in the Hôtel Lambert (figs. 82–83). In 1648 he founded the Academy of Painting and Sculpture, which would be the instrument of his conquest of power.

## Sculpture

That institution brought together painters and sculptors in the same academy, just as they had been together in the guild that stemmed from medieval practices. French sculpture, which benefitted from Goujon and de Pilon should have surpassed painting, which lacked notable antecedents. Instead, it was content to follow behind in a minor key. The sculptors of Henry IV were sound artisans; those of the reign of Louis XIII were respectable artists. The Parisian Simon Guillain, son of a sculptor, made a short visit to Rome; he returned in

1612. The only one of his works that has been preserved is the monument of the Pont-au-Change (figs. 24, 116), for which he was chosen over Sarrazin. However, Sarrazin was of another caliber. He was, perhaps, the sculptors' Vouet; he collaborated with that painter (whose niece he married) on the altarpiece of Saint-Nicolas-des-Champs (fig. 13). It was the first work he executed upon his return from Italy, where he stayed for many years (1610–1627) and where he saw the work of Gianlorenzo Bernini as well as that of Alessandro Algard. He had two talented disciples, Philippe de Buyster and Gerard van Opstal. He collaborated with Le Mercier on the realization of the Clock Pavilion at the Louvre (fig. 8). His last work is his masterpiece, the tomb of Henry of Condé (figs. 15–16). His talent is certainly equal to that of his successors, such as François Girardon and Antoine Coysevox, who would be brought to unparalleled fame by Louis XIV's patronage. The brothers Anguier were from Picardy. Michel was trained in Rome in Algardi's workshop; he collaborated with Romanelli on the summer apartments of the queen at the Louvre (fig. 100).

*The Royal Academy of Painting and Sculpture*

In the composition of the academy, Le Brun, son of a sculptor, could not forget the sculptors, but his intention was not to reproduce the organization of a guild. Rather, the

34–35. Laurent de La Hyre. *La Musique* (*Music*), 1649. (The Metropolitan Museum of Art, New York); *La Grammaire* (*Grammar*), 1650. (National Gallery, London)

*La Hyre produced two series of paintings representing the Liberal Arts. The paintings shown here probably came from the collection in the hôtel of Gédéon Tallemant, in the Marais. Gédéon Tallemant was the cousin of Tallemant des Réaux, author of the* Historiettes (Miniature Portraits). *A great lover of music, La Hyre represented several instruments in his painting: an angelica (a kind of theorbo) in the woman's hands; a lute, a violin and two recorders on the table; a shawm (wind instrument) behind the musical score; and an organ.*

academy presented itself as a kind of war engine against the guild. In fact, the guild had found itself fairly weakened by the exercise of royal warrants and protected zones, which since the beginning of the century had allowed artists coming in from the provinces and abroad to avoid the guild's rules, which only extended to the internal development of the trades. Either by warrant or by locating his studio in a protected zone, the artist could freely practice his trade. These zones were Saint-Germain-des-Prés, where Champaigne and the Le Nain brothers established themselves, or the workshops in the Great Gallery of the Louvre, placed at the disposal of artisans and artists by Henry IV. The academy received in 1654, with its statutes, the right to qualify itself as royal and for its members to carry the title of First Painter or First Sculptor to the king. The academy had the obligation to meet regularly; it did so at the Louvre. The reaction of the guild was strong; it created an Academy of Saint Luke, inspired by the one in Rome, and put Vouet at its head. Vouet had not been included among the first academicians because he was believed to be dying. The death of Vouet in effect saved Le Brun's Academy: painting and sculpture were definitively circumscribed within the circle of academies. It is worth noting that architecture, which we have already stated had not developed under comparable conditions to that of painting and sculpture, obtained its own academy only in 1671.

**36. Jacques Callot.**
*Fête nautique du 25 août 1629 (Nautical Festival. August 25, 1629), 1628–1629.*

*Probably prepared in 1628–1629, this view represents the nautical festival that was held every August 25: this represents the one held August 25, 1629. The Nesle Tower is on the left: on the right, the Louvre, with the wing of the Petite Galerie (Small Gallery) and the wing of the Grande Galerie (Great Gallery).*

**37. Mathieu Mérian.** *Plan de Paris (Map of Paris), 1615.*

*This map of Paris presents the state of the city at the death of Henry IV. One can see that the city is developed along the Right Bank, where the great east-west axis runs parallel to the Seine from the defended gate on the east by the Bastille to the western gate at the end of the Tuilerie Gardens. One can also see the cathedral, the palace, the Place Dauphine, the Pont-Neuf, the Nesle Tower on the Left Bank and the Tour du Coin on the Right bank. The towers on both sides of the river are vestiges of the medieval city wall, which still separates the Tuileries from the Louvre. The Louvre is linked to the Tuileries by the gallery wings: the Little Gallery, which runs from the Louvre to the Seine: and the Grande Galerie (Great Gallery or Waterside Gallery), which runs along the Seine from the end of the Petite Galerie (Small Gallery) to the Tuileries.*

Opposite:

**38. Jacques Gomboust.** *Plan de Paris (Map of Paris), 1652.*

*This map illustrates well the important urban planning project that involved the creation of the Pont-Neuf and the Place Dauphine by Henry IV. One sees the Louvre on the bottom: on the other bank, the Nesle Tower; above, the Ile de la Cité with the palace: on the large branch of the Seine, the Pont-au-Change, reconstructed with houses from 1639 to 1647; and the Pont Notre-Dame, which, along with its houses, dates from the end of the fifteenth century. On the Left Bank, the Pont-Neuf ends at the convent gardens of the Grands-Augustins, across which Henry IV had constructed the Rue Dauphine, which also was to be bordered with uniform houses, but this intention was not respected. In 1602 Henry IV had made a grant to the Fleming Jean Lintlaer for the construction of a water pump that abutted the Pont-Neuf. Gomboust's map shows it on the first pier on the side of the Right Bank: decorated by a representation of the Samaritan woman at the well serving Christ, it was known as the Pump of the Samaritan Woman.*

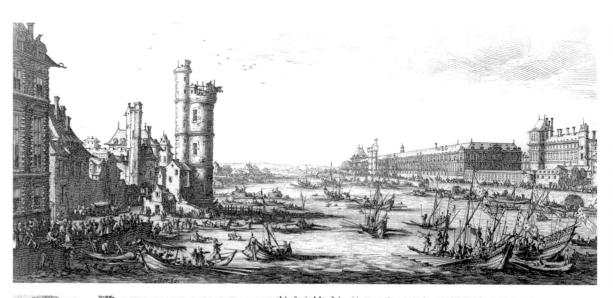

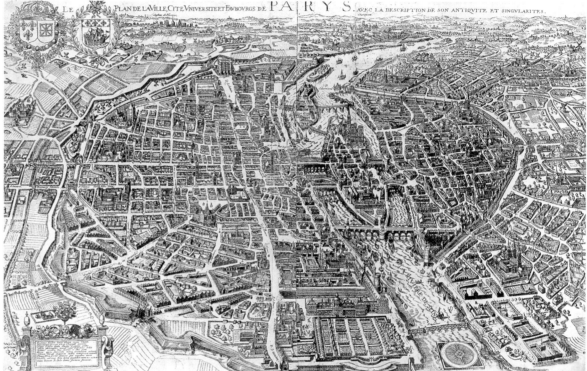

## 2 – THE CITY

The first half of the seventeenth century matters less in the history of French town planning for the number and originality of its new cities (Nancy, Charleville, Henrichemont, and Richelieu) than for the modifications made for the regularization and sanitization of an ancient city, Paris. The provincial cities would wait several decades before being effected by this movement.

Urban theory in France would remain rather elementary until the publication of *Discours de la méthode* (*A Discourse on Method*) in 1637, which brought the city into a general program for the rationalization of knowledge. Its author, René Descartes, stated the fundamental principle of town planning: the city is not an addition, it is an entity. The treatment of the city does not apply to the elements that make up the city, but to the relationships of these elements to each other. The planned city is therefore superior to the spontaneous city, for the relationships are established in a rational way. Descartes largely contributed to the discovery of the fully developed urbanite by writers and by the public. He justified, after the fact, the considerable work executed in the capital during the reign of Henry IV.

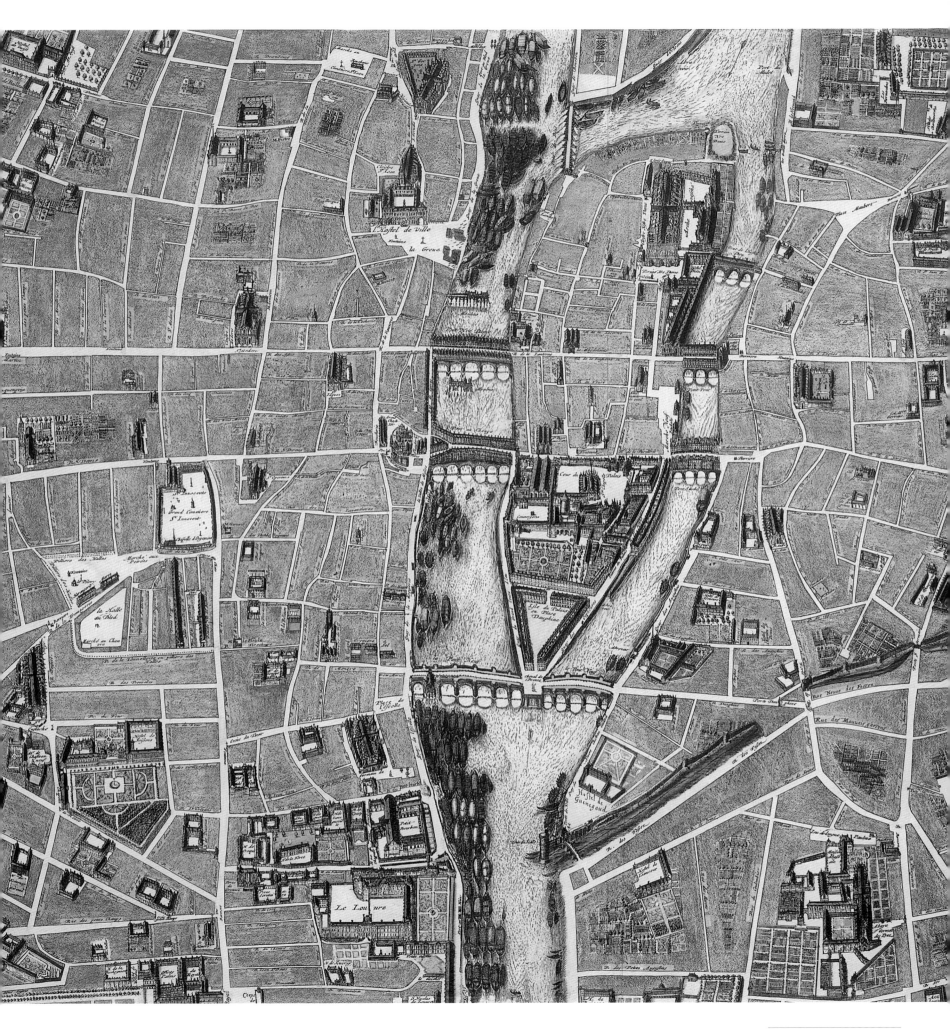

**39. Claude Chastillon.** *Pont-Neuf and Place Dauphine, engraving.*

*The Pont-Neuf was a project of the Valois's (it was to be called Pont-de-Valois). In the design by Baptiste Androuet du Cerceau, retained by Henry III in 1578, the bridge was not to have any houses. However, the bridge was remodeled according to a 1579 plan that envisaged the construction of houses. The part of the bridge spanning the small branch of the Seine was finished by 1588 when civil war stopped the work. It began again in 1598 by the initiative of Henry IV, who in 1601 decided definitively for the plan without houses. In 1604 the bridge was opened to traffic, but construction was not completely finished until 1606. In 1607 the king granted to the first president of Parliament the land on the tip of the island with the charge of dividing up the plots and constructing houses within an authorized area around an open area devoted to commerce and finance. The project called for a triangular area whose peak opened onto the platform of the Pont-Neuf and with an opening in the middle of its base toward the palace. There were to be fifty-two houses. The plans for uniformity were progressively circumvented; the square, called Place Dauphine, in honor of the future Louis XIII, was vandalized in the nineteenth century.*

The improvement of the capital, dearly bought at the price of a long siege and forced conversion, was arguably one of the great concepts of the reign. If Henry IV didn't manage to give Paris the stature of a grand economic metropolis, he knew how to make it into one of the most beautiful cities in Europe. The projects he undertook were organized around several simple ideas: to open the city to the river, give it open public spaces, structure it by the creation of authorized axes, and to clean it up. Public spaces, places to gather or places of amusement, were rare. There was no urban perspective. The Seine ran between walls like a canal; one crossed it without perceiving it on bridges bordered with houses. The bridges reconstructed in the sixteenth century, like the Pont Notre-Dame (fig. 71), along with their houses, based on the same model, constituted the only planned areas of Paris.

### The Pont-Neuf and the Place Dauphine

The importance of the Pont-Neuf, the first bridge constructed without houses built upon it, can only be evaluated in relation to other works: the reconstruction of the quays; the creation of Rue Dauphine on the axis of Pont-Neuf on the Left Bank; the creation of the Place Dauphine at the tip of the Ile de la Cité, which supports Pont-Neuf in the middle; and the eventual construction of the Pump of the Samaritan Woman (*La Samaritaine*). It was an incomparable urban ensemble, for which Henry IV was entirely responsible (figs. 38–40).

In 1607 commercial letters document the projected opening of Rue Dauphine and Place Dauphine that was to be bordered by authorized houses. This order was only respected on the square, which backed up against the Palais de la Cité and was to be a market square for the stock market and exchange of currency, which still took place inside the palace. Its triangular plan was intriguing, but the prow of the island almost necessarily called for this form. The ensemble was completed by a veritable shrine, the Pump of the Samaritan Woman, constructed on the Pont-Neuf between 1602 and 1608. This was

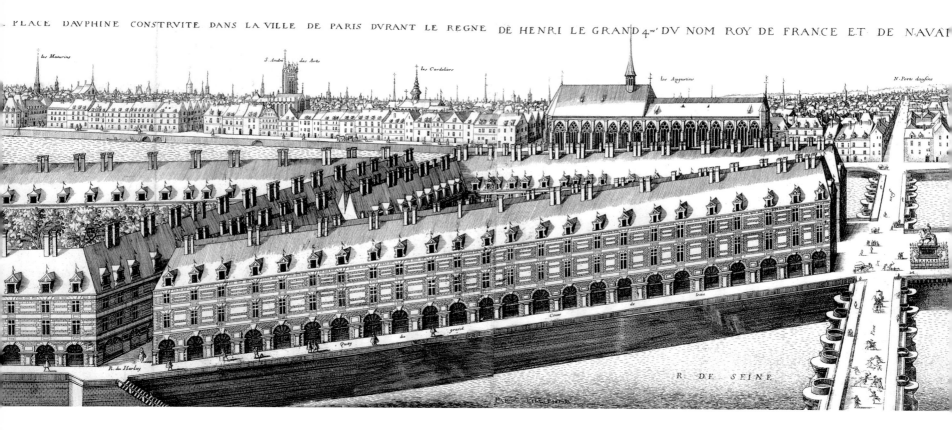

PLACE DAVPHINE CONSTRVITE DANS LA VILLE DE PARIS DVRANT LE REGNE DE HENRI LE GRAND 4.ᵐᵉ DV NOM ROY DE FRANCE ET DE NAVAR

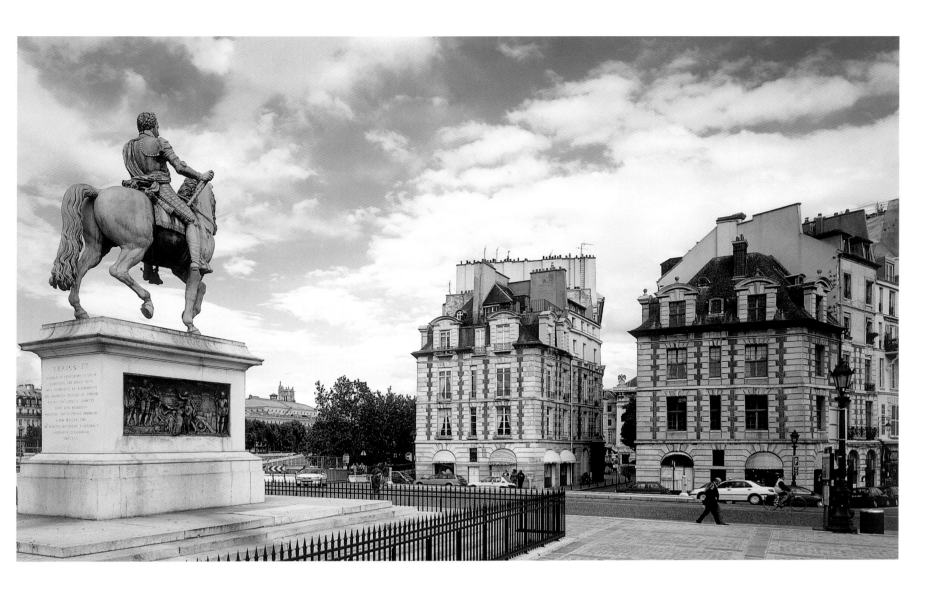

the solution found by Henry IV to the difficult problem of bringing water to the capital. The large aqueduct bringing the water from Rungis in the south was not constructed until 1613.

To crown this grand scheme, the only thing missing was a statue of the king. It was erected in 1614. This was, for France, the first monumental statue that was not linked to a building or a temporary decor. In 1559 Catherine de Médicis had ordered from Daniele de Volterra an equestrian statue of Henry II, but, as we have noted, it is not known where the queen had wanted to place it; though perhaps in the courtyard of one of her dwellings. Henry III was probably the first to think of placing a statue on the Pont-Neuf. Marie de Médicis ordered the statue of Henry IV from Giovanni da Bologna, modeled after equestrian statues of the Médicis grand dukes. The horse for Henry IV was even cast from the mold of the horse for the Grand Duke Ferdinand, Marie's uncle.

### The Place Royale

The creation of the Place Royale (now the Place des Vosges) is equally important (figs. 41–43). Catherine de Médicis had wanted to raze the Palace of the Tournelles, where Henry II had come to die after a dramatic tournament, and as of 1563, had envisaged making a square on that spot. Henry IV founded a silk, gold, and silver drapery manufacturer there before returning to the idea of a square; as a sign of the times, the monument project had better luck than the mercantile project. The square was built from 1605 to 1612. Situated at the heart of the Marais, a fashionable neighborhood, it was divided into lots, built up by speculators, and its pavilions were rented to people of high standing.

**40. Statue of Henry IV on Pont-Neuf**

*Set on the platform of Pont-Neuf was an equestrian statue of Henry VI. It had been commissioned in 1601–1605 from Giovanni da Bologna by Marie de Médicis, but it is not clear whether she planned at that stage to take up Henry III's idea of setting a royal equestrian statue on Pont-Neuf. Although the foundation stone for the pedestal was laid on the platform in 1615, the slaves decorating the base were not set in place until 1635. The statue consisted of a horse made from a mold Bologna had already used for the equestrian statue of Arch-Duke Ferdinand I de Medici, the queen's uncle; and from a knight by Pierre Franqueville that had been modified with a bust of Henry IV. The equestrian statue was completed after Giovanni da Bologna's death by Pietro Tacca. The original statue was destroyed during the Revolution, and only Franqueville's slaves survive (now in the Louvre). It was replaced in 1818 with a sculpture by Frédéric Lemot.*

## 41–43. *Place Royale*
### (currently *Place des Vosges*)

*In 1603 Henry IV founded a factory for silk, gold, and silver cloth "in the manner of the Milanese." In 1604 he endowed it with land appropriated from the Tournelles Hôtel development, on which workshops and houses for the artisans he had brought from Milan were constructed. In 1605, when the factory was running, Henry IV decided to create a closed-off square: the factory would constitute the north side of it. The idea was to make a square for commerce and industry whose building ranges would be occupied by the workers. This square would also serve as a "strolling area" for the people of the city and a place for festivals. The ranges, which were to present uniform facades, were on strips eight measures (of six feet each) wide and twenty-two or thirty-two measures long. Fashionable apartments could not be built on the square: these conditions allowed for the construction of decent bourgeois houses, but not individual hôtels. However, the lure of a particularly large public space in a fashionable neighborhood, the Marais, attracted the aristocracy. By consolidating the lots or expanding from the back, behind the facades, some of the advantages of individual hôtels were regained. Taking into account this evolution, in 1607 Henry IV relocated his commercial project to the Place Dauphine and ordered the factory's demolition and replacement by ranges similar to those that had already been constructed on three sides. At the death of Henry IV, the square had just been completed. In 1639 an equestrian statue, ordered by Richelieu, was placed at its center: the horse was the one that had been ordered in 1559 by Catherine de Médicis from Daniel de Volterra for an equestrian statue of Henry II. The horseman was a work by Pierre II Biard. The statue that one sees today is a creation of the Restoration, replacing the original monument destroyed by the Revolution. In 1682 the riverside residents had obtained the creation of a central garden bordered by gates, which profoundly modified the spirit of the original project. That project is known from the engraving by Claude Chastillon, representing the Carrousel organized in 1612 for the marriage celebrations of Louis XIII and Anne of Austria. The painting shown at right is a copy of the engraving.*

Almost entirely closed off, in the wings of the Rue Saint-Antoine, it constituted the great street of the time, a place of relaxation and festivals. In the royal declaration of 1605, it was anticipated that the square would serve as a "strolling area for the inhabitants of [the] city, who were densely packed in their houses because of the multitude of people who came in from every side, as it would be on holidays when there would be large assemblies." The square was inaugurated with a carrousel, a new royal distraction replacing the condemned tournaments. The statue of Louis XIII, added during Richelieu's time, caused it to lose its

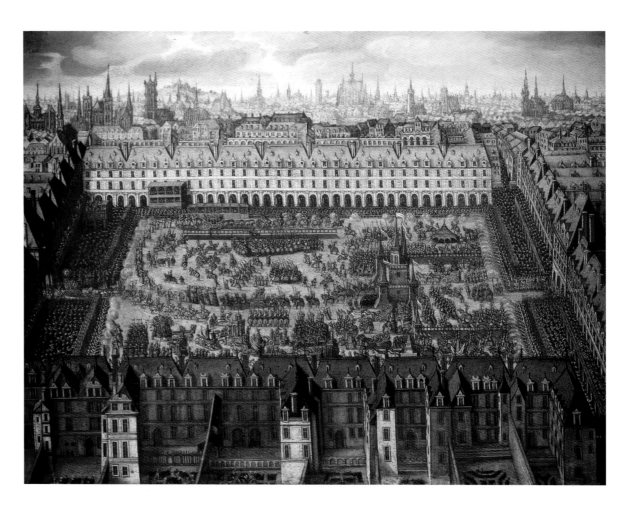

private square character. The horse was the one that Catherine had ordered for Henry II (the present statue dates to the nineteenth century).

### Other Urban Projects

The Place de France project also belongs to the reign of Henry IV (fig. 44). It was highly symbolic because its radiating thoroughfares would bear the names of the provinces. It was to be a governmental square: the buildings would look like contemporary *hôtels de ville* (town halls). The author of the project for this square was almost certainly Claude Chastillon, who also constructed the Saint-Louis Hospital (figs. 45–46). The two works would share not only an organizer, but also a location in the northern limits of Paris (inside the city wall for the square, outside it for the hospital). The hospital was in fact for contagious patients, and was only used during epidemics, which obviously had to be kept outside the city.

The similarities among all the constructions under Henry IV raise the problem of the role played by Claude Chastillon and, more generally, that of project developers. Claude Chastillon was an engineer from Champagne, appointed topographer to the king in 1580, who often drew up views of cities and castles during war. These were the subject of a

posthumous publication (he died in 1615) *Topographie française ou représentation de plusieurs villes (French Topography, or the Representation of Several Cities)*, 1641. The topographical aspect is more important than the architectural aspect in the squares during the reign of Henry IV: the squares were the product of plot development, with a standard facade imposed on the purchasers, who were then obliged to build. The facades, which are attractive because of their palette of stone, brick and slate, have the simplicity and efficiency of barracks. However, it is possible that another architect besides Chastillon was involved. This

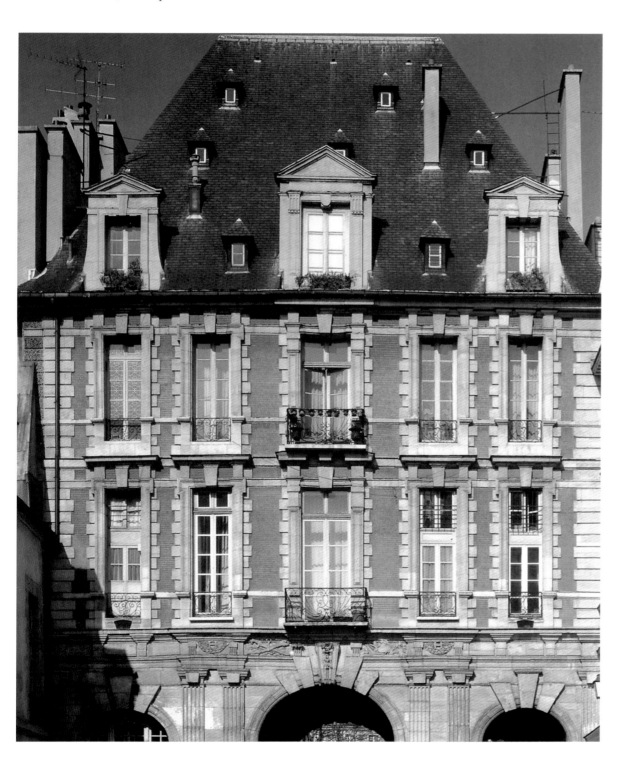

**42. Place Royale (now Place des Vosges):
Le Pavillon du roi (The King's Pavilion)**

*This pavilion marks the middle of the southern side (to the left, on Chastillon's engraving). The facade is above the street, which enters the square by passing under the pavilion.*

might have been either Jacques II Androuet du Cerceau or Louis Métezeau, who were both architects to the king.

Following two pages:

**43. Place Royale (now Place des Vosges)**

*This is the northern side, with the Queen's Pavilion in the center.*

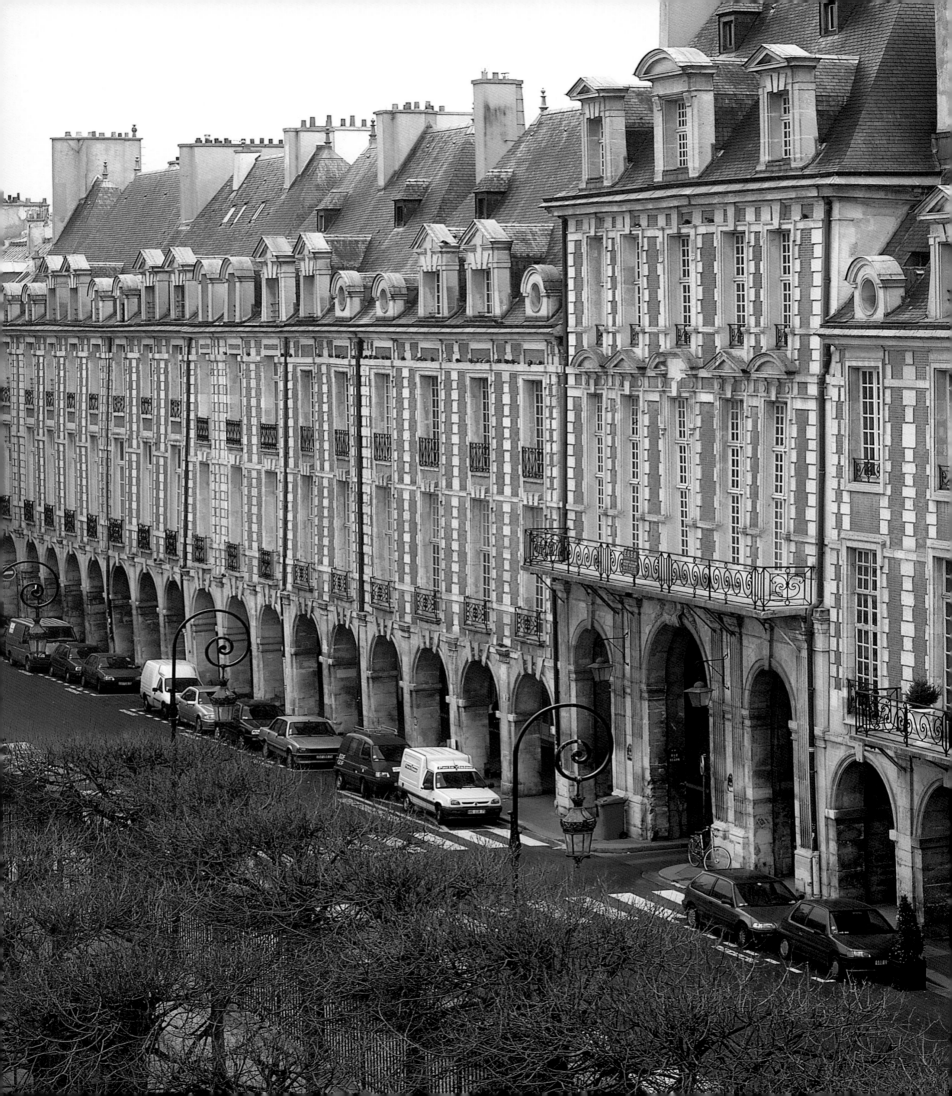

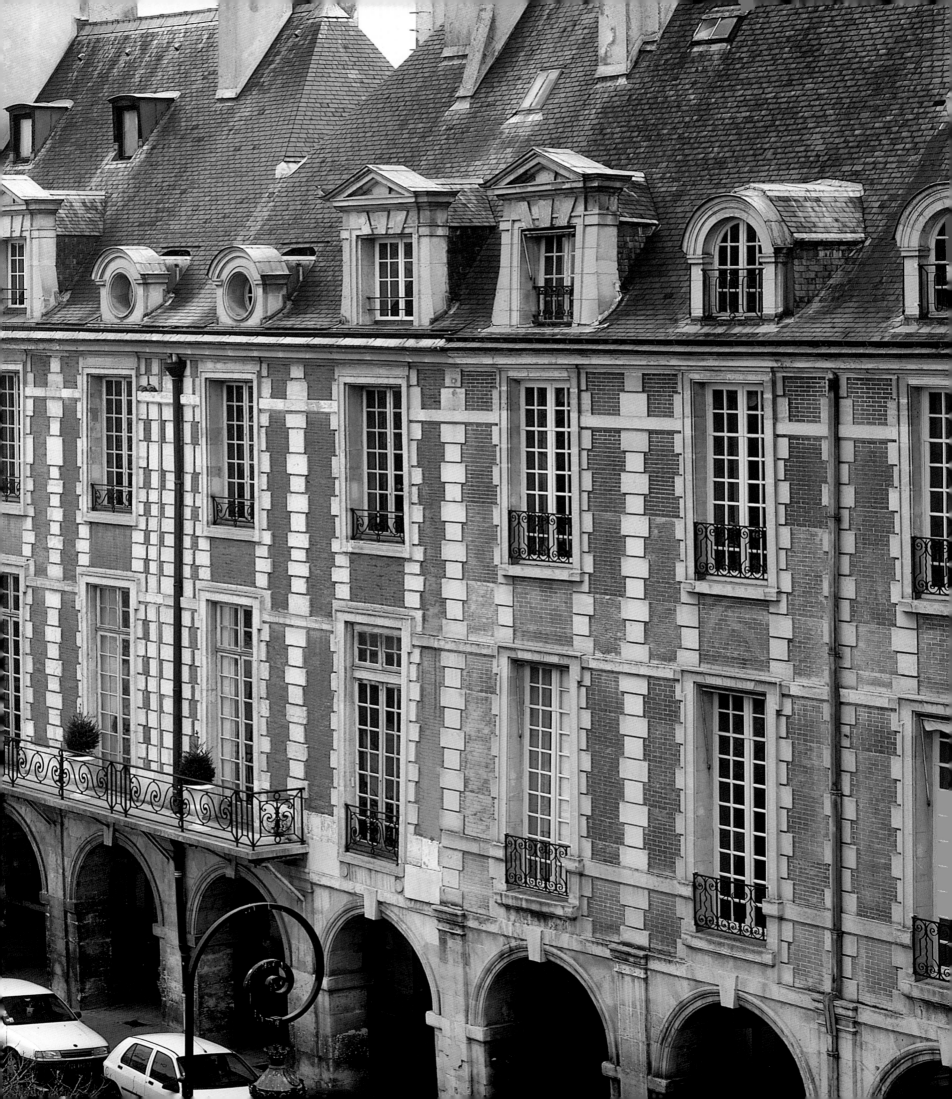

**44. Claude Chastillon.
Project for the Place de France.**

*This square with radiating streets was planned
in 1608 by Claude Chastillon, on the initiative
of Henry IV. It was to back on the Porte de
France gate in the city wall and to be developed
on land belonging to the Temple, in the north
of the Marais neighborhood. It was to be a
government square with a hôtel for the Grand
Conseil (High Council): the avenues would
bear the names of French provinces. The apart-
ment buildings on the square were made to look
like contemporary hôtels de ville (town halls).
The death of the king caused the project to be
abandoned. The land was split into lots in 1626.*

Taking into account only the constructions of this reign, it is clear that in ten years there was a transformation of the city, though without significant innovation. The ideas had been around in Paris since the sixteenth century. The work of the following reign was not less important, but it stands out less because the sovereign himself had less panache and also because he took little initiative. During the first half of the seventeenth century several promenades were renovated, notably the Arsenal mall, for a game called *"pailmaille"* (a kind of croquet), created in 1604 by Sully between the Arsenal and the Seine. The most important of these promenades, the Cours-la-Reine, was opened only in 1616 by Queen Marie de Médicis. This promenade along the Seine was an imitation of the walk in the Park of the Cascine, in Florence, along the Arno River. The Cours-la-Reine extended westward the shady areas of the Tuilerie Gardens, created by Catherine de Médicis, and prefigured the Champs-Elysées, which would not be sketched out until 1665 and then in the axis of the garden.

During the reign of Louis XIII no fewer than five new bridges were constructed, which resulted in a doubling of the number of the bridges in the city, but their financing was private, along with their initiative, which explains why they were still constructed with houses to make the operation more profitable. Again on the initiative of speculators, entire neighborhoods were divided into lots; one example, the Ile Saint-Louis, was deserted at the time and still preserves the constructions of the years 1640 to 1660. In *Le Menteur* (*The Liar*), 1643, Corneille has one of his characters say about the Ile Saint-Louis: "Paris seems to my eyes to be the country of a novel / I thought this morning to have seen an enchanted island / I left it deserted and now find it inhabited / Some new Amphion without the help of masons / Has changed its bushes into superb palaces." In the area of the Fossés-Jaunes, the palaces of Cardinal Richelieu and Cardinal Mazarin were constructed: Richelieu had obtained the report of the fortifications to create a new neighborhood north of the Louvre. *L'Etat de la France* (*The State of France*), 1652, by John Evelyn witnessed the building activity: "Not only are these houses that are being built daily, but entire streets, so beautiful, so regular in form, that rather than believing yourself in the middle of a real city, you would imagine that you are attending some Italian opera where the diversity of the scenes and their changing views surprise and charm the spectator." On the whole, this activity appeared to be intense during the period from 1600–1660, but it is difficult to date and to attribute specific decisive changes to it.

One questions in particular the history of the Grand Design of the Louvre, whose realization contributed substantially to the development of the city to the west. The portion that one attributes traditionally to Henry IV may be wrong, however. With the declaration of 1624, Louis XIII authorized the execution of plans "halted after good and thoughtful deliberation during the reign of king Henry II." In his *Histoire de Louis XIII* (*History of Louis XIII*), 1646, Charles Bernard reported that in 1624, Louis XIII decided to execute the Master Plan, which had been interrupted for sixty years, since around 1564, when Catherine de Médicis began constructing the Tuileries and the connecting wings. Under these conditions, it is difficult to attribute the concept for the Master Plan to Henry IV. In fact, it must be taken back to the project by Sebastiano Serlio (chapt. VI, fig. 45). At that time, there could only be one plan for the Louvre because the Tuileries did not exist: its Cour Carrée (Square Courtyard) had the dimensions and the positioning of Lescot's plan, but the ensemble extended only as far as Charles V's city wall.

**45–46. Claude Chastillon and G. Mérian. Saint-Louis Hospital, engraving**

*The Saint-Louis Hospital is in the foreground of the engraving by G. Mérian, seen below, representing Paris seen from the north (around 1620). It was constructed on the order of Henry IV in 1607, probably by Claude Chastillon, author of the engraving above. It is a hospital that was reserved for the treatment of epidemics, which explains its location outside the city walls. In order to deal with epidemics, provisional hospitals were created during the sixteenth century. The Saint-Louis Hospital, while constructed as a permanent site, was only to be used for cases of epidemic. The hospital has preserved its general layout to this day.*

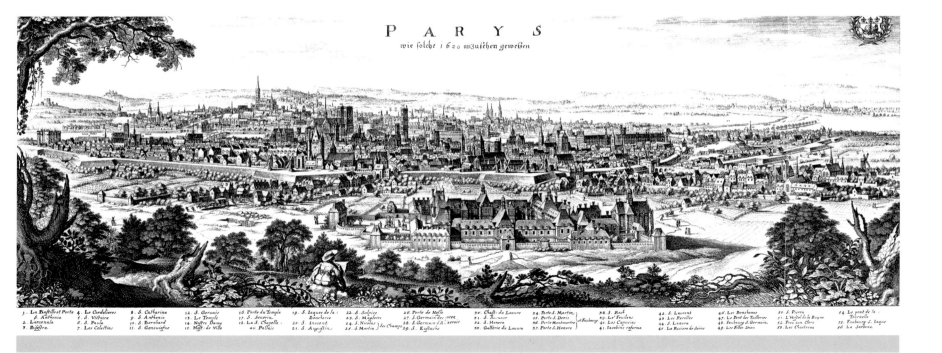

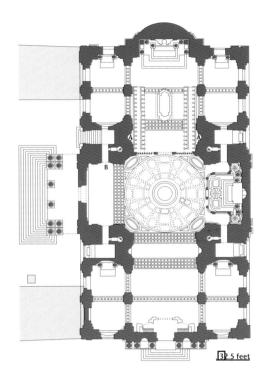

32.5 feet

There was no church in the Louvre, the palace of the king, and the apartments of the king and queen contained only oratories. The nearby parish church of Saint-Germain-l'Auxerrois served as the royal church instead. Certain versions of the Grand Design envisaged a church that would be rather small in comparison to the Sainte-Chapelle in the Palais de la Cité (the palatine chapel *par excellence*), and especially in comparison to the main church in the Spanish palace of the Escorial, paragon of the Counter-Reformation. The construction of the church at the Escorial began as soon as the Council of Trent (1563) ended, and was the Catholic Church's response to the Protestants.

The Louvre illustrates the state of the architectural tradition in France. The level of perfection that churches had reached in the Middle Ages seems to have inhibited the desire to renew and build again for a long period of time. Until the end of the ancien regime and practically without interruption, the Gothic style was used in the provinces. The predominant medieval plan with side aisles, a transept, an ambulatory, and radiating chapels continued to be used for the main parish churches in Paris. Saint-Sulpice, Saint-Roch, and Saint-Nicolas-du-Chardonnet (all of which were begun between 1646 and 1656) no longer appeared Gothic, but did retain the same plan as the cathedrals.

Another aspect of the French national tradition was the unwillingness of the Gallican Church to accept Roman authority, which delayed the application of Council of Trent decrees until 1615. However, and albeit with some delay, France contributed significantly to the work of the Counter-Reformation, due mainly to the vigor of its unique institutions, its religious communities of men and women, and its reform of old monastic and mendicant orders. The first half of the seventeenth century in France was marked by what might be called a monastic inflation, particularly noticeable in Paris. Paris and its suburbs contained twenty-four religious institutions in 1600, and seventy-seven more were created between 1600 and 1670. This proliferation creates a marked curve, the peak of which was reached in

### 47–50. The Sorbonne

*Richelieu instigated the remodeling of the old Sorbonne in 1626. The chapel was built from 1635 onward by Jacques Le Mercier. It was intended to accommodate the cardinal's tomb, but this was not actually made until 1675–1694. The tomb was placed directly in line with the lateral facade overlooking the courtyard. The facade overlooking the square, as it was executed, is shown on the frontispiece of a thesis defended at the Sorbonne in 1639; here Robert de Sorbon, chaplain of Saint-Louis and founder of the institution, can be seen bowing to Richelieu, the Sorbonne's new protector. In the heavens are Saint Louis, first benefactor of the university, and Louis XIII. In the background is the scene of the oral defense of a thesis. The inscription at the top of the engraving on the right reads: "Lateral facade of the Sorbonne Church as seen from the main courtyard of the university."*

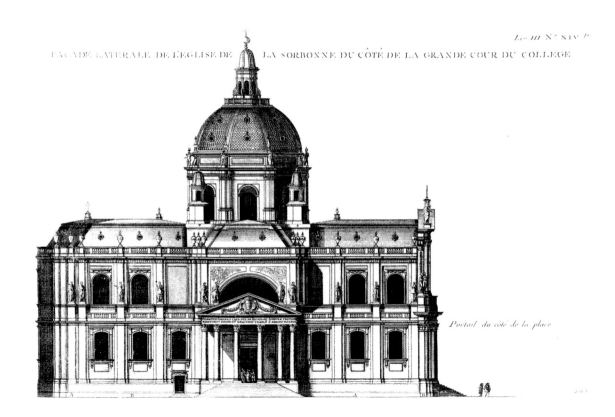

FACADE LATERALE DE L'EGLISE DE LA SORBONNE DU CÔTÉ DE LA GRANDE COUR DU COLLEGE

*Portail du côté de la place*

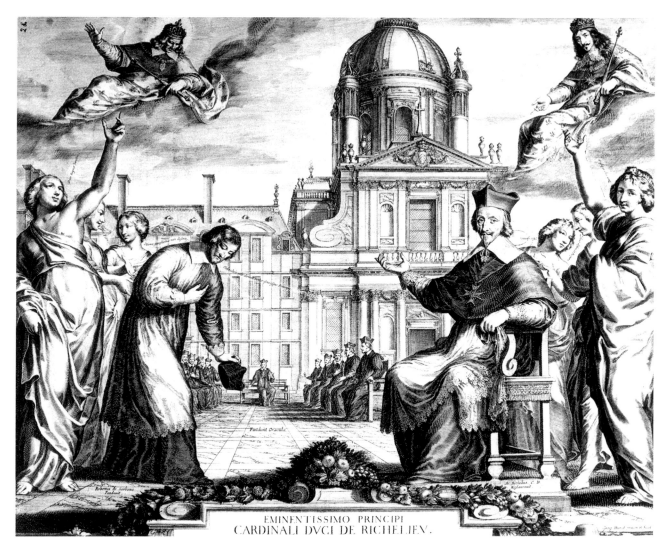

EMINENTISSIMO PRINCIPI
CARDINALI DVCI DE RICHELIEV.

Grégoire Huret. Engraving
for the frontispiece of the
thesis defended by Jean Chaillou
at the Sorbonne in 1639.

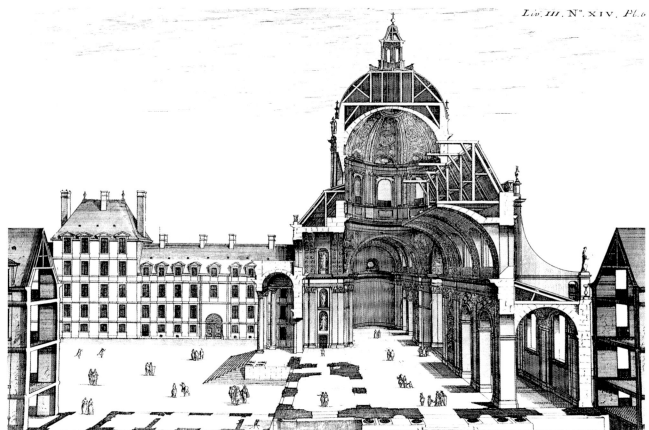

*Liv. III. Nº. XIV. Pl. 6*

Jean Marot.
*The Sorbonne,*
engraving.

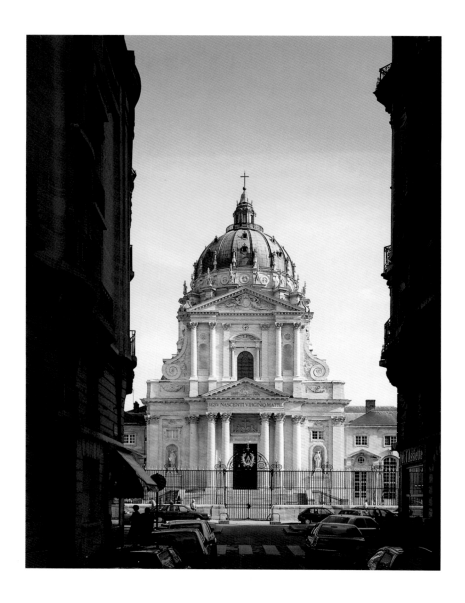

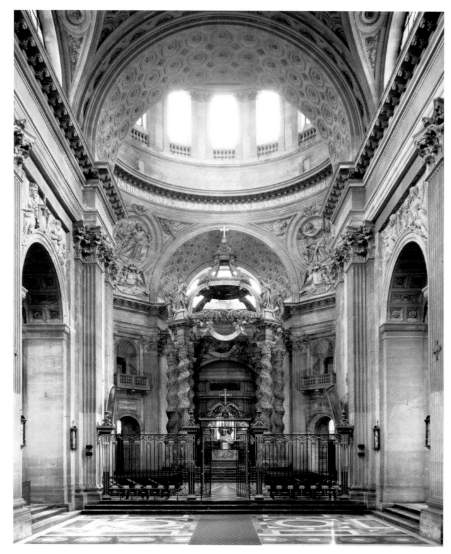

### 51–57. Convent of Val-de-Grâce

*In 1624 Queen Anne of Austria laid the
foundation stone for this Benedictine abbey
for women. However, the queen did not lay
the stone for its church until 1645 when she
became regent for the young King Louis XIV:
in this way, she fulfilled the vow she had made
for the birth of a son. She asked François
Mansart to draw up a plan. After a dispute
with the queen, Jacques Le Mercier replaced
him in 1646 and carried out Mansart's plan
with very few modifications. After completion
of only the first level, construction was halted
during the Fronde (a period of revolt against the
absolutism of the crown). Work resumed after
Le Mercier's death in 1654 under the super-
vision of Le Muet and his assistant Gabriel Le
Duc. The upper sections (the second level of
the façade, the vaults, and the lantern tower)
were carried out according to Le Muet's
design. While constructing the upper sections,
Le Muet also raised the original convent
buildings and added a pavilion at each of
their four corners: the first pavilion, built in
1655–1656 (on the northeast corner) housed
the apartments of the queen mother.*

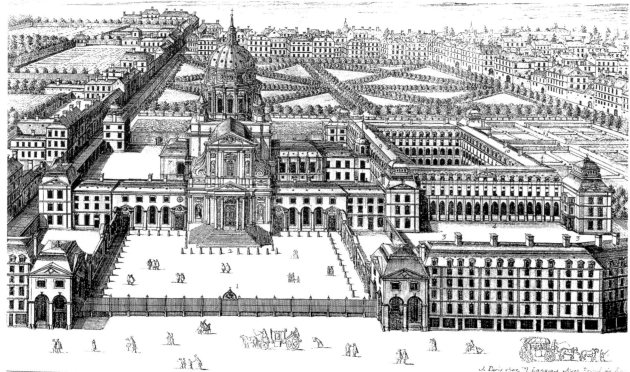

LE MONASTERE ROYAL DE VAL DE GRACE  q'Anne d'Autriche Reine de France fit bastir en action de Graces des 2. enfans  que Dieu luy avoit donnez, Elle acheva cet Edifice
en 1668, aussi bien que celuy de la  nouvelle maison des Religieuses que Marguerite d'Arbouze avoit commencée en 1622. Mansart, le Duc, le Muet et Du Val en ont esté les Architectes et
Mignard en a peint le Dome à fresque.      1 Grande Cour.  2 Eglise.  3 Basse Cour.  4 Refectoire.  5 Cloistre. 6 Cazernes Religieuses.  7 Chapelle de la Reine.
8 Clocher.  9 Cuisine.  10 Infirmerie.

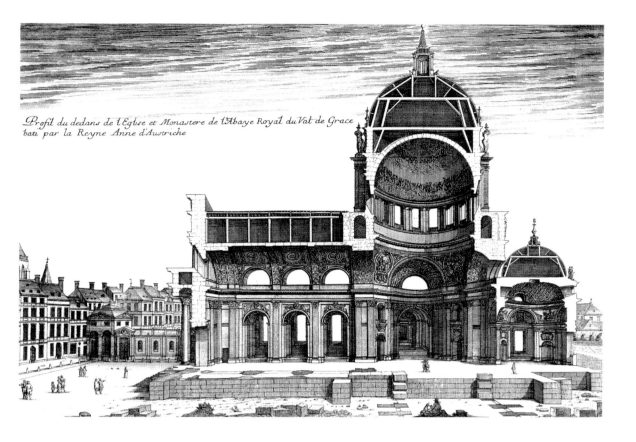

Profil du dedans de l'Eglise et Monastere de l'Abaye Royal du Val de Grace bati par la Reyne Anne d'Austriche

the 1630s: five institutions were founded in the 1600s; nine in the 1610s; fourteen in the 1620s; twenty in the 1630s; fourteen in the 1640s; ten in the 1650s; and five in the 1660s. In 1630, no fewer than 15,000 religious institutions existed in France, half of which were newly created.

Educating the youth, training priests, ministering to the faithful and to infidels, the over-all rebuilding of the church, filling the void left by the Reformation, and the conquering of pagan lands all rested on the shoulders of the local priests. Some of the best known of these societies were Parisian, notably the Jesuits; the Oratorians (1611), founded by Pierre de Bérulle; and the Sulpicians (1641), founded by Jean-Jacques Olier, the builder of the Saint-Sulpice Church. The church of the Oratoire was built north of the Louvre by the royal architects Métezeau and Le Mercier; in the year prior to the revival of the Grand Design, Louis XIII designated it as the Louvre's new church. The architectural achievements of the Jesuits, in number and scope, earned them a name in Counter-Reformation art. Fortunately, the pejorative sense of the term "Jesuit Style" (a synonym for pretentiousness and excessive decoration) and the misunderstandings on which that term was based, caused the style to be condemned—without, however, reducing the society's artistic influence. On the contrary, in fact, the Society's strongly centralized organization lent itself to the formation of its own style. All plans had to be submitted to the Jesuit Superior for approval, and in certain provinces where the priests were especially mindful of unity, they begged him to provide model plans. In Rome a reviewer scrutinized the plans. In the early days Brother Giovanni Tristano (who died in 1575), co-creator of the famous Roman church Il Gesù, held this position. The Jesuit Superior could also choose a *praefectus fabricae* (Master of the Works) to supervise the building sites in one or several provinces. Brother Etienne Martellange (who died in 1641) traveled across France for over twenty years in this capacity (1605–1627).

**55. Church of Val-de-Grâce**

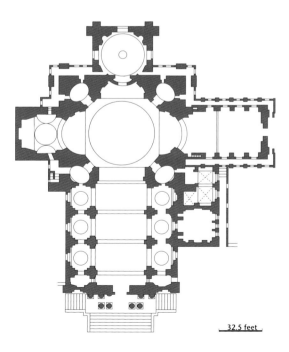

32.5 feet

*From the church, and viewed right to left, are the choir and the accommodations for the nuns, the queen's chamber resting on columns, and the queen's apartments, with three wrought-iron balconies.*

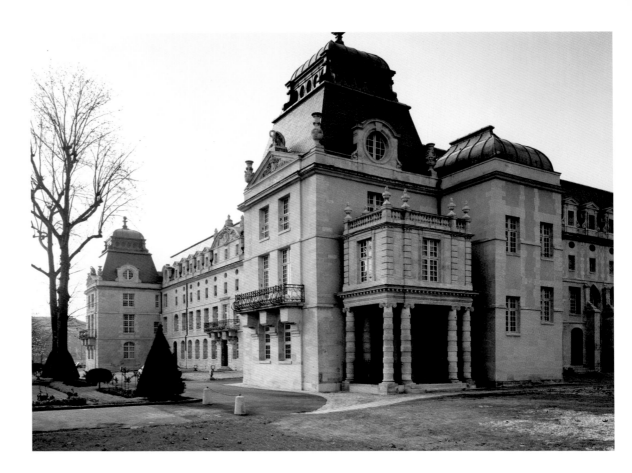

## THE NEW CHURCH ACCORDING TO THE COUNCIL OF TRENT

*In his instructions published in 1577, Saint Charles Borromeo, Archbishop of Milan and principal interpreter of the council's wishes regarding architecture, recommended the Latin cross plan, which allowed the community of the faithful to be gathered in a single area. Because faith spread through preaching, it was very important that the preacher was visible and audible, which was not always the case in medieval churches with multiple side aisles. Practicality resulted in a plan that efficiently met the council's requirements and served the needs of the new congregations especially well. The plan called for a single wide nave flanked by lateral chapels, a transept, and a simple choir without side aisles, ambulatories, or chapels.*

*Confessionals appeared in the nave chapels (reaffirming the sacramental nature of confession by the council, which had been disputed during the Reformation.) The chapels had openings leading from one into the other, to maintain at least a basic flow of lateral traffic, which the medieval side aisles had ensured. The transept remained as a material representation of the cross, but it was shorter so that the church could be fitted more compactly into the rectangular urban plot. To facilitate the insertion of a church into that lot, the requirement that the choir face east was abolished. The choir, short and simple and ending in only an apse, suited parish and congregational (locally organized) churches alike, since unlike monks and canons, the parish priests did not hold services in the choir. Il Gesù (the church of the Jesuits in Rome) is a perfect illustration of this type.*

### The Jesuit Seminary

These practices could only lead to a sort of uniformity in appearance among all Jesuit churches. But the *modo nostro* (the approach to architecture, including materials and method) of Brother Tristano and the stereotypical constructions of Brother Martellange derive from a type of architecture that is austere, and formed in the spirit of renunciation imposed by the rule of the Jesuit society. The control of Rome favored efficiency above all, and for that reason the use of local architectural resources rather than the adoption of a single or consistent international style was recommended. Besides, those in Rome did not always exercise their control, as in the case of the seminary church in Paris, where Father François Derand, supported by the Parisian Jesuits, finally won out over Brother Martellange who had been selected (in Rome) by the Jesuit Superior in 1625. Begun in 1627 according to Brother Martellange's plan and constructed by Father Derand, the church of the Jesuit Seminary in Paris had a very Roman organization (figs. 58–63). But it rivaled the church of Il Gesù more than it imitated it. Comments made by contemporaries indicate quite clearly that Martellange wanted the first French Jesuit church to equal the one in Rome. In any case it became the paragon of French churches of the Counter-Reformation because of its wide nave, its numerous confessionals, and its galleries. Galleries were practically a requirement in all Jesuit churches in France because the clergy and the students used them, whereas the nave was reserved for the congregation. This "almost" royal church was dedicated to Saint Louis and protected by Louis XIII. Situated within the Marais section of Paris, it was destined to play a major role in the spiritual life of polite society, and even in fashionable worldly circles because of the renown of its noted confessors, its magnificent services, and its eloquent preachers. There was such large attendance during Lenten sermons that footmen were sent to the church several hours in advance to reserve seats.

### Churches by François Mansart

The central plan, which the Renaissance had designated as the ideal for modern churches, had been implicitly condemned by the Council of Trent because of its pagan origins. That

plan did not enjoy much success in sixteenth-century France, where it had been used only for chapels in castles or churches. The Church of the Visitation in Paris (figs. 68–69) is probably tied to this tradition. The church was built by Mansart for the Sisters of the Visitation, a congregation of women founded in 1610 by François de Sales and Jeanne de Chantal. The founders' design models, as well as their recommendation for restraint, were not followed in Paris. Instead, the plan for this Church of the Visitation clearly drew upon Santa Maria Rotonda, which is the pagan temple of the Roman Pantheon. The *herresco referens* (essential example) are Mansart's kidney-shaped chapels surrounding the central and centralizing nave in the church, which are reminiscent of the Roman churches of Francesco Borromini, such as San Carlino, which is contemporary with the Paris Church of the Visitation.

In 1657, at the church of the Minimes (a mendicant order), Mansart initiated a facade that should have been part of the view from the Place Royale, which had been gouged out in preparation for it. It is one of the most outstanding compositions in French art (fig. 70) and justifiably famous for Mansart's masterly hierarchy of the masses. Its pyramidal structure recalls the compositions used in paintings by Leonardo da Vinci and Raphael. The pyramidal effect is not achieved at the crossing, but on the first bays of the nave, by building a domed lantern-tower that seems to dominate an edifice with a central plan.

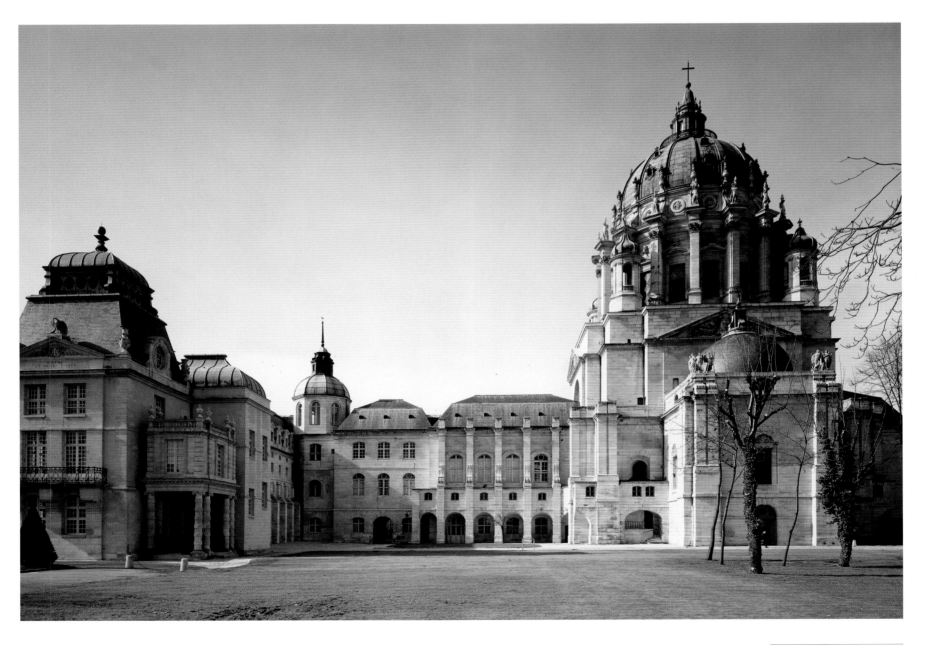

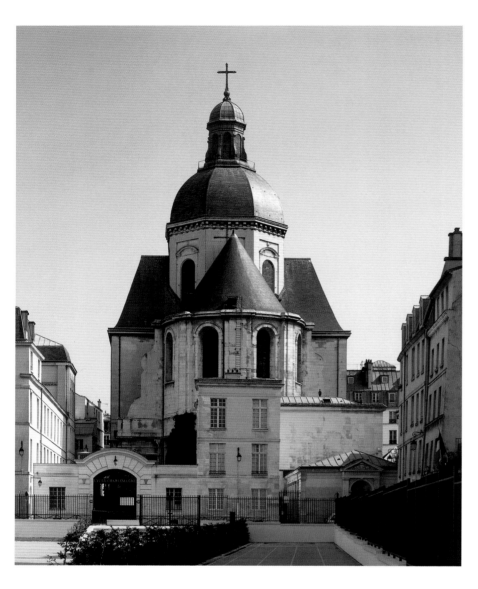

The design was too ambitious for the Minimes' financial means, and would be fundamentally altered prior to execution. Mansart may have originally proposed the design for Val-de-Grâce. The abbey of Val-de-Grâce (figs. 51–57) was the fulfillment of a vow in which Anne of Austria had promised to finance the construction of a great church should God grant her a son; that son was Dieudonné (meaning God-given), the future Louis XIV. The plan for this church was a mixture of various elements. The choir was treated like a centrally-planned church, onto which the nun's choir was grafted to the right and the queen's oratory to the left. Finally, the nave was reserved for the congregation of the neighborhood, who had no parish church. A comparison between the Minimes project and the actual execution of the design at the Val-de-Grâce highlights the major flaw in the design: within the main sight line, the nave hides the dome.

### The Sorbonne

Due to its ambiguousness and the element of surprise created when its double identity is revealed, the Sorbonne's mixed plan, derived from the central as well as the long plan, is also characteristic of Roman architecture in the first half of the seventeenth century, all the more so since it is based on an illustrious precedent. In 1607 Carlo Maderna had "reformed" Saint Peter's according to the spirit of the Council of Trent by adding a nave to the centrally-planned church by Bramante and Michelangelo. The church of San Carlo ai Catinari, which was begun in 1612 when Le Mercier was in Rome, may have served as a model for the Sorbonne Church, which was begun in 1635 by Mansart for Richelieu (figs. 47–50). The two plans are almost superimposed on one another, except that in the French plan there is an

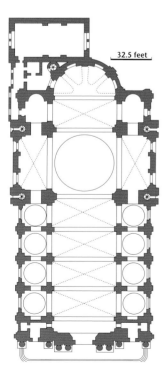

32.5 feet

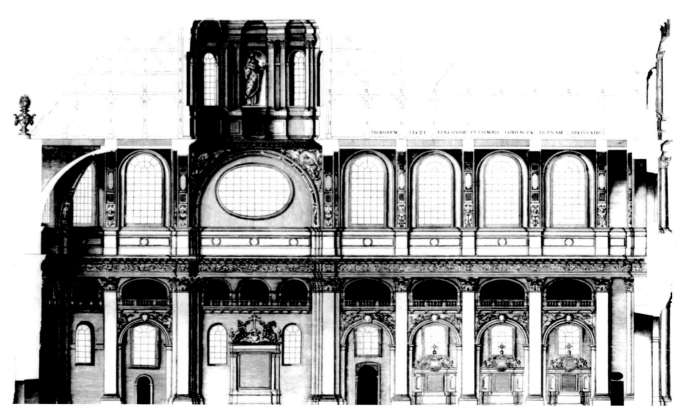

additional side entrance that gives meaning to this ambiguity: the public entrance on the facade facing the square leads to a church with the long plan normally found in universities and convents; while another side entrance in the courtyard facade opens into a centrally planned mausoleum, at the far end of which is the cardinal's tomb.

### Augustinian, Carmelite, and Cistercian Churches

The dome, or more precisely the lantern tower with a cupola (or vault) and a dome (or roof), despite the fact that it goes back to Brunelleschi, one of the most important architects in Florence during the Renaissance, was considered by the French in the seventeenth century to be essentially Roman in origin. This was obviously due to a familiarity with the renowned church Il Gesù, which had a lantern tower at the crossing. According to contemporary accounts, the first cupola in Paris (really a false cupola because it was a trussed construction) was the one built in 1608 over the centrally planned chapel of the Barefoot (or "Discalced") Carmelites Augustinians (now the Ecole des Beaux-Arts). The first lantern tower with a cupola (also false) with a dome was added in 1628 to the church of the Barefoot Carmelites (the Institut Catholique). Discalced Augustinians and Carmelites belong to those old orders which, after a reform, returned to strict observance of the rule. The lantern tower of the monastery itself is equipped only with a false cupola. The first real cupola, that is the first one duly sheathed in stone that forms part of a domed lantern tower, seems indeed to be the one built at the Sorbonne.

The Cistercian Abbey of Port-Royal-des-Champs, separated from Cîteaux and brought back to strict observance in 1609 by Mother Angélique Arnauld, was established in Paris in 1625, but was suppressed in 1664 following the nuns' refusal to sign the condemnation of the Five Propositions of Jansenius. It is known that this abbey became the center of Jansenism in France. The Jansenist doctrine of grace and predestination influenced the arts only insofar as it inspired an austere code of morals and attracted a few artists such as Philippe de Champaigne. "The pleasure that one derives from visual things serves to diminish the life of grace to the same extent," said Mother Angélique, who asked Antoine Lepautre to simplify the project he designed for the chapel of the abbey. Even when deprived of its columns and granted only the smallest share of its pilasters, the chapel was still "so pretty" that the abbess felt some "embarrassment." Work on the chapel was begun in 1646. It belongs to the mixed category, or to what is usually identified as the baroque, but can it really be said that the austere art of the Jansenists was baroque?

It would be nice to combine the ideas of baroque inspiration with Roman influence and regard classicism as an anti-Roman reaction by the French, fueled by a return to strict observance. However, such clear divisions must be avoided, because it would limit the Roman baroque to the very unusual works of Borromini and his followers. Fréart de Chambray was probably thinking about Borromini when he remarked in his *Parallèle de l'architecture antique avec la moderne* (*The Parallels between Ancient and Modern Architecture*) that "the Italians are even more licentious (sic) nowadays and they make it quite evident that in today's Rome there are moderns as well as ancients." But the first rare assaults of Borrominism did not breach Paris until the second half of the century, and this was the classical half of the century!

### Church Facades

The church facade best suited to the ideal of the Intelligents (the group around Sublet de Noyers) was also the most Roman one in Paris. The facade constructed by Martellange for the Jesuit novitiate, at Sublet's expense (fig. 65), took inspiration from Il Gesù, which had two levels that were conservatively ornamented with pilasters. "It is considered the most regular facade in Paris," wrote Fréart de Chambray in *Parallèle de l'architecture*, "and although it is not laden with as much ornamentation as some others, it nevertheless looks very beautiful to the eyes of the Intelligents, the whole being made with an extraordinary

*The Society of Jesus had been founded in Montmartre in 1534 on the oath of Ignatius of Loyola and his initial followers, and was legally recognized in 1541. The society had established itself in France by 1550. Its expansion was thwarted by opposition from the Parliament of Paris, which had even managed to effect expulsion of the society in 1594. Because the example set by the Parliament of Paris was not followed by all the provincial parliaments, the Jesuits managed to escape total banishment. But it was not until after a 1603 edict to reestablish them, and with personal support from Henry IV (Father Coton, the king's confessor, was a Jesuit), that the Jesuits began to prosper. In 1601 there were forty-five Jesuit institutions in France. They numbered seventy-two in 1629, and 109 in 1643. Among them were the seminaries, which were centers for apostolic action where the elite of the society would preach and confess; there were also novitiates, which trained Jesuit priests, and teaching colleges. In Paris, the Jesuits ran the Collège Louis-le-Grand, a novitiate that does not exist any more but was once the most important of the professed houses (today it is the Lycée Charlemagne) along with the church of Saint-Louis (today called Saint-Paul-Saint-Louis).*

**58–63. Saint-Louis Church at the Jesuit Seminary (now the Church of Saint-Paul-Saint-Louis)**

*Construction on this church began in 1627, according to the plan of Brother Etienne Martellange, on a parcel of land donated by Louis XIII. Father François Derand, who supervised the building site as early as 1629, designed the elevations, the facade, and the main altar. Construction was stopped in 1641. The erection of the facade and the commission of an altarpiece by Vouet (fig. 12) were financed by Richelieu. An engraving by Edme Moreau was published by Derand as early as 1643 and dedicated to Sublet de Noyer, superintendent of the royal buildings.*

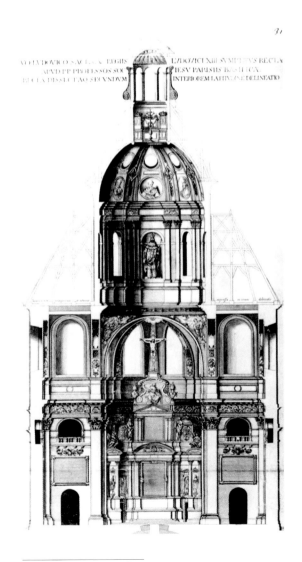

understanding." The text makes a thinly disguised reference to the Derand facade of the church of the seminary: faults in design, the exclusive use of rich columns and orders (Corinthian and composite), and heavy embellishments borrowed from Flemish patterns made this facade a target for the critics (fig. 63).

The archetypal facade with orders on two levels, defined as early as the fifteenth century by Alberti, has been largely transformed and distorted since then. The facade of the church of Saint-Etienne-du-Mont (fig. 67) is a good example of the way the model appeared at the beginning of the seventeenth century. On the other hand, the facade of Saint-Gervais (fig. 64) is the paragon of French classical-style facades, but only because it was French. In fact, nothing in particular identified it as a reference point for classical aesthetics, although critics certainly promoted it to the rank of national exemplar. The work was "so full of knowledge and majesty that experts consider it the best in Europe," according to Sauval, who referred to the work in his *Histoire et recherches des antiquités de Paris* (*History and Discovery of Antiquities in Paris*), written in the mid-seventeenth century. The architect had to build a facade in front of a church that had been completed in a Gothic style. The relationship between the height and width of the nave and aisles necessarily forced a loftier composition than the Roman exemples. The architect recalled the facades with three tiers of orders that had appeared in France in the 1550s, and especially the one at Anet, from which he drew direct inspiration. Thus a good half century had been required for this example of perfect canonical correctness (perfect since it illustrated the superimposition of the three "Greek" orders) to pass from civil to religious architecture. The Saint-Gervais facade is a *facciata* (facing), namely a composition limited to a two-dimensional design, yet it contains a striking outline of moldings (the high relief that would never vanish from French architecture). Clapped onto a church that it disguises more than it reveals, it is as deceptive as any Italian facade, but it has the verticality of French facades.

The only facade in Paris that hearkens to antiquity was the side facade of the Sorbonne (fig. 1): this exception can be explained because it functioned as an entrance into the mausoleum containing the tomb of Cardinal Richelieu.

*Church Ornamentation*

The great retable (altar backdrop) was built above the altar to the height of the nave and treated like a facade. It was the dominant furnishing of the Counter-Reformation church, but was only new in its treatment (that exploited the repertoire of the orders) and its incorporation of the Eucharistic tabernacle (which replaced hanging containers, cupboards, and Eucharistic towers). The silver and vermeil tabernacle in the Jesuit seminary church in Paris (fig. 11) was placed in front of a multicolored marble retable which was highlighted with gilded bronze ornaments (prior to 1643). "There is no other altar in the kingdom that is more richly ornamented, and on which there can be found such a large quantity of reliquaries, vases, candelabra, candlesticks, chandeliers, lamps, and other such items unknown to our forefathers whose preference was for simplicity in the house of God. These items have been created by the new order so that the devotion which has grown so cold in the last few centuries might be rekindled," wrote Brice in his *Description de Paris* (*Description of Paris*), 1752. Indeed, such was the Jesuits' intention. A desire to be efficient did not preclude that gold donated by pious benefactors be put on the altars: where else would the golden glories of the triumphant Roman Church be more at home than in the churches of the champions of the papacy? To Fréart de Chantelou, who told the Jesuits that they were "spoiling their church by filling it with too many unsightly ornaments," the Jesuits might have replied "that the number of ignorant folk is greater than the cognoscenti and it is necessary to please the masses, who like this kind of decoration" *Journal du voyage de cavalier Bernin en France* (*Diary of the Knight Bernini's Visit to France*), 1665, de Chantelou.

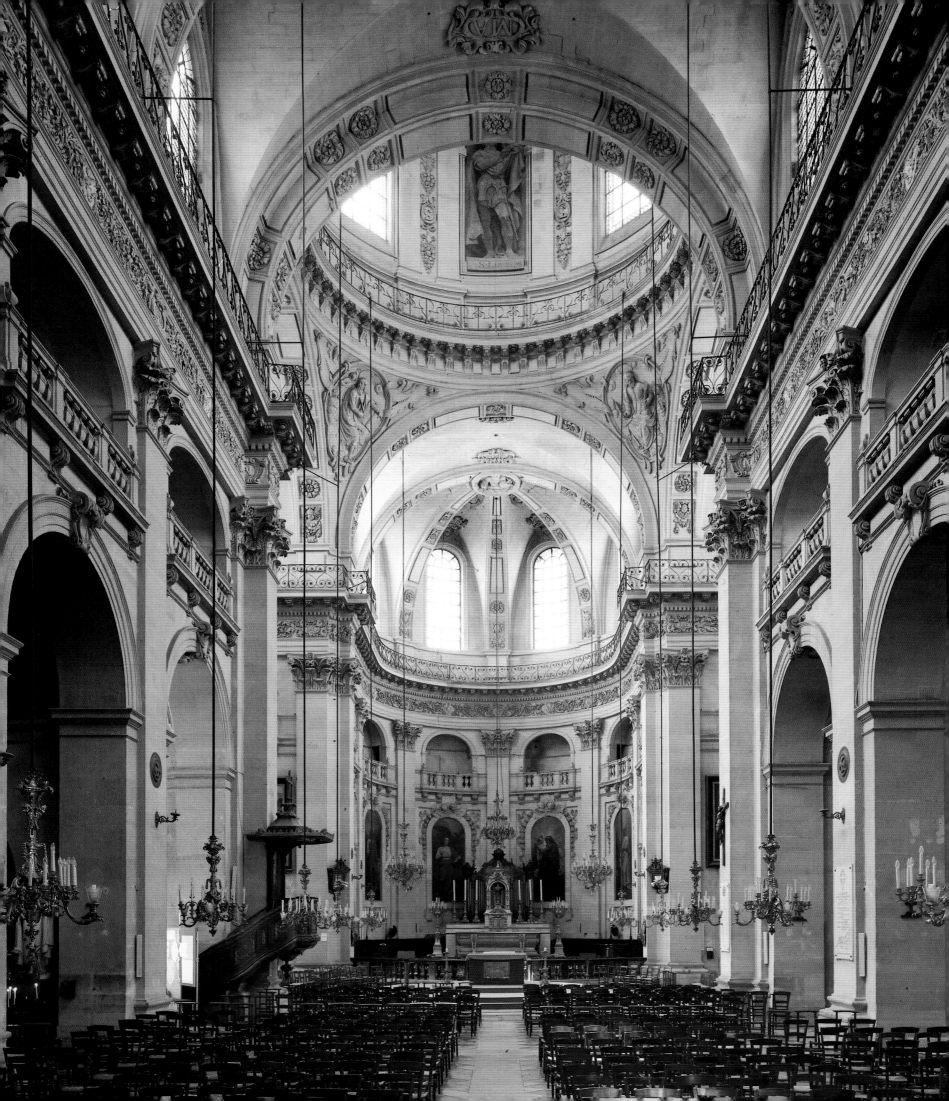

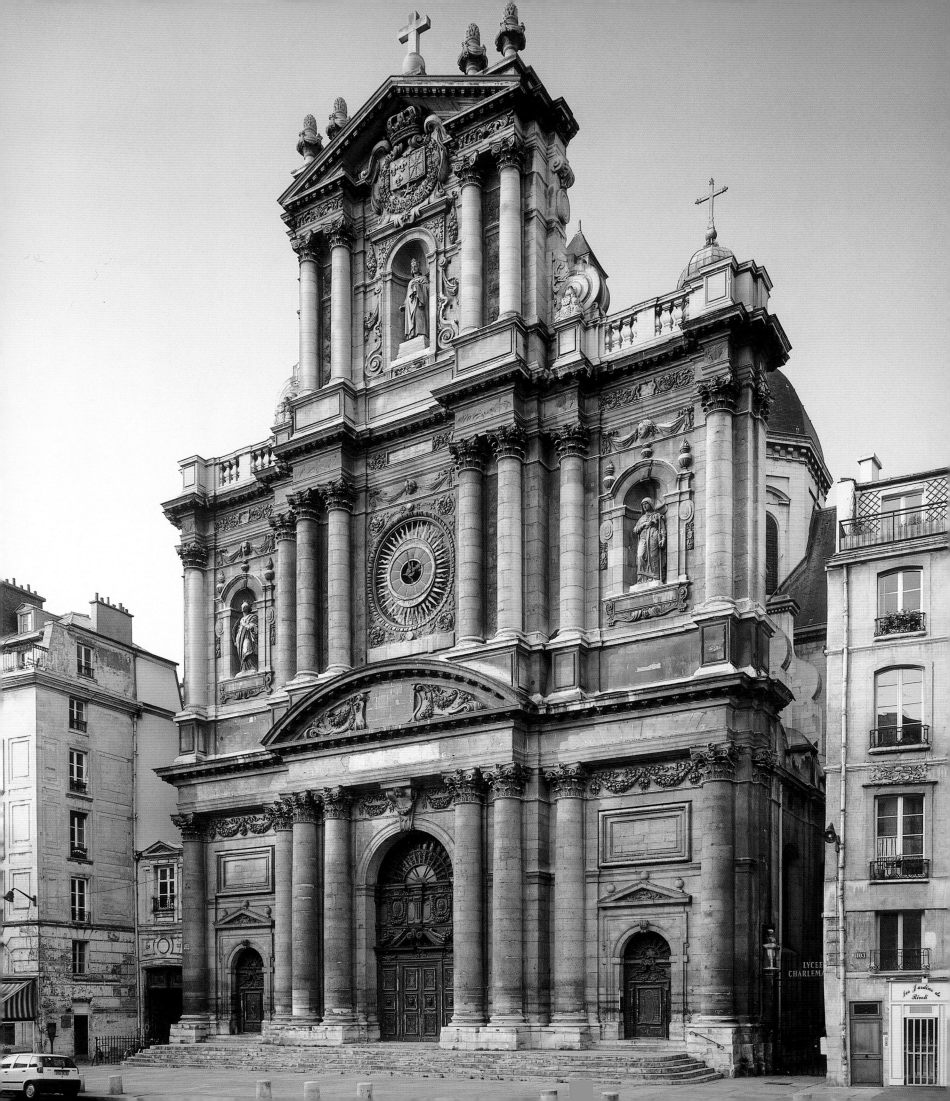

To please crowds, to touch feelings rather than intellect, to demonstrate through decoration the triumphant rehabilitation of the Roman Church—these were the intentions that finally carried the art of the Counter-Reformation far from the spirit of strict observance that had inspired the religious orders and buildings in earlier days. The Council of Trent had provided no instruction regarding the embellishment of churches, but it had justified "lighting, incense, and ornamentation" because of "human nature," which "cannot easily, and without some outside help, elevate itself to meditate on divine things." As we have seen, this was already Abbot Suger's doctrine. The council had approved the devotion to images that the Protestants criticized, but had recommended at the same time a major revision of the themes and means of representation, and a purification of Renaissance art, which was judged too pagan and often immodest: it would have been impossible to proscribe nudity of the saints and to advocate nudity of the sanctuaries at the same time. The Jesuits were among the first to think it necessary to distance themselves from the Reformation, a religion "poor in every way," one with churches that looked like "indoor tennis courts."

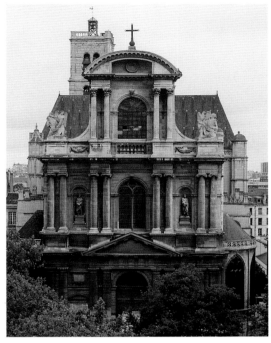

**64. Above: Facade of Saint-Gervais**

*Salomon De Brosse constructed this facade between 1615 and 1621.*

**65. Left: Jean Marot. Church of the Jesuit Novitiate (destroyed), engraving.**

*Built in 1630 on the order of Sublet de Noyers, the superintendent of royal buildings, this church was completed by Brother Martellange. The facade is no longer extant.*

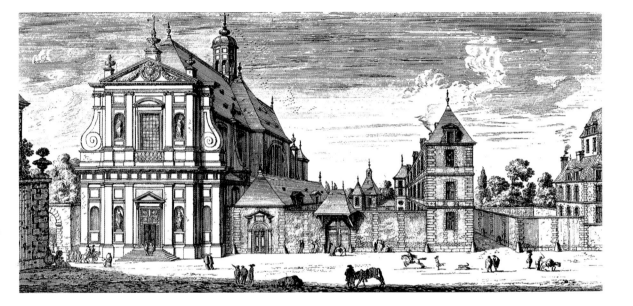

### The Temple of Charenton

The Reformation was in itself a factor of change. But opportunities for Protestantism to make its mark in the field of architecture were limited, even during its most favorable time between the signing of the Edict of Nantes (1598) and its revocation (1865), an act that subsequently led to the destruction of the Protestant temples. The modest creations of the Protestants were, in some ways, closer to the classical style. The temple built in Charenton for the use of the Huguenot community in Paris was a large rectangular room surrounded by two levels of galleries supported by columns (fig. 66). It was a remarkable imitation of a type of classical basilica that Vitruvius described in his treatise.

However, the Charenton Temple was also a touching reminder of the modest barns where rural Protestants gathered. If the style of Charenton was so often used as a model in Protestant states, it is because it contrasted with Catholic tradition so strikingly without forsaking its Latin roots. The Protestants who, with Calvin, condemned all Christian art beyond the fourth century, were probably better equipped to succeed in that return to the classical style that had been the ideal in the Renaissance. All in all, the choice between the baroque and classical styles is only indirectly linked to aesthetics; the choice is rather a religious (with differing opinions regarding the appearance of the reform) or even a philosophical one. This kind of choice pits Poussin against Vouet with regard to artistic conscience in a much more profound way than in their different treatment of altarpieces. It might therefore be said that when it comes to the architecture of dwellings, the baroque-classical dilemma no longer makes any sense.

**66. Charenton Temple**

*This church, for the use of the Paris Protestant community, which was deprived of the right to have a church in the capital itself, was built in 1623 by Salomon de Brosse. Destroyed after the revocation of the Edict of Nantes, it is known through Jean Marot's engravings.*

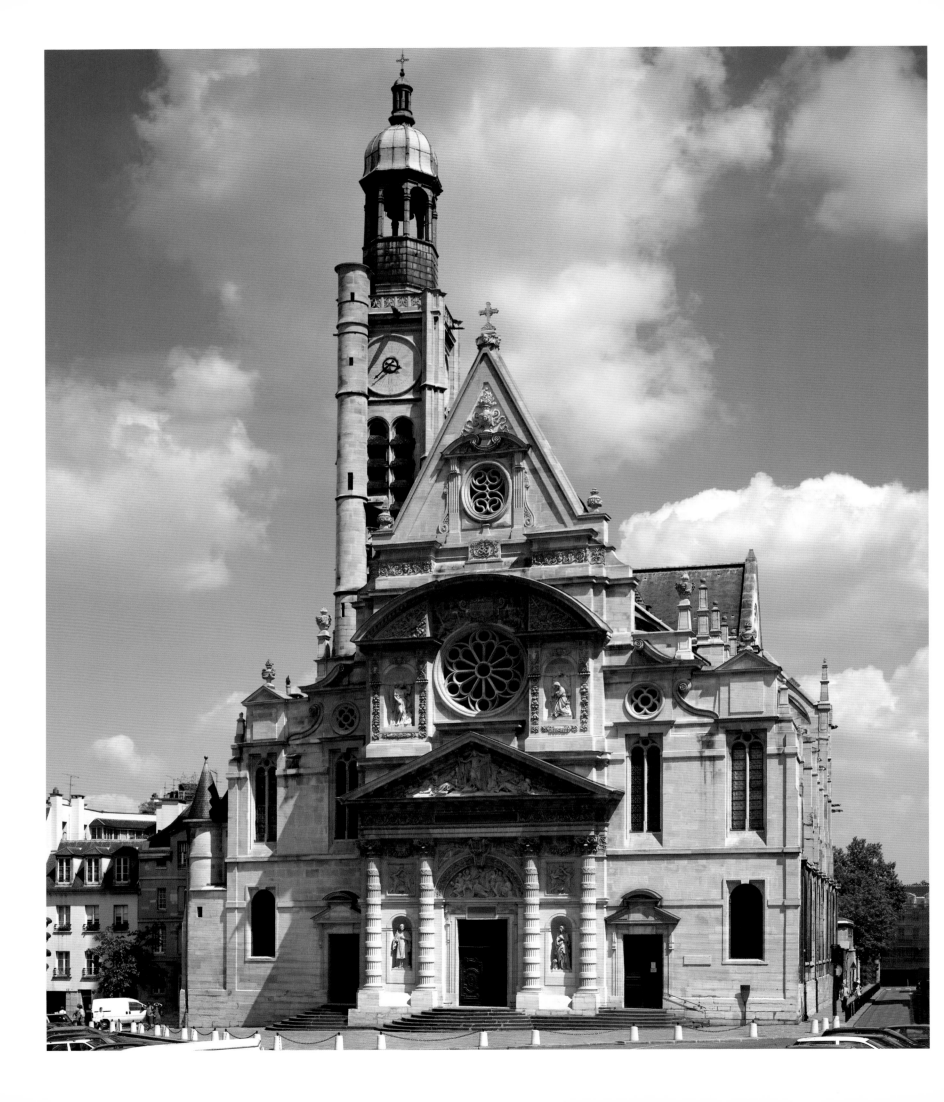

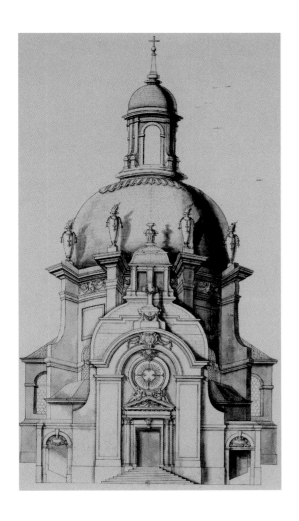

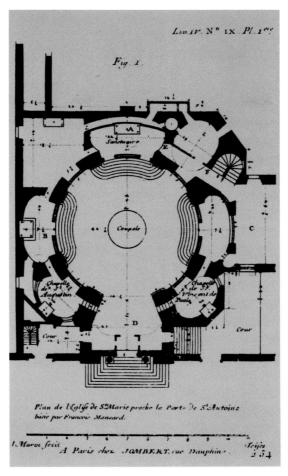

**68–69. François Mansart. Church of the Visitation de Sainte-Marie, 1632–1634.**

*François Mansart built the church at the convent of the Sisters of the Visitation on the Rue Saint-Antoine between 1632 and 1634. The central area, covered with a cupola, formed a kind of nave onto which three chapels and the sanctuary (labeled A, at the top) with the high altar opened. The nuns' choir (labeled C, at right) had no view onto the high altar: the nuns took communion at the area labeled E via the corridor labeled F (at top right). The original appearance of this church was almost entirely preserved until the restoration in the twentieth century.*

**70. François Mansart. The Church of the Minimes.**

*This was François Mansart's design for the frontal of the Minimes Church, which he began in 1611. The project was started in 1657, but construction was halted due to financial difficulty after the first level was finished in 1665, just one year prior to Mansart's death. When construction resumed in 1672, it was completed according to a much-altered design. The composition, little of which remains, closed off the view of the street running north from the Place Royale (now Place des Vosges).*

Opposite:

**67. The Façade of Saint-Etienne-du-Mont**

*Construction of this church was completed when the façade was added, beginning in 1606 according to Claude Guérin's design. But the first stone was not laid until 1610. The façade was left incomplete in 1622.*

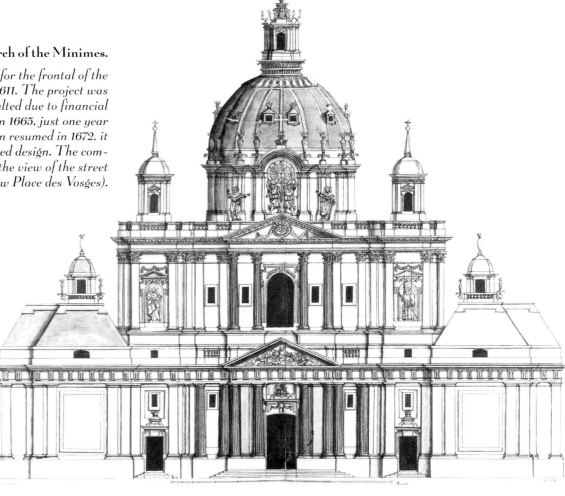

**71. The Tanners' and Tawers' District, drawing, late seventeenth century. (Musée Carnavalet, Paris)**

*Between the Pont-Au-Change and the Pont Notre-Dame, the banks of the Seine were lined with houses which, until 1673, were inhabited by tanners and tawers who were dependent on the water supply for their trade. In 1673 they were forced to move their activity to the Bièvre River in the Saint-Marcel area. A late seventeenth-century drawing (traced from a lost one) shows the houses of the tanners on the Ile de la Cité between the Pont Notre-Dame (visible on the left) and the Pont-Au-Change. The entrance to the houses was on the Rue de la Pelleterie (now gone). The tawers and tanners who specialized in treating soft hides used in clothing (gloves, etc.) lived on the right bank, up- and downstream from the Pont-Au-Change (quai de Gesvres and quai de la Mégisserie).*

## 4 – Housing

The first half of the seventeenth century is certainly one of the most productive periods in the history of French architecture. Not only did it witness the birth of the modern church, but it also stimulated major development in the centuries-old layout of French-style houses, and it all occurred in Paris.

Circumstances were particularly favorable in Paris at this time. In the faubourgs, 14,000 houses destroyed during the time of the wars that occurred during the Fronde had to be rebuilt. A considerable rise in demographics had to be addressed. The 20,000 existing houses no longer met the demand. In the first fifty years of the century, rent tripled. Real estate income, in the range of 4 to 6 percent, was among the highest. Therefore it is no wonder that housing developments boomed. Many landowners were investors, including architects who purchased land, built houses, then sold or rented them out. However, it was usually up to the office holders and financiers to initiate building projects. The strengthening of the power of the state under Henry IV also accounted for an increase in the powers that were delegated to office holders, who bought their positions with an annual fee, institutionalized by the impoverished state. From 1596 to 1635, the average worth of the office of counselor went from 10,000 to 120,000 *livres* (the form of currency at the time in France), with an inflation rate of 40 percent during that same period. Financiers were given the task of tax collecting and made fortunes that could reach up to two or three million *livres*. Ministers of the Treasury, who could become as rich as princes of blood, made even more (Condé made ten million). However, the quality of the houses they wanted built was not just a function of their personal wealth, because construction was relatively inexpensive. The construction of the very important private mansion of Louis Phelypeaux de la Vrillière, secretary of state and son of the former secretary of state, was financed by the 300,000-pound dowry of his wife, a daughter of the minister of the treasury, Michel Particelli d'Emery.

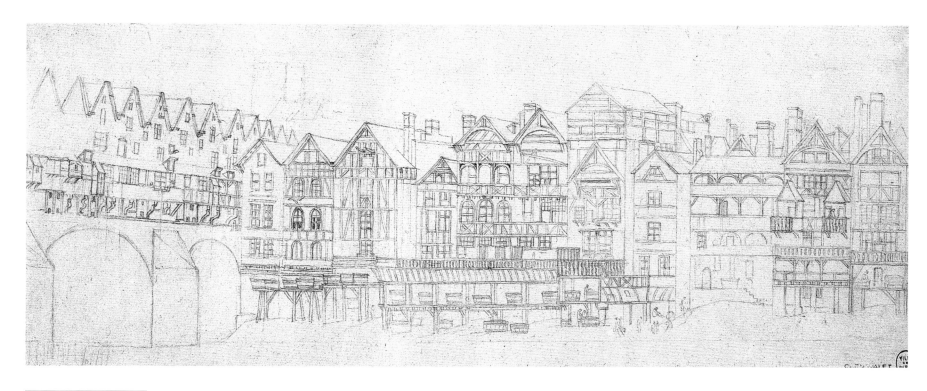

*Le Muet's Building Method*

Builders had at their disposal a kind of catalogue for house building: the *Manière de bastir pour toutes sortes de personnes* (*The Art of Fair Building Fitting for Persons of Several Qualities*), published in Paris in 1623 by Le Muet, who had been receiving a pension from the king since 1618 "in order to work on housing types and elevations." The book is important because it fills a void in the tradition of Serlio left almost empty by Du Cerceau, which was the urban dwelling, or more specifically, row houses (figs. 72–74). The simplest models are also the most old fashioned, products of a practical spontaneity that predated the institution

of sound theory. The houses of Le Muet included features common in northern French town houses since at least the fifteenth century. But Le Muet's book is neither a simple report nor a collection of plans like Serlio's and Du Cerceau's. Its remarkable novelty is his method of composition: it can be called a manual of models comparable to those of architectural orders. The order here is the "footprint," or surface area a building requires; the modules are the window bays and the major structural components (the floorboards and rafters), whose limited span of between twenty and twenty-four feet dictate the size of the whole. The collection of drawings presents thirteen footprints of varying size.

*The Luxembourg Palace*

The most important "house" built in Paris in the first half of the seventeenth century did not belong to Le Muet's row-house typology. In fact the Luxembourg Palace (figs. 3–6) was not even an urban mansion, but a castle built within the city limits, completely free-standing, and surrounded by gardens: the entrance was placed in line with the street so that the latter could serve as its avenue. The general approach chosen by Salomon de Brosse still follows the one used at Château de Verneuil, the great Du-Cerceau-de-Brosse family

**72–74. Pierre Le Muet.** *Manière de bastir pour toutes sortes de personnes* (*The Art of Fair Building Fitting for Persons of Several Qualities*), 1623.

*The house models by Pierre Le Muet, categorized from smallest to largest, are shown according to "footprint," meaning the surface area allocated to each house. The first, fifth, and sixth footprints are shown here. In the first, the house has only a single block overlooking the street and a single window bay, with a side entrance corridor leading to the staircase and courtyard. In the fifth, the main block is at the far end of the courtyard. The street block has three window bays and one central entrance for pedestrians. The staircase linking the two main areas of the house zigzags. In the sixth footprint the main block overlooks the street.*

## 75–78. Hôtel de Mesme Gallet, also called Hôtel Sully

*Started in 1625 for Mesme Gallet, the comptroller of the treasury, the mansion was completed in 1630, probably by Jean Androuet Du Cerceau. In 1634 Sully, Henry IV's prime minister, after whom it is named, acquired it. It was built on the Rue Saint-Antoine between a courtyard and garden, which has an orangery at the far end; there is a courtyard for the servants' quarters opening onto the street (the courtyard is merely suggested by its street entrance on the engraved plan). The sculpture on the courtyard and garden facades represent the four seasons and the four elements.*

project, and at Château de Coulommiers, built by Salomon in the vicinity of Paris at the same time. It is a combination of pavilions, which housed apartments, and connecting wings for reception rooms as in Lescot's Louvre. The courtyard is enclosed on all four sides, and entry is made through an ornate tower. Like the Tuileries, the Luxembourg Palace is a double castle, half for the queen mother, and half for her son, the king. On the queen's side, to the right of the courtyard, the upper gallery in the wing was to contain Rubens's paintings of the queen mother's life (fig. 23); the gallery on the king's side was to be lined with paintings of his life. The twofold nature of the palaces had nothing to do with craftiness on the part of the two Florentines; it was, rather, in accord with the image of power during the regency period. The distinctive tastes of the two Medici's evident in the choice and treatment of materials: multicolored marble at the Tuileries, and the rusticated masonry (roughly chiseled stone) at the Luxembourg Palace. The use of ashlar (dressed stone) was still unusual in Paris; banded rustication over entire facades was unprecedented. Marie de Médicis took inspiration from the Pitti Palace where she spent her childhood, especially from the areas built between 1558 and 1570 by Ammannati, a successor of Michelangelo. However, it would be a mistake to think that this rustication is indicative of an ephemeral baroque style. Contemporaries were correct in regarding them as marks of the durable Tuscan style: even Brunelleschi's fifteenth-century sections of the Pitti Palace were rusticated. Yet the fact that the Palace was Italianate in design did not prevent its inclusion in an anthology of French architecture. In his *Vitruvius*, 1673, Claude Perrault identified it as "the most excellent building in Europe."

It is not impossible that Marie de Médicis might have also intended to imitate the Boboli Gardens, which complemented the Pitti Palace. The very Italianate Medici fountain might constitute the proof (fig. 7). This may be the work of the Francini, a family of hydraulic engineers and fountain makers, who had come to France from Florence in 1598: whether done by Tommaso, who created the gardens of Saint-Germain-en-Laye for Henry IV after those at Boboli and Pratolino, or by his brother Alexander, whose *Livre d'Architecture (A New Book of Architecture)*, 1631, presented numerous compositions reminiscent of the Medici

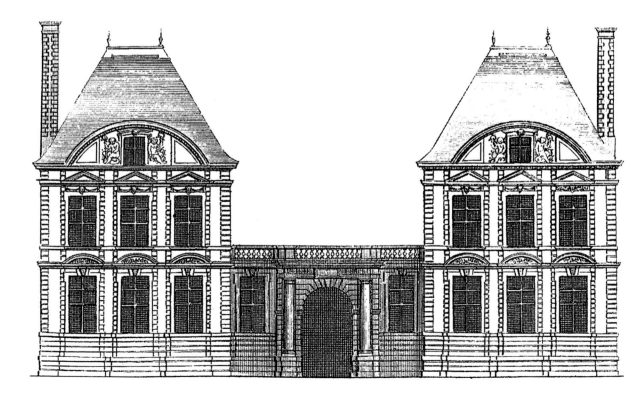

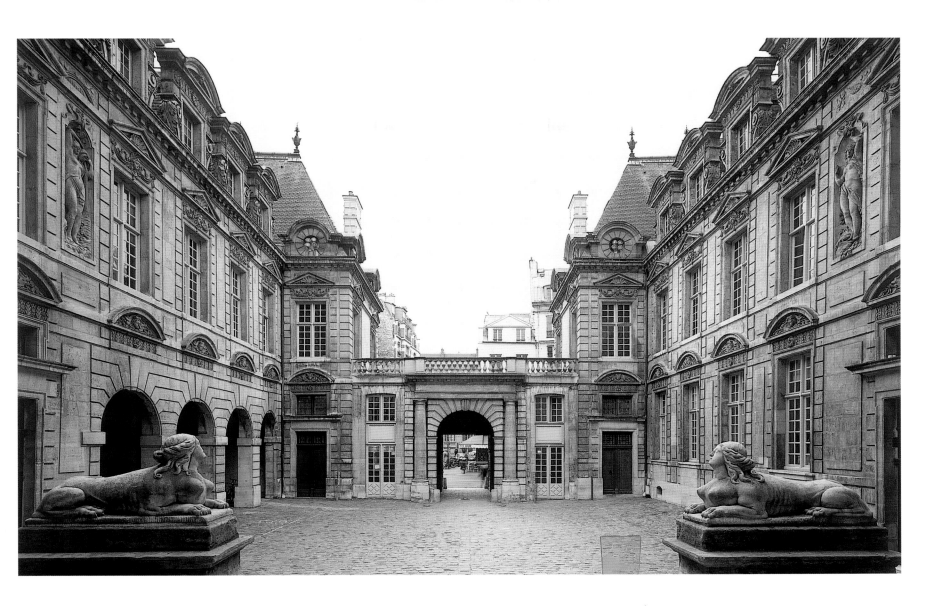

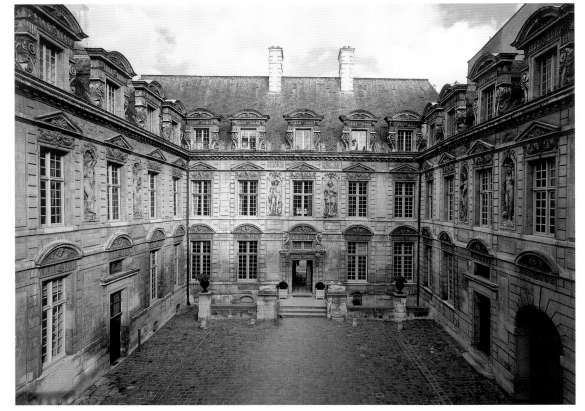

## THE FRENCH HÔTEL (TOWNHOUSE)

*Louis Savot's* L'Architecture françoise des bastiments particuliers (French Architecture in Private Buildings), *1624, described practices that were centuries old when affirming their French character. "This form is usually used when building on all four sides of the courtyard, on one side of which (opposite the main entrance facade) is the main living block, which is almost always bigger and more spacious than any other ... The other two sides of the* hôtel *are called arms, wings, or cross-pieces, one of which often contains a gallery and the other a variety of lodgings ... In France the front entrance is usually kept to the ground level, to give a more pleasant and open aspect and make the courtyard more airy and sunlit." The Hôtel Mesme Gallet, also called Hôtel Sully (figs. 75–78), illustrates the type described by Savot quite well.*

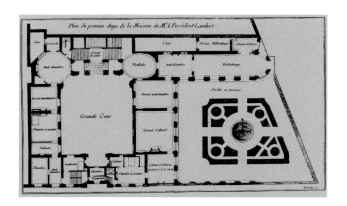

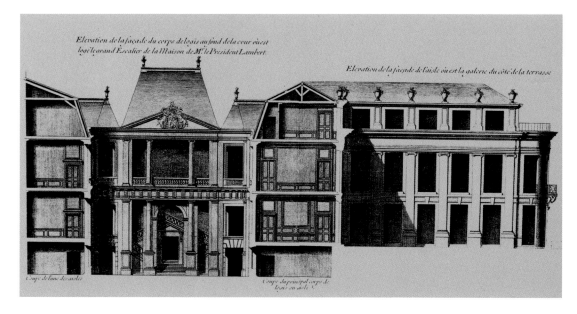

### 79–88. Hôtel Lambert

*This hôtel, constructed by Louis Le Vau for the adviser and secretary to the king, Jean-Baptiste Lambert, around 1641, was among the first to be built on the newly available Ile Saint-Louis. Today it is considered one of the most important hôtels of the seventeenth century and one of the best preserved, including its interior decoration.*

fountain. But the designer of the gardens in the Luxembourg (much changed today and decreased in size) was a Frenchman, Jacques Boyceau, author of *Traité du jardinage selon les raisons de la nature et de l'art* (*A Treatise on Natural and Artistic Garden Design*), 1638, a posthumous work (the author died in 1635) that was the first treatise in French devoted to gardens. The *parreterres de broderie* (curly-patterned flowerbeds) designed by Boyceau for the Luxembourg Palace could well have been the first in France. In sixteenth-century gardens, flowerbeds were in squares of many different patterns, just like the square plots that were and still are in vegetable gardens, but the *parreterres de broderie* were vast and contained symmetrical patterns of curls suited to arrangements like Le Nôtre's, which form a coherent whole. Yet it is also possible that the first *parreterres de broderie*, which were formative for French gardens of the future, were designed for a modest place that Louis XIII had built on the outskirts of Paris so as to escape from court etiquette—Versailles.

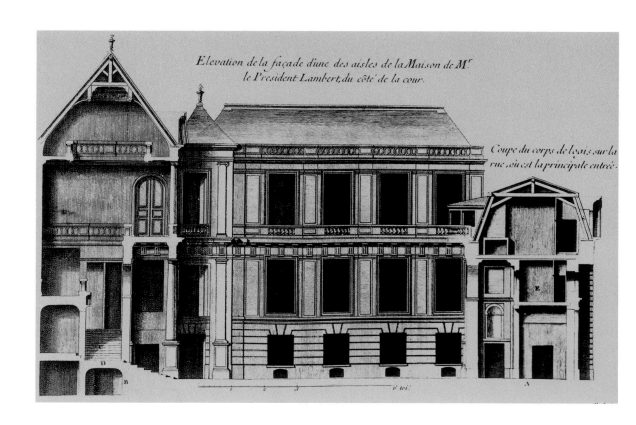

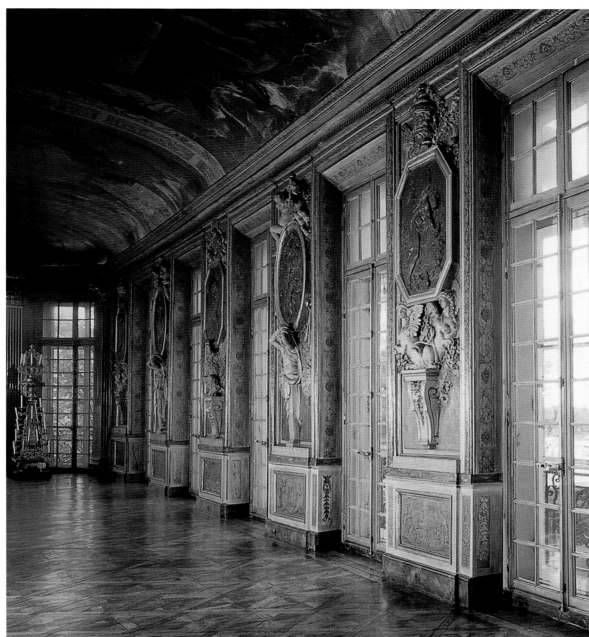

*The apartments of the Lambert hôtel were decorated for Nicolas Lambert, brother and heir to Jean-Baptiste Lambert, who had the hôtel built by Le Vau. The Galerie d'Hercule (Hercules Gallery) was decorated from 1650 by Le Brun, with stucco by van Opstal. The ceiling vault is divided into unevenly assembled portions that are only* trompe l'oeil.

## The Palaces of Richelieu and Mazarin

The Parisian dwellings of the cardinal-ministers, whose fortunes were considerable, were not very impressive: they left a deep mark on the heart of Paris, but their reputation rested on only a few beautiful objects, their painted decoration, and even more to the exceptional collections they contained. As Sauval noticed, the irregularity of the cardinal's palace "comes from the fact that we have seen it spread out and enlarge at the same rate as the wealth and aspirations of the prime minister." Land was first purchased in 1624 near the Louvre (and the king) so that construction of a *hôtel* could begin. But in 1633, after purchasing more land and laying more roads, Richelieu was still waiting for Le Mercier to turn his mansion into a palace. Besides, like a bourgeois, Richelieu took advantage of the opened up streets to reserve lots for houses around the perimeter of his garden. The Palais Cardinal would never emerge from the confusion on this city-block. The neighboring Mazarin palace followed a similar course of development, but with an even less impressive result. The Palais Cardinal, which became the Palais Royal after Richelieu donated it to the king, also outdid Mazarin's palace because of its famous interior decor, especially the *Galerie des Illustres* (Gallery of Fame; fig. 25), and because it had a theater.

### The Theaters

As early as the sixteenth century, the Italians created showrooms inspired by those of antiquity. In France, performances still took place in rooms that were hastily and temporarily set up, often in indoor tennis courts. The small room built by Le Mercier in 1635 at the Palais Cardinal might be the first French theater room; it was soon replaced by a larger one, also by Le Mercier and opened in 1641 (fig. 26). This room welcomed Molière's troupe in 1658. With its long length and a height reaching to the second floor, plus an artificial third-floor addition, the Palais Cardinal theater was hardly different from indoor tennis courts. There was no theater at the Mazarin palace, but the cardinal had one built in 1659 in the Tuileries by the Vigarini family. This one was Italian in many respects: it was built by Italians, and intended for operas (a genre recently arrived from Italy); its height reached from the ground floor past the second floor up to the roof; the auditorium was U-shaped; and an extremely deep stage lent itself to operating the machines that gave the theater its name: The Salle des Machines (Mechanical Theater) contained important devices to create special effects.

### Vincennes

Mazarin had no rural dwelling to compete with Richelieu's castle, the largest in France built prior to Versailles. At Vincennes, which Mazarin asked Le Vau to remodel, the large palace that one might expect to belong to this Italian besotted with contemporary Roman achievements is not found. Perhaps it should be sought in the collection *Desseins de plusieurs palais* (*Designs for Several Palaces*) by Antoine Lepautre, published in 1652 and dedicated to Mazarin (fig. 2). Even in Rome there existed no palace at the time more Roman than this one. It seems that Mazarin, an immigrant that the rebels of the Fronde exiled for a while, was reluctant to draw attention to his colossal fortune by building ostentatiously, and preferred artistic investments that were more easily encashed or removed.

The surviving mansions, quite numerous, in fact, sufficiently illustrate the important trends in architectural evolution during the half century. It is not necessary to name them all, even though all are worthy of recognition, or to refer to those that have been destroyed and are known only through engravings, although it is often through these that innovations are located and dated.

### Hôtel Sully

The previously mentioned Hôtel Sully (figs. 75–78), dating from 1625, is one of the most important in the Marais district of Paris. It is located on the main thoroughfare, the Rue Saint-Antoine, and its garden stretches as far as the Place Royale. However, it was only a "row house" *hôtel*. Its approach is no different than that of the Hôtel des Ligneris/Carnavalet (chapt. VI, figs. 56–58), almost a century old at the time; it is even less "modern" since its zigzag staircase remains in the center, impeding passage from the courtyard to the garden and splitting the main house in half. The Hôtel Sully also recalls Carnavalet in its low-relief figures between the windows, a style finding its last expression here, and in its use of ashlar. However, the ashlar was added only after construction began; the original contract planned for mixed brick and stone, another fashion on its way out.

**84. The Chambre des Bains (Chamber of Bathing Scenes) in Hôtel Lambert**

*Le Sueur painted the vaulted ceiling. At the corners are medallions: in the frames are the* Triumph of Neptune, Triumph of Amphitriton, Diana and Acteon, *and* Diana and Callisto.

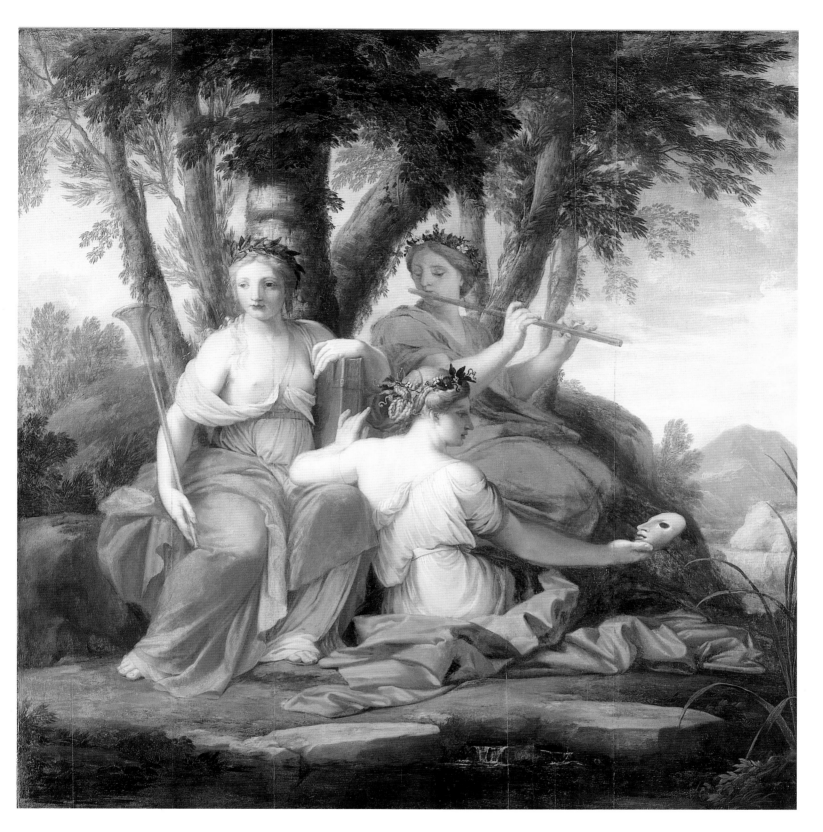

## 85–88. Private Drawing Rooms of the Hôtel Lambert

*The Room of Love (engraving, left) was commissioned c. 1645 from several painters, including Le Sueur, who probably supervised the entire project. The Room of the Muses (engraving, right, and paintings top, left, and right) was commissioned from François Perrier, who painted a history of Apollo on the vault before he died in 1649. Le Sueur, Perrier's successor, finished the ceiling and painted the muses on the walls. The decor of these drawing rooms was dismantled and the main pieces deposited in the Louvre. The engravings published in 1740 reveal the original placement of the pieces, with the exception of obvious additions of the mirrors and the fireplace in the Room of the Muses.*

## 89–92. Hôtel Beauvais

*Constructed in 1654 by Antoine Lepautre for Catherine Bellier, wife of Pierre de Beauvais and chambermaid of the queen mother, this* hôtel *was disastrously transformed in the eighteenth and nineteenth centuries and by recent restorations. The main house on the street owes its exceptional depth to the foundations of medieval houses. The roofs of the stables were a raised garden. High up at the back of the courtyard was the chapel. The main entrance was on the Rue Saint-Antoine, the great east–west avenue in the Marais district used for the entry of the royal couple in 1660. On that occasion, the windows of the* hôtel *were occupied by the queen mother, Cardinal Mazarin, and several important court figures. Marot's engraving of 1665 depicts this event.*

### Hôtel Lambert

The Hôtel Lambert, built from 1641 by Louis Le Vau, is one of the finest *hôtels* of the 1640s and another perfect example of a masterful experiment, in which the canonical model of the *hôtel* between a courtyard and a garden (figs. 79–88) is adapted to a particular site. It is located on the Ile Saint-Louis in a corner between the street (Rue Saint-Louis-en-l'Ile) and the riverbank. The plan was to provide the fine apartments a view of the Seine. Le Vau placed the courtyard entrance on the street. "Sir's" apartments are on the second floor and "Madame's" are on the third, in the right wing, which is actually the main house. On the side with a view, the man's apartments are at the same level as the raised garden that occupies the corner between the street and the quay side. The raised garden conceals the *hôtel* from peeping toms and thieves, and eliminates the necessity for a surrounding wall, which would have blocked the view. The gallery wing has a garden view, as it should, but is shifted to the side like the garden. The elevation is remarkable not only because of its colossal pilasters, but especially for its *portes-fenêtres*, among the first known. The *porte-fenêtre* can be described either as a window that goes down to the ground, or a door with glazed panels like a window: it permits direct access between rooms and the courtyard or garden. Used in this way, it became a hallmark of French architecture: indeed, it is called a French window in England. The servants' quarters, accessible via a long passage from the quay side, were skillfully placed at the rear under the large staircase pavilion, which is also at the back of the courtyard.

### Hôtel Beauvais

Hôtel Beauvais (figs. 89–92), built in 1654 by Antoine Lepautre for Catherine Bellier, wife of Pierre de Beauvais, is another famous example of expert solutions to problems created by an irregular plot and old foundations. Indeed, the *hôtel* owes part of its organization to the foundations of three medieval houses; the dividing wall that runs through the main block overlooking the road and the rotunda overlooking the courtyard are also very early. But Lepautre's hand can be seen in the monumentalization of the courtyard and that rotunda, which forms a porch. The tiny courtyard is beautifully accentuated by a perspectival trick; the rotunda is reminiscent of the Roman porch of Santa Maria della Pace, by Pietro da Cortona and dated from 1656; there was no place in all of Paris where one felt more in Rome. There is a chapel at the far end of the courtyard above the storeroom.

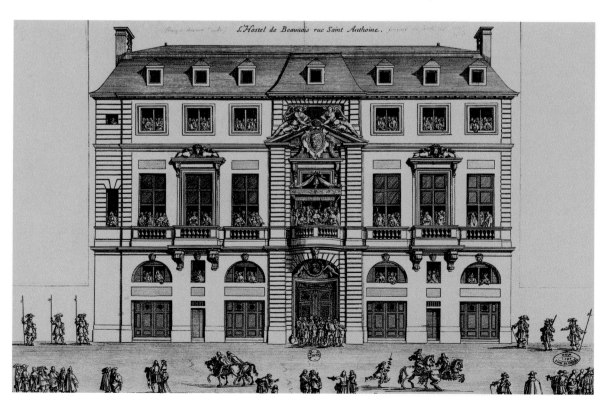

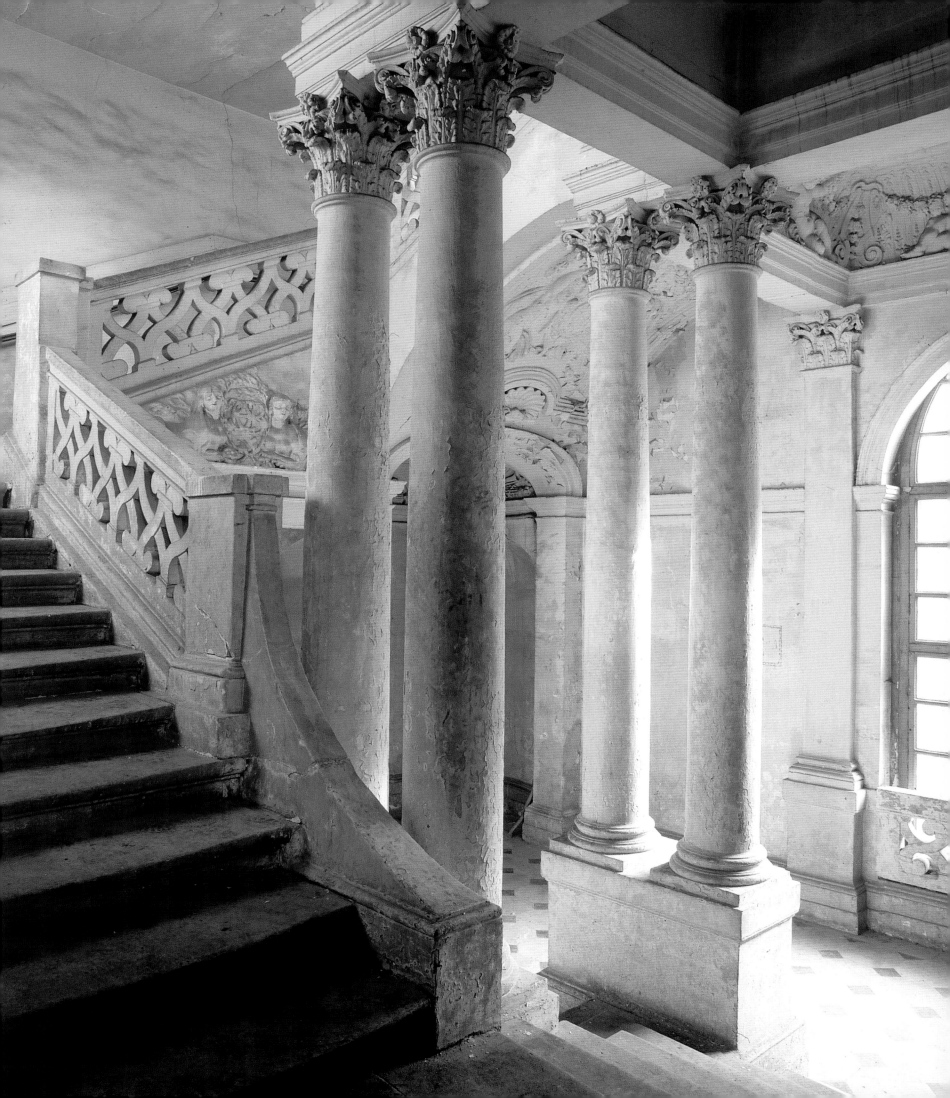

**93–95. Hôtel Aubert de Fontenay, more commonly known as Hôtel Salé (now the Musée Picasso)**

*This hôtel was built by Jean Boulier de Bourges between 1656 and 1659 for Pierre Aubert de Fontenay, a general collector of the salt tax, and nicknamed Hôtel Salé. The plan, redrawn according to a manuscript now in the Archives Nationales (National Archives) shows the state of the hôtel in 1675.*

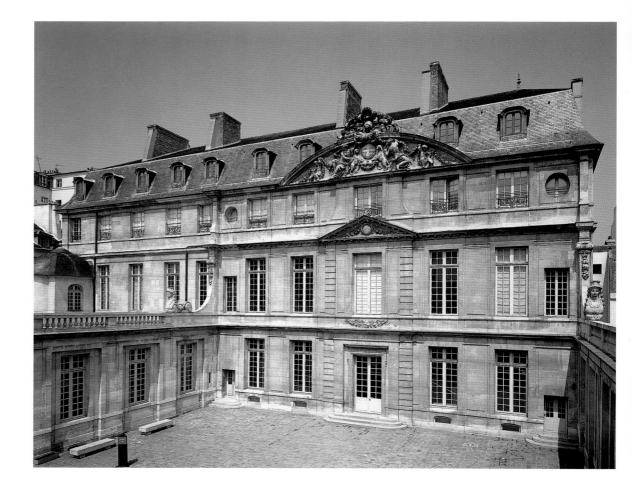

On the first floor to the right, the servants' quarters open onto a secondary street, and on the second floor the gallery and the garden are raised as in the Hôtel Lambert. Because Catherine Bellier (chambermaid of the queen mother), had a rather meager fortune, the central building of her house over the street contains both shops and the main apartments, so as to take advantage of a fine location on the main route (today, the modest Rue François-Miron), which the royal carriages used as an east entrance from Paris to the Louvre. On August 26, 1660, the entire royal court stood at the windows of the Hôtel Beauvais to witness the triumphal entry of Louis XIV and Maria Theresa on the occasion of their marriage, arranged according to the Treaty of the Pyrenees. The real triumphant victor, the negotiator of the treaty, was Cardinal Mazarin, who led the procession and joined the queen mother, Anne of Austria, on the balcony to see the product of his very last endeavors go by. Could there have been a better place chosen for the aging minister's last long gaze down upon the future of the young king than this Mazarin-styled balcony of French construction?

*Hôtel Salé*

The Hôtel Salé, built between 1656 and 1659 for a salt-tax collector, perfectly encapsulates the architectural progress achieved over a fifty-year span (figs. 93–95). The main courtyard was placed completely off-center to make space for the outbuildings. It is bordered on the left only by a "fox," that is, a fake facade that matches the one on the right, which provides access to a service courtyard. The main courtyard is accessed from the street by two "turn-arounds," that is, two concave recesses, which are back to back in the plan. The main building is doubled in depth, with rooms overlooking both the courtyard and the garden. That double size upsets the organization by disrupting the interconnections between the rooms that typified the long sequences of older *hôtels*. This was made possible by a hipped roof style, whose structure lends itself to wide spans. The combination of a double central building with a hipped Mansard roof is undoubtedly an innovation by François

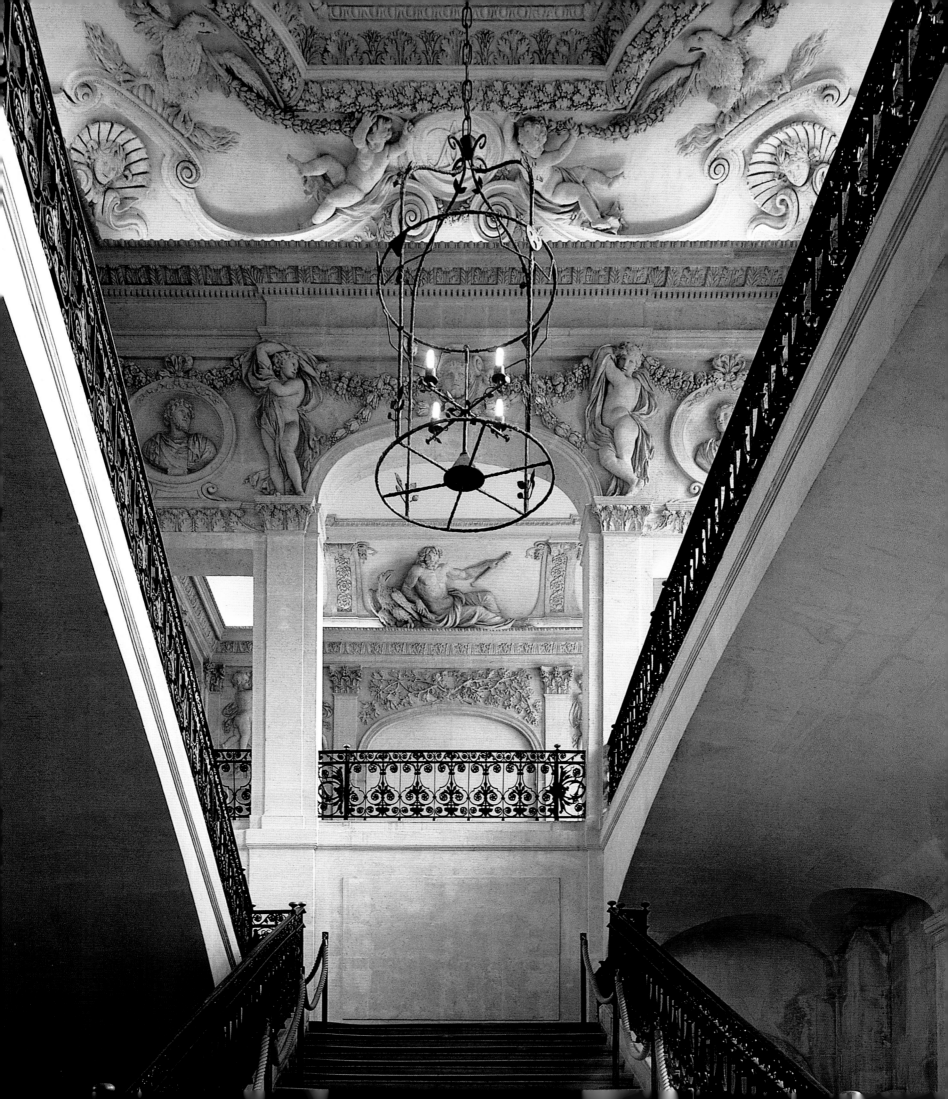

From left to right:

**96. Jean Marot. Hôtel des Ambassadeurs de Hollande, portal, engraving.**

*This hôtel belonged to the Dutch ambassador at the time it was built.*

**97. Hôtel Châlon-Luxembourg**

*This hôtel was built between 1623 and 1625 for Guillaume Perrochel, French treasurer in Amiens, by an unknown architect who may have doubled the thickness of an older mansion, built in 1615 for Antoine le Fèvre de La Boderie, Henry IV's ambassador to London. It belonged to the Châlon family and was purchased in 1658 by a lady descended from the Luxembourgs. The entryway could well date back to that change of hands.*

**98. Hôtel d'Alméras**

*Louis Metezeau built this hôtel in 1611 for Pierre d'Alméras, an advisor and secretary to the king.*

Mansart in the 1640s. The doubled size of the Hôtel Salé also facilitated the organization of a complete apartment for the man of the house on the ground floor and one for the woman of the house on the next. The staircase is one of those wonderful accomplishments for which Parisian architecture is famous (sadly, often destroyed): the flying staircase, in which the stairs are set sideways and cantilevered from the walls to clear space for a vestibule. The guardrail is wrought iron.

The staircase in the Hôtel Salé is not the first of its kind. It should be remembered that De l'Orme had constructed one in the Tuileries without a central pier or secondary support wall, but self-supporting and equipped with a metal banister. However, the use of wrought ironwork in architecture was fully developed by the seventeenth century. This development was encouraged by the mechanization of metalworking: foundries, where iron was refined, took their place in the manufacturing process alongside blast furnaces and ironworks. Moreover, applications were tested near the provincial centers of production (at Saint-Marcel-de-Félines in Fourez and Carrouges in Orne) before appearing in Paris. The designs of staircase guardrails recalled the balusters in stone guardrails. Balconies were not the norm in Paris, but became very fashionable in the seventeenth century, which is why a simple-looking structure was often chosen for balconies on facades that lacked them, as at the Place Royale (fig. 43). There is a balcony at the end of the wing at the Hôtel Lambert.

The Hôtel Salé is also a good example of simplified facade design that typified contemporary architecture. Portals are the most intricate parts of mansion design (figs. 96–98), their tympana providing a refuge for sculpture. All that remains of Lescot's facade at the Louvre (chapt. VI, fig. 46) is the subtle play of frontispieces. The principal decor has been removed to the interior where, thanks to the vitality of contemporary paintings, its quality becomes incomparable (figs. 99–101). Unfortunately, and all too frequently, only the paintings are preserved, converted into pictures.

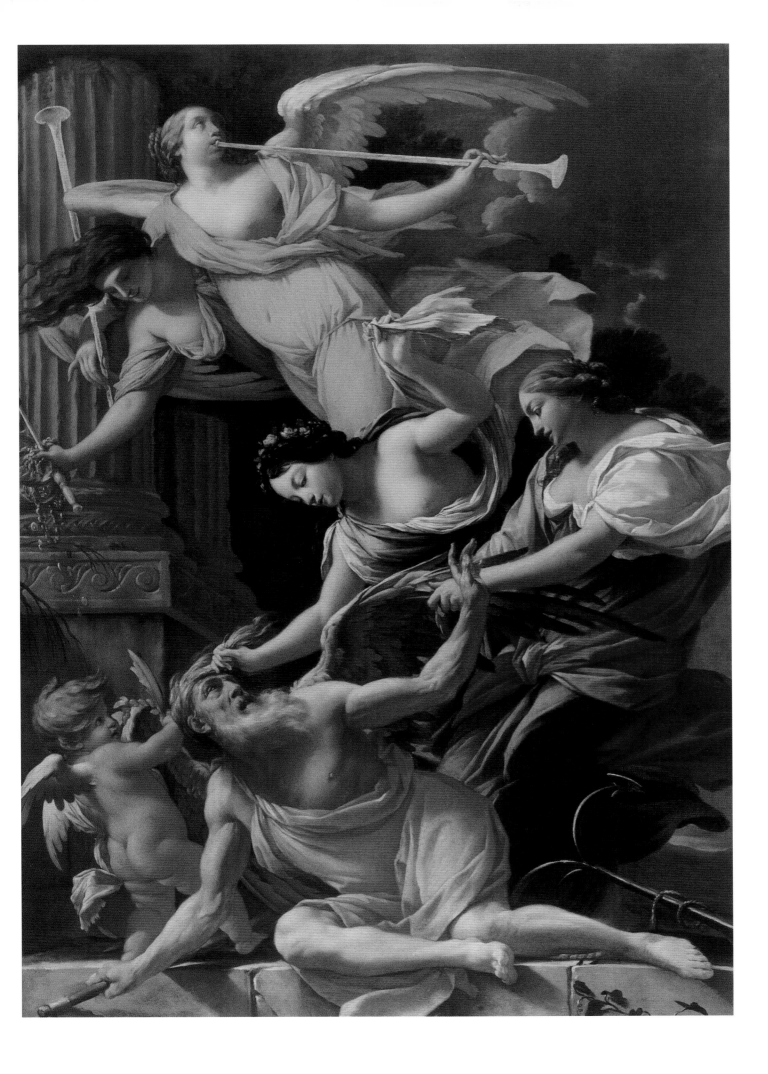

99. Simon Vouet. *Saturne vaincu par l'Amour, Vénus et l'Espérance* (*Saturn Vanquished by Cupid, Venus, and Hope*), c. 1645–1646. (Musée du Berry, Bourges)

*This was painted for the fireplace in the private drawing room of the Hôtel Breton-villiers, one of the most significant hôtels on the Ile Saint-Louis, since destroyed.*

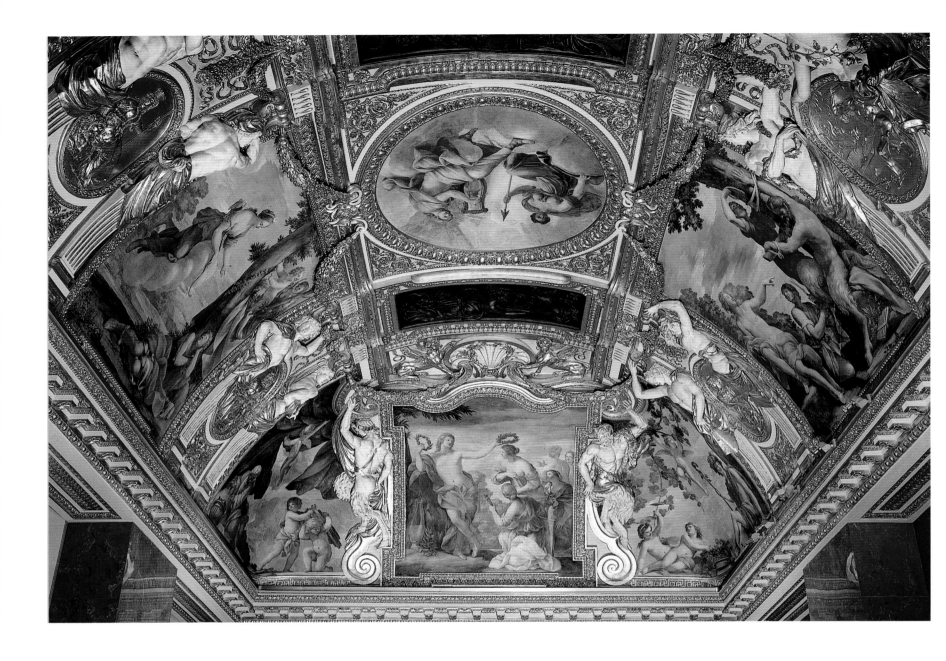

### 100. Summer Apartment of Anne of Austria in the Louvre

*In 1643 when Richelieu died, Queen Mother Anne of Austria and the young Louis XIV took over the Palais Cardinal, which Richelieu had bequeathed to the king. Having become the royal palace, the residence showed its vulnerability (it lacked a moat) during the Fronde, and the king had to flee Paris. Thus, when the king came back, he returned to the Louvre. Finding the queen's apartments on the ground floor of the south wing of the Cour Carée too hot in summer, Anne of Austria had Le Vau establish a summer apartment in the Petite Galerie (Small Gallery). This gallery had been built in the sixteenth century to connect the Louvre to the Grande Galerie (Great Gallery) leading to the Tuileries. Between 1655 and 1658 Romanelli, a painter who also provided stucco designs to the sculptor Michel Anguier, decorated these summer apartments, which fortunately have been preserved.*

### The Interior

The Hôtel Lambert, decorated by Le Sueur and Le Brun, clearly illustrates the evolution of decor over a few decades (figs. 85–88). The Room of Love (1646–1647) is modern only because of its panels, but the division of these panels into three stories, the almost ritual hierarchy of a bas-relief or still-life level, a landscape level, and a level of formal paintings (mythology, history, religion), and even the flat and compartmentalized ceiling, are not at all in the latest style. In the Room of the Muses, somewhat later (c. 1650), there is only one level of paintings left; the vault, which makes the ceiling look like a cupola, is the most evident Italianate feature. Lescot had already used it for the king's chamber in the Louvre. However, coverings shaped like vaults to increase the surface area for paintings replaced compartmentalized ceilings with joists. Rooms covered in this way were considered to be Italianate. Yet it happens that the expression "Italianate" applies to even more monumental compositions, as in rooms no longer restricted by divisions into stories and which occupy the entire height of the main building, like naves in churches. Le Vau, the likely importer of this type, despite the fact that he is not known to ever have gone to Italy, built at least seven Italianate rooms between 1639 and 1643, and with the exception of the colossal rooms of the castle of Vaux-le-Vicomte, they are unfortunately no longer known. We know from these that the Hôtel la Rivière's private drawing room (fig. 101), where Le Brun tested his talent for painting vaults

before going on to use it at Vaux-le-Vicomte, was Italianate. The Hercules Gallery in the Hôtel Lambert (figs. 82–83), also by Le Brun, was inspired by Italian examples like the gallery in the Palazzo Farnese (1597–1604), where the Carracci brothers reworked the Sistine Chapel ceiling. The engraver and decorator Jean Lepautre, Antoine's brother and perhaps inspiration for the Hôtel Beauvais decor, went to Italy and benefited from Cortona's and Bernini's influence. His first collection of ornaments dates from 1657. Between 1660 and 1665 he published several collections of designs for alcoves, ceilings, fountains, and ornaments, all in the Italian or Roman style (fig. 112).

While interiors may have been Italian in form, in function they were typically French: as a cause or consequence of society's evolution, French interiors cradled at birth a new art of living, "sociability." One would look for it in vain in the little houses described by Le Muet, where about twenty inhabitants were crammed together, three to a room, according to a remarkable vertical organization in which the owner occupied the ground floor and perhaps also a room on the next floor, and the rest cohabited in indiscriminate mix. The bourgeois were better off, but their rooms were still multifunctional, as

**101. Decoration of the Hôtel La Rivière**

*The Abbot de La Rivière had a hôtel on the Place Royale (Place des Vosges) decorated by François Le Vau. The mansion was famous for its interior decoration. The apartment was composed primarily of a large room (now gone) with an Italianate ceiling by Vouet's disciples Michel Dirigny and François Tortebat and stucco by Jacques Houzeau; a large drawing room; and a bedroom, whose decoration, commissioned in 1652 from Le Brun, has been partially reassembled at the Musée de Carnavalet. All that remains of the bedroom is the ceiling painted with the story of Psyche; and from the great drawing room, the lower paneling, the pilasters (which once had paintings between them, no longer extant), and the vaulted ceiling with stuccoes by van Opstal. The center painting represents daybreak.*

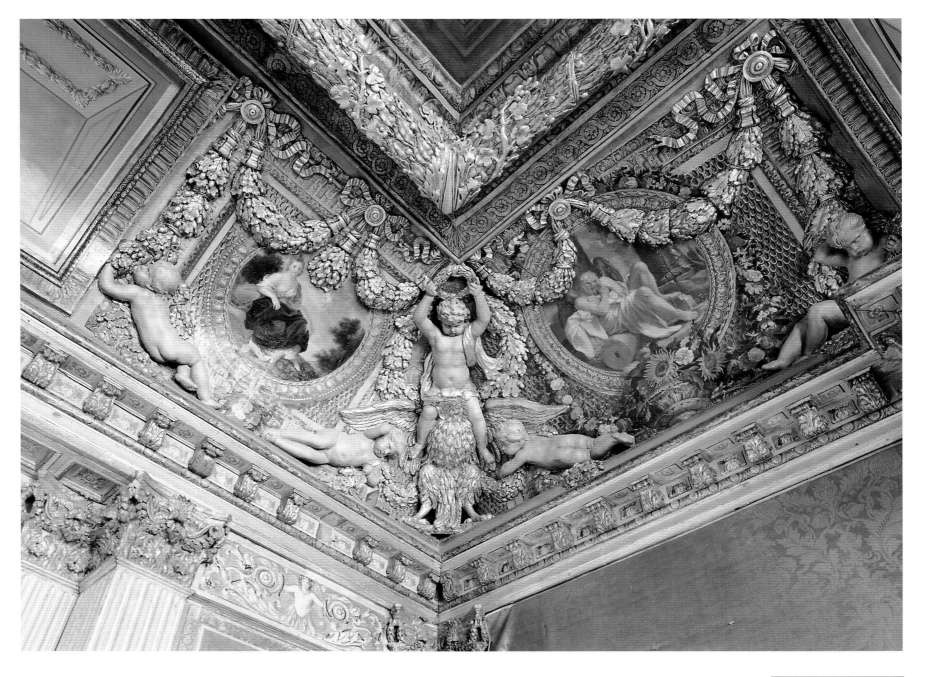

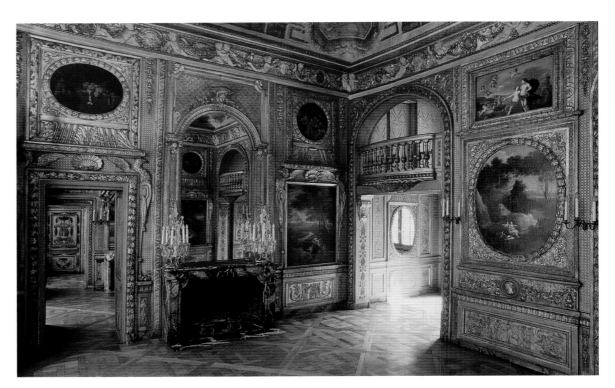

**102–106. Hôtel Gruyn, called Hôtel Lauzun**

*Charles Chamois built this mansion for Charles Gruyn des Bordes in 1656. The decorators are unknown, but the paintings on the ceiling might be by Michel Dorigny.*

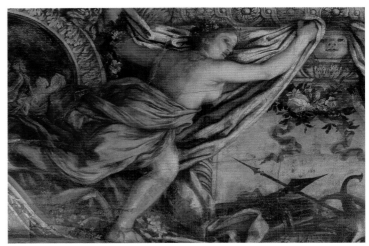

Abraham Bosse's remarkable etchings show, a rare testimonial to French society in the 1640s (fig. 111). The principle object in the room was the bed with its covered top and curtains that could be drawn to keep out either the cold or the curious. Guests were received in the "ruelle" (little alleyway), the space alongside the bed. The room was large enough to accommodate a dining table, and furniture such as seats and chests lined up against the walls. The walls were covered with hangings of greenery, and mirrors and paintings were unhesitatingly clapped on top of them. The windows were still casements with inside shutters. The projecting fireplace was an essential component: people cooked there.

French interiors are characterized primarily by the apartment, or set of rooms with diverse and complementary functions, however. To the medieval public rooms, domestic rooms, and closets the Renaissance added antechambers and private drawing rooms. The first half of the seventeenth century added dining rooms and communal sitting rooms or *salons*, a term apparently coined in 1664 from the Italian *salone*, but characterizing the social and intellectual life of Parisian literary groups like the one at the Hôtel de Rambouillet.

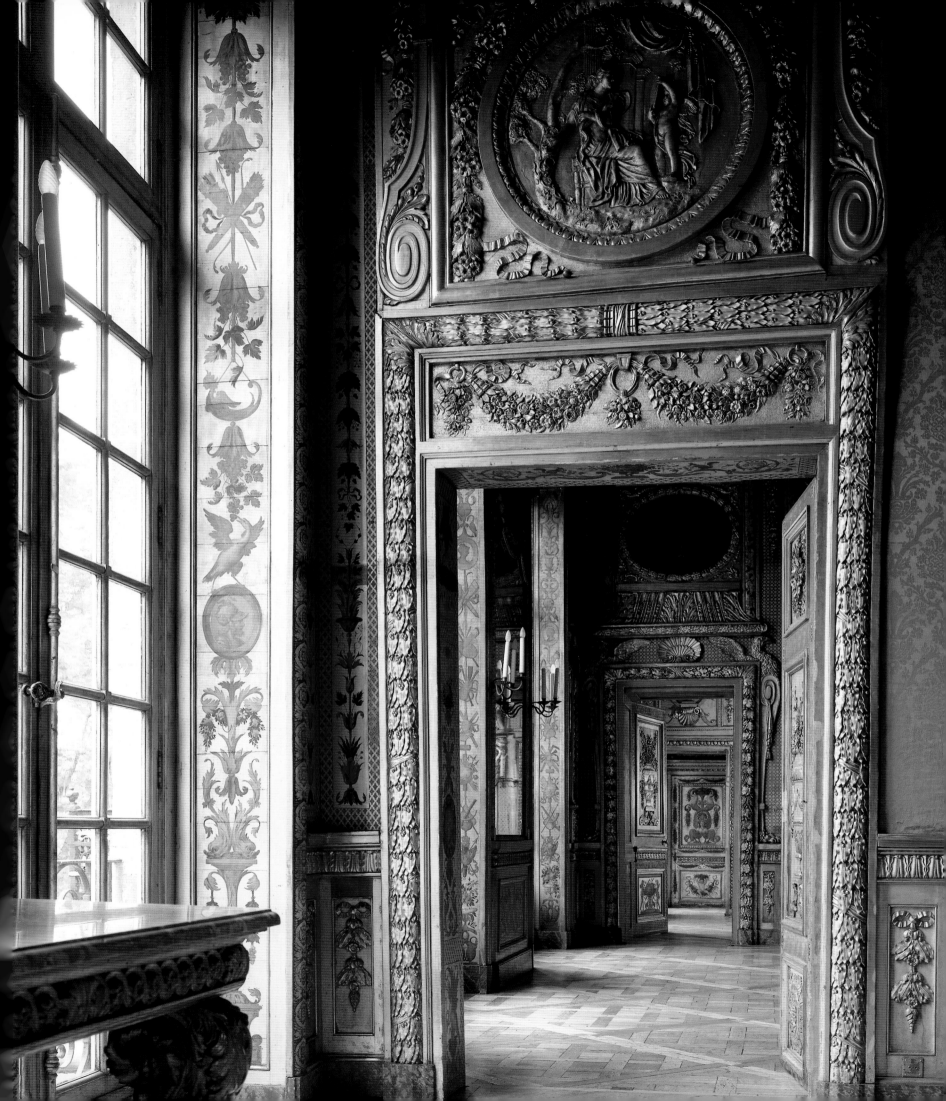

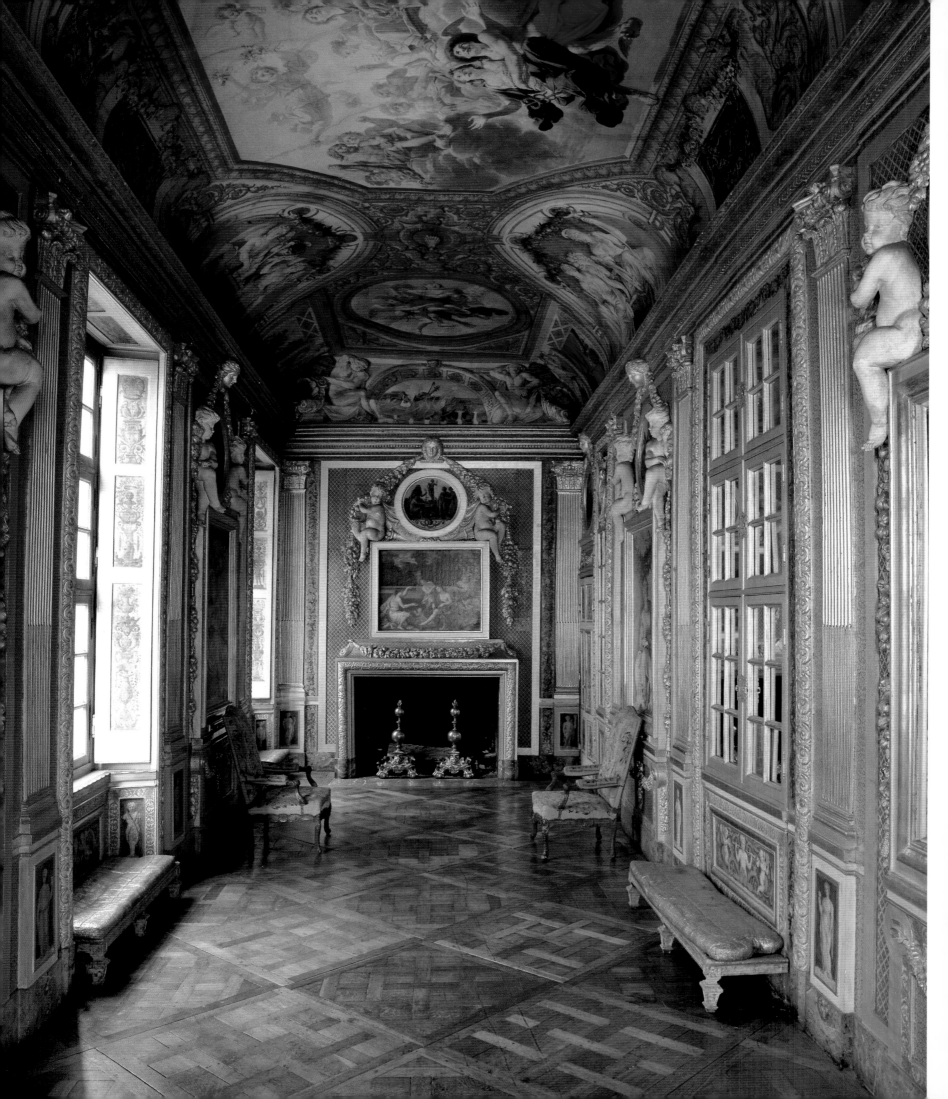

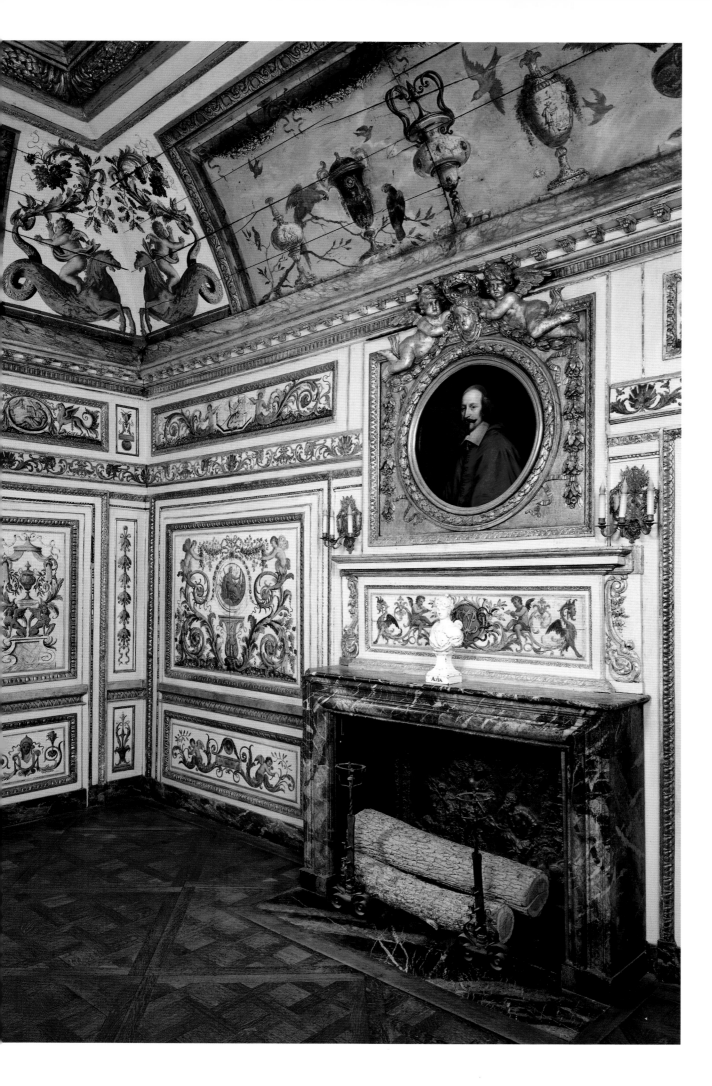

## 107. Hôtel Amelot de Bisseuil, called Hôtel des Ambassadeurs de Hollande

*Pierre Cottard built this mansion for Jean-Baptiste Amelot de Bisseuil in 1657–1661. The paintings adorning the interior are by Charles Poerson, Michel Dorigny, Louis Boulogne, Michel Corneille, and Jean Cotelle. In the gallery, shown here, only the decoration on the vault is original.*

## 108. Hôtel Colbert de Villacerf

*This mansion was built in 1660 by Edouard Colbert de Villacerf, cousin of the minister (Colbert). The drawing room was reassembled at the Musée de Carnavalet.*

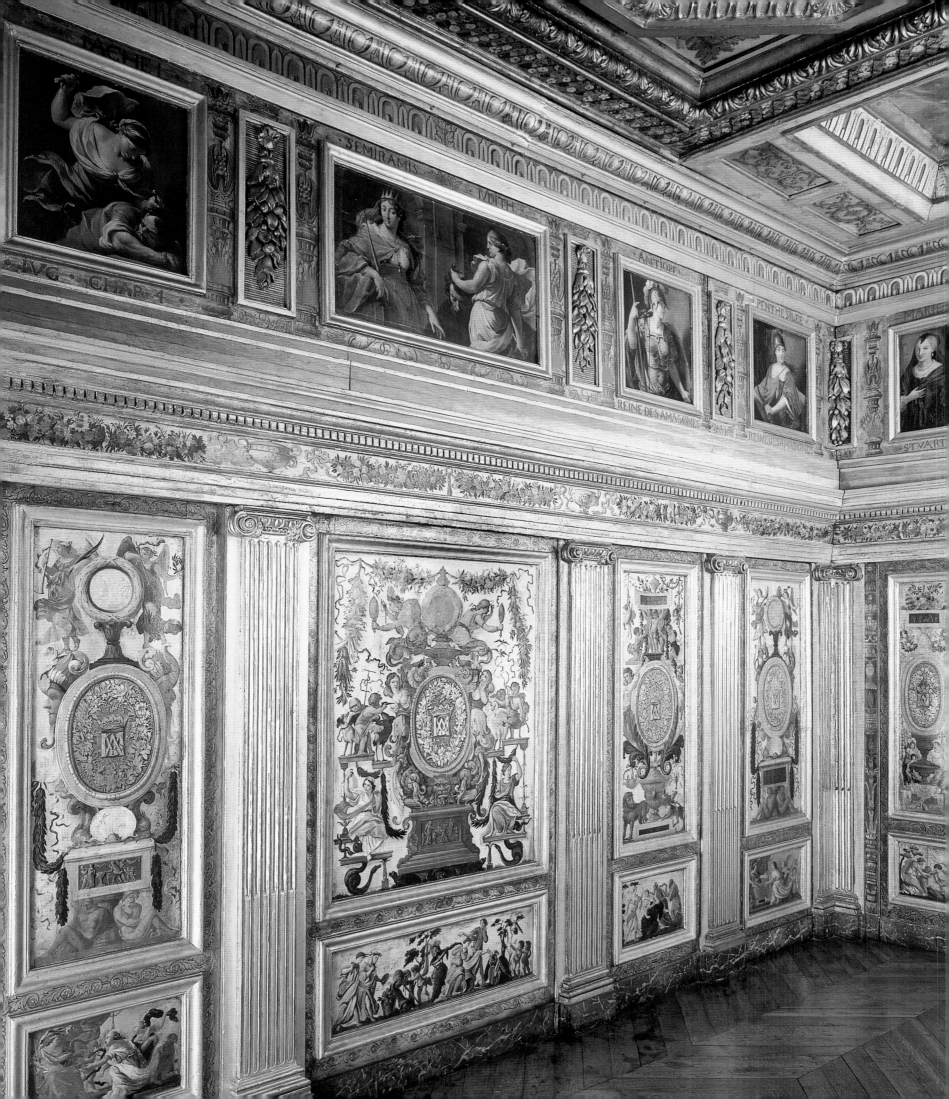

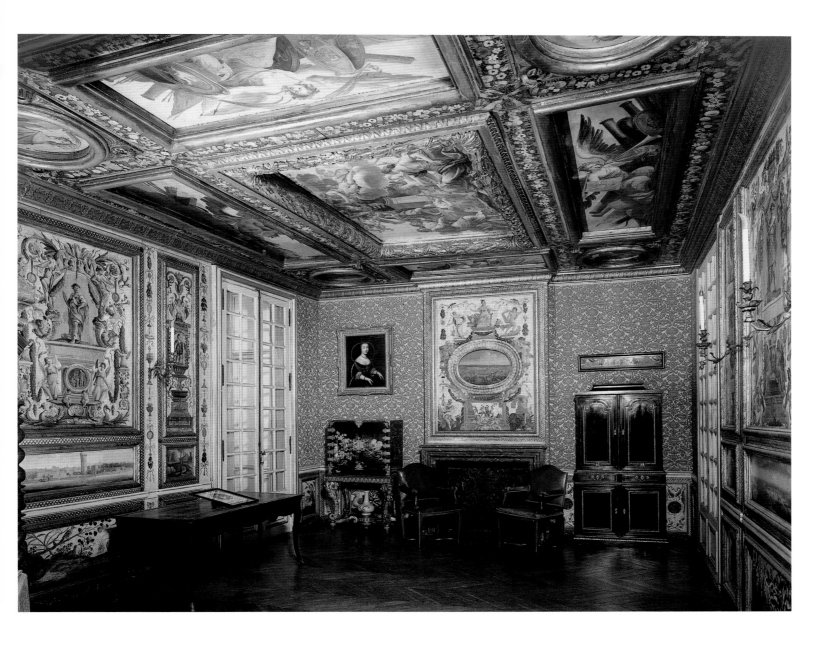

*The Hôtel de Rambouillet*

No example better fosters understanding of the manners of the time and place than this *hôtel* where Madame de Rambouillet conducted her salon. It was here that manners triumphed over the crassness of Henry IV's court and perfect decorum distinguished a gentleman. This famous marquise is thought to have personally supervised the construction of her mansion in 1619–1620, and to have introduced innovations that were probably not new. Among them are the staircase, moved from the center to the end of the dwelling to accommodate a series of adjoining rooms (such a staircase already appeared in the sixteenth-century Hôtel Carnavalet), the alcove (already in the sixteenth-century castle of Madrid), the sequence of doors (in the sixteenth-century Grand Ferrara palace) and the French windows (not widely used until the 1640s at the Hôtel Lambert, for instance). Actually, these may have been ordinary windows altered later by suppressing the low wall separating the windowsill from the floor. Still, it would not be coincidental if the French window was conceived at the Hôtel de Rambouillet: those window bays, open down to thresholds and recognized throughout Europe as a distinct feature of French architecture, are the image of a gracious society. Conversation and courtesy became a French art at the hands of this polite society (without Madame de Rambouillet, Louis XIV would never have spoken to his ladies-in-waiting). If the "blue room" of Madame de Rambouillet was a language workshop inventing neologisms, why could it not also have invented French windows?

**109–110. Madame de la Meilleraye's apartment at the Arsenal**

*In 1640–1645 the Duke de la Meilleraye, grand master of the artillery, had this apartment at the arsenal decorated for his wife. The adornments remain, but not in their original locations, including the chamber, or domestic room (shown above), and the large drawing room with paintings on the theme of "great women" (see opposite page). The paintings, like the ones on the chamber ceiling, are attributed to Charles Poerson.*

The first half of the seventeenth century reserved opposite fates for two traditional applied art objects, the stained-glass window and the tapestry.

### Stained-Glass Windows

Lack of quality in production and decline in demand caused the stained-glass window to disappear. The Pinaigrier family continued to work during Henry IV's reign: they were commissioned for stained glass in the churches of Saint-Gervais and Saint-Etienne-du-Mont until 1620. The use of transparent glass gradually replaced stained glass in churches. The Counter-Reformation preferred their sanctuaries to be well lit and illuminated, just like their doctrine, so that the faithful could more easily see the daily prayers in their mass books. Paintings came to be preferred over stained glass, as evidenced by the large collection of "Mays" hanging in the nave of Notre-Dame Cathedral (fig. 20).

### Tapestries

If tapestry production, which could also have suffered from competition with paintings, experienced a boom, it was perhaps due to the example set in Brussels, where tapestries, like engravings, began to reproduce paintings (figs. 18–19). But the main reasons were that tapestry production was an industry, and that it contributed to the economy. Thus it benefited from the protectionist policies of Sully, Henry IV's prime minister. His policy of dismissing foreign artisans, protecting factories, reducing the number of imports, and encouraging exports tended to assure the accumulation of wealth within the kingdom. In 1597 Girard Laurent set up shop on the Rue Saint-Antoine inside a seminary from which the Jesuits had been expelled. He was joined by Maurice Duboit, formerly from the La Trinité workshop founded by Henry II; when the Jesuits returned in 1606, the company was welcomed to a wing of the Louvre's Great Gallery, where Henry IV opened lodgings

**111. Abraham Bosse. *L'Hyver* (*Winter*), c. 1630.**

*Abraham Bosse's engravings provide invaluable testimony to the private lives of Parisians in the second quarter of the seventeenth century. In well-to-do houses, the same room could serve as kitchen, dining room, and bedroom. Here, the casement windows with interior shutters are mullioned and transomed, and set with small square lead-framed panels called quarries. The walls are covered in tapestries to which paintings and mirrors could be attached. The fireplace is still in the French style: it juts into the room and is covered with a hood. The furniture is simple: bed, table, chairs, and stools.*

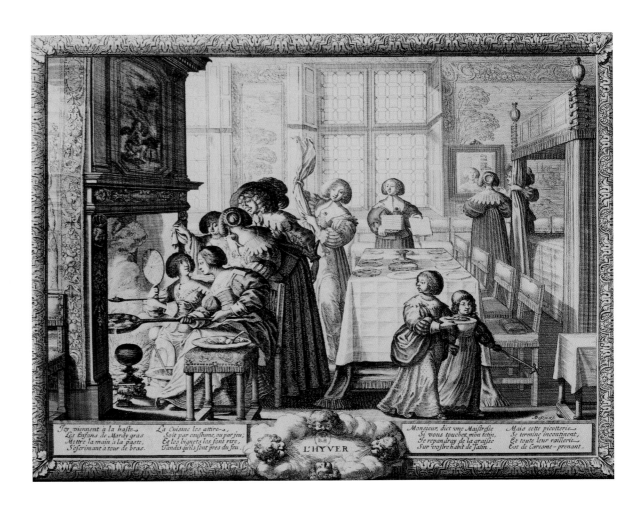

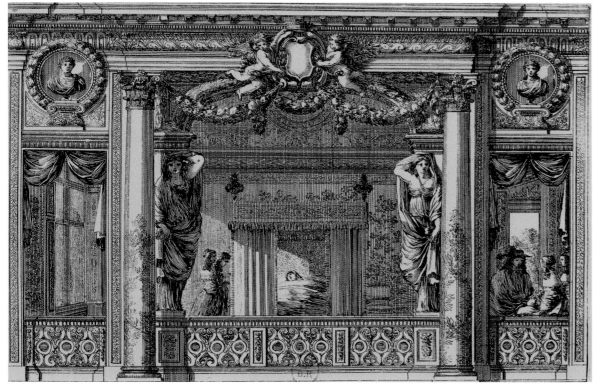

and workshops for artists and artisans freed from concerns of running businesses. They called on the services of two Flemings, Marc de Comans and François de la Planche, one with a shop at the Tournelles palace and the other at the Gobelins factory (a name destined to become famous) in the Saint-Marcel district. Associated since 1601, they merged shops and settled in the Gobelins in 1607. In exchange for their undertaking to keep eighty looms going, sixty of them in Paris, they secured the important privileges of a royal factory.

Between 1600 and 1660 Parisian shops produced a minimum of 1,300 tapestries, most of them royal commissions. Paris churches and individual clients desiring pieces for chambers and antechambers also placed orders, but in salons and galleries, tapestries competed with painting. Paris also vied with Aubusson and Felletin, where production had resumed. There were also weavers at Amiens and Tours, in workshops annexed to the Gobelins factory. But Paris never managed to take precedence over Brussels, whose fame was revived after the arrival of the Rubens cartoons. In 1622, Louis XIII commissioned Rubens for a *Histoire de Constantin (History of Constantine)* ultimately accorded the same fate as his *Vie de Marie de Médicis (Life of Marie de Médicis)*. The work was much admired, but failed to contribute significantly to tapestry weaving in France. Here again, the critical event was the return of Vouet in 1627, who provided designs and reorganized the manufacturing process just as Le Brun would do in the second half of the century. There is a Vouet style in Parisian tapestries, just as there would later be a Le Brun style (fig. 19).

Support for the tapestry industry was only one aspect of the king's policy of encouraging the luxury trade. The Place Royale, a site originally intended for artists and artisans, at first contained a factory of silk, gold, and silver cloth, which Henry IV founded on Hôtel des Tournelles plot. Apart from this, all industries dealing with personal appearance prospered in Paris; the artisans, numerous and industrious, all now worked for fashion, which finessed its hold over its customers like the king over his subjects and, like him, it exerted pressure on them.

 FASHION ACCORDING TO
*THE SCHOOL FOR HUSBANDS*

Maintien et habit d'vne Bourgeoise d'honneste
condition, allant par la ville, ou pour visites
particulieres en son voysinage, ou parente

Habit d'vne damoiselle de france comme le portent
celles qui ont l'honneur d'estre filles des Reynes lors
qu'elles sont dans la chambre du lict

**113–115. Fashion**

*Top left and right: These are a middle-class woman and a maid-of-honor to the queen, drawings by Jean de Saint-Igny, engraved by Isaac Briot, c. 1635.*

*In the middle is a gentleman by Abraham Bosse, 1629.*

*Clothing*

These engravings celebrate the triumph of fashion (fig. 116) at the end of the Pont-Au-Change on the bank of the Mégisserie River. Here tawers shaped soft, supple pelts into gloves, belts, and boots. The engravings also show the book and lace-making trades in the Galerie des Mercière (notions gallery) of the Palais de la Cité (fig. 117). Regarding books, the word *mode* returned to its original meaning (and masculine gender) to describe things related to the mind; whereas in the feminine, the word *la mode* referred strictly to articles of clothing.

**116. Anonymous. *La Mode triomphante en la Place du Change* (Fashion Triumphant on the Place du Change). (Musée du Louvre, Rothschild Collection, Paris)**

*This engraving shows a square at the end of the bridge on the Right Bank of the river, lined with accessory boutiques selling leather goods. The Pont-au-Change area was rebuilt with stone houses between 1639 and 1647 by Jean Androuet Du Cerceau. To honor the young Louis XIV, the town erected, at the homeowners' expense, a monument (fig. 24) on the house between the two streets converging toward the bridge.*

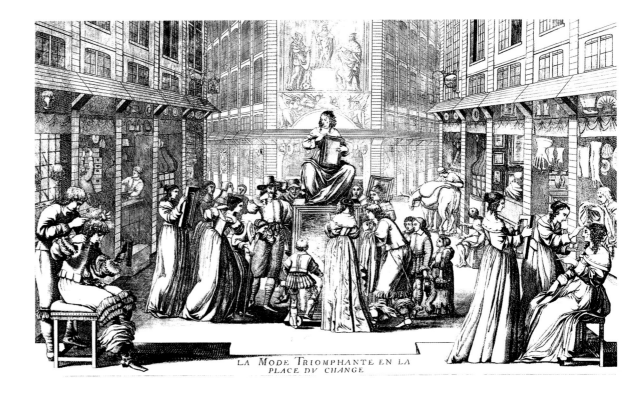

LA MODE TRIOMPHANTE EN LA
PLACE DV CHANGE

The first engraved fashion pictures appear in oddly-titled collections such as *Le Jardin de la noblesse françoise dans lequel se peut cueillir leurs manières de vettements* (*The Garden of French Nobility from Which Their Different Styles of Clothing Can Be Chosen*), 1629, or *Le théâtre de France contenant les diversitez des habits selon les qualitez et conditions des personnes* (*Theater of France Containing Varieties of Clothing Chosen According to People's Class and Wealth*), 1629. Vignettes by Jean de Saint-Igny and engraved by Briot, and one by Bosse, present outfits for all budgets and occasions (figs. 113–115), as Le Muet's contemporary treatise had done for houses. These collections were visibly inspired by *La Noblesse lorraine* (*The Nobility of the Lorraine Province*) drawn and engraved by Callot between 1620 and 1623. The first publication of this kind was edited in Venice in 1590 by Vecellio, setting aside the *Recueil de la diversité des costumes* (*Collection of the Variety in Outfits*) published in the mid-sixteenth century

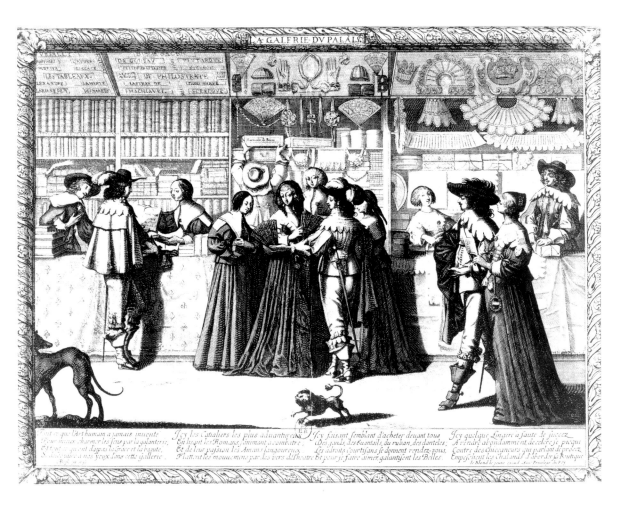

by Desprez, which was more topographical in genre. From this point on, the genre evolved into something between a fashion parade and a portrait of society.

Furetière's dictionary, from 1690, defines French fashion as "the style of dressing reflecting the customs of the royal court." Such customs were effectively laws if the facetious title on the engraving, *Courtisan suivant l'édit de l'année 1633* (*Courtier Obeying the Edict of 1633*), is to be believed. If such an edict did exist, it was intended to prevent popularizing fashion, which would erase social differences, endanger bourgeois' financial stability or way of life, or strain the economy in the kingdom. "Extravagant expenditure" edicts were issued in 1629 and 1633. But rulebooks of court etiquette record a very curious custom of wearing the "warranted jerkin around 1662, the king granted a dozen courtiers, and later about forty of them, the right to wear a jerkin identical to his when they stayed at Saint-Germain and in Versailles! The lucky ones received a warrant! The monarchy of fashion, henceforth absolute, was to reign in Versailles, but the designers would remain in Paris.

**117. Abraham Bosse. The Mercers' Gallery at the Palais de la Cité.**

*This gallery was a meeting place for purveyors of books and lace. The caption on the engraving reads:*

"*All that human Art ever devised
To better charm senses with gallantry,
And all that grace and beauty attract,
Is uncovered for our eyes in this gallery.
Here the most adventurous cavaliers
Are urged to fight by reading novels;
And in their passion, languorous lovers
Adorn their acts with theatrical verses.
Here in the public eye, pretending a purchase
Of gloves, fans, ribbon, and lace;
The skilled courtiers meet up,
And woo the beautiful ladies
     in order to win their love.*

FASHION

*The poet is right to call her a daughter of Saturn or change, since she transforms constantly…She has etched her laws mainly in France.*

La Nouvelle Mode de la Cour
(New Court Fashion), *1622.*

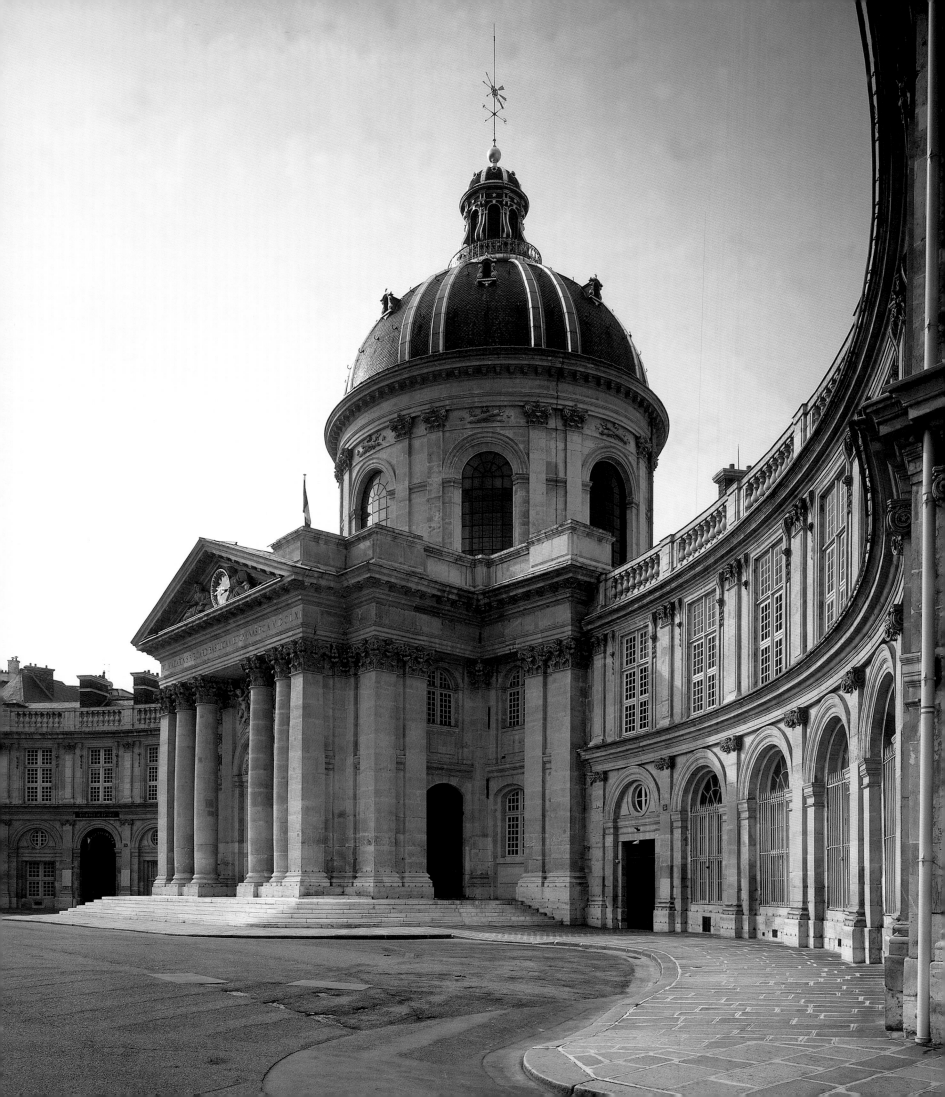

# Chapter VIII
# THE FIRST THIRTY YEARS
# OF THE PERSONAL REIGN OF LOUIS XIV
## (1660–1690)

**1–2. Collège des Quatre-Nations Chapel (now Institut de France)**

The beginning of the "personal reign" of Louis XIV spanned the years 1660 to 1661. It was inaugurated in 1660 by the king's marriage, followed by the royal couple's solemn entrance into Paris, but only became effective in 1661 when Cardinal Mazarin died. He would have no successor as prime minister—Louis XIV would rule alone. However, he gave Jean-Baptiste Colbert extensive ministerial powers that included foreign affairs and even war. In 1664 he went on to make Colbert superintendent of buildings, arts, and factories, and this gave him an additional role as minister of fine arts and industry. Colbert's financial policy had immediate effects, with obvious consequences for the arts: of the eighty million *livres* paid in taxes in 1660, only twenty-six million went to the king. In 1665, the king received sixty-three million *livres* from a total of ninety-four million. Colbert's name has remained attached to his economic policy, which included a tendency to reduce imports while creating factories in France, he also invited foreign artists and craftsmen to establish their talent and skills in France. It had more important consequences as well. Producers of luxury goods worked almost exclusively for the crown: the royal warrant became phenomenal and French style was identified with the king's taste. In the first thirty years of his reign, "the glorious thirty," a group of Italian artists in France at the invitation of Mazarin and Colbert, brought a more restrained art to the country while pandering to the king's taste for opulent forms and precious materials. The whole enterprise devoted to satisfying the royal desire was centered in Paris.

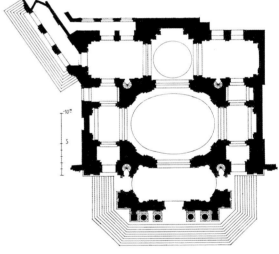

At the outset of his personal reign, Louis XIV came to live in Paris. Even then, the capital was known as a "wonderland, the center of good taste, nobility and romance"—Molière, *Les Précieuses Ridicules* (*Affected Ladies*,1659). Colbert also wrote, "Paris being the capital of the kingdom and the abode of kings, it directly affects the rest of the country, and all business begins in Paris." But then the king chose to leave Paris for Versailles. Thereafter, the lifestyle that gradually affected the whole kingdom was concentrated in two distinct poles, the difference between them being equal to the considerable distance between Paris and Versailles. The distinction would have gone unnoticed if, as La Bruyère claimed in *Les Caractères* (*The Characters*), 1688, Paris had been a mere "court jester." But the situation was quite the reverse. As Vauban wrote in about 1680 in his memoir *De l'importance dont Paris est à la France* (*The Importance of Paris for France*), Paris was "the true heart of the kingdom, the universal mother of the French and the microcosm of France that maintains all the people of this great state." Paris was promoted at the expense of the "provincial" countryside, a new concept that superseded the regional variety associated with the provinces. The countryside, where the king had chosen to live, became a place of boredom (Jean Racine), ridicule (Molière), and even vulgarity (Philippe Quinault).

## 1 – THE LEGACY OF CARDINAL MAZARIN

Mazarin was so involved in civil and foreign wars that he never found time to formulate an arts policy for France. As we have seen, he was determined to attract artists from Rome. As early as 1640–1641, when superintendent Sublet de Noyers sent Fréart de Chantelou to Rome in search of Nicolas Poussin, Mazarin (who was only a shadowy figure at the time) commissioned a bust of Richelieu from Gianlorenzo Bernini in the hope of winning the cardinal's favor.

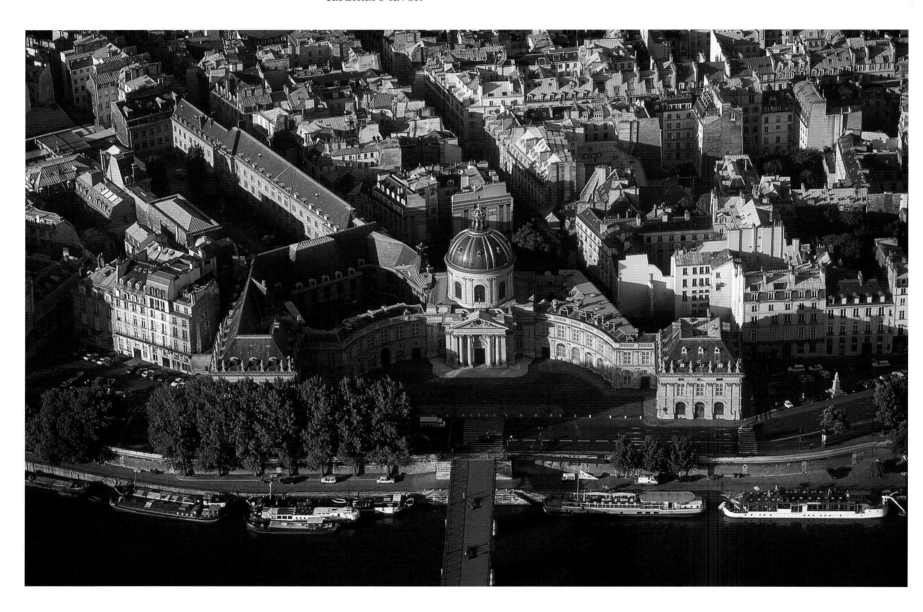

Above: Collège des Quatre-Nations

*The Collège de Quatre-Nations*
Mazarin had hoped to have Bernini design the establishment that was to be built on the site of his own palace and linked by a bridge to the Louvre, the future Collège des Quatre-Nations (figs. 1–6). When the Italian declined that honor, Colbert, who was in charge of Cardinal Mazarin's building work, suggested François Mansart and Louis Le Vau as alternatives. In fact Colbert could hardly have avoided including Le Vau, who was the cardinal's official architect. In 1657, within Mazarin's lifetime, Le Vau submitted a preliminary proposal about which we only know that it was considered too expensive. But it might be shown in his "Pont de la Paix" plan (fig. 11) for the new Louvre of 1660 (also within Mazarin's lifetime). If so, he envisaged a building around the old Nesle Tower very different from what was finally built there. Surprisingly, given Colbert's reputed hostility, Le Vau remained in charge of the project after Mazarin's death and the reading

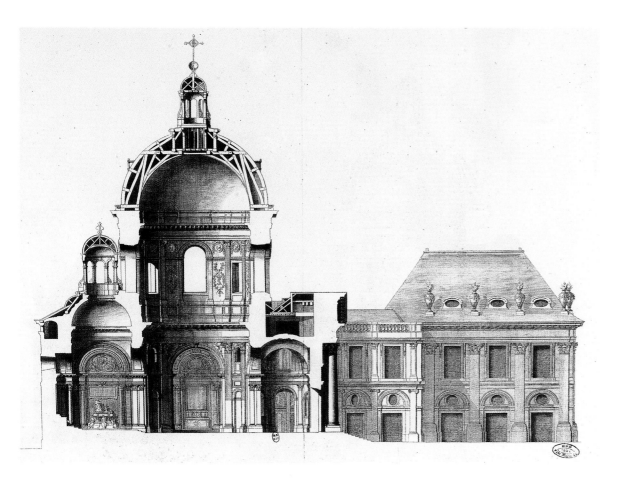

*The Collège des Quatre-Nations was founded in accordance with Cardinal Mazarin's will of 1661. It was to receive and train sixty gentlemen from the provinces reunited to the kingdom by the Treaty of Westphalia (1648) and the Treaty of the Pyrenees (1659) — Alsace, Flanders, Artois, Hainaut, Luxembourg, Roussillon, Conflent, Sardinia, and Pignerol — organized into artificial "nations" of the north, east, southeast, and south. Colbert, who was one of the executors of the will, chose to place it opposite the Louvre and appointed as architect Louis Le Vau, who had also been the cardinal's architect. The plan was drawn up, and approved by the king in 1662. The boggy riverbank was replaced by a quay. The building included a chapel at the center. At the end of each wing was a pavilion of the arts (on the right of the image), which would receive the academies, a riding school, and a fencing school; and another pavilion (to the left), which received the Bibliothèque Mazarine (Mazarin's Library). The library was then and is still open to the public. Behind all this, the college buildings were set aslant following the foundations of Philip Augustus's city wall. The major work was done by 1667–1668, and the decoration was completed by François d'Orbay after Le Vau's death. D'Orbay designed the lantern tower on the chapel, whose construction was completed in 1674. Mazarin's body was transferred to the chapel (figs. 31–34) in 1684.*

of his will (which provided for founding the college). But then Colbert was not sole executor of that will. Among others there was also the still powerful superintendent of finances, Nicolas Fouquet, who had hired Le Vau at Vaux-le-Vicomte. Le Vau's plan for the college was initiated in 1662 and has obvious similarities with the Louvre designs of Mansart and Bernini. If Mansart's earliest plans indeed date to 1662, it is possible

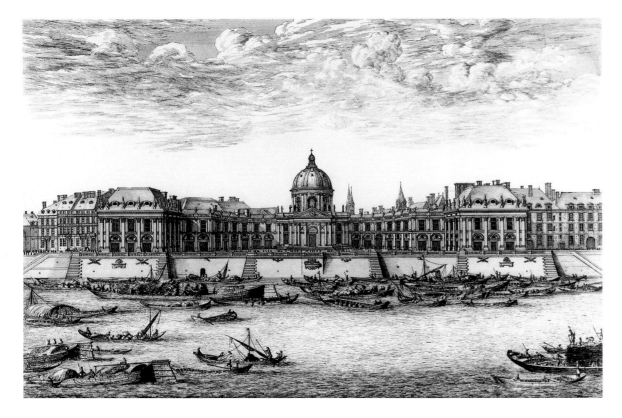

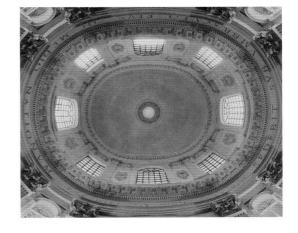

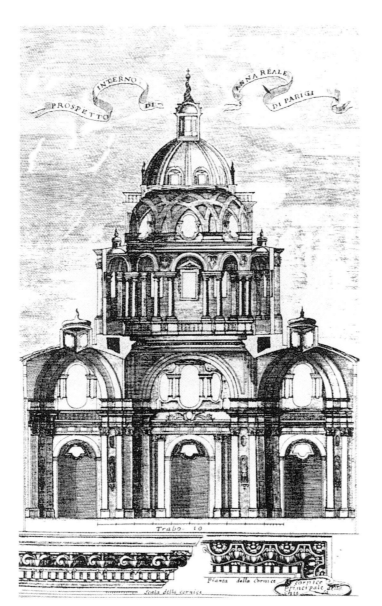

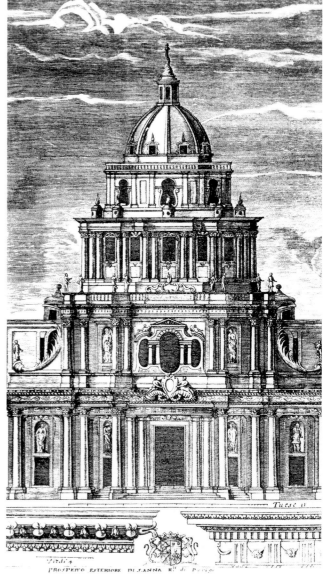

**7–9. Church of Saint-Anne-le-Royale (destroyed), engravings. (Archives Nationales de France, Paris)**

*The church of the Theatine Convent, built after 1662 to the designs of Father Guarini. The name is a tribute to Queen Anne of Austria.*

*Bottom:*
*Plan of the church with half of the plan of the cupola.*

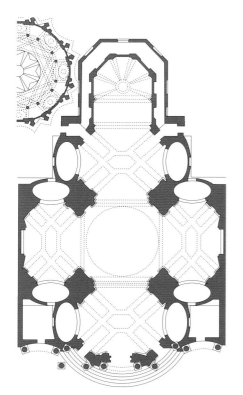

that Le Vau borrowed several ideas from his colleagues in order to secure the approval of the executors. On the other hand, it seems too early for him to have borrowed from Bernini, since this architect had to inquire about French taste before he could finalize his first project.

*The Theatine Convent and Sainte-Anne-la-Royale*
Mazarin's will also provided for the construction of a church or convent for the Theatines, who were to receive his *praecordia* (parts of the human heart). Indeed, he had invited the Theatines to Paris in 1644, and had chosen one of them as his confessor. Before he died, Mazarin retained the services of the virtually unknown Maurizio Valperga to design the church of the Theatines as well as the new Mazarin palace itself. But the Theatines rejected Valperga's plan in favor of one by Father Guarini, an itinerant architect of their order and devotee of the baroque. When it first appeared as a stylistic term in the eighteenth century, the word *baroque* was an alternative for *Gothic*. Guarini fully justified this confusion with the "skeletal" structure of his architecture—his use of ribs—and his interest in Gothic works. Paradoxically, this genial admirer of Francesco Borromini, who planned or built churches in Prague, Lisbon, Turin, Messina, and Nice, did much for French classicism. By building the church of Sainte-Anne-la-Royale (figs. 7–9) for the Parisian Theatines, Guarini presented the Parisians and classically minded critics with an essential example

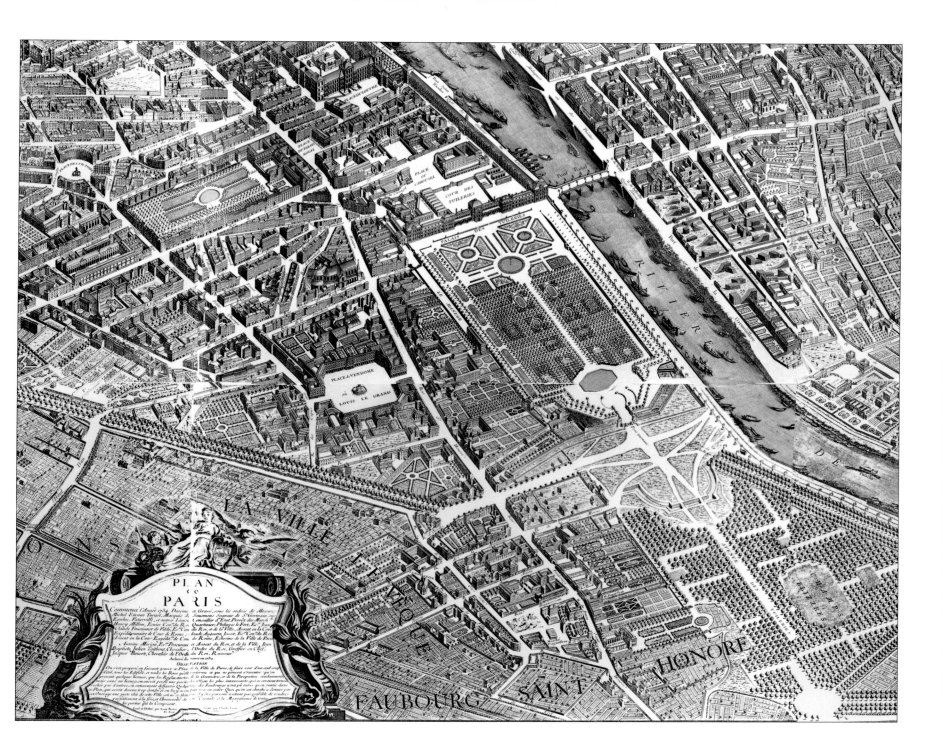

**10. Plan of Paris, called the "Turgot Plan," 1734–1739.**

*This plan of Paris was prepared by the architect Louis Bretez at the
behest of Michel Turgot, provost of merchants. The area reproduced
shows several architectural series that were made in this period. Note
that the Louvre was not yet roofed. The Tuileries Garden and the Pont-
Royal are at the center. To the left is the Place des Victoires near the
Palais Royal. Below, from left to right, are the Place Vendôme, part of the
boulevards, the site later occupied by the Place de la Concorde at the end
of the Tuileries Garden, and the beginning of the Champs-Elysées and
the Cours-la-Reine. On the Left Bank is the Palais Bourbon.*

11. Louis Le Vau.
Plan for completing the
Louvre, called the "Pont
de la Paix" plan, 1660.

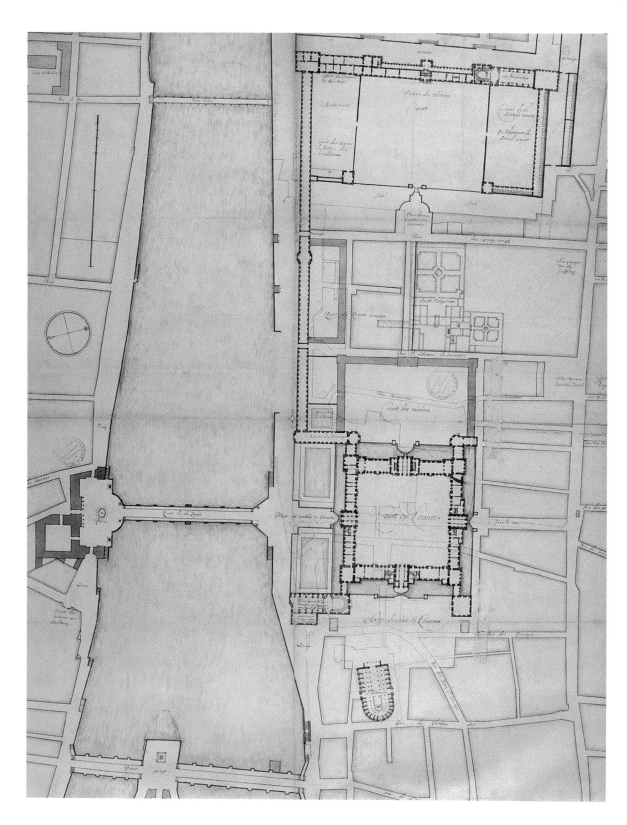

of everything they condemned. In the intersecting elliptical spaces, the projecting angled pilasters that followed the slant of the piers, the ribbed vaults, and many other features, Parisians easily recognized "the extravagances of that deplorable Borromini" (G. Brice, *Description de Paris*, 1694 edition). All the same, it is not clear that Guarini's design would have pleased Mazarin, who was completely taken with Bernini. This was entirely the wrong kind of baroque for France!

However uncertain Mazarin's posthumous work may be, one inference is clear: at the beginning of the reign of Louis XIV, Rome was still the artistic capital of Europe. Within a few decades, Paris would lay claim to that trophy.

## 2 – The Louvre, or the Conflict between French and Italian Style

After the Peace of the Pyrenees (1659), which crowned Mazarin's diplomatic career, royal architecture regained the impetus and ambition previously diverted to the war against Spain. Once the treaty was signed, the grand plan for the Louvre was revived. It had begun under François I with Sebastiano Serlio's plan (chapt. VI, fig. 45). Charles V's old fortress still stood in what would become the Cour Carrée (Square Courtyard), three sides of which were reasonably complete, having been initiated by Lescot and expanded by Le Mercier. But the town encroached almost up to the castle walls, and now had to be cleared to make way for the new eastern wing, which would be the main entrance to the complex.

The ideal solution would have been to level everything as far as the Pont-Neuf, without sparing the church of Saint-Germain-l'Auxerrois, the oblique orientation of which ruined any hope of regularity. In addition, the king's apartment in the southern wing was too narrow. Moving it into the eastern wing above the entrance would only be viable if there was sufficient clearance to protect the king from the violence and disease of the city.

As early as 1660, Louis Le Vau, First Architect to the king, submitted the Pont de la Paix plan (fig. 11). It foresaw the completion of the Cour Carrée, the construction of a bridge (where the Pont des Arts is now), and, at the bridge exit on the Left Bank, the foundation of a building that would become the Collège des Quatre-Nations and provide a monumental view for the king from his residence in the south arm of the Louvre.

In 1661 an unworkable but grandiose proposal with round courtyards recalling Serlio's design was submitted by the otherwise unknown Antoine-Léonor Houdin, who may have been an Italian from Udine with a French-sounding name, summoned during Mazarin's last years. In the end, work was begun on a Le Vau plan in 1661 (and modified in 1662), the main feature of which was a huge Italianate oval salon forming the central pavilion of the eastern facade that echoed on a grander scale the Italian room that Le Vau had built at the château of Vaux-le-Vicomte.

But in 1664, Colbert, newly appointed superintendent of buildings, halted the work and invited French architects to submit new proposals. This decision has been attributed to Colbert's hostility to Le Vau, who was suspected of dishonesty and incompetence, but it is possible that the superintendent simply wanted to make his authority felt by the strong-willed First Architect. At any rate, that was the end of Le Vau's design for the Louvre. Colbert is known to have criticized the salon's oval floor plan as being in poor taste, although that did not prevent him from summoning Mansart who, in his turn, produced a proliferation of gourdlike and kidney-shaped rooms.

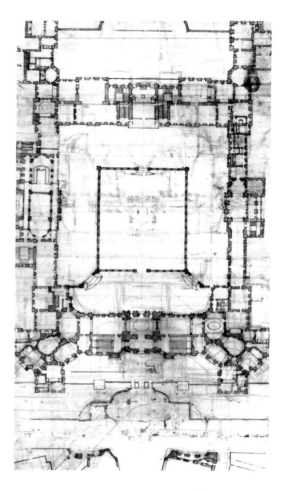

**12–13. François Mansart. Plans for the Louvre. (Bibliothèque Nationale de France, Estate of Robert de Cotte, Paris)**

*In 1664 Colbert asked François Mansart for a proposal to complete the Louvre, and Mansart made several. Some plans may have been completed earlier than 1664. On the plan above, the Lescot Wing can be seen at the back of the courtyard, already doubled in length and width. In front of the eastern facade a square is planned with masking walls and a V-shaped opening to hide the skewed church of Saint-Germain-l'Auxerrois. The elevation (which does not belong to the same project as the plan) shows two variants (to the left and right) for the eastern facade.*

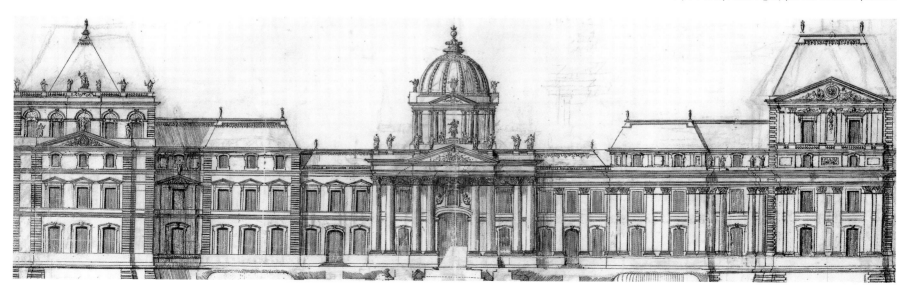

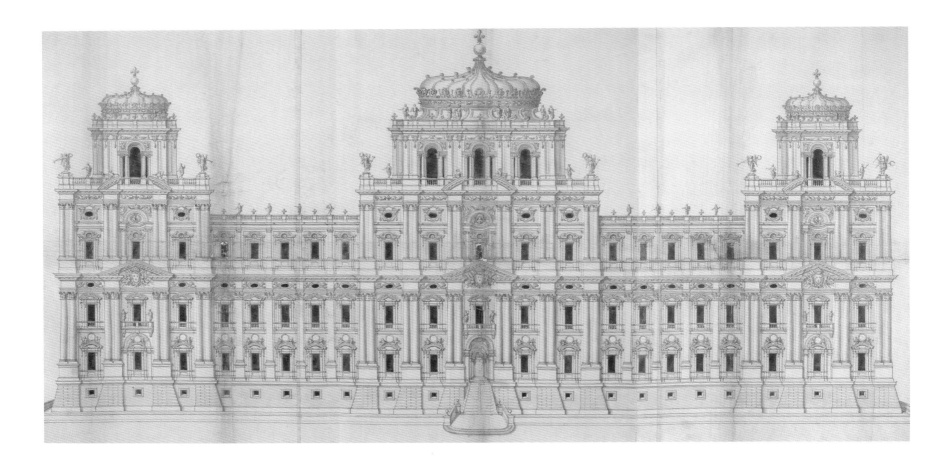

**14. Carlo Rainaldi.**
**Plan for the Louvre, 1664.**
**(Musée du Louvre, Paris)**

*Rainaldi sent this proposal for the*
*eastern facade of the Louvre from*
*Rome in 1664 at Colbert's request.*

### François Mansart's Proposals

Mansart's proposals effectively date from 1664—although the oldest ones may go back to 1662, and the latest precede his death on September 23, 1666, by a few months or only a few days. Mansart's drawings are among the most beautiful from the French School in the seventeenth century (figs. 12, 13). Among them, six main plans of varying scales have been identified. Mansart kept to the tradition of many separate rooms, allowing him to add more projections to the facade. In one of his most original designs, rooms and pavilions develop diagonally across the corners, the ground level in the Cour Carrée is raised at the sides in terraces (an arrangement dear to Mansart) and the eastern frontage has a sunken area along Saint-Germain-l'Auxerrois, creating a framed vista in the Italian manner. These designs by the father of French classicism had the vigor, the strong relief, and the monumental generosity that also characterize the grand manner of Rome. Mansart's failure at the Louvre was the direct result of his own indecisiveness, which had already cost him the Val-de-Grace workshop. "This excellent man who could please everyone with his fine works could not please himself. Better ideas always occurred to him in the middle of work on things which he should have finished first.... It was this abundance of great thoughts that stalled progress on the facade of the Louvre so long that it was not built under his leadership or according to his design" was Charles Perrault's verdict in his *Les hommes illustres qui ont paru en France pendant un siècle* (*A Century of Illustrious French Men*), 1696–1700.

### Italian Plans

Mansart's standstill must have been obvious for Colbert to resort to summoning Bernini, who "certainly had no advantage over him [Mansart] in architectural terms" (Perrault). The ghosts of Mazarin, who still haunted the Louvre, inspired Colbert to send Le Vau's plans to Rome in search of Italian recommendations. Celebrated masters including Cortona, Rainaldi, and even Bernini took part in the competition of 1664. Candiani, an unknown, also sent in a plan, and Guarini's palace design published in *L'Architettura Civile* (*Civic Architecture*), 1737, may also be a Louvre proposal. But Colbert considered

these plans "bizarre," failing to see in them any "taste for beautiful, straightforward architecture." The gulf between the extremes of Roman and French taste shows clearly in a comparison of Rainaldi's plan (fig. 14) and those of Mansart (fig. 12). Rainaldi's proposal was peppered with Michelangelesque motifs that were no longer current in France (for example, the reclining figures on the window pediments), and the central niche seems to be borrowed from Borromini, not to mention the roofs like crowns topped with fleurs-de-lis.

### Bernini's Plans

Bernini's plan (fig. 15), on the other hand, might have derived from the compilation published by Lepautre (chapt. VII, fig. 2) in 1652. The oval pavilion, the domeless drum (the "open crown" that Colbert disparaged), and the colossal pilasters already featured in the French masters' designs. Is it more likely that they later "Romanized" their work or that Bernini sought to accommodate French taste with an echo of Lepautre? Indeed, Colbert's criticism of Bernini's plan concerned not the style but the amenities, the porticos and terraces being ill-adapted to the French climate.

In January 1665 Bernini sent a second drawing (fig. 16) that retained the concave facade but converted the central pavilion to a frontispiece in place of the rotunda. This frontispiece is an arrangement that would later be very successful in France, in which the ground floor is treated as a rusticated podium and the two upper stories are connected with colossal pilasters. Of this second plan Colbert said that there was "nothing more beautiful," but he informed Bernini, who envisaged the destruction of Lescot's Louvre, that they should conserve what had been done "when the first civilized men resurrected architecture from the tomb where the barbarism of the Goths and the centuries that followed them have buried it."

It seemed likely that the flaws in Bernini's proposals were caused by misunderstandings that would have been dispelled by a visit to Paris. Abbot Elcipio Benedetti, the agent in Rome for both Mazarin and Colbert, spent several years trying to overcome Bernini's reluctance to journey to France. He attributed this to contemptible motives: "his absence might show that it was not only possible to make great things without him, but perhaps also to produce better architecture—for which many think he has not the least aptitude." The brilliant designer had, in fact, suffered a worrisome technical reversal in the construction of the facade of Saint Peter's.

**15. Gianlorenzo Bernini. First Plan for the Louvre. 1664. (Musée du Louvre, Paris)**

*Bernini made at least four plans to complete the Louvre. The first, sent to Rome in 1664, is characterized by the oval pavilion at the center.*

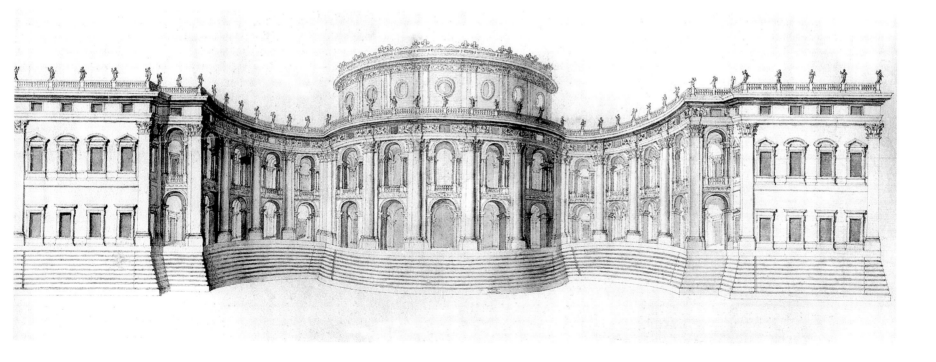

Bernini made up his mind at last and left Rome on April 29, 1665. At the king's orders, he was received with honors normally reserved for princes when he arrived in France. Chantelou was appointed his guide and interpreter, and he left a *Journal de voyage du Cavalier Bernin en France* (*Journal of the Knight Bernini's Travels in France*), an essential document for understanding mid-century Italian-French (or rather, Roman-Parisian) architectural relations. All of Paris awaited Bernini with impatience, "some because of an inflated idea of their own ability, others to see what would come of this event and the insult they claimed had been perpetrated on them as French architects" (Vigarini). What came next is well known. Bernini designed a third plan that was perhaps a little more French with its three pavilions (fig. 17). By all accounts, the design was much admired, and a foundation stone was laid on October 17. Two days later, Bernini took leave of the king with important gifts and the assurance that his proposal (a fourth version, very similar to the third but taking into account some criticisms it had received) would be executed. The work began, in fact, but it was soon stopped. In a letter of July 15, 1667, Colbert informed Bernini that his design had been abandoned.

During his visit, Bernini had two important conversations, with the king and with Colbert. The conversation with the king was celestial. The Sun King said that the expense mattered little to him, that he would be displeased to destroy what his ancestors had made, but that he would sacrifice it if necessary. He commended Bernini's design and expertly justified his approbation of the third plan. "You have never seen the works of Italy, yet you have a remarkable taste in architecture," enthused Bernini with spurious amazement. The king immediately approved the "catch," that part of the plan Bernini had feared he would have to sacrifice to French taste. The catch was the foundation wall, the part of the facades rising from the ditches, treated like rough rock. The idea was dear to Bernini, as shown by his use of rocks in the Piazza Navona fountain in Rome. But they were not entirely new in France; De l'Orme had already used them.

With Colbert, who feared that the catch would merely trap the sewage that was customarily thrown into the ditches from château windows, the tone of the conversation was very different. "The Knight went into no detail, dreaming only of great rooms for theatricals and banquets and paying no attention at all to the necessities…Mr. Colbert, by contrast, wanted to know exactly where and how the king would be lodged" (Perrault, *Mémoires de ma vie*, or *Memories of My Life*). According to Colbert, Bernini's plan, "no matter how stately and beautiful, was nonetheless so badly conceived for accommodating the King and his

**16–18. Gianlorenzo Bernini.**
**Plans for the Louvre.**

*The second plan (bottom), sent from Rome in January 1665, is characterized by a double-concave recess.*

*The third plan (opposite, top) was drawn up in Paris and engraved by Jean Marot.*

*The fourth plan (opposite, bottom), kept at the Musée du Louvre, was produced just before Bernini's return to Rome and differs from the third only by the addition of an oval chapel. On the plan of this fourth design, the older parts to be preserved are pink to distinguish them from the new parts, in brown.*

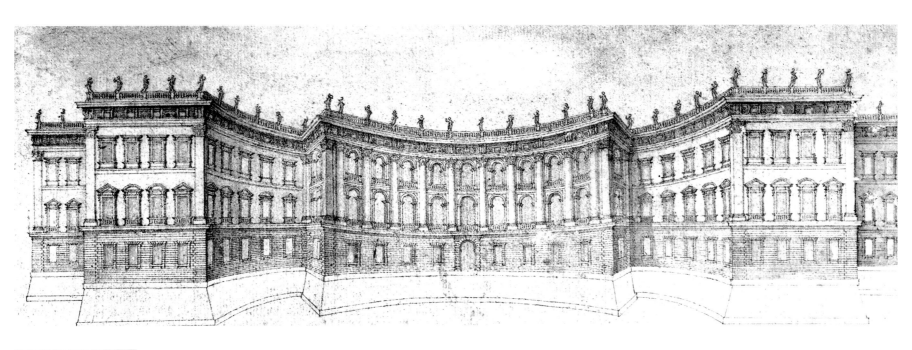

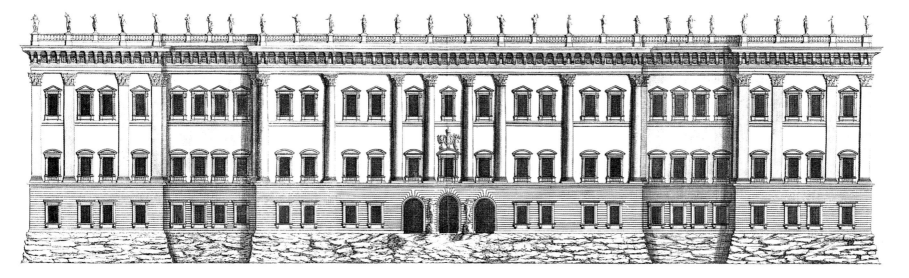

apartment in the Louvre, that he would have been left as cramped in his allotted space in the new Louvre after the outlay of 10 million as he was before going to this expense" (Chantelou). It is only fair to say that Colbert went so far as to speak of latrines, while Bernini went so far as to call the minister (behind his back) a related rude name. Later, after insisting on the superiority of the Roman masons, casting aspersions on the French masons' skills, Bernini had test walls built by the masons of each nation. Charles Perrault reports with relish that "the Italians' wall fell at the first frost, while the whole length of the French wall stood firm."

After Bernini's departure in 1667, Colbert reconvened a small task force consisting of Charles Le Brun, Le Vau, and Claude Perrault to finalize the plan and the eastern wing. Perrault put the finishing touches on the design that was built. When the work was definitively halted in 1678, the colonnade still lacked the necessary clearance in front of the palace entrance and the buildings of the Cour Carrée still had no roofs (fig. 10).

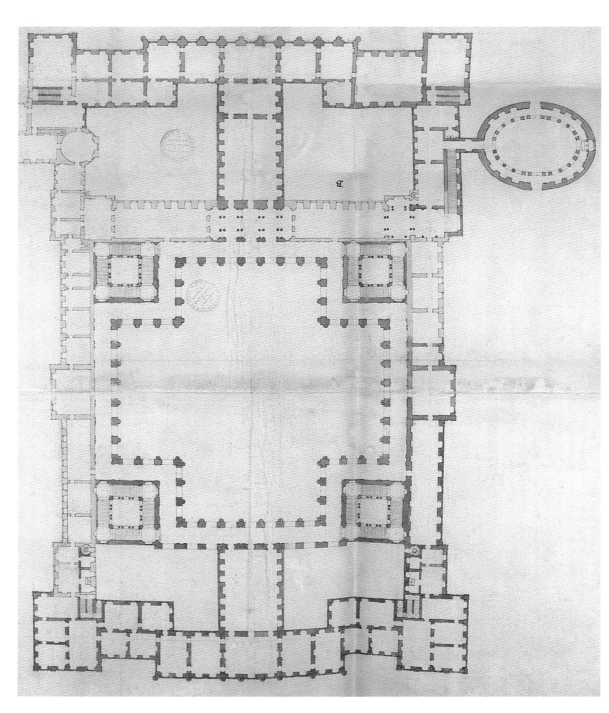

"Public opinion was my great enemy in Paris," announced Bernini, who through his systematic criticism of French art had reversed his initially favorable reception. By conviction or by duty, Chantelou got along with the Italian. Both men agreed that Borromini was an "immoderate architect"—but the cordiality waned when Chantelou spoke of Michelangelo's unorthodoxy, because Bernini wanted to be the Michelangelo of his century. Bernini's opinions of the monuments he visited are very revealing. The Tuileries were a "great little thing," and the tomb of François I at Saint-Denis had "little imagination and little style." On the other hand, Bernini instinctively identified the Italian manner. Thus he admired the Luxembourg (doubtless for its resemblance to the Pitti Palace), the church of the Sorbonne (so similar to the Roman church of San Carlo ai Catinari), the facade of the Jesuit novitiate (almost identical to that of Santa Maria dei Monti), and the Roman decorations by Jean Lepautre. But he criticized the facade of the church of the Professed Jesuits as too full of ornament. Concerning the Saint-Cloud cascade (fig. 19), which was not rough and rocky enough for his taste, he said "people here are unaccustomed to natural things, they want everything as small and artificial as a sister's sampler." So much for Lepautre, whose incredibly vigorous work was compared with a nun's embroidery! Doubtless put on his guard by Chantelou, who warned that his comments had reached the king, who found them increasingly irritating, Bernini said he liked Maisons and Vincennes.

**19. Antoine Lepautre. Cascade at the Château de Saint-Cloud. 1664–1665.**

*Antoine Lepautre, architect to Monsieur (the king's brother), is responsible for his château of Saint-Cloud. The basin and canal at the bottom were added by Jules Hardouin-Mansart in 1698–1699.*

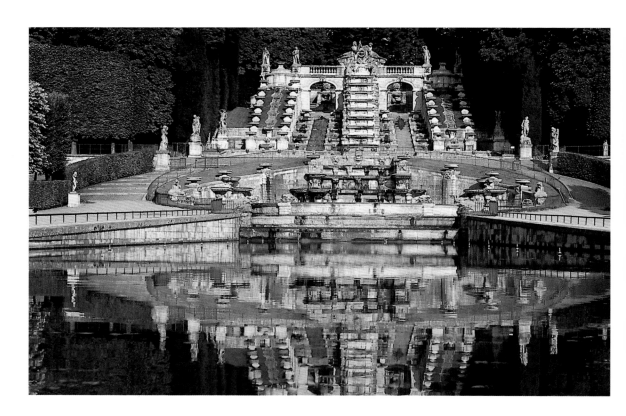

**Opposite and following two pages:**

**20–21. Baldachin and Cupola at the Val-de-Grâce**

*The baldachin was designed by Pierre Le Muet and Gabriel Le Duc in 1663 and assembled in 1669. The cupola was painted between 1663 and 1665 by Pierre Mignard.*

### The Cabal against Bernini

These unwise comments fed what Chantelou called "the grand architectural cabal against the knight." If Colbert himself was not part of the cabal, his assistant Charles Perrault, author of *Contes* (*Narratives*), who was disparaged by Bernini, very likely was. Surely, summoning a foreigner was against Colbert's general political principles? The knight responded to this attack with a first line of defense, saying that it was perfectly natural to call an Italian to create architecture, just as one would call in the French concerning the art of war. As Chantelou put it, "When his plan was executed, people would come to France to see architecture as they had once come to see armies." The French were in fact already

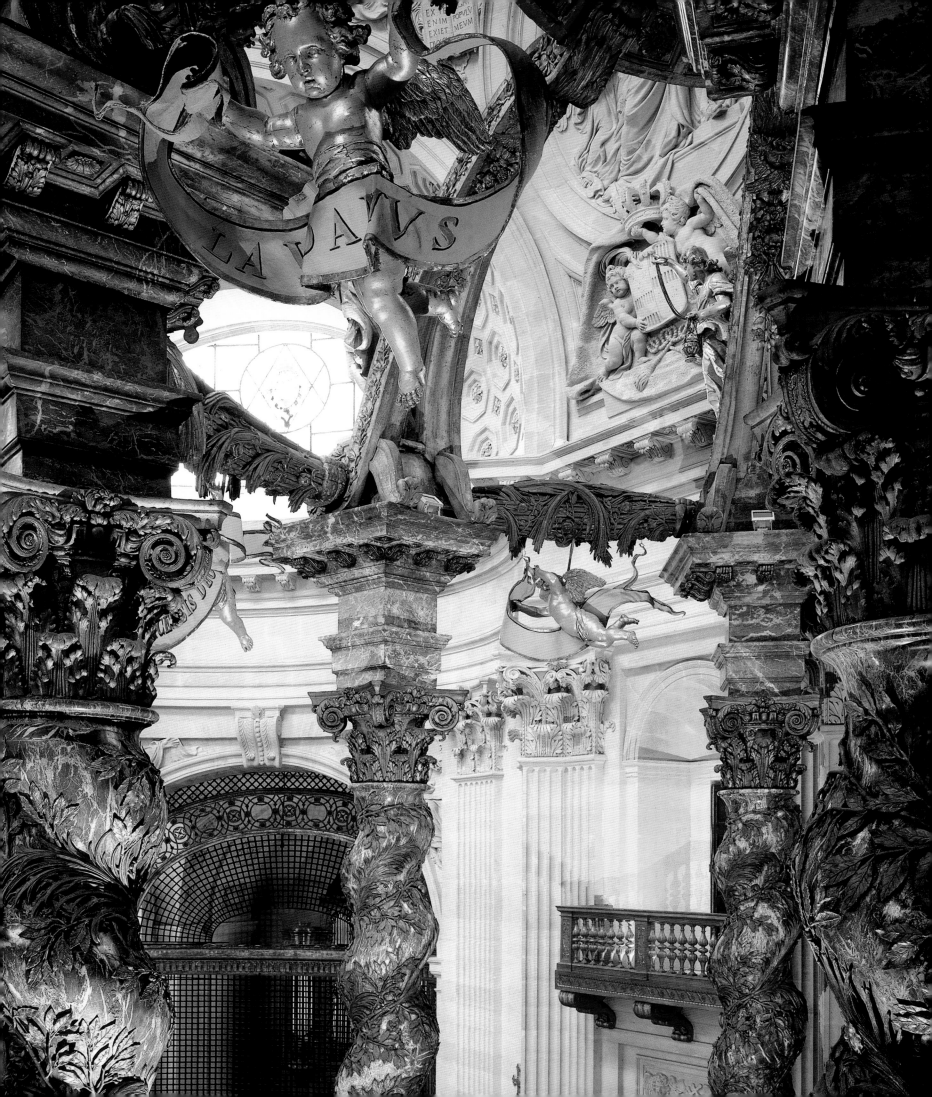

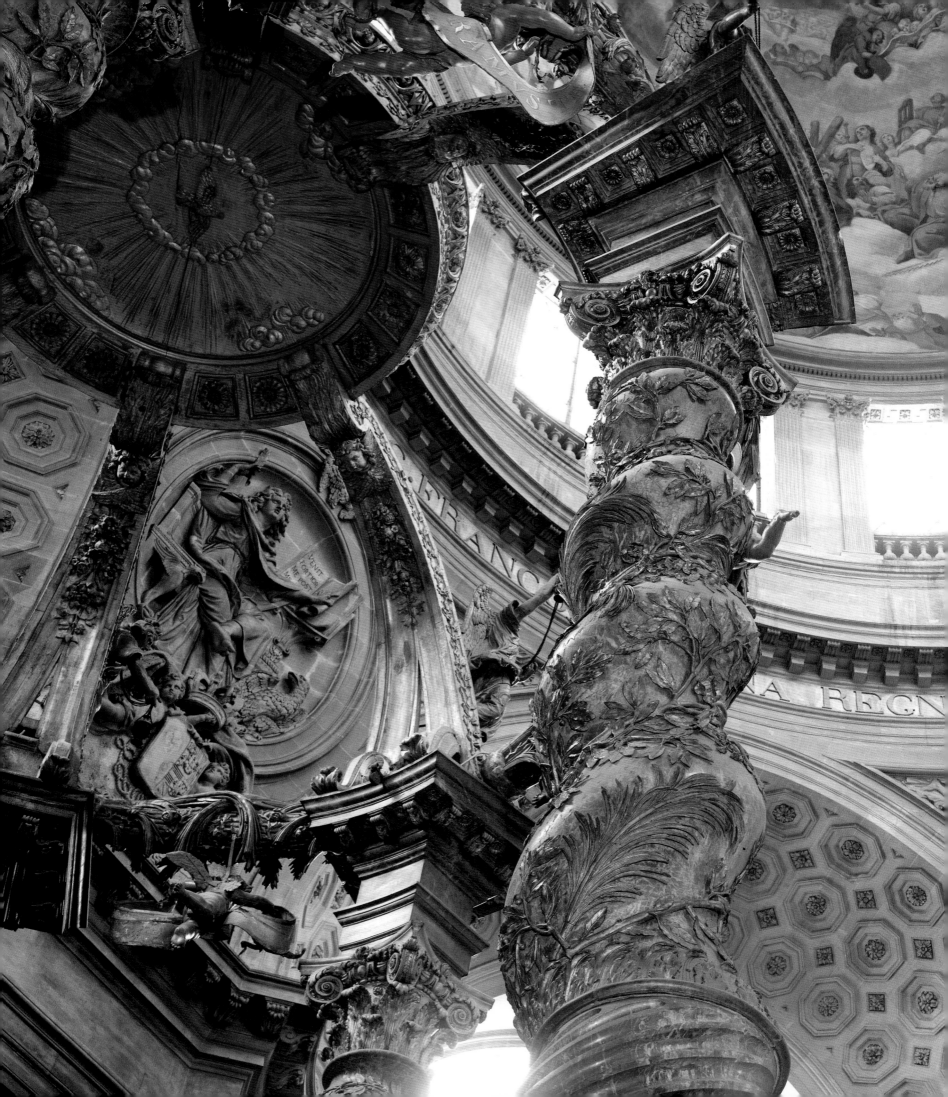

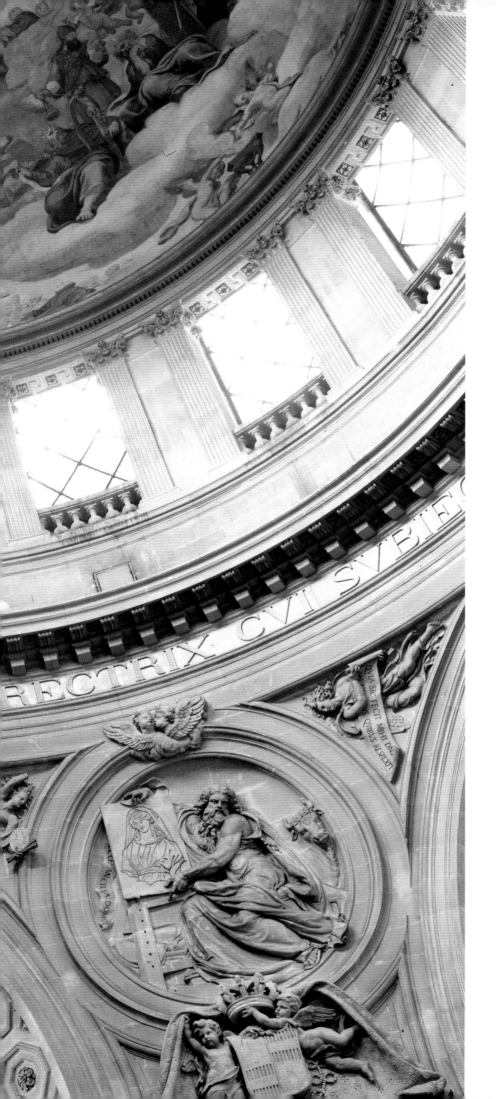

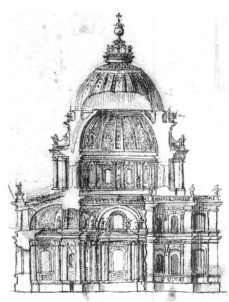

22–25. François Mansart.
Plans for the Mausoleum-Church of the Bourbons, 1664–1665.

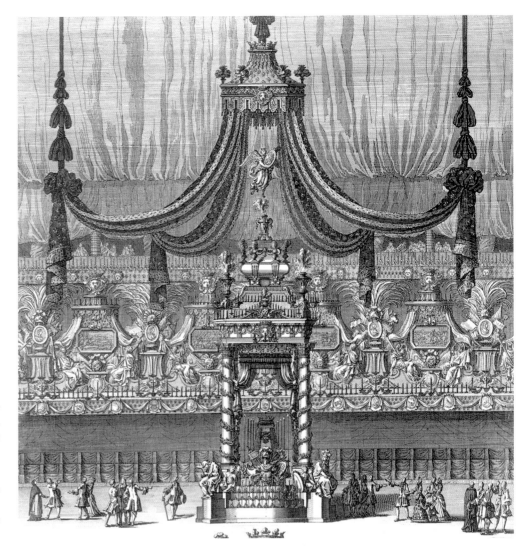

**26–27. Funerary Obsequies for the Grand Condé at Notre-Dame, 1687. (Bibliothèque Nationale de France, Paris)**

*The funerary obsequies for the Grand Condé, victor of Rocroi, were organized by Jean Bérain in 1687. Engravings by Jean Bérain and Dolivar show the bier (opposite) and the pulpit from which Bossuet gave one of his most famous eulogies (below) on this occasion.*

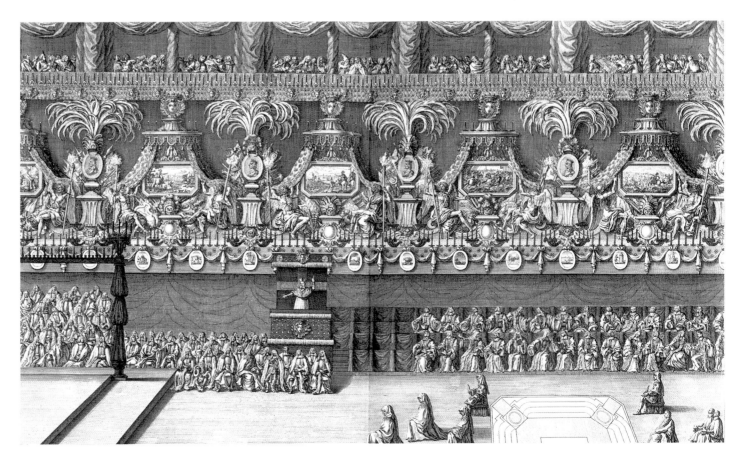

the masters of this war, and the Italian retreated to further defensive positions. He protested that "if the Pope had wanted a building in the French style and had called an architect from France, there would have been nothing more to say; the King wanted a Roman-style palace, and in his opinion they {the French architects} should certainly not find fault with that." Clearly, the factions were equally matched.

This confrontation between the Roman champion and the French architects made almost as much noise in Europe as the battle of Rocroi: the echoes reverberated throughout the eighteenth century. In his *Architecture Française*, 1752–1756, Jacques-François Blondel proposed a correction for the facade with "the catch": the lower part was too tall, the central frontispiece (which was almost half the total length) was too wide, the equal height of the two upper stories was unacceptable, the order was Corinthian when the entablature was composite, the windows were too small and unattractively grouped in pairs, the wall panels were unequal, sometimes too narrow but more often too wide, the triple portal was not distinguished by any projections and therefore did not have the relief expected of a principal entrance, and finally, the Herculeans that guarded it were ludicrous. This exhaustive analysis led to an overall conclusion "that it is essential to subordinate one's production to the dominant taste of the nation where one is called to exercise his talents." In fact, applying Blondel's corrections to Bernini's design would produce a much more French design.

The confrontation of 1664–1665 gave decisive impetus to considerations of a national style, of the differences between the two nations, and of the possibility of exploiting their complementary aspects to create a perfect style. Abbot Benedetti remarked of Bernini's first plan, "As regards the distribution of rooms and the arrangement of the conveniences, our Italian architects are so imbued with our country's ways that it is hard for them to conform to the rather different French customs. By contrast, French artists who have little knowledge of the magnificence of our buildings lack a certain nobility that we have here. For best results, they should choose the best aspects of each other's approach." This idea was seeded abroad through the 1665 journey and Chantelou repeated it in these terms: "the Knight and Mansart could accommodate each other, the Knight for great and noble concepts, and Mansart for interior management." Italian outside and French inside would become an ideal throughout eighteenth-century Europe.

**28. Antoine Coysevox. Bust of the Grand Condé. 1677. (Musée du Louvre, Paris)**

*This is the bronze bust commissioned by the Prince de Conti, nephew of the Grand Condé, for his hôtel in Paris.*

**29. Martin Desjardins. Bust of Pierre Mignard, c. 1675. (Musée du Louvre, Paris)**

*This marble bust was given to the Académie Royale de Peinture et de Sculpture by Mignard's daughter in 1726.*

### 30. Le Brun. His Mother's Tomb. c. 1690.

*Tomb after Le Brun's design by the sculptor Jean Collignon. c. 1690. The words of the psalm "I shall be satisfied when Your glory brightens my eyes" are engraved on the tomb. The chapel at the church of Saint-Nicolas-du-Chardonnet, which contains this tomb as well as that of Le Brun himself, was bought by the artist in 1667 to serve as a burial chamber for his family.*

### SERMON ON DEATH

*"What will it avail you to have written so much in this book, to have filled all its pages with fine characters, when a single stroke will erase it all in the end? Yet a stroke would leave at least a few traces of itself: at that spot where the final moment will blot out your whole life at once it will lose itself with all the rest in that great gulf of emptiness. There will be nothing left on earth, no vestiges of what we are. The flesh will change its nature, the body will take a new name—even that of corpse will not remain to it very long. It will become, says Tertullian, an unknown thing that no longer has a name in any language."*

Bossuet

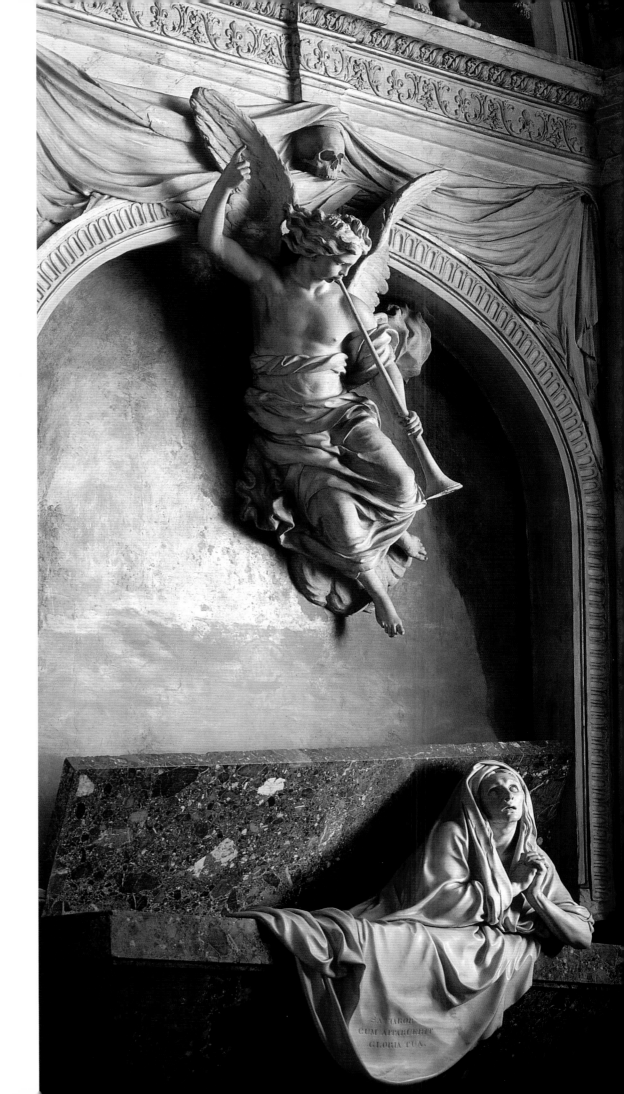

*Bernini's Influence*

During his time in France, Bernini competed with French architects for other projects in addition to the Louvre. He and Mansart both submitted proposals for the Bourbon mausoleum that Colbert wanted to build at Saint-Denis (figs. 22–25). Each master designed a kind of centrally-planned church with a corona of chapels around an open center that had haunted architects from the beginning of the Italian Renaissance. At the Val-de-Grâce, the queen mother asked Bernini to submit a design for the high altar, but it was the existing plan by Le Muet and Le Duc that was finally built (figs. 20–21). This consisted of a baldachin of the kind Bernini had conceived for Saint Peter's in Rome thirty years earlier, which had not yet been imitated in France. These two examples further clarify the similarities and differences between Italian and French building. The differences were almost entirely concentrated in civic architecture, which was completely subordinated to social custom, whereas Italian churches were reference points, challenges to be surpassed.

By contrast, Bernini's unprecedented and incomparable settings for the divine mysteries, which the brilliant sculptor produced in the baldachin and the throne of Saint Peter and in the sculpture of Saint Theresa in ecstasy, were only belatedly imitated in France. Traditionalizing France went for this kind of baroque for a century. This was most noticeable in the area of ephemeral architecture (such as ceremonial funerary apparatuses, or banqueting and theatrical decor) where the excesses seemed harmless because of their transience. In 1670 Jean Lepautre, designer of Romanized decoration, buried the Duc de Beaufort with all required obsequies. To mourn this great dignitary he was apparently inspired by the *castrum doloris*, with the pyramid, skeletons, and angelic trumpeters that Bernini had set in the church of Santa Maria in Aracoeli. Other achievements of this genre included the state funeral organized by Le Brun for Chancellor Séguier (1670), as well as those organized by Jean Bérain for Queen Marie-Thérèse (1683) and for the Grand Condé (1687; figs. 26–27). For Condé's funeral, Bérain had been assisted by Father Ménestrier, a Jesuit and author of a treatise entitled *Des décorations funèbres* (*Funerary Decor*), 1683, and a great enthusiast of complicated metaphors for use in festivals, whether melancholy or cheerful. Some ten years earlier, he had set up a similarly ludicrous bier for an important French soldier, likewise overflowing with symbols.

The only finished work Bernini left in France is the famous bust of Louis XIV, a work in marble enlivened by a typical breath of baroque. But Bernini was not the only sculptor whose gestural verve embraces space in an almost architectural way. His contribution to the florescence of great French sculpture under Louis XIV was strong but subtle, for France already had a tradition in this field. The bust of Condé by Antoine Coysevox (fig. 28) and that of Pierre Mignard by Martin Desjardins (fig. 29) both derive from the bust of Louis XIV. Le Brun's concept for his mother's tomb in the family chapel at Saint-Nicolas-du-Chardonnet (fig. 30) is undeniably new, but this resurrection portraying the very moment of the tomb's opening recalls Bernini's melodramatic sepulchers. Paradoxically, the purest Parisian example of sculpture in the French manner—calm, moderate, and suitably devout—is the tomb of Mazarin (figs. 31–34). The figure praying with its hand on its heart and the attendant virtues belong to the tradition of the tombs of Henry II (chapt. VI, figs. 77–79) and Henry de Condé (chapt. VII, figs. 15–16).

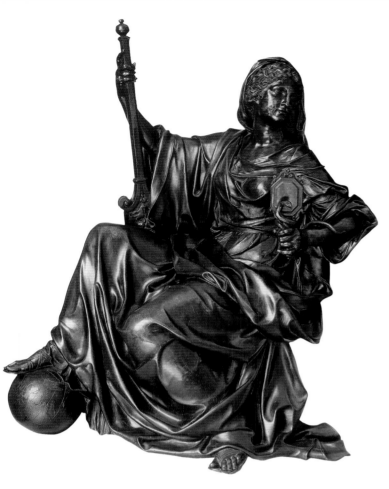

## 31–34. Mazarin's Tomb

*This work was commissioned in 1589 and set up in 1693 in the chapel of the Collège des Quatre-Nations (now the Institut de France), which was established in accordance with the will of the cardinal. Jules Hardouin-Mansart designed the group, possibly inspired by a design by François d'Orbay. The statues of the cardinal, Prudence (on the left of the tomb), Fidelity (on the right of the tomb), and possibly that of Religion (top left, under the vault), are by Antoine Coysevox. The figure of Peace (in the center) and possibly of Charity (top) are by Jean Baptiste Tuby. The details shown on this page are the three bronze statues of Prudence, Peace, and Fidelity.*

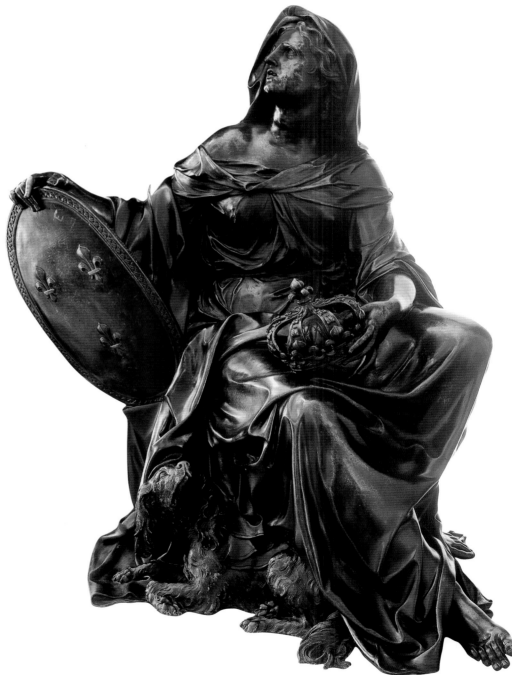

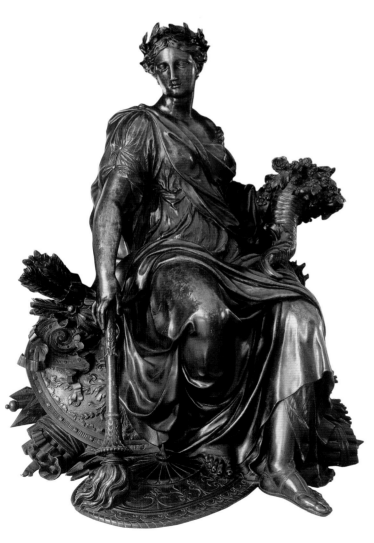

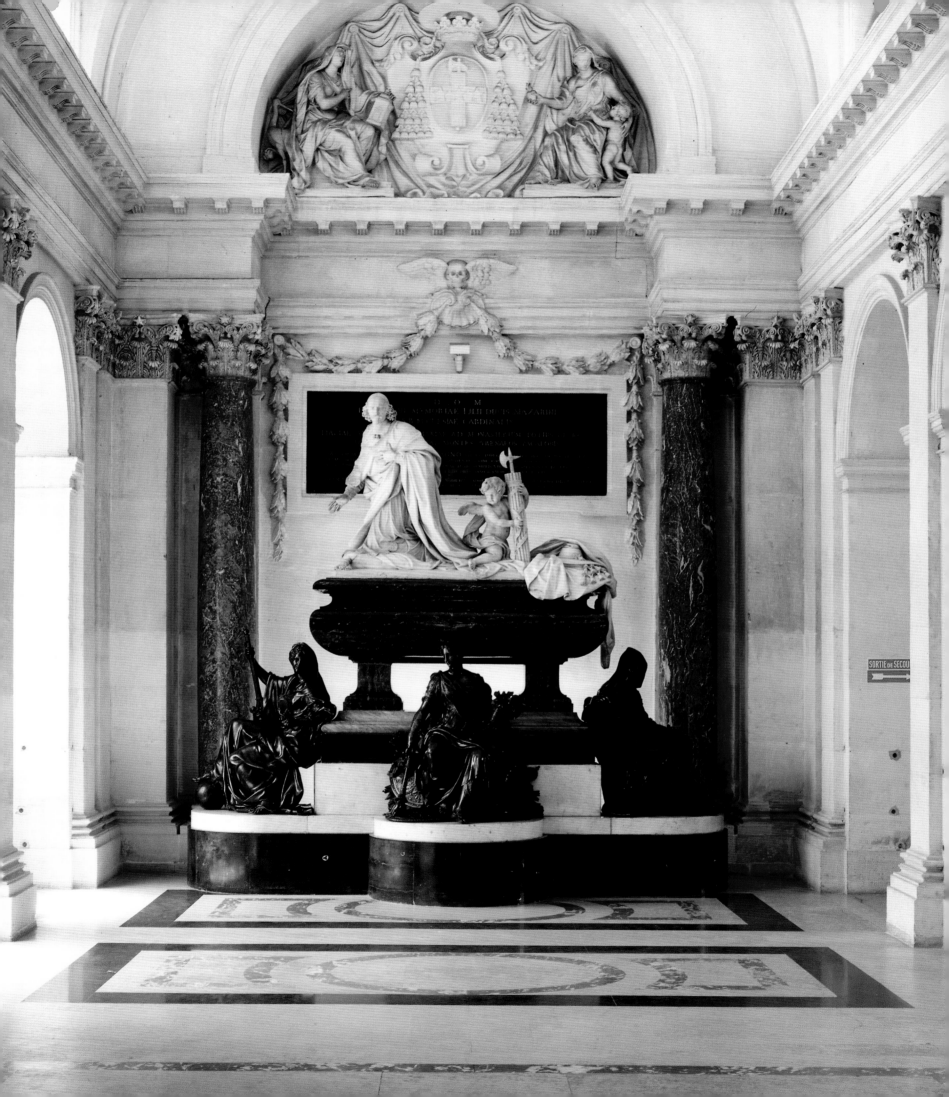

## 35–36. Porte Saint-Martin and Porte Saint-Denis

*The demolition of Charles V's city wall, to be replaced by a tree-planted boulevard, involved the construction of monumental gateways, the first permanent use of the triumphal-arch motif in Paris. From this series, only the Porte Saint-Denis and the Porte Saint-Martin remain, each at the northern exit of Paris, on two similar and parallel routes, the Rue Saint-Denis and the Rue Saint-Martin. The Porte Saint-Denis (opposite page) was made in 1672 by François Blondel, director of the academy, who also composed the Latin inscription celebrating victories in the Dutch war. The sculpture was begun by François Girardon and completed by Michel Anguier. The low reliefs represent the Siege of Maastricht and the Passage of the Rhine; the allegorical figures are Holland in Despair and the Rhine Vanquished. The Porte Saint-Martin was done in 1674 by Pierre Bullet according to his own design or perhaps that of Blondel, Bullet's superior. The Latin inscription celebrates the conquest of Franche-Comté. The sculptures are by Etienne Le Hongre, Pierre Legros, Gaspard Marsy, and Martin Desjardins.*

While Colbert took care of Paris, Louis XIV was only really interested in Versailles. Colbert's famous letter to the king in September 1663 is especially memorable—even after an expenditure of 500,000 *écus* (French currency at the time), the Versailles site was hardly initiated. This letter conveys the status of royal architecture so well that it deserves to be quoted at length. "This house [of Versailles] serves His Majesty's pleasure and entertainment better than his glory... While His Majesty has been spending such huge sums on this house, he has neglected the Louvre, which is unquestionably the most stately palace in the world and the most worthy of Your Majesty's greatness... Your Majesty knows that, failing brilliant acts of war, nothing better distinguishes a prince's greatness and nobility than his buildings, and all posterity measures the character of the stately homes raised during his lifetime. Ah! What a pity that the greatest king... should be measured by the character of Versailles!"

In 1676 Colbert commissioned his two most trusted architects, François Blondel and Pierre Bullet, to make a plan for Paris showing projected improvements. Proving the physical line linking the capital to the kingdom, he replaced Paris's fortified wall with boulevards. General Vauban's work at the frontiers had given France such a solid buffer zone that Colbert could disarm Paris. This was the moment when the word *boulevard* (literally, rampart) lost its military connotations and took on its civil sense. The ring of boulevards (tree-lined walks) was to become the most characteristic feature of French towns in the eighteenth century. On these *boulevards*, Blondel and Bullet set triumphal archways in honor of Louis XIV (figs. 35–36). Meanwhile, in 1667, Le

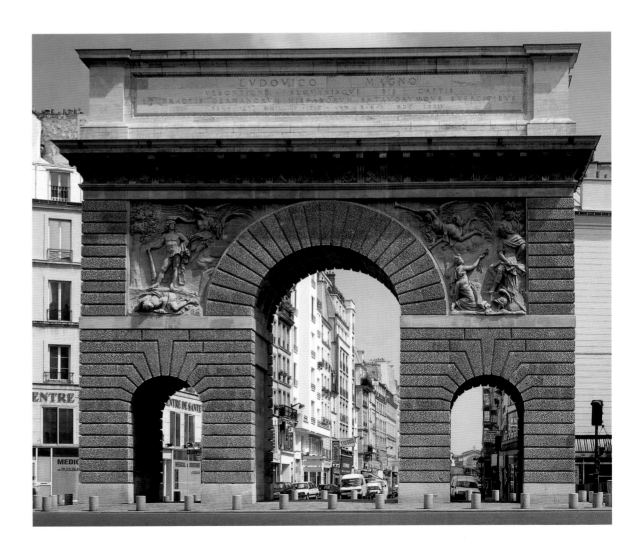

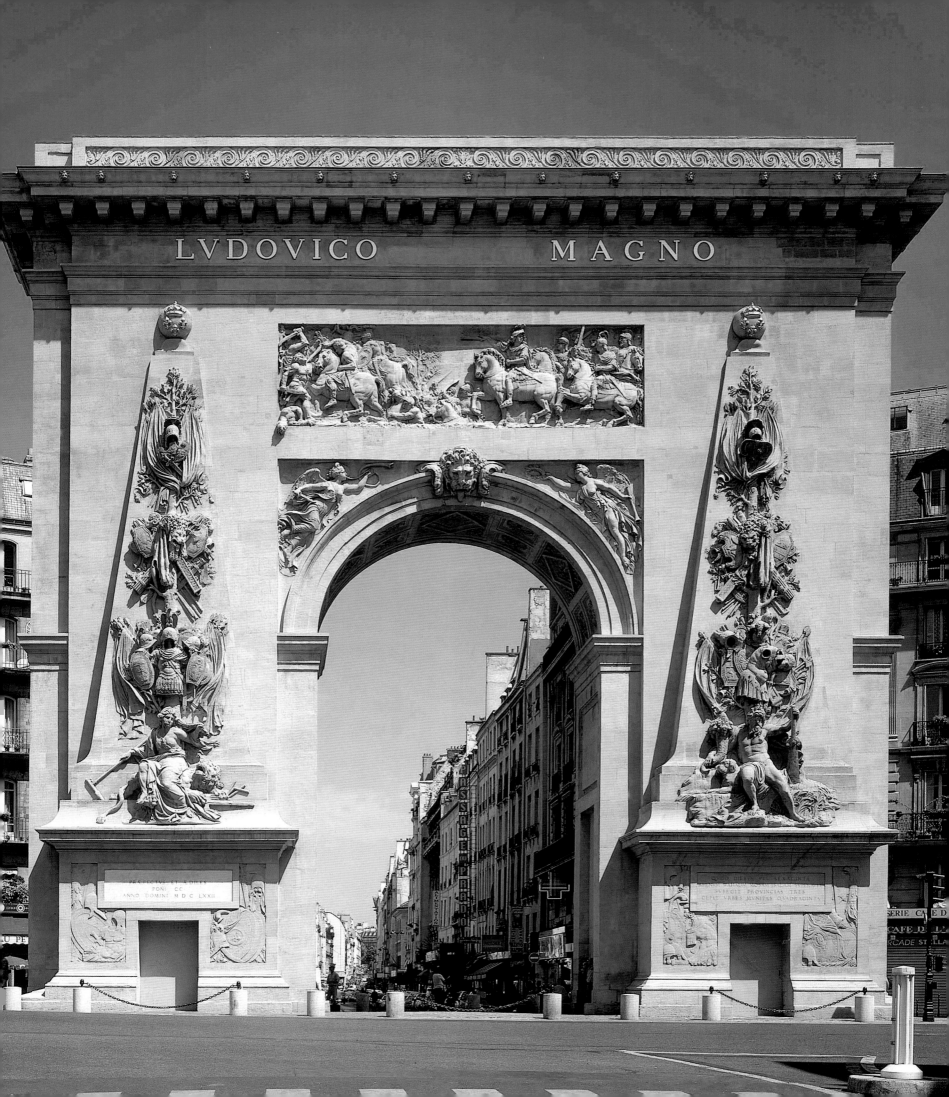

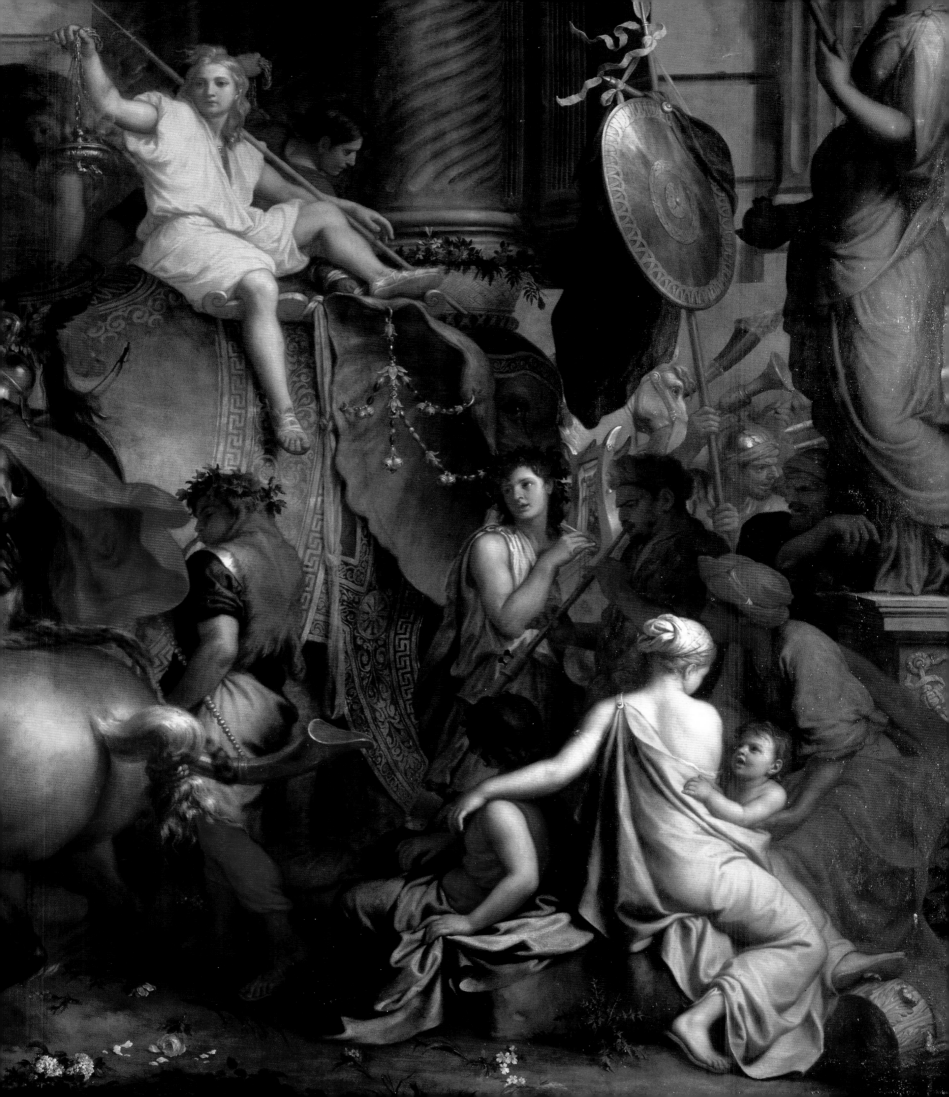

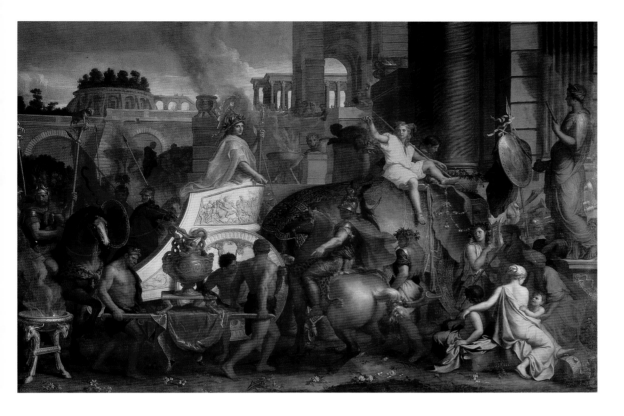

37–38. Charles Le Brun. *Entrée d'Alexandre à Babylone* (*Alexander's Entry into Babylon*). (Musée du Louvre, Paris)

The Entry into Babylon *was part of the* Alexander *series. It consisted of enormous panels (the* Entry *is approximately thirteen feet by twenty-one feet) painted by Le Brun during the 1660s for an unknown destination, though certainly for the king and probably for the Louvre, where they were stored on their completion and displayed in the Gallery of Apollo. The panels were copied in a hanging by the Gobelins and were engraved by Audran.*

Nôtre had redesigned the gardens of the Palais des Tuileries (which was now complete), and set the great avenue of the Champs-Elysées on the axis. This would play a decisive role in the development of Paris as the city was pulled westward by a constellation of royal houses grouped around Versailles.

At Colbert's behest, Le Brun directed the French fine arts project. Thanks to Le Brun, who supplied the cartoons for the painting, as well as those for the sculpture and the applied arts, the royal work was exceptionally unified, but most of this material has gone to Versailles. The decoration of the vault in the Gallery of Apollo in the Louvre, interrupted soon after it was begun in 1663, was not enough to justify mentioning Le Brun in a study of Paris. But the colossal *Histoire d'Alexandre* (*History of Alexander*) series (figs. 37–38), which was stored in the Apollo Gallery, was perhaps always intended for the Louvre. The paintings were used as cartoons for a wall hanging woven by the Gobelins factory.

*The Royal Factories*
In 1662 Colbert bought the premises of the Gobelin family of dyers at the Faubourg Saint-Marcel, with the aim of centralizing the royal tapestry studios currently scattered around Paris. With his appointee Le Brun as director, the new royal factory would make the Gobelin name world famous. The works took the title "Royal Factory of Crown Furnishings" at that time; the factory received its definitive organization in 1667. Under Le Brun's leadership, this concern employed not only painters and carpet makers, but also sculptors, goldsmiths, bronze founders, and cabinetmakers. A panel from the *Histoire du Roi* (*History of the King*) series (fig. 39) shows Louis XIV visiting the Gobelins, and illustrates the diversity of the factory's products, especially the sumptuous silverware intended for Versailles.

The silver goods were designed by Le Brun and executed at the Gobelin factory by Claude Ballin, for whom this Parisian silverwork earned the tribute of a notice in the *Hommes Célèbres* (*Famous Men*), by Charles Perrault, in 1696. Ballin's work included vases, bowls, perfume vessels, andirons, chandeliers, massive silver planters for orange trees, seats, pedestal tables, and silver-plated wooden tables. Cabinetwork inlaid with gilt bronze was part of Mazarin's legacy. It had been brought to France by one of the artists he summoned, Domenico Cucci. The goods he produced for the king at the Gobelins were often modeled

Following two pages:

39. Charles Le Brun. *Visite de Louis XIV aux Gobelins* (*Visit of Louis XIV to the Gobelins*), tapestry. (Mobilier National, Paris)

*This tapestry shows Louis XIV's visit to the Gobelins 1667, and was part of the* History of the King *cycle, a set of hangings about the life of Louis XIV. Charles Le Brun worked on them for ten years, and the weaving began in 1665. This scene takes place in a courtyard of the Gobelins, which did not become a royal factory until November that year.*

*Among the figures around the king are Colbert and Le Brun (hat in hand). All the objects shown were made at the Gobelins, although some of them post-date the 1667 visit. On the walls are hung pieces showing three other sets of hangings woven at the factory. From left to right are a fragment of* The Months*, a panel from the* Alexander *series, and a fragment of the* Maisons Royales*. In the foreground are several pieces of silverware. To the right is one of the two famous ebony cabinets by Cucci.*

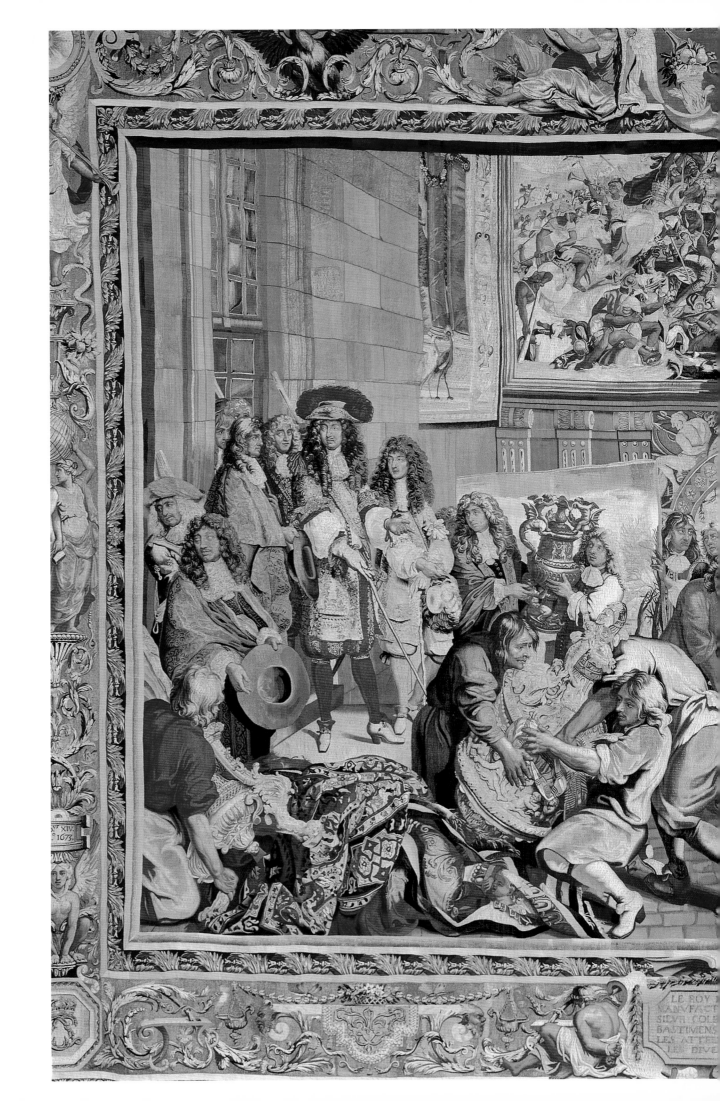

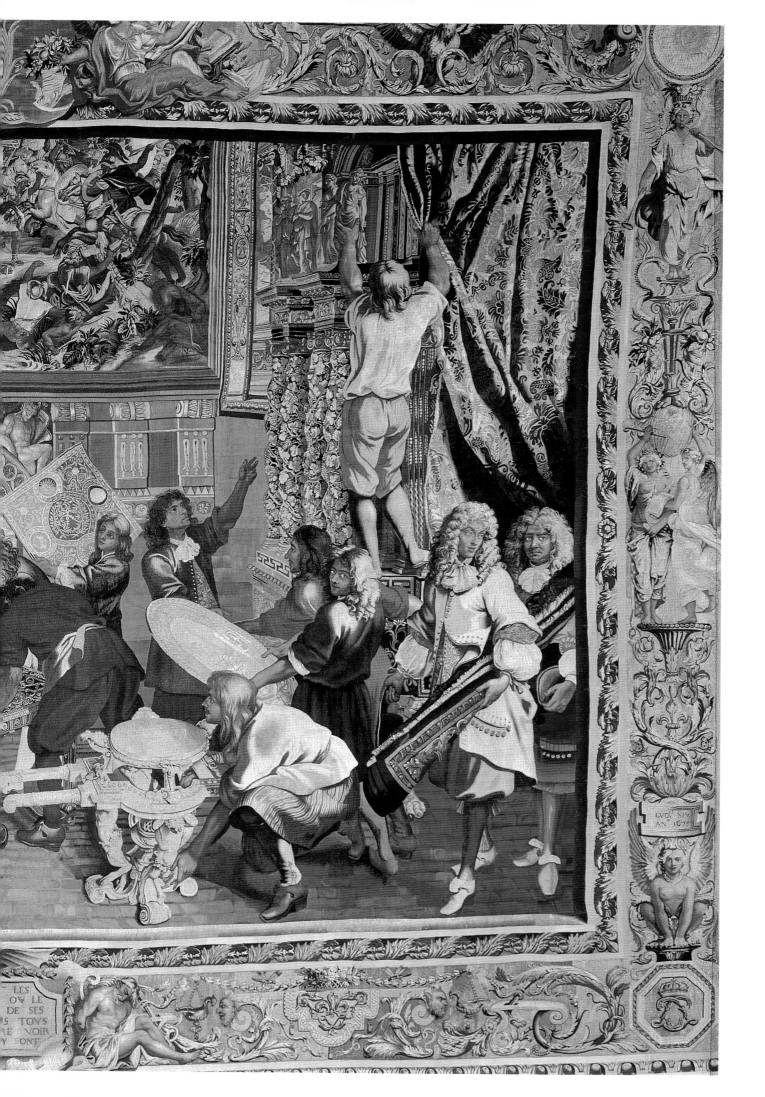

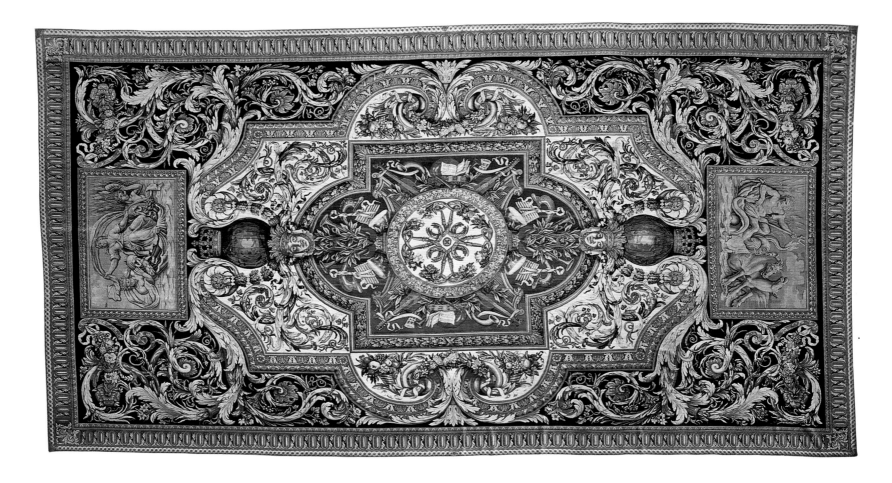

**40. Carpet from La Savonnerie.
(Musée du Louvre, Paris)**

*This carpet with the coat of arms of France was
made for the Gallery of Apollo in the Louvre.*

**41. Carpet from La Savonnerie.
(Musée du Louvre, Paris)**

on designs by the Italian sculptor Jean-Baptiste Tuby, another of Mazarin's beneficiaries placed under Le Brun's authority. Under the same patronage and the same authority, carpentry gained a strong impetus from Philippe Caffieri, who in 1660 had left the pope's service to come to Paris.

Also put under Le Brun's authority was the Turkish and Levant carpet factory called "La Savonnerie." Founded by Henry IV at the Louvre to prevent the import of Oriental hangings, it had been transferred by Louis XIII to an old soap factory at the foot of the hill of Chaillot. In 1665 the factory began to make thirteen carpets for the Gallery of Apollo and ninety-three carpets for the Grande Galerie at the Louvre (figs. 40–42). Finally, that same year, Colbert founded the royal glass factory at Reuilly, Faubourg Saint-Antoine, where craftsmen lured away from Venice made glass in the grand Venetian manner.

Colbert died in 1683 and was replaced by Marquis Louvois, leaving Le Brun in a state of semi-disgrace. Le Brun died two months after silver goods began to be melted down; the most exquisite part of his work was sacrificed to outfit armies for war in a Europe united against Louis XIV. The melting of 1688–1689 produced twenty tons of silver, but as Saint-Simon remarked, the "glorious craftsmanship" was worth more than the material.

*Le Brun's Rivals*
Despite opinions to the contrary, Le Brun's influence on French art was not unchallenged. Perhaps because he was not trained under Le Brun's authority, Jean Bérain's decorative style triumphed over the financial difficulties of the 1690s. Bérain became designer of the king's chamber in 1674. He revived the art of arabesques (decorative motifs consisting of delicate inhabited architectural parts). He designed robes, furnishings, tapestries, silver pieces, and banqueting and theatrical decorations. He also published several collections of engravings that spread the Bérain style between 1680 and 1700. A ceiling in the Parisian Hôtel de Mailly (fig. 43) is a good example of this style dating from 1687.

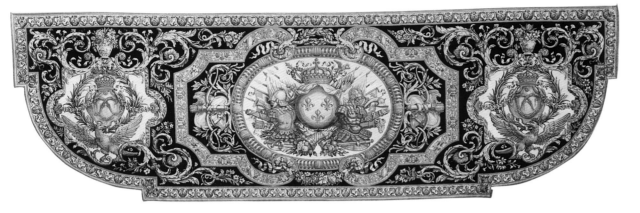

42. Carpet from La Savonnerie.
(Musée du Louvre, Paris)

*This carpet with the coat of arms of France was made for the alcove of the king's bedroom in the Tuileries.*

Le Brun's two main rivals, however, were Errard and Mignard. Neither could be said to have a different artistic sensibility from Le Brun, but the first painter's means of keeping them in the background does much to explain his reputation for having exercised an exclusive influence on French art. He got rid of Errard in a most elegant way. By having him appointed director of the Academy of France founded in Rome in 1666, Le Brun kept Errard out of Paris. He was less successful with regard to Mignard, who, on his return to Paris after more than twenty years in Italy, distinguished himself by painting the cupola of the Val-de-Grace (fig. 21). Here, a jumble of figures in swirling clouds recalled the manner of Correggio's domes in Parma from one hundred years earlier. But Le Brun could hardly characterize as mediocre a work eulogized by Molière! Mignard then added to Le Brun's discomfort by provocatively championing the use of color, in opposition to the Academy (then under Le Brun's directorship), and getting himself elected head of the Academy of Saint Luke in Rome. Mignard finally triumphed over Le Brun (who was by then dying) after Colbert's death and the rise of Louvois. Thus intrigue can sometimes create the illusion of genius.

But the color debate, that is, the relative importance of color versus drawing technique (which set Rubenistes against Poussinistes at the Academy), was more important than these personal rivalries. In his *Dialogue sur le coloris* (*Dialogue on Color*) of 1673, Roger de Piles had

43. Jean Bérain. Ceiling in the Hôtel de Mailly, 1687.

*In 1687 Jean Bérain decorated four rooms in the hôtel belonging to Louis-Charles de Mailly, Marquis of Nesle, which was on the Quai Voltaire. The decor is known from bills addressed to Nicodemus Tessin. The ceiling of the bedchamber (also called the "golden room") is still in place.*

### 44–45. Place des Victoires

*Following the Peace of Nijmegen (1678), the high point of Louis XIV's reign, the count of La Feuillade commissioned a stone statue of the king (to whom he gave it) from Martin Desjardins. In 1685 he commissioned Jules Hardouin-Mansart to design a square in which to set up a bronze replica of Desjardins's statue. The square was inaugurated in 1686. It was modified in the nineteenth century. The statue of the king in religious garb was destroyed in the Revolution and was replaced in the nineteenth century.*

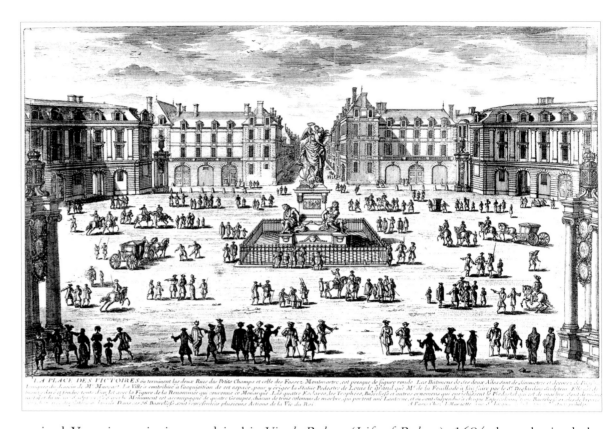

LA PLACE DES VICTOIRES où terminent les deux Rues des Petits Champs et celle des Fossez Montmartre, est presque de figure ronde. Les Batimens de ses deux Ailes sont de simmetrie et decorez de Pilastres...

Opposite, top:

### 46. Place Vendôme

*The first idea for the square goes back to 1677 and came from a group of speculators. In 1685 it was revived by Louvois, who bought the Hôtel de Vendôme (his name is still there) on behalf of the king. On this site, Jules Hardouin-Mansart began the first project. The square was to be largely open to the south on the Rue Saint-Honoré, and surrounded by public buildings. In 1699 the king resold the property to the city. The completed facades were then destroyed and rebuilt some sixty feet in front of the original ones. This both reduced the overheads of the square and increased the amount of saleable land behind the facades. The square was later closed off, and crossed only by a north-south road. This final plan was also by Jules Hardouin-Mansart.*

praised Venetian painting, and in his *Vie de Rubens* (*Life of Rubens*), 1684, he eulogized the painter from Antwerp. Interestingly, since the Luxembourg episode, Rubens had been considered a secondary master in Paris. By affirming the preeminence of color over drawing, Piles set off an unusually vehement war of words. If Le Brun championed the Poussinistes, champions of drawing, was this because he controlled the artistic production of his time through cartoons to be executed by painters, sculptors, weavers, and goldsmiths? The Rubeniste group may have been impelled by a justifiable urge for independence. After all, the previous generation, nourished by admiration for Poussin (elected founder of the Ecole Française), had been angry that young artists took their lessons in the Medici Gallery at the Luxembourg. But it would be wrong to suspect a rebellion of youthful students eager to shake off interference. The modern belief in Le Brun's dictatorship is a mere illusion reflecting the absolutism of the monarch. Master cartoons had been used to maintain the unity of great artistic ensembles as far back as Primaticcio.

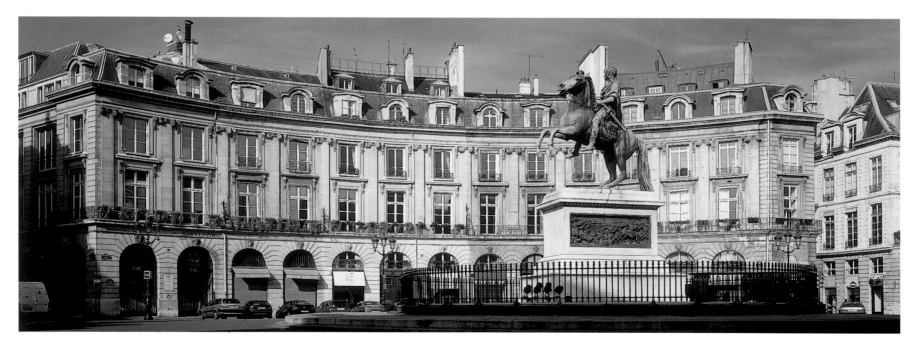

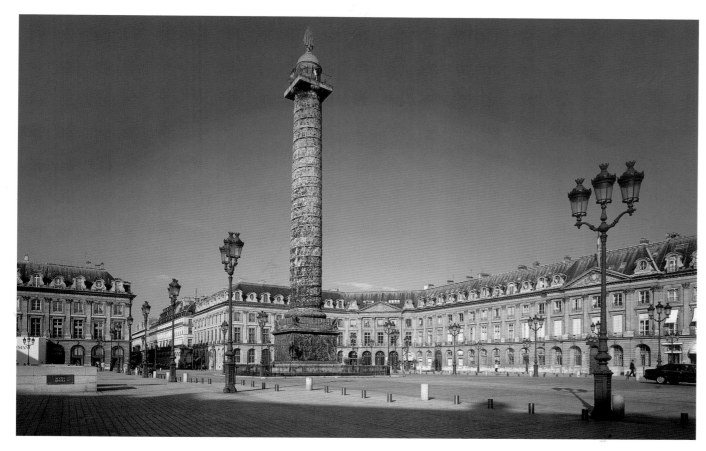

## Place des Victoires and Place Vendôme

Jules Hardouin, called Hardouin-Mansart, did not work for the king before 1674, it seems. In 1678 he de facto directed the Versailles works. His work benefited from ten years of peace between the Treaty of Nijmegen (1678) and the War of the League of Augsburg (1689). In 1686 he was appointed First Architect to the king, and in 1699 he became superintendent of buildings (the function previously held by Colbert), which gave him the rank of minister. His Place des Victoires (figs. 44–45) was commissioned by General de La Feuillade to commemorate the Peace of Nijmegen, and may in fact be the first royal square originally intended to feature a statue of the king. While the statue of Henry IV at the Place Dauphine and that of Louis XIII in the Place Royale were probably afterthoughts, the Place des Victoires was designed in 1685 to receive the statue La Feuillade had already had made in 1678. The history of the Place Vendôme (figs. 46–47), also called the Place des Conquêtes and Place Louis-le-Grand, is more complex, but articulated by the same dates of 1677, 1685, and 1699.

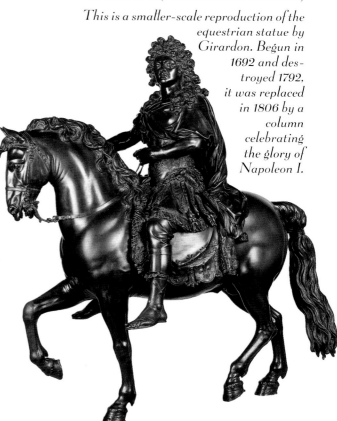

**47. Place Vendôme, Equestrian Statue of Louis XIV. (Musée du Louvre, Paris)**

*This is a smaller-scale reproduction of the equestrian statue by Girardon. Begun in 1692 and destroyed 1792, it was replaced in 1806 by a column celebrating the glory of Napoleon I.*

Mansart designed the Place des Victoires as a perfect circle, which had not been done before (Saint Peter's Square in Rome being an ellipse plus a trapezoid). The original statue was destroyed during the Revolution, but its height defined the proportions of the space. The radius was three times the statue's height, and the facades were designed at a ratio of 2:5. The partitioning of the facades, which are almost identical in both the Place des Victoires and the Place Vendôme, is not original; it had already appeared twenty years previously on a few Parisian *hôtels*. Indeed, if one considers only the essential elements (a podium level below a double story bound by colossal pilasters), one can even find its antecedents in Italian architecture, such as Bernini's second plan for the Louvre (fig. 16). But Mansart's Parisian facades are immediately recognizable in the many imitations that have been made since. The distinguishing features are thus in the proportions and the details. The first level has continuous rustication, and openings in the manner of Lescot (chapt. VI, fig. 46) contain the windows of both ground floor and basement under semicircular arches. The proportion of the first and second stories should also be noted, along with the alignment of solids and voids, and the crowning with a (double-sloped) Mansard roof.

## 48–54. Hôtel des Invalides

*In 1674 Louis XIV founded the Royal Hôtel des Invalides, a hospice intended for wounded or aging and impoverished officers and soldiers. The surviving plan by Libéral Bruant comprised only a single central courtyard flanked by two smaller ones. Most of this plan was built from 1671 to 1674, and the first boarders were installed in 1675. With the exception of the church, the hôtel was completed in 1678. The hôtel proper consists of refectories and infirmaries at ground level around the central courtyard and elsewhere. The soldiers' lodgings are set around the little courtyards.*

*The church is the work of Jules Hardouin-Mansart, who came on site in 1676. The two parts were intended to complement each other and are locally known as "the Soldiers' Church" and "the Dome." At their junction, a high altar is visible from both parts. The Soldiers' Church has a long plan and is like a convent choir reserved for the monks and nuns—this is the hôtel boarders' church, built in 1676–1677. The second was founded in 1677, but the major work was not complete until 1691 because of financial difficulties, and the decoration was finished later still, in 1706. This church, with its central plan and cupola topped with a domed lantern tower, has no obvious function. It has been suggested that Louis XIV planned to make it the Bourbon mausoleum. In front of the dome, Jules Hardouin-Mansart had planned a square contained by two curved wings that were never built. The hôtel's decoration involved the greatest artists, including sculptors (Antoine Coysevox and Guillaume Coustou, among others) and painters (Charles de La Fosse, Jean Jouvenet, and others).*

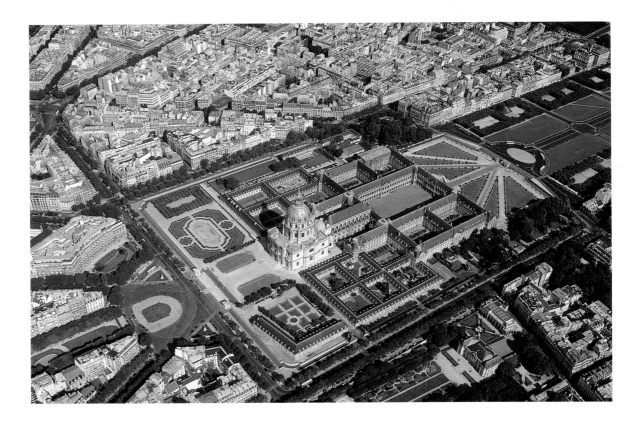

### Les Invalides

Jules Hardouin-Mansart reserved his masterpiece—perhaps the masterpiece of all classical French architecture—for Paris: the Hôtel des Invalides (figs. 48–54). The *hôtel* itself was begun by Libéral Bruant and recalls such great models of hospital and convent architecture as Milan's Ospedale Maggiore and Madrid's Escorial. But Mansart was responsible for the church, which consists of two parts, or, rather, two churches: the long-plan soldiers' church, which was reserved for boarders of the *hôtel*, and the centrally planned "dome," which may have been conceived as a mausoleum for the Bourbons (later established at Saint-Denis in Paris). Indeed, Jules Hardouin (nephew and legatee of François Mansart's name and papers) quite simply reproduced the mausoleum plan his uncle had designed for Saint-Denis (figs. 22–25). All its unusual features appear again here, notably the nested cupolas, an open one above a painted one, which thus receives indirect daylight. Aspects of François's oeuvre, notably at the Val-de-Grace (fig. 21) and at the Minimes (chapt. VII, fig. 70), are legion. The effects of indirect lighting were researched by both François Mansart and Bernini, but the designs for the square to complete the dome of the Invalides, and for the baldachin over the high altar between the two churches, are obvious citations of Saint Peter's in Rome.

This pragmatic use of his uncle's plan offends current notions of creativity as the product of individual genius. But in the seventeenth century architectural design was still a collaborative, even dynastic, enterprise. Thus it is meaningless to accuse Hardouin-Mansart (or Le Vau) of merely signing designs worked out by collaborators. Jules descended from the Hardouins, the Mansarts, the Pilons, and the Gaultiers—all painters, architects, and sculptors to the king. Originally from Beauvais, the Hardouins were part of that influx of artist-craftsmen families who established themselves in Paris at the beginning of the seventeenth century. Jules's brother, Michel, and his two grandsons, Mansart de Jouy and Mansart de Lévy, were architects. His principal collaborator and his successor as architect to the king was his brother-in-law Robert de Cotte, himself the son and grandson of an architect.

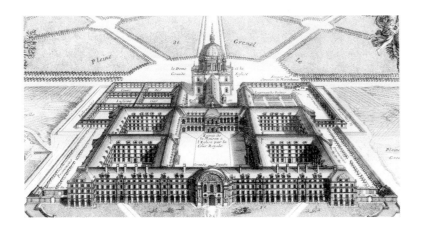

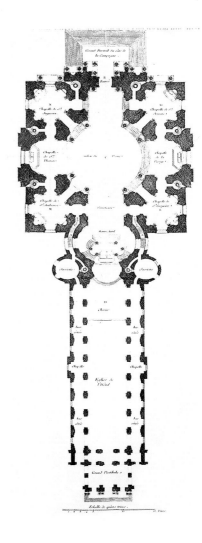

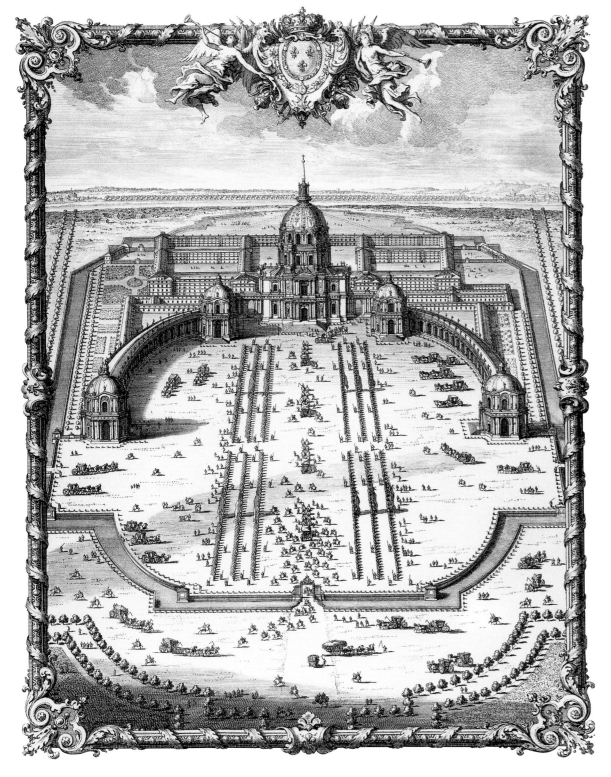

This is a vast stone building. The old soldier is shut between thick walls. The vaults where the sun never penetrates, even in summer, seem to make this great place very cold, very somber, and very depressing for the aged ... The kitchen is remarkable for its huge ovens, its many spits, and its quick and impartial service. There is something so curiously brisk in the way the wine is served in lead tankards that the eye is amazed ... Louvois had intended the great cellars placed under the church for the burial of our kings and assumed he would transfer to them the tombs of Saint-Denis.

Louis-Sébastien Mercier, Tableau de Paris (Map of Paris), *vol. VI, 1783.*

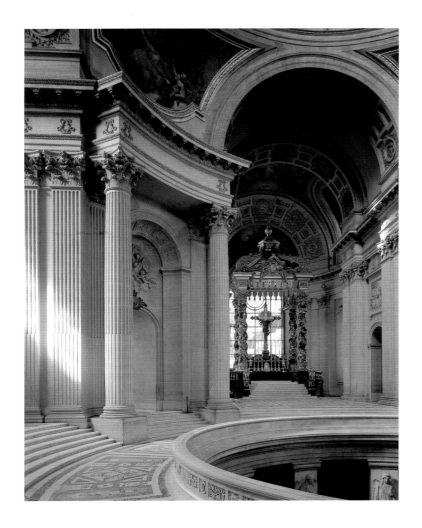

In a society in which authority was hereditary, the age and continuity of a dynasty was the basis of its legitimacy. The eighteenth century would demonstrate the Mansarts' right to occupy the first rank among architects. In his *Histoire littéraire du règne de Louis XIV* (*Literary History of the Reign of Louis XIV*), 1751, Abbot Lambert wrote "this family, originally from Rome but established in France for almost 800 years, fulfilled successively and almost without interruption the functions of architect, painter, and sculptor to our kings." It is even possible that a Mansart, legitimized by this fictitious Roman origin, but already a naturalized Frenchman, was at the service of Hugh Capet (since the Capetians themselves claimed descent from Charlemagne and even from the Trojans). And Jacques-François Blondel was genealogically qualified to make his *Cours d'Architecture* (*Architectural Classes*), 1771–1777, "the occasion for summarizing most of the rules practiced by the Mansarts in their buildings."

## 5 – French Classicism

French classicism is not so much a style as an approach, a national and royal ideology, a range of approved monuments, and a promotion of French artists. In a translation commissioned by Colbert, Claude Perrault rightly commented that the names of French architects "are known to no one, whereas the least Italian architect is consecrated forever by the most excellent writers of their time," *Dix livres d'architecture de Vitruve* (*The Ten Books on Architecture by Vitruvius*) 1673. Paid as a chronicler to fill this gap, André Félibien published his *Recueil historique de la vie et des ouvrages des plus célèbres architects* (*Historical Compendium of the Lives and Works of the Greatest Architects*), 1687; and Perrault produced his *Hommes illustres qui ont paru en France pendant le XVII^e siècle* (*Famous Men in Seventeenth-Century France*), 1697–1701, most of which concerned French architects, especially the Mansarts.

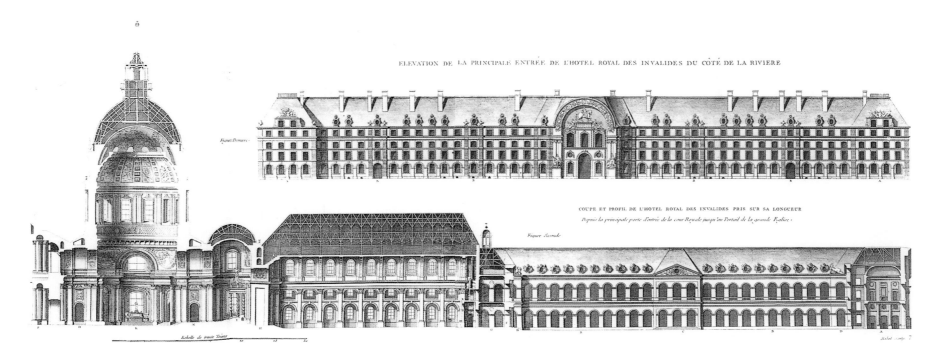

ELEVATION DE LA PRINCIPALE ENTREE DE L'HOTEL ROYAL DES INVALIDES DU CÔTÉ DE LA RIVIERE

COUPE ET PROFIL DE L'HOTEL ROYAL DES INVALIDES PRIS SUR SA LONGUEUR
Depuis la principale porte d'entrée de la cour Royale jusqu'au Portail de la grande Eglise.

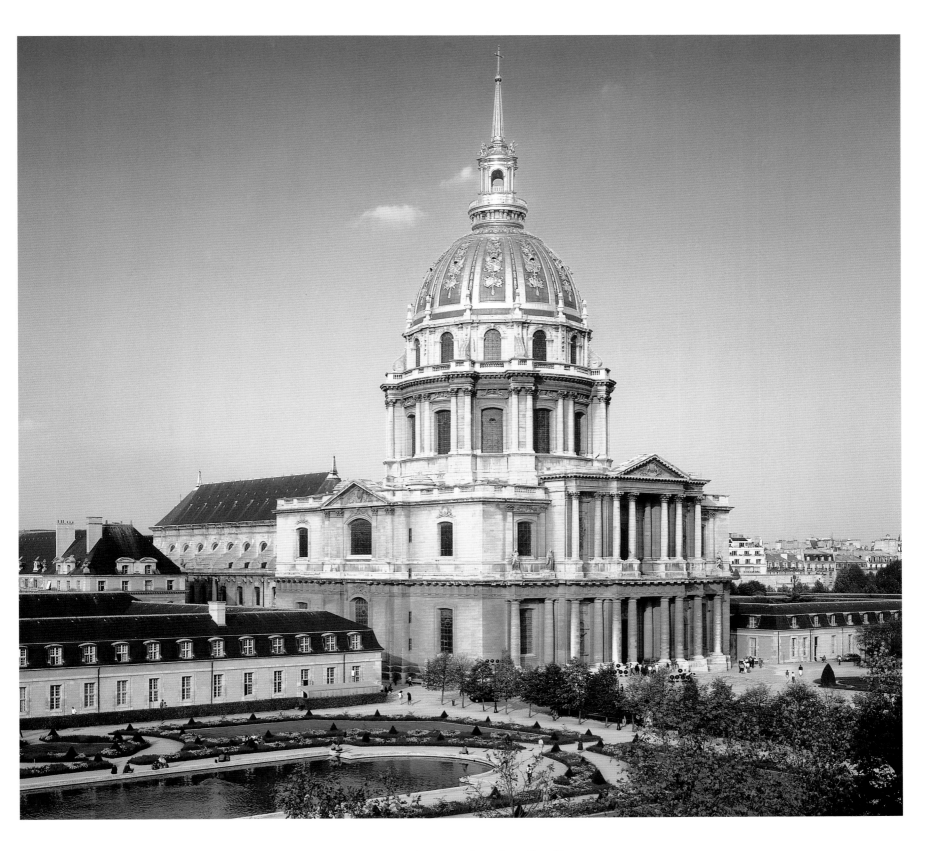

In 1671 Colbert set up a competition to create an architectural order for France. Apparently, he hoped to canonize the French prototype by grafting it into the antique system (originally consisting of five orders: the Tuscan, Doric, Ionic, Corinthian, and composite). His competition must have garnered over a thousand designs from France and even Italy. The undisputed winner was Claude Perrault, at least according to his ever-loyal brother Charles. Perrault's French order is depicted with his Louvre colonnade on the frontispiece to his (French) translation of Vitruvius (fig. 57), a remarkable work that would become authoritative throughout Europe with regard to the ticklish business of interpreting this Latin author.

**55–56. S. Leclerc. *The Louvre Colonnade*, engraving, 1677.**

*The idea of making the eastern facade of the Louvre into a colonnade on a podium appears in several designs developed after the competition for completing the palace was opened in 1661. Notably, it is found in a form close to its final one in a plan designed in the circle of Le Vau, probably by François d'Orbay, and submitted to the "Little Council" set up by Colbert in 1667. But its final resolution in 1668 was thanks solely to Claude Perrault. S. Leclerc's engraving of 1677 (bottom) shows Perrault's plan without the attics that were to have crowned the end pavilions. At the beginning of the nineteenth century, the niches planned for the basis of the loggia were replaced with windows, and the portal of the central pavilion was modified. The ditches, which had been built but filled in, were reopened in 1964 (opposite, top).*

The ancient book's tribute to the allegorical figure of France should be seen in the context of the famous quarrel between the ancients and moderns that was coming to a boil among great minds, and in which the two Perrault brothers were on the front line of the moderns. Charles Perrault struck the first blow by reading his poem *Le Siècle de Louis le Grand* (*Louis the Great's Century*) to the French Academy in 1687 and publishing his *Parallèles des Anciens et des Modernes* (*Parallels between the Ancients and Moderns*) the following year. The goal was to authenticate France's primacy in time and space by demonstrating the superiority of its modern artists and authors over the ancients. In the Louvre's Cour Carrée, the French order crowned the ancient orders, thus making literal that famous metaphor of the moderns seeing further from their perch on the shoulders of the ancients.

The very construction of the colonnade took on symbolic overtones, suggesting the victory of France over Italy, as Rocroi had been a victory over Spain: Lescot's strength against Serlio was renewed in Perrault's replacement of Bernini (figs. 55–56). Thus the colonnade became, in Lafont de Saint-Yenne's expression, "the portrait of the nation's character," and in his *L'Ombre du grand Colbert* (*The Shadow of the Great Colbert*), 1749, he deplored the failure to complete Colbert's work.

Colbert knew that the French system would ultimately be defined by the Academies. In 1663, The Académie Royale Des Inscriptions (or the Petite Académie) had been set up to systematize decoration and to draft inscriptions for royal buildings. In 1671 the Académie Royale d'Architecture was mandated to define the principles for the art of building. But as

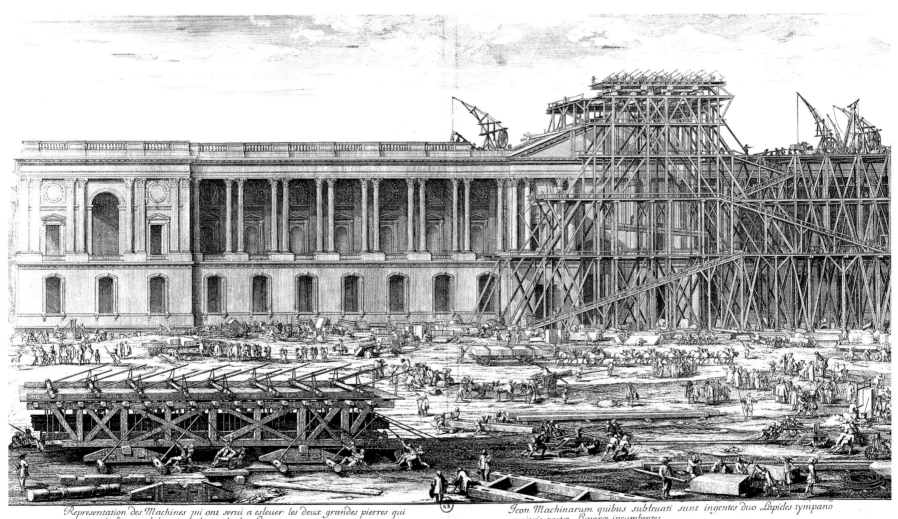

*Representation des Machines qui ont servi a eslever les deux grandes pierres qui couvrent le fronton de la principale entrée du Louvre.*

S. le Clerc Sc. 1677.

*Icon Machinarum quibus subleuati sunt ingentes duo Lapides tympano majoris portæ Luparæ incumbentes.*

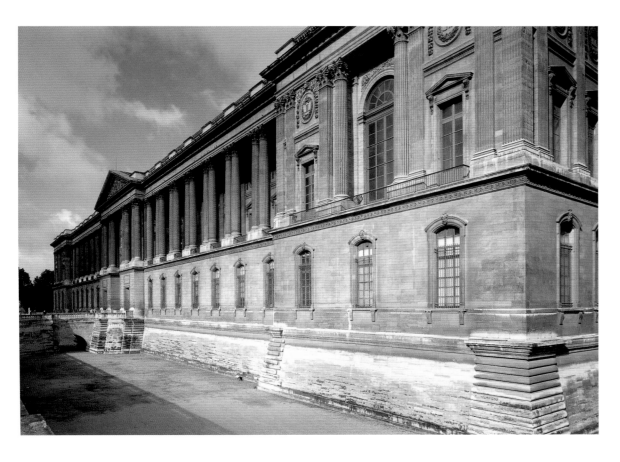

far as that went, the Academy of Architecture was content to hold forth learnedly on the theory of orders and proportion as it had been formulated in treatises, notably Italian treatises. By inscribing the Saint-Denis Gate (fig. 36) in a square and dividing its base into three equal parts, François Blondel, who was the director of the Academy, had done no more than reproduce the scheme of *Divines Proportions* presented by De l'Orme in his treatise— the ideal here being complete simplicity and proportion. But Blondel was also a teacher at the Academy, and he wanted to produce an object lesson. Thus also Desgodets, his successor as teacher, "seeking to establish a general rule, conformed as far as he could to what had been done in the most noteworthy and admired Parisian buildings," from *Procès-verbaux de l'Académie* (*Verbal Proceedings of the Academy*), 1709. The point of academic example was not to control creativity by imposing irksome prescriptions, but to promote the grand French manner by identifying signs of excellence.

For an artist, election by one of the royal academies (whether that of painting and sculpture directed by Le Brun, or that of architecture directed by Mansart) was to be canonized. According to the rules, presence at the academic meetings was an obligation, which one could escape only briefly and by special permission. The consequence was obvious: the canonization of talents fixed the professional artistic elite in Paris. The provinces were ignored because Colbert had organized letters to encourage the creation of provincial artistic academies; but their effects would not be felt before the 1740s.

Colbert's system would have been perfect if the minister had not had the odd idea of creating one further academy, the Academy of France, to cater to young artists in Rome on stipends from the king. This would allow the French to mine the resources of the Eternal City, but it involved a risk that its boarders might come to think the eternity of Rome better than that of Paris.

57. S. Leclerc. Frontispiece to *Dix Livres d'Architecture de Vitruve* (*Vitruvius's Ten Books of Architecture*) translated by Claude Perrault, engraving, 1673.

*In the foreground, France receives the tribute of the book. To the left is the capital of the French order invented by Perrault. Above is the triumphal arch in the Place du Trône, which was set up according to one of Perrault's designs for the solemn entrance of Louis XIV in 1660. In the background are the colonnade of the Louvre and the observatory, two more of Perrault's works.*

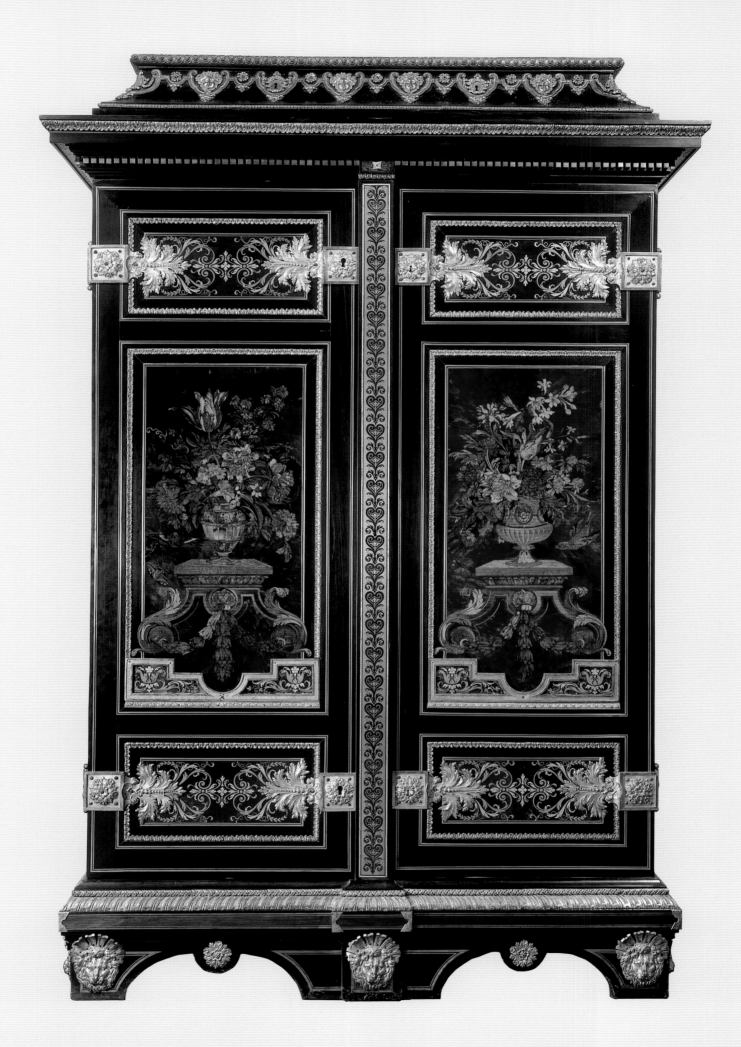

# Chapter IX
# THE LATE LOUIS XIV STYLE AND THE ROCOCO
## (1690–1760)

By the end of the seventeenth century, French high society had centered itself in Paris. This is indicated by the choices of the less subjugated courtiers, foremost among them the duke of Orléans, future regent, who took the risk of displeasing the king by preferring to stay in Paris as opposed to Versailles. Thus it was in Paris that the literary and philosophical gatherings, *"bureaux d'esprits,"* convened, and it was there that the codes of behavior began to ease (as they related to etiquette and morals), transforming actresses' homes, boudoirs, and alcoves into schools of gallantry or romantic intrigue. Lord Chesterfield wrote these lines to his son, who had come to Paris to "sow his wild oats": "These intimate suppers and balls are now your schools and universities." However, the art business experienced a different situation. It is true that the rest of Europe came to Paris to purchase the latest fashions, fabrics, and fashionable haberdasher's notions. Yet the rococo style that could have been the fashion of these schools did not enjoy full freedom in Paris. Indeed, many supposedly enlightened minds who were indifferent to the changing etiquette, behavior, and customs, deplored the general abandoning of the grandness of the Louis XIV style. The philosopher Voltaire was one of these nostalgic people who regretted "the celebrated era in the history of the human spirit in which the great Corneille made the Great Condé shed tears of admiration."

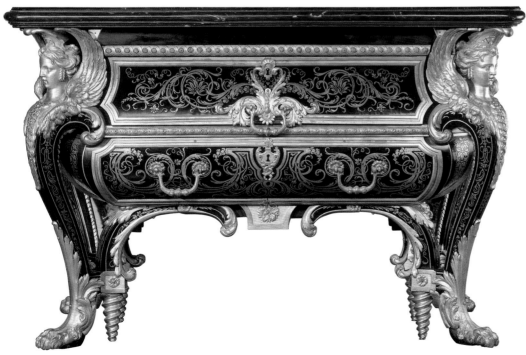

2. André-Charles Boulle. Commode for Trianon, 1709. (Musée National du Château de Versailles)

*Vestiges of the furniture of Louis XIV include this commode (chest of drawers on legs) and its pair among the rare pieces that can be identified with certainty as having been made by André-Charles Boulle. With an ebony veneer, it is typical of the style of this well-known cabinetmaker, whose pieces have been widely copied. One is inlaid with copper in a tortoiseshell background, while the other is tortoiseshell inlaid in a copper background. These pieces of furniture are more trunks with legs and were the first style of chests of drawers that would become highly successful and widespread during the eighteenth century.*

### 3-6. Notre-Dame Choir

Louis XIII dedicated the kingdom to the Virgin, and his wish included the commitment to provide a new high altar for the cathedral. However, in his lifetime, the only work achieved was the painting by Philippe de Champaigne (chapt. VII, fig. 22). In 1698 Jules Hardouin-Mansart presented the king with a plan for a high altar with canopy. The plan was approved, but the new decoration of the high altar was only begun in 1708, thanks to a donation from a canon, matched by a donation from Louis XIV, and it was finally finished in 1726. The whole ensemble included: an altar attributed to F. A. Vassé (which has been moved); a Pietà by Nicolas Coustou, housed in a niche, which makes reference to Champaigne's work and which was placed in the church in 1714; above the niche is a sunburst relief; on either side of the altar are two statues of kings on their knees, Louis XIII by Guillaume I Coustou and Louis XIV by Coysevox; bronze statues of angels on the pillars by various sculptors; metal screens between the pillars; and relief sculptures of the Virtues above the arches.

The stalls on the right side were designed by Hardouin-Mansart and Robert de Cotte and sculpted by the king's sculptor-decorators working under Jules Degoullons, with help from Vassé. The Life of the Virgin is depicted on the stalls.

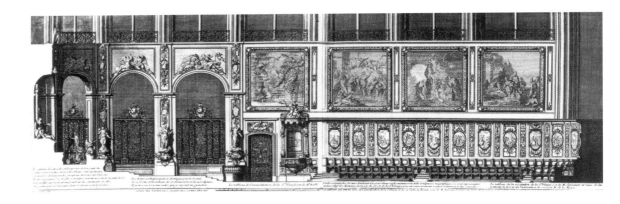

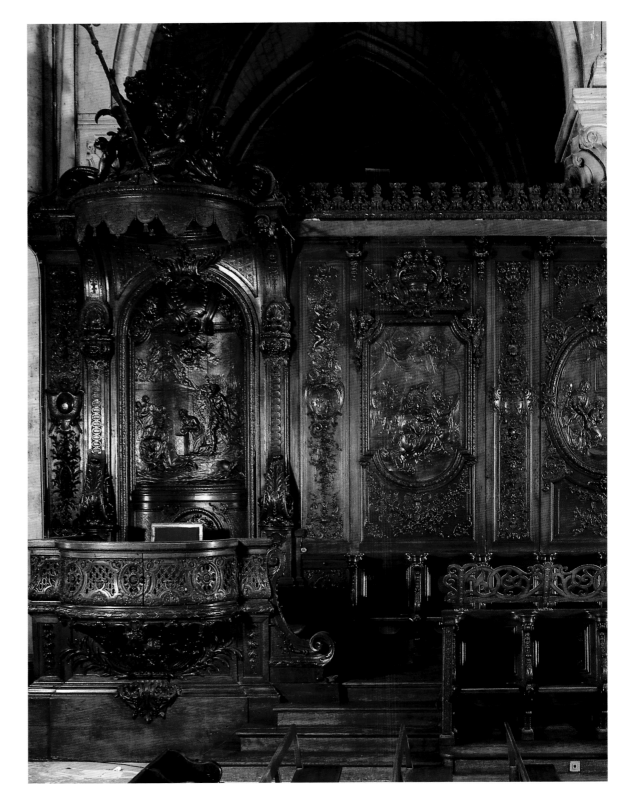

The trouble that developed toward the end of the reign of Louis XIV, which made silver furniture an impossibility, imposed transformations that first affected Trianon and Marly, the satellites to Versailles. The style of decor became more economical, though not necessarily simpler. New and refined uses were made of cheaper materials. For example, wood was used to panel interior walls, plaster was used on the ceilings to decorate arches, and mirrors were also used since they could now be manufactured in large panels. The first royal fireplaces, thought to have been invented by Robert de Cotte and Pierre Lepautre, François Mansart's main assistants, appeared in Trianon and Marly. These consisted of a fireplace with a mirror placed above the mantel, so commonplace today that their royal origin has been completely forgotten. The new style came to be called French Regency, and was already in vogue before the death of Louis XIV. It remained popular throughout the youth of Louis XV, and even into the 1730s. The subsequent blossoming of the Louis XV style took place during the period from 1730 to 1750, and was dubbed the *rocaille* style, a term borrowed from the *rocaille* artists who decorated rock grottos and fountains with stones and seashells of various colors. (The term "rococo" was a derisive mutation of the word *rocaille*.) Starting in 1750, there was a half-humorous, half-serious stylistic reaction that came to be called Greek Revival, which was approved of by the Marquise of Pompadour, who though no longer the royal mistress, still governed the king's official taste in style.

The interior decoration of the century was the result of a collection of architects, sculptors, decorators, painter-sculptors, and ornamental sculptors working together. The First Architects to the king, from Robert de Cotte to Ange-Jacques Gabriel, constantly provided drawings for the decoration of the palace rooms. Germain Boffrand and Gilles Marie Oppenord, architects and interior decorators, both worked for the king's Buildings Office. Pierre Lepautre and François Antoine Vassé were two sculptors who contributed to the grand decor, though they were not absolutely specialized in specifically ornamental work or figure carving. Vassé participated in sculpting the ornamentation on the stalls in Notre-Dame Cathedral, and he also designed the high altar with its two angels (figs. 3–6). The Degoullons and Jacques Verberckt were ornamental sculptors, as was Nicolas Pineau, who were among the inventors of the rococo style.

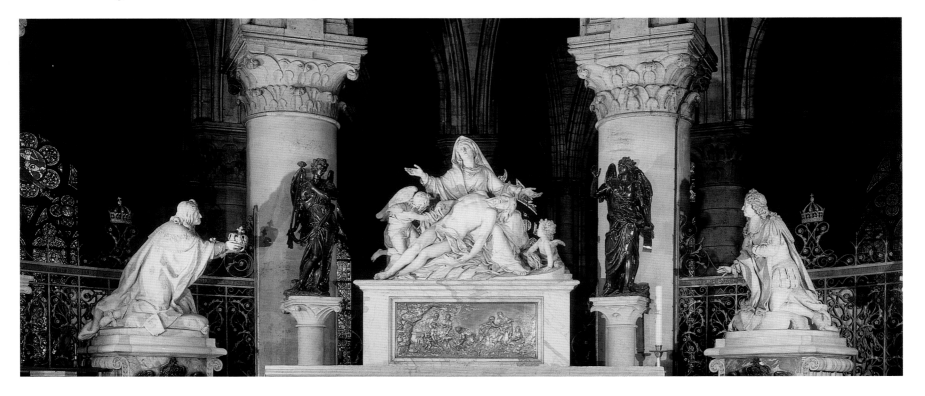

## 7. Gallery of Aeneas in the Palais Royal (now destroyed)

*The far ends of the gallery, as printed in J.-F. Blondel's work* Cours d'Architecture *(1777), were designed as early as 1716 by Gilles Marie Oppenord, architect to the duke of Orléans, who had just been appointed regent.*

## 8. Antoine Coypel. *L'Assemblée des dieux* (*Assembly of the Gods*), sketch for the vaulted ceiling of the Gallery of Aeneas in the Palais Royal. (Musée des Beaux-Arts, Angers)

*Between 1702 and 1718 Antoine Coypel, who was the royal painter to Philippe, duke of Orléans and future regent, decorated the gallery of the duke's apartments in the Palais Royal with the Story of Aeneas. Unfortunately, only a few sketches, paintings, and engravings remain. The sketch for the gallery's ceiling portrays Venus asking Jupiter to protect Aeneas.*

### Interior Decoration

Paris had so much interior decoration in the eighteenth-century style that despite the fickle nature of fashion, which inspired destruction as well as pillaging, numerous and prestigious examples can still be seen today. The most deplorable destruction is without a doubt that of the Gallery of Aeneas in the Palais Royal (figs. 7–8), a masterpiece by Antoine Coypel and Oppenord, who were respectively painter and architect to Duke Philippe of Orléans. This decor

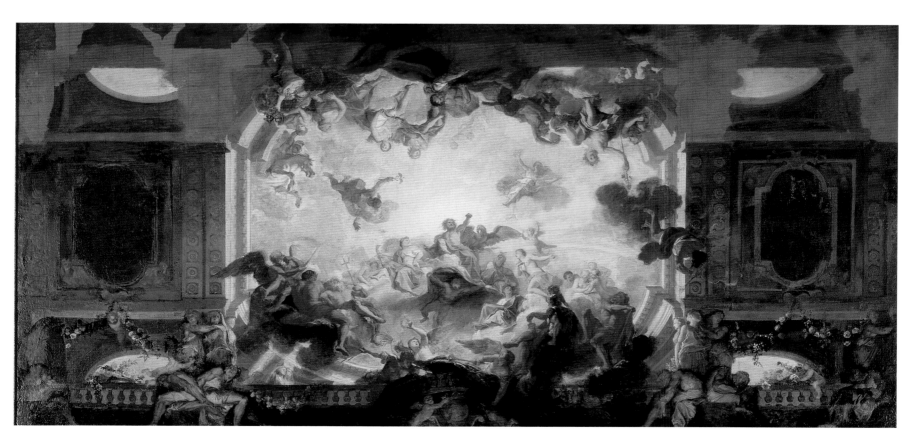

was the most remarkable example of the French Regency style, painted in the last years of the reign of Louis XIV in the Palais Royal, which was the former Palais Cardinal. The Palais Royal, which the king had left to the younger branch of the Orléans family, would become the headquarters and nerve center of power and society during the short reign of Louis XV. Philippe d'Orléans was the single best representative of the French Regency style: he was debauched and cynical, and was also a philosopher, chemist, and an artist. He fled Versailles quite early because his habits and ideas were disapproved of, and he spent most of his time in Paris. The painting on the vaulted ceiling of the Gallery of Aeneas made it one of the grandest galleries of the seventeenth century along with those in the Louvre and in Versailles. Its pilasters, obelisks covered with hunting trophies, and the royal-style fireplace, were still in the Louis XIV style. The putto candelabra were borrowed from Jean Bérain, and the winged, draped figures crowning the mirror were made by an admirer of Gianlorenzo Bernini's.

The Dorée Galerie (Golden Gallery; fig. 9) is the retort that the count of Toulouse, natural son of Louis XIV, aimed at his cousin and rival, the regent. It is well known how the regent orchestrated a veritable coup d'etat pushing aside the power of the legitimate princes. The count of Toulouse did, however, preside over one of the committees of the regency. He bought the former house of La Vrillière next to the Palais Royal, which also had a famous gallery. He kept the painting on the vaulted ceiling and the seventeenth-century paintings, but had the decor redone by Vassé. The story goes that the legitimate prince wanted to "one-up" the regent and asked Vassé, whose style was rather sober at Versailles, to give free reign to all his talent when decorating this gallery. For the first time in French decor, the pedestals of the pilasters were curved, and the fireplace mantelpiece, on which Bérain's putti were to be placed, and the crown ornamenting the mirror, were more convoluted than a cornice by Francesco Borromini.

**10. The Cabinet de Singes (Monkey Room) in the Hôtel de Rohan, 1750.**

*The Hôtel de Rohan, located near the Hôtel de Soubise, was also designed by Pierre-Alexis Delamair in 1705. It was built for A. G. M. de Rohan, the prince-bishop of Strasbourg, future cardinal and son of the prince of Soubise. The Cabinet de Singes was part of the large apartment of the Rohan cardinals (there were four Rohan cardinals in the eighteenth century). The room was painted by Jean-Baptiste Huet in 1750, and these paintings depict games being played by Chinese women and men, with monkeys at the top of each panel.*

**11–12. Apartments in the Hôtel de Soubise, 1735.**

*The apartments in the Hôtel de Soubise, including that of the prince on the ground floor and that of the princess on the upper floor, were decorated for Prince Hercules Mériadec de Soubise for his wedding. The artist, Germain Boffrand, was aided by a team of painters that included François Boucher and Charles Natoire. The latter also painted the Histoire de Pysché (The Tale of Pysche), (1737–1738), in the Oval Salon located in the princess's apartment. The ornamental sculpture in the Cabinet de Fables (Fables Room) is thought to have been done by Jacques Verberckt.*

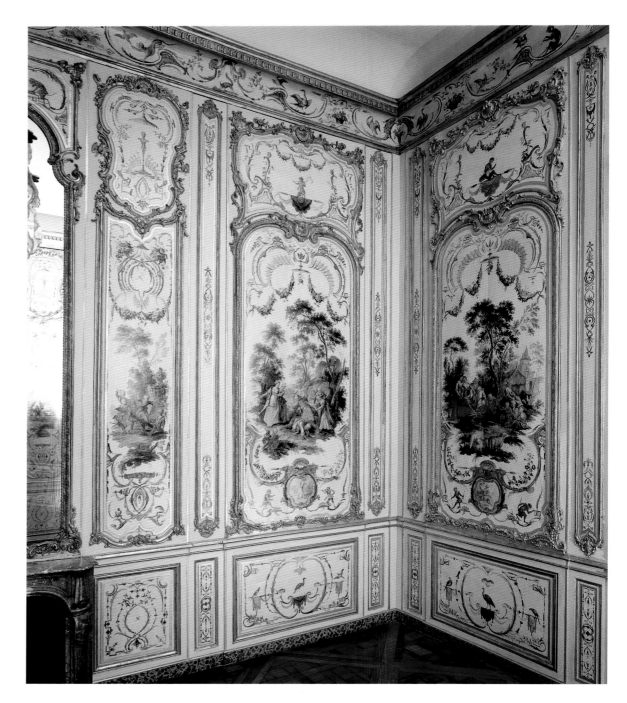

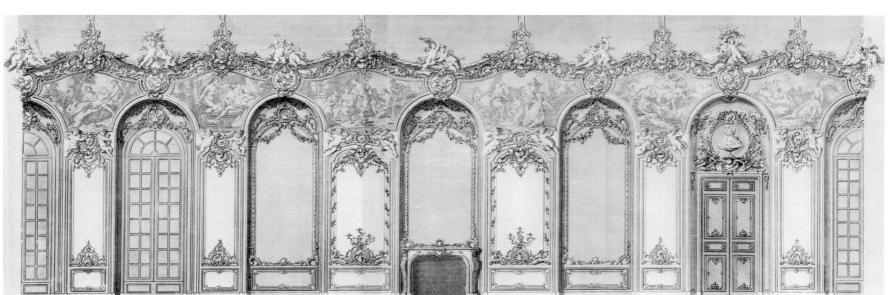

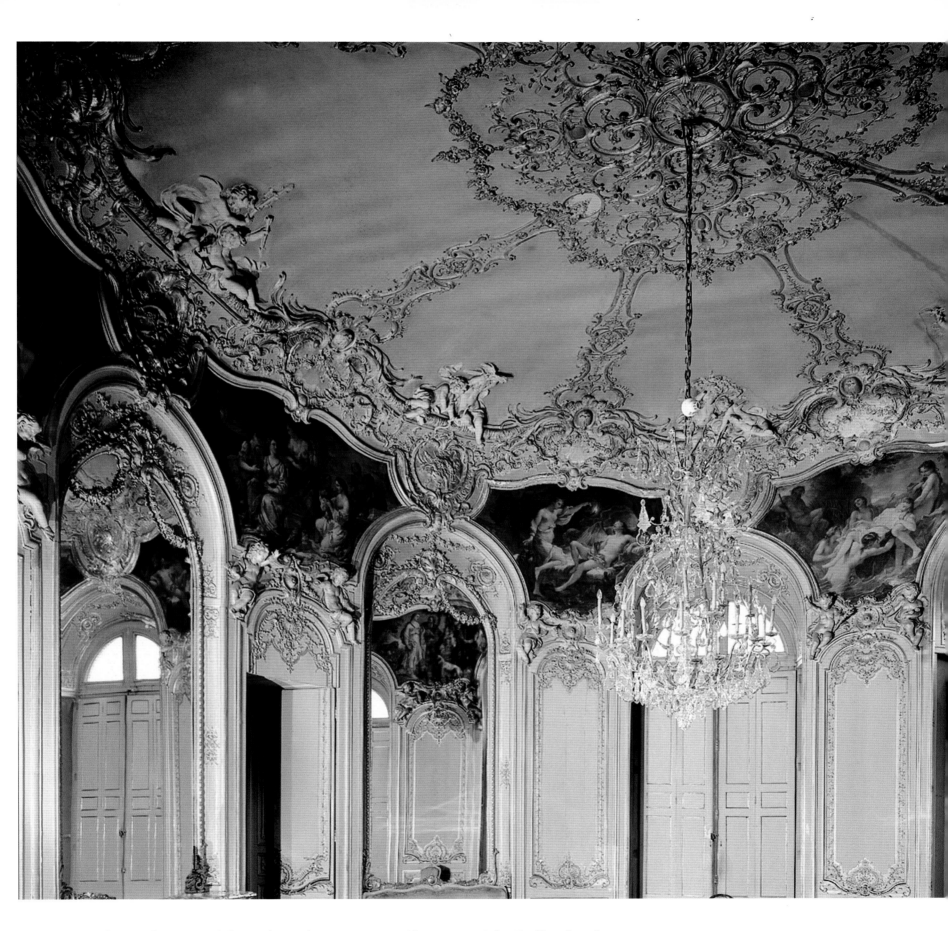

The interior decor of the Hôtel de Soubise, dating to 1735 (figs. 11–12) by Boffrand and his assistants, represents the peak of the rococo period. The spandrels, decorated with paintings by Charles Natoire, alternate and contrast with the plasterwork, which does duty for the cornice, projecting it onto the curved edge of the ceiling; the decoration froths its way to the center. This is thought to be the work of Jacques Verberckt.

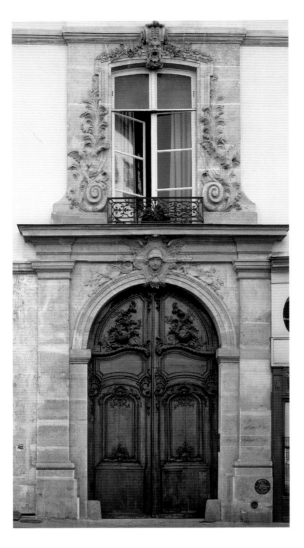

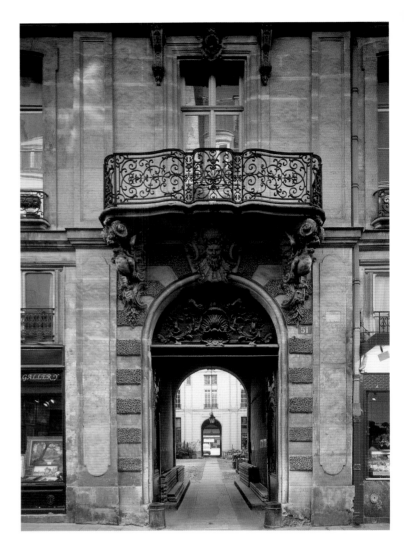

**13. House, 4, Rue Monsieur-le-Prince**

*The portal was made in the first half of the eighteenth century, probably for a man named Darlons, secretary to the prince of Condé, by an unknown architect. The entrance gate opens off an alley linking the Rue Monsieur-le-Prince to Rue de Condé. The decorative sculptures represent Mercury and the theme of science.*

**14. House, 51, Rue Saint-Louis-en-l'Ile**

*This seventeenth-century house was redecorated from 1726 to 1728 for François Guyot de Chenizot, general receiver of finances for Rouen and its suburbs. The renovations were done by the architect Pierre de Vigny, who was assisted by Nicolas Viennot for the ironwork and François Roumier for the sculpture.*

*Exterior Decorative Sculpture*

*Mascarons*, decorative masks ornamenting the keystones of arches, bays, and balconies, were typical of the decorative sculpture of Parisian building facades of this period. The middle class frequently decorated its houses and apartment buildings with such high-quality relief sculptures (figs. 13–22). The iconography was always adapted to the design of the composition. Typically there is one figure above the carriage entrance, which might be the head of Hercules, the protecting god, or of Mercury, the messenger of commerce and the arts. If there are three figures placed on the sides of the arch, they all looked toward the central figure, either a woman flanked by two men or a man between two women. If there are four figures, the range of subjects is endless: seasons, time, the elements, and so on. If flora was the theme, then faithful to tradition, each plant subtly tells a tale: for example, a sunflower symbolized homage to the Sun King, and made reference to the myth of Clythia. (The legend of Clythia is that she was in love with Apollo, but was turned into a sunflower.) If the decorative theme was animals, the sculpted menagerie would include rococo dragons. One example is the Hôtel de Rohan, whose decorative sculpture of sun horses shows these creatures bursting out of the rays of the dawn and clouds, which comes directly from Bernini-style naturalism. On the whole, the impression that less space was devoted to decorative sculpture is an illusion resulting from the popularization of the technique, whose use was necessarily circumscribed on the smaller houses. It is true that in Paris the only true facade statues to be found are at the Hôtel de Soubise (figs. 64–65). Monumental sculpture in the round moved away from architecture to take up a new place in gardens and in public squares. The pair of horses at Marly that ornamented Place Louis XV (figs. 23–24) are a reminder of Bernini's characteristic way of capturing the moment.

*Interior Decor of Churches*

The heritage of Bernini's style is indisputable as far as the interiors of church sanctuaries, decorated with baldachins and sunburst reliefs, is concerned. One example is the sunburst

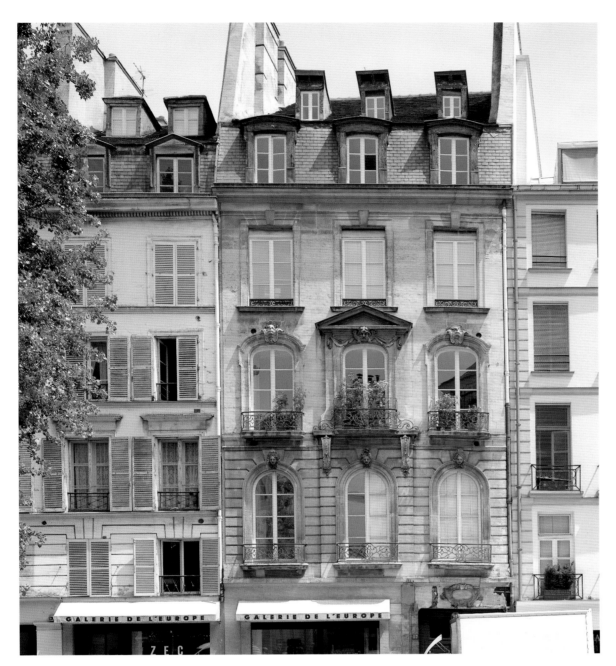

relief of Saint Roch radiating out from an oculus, a small round window allowing natural light (fig. 27), like that of the Cathedra Petri in Rome. How can Robert de Cotte's design of the scene, in an indirectly lit niche in Notre-Dame housing two kings looking on at the lamentation over the body of the dead Christ, be explained without reference to Bernini's *Ecstasy of Saint Theresa*?

The idea of angels on their knees at either end of the altar table, which can be seen both in the chapel of Versailles and in Notre-Dame, comes from the Chapel of the Blessed Sacrament in Saint Peter's in Rome, which was designed by Bernini and was often copied.

Organ cases were also the focus of grand ornamentation (fig. 25). Organs had always abounded in Paris, but these instruments were built by Flemish or Rouen manufacturers. Starting in the mid-seventeenth century, some now-famous dynastic Parisian organ builders, the Thierrys and the Clicquots, began to take over. Paris became the capital of the French organ building business. In the eighteenth century, François Henri Clicquot, the king's organ builder, was consulted all over the provinces, playing a role similar to that of the royal painter or royal architect.

**Below:**

**17. Houses, 4–6, Rue de Braque**

*These semi-detached hôtels were built in 1731 by Victor-Thierry Dailly. The sculpture was done by Michel de Lissy and Jean Bourguignon.*

**Right, from top to bottom:**

**18–20. House, 30, Rue de Condé**

*This house was built between 1733 and 1735 by Jean-François Blondel. The sculpture was done by Nicolas Pineau.*

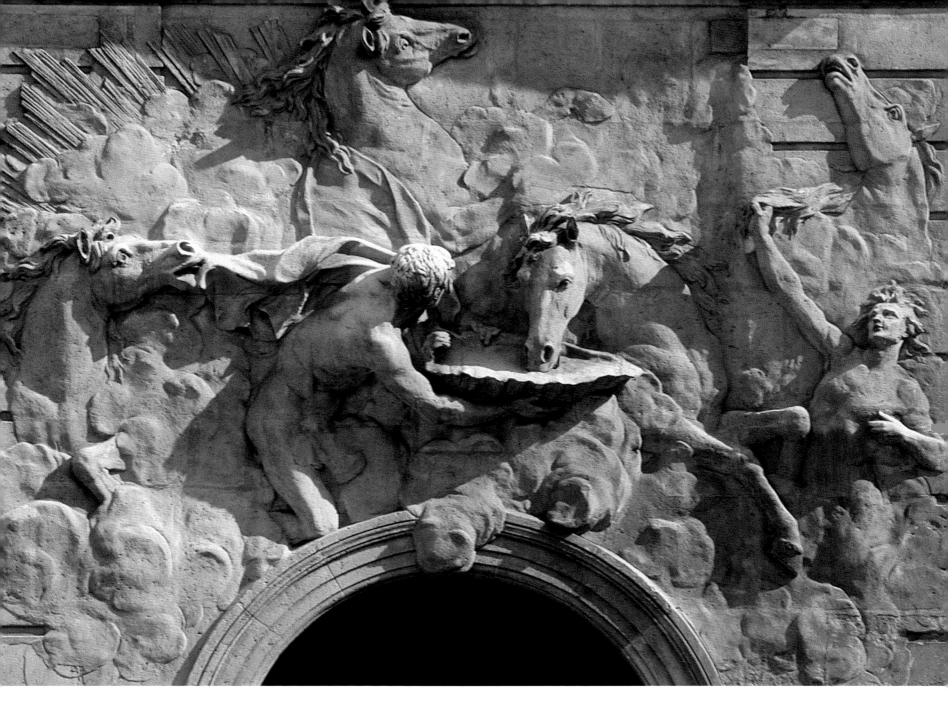

**21. The Stables of the Hôtel de Rohan, c. 1735**

*The relief sculptures are by Robert Le Lorrain, depicting the horses of Apollo's chariot quenching their thirst.*

**22. Detail on House, 52, Rue Saint-André-des-Arts, 1737 (or 1739).**

*This house was designed and built by François Debias-Aubry.*

Following two pages:

**23–24. The Horses at Marly**

*These equestrian group statues came from the Marly drinking trough, and were later placed on either side of Place de la Concorde, one group decorating the terrace of the Tuileries, and the other at the entrance to the Champs-Elysées. The originals, which are now in the Louvre, were replaced with copies. The two sculptural groups, one of which represents Mercury and the other a Victory, were made by Antoine Coysevox. They were placed in Marly in 1702, and moved to the Tuileries in 1719 (right page). At Marly, they were replaced in 1739–1745 by two sculpted groups by Guillaume I Coustou, which in turn were removed to the entrance to the Champs-Elysées in 1795 (left page).*

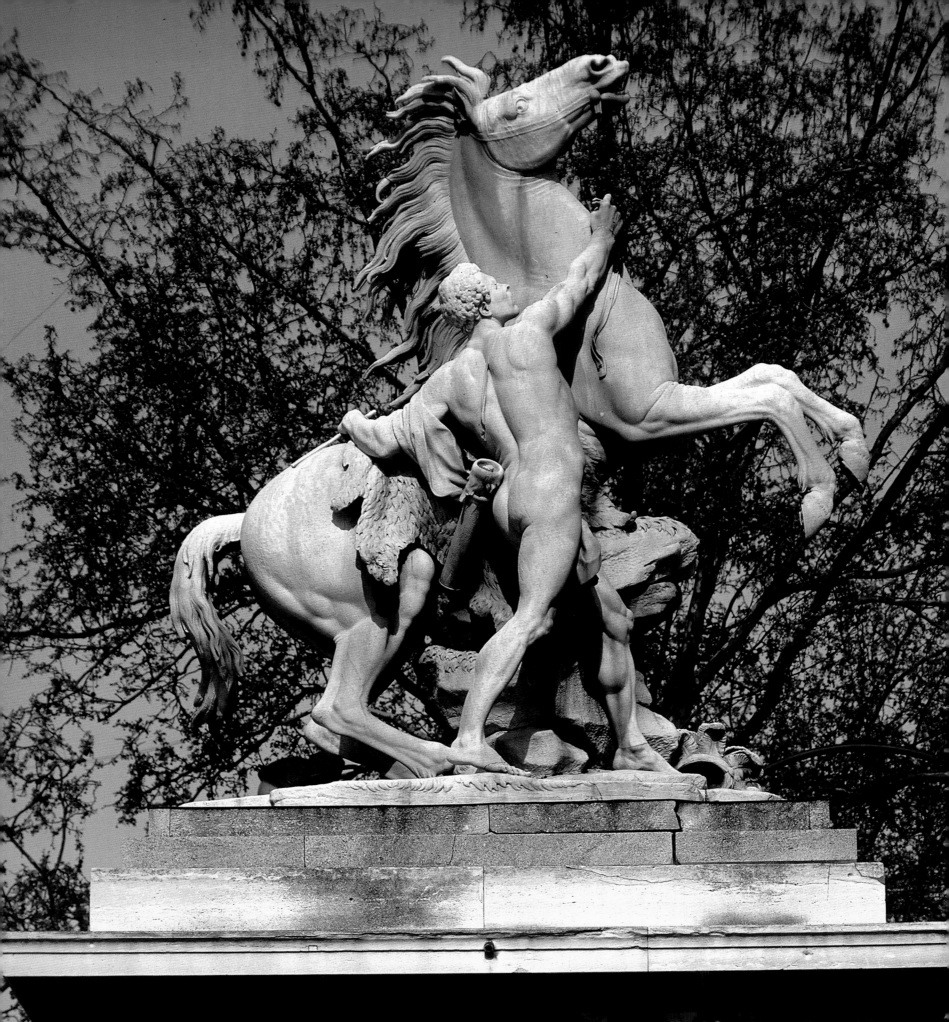

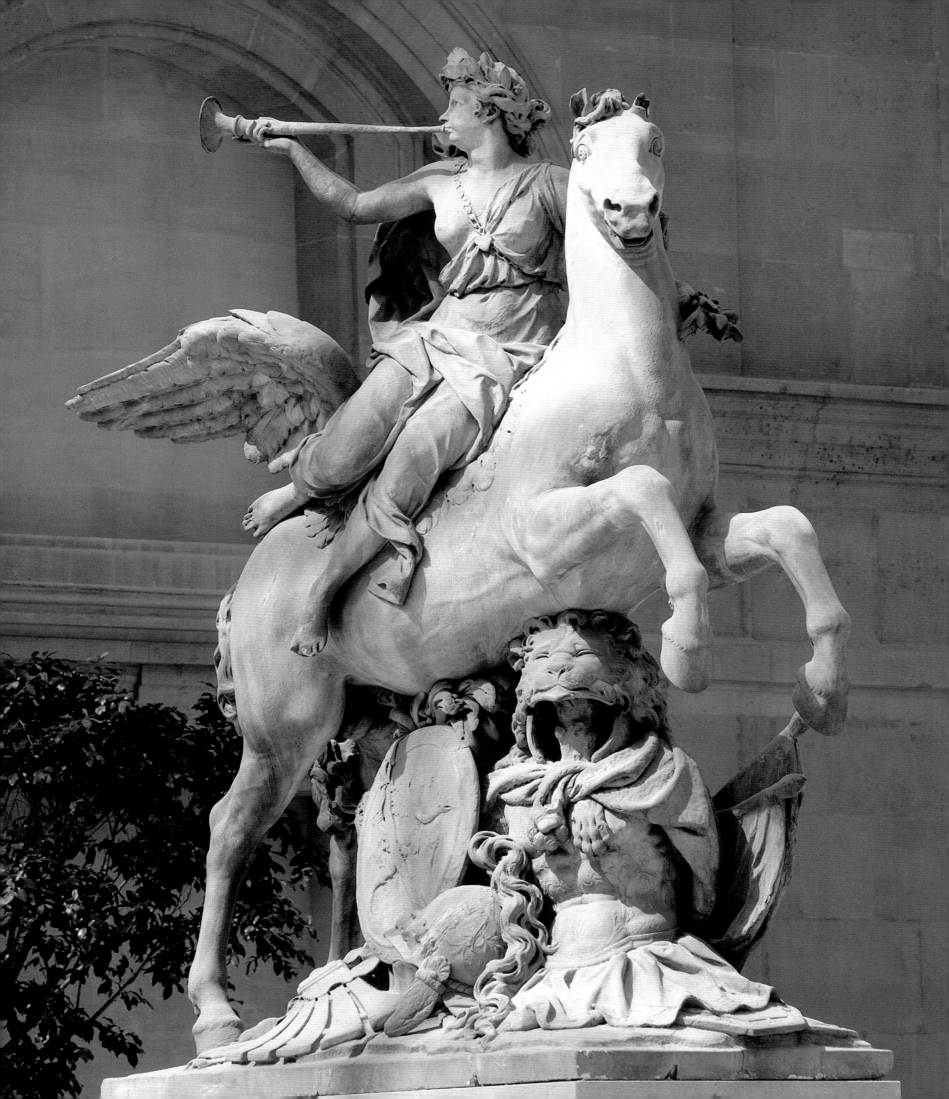

## 25. Organ Pipes in Saint-Gervais

*The gallery was built in 1628, and the organ case was sculpted by the cabinetmaker Pierre Claude Thierré in 1759. Although the organ includes reused parts from the sixteenth century, it essentially dates back to the eighteenth century, in particular its reconstruction in 1768 by François Henri Clicquot. The Couperin family owned the organ from 1656 to 1826.*

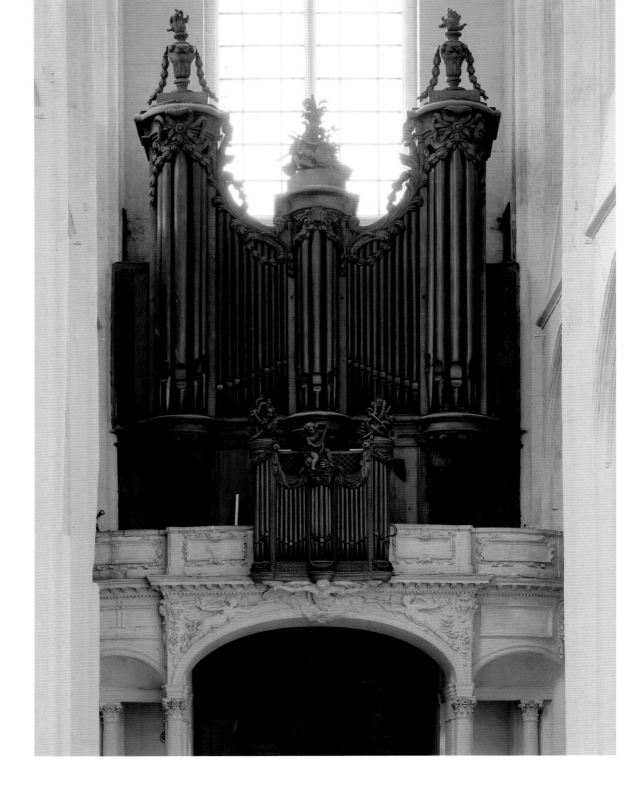

## 26–27. The Chapel of the Virgin in Saint-Roch Church, 1756.

*The parochial church of Saint Roch was rebuilt in 1653 based on plans by Jacques Le Mercier. In 1705 Hardouin-Mansart added a chapel of the Virgin to the choir. It is formed by a circular nave surrounded by an annular ambulatory, from which the Communion chapel, added by Pierre Bullet, Mansart's successor, opens out. The dome of the chapel of the Virgin was decorated with an Assumption by Jean-Baptiste Pierre in 1756. At the same time, the sculptor Etienne-Maurice Falconet placed an Annunciation group (which has now disappeared) above the altar, and topped it with a sunburst relief. The Nativity scene placed on the altar and attributed to Michel Anguier (1665) came from the Val-de-Grâce and was only placed in Saint-Roch after the Revolution.*

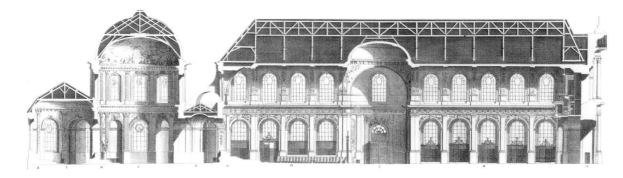

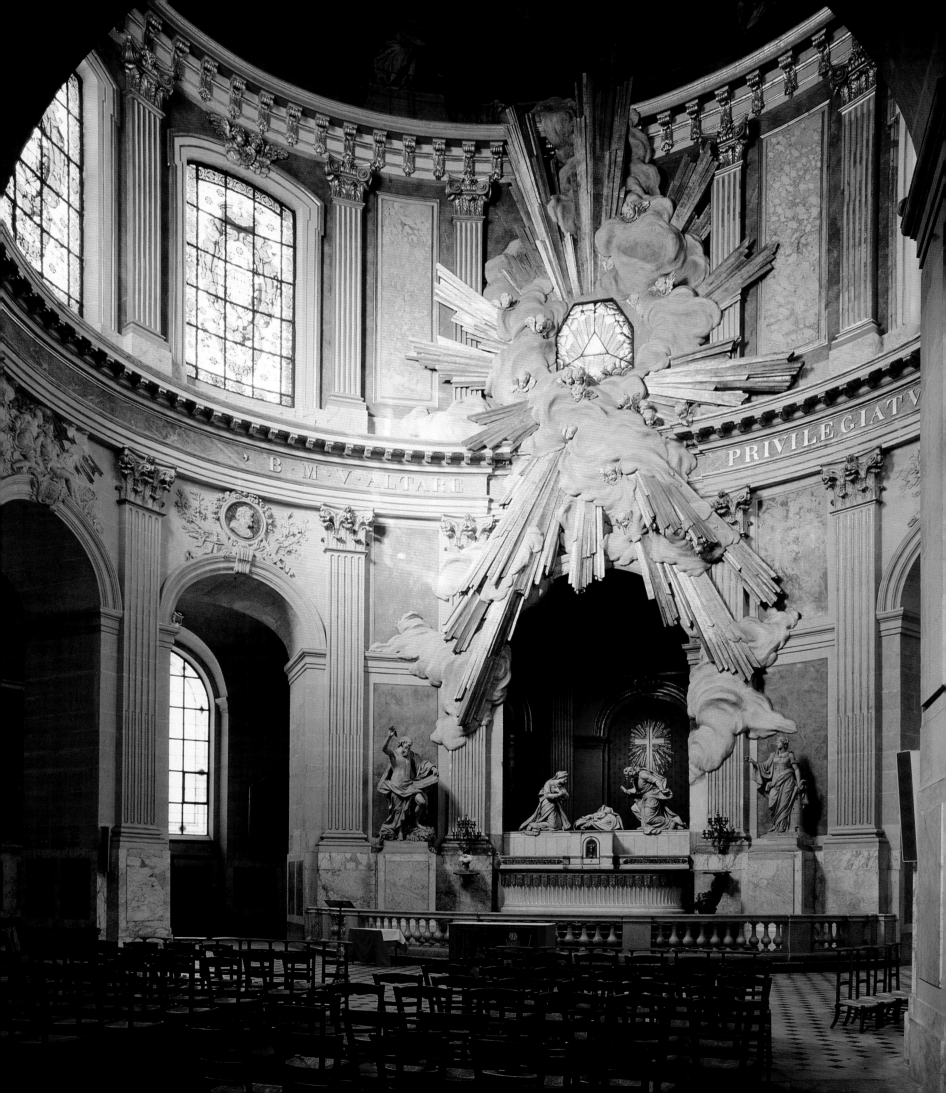

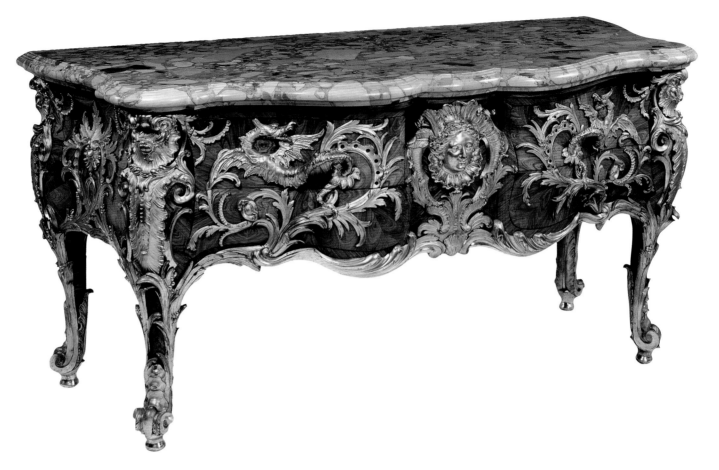

**28. Charles Cressent. Commode belonging to Marcellin de Selle. c. 1738. (Wallace Collection, London)**

*This chest of drawers on legs was made in about 1738 for Marcellin de Selles, the paymaster of the navy. It was made by Charles Cressent, loosely based on a drawing by the Slodtz brothers. It is a good example of the transitional style between the French Regency and Louis XV styles. It has a rosewood veneer.*

## 2 – FURNITURE AND FURNISHINGS

Furniture is naturally complementary to interior decor: its exact placement in the room was generally planned; for example, when the curved back of a sofa fit exactly into the contour of a mirror or a mantel. During the eighteenth century, the Parisian furniture making industry benefited from an unprecedented expansion not unlike that of the ivory carving industry in the thirteenth and fourteenth centuries. Cabinetmaking, which employed veneering techniques, profited from the arrival of exotic woods. The craft emerged in the middle of the seventeenth century when it featured ebony alone, from which it gained its first designation, *"menuiserie d'ébène"* (ebony work). By the eighteenth century, Parisian cabinetmakers were using seventy-eight different types of wood, mostly imported. These included ebony and rosewood from the Antilles, mahogany from Ceylon (now Sri Lanka), Indian rosewood, and sandalwood from Siam (now Thailand), among others. The veneered woods were then enriched with inlaid work in tin, copper, shell, coral, and ivory. Production was characterized by a proliferation of types: where the seventeenth century had seen little more than the cabinet, the table, and the chair, the eighteenth century invented a hundred ways to organize and display goods. Royally commissioned furniture was naturally the driving force behind this effervescence: both Louis XIV and Louis XV had a passion for furniture, and they did not restrict its use for themselves. The log of gifts from the king, which fortunately has survived, shows that both kings generously gave gifts of furniture and rugs, tapestries and gold work, especially to foreign courts, which guaranteed the international prestige of the Parisian furniture makers.

The individual private customers of the furniture makers, motivated by the king's example, also spent considerable sums on furniture, and even gold work and tapestries. Louis-Sébastien Mercier observed in the *Tableau de Paris*, 1781–1788, that this was as true in the early part as in the second half of the eighteenth century: "Pieces of furniture have become a luxury item subject to great spending; every six years people change their furniture in order to purchase the most beautiful furniture that the elegance of the day has inspired." Lazare

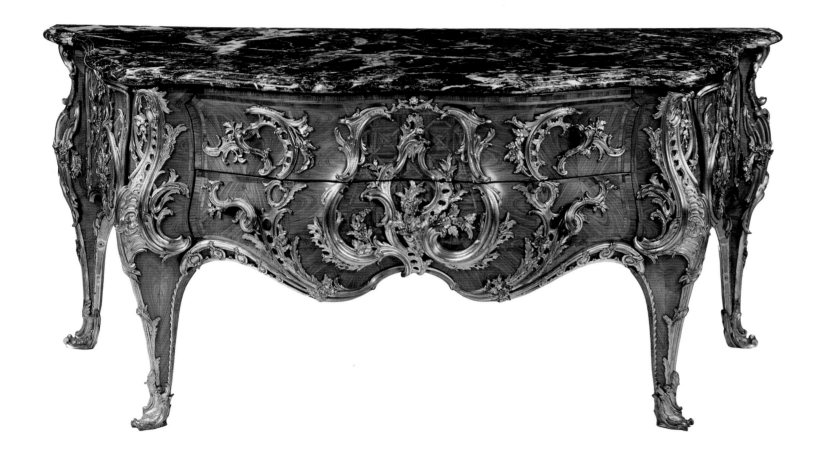

**29. Antoine Gaudreaux. Commode for the bedroom of Louis XV in Versailles, 1739. (Wallace Collection, London)**

*This commode was delivered to Versailles in 1739, made by the cabinetmaker Antoine Gaudreaux, loosely based on a drawing by Antoine-Sébastien Slodtz. The gilt bronze work is by Jacques Caffieri.*

Duvaux kept a journal from 1748 to 1758 that gives an idea of the astounding extent and extravagance of the clientele of "an ordinary supplier to the king." The monarchy forced furniture production to be centered in Paris by creating *"enclos privilégiés,"* or privileged zones. Thus the eighteenth century was the great century of the Faubourg Saint-Antoine, a working-class neighborhood, because it was granted special tax exemptions by the Abbey of Saint-Antoine, and because it was located on the riverbanks of the Seine where wood was unloaded from boats and stored. Furniture making was not the only tax-exempted activity in this neighborhood, which became *the* Parisian art and craftsmanship quarter. Because the artisan's trademark stamp was not made mandatory until the mid-eighteenth century, only the most prestigious furniture items made before then are stamped.

### André-Charles Boulle

André-Charles Boulle was named furniture-maker to the king in 1672, and he perfected the Louis XIV furniture style. He was fortunate in having the savoir-faire of a Cucci, and to work at the time when circumstances led to the melting down of silver furniture, for which he had to find a suitably elegant replacement to satisfy the royal taste for pomp. The taste-fully orchestrated combination of veneer, inlaid marquetry, and bronze was the answer. Boulle made paired items of furniture that exactly fulfilled this demand, and his inlaid marquetry combined tortoiseshell with soft metals, pewter, and brass. The layers were superimposed in order to be carved together, such that the material carved in "positive" on one of the pair could be carved in "negative" on the other. Boulle made pieces of furniture for storing items that were sometimes called cabinets and sometimes wardrobes (fig. 1): their perfection was such that in comparison, Cucci's cabinets appear more pompous than magnificent. Boulle was also the inventor of the "commode," a chest of drawers on legs. The word "commode" only appeared in 1714, yet the two items delivered in 1708 under the name *"bureaux,"* or desks, for the king's bedroom in Trianon were in fact commodes. During the nineteenth century, these chests of drawers and the desks of the first Louis XIV style were dubbed "mazarin," proving the extremely influential legacy of Cardinal Mazarin, even though they were designed after his death.

**30. Rolltop desk belonging to Louis XV made for his inner study at Versailles, 1760–1769. (Musée National du Château Versailles)**

*The rolltop desk was begun in 1760 by J.-F. Oeben and was finished after his death (in 1763) by his assistant and successor Henri Riesener. The desk was finished and delivered to Versailles in 1769. The bronze work was done by Duplessis and was carved by Hervieu. The inlaid marquetry designs represent a very diverse range of themes including poetry, astronomy, mathematics, shipping, and war.*

**31–32. Bernard II van Risenburgh. Wardrobe, c. 1750–1755. (Musée du Louvre, Paris)**

*This wardrobe made of rosewood, violet wood, and Chinese lacquer may have been designed for the Versailles apartment of Crown Princess Marie-Joseph of Saxony. Bernard II van Risenburgh was the most famous of this family of cabinetmakers, and was known by his trademark stamp BURB.*

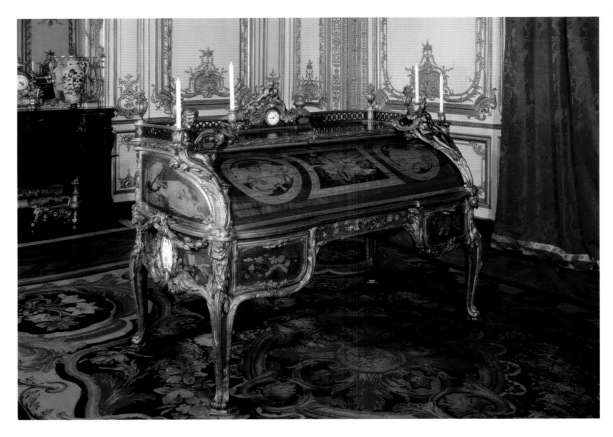

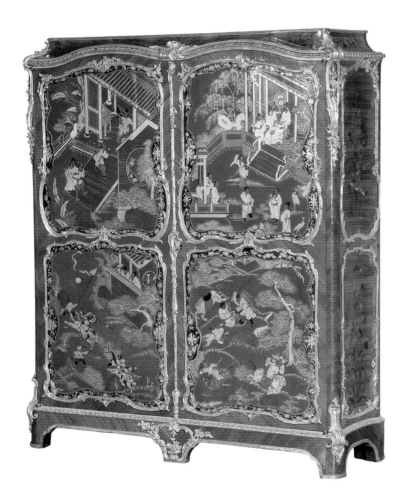

*French Regency and Rococo Furniture*

The work of Charles Cressent, who was named cabinetmaker to the regent in 1719 and who stood out for the exceptional quality of his bronze work, is a perfect example of the French Regency style and the transition style preceding the Louis XV style. The *commode* from the Wallace Collection (fig. 28) is one of the prime examples of a *commode* without a transverse between the drawers, which freed up the space for bronze ornamentation. The strict symmetry of this piece, and the central *mascaron* decoration still belong to the Regency style, whereas the *rinceaux* and especially the dragons, a popular motif under Louis XV, all foreshadow the rococo style. In 1739 Antoine Gaudreaux, arch rival of Cressent, delivered a commode to Versailles that is an excellent example of the full-blown rococo style (fig. 29). Its edges are full of curved contours and the sides have an almost exaggerated bulge. The bronze work by Jacques Caffieri, son of Philippe, and probably the best bronze chaser of the century, crescendos in a quasi-vegetal profusion. The rococo is like golden lichen covering furniture, ceilings, and wood paneling in a kind of fine netting, a sort of degeneration of the ample leaves so popular in the Louis XIV style. Bernard II, who was the most illustrious member of the van Risenburgh family, produced remarkable examples of the fashion for Chinese lacquer (figs. 31–32). Attempts to copy the precious lacquerwork of the Far East had fostered the simultaneous development of new techniques by several "Japanners" (imitators of Oriental lacquer) in Paris, although none were as successful as the Martin brothers. Louis XV's flat bureau by Gilles Joubert illustrates the use of "vernis Martin," the lacquer technique invented by the brothers. The rolltop desk of Louis XV is considered a masterpiece of French furniture making (fig. 30). It was begun by Jean-François Oeben, the king's cabinetmaker since 1754, and was finished by Jean-Henri Riesener, who initiated the Louis XVI style under Louis XV. It is therefore a transitional piece. The part that was almost certainly designed by Oeben (a great inventor of furniture with secret compartments) was the roll top, a kind of paneled blind allowing the desk to be closed, which was invented especially for Louis XV.

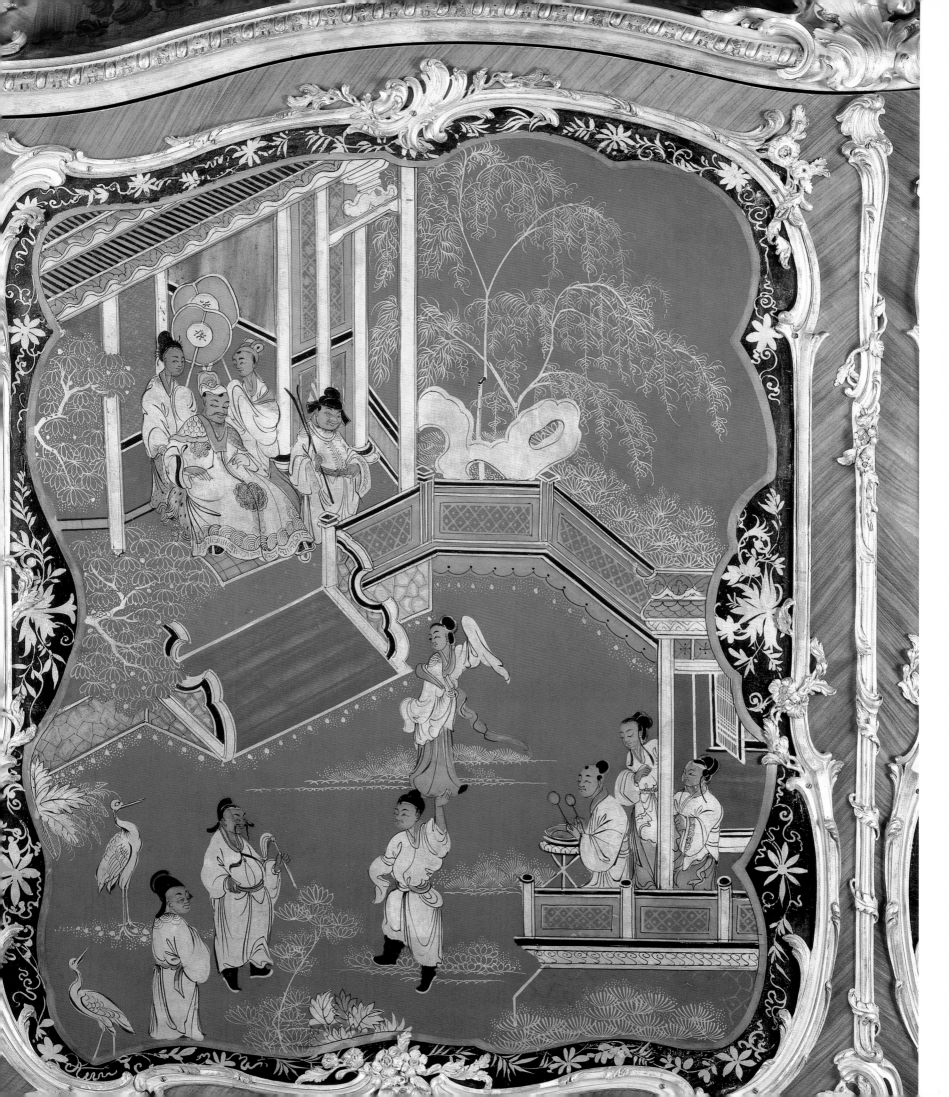

Opposite:

**33. Saint-Sulpice Church.
Holy Water Stoups.**

*These stoups (there are two of them) include
a shell that the Republic of Venice had given
to François I and which Louis XV donated
to the church of Saint-Sulpice in 1745. It was
set on a pedestal sculpted by Jean-Baptiste
Pigalle in the shape of a rock decorated
with coral, mollusks, and a starfish.*

**34. Hôtel de Marsilly. Banister Newel.**

*The Hôtel de Marsilly (at number 18, Rue de
Cherche-Midi) was built by the architect
Claude Bonnot in 1738 as a gift to his daughter,
wife of Jacques de Commines de Marsilly. The
banister newel was made by Nicolas Pineau.*

**35. Juste-Aurèle Meissonnier. Design
for Gold and Silver Work, 1735.**

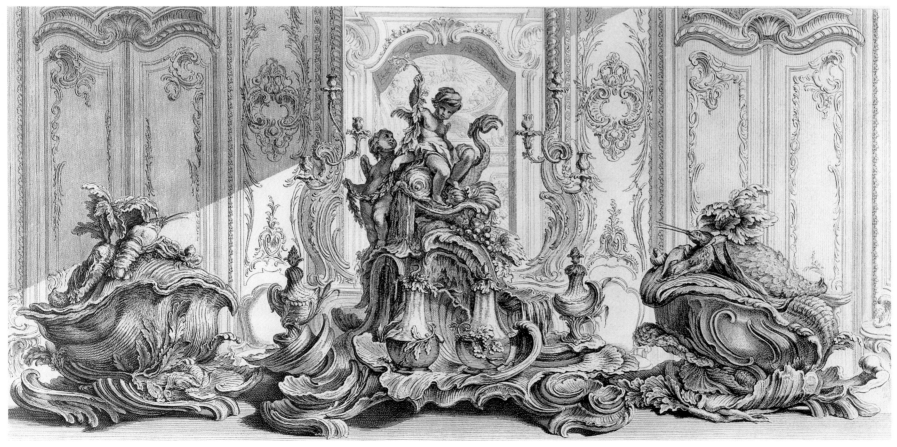

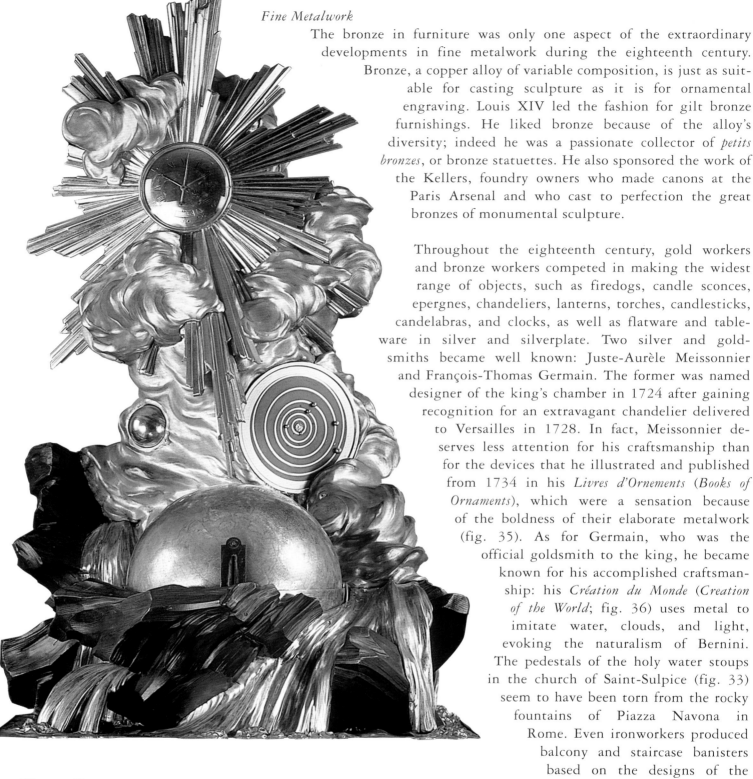

## Fine Metalwork

The bronze in furniture was only one aspect of the extraordinary developments in fine metalwork during the eighteenth century. Bronze, a copper alloy of variable composition, is just as suitable for casting sculpture as it is for ornamental engraving. Louis XIV led the fashion for gilt bronze furnishings. He liked bronze because of the alloy's diversity; indeed he was a passionate collector of *petits bronzes*, or bronze statuettes. He also sponsored the work of the Kellers, foundry owners who made canons at the Paris Arsenal and who cast to perfection the great bronzes of monumental sculpture.

Throughout the eighteenth century, gold workers and bronze workers competed in making the widest range of objects, such as firedogs, candle sconces, epergnes, chandeliers, lanterns, torches, candlesticks, candelabras, and clocks, as well as flatware and tableware in silver and silverplate. Two silver and goldsmiths became well known: Juste-Aurèle Meissonnier and François-Thomas Germain. The former was named designer of the king's chamber in 1724 after gaining recognition for an extravagant chandelier delivered to Versailles in 1728. In fact, Meissonnier deserves less attention for his craftsmanship than for the devices that he illustrated and published from 1734 in his *Livres d'Ornements* (*Books of Ornaments*), which were a sensation because of the boldness of their elaborate metalwork (fig. 35). As for Germain, who was the official goldsmith to the king, he became known for his accomplished craftsmanship: his *Création du Monde* (*Creation of the World*; fig. 36) uses metal to imitate water, clouds, and light, evoking the naturalism of Bernini. The pedestals of the holy water stoups in the church of Saint-Sulpice (fig. 33) seem to have been torn from the rocky fountains of Piazza Navona in Rome. Even ironworkers produced balcony and staircase banisters based on the designs of the great *ornemanistes* (metalwrights and blacksmiths), such as the banister newel in the Hôtel de Marsilly (fig. 34), designed by Pineau.

**36. François-Thomas Germain. Creation of the World clock, 1754. (Musée National du Château Versailles)**

*Dupleix commissioned this clock to be made in 1754 by the sculptor and goldsmith Germain as a gift to the king of Golconde. The clock mechanism inside was made by Passemant.*

## Porcelain

During the eighteenth century, Parisian artist-craftsmen discovered a new material that had similar possibilities of color and shine as metal and hard stone: porcelain—soft porcelain—a substitute for the Chinese porcelain of which the exact composition was not yet known. Soft porcelain was first made in Saint-Cloud in 1693 under the auspices of Monsieur, the brother of the king. Defectors from the Saint-Cloud factory founded their own factory in 1730 in Chantilly, under the patronage of the prince de Condé. Likewise, some deserters of Chantilly founded a porcelain factory in Vincennes in 1733, which eventually became the

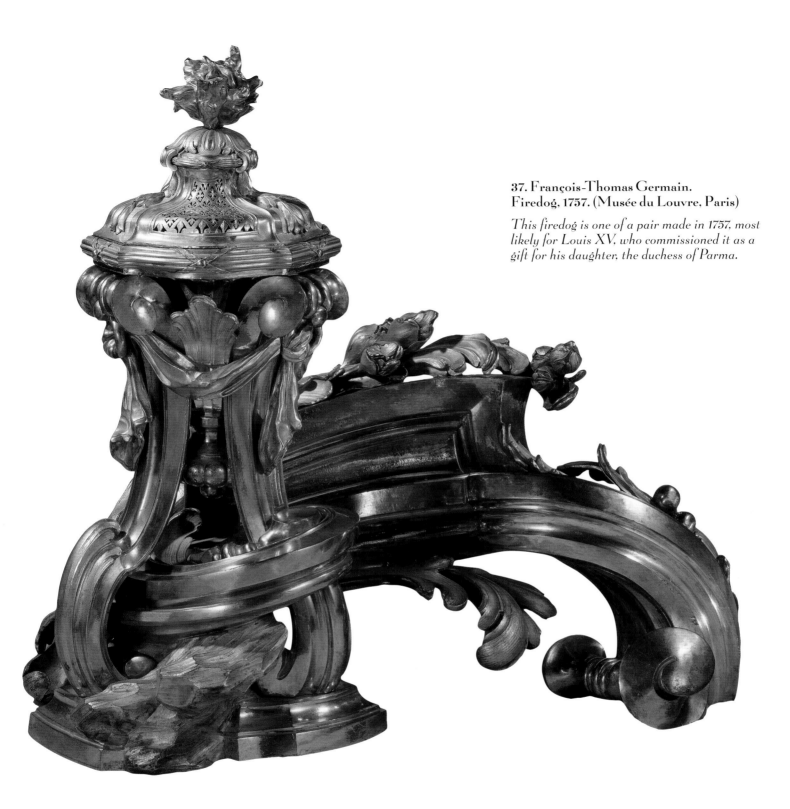

**37. François-Thomas Germain. Firedog, 1757. (Musée du Louvre, Paris)**

*This firedog is one of a pair made in 1757, most likely for Louis XV, who commissioned it as a gift for his daughter, the duchess of Parma.*

Royal Porcelain Factory in 1753. This third factory was transferred to Sèvres in 1756, and began producing hard porcelain in 1769 using kaolin from the Limousin region. It was only then that the reputation of Parisian porcelain began to equal that of the other great European porcelain manufacturers, particularly Meissen of Saxony, who were already able to produce hard porcelain according to Chinese processes as early as 1709.

The eighteenth century was the golden century of Parisian art objects. This was once again thanks to the activities of the haberdasher merchants: it was in their boutiques that they imposed the laws of fashion on their regular customers. One of these haberdashers, Edmé-François Gersaint, is known to us now because of the shop sign that he had painted by Jean-Antoine Watteau (fig. 42).

The study of Peter-Paul Rubens's works and contact with Venetian painting, especially through Sebastiano Ricci and Gian Antonio Pellegrini, changed the palette of French painting, which was lightened and brightened during this period. Ricci, a cross between Veronese and Tiepolo, lived in Paris from 1712 to 1716. On his arrival in Paris in 1720, Pellegrini (who produced great Venetian-style decor in Germany and England) frescoed the ceiling of the Mississippi Gallery (destroyed) in the Hôtel de Law, which housed the Royal Bank in the Rue de Richelieu. An exceptional honor for foreigners, Ricci and Pellegrini were appointed members of the Royal Academy of Painting and Sculpture. Of the Parisian painters, Charles de la Fosse was the most "Venetian." He was a student and assistant of Charles Le Brun and he sojourned for many years in Venice. His painting *Moïse sauvé des eaux* (*Moses Saved from the Waters*; Musée du Louvre) borrowed shamelessly from the same subject painted by Veronese. In Paris La Fosse painted the domes in the churches of the Assumption and the Invalides. The most Rubens-like painting by a French painter is definitely *Descente de la croix* (*Descent from the Cross*; Musée du Louvre) painted in 1697 by Jean-Baptiste Jouvenet, another assistant of Le Brun's. This painting was done for the church of Les Capucines Convent. Jouvenet made a specialty of producing immense paintings for Parisian churches, such as the works in Saint-Martin-des-Champs Church and the choir of Notre-Dame. The most justly famous masterpieces of this new style, which fortunately have been preserved, are in Versailles on the vaulted ceilings of the Hercules Salon and in the chapel. The authors of these works also left proof in Paris of their capacity for soaring imagination in the Venetian manner when François Lemoyne painted an *Olympus* for the Royal Bank (1718), and Antoine Coypel painted an *Assembly of the Gods* for the Gallery of Aeneas in the Palais Royal (fig. 8).

At first glance, it is hard to tell the difference between works painted by Le Brun and those painted by his successors. The vaulted ceiling of the Hercules Salon is reputed to be the largest undivided ceiling painting in France. But Le Brun had already sketched a composition of the same size intended first for the chapel and then for this same room. Not only that, Le Brun had also made a noticeable change in the classical iconography. In the large apartments of Versailles, mythology was still the usual way of paying homage to the king, who was represented as Apollo.

**38. Jean-Antoine Watteau. *Etudes de neuf têtes* (*Studies of Nine Heads*). (Petit Palais, Paris)**

*This drawing in three colors shows the studies of the head that Watteau used in his* Pèlerinage à l'île de Cythère (*Pilgrimage to the Isle of Cythera*).

Yet in the Mirror Gallery, which was done later, the images showed the deeds of the king clothed like a Roman emperor, and only recognizable by his wig! The solemn nature of the place doubtless made it necessary to develop this strange iconographic hybrid. It is no longer found in the hanging king cycle, in which Le Brun depicted the history of the reign with the figures in contemporary clothing (chapt. VIII, fig. 39). However, the innovation was not imitated until the second half of the eighteenth century and the spectacular return to history painting.

Although French painters continued to paint some monumental works, French painting on the whole began to lean toward smaller formats and genres. In fact, monumental painting almost ceased in favor of easel paintings. There are several distinct yet complementary reasons for this. First of all, architectural space changed as the plaster ceiling replaced the vault. Secondly, with the development of the Salon, an artist's reputation was earned by presenting his works at a show, in which the smaller size of an easel painting was an advantage. Finally, and indeed what could be the most important reason, was that artists were progressively abandoning the "grand manner," which is to say historical and mythological paintings. Meanwhile, the genres that had been considered minor, such as portraits, still lifes, and genre scenes, came into fashion. The reason for this trend was high society's rejection of the pomp of the court, and their desire to retreat to more private gatherings, protected from indiscreet and tiresome people. Through the genius of two artists, Watteau and Jean-Baptiste-Siméon Chardin, the boudoir door was opened to the sublime.

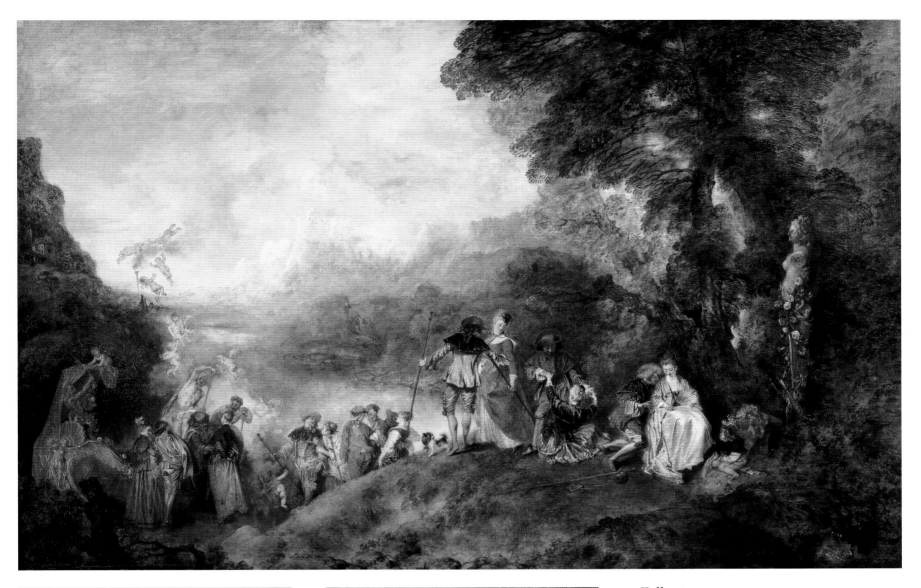

**Following two pages:**

**42. Jean-Antoine Watteau.** *L'Enseigne de Gersaint* (*Gersaint's Shop Sign*), 1720. (Schloss Charlottenburg, Berlin)

*Watteau painted this shop sign at the end of 1720 for the haberdasher Gersaint, whose boutique Le Grand Monarque was located on Pont Notre-Dame. The shop sign was admired throughout Paris, despite the fact that it hung under the awning of the shop above the window display for only fifteen days. The two halves of the painting were done on two separate canvases forming one picture, which was arched. Indeed, one can still see the faint line of the arch, and the upper corners were clearly not done by Watteau. Perhaps the spectator on the left was added by Jean-Baptiste-Joseph Pater where Watteau would have painted a hay cart. The paintings shown have not been identified.*

**39–41. Jean-Antoine Watteau.** *Le Pèlerinage à l'île de Cythère* (*Pilgrimage to the Isle of Cythera*), 1717. (Musée du Louvre, Paris)

*Watteau was accepted into the academy in 1712 but he failed to deliver his reception piece, this work, until 1717, having been reprimanded for this several times. Every academician was required to produce such a work on his induction. The painting has had various titles, including* Pilgrimage to the Isle of Cythera *and* Embarkation for the Isle of Cythera.

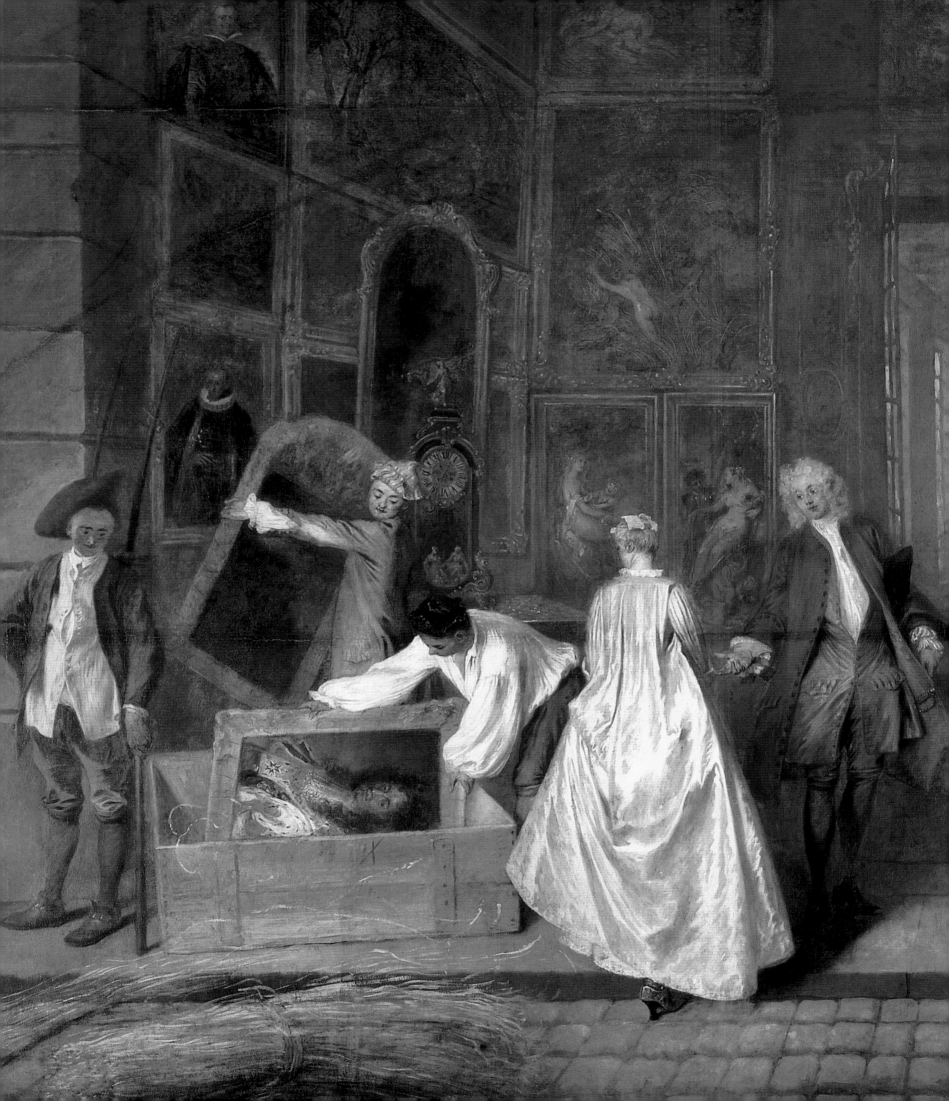

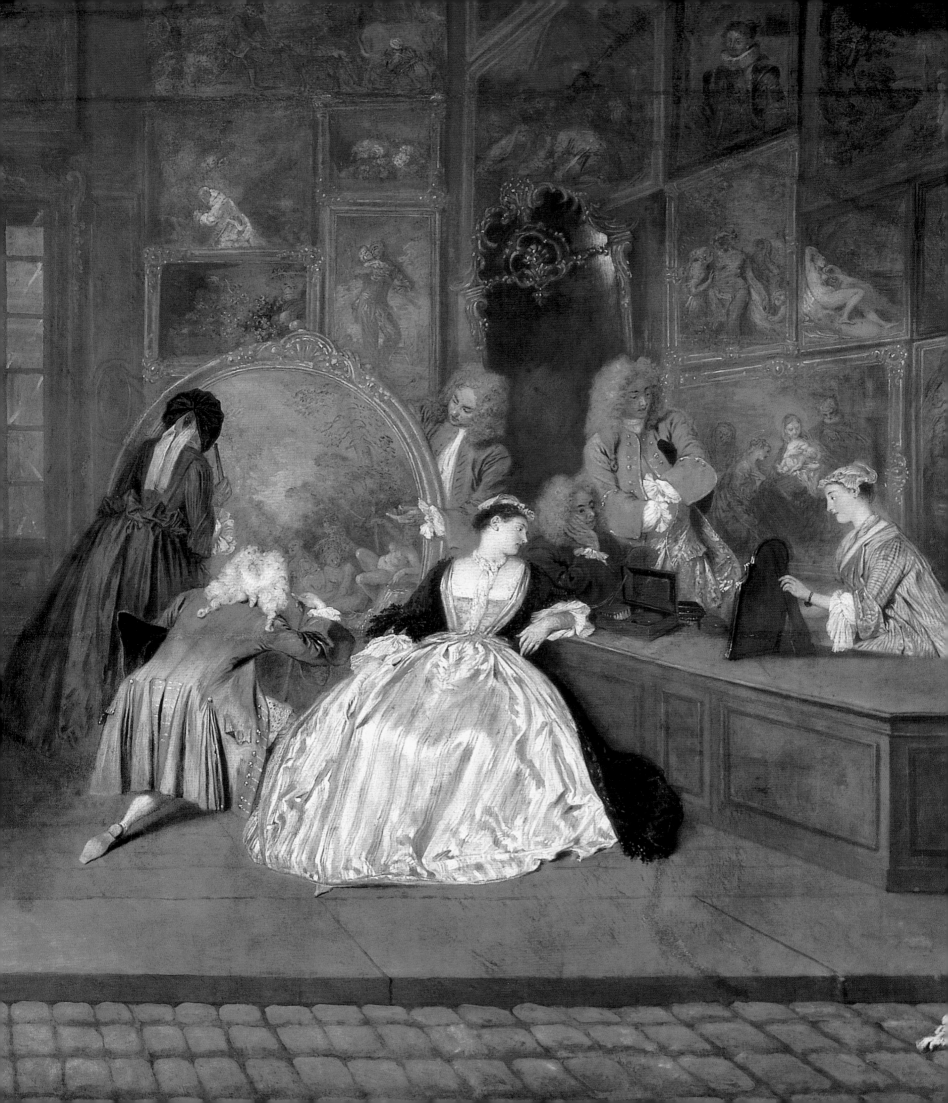

**43. Jean-Baptiste Oudry. *Le Canard Blanc (The White Duck)* or *Étude d'objets blancs (Study of White Objects)*. 1753. (Private collection)**

*In 1749 Oudry gave a lecture at the Royal Academy of Painting on the difficulty of painting varying shades of white and silver. This study, which he used to illustrate his lecture, was a sensation at the 1753 show.*

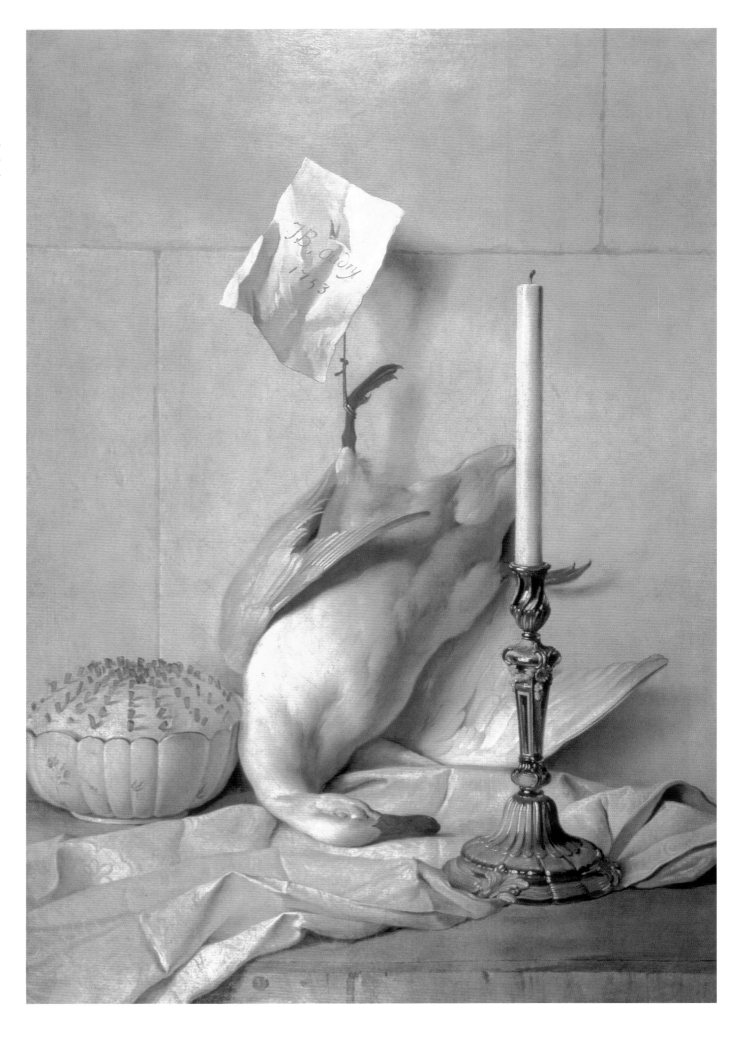

44. Jean-Baptiste-Siméon Chardin.
*La Raie* (*The Skate*), c. 1726.
(Musée du Louvre, Paris)

This work was presented to the Academy in 1728 as a reception piece. It is unique among Chardin's works because of the presence of a live animal (the cat) and a hideous cadaver (the skate).

45. Jean-Baptiste-Siméon Chardin.
*La Pourvoyeuse* (*The Return from Market*),
1739. (Musée du Louvre, Paris)

There are three signed versions of this work, which features "a cook who has just done the shopping and who has brought back bread and meat" (Mercure de France, November 1742). Lépicié printed The Return, one of Chardin's most famous works. The print was accompanied by the following quatrain:
"A votre air j'estime et je pense
Ma chère enfant, sans calculer
Que vous prenez sur la dépense
Ce qu'il faut pour vous habiller."
("Just by your look I can tell and I believe
My dear child, without even counting
That you have taken from the spending money
the amount needed for your clothing.")

46. Alexandre-François Desportes.
*Nature morte à la niche de marbre*
(*Still Life with Marble Alcove*), 1706.
(Musée du Louvre, Paris, housed
at the Ministry of Justice)

## Jean-Antoine Watteau

One word sums up the whole of Watteau's works: ambiguity. What are his paintings *Pèlerinage à l'île de Cythère* (*Pilgrimage to the Isle of Cythera*; figs. 39–41) and *L'Enseigne de Gersaint* (*Gersaint's Shop Sign*; fig. 42) if they are not fashion shows and *marivaudage* (amorous set-pieces)? It has often been remarked that Marivaux's play titles could easily be used for Watteau's paintings, which often portrayed the theater world: *La Surprise de l'Amour* (*The Surprise of Love*), *Le Jeu de l'Amour et du Hasard* (*The Game of Love and Chance*), and *Les Fausses Confidences* (*False Confidences*). However, upon closer inspection, Watteau's works are less clear. The painting *Pèlerinage à l'île de Cythère* had other titles, including *Embarkation for the Isle of Cythera*. Does the painting portray a departure or an arrival instead? Is the backward glance of the woman in the central couple a look of resistance to seduction, or does it evoke one last nod to shared pleasures? Is the island hidden in the murky haze really Cythera, the island of Aphrodite, goddess of love, who emerged from the water? Or could it be the shores of the Lethe, the river of forgetting, which engulfs a funeral procession dressed

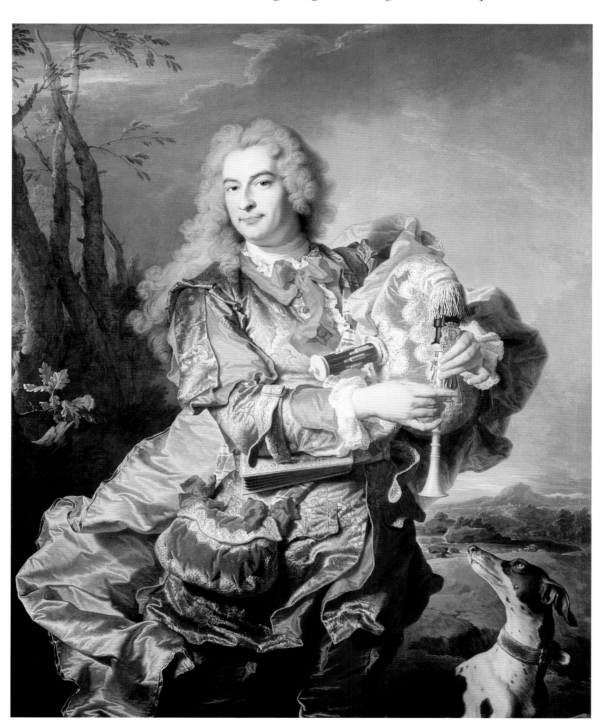

**47. Hyacinthe Rigaud.**
***Portrait of Gaspard de Gueidan*, 1735.**
**(Musée Granet, Aix-en-Provence)**

*Gueidan, advocate general in Aix-en-Provence, was besotted with the nobility to the point of inventing a false genealogy for himself, and a tomb of false ancestors who had supposedly been companions of Saint Louis during the crusades. He actually succeeded in his bid for nobility when Louis XV designated one of his landholdings as that of a marquis.*

Opposite:

**48. Hyacinthe Rigaud.**
***Portrait of Fontenelle*, 1713.**
**(Musée Fabre, Montpellier)**

*Rigaud painted several portraits of Fontanelle including this one, probably intended for Fontanelle himself.*

in silk? After all, it could even be an outdoor celebration, a pictorial genre that appeared in France at the end of the seventeenth century.

Watteau himself described *L'Enseigne de Gersaint* (*Gersaint's Shop Sign*) as nothing significant, just a quick sketch painted to "warm up his fingers," an advertising image that fashionable merchants would copy to show that their boutiques attracted the right people. In the painting, one might merely see fashionable outfits shown with a conventional front and back view as on fashion plates (chapt. VII, figs. 113–115). Moreover, Watteau has recorded fashion figures in the tradition of the seventeenth-century collections. The waistless, floating robe worn by the woman on the left is a *ballande*: it appears so often in Watteau's work that he was thought to have invented the style. Yet *L'Enseigne* alludes to the theater even better than Watteau's paintings depicting actors, because its original arched frame evokes the opening of the curtains in a theater. We catch ourselves with a Marivaux-style retort coming to mind. The saleswoman to the right of the painting could be saying to the group of three people before her: "Are you together?" and the man of the couple on the left could be making an aside while glancing at the woman in the flowing dress: "No, not yet!" There is something Cytheresque about this painting, something fresh and spontaneous, though it was painted by Watteau in the last years of his short life. The collection of Venetian- and Flemish-style paintings that Watteau liked and portrayed in *L'Enseigne* is imaginary, a mere mirage like the portrait of Louis XIV that is being wrapped up. Watteau was much admired during his lifetime, yet became the main victim of the backlash in the second half of the eighteenth century that condemned frivolous paintings.

If Watteau's skills were reduced to just the drawings, which are only studies of details, then his works would still be first rate. His *"trois crayons"* technique—using red, black, and white crayons, occasionally combined with pencil and pastels, on tinted paper—is clearly the technique of a colorist trained in the Rubens and Van Dyck schools (fig. 38).

## Still Life

It is through the still life that Chardin managed to transform the fleeting nature of genre scenes into a moment of eternity. His painting *La Pourvoyeuse* (*The Return from the Market*) is one of the most famous in the Louvre and has rightly been compared to Pieter de Hooch's paintings and even to Vermeer's works. Chardin simplified his compositions and was compared with Camille Corot and Georges Braque by André Malraux. His still-life objects—stoneware jars and pewter dishes—have rustic qualities reminiscent of the Le Nain brothers, and his bread and wine evoke the country Eucharist. *The Skate* (fig. 44), which Chardin's contemporaries thought had been painted by a Flemish artist, borrowed effects from the coarse, northern style, such that this unusual painting in Chardin's repertory was copied by Paul Cézanne and Henri Matisse and was often imitated by Chaïm Soutine (chapt. XIII, fig. 27). Denis Diderot admired how Chardin was able to "use his talent to prevent the viewer's disgust at certain aspects of nature."

Desportes and Oudry also painted still lifes (figs. 43 and 46) that are beautiful to look at; however, they are empty of meaning and do not inspire metaphysical discussion. Yet make no mistake, these painters of animals, portraits of dogs, and

49. Nicolas de Largillière.
*Etudes de mains* (*Study of Hands*), c. 1715.
(Musée du Louvre, Paris)

50. Nicolas de Largillière.
*Portrait of François-Thomas Germain and His Wife*, 1736.
(Calouste Gulbenkian Foundation, Lisbon)
*Several works by the famous goldsmith are included in this painting.*

chronicles of hunts were not brilliant decorators for kennels and stables. Desportes has left stunningly modern landscape studies, which could be ranked alongside the great landscapes of the nineteenth century. The *White Duck* (fig. 43) is an amazing example of chromatic virtuosity. Oudry was also recognized as one of the best landscape artists of his time.

### The Portrait

If the portrait found even more favor in the eighteenth century than it had in the seventeenth, it is because unlike history painting, it told the story of the present. The artists themselves often portrayed one another as part of their professional practice. Le Brun had set the example by posing as a painter painting for Nicolas de Largillière; Mignard, adopting exactly the same pose, trumped him, and did so in the most decisive way (both works are in the Louvre). Without their enduring gaze, in which the spirit of the century burns, the personages cocooned in velvet, silk, and satin by Rigaud and Largillière (portrait virtuosos and disciples of Rubens and Van Dyck) would be nothing but high-fashion dummies (fig. 47). The tempo of its production suggests that the portrait industry could also be "ready to wear": in one amazing piece, Largillière equipped himself with a repertoire of hands (fig. 49), which he deployed as the nineteenth-century portrait photographer would utilize his props. On the other hand, Quentin de La Tour's portraits are often reduced to a face flecked with streaks of pastel color, a technique that also came from Venice. The eighteenth-century French craze for pastel portraits was launched by the Venetian Rosalba Carriera, a specialist in the genre. She received an overwhelming welcome when she passed through Paris in 1720.

The portrait of Madame de Pompadour painted by Boucher (fig. 52) is a sumptuous genre scene. Baron Friedrich Melchior Grimm, an encyclopedist and friend to the queen, saw in it nothing but a robe "overloaded with ornaments, pompoms, and all sorts of furbelows." This was the robe that the "Favorite" (the king's favorite, who no longer served the king) wore

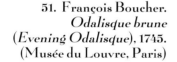

51. François Boucher.
*Odalisque brune*
(*Evening Odalisque*), 1745.
(Musée du Louvre, Paris)

Opposite page:

52. François Boucher.
*Portrait of Madame de Pompadour*, 1756.
(Alte Pinakothek, Munich)

*This portrait was shown at the Salon of 1757.*

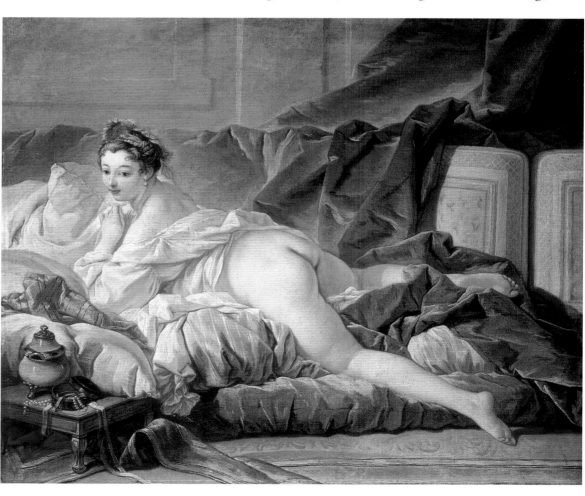

the day she entered the service of the queen as lady in waiting, a badge of honor that she considered worth turning to religion for. But was her conversion real? Contemporaries doubted it—the luxury of this gown (which yet again upstaged her queen) scandalized them. In any case, Madame de Pompadour was certainly not yet converted to the *goût grec* (the early stage of neoclassicism)—the little writing table in the foreground (possibly signed by Bernard II van Risenburgh) is a fine example of that rococo that is also known as the Pompadour style. It would have been nice to be able to set this portrait of Pompadour beside Nattier's delightful portrait of the queen, which evokes the soul of a modest and pious sovereign. But although Boucher's portrait could have been painted during a visit of the "Favorite" to her *hôtel* in Paris, the one by Nattier could only have been painted at Versailles: as the official painter of Louis XV's daughters, the important part of Nattier's career took place outside Paris.

*Low Genre and High Genre*

For the low genre paintings that were so much in fashion, the yards of fabric available were apparently limited. Boucher, who amply draped the cushions in the background with a glorious blue velvet, could not find enough of it to decently cover the *Odalisque brune* (*Evening Odalisque*; fig. 51) that Diderot described in these terms: "a completely nude woman spread-eagled on the pillows, a leg here, a leg there, offering the most sensual face, the most beautiful back, the most gorgeous buttocks, inviting pleasure, and inviting it by the easiest most comfortable position for what one might even call the most natural thing." This nudity would have been less provocative if it had concerned one of Jupiter's love interests, but the work is in all likelihood a portrait, and, moreover, a portrait of Mrs Boucher herself, who was known for being unfaithful to her husband; one such affair was with Casanova. Such paintings did much to corroborate the depraved reputation of Louis XV's reign. The art lover will see nothing more in it than a racy moment of that particularly French sort of painting that was very provocative, such as Le Sueur's *Venus* (chapt. VII, fig. 30) and Ingres's *Odalisques* (chapt. XI, fig. 88).

53–54. François Boucher.
*L'Enlèvement d'Europe*
(*The Rape of Europa*), 1747.
(Musée du Louvre, Paris)

*This picture was painted for the competition opened in 1747 by the new director of the king's buildings, Lenormant de Tournehem, in order to rehabilitate high genre painting (mythology or history). Boucher chose the moment when Jupiter, disguised as a bull, gets ready to carry off Europa.*

Boucher's modernity is affirmed by the diversity of his work, in his landscapes, and in his interior decorations (chapt. X, figs. 69–71). The splendor of his touch must be ignored if one is to see only convention in his mythological scenes. And his *Europa* is certainly a little *godiche*, or silly. The term is contemporary with the *L'Enlèvement d'Europe* (*Rape of Europa*; figs. 53–54) that Boucher painted for the competition of 1747. It was started on the initiative of the new director of buildings, Lenormant de Tournehem, who wanted to revive high genre painting. But Boucher was content to produce low genre in high format. He was on the crest of the wave when he presented the picture to the Salon. It triumphed there, but it earned its author his first unfavorable reviews. Thus the first signs of a change in taste can be dated to this initiative by Pompadour's uncle, de Tournehem. The same year, Lafont de Saint-Yenne published his *Réflexions sur quelques causes de l'état présent de la peinture en France* (*Reflections on Some Causes for the Present State of French Painting*). "The history painter is the only painter of the soul. The rest paint only for the eyes," he wrote. The following year, the Ecole des Elèves Protégés (School for Special Students) was created at the academy in order to inculcate young artists with good principles.

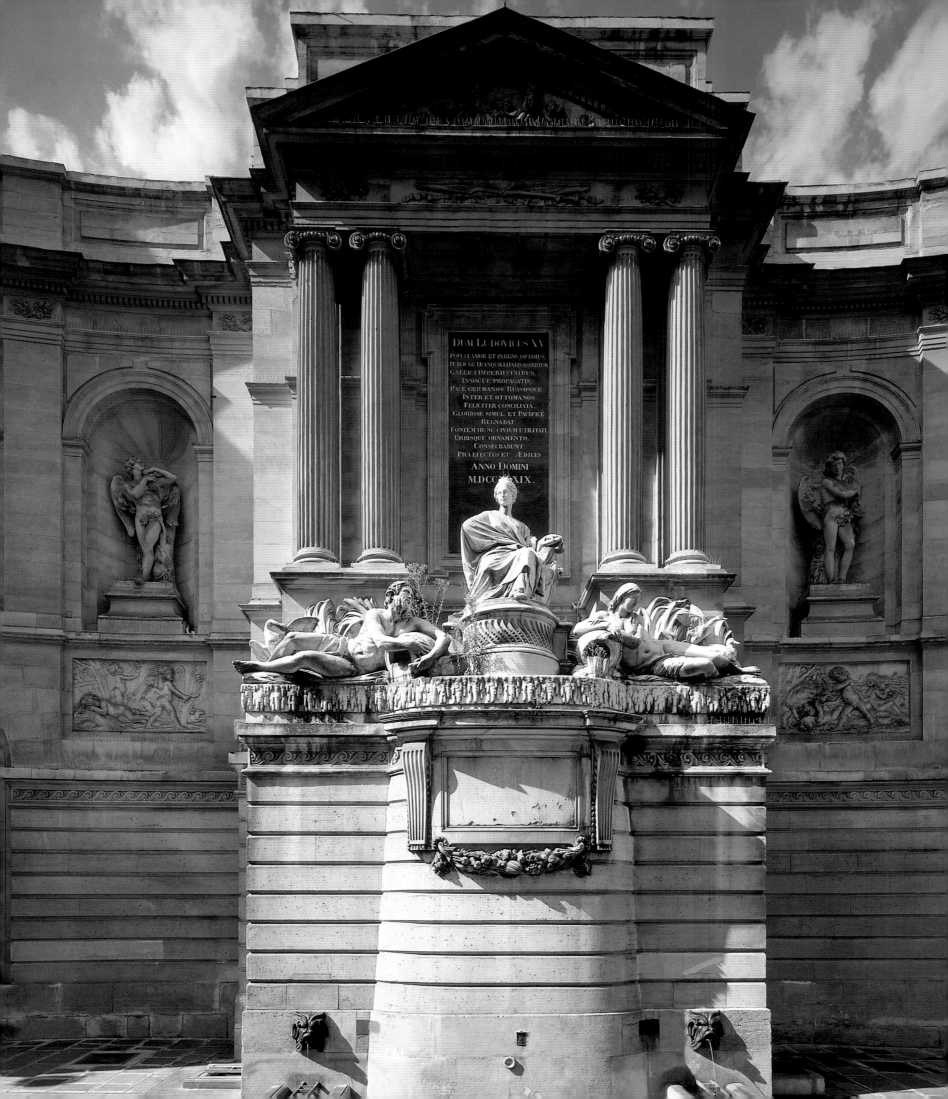

DUM LUDOVICUS XV
POPULI AMOR ET PARENS OPTIMUS
PUBLICAE TRANQUILLITATIS ASSERTOR
GALLICI IMPERII FINIBUS
INNOCUE PROPAGATIS
PACE GERMANOS RUSSOSQUE
INTER ET OTTOMANOS
FELICITER CONCILIATA
GLORIOSE SIMUL ET PACIFICE
REGNABAT
FONTEM HUNC CIVIUM UTILITATI
URBISQUE ORNAMENTO
CONSECRARUNT
PRAEFECTUS ET AEDILES
ANNO DOMINI
MDCCLXXIX

In the first half of the eighteenth century, when staying in Paris was still very popular, public construction projects ceased. It is true that Hardouin-Mansart had already accomplished a lot, but there was still much to be done. The Cour Carrée (Square Courtyard) of the Louvre remained roofless, and the area around the Colonnade still needed to be cleared. There was no Jean-Baptiste Colbert to remind King Louis XV, who had swiftly moved back to Versailles, what he owed to the capital. This is exactly what Lafont de Saint-Yenne declared in *L'Ombre du grand Colbert* (*The Shadow of the Great Colbert*), 1749, when he deplored the abandoning of the minister's great projects for Paris. At the same time, Voltaire published *Embellissements de Paris* (*Refurbishing Paris*), 1749, and he had previously written his *Discours sur ce que l'on ne fait pas et sur ce qu'on pourrait faire* (*Essay on What is Not Being Done and on What Could Be Done*), 1742, in which he recommended the application of modern town planning around artery roads, citing the example of London's reconstruction after the Great Fire of 1666.

This inertia in public construction was due to several factors, the most important of which was the debt left behind by Louis XIV, which had become a serious burden on state finances. On top of that, neither the regent nor Louis XV had a taste for formal display, ostentation, great spaces, or monuments. "It seems that it was this lack of opportunity to build great monuments which imperceptibly accustomed architects to lose sight of the origin of the precepts of their craft" wrote Jacques-François Blondel in *De la distribution des maisons de plaisance et de la décoration des édifices en général* (*On the Distribution of Secondary Leisure Residences and the Decoration of Buildings in General*), 1737–1738.

*Publicly Commissioned Buildings*
The main construction project of the first half of the eighteenth century was to finish the church of Saint-Sulpice. This parish church had become one of the most important in Paris thanks to the development of the Faubourg Saint-Germain. In 1726 Meissonnier apparently took the initiative of designing plans for the west facade of the church, but his design (fig. 56) was as convoluted and overly ornate as his famous candlestick. In 1732 an architectural competition was set up for the church's front wall project. Servandoni's design (figs. 57–58) won the competition over that of Gilles-Marie Oppenord. Oppenord had been directing the construction work since 1719, even though Servandoni was only a specialist in theater set design, trained by Giovanni Pannini, the great painter of Roman scenography. Strangely enough, Servandoni's design was not that different from Oppenord's, and in fact rather banal. At that time, facades with two towers

**55. Edmé Bouchardon. Fountain of the Four Seasons, also called Grenelle's Fountain, 1739–1745.**

*This fountain was built on Rue de Grenelle between 1739 and 1745.*

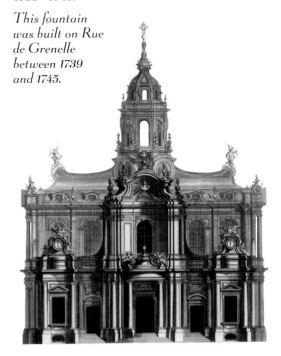

**56–59. West Facade of the Church of Saint-Sulpice**

*In 1726 Juste-Aurèle Meissonnier presented a design for the west facade to finish the church of Saint-Sulpice, whose construction had begun in 1643 (above). But the elevation was finally built according to the design of Giovanni Niccolò Servandoni, who won the architectural competition held in 1732 to finish the church. The plans changed quite a bit between 1732 (top design shown) and 1749 (bottom design shown). However, by the time the church was officially consecrated, only the lower parts had been built, and the construction work was officially halted in 1775 before it could be finished.*

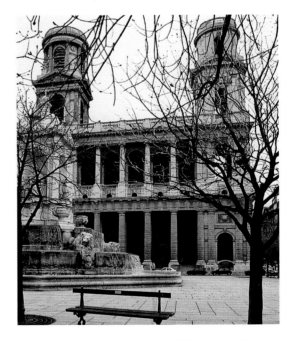

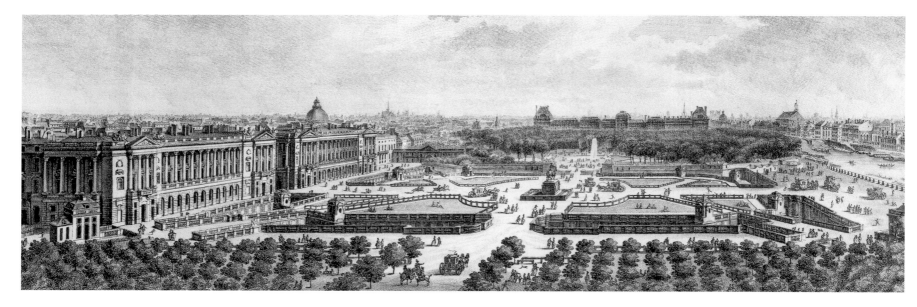

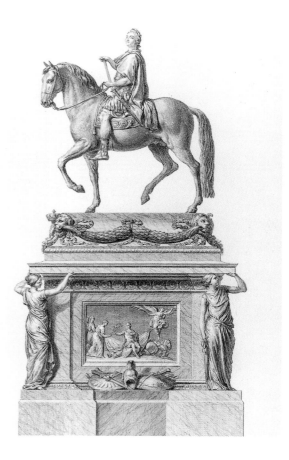

### 60–63. Place Louis XV (Place de la Concorde)

*In 1748 the city of Paris decided to erect a statue in honor of Louis XV, and so the Academy of Architecture launched a competition for the design of a royal square. In 1753 a second competition was held: the square had to be situated on the banks of the Seine between the end of the Tuileries gardens and the beginning of the Champs-Elysées. A.-J. Gabriel, First Architect to the king and director of the Academy, was given the task of combining the best ideas from the various proposals. The final version of the design was approved in 1755, but the project was delayed by the Seven Years War (1756–1763). The facades were finished in time for the inauguration of the statue in 1763. The statue was commissioned from Edmé Bouchardon in 1749 and finished after his death.*

were in fashion, and both Servandoni's and Oppenord's designs featured them. This part of the design was deemed medieval because of the towers, but it also recalled the designs for the facade of Saint Peter's in Rome of the early sixteenth century, which had the same structure. As for Servandoni's towers, they were clearly borrowed from Borromini's design for the Roman church of Sant'Agnese. In 1749 the construction work was halted and Servandoni left for England, where he was authorized by the British parliament to publish a print of his design, which looked more like Saint Paul's Cathedral in London (designed by Christopher Wren) than what he had just built in Paris. Clearly the reference to Saint Paul explains the significant changes in his design from the time the original plans had been submitted. Nevertheless, Servandoni obviously could not entirely give up his original ideas for the church, and so his final design lacked the noble gravity of Wren's masterpiece. Still, Servandoni's design gave him the reputation as a precursor of neoclassicism.

While rococo triumphed for interiors, only Grenelle's Fountain (fig. 55) still preserved the "Grand Manner"—that is, it drew from the past and the future with the concavity (called the *tour creuse* or "hollow face" in the language of the time) of the Collège des Quatre-Nations (chapt. VIII, fig. 1) and the style of Louis XVI that was still in the shadows; indeed the reliefs of the four seasons were copied hundreds of times during the second half of the century.

As in every era when publicly commissioned works were few and far between, architecture turned to "paper projects," or architecture that is designed in the knowledge that it will probably never be realized. The most grandiose, diverse projects were set forth, especially for the design of the proposed royal square dedicated to Louis XV. There were multiple designs for the square, as is witnessed in Pierre Patte's *Monuments érigés en France à la gloire de Louis XV* (*Monuments to the Glory of Louis XV Built in France*), 1765, which also contains a great many monuments that were never built. The project for the royal square did not come into being until the middle of the century, when Ange-Jacques Gabriel directed the work on the new Place Louis XV (figs. 60–63). Gabriel, who was the First Architect to the king, was the son of Jacques Gabriel, who had held the same title, grandson of Jacques IV, who had also been a royal architect, and great grandson of a provincial architect. He was therefore the guardian of and heir to a long tradition that legitimately included that of the Perraults and the Mansarts. His design for the Louis XV square shows this. He placed the square at the edge of the city, as Hardouin-Mansart's Invalides had been, and as Gabriel's Ecole Militaire would also be. It is true that the weight of circumstances played an

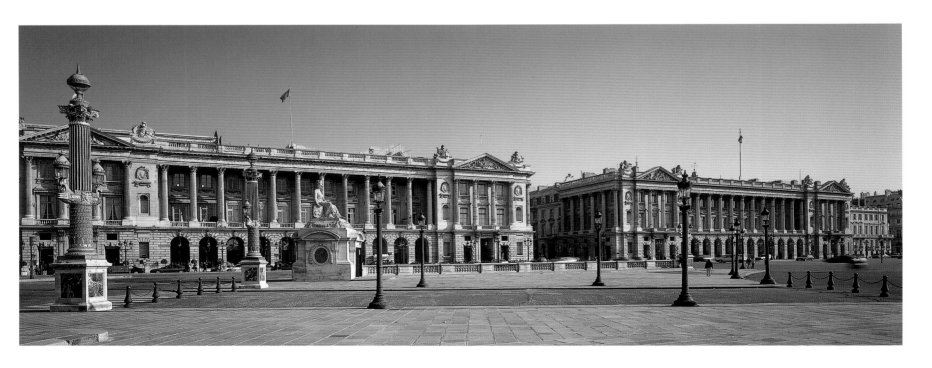

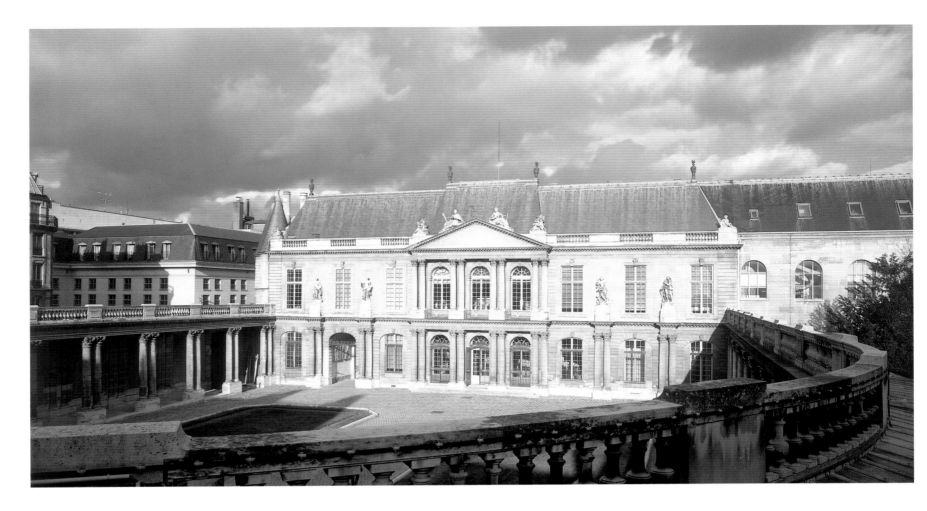

### 64–65. Hôtel de Soubise

*This hôtel, one of the biggest in the Marais quarter, was built starting in 1704 by Pierre-Alexis Delamair for François de Rohan, prince of Soubise, on the location of the former Hôtel de Guise. In order to make space for the unusually large courtyard, Delamair turned the building ninety degrees, placing the new entrance on a street (Rue des Francs-Bourgeois) perpendicular to the original entrance. This meant that the main building, which had not been rotated, ended up perpendicular to the building at the back of the courtyard and hidden by it. The prince's apartments (on the ground floor) and also the princess's (on the second floor) were located in this main building and were redecorated starting in 1732 for the wedding of Hercules Mériadec, François de Rohan's son. The redecoration work was directed by Germain Boffrand (figs. 11–12).*

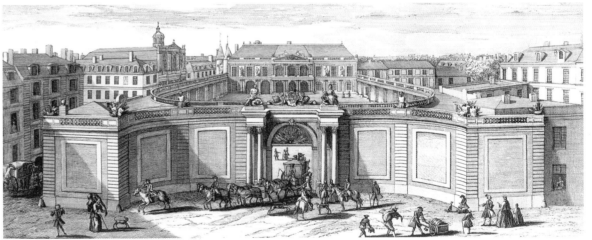

undeniable role in the choice of location, but the choice was also clearly based on a view of urban planning that was the exact opposite of what Voltaire advocated, because it implied the destruction of the old city.

The layout of the square was unprecedented. The royal statue in the center was isolated by a ditch, which formed a kind of sanctuary, and the square was made up of wide open spaces facing out on nature on three sides (the river, the Champs-Elysées, and the Tuileries gardens), with buildings on only the fourth side. The design of the buildings owes much to the Louvre Colonnade, and the resemblance goes as far as the details, such as the alignment of the podium with the columns and the medallions draped with garlands, which Perrault had himself borrowed from Lescot's Louvre. On the other hand, deeply grooved rusticated masonry is closer to the Italian style of the sixteenth century. The same style of rustication also features in Inigo Jones's design for Covent Garden and in most works by English

Palladians from 1720–1730. Gabriel's design for the Place Louis XV was fixed before the declaration of the war against England, which lasted seven years, but construction only began after the Peace of Paris, which confirmed the enemy's superiority in 1763.

Thus the slack in public construction, whose onset can be identified in the abandoning of Hardouin-Mansart's project for the square in front of the Invalides (chapt. VIII, fig. 51), lasted for a good half a century. But this did not prevent leaps of imagination. Temporary architecture for funerals and public celebrations served as outlets. Thus the Jesuits' students staged tragedies every year with scenery by their own Andrea Pozzo, a brilliant set designer and author of the superlative *Ascension of Saint Ignatius* in Rome. The academy's annual Grand Prix competition, whose laureate won a royal pension allowing him to study at the French academy in Rome, was a fine opportunity to create architectural fantasies on paper, if under the supervision of the academy (figs. 77–78). In 1752 the academy chose Charles de Wailly's project as the winner, a precociously Roman design for a student who had not yet seen Rome (fig. 79).

*Privately Commissioned Works*
For half a century, private commissions (which were particularly intense between the death of Louis XIV and the start of the Seven Years War) took up the slack from public commissions. Following the example set in Hardouin-Mansart's time, the most notable creations were concentrated in the new quarters, now expanding toward the west. The nobility particularly coveted the Faubourg Saint-Germain on the Left Bank. On the Right Bank, from the Palais Royal to the Faubourg Saint-Honoré, a vast complex developed that might be called a "business quarter"—if the notion of commerce can be applied to the profitable business of luxury and love. Madame de Pompadour had her *hôtel* in this quarter, on the western edge of Paris (now the president's Palais de l'Elysée). One exception was the Hôtel de Soubise (figs. 64–65), which was built on a historically significant site in the old Marais quarter. But it is important not to overlook the numerous decorated rococo facades, which show that other (clearly) important residences were also built or renovated in the old quarters. These houses, constrained by their small plots, grew ever taller. This greatly astonished Persan de Montesquieu: "The houses are so tall that one would think only astrologers lived in them. [Paris is] a city built in the air, with six or seven houses stacked on top of one another" (*Lettres Persanes*, or *Persan's Letters*, 1721). Thanks should be given to those middle-class Parisians who modernized the center of the city without destroying it, in spite of Voltaire.

**66–67. Hôtel Amelot de Gournay**

*This hôtel was built by Germain Boffrand on a piece of land that he bought in 1712 (1, Rue Saint-Dominique). A year later he sold the house (still under construction) to a diplomat, Michel Amelot de Gournay.*

**68–69. Hôtel Matignon**

*It was begun in 1720 by Jean de Courtonne for Christian-Louis de Montmorency-Luxembourg, Lieutenant General of the king's army. In 1723, during its construction, it was sold to Jacques de Matignon, count of Thorigny.*

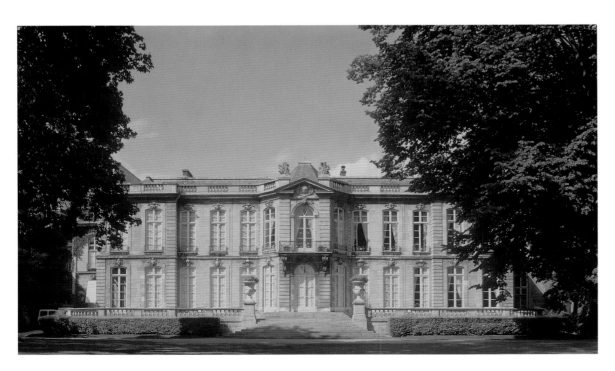

Exclusively Parisian, the *hôtels* that have contributed so strongly to the reputation of French architecture throughout Europe are distinguished principally by their organization and interior decoration. Interior organization, a specialty developed by French architects, became a form of perfection. Through the multiplication and specialization of the rooms (and the miniaturization of some), the improved connections helped to reduce and even eliminate the buildings' inconveniences. The greatest ingenuity was devoted to making houses more comfortable. At the Hôtel Amelot (figs. 66–67) the oval courtyard is not only a pleasant elegance, not only a quasi-reception room or a meeting place, it is also a device that packs into a tight space all the rooms of that repertoire, from the porter's lodge to the salon. In the Hôtel Matignon (figs. 68–69), which is the French Regency *hôtel par excellence*,

**70–73. Hôtel Peyrenc de Moras, also called Hôtel Biron, now the Musée Rodin**

*This hôtel was built in 1727 by J. Aubert for the financier A. Peyrenc de Moras.*

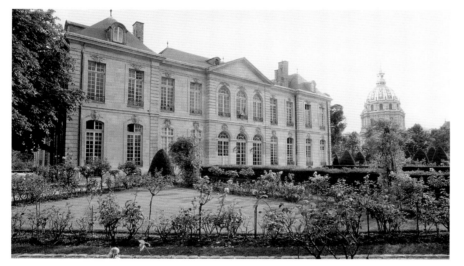

all of the traditions of French architectural layout as they appear in the imitations of Mansart's and Louis Le Vau's *hôtel* designs were reproduced and reconceived. The continuous wall that would ordinarily divide the main building into two rows of rooms has been replaced with shorter partition walls that cut the block into sections. This solution perfectly reconciles the misalignment of the garden and courtyard through the offset frontispieces on each side. In another typical feature of the French Regency style, the main building is to some extent freestanding, which allows it to have side facades, which face the garden.

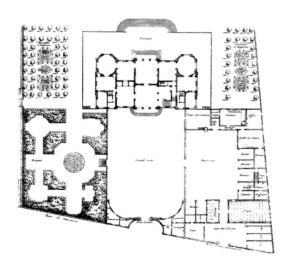

The freestanding design can only be explained by reference to the emerging success of the country house, that second home of the Parisian *hôtel*-owners, in the Ile-de-France. Two Parisian residences originally built outside Paris, in the Faubourg Saint-Germain, will provide examples. These are the Hôtel Peyrenc de Moras (figs. 70–73) and the Palais Bourbon (figs. 75–76). Because of its unusually extensive land, the close similarity of its plan to those of contemporary châteaux (such as Champs-sur-Marne), and its completely freestanding main block, the Hôtel Peyrenc de Moras is justifiably representative of the ideal residence described in treatises *De la distribution des maisons de plaisance* (*On the Layout of Country Seats*), 1737, by Blondel and *L'Art de batir des maisons de campagne où l'on traite de leur distribution, de leur construction et de leur décoration* (*The Art of Building Country Houses, Their Layout, Construction, and Decoration*) by Charles-Etienne Briseux. In its original state, the Palais Bourbon, which was inspired by the Great Trianon of Versailles, was unquestionably the most prominent *hôtel* in Paris. Not since the Luxembourg Palace had a private building been such an important part of the sights of the city. It was also important because of its reputation for being the first example of the modern arrangement. It was especially admired for the rigorous separation of the reception rooms and the private apartments.

In the private apartments, the overlapping of the open spaces and the miniaturization of the rooms was pushed to an extreme. This palace justified Cochin's saying "The higher a person's dignity, the smaller their apartment!" In fact it was Louis XV himself, in his desire for privacy, who had launched the fashion for such small rooms.

This is why the best example of this miniaturization of rooms was not in Paris but at Versailles: the Petite Trianon, built in 1762 to 1764 by Gabriel for Louis XV, who wanted it to be a gift to Madame de Pompadour. But the very Parisian annual academy competition can be cited as well, and produced many works of the nascent Louis XVI style (figs. 77–78). That competition and the Trianon were rightly considered the first signs of what could already be called the Louis XVI style.

*Relations with England*

There is a question of just how much English architectural style influenced the Louis XVI style. Up until then, French architects had not traveled to England, where Palladio's works had produced such an original classicism. The one exception was Servandoni. However, the growing Anglo-mania, which developed thanks to the circulation of ideas, created a favorable atmosphere in France for the *Vitruvius Britannicus* (1715–1717) to be received. Colin Campbell published this work to show the excellence of contemporary architecture in Great Britain. Yet the publication did not convince everyone. A connoisseur, Abbot Le Blanc wrote in his *Lettres d'un Français* (*Letters from a Frenchman*), 1745. "The English Vitruvius seems to have been written to prove that architecture was not naturalized in England." Still, in this case Jacques-François Blondel's opinion carried more weight. On the subject of the nations of Europe he wrote: "With the exception of a few monuments for which these countries had called famous French and Italian architects, one can hardly see anything in their buildings but incorrect members, weird forms, and muddled ornamentation. England, if I may say so, is perhaps the only one that has kept to the good form of the Ancients … The English have resisted that nationalistic spirit which has conquered all courts." Of course, this "confession" was only torn from him belatedly, in the *Cours d'Architecture*, 1771–1777, yet it must have pained Blondel, an ardent partisan of French classicism. To counter the effect of the *Vitruvius Britannicus*, he had published the great work *L'Architecture Française* (*French Architecture*), 1752–1756. Even more significant, he founded in Paris, on Rue de la Harpe, an art school that was officially recognized as a public teaching institution in 1743. It was to ensure the spread of the French example throughout Europe for many decades. Blondel's stroke of genius was to transform the collective school model into a teaching institution without precedent in Europe. The students were meant to "go forth to far away countries and carry with them our French models and building designs, carry our professional practice far abroad, one day" (*Cours d'Architecture*). However, it was not Blondel who brought the first foreign architect to Paris for his training: passing through Paris in 1669, the great Wren—future architect of Saint Paul's Cathedral in London—had already declared that France (evidently he was thinking of Paris) was an "architectural school" and "probably the best in Europe today."

74. Jean-Sylvain Cartaud. Hôtel Heusch de Janvry, also called de Boisgelin Hôtel (47, Rue de Varenne), built in 1732.

**75–76. Palais Bourbon**

*The Palais Bourbon was built on the banks of the Seine between 1722 and 1728 for the dowager duchess of Bourbon. Of the various architects who worked on the building, it is not clear who was responsible for which parts: there were Giardini and Lassurance, who were project managers for a short time; J. Aubert, who signed the construction contracts (but only in 1726); and Jacques Gabriel, who guaranteed his contracts. The Palais Bourbon underwent drastic changes in the nineteenth century to house the Parliament. The reception rooms were in the center and the right wing, whereas the private apartments were in the left wing.*

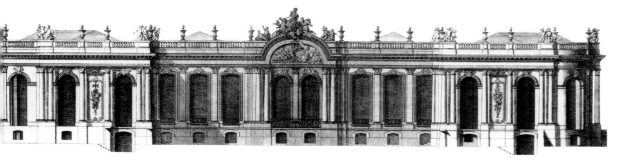

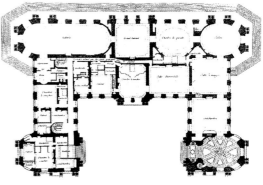

*In 1758 the theme for the academy's annual competition was a pavilion. The Grand Prix was awarded to this plan by Cherpitel.*

## 5 – THE ORIGIN AND SPREAD OF THE FRENCH STYLE IN THE EIGHTEENTH CENTURY

The decorative art that developed in Paris and Versailles from 1700 to 1760 has been interpreted in contradictory ways. The rococo style was supposedly the natural evolution of the official royal style, which had to adapt to financial hardships, the aging of the court, the move toward Paris, the rejection of etiquette, and the relaxation of manners. For some contemporaries, the *rocaille* style came from far away: it was the resurgence of the Gothic tradition, with which it shared a certain naturalism. President de Brosses wrote in his *Lettres d'Italie* (*Letters from Italy*), 1739, "In questions of fashion, we are returning to the taste for Gothic. Our fireplaces, our gold boxes, our silver dishes are curved and convoluted, as if we had no more use for round and square shapes … Our ornaments have become the latest baroque." The word "baroque" (defined in dictionaries of the late seventeenth and early eighteenth centuries as a term for jewelry, typically meaning "irregular" or "strange") is here associated with the word Gothic (itself a recently coined disparaging epithet) in one of its first applications to the arts. Similarly, Borromini's detractors did not call him "baroque," but *gotico ignorantissimo* (extremely ignorant Gothic).

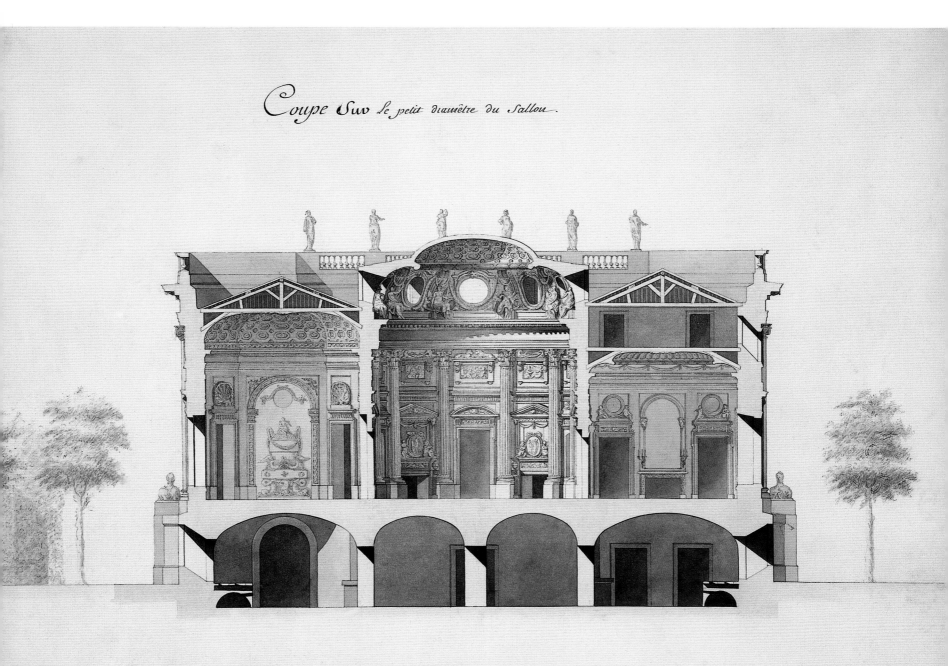

*Coupe sur le petit diamètre du Sallon.*

*Gothic*

However, the true Gothic style began to find its champions. The essential texts are the *Dissertation touchant l'architecture gothique et l'architecture antique* (*Dissertation Concerning Gothic and Antique Architecture*), 1699, by André Félibien; *Mémoires critiques d'architecture* (*Critical Memoirs on Architecture*), 1702, by Michel Frémin; *Traité de toute l'architecture* (*Treatise on all Architecture*), 1706, by Abbot Jean-Louis de Cordemoy; and *Essai sur l'architecture* (*Essay on Architecture*), 1753, by Father Laugier. Cordemoy wrote on the subject of cathedrals, "How can one enter them, Gothic as they are, and not be seized with admiration?"

What was admired was the loftiness and light of the Gothic cathedral, not its pointed arches, its compound piers, or its lancet and rose windows. So true is this that the compound piers of Gothic choirs in Paris were being disguised as classical columns at that time. Saint-Séverin was converted as early as 1681, followed by Saint-Merri, Saint-Nicolas-des-Champs, and Saint-Germain-l'Auxerrois in the middle of the eighteenth century. So how could anyone have predicted that the hidden cost of rehabilitating the Gothic would be the bankrupting of classicism and neoclassicism—in other words, the Counter-Reformation and churches of late antiquity, which comprise three or four centuries of religious architecture?

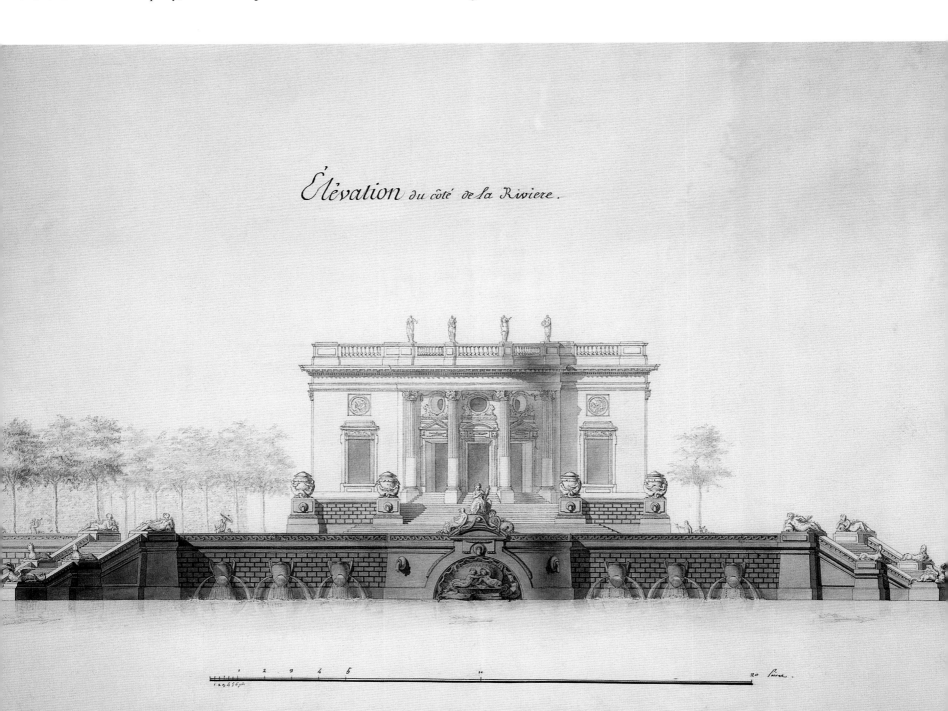

*Baroque*

The eulogists of classicism blamed all this disorder on immigration, which brought with it the virus of the baroque. Analysis proves them right. Cardinal Mazarin's Italians, the Cuccis and the Caffieris, created the Louis XIV style. In the working-class neighborhoods, one out of three cabinetmakers came from the Netherlands. Van Risenburgh was Dutch. Oppenord, also of Dutch origin, was one of the first to have a royal scholarship at the Academy of France; he used his stay in Rome to devour Bernini's and Borromini's work. Cochin, one of the advocates of *goût Grec* (the early stage of neoclassicism), complained "He turned his back on the good taste of the century of Louis XIV." Meissonnier, who was born in Turin, where Guarino Guarini produced his masterpieces, also owed a lot to Borromini. "He was an undisciplined genius, and also was spoiled in Italy by his admiration for Borromini," stated Cochin. Vassé arrived just as Oppenord returned from Italy. Indeed, the prow above the mirror in the Dorée Galerie (Golden Gallery), emblem of the count of Toulouse, admiral of France (fig. 9), could have come from the naval shipyard in Toulon where Vassé had begun his career and where Puget, the famous sculptor, carved figureheads that would have been right at home in the naval shipyard of baroque Genoa. Pineau and Boffrand's rococo owed a great deal to the time these masters had spent in Russia and Germany. The drawing room in the Hôtel de Soubise would fit right in with Amalienburg, near Munich. Oeben and Riesener were both of German origin: from the mid-eighteenth century on, a third of the foreign cabinetmakers in the working-class neighborhood were no longer Dutch, but German.

*The King's Taste*

Nonetheless, the metamorphosis was accomplished in the Parisian melting pot. Perhaps this change would have remained purely local if it had not been governed by the most powerful monarch in Europe. It was the king's taste and influence that allowed Parisian craftsmanship to become known all over Europe. Despite the obvious differences between the Louis XIV and Louis XV styles, the period drew real unity from the direct reference to the king. It would be nice to be able to make a distinction between the two styles by drawing a line at the exact year of the elder's death in 1715. Naturally, his death accelerated the courtiers' return to Paris, but it did not coincide with the birth of the transitional style of French Regency that owes its name to the regency of the duke of Orléans. The biggest changes happened before then, around 1700, as a consequence of financial problems, but also because of a change in taste of Louis XIV. The aging monarch wrote on a 1699 memo from Mansart proposing a mythological decor for the menagerie at Versailles: "The themes are too serious ... there has to be some youthfulness in what we do!" It is equally fruitless to look for a second change when the court returned to Versailles and when Louis XV came of age (1722 and 1723); rococo did not become established until the 1730s.

*Eclecticism*

Nevertheless, perhaps nothing would have happened without the decay that set into the system during the first years of Louis XIV's personal reign. At the Parisian academy, Colbert's two protegés, François Blondel and Claude Perrault, fought over the definition of beauty. Blondel, a mathematician and engineer, championed the existence of "positive rules." Perrault, who was a man of experimental science, declared that good taste was nothing more than a matter of habit. Perrault's theory on the relativity of beauty held the least eclecticism. Just as audacious was Perrault's proposal to create apartments in the Louvre in "the styles of all the most famous nations—the Italian style, the German style, the Turkish style, the Persian style, and the styles of Mongolia, the King of Siam, and China" so that the ambassadors of these countries could say that "France is like a microcosm of the world" (quoted by Blondel in *L'Architecture française*, or *French Architecture*, 1752–1756).

The questioning of the authority of ancient and traditional beliefs, the critical revision of fundamental notions, the resorting to the experimental and comparative method, and the discovery of relativity all appear simultaneously in the *Parallèles des Anciens et des Modernes* (*Parallels between the Ancient and the Modern*), 1688, by Perrault and in *Entretiens sur la pluralité des mondes* (*Discussions on the Plurality of our Worlds*), 1686, by Fontenelle. The philosopher's thoughts, which attacked both revealed and metaphysical religions, were certainly more subversive. But Perrault's ideas, in as much as they comported with academic authority, introduced a disjunction into the ordered beauty of Louis XIV's reign, which, with time, would become fatal.

The discovery of the world began with China. At first it was only the importing of lacquer and hard porcelain, and French artisans worked hard to try to figure out how this porcelain was made. But by 1670 Le Vau had built a little castle at Trianon in the Chinese style and it was called the "porcelain" Trianon because it was entirely covered in blue ceramic, which was actually pottery. The chinoiserie then began to appear in decoration, often associated with Bérain-like grotesques and monkey motifs—an association that was not a mockery of the empire of the east, but the cheeky face of an apish culture reduced to imitation by the tyranny of fashion. Jean-Baptiste Huet, a coach and sedan chair painter, made monkey designs his specialty (fig. 10), while a monkey painting a picture became the subject of paintings.

*The Classical Reaction*
Exactly one hundred years after Fréart de Chambray had led a fight against "transalpine architecture that is even more barbaric and less pleasant than the Gothic style," a reaction was organized to restore a grand style by imposing an ersatz called *goût Grec* (the early stage of neoclassicism). This style did not have much to do with Lescot or Goujon's Atticism, which was the source of French classicism, nor with the image of ancient Greece that began to appear through the Roman style. The important thing was that it was new, and that the Parisians, who were great consumers of anything new, were bored with the rococo. But in *L'Ombre du grand Colbert* (*The Shadow of the Great Colbert*), 1749, which has already been cited, Lafont de Saint-Yenne did not burden himself with false pretenses: this was all about returning to the Louis XIV style. The same year as this declaration, the Marquis de Marigny (the younger brother of Madame de Pompadour) whom Louis XV had chosen to be director of buildings, traveled to Italy accompanied by three mentors, Cochin, Soufflot, and Abbot Leblanc. It was an initiation journey whose sole aim was to warn him against Italian *concetti* (ideas). In 1754 Cochin published *Supplique aux orfèvres* (*Petition to Goldsmiths*), in which he wrote: "Only when objects can once again be square, when [goldsmiths] deign to not convolute them, only when crowning decorations will be centered on arches, when they agree to not corrupt with S-shaped contours, and when they seem to have learned from master writers, who are so much in fashion ..." The conclusion of the *Supplique* is peculiar: "... Only then, we consent to [the goldsmiths] serving up such convoluted merchandise to provincials and foreigners who are poor enough connoisseurs to prefer our modern taste to that of the last century. The more we spread our inventions among foreigners, the more we can hope to maintain the superiority of France." France (here explicitly confused with Paris) is exhorted to remain or to become again the paragon of good taste.

*The Destiny of the Provinces*
One wonders what was happening in the provinces all this time. The stigma of the provincial only really affected the countryside and small towns: under the strong leadership of the Intendants (the administration set up by Colbert), provincial capitals would try to raise themselves to the level of Paris. After Lyons (in 1700), the big cities set up academic institutions. Thanks to the commissions of the king's architects, the provincial capitals were profoundly transformed—made somehow more French—during the first half of the eighteenth century, and the local vernacular was pushed farther into the countryside.

In order to achieve this transformation, they first had to convince the provinces of their poverty. This work on the provincial mind took place in the last years of the seventeenth century when Louvois attempted to convince the provincial capitals to create royal squares following the example of Paris. "One has to go all over Paris and the surrounding area to see all the town halls and country residences. It is only up to the specialists, the partisans and merchants, to build in the Paris region. The Provincials, as they have nothing, do nothing." This passage is quoted from a twenty-four-page book without illustrations that was pompously entitled *Traité d'architecture* (*Treatise on Architecture*), published in Bourges in 1688 by Catherinot. But if one judged only by contemporary accounts, there were no longer any architects in the provinces who knew how to build. The publication of treatises in Paris specifically aimed to make up for the shortcomings of the provincials increased. *L'Art de bâtir* (*The Art of Building*) by Briseux was one of these: "People who frequent the provinces will recognize the need for this work much better, because they know the visible lack of order in the buildings raised there ... This lack often results from the difficulty in finding a skilled architect in these places."

If this architectural void in the provinces was less noticeable in the eighteenth century, it was because Paris had invaded France. "From the capital of France, good taste in the arts spread to the major cities of our provinces" wrote Blondel in *Cours d'Architecture*. This simply meant that Hardouin-Mansart showed up in Arles, Dijon, Tours, Lyons, and so on, and that his example was followed by architects like De Cotte, Gabriel, and other resident foreigners. This investment in the provinces was made by the capital rather than by the king. The concept of urban architecture was spread and the big provincial cities were beneficiaries. "In the wake of the capital, our provincial cities showed their appetite for improvement ... A century ago, there were hardly any cities worthy of foreign interest; today, a great many are adorned with the most sumptuous buildings" (*Monuments érigés à la gloire de Louis XV*, *Monuments Raised to the Glory of Louis XV*). Patte illustrated this statement with all the royal squares that had been commissioned from Parisian architects by the provincial administrators. In the same period, La Martinière wrote: "Aix is one of the cities in the whole kingdom that best imitates Paris, as much by the grandeur of its buildings as by the urbanity of its inhabitants" (*Le Grand Dictionnaire géographique et critique*, or *The Great Geographical and Critical Dictionary*, 1726–1739).

The first success of the French School was in the provinces where schools of architecture (copies of Blondel's institution) began to open. The one in Lille was founded in 1762 by the architect Gombert, who taught that "modern architecture is that which is organized according to Classical proportions, comprises formal elegance and interior comfort, and may be designated by the term French architecture." It should be understood that the French style of architecture was on a mission to test new ground in Lille, which had only been annexed to the kingdom in 1667, and its architecture up until then could be summarily labeled as Flemish.

Even more than Paris, the south of France was permeated with Bernini's designs. Puget was perhaps the most Berninian of French sculptors, although he also made wide use of the resources of Italian sculpture. Puget's career was circumscribed by Marseilles and Genoa, and his two masterpieces, *Milon de Crotone* (*Milo of Crotona*) and *Persée délivrant Andromède* (*Perseus and Andromeda*), were only belatedly drawn toward Paris and got no farther than Versailles. Talented sculptors and painters remained active in the provinces throughout the century, especially in the Languedoc. But Watteau quit Valenciennes to come to Paris, and Hyacinthe Rigaud abandoned Perpignan. Thus the capital's magnetism was felt from frontier to frontier, north and south of the kingdom.

Luxury industries were not completely missing from the provinces. Lyons had the monopoly on silk. Carpetmaking was installed at Beauvais, and developed in Aubusson and Felletin as

well. The production of mirrors in Reuilly fled to Tourlaville in Normandy, then to Saint-Gobain in Picardy. Faïence prospered in Marseilles, Rouen, and in Moustiers-Sainte-Marie. But cabinetmaking, with rare exceptions at Lyons, Marseilles, and Bordeaux, was unknown in the provinces—although utilitarian furniture making continued to flourish there. The eighteenth century was the great century of regional furniture, from the Normandy wardrobe to the Provençal buffet.

With respect to the spread of French style, the foreigner was put on the same footing as the provincial in Cochin's astonishing comments cited above. The eighteenth century originated the extraordinary fact that the distance separating the capital and provincial towns seemed no less great than the distance separating that capital from those of other kingdoms. Whereas Baron de Montesquieu recognized in the provinces the problematic buffer zones of neighboring states, the enterprising citizenry of those states declared themselves French. Thus in the Lorraine (which is still not completely French) Duke Stanislas created a square in Nancy, in 1752, to receive a statue of Louis XV—and the facades constructed by Héré, a student of Boffrand's, extended those built by Boffrand himself in the neighboring square—which in turn relied on the royal squares by Mansart. And in Toulouse, in the Capitole in 1750, the same scenario repeated itself, with the same stylistic consequences. Thanks to Paris, France—if not Europe—was from then on truly French.

*The Conquest of Europe*
The Abbot of Saint-Pierre gave the signal for the intellectual and artistic conquest of Europe in his induction speech to the Academie Française in 1695: "Instead of our arms, which have been so long victorious, our (artistic) works will conquer Europe by imperceptibly subjecting other nations to our opinions, sentiments, and taste." The universality of the French language had opened up the way for literary and artistic products. "The French language is, from now on, the form of communication of all the nations of Europe, a language that could be called transcendental," wrote Bayle in 1685 in *Les Nouvelles de la République des lettres* (*News of the Republic of Letters*), published in Amsterdam. But there again, leadership was not absolute. The English model had more and more followers among the French elite. As a result of the Great Fire of 1666, which made complete reconstruction necessary, London had taken on the appearance of a modern metropolis. From then on its population exceeded that of Paris, with 700,000 inhabitants in around 1750 while Paris only achieved 600,000 by the eve of the Revolution.

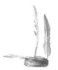
**79. Charles de Wailly.**
**Architectural plans submitted for the Grand Prize of the academy competition in 1752.**
(Ecole Nationale Supérieure des Beaux-Arts, Paris)

*De Wailly won the 1752 Grand Prize with this plan for the facade of a palace.*

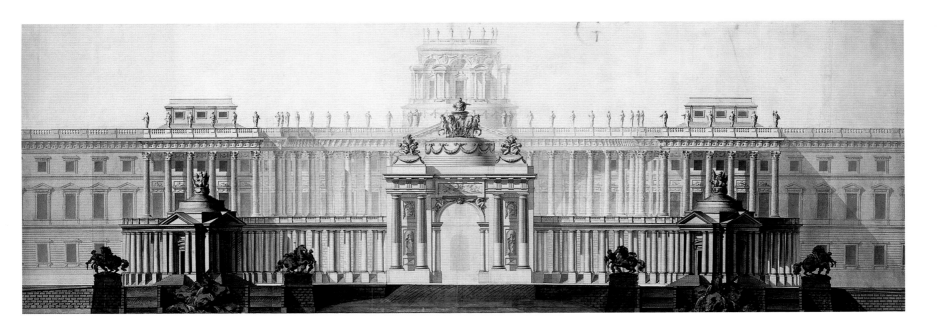

# The Pantheon
# Formerly the Church of Saint-Geneviève

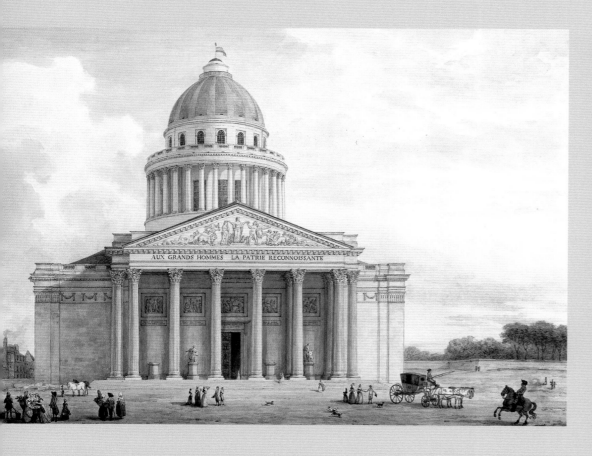

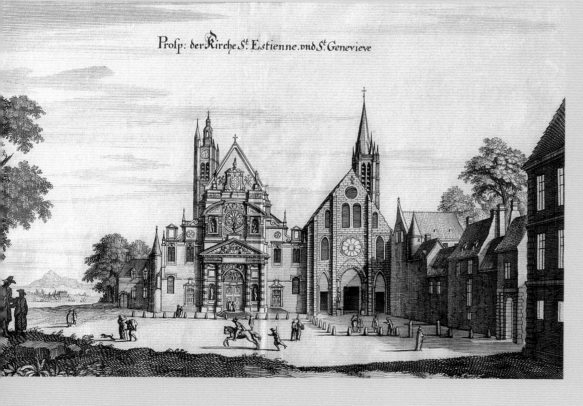

Prosp: der Kirche St. Estienne. vnd St. Genevieve

The church of Saint-Geneviève was built at the top of Mount Saint-Geneviève in the second half of the eighteenth century, and was transformed into the French Pantheon in 1791 to house the tombs of the great men of the nation. (Voltaire's tomb was placed there in 1791 and Rousseau's in 1798.) Twice returned to the church during the nineteenth century, it reverted to the Pantheon in 1885 to receive the body of Victor Hugo.

At the top of the hill that would later take the saint's name, Clovis had built the church of the Holy Apostles in 508 to house his own tomb, that of his wife Clothilde, and that of Geneviève. A new church dedicated to Saint Geneviève was built in the eleventh and twelfth centuries, and it was only demolished in 1802 to make way for a new street, Rue Clovis. Part of it survives in the bell tower, called the Clovis Tower. The church was tended by a chapter of regular canons called the Genovéfains; part of their convent buildings are still standing in what is now the Henry IV High School. In 1744, as the result of a vow, Louis XV made a pilgrimage to visit the tomb of the saint and promised the Genovéfains that he would rebuild their church at the crown's expense. The work only began in 1757 based on a design by Jacques-Germain Soufflot. The new church was founded in front of the eleventh- and twelfth-century structure. It took another ten years to build the crypt. In 1764 the cornerstone was laid in a ceremony held before a full-scale painting of the future portico. By the time Soufflot died in 1780, the main body was much advanced. Soufflot's intention had been to reconcile ancient Greco-Roman architectural style with the complex structures of Gothic architecture. His cupola with a domed lantern tower took inspiration from Saint Paul's Cathedral in London.

In order to transform the church into the Pantheon, the windows were walled up. The present facade was designed in 1830 by David of Angers. The program for the interior paintings was established in 1874 when the building was returned to the church. The principal paintings are by Pierre Puvis de Chavannes, Jean-Paul Laurens, and Léon Bonnat.

Opposite, top:

*B. Hilaire. The Pantheon in the year II (Bibliothèque National de France, Cabinet des Estampes, Paris)*

Opposite, bottom:

*Mérian. The church of Saint-Etienne-du-Mont and the original church of Saint-Geneviève, engraving, seventeenth century.*

Above:

*Pierre Puvis de Chavannes. Geneviève soutenue par sa pieuse sollicitude veille sur la ville endormie (Geneviève Sustained by Pious Concern Watches over the Sleeping City), 1898. (Pantheon, Paris)*

Left:

*General view of the Pantheon from the Val de Grâce.*

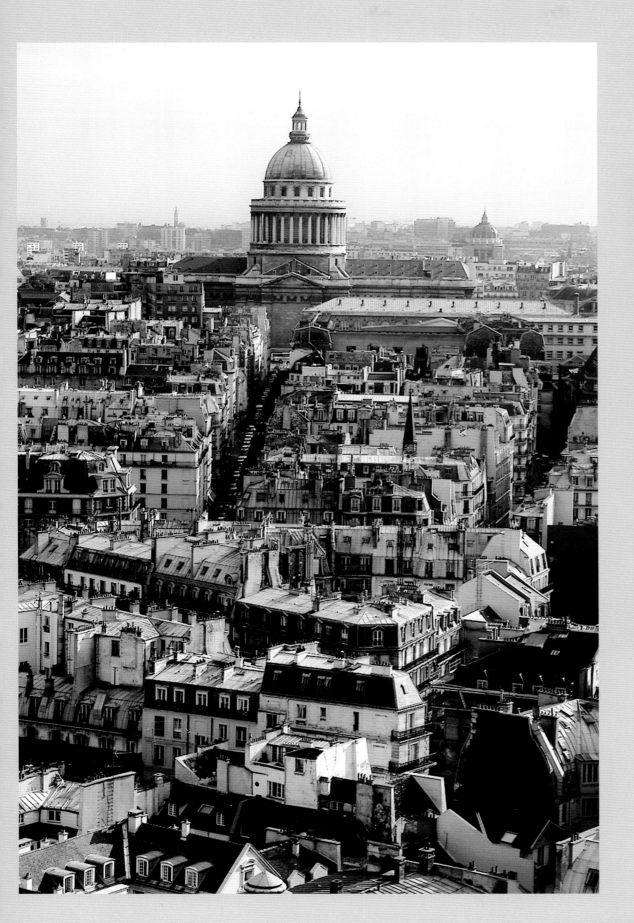

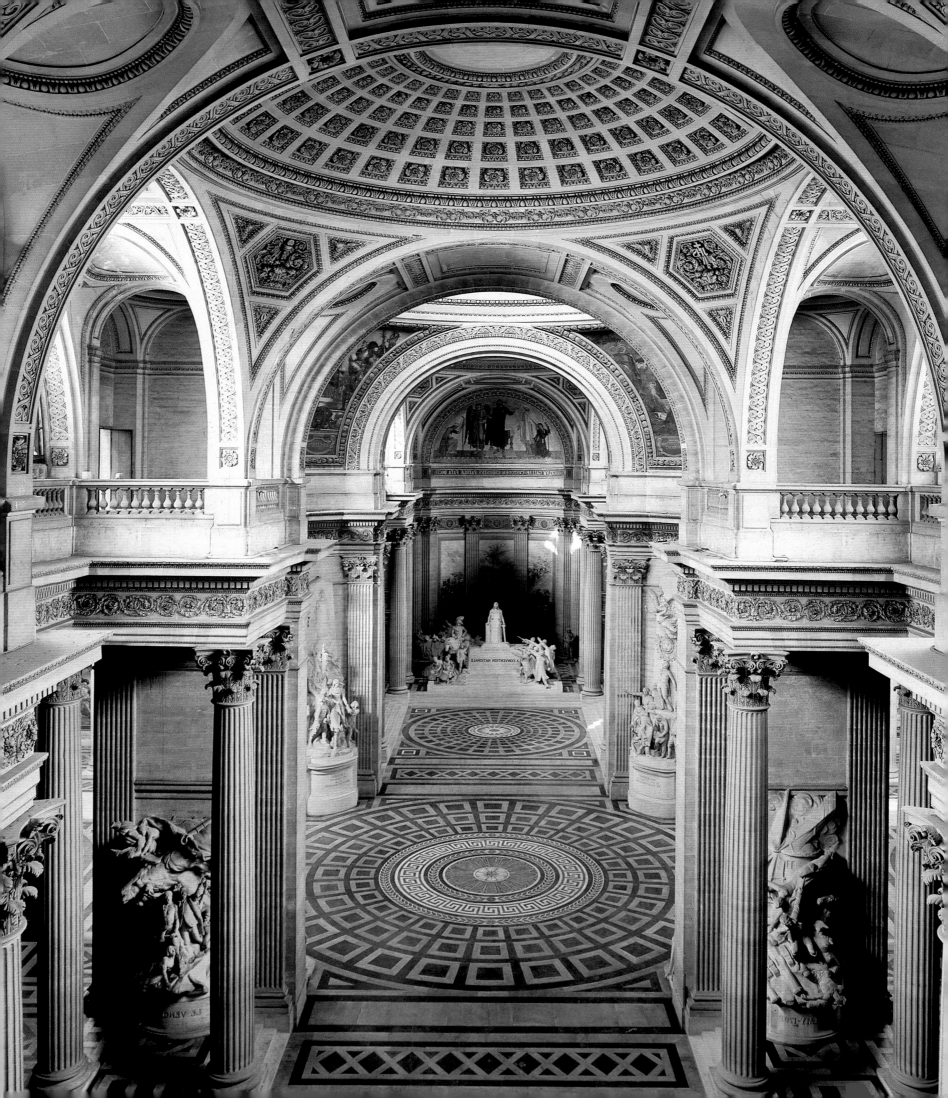

1. Church of the Abbey
of Sainte-Geneviève
(now the Pantheon)

# Chapter X
# ANTIQUITY AND THE REVOLUTION
## (1760–1800)

The movement that emerged from Rome and developed in the last years of the reign of Louis XV was riddled with contradictions, and the French way of life started to be questioned. The rococo style, which some people wanted to ban, was French taste par excellence, and expressed the taste of this frivolous people whose government was absolutist, whose religion was Catholicism, and who had the most terrible of morals, if Isaac Ware writing in *A Complete Body of Architecture*, 1767, is to be believed. He was an architect of that island where, after Inigo Jones, a follower of Palladio, "the throne of architecture" was established.

Supporters and opponents of the French way of life, however, agreed in their criticism of the style of Ange-Jacques Gabriel, the leading architect, director of the academy, and institutional guardian of the national way of life. "All these pompous titles did not prevent him from being regarded after his death as a most mediocre artist." This was published after his death in 1782 in *Les Mémoires secrets* (*The Secret Memoirs*). The author adds: "This can be seen by looking at his colonnade in the Louis XV Square and comparing it to the one in the Louvre." The facades of the Louis XV Square, where "the bright light of French architecture burns," become the object of an ironic description by the architect Ledoux: "Medallions decorated with garlands and attached with ribbons fluttering whichever way whim takes them … window casements splendidly crowned by drapes obligingly taking on many different forms …, highly ornate balustrades, etc." Gabriel, who had been the leading architect for forty years, had lived too long; he died eight years after Louis XV, his protector whose own reign had also been too long. The Prussian king, Frederick II, an expert in this field, dated the death of Voltaire (1778) as being the official end: "The tomb of Voltaire is the tomb of the Beaux-Arts. It marks the closure of the beautiful century of Louis XIV [*sic*]; we are entering into the century of Pliny, Seneca, and Quintillian" (*Hommage à Voltaire*, or *Tribute to Voltaire*), 1778.

**2. Hôtel de Chabannes
(now destroyed)**

*This home on the Boulevard du Temple was constructed in 1758 by Moreau-Desproux for Jacques Chabannes, who was part of the Chambre des Requêtes (Chamber of Petitions).*

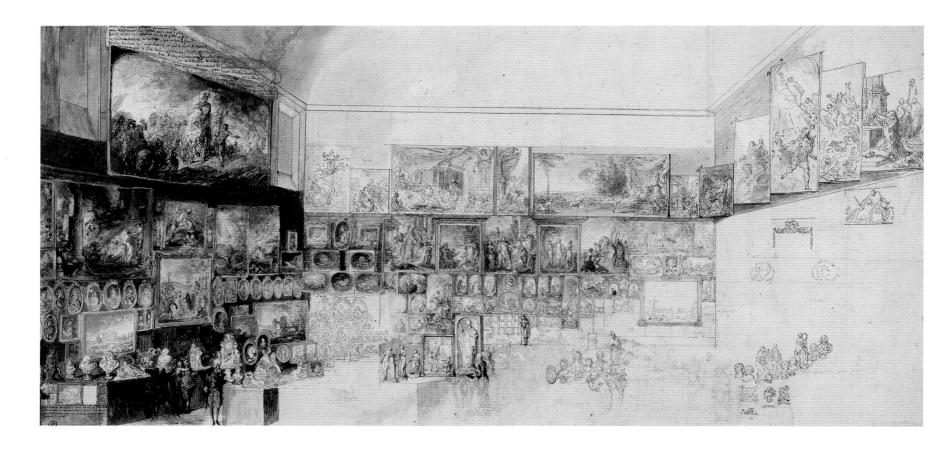

3. Gabriel de Saint-Aubin.
*The Salon of 1765.*
(Private collection)

*Most of the paintings exhibited in the Salon Carré at the Louvre in 1765 can be identified in this drawing.*

THE GREEK STYLE

*What, then, is this "Greek style" that seized the 1760s and threatened to replace the French style? Often barely more than a frieze on a facade, a Greek key pattern, or a series of ornaments in succession. At its best it was the art of Soufflot, then a prizewinning student of the academy, who had set off for Naples and discovered with delight and amazement the Doric temples of ancient Poseidonia, Paestum, the City of Neptune. This was as fateful a discovery as that of the temples of mainland Greece and the Peloponnesian Islands whose strange proportions would cause trouble among the young back-to-antiquity enthusiasts in Paris!*

## 1 – INSTITUTIONS, OPINIONS, AND FASHION

*The Role of Marigny, Director of Buildings*

The directors of the king's buildings, gardens, works of art, and property, those who inherited the post of superintendent that Jean-Baptiste Colbert had occupied, played a determining role in the second half of the eighteenth century. The journey to Italy of the younger brother of Madame de Pompadour, the Marquis de Marigny, has already been mentioned. He held the post of director of buildings from 1751 to 1773. It was not a question of initiating him into the beauty of antiquity, but instead of teaching him to distinguish between "real beauty and what has only the appearance of such," said the Marquis d'Argenson, one of the French ministers. Marigny became the head of a close circle made up of his fellow travelers Jacques-Germain Soufflot, Cochin, and Abbot Leblanc: this close group took its aims from the Intelligents, with the group around Sublet de Noyers. "The decisive moment was the return of M. de Marigny from Italy," wrote Cochin in his unpublished memoirs. The instructions from the director were: neither "modern razzmatazz" nor "ancient austerity." His policy was, in fact, one of compromise. Following the advice of Cochin, he attempted to relaunch history painting, which his predecessor Tournehem had already emphasized in the competition of 1747. However, in naming Boucher First Painter to the king in 1765, Marigny demonstrated that genre painting was his favorite. In architecture he favored Soufflot, who had been a resident at the Academy of France in Rome, to the detriment of Gabriel, who had not been to Italy. Marigny had sensed the dangers of a radical condemnation of the rococo style. "I would like our architects to busy themselves ... rather with affairs more related to our values and our customs than to temples in Greece," he wrote in 1762 to the director of the Academy of France about the work of the residents. Cochin commented in his unpublished memoirs: "Everyone got back or tried to get back on the path of good taste of the previous century. And since everything had to be turned into a nickname in Paris, this was called architecture in the Greek style. This only remained good taste in the hands of a certain small number of people, becoming madness in the hands of others."

*The Role of the Comte D'Angiviller, Marigny's Successor*

The financial difficulties of the last years of the ancien régime limited the interventions of the Comte D'Angiviller, Marigny's successor, in the field of architecture. He nevertheless managed to impose his authority by claiming to extend the authority of the director of buildings to all construction in the kingdom. On the other hand, in the fields of sculpture and painting, his efforts were successful. His wish to use moralizing art in the hope of reforming the morals of the French favored a grand style. The commission of art to honor great men and great deeds should "revive morals and patriotic feelings"; this gave neoclassical art one of its main features. In 1776 D'Angiviller announced his intention of inviting four sculptors each year to sculpt a famous Frenchman in marble. On the eve of the Revolution, the series called the Great Men of France consisted of twenty-two statues sculpted by the greatest artists (fig. 4). Painting commissions were less regular but more important. For example, D'Angiviller commissioned from Jacques-Louis David two of the most important paintings of European art, *Le Serment des Horaces* (*The Oath of the Horatii*) and *Brutus* (fig. 5). David had himself chosen the subjects, which could not have been called very republican; neither painting entered the royal collection. These commissions occurred in the context of a strict moral reform in the Salons, where Libertine images were banned. As a result, genre painting, which had proliferated at the expense of history paintings, was put at a disadvantage.

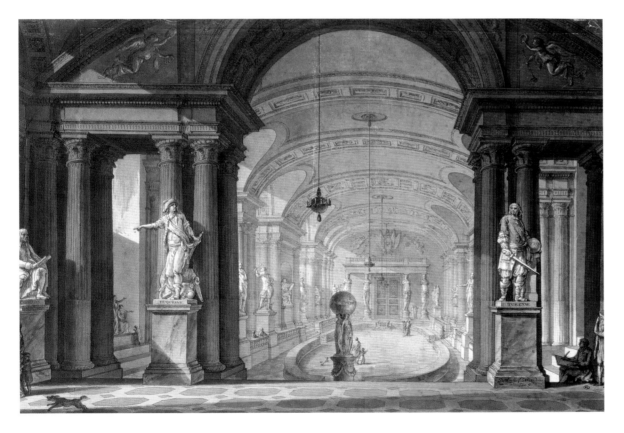

4. Charles de Wailly. Plan to adapt the Louvre's Caryatids Hall to receive the general meetings of the Institute, 1795. (Musée du Louvre, Paris)

*The Caryatids Room would hold the plenary meetings of the Institut Français founded in 1795. De Wailly planned to present the statues of great men commissioned by D'Angiviller in 1776. The statues of Duquesne by Morot and Turenne by Pajou can be recognized.*

*The Function of the Parisian Academies*

If relations between the directors and the royal academies were not always serene, the conflicts were always about the functioning of these relationships and not the essence. Officials in the provinces and others abroad asked the advice of the Académie d'architecture (Academy of Architecture) more and more often. In 1762 Jacques-François Blondel, the founder of the Ecole des Arts, became professor at the academy. He continued to teach François Mansart's art while fighting less against the recent past, outdated of course, than against the menacing future full of imitations of ancient Rome. "Without doubt the work of

**5. Jacques-Louis David.** *Les Licteurs rapportant à Brutus les corps de ses fils (The Lictors bring to Brutus the Bodies of his Sons),* 1789. (Musée du Louvre, Paris)

*This was painted for the king, and exhibited in the Salon of 1789. The consul Brutus had sentenced his sons to death for conspiring against the Roman Republic. On the left, Brutus is seated beside the statue of the Republic; on the right are the mother and sisters of the executed men.*

**6–7. Hôtel des Monnaies**

*This hôtel was constructed on Quai Conti between 1767 and 1775 by Jacques-Denis Antoine.*

### THE SCHOOL OF SURGERY

*How monotonous the minds of our French architects are! They subsist on copies and endless repetitions! They can no longer design the smallest building without columns, always columns, so that monuments no longer have their own character; they all more or less resemble temples. The Italian Theater has the same portico as the basilica of Sainte-Geneviève; l'Ecole de Chirurgie has regal columns that hide a narrow amphitheater where bodies are dissected. This absurdity is all the more reprehensible, and all the more culpable, because this building would not have been built except for this very amphitheater. By an unpardonable blunder, the principal has become the accessory, and the columns have invaded the building ... One no longer dares propose a public building; the architect comes along with his columns, and buries the charitable enterprise.*

*Louis-Sébastien Mercier,* Tableau de Paris (Picture of Paris), *1781–1790.*

the Ancients can help to make us think, but we cannot think like them. All peoples have a character, a way of feeling that is their own" (*Cours*, 1773). Blondel was worried about the young architects looking for models "in the bowels of Rome" and imitating them "without taking into account our materials, our customs." Before going to Rome, they need to have received a solid grounding, he said: "Without this practice in Paris under the supervision of their teachers, most of them only bring back wrong ideas" (*Cours*, 1771).

### The Function of the Salons

The Salons originating from the Academy de Peinture et de Sculpture (Academy of Painting and Sculpture) also played a considerable role in the growing popularity of art. The exhibitions of the Salon Carré (Square Salon) of the Louvre were held every two years starting in 1775. The attendance increased regularly: in 1755, 8,000 copies of the catalogue of the exhibited works were sold; in 1783, 20,000 copies were sold and between 700 and 800 visits a day were recorded. The Salons helped to ensure the popularity of museums and of art criticism.

Eventually this trend culminated in the creation of the Musée du Louvre due to the following: the increased general interest in collecting—whether it was information (as in the encyclopedias that were being compiled at the time) or art objects—and the growing popularity of both public and private collections (collections of objects were frequently the subject of paintings in the Salon, which bolstered public interest even more).

### The Beginnings of Art Criticism

Lafont de Saint-Yenne, the author of *Réflexions sur quelques causes de l'état present de la peinture en France* (*Thoughts on Some of the Causes of the Present State of Painting in France*), 1747, and of *L'Ombre du grand Colbert* (*The Shadow of the Great Colbert*), 1749, was a passionate advocate for the return to the Louis XIV era. He is said to be the founder of independent art criticism, breaking the monopoly of the official judgment of the academies. Nevertheless, Saint-Yenne's reputation was eclipsed by Diderot's. Friedrich Melchior von Grimm, the German critic, gave him the task in 1759 of compiling the Salons' reviews for the *Corréspondance littéraire* (*Literary Correspondence*). Diderot approached art (though he was less interested in sculpture) as a moralist and a writer. "The deterioration in taste, color, and

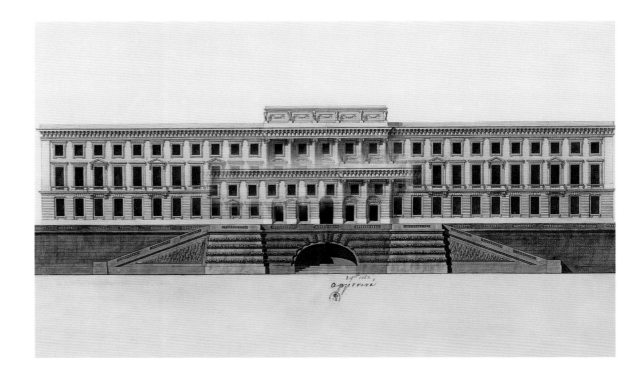

expression in paintings followed a little time after the moral decline," he wrote. Boucher, in response, stated: "What do you expect this artist to paint on his canvas? What he has in his imagination. And what can a man have in his imagination who spends his life with prostitutes of the lowest order?"

Diderot's aesthetic theory was formative for the period: he proposed that the beauty of a work be measured by how much emotion it aroused; at most it "wants something enormous, barbaric, savage." Its model was nature, not classicism, as was the desire of Caylus, the classicist whom Diderot called the "Etruscan crackpot." The seven volumes of the *Recueil des Antiquités* (*Collection of Antiquities*), published by Caylus from 1752 to 1767, were used frequently by artists.

The developing art criticism was not only concerned with painting and sculpture. Because of it, the first designs by architects like Louis, Boullée, or Ledoux were assured of publicity. These architects made themselves known and imposed their presence. And this was the beginning of a major transformation in the relationship between architecture and its public.

### The Importance of Fashion

Architecture aligned itself with fashion, which the public was following more than ever. The public loved novelties. The sellers of fashion, the modern version of the haberdashers, stood out because of their commercial methods. Their shops were salons where society liked to meet. Europe waited impatiently for the latest fashion in dolls from France. Fashion magazines, filled with advertisements, such as the *Cabinet des modes* (*Cabinet of Fashion*) or the *Journal du goût* (*Journal of Taste*) were produced from 1750 onward. Nothing was more dangerous than "fashion talk": it concerned both the political and the social worlds. It was debatable whether it was the queen or her "fashion minister," Rose Bertin, who was the leader of fashion. This famous *modiste*, who owned a boutique on the Rue Saint-Honoré from 1770, went to Versailles regularly. Was it to cater to the whims of the queen or to turn the queen into a model so as to show off her own creations?

In 1775 the *Suite d'estampes pour servir à l'histoire des mœurs et des costumes des Françaises dans le XVIIIe siècle* (*A Series of Engravings to Record for Posterity the Values and Customs of the French in*

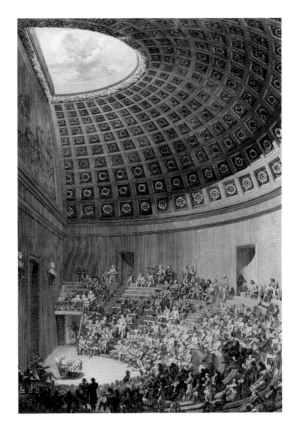

**8–10. Ecole Royale de Chirurgie (Royal School of Surgery)**

*This building (12. Rue de l'Ecole de Médecine) was constructed to house the Académie Royale de Chirurgie, founded by Louis XV in 1765. The land was purchased in 1769: the foundation stone laid in 1776: and the work was finished in 1786. The project was designed by Jacques Gondouin.*

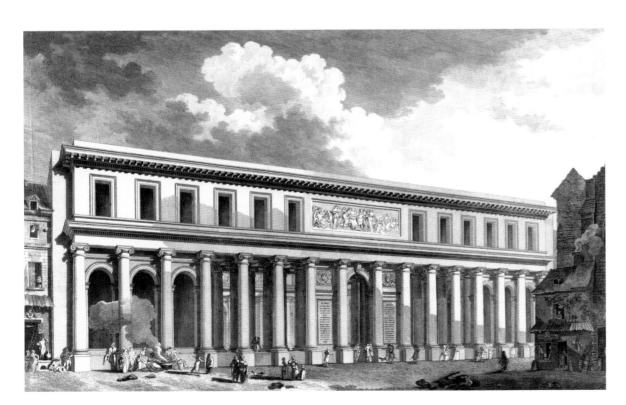

## 11–13. Ecole Militaire (Military School)

*The school was founded by a charter of Louis XV in 1750 and provisionally installed in Vincennes. The idea for this military school (which offered officer training for impoverished young aristocrats or for the sons of officers killed in the king's service) was presented to the king in 1748 by the financier Pâris-Duvernay and supported by Madame de Pompadour. Construction of the school was begun by Ange-Jacques Gabriel. The project was to consist of a church in the middle of a gridwork of buildings as at the Invalides. In 1756 the school moved into the few buildings already completed. But the work was abandoned in 1760 because of financial difficulties caused by the war. When the Seven Years War was over, the plan, considered too expensive, was abandoned. Gabriel received the order to design a new project, whose foundation stone was laid in 1769. The original plan was completely reoriented and the church was never built. The main building (called "the château" or "castle") was built on the site originally intended for the entrance.*

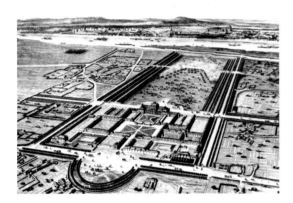

*the Eighteenth Century*) appeared, with Sigmund Freudenberger's engravings. A year later it was followed by a second edition illustrated by Moreau the Younger. The illustrations of diverse moments in the life of a young woman were pretexts to paint genre scenes (fig. 14) and to produce descriptions of costumes. The first text, a bit dry, was entirely rewritten by Restif de La Bretonne, who made it into a little novel published as *Monument du costume physique et moral de la fin du dix-huitième siècle* (*A Monument to Physical and Moral Dress of the End of the Eighteenth Century*) in 1789.

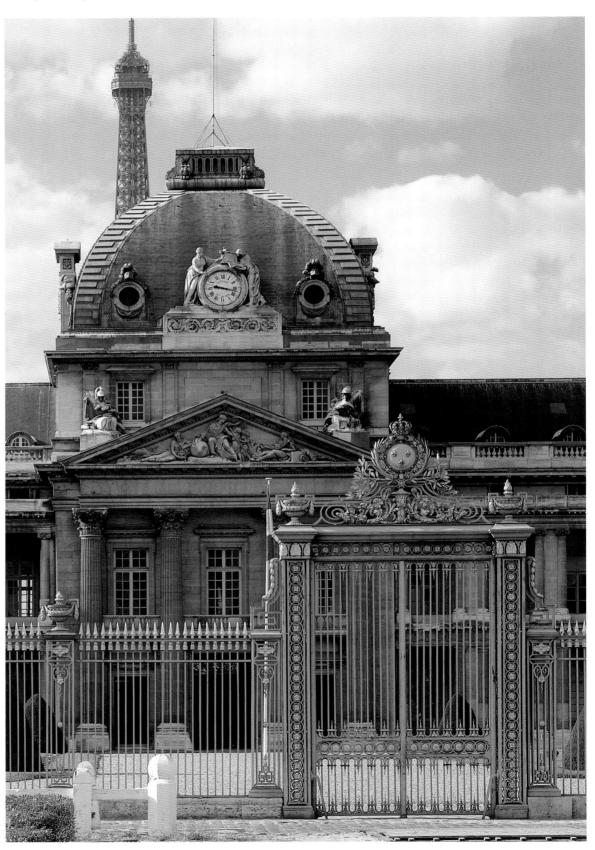

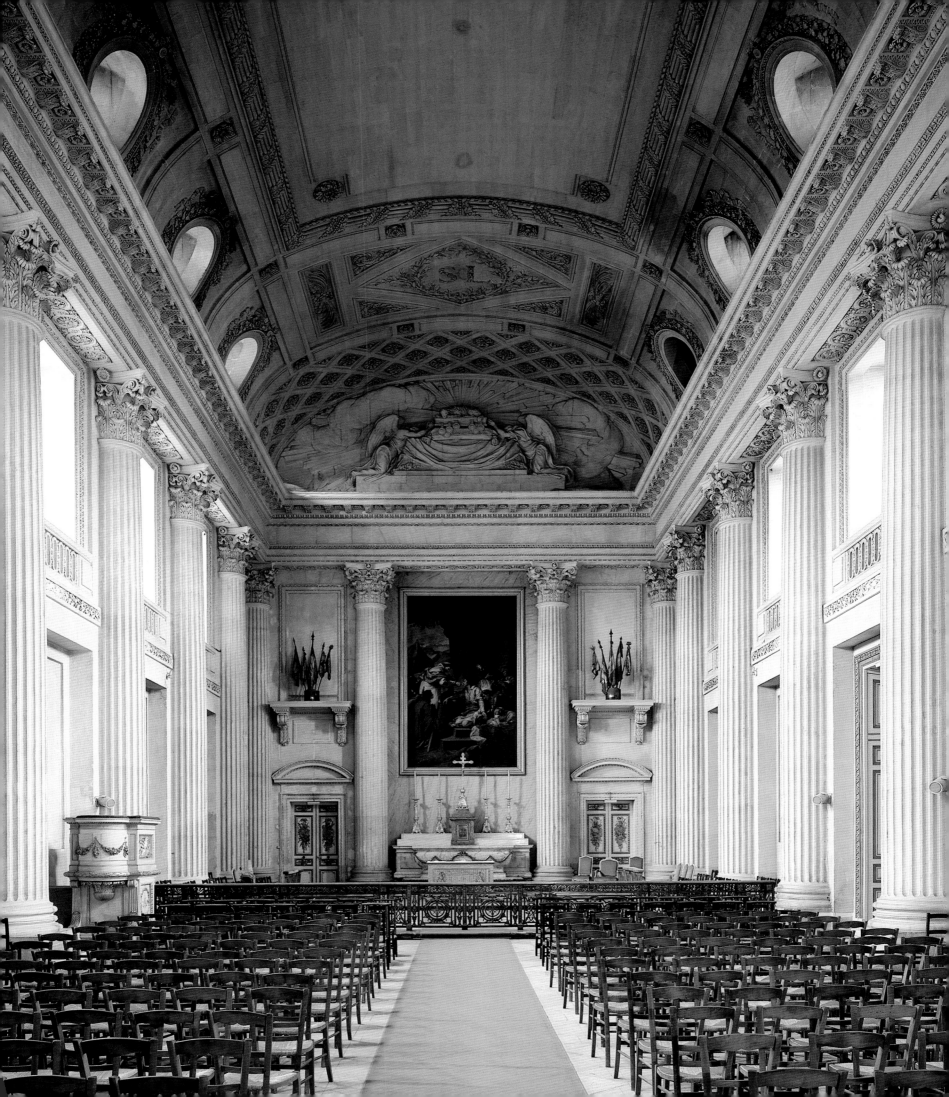

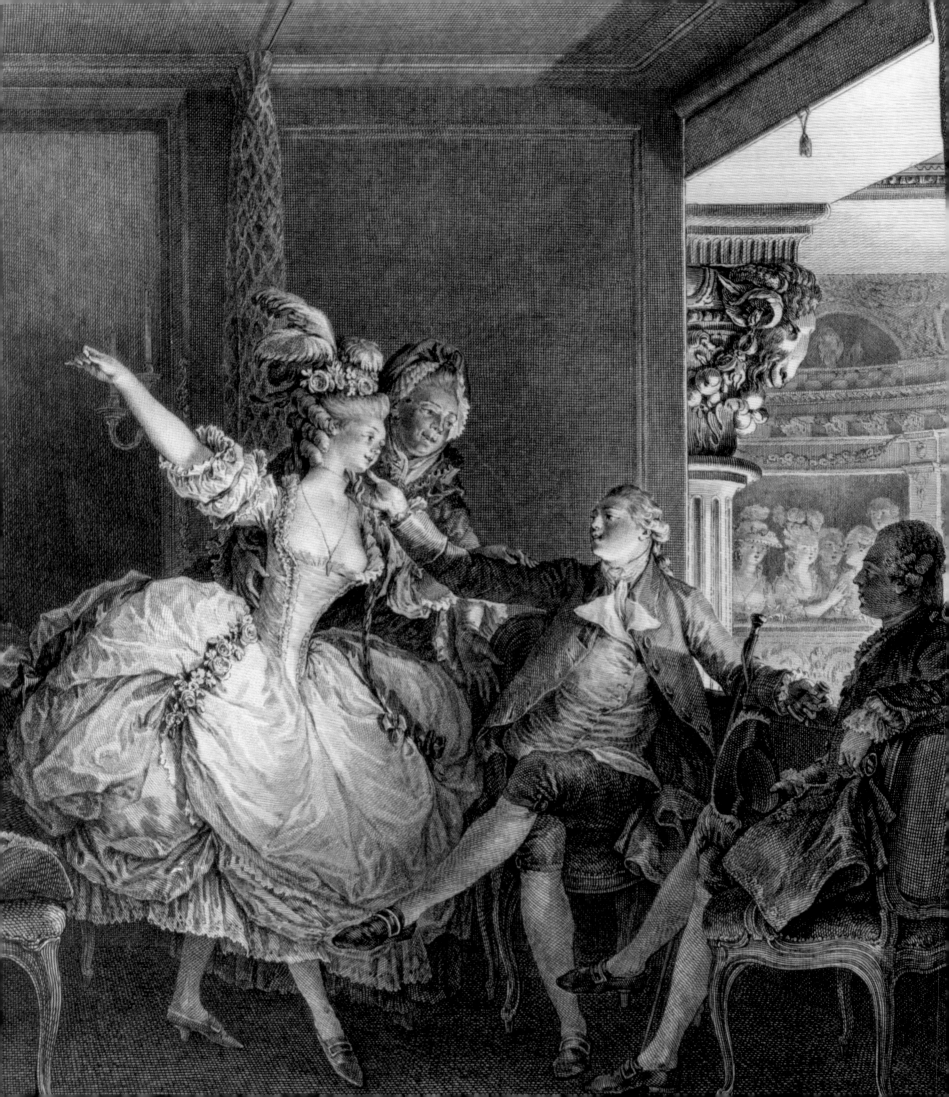

## The Academy of France in Rome

The French had become coy. There had to be a reaction, and it came from Rome. During the reign of Louis XV, the Academy of France had entered into a lethargic state due to the amiable negligence of its director and the competition coming from the Ecole des Elèves Protégés in Paris. D'Angiviller took on the task of resurrecting it: he did away with the Ecole, appointed a new director, and reformed the morals of the students by imposing a strict regime. The results far exceeded his expectations. At the Academy of France, the artists who won the competitions run by the Parisian academies benefited from a Royal grant so that they could "absorb the principals of the Greeks and Romans that would be used in France to combat what is called French architecture" according to Peyre, writing in his *Oeuvres d'architecture* (*Architectural Works*), a key publication of 1765. Peyre included the projects that he had done as a student, which owed more to Bernini than to the classical tradition. The first generation, Soufflot among them, hardly considered anything other than modern Rome. The visionary archeologist, Piranesi, had a workshop next to the Palazzo Mancini (seat of the academy). It was he who had to recreate the classical mirage, which consisted of a mass of tombs, collapsed and partly buried, but nevertheless gigantic, so that the students could decipher the classical Roman model that had been highly neglected since the end of the Renaissance. An international community had formed around the academy and Piranesi's workshop. In Rome the artists learned to "despise the masterpieces that surrounded them, to shake national prejudices," wrote Clérisseau, the French Piranesi, who remained in Italy for twenty years. Quatremère de Quincy, the foremost French theoretician of classical antiquity, added: "How many artists only forget their inborn prejudices in Rome… their vicious national preferences which, like so many bad accents, can be lost only in the capital of the republic of Arts… By a happy revolution, arts and sciences belong to the whole of Europe and are no longer the exclusive property of one nation" (*Lettre sur les déplacements des monuments*, or *Letter on the Removal of Monuments*), 1796.

## The Supporters of Classicism Take Paris

Was the cultural hegemony of France also threatened, and thereby Paris's important role? Not at all, because the Roman academy graduated the greatest artists of the time, and they came to Paris to stage their revolution. In 1774 Louis XV and Blondel died; the latter, who was professor at the academy, was succeeded by David Leroy, a specialist in Greek architecture. At the Grand Prix competition the winning project took its inspiration from the Roman baths. In 1778 a new ruling made it obligatory for the students to sculpt a classical relief during their stay in Rome. In their *Description de Paris* (*Description of Paris*), 1818 ed., Legrand and Landon describe the issue of "the long-established struggle at the Ecole between modern architecture and classical architecture: doubtless, it will not be regretted that the latter maintained the advantage and that le Peyres, David Leroys and Clérisseaus, who imitated the classical style, won against Blondel's approach. It is indeed unfortunate that this revolution did not happen a hundred years earlier because many of the monuments erected during the reign of Louis XIV and Louis XV would not have carried the mark of a petty-minded taste." A real revolution? It should be noted that in the above text, the adjectives "modern" and "classical" have regained the meaning that they took on during the Renaissance and lost in the fight between the ancients and the moderns. Sometimes modernity is the present that the innovators are arguing against, sometimes the future that they want to promote.

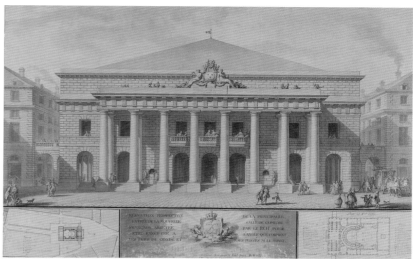

*Opposite:*

*14. Jean-Michel Moreau, called Moreau the Younger. La Petite Loge (The Little Box). (Musée Carnavalet, Paris)*

### 15–16. Odéon Theater

*In 1767 Marigny, director of the king's buildings, commissioned Marie-Joseph Peyre and Charles de Wailly to build a new Comédie Française to replace the old one, called Hôtel des Comédiens du Roy (Residence of the King's Actors), dating back to the end of the seventeenth century. The new building was supposed to be built on the site of the hôtel of the prince of Condé, who wanted to develop his property. The two architects produced many designs, and it wasn't until 1779 that one of them was adopted; the project was inaugurated in 1783. The apartment buildings on the site were also built by Peyre and De Wailly. The theater, which took the name "Odéon" in 1794 in reference to the choruses at Greek celebrations, was destroyed and rebuilt many times during the nineteenth century more or less in its original form. The two drawings are by De Wailly and show the state of the project in 1771 (the facade drawing carries that date, although the interior section dates from 1776). The removal of the two columns that divided the proscenium arch into three sections was the principal modification for the design adopted in 1779.*

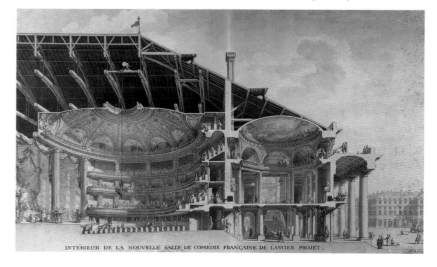

INTÉRIEUR DE LA NOUVELLE SALLE DE COMEDIE FRANÇAISE DE L'ANCIEN PROJET.

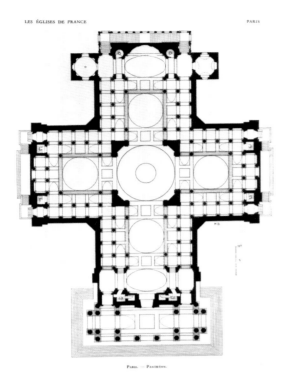

PARIS. — PANTHÉON.

## 17–20. Church of the Abbey of Sainte-Geneviève (now the Pantheon)

*In 1744, following a vow he made at Metz during a near-fatal illness, Louis XV made a pilgrimage to the church of the Génovéfains Abbey on Mount Sainte-Geneviève. This church contained the tomb of the saint to whom the king attributed his recovery. On this occasion, the Génovéfains were promised that the church would be rebuilt at the crown's expense. The renovation was carried out by Soufflot according to a 1757 plan, but work was delayed until 1764. The design for the lantern tower was modified several times and only took its final form in 1774. Soufflot's section (reproduced opposite page, top), dating to 1764, shows one of the stages of the lantern tower design, and at the center the tomb of the saint supported by four sixteenth-century statues (today at the Louvre).*

## 18. Pierre-Antoine De Machy. *La pose de la première pierre par Louis XV (Louis XV Lays the Cornerstone), 1765. (Musée Carnavalet, Paris)*

*Pierre-Antoine de Machy's painting shows King Louis XV laying the cornerstone for Sainte-Geneviève in 1765 in front of a life-size painted canvas reproduction of the design for the portico with pediment. The church included two bell towers on either side of the choir, which were later destroyed. In 1791 the church was transformed into a pantheon by Quatremère de Quincy, who blocked up all the windows built by Soufflot.*

## 2 – PUBLIC ARCHITECTURE

### The Invention of the Public Building

At this sign of recovered peace between the two main camps, the "ancients" and the "moderns," Paris was elected as the place to develop buildings of a kind previously neglected. Apart from a few rare buildings, monumental architecture that ensured not only a venue but also an official and dignified representation for diverse activities of public life was unknown in France (and indeed throughout Europe generally). The situation was that of a society in which the most important functions, in particular those linked to the function of the sovereignty, were confused with the people who carried them out in their residences. The distinction between the job performed and the person who performed it, which resulted in an increase in public buildings in the nineteenth century, was indeed the cause of the Revolution. However, the origin of the problem can be traced back to the measures taken at the end of the ancien régime, and notably in the royal decree of 1786 in which Louis XVI ordered the resumption of improvements in Paris that had been halted in 1765. That the phenomenon was nearly exclusively Parisian shows that Paris entirely assumed its role as a capital, notwithstanding the presence of the court and the government at Versailles. There is no more salient proof of this transformation in public architecture than the transfer of the institution producing money (a kingly function *par excellence*) from the uninteresting buildings where it was based to the monumental Hôtel des Monnaies (figs. 6–7) built in 1767 at the edge of the Seine, in the middle of the Parisian landscape between the Collège des Quatre-Nations and the Pont-Neuf.

### From Conventions to Character

Little by little, the monarch was persuaded by the royal academy to accommodate his duties more suitably. Appropriateness, a rule of French classicism as fundamental as the hierarchy of orders, dictated that a building must look like exactly what it is, just as the subject must respect the hierarchy of symbols. Appropriateness was fast becoming a new obligation to impose on the architect; he was now responsible for giving his creations their proper character. A building was said to have "character" when it elicited feelings connected with its function: a church should inspire contemplation; a theater must put one in a festive mood; a prison must intimidate. Appropriateness was a rule of propriety, and character was a physical virtue. This idea came into being in the middle of the eighteenth century influenced by popular philosophy, and it benefited by being labeled "academic." Blondel wrote in his *Cours* (*Course*), 1771: "All the different kinds of activity that depend

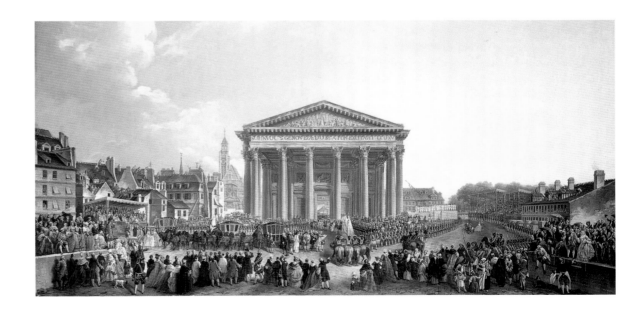

on architecture must bear the imprint of the particular purpose of each building, all must have a character that determines their general form."

*A Classic Example: The Ecole de Chirurgie (School of Surgery)*
Classical architecture (and especially Roman architecture with its wealth of public buildings that could be authoritatively invoked) was the precedent for several architectural clichés such as the portico of columns under a pediment. It also authorized radical departures from the French tradition. The Ecole Royale de Chirurgie (figs. 8–10), built by a graduate of the academy on his return from Italy, served as a manifesto for the supporters of the rupture. "The entire system of old French architecture was turned upside down by this unexpected example, and those who supported the norm were astonished to see a facade without a frontispiece in the middle, without a projecting back,

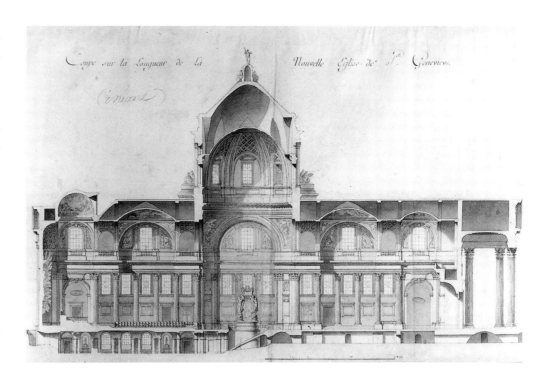

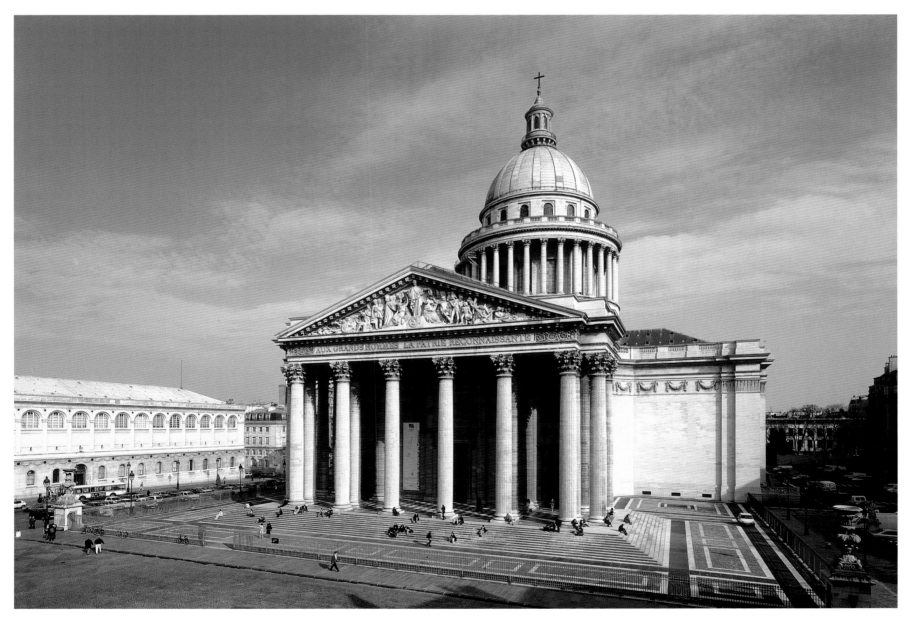

*Hubert Robert was "keeper of the king's paintings," a post to which he had been assigned in 1784, while a member of the museum's Conservatoire, a body of six members created in 1794. Robert painted the Louvre's Grande Galerie (Great Gallery), which would become the main focus of the museum, several times. He painted it as a ruin or transformed through his own imagination. The ruin pictured here, dated 1796, is fiction: in the foreground is the Apollo Belvedere, one of the ancient sculptures that was taken from the Vatican during the Italian wars. The painting on the opposite page was exhibited at the Salon of 1796: many famous paintings are recognizable, notably the great Holy Family by Raphael. This design includes two ideas dear to Robert that would be brought about by Percier and Fontaine during the empire: transverse arches breaking the monotony of the long gallery without interrupting its continuity, and overhead lighting.*

and whose cornice ran from end to end without rising or jutting, which was not customary in France. Indeed, Constant, Gabriel, and Soufflot had just produced recent and extravagant examples in the Ecole Militaire (Military School), the Madeleine, and the new church of Sainte-Geneviève. Nevertheless public opinion remained quiet and the Ecole de Chirurgie was pronounced by all people of taste to be the masterpiece of our modern architecture," wrote the architect Legrand in the *Annales du musée* (*Museum Annals*), 1803.

The design itself called for innovation because it was destined to house a faculty that was itself in the midst of change: the Académie royale de Chirurgie, founded by Louis XV, was taking over the monopoly on practical training from the Guild of Surgeons. So against accepted custom, the facade on the Rue d'Ecole de Chirurgie was reduced to a portico delimiting the courtyard without hiding it, and the facade was stripped of the projections made by the usual three frontispieces. The moldings, normally so generously rendered, were reduced to the most simple expression: the entablature consisted only of an architrave and cornice with no frieze. Yet the narrative frieze in low relief is characteristic of the new style. At the back of the courtyard, behind the predictable portico with a pediment, is the dissection room, which has all the appearance of a classical theater, being lit only from above. This room, which immediately became famous, is one of the first examples of the fashion for overhead lighting borrowed from classical architecture.

### The Ecole Militaire

While the supporters of classicism imposed their ideas on the Ecole de Chirurgie by cutting away the superfluous details of French architecture with the sangfroid of a dissector, the First Architect attempted a revival of official art at the Ecole Militaire (figs. 11–13). Its location on the outskirts of Paris, its program, and the plan for the entire ensemble in his first version revealed the extent to which the Ecole Militaire drew on the Hôtel

des Invalides. The "castle," however, the principal part of the Ecole Militaire, which was built at the end of the war after a complete revision of the plan, presented a central frontispiece and a chapel with columns that should have been received as masterpieces of the new style by partisan critics. Legrand, however, merely regarded the Ecole Militaire as "costly."

The partisan spirit of the time explains why Gabriel had been removed from two major projects that he could have expected to lead: the Odéon Theater and the church of Sainte-Geneviève. In both cases, academy-trained architects (albeit the most talented) were appointed by Marigny in place of the aging First Architect.

### The Odéon
The auditorium of the Comédie-Française, later named the Odéon (figs. 15–16), was in its time the most modern theater in Paris. The modernity of a theater was judged in those days by its location in town, by the organization of the auditorium, and the number of exits. The Odéon, built on the site of a big hotel, was the first completely freestanding theater in Paris, liberated from the constraints of the shared plot and presenting its classical portico as the visual focus of the streets of a new district. The rotund auditorium with ground-floor seating and balconies was perfect for performances. The exits, foyer, stairs, and actors' dressing rooms were generously built, without attaining the profusion of exits of the contemporary theater in Bordeaux, the most famous "Italian" theater of France.

### The Growing Number of Theaters in Paris
The establishment of the modern theater had been Italy's project as inheritor of the classical theater and its Palladian interpretation. It had been achieved with the Theater of Turin, 1738–1740, which was copied throughout Europe. France began this work belatedly. Paris was later than Lyons, where Soufflot had set the example, and later even than Versailles,

where Gabriel had designed the most beautiful opera auditorium. On the other hand, in the last thirty years of the century Paris caught up and became the city of theaters; a good twenty were built, notably on the boulevards. At the Palais Royal (which after two fires had lost the privilege of featuring the opera) Victor Louis, the architect of the theater in Bordeaux, built a theater that is known for a real innovation: the use of a metal framework covering for the first time in France and apparently in Europe.

### The Church of Sainte-Geneviève

Sainte-Geneviève (figs. 17–20), renovated thanks to royal subsidies granted to the Genevofains's abbey, guardians of the memory of Clovis and of the tomb of Saint Geneviève, is in its own way as important as the Odéon, but the church belongs to the same register of works by Marigny's protégées, who wanted to finish rather than to innovate, motivated by their desire to complete the reform of French architecture. In preparation for the creation of an ambitious work, Soufflot had studied churches as different as Notre-Dame in Dijon, the Holy Shroud in Turin, and Saint Paul's in London.

His intention was to reconcile the Greek style and Gothic structure. Greek style had less to do with the portico with pediment (which had already been seen elsewhere) than with the

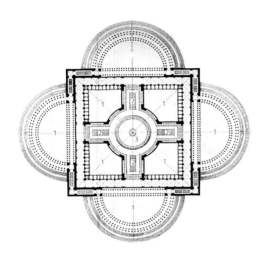

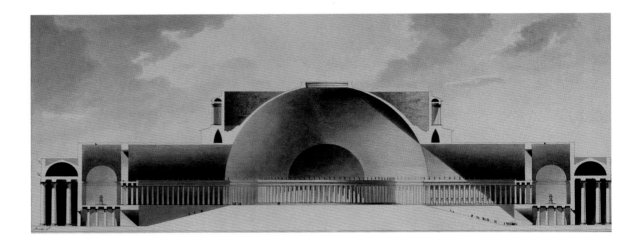

interior colonnades that replaced the arches on massive piers typical of Counter-Reformation churches. The columns themselves could not be regarded as new. The arcade of columns had already been used during the Renaissance, notably at Saint-Etienne-du-Mont (chapt. VI, fig. 1) the church adjoining Sainte-Geneviève; this style was applied in the eighteenth century in churches of northern and eastern France. But it was in the chapel of the château of Versailles and in a plan that Perrault had done some time before for Sainte-Geneviève that Soufflot must have found his models for the Greek manner: that is, interior columns carrying an entablature rather than arches. Contemporaries immediately made the connection between the new church and the colonnades of the Louvre, which was Perrault's work.

It is the Gothic part of Soufflot's project that appears the most original. Reference to the Gothic could once again pass as modern. Instead of the great barrel vault on transverse arches typical of Counter-Reformation churches (for example, the church of Val-de-Grace, chapt. VII, figs. 51–57) and the Versailles Chapel, Soufflot substituted compartmentalized vaulting, which borrows the Gothic principal of diverting the thrust onto several points. From the specifically Parisian Gothic tradition (chapt. III, fig. 21) Soufflot had also kept the idea of the bell towers on either side of the choir; those were built, but have not been preserved.

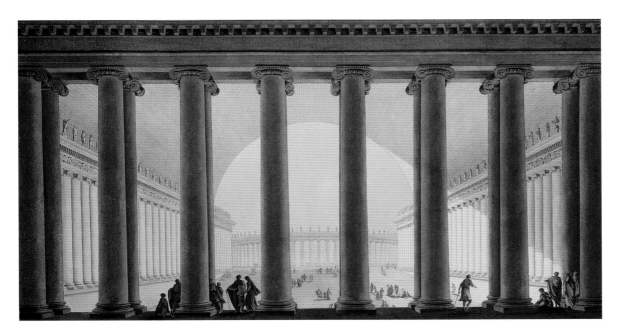

Soufflot's work included a third basic idea: the lantern tower at the crossing. After a lot of deliberation, Soufflot finally opted for a striking lantern tower with cupolas and a dome, taking the nested cupolas that fit together from Mansart's plans and his colonnade around the drum from Bramante's design for Saint Peter's in Rome and Wren's work at Saint Paul's in London.

### The Evolution of Religious Architecture: From Grandiosity to Modesty

Soufflot's Sainte-Geneviéve, so scholarly and so well thought out, was the realization of a plan to return French architecture to the position it had occupied in Europe during the time of Louis XIV. To make his mark, Soufflot's work needed the size that Boullée gave his Métropole project. None of the construction sites opened under Louis XV and Louis XVI were big enough to incorporate the influx of ideas that archeology had produced. Piranesi had noticed this: constructions on the same scale as the ancient Romans' were not being undertaken. Fortunately, and the Italians had proven this, architecture on paper was the natural outlet of the boldest ideas. In the religious architecture of France, and

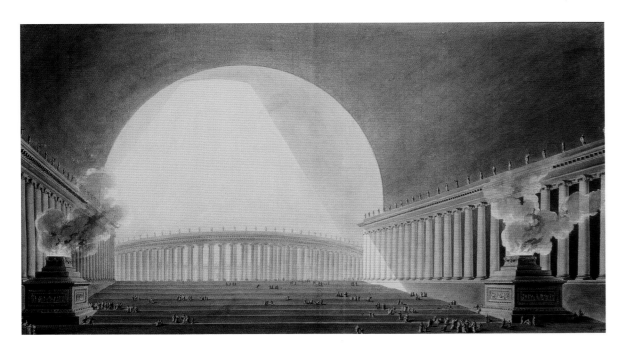

*In 1790 a repository was built at the convent of the Petits-Augustins to house the works of art taken from the churches during the confiscation of the clergy's goods. This convent was part of the hôtel that Queen Margot had had built on the site of the "Séjour de Nesle," on the Left Bank, facing the Louvre (the chapel was kept). Alexandre Lenoir, made responsible for the provisional repository of the Petits-Augustins in 1791, gradually transformed the establishment into a museum, which was opened to the public in 1795. The Musée des Monuments Français included most importantly a garden, l'Elysée, in which Lenoir had assembled actual or invented tombs of famous people. In 1816 the museum was closed: the works were returned to their original location when possible or lodged in museums, and the former convent was assigned to the all new Ecole Royale des Beaux-Arts (Royal School of Fine Arts).*

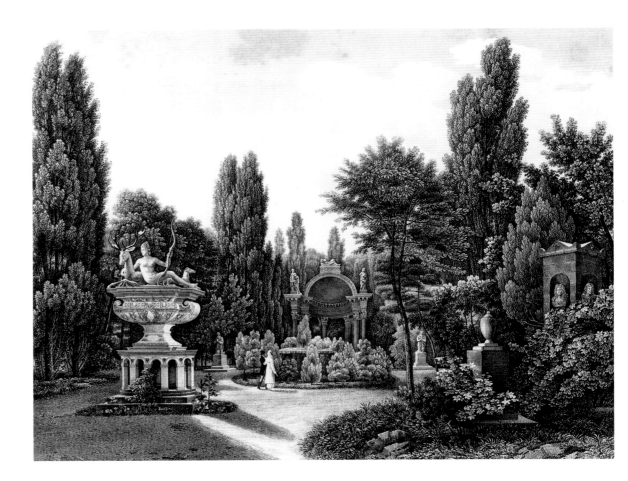

strangely enough for that of Paris, the tendency was no longer toward extravagant projects. In his first plan for the Ecole Militaire, Gabriel had designed an enormous church at the center of the plan, like the one at Les Invalides; in his actual design, the chapel is only a room in the castle (fig. 13), certainly very big, but without an external casing, without sides, and without towers. The future lay in more simplified architecture, which the contemporary construction of the Saint-Philippe-du-Roule Church illustrates: the imitation of the ancient basilica, more or less Christianized, permitted one to obtain at least a flavor of authenticity. This formula was very successful in Paris in the first decades of the fourteenth century.

*The Question of the Library and the Royal Collections*
For the purposes of innovation, architects would have to tackle something other than the well-worn church project. Current events would provide one destined for a long future. The problem of assembling the dispersed library and royal collections (which were often inaccessible), and of opening them to a larger public rather than to just an elite few, was one of the directors' policy plans—originating as much from Marigny as from D'Angiviller. Free access to the royal collections was considered by Lafont de Saint-Yenne, in his *Réflexions sur quelques causes de l'état present de la peinture en France (Reflections on Several Causes of the Present State of Painting in France)*, 1747, as requisite for the revival of French painting; the future would show that he was right. The location of the library and the Louvre collections that the directors made Gabriel and Soufflot study, as well as the completion of the Cour Carrée (Square Courtyard) and the clearance for the colonnade, was part of a perfectly coherent program. In 1768 Marigny proposed a "museum" project to Louis XV (who approved it) to bring together the collected books, paintings, furniture, and works of art belonging to the king. In 1775 D'Angiviller relaunched the proposal, but without any real results other than the nomination of Hubert Robert as "guardian" (or curator, as he would be called today) of the king's paintings. Then arose the question of the lighting of

the Grande Galerie (Great Gallery), where the paintings of the greatest masters would be displayed. Robert was an advocate of overhead lighting to complement or replace the existing side lighting (fig. 22). In 1783, gathering the newest ideas on the function of a museum, Boullée showed that this encyclopedia in space, this assembling of the sciences and arts, could be the temple of a new cult (figs. 23–26).

## The Granary

To understand what happened in Paris in the decades preceding the Revolution, it is necessary to define a new term, "monumentalization." The full extent of this urge to make a monument out of everything can best be measured as it was applied to the functional constructions of commerce, like markets and customs houses. The Granary in Paris owes its astonishing fame to a wonderful meeting of function, technique, and knowledge: the 1767 construction owed its annular (ring-shaped) plan to the advice of Physiocrats (proponents of the free market who believed that the soil was the ultimate source of all wealth), who understood about the circulation and commercialization of wheat. In 1782 to 1783 the

**28. Charles Percier.** *Vue d'un muséum* (*View of a Museum*), 1796. (Musée Antoine Vivenel, Compiègne)

*This drawing of an imaginary museum dates from the same year as Hubert Robert's design for the Grande Galerie (Great Gallery) in the Louvre and the installation of the Antiques Museum in the apartments of Anne of Austria on the ground floor of the Petite Galerie (Small Gallery) wing.*

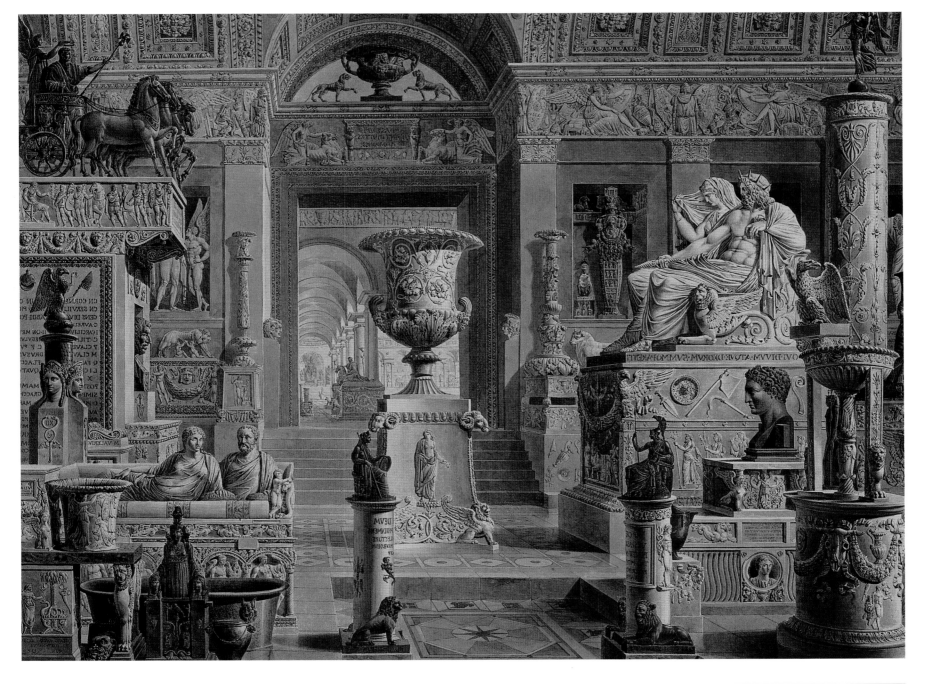

**29–30. Jean-Louis Prieur. Two drawings from** *Tableaux historiques de la Révolution Française* **(Historic Scenes of the French Revolution).**

*Prieur's drawings, showing some of the most important moments of the French Revolution, were engraved by various artists, including Berthault, and published in* Tableaux historiques de la Révolution Française *(Historic Scenes of the French Revolution), of which five editions were printed from 1791 to 1817. The original drawings are for the most part preserved at the Musée Carnavalet. The two scenes illustrated here show customs barriers of the wall of the* Fermiers généraux, *built by Ledoux (see opposite page). The Conférence barrier (below) was attacked by the people of Paris on July 12, 1789. The Roule barrier (above) was attacked on June, 26, 1791, the day the king returned after his arrest at Varennes. Some barriers fell victim to Parisian hostility to the levies, which were seen as a manifestation of despotism. The Roule barrier, despite its location in the west, saw the return of the king, whose flight had been checked at Varennes in the east: in fact, the carriage had been diverted to avoid the populated quarters on the east and reached the Tuileries through the less dense and less populated western quarters. The Conférence barrier (also called the Versailles, Passy, or Bonshommes barrier) was set in the middle of the road from Versailles.*

### The Wall of the
### *Fermiers Généraux*

*The inconceivable wall, fifteen feet high, nearly seven leagues round, which will soon encircle Paris entirely, should cost twelve million; but, as it should bring in two million per year, it is clearly a good business deal. Make the people pay more, what could be better? But we know how architects calculate, and Mr. Ledoux has shown in this respect that he is the best of them all ... So we should not be astonished if instead of costing 12 million, this beautiful fiscal wall costs 40 million. That will have to be recouped, and we will pay, useful prisoners that we are, for the works of the honest jailer, Mr. Ledoux ... But the most outrageous thing of all is to see these monniers' dens transformed into porticoed palaces, which are outright fortresses. Ah! Mister Ledoux, you are a terrifying architect!"*

*Louis-Sébastien Mercier,* Tableau de Paris *(Portrait of Paris), 1788.*

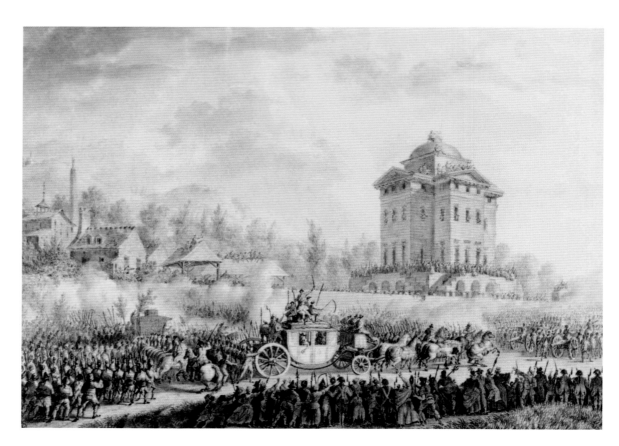

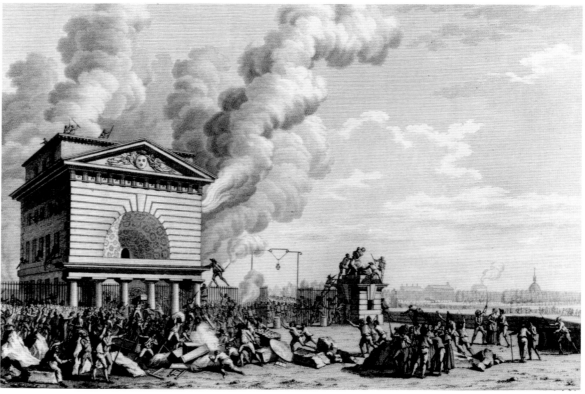

circular central courtyard was covered by a fake cupola made with a wooden framework according to the method of Philibert De l'Orme, promoted at last, after two centuries, to the rank of a modern technique. For the half a century until the popularization of metal framework, all of Europe, and even America, would use a matchwood framework for wide-span roofs.

## The Tax Wall

The construction of the customs barriers of the city-tax wall, imposed on the town by the *fermiers généraux* (tax collectors; figs. 29–33), marked the apogee of the tendency to monumentalize everything. The presence of these sixty customs offices at all the entrances to the capital clearly indicates that they were one of the most original creations in French architecture, in spite of their echoes of sixteenth-century Italian architecture, seventeenth-century French architecture, and eighteenth-century English architecture.

**31–33. The Wall of the *Fermiers Généraux***

*The wall of the* Fermiers généraux *was raised from 1785 and controlled by the* Ferme —*that is, the group of businessmen who contracted to collect taxes and especially the local duties. It was a continuous wall, only interrupted by customs barriers through which everyone entering or leaving the city had to pass. Ledoux built the barriers. When work stopped in 1789, sixty of the originally planned sixty-five buildings had been built. Only four of these have been preserved: the Enfer (Hell) barrier (Place Denfert-Rochereau, above left); the Trône (Throne) or Vincennes barrier (Place de la Nation, above right); the Villette barrier (Place de Stalingrad, below); and the Orléans rotunda (Monceau Park, not shown). The wall itself has now made way for the outer boulevards. The buildings are known through the many contemporary representations of them.*

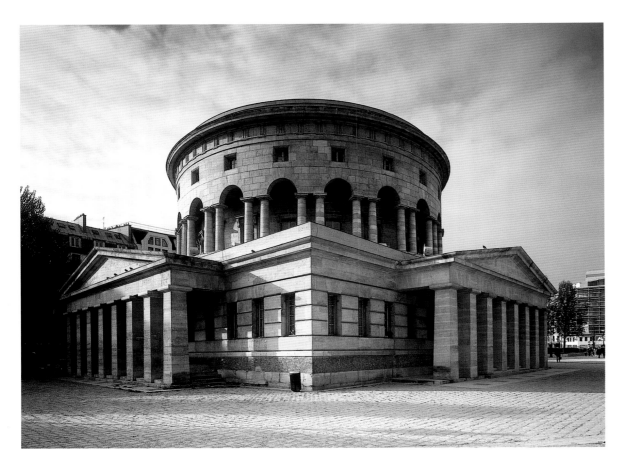

## 34–36. Hôtel d'Uzès (now destroyed)

*This was an old hôtel modernized by Claude-Nicolas Ledoux for the duke of Uzès in 1768. The paneling of the grand salon (conserved in the Musée Carnavalet) was decorated with trees bearing the attributes of the Arts and War, which, like the allegorical doors of the Continents, were designed to Ledoux's instructions by Joseph Métivier and carried out by J.-B. Boiston.*

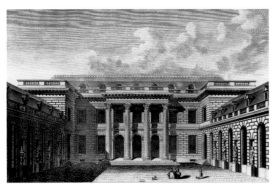

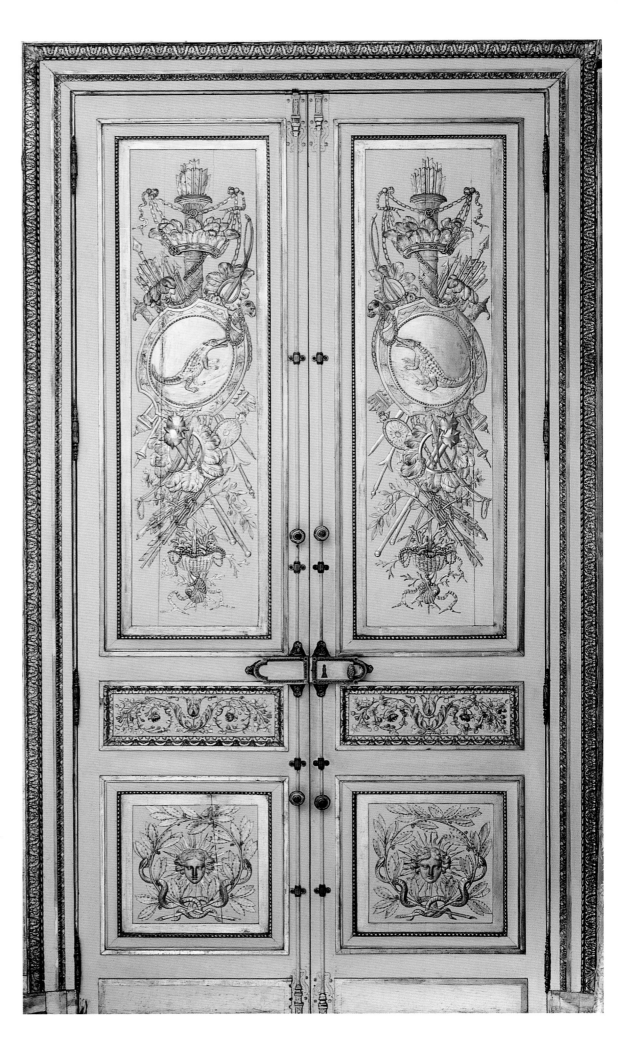

## 3 – PRIVATE ARCHITECTURE AND DECOR

*The "Building Frenzy"*

In fact, "monumentalization" was not only a phenomenon of public architecture, but a general movement, which in its heyday during the decades of the *"anticomanie"* (classical mania) and especially toward the end of the century, also concerned private buildings. After the fever had died down, columns and pediments would remain a distinctive sign of public majesty. Blondel could then, with every right, denounce the columns that his pupil Ledoux had built at the Hôtel d'Uzès as a breach of etiquette: the doorway on the street was flanked by two lone trophy-bearing columns, while the courtyard side of the house was orna-mented with a portico (fig. 35). However, one might make a different judgment than

Blondel, because for the first time in the history of Paris, traditional individuality was sacrificed for the beauty of the city. An intervention of public authority could not have brought this about; speculation and fashion brought it about spontaneously in the new districts. But in the next century the authorities, thinking only of their own project—which was the town planning operation *à la* Voltaire—and invoking concerns about hygiene in the overpopulated central districts, would raze to the ground masterpieces of French architecture, the natural offspring of racketeering and flirtatious behavior. At the

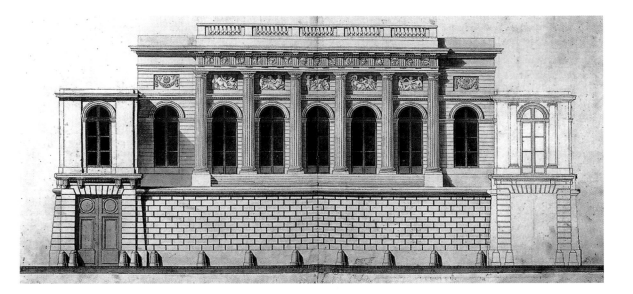

**37–40. Hôtel Bouret de Vézelay (now destroyed)**

*This hôtel was built on the Rue Basse-du-Rempart by Brongniart in 1775 for the general treasurer of the artillery and military engineers, Jacques-Louis Guillaume Bouret de Vézelay. It was better known as the Sainte-Foix Hôtel, because it had been sold by Bouret in 1779 to the financier Maximilien Radix de Sainte-Foix. The Rue Basse-du-Rempart was below the boulevard, at the far south of the Chaussée-d'Antin. The facades of the hôtel had been decorated with bas-relief carried out by Clodion around 1775. The terra-cotta models were exhibited at the Salon of 1779.*

*Above and on the following two pages: on the street facade Allégorie des Arts (Allegory of the Arts) by Clodion. (terra-cotta models, Musée Thomas-Henry, Cherbourg).*

*Bottom: on the garden facade, Triomphe de Galatée (Triumph of Galatea), by Clodion. (terra-cotta models, Statens Museum for Kunst, Copenhagen).*

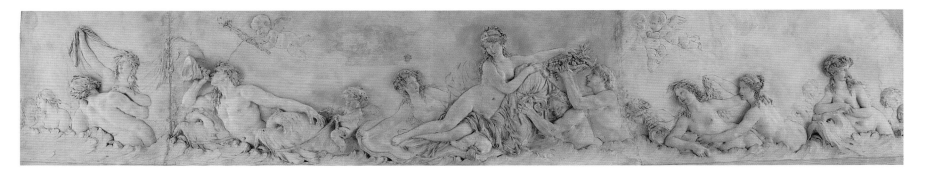

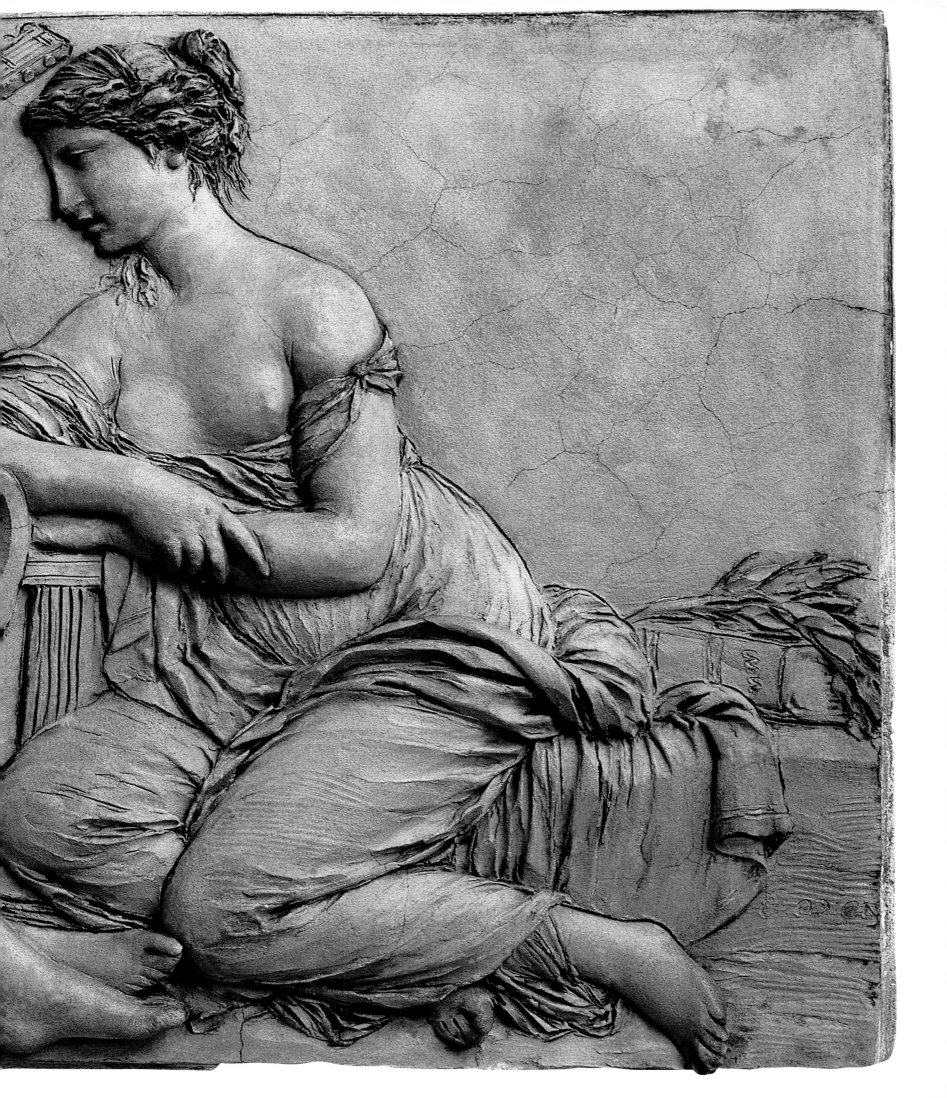

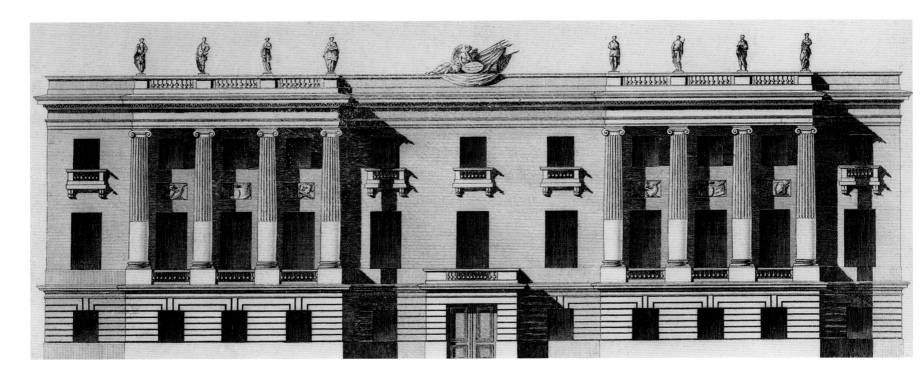

## 41–42. Hôtel de Montmorency (now destroyed)

*This hôtel was built in 1769 by Ledoux for the prince of Montmorency, at the corner of the boulevard and the Chaussée-d'Antin. The elevation, from L'Architecture, 1804, by Ledoux, has been enhanced; that is, the three elevations of this corner hôtel have been combined in a single view. The remarkable interior decoration of the salon is preserved in the Museum of Fine Arts, Boston.*

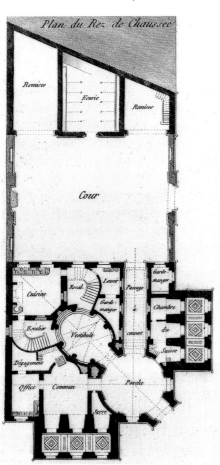

Chaussée-d'Antin, the *hôtels* (townhouses) of financiers stood side by side with those of the most famous courtesans, the ultimate beneficiaries of those operations. The end of the war and the incentives to build, such as the decree of 1766 offering particularly good terms for credit in order to build, launched what Mercier in his *Tableau de Paris* called the "frenzy of building." This gave to the town an "air of grandeur and majesty." He added further: "Masonry rebuilt a third of the town in twenty-five years," that is, between 1760 and 1785.

### The Boulevards of the North

Most of the construction was concentrated on the northern boulevards and the empty land to the north of them. The Hôtel de Chabannes (fig. 2), built by a former academy student on his return from Italy, was one of the first examples of the *goût Grec* (the early stage of neoclassicism) and of the *hôtel de boulevard* with a showy facade on the boulevard, benefiting as much from the greenery as it contributed to the splendor of the promenade. "The architect who drew up the plans for [this] house showed the public that one can, in a small space, make something impressive" wrote Abbot Laugier, an eminent critic, in his *Observations sur l'Architecture* (*Observations on Architecture*), 1765. The plan of the *hôtel* would be needed to judge the accuracy of this remark. The composition of the facade, with its lateral frontispieces at each end, each the width of a single bay, was original (possibly inspired by the Italian, or rather, Palladian models); it was certainly foreign to the French tradition and therefore seemed Greek to contemporaries. A stylish display was achieved with a continuous Greek key pattern set between the two levels. This is what Mercier called a "very good style, especially as regards the ornamentation."

The Hôtel Bouret de Vézelay (figs. 37–40) was an excellent example of the *hôtel de boulevard*, partly (of course) due to its location on the boulevard at the southern end of the Chaussée-d'Antin district, and partly because its creators, the financier Bouret and the architect Brongniart, were both keen speculators who built only ready-to-occupy *hôtels* for resale (as was the case with the Hôtel Bouret). It was also the quintessential *hôtel de boulevard* because of its layout with a grand elevated courtyard open to the boulevard, and because of the exterior decoration of low-relief panels and friezes by Clodion, a specialist in the genre.

Bas-relief panels placed above the openings, invented in the seventeenth century by Le Vau, came back into fashion (or more precisely into use), because their original function was also

*This hôtel was built in 1778 by
Ledoux on the Chaussée-d'Antin
for Madame de Thélusson, the
widow of a banker from Geneva.
These engravings, published in
L'Architecture (Architecture),
1804, by Ledoux, were made
at the time of construction
and circulated as a promotional
preview by the architect.*

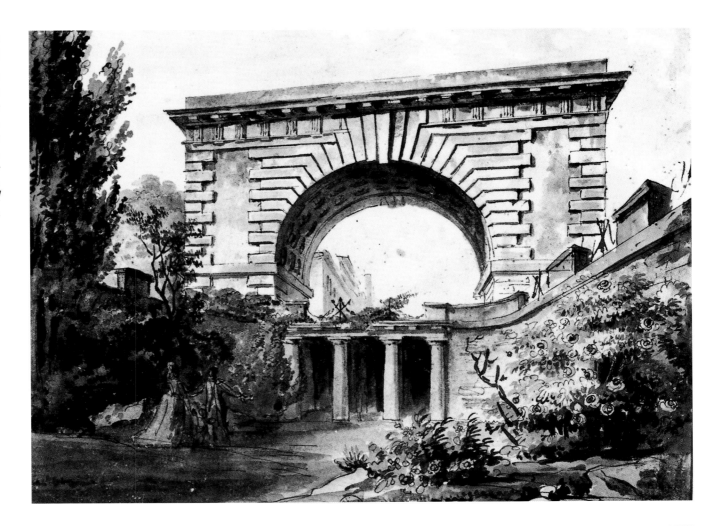

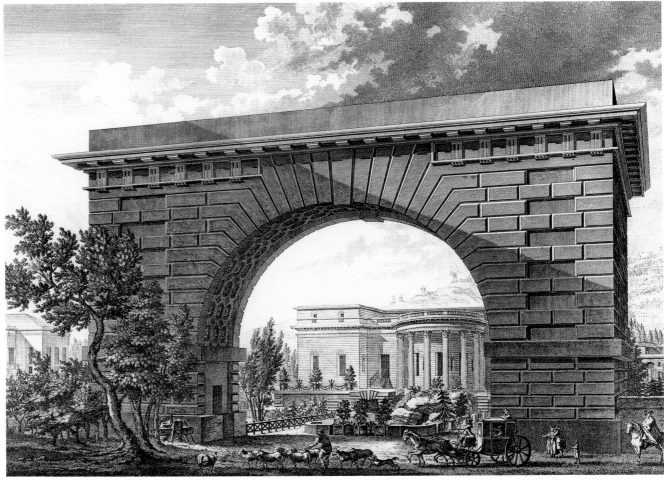

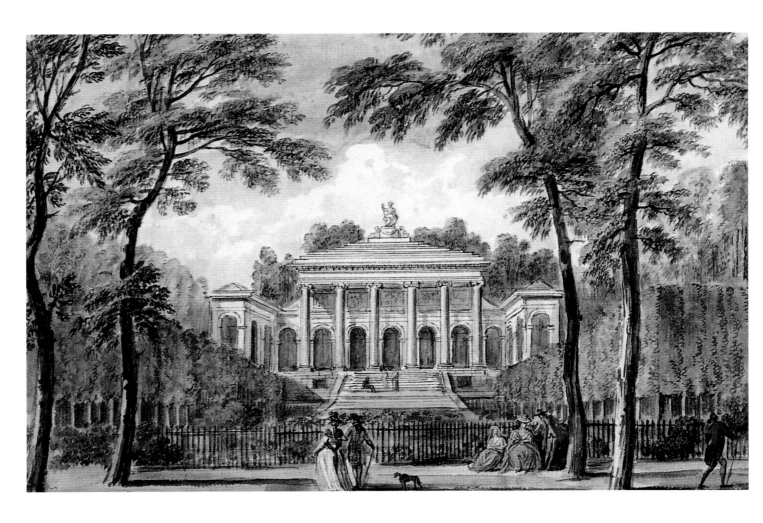

**45–46. Hôtel de Brunoy (now destroyed)**

*This* hôtel *was built in 1775 by Boullée for Madame de Brunoy between the Rue du Faubourg-Saint-Honoré, where the entrance was, and the Champs-Elysées, where the garden was. This view, with the Champs-Elysées in the foreground, is taken from Lallemand and Née,* Voyages pittoresques de la France *(Picturesque Journeys in France), c. 1787. The elevation, cross section, and plan (opposite page) are taken from J.-C. Krafft and N. Ransonnette,* Plans... des hôtels construits à Paris *(Plans of Hôtels Built in Paris), 1771–1802.*

revived: Le Vau had designed them to decorate the exterior panels masking interior vaults. Vaulting in general came back into fashion, which did away with plaster ceilings. Nevertheless, the seventeenth century had ignored these long bas-reliefs whose function was to make the facades more monumental. Now, because of overhead lighting, the main facades could be purged of these window bays, which lent a casual air to these traditional homes.

The Hôtel de Montmorency (figs. 41–42), built at the corner of the Boulevard and the Rue de la Chaussée-d'Antin, is not distinguished for the originality of its facades, which were similar to Hardouin-Mansart's, but rather by their distribution: Ledoux had taken the step of placing the entrance at an angle and assembling the rooms around a central space lit from above. The recourse to overhead lighting changed the coordinates of the French distribution of space without, however, making it appear unnatural. "Inside, our houses are organized with the most charming convenience, completely unknown to all the other peoples of the earth," wrote Mercier. "Knowledgeable and ingenious arts make economical use of the land, multiply it and provide new and precious conveniences: this would astonish our forefathers very much, who only knew how to build long or square halls spanned by enormous beams made out of whole trees. Our little apartments are turned out and laid out like round and polished shells, and one can live with light and pleasure in spaces previously wasted and inconveniently dark," stated the author of the *Tableau de Paris* (*Portrait of Paris*). Along with these remarkable *hôtels*, the boulevards of the north had welcomed baths (fig. 60), cafés, and theaters.

*The Chaussée-d'Antin and the Northern Faubourgs*
It is once again Ledoux who is credited with the Hôtel de Thélusson (figs. 43–44), the most famous *hôtel* on the Chaussée-d'Antin, the one whose unnecessary disappearance has caused the most regret. The *hôtel* had such a strong status as a public monument that one did not go to Paris without visiting it, and one year after its completion, there were such crowds

that one had to buy a ticket in order to get in. It is true that Ledoux, a skillful promoter of his work, had published engravings to assure the reputation of the *hôtel*. To produce a Piranesi effect on the engravings, the bars of the principal entrance were done away with, and the grand arch was shadowed in a rather dramatic—and artificial—fashion. But this monumental arch is indeed the one that was built; it belonged to a type of architecture

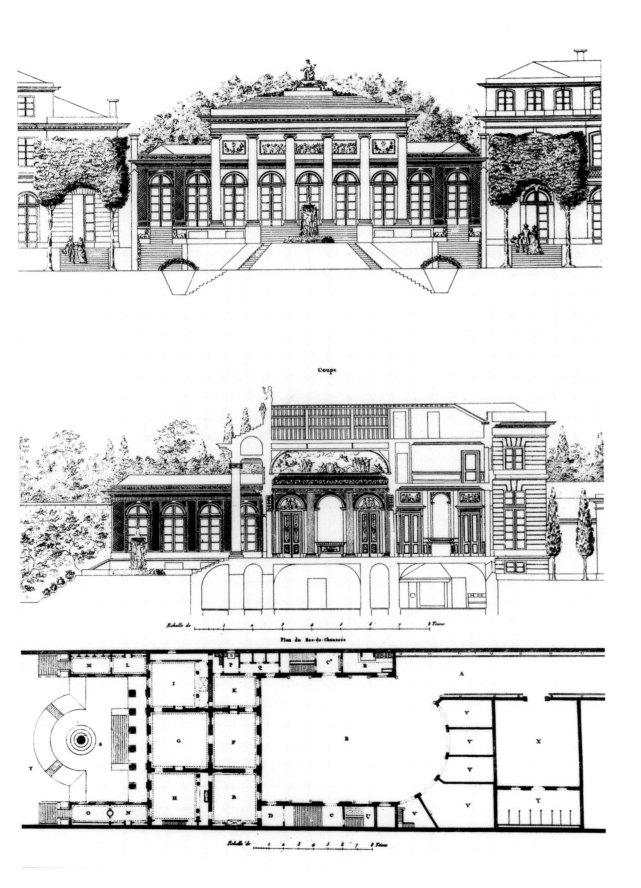

*This hôtel was built in 1783 by P. Rousseau for the prince of Salm at the edge of the Seine, on the Left Bank adjacent to the Jardin des Tuileries (Tuileries Gardens).*

*Pages 438–439 contain an anonymous painting showing the construction of the Hôtel de Salm (Musée Carnavalet, Paris).*

called *"ensevelie"* (buried), which is a building that is partially buried, imitating classical monuments just as they appear on Piranesi's etchings. After passing through the entrance, one circled the perimeter of a sunken garden complete with a grotto under the main building, which itself was made to look like a temple. The access for vehicles was hidden under the main residence. Vehicles could exit through a courtyard with a secondary entrance as the *hôtel* extended the full length of the block.

The Maison Gouthière (fig. 51) at the Faubourg Saint-Martin, fortunately preserved, is an example of the plot division that would be seen again in the first half of the nineteenth century. The house of the famous bronze chaser is at the end of a long courtyard surrounded by buildings, like the main residence of a *hôtel* at the heart of a block well insulated from the noise of the town; nevertheless, the buildings looking onto the courtyard are a row of individual houses. Perhaps it is merely another development of attached houses with adjoining courtyards of the kind that could be found in Paris in the seventeenth century. The courtyard facade of the Maison Gouthière is that of a temple to Apollo.

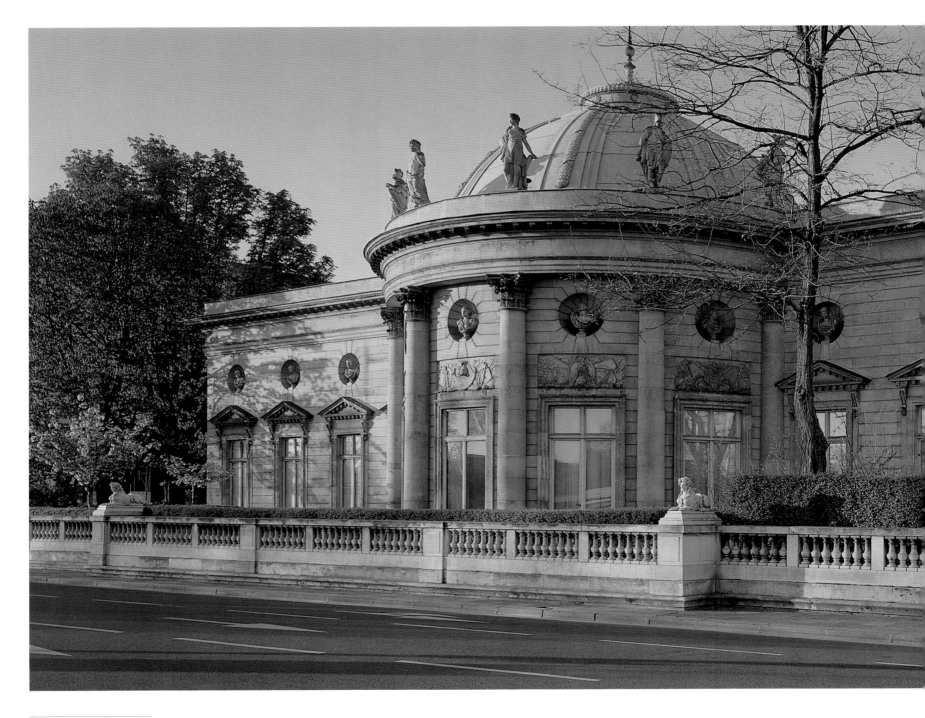

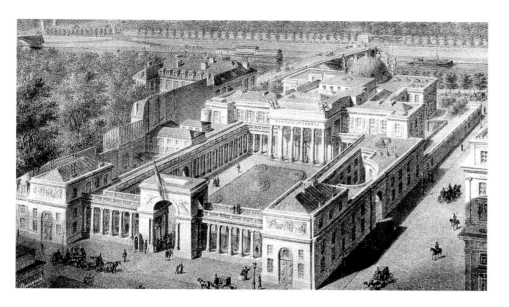

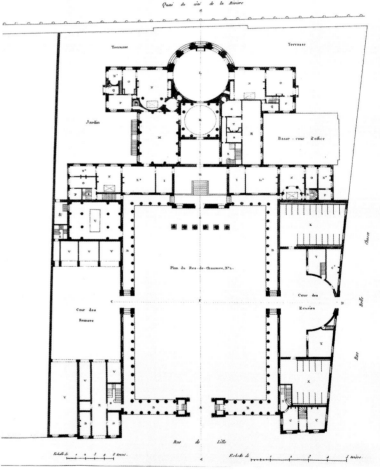

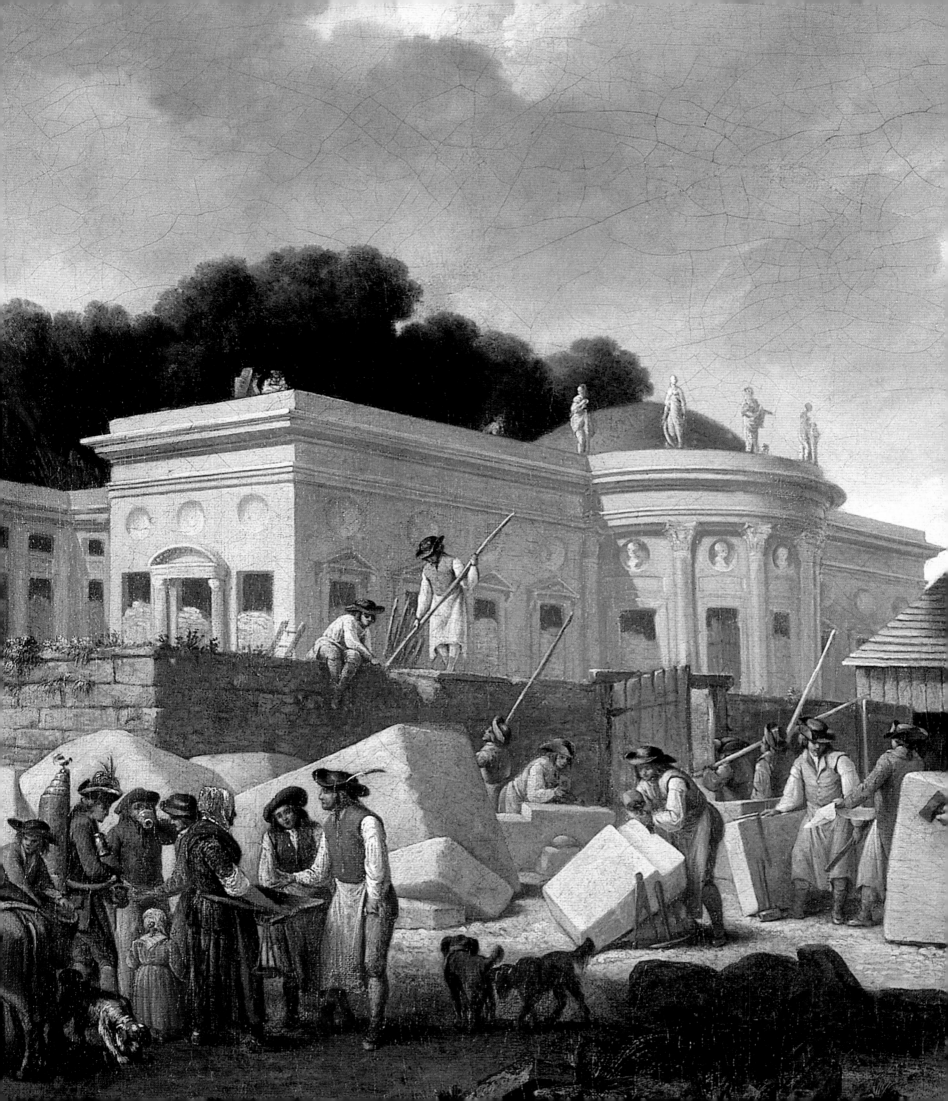

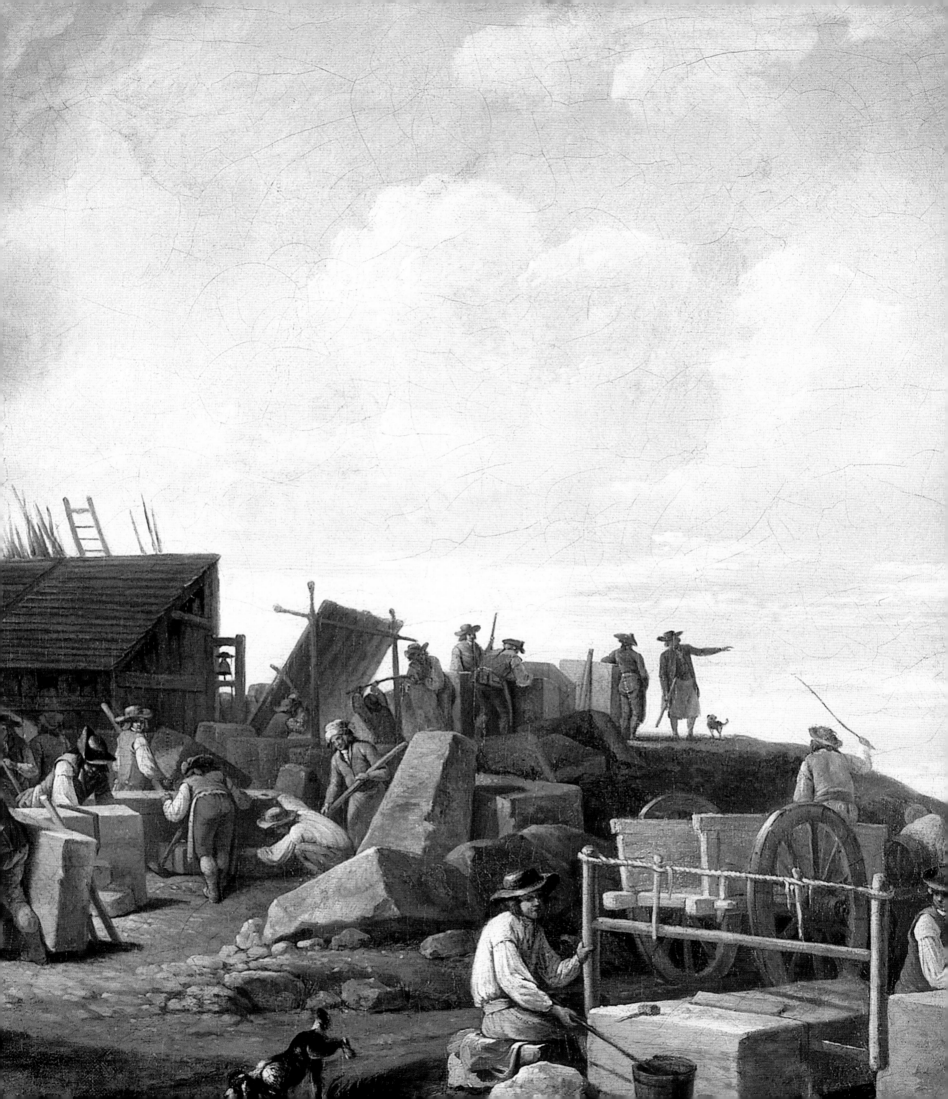

## 51. Maison Gouthière, 6, Rue Pierre-Bullet

*This was built in 1780 by Joseph Métivier for the famous bronze chaser and gilder Pierre Gouthière. Above the entrance is Apollon couronné par les muses (Apollo Being Crowned by the Muses); above that Bacchanalia; and in the round niches, gorgons.*

## BAGATELLE

*In the Bois de Boulogne {the Boulogne woods} there is a kind of country cottage called Bagatelle, which by various arrangements now belongs to the Count of Artois. This prince has a particular taste for the trowel, and apart from the buildings of all kinds that he has already undertaken (some four or five), he wanted to extend and embellish this one, or rather to change it completely, and make it worthy of himself. He discovered a very ingenious way of making sure that the expenses were covered. He had a bet of 100,000 francs with the queen that this fairy palace would be started and finished during the journey to Fontainebleau, so as to be able to throw a party for {His Majesty} on his return. There are 800 workers and the architect to {Her Royal Highness} hopes that he will win.*

Bachaumont, Mémoires secrets (Secret Memoirs), October 22, 1777.

### The Western Faubourgs

The Hôtel de Brunoy, built by Boullée (figs. 45–46) and situated between the Rue du Faubourg-Saint-Honoré and the Champs-Elyseés, shares several characteristics with the Hôtel de Thélusson. The building is famous because Boullée maintained the layout and the distribution of space of a traditional Parisian *hôtel* (both proven successes), while still offering those strolling down the Champs-Elyseés a wonderful view of the Temple of Flora. A statue of the deity sat enthroned at the top of the building on which trellis and greenery were mixed in with foliage from the garden in order to isolate the frontispiece of the temple.

The Hôtel de Salm (figs. 47–50), the only great home preserved from this era, is situated on the banks of the Seine in the Faubourg Saint-Germain, the full expression of the monumentalization of Parisian residences in the tradition of the Palais Bourbon, which had heralded the onset of that trend at the beginning of the century (chapt. IX, fig. 75). It reproduced—twenty years later—the essential feature of a Hôtel de Condé that Peyre had published in his *Oeuvres d'architecture (Architectural Works)* in 1765. It is representative of the highly admired reconciliation of classical order and French organization, once again perfected by the use of overhead lighting.

### The Palais Royal (The Royal Palace)

The famous plotting out of the Palais Royal (figs. 52–55) would have been similar to that of the Place Royale if the order of colossal pilasters had not been substituted for that of the pavilions, and a private garden for the public open space. Indeed, on three sides of the garden (which belonged to Richelieu) the future Philippe Egalité and heir of the duke of Orléans arranged for condominiums to be built that were resold by the unit. The duke's residence should have stood on the fourth side of the garden, its construction financed by the sale of the apartments, but only the foundations of the main block were completed, sheltered under a wooden construction. They were soon used for commercial purposes, as were the galleries in the surrounding blocks. The sheds of the Palais Royal were called "the camp of the Tartars" or the "den of thieves," probably because of their resemblance to the *souk* (covered market), a forerunner of the covered passages of the nineteenth century.

The count of Artois, the future Charles X, tried to compete against his cousin by planning an area similar to London: a row of connected houses "in the English style," a grouping that nineteenth-century city planners would call a *cité*. The person responsible for the project was François-Joseph Bélanger (the count's architect), who had traveled to England to study its architecture, but not to Italy. The apartment building with common areas was quite different from the traditional setup of the multi-family house; the apartment block whose nineteenth-century clones would create the Paris we still see today was instituted in the years 1770–1780 (fig. 56).

### The Follies

Follies were built in suburban areas. The word comes from the French *"feuillée"* (leafy) and means a house in a natural setting; but this word also has the meaning of "bagatelle," the nickname of Artois's Folly, which was an extravagant expense for a discrete place of pleasure. The Parisians, to whom Rousseau had given a taste for nature, went to the outskirts of the town in search of it since they didn't let it enter the town itself. Bagatelle was built in a few days as the result of a bet between the count of Artois and the queen, was known mainly for the large number and quality of the constructions in its park, where the Dutch house was next to the Swiss house, and the Indian pavilion next to the hermit's hut. Nothing is left of these constructions. The nearby Saint-James's Folly (fig. 59), next to the Bois de Boulogne, has fortunately kept its famous rock. The Chartres Folly, attributed to Philippe Egalité, who was then still the duke of Chartres, was as over the top as its owner. Its disappearance is not regretted, as it was replaced by the Monceau Park. The Neubourg Folly, built at the southern edge of the boulevard, was to private

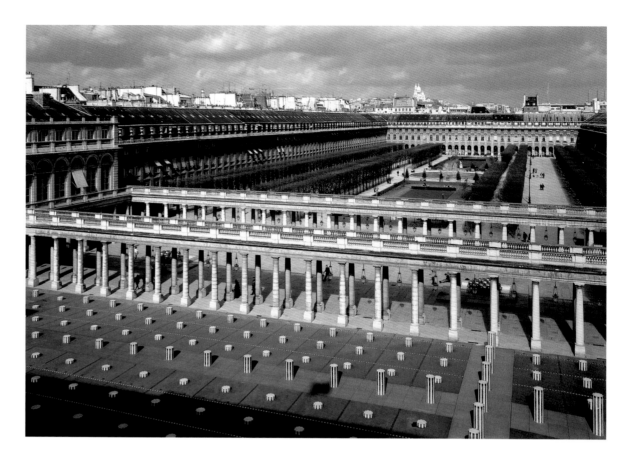

### 52–55. The Palais Royal (Royal Palace)

*In 1780 the duke of Chartres received the Palais Royal as a gift from his father, the duke of Orléans. In 1781 a fire destroyed the auditorium of the Opéra (which was part of the palace). This had itself been rebuilt after an earlier fire (in 1763) destroyed the auditorium built by Le Mercier for Cardinal Richelieu (who had built the original palace). There was now an opportunity to rebuild the palace almost completely, and the architect Victor Louis was commissioned. Roads were laid on three sides of the garden, cutting it off from the houses Richelieu had had built along its edges. Additional rows of houses were then raised between the new roads and the garden. These, completed in 1784, were always intended to be sold. The proceeds of the sale were to finance the building of a new palace on the fourth side of the garden, replacing the clutter of original palace buildings. Only the foundations were completed. To protect them until work could continue, Philippe (now duke of Orléans since his father's death in 1785) had a wooden hangar built. This should have been temporary, but it lasted fifty years (until his heir, King Louis-Philip, assumed control in c. 1830). Meanwhile, the duke of Orléans speculated by renting out commercial booths in the hangar (dubbed the "camp of the Tartars" or "den of thieves"), which was instantly popular but notorious. Business scams and prostitution spread throughout its galleries, thus ensuring that its owner (the future Philippe-Égalité, who voted for the death of Louis XVI) got his just desserts.*

architecture what the Ecole de Chirurgie was to public architecture: a manifestation or quintessential example of a folly brought to life in 1762 by Peyre and published in his *Oeuvres d'architecture (Architectural Works)*, 1765. Inspired by Italian towns of the sixteenth century, the architect symbolically sacrificed the trivial order of French tradition. The facade, with two projecting frontispieces instead of three, is similar to the Hôtel de Chabannes.

*Interior Decoration*

Both classical art and nature served as inspiration for interior decoration. Clérisseau, back from Rome, designed the decor of the Hôtel de Grimrod de La Reynière in imitation of the classical grotesque style (fig. 61). The decoration, called Pompeian although it owes more to the paintings of the Vatican than those of Pompeii, had been very fashionable for some decades (fig. 64). The classical style appeared in Ledoux's Café Militaire (figs. 66–67) with its bundled branches in place of pilasters and relief panels adorned with trophies, but one cannot admire the trophies on the panels without recalling the place that battle trophies in bas-relief occupied in the work of Jules Hardouin-Mansart (chapt. VIII, fig. 32). At the very end of the century, in the hands of two prizewinning students of the academy who went on to become the architects and decorators of the empire and Restoration, Percier and Fontaine, the classical style produced decors that no longer had anything in common with French decor (fig. 68). The transformation of salons into groves could, on the other hand, refer back to French examples of the fourteenth century, those of the Hôtel Saint-Pol in particular. Aided by Fragonard and Huet, Boucher transformed the salon of the engraver Demarteau (who was his friend and the engraver of his paintings) into a kitchen garden and farmyard (figs. 69–71). The salon of Mademoiselle Guimard's Hôtel, by Ledoux, was pure foliage. At the Hôtel d'Uzès, Ledoux planted great trees in the salon (fig. 34), thus eliminating decorated paneling on the lower part of the wall against which furnishings had traditionally been placed. The innovation presupposed a new concept in furniture and probably encouraged the increase in small freestanding pieces. But typical mid-century furniture was still intended to rest against the wall.

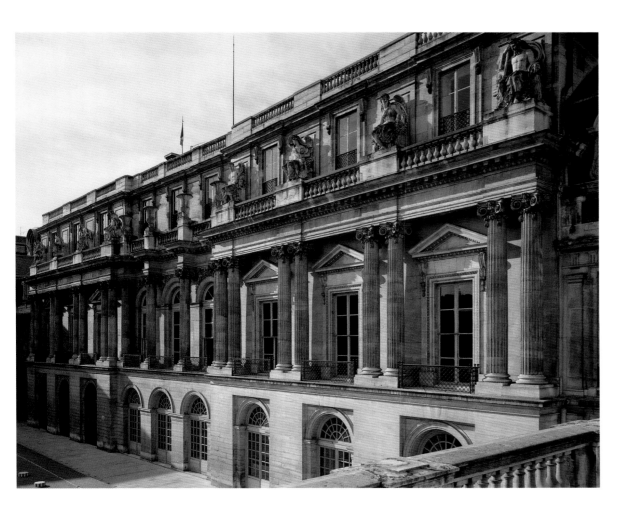

## THE PALAIS ROYAL

*A unique landmark in the world. Visit London, Amsterdam, Madrid, Vienna, you will never see anything like it ... It is called the capital of Paris. Everything can be found there ... This enchanted place is a luxurious little town, enveloped by a bigger one; it is the temple of delight, where glittering vices have banished even the ghost of decency: no dance hall in the world is more luxuriously depraved; one laughs there, and innocence blushes again ... With what magical speed we saw it rise. But it did provoke vigorous public protests:* IT WAS ON *that occasion, when we explained to the venerated owner that his building was going to be an enormous expenditure, he retorted gaily: "Not at all, not when everyone is betting on it."*

Louis-Sébastien Mercier, Tableau de Paris, (Portrait of Paris), 1781–1790.

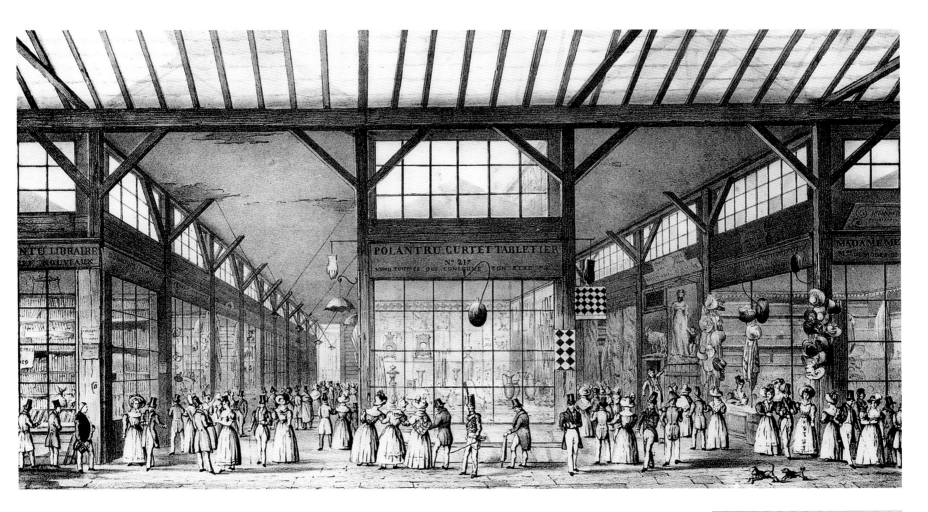

## 56. Apartment Building, 12, Rue de Tournon

*This building, with two apartments per floor, was built in 1777 by Charles Neveu.*

Plan

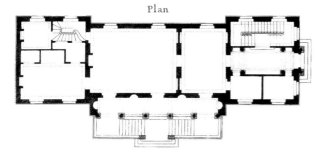

## 57–58. Le Prêtre de Neubourg Folly (now destroyed)

*This "folly" was built in 1762 on the boulevard to the south of Paris by M.-J. Peyre for Madame Le Prêtre de Neubourg, and was published by Peyre in his Oeuvres d'architecture (Architectural Works), 1765.*

MOTIFS HISTORIQUES
PAR Mʳ CESAR DALY, ARCHᵗᵉ

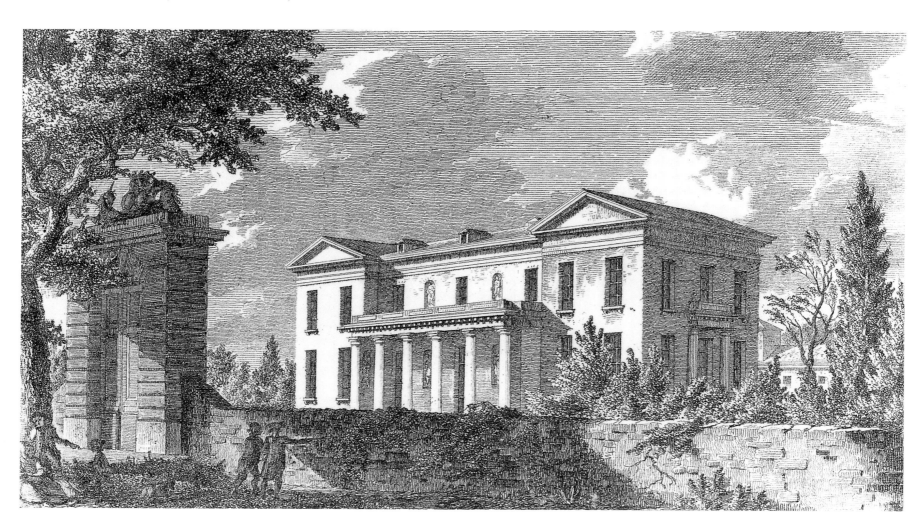

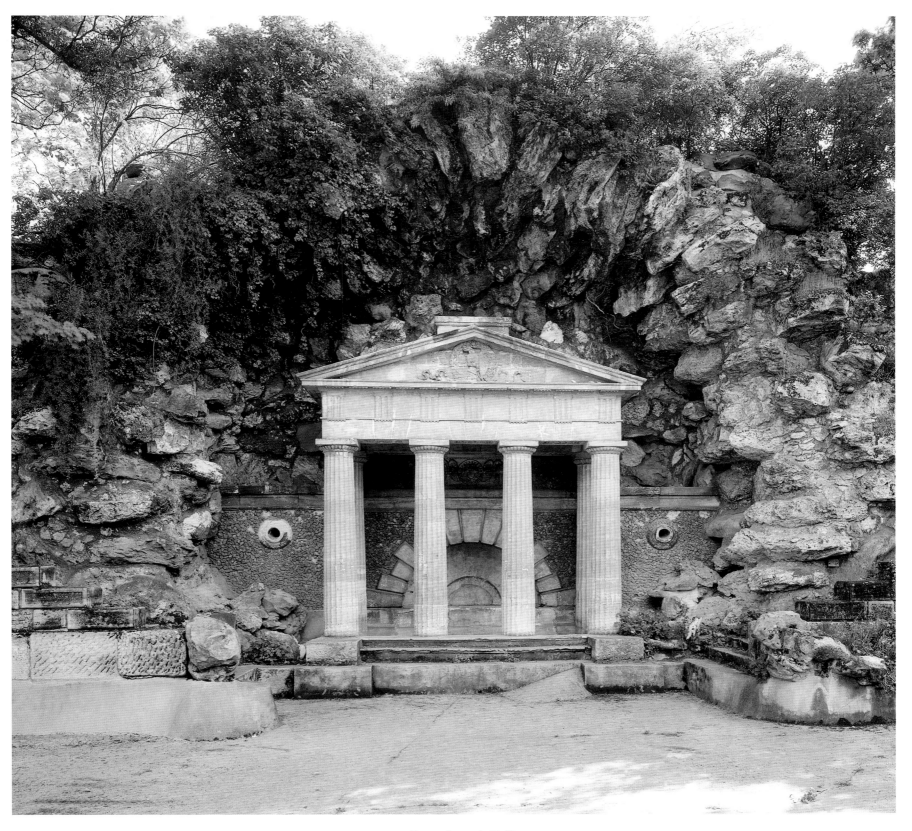

### 59. Saint-James's Folly

*Saint-James's Folly, a country house encircled by an English-style (natural-looking) garden at Neuilly, Avenue de Madrid, was created for Claude Baudart de Saint-James on land acquired in 1772 near the Bois de Boulogne by the architects Bélanger and Chaussard. As general treasurer of the colonies, Baudart, who was born in Saint-Gemme-sur-Loire (from which the Anglicized form of the name is derived), had amassed millions. All that remains of the folly are the house and the crag (the main construction in the garden, although there were several, recognizable now only from engravings). The crag, designed by Bélanger, is a mass of rocks with the façade of a temple, which originally contained baths. Louis XVI, having seen one of these grey blocks being pulled along by forty horses while hunting at Fontainebleau, gave Baudart the nickname of "the man of the rock."*

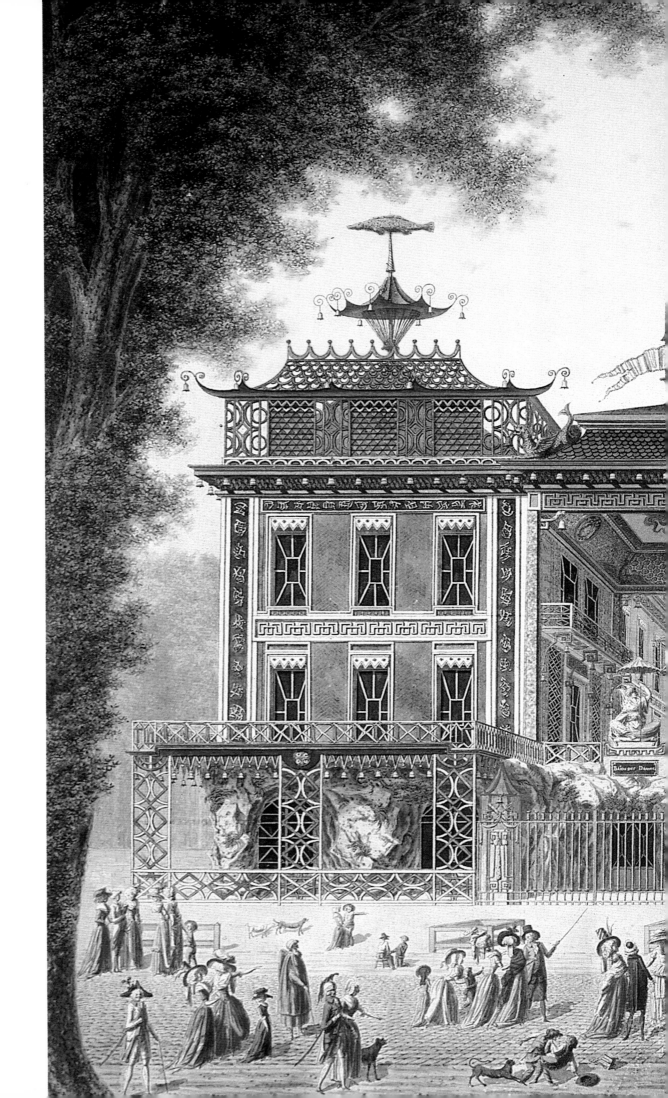

**60. Chinese Baths.**
**(Musée Carnavalet, Paris)**

*Built on the Boulevard des Italiens by Lenoir in 1787, these public baths were laid out in the shape of a horseshoe, and included individual changing rooms for men and women, reading rooms, and a café. It was meant to look like a Chinese building built on a rock.*

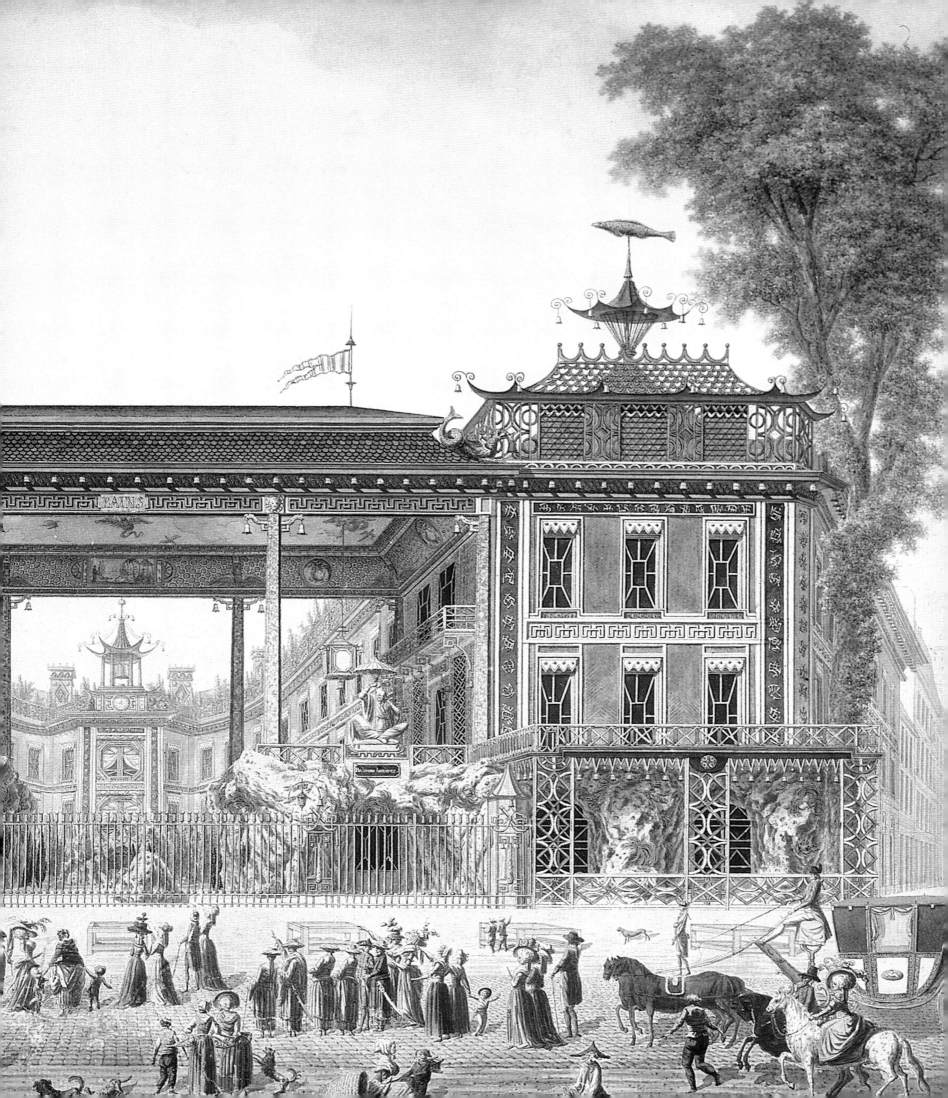

*Furnishings*

These enormous residences contained the greatest works of French decorative art. The Greek style had appeared first in some furnishings designed (in a very Louis XIV style) for Lalive de Jully by the recently returned prizewinning academy artist Louis-Joseph Le Lorrain. Moreover, in the Faubourg, furniture was again being made that could be mistaken for the work of Boulle. Nevertheless, there was indeed cabinetmaking in the Louis XVI style, as illustrated by the masterpieces of Riesener (fig. 62), Benneman, Schwerdfeger (fig. 63), Weisweiler, Roentgen, and Carlin—all Germans from the Rhineland.

Jean-Henri d'Eberts, another Rhinelander, was also established in Paris and specialized in the export of paintings and art objects to Germany. It was he who launched the

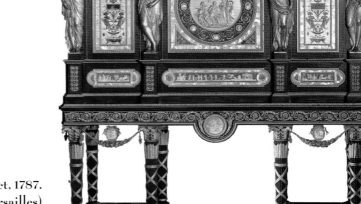

62. Jean-Henri Riesener. Commode from the Salon des Nobles at Versailles. 1779.

63. Ferdinand Schwerdfeger. Jewelry cabinet. 1787. (Musée National du Château de Versailles)

*This piece, bearing statues representing the four seasons, was destined for the bedroom of Queen Marie-Antoinette at Versailles.*

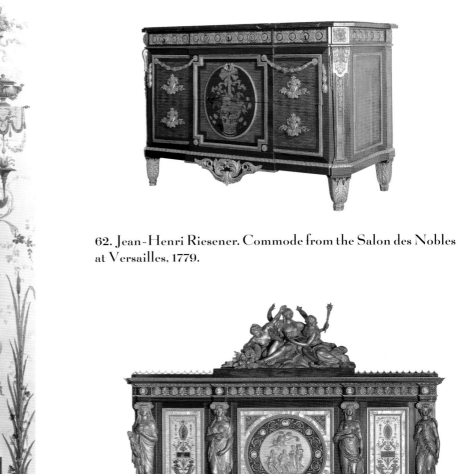

"Athenienne," an object that would cause a furor. In 1762 he had commissioned a picture from Joseph-Marie Vien showing a young priestess of Athena officiating at a tripod copied from Caylus's *Antiquities* (fig. 74). Ten years later, Eberts conceived the idea of using this object as the model for a wide range of furnishings, including console tables, chafing dishes, aquariums, planters, flower vases, hot plates, chiffonniers, and washstands; the objects made in this style were referred to as "*à l'Athenienne*." Gouthière, an exceptional bronze chaser, produced a perfume basin *à l'Athenienne* (fig. 75), a masterpiece of Parisian art.

Following the example of Le Lorrain and of Vien, painters and architects started to design furnishings for the home. The first and the most beautiful "Etruscan" furniture, popularized by the Directoire (a governing body during the French Revolution) and the empire (during the reign of Napoleon I), appeared in David's paintings of the 1780s (fig. 5). David placed an order for his own use with Jacob, the famous woodworker for the seats in the *Le Serment des Horaces* (*The Oath of the Horatii*). The architect Brongniart also submitted designs for the factory of Sèvres, where his son would take over the directorship in 1800. But the finest works from Sèvres would be produced by its own professionals, the designer Simon-Louis Boizot and the bronze chaser Pierre-Philippe Thomire (fig. 76). Nevertheless, Thomire, pupil of Gouthière, had transformed the workshop of the master into a business that, around 1787, employed some six hundred workers. The industrialization of decorative art had begun.

### Foreign Architects in Paris

The model of the French residence remodeled in classical style attracted a lot of young foreigners, who were destined to be the most famous architects of their country: Sir William Chambers and Sir John Soane from England; Friedrich Gilly and Karl Friedrich Schinkel

## 64–65. Dining Room of the Hôtel Botterel-Quintin

*This dining room is part of the ground floor designed for the Comte de Botterel-Quintin, who in 1785 acquired a hôtel that had been built in 1780, no. 44 Rue des Petites-Écuries. The room has a rectangular plan with an apse at each end and overhead lighting. Apart from the women carrying goblets, by Clodion, the authors of this composition are unknown. Though there is no definitive proof, the following attributions have been proposed: the design has been credited to the architects Pérard de Montreuil and Bélanger; the painting in the vault representing the four seasons has been attributed to Prud'hon; and the stuccos to Dugourc or to Lhuillier. Above one can see the Pompeian-style painted panels and the stuccos imitating the yellow marble of Sienna.*

from Prussia; and Bajenov and Zakharov from Russia. Paris attracted the first of its American guests, the architect Thomas Jefferson, future president of the United States of America, from 1785 to 1789. During that time Jefferson was the ambassador in Paris of the young republic that had just won its independence with the help of the French; Jefferson showed an insatiable curiosity for all that was being built at that time in Paris.

**69–71. François Boucher, Jean-Honoré Fragonard, and Jean-Baptiste Huet. The Salon of the Engraver Gilles Demarteau, c. 1765. (Musée Carnavalet, Paris)**

*Demarteau was the engraver of Boucher's works. Fragonard was probably responsible for the painting of a door and Huet for the painting of the animals.*

### Jean-Honoré Fragonard

Luckily for French art, taste evolved more slowly than the *doctrinaires* (philosophers and political men of the time) would have wanted, and Fragonard, who carried on the tradition of Watteau and Boucher, thus enjoyed a few years of success before becoming outdated. It is at least possible that he owed his success to the persistent taste of the French for provocative scenes, paintings that can be understood without having to hear a sermon. *Le Feu aux poudres* (*The Torch*) by Fragonard is an inversion of the *Odalisque* in which Boucher, Fragonard's master, had shown the back view. While the audience must usually ignore

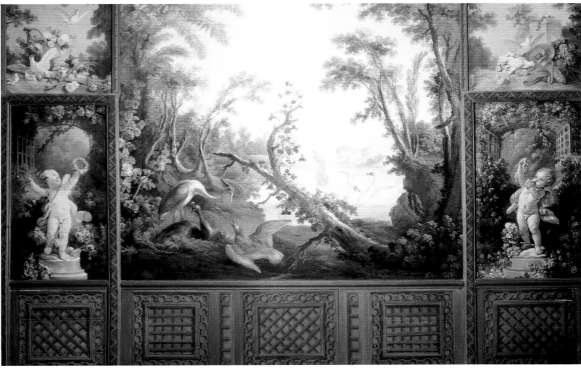

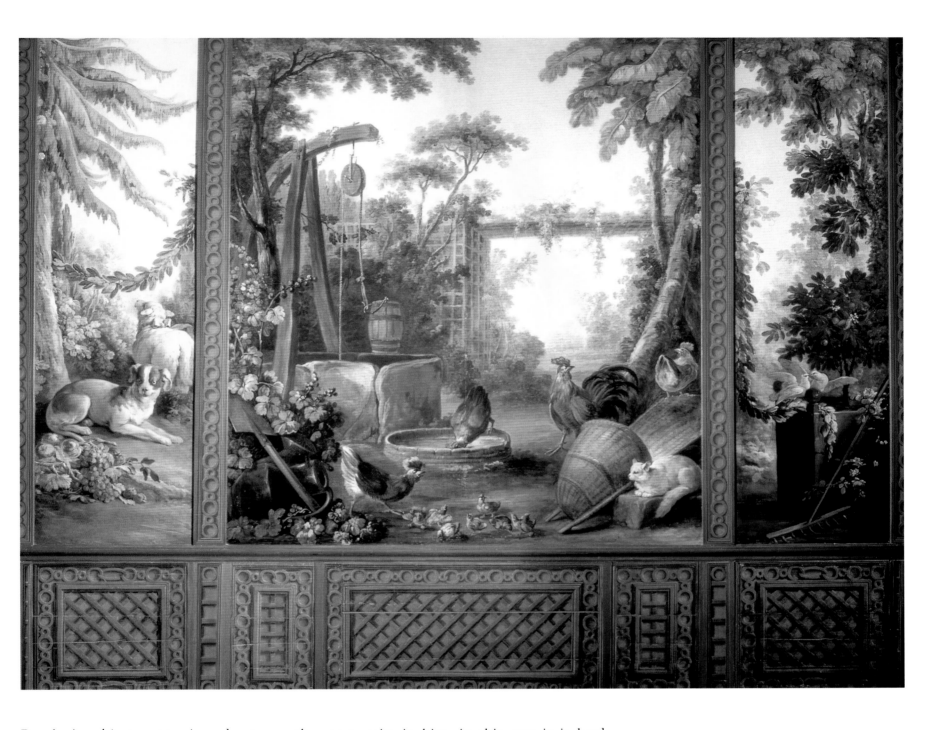

Boucher's subject matter in order to see the great artist in him, in this case it is hard to recognize that Fragonard has a subject at all. The portrait of the Abbot of Saint-Non (figs. 77–78) is a vigorous medley of Prussian blue, orange-red, lemon yellow, white, gray, and fawn. Only after analysis does the "fantasy figure" of Fragonard's imagination appear. He painted this picture in less time (one hour!) than Watteau took to paint his famous shop sign (chapt. IX, fig. 42). French artists liked to work fast, as they wanted to be seen as not having "interfered" too much with the creation. (That was the idea behind the bet on the Bagatelle, which was built in several weeks.) To work slower would be to pose, and for some time still, French society refused poseurs. A more detailed analysis of Fragonard's painting would produce the impression of a portrait, the Abbot of Saint-Non, who was Fragonard's mentor in Italy; and even though the picture is not the psychological portrait so much admired in France, it can be inferred that the Abbot was a man of spirit.

Fragonard won the first prize for painting in 1752, and was in Italy from 1756 to 1761. With Hubert Robert, he painted his first works in the Roman countryside. Nevertheless,

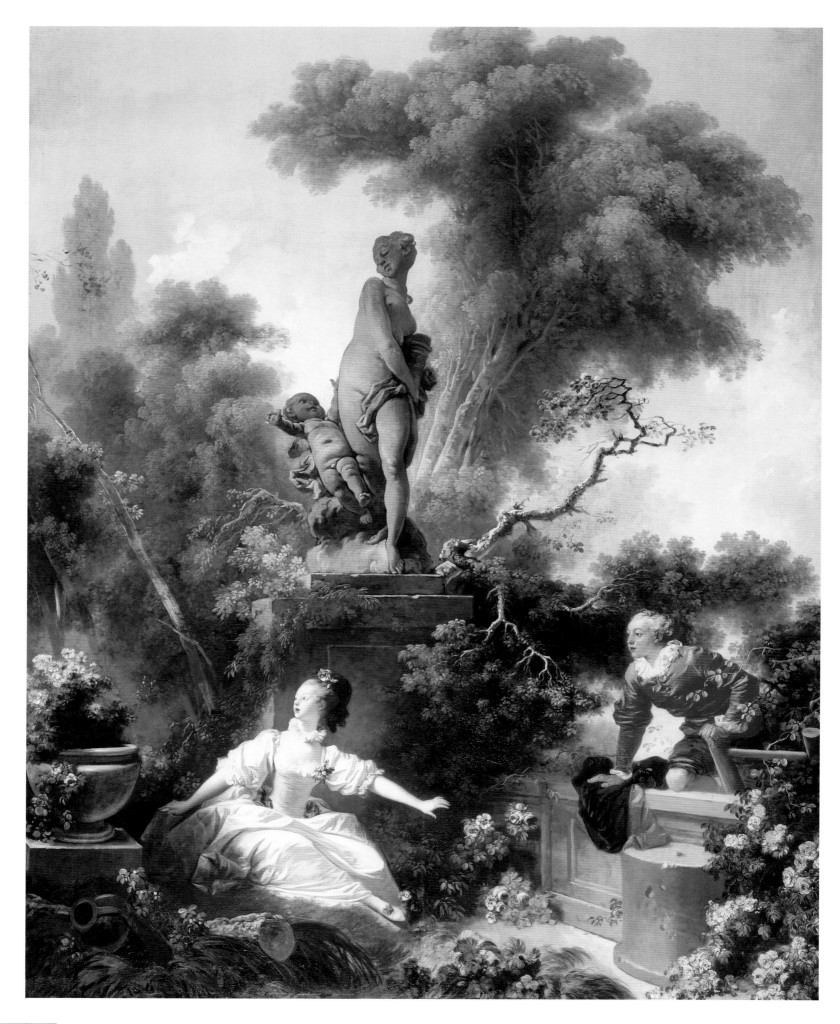

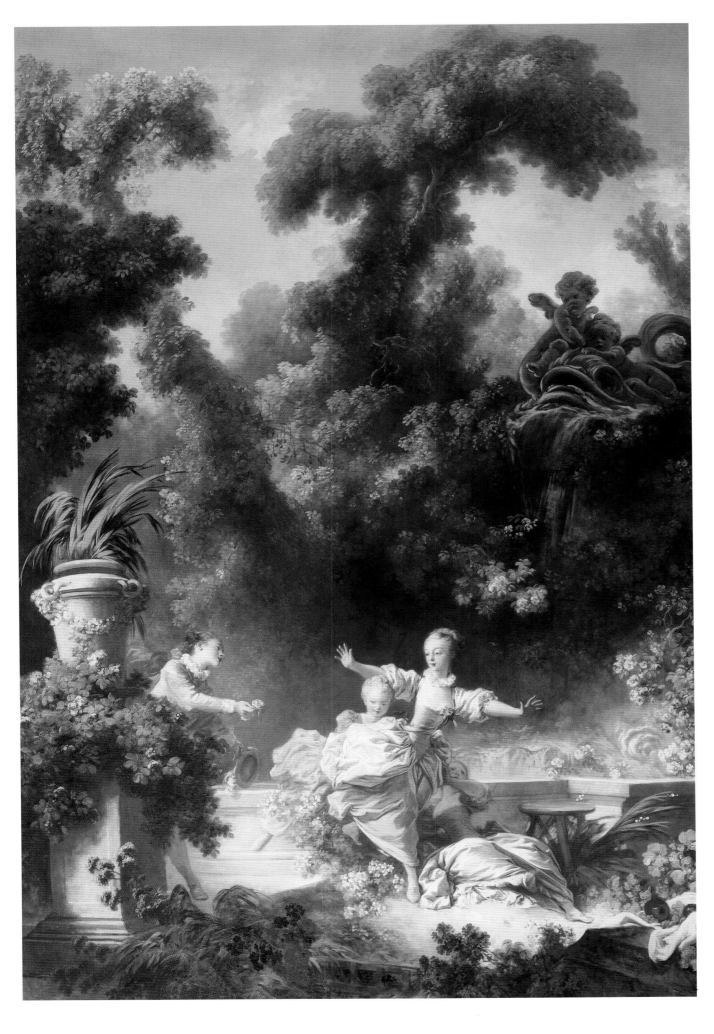

**72–73. Jean-Honoré Fragonard. Decor for the Louveciennes Château, 1771–1772. (Frick Collection, New York)**

*This was a series of panels commissioned from Fragonard by Madame Du Barry for her Louveciennes Château. The fourteen canvases were painted between 1771 and 1772; the four large ones are more than ten feet high. They represent La Surprise (The Surprise), La Poursuite (The Chase), L'Amant couronné (The Crowned Lover), and L'Amour-Amitié (Love-Friendship). However, in 1773, Madame Du Barry refused Fragonard's work and commissioned four paintings from Joseph-Marie Vien on the same theme to replace it (in the Louvre).*

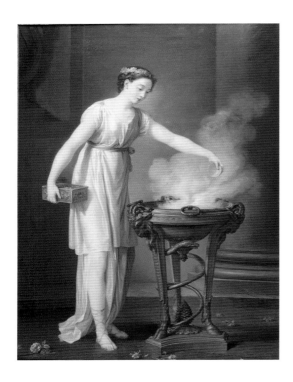

**74. Joseph-Marie Vien.**
*Vertueuse Athénienne*
(*Virtuous Athenian Woman*), 1762.
(Musée des Beaux Arts, Strasbourg)

*This work was painted in 1762 for
Jean-Henri Eberts, who was an editor
of fashion magazines. The Athenian woman
is pouring incense into a perfume basin.*

**75. Pierre Gouthière.
Perfume Basin, c. 1780.
(Wallace Collection, London)**

*The jasper perfume basin was
mounted by the bronze chaser
Gouthière around 1780 for the
duke of Aumont, and bought in
1782 by Marie-Antoinette. A
perfume basin (or "fragrancer")
is for heating perfume.*

he probably learned less in Italy than in the gallery in the Luxembourg Palace where, having returned from Paris, he studied Rubens. Wanting to be recognized as a history painter, he painted *Le Grand Prêtre Corésus, se sacrifiant pour sauver Callirhoé* (*Coresus Sacrificing Himself to Save Callirhoe*, in the Louvre), a sublime couple who are unfortunately lost in the great mass of columns and secondary characters that were included to please the academy. Thus Fragonard came to be regarded as the new head of the French School. At the behest of Madame Du Barry, he painted a series of masterpieces for the château de Louveciennes (figs. 72–73), which Louis XV's "favorite" (Madame de Pompadour) rejected. She had them replaced by a group of works painted in Vien's style. How was it possible in 1773, when Louis XV was still alive, to refuse the luxuriant vegetation of Fragonard's panels, which would have transformed the salon of Louveciennes into a wonderfully verdant and fashionable room, and to instead prefer the staged scenery against which Vien posed his porcelain dolls in decorous imitation of *Les Progrès de l'amour* (*The Progress of Love*) in the Louvre?

### Joseph-Marie Vien

Vien's reputation set him at the head of the French School, as acknowledged by David himself. The curious thing was that Vien was not a high genre painter, but a specialist of rather impersonal gallantry; his cold style was opposed to the passionate work of Fragonard. Vien forced himself to paint; Fragonard would have had to force himself not to paint. Vien received the prize for painting in 1743 (around ten years before Fragonard) and in 1750 came back from Rome wanting to paint in the classical style. Since recent finds had shown that Roman painting was less scientific than had been previously thought—that is, without perspective, without chiaroscuro—Vien turned this clumsiness into a style, which had success and even a future; this prefigured the "primitive" style. An odd effect of revolutions is that it is often enough to be one step ahead of the current thinking to be considered a genius. This is what happened to Vien in France and to Anton Raffael Mengs in Europe, a mediocre German painter who in Rome was hailed as the new Raphael. Vien made himself known by presenting in the Salons of 1761 and 1763 the "Atheniennes," in which the viewer isn't sure if the subject is the cauldron on three legs or the young women that the painter depicted in short skirts. His triumph was *La Marchande d'Amours* (*The Cupid Seller*), a close reproduction of a Roman painting that had recently been rediscovered in which rotund cupids are taken from cages and offered to young girls, who do not seem to know what to do with them. "It is a completely farcical little ode ... The artist is like Apelles resurrected in the middle of a group of Athenian women," wrote Diderot, whose only reproach to Vien was that a cupid delicately held by the wings was making a V sign! Diderot liked anecdotes and details, as long as they were not out of place. Therefore he did not admire the young Athenian women of the 1760s without reservation. He said about a young Greek woman of Vien's: "The subject is charming; but what is it about? A great purity in his drawing, a great simplification of the drapery, an infinite elegance in the whole figure? I wonder if that is it. Ingenuity, innocence, and delicacy in the character of the head? I wonder if that is it. As much grace as possible in the arms and in their movement? I wonder again if that is it...That was the subject of a bas-relief and not a painting," Diderot wrote very aptly during the Salon of 1761.

### Jean-Baptiste Greuze

At the same Salon of 1761, Diderot discovered *L'Accordée de village* (*The Village Bride*; fig. 84) and Greuze, the painter whose works he would praise when they dealt with virtuous, rustic, and familial happiness, and less so when *Filial Piety* was succeeded by *The Paternal Curse*, *The Punished Son*, *The Return of the Drunkard*, and finally *Death of the Unnatural Father*. There are several reasons for Diderot's interest in Greuze's work. About *Filial Piety* of the Salon of 1763, Diderot wrote: "The genre pleases me. It is moral painting. Has the brush not enough and for too long been dedicated to portraying debauchery and vice? Should we not be glad to see it turning at last, along with dramatic poetry, to touch us, to instruct us, to correct us, and to encourage us toward virtue." Here, Diderot describes an engaged art that must use the full expressive range. A debate began between Diderot and Grimm about whether the woman behind the father in *The Bride* was a servant or the bride's jealous sister. But they agreed that it is a charming painting. Diderot's description of it shows that, for him, art criticism was first and foremost a type of description, an occasion for a writer to produce literature. Diderot liked paintings that gave him something to say; something was always happening in Greuze's paintings. But the vogue for history painting was returning. Greuze tried to gain admission to the academy as a history painter with *Sévère et Caracalla* (*Septimus Severus Reproaching Caracalla*, 1769), which indeed made him a member of the French Academy, but as a genre painter: "He was

**76. Simon-Louis Boizot and Pierre-Philippe Thomire. Sèvres Vase, 1787. (Musée du Louvre, Paris)**

*This hard porcelain vase was made by Boizot and Thomire, who respectively ran the sculpture and bronze-chasing studios at the royal factory of Sèvres. It is a kind known as a "Medici Vase." The blue is characteristic of Sèvres porcelain.*

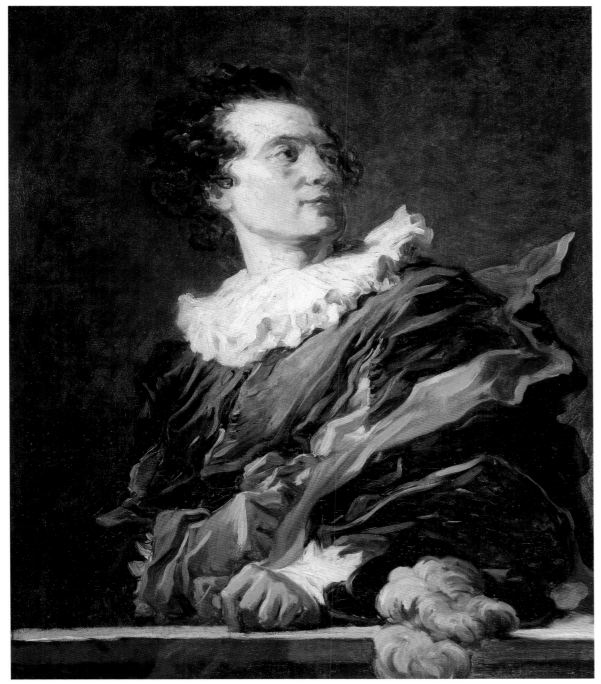

able to scrupulously imitate nature, but he was not able to rise to the sort of exaggeration that historical painting demands," wrote Diderot.

*The Return to History Painting*
The official commission of the paintings of the history of France, which were to be used as models for a wall hanging made at the Gobelins, was an extremely important event. In part, this was because it elevated the whole genre of history painting, but much more because of its formative effect on national consciousness. The series would provide patriotic themes for the Revolution, and it would cause the first stirrings of the taste for the Middle Ages. Thus there were, among others, Nicolas-Guy Brenet's *Mort de Du Guesclin* (*Death of Du Guesclin*) and Ingres's *Mort de Léonard de Vinci* (*Death of Leonardo de Vinci*), which met with brilliant success at the Salons of 1777 and 1781. The commission itself even included *Assassinat de l'amiral de Coligny* (*Assassination of the Admiral de Coligny*) by Joseph Benoît Suvée (a sixteenth-century

Huguenot leader who was murdered in the Saint Bartholomew's Day massacre), showing an extraordinary freedom of conscience at the end of the ancien régime.

The development of history painting was disturbed for a while by the return of some Roman academicians who brought the "grand history" genre with them. David, who alone could render Fragonard obsolete, was responsible for this turnabout. Having won the painting prize of 1774 and having gone to Rome the following year with Vien (who had just been appointed director of the French Academy there), David returned to Paris in 1780 to paint *Bélisaire* (Belisarius). He established a workshop that was attended by many students, and began a reign over the arts that can only be compared to that enjoyed by Le Brun in his time. The painting illustrating this new school is *Le Serment des Horaces* (*The Oath of the Horatii*). This elegy to republican virtue was also commissioned by D'Angiviller (who was definitely very broad-minded). However, in order to accomplish this extraordinary work, David felt in need of inspiration and returned to Rome. He produced the painting there and sent it to Paris, where it was presented at the Salon in 1785. The *Brutus* of the Salon of 1789 (fig. 5), was the last work commissioned by the monarchy. The choice of subject—illustrating the sacrifice to the *res publica* (public good)—was left to the artist. The two-part composition is set before Doric columns: on the left, republican virtue and masculine resolution (to the left) literally and figuratively oppose family pain and feminine compassion to the right. This painting is more "French" than it first appears; in Rome, French painters had in Poussin a prestigious precursor, and David's first paintings reveal the influence of the works of that seventeenth-century master.

*Sculpture*

Jean-Antoine Houdon's *Diana* (fig. 90) and Augustin Pajou's *Psyche* (fig. 88) are two embodiments of the French woman. The terra-cotta version of Diana dates from 1778, the marble from 1780, and the bronze from 1782. A critic who saw Diana displayed at the 1802 Salon remarked that she did not have "the least bit of clothing to hide her French build [*sic*]!" The complete nakedness of *Psyche* was also a scandal. At the Ecole des Elèves Protégés, students of painting and sculpture alike were taught to draw from life, but only from a male model. The students had no difficulty finding female models outside the school, but that did not hide the fact that the male nude was used exclusively for "high genre" history painting and the female nude for "low genre," those elegant little courtship scenes for the boudoir. But in this statue, the rejected lover (who is so enchanting that one cannot forget that her robes were stolen in the myth) is shown life-size. The work, presented to the Salon of 1785, was, once again, commissioned by D'Angiviller. On the marble version, dated from 1790, Pajou proudly followed his signature with the phrase "citizen of Paris."

In the final analysis, it is in sculpture, an art form that until that time had suffered only rare and short suppressions in Paris, that the charms of French are best preserved. Clodion (the Fragonard of sculpture, and a specialist in bas-relief; fig. 37) is also the spiritual creator of playful little groups in terra-cotta: his *Psyche* (fig. 87) is caught just before Cupid abandons her; his *Offering to Priapus* (fig. 89) includes an Athenienne-style cauldron.

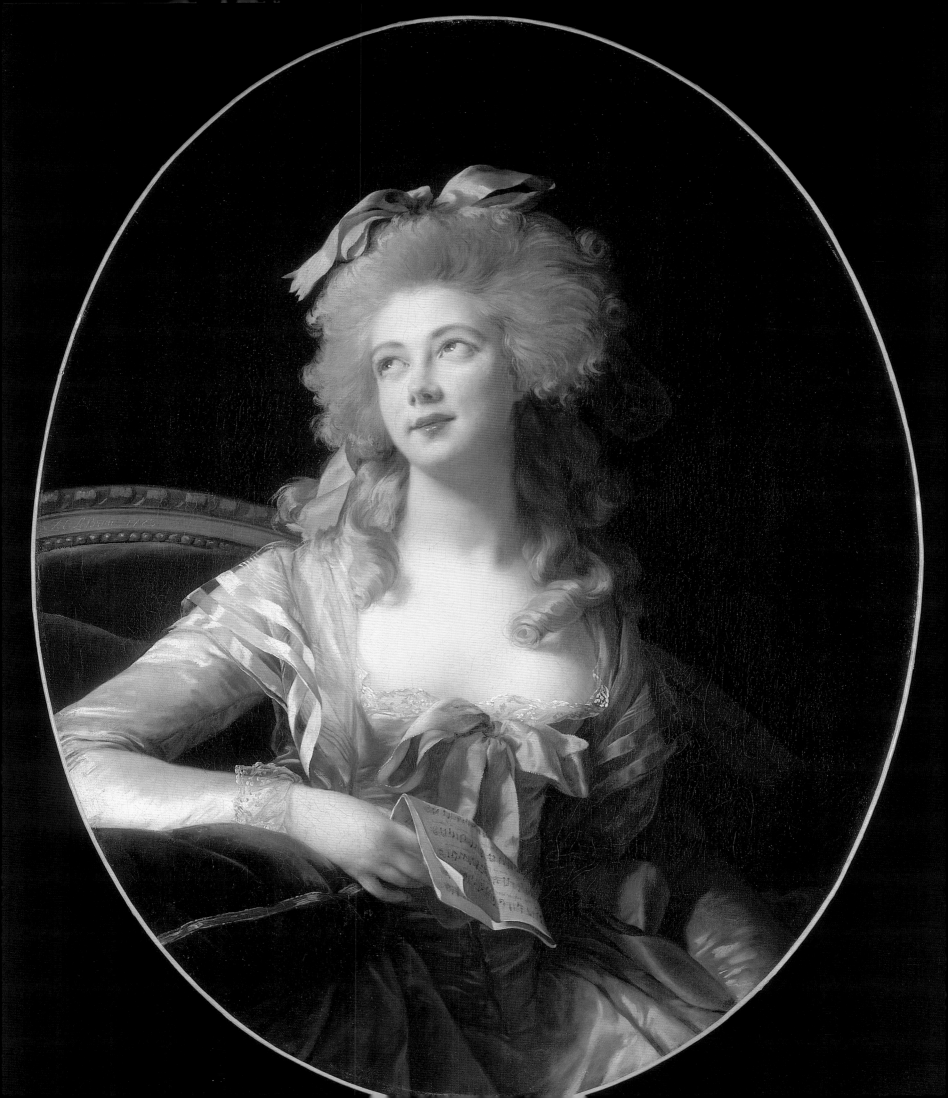

**84. Jean-Baptiste Greuze.**
*L'Accordée de village (The Village Bride),*
**1761. (Musée du Louvre, Paris)**

*This was painted for the Marquis de Marigny and
exhibited at the 1761 Salon. Greuze had given it the
title* A Marriage *but it is commonly known as* The
Village Bride. *It shows the moment when a father
gives his son-in-law the dowry. "This girl ... has a
gentle and accommodating cast to her face and limbs
that fill her with grace and truth. She is certainly
pretty—very pretty, even. Her lovely throat is covered
so that one can hardly see it. But I see that there is
nothing supporting her; she stands on her own. Closer
to her fiancé would be immodest; more toward her
mother or father would be an affront to him. She has
her arm half under her future husband's, and the tips
of her fingers press softly on his hand; it is the only sign
of tenderness that she shows to him, maybe even with-
out being aware of it herself." (Diderot, Salon of 1761)*

*Portraiture*

At this time, portraiture, a genre cultivated in France since Jean le Bon, was rather mild
mannered. Elisabeth Vigée-Lebrun, the official painter of Marie-Antoinette, portrayed the
queen more than thirty times. The female painter organized Greek dinners at her house,
where the women dressed Athenian-style. She escaped the guillotine by immigrating, and
she conveyed to all the European courts the last good times before the Revolution. Madame
Grant (fig. 81), a courtesan and a spy who saved her life through flirtatious alliance, is
portrayed with her eyes raised to heaven and a musical score in her hands: the psychological
veracity of portraits in the first half of the century was replaced in the second half by
expression, though at times a bit exaggerated or theatrical.

The French bust portrait became the genre of choice for the greatest French sculptors.
Pajou, who had studied at the academy in Rome and was the sculptor most often
commissioned by the greats (he sculpted Descartes, Bossuet, Turenne, and Pascal), was the
most French of the sculptors of that time. It was he who added to the work of Jean Goujon
for the Fountain of the Innocents (Fontaine des Innocents). In his portrait busts, he used
terra-cotta, a technique that enjoyed unprecedented favor; he used it to produce spontaneous

**85. Joseph-Benoît Suvée. *Cornélie, mère des Gracques* (*Cornelia, Mother of the Gracchi*), 1795. (Musée du Louvre, Paris)**

*Cornelia is presenting her children to a visitor who is showing her jewelry. The children are her true riches. As public defenders, her two sons will be reformers of the Roman republic. This painting, whose subject was topical, was a great success at the Salon of 1795, but the deliberately archaic character of the treatment was astonishing. It is a good example of the prevailing "primitive" style, notably in the works of certain followers of David's.*

**86. Pierre-Henri de Valenciennes. *Paysage avec Enée et Didon* (*Landscape with Dido and Aeneas*), 1792. (Musée Sainte-Croix, Poitiers)**

*This is one of the first examples of the return of the historical landscape genre, which had been very popular in the seventeenth century.*

Right:

87. Clodion. *Cupideon et Psyché*
(*Cupid and Psyche*).
(The Victoria and Albert Museum, London)

88. Augustin Pajou. *Psyché abandonnée*
(*Psyche Abandoned*).
(Musée du Louvre, Paris)

*A marble version, dating from 1790,
of a work presented to the Salon in 1781.*

effects that could be compared to those obtained by the pastel portraitists in the first half of the century. His portrait of Vigée-Lebrun (fig. 82) is a new example of the mirror game introduced in the late seventeenth century, in which artists sat for each other. Hubert Robert posed in this way for both Vigée-Lebrun (fig. 79) and Pajou (fig. 80).

Houdon, another Roman "academician" who made portrait busts of famous people from two continents, sculpted a certain Sophie Arnould (fig. 83), which could serve as a pendant to Vigée-Lebrun's Madame Grant. The singer is portrayed at the height of her glory in the title role of *Iphigénie en Aulide* (*Iphigenia in Aulis*) by Gluck, shortly before the scandal about her love life forced her to take early retirement. There is still something of Bernini in this lyrical bust. Little cubes can be observed in the pupils, which give life to the eyes. "Monsieur Houdon is perhaps the first sculptor who knew how to model eyes," wrote Grimm in *Correspondance* (*Correspondence*). Houdon used the same technique to give spirit to his bust of Voltaire. Houdon devalued his sculptures a little with multiple versions of his most famous portraits, such as those of Voltaire and Diderot. He delivered thirty copies of the bust of Sophie Arnould to her, for old or new lovers. Among these was Bélanger, the architect who was planning a *hôtel* for her at the Chaussée-d'Antin, which stood beside the one that Ledoux had had constructed for La Guimard, a dancer, of whom the singer was jealous.

Left:

89. Clodion. *L'Offrande à Priape* (*Vestal Presenting a Young Woman at the Altar of Pan*), c. 1770–1775. (The John Paul Getty Museum, Los Angeles)

Bottom:

90. Jean-Antoine Houdon. *Diana*, 1776. (Musée du Louvre, Paris)

*The plaster cast of this Diana was meant for the duke of Gotha and dates to 1776. There is also a marble version of this Diana from 1780 (Calouste Gulbenkian Museum, Lisbon) and three bronze ones: the first dates from 1782 (Henry E. Huntington Art Gallery, San Marino, California) and was exhibited at the Salon of 1783; the second, shown here, is dated from 1790; and the third was made posthumously in 1839 (Musée des Beaux-Arts, Tours).*

Following two pages:

91. François Gérard. *Psyché et l'Amour* (*Cupid and Psyche*), 1798. (Musée du Louvre, Paris)

*This painting was immensely successful at the Salon of 1798 and secured the artist's reputation.*

92. Pierre Prud'hon. *Phrosine and Melidor*, 1798.

*This is an illustration from the erotic works of Bernard, published by Didot the Elder. Melidor, robed as a monk, welcomes Phrosine, who had swum to his island of refuge.*

Portraits of the second half of the eighteenth century respected the principle of the genre, which was the search for a likeness. However, the effects of the competition for the *tête d'expression* (loosely translated as "expressive face") were also evident in the portraits. This competition, founded at the Academy in 1760 by the Comte de Caylus, was intended to stimulate "the art of portraying the expression of passions," an art which, of course, was based on Le Brun's studies on this theme, which were widely disseminated through publication.

*Landscape Painting*

Landscape saw the introduction of two innovations (or rather the reintroduction of previous innovations) that would not become important until the nineteenth century: outdoor landscape studies and the *"paysage historique"* (a Poussinesque combination of landscape and history painting). In the tradition of Alexandre-François Desportes, both Joseph Vernet and Pierre-Henri de Valenciennes made outdoor sketches of the landscape: their studies in the Italian countryside foreshadow those of Camille Corot. Frequent visits to Italy inspired Valenciennes to revive Poussin's *"paysage historique"* (fig. 86), a genre that would become an academic competition category in the nineteenth century.

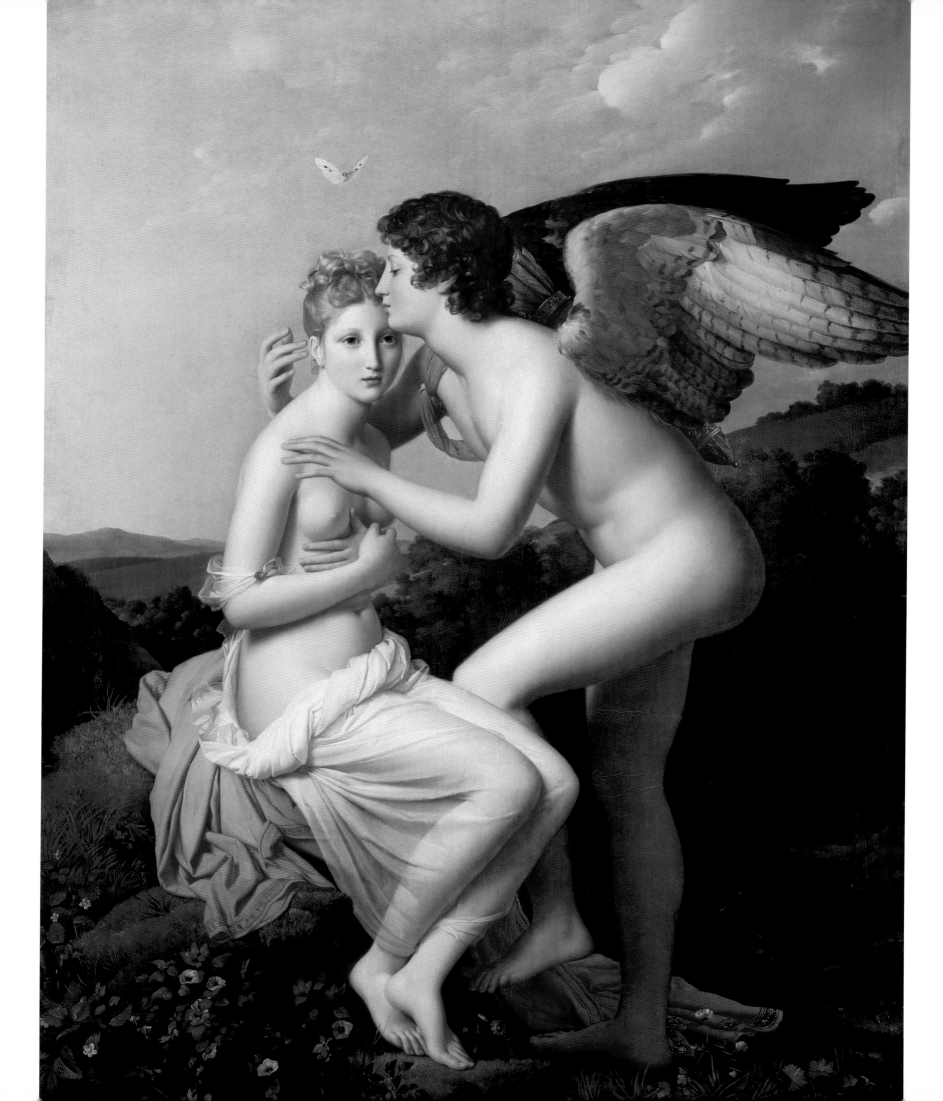

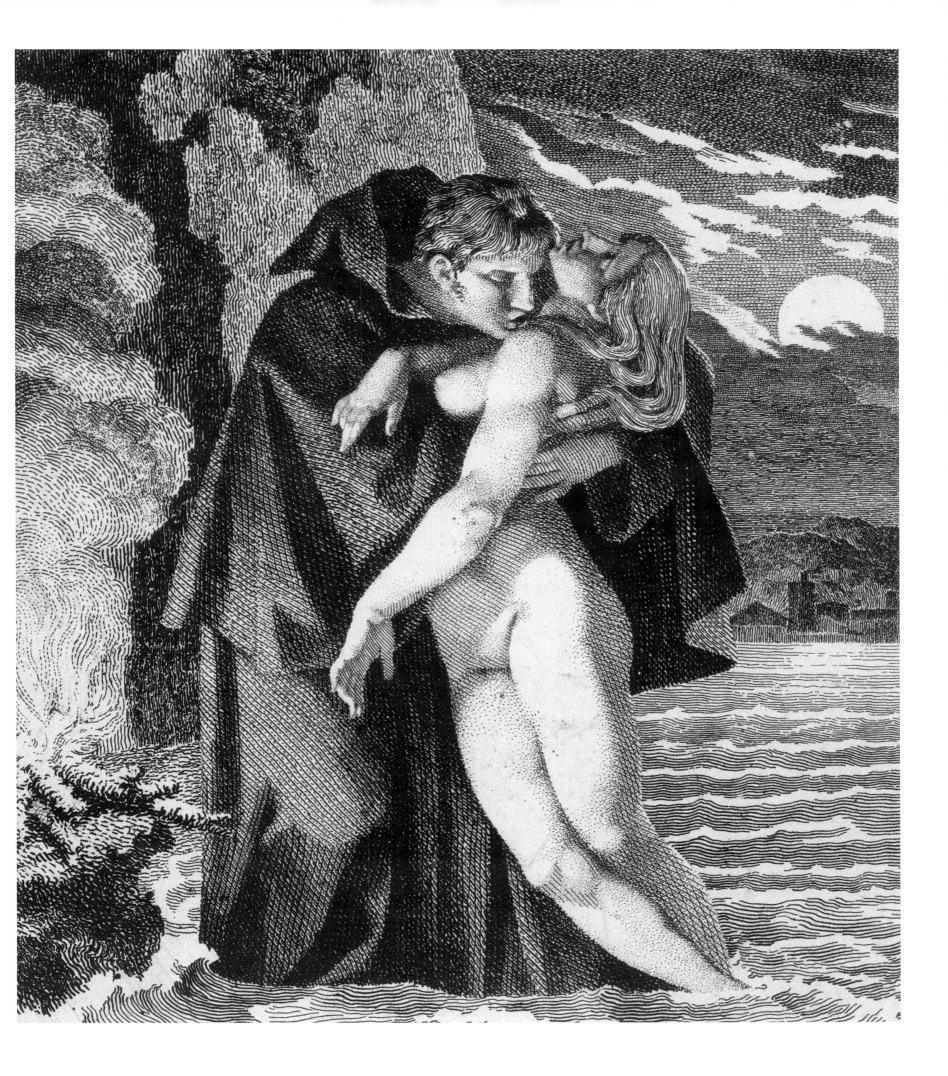

**93. Jacques-Louis David. *Triomphe du Peuple français (The Triumph of the French People)*, 1794. (Musée Carnavalet, Paris)**

*The French people are represented as Hercules with Liberty and Equality at his knees. The four figures in front of the wagon are Commerce, Abundance, Science, and the Arts. On the side of the wagon are the nine muses. The wheels of the wagon crush the symbols of feudalism, royalty, and fanaticism. Victory flies above the representatives of the people, killing the fallen kings. Behind the wagon are historical victims of tyranny: at their head, the mother of the Gracchi and her two children; behind her Brutus brandishes the death sentence for his two sons, who conspired against Liberty.*

**94. Jean-Jacques Lequeu. *Porte de Parisis (Gate of Paris)*. (Bibliothèque Nationale de France, Paris)**

*This project entitled "Porte de Parisis," which can be called the "arch of the people" was designed by Lequeu for one of the competitions organized by the National Convention in year II of the revolutionary calendar.*

## 5 – THE REVOLUTIONS

At the time of the Revolution of 1789, art had nearly accomplished its metamorphosis of institutions and the society of the ancien régime. Some artists enthusiastically welcomed the revolution, others died in it; many experienced fear and a prison term. The revolution should have made the new art its own, and thus left an inspirational testament to itself, but there was little agreement and no such testament was ever made.

### The National Convention's Competitions

The National Convention practiced and prescribed "official" art just as the ancien régime had. It created a commission of artists to compile a map of Paris showing projects to modify the city's road system, as required by the development of properties confiscated from immigrants and the church. Similar in conception to the map developed by Bullet and Blondel at the end of the seventeenth century, this compilation of speculative plans and somewhat radical proposals for the destruction of certain roads was not even gathered onto a single plan (called the "artists' plan") until the centennial of the Revolution.

To come to the aid of artists deprived of their usual clients, the convention organized competitions (twenty-five, encompassing just about all areas of the arts) in the same way as the suppressed academies had done. However, the prizes that were supposed to save the artists from need were only awarded very late or not at all.

For the triumphal arch competition, Lequeu, a solitary artist, who was a misanthrope with no political convictions, drew a "Porte de Parisis [*sic*] which can be called the arch of the people" (fig. 94). The statue of the "Peuple Parisi" (People of Paris) was to be "made of planks [*sic*] of silvered tin or gilded copper." This colossus-like "peuple," complete with Phrygian cap (a symbol of the Revolution), holds Liberty in his left hand and the club of Hercules in his right, while he crushes a crown, scepter, miter, crosier, and chalice. Even the gateway on which he sits is probably an allusion to his hated colleague Ledoux's customs barriers (figs. 31–33). On the back of the drawing, an inscription added afterward tells us that this project was only a sop to the Revolution to avoid the guillotine.

The public festivals organized by the convention made contemptible use of the iconography of the ancien régime, with much speechmaking in which Hérault de Séchelles's emotional appeals replaced the eloquence of Bossuet.

Hérault de Séchelles was the principal designer of the festival of August 10, 1793, which was organized in order to mark the promulgation of the constitution of the first year of the revolutionary calendar. At the Place de la Bastille, before the enormous statue of Nature with an Egyptian hairstyle in the role of a fountain of Regeneration (fig. 95), he uttered these immortal words: "Oh Nature…let these fertile waters that spring from your breasts consecrate in this cup of fraternity and equality the oaths that France makes to you today, the most beautiful day that the sun has ever shone upon since it was suspended in the immensity of space."

Robespierre, who had been jealous of the role played by de Séchelles at that festival, issued him a ticket to the guillotine and hurried to institute the cult of the Supreme Being. For the Festival of the Supreme Being on June 8, 1794, a mountain was created on the Champ-de-Mars, which was chock full of various constructions similar to the follies mentioned earlier. Robespierre had an engraving of the spectacle made (fig. 96). On the eve of the festival, David, who was the producer, had presented the program to the convention in these terms: "Dawn has barely announced the beginning of the day, and already the sound of warlike music is sounding all around and causes the calm of sleep to be followed by an enchanted reawakening…Meanwhile, the cannon thunders; in an instant, dwelling places are deserted; they remain under the protection of the Republican laws and virtues; the people fill the streets…In the midst of the people appear their representatives; they are surrounded by children decorated with violets; adolescents with myrtle; the young men with oak; the white-haired old people with vine and olive leaves."

**95. *Fountain of Regeneration*, 1793.**

*This illustration shows a temporary fountain erected on the ruins of the Bastille during the festival organized on August 10, 1793 on the occasion of the promulgation of the constitution of the year I (the first year of the revolutionary calendar). Hérault de Séchelles, a member of the National Convention and author of the constitution, is portrayed at the foot of the Nature statue, catching the water that flows from its breasts.*

**96. *The Champ-de-Mars Mountain*, 1794.**

*This was built on the Champ de la Réunion (Champ-de-Mars) for the Festival of the Supreme Being, held on June 8, 1794. The construction in the form of a mountain included a grotto, a column, four Etruscan tombs, a pyramid, a Greek temple, an altar, candelabras, and, at the top, the Tree of Liberty.*

*Night came while I was wandering around. I returned into the town; I went to the Orléans Palace. Tumultuous groups told each other with fury what had happened during the day. They were menacing! They were putting prices on heads!…I was shaking: I saw a cloud of evil forming over this unfortunate capital, previously the most voluptuous town in the universe, the happiest…For twenty-five years, I had lived in Paris freer than air! Two methods would suffice for all men to be as free as me: to have integrity; and not to print treasonous booklets. Everything else was allowed, and nothing had ever hindered my liberty. It is only since the Revolution that a villain has come to arrest me twice.*

Restif de La Bretonne, Les Nuits de Paris (Paris Nights), July 12, 1789.

VUE DE LA MONTAGNE ELEVÉE AU CHAMP DE LA REUNION

la fête qui y a été célébrée en l'honneur de l'Être Suprême le Decadi 20 Prairial de l'an 2e de la Republique Francaise

A Paris chez Chéreau Rue Jacques, aux deux Colonnes, près la Fontaine Severin. N° 25.

**97. Jacques-Louis David.**
*Le Serment du Jeu de paume*
*(The Tennis Court Oath)*, 1791.
(Musée National du Château de Versailles)

*On June 20, 1789, the representatives of the Third Estate and some representatives of the clergy assembled in a tennis court near Versailles (the king had closed down the room where the representatives of the Estates General met). Under Bailly's presidency, they swore an oath not to disband until they had adopted a new constitution for the kingdom. Bailly can be seen in the center standing on a table: in front of him the representatives of the clergy come to an understanding with a representative of the Third Estate; on the far left, an ill representative who has to be carried into the room: and on the far right stands the only representative who refused to take the oath. David began the composition of his work in 1790, but it was never completed, no doubt because the work on the painting did not keep up with events; certain representatives fell under suspicion and were even condemned to death in 1789. This drawing in pen, signed and dated 1791, shows the general composition. A number of incomplete studies of the painting exist.*

*Allegory and History*

Organized and carried out by citizens who had not been chosen as representatives of the people because of their artistic gifts, the tawdry Revolutionary festivals only appear ridiculous because they borrowed from ceremonies that should have disappeared with the regime they originally served. Left to themselves, the artists naturally moved with the times, and thus achieved some remarkable results. In the *Triomphe du Peuple français* (*The Triumph of the French People*; fig. 93), David's talent renewed the old liturgy of triumph. The sculptors, however, were less inspired: no doubt they were as fragile as the statuettes they created and were therefore crushed by the magnitude of their tasks. Allegory would continue to be used during all the regimes.

The originality of the Revolution lay in redirecting painters' and sculptors' historicizing tendencies to the present. But the only undertaking, in that sense, that actually came to fruition was the extraordinary series of drawings by Jean-Louis Prieur, engraved in the *Tableaux historiques de la Révolution Française* (*Historic Scenes of the French Revolution*), 1799–1817 (figs. 29–30). David's *Le Serment du Jeu de paume* (*The Tennis Court Oath*; fig. 97), which combines the portrait genre, history, and the sacredness of the oath, is the most famous image of the Revolution. "No, I do not need to invoke the gods of the fables to inspire my conscience, French nation, it is your glory that I want to propose," wrote David in 1792. Unfortunately, not being able to work as fast as the guillotine, which was removing his subjects one at a time, David was not able to finish his work.

98. François Gérard.
*Le Peuple français destituant le tyran*
(*The French People Bringing Down
the Tyrant*, August 10, 1792), 1794.
(Musée du Louvre, Paris).

*This is a sketch for a painting that was never executed. The scene
takes place in the Riding School (the stable in the Tuileries that was
hurriedly adapted to receive the Legislative Assembly). On August 10,
1792, the people stormed the Tuileries, where Louis XVI and his family
came to put themselves under the protection of the assembly. As it could
not legally proceed with deliberations in front of the king, he was placed
with his family in the box behind a grill, where the stenographers
normally sat (to the right in the drawing). People demanded the
abdication of Louis XVI. Vergniaud, who was presiding, objected that
the constitution did not allow the assembly to demand the abdication of
the king. But the suspension of Louis XVI as king was decided upon, as
was the creation of the National Convention.*

## 99. Convention Hall

*The former Opéra of the Tuileries, called the
"Salle des Machines" (a specially designed, state-
of-the-art, stage-effects theater), was radically
altered by J.-P. Gisors to house the National
Convention, which had been temporarily installed
in the Riding School. The new room was inaug-
urated in May 1793. The engraving shown here,
published in F. L. Prieur's Collection complète
des tableaux historiques de la Révolution fran-
çaise (Complete Collection of Historical Images
of the French Revolution), 1798, shows the assas-
sination of the Deputy Ferraud. He was killed for
opposing the populace who forced open the doors
of the convention; his head was presented on a
pike to the president of the convention.*

The invasion of the Riding School by the people on August 10, 1792 inspired François Gérard to create a powerful drawing (fig. 98). The Riding School, which was actually the stable in the Tuileries, was the makeshift home of the Legislative Assembly. King Louis XVI had come to that site with his family seeking protection from the assembly. On that day, the people stormed the Tuileries. The chiaroscuro and the raised arms in Gérard's sketch would have made a great painting; unfortunately, this one was never painted. The definitive image of the Revolution would have to wait until 1830, when it was produced by Delacroix (chapt. XI, fig. 81). However, an unexpected result of the Revolution was to benefit genre painters (who might be seen as victims of the artistic policies of the ancien régime). Genre scenes and landscapes proliferated in the Salons. Indeed, high genre painting had always required public support, which from then on was lacking. Meanwhile private, bourgeois commissions, which favored low genre, continued to be strong.

*Fashion*

Fashion, which had become much more simple in the last years of the ancien régime, made strong statements about the Revolution. It was at the festivals that the "*sans-culotte*" (literally, those without pants) first appeared: these were Robespierre's main revolutionary supporters who wore striped trousers and a *carmagnole* (short jacket). This sophisticated version of the people's clothing, completed by the "cap of shame" (a red Phrygian cap), was first worn by an actor. The Thermidorian Reaction, in which the convention executed Robespierre (whom it no longer trusted) and sought the suppression of the *sans-culottes* as his supporters, also had its masqueraders' clothes closet. It was worn by the Muscadins of the Gilded Youth, militant bourgeois royalist sympathizers who gave themselves aristocratic airs while aping the excesses of the ancien régime. They wore musk perfume and rather extreme clothing, an added provocation to the *sans-culottes*, which led to two uprisings. Once order was restored, the *merveilleuses* ("shockers"), the women of the Gilded Youth, who wore transparent gowns with nothing underneath, kept the style of the gown but did away with the transparency.

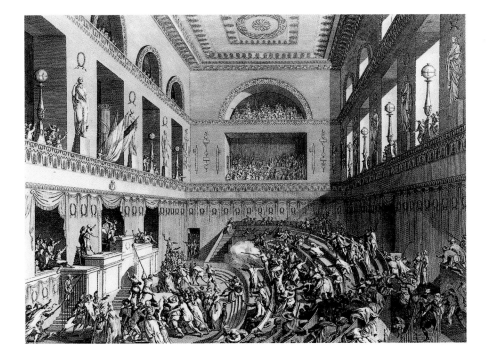

### 100. Rue des Colonnes

*This road, opened in 1793, was built by the architect Joseph Bernard according to the design of the architect Nicolas-Jacques-Antoine Vestier. The road still exists, but only for part of its original length.*

*Construction*

The Revolution built very little, but this does not mean that individuals did not build during the Revolution. They even produced remarkable ensembles in the same spirit as the developments of the ancien régime, notably the Rue des Colonnes (fig. 100), the Hoston houses (fig. 102), and the Feydeau arcade. The Rue des Colonnes had covered walkways at the roadside that were opened up with "Etruscan" arcades (Doric columns without bases with arches and palmettes) inspired by the *Serment des Horaces* (*The Oath of the Horatii*). The modular repetition of the Hosten houses was not new, as Androuet Du Cerceau and many others had done this before Ledoux. The originality lay in the organization of Hosten's *hôtel* and associated buildings around a picturesque garden. The Feydeau arcadee, built in 1791, now destroyed, was the first example of a private covered street, which would become popular in the nineteenth century.

But during the Revolution, the authorities did not so much build as stimulate "speaking" architecture. The necessary vocabulary had been perfected prior to 1789 with a view to giving public buildings a suitable character, with dubious success. For example, the tax wall (figs. 31–33) made Paris grumble: *"Le mur murant Paris rend Paris murmurant"* ("the wall walling Paris is an appalling walling") as they put it. The only achievement of any

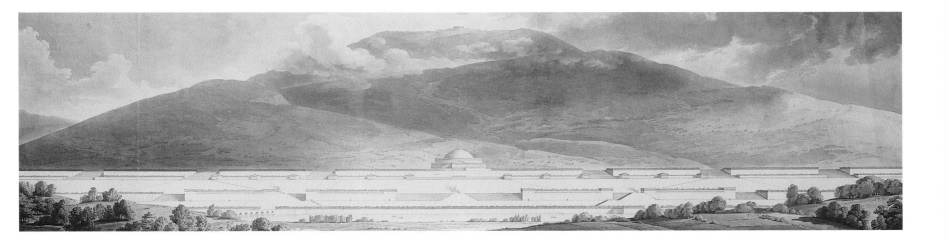

importance was the renovation of the Convention Hall in the former Opéra des Tuileries (fig. 99). This resulted from deliberations (which had been conducted since the convocation of the Assembly of Notables in 1787) on the functions of an assembly room. An early example of "Architecture Messidor" (better known as the style of the Directoire period), reaction to it is suggested by Victor Hugo, who left a very suggestive description of the room: "The whole ensemble was violent, austere, military. Fiercely correct ... One vaguely remembers the old theater, with its garlanded boxes and azure ceiling ... and all around one sees those harsh right-angled corners, as cold and sharp as steel; it was something like Boucher guillotined by David."

## Universal and Natural Architecture

The art that can be considered revolutionary only shares certain sources with the Revolution and very little else. The design for Newton's Cenotaph (fig. 103), in the shape of a ball, dates to 1784, as does *Le Serment des Horaces* (*The Oath of the Horatii*); it illustrates the natural aesthetic of Boullée. All attempts to find classical models for a universal architecture (to which the ancients aspired) had failed. The next attempt was a tremendous effort to go back to the source, to primitive architecture from before the diaspora of the nations, and indeed to the very model for this architecture: nature itself. The cenotaph was a metaphor of the universe explored by the great scientist Newton. The geometrical volumes and sphere stripped of all decorative molding would have been a sort of statue to great men, a hero without clothing.

**101. Etienne-Louis Boullée.**
*Plan for a Monument to the Supreme Being* (Bibliothèque Nationale de France, Paris)

*This drawing, whose date and original purpose are unknown, may be contemporary with the Festival of the Supreme Being, celebrated by Robespierre in 1794.*

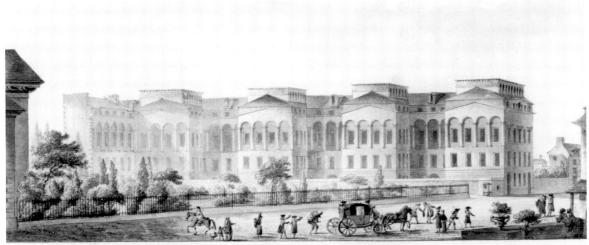

BATIMENT DE M. HOSTEIN
Exécuté d'Après les Ordres et desseins de M. le Doux Architecte de l'Académie
par M. de l'Arbre Entrepreneur de Batiment à Paris l'An 1792.

**102. The Hosten Houses**

*This group of houses was built in 1792 by Claude-Nicolas Ledoux for J.-B. Hosten on a large piece of land which was to accomodate fifteen rental houses as well as the hôtel of the proprietor.*

Nevertheless, classicism did not follow the path of purification but rather that of classification. Durand, a disciple of Boullée, in his *Recueil et parallèle des édifices de tout genre* (*Collection and Parallel of Buildings of All Kinds*; fig. 105), put all the monuments of humanity on the same scale (greatly reduced, however) and classified them by type. These monuments fill the page like flowers in the botanist's albums and insects in the etymologist's boxes. This work would become the encyclopedia for architecture of the nineteenth century. And in the work of Lequeu, who wrote the first essay in eclecticism, is found that mix of genres that was so popular in the nineteenth century (fig. 104).

### The Painting of the Primitives and the Pre-Romantics

The dissidents in David's school, who called themselves "primitives" or "barbarians," accused their master of being too "Pompadour," They also advocated an archaic art, without really knowing what they meant by that. It included the classicizing tendency that Vien illustrated with such naturalness, as did Suvée in *Cornélie, mere des Gracques* (*Cornelia, Mother of the Gracchi*, 1795; fig. 85), as austere as the virtue of the Roman Republic. Armand-Charles Caraffe's *Le Serment des Horaces* (*The Oath of the Horatii*) is not a parody of the painting by David, but the version of a Jacobian Uccello. One can see the Nazarenes and the Pre-Raphaelites of the nineteenth century appearing on the horizon.

**103. Etienne-Louis Boullée.**
*Newton's Cenotaph,* 1784.
(Bibliothèque Nationale de France, Paris)

*With this symbolic cenotaph, Boullée intended to honor the man who discovered universal gravity, and at the same time show that there could be a type of architecture imitating nature. The plans include several variations, including a view by day and a view by night that recall Masonic rites. It is possible that these variations are all for different projects, collected in 1784 under Newton's name.*

*Le Sommeil d'Endymion* (*Endymion Asleep*) was altogether different, and also not of David's style. This was painted by Girodet in Rome in 1791. The halo veiling Endymion's torso owes something to the *sfumato* technique; that is, according to Diderot, the "method of blurring the outlines with a light mist" found in Leonardo's or Correggio's work. The

exaggerated chiaroscuro of the tenebrists is also evident. However, the model of the effeminate body, languid, sated, set under the provocative glance of a cupid and lit by a moonbeam, into which the amorous Diana had changed herself, is—can anyone doubt it?—a "profane" version of Bernini's *Ecstasy of Saint Theresa*, who was about to be pierced by a divine arrow. "It seemed to me to be improper to paint a goddess famous for her chastity in her only lover-like moment," wrote Girodet. Girodet, David's favorite pupil, though an unfaithful one, could report truthfully: "What pleased me was that only one person said [about *Endymion*] that my work did not resemble David's at all!"

Girodet's work (in the Louvre today) is Roman in more than name. Although it enjoyed tremendous success in the 1793 Salon, it is beyond the scope of this book. It shall be illustrated by its derivatives, which were numerous. Within the chronological limits of this chapter, we already have *Psyche and Cupid* by Gérard (fig. 91). Before the end of the century, the artist who recorded that tragic scene in the Riding School (fig. 98) returned to the inexhaustible fount of inspiration: the love of Psyche. All that is missing from *Psyche* is the violent chiaroscuro of the *Endymion*. Gérard's models are (too obviously) Canova's *Cupid* and *Psyche* (both in the Louvre). *Phrosine et Mélidor* (*Phrosine and Melidor*; fig. 92) is one of the most famous examples of the moonlit scene, a precursor of Romanticism, and Pierre Prud'hon's masterpiece. A lover of misty love scenes and an imitator of Correggio, Prud'hon was an inconsistent painter, yet he was also a great rival of David's and an enthusiastic admirer of Canova. As the Bernini of the century who could breathe life into Carrara marble, Canova's ideal would dominate French art. Johann Winckelmann, theorist of neoclassicism, would define ideal beauty in this way: "Beauty should have no more noticeable flavor than pure water!"

106. Alexis Chataigner.
*La nouvelle et l'ancienne mode*
(*New and Old Fashion*),
engraving, late eighteenth century.

AH! QUELLE ANTIQUITÉ !!!     OH! QUELLE FOLIE QUE LA NOUVEAUTÉ....

Opposite:

107. The Tomb of Héloïse and Abelard

*The remains of the famous lovers, buried together
at the Paraclete, were exhumed in 1800 and
transferred to the Musée des Monuments
Français by Alexandre Lenoir, who had this
monument made containing some fragments of
medieval tombs. This monument was transferred
to the Père-Lachaise cemetery in 1817.*

*Museum Making*

These developments taking place alongside the Revolution should not be attributed to it. If the Revolution made a profound mark on the history of French art, it was not because it inspired creativity, but because it initiated conservation. The result was the opening of the Musée des Antiques (Museum of Antiquity) and the Musée des Monuments Français (Museum of French Monuments). The Musée des Antiques was established in the former apartments of Anne of Austria—the ones decorated by Romanelli and Angier—according to a plan by Hubert Robert, who had gained a position as curator of the museum after he served a term in prison; it was the first department of the Louvre open to the public.

At about the same time, in an important presentation to the convention, Abbot Gregory had used the word "vandalism" for the first time to characterize the destruction of national monuments. As a provisional shelter for the threatened works, Alexandre Lenoir had opened a repository at the former convent of the Petit-Augustins, near the site that the Nesle Tower had occupied. This temporary repository became the official Musée des Monuments Français. The result was inevitable: collecting became an end in itself (fig. 27).

The enrichment of museums justified the most regrettable extortions, those that Lenoir committed at the expense of the French heritage and those of the Republic's armies at the expense of Belgium and Italy. They took pride in what was nothing less than plundering. A classical-style triumph was celebrated in Paris when the antiques stolen from the Vatican arrived. One lone man protested, but he was ignored. Quatremère de Quincy called the Musée des Monuments Français a "monumental harem." The insatiable curiosity about things that had spanned the whole of the Age of Enlightenment became dull in the shadows of ruins. Hubert Robert prepared his designs for the Grande Galerie (Great Gallery) by presenting it as a ruin (fig. 21). The Elysée, the focal point of the Musée des Monuments Français, was a cemetery for great men: its tombs formed from more or less imaginary monuments like the tomb of Héloïse and Abélard (fig. 107), or abstracted from their context like the famous fountain of Diana l'Anet, who became a beautiful corpse on her sarcophagus (fig. 27).

# THE PALAIS ROYAL

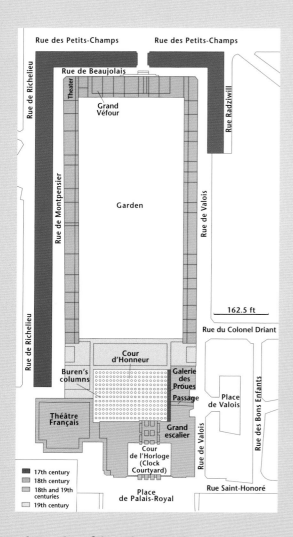

*Above: plan of the Palais Royal.*

*Right: Daniel Buren's columns in the Cour d'honneur (Courtyard of Honor), installed between 1985 and 1986.*

**Opposite page:**

*Top: the Grand Escalier (Grand Staircase) built by Constant d'Ivry in 1765–1768.*

*Bottom: the Council of State. Chamber of the General Assembly. On the wall is a painting by Henri Martin, Le Port de Marseille (The Port of Marseille).*

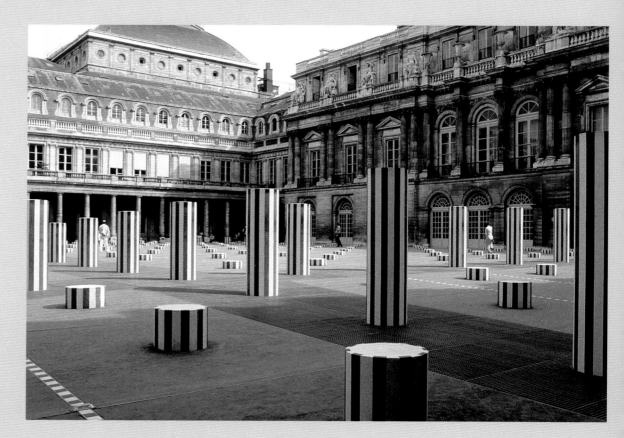

In his will, Cardinal Richelieu bequeathed to the king the palace that he had built in a new quarter created for the purpose. Put together through a series of enlargements, the Palais Cardinal was not known for the coherence of its architecture, but for the presence of a theater, the cradle of the French classical repertory, which the cardinal encouraged. It was also famous for the beauty of the painted galleries, notably the Galerie des Illustres (Gallery of Fame), and for the richness of its collections. Nothing remains but the general foundations of the buildings and the great garden, a few modest traces still in place, and some masterpieces of painting kept in the museums.

The regent Anne of Austria had the palace (now the Palais Royal) transformed and moved there with the young King Louis XIV, crossing the road that separated the palace from the depressing medieval Louvre. This was not the best situation: the palace was not fortified, and the king found himself at the mercy of the revolutionaries. He had to flee and returned to the Louvre. Once he became an adult, Louis XIV made a present of the palace to his brother, Philippe d'Orléans. In its present state, the Palais Royal is almost entirely the work of the Orléans family, notably of Philippe, the nephew of Louis XIV and regent when Louis XV was still a minor; of Louis-Philippe the Great, grandson of the regent; and especially of the son of the former, the sinister Philippe Egalité, who voted for the death of Louis XVI but ended up at the guillotine himself; and finally of Louis-Philip, son of the regicide, who became king of France in 1830.

The majority of the complex was built in the second half of the eighteenth century by Constant d'Ivry, architect of Louis-Philippe the Great, and by Victor Louis, architect of Philippe Egalité. The main block, which should have occupied the site of the colonnade that now separates the great courtyard from the garden, was never finished. A wooden structure was raised on its foundation. Philippe Egalité rented it out at a good price to stall

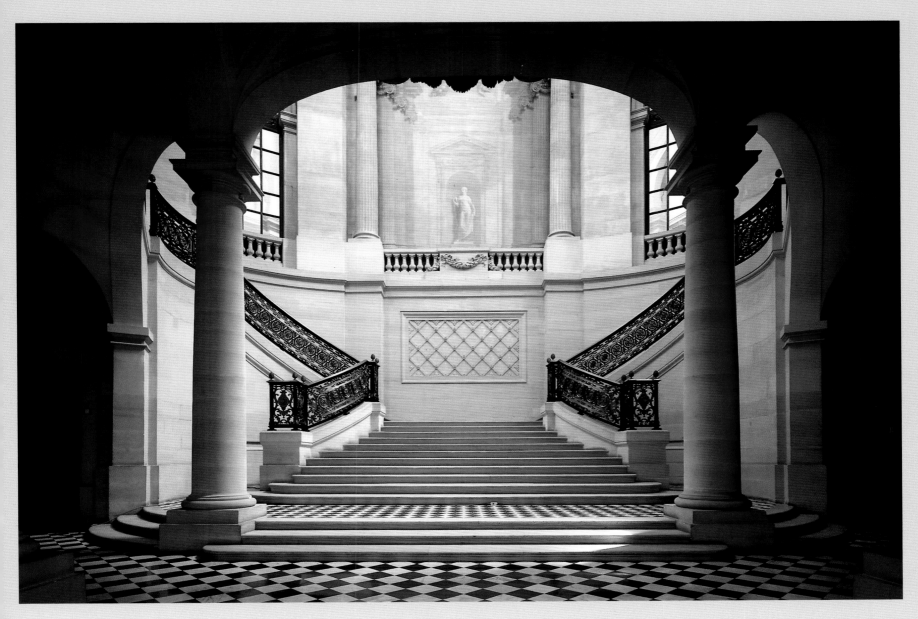

holders, and he also tolerated the most prosperous center of Parisian prostitution there. This activity not being compatible with royal dignity, Louis-Philip razed the shed to the ground and built the colonnade, while having his architects Percier and Fontaine complete the palace. The buildings that once surrounded the garden were built at the perimeter of Richelieu's garden by Victor Louis for Philippe Egalité, who wanted to earn money by renting out the apartments. At the same time, the theater of the palace was rebuilt in its current state; only minor renovations have been made in the interim. It is now called the "French Theater" and is the seat of the celebrated Comédie Française theater troupe. Today the Palais Royal is occupied by the Constitutional Council, the Council of State, and the minister of culture.

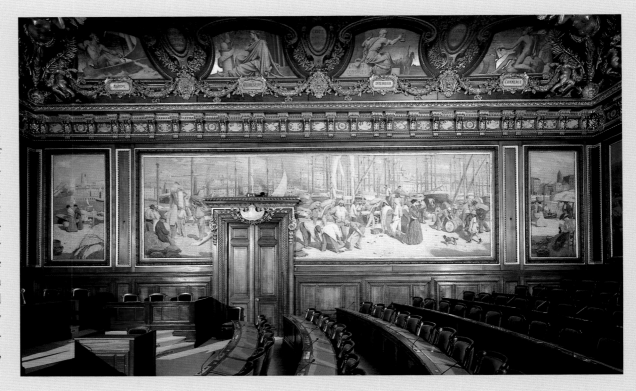

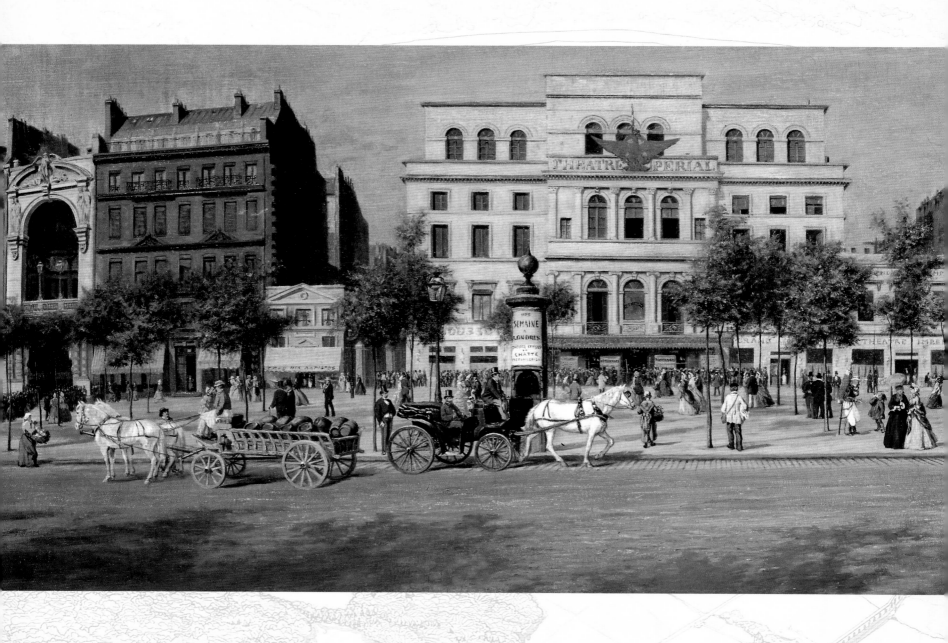

# PART THREE:

# THE CONTEMPORARY ERA

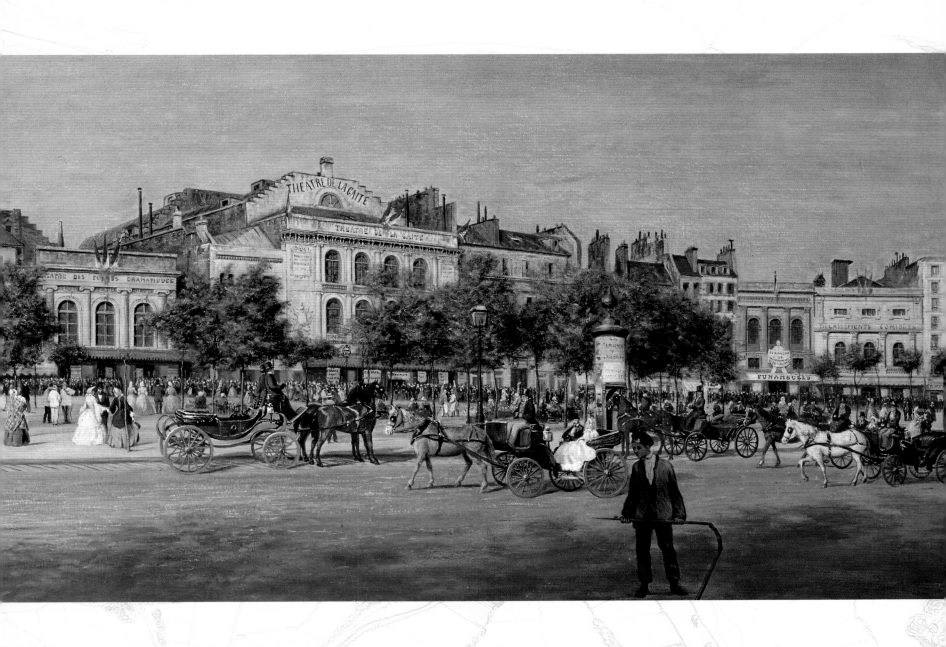

# CHRONOLOGY - PART THREE

1800   Installation of Napoleon Bonaparte in the Tuileries, which were restored by Percier and Fontaine.

1801   Chateaubriand, *Atala*.
Père-Lachaise cemetery is created.
Construction of the Pont des Arts.

1802   Chateaubriand, *Le Génie du christianisme*.
The Ourcq Canal is dug.

1803   Fulton presents his steamship on the Seine River.

1804   Napoleon I crowns himself emperor.
Execution of the duke of Enghien in the dungeon of the Château de Vincennes.

1805   Victory of Austerlitz.

1806   Death of Jean-Honoré Fragonard.
The first stone is laid for the construction of the Arc de Triomphe du Carrousel.
The first stone is laid for the construction of the Arc de Triomphe de l'Etoile.

1810   Inauguration of the column on the Place de Vendôme.

1814   Capitulation of Paris. Abdication of Napoleon I.
Louis XVIII enters the capital.

1815   Defeat of Napoleon I at Waterloo.
Second abdication of Napoleon I.

1816   Installation of a regular steamship line between Paris and Montereau.
Introduction of gas street lamps.

1820   Assassination of the duke of Berry at the Opéra.
First stone is laid for the Ecole des Beaux-Arts.

1821   Restitution of the cult of the Pantheon.

1823   First stone is laid for Notre-Dame-de-Lorette.

1824   Death of Louis XVIII. His brother Charles X succeeds him.
First stone is laid for Saint-Vincent-de-Paul.
Opening of *La Belle Jardinière*, the first large department store in the world.

1825   Death of Jacques-Louis David.
General Foy is buried at the Père-Lachaise cemetery, great manifestation of the liberal opposition.

1826   First regular steamship line on the Seine between Paris and Saint-Cloud.

1827   Arrival of the giraffe that was given to Charles X by the Egyptian pasha, the first ever seen in Paris.

1830   Controversy over Victor Hugo's play *Hernani*.
First forays of the vespatians on the boulevards; columns serve double purpose: for public notices and as urinals.
Abdication of Charles X. Louis-Philip, duke of Orléans, becomes king.

1833   Arrival of the obelisk from Luxor, Egypt.

1834   Republican revolt. The inhabitants of 12, Rue Transnonain, are massacred by the army.

1836   The first inexpensive daily newspapers, *La Presse* and *Le Siècle*, are established.
Consecration of the church of Notre-Dame-de-Lorette.

1837   Opening of the railway line between Paris and Saint-Germain-en-Laye.

1839   Experiments with daguerreotypes.

1840   Napoleon I's remains are transferred to the Invalides.

1841   Creation of the fort called le Thiers.

1842   Death of the duke of Orléans, heir to the crown.

1843   First experiments with electric street lights.

1844   Inauguration of the church of Saint-Vincent-de-Paul.

1847   Henri Murger, *Scènes de la vie de bohème*.

1848   Louis-Philip is overthrown.
Proclamation of the Republic.
Louis Napoleon is elected president.

1851   Beginning of the restoration work on the Louvre Palace. Coup d'état on December 2.

1852   Proclamation of the Second Empire.

1853   Haussmann becomes prefect of the Seine.

1855   International Exposition.
Opening of the theater of the Bouffes-Parisiens under the direction of Jacques Offenbach.

1857   Baudelaire, *Les Fleurs du mal*.

1858   Birth of haute couture with the installation of Charles Frédéric Worth Rue de la Paix; he becomes the couturier of Empress Eugénie.
Vote on the laws concerning the great restoration of Paris under the aegis of Haussmann, prefect of the Seine.

1860   Annexion of neighboring towns into Paris, which increases the number of arrondissements (neighborhoods) from twelve to twenty.

1862   First stone is laid for the new Opéra.

1863   Death of Eugène Delacroix.

1864   Consecration of the church of Notre-Dame after its restoration by Viollet-Le-Duc.

1866   Offenbach, *La Vie parisienne*.

1867   Death of Jean-Auguste-Dominique Ingres.
International Exposition.

1868   Inauguration of the church of Saint-Augustin.

1870   Fall of the Second Empire.

1871   Armistice and capitulation of Paris.
Beginning of the Commune of Paris.

1873   Law providing the building of a church dedicated to Sacré-Coeur on Montmartre as atonement for the crimes of the Commune.

1874   First exposition of the impressionist painters in the studio of the photographer Nadar.

| | | | |
|---|---|---|---|
| 1875 | Inauguration of the Opéra. | 1926 | Death of Claude Monet. |
| | Death of Camille Corot. | 1927 | First flight from New York to Paris by Charles |
| | Vote on the Wallon amendment. | | Lindbergh in his *Spirit of Saint Louis*. |
| 1877 | Death of Gustave Courbet. | 1931 | Colonial Exposition. |
| 1878 | International Exposition. | 1936 | Elections of the Front populaire. |
| 1881 | Opening of the first modern cabaret, "Le Chat noir," | 1937 | International Exhibition of Arts and Techniques. |
| | at Montmartre. | | Inauguration of the Musée des Monuments Français |
| 1882 | Inauguration of the Hôtel de Ville. | | at the Trocadéro. |
| 1883 | Death of Edouard Manet. | 1939 | Great Britain and then France declare war on |
| 1885 | National mourning for Victor Hugo, who is buried | | Germany. |
| | at the Pantheon. | 1940 | German forces occupy Paris. |
| 1886 | Inauguration of the Musée de la Sculpture comparée | 1944 | Liberation of Paris by U.S. troops. |
| | (Museum of Comparative Sculpture) at the Trocadéro. | | Death of Jean Giraudoux. |
| 1887 | Beginning of the construction of the Eiffel Tower. | 1945 | General capitulation of the German forces. |
| 1888 | The first electric street lights in the capital. | | Death of Paul Valéry. |
| 1889 | International Exposition. | 1951 | Death of André Gide. |
| 1892 | First use of reinforced concrete in Paris by François | 1954 | Defeat of the French colonial forces at Diên Biên |
| | Hennebique. | | Phu, Vietnam. |
| 1893 | Etienne-Jules Marey builds the first movie projector. | | Death of Henri Matisse and Colette. |
| 1895 | Worldwide premiere of cinematography. | 1955 | Death of Paul Claudel, Fernand Léger, and |
| | The Lumière brothers invent their first photo camera. | | Maurice Utrillo. |
| 1896 | Tsar Nicolas II lays the first stone for the Pont | 1958 | End of the Fourth Republic. Charles de Gaulle is |
| | Alexandre III. | | elected President of the Republic. |
| 1897 | Decree authorizes women between the ages of fifteen | 1960 | Death of Albert Camus. |
| | and thirty years to attend the Ecole des Beaux-Arts. | 1962 | Ceasefire in Algeria's war for independence from |
| 1898 | Construction of the metro begins. | | France. |
| 1899 | Inauguration of the *Triomphe de la République*, a monu- | | The Malraux Law on the protection of France's |
| | ment by Jules Dalou, on the Place de la Nation. | | historical heritage establishes "protected sectors" |
| 1900 | International Exposition. | | in the cities. |
| 1901 | Death of Henri de Toulouse-Lautrec. | 1963 | Death of Georges Braque. |
| 1904 | Consecration of Saint-Jean-l'Evangéliste on | 1965 | Death of Le Corbusier. |
| | Montmartre. | 1968 | Student uprisings and social unrest in May. |
| 1906 | Death of Paul Cézanne. | 1969 | Resignation of Charles de Gaulle. |
| | Flight of the *L'Oiseau de proie*, an airplane, by | | Election of Georges Pompidou. |
| | Santos-Dumont at Bagatelle. | 1973 | Death of Pablo Picasso. |
| | Creation of the first airplane factory in the world at | 1974 | Death of Georges Pompidou. |
| | Billancourt. | | Election of Valéry Giscard d'Estaing as President |
| 1913 | Inauguration of the Théâtre des Champs-Elysées. | | of the Republic. |
| 1914 | Germany declares war on France. | 1976 | Death of André Malraux. |
| 1917 | Death of Edgar Degas. | 1977 | Jacques Chirac elected Mayor of Paris. |
| 1918 | Death of Guillaume Apollinaire. | 1980 | Death of Jean-Paul Sartre. |
| | Armistice of Rethondes ends World War I. | 1981 | Election of François Mitterrand to be President of |
| 1919 | Treaty of Versailles. | | the Republic. |
| | Opening of the world's first commercial airline | 1986 | Legislative elections: victory of the conservative |
| | between Paris and London. Installation of the first | | parties (R.P.R. and U.D.F.) and their allies. |
| | airline transporting passengers between Paris and | 1989 | Inauguration of the Grand Louvre. |
| | Brussels. | | Inauguration of the Opéra de la Bastille. |
| 1922 | Death of Marcel Proust. | | Inauguration of the Grande Arche de la Défense. |
| 1925 | International Exhibition of Modern, Decorative, and | 1995 | Jacques Chirac elected President of the Republic. |
| | Industrial Art. | | |

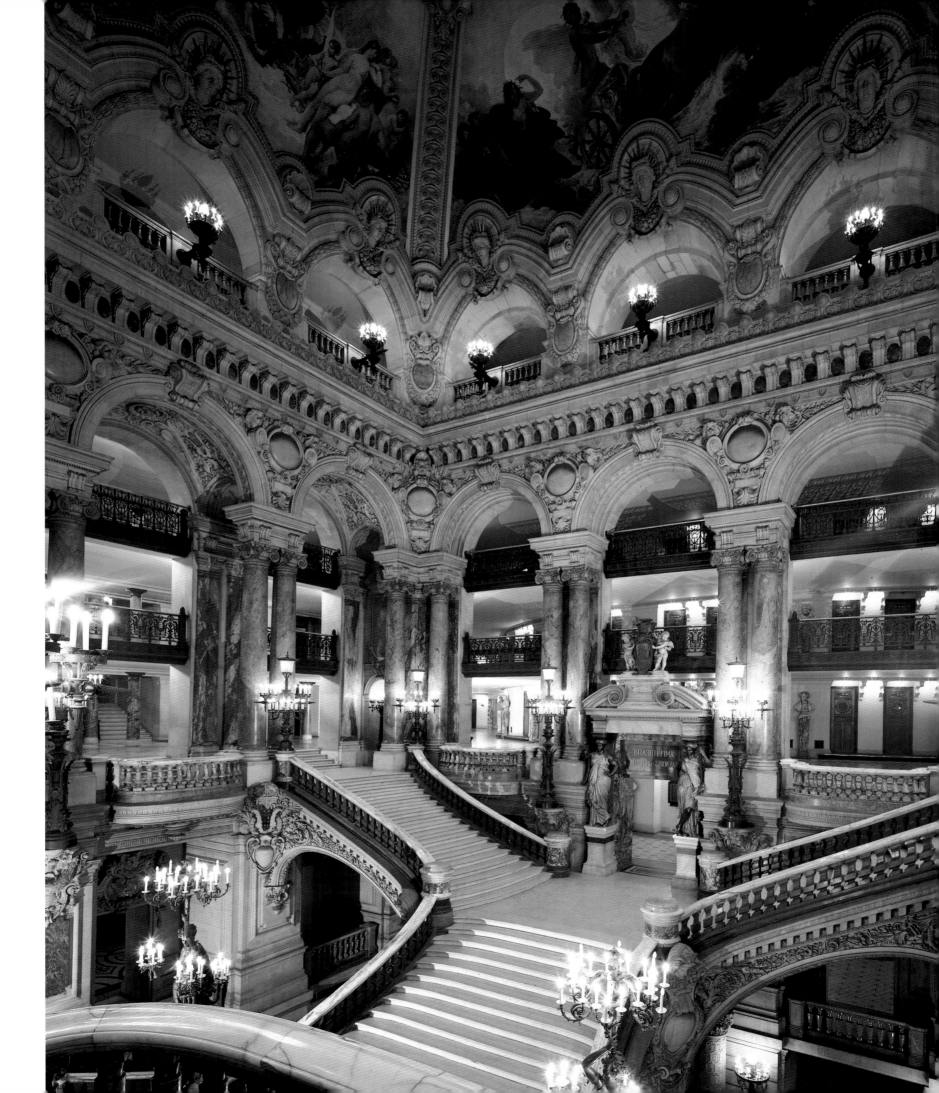

# Chapter XI
# THE LAST KINGS
## (1800–1870)

The contrast between the eighteenth and nineteenth centuries is striking. While it is true that the peerless charm of life whose disappearance was deplored by the old guard of the ancien régime was the good fortune of an elect few, its rays spread through a country relatively free from war and touched slowly but surely by increasing wealth. The Revolution caused a shockwave that affected the entire next century. Twice, a coup d'état would bring Napoleon to power; on abdicating, he would deliver to foreign armies a capital they hadn't seen for centuries. Searching far and wide, the only potential kings of France who could be found were a count of Artois and a count of Provence, both refugees from that court whose privilege had condemned the previous monarchy. One revolution would win and another would lose the crown of the king of the French for Louis-Philip, duke of Orléans and son of Philippe Egalité (himself a principal of the old court and suspected regicide). As the wheel of fortune turned, the flow of liberal and republican ideas would be easily diverted. The amazing fame of the man who re-created a court aristocracy and restored the art of war to its state in the time of Alexander the Great and Julius Caesar opened the floodgates for the broadest minds. In his lawsuit of 1832, Victor Hugo compared the censorship under Louis-Philip to the good time of the First Empire in these words: "We were robbed of all our freedom..., we had an official censor, our books were burned, our writings were scored through with deletions; but we could answer all our complaints with a single magnificent idea. We could answer: Marengo! Iéna! Austerlitz!"

1. The Opéra, Grand staircase

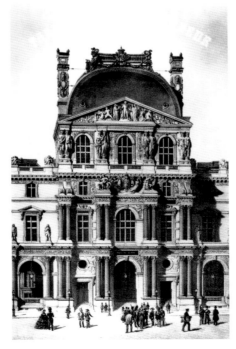

2. Musée du Louvre, Pavillon Denon. Engraving from *Paris in Her Splendor*, 1866.

*The plan to connect the Louvre to the Tuileries by demolishing the area between them was initiated by Charles Percier and Pierre François Fontaine for Napoleon I and completed under Napoleon III by Félix Duban and Hector Lefuel. The group of buildings surrounding the space freed by the destruction of the quarter (which includes the Pavillon Denon) was built by Lefuel between 1853 and 1880.*

**3. Ecole des Beaux-Arts.** Image from Duban, *Vues de quelques monuments de Paris achevés sous le régne de Louis-Philippe* (*Views of Some Paris Monuments Raised under Louis-Philip*), 1836. (Kupferstichkabinett, Berlin)

*In 1816, on the closing of the Musée des Monuments Français, which Alexander Lenoir had made a safe haven for monuments threatened by revolutionary vandalism, the premises were taken over by the Ecole des Beaux-Arts. The construction of new buildings was first entrusted to François Debret, and then, when he was called to Saint-Denis to restore that abbey-church, to Felix Duban. The Palais des Etudes, or, rather, the Musée des Etudes, was the main building closing off the Court of Honor. Although this had been built in accordance with Debret's intentions, Duban re-arranged it to receive the plaster casts of various antiquities and the architectural models studied by the students, as well as prizewinning projects and the great amphitheater. Duban kept the pieces left behind after the Musée de Lenoir was suppressed, notably the portal by Gaillon, to decorate and reorganize the Court of Honor. This group, around which generations of artists were trained, has been "destroyed": in 1971, the casts went to Versailles, and Gaillon's portal was returned to its original location in 1977.*

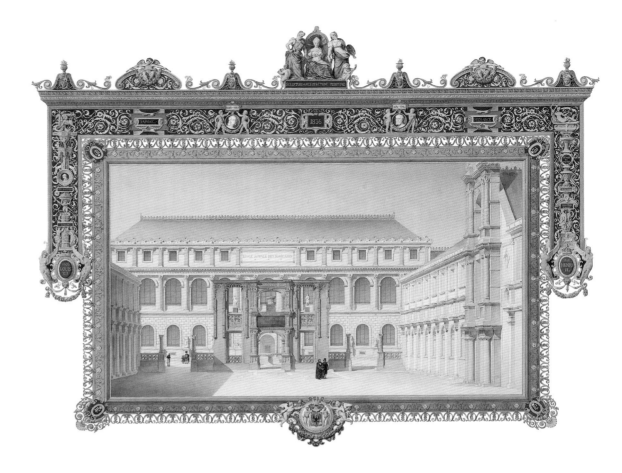

**4. Musée Cassas.** 1806. Engraving by Baltard from the Athenaeum.

*Collection of seventy-six models assembled and organized by Louis-François Cassas and presented to the public from 1806 at the Rue de Seine. The collection aimed to represent all styles of architecture.*

In 1805, Napoleon considered making Lyons the capital of the empire, but the primacy of Paris was not seriously threatened. The growing network of railways may have reduced Lyons's disadvantage in being too far south, but it also strengthened Paris by facilitating southerners' access to it. Paris, which had no local council, was identified with "the state." "All that is not Paris, is France," announced Jules Michelet, whose inaugural class at the Collège de France (1838) was called "Introduction to the History of France organized round a picture of the City of Paris." The revolution of 1789 had been the work of the commoners gathered at the Estates General, but the revolutions of 1830 and 1848 were brought about by "the people of Paris." Among the revolutions that spread through Europe, only the one that took place in Paris saw itself as the bearer of democratic progress. Ironically, though, by instituting universal male suffrage, the revolution of 1848 favored the expression of public opinion, which was much more conservative than that of Paris. The public would remain consistently favorable to Napoleon III, and would marginalize republican ideas, which even in Paris regained strength only during the last decade of the Second Empire.

*Industry*

Like all great European cities, Paris was changed by industrialization and its consequences, the agricultural exodus and the birth of the proletariat. The most obvious effects were the population explosion and the overcrowding of the public neighborhoods. In 1846, Paris had over one million inhabitants. From 1831 to 1846, its population increased by 36 percent. In 1860, its official limits were extended to the city wall built in 1840–1846, thus absorbing the suburbs. Within these new limits, which are still recognized today, Paris had reached a population of two million in 1870.

Paris was the first city in Europe, but it was outstripped by the more industrialized London. In Paris, industrialization was only partial, and heavy industry remained less developed than light industry, which arose out of traditional craftsmanship. Clothing and accessories came first, followed by building, while furnishing and jewelry are still important activities today.

All these handicrafts, which are often done at home, can be seen as genuinely Parisian in that they were practiced within the city limits. With increasing mechanization, industry moved to the suburbs. In spite of this, living conditions in Paris were profoundly degraded for the common people, whom Honoré de Balzac described as "horrible to see, gaunt, sallow,

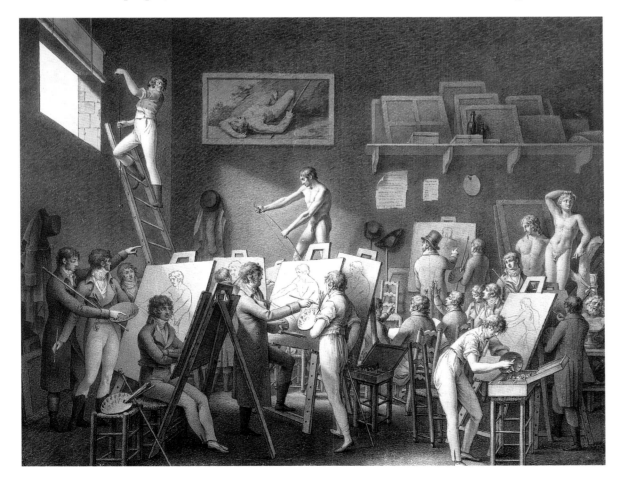

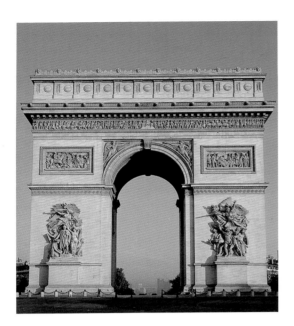

**7. Arc de Triomphe at L'Étoile**

*The first stone of this triumphal arch was placed in 1806, the day after Austerlitz, so it must be dedicated to the glory of the Grande Armée. The project, which was modified several times, is due to Chalgrin and was not approved until 1809. Work was interrupted by the return of the Bourbons and was not completed until after 1830. The main changes involved the iconographical program, completed in 1833, which was expanded to include the wars of the revolution. The most famous of the high-relief sculptures is the* Departure of the Volunteers in 1792, *or* La Marseillaise, *by Rude, 1833–1836.*

**8. Charles Percier and Pierre-François Fontaine. Plan for the Palace of the King of Rome, 1811.**

*In an imperial decree of 1811, Napoleon commanded the construction of an imperial palace on the heights of Chaillot, with the Bois de Boulogne acting as its park. Some months later, the son whom Napoleon would call the king of Rome was born, and that name became attached to the palace. Fontaine had to produce many schemes to satisfy the emperor's changing demands. The work was halted upon the fall of the empire.*

**Opposite:**

**9. Arc de Triomphe at the Carrousel**

*This triumphal arch was built between 1806 and 1808 by Percier and Fontaine on the order of Napoleon I. The arch was to have been crowned by a chariot bearing the emperor and pulled by the famous antique horses looted from San Marco in Venice. Napoleon refused the imperial statue, and the horses were returned to Venice in 1815. In 1827 a chariot was made to a design by Percier: this carries a statue depicting the Restoration and is drawn by copies of the Venetian horses.*

leathery, and living among foul stenches" (*La Fille aux yeux d'or, The Girl with the Golden Eyes*, 1834). There were repeated outbreaks of cholera; prostitution, vagrancy, and crime riddled the working class, or the "the dangerous class," as Eugène Soue described them in his *Mystères de Paris* (*Mysteries of Paris*, 1842–1843).

### Immigration from the Rhineland

Although the market for art and luxury products attracted increasing numbers of rich foreign tourists to the "drain of Europe" (Restif de La Bretonne), immigration took a noticeable form. Half of all Parisians were born outside Paris; one in twenty-five were born abroad. Despite their numerical insignificance, immigrant artists, intellectuals, and exiles from other European revolutions enhanced the reputation of the city. Most significant of these were the German immigrants. In 1831, there were 7,000 Germans in Paris (17 percent of all foreign immigrants); in 1839, there were 23,000 (25 percent); and by 1846 there were 54,000 (34 percent). The Germans were a specialized workforce, sought after for the quality of their work. The influx of Rhenish cabinetmakers in the second half of the eighteenth century was noted earlier. At this point, two German architects established themselves in Paris, which was a very rare occurrence. Both Jacques Hittorff and François Chrétien Gau successfully integrated themselves in a way that had eluded Italians in previous centuries. These two architects, both born in Cologne, were also Rhinelanders. Baron Haussmann, the powerful prefect of the Seine under Napoleon III, was himself born in Alsace to a family originating in Cologne. The Rhineland had long been occupied by French troops both from the Revolution and from the empire. At the beginning of the century, these Rhinelanders possessed French nationality. They lost it with the collapse of the empire and the restitution of the Rhineland to Prussia, leaving them little recourse other than emigration to France. In 1831, the Rhinelander Heinrich Heine came to Paris to find asylum for his liberal ideas. Like Michelet, he proclaimed in 1832, "Paris is, properly speaking, the whole of France … Anything distinguished in the provinces comes quickly to the capital, center of all glamour and brilliance." Thus immigration reflected the prestige Parisian art enjoyed throughout Europe, especially in Germany.

### The German Manner

Yet in Paris, Germany was all the rage. In that much admired publication *German Culture* (1810–1815), Madame de Staël compared France and Germany, intimating that where France sleepily submits to Napoleonic dictatorship, Germany is awake, passionate, philosophical—in a word, Romantic. Then, too, the misleading term *Gothic* gave credence to the idea that this newly rediscovered architectural style was born in Cologne rather than Paris. Since the archeologists had proved that Cologne cathedral was earlier than Amiens

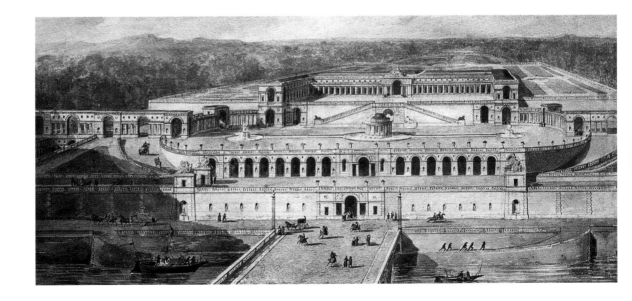

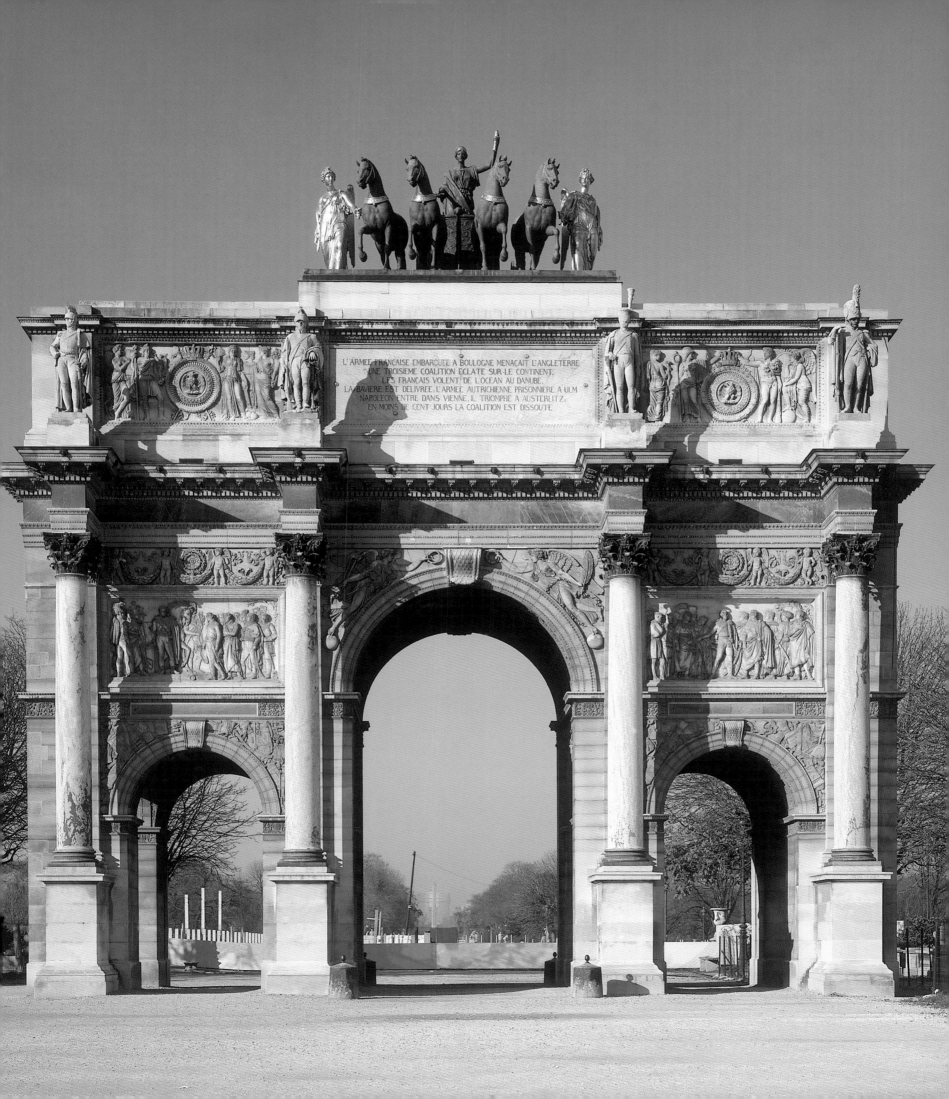

## 10. Rue Lafayette

*The central section of this road was created in 1823 to facilitate a development. It extended a preexisting street that led to the city wall. The name Lafayette was given to that central section in 1830 and applied to the whole street in 1849. Twice, in 1859 and 1862, this roadway was further lengthened toward the town center until it met the boulevards (visible at the bottom of the photo). These successive additions more than doubled the length of the original central section of the road.*

## 11. Parc des Buttes-Chaumont

*The area of Les Buttes was a series of gypsum quarries that had been exploited since the Middle Ages. In 1863 Haussmann expropriated the property and had the engineers Adolphe Alphand and Darcel plan its conversion to a park. They achieved this with skill, strengthening and enhancing the picturesque forms left by the quarrying. The park was planted by the landscape architect Pierre Barillet-Deschamps in 1866, and inaugurated during the World's Fair of 1867.*

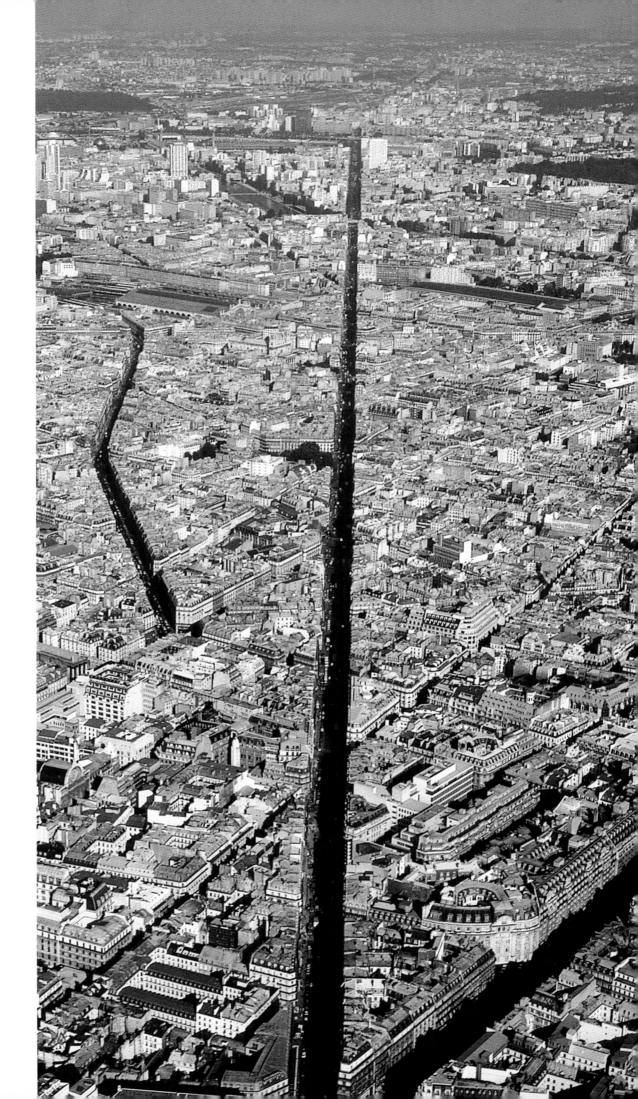

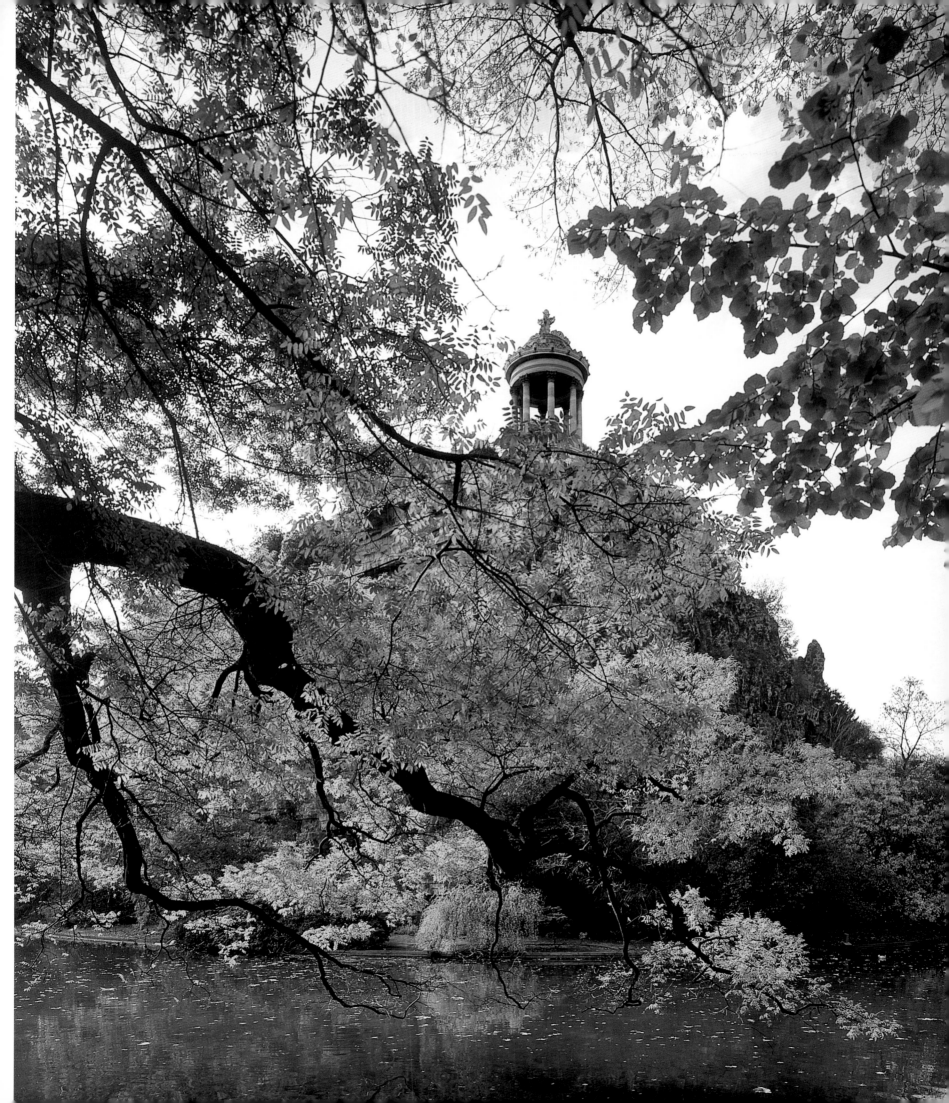

**12. Monuments of Paris.
Panoramic painting on paper,
detail, 1812–1814.**

*Produced by the manufacturer Dufour,
this panorama is thirty sheets wide. From
left to right: the Tuileries, the Carrousel
Arch, the Collège des Quatre-Nations
(Institut), and Porte Saint-Denis.*

**13. Anonymous daguerreotype
depicting Paris, c. 1845–1850.**

*In 1839 Daguerre announced his discovery
of the photographic process he had developed
from research conducted in collaboration with
Niépce. The process was first used to document
views of Paris, thereby making the city the very
first photographic subject. The daguerreotype
below does not belong to that first series, but was
made only a few years later. It presents a view,
from right to left, of the following: the Pont-
Neuf, the Louvre, and the Quai de la
Mégisserie. It may have served as the model
for a painted paper panorama.*

(rather than the other way around), the French classicists agreed that the style originated in Germany and were thus able to blame foreigners for the Gothic revival they despised. It was an easy mistake—after all, Cologne is not far from the Mosan region, whose landscape is so easy to confuse with the area around Paris, which was the true birthplace of the Gothic!

Some of the German influence came to Paris via Rome. Johann Winckelmann's theories on ideal beauty and the painting of that "new Raphael," Anton Raffael Mengs, had both been influential in the eighteenth century. In the first half of the nineteenth century, the Nazarenes, a small group of German painters living in an abandoned monastery in Rome and painting in an early Renaissance style, encouraged one of the newest tendencies in religious painting in France. However, even "German mania" had its limits in Paris. A performance of Richard Wagner's *Tannhäuser* in 1861, was judged intolerable and marked

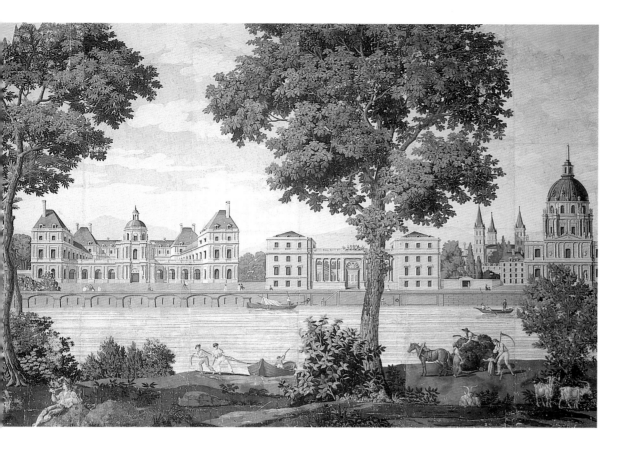

14. Charles Méryon. Saint-Etienne-du-Mont, etching, c. 1852.

a change in attitude toward things German in Paris: Prussia's increasing power now began to be worrisome.

## The Art Schools

The influence of Parisian art, so powerful in the eighteenth century, remained strong in the nineteenth century. The Revolution had only broken the political and social mechanisms for the arts. Under the ancien régime, innovation had come from the top, so society imitated royal taste. Now, a phalanx of new institutions set up by the Revolution and the empire established a conservative style that was not quite official, but nonetheless set the standards of reference throughout the arts. From now on, innovation would come from subversion. Four institutions—the Académie des Beaux-Arts, the Ecole des Beaux-Arts, the Council for Civic Buildings, and the Salon—were the fulcra of the system. The Académie controlled the teaching at the Ecole by administering the Prix de Rome, that supreme reward that earned the recipient four years of training in art or architecture at the French Academy in Rome. The Council for Civic Buildings was consulted for all public architectural projects, and its opinions were authoritative. The biennial public exhibitions at the Salon (which became annual after the Revolution) provided the only significant exposure for practicing artists, and access to these exhibitions was controlled by an admissions jury. The same entrenched professionals administered the Académie, formed the juries for the Prix de Rome and the Salons, ran the Council for Civic Buildings, and taught at the Ecole. The effects were enervating. The winners of the Prix de Rome were ensured of work for life, but there was little hope for the rest. Although the title of architect was no longer legally defined, few were trained outside the Ecole. Because fame could only come from the Prix de Rome or public acclaim, the architect was a prisoner of the system—unless the stay in Rome was (even more than in the eighteenth century) liberating: several rebels were erstwhile Romans. The situation was the same for painters and sculptors. The prizewinning students at the academy in Rome gained luster by default after the death of Antonio Canova, the last great Italian sculptor, in 1822. Indeed, following its move in 1803 from the Palazzo Mancini in the heart of Rome to the Villa Médicis overlooking luxurious parkland at the edge of the city, the French Academy had become no more than a glamorous holiday camp for the protégés of Parisian institutions.

**15. Gustave Doré.**
**Frontispiece of *Nouveau Paris* (*New Paris*)**
**by Emile la Bedollière, 1860.**

*This frontispiece is as ambiguous as the book it introduces, divided between regret for the destruction of old Paris and admiration for the emerging new city.*

*The Salon and the Museum*
The Salon was an almost obligatory ritual for painters and sculptors seeking clients. Attempts to evade the jury took a variety of forms and achieved limited success. During the revolution of 1848, the Salon went without a jury, but the indiscriminate exhibition of 5,580 works (more than double the number selected by jury in the traditional way) was the object of public derision. After this fiasco, other attempts to escape the jury became increasingly common. One of these was the private exhibition. In 1855 the Salon jury rejected Gustave Courbet, who responded by

exhibiting his work in a makeshift stall at the entrance to the World's Fair that year. In 1863 even Napoleon III felt that the jury was too severe and facilitated a parallel Salon, the Salon des Refusés. This was where the works of Courbet and Manet could be seen. Following the precedent of the eighteenth century, artistic criticism flowed from the pens of the best and most independent intellectuals: Théophile Gautier was somewhat eclectic, Charles Baudelaire admired Eugène Delacroix, and Emile Zola defended Edouard Manet. However, criticism was mostly limited to reviews of the Salons, to which, from every point of view, it was preferable to have been admitted.

17. Adolphe Potémont. *Rue de Lourcine.*

Painters and sculptors had one advantage over architects. They trained in a forum that could not be fully controlled: the museum. Specifically, that museum was the Louvre, where the greatest artists of the nineteenth century trained by copying old masters. Lafont de Saint-Yenne had been right to believe (in 1749) that establishing the Louvre would lead to the renewal of French art. The Spanish Gallery was particularly important in this regard because it contained the personal collection of Louis-Philip, which was added to the Louvre in 1832 and unfortunately had been sold by the time of the revolution of 1848. This was the collection that inspired artists like Manet to visit Spain to develop their interests in Diego Velázquez, Esteban Murillo, and Francisco de Goya.

*Styles*
All in all, this century, which suffered the tyranny of hidebound institutions and a narrow-minded public, is riddled with contradictions, and thus were formed the "isms" of art history.

Romanticism was born in 1816 from the word *Roman*. As early as the seventeenth century this word had produced the concepts of "Romanesque" style and "Romantic" literature. In fact, the connection with literature is one of the most obvious characteristics of Romantic art, which was often applied to the illustration of great novels (figs. 93–94). But according to Baudelaire, Romanticism was not a style but a manner or feeling. On the other hand, the term *classicism* was only invented in 1825 to complement Romanticism. From the sixteenth century, the term *classic* (from *classicus*, which designated the upper class in ancient Rome) referred to the highest artistic qualification: the masterpiece. In the strictest sense, classicism was the ideal of a universal art and an absolute beauty, as we have seen. But once this ideal had become synonymous with antiquity, its sense was narrowed to a mere

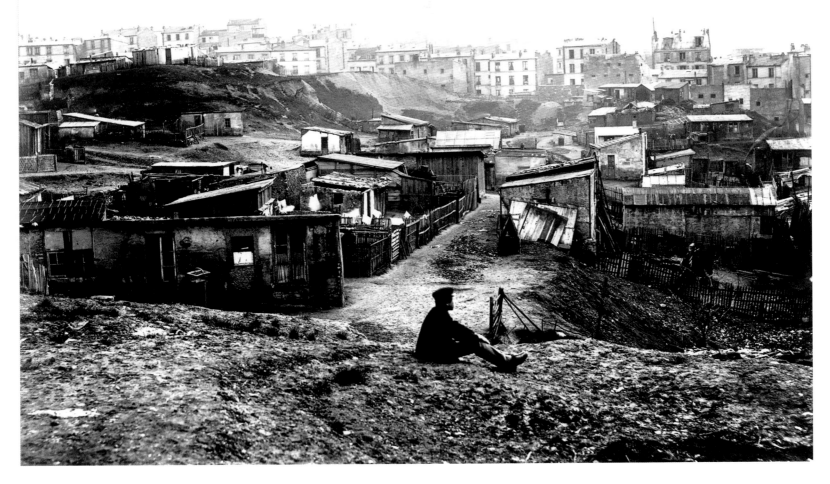

## 21. Place and Passage du Caire

*This covered passage and the apartment block (No. 2) that gives access to it were built in 1798. The covered passage forms one of the first shopping malls in Paris. The name of the complex refers to Bonaparte's Egyptian campaign and the taking of Cairo (July 1798). The facade is an odd mixture of Gothic and Egyptian motifs, and may not be homogenous. The heads are reasonably authentic versions of those in Egypt and may have been based on Frederik Ludwig Norden's publications. Even if we cannot definitively associate their creation with the Egyptian campaign, they are certainly among the first examples of nineteenth-century Egyptomania.*

## 22. Hôtel de Beauharnais

*An hôtel from the first half of the eighteenth century (78, Rue de Lille), it was modernized for Napoleon's son-in-law, Eugène de Beauharnais. The most famous part of it is the Eygptian Porch, built c. 1807, which probably refers to de Beauharnais's participation in the Egyptian campaign.*

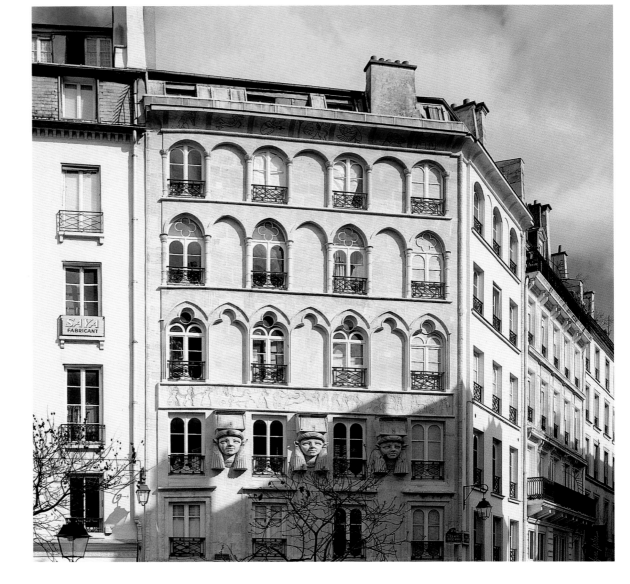

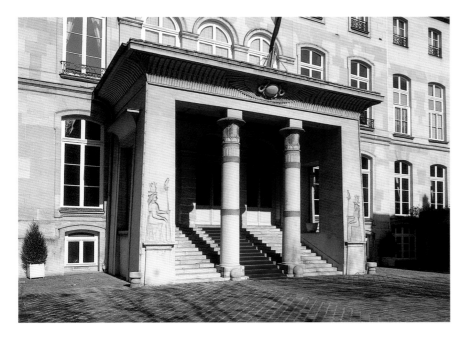

style—neoclassicism—one form among many laying claim to an imagined cultural heritage. Devotees of different historic periods extolled stylistic purity and discouraged eclecticism. *Eclecticism*, wrote Delacroix, is "a pedantic word introduced to the language by the philosophers of this century." He was right about the philosophical origin, but the word had actually appeared in the middle of the previous century. Delacroix mistook the date because Victor Cousin revived Eclecticism (which recommends borrowing and reconciling the best ideas of various philosophies) at the beginning of the nineteenth century. Artistic eclecticism, however, has a longer history. It appears in Sebastiano Serlio's projects claiming to bring together French "distribution" with Italian "order," and in those of Jacques Soufflot and his Greek-Gothic mix.

Another "ism," Realism, was probably invented by Courbet, although he wrote "the title of Realist has been as much imposed on me as the title of Romantic was imposed on the men of 1830…I have studied ancient and modern art completely independently…Quite simply, I wanted to use that full knowledge of tradition to form a sense of myself as a free and thinking individual." Given the artist's reputation as a revolutionary, this tribute to tradition is surprising. It is hard to understand what Realism meant in the mid-nineteenth century. Even the aggressive and provocative

realism of Courbet's work had its antecedents in still lifes such as *La Raie*, by Chardin (chapt. IX, fig. 44).

Any attempt to classify the art through all these "isms" is doomed to failure. "Qualifications never give a true idea of things, otherwise the works themselves would be superfluous," wrote Courbet, again with regard to Realism. He refused to justify himself "in terms of greater or lesser correctness according to a classification that no one, it is to be hoped, is believed to understand well." Bearing in mind the use innovative artists such as Delacroix, Courbet, and Manet made of learning from the old masters, these modern artists were rabid classicists. Delacroix, indeed, wanted it this way. And Manet was still a painter of subjects, regardless of anything that might be said about the disappearance of the subject, that fundamental sacrifice of twentieth-century art. Yet *La Musique aux Tuileries*, painted in 1860 and causing such outrage at the Salon of 1862 (fig. 108), is recognized as the fountainhead of twentieth-century modernity: the first "pure" painting, the first picture produced with "taches," or daubs of paint (the expression comes from contemporary criticism, notably Zola). This is the work that twentieth-century interpreters take to mark the disappearance of the subject in art.

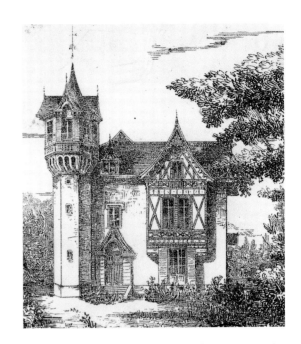

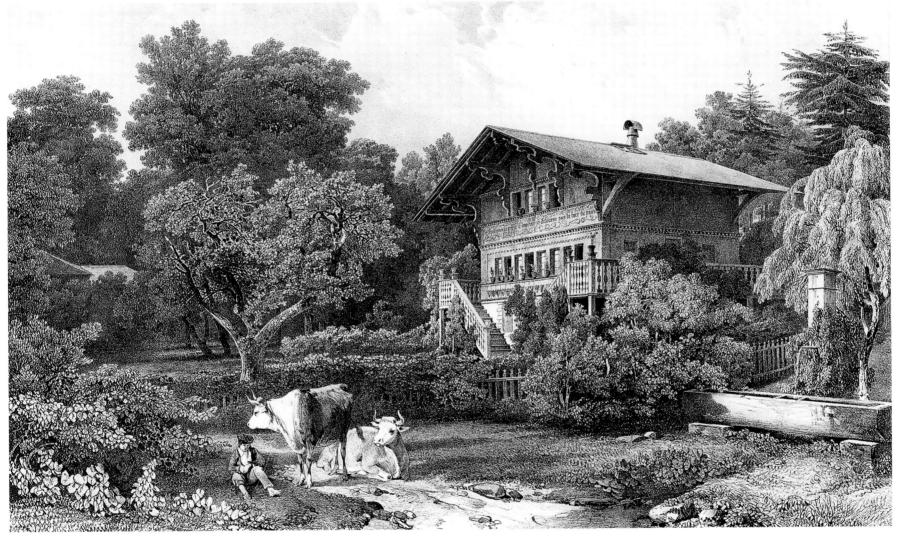

Above:

### 23. Villa of the Hameau Boileau (Boileau Village)

*This half-Gothic, half-Romanesque villa was built before 1849 by Danjoy in the Hameau Boileau. The Hameau was a housing development begun in 1839 for the lithographic printer Rose-Joseph Lemercier. The architect was Théodore Charpentier, who designed the park in the English manner as a setting for the houses.*

24. Chalet Delessert. Lithograph by Villeneuve and Engelmann, 1829.

*The chalet was prefabricated in Switzerland in 1824 for Benjamin Delessert, and was set into his park in Paris (which was destroyed in 1930).*

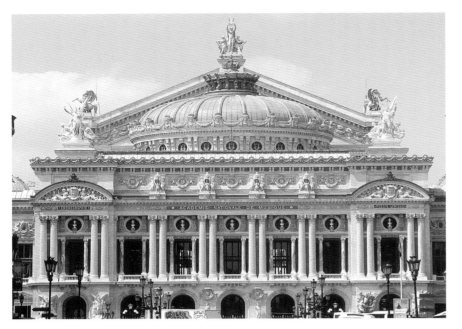

Architecture was the first discipline to be affected by the fad for historical references. They proliferated through publications, journals, and (to some extent) the creation of specialized museums, and the short-lived exhibitions of the World's Fairs. Among these were the Rue de Seine architectural museum comprising models collected by Louis-François Cassas (fig. 4), the plaster cast collection of the Ecole des Beaux-Arts, now installed in the old premises of the Musée des Monuments on the Quai Malaquais (fig. 3), and the exotic pavilions of the World's Fairs that were held in Paris in 1855 and 1867.

*Historicism and Rationalism*

Not all citations were equally important. Roman antiquity remained the academic reference point, and imitating it was routine for public buildings. But the discovery of Greek architecture created a schism among the classicists. From the end of the eighteenth century, architects had to acknowledge the proportions of the Greek Doric order, which had been unknown until then. Now, thanks to Hittorff, they learned that Greek temples had also been painted. The doyens of the academy had long known that the architectural members of the Greek temple were customarily painted but they could not accept that exterior walls had also been decorated with painted figures and narratives. Nevertheless, and in spite of academic reticence, Hittorff's discoveries would have modern applications.

### 25–32. The Opéra

*After two competitions in 1860 and 1861, the Paris Opéra was built by Charles Garnier. It has been known as the Opéra Garnier since 1985 to distinguish it from the Opéra de la Bastille, which was opened that year. Construction lasted from 1862 to 1875. At its inauguration, the Paris Opéra was the biggest in the world (118,500 square feet, 519 feet long). It consists of a series of blocks, each with its own roof, including the vestibule, with the public foyer on the floor above, the great staircase, the auditorium, with its domed roof and flanking rotundas (originally these were the imperial and subscribers' entrances), the stage, whose great gable rose above the dome, and finally the dancers' salon and the administrative offices. The auditorium is relatively small, containing only two thousand seats. More than two hundred of these offer neither sight nor sound of the stage, having been added by a later director who was keen to increase revenues.*

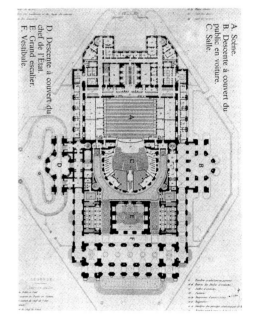

The Gothic revival initially took the form of the picturesque: it appeared in garden pavilions and temporary decorations such as the entrance to the cathedral for Napoleon's coronation in 1804. It also stimulated the restoration projects for the Sainte-Chapelle and Notre-Dame, whose permanent workshops served as training grounds for the architect-restorers, Jean-Baptiste Lassus and Eugène Viollet-le-Duc. But it was the restoration of Saint-Denis, where the young, self-taught, Viollet-le-Duc replaced the academician François Debret, that canonized the specialist architect's knowledge and discredited the universalism of the academician. Viollet-le-Duc's informed understanding of Gothic architecture was made widely available by his ten-volume reference work, *Dictionnaire raisonné de l'architecture française du XI au XVI siècle* (*Annotated Dictionary of French Architecture from the Eleventh to the Sixteenth Century*), which he published between 1854 and 1868. Gradually, this knowledge also appeared in

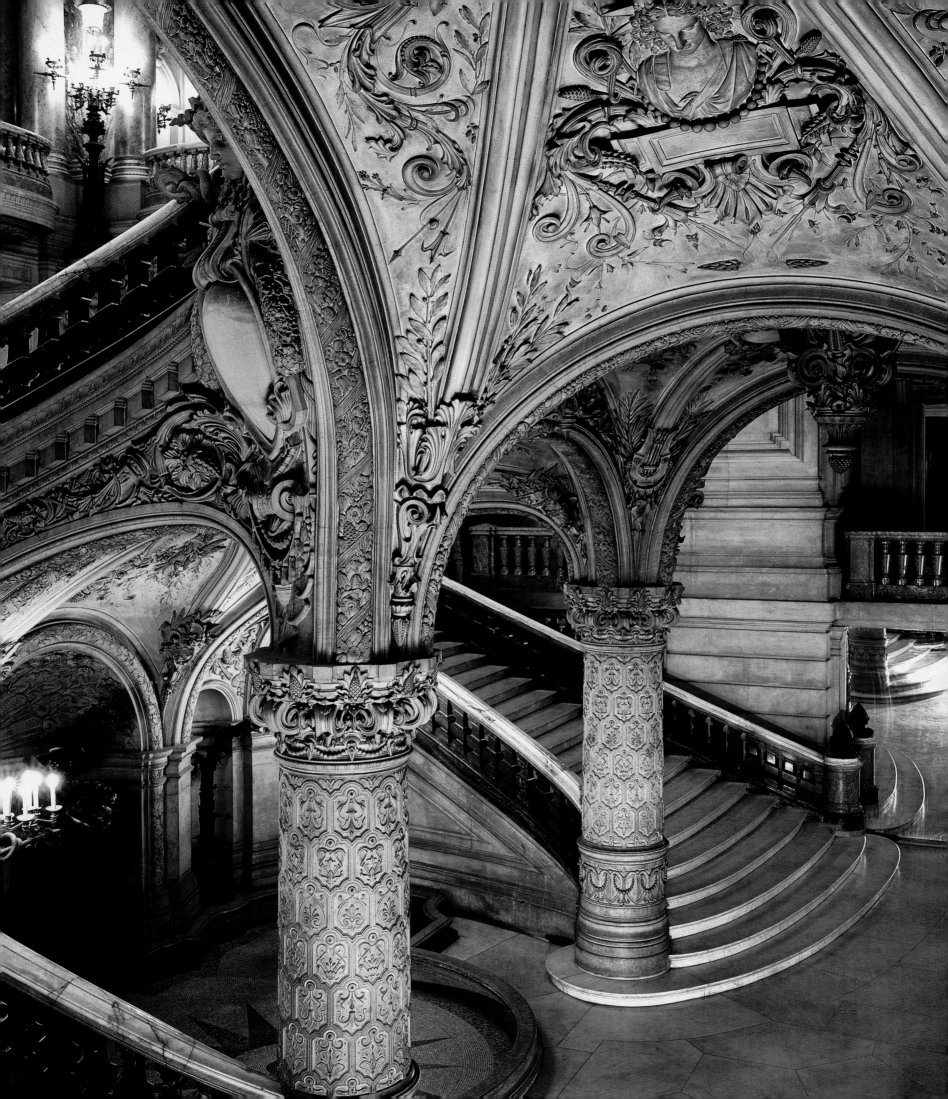

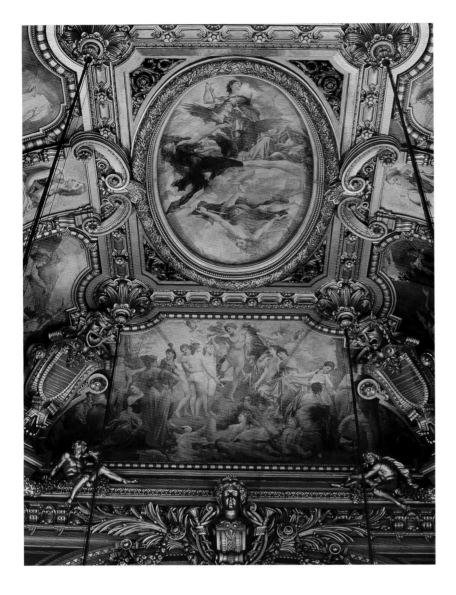

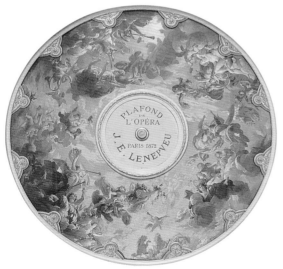

the designs of new churches, which had until then been subject to archeologically ignorant improvisations.

Among the many other manifestations of historicism, two important ones must also be considered. One of these was Egyptian architecture, of which the house of the Place du Caire (fig. 21) and the portico of the Hôtel de Beauharnais (fig. 22) are two remarkable Parisian examples. In the middle of the previous century, Piranesi had the idea of reintroducing Egyptian motifs into architectural decor, as had already been done in the Renaissance. But the French phenomenon must have been sustained by the extraordinary repercussions of Napoleon Bonaparte's Egyptian campaign. In any case, Egyptomania had only a relatively short sway. Rustic architecture, which appeared in the parks of the châteaux around Paris in the second half of the eighteenth century, was of a completely different order. This was an architecture inspired by country cottages and first appeared in garden pavilions before becoming the basis of the unpretentious suburban house. The description of the chalet in Jean-Jacques Rousseau's *La Nouvelle Héloïse* inspired buildings near to Paris, from Ermenonville to Saint-Cucufa. Indeed, there was a chalet raised in the Auteuil neighborhood by the Swiss industrial magnate and collector Benjamin Delessert that was manufactured in Switzerland (fig. 24). However, the fashion for swimming in the ocean would keep most of the rustic buildings, including the most extraordinary ones, outside Paris.

The proliferation of styles was fostered by the increase in public buildings resulting from the decentralization of institutions since the Revolution. This phenomenon touched all French towns, especially Paris, which contained the functions of the state, the headquarters of finance and industry, and the more notable theaters. The narrow taste of the sovereigns and the limiting control of the Council on Civic Buildings condemned many public buildings to a solid but pedestrian classicism, although there was also a charmingly relaxed classicism (best seen in the Varieties Theater), and a transcendant classicism regulated the Charenton asylum, a modern version of the too often quoted Temple of Fortune at Praeneste. Surprisingly, the architect of this hospital, a Prix de Rome recipient, claimed connection with the rational tendency, which indeed can be seen in the rigor of the distribution, and could hardly be called new. Rationalism was not a style, and this allowed widely differing builders to authenticate themselves through it. Among these were the disciples of Jean Nicolas Louis Durand, who had described architecture as a game of cubes in his *Précis de leçons d'architecture donnée à l'Ecole polytechnique* (*Summary of Architectural Classes Given at the Ecole Polytechnique*), 1802–1813; the followers of Viollet-le-Duc, who demonstrated the rationality of eighteenth-century architecture; and civil engineers with no other rationale than the calculation of forces and resistance of materials.

### The Style of Napoleon III

Even at the time, Parisian eclecticism was known as the style of Napoleon III. When Charles Garnier presented his project for the Opéra to the imperial couple, the empress protested that it lacked any known style. He explained smoothly that his Opéra was quite simply in the style of Napoleon III. Garnier's Opéra and Hector Lefuel's Louvre, both odd amalgamations of imagination and grandiloquence, are paragons of the style of Napoleon III. The Opéra (the twelfth built in Paris since 1669) borrows from the facades of Venetian palaces and those of the Place de la Concorde, from the Ambassadors' staircase at

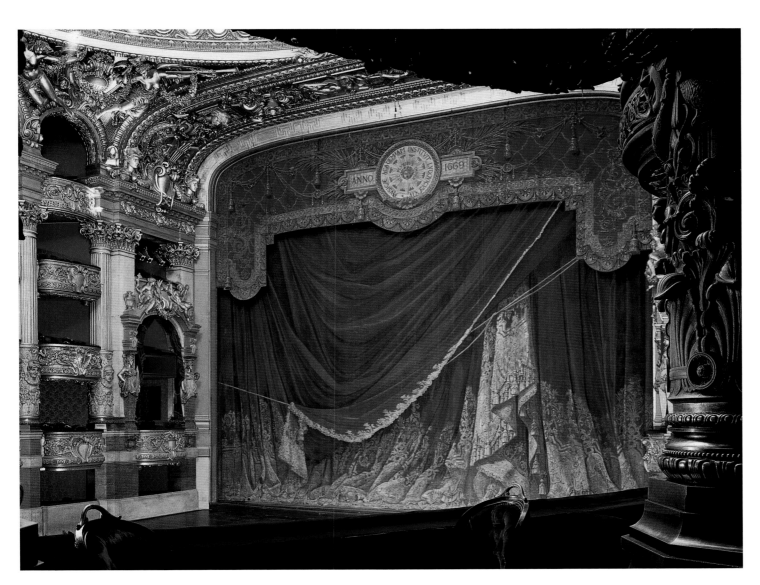

**29–32. The Opéra**

*Most of the paintings are by Paul Baudry, Félix-Joseph Barria, Jules-Elie Delaunay, Jules Eugène Lenepveu, and Gustave Boulanger. The sculptures are mainly by Jean-Baptiste Carpeaux, although the famous Danse on the facade is by Carrier-Belleuse.*

**Opposite, bottom:**

*Lenepveu's painting in the auditorium cupola was covered with a work by Marc Chagall in 1962, at the behest of André Malraux.*

Versailles and the theater staircase at Bordeaux. It is as colorful as a building can be, with its marbles, its golds, and its luxurious painting. Harlequin it may be, but it is still a masterpiece of theatrical architecture. For the new Louvre, however, it was thought necessary to destroy the old in order to join it to the Tuileries. But soon after this disastrous joining was completed, the Tuileries was destroyed by the Commune. The Louvre of Napoleon III is clearly stamped with imperial majesty: it is all "pouf"—a word that from 1829 would designate the short quilted stool that became the rage in courtly drawing rooms, and from 1872 would characterize the bustle that puffed out behind the skirts of the ladies of high society. Lefuel was the emperor's appointed architect, and Garnier an outsider who won the commission for the Opéra over Viollet-le-Duc, whom the empress preferred.

The extensive international reach of the style is well illustrated by the American architectural historian H. R. Hitchcock, who coined the expression "International Second Empire Style" in an attempt to describe it without the ambiguities suggested by the word *eclecticism*. Ironically, though, the sources of that international style are not exclusively French, although citations of Parisian architecture from the time of Napoleon III predominate. The most important of these is the Louvre, whose florid style can be found in many capital cities, especially in the United States, where Anglo-Saxon traditions had dominated for so long. This began with Jefferson, who had already initiated young American architects to Parisian ways in the later eighteenth century. In the nineteenth

## 33. Bibliothèque Sainte-Geneviève

*When the abbey of Sainte-Geneviève was converted to a grammar school, Henri Labrouste rehoused its famous library near by at the Place du Panthéon, between 1844 and 1850. The reading room, which took up the entire second story, was a metal-framed double hall.*

## 34. Reading Room of the old Bibliothèque Nationale

*The main nineteenth-century addition to the old Palais Mazarin, occupied from the eighteenth century by the Bibliothèque Royale, was the reading room. It was constructed between 1859 and 1867 by Henri Labrouste.*

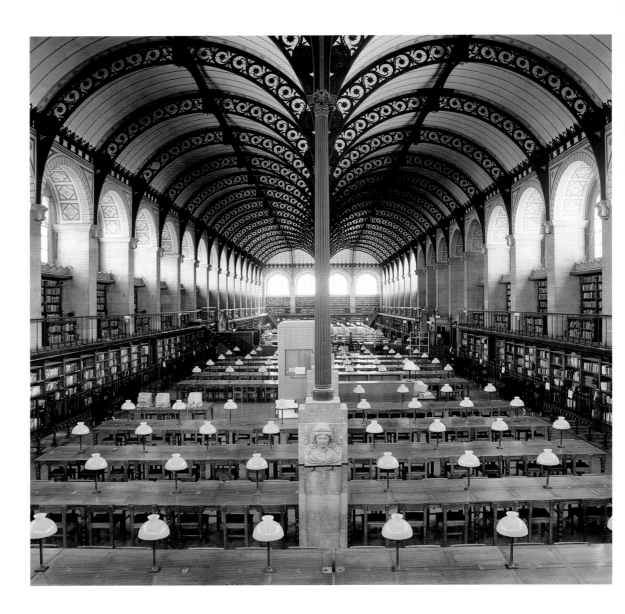

century, Paris had more than history and culture to attract them. It also had the highly reputable Ecole des Beaux-Arts, which would train some of the most famous American architects of the nineteenth century: Richard M. Hunt, H. H. Richardson, James Renwick, and Ch. F. Mac Kim. Even the methods of the Ecole des Beaux-Arts were exported to America, when two prestigious foundations, the Massachusetts Institute of Technology in Boston and Columbia University in New York, adopted them.

*The New Programs*
The variety of public architecture expanded in the nineteenth century. One new building feature was the panorama. The panorama is a building containing a circular room with a huge, continuous painting on its walls. This is equipped with a central observatory from which the visitors are invited to contemplate the panoramic view of a town or battle. Although invented in 1787, the panorama did not appear in Paris until 1799, and it was particularly fashionable in the 1820s. Thus from the heart of Paris one could see the Battle of Wagram in 1802, the Battle of Navarin in 1831, the Fire of Moscow in 1839, the Battle of Eylau in 1843, the Battle of the Pyramids in 1853, and the Siege of Sebastopol in 1860.

From 1834, when the first platform was built, private companies endowed Paris with six train stations. But the modernity of these Parisian stations should not be overestimated. For a long time, their novelty was confined to the construction of the station hangars, which

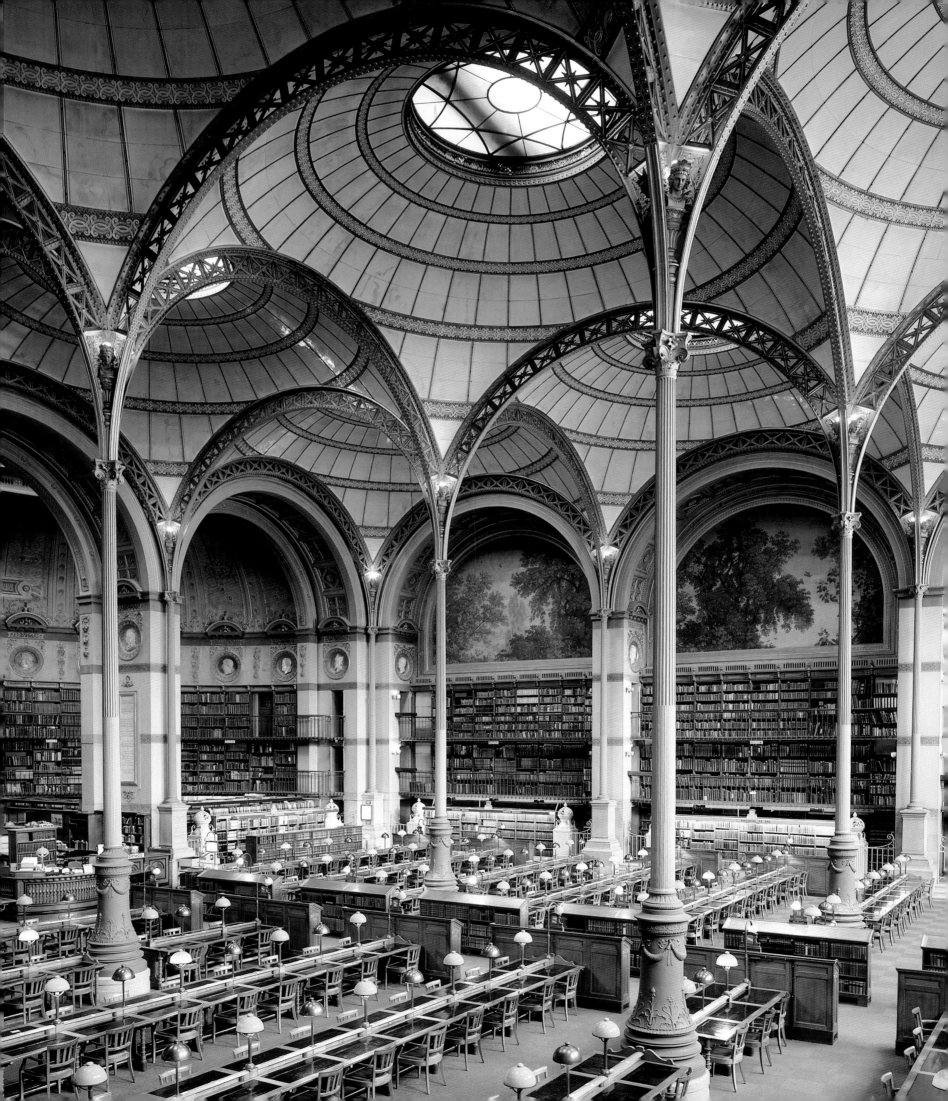

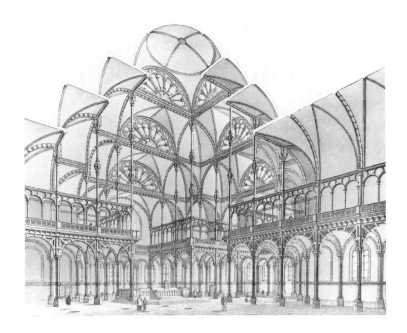

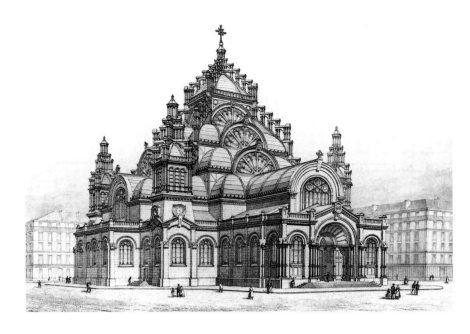

**35–36. L. A. Boileau. Project for a synthetic cathedral, c. 1865.**

*This was a project for a cathedral resulting from Boileau's mid-century research to create a composite architectural style.*

**37–38. Les Halles du Marché Central**

*In 1851, the president-prince laid the foundation stone for a metal-framed pavilion faced with stone. The project had been designed by Victor Baltard as part of the complete reconstruction of the twelfth-century hall buildings of the central market in Paris. When the work was found unsatisfactory, a series of spontaneous competitions gave rise to about forty alternative proposals. A new metal-frame design by Baltard was adopted in 1853. The two first pavilions were inaugurated in 1854, the four next in 1858, and four more in 1860 and 1874. The project comprised twelve halls, but the last two were built in a different style in 1935. In 1962, the market was transferred to Rungis, and the pavilions were all demolished, apart from one that was moved to Nogent-sur-Marne.*

were hidden by stone facades rather than exposed. The metallic hangar of the Gare de l'Ouest (now the Gare Saint-Lazare) was made in 1851–1852. By this date, its 150-foot span was a world record, surpassing by 30 feet the best efforts of the English. To achieve it, the engineer, Eugène Flachat, developed the framing system invented by Antoine Polonceau in 1837, which was used for most of the metal roofs in France.

The use of metal framing revolutionized the conception of traditional buildings such as libraries and markets. When Henri Labrouste designed the Sainte-Geneviève Library (fig. 33) and the reading room of the old Bibliothèque Nationale (fig. 34), his achievement was based on the use of cast iron for the supports, wrought iron for the arches, and glass and tiles for the roof and walls. A recipient of the Prix de Rome, Labrouste is linked with the rationalist movement through his many Gothic references, which can be seen in the way he modeled the Sainte-Geneviève Library on the refectory of Saint-Martin-des-Champs (chapt. III, fig. 23). But it was through the reorganization of the central market of Paris that these metal halls gained public acceptance. It is considered a masterpiece of the genre (figs. 37–38).

One of the entrants in the competition for that central market was Hector Horeau. Previously, he had been placed first in the London competition to house the first of the World's Fairs—that of 1851, that of the world-famous Crystal Palace, that cathedral of glass and steel created by Joseph Paxton, who was finally preferred over Horeau. Although one customarily attributes this rebuff to British chauvinism, they were right to choose Paxton's project over that of Horeau. Horeau, whose style remained uncertain, was a zealot for the grand span, the challenge of the century. His first proposals were in wood, worked in the framing technique invented by Philibert De l'Orme. Similarly, the synthetic cathedral, a masterpiece by Louis Auguste Boileau (figs. 35–36), had been conceived in masonry before it had been rethought in metal. Horeau and Boileau had points in common: they were self-taught, rationalists and eclectics, and victims of the omnipotence of the Council on Civic Buildings. But Boileau was the true inventer of forms. His cathedral is covered with a pyramid of vaults, borrowing as much from medieval flying buttresses as from classical ambulatories, from Russian Kokochniki as from Guarini's multitiered and pierced vaults. As a building, this cathedral served many purposes: it was as able to enshrine industry at a World's Fair as it was to enshrine the Catholic faith.

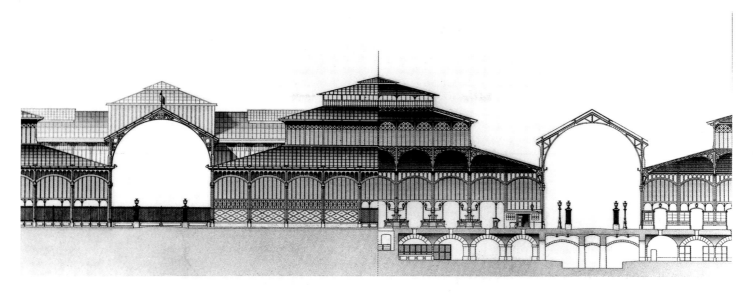

FACE COTE SUD        Echelle de 0 1 2 3 4 5    10       20 mètres        COUPE SUIVANT L'AXE

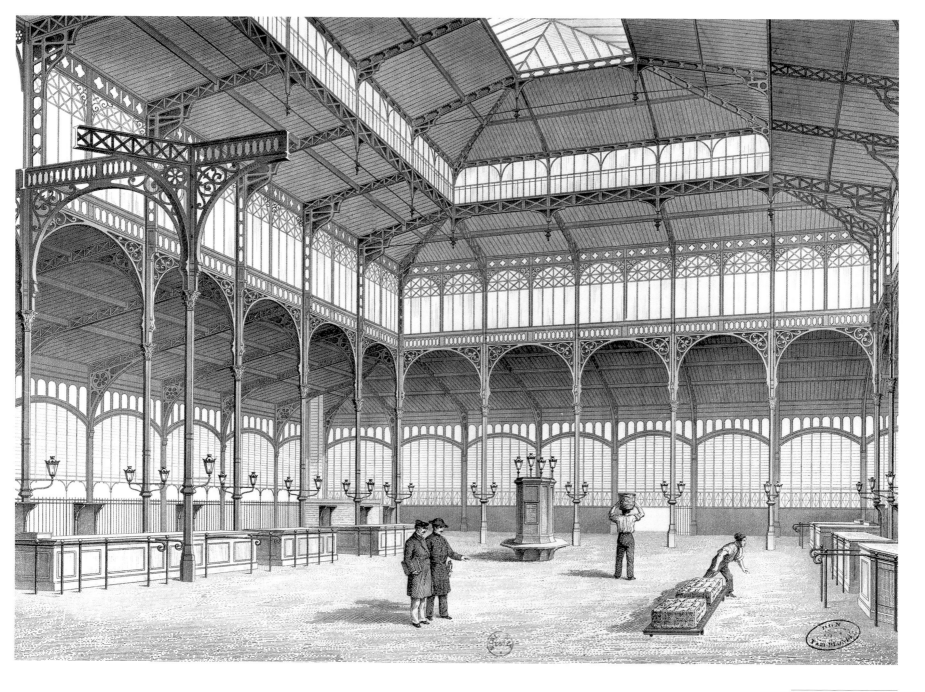

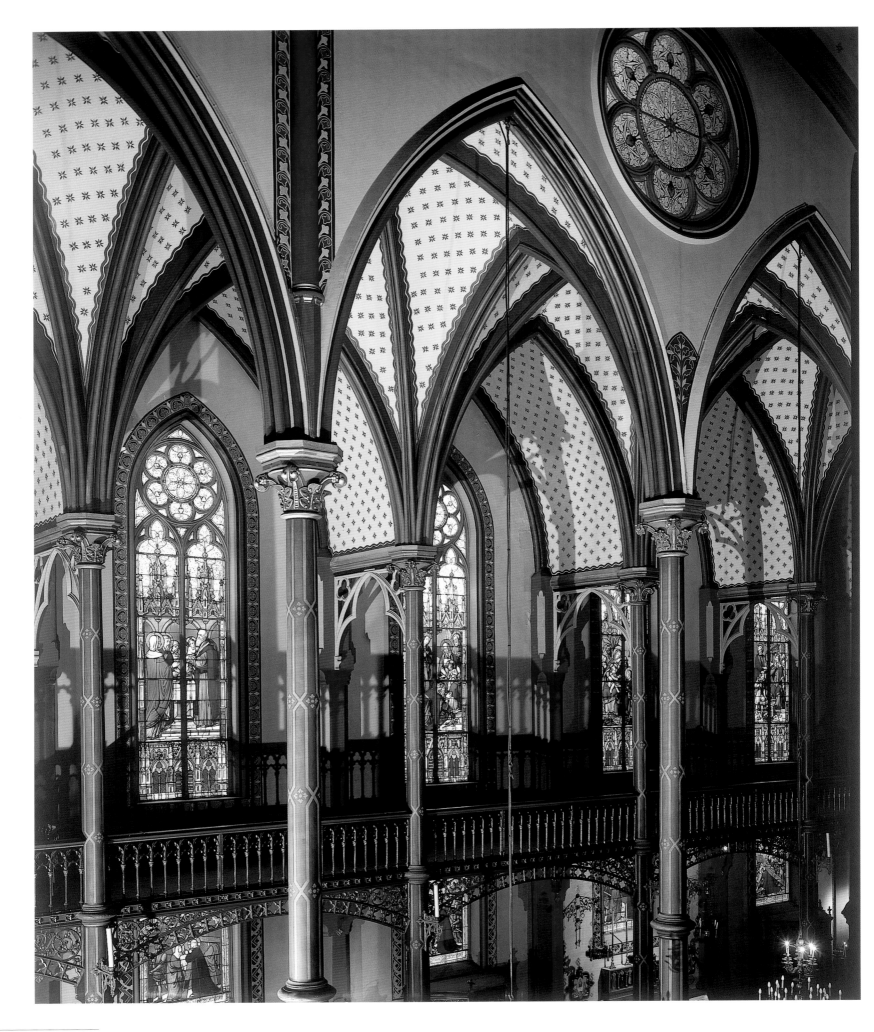

*Churches*

The nature of nineteenth-century Parisian modernity may be betrayed most obviously in religious architecture, although there are a few qualifications to this assertion. The church of the Madeleine might have been a great work, but it was delayed by the financial problems that had disrupted work since the building workshop opened in the eighteenth century. Not until the Restoration would there be a sustained policy of ambitious church construction. Meanwhile, the parish churches built by Etienne Godde (Saint-Pierre-du-Gros-Caillou, 1821; Saint-Denys-du-Saint-Sacrement, 1826) continued the modest approach adopted at the end of the eighteenth century at Saint-Philippe-du-Roule. Only the Chapel of Atonement (figs. 41–42), an adaptation of the Renaissance central plan, and Notre-Dame-de-Lorette, an adaptation of the early Christian church (figs. 43–44), show designs that might suggest a Restoration style.

Without the intervention of Hittorff in 1833, Saint-Vincent-de-Paul (figs. 45–48) would have resembled Notre-Dame-de-Lorette. Both churches have interior colonnades. At Notre-Dame-de-Lorette, this is surmounted by a story of windows alternating with large narrative paintings, an approach that would set a new fashion although it was derived from the mosaic decoration of the early Christian churches. At Saint-Vincent-de-Paul, there are two stories of colonnades, a more original approach, the precedents for which were some isolated experiments and projects from the eighteenth century. Now, the change to two tiers of colonnades was made before Hittorff took control of the workshop; he was content to change the orders and to insert a frieze of figures on a gold background between the two colonnades. But these contributions are important. Hittorff always preferred the Greek Ionic of the Erectheum to the Roman Corinthian that is ubiquitous in French neoclassical architecture. He made Saint-Vincent-de-Paul a manifesto for polychromatic architecture by coloring the architectural members and by drafting a program of narrative paintings for the whole building. The innovation here was not merely the presence of paint in a church, but the fact that the architect himself had defined the program and directed its execution and, above all, that the painting extended onto the outside walls.

The Gothic style had not yet been recognized as the quintessential ecclesiastical style; that would come later. Meanwhile, doubts were raised by the public debate about its national origins and its definitive archeological and technical features. Significantly, the first neo-Gothic church in Paris (and indeed in France), the church of Sainte-Clotilde (1845–1857), was built by Franz Christian Gau, a Rhinelander like Hittorff. Arrayed against this project were the Council on Civic Buildings, which disapproved of the Gothic in general; and the medievalists, who disapproved of this particular version, which, ironically, was qualified by Prosper Mérimée as the "Gautique" style. The design was roundly criticized. The archeological inaccuracies were deplored, as was the

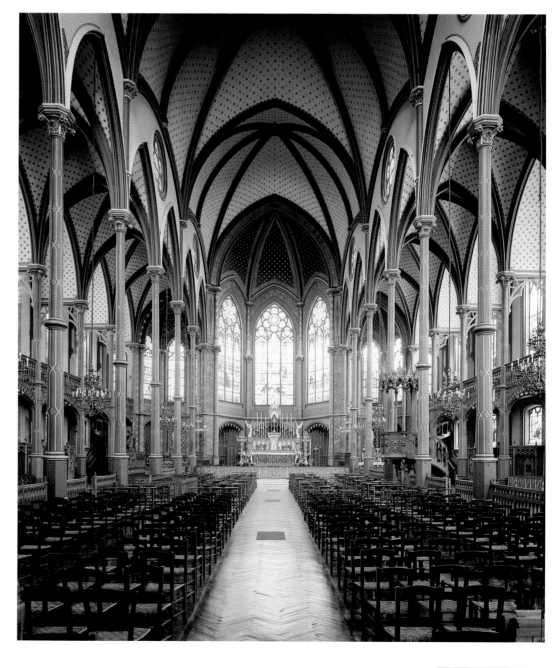

**39–40. The Church of Saint-Eugène and Sainte-Cécile**

*Built within two years by Louis-Auguste Boileau and inaugurated in 1855, this was the first metal church in Paris. It has a nave and aisles whose vaults are supported on slender cast-iron columns. The windows (1857–1858) are by Antoine Lusson, and the paint was faithfully restored between 1982 and 1984.*

harshness of the design, and even the use of the Gothic style itself. Gau's project would have died without the constant support of Claude Philibert Rambuteau, prefect of the Seine, who liked the Gothic aspects. Then suddenly in the middle of the century two churches were begun in the Gothic style. These were Saint-Jean-Baptiste-de-Belleville (1854), by the architect-restorer Lassus, and Saint-Eugène (1853; figs. 39–40), a more inventive than erudite church in iron and steel by Boileau. (But it should be remembered that churches had been made in iron and steel since the beginning of the century in Great Britain.)

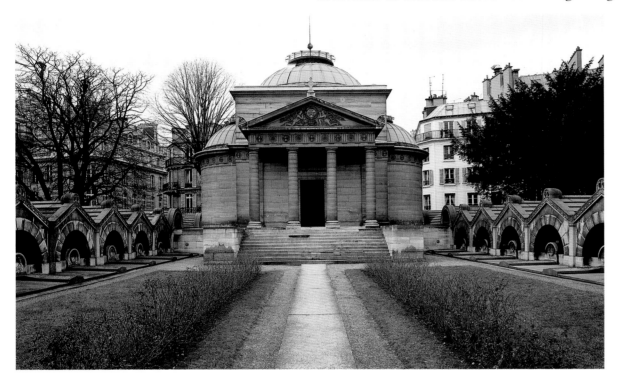

The masterpieces of eclecticism under Napoleon III are the churches of Saint-Augustin (1860; figs. 49–50) and the Trinity (1861; figs. 51–53). The style of Napoleon III is not easy to define, yet one could not confuse it with any other. For example, the church of Saint-Pierre-de-Montrouge (1863) is almost contemporary with the two mentioned above, and has a Byzantine-Romanesque style. Félix de Verneilh (*L'Architecture byzantine en France*, or *Byzantine Architecture in France*), 1854 had suggested that French Romanesque architecture derived from the Byzantine style, but his theories had little immediate effect in Paris. On the other hand, the neo-Romanesque was well received in the southern regions where many examples of true Romanesque architecture had survived.

### 41. Chapelle Expiatoire (Chapel of Atonement)

*The chapel was built between 1816 and 1826 by Fontaine at the command of the king, Louis XVIII, at the founding of the cemetery to receive those guillotined at the Place de la Révolution (now the Place de la Concorde) and the Swiss Guards who were massacred on August 10 at the Tuileries. Among the guillotined were Louis XVI and Marie-Antoinette. The chapel contains statues of the king and queen by François-Joseph Bosio and Jean-Pierre Cortot. The square in front of the chapel is surrounded by ranks of cenotaphs. It was originally empty and treated as a campo santo.*

### 42. Turpin de Crisse. *Cérémonie à la chapelle expiatoire* (*Ceremony at the Chapel of Atonement*). 1855. (Musée Carnavalet, Paris)

Opposite:

### 43. Church of Notre-Dame-de-Lorette

*In the background one can see the church of Sacré-Coeur in Montmartre.*

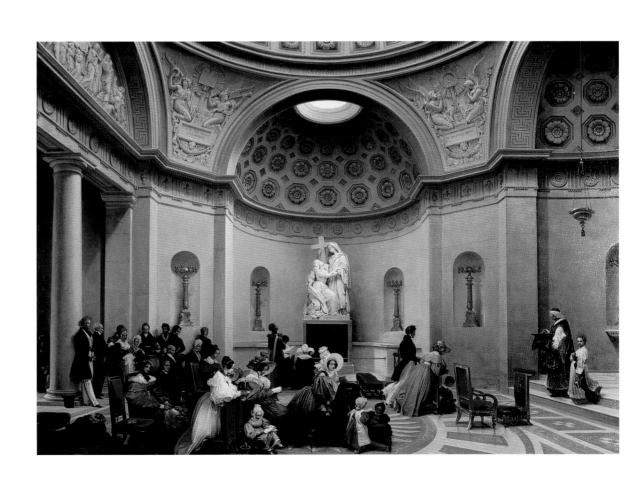

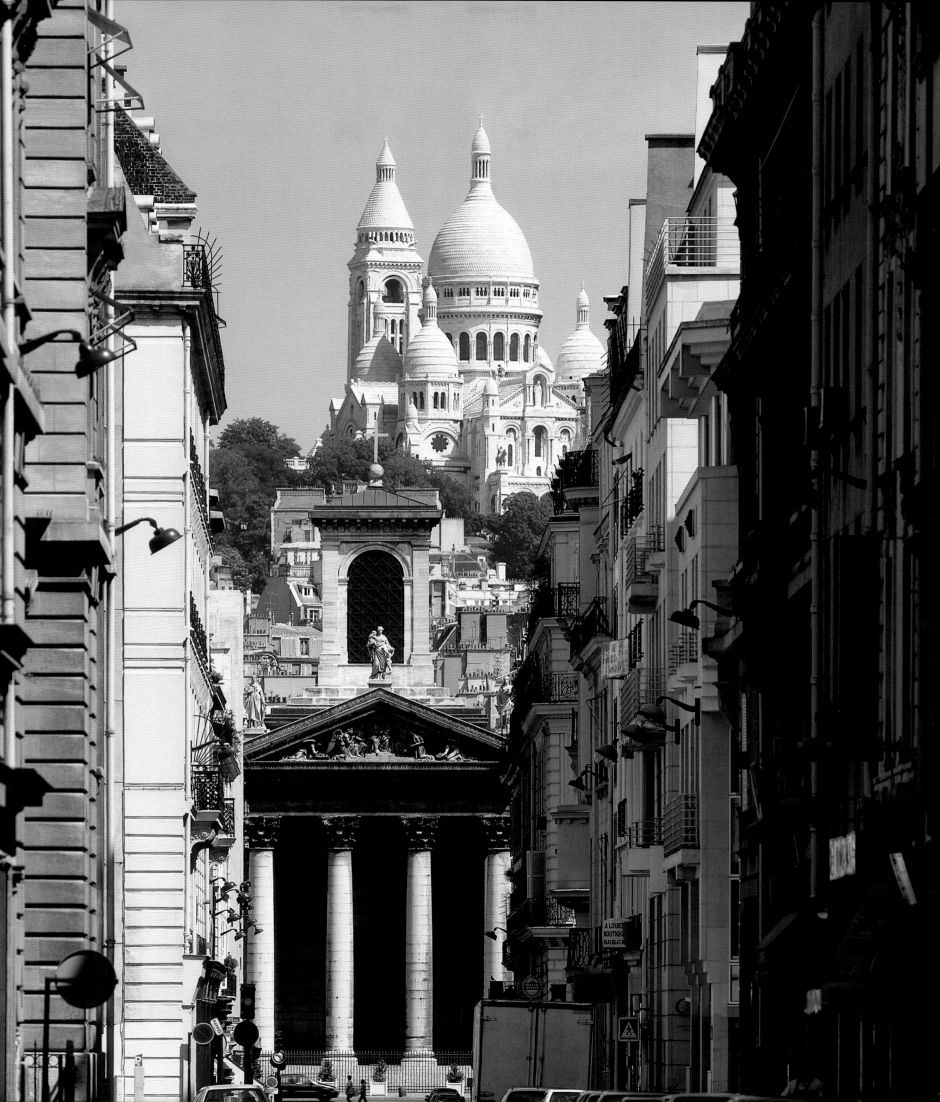

## 44. Church of Notre-Dame-de-Lorette

*The church was built between 1823 and 1836 by Hippolyte Lebas to serve as parish church for the northern extension of Paris. The paintings, by an important team of artists, show the life of the Virgin. This drawing is taken from* Vues de quelques monuments de Paris achevés sous le régne de Louis-Philippe *(Views of Some Paris Monuments Raised under Louis-Philip), by Duban.*

VIEWS OF SOME PARIS
MONUMENTS RAISED
UNDER LOUIS-PHILIP.
(KUPFERSTICHKABINETT, BERLIN)

*This album shows the privileged relations established between France and Germany in the first half of the nineteenth century. It was commissioned from the architect Duban in 1836 by Duke Ferdinand of Orléans, son of Louis-Philip and heir to the throne, for the crown prince of Prussia, the future King Frederick William IV. In Paris in 1814 with the occupying troops, Frederick William had met Percier and Fontaine, the fallen emperor's architects. This album shows the principal buildings of Paris constructed or completed during the reign of Louis-Philip (see figs. 3 and 44). The gift was presented in 1836, when Ferdinand traveled to Berlin. The following year he would marry Helen of Mecklenburg-Schwerin.*

BEATISSIMA MARIA VIRGO LAURETANA

SANTA CASA

DE LORETTE

VUE D'UNE CHAPELLE

E DE LA NEF PRINCIPALE

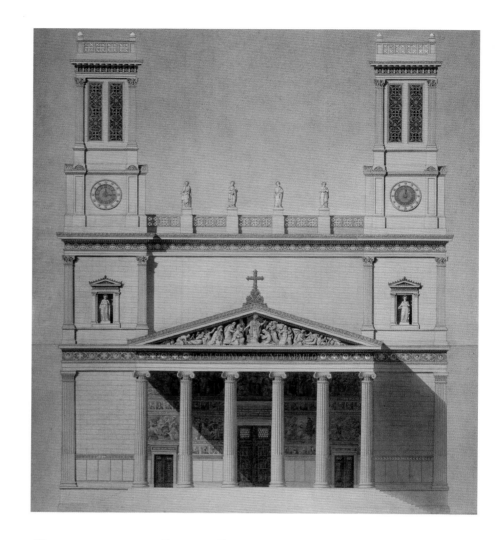

## 45–48. Church of Saint-Vincent-de-Paul

*In 1824, the foundation stone was laid for a church designed by Jean-Baptiste Lepère to resemble the design of the contemporary church of Notre-Dame-de-Lorette. This initial project was much altered in 1833 by Hittorff, who directed building until its completion in 1844. The interior of the central nave was painted by Hippolyte Flandrin in 1853.*

## 2 – URBAN DEVELOPMENT AND PRIVATE BUILDING

As the nineteenth century progressed, the development of Paris and its architectural landscape would be turned on its head by those representatives of power, the prefects of the Seine. Until now, the town had grown almost entirely through land speculation. Throughout the centuries, such speculation had produced some remarkable results, such as the prestigious housing developments on Sainte-Catherine's fields in the sixteenth century, and those on the Chaussée-d'Antin in the eighteenth century. Because the developers had no powers of expropriation, their construction works were forced onto fresh ground and thus spared existing buildings. The city had therefore developed by addition rather than subtraction. Similarly, the monarchy of the ancien régime had prioritized the development of free spaces, such as the gardens of the Grands Augustins for the Rue Dauphine, and fields for the Hôtel des Invalides, the Ecole Militaire, and the Champs-Elysées. But it had also redeveloped crown properties, including the Hôtel Saint-Pol and the Hôtel des Tournelles (the great ducal mansion-complexes near the Louvre), thus destroying the most prestigious aspect of the architectural heritage of Paris, and setting a precedent for the future.

### Private Initiatives

During the first half of the nineteenth century, the natural growth of cities through private development reached its height. In Paris, this had left scattered islands of small complexes gathered into districts controlled only by the permits needed to open the roads that defined the new blocks. These private developers invented those shopping malls under glass

known as *passages couverts*, or "covered ways," that spread all over Paris and struck foreign observers and imitators as one of the most typical and delightful characteristics of Parisian architecture. The Feydau Passage of 1791 (mentioned in the previous chapter, but now destroyed), was the first of its kind. The Passage du Caire of 1798 (fig. 21), which extends from the house at the Place du Caire, is little more than a marketplace. But the Galeries Colbert et Vivienne (fig. 64) are a lovely maze that date to 1826 and were lucky to survive a sudden commercial decline. The developers had counted on the proximity of the Palais Royal, a great center of all kinds of commerce that was currently under renovation. Their hopes were dashed four years later, when Louis-Philip, who owned the Palais Royal, ascended the throne and instantly closed down his newly completed malls.

Most of the Parisian covered ways had been built before 1830. The *cités*, compact middle-class residential blocks, came a little later. These communities, such as the Cité Bergère (1825), the Square d'Orléans (1829), and the Cité Trévise (1840), were communal refuges from the bustle of city life. They consisted of closely grouped apartment buildings whose individual courtyards, sometimes only marked off by railings, came together in a large free central space. In other words, the refinements of French distribution no longer applied only to the building, but to the apartment house, the block, the community—in short, to the whole development. Thus the amenities of the new *cités* were designed to rival those of districts such as the rapidly expanding Chaussée'd'Antin. The Chaussée-d'Antin contained only thirty-two country houses in 1760. By 1829, it boasted six hundred *hôtels* (townhouses), of which only one hundred dated to the eighteenth century.

Three of the most beautiful neighborhoods of the first half of the nineteenth century—François I, Nouvelle Athènes, and Saint-Georges—were designed by the architect Auguste Constantin. The latter two are situated in the area between the major boulevards and the foot of the Montmartre outcrop, in the northern part that was then in full development. This area was particularly fashionable because all the famous writers, musicians, artists, and actors of Paris lived there. A set of conditions for the New Athens road stated the legal requirement for "a considerable mass of air" between the houses by courtyards and gardens, and restricted the tenancy

## HITTORFF AND GREEK ARCHITECTURE

*Hittorff trained in Paris under Percier, who created the florid decorative style of the Directorate and the empire (chapt. X, fig. 68). In 1815, he lost the French nationality to which he had been born in Cologne, so he could not compete for the Prix de Rome. Instead, in 1822 he went to Sicily at his own expense and discovered the painted Greek temples there. He published these twice, in* Ancient Greek Architecture in Sicily, *of 1827–1829, and in* The Painted Architecture of the Greeks, 1851. *His restoration of the Temple of Selimont was for the classicists what Viollet-le-Duc's "ideal cathedral" would be for the Gothicists.*

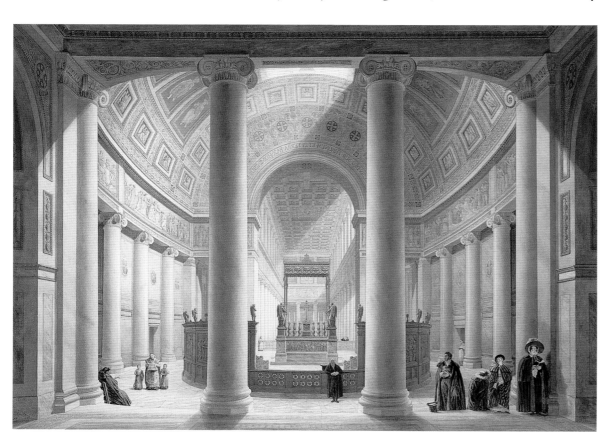

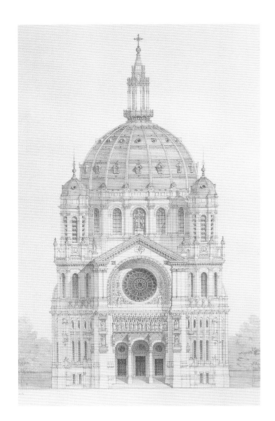

**49–50. The Church of Saint-Augustin**

*Built from 1860 to 1871 by Victor Baltard. The structure is cast iron, entirely sheathed in stone.*

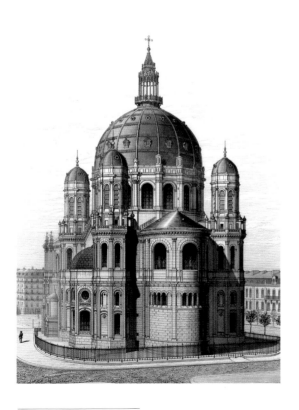

to "select people known for letters, science, or pedigree." Yet the artist Horace Vernet and three famous actors, Talma, Mademoiselle Mars, and Mademoiselle Duchesnois (fig. 54), could all be seen on this road at that time. An essential part of the very Parisian reputation of the northern sector was the "lorette," a young kept woman, ostensibly religious and innocent, living with painters and poets who were not necessarily very wealthy. Her nickname was taken from the parish church for the area, Notre-Dame-de-Lorette. In the satirical press, the *lorette* represented the spirit of Paris ridiculing bourgeois respectability.

Despite its political and pejorative connotations, the Restoration style is appropriately named to suggest its strong preference for the forms of the Italian and the French Renaissance. This style revives the approach of Lescot and Goujon, and to dismiss it as mere decoration is to ignore the marvelous organization that controls the elaborate facades. House building was particularly lavish between 1821 and 1828, and again from 1830 to 1840. The Hôtel de Mademoiselle Duchesnois at Nouvelle Athènes (fig. 54) and the Hôtel Bony in the Rue de Trévise (figs. 55–57) are good examples of the style of the 1820s. The Maison Dorée, a mecca for the elegant patrons of theaters, restaurants, and cafés, is representative of the 1830s, as is its close neighbor, the Cité des Italiens (figs. 58–59), and the house at the Place Saint-Georges (fig. 63). Characteristically, these buildings are of restricted height and have been made to look like private *hôtels*. From the 1840s, the Maison Place Jussieu (fig. 61) clearly shows the Renaissance style giving way to the baroque in the last years of Louis-Philip's reign. Finally, the Maison Jollivet in the Cité Malesherbes (fig. 65), dates to the beginning of the Second Empire, and is a rare example of a painted facade. This is where Hippolyte Flandrin lived, the man who helped Hittorff paint the church of Saint-Vincent-de-Paul.

Two developments from the first half of the century are important to consider. The first is Boileau village (1839), a garden-city created before the official beginning of the genre, formed of villas in a park. The villa (fig. 23), which was used to promote the development, is the archetype of the painted asymmetrical suburban house. The second development is the Cité Napoleon (1849–1853), on the Rue de Rochechouart. Prince Louis-Napoleon had just been made president of the Republic, and this working-class community is one of the rare applications of his social ideas. The Cité Napoleon marks a turning point in the history of social housing by demonstrating that the urban principles of the Parisian speculators could be applied to workers' homes. The workers' *cité* on the Avenue Daumesnil is also due to the initiative of Napoleon III, but it dates as late as 1867. While the first *cité* is contemporary with his campaign promises, the second marks their final fulfillment.

*Town Planning under Napoleon I*

It was mainly in the second half of the century that state control was imposed on Paris. Jean-Baptiste Colbert had dreamed of it, and had commissioned the Bullet-Blondel plan. Voltaire and Lafont de Saint-Yenne had deplored abandoning Colbert's projects, which the Convention revived with its "artists' plan." Napoleon I professed that to embellish Paris, he needed to destroy more than he built. During the Egyptian campaign he wrote, "if I was master of France, I would make Paris not merely the most beautiful city in existence, but the most beautiful city that can exist." Once he was emperor, he confided to his architect Fontaine, "when we have peace, we must get on with making Paris the most beautiful city in Europe." It is clear what had happened: Moscow had awakened Napoleon to the concept of grandeur, and St. Petersburg had shown him the great neoclassical city he might create. Fortunately, there is little to complain about because, whether perforce or by persuasion, Napoleon's urban plans were restrained. He can be reproached only for the academicism of his architectural choices (what might Paris have been if Napoleon had called on Ledoux, who was still living?) and the lack of purpose that prevented or delayed

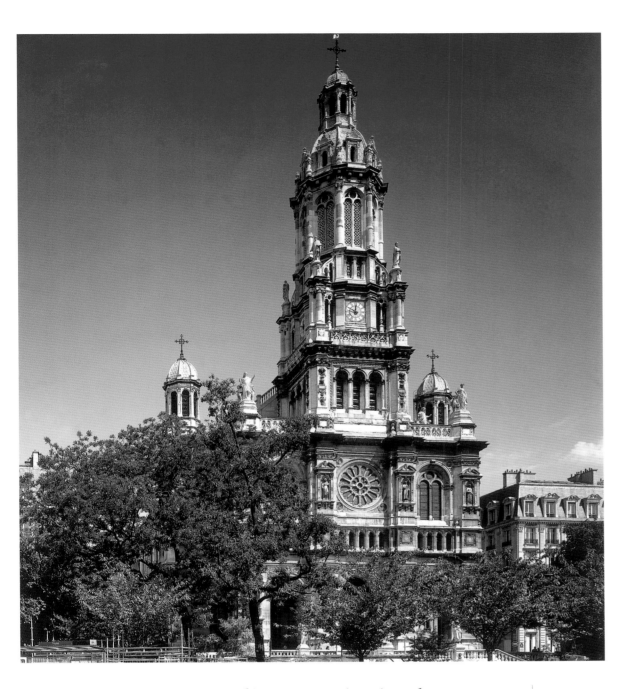

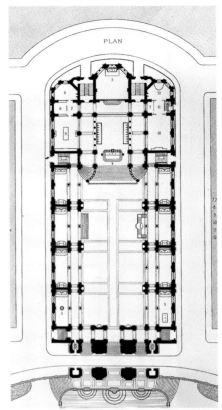

## 51–53. The Church of La Trinité

*The church of the new parish of the Trinity was built from 1861 to 1867 by Théodore Ballu.*

some projects. The great concept of his reign was the palace of the king of Rome (fig. 8), which would have been built on the hill of Chaillot with the Bois de Boulogne for its park, a project worthy of comparison with those out-of-town masterpieces of the ancien régime: the Invalides and the Ecole Militaire. But Napoleon could not commit to any of Fontaine's plans. On the other hand, he did commit to connecting the Louvre to the Tuileries by organizing an additional monumental axis to the west between the Place de la Concorde and the Etoile: two triumphal arches, one at the Carrousel (fig. 9) and one at the Etoile (fig. 7), plus two classicizing porticos, that of the Chambre des Députés and that of the Madeleine. Together, these had to form the monumental outline of the grand design.

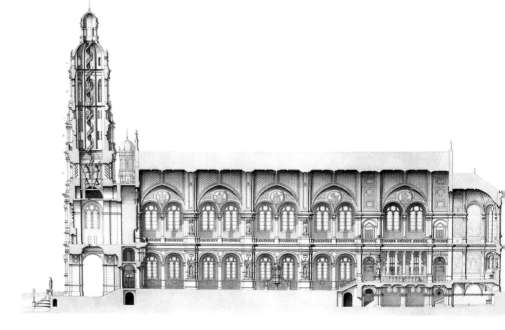

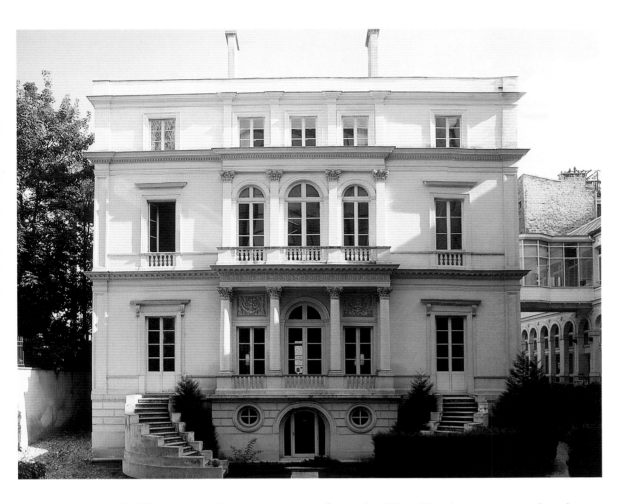

Opposite:

**54. Hôtel de Mademoiselle Duchesnois**

*This hôtel was built in 1820 by Constantin and financed by Madame de La Peyrière. These two created the Nouvelle Athènes Quarter, where this hôtel is located. Its first occupant was Mademoiselle Duchesnois, a famous tragic actress.*

The most remarkable aspect of town planning from the First Empire concerns the cleansing of the city by creating the Ourcq Canal to supply the new fountains with water, and by relocating cemeteries away from the city center. The ancien régime had been content merely to plan these hygienic measures. The new eastern cemetery, known as the

**55–57. Hôtel Bony**

*This hôtel was built in 1826 for the businessman and speculator René Bony by Jules-Jean-Baptiste de Joly.*

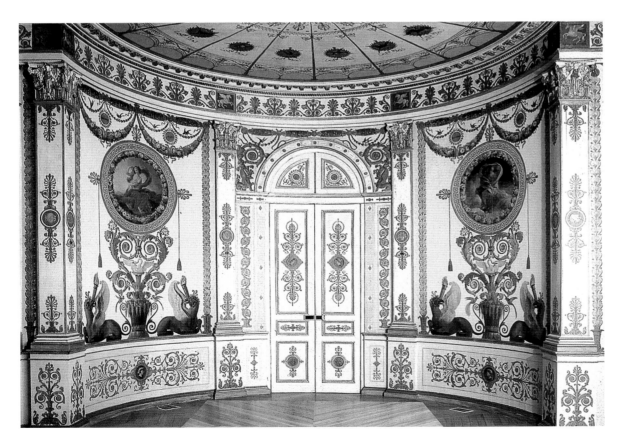

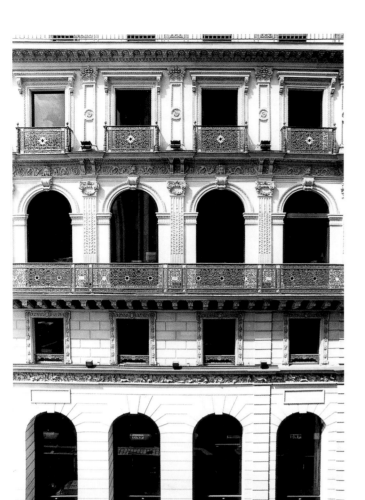

*The apartment block at No. 1 Rue Lafitte and the corner of the Boulevard des Italiens was built in 1838, and is known as the Maison Dorée because of its gilded decoration and brass balconies. The sculpture is by a team that included Jean-Baptiste Klagmann. From 1840, the building contained a famous restaurant, which was one of the most fashionable places on the boulevard during the Second Empire. The Cité des Italiens, at No. 3 Rue Laffitte, built on the site of the same private hôtel as the Maison Dorée, is contemporary with it. Its double-doored twin entrances lead to a series of courtyards that form a private cité that continues the style of the facades on the road. These architectural masterpieces from Louis-Philip's time were ruined in 1974 and 1976 when the courtyards were destroyed and the facade on the boulevard doubled in length.*

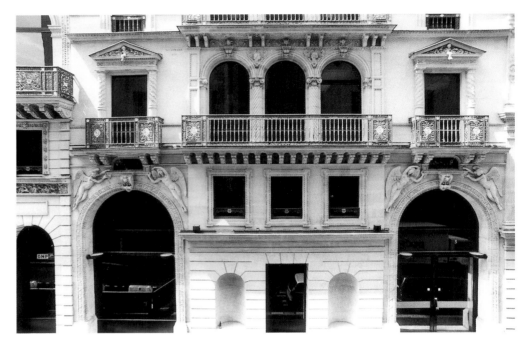

### 60. The Grand Véfour Restaurant

*The old Café de Chartres at the Palais Royal was acquired by Jean Véfour in 1820: the decorations date from that acquisition.*

Père-Lachaise, was a garden cemetery and open-air pantheon. Here, haunted by Piranesian visions and memories of the Musée des Monuments Français (chapt. X, fig. 27), the monumental piles of the Via Appia and the somber shadows of the Jardin-Elysée were reconstructed (fig. 5).

The prefect of the Seine under Louis-Philip was Rambuteau, whose supervision maintained the city's standards. The achievement of his tenure, which was particularly concerned with completing the work of Napoleon I, was the realization of the Place de la Concorde, the Champs-Elysées, and the Place de l'Etoile. Apart from the connection between the Etoile roundabout and the Champs-Elysées, this group survives almost completely unchanged.

### Town Planning under Napoleon III

In this part of the Champs-Elysées, the Hôtel de la Païva (figs. 66–70) is a rare surviving example of the kind of private architecture produced under Napoleon III, when it would have been considered appropriate for its location on one of the biggest avenues of Paris. For it was his reign that introduced that new kind of wholesale town plan that sought to enliven a sluggish city by slicing through it with major highways. Admittedly, Napoleon I had already opened the Rue de Rivoli along the Louvre-Tuileries complex, since this was an essential part of the "grand plan." But it was also the thin end of the wedge. Haussmann, prefect of the Seine for Napoleon III, now extended the Rue de Rivoli to join the Rue Saint-Antoine. The Rue Lafayette (fig. 10) was only a local street when the area was first developed in 1822, but after a series of extensions and expansions it ended up slashing through the residential city to its outer edges, leaving fragmented plots in its wake. It was Haussmann's administration that turned this road into such a scar.

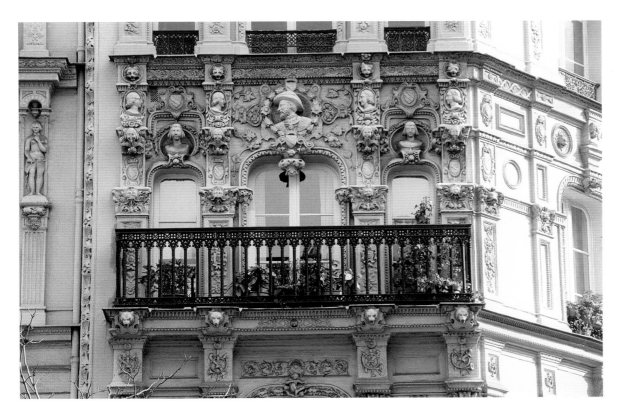

*Built in 1842, it was created in a style inspired by that of the renaissance of François I.*

Supported by Napoleon III, his technocratic and ostentatious approach was intended less to embellish the city than to make it clean and functional. The parks and gardens that beautify Paris (such as the Parc Monceau, the Parc des Buttes-Chaumont [fig. 11], the Parc Montsouris, the forests of Boulogne and Vincennes, and the many town squares) were the brainchild of Napoleon, an Anglophile who had admired Hyde Park in London. So Haussmann's work should not be judged aesthetically, but instead by its effect on the character of the capital.

Contemporaries deplored the mediocrity of the buildings along the new routes. They also noticed that the traditional apartment block (fig. 62), which typically housed residents from different classes and fortunes, had been discarded in favor of zoned bourgeois and working-class neighborhoods that were designed to clash. Yet the reform of the traditional apartment block had less to do with the Prefect's interventions than with the proliferation of the machine christened the "elevator" at the Worlds' Fair of 1862. It was the elevator that broke down the hierarchy of floors, equalizing the social and financial conditions of the inhabitants of a single block. Together, all these factors led to an increase in prefabricated buildings and a standardization of facades. It is no longer possible to experience the sense of uniformity that emerged with the new Paris because the bylaws of the Third Republic modified the standardization that caused it. But Victor Hugo wrote, "How beautiful it is! You can see from Pantin to Grenelle! Old Paris is no more than an endless road, advancing straight as an arrow, announcing Rivoli, Rivoli, Rivoli!" In the second half of the nineteenth century, more French and European towns began modernizing themselves with a bulldozing policy dubbed (perhaps too quickly) "Haussmannization."

*The Destruction of Old Paris*

And did the prefects of the Seine, in spite of themselves, save the soul of Paris? After all, it was their intention that Paris should remain a bourgeois city, dedicated to the art industry, and spared the proletariat-generating heavy industry. But for this purpose they had to destroy or permit the destruction of old Paris and, with it, several important works that should be considered: the cloister of the Celestines (chapt. VI, fig. 29); the abbey-church of

**62. Section through a Parisian Apartment Block in 1845**

*Bertall's vignette was lithographed by Lavielle. It shows how people of all socioeconomic backgrounds shared floors in a Parisian apartment block on January 1, 1845. It was published in* Le Diable à Paris, *and in* Illustration *in 1845.*

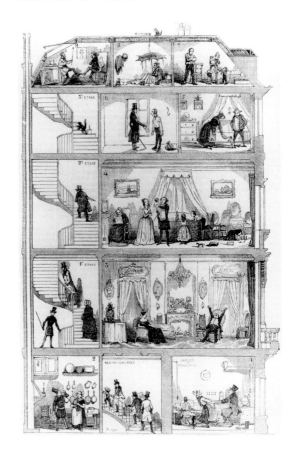

### 63. Apartment Block at No. 28 Place Saint-Georges

*This rental block was built in 1840 by E. Renard. The Marquise de Païva had lived in one of these apartments before she set herself up in the Champs-Elysées (fig. 66). Notably, the sculpture features figures representing Architecture and Sculpture, as well as Diana and Apollo.*

### 64. Galerie Vivienne and Galerie Colbert

*These interconnected covered passages and shopping malls were built in the 1820s near the Palais Royal to profit from its popularity. But Louis-Philip's "reformation" of the Palais Royal in 1830 greatly reduced the commercial activity of the malls. The Galerie Vivienne was built by a notary and inaugurated in 1826. The Galerie Colbert was built in the same year by a speculative group. The whole complex was accurately restored in 1985.*

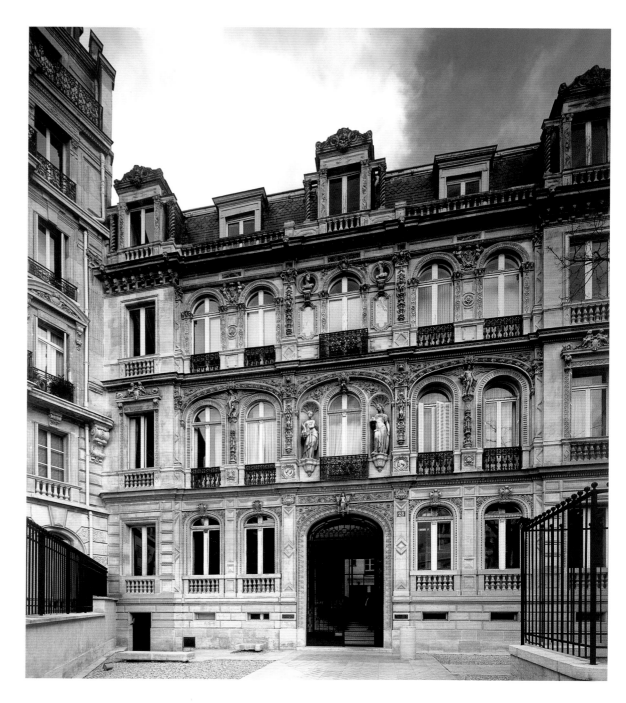

Sainte-Geneviève; the cloister and refectory of Saint-Germain-des-Prés (chapt. III, fig. 20); the abbey of Saint-Victor; the keep of the Temple (chapt. III, fig. 44); the church of the Theatine Convent (chapt. VIII, figs. 7–9); the Hôtel de Thélusson (chapt. X, figs. 43–44); the Hôtel Legendre, called La Trémoille (chapt. V, figs. 56–58); the turrets of the Castle of Vincennes (chapt. IV, figs. 1–2); and the paintings of the Hôtel de Guise (chapt. VI, fig. 6). Of course, not all these losses resulted from governmental directives, and the most important of them occurred before Haussmann's tenure. What Haussmann's contemporaries really blamed him for was destroying that monument of monuments: the city, the Paris of the people. The many demolitions hurt more than the remains of old Paris. They also hurt the new constructions, such as those at the Chaussée-d'Antin, a disaster whose crassness was denounced even in Haussmann's own time. As someone wrote in *Les Démolitions de Paris* (*Demolition Work in Paris*), 1861, "when will they stop tearing down good solid houses with fair rents and clean, commodious apartments...only to replace them with oversized shacks divided into little rooms like chicken coops?"

It would be nice to exonerate these nineteenth-century vandals by recognizing that they were no more harmful than their predecessors of the ancien régime. But this would be to forget that the Revolution had made people aware of how a nation's memory is destroyed with its monuments, and that the most eminent figures were there to remind them. It was Balzac and Victor Hugo who conceived the idea of "old Paris." Balzac wrote of the "deep and silent alleys where the real poetry of Paris hides," and he mourned, "Alas, old Paris disappears with frightening speed" (*Les Petits Bourgeois*, or *The Petty Bourgeois*, 1843–1844). With a curious intrusion of his political ideas into the field of nostalgia, Balzac connected the disappearance of "picturesque innocence" with that of "princely grandeur." "For those who watch Paris, but above all for the alert and interested inhabitant, there is a strange social transformation...As the grand ways of life die out, the humble ways vanish, too... The people follow the king. These two great institutions leave arm in arm to make way for the citizen, for the bourgeois, for industry and its victims" (*Ce qui disparaît à Paris*, or *Disappearing Paris*, 1844). In 1832, Hugo had published his *Guerre aux démolisseurs* (*War Against the Destroyers*) in the *Revue des Deux-Mondes*. And in 1839, the destruction of the Hôtel Legendre (chapt. V, figs. 56–58) had caused widespread outrage, notably from the residents of the quarter that intruded on the court of the *hôtel*. Mérimée, Viollet-le-Duc, and others lobbied in vain for a court injunction. Viollet-le-Duc seized the *hôtel*'s staircase from the English architect commissioned to restore it for the new Chamber of Commerce in London, and entrusted it to the Ecole des Beaux-Arts, where it was placed in the courtyard. "Old Paris is no more. Alas, the shape of a city changes faster than the heart of a man!" wrote Baudelaire in *Les Fleurs du mal* (*The Face of Corruption*), 1859. His metaphor pinpoints the moment when demolition work, accelerated by order of the Prefecture, could be completed within a lifetime. Yet Baudelaire was writing before the calamitous events caused by the Commune in 1871, the burning of the Tuileries and the Hôtel de Ville.

Many artists captured the charm and uniqueness of old Paris, the Paris so many mourned. Work by several of these artists, including Gustave Doré and Charles Marville, can be found at the beginning of this chapter (figs. 14–20).

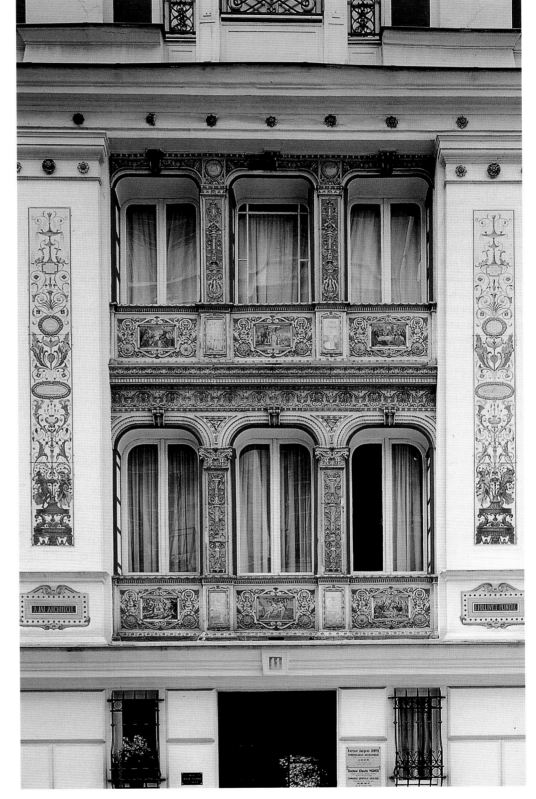

### 65. Maison Jollivet, Cité Malesherbes

*The house was built in 1856 by Anatole Jal for the artist Pierre Jules Jollivet, a painter who worked in enamel on lava or terra-cotta. The facade is covered with enameled terra-cottas reproducing famous pictures. Jollivet had his studio at the bottom of the garden.*

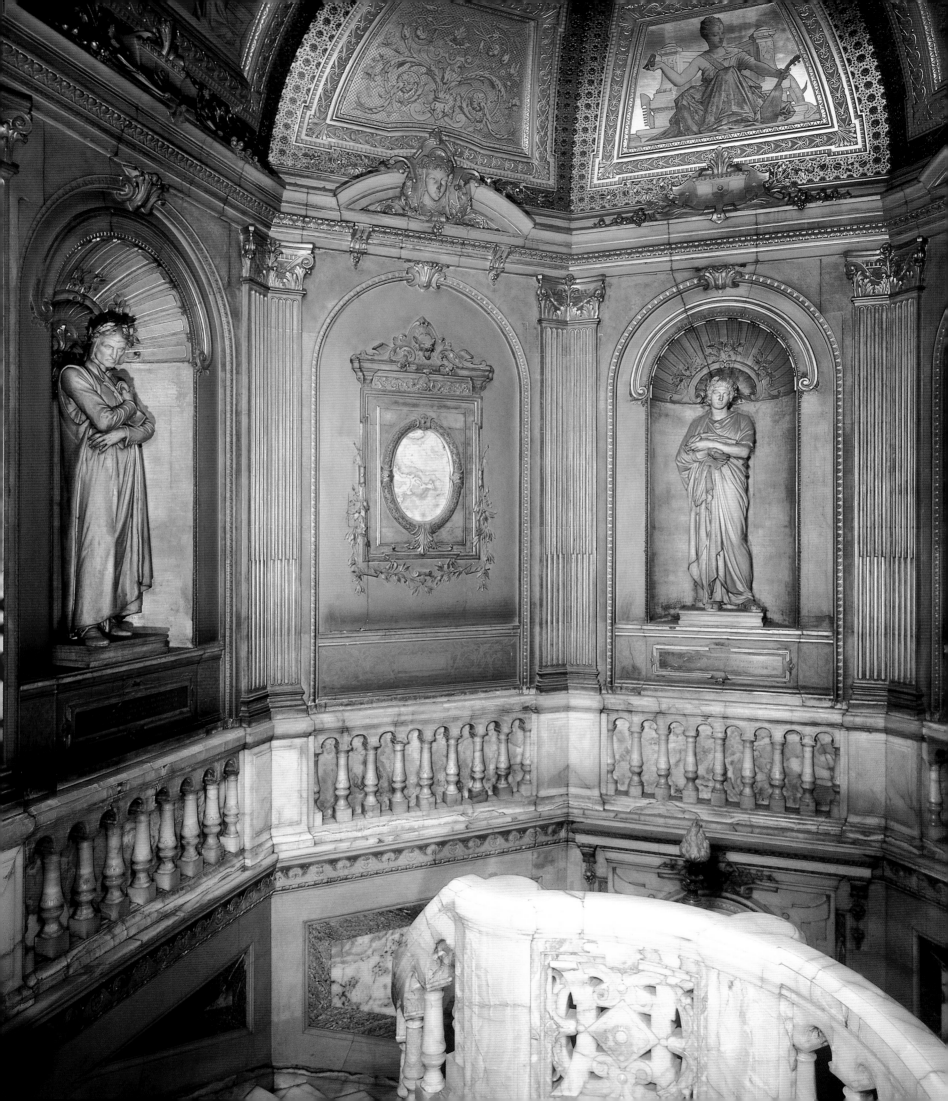

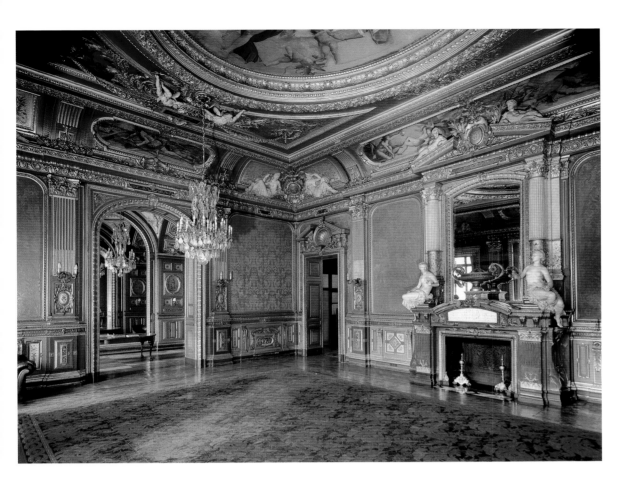

## 66–70. Hôtel de la Païva

*This hôtel was built on the Champs-Elysées and decorated between 1856 and 1866 for Esther Lachmann, the separated wife of the extraordinarily wealthy Marquis de Païva, at the expense of her lover and future husband (the third), Count Guido Henckel de Donnersmarck, cousin of Bismarck. She was of Russian descent and had married a poor French tailor at the age of seventeen. Esther (or Thérèse) was an adventurer, and was also a suspected spy because of her nationality and her relations with her third husband. The hôtel was built by Pierre Mangin and decorated by the artists Gérôme, Baudry, and Hébert; by the sculptors Carrier-Belleuse, Dalou, Barrias, and Delaplanch; and by the cabinetmaker Kneib. The reception rooms are on the ground floor, and the private apartments are on the second story. The staircase is faced with onyx. In the bedroom is a fireplace in green malachite with a sculpture by Carrier-Belleuse.*

**71. Jean-Auguste-Dominque Ingres.** *Achille recevant les ambassadeurs d'Agamemnon* (**Achilles Receiving the Ambassadors of Agamemnon**), 1801. (École Nationale Supérieure des Beaux-Arts, Paris)

*Ingres won the Prix de Rome competition of 1801 for this work. The competition's subject was taken from Homer's Iliad. During the siege of Troy, Agamemnon, leader of the Greeks, sent Ulysses (in the middle) and Ajax (on the right) to convince Achilles (on the left), who had left the battle, to return to combat. It was not until Patrocles (standing next to Achilles) was killed in a battle against the Trojans that Achilles took up arms again in order to avenge the death of his friend. The woman on the far left is Briseis, the captive Trojan over whom Achilles and Agamemnon had their initial falling out.*

## 3 – PAINTING

### The Studios

More than any other art, painting eludes the constraints of locale and classification. Nineteenth-century painters made extended trips to Rome. They pitched their easels in the countryside. They became established in the themes of their favorite landscapes, even those in their own provinces. They fled the Paris of riot barricades and cholera and set up studios in their family homes or built studio-homes of their own: Camille Corot did so at Ville d'Avray, Théodore Rousseau and Jean-François Millet at Barbizon, and Charles-François Daubigny at Auvers-sur-Oise. Despite the fact that some famous artists left the city, Paris was not lacking in prestigious studios. Some four hundred students apprenticed in Jacques-Louis David's workshop, a large number of whom were foreigners from Germany, Italy, Switzerland, and the United States; this famous studio was portrayed in several paintings (fig. 6). The same can be said for many others, including those of Antoine Gros and Horace Vernet; Gros even inherited students from David. Théodore Géricault's studio on Rue des Martyrs behind the Notre-Dame-de-Lorette Church (a neighborhood known for prostitution), was an important meeting place. Paul Delaroche and Ary Scheffer's studio-homes

were located in the same neighborhood; Scheffer's is currently the Musée de la Vie Romantique. Even more famous was the studio Delacroix built on Place Furstenburg (now the Musée Delacroix). Cafés were important places outside of the studio where art was discussed. The Café Guerbois, the Café de la Nouvelle Athènes, and the Café Momus are a few of the most significant.

## The Position of Painters

In fact, many illustrious painters like Delacroix, Courbet, and Manet were fairly well off; they never experienced the bohemian lifestyle. The scandals that made them famous miscast them as *"peintres maudits"* ("accursed painters"), avant-garde French artists with a reputation of being social outcasts. Manet was a complete bourgeois and he was quite surprised—even upset—that he could be labeled as a public agitator. Millet, the painter who hailed from peasants did not pass unnoticed by the art establishment. In 1870 he fled the uprising in Paris against the Second Empire and ultimately refused to join the artistic federation of the Commune, the newly formed government. Courbet, on the other hand, declined the Legion of Honor after having been nominated and was an active participant in the Commune. For this he was condemned to exile. Honoré Daumier cut a slightly more presentable *"peintre maudit"* figure. The huge number of

72. Evariste Fragonard. *Diane de Poitiers dans l'atelier de Jean Goujon (Diane de Poitiers in Jean Goujon's Studio)*, 1830. (Musée du Louvre, Paris)

*This work shows Jean Goujon sculpting the fountain of Diane d'Anet in front of Diane de Poitiers. At the time of the painting, the fountain was attributed to Goujon.*

lithographs that he produced (nearly four thousand) allowed him a comfortable lifestyle, but he nevertheless died penniless. His caricatures brought him public censure and even imprisonment, while his painting remained relatively unknown. Historically speaking, the myth of the misunderstood artist ahead of his time was bolstered by those critics and historians searching for the artistic lineage of certain early twentieth-century painters. Géricault, many have argued, was responsible for Edgar Degas and Vincent van Gogh. Delacroix and Théodore Chassériau prefigured Gustave Moreau and Puvis de Chavannes; Corot heralded Paul Cézanne and Jean-Auguste-Dominique Ingres was the forefather of Picasso.

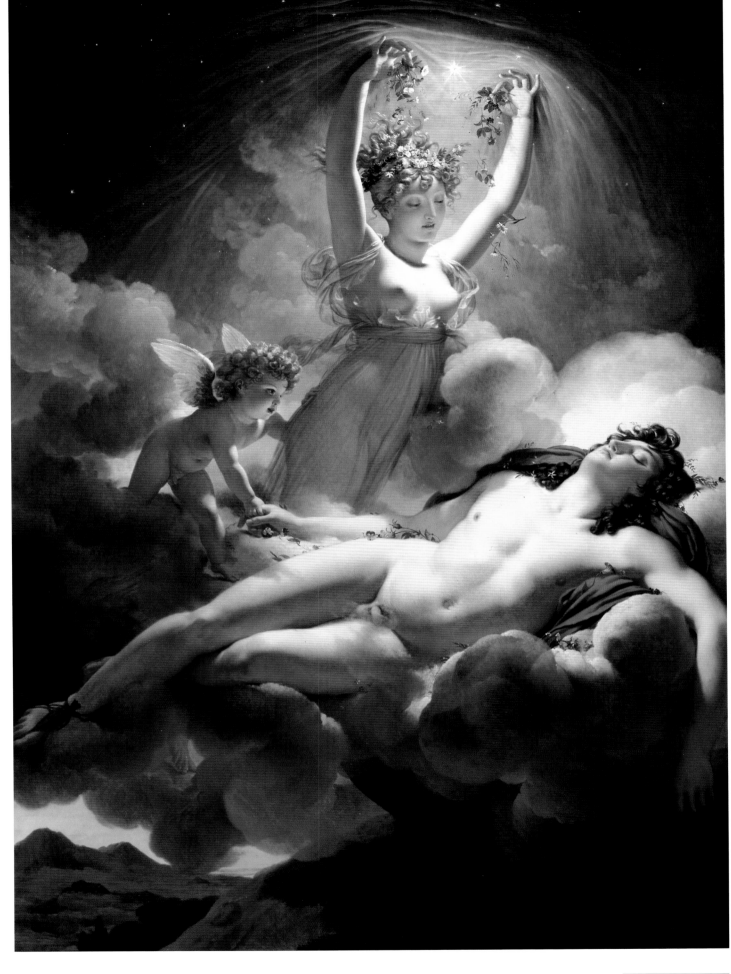

Opposite:

73. Anne-Louis Girodet-Trioson. *Apothéose des héros français morts pour la patrie pendant la guerre de la Liberté* (known as *Ossian*; also as *Apotheosis of French Heroes Who Died for Their Country During the War of Liberty*), 1802. (Musée National de la Malmaison, Rueil-Malmaison)

*Painted for the Malmaison home of Napoleon I and Josephine and shown at the Salon of 1802, this work portrays the shadows of French heroes being welcomed by Ossian, who is surrounded by his warriors. The small eagle flying past the allegorical French cock is the Austrian eagle. This is a reference to the chasing away of the Austrian Marie-Antoinette and her lineage.*

74. Pierre-Narcisse Guérin. *Aurore et Céphale* (*Aurora and Cephalus*), 1810. (Musée du Louvre, Paris)

*Exhibited at the Salon of 1810, this portrait shows Aurora smitten with Cephalus. Painted in 1811, its companion piece Iris et Morphée (Morpheus and Iris; in the Louvre) featured its two main subjects in an inverse composition.*

**75 and 77. Jacques-Louis David.**
*La Distribution des aigles*
(*The Distribution of Eagles*), 1804.
(Musée National du Château Versailles)

Napoleon commissioned this painting, along
with a series of three others, in 1804 to commem-
orate the celebration of his coronation. Only Le
Couronnement (The Coronation) and La
Distribution des aigles (both in the Louvre)
were completed. The decision to use the eagle as
the empire's mascot dates from 1804. The eagles
on the flag posts were designed by Chaudet and
created by Thomire. On December 3 and 5,
delegates from the troop's corps received flags in
a ceremony that took place at the Ecole
Militaire, where Percier and Fontaine had set
up a tent. After Napoleon's divorce, David
altered the painting to remove Josephine, who
was originally at the emperor's side.

**76. Pierre-Narcisse Guérin.**
*La Rochejaquelein*, 1817.
(Musée des Beaux-Arts, Cholet)

Exhibited at the Salon of 1817, this posthumous
portrait of Henri de La Rochejaquelein is one of
a number of paintings portraying generals from
the Vendeen province. Louis XVIII commis-
sioned this work in 1816 as decoration for his
Château de Saint-Cloud. Most notably, the series
contains a portrait of Bonchamps by Girodet
and one of Talmont by Guérin. Appointed
general in charge of the Vendeen armies in
October 1793, La Rochejaquelein was killed at
the age of twenty-one by a Republican
soldier whose life he had just spared.

## Visiting Rome, or Academicism Liberated

Like Picasso, Ingres was exceptionally proficient in many styles. Trying to fit him into one stylis-
tic category only highlights his originality. A good number of his most significant works were
created in Rome, where he stayed for two long stretches of time. First, from 1806 to 1824, he
was a boarder at the academy. Then he spent several years as its director from 1834 to 1841. Every
aspect of his life's work can be traced to paintings he created during the first sojourn in Rome:
*Jupiter et Thétis* (*Jupiter and Thetis*, 1811; The Musée Granet, Aix-en-Provence), *Grande Baigneuse*
(*The Bather of Valpicon*, 1808; Musée du Louvre, Paris), *Grande Odalisque* (1814; Musée du Louvre,
Paris), *Venus anadyomène* (1848; Musée Condé, Chantilly), and the famous *Source* (1856; Musée
d'Orsay, Paris), praised as the most beautiful nude of the nineteenth century. Nothing could be
less classical than Ingres's disturbing mixture of mythology and Orientalism that depicted
women affected by strange anatomical malformations like Thetis's goiter, a long arm without
joints, or the odalisque's arm missing its elbow and wrist. The *Vœu de
Louis XIII* (*The Wish of Louis XIII*), the matching piece to the famous
Champaigne painting (chapt. VII, fig. 22), was created during his first
stay. It was the prototype of the pious image. In fact, Ingres took advant-
age of his Roman stay to test his skill at all the fashionable genres of the
day. For example, his *Songes d'Ossian* (*The Songs of Ossian*, 1813; Musée
Ingres, Mountauban) belonged to a genre inspired by poems published in
1760 and attributed to the third-century poet Ossian, whose themes, in
turn, inspired French Romanticism. With the miniature portraits *Mort de
Léonard de Vinci* (*Death of Leonardo da Vinci*, 1818; Musée du Petit Palais,
Paris) and *Paolo et Francesca* (*Paolo and Francesca*, 1819; Musée Turpin de
Cuissé, Angers) he dabbled in the Troubadour genre. The unique *Entrée à
Paris du dauphin futur Charles V* (*Entrance of the Dauphin, Future Charles V,
to Paris*, 1821; Wadsworth Atheneum, Hartford), in which Ingres turns
back the clock to imitate Fouquet's style, is a technique called "in the style
of…" often used by Picasso. This is the range of work that Ingres, the
supposed paragon of academicism, accomplished during his Roman stay.

## Subjects from Antiquity

If the spreading eclecticism characteristic of the nineteenth century made
it impossible to neatly classify painters, we can nevertheless cite a certain
categorization of themes. Mythology was used as a pretext for classical

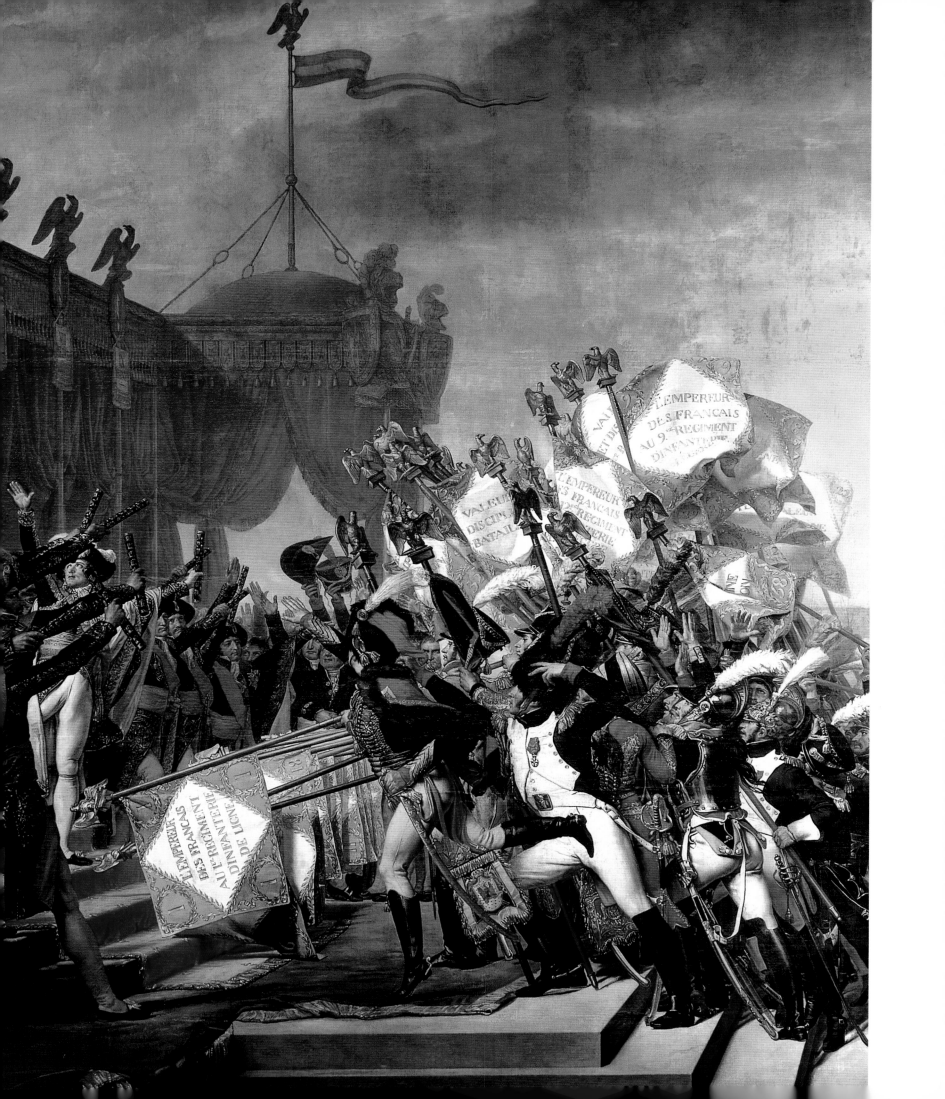

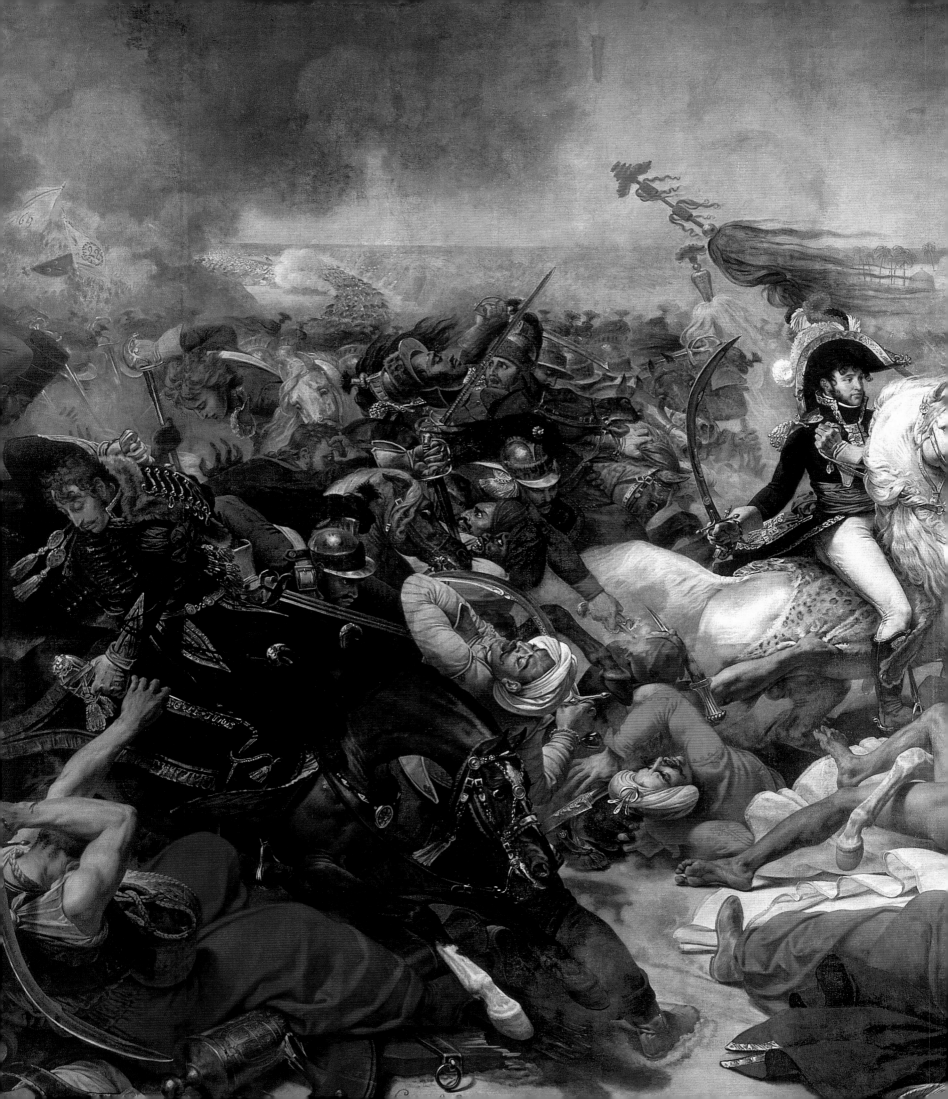

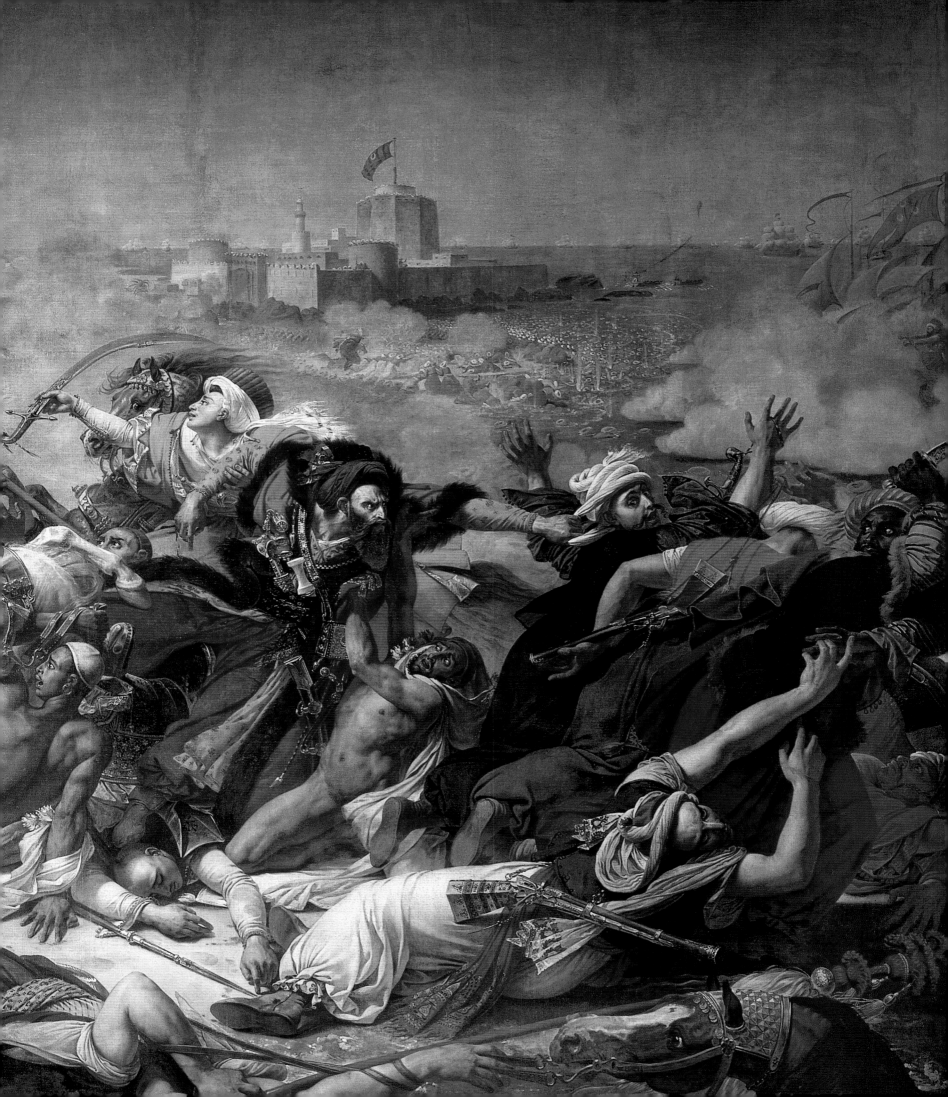

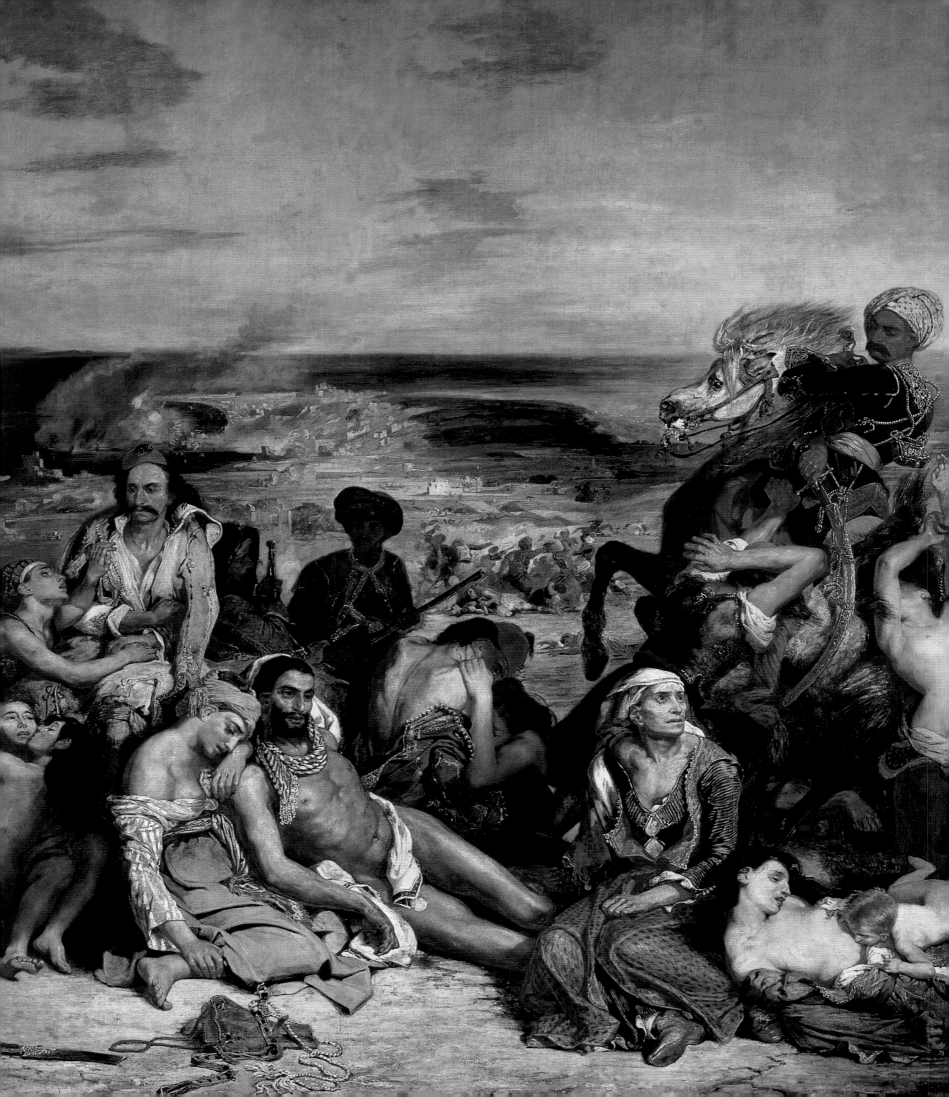

references and heroic nudes. The Prix de Rome Competition of 1801 whose subject was *Achille recevant les ambassadeurs d'Agamemnon* (*Achilles Receiving the Ambassadors of Agamemnon*, 1801; fig. 71) was perfectly orthodox in this regard. Ingres faithfully re-created the scene described in Homer's *Iliad* thanks to his stay in Rome. He modeled his Ulysses on a Vatican antiquity of the hero that he saw during his trip and was able to reproduce it from memory far away in his Paris loggia. (It was taken by the French in wartime and is now housed in the Louvre.) Practically a composite of his work, this male nude is an idealized portrait of a hero without body hair or calluses. The artist wrote, "Beautiful forms are firm and full with details that do not compromise the appearance of large masses." However the androgynous Patroclus, cut off above the knees like a Hellenistic statue of Apollo, belongs to the feminine universe that Ingres would regularly explore throughout his career. The unstable posture of Achilles is an expression of movement—albeit naive—that would enter into the academic repertory.

Pierre-Narcisse Guérin's *Aurora and Cephalus* (fig. 74) is only a Parisian derivative of Anne-Louis Girodet-Trioson's *Endymion* (*Endymion Asleep*, 1793; Musée du Louvre, Paris) painted in Rome. There are some marked differences between the two, however. While Girodet represented Diana's feelings for Endymion by only a moon ray, Guérin's Aurora has a pretty little face; Cephalus's melancholic persona is seemingly fashioned from porcelain instead of marble. Pierre Prud'hon also developed a little trade in these transparent beauties; his style earned him the flattering nickname of the "French Caravaggio." In *Le Tepidarium* (fig. 86), Ingres's apprentice Chassériau scored a brilliant victory for beauty reminiscent of Raphael's work. Thomas Couture's *Les Romains de la*

Previous two pages:

78. Antoine-Jean Gros. *Bataille d'Aboukir* (*The Battle at Aboukir*), 1806. (Musée du Louvre, Paris)

*Measuring thirty feet in length, this large painting was commissioned by Murat, a general who played a decisive role in the Aboukir Battle (July 27, 1799), one of the principal engagements of Napoleon's campaign in Egypt. Murat is in the center and, in front of him, the pasha, having been thrown from his horse, tries to grab cowardly deserters. With one hand the pasha's son supports him; with the other the son extends his father's sword to Murat as a sign of surrender. This painting was exhibited at the Salon of 1806.*

Opposite:

79. Eugène Delacroix. *Les Massacres de Scio* (*The Massacres of Scio*), 1824. (Musée d'Orsay, Paris)

*This is a scene from the Turkish massacre of the Greeks on the island of Chios in 1822. During this bloody episode of the Greek War of Independence, only one thousand of the island's ninety thousand inhabitants survived. Stories told by survivors inspired Delacroix to paint this work. He exhibited it at the Salon of 1824.*

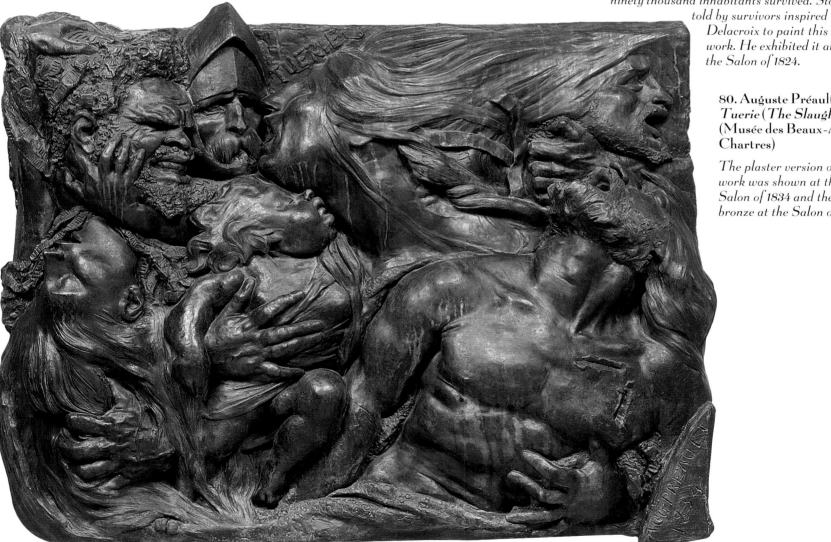

80. Auguste Préault. *La Tuerie* (*The Slaughter*). (Musée des Beaux-Arts, Chartres)

*The plaster version of this work was shown at the Salon of 1834 and the bronze at the Salon of 1850.*

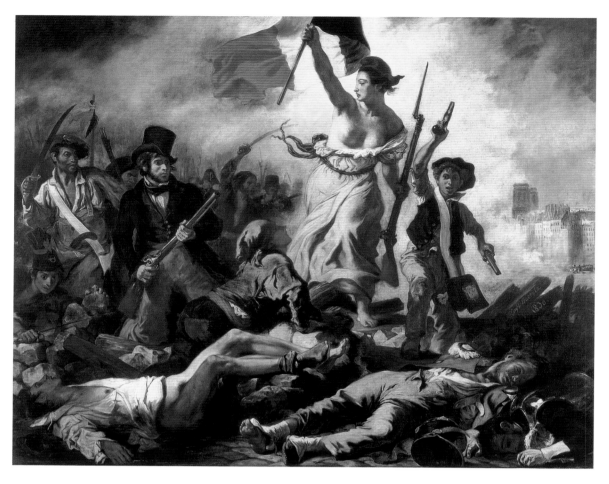

**81. Eugène Delacroix.**
*La Liberté guidant le peuple*
(*Liberty Leading the People*), 1830.
(Musée du Louvre, Paris)

*Exhibited at the Salon of 1831, this painting portrays an allegorical Liberty marching over a barricade raised on July 28, 1830 during a three-day uprising that put an end to the Bourbon reign. Delacroix, a Bonapartist, did not actually participate in the insurrection, although he was in Paris at the time. He did, however, become impassioned at the reappearance of the red, white, and blue flag known as the "tricolor."*

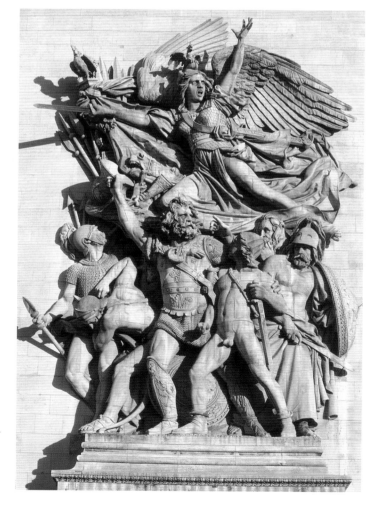

**82. François Rude.** *Le Départ des volontaires* (*The Departure of the Volunteers*), more commonly known as *La Marseillaise,* 1833–1836.

*This is the most famous of the sculptures that embellish the Arc de Triomphe on the Place Charles de Gaulle-Etoile.*

*décadence* (*The Romans of the Decadence*; fig. 84) is a composition in which references to Paolo Veronese and Rubens intermingle. Although it was painted ten years after the beginning of the Second Empire, this work would not have detracted from the colorful Hôtel de la Païva (figs. 66–70), the home of a courtesan and suspected German spy. For her home, the aphorism by Jouvenel that inspired the work's subject would have served well as a coat of arms: vice destroys civilization as surely as war. In the two men on the right contemplating the Roman orgy, Couture's contemporaries saw the Germans calculating the right moment to invade France. The orgy itself is perhaps symbolic of the decadence of French society. Couture painted a small variation of this work that he put in the Maison Dorée Restaurant (fig. 85).

## Contemporary History

With an unprecedented amount of political turmoil in France at the end of the eighteenth century, history painting began to portray contemporary events. Recording the events of everyday life slightly altered, as though they were commemorating the recent past, which was still silenced from every corner, became the major preoccupation of painting. With the same amount of lyricism, David and Gros illustrated both the Napoleonic epic

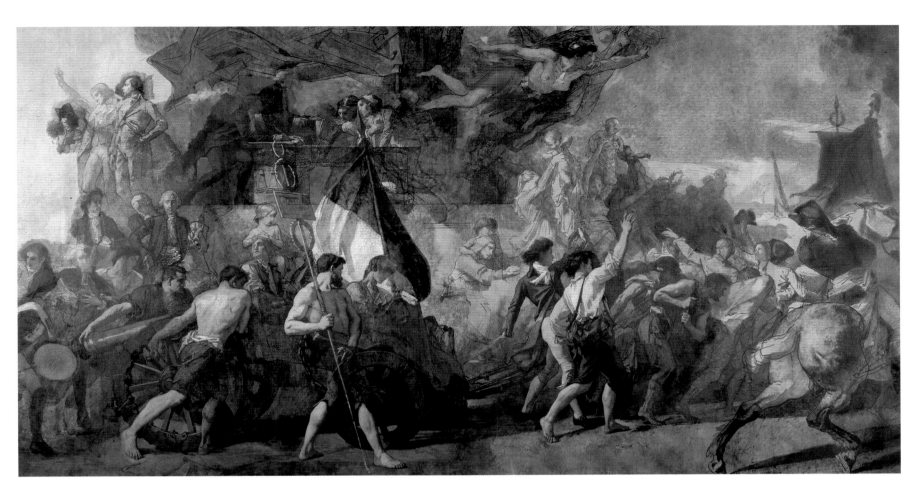

83. Thomas Couture. *Enrôlement des volontaires de 1792* (*Enrollment of the Volunteers of 1792*), 1848.
(Musée Départmental de l'Oise, Beauvais)

*Commissioned by the Second Republic government, this painting was made for the main room at the Assemblée Nationale.*

and Imperial propaganda. Robespierre's fall from power snuffed out David's streak of genius, but he retained enough talent to create an excellent first portrait of Napoleon in 1798, now in the Louvre. When the monarchy came to power again during the Restoration, it was more difficult for David to endure a self-imposed exile out of allegiance to Napoleon. In his paintings created during his exile in Brussels over the last ten years of his life (he died in 1825), characters simper, writhe, and show us faces struck by stupor. Of David's works commissioned by Napoleon, people are correct to prefer the soaring *La Distribution des aigles* (*The Distribution of the Eagles*, 1804; figs. 75 and 77) to the solemn *Couronnement de l'empereur et de l'impératrice* (*Consecration of the Emperor Napoleon I and Coronation of the Empress Josephine in the Cathedral Notre-Dame de Paris on December 2, 1804*, 1808; Musée du Louvre, Paris). In *La Distribution des aigles*, the shower of flag bearers carried away by an outburst of joy is superb. Balancing on his tiptoe like Mercury, the first flag bearer completes a movement initiated two years earlier by Ingres's Achilles. But does the flag bearer not seem a bit overzealous, rushing forward with the platform so near? The courtiers, who are declaring their fidelity to the emperor, imitate the stances of figures in the *Serment du Jeu de paume* (*The Tennis Court Oath*; chapt. X, fig. 97). They appear to want to quell an uprising! Originally Josephine could be seen at Napoleon's side. After their divorce she was eliminated from the work. As one can see, totalitarian propaganda methods were not invented in the twentieth century.

Gros was one of David's apprentices and an admirer of Rubens. He was the French School's colorist and, because he painted Napoleon's battles with ardor, he could pass for a Romantic, though he lacked the trademark melancholic soul. He opened the department of military painting. Throughout the century, until the 1870 work *Dernières cartouches* (*Last Cartridge*), compositions by Vernet, Ernest Meissonier, and Alphonse-Marie de Neuville were exhibited there. A beautiful work of propaganda made to make people forget that Bonaparte was readying to abandon his crestfallen, plague-infested army was Gros's *Bonaparte visitant les pestiférés de Jaffa* (*Napoleon Bonaparte Visiting the Plague-Stricken at Jaffa*, 1804; Musée du Louvre, Paris). The subject of Girodet's *Bataille d'Aboukir* (*The Battle at Aboukir*; fig. 78) was the last glorious show of arms before pulling out of Egypt. It contained references to Le Brun's *Histoire d'Alexandre* (chapt. VIII, fig. 38)

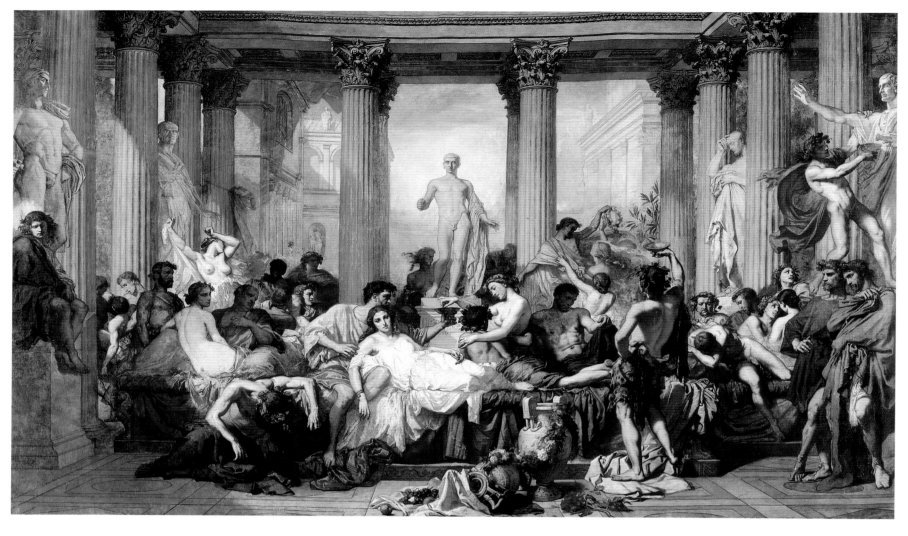

Top:

84. Thomas Couture. *Les Romains de la décadence* (*The Romans of the Decadence*), 1847. (Musée d'Orsay, Paris)

*Commissioned by the state, this work was shown at the Salon of 1847. Its subject comes from one of Jouvenel's sixteenth-century* Satires (Satires).

and was admired by Delacroix. The composition's balance is obtained by clever devices comparable to those used by David in *La Distribution des aigles* (*The Distribution of the Eagles*); in terms of action, the left side mirrors the right; in terms of composition the left stabilizes the right side, which appears to be collapsing. The right section records the first traces of Orientalism in French art. If Romanticism was an echo of a society whose current events resounded with noise and fury, then Géricault was certainly the Romantic artist *par excellence*. But like Ingres he left the best of his work in Italy where he studied Michelangelo's tortured figures and Caravaggio's dramatically lighted canvases. Moved equally by a passion for Bonaparte and for horses, Géricault painted *L'Officier de chasseurs à cheval chargeant* (*The Charging Chasseur*; Musée du Louvre, Paris) in 1812 and the *Cuirassé blessé quittant le champ de bataille* (*The Wounded Battleship*; Musée du Louvre, Paris) in 1814. In a way, these two works symbolize Napoleon's conquest and eventual retreat, his campaign in Russia, and the return home. Not to be outdone by the Napoleonic epic, the Restoration period saw the revival of the tradition of paying homage to great men with the commission of posthumous portraits of the Vendeen leaders, generals from the Vendeen province in western France who led a royalist insurrection there during the 1789 Revolution, as in Guérin's *La Rochejacquelein* (fig. 76).

Delacroix was truly a Parisian painter in that he did not leave Paris except for short sojourns to England and North Africa. He also helped painting escape the arena of official, partisan commissions. For the creation of his *Massacres de Scio* (*Massacres at Scio*; fig. 79), a work relating a particularly dramatic episode in the war for Greek independence, Delacroix's sole motivation was the sympathetic opinion that the western European public held of Greek oppression by the Turks. (Lord Byron, a poet committed to the rebel cause died at the western Greek city of Missolonghi the same year Delacroix painted *Massacres*). Although Delacroix's composition owes much to Gros, the latter

did not see much in the work apart from a "massacre of painting": unwittingly a fitting moniker for the inventor of modernity! Five years later, Hugo published the *Orientales* (*The Orientals*, 1829), a collection of poems partially devoted to Greece's hardships and illustrated using a colorful palette reminiscent of Delacroix's. In Delacroix's famous portrait, *Liberté guidant le peuple* (*Liberty Leading the People*; fig. 81), Liberty, traditionally wreathed in a laurel, assaults the 1830 barricades looking like a "fishmonger," as one Salon critic put it. (Barricades were erected all over the city of Paris from July 27–29, 1830 to try to control revolutionaries who finally succeeded in ending Charles X's reign under the Restoration.) Salon critics denounced Delacroix's use of "cruel color" and reproached him for only representing the popular class in the important painting. The Parisian working-class woman depicted as Liberty assumes the posture of a classical allegorical figure eternally frozen in a spontaneous rush forward. Once again Delacroix seems to have inspired Hugo. On the right side of the composition is a small, sickly boy from Paris who follows on Liberty's heels. Hugo based his character Gavroche in his famous novel *Les Misérables* (1862) on this young lad. Although the Musée Royal (at that time in Luxembourg) acquired the painting, it was quickly taken down and returned to its creator for fear that it would incite a riot. Its exhibition would be more short-lived than illusions planted by the revolution of 1830, which was followed by another insurgence in 1848 that led to the end of the Restoration and instituted the Second Republic. Couture's *L'Enrôlement des volontaires de 1792* (*Enrollment of the Volunteers of 1792*; fig. 83), commissioned in 1848 by the government of the Second Republic as decoration for the quarters of the Assemblée Nationale (Congress), met the same end as Delacroix's *Liberty*. After Napoleon III's coup d'état in 1851 took the government out of the people's control once again, such a proof of the vitality of Republican ideals could no longer be exhibited.

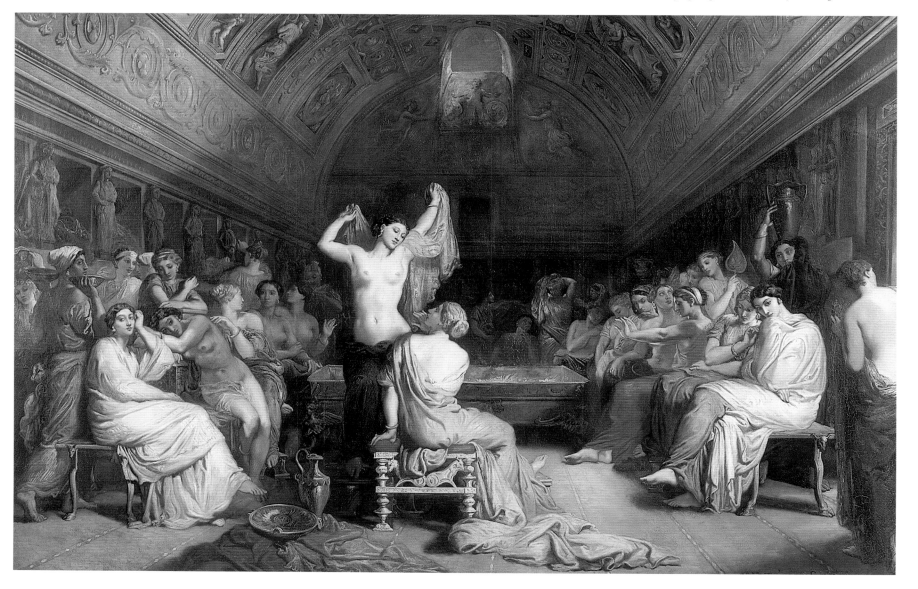

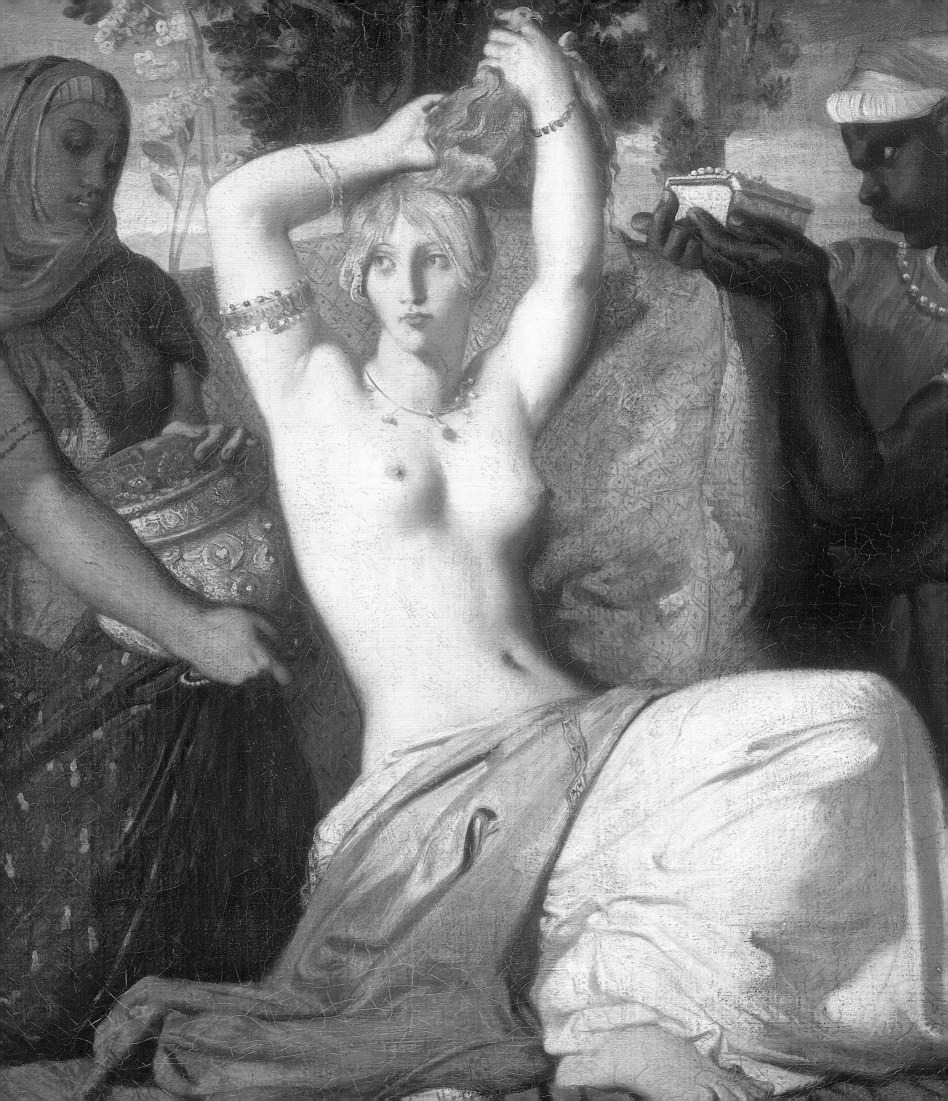

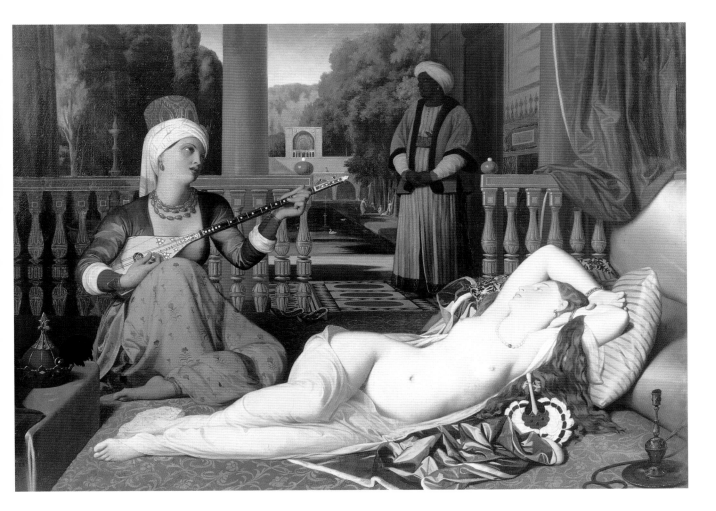

87. Théodore Chassériau.
*La Toilette d'Esther*
(*Toilet of Esther*), 1841.
(Musée du Louvre, Paris)

*According to the Bible, Esther,
a very beautiful young Jewish
girl, saved her people from
extermination by seducing
Xerxes, the king of Persia, who
had condemned them to death.*

88. Jean-Auguste-
Dominique Ingres.
*L'Odalisque à l'esclave*
(*Odalisque and Slave*), 1842.
(The Walters Art Gallery,
Baltimore)

*Created in Paris, this painting
is a copy, with some variation, of
one Ingres did in Rome in 1839.*

89. Edouard Manet.
*Olympia*, 1863.
(Musée d'Orsay, Paris)

*One of the most discussed
works in the history of paint-
ing, this portrait of a prostitute
caused a great scandal in its
time. It was inspired by the work
of Titian, Goya, and Ingres.*

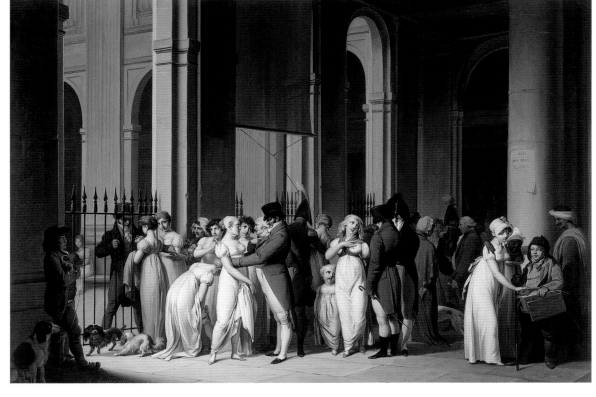

*The Realities of Daily Life*

Daily articles on sordid or scandalous events linked to the government of the Restoration enriched newspapers' political columns. These caught the attention of the political opposition's painters such as Géricault. No longer satisfied painting studies of Michelangelo and Caravaggio in Italy, he depicted a political assassination in *L'Affaire Fualdes* (*The Fualdes Affair*, 1818) and a shipwreck due to the government's incompetence in *Le Radeau de la Méduse* (*The Raft of the Medusa*, 1819; Musée du Louvre, Paris). He also did studies of cadavers in hospitals, morgues, and heads of guillotined prisoners. His portraits of madmen (fig. 91) predate by seven years the young Hugo's revolutionary *Préface de Cromwell* (the famous preface to Hugo's lengthy, "unperformable" play *Cromwell*, 1827). Important artists recorded the daily deprivation (fig. 90) and drama (fig. 92) of Paris at this time in history, painting a somber

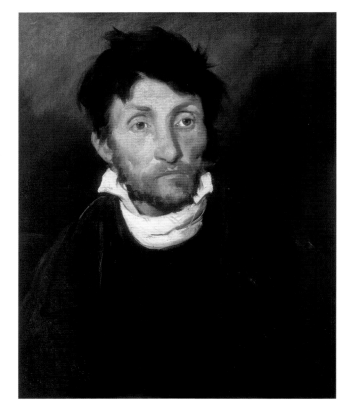

portrait of the capital city. Nothing, however, would equal the horrific scenes that Doré brought back with him from London: the destitution of Charles Dickens's city would still win out over that of Honoré de Balzac and Eugène Sue's Paris.

Masters of Realism, Millet and Courbet revealed something in their retreat back to the provinces of Normandy and the Franche-Comté. Millet went to Paris for the first time in 1837. He set up shop there in 1845, but as early as 1849 he moved permanently to Barbizon, just outside the Fontainbleu Forest about forty miles from Paris. There he painted *Le Semeur* (*The Sower*,

1850; Museum of Fine Arts, Boston) the first of his works to bring him wide attention, and his masterpiece *Les Glaneuses* (*The Gleaners*, 1857; Musée d'Orsay, Paris). With his powerful and solid build and provocative paintings, Courbet would have been the perfect leader of the Parisian Realists, but his major paintings were all completed outside of Paris: *L'Enterrement* (*The Burial*) and *L'Atelier* (*The Studio*) were painted in Ornans and *La Rencontre* (*The Encounter* or *Meeting*) in Montpellier.

*The Novel and Romanticized History*
Ideally, the novel should have been able to provide distraction from the stress and strain of everyday life. Although painters of the day did not fail to illustrate many great literary texts, they certainly did not choose the most invigorating ones. The Scottish bard Ossian inspired David, Gros, Ingres, Girodet, Gérard, and others to portray Nordic scenes covered in fog and ice (fig. 73). This atmospheric artifice tends to inhibit emotion rather than inspire it. For this reason, one is entitled to favor Chateaubriand's narration of *Atala's Obsequies* (fig. 94) to Girodet's painting inspired by this

**92. Honoré Daumier.** *Massacre de la rue Transnonain* (*Massacre on the Rue Transnonain*), 1834.

*This famous lithograph portrays the April 15, 1834 massacre committed by troops ordered to repress an uprising in Paris. It was published in L'Association mensuelle in July 1834. The Association was a series of politically pointed lithographs Daumier printed in 1832–1834 and includes some of his masterpieces. This work is often said to mark the birth of the nineteenth-century French Realism movement.*

particular sequence of *Atala*. The young Delacroix made a name for himself with the masterful *Barque de Dante* (*Dante's Bark*; fig. 95), in which references to Dante and Michelangelo become "pale floating blobs," eternally damned men who look a great deal like the ones drowning in *Le Radeau de la Méduse* (*The Raft of the Medusa*). Delaroche's paintings, *L'Assassinat du duc de Guise* (*The Assassination of the Duc de Guise*, 1835) and *Le Supplice de Jane Grey* (*The Execution of Lady Jane Grey*, 1834; private collection) are as historically questionable as Alexandre Dumas's novels. In other respects these are great works, or at the very least, works of great size. Small-format paintings in the Troubadour style lent themselves to more likeable and as inventive scenes as in

**93. Gustave Doré. Illustration for the 1863 edition of Chateaubriand's *Atala*.**

*This lithograph from an edition of* Atala ou les amours de deux sauvages dans le désert *(Atala, or The Love Affair of Two Savages in the Desert) perfectly matches Chateaubriand's description: "The fire spread like a hairpiece in flames. Columns of smoke and sparks assailed the clouds that vomited lightning into the vast blaze. Then the Great Spirit covered the mountains with thick shadows. In the midst of this chaos arose a confused howling made by the roaring wind, groaning trees, and wailing, ferocious beasts."*

**94. Anne-Louis Girodet-Trioson. *Funérailles d'Atala* (*The Burial of Atala*). 1808. (Musée du Louvre, Paris)**

*Published in 1801, Chateaubriand's Atala was a bestseller. This work shows Atala's funeral ceremony held by her lover and the hermit whose song can be seen on the rocks: "I have passed away like a flower; I have withered like grass in the fields." The painting was greatly admired, most notably by the novel's author.*

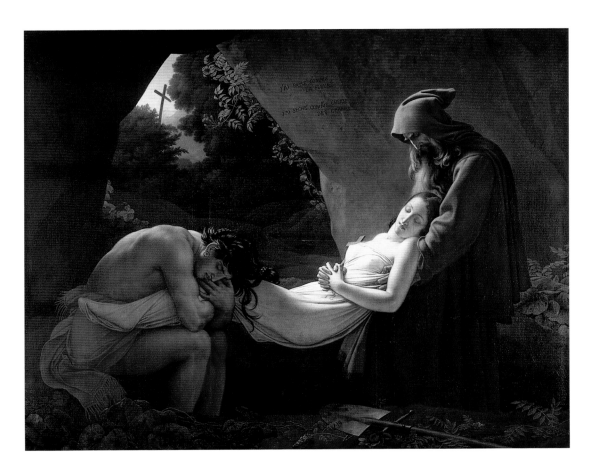

Fragonard's *Diane de Poitiers dans l'atelier de Jean Goujon* (*Diane de Poitiers in Jean Goujon's Studio*, 1830; fig. 72), but the two main specialists in the genre, Fleury Richard and Revoil, belonged to the School of Lyons.

### The Orient

The discovery of the Orient and in particular of the Near East, an area curiously defined as extending from Anadolu (Asia Minor) to North Africa, saved some painters from the deleterious effects of melancholia. This region completely changed the scenery with its delightful sun and bewitching half-lights. Eighteenth-century travelers described this part of the Orient, but François Boucher's sultans were little more than theater characters. The Egyptian and Greek battlefields painted early on by Gros and Delacroix were at this point Orientalist works invented in the studio. In 1827 Alexandre Decamps discovered that the Turks were not all elite soldiers of the Ottoman infantry from the sultan's guard; he then painted picturesque scenes of working class life on the streets and the people's customs. In 1832 Delacroix traveled to Morocco and Algeria. From sketches made during this trip, he painted his

95. Eugène Delacroix.
*La Barque de Dante* (*Dante's Bark,
or Dante and Virgil in Hell*), 1822.
(Musée du Louvre, Paris)

*One of Delacroix's first paintings, it
was presented at the Salon of 1822.
It was called "unfinished" by one critic,
but recognized as a work of genius by
others. Portraying a scene from Dante's
Inferno, it shows Virgil leading Dante
through the waters of the damned: Dante
recognizes some men from Florence.*

96. Gustave Doré. Illustration
for Dante's *Inferno*, 1862.

*This lithograph was visibly inspired
by Delacroix's 1822 painting. It illus-
trates the same passage from
the* Divine Comedy.

*Femmes d'Alger dans leur appartement* (*Women of Algiers in Their
Apartment*; fig. 104) in his Paris studio. It portrays white mis-
tresses and a black servant locked behind the closed doors of the
harem; it was a very influential work. "Just paint, nothing more,"
was the criticism hurled at Delacroix during the Salon of 1834.
Yet the poet Charles Baudelaire saw past that opinion. In a com-
mentary on the Salon he wrote, "This little inner poem, full of
peace and quiet, exhales some sort of perfume of evil that
leads us fairly quickly toward the abysmal edge of sadness."

*Landscapes*

The inevitable return home to Paris from the Orient was
accompanied by a foul odor in the capital city's air. No
doubt the need for a pure atmosphere attracted painters to
the countryside. At the turn of the century, Georges Michel
painted the countryside near Paris, including the Mont-
martre hill and its windmills. As a descendant of Dutch
landscape artists, he was partial to the stormy countryside:
dark clouds through which a crude light breaks to illu-
minate the edge of a wood or the fringe of a wheat field.
Corot showed his true colors early on in his first scene of
Ville-d'Avray (fig. 97), which was painted before his travels
to Italy. It was the first image of the pleasant Ile-de-France
that all the impressionists admired. Corot was trained by

**97. Camille Corot.** *Ville d'Avray, Les Maisons Cabassud (Ville d'Avray – The Pond and the Cabassud House),* before 1825. (Musée du Louvre, Paris)

*One of the first known works by Corot, this painting depicts a site he would repaint several times. The view is from a house Corot's parents purchased at Ville-d'Avray in 1817. Although the work is not dated, it is believed to have been done before Corot's departure for Rome in 1825.*

**98. Achille-Etna Michallon.** *Démocrite et les Abdéritains (Democritus and the Alberitons),* 1817. (Ecole Nationale des Beaux-Arts, Paris)

*Michallon presented this work at the first historical landscape competition opened at the Ecole des Beaux-Arts: it won top honors. The subject of the painting is Democritus, who, according to Aristotle, became a hermit and lived in the countryside near the city of Abdera. The townspeople believed him to be mad.*

Opposite:

**99. Camille Corot.** *Le Berger d'Arcadie (The Shepherd of Arcadia),* 1840. (Musée des Beaux-Arts, Metz)

*This painting, also called* Petit Berger *or* Paysage soleil couchant, *was presented at the 1840 Salon. It confirmed Corot's success with the public, a success that was already palpable at the Salon of 1835.*

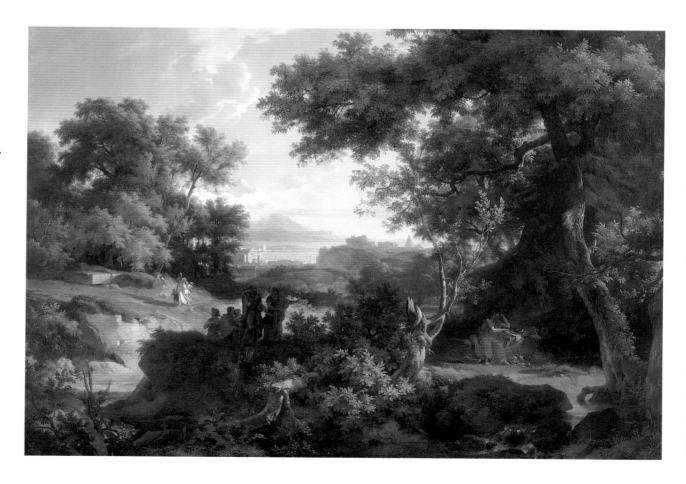

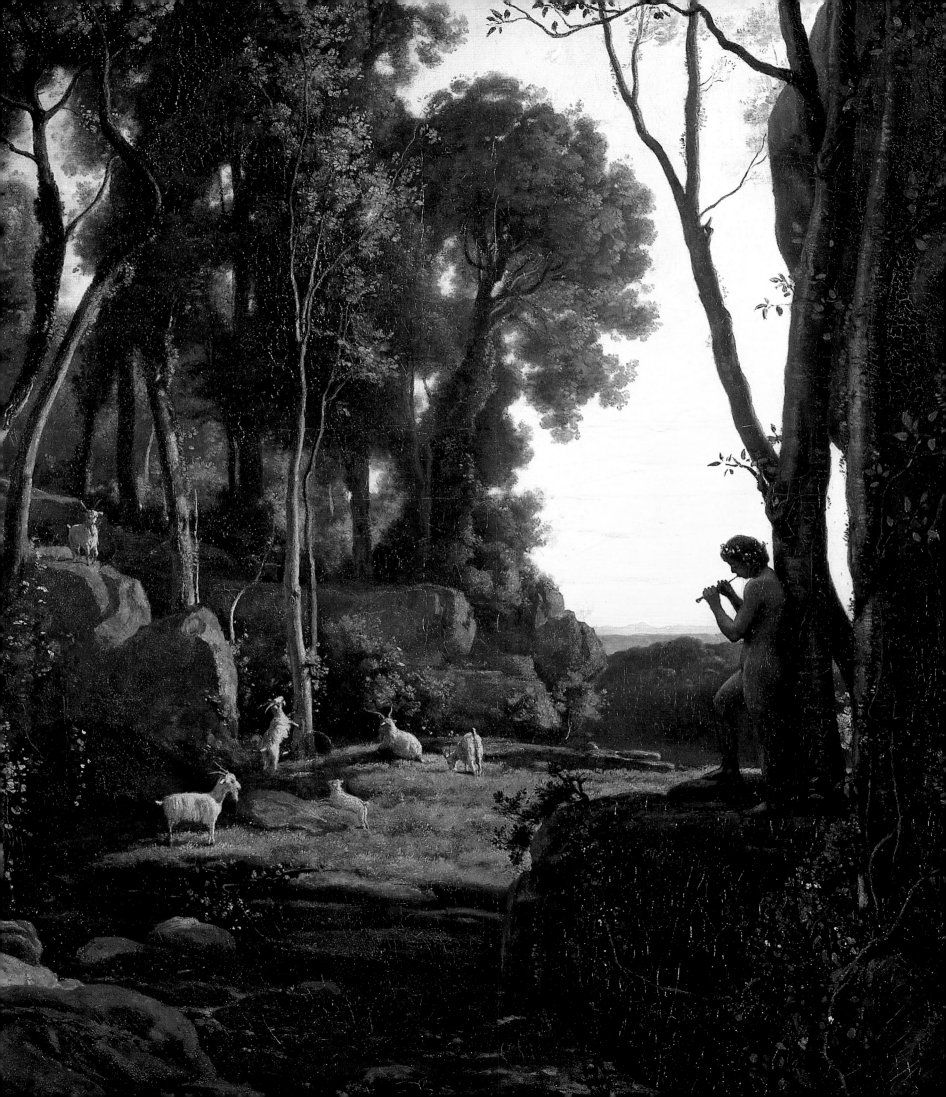

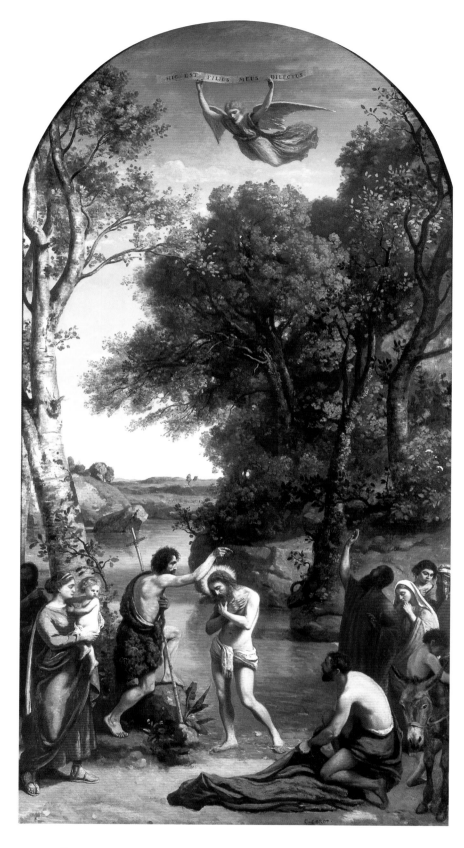

HIC EST FILIUS MEUS DILECTUS

**100. Camille Corot.** *Le Baptême du Christ (The Baptism of Christ),* 1845–1847.

*The city of Paris commissioned Corot to do this painting for the church of Saint-Nicolas-du-Chardonnet. At the time, he had just returned from his last sojourn in Italy. This was the only official commission the artist would ever receive.*

Achille-Etna Michallon, who was himself one of Pierre-Henri de Valenciennes's apprentices. Just as his master had done, he would train his young apprentice in open-air landscape painting, done directly on site. The landscapes Corot did in Italy during sojourns abroad in 1825, 1834, and 1843 are among his most beautiful. Corot's easel, his folding chair, his parasol, and his big white painter's smock were seen all over the French countryside: in Brittany, Normandy, Auvergne, Languedoc, the Morvan, Bourgogne, Saintonge, Picardie, Provence, the Jura mountains, and, of course, the Ile-de-France. Nonetheless, his studio was in Paris and his parents' home in Ville-d'Avray. A number of his works sketched on site were later finished in his studio. Corot was influenced by English landscape artists, especially Constable and Turner. Scenes by the "Barbizon" painters Rousseau and Daubigny, by the Dutch artist Johan Barthold Jongkind, and by the Parisians Corot, Manet, and Monet reminded their public that there was such a thing as an urban landscape. Manet, who did not like the countryside, rarely painted anything but the city.

*The Historical Landscape*

In this way, a bit insidiously, painting brought artists back into the city and the studio. That is where historical landscapes in the tradition of Poussin were thought out and revitalized by Valenciennes (chapt. X, fig. 86). The historical landscape was not only an immense landscape whose scale was shown by tiny characters supposedly living a mythological, legendary, or historical moment; it was also a meaningful landscape that expressed its subject on its own. For this reason, it soon became a genre. The academy recognized it as such by instituting an award for historical landscape painting. In 1817 Michallon was the first winner for *Démocrite et les Abdéritains* (*Democritus and the Alberitons*; fig. 98). Corot made his first splash at the Salon with *Agard dans le désert* (*Agard in the Desert*, 1835). His *Berger d'Arcadie* (*Shepherd of Arcadia*; fig. 99) paid homage to Poussin's famous *Et In Arcadia Ego* (1638–1640; Musée du Louvre, Paris) in subject matter and made reference to Claude Lorrain in its style. This depiction features the same evening-sky light that so often suffuses Lorrain's and Corot's work with melancholy. The rocks were fashioned after sketches made in Italy, near Volterra. The clump of trees was used again in *Le Baptême du Christ* (*The Baptism of Christ*; fig. 100), whose "naive beauty" Delacroix admired. In the nineteenth century, the naive was an important quality for the landscape artist. On the canvas, this quality came off as sincerity, open-mindedness, and an unbiased imagination, all of which indicated an artist's gift for seeing nature as it truly is.

*Religious Painting*

Religious painting also made the naive a virtue, but the type of naivete that religious artists specialized in was purity of soul. In François René Chateaubriand's *Le Génie du christianisme* (*The Spirit and Beauty of the Christian Religion*), 1801, a work that contributed greatly to the renewal of both the art and practice of Christianity, the author wrote, "Of all the religions that have ever existed, Christianity is the most poetic, most humane, and most favorable to freedom in art and literature." At the end of the Revolution, the Catholic church sent apostles out to a France that was becoming less and less Christian. The church was able to incite a

tangible renewal of sacred art. The Nazarenes, a group of German artists founded in 1809 in reaction to the neoclassical movement, arrived in Paris by diverse paths. They were models of guilelessness who, as their contemporary countryman Goethe put it, went forward by taking a step back. Some came to Paris because of the theoretical invectives of Paillot de Montabert against the "pompous works" of the "much too famous Michelangelo" who "made art from Antiquity lose its naivete" (*Dissertation sur les peintures du Moyen Age, Essay on the Paintings of the Middle Ages*, 1812). Others, like Paul Flandrin, came from the School of Lyons. "Never was a talent so pure, so chaste, so elevated put to the service of a more religious inspiration," wrote the poet Théophile Gautier right after Flandrin's death, "There was a bit of Beato Angelico's tender shyness, virginal delicateness, and angelic spirituality in his nature." Gautier called Flandrin's main work, *Procession des saints* (*Procession of the Saints*) in the church of Saint-Vincent-de-Paul, a "Christian Panathens" (the Christian version of the feast held in Athens to honor the goddess Athena). Yet as an apprentice of Ingres, Flandrin remained attached to the art of his master, who had deeply admired Raphael. At a time when Ingres recognized Eustache Le Sueur as the "French Raphael," the French School, previously slowed down by its classical roots, tried to follow the Pre-Raphaelites, the Germans, and the English in making their way back to the origins of Christian art. Ingres created the most Raphaelesque of pious images, *La Vierge à l'hostie* (*The Virgin with the Host*; fig. 101). The maker of religious objects, pictures, and books located next to the Saint-Sulpice church in Paris's Latin Quarter gained one of its greatest commercial successes from the sale of this image. But was this painting more than a beautiful icon? Would its spiritual power, like that of a relic too generously shared, lose its effect from overexposure? *La Vierge à l'hostie* (*The Virgin with the Host*) is not, by the way, just an excerpt from the *Vœu de Louis XIII* (*Wish of Louis XIII*), a painting that is not simply a superb historical painting. In painting, the line between history and religion has never been clearly drawn. Chassériau's *Esther* (fig. 87) is Xerxes' seducer. The prudish *Marie l'Egyptienne* (*Marie of Egypt*) painted by Chassériau in the Sainte-Marie Chapel of the Saint-Merri Church is perhaps even more seductive (figs. 102–103).

101. Jean-Auguste-Dominique Ingres. *La Vierge à l'hostie* (*The Virgin of the Host*), 1854. (Musée d'Orsay, Paris)

*This Virgin of the Host belongs to a series of works by Ingres of the same subject. The oldest version dates from 1841. The 1854 version was painted in Paris.*

Following two pages:

102–103. Théodore Chassériau. *Vie de Sainte Marie l'Egyptienne* (*The Life of Saint Marie of Egypt*), 1841–1843.

*Commissioned for the decoration of the Sainte-Marie-l'Egyptienne Chapel at the church of Saint-Merri, this ensemble is formed of two panels. Of the parts shown here we have the burial, conversion, and communion of the saint on the left; the right piece depicts the saint's ascension into heaven and Zozima telling her life story.*

## Censorship, or The Return of "Decency" to Painting

The censors of morality were vigilant. They condemned the so called "immodest" images painted by Jollivet on the facade of the church of Saint-Vincent-de-Paul, which were simply pious nudes of Eve before the advent of original sin and Jesus awaiting his baptism. In any case, Jollivet's depictions caused a scandal and were withdrawn from public view. On this occasion, the censure was supported by the socialist journalist Pierre Proudhon: "From every

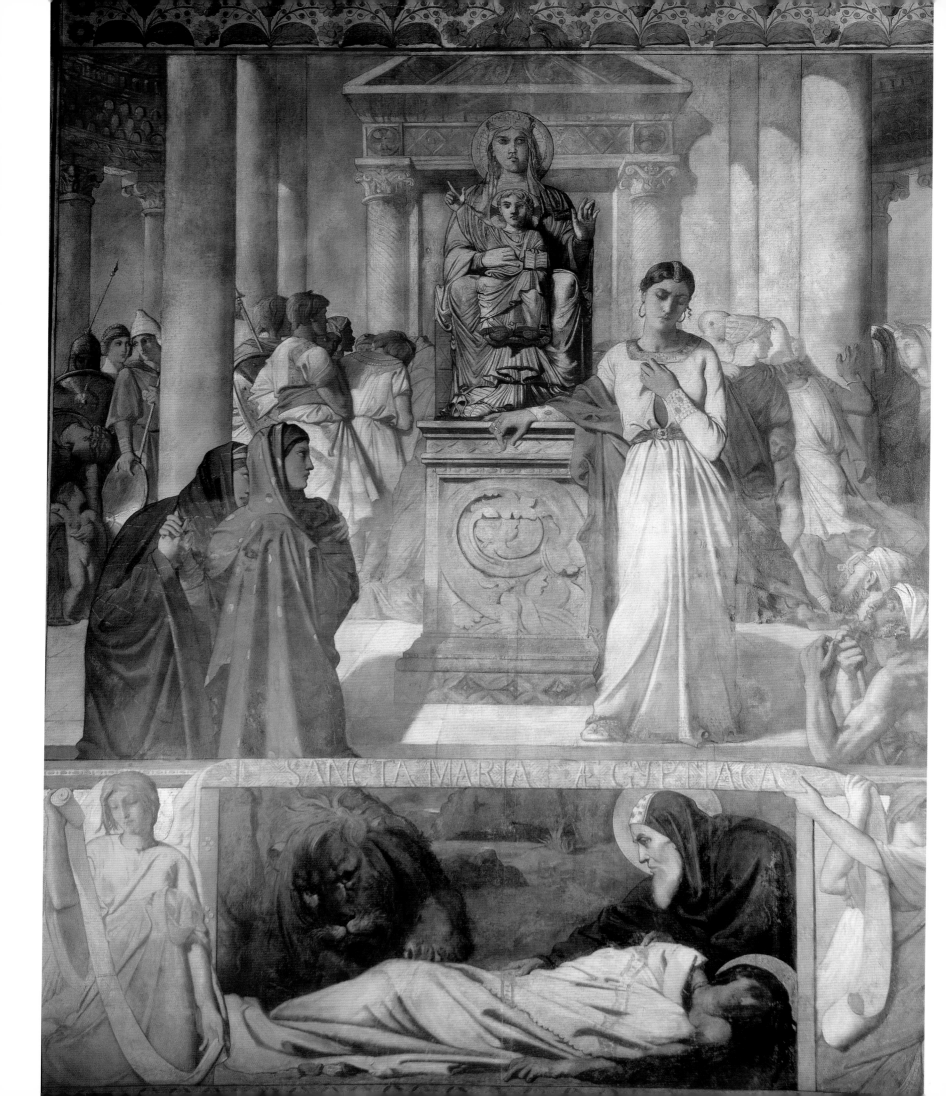

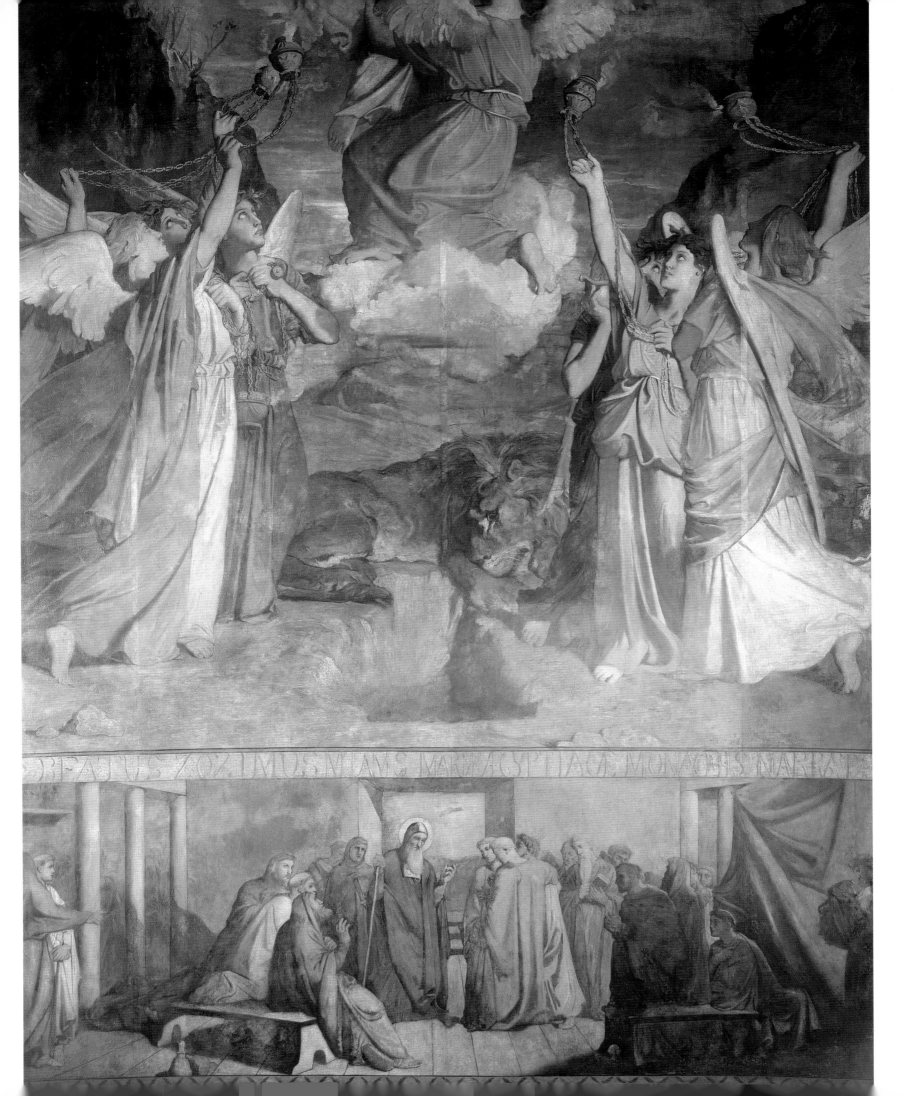

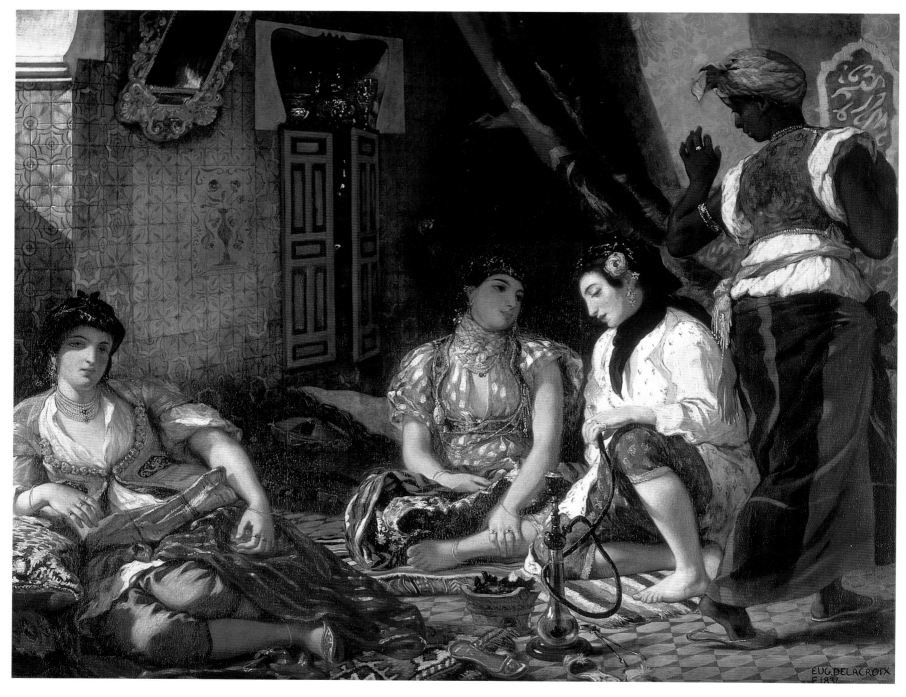

**104. Eugène Delacroix.**
*Femmes d'Alger dans leur appartement*
*(Women of Algiers in Their Apartment),* 1834.
*(Musée du Louvre, Paris)*

*This work was painted by Delacroix two years
after his return from a voyage in North Africa
and comes from memories of his visit to a harem
during a trip to Algiers from June 25–28, 1832.*

point of view, from the perspective of Christian piety, art, and morals, these lewd 'mystic' pieces are, to put it simply, worthy of the bonfire" (*Du Principe de l'art, On the Principles of Art*, 1865). Christian art deferred to the definition of beauty that Victor Cousin gave in his teaching from 1815 to 1821: "Beauty's task is not to irritate or to inflame desire, but to make it pure and noble… An artist who is content to reproduce voluptuous forms that appeal to the senses clouds, even disgusts, our chaste idea of beauty" (*Du Vrai, du beau, et du bien*, or *Of Truth, Beauty, and the Good*, 1853).

If, as Plato said, there is a heavenly Venus and a terrestrial one, it is definitely the second Venus that French painters have courted. This fact is evident in that she is normally barely clothed and is always pursued by defenders of virtue. In nineteenth-century French painting, provocative themes were explored with great frequency. Ingres went directly from the Roman *gynaeceum* to the harem (fig. 88). He was a specialist in line drawing, not color, and called his technique "round modeling." To create his "classically voluptuous" women, he "followed the slightest undulations of their bodies with an amorous servility," commented Baudelaire in his *Salon of 1846*. Ingres had cautiously pushed the envelope,

however. His *Bain turc* (*Turkish Bath*; fig. 105) was only for the eyes of private collectors. First it was sold to Prince Napoleon, who later returned it to the artist because of his wife's objections. It was then acquired by an actual Turk who collected this genre of painting. Gérôme also explored these more tawdry themes, but was somewhat hypocritical about his attitudes toward women. This painter of the Egyptian dancing girl, the slave market, and the Greek courtesan Phrynes in front of her judges was the same professor who forbade women at his drawing classes at the Ecole des Beaux-Arts either as students or as models during drawing sessions. "It seems impossible to me, absolutely impossible," he wrote, "to submit young girls to such a promiscuous environ- ment. When we become complete savages, which is a distinct possibility, then it could happen." In the meantime, he suggested that the models sport long underwear!

The refined portrait embellished ugly women and dressed up the beautiful ones. Not satisfied just revealing the neck and shoul- ders of the beautiful Récamier, François-Pascal Gérard put her in a lightweight shift, similar to a nightgown. It was as if Alphonse Daudet was looking at the Franz Xaver Winterhalter group portrait titled *L'Impératrice Eugénie entourée des dames du palais* (*Empress Eugénie and Her Ladies in Waiting*; fig. 106) when he wrote *Nabab, moeurs parisiennes* (1877): "On low chairs groups of women pressed together. The vaporous colors of their dresses formed an immense basket of living flowers under which the glow of their bare shoulders floated. Their hair was stud- ded with diamonds that looked like drops of water on the brunettes and sparkl- ing sunrays on the blonds." With *Florinda* (1852; Metropolitan Museum of Art, New York), Winterhalter had at first painted a Gothic version stripped of the queen and her attendants. At the Royal Aca- demy of London, where the work was shown, the critics only saw in it "enchanting forms without an unbecoming detail." (These comments made it possible for the queen to acquire the painting and give it as a gift to her husband.)

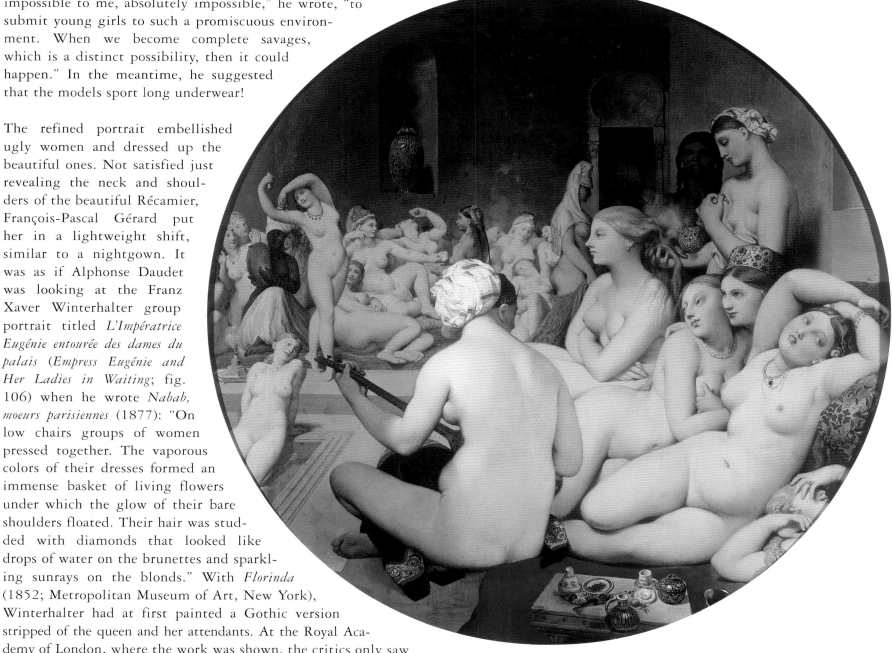

It is not hard to reconstruct the arcane rules of the codes of propriety from the documentation of the scandals Courbet provoked with his violation of the law. Women must never be portrayed lying around in their underwear after a bath, especially not with their dresses suggestively strewn about as in *Les Demoiselles des bords de Seine*. Exhibited at the Salon of 1853, Courbet's *Les Baigneuses* (*The Bathers*) caused a scandal because one of the bathers resembled an overly buxom peasant woman. Supposedly the empress called her a

**106. Franz Xaver Winterhalter.** *L'Impératrice Eugénie entourée des dames du palais (Empress Eugénie and Her Ladies in Waiting).* 1855. (Musée National du Château, Compiègne)

*On the empress's left and right sit the grand mistress, the princess of Essling, and the duchess of Bassano, who held the two main positions in the empress's home. This work was commissioned by the empress and was exhibited in a place of honor at the International Exposition of 1855.*

Percheron draught horse and Napoleon III threatened to whip her with a crop. In 1863 Cabanel's *Vénus* (Musée d'Orsay, Paris) and Baudry's *Vénus* (1858) were shown at the official Salon and Manet's *Déjeuner sur l'herbe (Luncheon on the Grass)* was exhibited at the Salon des Refusés (fig. 107). Chennevières, who would be named the director of the Ecole des Beaux-Arts in 1874, described the two Venuses as "pure works of art." But then why does he condemn "the stifling series of nude women, lying on their fronts and on their backs, that have invaded the Salons ever since, each more scantily clad and more provocative than the others" (*Souvenir d'un directeur des Beaux-Arts, Recollections of a Director of the Beaux-Arts*)? The same traits that Cabanel's *Vénus* was praised for by Salon judges were those that the critics of the Salon of 1869 reproached: "His desire to be nice drove him to suppress all the unusual traits, all the individual marks that are the signs of life." As for Manet, try as he might by taking inspiration from Titian's *Concert champêtre* (1510–1511; Musée du Louvre, Paris) or by grouping together his subjects in the way of Leonardo da Vinci or Raphael, his *Déjeuner sur l'herbe (Luncheon on the Grass)* will never be more than a straightforward attempt. Nothing could be more trivial than the subject matter of *Olympia* (fig. 89), yet Manet turned the scene into another masterpiece, in which a white woman is being presented by a black servant as if she were for sale in a brothel. In any case, "Manet neither desired to overthrow the art establishment nor to create a new one," wrote the artist himself in the catalogue of his 1867 exhibition. It was not painting that changed, but the public. Manet's art was made for enlightened princes of the Renaissance!

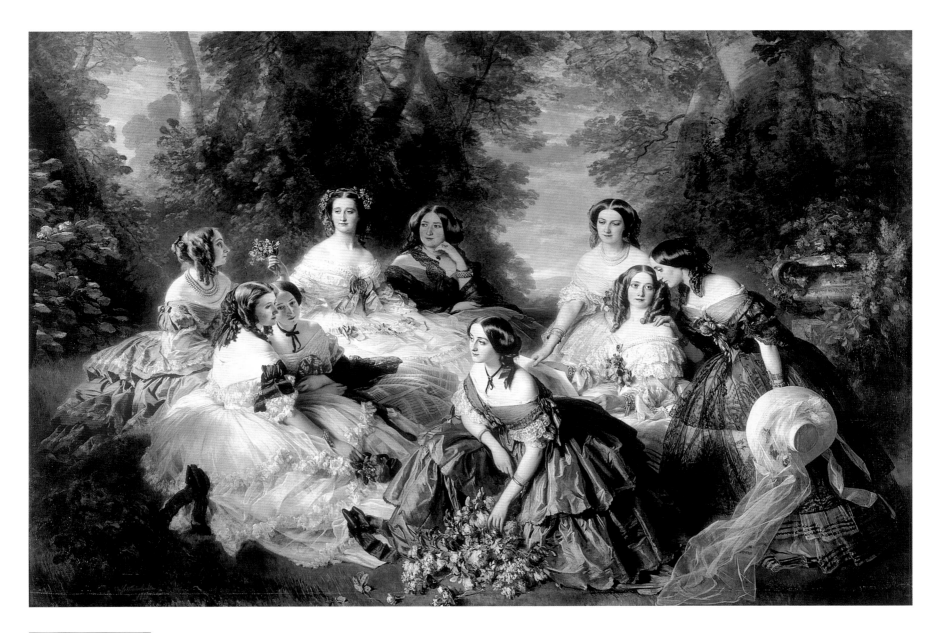

**107. Edouard Manet.**
*Le Déjeuner sur l'herbe*
*(Luncheon on the Grass)*, 1862.
(Musée d'Orsay, Paris)

*This work was shown at the Salon des
Réfusés, the alternative salon that opened
next to Napoleon III's "official" Salon for
artists who judged the official Salon's
selection jury to be too harsh. At that
time, the work was titled Le Bain.*

On the following two pages:

**108. Edouard Manet.**
*La Musique aux Tuileries*
*(Music in the Tuileries)*, 1860.
(The National Gallery, London)

*Painted in 1860 and shown at the Salon of 1862, where it caused a scandal, this
work portrays a group of socialites who met in the Tuileries Garden (the Imperial
Residence) to hear the regularly performed concerts. Among the crowd, at the
far left, are Manet, the poet Charles Baudelaire, and the musician Offenbach,
whom Rossini labeled the "Mozart of the Champs-Elysées." Perhaps one of
Offenbach's compositions was being played that day, although he had not yet
written the music that would make him most famous: La Belle Hélène (The
Beautiful Helena) of 1864 and La Vie Parisienne (Parisian Life) of 1867.*

A bit out of touch with the whirlwind of their times, nineteenth-century sculptors only managed in rare instances to distinguish their work from the best examples of the eighteenth century. Sculptors inherited a remarkable savoir-faire that sustained their art throughout the century at a high level. There were also a good number of clichés that trapped sculpture in an oppressive academicism, though some rare threads of genius stand out. It is very tempting to attribute the genius to the *peintres maudits* banished from the salons and official commissions, especially when their unique personalities and their political ideas led them to revolt. Should a few acts of resistance wipe away Carpeaux's collaboration with Napoleon's regime, his multiple statues of the self-proclaimed emperor, the empress, and the prince, and an artistic production of average quality apart from a few exceptional works neither more nor less academic than that of Albert-Ernest Carrier-Belleuse? At the end of the century, there was an important event: the return to Michelangelo's technique of direct chiseling. Whether the finished product was of marble or bronze, nineteenth-century sculptors were "modelers"; they created works from clay or wax models, as did their predecessors from the eighteenth century.

*Great Men*

As in the eighteenth century, sculpture honored major public figures. Public commissions arranged for a series of sculptures to be placed on the Pont de la Concorde and in the Luxembourg Gardens. For the first commission, David d'Angers created a statue of Prince Condé who looked like Gautier's Captain Fracasse. For the second, Auguste Préault, one of David d'Anger's apprentices, created a statue of Clémence Isaure as discrete as the first was "cowardly," the adjective that French historian Jules Michelet used to describe the Condé work. On public squares, Restoration sculptors tried hard to forget the royal effigies destroyed during the Revolution. David d'Angers received all the memorials: "Michelangelo had Rome and David has Paris," wrote Hugo (*Les Feuilles d'automne*, or *Autumn Leaves*, 1831; *Les Rayons et les ombres*, or *Sunrays and Shadows*, 1840). Was this unconscious perfidy? After all, Hugo did not say "Paris has David." The masterpiece of this politically involved republican was paradoxically the monument that the Restoration erected to the leader of the Vendeen rebels, Bonchamps. The death of General Foy, the leader of the liberal opposition to the Bourbon Monarchy whose burial at the Père-Lachaise Cemetery was the occasion of a

**109. Gustave Courbet.**
*Le Sommeil (Sleep)*, **1866.**
**(Petit Palais, Paris)**

*This work was painted for Khalil-Bey, a former Turkish ambassador to Russia who had moved to Paris and acquired a specialized collection of Parisian art, including Ingres's* Bain turc *(Turkish Bath).*

Opposite:
**110. James Pradier.** *Satyre et Bacchante (Satyr and Bacchante)*, **1834.**
**(Musée du Louvre, Paris)**

*Exhibited at the Salon of 1834 and judged licentious, this statue was displayed in a little room apart from the rest.*

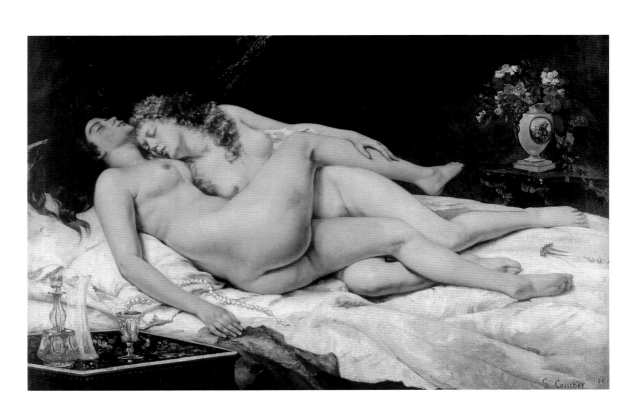

huge demonstration by those opposing the Restoration regime, only inspired d'Angers to create a statue draped like those from antiquity, skillfully placed up high to allude to the general's greatness. D'Anger's contemporaries criticized him for not having portrayed the general in contemporary clothing. For the statues of great men, trends wavered between the ancient-style nude and the draped Romantic. Out of modesty, he claimed, Bonaparte refused the large Napoleon that he ordered from Canova, the Italian known as the master of neoclassicism in sculpture, on the pretext that the artist conferred upon him a physique fitting only for the gods. A nude of the General Desaix that Napoleon described as "rubbish" made a short appearance on a public square in Paris before being hidden behind a fence, then eventually taken away.

As public spaces, squares, small gardens, and cemeteries sprang up, they became a breeding ground for sculptures of great men. However, the most remarkable funeral monuments of the first half of the nineteenth century were still in the churches: Bosio and Cortot's statue of Louis XVI and Marie-Antoinette at the Expiatoire Chapel, James Pradier's statue of the duke of Berry at the Versailles Cathedral, and Marochetti's statue of the duke of Orléans in the Saint-Ferdinand Chapel. The sculptors were skilled at re-creating the emotion that these tragic endings aroused without going so far as to create new iconography. As in Bernini's day, new ideas came from Italy: Canova invented the theme of the funeral procession entering a pyramid that Paul-Albert Bartholomé, sculptor of cemetery monuments, would copy at Père-Lachaise nearly a century later in 1895.

### The Beautiful Ideal

Canova was a master of the "beautiful ideal" promoted by Winckelmann. In his treatment of Carrara white marble, his skill equaled that of the ancient masters. Apprentices in Rome spent time with him and copied his work. One of these apprentices,

Denis Chaudet, a boarder from 1784 to 1788, produced a white marble statue in 1802 entitled *Amour au papillon* (*Cupid and the Butterfly*; Musée du Louvre, Paris) that belongs to the same family as Gérard's *Amour et Psyché* (*Cupid and Psyche*; chapt. X, fig. 91). Called the "Athenian" because of the great influence Canova had on his work, Pradier's *Les Trois Grâces* (*The Three Graces*, 1825; Musée du Louvre, Paris) indeed evoke those of Canova, who was the modern equivalent of Praxiteles, the great Athenian sculptor from 400 B.C., with their simple marble and pure nudity. When classicism and mythology lost out, "Praxitelism" influenced sculptors who normally gravitated to a rounder sort of beauty (fig. 114). Rude's *Jeune Pêcheur* (*Young Fisherman*; Musée du Louvre, Paris) caused a sensation at the Salon of 1833, because the young fisherman was holding a tortoise instead of the butterfly held by Chaudet's *Amour*. Clearly Rude and Chaudet sculpted the same smooth-skinned adolescent, but from the Neapolitan fisherman's cap on Rude's figure, we can see the transition from classicism to Romanticism—a working class, picturesque Romanticism! Nineteenth-century sculpture was so desperate for major events that Carpeaux's *Pêcheur au coquillage* (*Fisherman with a Shell*, 1858; Musée des Beaux-Arts de Dijon) was exhibited at the Salon some twenty years after Rude's fisherman. This was not a great find: Rude was Carpeaux's master!

## Polychromy and Exoticism

The nineteenth-century renewal of various styles and genres in sculpture were the result of three important phenomena: a renewed interest in archeology, colonization, and voyages. The ancient technique of polychromy, the application of color to statues, was used with a combination of materials like bronze, onyx, and marble from Algerian quarries. The models *par excellence* were Phidias's ivory and gold elephant statues ("*chryséléphantins*") described by Quatremère de Quincy. Simart, the Parisian sculptor of Napoleon's tomb, made a silver, golden bronze, and ivory reconstruction of the Parthenon's Athena for Dampierre's château near Paris. The château was also decorated by the team of Duban, Ingres, and the Flandrin brothers; Simart's piece was unveiled in front of Ingres's famous painting *L'Age d'or* (*The Golden Age*, 1862; Fogg Art Museum, Harvard University).

Ethnographic sculpture cleared the way for Orientalism in painting. The masterpiece of this genre is the group of sculptures called the *Quatre Parties du monde* (*Four Quarters of the World*) that top the Observatory Fountain (fig. 115). This group, one of Carpeaux's last works, is made of four women each representing one of the four continents of classical iconography. Carpeaux had planned to accentuate their distinctive traits by painting their skin its natural color. The world's spinning effect is rendered by four views: the frontal, the three-quarters, the back, and the profile. Contemporary critics called this superb world of four nude allegorical figures "demi-monde" (a play on words that refers to a turn-of-the-century society of flighty women of questionable morals, but also literally "half-world"; 1855).

## The Female Nude and the Portrait

Although omnipresent, nineteenth-century reactions to the female nude were decidedly unique. *La Danse* (*The Dance*, 1867–1868; The Opéra, Paris), Carpeaux's famous group of women, was a circle of ethereal sylphs surrounding a leaping male dancer, a sacred rite of spring of masked eroticism. They were made to adorn the Opéra's facade, but were doused in ink the day after their unveiling and then withdrawn from their site. Such was the fate of *La Danse* (*The Dance*), while James Pradier's crude *Satyre et Bacchante* (*Satyr and Bacchante*; fig. 110) was accepted into the Salon, although put in a small room separate from the other works. It created a scandal and was attacked for its "lasciviousness." The model (once believed to be Juliette Drouet, Prodier's mistress) was chubby, and she conformed to the canon of femininity of the day. The work also encouraged other artists to mold sculptures directly onto living

113. Antoine-Louis Barye. Decorative table piece owned by the duke of Orléans. 1834–1838. (The Walters Art Gallery, Baltimore)

*This decorative table piece was commissioned from the painter Claude-Aimé Chenavard in 1834 by Duke Ferdinand of Orléans, the eldest son of King Louis-Philip. Of the eight bronzes by Barye in the ensemble delivered in 1838 (the plaster models are in the Louvre), there are four animal "duels" (between a lion and a wild boar, an eagle and an ibex, a python and a wildebeest, and a tiger and an antelope) and four "hunts" (a man against a lion, a wild bull, a bear, and an elk).*

models. Supposedly formed on the body of Baudelaire's mistress Madame Sabatier, the painting *Femme piquée par un serpent* (*Woman Bitten by a Snake*; Musée d'Orsay, Paris) caused a scandal at the Salon of 1847. This work by Clésinger is one of several portrayals of a reclining female nude, her body contorted with desire or because of some discomfort: in this case, she is the victim of a snake bite. In antiquity, the snake was the archetypal figure for the hermaphrodite.

*Animals in Art*

Pradier's *Satyre et Bacchante* (*Satyr and Bacchante*) developed a successful theme: man's struggle with beast, especially a half-human, half-animal hybrid. Barye sculpted several of these types of works: man confronting a monster (fig. 112), man fighting a wild animal (fig. 113), and large cats battling each other. For this sculptor, every living creature was either predator or prey. The couples were labeled "hunts" when they pitted man against animal and "duels" when they pitted beast against beast. Barye suggested crowning the Arc de Triomphe located in the Place Charles de Gaulle-Etoile with an enormous imperial eagle with spread wings and deadly talons. This violent bird that the Napoleon family rightly adopted as their symbol also fit perfectly when France "welcomed" the King of Prussia at the Place Charles de Gaulle-Etoile in Paris in 1871, after the French defeat in the Franco-Prussian War. Gustave Doré's 1870 drawing showed the eagle readying to pick apart the cadaver of France. The monster, animal, and hero trio often depicted by painters was also a favorite of sculptors. Barye's *Angélique et Roger* (*Angelica and Roger*; fig. 111) was taken from the same reference used in Ingres's painted version.

*War and Hell*

Two works by Rude and Carpeaux dominated the century: *Le Départ des volontaires* (*Departure of the Volunteers*) from the Arc de Triomphe (fig. 82) and *Ugolin*. Deservedly famous, *Le Départ des volontaires* (*Departure of the Volunteers*) was a sculptural version of heroizing work by the painters of the period. *Ugolin* (1858–1860), on the other hand, is a powerful, original incarnation of the century's torments, but this is a work made while Carpeaux was a boarder in Rome, just as *Pêcheur à la coquille* (*Fisher Boy of Naples*; Peabody Art Collection, Baltimore) was. The unfortunate Ugolin who devoured his children in Dante's *Inferno* was created like a bronze maze explicitly inspired by another famous Hellenistic marble portraying Laocoön and his children being crushed by an enormous snake. It resembles Michelangelo's *Slaves* (1513–1515; Musée du Louvre, Paris) and *Last Judgment* (1535–1541; Sistine Chapel, Rome) and announced Rodin's *Porte de l'enfer* (*Gates of Hell*, 1880–1917; Musée Rodin, Paris).

Even closer to Rodin, Préault's *Dante et Virgile* (*Dante and Virgil*) was intended to be a relief sculpture, but never got past the sketch stage. Préault's enigmatic *La Tuerie* (*The Slaughter*; fig. 80) was labeled "Dantesque" by contemporary critics. Paradoxically, it was only accepted at the Salon of 1834 as a way to embarrass Préault, but the *Journal des artistes* (*Artists' Journal*) felt "the frenzy of rebellion" in it. Despite his fairly conventional output, Préault was the Romantic and revolutionary sculptor par excellence. He took part in the fight caused during the first production of Hugo's revolutionary play *Hernani* (1830). His strange chaos of figures can perhaps be linked to his passion for theater. Between Delacroix's *Massacres de Scio* (*Massacres at Scio*, 1824) and Picasso's *Guernica* (1937; chapt. XIII, fig. 49), *La Tuerie* (*The Slaughter*) goes down in history as one of the most lively denunciations of crimes against humanity. About this work, Préault said it all when he presented it as an "episodic fragment of a large bas-relief or a large painting." It was, in a way, the right-hand side of *La Bataille d'Aboukir* (*The Battle at Aboukir*; fig. 78).

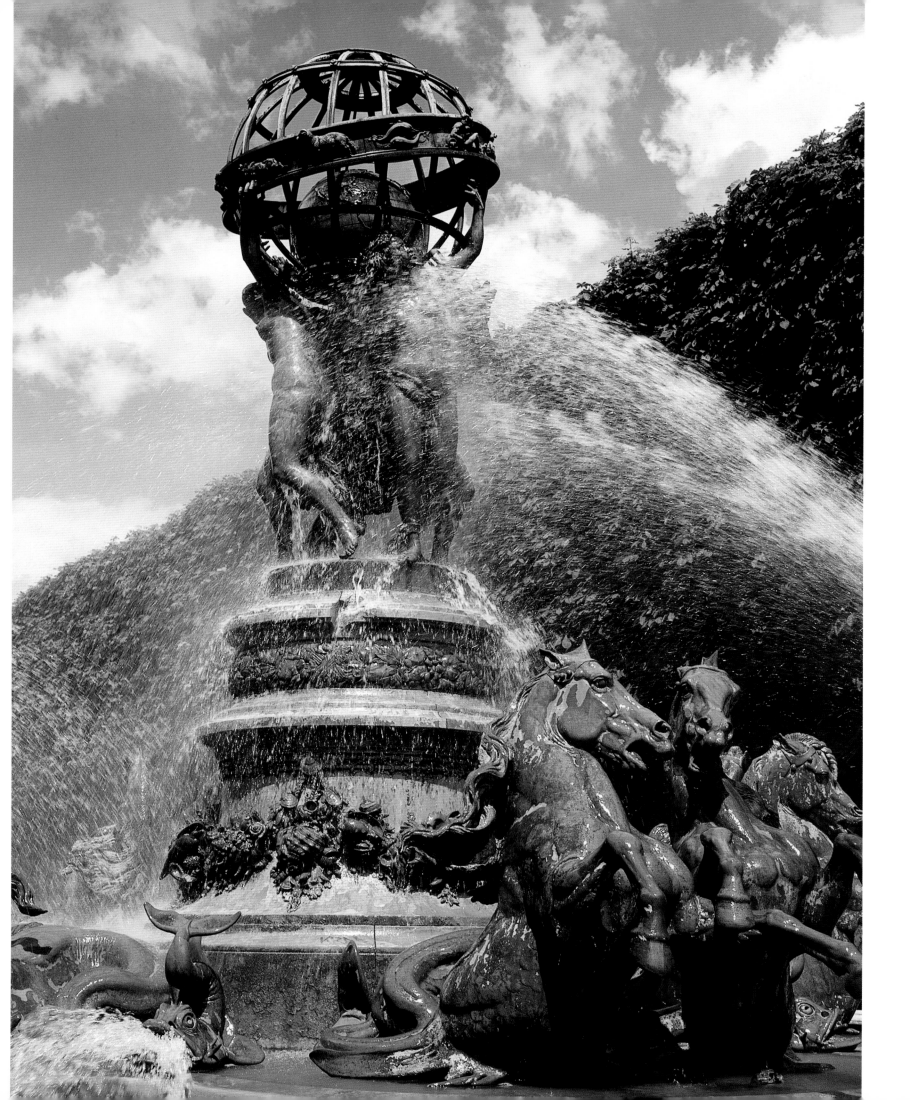

Nineteenth-century artists were compelled to engage with the new realities of social and economic revolution. On the one hand, they had a larger, less savvy public who often confused aesthetics with morality and art with pornography. On the other hand, in response to growing demand, the economic revolution brought with it new manufacturing techniques, new modes of production, and changes in commercialization.

*Metal Structures*

The three products stemming from the transformation of iron ore—pure metal, steel, and cast iron—were not inventions of the Industrial Revolution. Ironwork is a very old technique, but its usage was limited by the large amount of labor it took to forge it. Because it molds easily and resists compression very well, cast iron was frequently used in nineteenth-century building. Pre-nineteenth-century cast-iron works are rare. One such rarity is the stairway ramp in the seventeenth-century Saint-Fargeau Hotel in Paris. Cast iron replaced iron in stairway ramps, balcony grillwork, and even in urban building and church furnishings such as those in the church of Saint-Vincent-de-Paul by Hittorff. But for structural frameworks it was used in conjunction with iron because the latter better resists traction. Steel was used during the eighteenth century, but it only started being used in construction during the late nineteenth century. When it did, there was a decline in cast iron and iron usage. As early as 1867, Jean-François Cail, the owner of a large iron empire, had a steel and bronze staircase ramp built for his Paris home. But five years earlier, a steel house had already been built in Liverpool. France's late coming to the architectural uses of steel stem from the fact that the Bessemer (1856) and Siemens-Martin (1864) procedures, which made the industrial production of steel possible, were not adapted to treating phosphorous ore, France's primary natural resource.

The deficiencies of French industry limited the usage of iron and cast iron during a good part of the century. Some of the pieces used to build Les Halles, the central market in Paris, had to be made in Great Britain. Plans for building the Palais des Arts et de l'Industrie on the Champs-Elysées for the first International Exposition, held in 1855, had to be changed because French industry was incapable of furnishing certain pieces in time for the construction of what was to be France's rival to the Crystal Palace. Originally only metal was to be used in the building. To complete the Gare du Nord train station, which was built from 1861–1866, some of the metal pieces had to be sent over from Glasgow.

In addition to production problems, metal architecture did not take an immediate hold in a country passionate about stone. The construction of the Pont des Arts, the first metal bridge in France (1801–1803), was in this way exemplary. Pointing to the British example, Napoleon I wanted the bridge made of metal. His architect, Pierre-François-Léonard Fontaine, wanted to

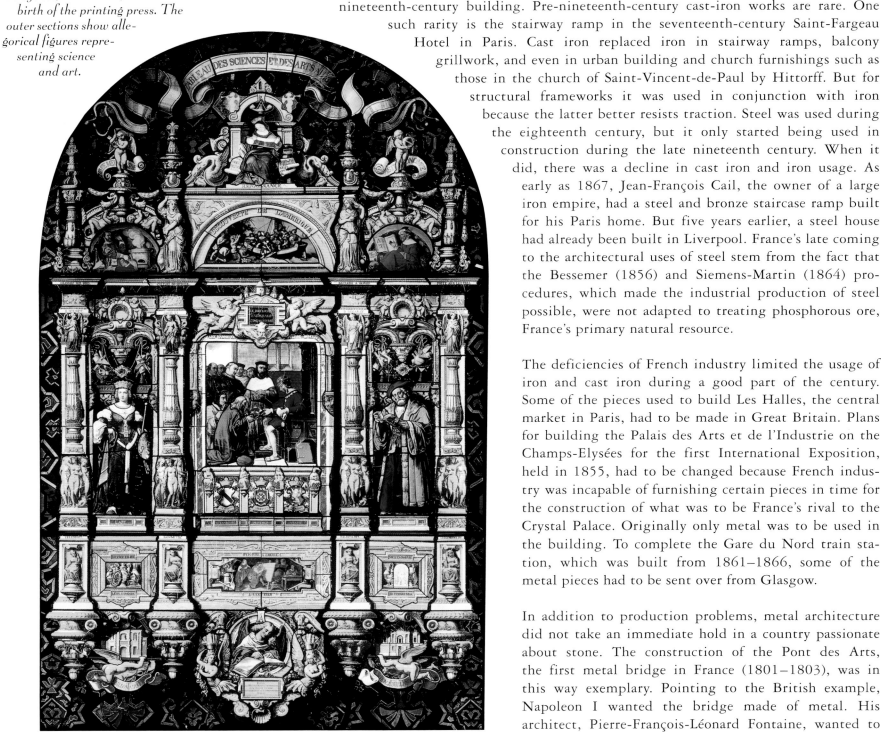

**116. Claude-Aimé Chenavard.**
*La Renaissance (The Renaissance),*
**stained-glass window, c. 1833.**

*In 1832, Brongniart, the director of the Royal Manufacture at Sèvres, commissioned Chenavard to make a stained-glass window devoted to "inventions, discoveries, and work particular to the Renaissance era, between 1450 and 1550" to embellish the parlor of a large museum of art. A copy was put up in the Louvre's Pavillon de l'Horloge in 1838 during an exposition of works produced by the Royal Manufacture. The middle section depicts King Louis XI receiving the first printed Bible as well as the coats of arms of Strasbourg, Mayence, and Venice, cities attributed with the birth of the printing press. The outer sections show allegorical figures representing science and art.*

use stone, arguing that there was plenty of it in France and that the English only used metal as a second choice, because they did not have enough stone. Denon, the director of Napoleon's museums, wrote at the time, "It would be desirable to consecrate the larger-than-life circumstances under which we are living with colossal monuments...We must adopt a style capable of weathering greed, weather, and an intemperate, destructive climate. The style or means must be melted iron, the same sort of iron used during the war to serve victory and in times of peace, to make trophies" (Report to the Institute, 1803). The Pont des Arts was simply an iron bridge with a wooden bridge structure. On the other hand, the Pont du Carrousel (1833, now dismantled), attributed to the engineer Polonceau, exhibited a new type of structure adapted to cast iron. The same is true of the Pont d'Arcole (1854), an iron bridge with one single arch spanning 262 feet, a record at that time. The competition between stone and metal reappeared in all the symbolic work sites, especially that of the cupola in the Halle aux Blés (1809–1813) and the one in the Halles du Marché Central (figs. 37–38). In this last case, metal did not completely win until an energetic intervention by Napoleon III assured its success.

The metal structure of the Halle aux Blés was originally covered in copper, but as a covering material, copper only had limited usage in France. For the same purposes, laminated lead's usage spread across Paris during the eighteenth century, after a royal manufacturing plant was created in the Saint-Antoine suburb in 1729. In the nineteenth century, laminated zinc covered the city over with a bluish tint of gray that artists would try hard to re-create on their palettes.

Building site organization also underwent important transformations. Architectural prefabrication did not begin in the nineteenth century; it was traditionally used in wooden skeleton constructions. But chalet-style houses became so fashionable that factories opened inside the capital city itself to satisfy consumer demand. The Seiler-Mulheman Company first opened on the Avenue de Flandre. Its mission, according to company line, was the fabrication of "wooden chalets sculpted in the Swiss style, built, delivered, and erected on site in six weeks to two months." We have already seen how the decorative industry was born in the second half of the eighteenth century. At the beginning of the nineteenth century, Francesco Piranesi, the son of the famous engraver, created a terra-cotta architectural decoration factory in greater Paris.

### Electroplating and Cast-Iron Art

The development of electroplating, a technique enabling one metal to cover another through the technology of electrolysis, turned the sculpture and art market upside down. In 1840 the famous Parisian industrial magnate Christofle acquired a patent known by the name of Ruolz for a gold and silver electroplating procedure to be used for decorative purposes. This process made mass production of less expensive jewelry, called "Paris items," possible. Such items were in great demand, especially in foreign countries. The phenomenon of religious medals got its start on the Rue du Bac in 1830 with medals of the Virgin Mary. Ten million copies were produced in the nineteenth century!

Electroplating and traditional cast-iron processes were used at the same time in the bronze art industry. They made the reproduction of works by the likes of Barye and Rude possible. The refinement of a technique of mechanical reduction in the 1840s enabled large monumental sculptures to be reproduced on a small enough scale for the average bourgeois apartment. Barbedienne, the most famous manufacturer in the industry, made his in Paris.

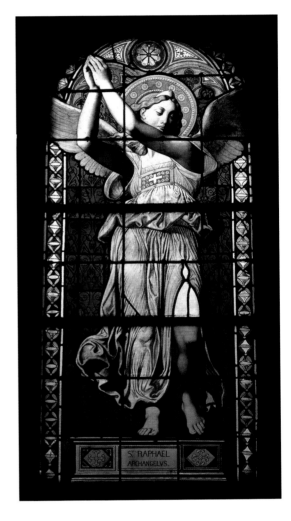

117. Jean-Auguste-Dominique Ingres. *L'Archange Raphaël (Archangel Raphael)*, stained-glass window made by the Royal Manufacture of Sèvres for the chapel of Notre-Dame-de-la-Compassion, 1842–1843.

*King Louis-Philip himself chose Ingres to design the stained-glass windows for the Notre-Dame-de-la-Compassion Chapel erected on the spot where the heir to the throne was accidentally killed. It was built according to plans drawn by Fontaine. There are a total of seventeen stained-glass works in the chapel.*

*Painting on Lava Rock and Glass*

Painting on lava rock began in 1827. Its utilization was encouraged by Volvic, Charles X's prefect of the Seine, who had lava rock brought to Paris from his province of Auvergne. The Saint-Vincent-de-Paul's facade decor was the first and most important example of the use of enameled lava rock. This type of art, however, was not popular. The failure was not due to a technical problem, but rather the taste on the part of the public for other similar arts, like painted porcelain.

A studio devoted to rediscovering the medieval technique of stained-glass window making was created at the Sèvres porcelain manufacturing company. At the beginning of the 1830s, the director Brongniart commissioned a stained-glass window for demonstration purposes from Claude-Aimé Chenavard, one of their artistic advisors. The window appropriately featured inventions and discoveries of the Renaissance (fig. 116). The first windows were installed in the churches of Notre-Dame-de-Lorette and Saint-Vincent-de-Paul. Louis-Philip commissioned windows for his family's funerary chapel at Dreux and for the chapel built in Paris on the site of the accident that took the life of Ferdinand, heir to the throne (figs. 41–42).

*Lithography*

At the end of the eighteenth century, the Bohemian Aloys Senefelder invented the lithographic process using stone from Bavaria. Lithography started off slowly in France but it met with overwhelming success during the 1830s. It became the primary means of distribution for the drawings of artists like Daumier and Paul Gavarni, whose work was often political satire and caricatures. The negative image of French society under the rule of Louis-Philip as comprised of an idiotic bourgeoisie and an endearing bohemian sector was bolstered because of the wide dissemination of images made possible by lithographs. Lithography certainly helped increase the circulation of specialized periodicals like *Le Charivari*. Striking the same note as that of rebels against the powers to be, the magazine made it seem as if the times of the horse Fauvel and his honeymoon with Lady Fortune (chapt. III, fig. 8) had returned. Within this context, the Swiss Rodolphe Toepffer gave birth to the comic strip. Almost simultaneously the photographer Félix Nadar drew the political comic strip *Mossieu Réac (Mister Reac)* for the *Revue comique à l'usage des Français* ("*Humorous Review for the Use of the French People*"), founded by the renowned Parisian editor Hertzel. Lithography competed with etching's capacity for rendering light and dark areas. Thanks to this process we today have a record of old France's

dark shadows in the *Voyages pittoresques* (*Picturesque Voyages*) by Taylor and Nodier. The most famous lithograph of the nineteenth century, the *Massacre de la rue Transnonain* (*Massacre on the Rue Transnonain*; fig. 92), shows contrasts between light and dark reminiscent of Rembrandt.

## Photography

According to Charles Baudelaire, photography was the "slave of painting"; it provided models of landscapes, portraits, and nudes that sculptors and painters could copy. And it also served as a means for making copies of their own work. Ingres was among the first to photograph his own paintings. Publication houses specializing in reproduction were founded in Lille in 1851 and at Mulhouse in 1862. Soon, however, the "slave" became a competitor. Paris was the subject of the very first daguerreotypes (fig. 13). Charles Nègre and Charles Marville, pioneers of photography, both worked in Paris. The artistic possibilities of the medium were evident immediately in Marville's work. He received an order from Haussmann to take pictures of works of art in museums and of houses in Paris that were to be destroyed as part of Haussmann's plan for remaking the city. Haussmann was intent on having Marville preserve the image of Paris's squalor as lasting testimony to the enormity of the task accomplished in remaking the capital city. But Marville, who was an artist (figs. 18–20), did not only record the razed city for posterity: both he and Nadar proved to be formidable competitors for painters, Nadar for portraits and Marville for urban landscapes.

It is difficult to list all the inventions and practices that influenced fine arts either directly or indirectly, but a few are very important to mention. In 1862 Dr. Duchesne made public the results of his research on paralyzed patients' reflexes elicited by electrical current that supposedly corresponded to feelings, which was published expressly for artists to use. Although they had a less immediate effect, the chemist Michel Eugène Chevreul's work on the codification of the principles of color published in his 1839 memoir *De la loi du contraste simultané des couleurs...dans ses rapports avec la peinture* (*On the Law of the Simultaneous Contrasting of Colors...as It Applies to Painting*) virtually spawned the impressionist movement.

If photography had so many applications to offer art, it also owed much to it. The contemporary camera was not much more than the *camera obscura* invented by Renaissance painters, and its technology is indebted to archeology for rediscovering forgotten or underexploited procedures. In this regard, neoclassicism was a movement of rebirth. Its insatiable curiosity for artistic practices of the past also applied to ancient techniques, like wax painting or Roman mortar.

**120. Mirror from the Duchess of Parma's vanity, 1845–1851. (Musée d'Orsay, Paris)**

*This vanity was purchased through subscriptions for Louise-Marie-Thérèse de Bourbon-Artois, King Charles X's great-granddaughter, on the occasion of her 1845 wedding with the prince of Lucques, the future duke of Parma Charles III. Some parts of it were exhibited at the Industrial Manufacturing and Agricultural Products National Exposition of 1849. Its creation necessitated the collaboration of the architect Jacques-Félix Duban, the goldsmith Froment-Meurice, and the sculptors Feuchère and Geoffroy-Dechaume. The entire work was comprised of a table, a mirror (shown here), two jewelry boxes, a pitcher and washbasin, and a pair of candelabras. The decoration uses gilt bronze, silver-plated bronze, enamel-encrusted silver, carved iron, enamel, and glass.*

### Furniture

The art and furniture market was affected by industrialization thanks to the development of studios and a clientele that took interest in the fine and decorative arts. The Parisian and royal court cabinet manufacturer Jacob-Desmalter, Georges Jacob's son, profited from the large order to refurnish palaces and private homes that were emptied by the revolution of 1789. Nonetheless, in the end the empire and Restoration styles were impoverished by the overdone furniture pieces and inadequate bronze statues made for dignitaries and government employees. This trend gave way to copies of Louis XV and Louis XVI furniture, in vogue during the reigns of Louis-Philip and Napoleon III. The duchess of Parma's extravagant vanity set (fig. 120), produced in the workshops of the market leaders Froment-Meurice, was a masterpiece of eclecticism before the rise of Napoleon III. The Poussielgue-Rusand Company, which specialized in religious precious metal art, flourished at Saint-Sulpice. The company worked to a large extent from Viollet-le-Duc's original designs, which were a combination of Gothic and art nouveau styles (fig. 119); they faced competition from a precious metal art company in Lyons specializing in religious items. Parisian furniture companies were also able to create original works of art (fig. 118). Although production at Sèvres was revitalized, manufacturing in the Gobelins neighborhood tapered off, as tapestry making suffered from the effects of heavy competition from wallpaper production.

121. Nadar. Photograph of Claude Monet.

### THE LADIES READY-TO-WEAR DEPARTMENT

*...and ready-to-wear clothing was there, in this chapel devoted to the worship of feminine graces... There was something for every whim. The fabric exaggerated the mannequins' round throats, their wide hips emphasized the slenderness of their waists, while mirrors on both sides of the windows, in a calculated game, reflected and multiplied infinitely, peopling the streets with these young women for sale...*

Emile Zola, Au bonheur des dames
(Ladies' Paradise), 1883.

### Wallpaper

Printing a motif on a large sheet of fabric for home decoration was industrialized in 1760 by Christophe Oberkampf at Jouy, the home of the famous "toile" fabrics. Printing on large sheets of paper was also practiced in some companies, including Jean-Baptiste Réveillon's in the suburb of Saint-Antoine, a town pillaged during the revolution of 1789. The mass production of panoramic wallpapers obtained by placing several sheets side-by-side only started at the beginning of the nineteenth century. The manufacturers Dufour (fig. 12) and Desfossé (fig. 85) were concentrated in Paris. Their only true competition was in the Alsatian region, at Mulhouse and Rixheim, where the Dollfuss and Zuber manufacturing companies built upon local weaving traditions.

### International Expositions and Department Stores

Wallpaper first appeared at the 1806 Exposition of Industrial Products. Its success was assured by an exposition of the same type held in 1819. These expositions, begun in 1798 by an initiative from the government, were to French industry and crafts what the Salons were to painting and sculpture. Eleven expositions of this type took place in a half century. They only ended to make way for the international expositions that were open to non-national products as well. The Crystal Palace, the first of these international expositions, was held in London in 1851. Napoleon III imitated the English example in 1855 and 1867. The Exposition of 1855 took place on the Champs-Elysées and welcomed five million visitors; the one in 1867 on the Champ-de-Mars included thirty nations and eleven million

visitors. It acted as the ultimate reinvigorating force for Napoleon III's tired regime. The kick-start given to industry by these repeated demonstrations was not entirely beneficial to art. Creative talent was expended toward producing exposition masterpieces and installations assembled with the help of barges, like the duchess of Parma's vanity (fig. 120).

The creation of department stores full of new products, and the affordability of these new products, completely changed distribution practices. In 1852 Bon Marché opened its doors to huge crowds of shoppers, both rich and of moderate means, whom they offered all sorts of industrially fabricated products. Other businesses soon followed: the Louvre in 1855, the Bazar Napoleon in 1856 (which later became the Bazar de l'Hôtel de Ville), Printemps in 1865, and Samaritaine in 1869.

### The Clothing Industry and Haute Couture

Fashion was particularly affected by the department store phenomenon. In *Au bonheur des dames* (*The Ladies' Paradise*), written in 1883, Emile Zola described a woman's universe in 1860. The date 1860 also marks the birth of haute couture and the ready-to-wear clothing industry—industrial manufacturing of clothing became commercialized with the advent of department stores. Charles Frédéric Worth is considered to be the founder of haute couture. He opened a shop on Rue de la Paix in 1860 and was the designer for Napoleon III's Empress Eugénie. His major contribution was presenting a collection of clothing each season using living models. At first oddly called "doubles" or copies of live models, mannequins made by sculptors were on permanent display behind the counters ready to sport dresses for the clients. Winterhalter's painting portraying ladies of the court, who were to a great extent dressed by Worth (fig. 106), thus became a sort of advertisement. Advertising also grew tremendously in the nineteenth century, putting color prints and famous authors' words to work toward its own ends. From 1814 P. A. de la Mésangère published an advertising periodical that simultaneously presented the latest in fashion, furniture, and interior decorating. Inspired by Moreau Le Jeune's (Moreau the Younger's) example in the eighteenth century (chapt. X, fig. 14), Deveria published *Les Heures du jour* (*The Hours of the Day*) in 1829, eighteen lithographs of dresses for different times of the day. Théophile Gautier founded *Ariel*, and Balzac and Nodier regularly wrote for *La Mode* (*Fashion*), a style magazine founded by a famous newspaperman named Girardin; Gavarni and Deveria collaborated on its illustration.

### Art's Destiny

The industrialization and commercialization of art began to have an effect before the twentieth century. Certain artists had the feeling that they would be the last representatives in a line of European artists that had originated a thousand years before. "The sight of all these machines profoundly saddens me," Delacroix wrote about the Exposition of 1855. "I do not like this inanimate matter that appears to do things worthy of admiration all by itself and left to its own devices." In *The Work of Art in the Age of Mechanical Reproduction* (1936), Walter Benjamin defined the consequences of this major transformation perfectly: "It is possible that the new conditions created by technology of reproduction leave the content of art intact, but in every way they devalue its here and now." In other words, the limits of space and time in which we have enrobed our discourse, if not our art, has begun to disintegrate. We should think about this odd remark made by Baudelaire to his friend Manet about his painting *Olympia*: "You are only the first to have begun the decay of your art." Photography gave birth to the illusion that a few chemicals and exposure to light could produce a work of art and that capturing a fleeting image in time and space could arouse emotion. Paris, the old Paris before Haussmann's reconstruction, which up to that point had been just a subject for painters, became a work of art itself. Or rather, it became a monument, a space of memories, matter transformed by an artist who had always been thought of as accursed: an artist called Time.

122. Nadar. Photograph of Edouard Manet.

123. Nadar. Photograph of Camille Corot.

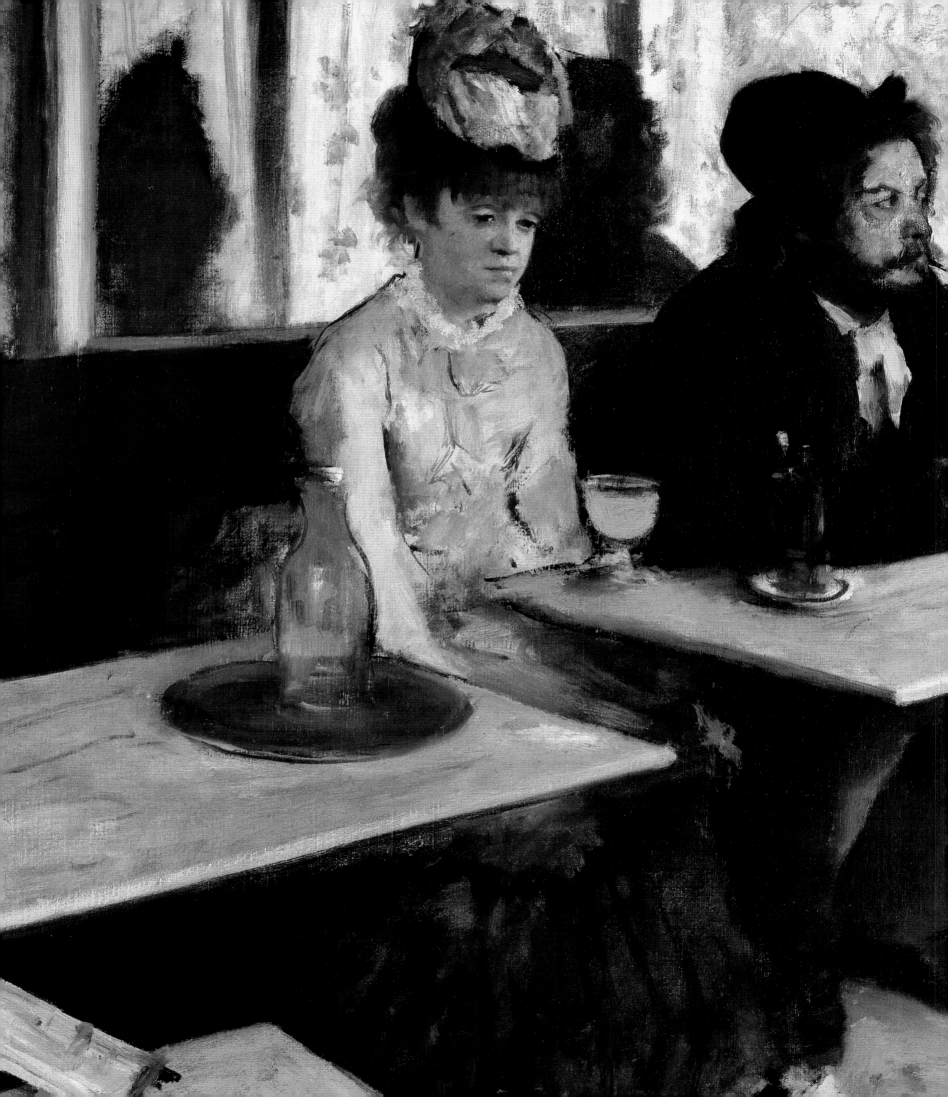

# Chapter XII
# THE BELLE EPOQUE
## (1870–1914)

During the last decades of the nineteenth century and the first decades of the twentieth century, the ambition to be modern, which has always been a periodic cause for disruption in the course of artistic production, was stimulated by an accelerated evolution of technology. This had significant economic and social consequences. In just a few years electricity, the telephone, the automobile, the airplane, cinema, steel, and reinforced concrete were invented. Painters and sculptors began to create what poets called "machines with a soul." Two famous locomotives, the Crampton and the Engerth, were described by Joris-Karl Huysmans in his novel *A Rebours* (*Against Nature*), 1884, as "an adorable blond with a shrill voice and a long slender body" and "an enormous, gloomy brunette, with hoarse, harsh voice and thickset hips" (Joris-Karl Huysmans, *Against Nature*, trans. Margaret Mauldon, 1998). Nonetheless, "it is not in the painter's and sculptor's studios that the oft foretold, oft desired revolution is brewing, it is in the factories. Forms are born under the crude hammer of the iron workers," wrote Octave Mirbeau about the Exposition of 1889, impetus for the construction of the Palais des Machines (Hall of Machines) and the Eiffel Tower. The international expositions, as meeting places and opportunities for competition among nations, with their grand displays of goods and throngs of peoples, had significant effects on Paris. These expositions spared the capital city during the period's frequent economic downturns. If Paris escaped the depression of the 1870s, it was surely due to work on the completion of the building sites begun by Baron Haussmann, as well as to activity associated with the international expositions held in Paris in 1878, 1889, and 1900. The Exposition of 1889, held on the 100th anniversary of the French Revolution, was the pinnacle. From 1895 onward, an economic upturn contributed to the euphoria of the Belle Epoque, an era ushered in by the Exposition of 1900.

2. Pablo Picasso.
*Le Repas frugal*
(*The Frugal Repast*),
etching, 1904.
(Bibliothèque
Nationale de
France, Paris)

*One of Picasso's very
first etchings, it was
executed in Paris. It is
contemporary with the
Rose Period and
illustrates one of the
period's common themes.*

## THE EIFFEL TOWER

This open letter published by *Le Temps* on February 14, 1887 was signed by François Coppée, Alexandre Dumas, Guy de Maupassant, Sully Prudhomme, Charles Garnier, etc. (Translation by Joseph Harriss, *The Tallest Tower: Eiffel and the Belle Epoque*, 1975)

### 3–4. Palais des Machines (Machines) of the Exposition of 1889

*The Palais des Machines was built between 1887 and 1889 by the architect Ferdinand Dutert, the engineer Victor Contamin, and the Fives-Lille et Moisant Company for the 1889 Exposition. It was dismantled in 1909.*

### 5–6. Below and opposite. Eiffel Tower

*The Eiffel Tower was erected from 1887 to 1889 for the International Exposition of 1889 by the engineers Maurice Koechlin and Emile Nouguier, the architect Stephen Sauvestre, and the Eiffel Company headed by Gustave Eiffel.*

### Artists in Paris

The Belle Epoque was marked by an influx of foreign artists that was unprecedented in size and diversity. The largest number of emigrants into France was from Central and Eastern Europe. Heavy Russian immigration right before World War I was perhaps a consequence of the Franco-Russian alliance, but most certainly was also an effect of modernity's influence on the old structures of Imperial Russia, a regime that would come to an end during the war. German immigration became just a curiously recorded memory in the Parisian

toponymy: Gustave Eiffel was a descendant of a Rhinelander who established himself in Paris at the beginning of the eighteenth century, where he practiced the craft of tapestry making. His name was impossible to pronounce in French, so he changed it to Eiffel, a name borrowed from a large mountain range near the city of Cologne and his hometown. By way of the famous tower, the name Eiffel went from dominating the heights of the Rhine River to towering over the Seine.

Foreigners and Frenchmen on the fringes of the academies grouped together at Montmartre. It has been described above how an artists' neighborhood was established in the area between the boulevards and the foot of the Montmartre hill. But the colony of artists on the hill itself was not formed until the last decade of the nineteenth century. It made the cabarets Le Moulin de la Galette, Le Moulin Rouge, Le Lapin Agile, and Le Chat Noir famous the world over. Le Bateau-Lavoir, previously a piano factory, was converted into ten studios, including one occupied by Picasso upon his move to Paris in 1904.

In addition to the growth of Paris itself, the return to the countryside, whose first signs were mentioned in the previous chapter, sparked growth mainly west of the capital—an area favored by development in Paris. In addition, the region of Normandy to the northwest was a draw. The main sites for impressionist painting were for the most part in present-day Paris, but sites were also located farther west. Artists practicing heliotropism, who had previously preferred Italy, began to favor almost exclusively the shores of the Mediterranean between the Alps and the Pyrenees mountain ranges. At first these migrations were seasonal, but during the war the number of lasting, even permanent, settlements multiplied.

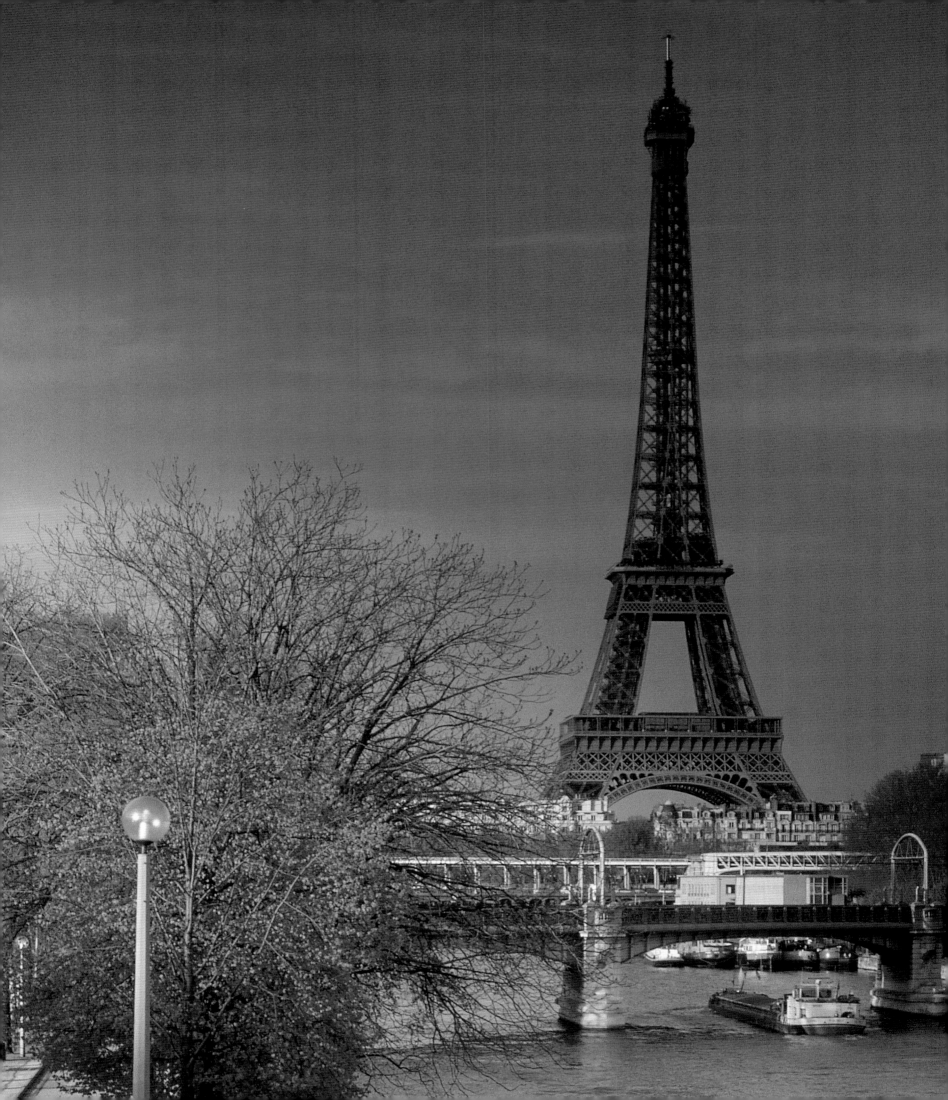

## 7. Menier Chocolate Factory at Noisiel

*This factory was founded in 1825 by J. A. B. Menier, a pharmacist who invented a millstone system that he could use to pulverize cocoa beans into powder. He invented the system while working at a pharmacy in the Marais, a historic district in central Paris. The factory was entirely rebuilt by his son Emile so that it could process cocoa continuously without interrupting the different operations of the manufacturing procedure. The main element is a water mill that draws its power from the Marne River. The architect Jules Saulnier and the engineer Armand Moisant built it from 1871 to 1872. The mill building is constructed of a metal framework and sheathed with light-colored enameled bricks decorated with the Menier "M" and earthenware cocoa flowers.*

### International Rivalry

The fact that Paris claimed to be the "artistic capital of the world," and was recognized as such, did little to hide an incongruous situation. Great Britain dominated the decorative arts thanks to the powerful Arts and Crafts Exhibition Society founded in 1886 by William Morris. The society rejected the mechanization of the manufacture of furniture and domestic objects, advocated a return to master craftsmanship, and abolished the long-held distinctions between the major and minor arts. The Arts and Crafts Society created works that can be classified under the rubric of "Total Art," or the "Modern Style." This style was also known as "Art Nouveau" in France and Belgium, as "Liberty" in Italy, as "Jugendstil" in Germany, as "Secession" in Austria, and as "Arte Juven" or "Modernista" in Spain. Although of a similar vein, each of these European derivatives of the Modern Style produced diverse forms. To do so the artists drew from many sources. Often, for example, they used Beardsley's silhouettes of women-flowers. An heir of the Pre-Raphaelites, Aubrey Beardsley illustrated Oscar Wilde's *Salome* from 1894. They borrowed from the *Japonisme* of Arthur Lasenby Liberty, a friend of Morris who founded a design house in 1875, and gave Europe a taste for Japanese art (hence Italian artists' use of the name Liberty to designate the Modern Style). One of the most frequent sources was the "Total Art" that Charles Rennie Mackintosh created in Glasgow (the School of Fine Arts was built in 1897) and whose developments were as far-reaching as Vienna and Brussels, which were two capitals of modernity in domains other than art.

In 1873 Vienna was the first city to break the stronghold on international expositions, which had been held exclusively by London and Paris until that time. From 1897 on, Brussels rivaled Paris in the number of expositions it hosted. In Vienna the Secession blossomed under the domination of Otto Wagner's powerful personality. Joseph Marie Olbrich, a disciple of Wagner, built the Secession building from 1898 to 1899. Following the Glasgow School's example, the Viennese school distinguished itself in two ways: in its philosophy of rationalism, and in the invention of a catalog of forms and ornaments. It was also in Vienna that the pioneer of the avant-garde, Adolph Loos, appeared on the scene to declare that decorative embellishment was a "crime." In 1906 Loos founded a "free" school of architecture that was not bound to the ideology of any one school in particular. In 1910 he constructed the Maison Steiner that was described as being as beautiful (in other words as simple and as functional) as a "container."

The Belgian Henry van de Velde, who had inherited ideas from the Arts and Crafts Society and whose career had become international, left Brussels for Paris, the city that cultivated the talent of all its exiles. In Brussels two architectural masterpieces were erected: the Hôtel Tassel (1893) and the Palais Stoclet (1905). Attributed to Victor Horta, the Hôtel Tassel is said to be the building that ushered in the French art nouveau period. The Palais Stoclet prefigured the modernity of the 1920s. It was built by Josef Hoffmann, a Viennese disciple of Wagner, and strongly resembles Mackintosh's 1901 house design project for art amateurs. Both the Hôtel Tassel and the Palais Stoclet were handed over to their owners complete with furniture fashioned in the art nouveau style. The designers of the palace even made outfits for the Stoclet couple!

As compared to its stylistic counterparts, the Catalonia region of Spain belonged to a world apart. Barcelona, its capital, gave European art the most famous examples of the style. A regional school was formed around Antoni Gaudi. Although not greatly influential, the school produced powerfully original work. Construction of the Sagrada Familia commenced in 1884; the Güell Park was begun

in 1898. In Germany in 1892, the Grand Duke Ernest Ludwig of Darmstadt, in conjunction with Olbrich and Peter Behrens, created an association of artists that would transform the capital, Darmstadt. The Deutscher Werkbund, founded in 1907, was an association that included van de Velde, Hoffmann, Behrens, and Walter Gropius. These last two artists left two brilliant works so innovative that they could date from the present time: the Turbinenhaus (a turbine factory) constructed by Behrens for AEG (Allgemeine Elektricitäts-Gesellschaft; 1907), and the Fagus factories made entirely of glass by Gropius (1911). Finland made its mark for the first time in the history of European architecture with the Finnish Pavilion built by Eero Saarinen for the Exposition of 1900. In Russia *Mir Iskoustva* (*The World of Art*) was founded. It was a journal for artists who intended to open up the Tzarist empire to western modernity. Its contributors included Alexandre Benois, Léon Bakst, and the creator of the Ballets Russes in Paris, Sergey Diaghilev. The United States had prepared to welcome the European emigration of modernity with open arms. During the same year, in 1871, Paris and Chicago both burned. In 1883, while Paris was still in the throes of Haussmann-inspired construction characteristic of the Napoleon III era, the first skyscrapers were erected in Chicago.

## Total Art

Considering its diverse inclinations, ambiguous protocols, and the versatility of its artists, Total Art could be characterized as eclectic. Ruptures among the various groups produced by incessant declarations of revolution could be seen as a natural evolution. If it had not been propelled forward by the mercurial progress of technology, the same avant-garde that had claimed to monopolize the modern movement and intended to break with the age-old, diverse history of forms, would have been just another discourse on modernity. Its metamorphosis, albeit superb, would have been merely stylistic. The avant-garde would have been regarded only as the gaudiest hue on the multicolored palette of modernity.

The sole conviction shared by a majority of artists in the Total Art group was that art constituted a whole, meaning it should include the mastery of architectural structures as well as the design of decor, furniture, and objects. According to Nabi painter Jan Verkade, interest in this kind of production, which did not allow painting the freedom of isolation from the other arts, arose around 1890. This proposition was nothing new. But neophyte practitioners of the theory of art as whole, who knew nothing of or preferred to ignore other precedents like the one set by Charles Le Brun and his Royal Factory, could commune in their faith in modernity. However, applied art's annexation of architecture, as well as its application to painting and monumental sculpture, paradoxically revitalized the decorative arts that the avant-garde had claimed to banish.

### 8-9. Church of Saint-Jean-de-Montmartre

*This church was built between 1894 and 1904 by Anatole de Baudot using reinforced concrete and modern hollowed bricks.*

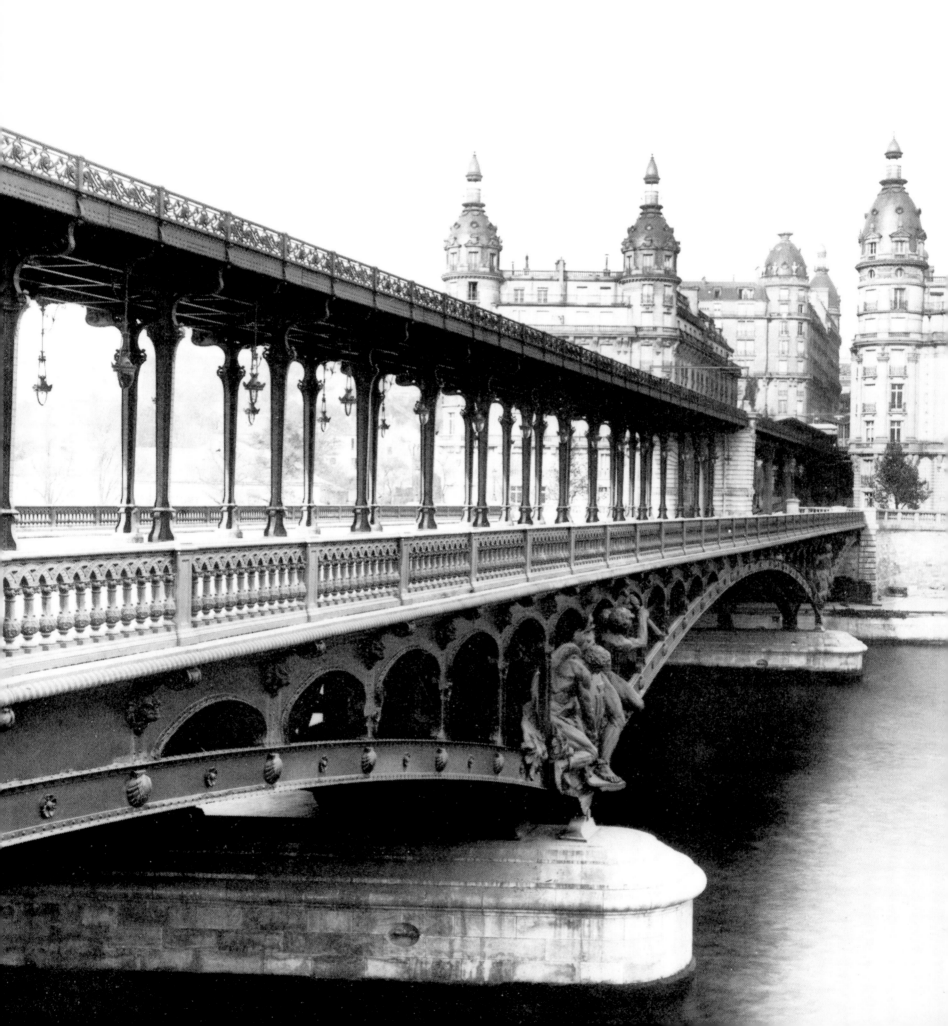

## Viollet-le-Duc's *Entretiens*

The founding doctrine of modernity in architecture was given a theoretical definition in Viollet-le-Duc's *Entretiens sur l'architecture* (*Lectures on Architecture*), an extensive history of universal architecture. It made considerable waves in France and abroad. Although the author was a fine scholar, a brilliant draftsman, an inspired expert on ornamentation, and a prolific restaurateur, he was a fairly mediocre architect. His discussion on the function of the ogive had certainly prepared him to become a leading theoretician of rationalism, despite the informed criticism made by Pol Abraham that classified Viollet-le-Duc's main thesis as "romanticized mechanical engineering." The creative imagination that he unleashed on restoration work sites proved to be a shortcoming when it came to his own productions, notably his feebly historicist design for the Opéra (1861), which rightfully lost the competition to the plan of the genius architect Charles Garnier. In addition to the failure of his plans for the Opéra, the teaching he

Opposite:

**10. Viaduc de Passy, also known as the Pont de Bir-Hakeim**

*This bridge was constructed between 1903 and 1904 by the engineer Louis Biette and the architect Jean-Camille Formigé and given the name Viaduc de Passy. The top level was reserved for the passage of Parisian métro (subway) trains. The sculptures portray riveters working on the bridge.*

attempted to dispense at the Ecole des Beaux-Arts in favor of a reform of the school was rejected by defenders of the classical tradition. Both of these major turning points in Viollet-le-Duc's career occurred at the beginning of the 1860s. But in 1863, he published the first volume of *Entretiens*. This was the material that he had planned to teach before he was booed out of the auditorium. In fact, Viollet-le-Duc was invited to teach history at the Ecole des Beaux-Arts, rather than the subject that he proposed. In 1872 the second volume was published, his swan song: he died in 1879. Surprisingly, the moderns looked to it as a source of support for their own ends. With this final maneuver, Viollet-le-Duc recaptured the avant-garde of his century. To give you one idea of its importance, we can say that the *Entretiens* became for modern archi-

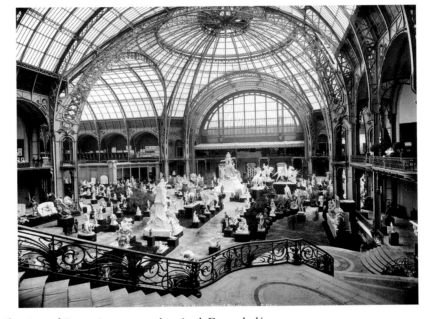

**11. International Exposition of 1900**

*Sculptures were displayed in the Grand Palais, a building that was constructed for the occasion.*

tecture what Nicolas Boileau's *L'Art poétique* (*The Art of Poetry*) was to classical French literature: it was a theoretical formulation subsequent to its first practical applications. The second volume of the *Entretiens* was published about a half a century after the work of Henri Labrouste and the other Boileau, the architect of the synthetic cathedral (chapt. XI, figs. 35) that inspired the most famous illustrations in the *Entretiens*. Furthermore, Viollet-le-Duc's professed doctrine fit well within the French rationalist tradition: "Architecture can only assume new forms if it seeks them out through the rigorous application of new structures," he wrote (Viollet-le-Duc, *Lectures on Architecture*, trans. Benjamin Buckness, 1987).

## Material Modernity

The avant-garde claimed that the use of new materials was what defined its project, but it was not the only movement using them. Its differences from conventional academism were primarily of appearance. What was at stake was purely stylistic: Should modern structures be shown, or hidden behind stone facades? That was the discriminating question. In reality, what could be called "material" modernity does not belong to any school. Its most noteworthy productions, like the metal Eiffel Tower (figs. 5–6) or the concrete Saint-Jean-de-Montmartre Church (figs. 8–9), escape any attempt at stylistic classification.

While the tower was under construction, Eiffel stated a perfectly orthodox profession of rationalist faith: "The first principle of architectural aesthetics is that the essential lines of a construction be determined by a perfect appropriateness to its use. What conditions, above all, did I have to take into account? Wind resistance. So then, I submit that the curves of the monument's four piers as

## 12. Grand Palais and Pont Alexandre III

*This building and bridge were built for the International Exposition of 1900. The Grand Palais is a covered hall of iron attributed to the engineer Albert Louvet. A team of workers created its stone facade and sculptures. The bridge, made of steel and cast iron, was built from 1897 to 1900 by a team of engineers, architects, and sculptors, notably the engineer Jean Resal and architects Cassien Bernard and Gaston Cousin. The bridge was named for Tzar Alexander III in celebration of Franco-Russian friendship.*

*Founded in 1852 by Aristide and Marguerite Boucicaut, the Bon Marché's first major construction work lasted from 1869 to 1870. The part built from 1872 to 1874, with an iron framework by Louis-Charles Boileau, made it the archetypal example of Parisian department stores.*

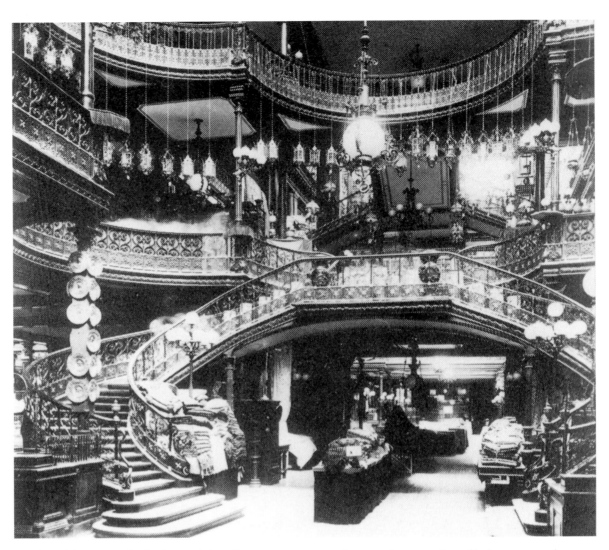

THE DEPARTMENT STORE:
*THE LADIES' PARADISE*

*It was like the nave of a train station, surrounded by ramps on two floors and bisected by suspended staircases. Iron staircases with two symmetrical wings added bold curves and provided extra landings. Like iron bridges, they were tossed out into empty space, wound around very high to the right. All this iron, under the white light of the windows, made for a light architecture, an intricate lace penetrated by daylight, the modern realization of a dream palace, of a high-rise Tower of Babel. It expanded the rooms and unfurled infinite vistas to other floors and other rooms. As for the rest, iron ruled everywhere. The young architect had the honesty and courage not to disguise it with whitewash in imitation of stone or wood… Under the covered arcades, the exposed bricks of the tiny arches were enameled with brilliant colors. Mosaic and ceramic tiles became ornamental, enlivened the friezes, and brightened the severity of the whole with their fresh notes.*

*Emile Zola,* Au Bonheur des Dames
(The Ladies' Paradise), *1883.*

produced by our calculations, rising from an enormous base and narrowing all the way to the top, will give a great impression of strength and beauty" (*Le Temps*, 1887). Debate over the conservation of the tower, which was originally to be dismantled at the end of the Exposition of 1889, shifted in focus; the architectural feat was then reconsidered in an aesthetic light. In an open letter from artists to the review *Le Temps*, the tower was described as an "abominable column of bolted sheet metal" (*Le Temps*, 1887). How different our perspective on the tower is today! In his 1964 essay *The Eiffel Tower*, Roland Barthes describes how this symbol of France stands as an "infinite cipher": "In turn and according to the appeals of our imagination, [the tower has become] the symbol of Paris, of modernity, of communication [it served as a radio transmitter], of science, or of the nineteenth century, rocket, stem, derrick, phallus, lightening rod or insect" (Roland Barthes, *The Eiffel Tower, and other Mythologies*, trans. Richard Howard, 1979).

*Engineers and Engineering Companies*
From the time of the Eiffel Tower debate forward, the threat of forever remaining the most modest category of fine arts weighed heavily on exposed metal architecture. This threat was fostered by engineers and engineering companies who were now competing against each other, instead of working together as they had done in the past, as producers of material modernity. Traditionally, engineers and engineering companies worked as one. Engineers founded firms in order to develop patents that would make each company the final, sole author of the work. The Eiffel Tower was named for Gustave Eiffel, the engineer who founded the firm. In reality, its construction was made possible by the competence of two in-house engineers, Nouguier and Koechlin. The role of the architect Stephen Sylvestre was quite secondary.

Economics, rapid assemblage and dismantling, industrialization, and prefabrication made metal the absolute choice material for the contemporary architecture for the expositions. This explains the

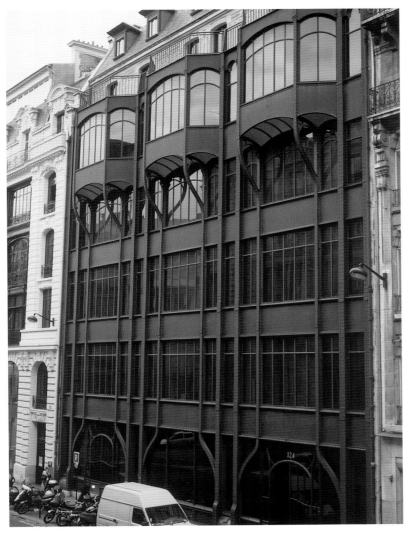

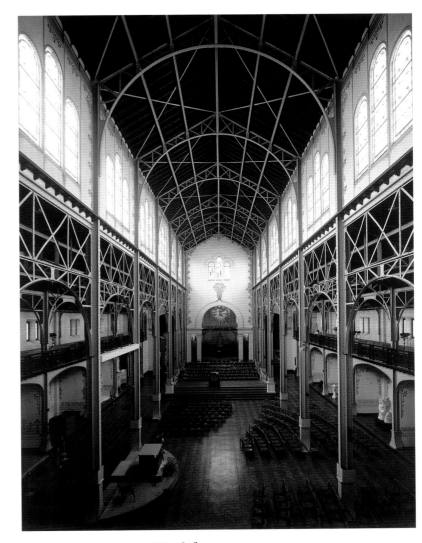

astonishing concentration of industries and companies working on architecture and works of art in the Parisian urban area. During the Belle Epoque some companies were located in Paris proper, others were in nearby suburbs. Eiffel was in Levallois-Perret; Moisant was first located at Vaugirard, then at Ivry; and Joly was at Argenteuil. It is true that the oldest and most powerful of the firms, Schneider, was established at Creusot, a location far from Paris, but the firm worked very little on architecture.

*The Capabilities of Metal Architecture*
Metal architecture triumphed in France during the period from 1870 to 1900. Metal manufacturing was spurred on during the entire Second Empire by the desire to displace the preeminent British industry. It was unbridled by the invention of the Thomas process from 1877 to 1881 that allowed for the production of steel from phosphorescent ore. From this time forward, France increased its performance and sucessfully repositioned its architecture as number one worldwide.

The architect Jules Saulnier and the engineer Armand Moisant, founder of the Moisant Company, built the first building in the world with an entirely metal structure: the famous mill of the Menier Chocolate Factory at Noisiel (fig. 7). The walls were formed of an iron lattice trellis and modern hollowed bricks. They were reminiscent of wooden constructions, but were no longer weight bearing. The weight was transferred to cast-iron pillars on the interior. The construction of this mill preceded the famous decade of the first Chicago skyscrapers, but originated from the same principle.

At the 1889 Exposition, France beat two records, one for height and one of range for supporting heavy weights. The Eiffel Tower was composed of 328 yards of riveted iron. The Palais des Machines was 126 yards wide, with a room measuring 49 yards high and 470 yards long (figs. 3–4): "In this incredible space, in all this emptiness, the enormous machines [seemed] shrunken down,

Top left:
### 14. Apartment Building, 124, Rue de Réaumur
*This building in iron, built by Georges Chedanne from 1904 to 1905, was used as a fabric warehouse.*

Top right:
### 15. Church of Notre-Dame-du-Travail
*Jules Astruc built this church for a working-class parish between 1899 and 1901.*

as if they were nearly dwarfs," wrote Huysmans (1889), who also described the palace as an "exorbitant ogive." Two important metal structure buildings, the Grand Palais (figs. 11–12) and the Gare d'Orsay (Orsay Train Station), were built for the Exposition of 1900 but not taken into account in the history of modernity since they were masked by stone. On the other hand, the Pont Alexandre III (fig. 12), another star of the Exposition of 1900, did make its mark in the record books as innovative, in that archivolts of molded steel were used for the first time. They formed a single, heavy, weight-bearing arch and although the metal structure was hidden by decoration, it was certainly cast iron and constituted a masterpiece of Belle Epoque art. The austere modern interior of the Notre-Dame-du-Travail Church (fig. 15), also built for the Exposition of 1900, approximates that of an airplane hangar. Like the Grand Palais and Gare d'Orsay, its exposed metal architecture is hidden. Despite its commonplace neo-Romanesque facade, it was saved from obscurity by its dedication to the work world.

Construction spanning the Seine provided Paris with several good examples of a technique for bridges that was only fully realized in mountain sites or at river estuaries. The Pont Mirabeau is a multi-span bridge ("pont-console") of a common type that the engineer Jean Resal perfected by using counterbalancing posts anchored below shallow waters in dry land. The modern poet Apollinaire recognized this as a poetic work of art. If the similarly constructed viaducts of Austerlitz and Passy (fig. 10) had been without the practical function of allowing overhead subway trains to cross the Seine from both the east and west, one could believe that they had been invented solely for the purpose of awakening a poet's imagination. Watching from the banks, the poet would first see two riveters on the flanks of the Passy viaduct, a Hercules with a hammer, then a Hercules of metallurgy. Both would then yield their place to welders, the bearers of fire who were attaching the city of Paris's coat of arms to the bridge. Above on the subway tracks, the metro car, having crossed the Seine, would finally be engulfed in a gorge between two turreted cornered buildings characteristic of Haussmann's architecture. For the poet, it would be as though the Third Republic's Parisian urban planning, after having survived crossing an abyss, had swallowed up all of modernity.

## THE PONT MIRABEAU

*The Pont Mirabeau is a multi-span bridge ("pont-console") whose operating principle can be compared to that of a crane. Two twin beams (the arm of the crane) positioned opposite one another come together in the middle of the bridge to form an arch. Concrete piles near the banks support the arch beams and carry the load. As counterweights, the piles are anchored in the ground, in dry land. The praises of this technological masterpiece were sung by the poet Apollinaire in his collection* Alcools *(1898–1913): "Under the Mirabeau Bridge the river slips away / And lovers / Must I be reminded / Joy came always after pain / The night is a clock chiming / The days go by not I …"*

*Apollinaire,* Alcools, *translated by Donald Revell, 1898–1913.*

### Cement and Reinforced Concrete

The capabilities of cement and reinforced concrete soon surpassed those of metal. Cement is a mixture of limestone and clay. When added to sand and water, it yields a paste that hardens when it dries. Concrete is obtained by mixing pebbles into the cement. The modern innovation in cement was one of composition (for the Romans were already making concrete and mixing pebbles with mortar), as well as in the usage of rods or metal trellises to reinforce the concrete. Due to its mass, reinforced concrete is the ideal material for resisting compression; its framework makes it ideal for resisting tensile stress. It responds to all sorts of structural demands with a remarkable holding power. Like cast iron, it can be easily molded. With the application of an appropriate treatment, or an addition of either glossy- or matte-colored materials, it can take on a beautiful finish. If reinforced concrete received bad press from the general public, the responsibility rests with the avant-garde, as we will later see, for using it as they did. Historically, there has been little concern for conserving early examples of its usage. Maintenance and conservation of the first reinforced concrete works continues to present serious problems.

The cement factory that opened at Saint-Denis in the middle of the nineteenth century was among the first of its kind. The first patents for cement were filed at the same time. In 1867 a building made of non-reinforced concrete was built in Paris. Reinforced concrete was used in the construction of a building as early as 1876, but this was in the United States. A patent filed in 1892 by François Hennebique stood out for its originality, but would become even more important when the works built by its holder demonstrated extraordinary commercial and industrial savoir faire. The networks of Hennebique agents and franchise holders even extended to foreign lands. So it is with reinforced concrete that the history of iron and steel companies was written. Hennebique's family home in Bourg-la-Reine in greater Paris became a good source of publicity for this innovation.

The church of Saint-Jean-de-Montmartre, built by Anatole de Baudot using a technique protected by a Cottancin-Baudot patent, stands out mostly for its daringly innovative structure. The church was seen as quite bold in its day, for it had a two-and-three-quarter-inch-thick slab between the crypt and the nave. It is less striking to us today since other more impressive reinforced-concrete overhangs have been built since. On the other hand, the building's style still arouses admiration. But just how can this particular style be defined? It would not be fitting to call it "eclectic," however, it is composed of Gothic, mudejar, and even baroque elements.

The Perret brothers—Auguste, Claude, and Gustave—were first and foremost building entrepreneurs who specialized in reinforced-concrete construction. They used the Hennebique technique of reinforced concrete without making any notable improvements to it, nor attempting to increase performance for its own sake; they were architects, though. As architects they practiced a strongly typecast, rationalist architecture. The Perret style could not be confused with any other. Completed in 1913, the Champs-Elysées Theater is a complex ensemble of three rooms supported by interior structures of reinforced concrete that are heralded by a classically strict marble facade. Unfortunately, we cannot be sure in the midst of all this what can be attributed to Auguste Perret, since van de Velde and another architect worked on the construction site before him. The actual facade should be attributed more to the sculptor Antoine Bourdelle than to Perret. The undeniable quality of the work would have earned it some notoriety; its fame came from the Ballets Russes and the Revue Nègre performed in the theater. Nonetheless, the architectural style typical of the Perret brothers was also significant in the contemporary life of the time. It was described as "Germanic." Later all concrete architecture would be called "Bolshevik." Despite these foreign labels, it was also identified with the first expressions of a classicism that would reverberate with French "touches" by the 1930s.

### Brick and Ceramic Surfacing

The use of brick and ceramic surfacing (figs. 21–24) during the Belle Epoque can only be called new in that it acquired a new prestige during the era. Brick and ceramic gained importance because stone went out of fashion, a taste developed for the multicolored look, and finally because of the industrialization of their manufacture. The multicolored brick of the Noisiel factory (fig. 7) was manufactured on site at the time of construction, just as it

had been done traditionally. In a half a century, from the middle of the nineteenth century, when brick and tile manufacturing became mechanized in Alsace, the industry began a symbolic migration toward the Parisian suburbs. The Alsatian machines multiplied the output of the brick maker five-fold. The refinement of mechanized tile production that made a system of interlocking tile possible was the work of the Alsatian Gilardoni family. In 1870 this family moved their factory to Choisy-le-Roi, a suburb just south of Paris, taking their cue from another Alsatian, Emile Muller, who established a tile factory in another suburban town south of the capital, Ivry-sur-Seine, as early as 1854. The neighboring communes of Choisy and Ivry were chosen because of the presence of traditional faïence craftsmen in the area. Thus, a zone of ceramic production was created on the banks of the Seine, upriver from Paris. The Boulenger Company, who produced the beveled white square tiles still found in the metro and on the facade of the Sauvage building on the Rue Vavin was also located there (fig. 21). By 1878 Hippolyte Boulenger had transformed his family's small business at Choisy-le-Roi into a highly profitable enterprise (fig. 31). Brick has a place in the history of style, but it also belongs to the history of technology for the usage that Baudot made of hollow modern brick in the church of Saint-Jean-de-Montmartre. At the Villa Weber (fig. 24), brick also joins a festival of colors, along with the other materials found there—tile, ceramic decor, millstone, and marble. The name of the ceramic artisan Antoine Bigot is associated with a number of buildings that lost nothing of their modernist reputation by being covered in the fired sandstone that became Bigot's specialty. Fired sandstone is a ceramic baked in fire. The flames create a variety of color tones. Of Chinese origin, the secret to this technique was only discovered in France in 1882, at Sèvres.

### 18. Comptoir national d'escompte (National Discount Trading Post)

*The headquarters of the National Discount Trading Post, founded in 1848, was reconstructed from 1878 to 1881 by Edouard-Jules Corroyer on its original site (14, Rue Bergère). The facade features three statues by Aimé Millet that represent Prudence, Commerce, and Industry. Edouard Didron created stained-glass windows and mosaics inside the building.*

### 19. Hôtel Menier

*Henry Parent built this single-family house (5, Rue Van Dyck) from 1872 to 1874 for Emile Menier, the industrial magnate who owned the Noisiel chocolate factory (fig. 7). Jules Dalou created some of the facade's sculptures.*

### Commercial Buildings

The technological revolution at the turn of the century did not just extend to exposition pavilions, public buildings, and works of art, although modernity's effects on areas outside this huge domain are more difficult to ascertain. The building on Rue de Réaumur, built in 1904–1905 for warehousing fabric (fig. 14), is famous for its freestyle plan ("plan libre") and its exposed metal structure. The freestyle plan is the quintessential modern plan. Wooden planks for floors were delivered to construction sites without divisions so they could be added later according to the user's request. Yet for a storage building like the one on Rue de Réaumur, the freestyle plan was commonplace. Although the building's metal facade had a rugged beauty, we cannot be sure that the designers had not originally planned to cover it over with ornamentation. The department store Samaritaine, a work of the same period by Frantz Jourdain, became famous for

its exposed metal structure, which to observers of the time seemed as scandalous as a nude woman. The store's designer managed a deft salvage act by making a series of public and published declarations that positioned him as a champion of modernity. At present, this "nude" is still adorned with jewels in the flowery style of art nouveau.

Despite provoking scandal, the use of modern materials added new dimensions, in terms of floor-plan design, to department stores and banks. They were reorganized around a vast central lobby featuring a grand staircase. This layout played the dual roles of enlivening things with an air of festivity and facilitating the distribution of goods. When standing in the middle, visitors and clients must have been struck by the power of the establishment. They also were able, in a glance, to take in the location of different departments and services. The lobby made a sort of division in the terracing of the galleries and balconies. Among the many examples, one of the earliest was the Bon Marché department store's large metal lobby (fig. 13). It was emblematic of the type of store that inspired Emile Zola to write the novel *Au Bonheur des dames* (*The Ladies' Paradise*), 1883. The coming together of different businesses in the department stores was a product of the Second Empire, but the accompanying architectural mutation did not take place until the Belle Epoque, otherwise known as the "belle époque" for department stores. This is why the Bon Marché department store, although founded in 1852, did not begin construction of its great lobby until 1872; it was finished in 1874.

*Residential Buildings*
The advent of freestyle planning and the disappearance of weight-bearing walls made possible by the construction of metal and concrete interior structures had important consequences for residential buildings. The French art of skillfully designing rooms around weight-bearing structures became unnecessary. Freestyle planning gave the builder choices about how to distribute weight for a less constrained use of space, and it could easily be adapted to the customs and the common practices of the times. From the time that walls no longer had to be weight-bearing, it also became unnecessary to group together openings in sections so as to reserve wide walls as supporting pillars between doors and windows.

Two works of note are the buildings on Rue Franklin (figs. 22–23) and Rue Vavin (fig. 21) that draw most of their originality from their relaxation of the rules that had so restricted Haussmann-style buildings. The Rue Franklin building's courtyard opening onto the street and the Rue Vavin building's terrace were not simply rote exercises in style; they reflected a profound reorganization of size and distribution that consequently would replace the traditional interior courtyard with an open space along the streetfront. After the long reign of Haussmann the most innovative architects applied new ideas to buildings that were freely developed in single-family houses at the end of the eighteenth century (see the Hôtel Bouret de Vézelay, chapt. X, fig. 38) and the first half of the nineteenth century (see the Hôtel Duchesnois, chapt. XI, fig. 54). The Franklin and Vavin buildings still incorporated features common at that time: a structure of reinforced concrete and partial or total ceramic resurfacing. Flowers on the Rue Franklin building were a concession to art nouveau. The Rue Vavin building's "clinical"- or "subway"-style ceramic work is one of the most striking expressions of "hygienic" style developed by the avant-garde.

New materials were put to use in public-housing projects. Nineteen similar buildings located on Rue des Immeubles-Industriels (aptly named the Industrial Building Street) and constructed in 1872 and 1873 were made of cast iron and brick. The buildings housed small industry workshops and accommodations for artisans. Each basement contained a steam engine to provide energy for the workshops and apartments. Individual workshops were located on the first floor, mezzanine, and second floor; the top floors were used as housing. In 1903 Henri Sauvage built a public apartment building of reinforced concrete for a philanthropic association on Rue Trétaigne. On the first floor it contained a library, a theater, a store, a restaurant, and a public bathhouse.

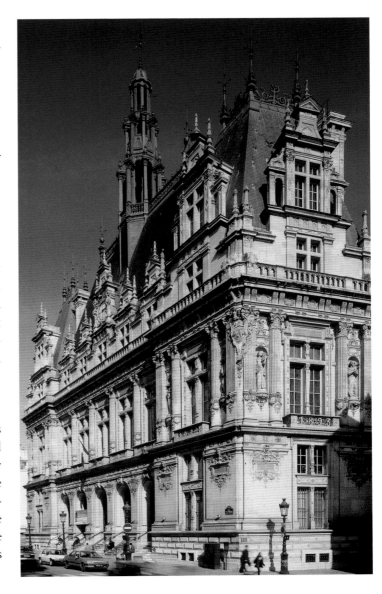

**20. City Hall, Tenth Arrondissement of Paris**
*Eugène Rouyer built this town hall between 1892 and 1898.*

### 21. Apartment Building, 26, Rue Vavin

*Henri Sauvage built this terraced apartment building covered with ceramic bricks from 1911 to 1912. He nicknamed it "la maison sportive" ("the athletic house") because sports were quite popular at the time of its construction.*

## 3 – THE BEAUX-ARTS STYLE AND ART NOUVEAU

The historical styles of architecture that dominated until World War I, including the style of Napoleon III, could be grouped under the rubric of the Beaux-Arts style. Indeed, it was in the studios of the Ecole des Beaux-Arts that these styles were taught and where most of the French practitioners and foreigners who would introduce Parisian architecture to their homelands learned them. The school's alumni directory published in 1907 contained the names of 350 foreigners, including 170 Americans from the United States. Between 1867 and 1908, a total of 400 Americans passed through the school.

After the failure of the 1863 attempts to reform the Ecole des Beaux-Arts, the Academy strictly controlled the teaching curriculum. In 1903 eight regional schools of architecture were created; the one in Paris still awards the competitive architectural prize, the Prix de Rome. Pastiche was taught in Paris. Although devalued as an art in the eyes of the modernist critic, it was nonetheless an art of invention fed by the past. With pastiche, an entire

history is evoked. This is so true that the Beaux-Arts style in any of its manifestations can be easily recognized. It is as easily identifiable as, for example, Picasso's own personal hand in his variations of paintings by Diego Velázquez, Eugène Delacroix, and Gustave Courbet. The Loire Valley style was used for the Hôtel Gaillard. For the city hall of the tenth arrondissement in Paris (fig. 20) the Renaissance style was invoked. The art of Ange-Jacques Gabriel, the First Architect under King Louis XV, whom neoclassical artists later mocked relentlessly, became stylish again after the Goncourt brothers' restoration of art in the Louis XV style found favor. Certain Parisian architects specialized in the "Gabriel" style; the Count of Fels used it for his château during the same period in which he wrote a serious monograph devoted to Gabriel (1912). The Palais Rose, a marble palace built by Ernest Sanson for Anna Gould, an heiress to an American locomotive fortune, and her vivacious husband Boniface de Castellane, a major figure of the Belle Epoque, was a Parisian palace of one hundred rooms that pastiched the Grand Trianon and Ambassadors' Staircase at Versailles. The palace would not have been a victim of speculation had it not been condemned from the

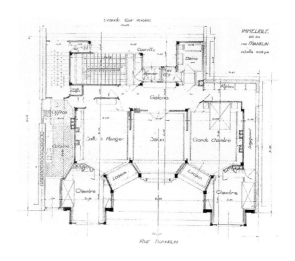

## 22–23. Apartment Building, 25, Rue Franklin

*From 1903 to 1904 this building was built according to plans drawn by the Perret Brothers—Auguste, Gustave, and Claude. It is made of reinforced concrete. François Hennebique's engineering firm did the technical calculations and Alexandre Bigot made the facade of fired sandstone.*

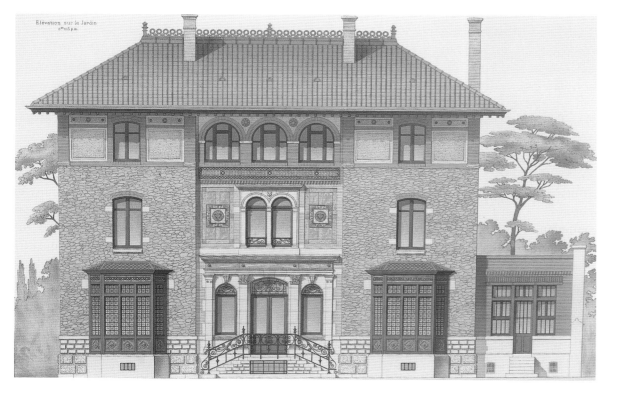

## 24. Villa Weber

*Paul Sédille built this villa, located at 9, Rue Erlanger, for Camille Weber around 1885.*

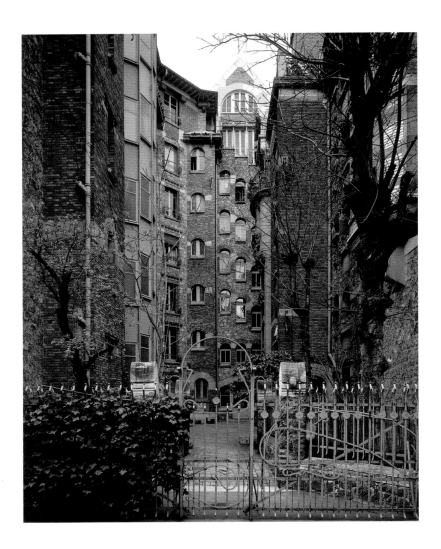

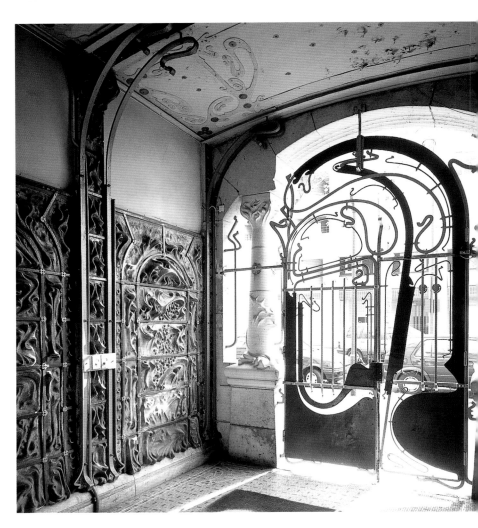

### 25–26. Castel Béranger

*Hector Guimard built this complex of connected apartment buildings, located at number 16, Rue la Fontaine, between 1895 and 1898. This is the first example of the Guimard style. Its facade took first prize in the city of Paris's first facade competition. For a rent-controlled building, the decoration was unusually extensive. Guimard had his agency develop the decorative plan.*

start by the dogma of modernist artists. Another even larger example of the Parisian palace called the Marble House can be found in Newport, Rhode Island. Richard Morris Hunt built it in the Beaux-Arts style for the American locomotive magnet Vanderbilt.

### The Sacré-Coeur Basilica

The Roman-Byzantine style made its way into the Parisian landscape with the basilica of Sacré-Coeur built on top of Montmartre (chapt. XI, fig. 43). It was commissioned by a conservative Catholic foundation called the National Vow Organization. Financed by subscription, the basilica served as a sort of retribution for the lack of religion that plagued the nation and to which the people attributed the catastrophes of the Franco-Prussian War and France's defeat in 1871. Some viewed the Gothic style as a sort of "national" style appropriate to such a project. To their indignation, it was not used in the design of the basilica. Perhaps because of his insistence that thirteenth-century Gothic was a secular style, Viollet-le-Duc actually undermined the style he had intended to defend. The competition's judges chose Paul Abadie's proposal. A church of the Roman-Byzantine style that the architect had previously restored, called Saint-Front De Périgueux, served as his inspiration. It is interesting to note that a controversial thesis contesting the Byzantine origin of the Roman style was formulated around Saint-Front. Abadie, an architect who restored the cathedral of Notre-Dame in Paris, was hired for the Saint-Front job. But his supposed restoration of Saint-Front was so radical that it was practically a redesign of the church. It is clear that Abadie was only imitating his own work: the Parisian Roman-Byzantine style was actually Abadie's own personal style. Due to Sacré-Coeur's distinguished location on the sacred Montmartre (whose name literally means the Mountain of the Martyrs) and the interest shown in it by "Montmartre" artists, it is the only monument not bordering the Seine that could be classified in the same league as the Eiffel Tower.

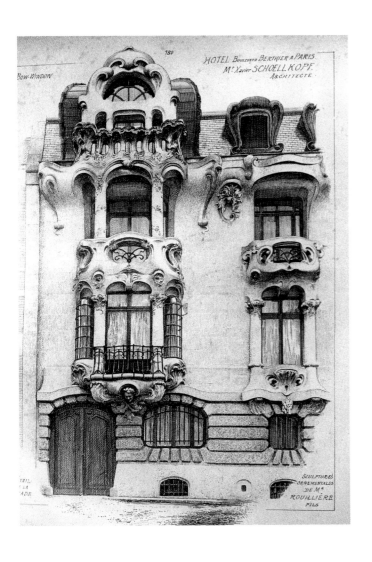

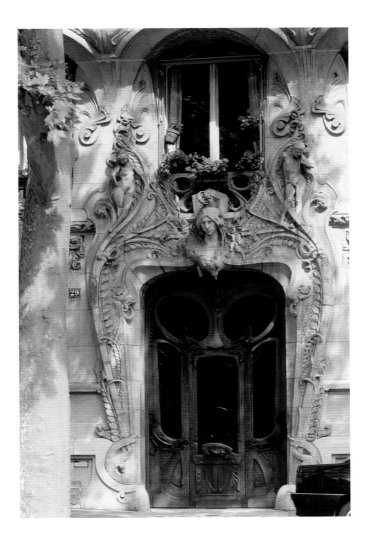

## The Palais du Trocadéro

The proliferation of architectural styles during the Belle Epoque was fueled by the capricious tastes of the Belle Epoque and by the international expositions that grouped together a caravanserai of nations on the banks of the Seine (figs. 16–17). The Palais du Trocadéro, built by the architect Gabriel Davioud on the hill of Chaillot for the Exposition of 1878, was the paragon of eclecticism: "Of the Palais du Trocadéro I would say that its style is Roman, Byzantine, and Florentine together and yet, at the same time, it is none of these styles," wrote Paul Sédille in 1878. Indignant modernists saw it as a "waste product of platitudes" and a "deplorable pot-pourri." This did not stop Viollet-le-Duc from firmly defending Davioud's proposal. A museum of comparative sculptures—a collection of molds of artworks from around the world, but notably from the French provinces—intended to pay tribute to the Parisian sovereign was created in the Palais du Trocadéro under Viollet-le-Duc's initiative.

## The Hôtel Menier

The Beaux-Arts style had direction and meaning: it expressed material success. Far from striking an incongruous chord next to steel and concrete architecture, it was its natural complement, for both were the ripe fruits of new wealth accumulated by the Industrial Revolution's innovative machinery and labor practices. Emile Menier, the leader of a progressive company and a deputy who voted for the extreme left, demonstrated this at Noisiel, where his metal chocolate mill was likened to a highly stylized worker's housing project and to a château in the style of Napoleon III. His mill corresponded to the style of the Hôtel Urbain, a building reputed to have been a model for the author Emile Zola's Hôtel de Rougon. A staunch defender of modernity, Zola chose this Beaux-Arts model as the fitting home for Rougon, an unscrupulous capitalist character described in the novel *La Curée*, published in 1871. For having too abundantly served the capital, the Napoleon III style, seen as a symbol

ART NOUVEAU

*The squash, the pumpkin, the marsh mallow root, and the wreath of smoke inspire an absurd type of furniture upon which the hydrangea, the bat, the tuberose, and the peacock's feather come to rest. These are the inventions of an artist seeking the fanaticism of a symbol. The furniture looks like the mental illnesses studied by psychologists, popular clinicians of the era. Their creators believe to be inspired by nature; never were they so wrong.*

*Paul Morand, 1900.*

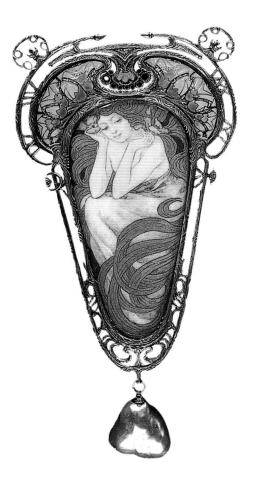

of the nouveau riche dripping with charm, certainly deserved disgrace. The fact remains that this style, so truly expressive of Paris's corruption and of the Belle Epoque, was nowhere near the last widespread international style that is still being identified today as truly Parisian.

### Art Nouveau in Nancy, France

Art of the Belle Epoque, called art nouveau, is not, despite appearances, specifically Parisian. In the city of Nancy, located in northwest France, the energy of the Lorraine region was truncated by the Franco-Prussian War, but its truncation proved to have made it more hardy. In Nancy Emile Gallé reinvented the art of glass, ceramic, and cabinetmaking. Cast, molded, and cut, his opaque and semi-translucent vases met with great success at the Exposition of 1889. The Ecole de Nancy, which specialized in the decorative arts, was founded in 1901. Yet the ties between Paris and Nancy were strong. In 1898 Henri Sauvage, a Parisian architect, built a house in Nancy, the first house that was constructed in the "Nancy" style, for the carpenter Louis Majorelle, who had himself designed the art nouveau decor of the Parisian restaurant Lucas-Carton.

### The Guimard Style

In 1895 the Castel Béranger was built in Paris (figs. 25–26). The framework of this large apartment building was almost finished when Hector Guimard discovered the art of Victor Horta, a Belgian architect and designer who rejected the academic dictates of his disciplines. After this, the project was profoundly modified. This "eccentric house" (as the painter Paul Signac, who lived there, described it) was like a catalog of the Guimard style, a style that Guimard was able to impose as the ultimate in art nouveau through skillful commercial politicking. A profusion of materials for both the framework and its second phase handled and shaped by the master's own hand included protruding elements that allowed the building to dominate the first annual facade competition. Organized by the city of Paris, this annual competition was a measure taken to free Parisian building from the heavy yoke of Haussmann-

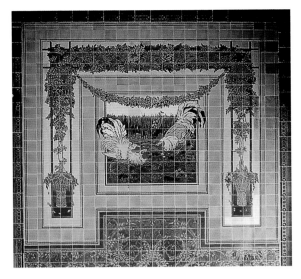

style architecture. The general tendency, which was expressly encouraged by a 1902 decree, was toward picturesque designs that would charm or amuse with surprising elements. It favored both art nouveau and eclecticism in Parisian buildings. Eclectic architects made the most of it by multiplying protruding balconies and bay windows and by decorating the facades with caryatids of large-breasted and ample-buttocked women fashioned to Belle-Epoque standards of female beauty. A few examples of Guimard's "kitsch" villas have been preserved in the suburbs. The Majorelle House in Nancy is characteristic of the style. It combined several different architectural forms intended to express the diversity of its functions. This course of action was nothing new. It first appeared in the early nineteenth century in suburban villas (chapt. XI, fig. 23) under Viollet-le-Duc's recommendation. Indeed, Guimard's career began as a deliberate tribute to Viollet-le-Duc. He used an illustration from the *Entretiens* to decorate the school of Sacré-Coeur on the Avenue de La Frillière.

### Samuel Bing, Jules Lavirotte, Alfons Mucha, and Others
In 1895, the same year that work began on the Castel Béranger, Samuel Bing opened an art nouveau gallery on Rue de Provence. Bing was a sort of old-fashioned haberdasher. As a collector of Japanese art, he manufactured Japanese *objets d'art* and also imported those made by Louis Comfort Tiffany of New York from 1879 forward. At the Exposition of 1900, the Bing Pavilion rivaled with the Loïe Fuller Theater built by Sauvage as representative of art nouveau. The American dancer Loïe Fuller's art was celebrated by Paris and was, in fact, a source for art nouveau. Like an "electric fairy" (a term of the era), Fuller wound enormous veils around herself and disappeared under them in a storm of light and wind. Even the design of the theater itself evoked a large, floating veil.

Jules Lavirotte covered Parisian buildings (fig. 28) with the "women-flowers" that the Czech painter and poster designer Alfons Mucha made famous in posters, book illustrations (fig. 29), and jewelry designs for the jeweler Georges Fouquet (fig. 30). Lavirotte also decorated Fouquet's jewelry boutique. The building designed by the architect Schoellkopf and built for Yvette Guilbert, the famous singer immortalized by Toulouse-Lautrec (fig. 27), was modeled after a slab of melting butter. It belonged to the "style nouille" ("noodle style"). Whether inspired by vegetation or pasta, this type of art definitely belongs to the art nouveau style that the artist Salvador Dali described as "edible architecture." All in all, the art nouveau movement only lasted a few years in Paris (1890–1905) before degenerating into a source of inspiration for commercial products. It broke with the Beaux-Arts style, but did so in finding inspiration in Gothic vegetation and in the rococo of Louis XV. Besides, Frantz Jourdain, the Belgian architect, writer, and critic, founded the Nouveau Paris association with Sauvage and Guimard. The association's aim was "to beautify our modern needs a bit and to renew the invigorating tradition of yesteryear that found ways of transforming life's most shocking materialities into works of art."

**31. Faïence Shop, 18, Rue de Paradis**
*Hippolyte Boulenger formerly owned this shop built by Jacquotin and Brunarius in 1889.*

**32. Alfons Mucha. Boutique Fouquet, 1900. (Musée Carnavalet, Paris)**

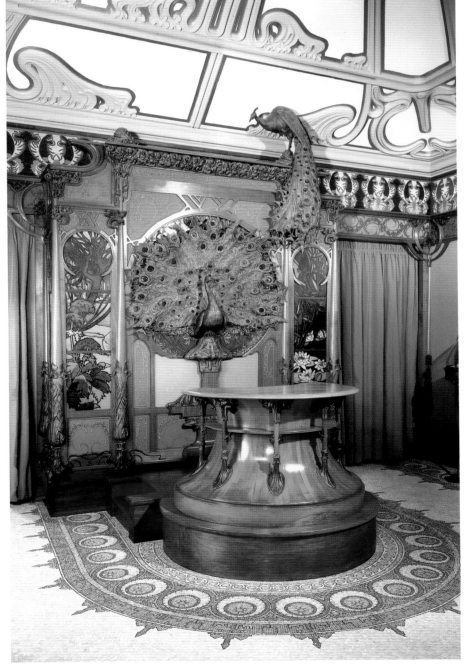

**33.** Maurice Denis. *Hommage à Cézanne* (*Homage to Cézanne*), 1900. (Musée d'Orsay, Paris)

*From left to right are: Odilon Redon, the Nabi painter Edouard Vuillard, the art critic André Mellerio, the Nabi merchant Ambroise Vollard, the Nabi painters Maurice Denis, Paul Sérusier, Paul Ranson, Ker Xavier Roussel, Pierre Bonnard, and Mrs. Maurice Denis. They are depicted in Vollard's boutique on Rue Lafitte. Hommage à Cézanne is also an homage to Redon and even Paul Gauguin who, prior to this painting, had owned the Cézanne painting in the foreground before poverty forced him to sell it. Gauguin even reproduced the Cézanne in some of his other paintings, including his portrait Marie Henry.*

*Haute Couture*

The oppressive obligation of renewal that constrained modernity culminated between 1870 and 1914 in the domain of the plastic arts—painting, of course; sculpture, in spite of its characteristic gravity; but also, and above all, the seasonal changes in haute couture fashion, as we have already discussed, were the subject of an abundant production of prints and of a literary genre that the greatest of writers were cultivating by the end of the eighteenth century. Under the funny pseudonym of Miss Satin, the poet Stéphane Mallarmé edited the magazine *La Dernière Mode* (*The Latest Styles*). In return, couturiers who were art collectors or patrons also contributed to the artistic life of their era in an unprecedented way. Jacques Doucet established two successive collections. His exceptional collection of eighteenth-century paintings and furniture, which he sold in 1912, was an expression of the popularity of the Louis XV style. The second collection was entirely composed of works of art contemporary to the Belle Epoque, including works by Vincent van Gogh, Paul Cézanne, and Henri Matisse. It also included major works such as Henri Rousseau's *La Charmeuse de serpent* (*The Snake Charmer*, 1907; Musée d'Orsay, Paris) and Picasso's *Les Demoiselles d'Avignon* (fig. 43).

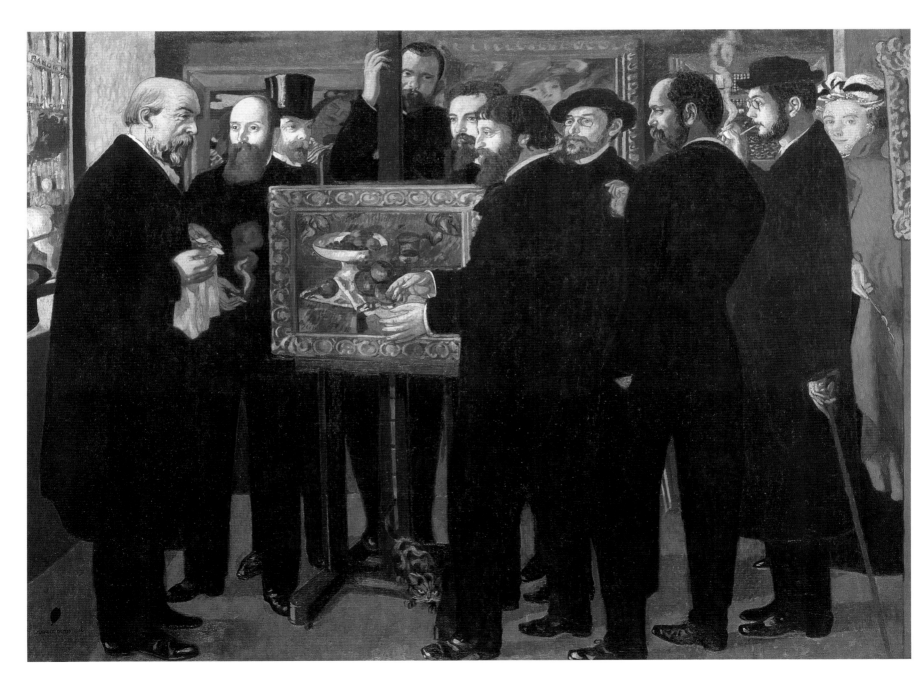

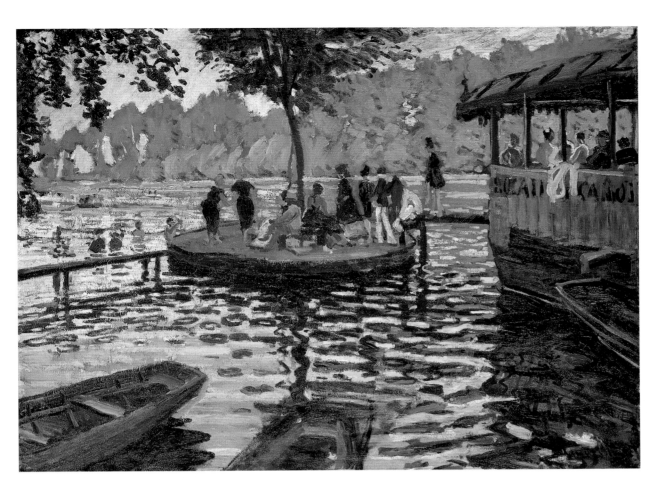

**34. Claude Monet.**
*La Grenouillère*, 1869.
(Metropolitan Museum of Art, New York)

The "grenouillère" was a pontoon on the Seine where small skiffs and bathing cabins could be rented. This swimming hole could be reached from the Bougival train station. It was popular with Parisians and had a bad reputation, as testified in Guy de Maupassant's short story, La Femme de Paul ( Paul's Wife). ("In this place all the world's dregs, all the distinguished scum, all the mold of Parisian society can be smelled.")

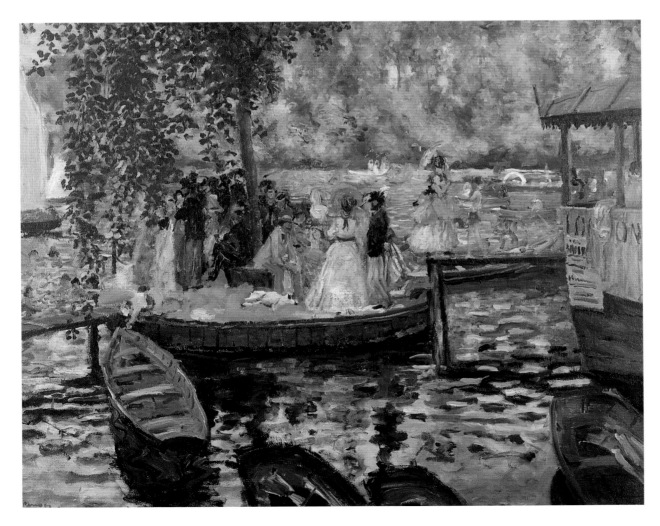

**35. Pierre Auguste Renoir.**
*La Grenouillère*, 1869.
(National Museum, Stockholm)

**36. Maurice de Vlaminck.**
*Restaurant de la Machine à Bougival*
(*Restaurant of the Machine at Bougival*),
**1905. (Musée d'Orsay, Paris)**

*Bougival was a favorite destination of painters
on the banks of the Seine near Chatou. It could
be reached by train from Paris's Gare Saint-
Lazare. The Marly Machine, a revolutionary
water pump, made during the reign of King
Louis XIV, was located here. It supplied
river water to the Marly Château.*

**37. André Derain.**
*Restaurant du Pecq.* **1904–1905.**
**(Private collection)**

*The Pecq restaurant is located on the banks of
the Seine downstream from Bougival.*

Paul Poiret, who was trained in the couture houses of both Doucet and Charles Frederick
Worth, turned the fashion world upside down when he did away with corsets, undergar-
ments that squeezed in women's waists and lifted their breasts. In their place he designed
the lampshade-style dress that made women resemble spinning tops and the "hobble skirt"
that hindered a woman's walk. He transformed women into supernatural fairies by raising
dress waistlines to just below the breasts or into harem concubines by dressing them in
puffy pantaloons. Muted colors went the way of the corset. The brightest colors inspired by
the Ballets Russes and by fauvist painting influenced the world of high fashion. Poiret
ordered his collection albums, which made his style well-known worldwide, from the
graphic artists and designers Paul Iribe and Georges Lepape. In 1917 he opened a branch of
his studio in New York, and after World War I he recruited the surrealist Man Ray to
photograph his creations. He had objects and furniture made under his trademark and had
his villa done by the French architect and designer Robert Mallet-Stevens.

*The Relationships among Artists*
Fashion imposed its allure on the artistic world. Certain tendencies proliferated under
diverse, often derisive, rubrics such as "impressionism" and "fauvism" that had been invented
by hostile critics. When it came to defining such artistic groups, social circles counted more
than artists' common techniques for practicing art, which explains the curious mention of

**38. Edouard Vuillard.**
*La Dame en bleu*
(*The Woman in Blue*), 1900 [?].
(Private collection)

*The interior depicted is the Nabi's "Temple,"
the Nabi painter Paul Ranson's living room,
located on the Boulevard Montparnasse. Nabi
paintings are hung on the walls and the reclining
woman is Mrs. Ranson, "the light of the Nabis."*

Edouard Manet or Edgar Degas among the impressionists. It is impossible to classify most artists, but unlike Gustave Courbet, they became part of a fraternity that could be flaunted in a collective portrait like Henri Fantin-Latour's *Un Atelier aux Batignolles* (*A Studio at Batignolles*, 1870; Musée d'Orsay, Paris) or Maurice Denis' *L'Hommage à Cézanne* (*Homage to Cézanne*, 1900; Musée d'Orsay, Paris) that portrayed a gathering of Nabi artists.

The groupings tended to substitute mutual promotion for the official promotion of the art salons, which were controlled by academic authorities of the academy. Impressionism began with a series of eight exhibitions held between 1874 and 1886 that grouped together artists as diverse as Claude Monet and Paul Cézanne, Edgar Degas, and Paul Gauguin. Certainly, we cannot confuse impressionism with any of the salon-organizing societies like the Société des artistes français (Society of French Artists) founded in 1881, or the Société des artistes indépendants (Society of Independent Artists) founded in 1884, that arranged salons devoid of juries and prizes. The neo-impressionists and the fauvists would show their work at the Salon des

Indépendants (Independent Artists' Salons). However, the styles of these groupings confer a misleading identity to artistic movements. In fact, there is only an ephemeral efflorescence of similarity that can be traced to hours and days when two artists working together on the same sites shared the same style to the point where it became hard to differentiate between the two artists' work. As for impressionism, the two artists were Monet and Pierre Auguste Renoir at Grenouillère (figs. 34–35). The fauvist artists Maurice de Vlaminck and André Derain worked near Chatou (figs. 36–37). Among artists of the Nabi movement, Edouard Vuillard and Pierre Bonnard painted in the privacy of their homes (figs. 38–39). Cubism was an extreme case, since it was born from a collaboration between Georges Braque and Picasso. These two artists claimed to base their works of art on collective, anonymous production (figs. 40–41).

*The Parade of Styles*

The parade of styles can be distinguished from the seasons of haute couture (in which a new character appeared on the scene during the Belle Epoque—the designer) in that the parade

**39. Pierre Bonnard.**
*Jeune femme à la lampe*
(*Young Woman and Lamp*), 1898.
(Musée des Beaux-Arts, Bern)

*The theme of a seamstress working under a lamp is so dear to Vuillard that the attribution of this painting to Bonnard could be put into question. This specific lamp may have belonged to the Natanson's, who lived on Rue Saint-Florentin. It appears in several Nabi paintings. A major Nabi theme is the interior of a room reduced to a circle of lamplight.*

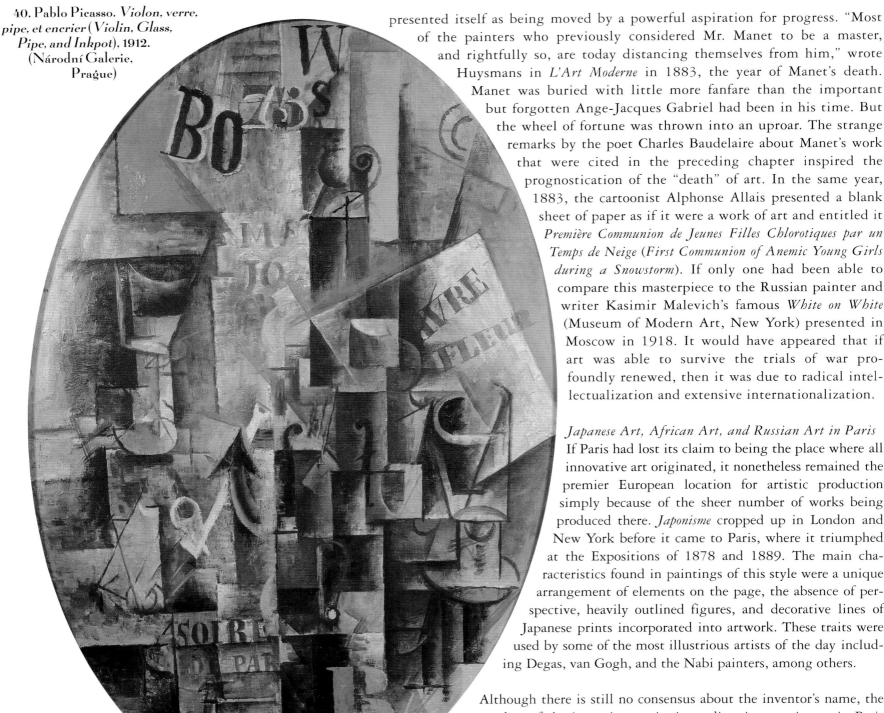

40. Pablo Picasso. *Violon, verre, pipe, et encrier* (*Violin, Glass, Pipe, and Inkpot*), 1912. (Národní Galerie, Prague)

presented itself as being moved by a powerful aspiration for progress. "Most of the painters who previously considered Mr. Manet to be a master, and rightfully so, are today distancing themselves from him," wrote Huysmans in *L'Art Moderne* in 1883, the year of Manet's death. Manet was buried with little more fanfare than the important but forgotten Ange-Jacques Gabriel had been in his time. But the wheel of fortune was thrown into an uproar. The strange remarks by the poet Charles Baudelaire about Manet's work that were cited in the preceding chapter inspired the prognostication of the "death" of art. In the same year, 1883, the cartoonist Alphonse Allais presented a blank sheet of paper as if it were a work of art and entitled it *Première Communion de Jeunes Filles Chlorotiques par un Temps de Neige* (*First Communion of Anemic Young Girls during a Snowstorm*). If only one had been able to compare this masterpiece to the Russian painter and writer Kasimir Malevich's famous *White on White* (Museum of Modern Art, New York) presented in Moscow in 1918. It would have appeared that if art was able to survive the trials of war profoundly renewed, then it was due to radical intellectualization and extensive internationalization.

*Japanese Art, African Art, and Russian Art in Paris*
If Paris had lost its claim to being the place where all innovative art originated, it nonetheless remained the premier European location for artistic production simply because of the sheer number of works being produced there. *Japonisme* cropped up in London and New York before it came to Paris, where it triumphed at the Expositions of 1878 and 1889. The main characteristics found in paintings of this style were a unique arrangement of elements on the page, the absence of perspective, heavily outlined figures, and decorative lines of Japanese prints incorporated into artwork. These traits were used by some of the most illustrious artists of the day including Degas, van Gogh, and the Nabi painters, among others.

Although there is still no consensus about the inventor's name, the exact date of the invention, or its immediate impact, it was in Paris during the years 1905 and 1906 that Picasso and the fauves Vlaminck, Derain, and Matisse recognized works of African art as artistic models. Until that point they had been considered to be simple ethnographic objects. Gauguin's return to the "primitive" was a longing for spirituality that he expressed by borrowing from different sources: folk art statuary from the Brittany region in the northwest of France, the exotic but learned art of Java, and perhaps from some Polynesian art objects as well. In 1907 Matisse painted *Nu*, a work as tuberous as a sculpture in the round of a black Venus. That same year Picasso painted *Les Demoiselles d'Avignon* (fig. 43). After visiting the museum in the Palais du Trocadéro, Picasso unexpectedly discovered the ethnographic museum also housed there. The figures to the right of *Les Demoiselles d'Avignon* appear to be marked by facial scarring or to be wearing African masks. Under the influence of African art, Amedeo Modigliani, whose short career took place almost entirely in Paris, painted his famous "*demoiselles.*" They were portrayed in hues of ochre with long, slender necks, egg-shaped heads, axe-like noses, slits for mouths, and empty-looking eye sockets. The legacy of African art in Modigliani's work would become most evident in his sculpture.

In 1909 the first performance of the *Prince Igor* dances took place at the Châtelet Theater in the heart of Paris. These dances were a prelude to the lengthy success of Diaghilev's troupe, called the Ballets Russes. In fact, the first several performances took place in Paris. Diaghilev was a founder of *Mir Iskoustva* (*The World of Art*), the group for which artists Alexandre Benois and Léon Bakst painted decor and designed costumes. Rhythm and color became the rule of the day in Paris, for they quickly lost their folkloric overtones after "joining" with modernism. Parisian musicians' productions, like those of Claude Debussy and Maurice Ravel, began to mix with the masterpieces of Igor Stravinsky. In 1912 Vaslav Nijinsky presented his first ballet choreographed to Debussy's score of *Le Prélude à l'après-midi d'un faune* (*Prelude to the Afternoon of a Faun*), which was presented in 1913 for the inauguration of the Champs-Elysées Theater. That same year, Nijinski presented his ballet *Le Sacre du printemps* (*The Rite of Spring*) there.

*Official Art*

Through all this turbulence, official art could no longer be identified with one specific style. It was simply art under public control. Third Republic Parisian decors are particularly extensive and noteworthy on public squares and buildings. Jules Dalou's inspiration for his sculptures located in several Parisian squares was the sentiment expressed in their subject and title, *Le Triomphe de la République* (*Triumph of the Republic*), which were commissioned by the newly formed Third Republic. This new regime gave amnesty to Dalou, a sculptor who portrayed breast-feeding mothers, who was sentenced in abstentia to forced labor for his political beliefs, and who proclaimed that "the glorification of the worker is the religion destined to replace all past mythologies." *Le Triomphe de la République* is reminiscent of Jacques-Louis David's *Le Triomphe du peuple français* (chapt. X, fig. 93) in that the assembled figures of the Republic, Liberty, Peace, and Work are allegories. They demonstrate that classical conventions never stifled creative genius as long as the conventions were not followed blindly. There are perhaps no sculptures more original and yet so traditional as those created by Antoine Bourdelle. His masterpiece was made in Paris and intended for a square in Buenos Aires (fig. 83). Bourdelle also created the facade of the Champs-Elysées Theater and the bas-reliefs worthy of antiquity that adorn it. Of particular interest is the bas-relief of *La Danse* (*The Dance*; fig. 87), a sublime metaphor that portrays dancers trying to push back the boundaries of the stage.

The decoration of important public buildings like the Opéra, the Pantheon, the Sorbonne, the Hôtel de Ville, and the various town halls in Paris neighborhoods mobilized important groups of artists, members of the academy, and the Ecole des Beaux-Arts. The dazzling savoir faire of

41. Georges Braque. *Femme à la mandoline* (*Woman with Mandolin*), 1910. (Bayerische Staats-gemäldesammlung, Munich)

the academicians was exhausted in trying to satisfy a public always hungry for more, but it still managed to produce a few of what could be called masterpieces. There would be unanimous agreement on this last point if the buildings had not been used as a foil in the struggle for modernity. To prove the point, if we were to date Bonnat's *Le Martyre de Saint-Denis* to the seventeenth century and attribute it to the Ribera School, then the work would only have one flaw: being ahead of its time. The portrayal of *Mort de Sainte-Geneviève* (*Death of Saint Geneviève*; fig. 47), also at the Pantheon, is without a doubt a masterpiece less subject to debate since it does not harken back to other paintings. It is, however, the work of a famous painter who specialized in historical scenes. Although barely practiced during the Second Empire (1852–1870), the Third Republic revived historical painting. The same can be said for allegory and symbolic art.

### Pierre Puvis de Chavannes

The work of Puvis de Chavannes can be found all over, from the Pantheon, to the Hôtel de Ville, and the Sorbonne. The monumental frieze in the Sorbonne's amphitheater (fig. 50) recalls the one painted by Paul Delaroche in the Ecole des Beaux-Arts's amphitheater. In his portrayals of ritualized, rustic yet monumental ceremonies, which earned him a place alongside the greatest of French artists, one can see the influences of Théodore Chassériau, Hippolyte Flandrin, and Camille Corot as well as a presence that reminds the viewer of primitive Italian frescos. No one would dream of citing Puvis de Chavannes as one of the pretentious painters, especially not Gérôme, who led a campaign in the name of the academy and hated him. Puvis, as he is often

42. Léon Bakst. Model of the decor for the ballet *Shéhérazade*, performance by Diaghilev's Ballets Russes, 1910. (Musée des Arts Décoratifs, Paris)

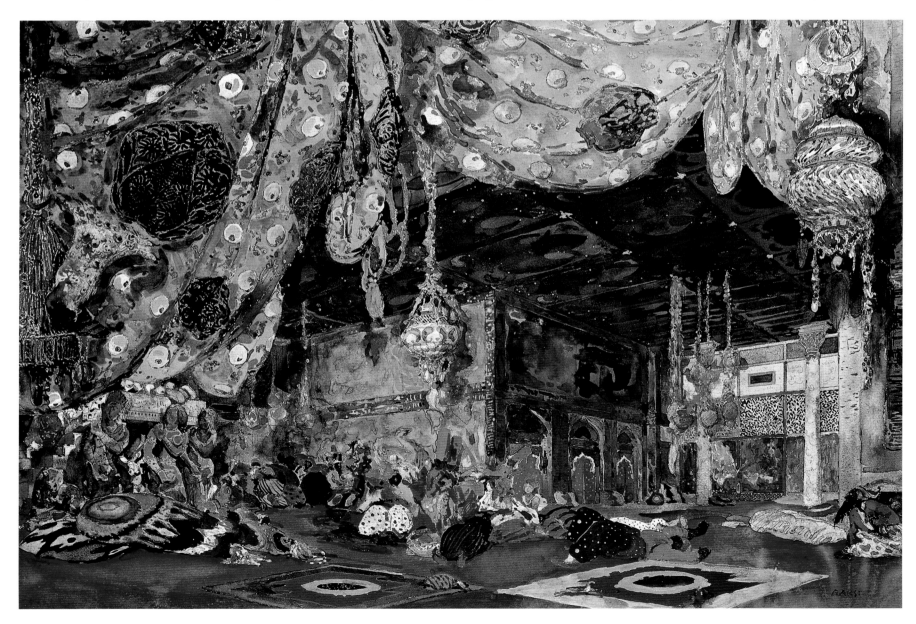

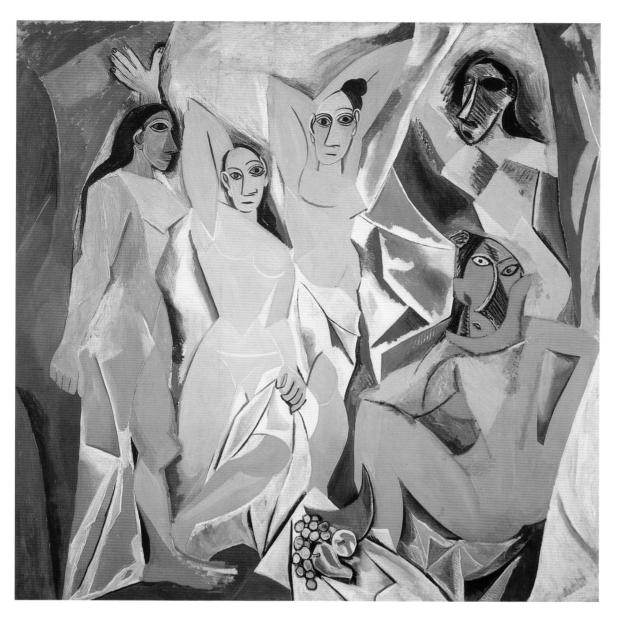

43. Pablo Picasso. *Les Demoiselles d'Avignon*, 1907. (Museum of Modern Art, New York)

Bottom left: 44. Vincent van Gogh. *Portrait du père Tanguy* (*Portrait of Père Tanguy*), 1887. (Musée Rodin, Paris)

*The old communist Tanguy was a major defender of avant-garde painting from 1870 to 1880. The wall behind him is covered with Japanese prints. Rodin acquired the painting for his personal collection.*

Bottom center: 45. Amedeo Modigliani. *Dame aux yeux bleus* (*Woman with Blue Eyes*), 1917. (Musée d'Art Moderne de la Ville de Paris)

Bottom right: 46. Amedeo Modigliani. *Tête* (*Head*), 1911–1913. (Solomon R. Guggenheim Museum, New York)

*This head is possibly part of a series of sculptures created in the Cité Falguière studio at Montparnasse, if there is any truth to the story that Modigliani himself destroyed several similar sculptures of his at Livourne.*

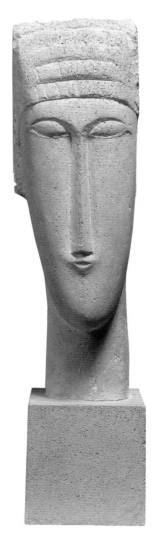

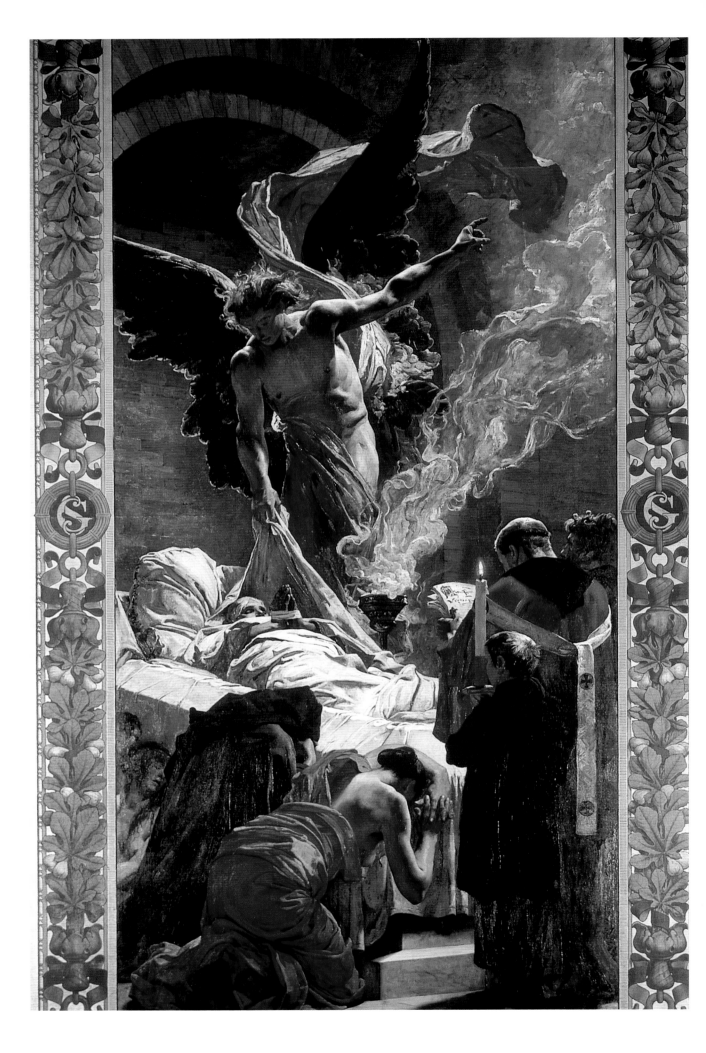

47. Jean-Paul Laurens.
*Mort de sainte Geneviève*
(*Death of Saint Geneviève*).
1874–1885. (Pantheon, Paris)

referred to, was often grouped among the symbolists, although he often defended himself against this classification. He was a master who influenced the likes of Gauguin and Seurat by his treatment of his subjects as sacred, his reduction of the depth of field, the readability of his narration, his suppression of facial contouring, his emphasis on outline, the monochrome effect of his blurred colors, the majesty of his silhouettes, and the solemnity of their gestures. (Gauguin reproduced Puvis's painting *L'Espérance* in one of his own.) His admirable *Jeunes Filles au bord de la mer* (*Young Girls at the Seaside*; fig. 69) falls somewhere between Chassériau's *Vénus marine* (*Venus of the Sea*, 1838; Musée d'Orsay, Paris) and Seurat's *Les Poseuses* (*The Models*; fig. 71) for its perfect geometric construction based on the three-fold representation of the same female model.

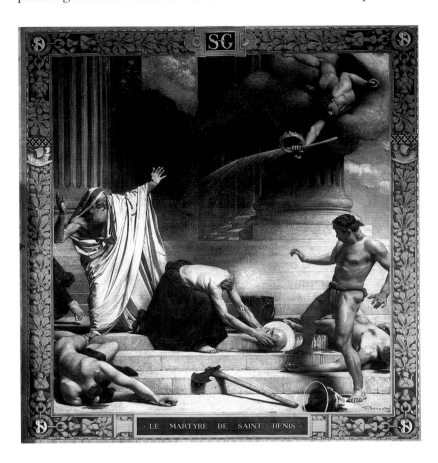

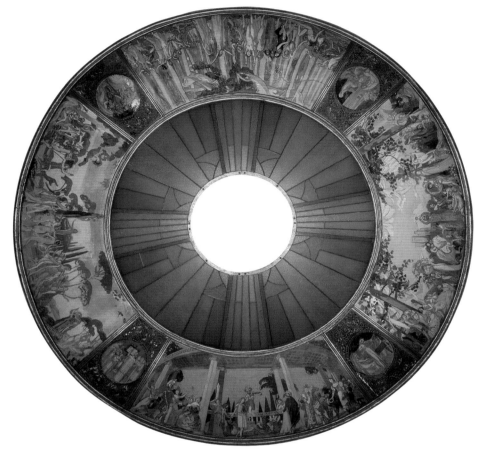

48. Léon Bonnat. *Martyre de saint Denis* (*Martyrdom of Saint Denis*), 1874–1885. (Pantheon, Paris)

49. Maurice Denis. Model of the Champs-Elysées Theater Dome, 1911. (Musée d'Orsay, Paris)

## Scandal at the Salon

The Salon produced fewer important works than official art produced by public order. Nonetheless, the exclusion of some paintings from exhibition at the Salons has always been significant. *Le Rolla* (fig. 51) is truly the only masterpiece of the fairly consistently mediocre academic painter Henri Gervex. His *Rolla* could probably be considered a masterpiece, even when compared to all the art of the era. Refused by the Salon, Gervex showed it in his own studio. The painting was supposedly refused by the Salon as sanction for the impropriety of its subject matter. But just what was in this painting that had not been shown to visiting families thousands of times before at other salons? Was it really more scandalous than the sculpture *Gorille enlevant une femme* (*Gorilla Carrying off a Woman*) by the animal sculptor Emmanuel Frémiet that won the Medal of Honor at the 1889 Salon? How can one not admire the white on white that owes quite a bit to the tradition of the Venetians of the cinquecento who showed so much sensuality by contrasting flesh and drapery? Were people bothered by the presence of the witness, who appears to be more a rapist than an onlooker, a man who is partially obscured in the twilight like the old men from the Bible ogling Susanna? Not at all! The slip and garter provoked the scandal, as they did in Courbet's *Les Demoiselles* (*Demoiselles on the Banks of the Seine*, 1856; Petit Palais, Paris) and Manet's *Le Déjeuner sur l'herbe* (*Luncheon on the Grass*, 1863; Musée d'Orsay, Paris). The funny thing is that Degas actually inspired Gervex to include the scandalous objects. "One must understand that a woman is not a model. Where is the dress she has slipped off? Put a corset on the ground!" Degas is reputed to have said to Gervex.

Following two pages:

50. Pierre Puvis de Chavannes. *Le Bois Sacré* (*The Sacred Grove*), 1884.

*This is the large amphitheater of the Sorbonne University.*

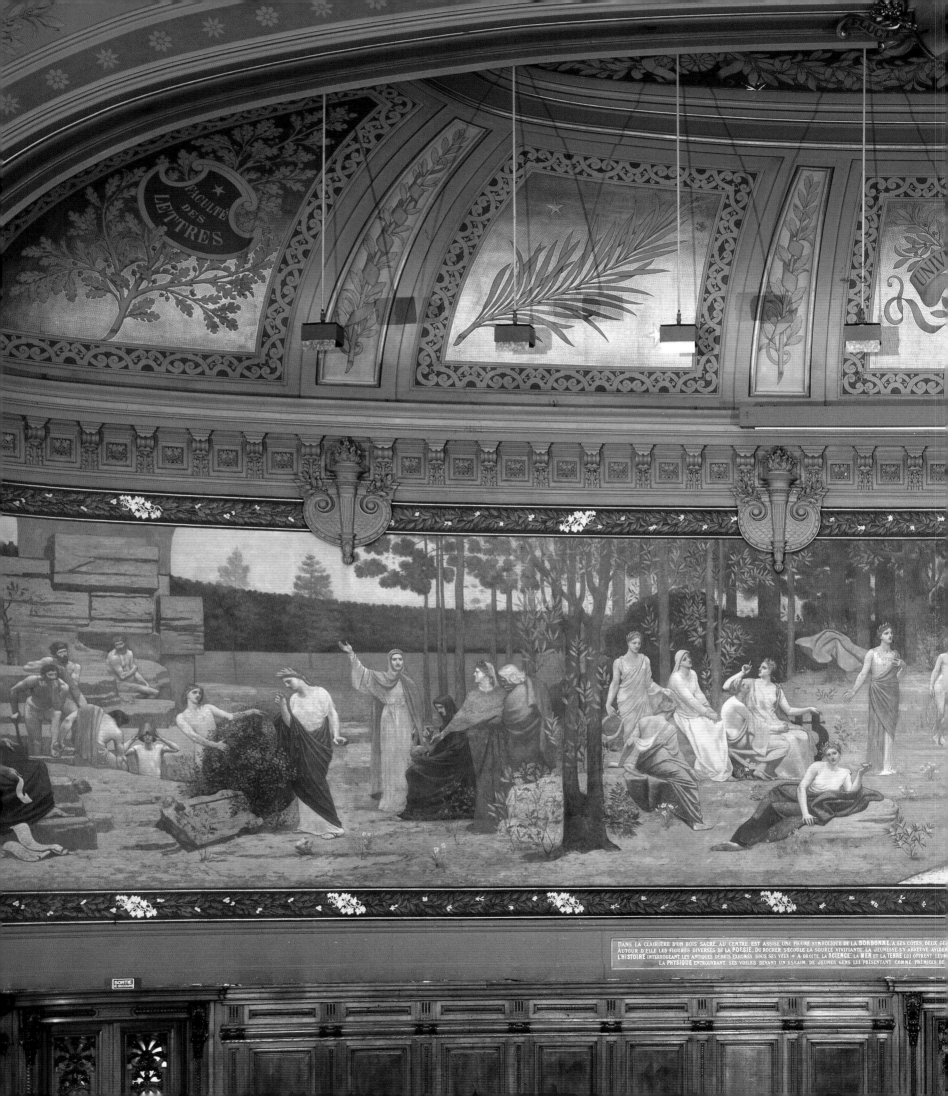

FACULTÉ DES LETTRES

SORTIE DE SECOURS

DANS LA CLAIRIÈRE D'UN BOIS SACRÉ, AU CENTRE, EST ASSISE UNE FIGURE SYMBOLIQUE DE LA SORBONNE, A SES CÔTÉS, DEUX GÉ...
AUTOUR D'ELLE LES FIGURES DIVERSES DE LA POÉSIE, DU ROCHER S'ÉCOULE LA SOURCE VIVIFIANTE, LA JEUNESSE S'Y ABREUVE AVIDE...
L'HISTOIRE INTERROGEANT LES ANTIQUES DÉBRIS EXHUMÉS, SOUS SES YEUX + A DROITE, LA SCIENCE: LA MER ET LA TERRE LUI OFFRENT LEU...
LA PHYSIQUE ENTR'OUVRANT SES VOILES DEVANT UN ESSAIM DE JEUNES GENS LUI PRÉSENTANT COMME PRÉMICES D...

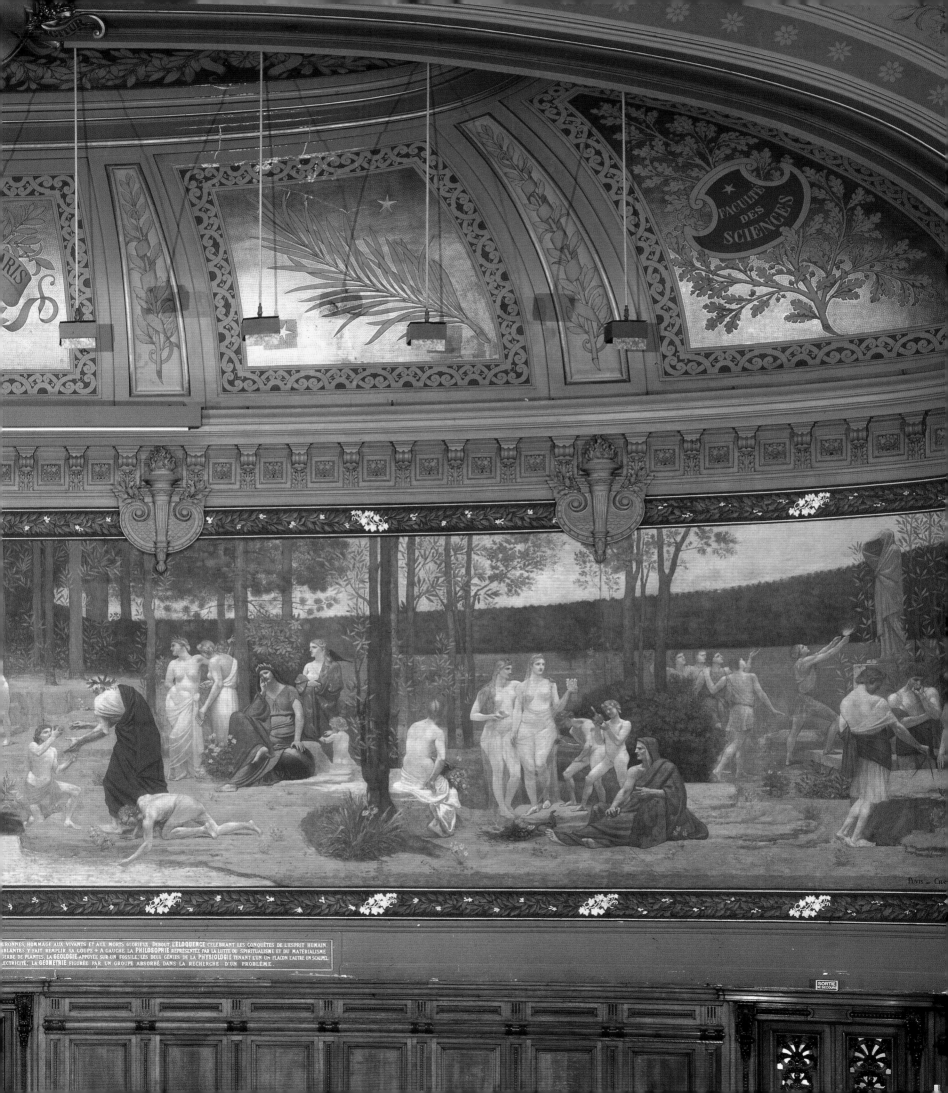

*Edgar Degas, Edouard Manet, and Henri de Toulouse-Lautrec*
With *Intérieur* (*Interior*, also known as *The Rape*; fig. 52), Degas, who had treated a similar subject to that of Gervex, sent the corsets back to the lingerie shop and metaphorically held out Oscar Wilde's "mirror of Dorian Gray" to *Rolla*: in it all the wrinkles of academic painting appeared, but the abuse of pleasures and clichés had withered. Degas's painting remains something of a mystery, but its ambiguity requires no definitive explanation. Perhaps, like *Rolla*, it illustrates a literary text. Both paintings contain a standing man, an open chest of valuables, a lighted lamp; but the satisfied, triumphant prostitute found in *Rolla* has been replaced in *Intérieur* by a woman who might be in the middle of doing something or who might have collapsed. In the first painting, we have one of those straightforward close-up scenes "under the lamp" that the Nabi painters would later reproduce (fig. 38). In the second painting, drama emerges from the shadows. The mirror held up to reflect reality actually shows nothing. It is a two-way mirror behind closed doors. The ambiguity of *Intérieur* is the source of its emotion.

**51. Henri Gervex. *Le Rolla*, 1878. (Musée des Beaux-Arts, Bordeaux)**

*This painting was inspired by Alfred de Musset's* Rolla: *"Rolla watched with melancholic eyes / The beautiful Marion sleeping on the large bed / Marion was expensive. To spend the night with her / He spent his last dollar."*

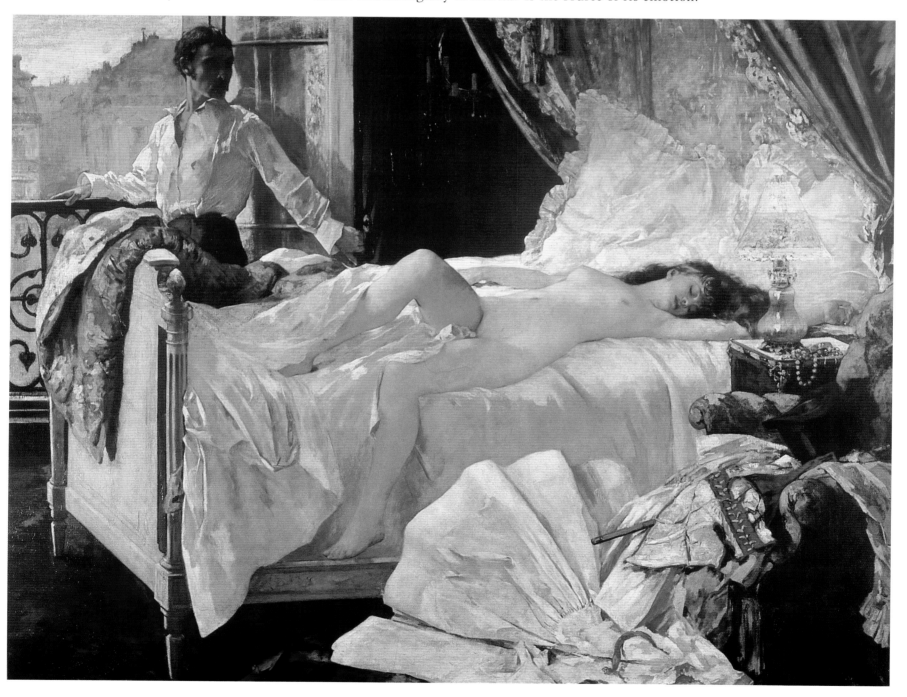

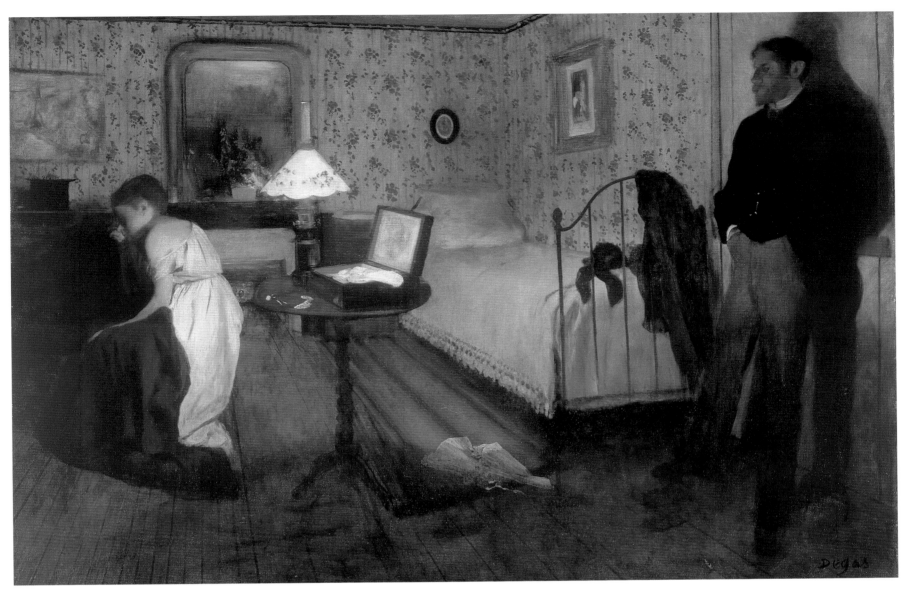

52. Edgar Degas.
*Intérieur* (*Interior*, also known as
*The Rape*), between 1868 and 1874.
(Museum of Art, Philadelphia)

*This work may have been inspired by one of
Emile Zola's novels, either* Thérèse Raquin,
*1867, or* Madeleine Ferat, *1868.*

In the mirror of *Un Bar aux Folies-Bergère* (*A Bar at the Folies-Bergère*; fig. 54), one of Manet's last paintings, an entire world that only exists as reflection is inscribed; this is apparent at first glance by the reflection of the beautiful barmaid's back. According to the law of optics, the onlooker at the right should be standing in front of the bar, however he is not. The look in the barmaid's eyes seems affected by a slight squint that adds a touch of tragedy to her disillusioned pout. A still life, with a similar function as the corset in *Rolla*, makes a distracting foreground that draws the viewer's attention away from the somewhat flagrant exhibition of corruption offered by the upper-class clientele. The very real half of the scene, the part in front of the mirror, includes the barmaid, who is not a model, but just a servant playing her role for eternity. She is a fresh-faced peasant girl with borrowed gestures strapped into a barmaid's finery.

Almost the entire repertoire of works by Manet, Degas, and Toulouse-Lautrec were created in Paris. Yet their similarity does not necessarily rest in their portrayals of dancing girls, servants, hostesses in cabarets, prostitutes, and seedy locales reflected and disordered by unique compositions. These painters, like the ancient masters, placed the human figure at the heart of their work and at the same time, they announced man's pitiful decline as if it were an inexorable erosion. Degas portrayed women in the midst of their daily grooming, whether they were preparing to dress (fig. 56) or performing rites of ablution (figs. 57–58). He portrayed them as if they were still lifes, silhouettes without expression in their eyes, zombies straight from the imagination of a believer in the supernatural, and a simple medium for the blurring of colors. *L'Absinthe* (fig. 1) represents a turning point in the era. It marks the shift from the portrayal of Géricault's insane people (chapt. XI, fig. 91) to the portrayal of

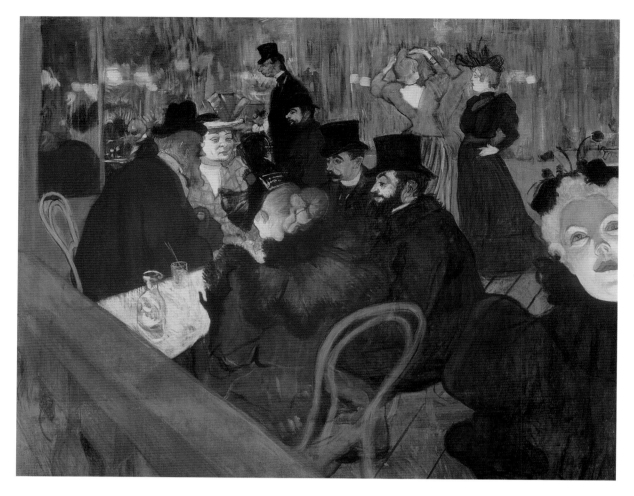

broken, fallen men whose appearance would seem even more melancholy at the hand of the expressionist painters.

*Vincent van Gogh*
Although Vincent van Gogh's only long stay in Paris was from February of 1886 to February of 1888, his discovery of the city radically transformed his style. His landscapes of Montmartre, his first self-portraits (fig. 60), and his famous portrait of *Père Tanguy* (fig. 44) were all painted in Paris. The influence of *Japonisme* (van Gogh discovered Japanese prints at Bing's studio during his stay) and of impressionism (he spent time with Signac) can be seen in their composition, their bright palette, and their visible brushstrokes, which resolutely contrasted with the charcoals of his Dutch period, painted during his early apprenticeship. Nonetheless, the most important of van Gogh's work took place outside the greater Parisian area in the southern French towns of Arles, Saint-Rémy-de-Provence, and Auvers-sur-Oise.

**53. Henri de Toulouse-Lautrec.**
*Au Moulin rouge (At the Moulin Rouge),*
**1892–1893. (Art Institute of Chicago)**

*The Moulin Rouge, opened in 1889, was a house of ill repute located at the bottom of the Montmartre hill. Its best-known attraction was the cancan, which was danced by girls who were often featured in works by Henri de Toulouse-Lautrec. The redhead in the front whose back is to us may be Jane Avril: La Gouloue, fixing her hair, is standing in the middle distance. Toulouse-Lautrec is seen from the side, standing above Avril. At first a bit too restricted, the composition was improved by the addition of black bands at the bottom right.*

*Pablo Picasso's Blue and Rose Periods*
Paris had the same effect on Picasso, who discovered the city in several trips there in 1900, 1901, and 1902. He, in turn, abandoned the style of his early Catalan works, but unlike van Gogh, he moved to Paris in 1904 and remained there for a long time. At first he set up his studio in Montmartre's Le Bateau-Lavoir. In Paris his Blue Period, essentially Catalan in its return to the countryside, began. The genesis of his Rose Period was also in Paris. Rose was the background color of a painting of a circle of hobos and acrobats whose colors turned from blue to rose after Picasso's romantic encounter with Fernande Olivier at Le Bateau-Lavoir. In his first prints, these figures were also treated in black and white (fig. 2). *La Buveuse assoupie (The Absinthe Drinker,* 1902; Hermitage, St. Petersburg) painted during the Blue Period, recalls Degas's *L'Absinthe.* Picasso assimilated the styles of Honoré Daumier, Toulouse Lautrec, Gauguin, and even that of Puvis de Chavannes. What part in Picasso's Parisian-inspired work did the terrifying views of Whitechapel and of the squalor of London published by Gustave Doré in 1872 play? There are strange similarities between Doré's *Les Saltimbanques (The Acrobats,* 1874) and Picasso's *La Famille d'acrobates (The Family of Acrobats,* 1905; National Gallery of Art, Washington, D.C.). However, Picasso did not stay faithful to one style for very long. The Blue Period lasted from 1901 to 1904; the Rose Period from 1905 to 1906. The true Parisian representatives of expressionism were Georges Rouault and Chaïm Soutine. The art Rouault produced in the ten years preceding World War I can be classified as "expressionist," after which he turned to religious themes. Soutine, a Lithuanian who arrived in Paris on the eve of the World War I, was active in the capital between World War I and World War II.

*Gustave Moreau, Odilon Redon, and Paul Gauguin*
Gustave Moreau's works add significant confusion to the concepts of expressionism, symbolism, and Academicism. This contemporary of Manet's (he was six years older than Manet), Delacroix admirer, and friend of Chassériau belonged to the academy and taught in

the Ecole des Beaux-Arts. Rouault was a fervent disciple of Moreau (fig. 59), and he also trained Matisse. The subjects of his paintings are borrowed from mythology or the Bible and they belong to the academic repertory. In addition, his *Oedipe et le sphinx* (*Oedipus and the Sphinx*, 1864; Metropolitan Museum of Art, New York) got the best reception at the 1864 Salon. But this artist devoted himself entirely to his work after the death of his mother and

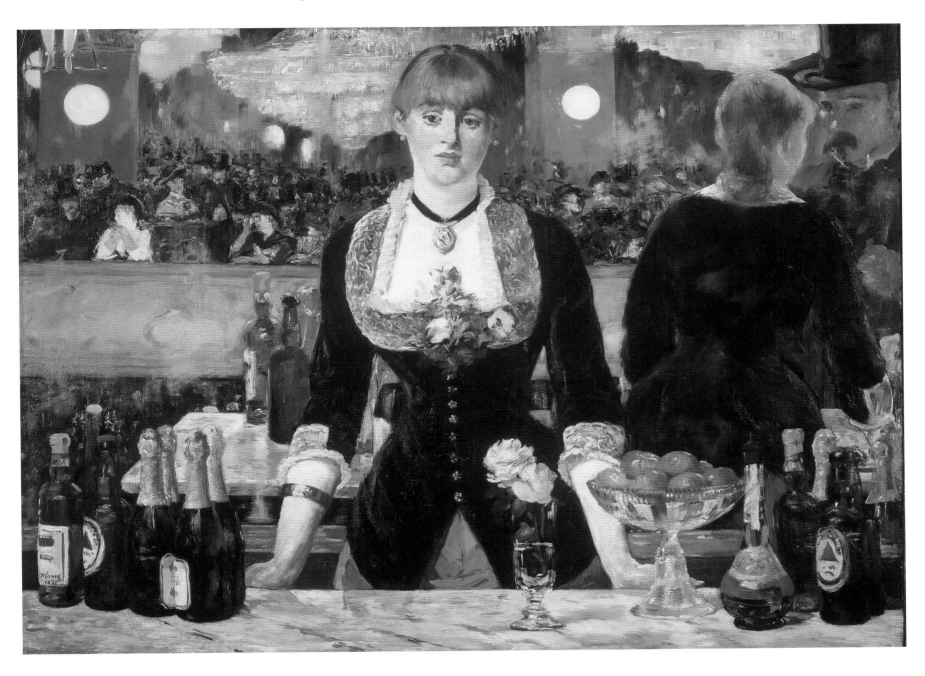

54. Edouard Manet.
*Un Bar aux Folies-Bergère*
(*A Bar at the Folies-Bergère*), 1881–1882.
(Courtauld Institute, London)

*A fashionable café-concert hall, the Folies-Bergère was described by Huysmans and Maupassant as a place of corruption. The young girl is not an artist's model, but a barmaid named Suzon.*

never left his Parisian studio after that time. (Luckily his studio is conserved today in its original state.) This "mystic enclosed in the middle of Paris" (as Huysmans called him) also locked up his characters in highly stylized poses and covered them with gold, precious gems, and unique colors. In a watercolor of superb, evanescent quality, a centaur tears the remains of a poet away from chaos (fig. 62).

Odilon Redon, an admirer of Moreau, shared a certain mysticism with him, as well as a propensity for isolating himself; Huysmans was also interested in him and mentioned him in *A Rebours* (*Against Nature*), 1884. The "blacks," as Redon called his charcoal drawings and black lithographs, formed one of the most original parts of his oeuvre; they were all painted during his summer vacation at Peyrelebade, the family house between Médoc and Landes. His pastels,

on the other hand, are definitely Parisian, for they were all completed after the sale of the house in 1897. His pastels portray religious icons from Christianity, Buddhism, and Orphism. The mystery of the origins of the world and the horrifying thought of its final destruction haunted Redon. The Nabi artists are Redon's direct artistic "heirs," but even the surrealists, who believed that art was "created" by the unconscious, could be called Redon's descendants.

Paul Gauguin, the most illustrious of Redon's heirs and considered to be the last classical painter and the first modern one, escaped the influence of Paris even more radically than the great baroque artist Nicolas Poussin, with whom, interestingly, he shares affinities. Since the altarpieces Gauguin created in Brittany and his landmark work created in the South Seas are outside the scope of this book, it would be inappropriate to consider less representative paintings he created in Paris.

*Auguste Rodin*
Rodin is an exact contemporary of Redon. His career took place almost entirely in Paris (in Paris proper, in his famous studio in the Hôtel Peyrenc de Moras, or at his studio in Meudon, in greater Paris). However, the famous *Age d'airain* (*The Age of Bronze*, 1877; Musée Rodin,

**55. Edgar Degas.**
*La Classe de Danse* (*The Dance Class*), **1873.**
(Corcoran Gallery of Art, Washington D.C.)

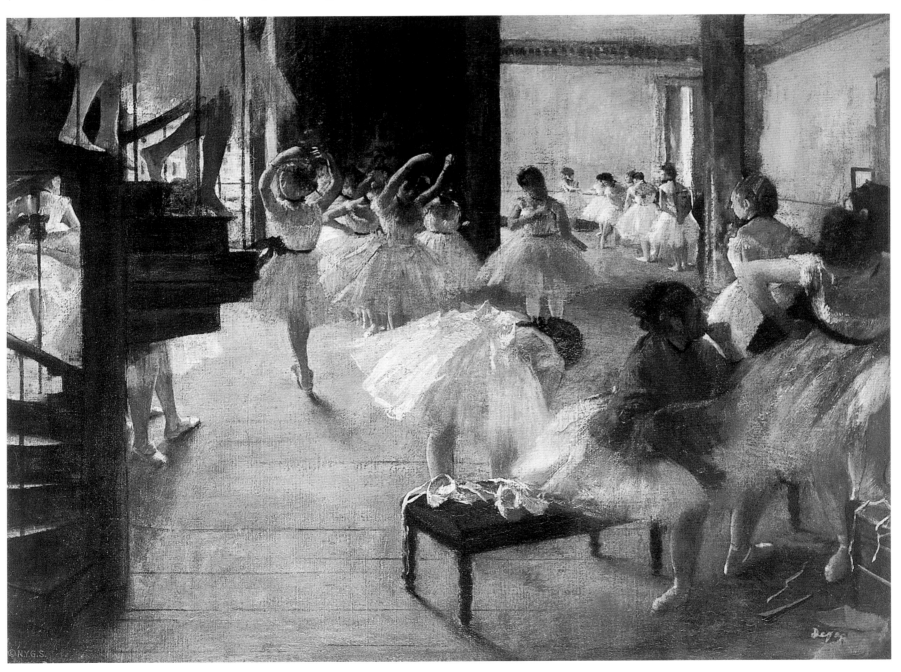

Paris), the first work that brought Rodin to the public's attention, belongs to his Belgian period. Rodin was wrongly accused of having created *Age d'airain* using the often practiced technique of *surmoulage* (overcasting), whereby the mold is created on a living model. On the other hand, Rodin often did use, or even abuse, consistent *marcottage*, a process of creating a new statue by dismantling or altering already existing clay or plaster casts from another work of art. We know

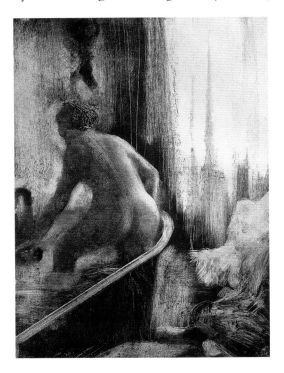

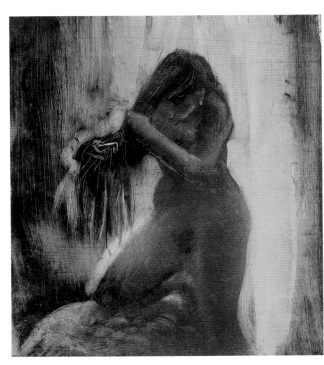

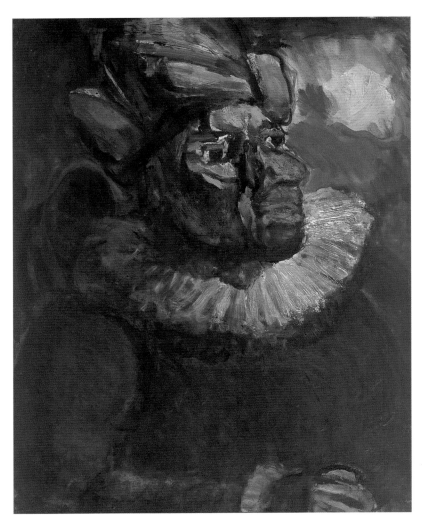

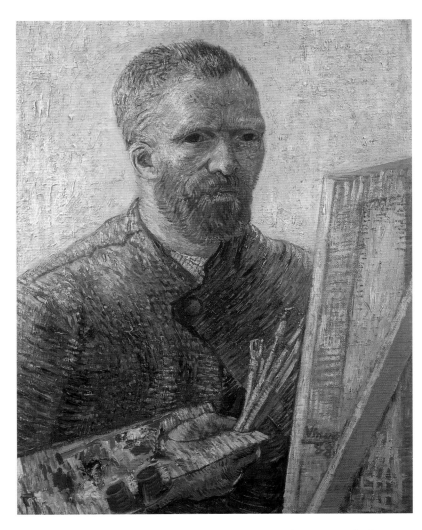

that like the famous sculpture he made based on Balzac's monumental novel *La Comédie humaine* (*The Human Comedy*), Rodin's *Porte de l'Enfer* (*The Gates of Hell*, 1880–1917; Musée Rodin, Paris) is the great ensemble from which all his creations came and to which they returned. From a torso torn from *l'Enfer*, Rodin made the couple featured in *L'Eternel Printemps* (*Eternal Spring*; fig. 81). References to Dante were common at this *fin-de-siècle* and the way that Rodin evoked episodes of this author's recalls Antoine-Auguste Préault and Jean-Baptiste Carpeaux.

Is it justifiable to trace Rodin's roots back to Michelangelo? The author André Gide viewed them both as "panting in the effort to master unruly forms." However, direct stone carving, a physically exhausting chiseling action, was a method used only by Michelangelo, not Rodin. In technique, therefore, Rodin belonged very much to the nineteenth century. Although he let others believe that he chiseled the work himself, he was a sculptor who left the cutting and casting to his apprentices. His studio employed fifty people in 1900. Plaster casts shaped over clay were produced in marble and then a reduced number of these plaster casts were used to create his bronzes. (Fifty copies of *L'Age d'airain* / *The Bronze Age* were produced during Rodin's lifetime.) Initiated by Gauguin, a return of direct chiseling in the last few decades of the century broke with the oldest traditions of French sculpture. Direct chiseling was clearly flaunted as a rebellion against established practice and aimed to put an end to Rodin's long reign. As for Rodin's status as a direct heir to Michelangelo, his modeled works, produced in terra-cotta, did successfully rival the most charming works by Clodion and Augustin Pajou (chapt. X, fig. 87). Yet to a greater extent, the legacy of Michelangelo that Rodin could rightfully claim was not in technique but in philosophy: the mind that tormented matter (the *terribilità*), that purposefully left works of art unfinished, or even completed them by mutilation. *L'homme qui marche* (*Walking Man*, 1905; Hirshhorn Museum and Sculpture Garden, Washington D.C.), a man without arms or head, is the finished form of Saint John the Baptist. A damned person from *L'Enfer* (*Hell*) was metamorphosed into a tropical butterfly, a sea goddess "modeled by the sea, the reservoir of

all forces," as Rodin remarked about the Venus de Milo. We see the siren's back fighting against the waves. She is like an ectoplasm emerging from a marble cliff, like a furtive apparition shrouded in mist and reminiscent of a painting by Moreau or Redon.

*Henri Rousseau and Marc Chagall*

Henri Rousseau, Marc Chagall, and Rodin shared a slightly devilish naivete. Rodin was Rousseau's contemporary; Chagall was a generation younger. Rousseau painted the lush vegetation and disquieting fauna from tropical forests that he saw in greenhouses and animal cages at the Jardin des Plantes (Garden of Plants) in Paris. His *Guerre* (*War*; fig. 65) was an ingenious version of Delacroix's *Massacres de Scio* (*Massacres at Scio*, 1824; Louvre, Paris), a masterpiece he had seen at the Louvre. Modern artists from Picasso to Delaunay and modern authors from Apollinaire to Jary celebrated Rousseau, an employee of Paris's customs office that collected taxes on imports (hence the nickname "Le Douanier," or "customs officer"). They admired him, but found his arrogance entertaining, for the self-taught painter Rousseau only compared himself to the academic masters that he admired, like Adolphe-William Bouguereau and Jean-Léon Gérôme, and to Matisse, whom he hated. Matisse returned this sentiment, proclaiming about Rousseau's art, "How ugly! How sad!"

Chagall's first visit to Paris lasted from 1910 to 1914. He lived in La Ruche (The Hive), an artist's apartment building similar to Le Bateau-Lavoir in Montmartre. He spent time with the poets Blaise Cendrars and Apollinaire, who were filled with enthusiasm about his paintings. He dwelled on memories of his native Russia, and composed folkloric images that were more Russian than the Ballets Russes but animated by the same Slavic genius (fig. 64).

Bottom left:

61. Odilon Redon.
*Roger et Angélique*
(*Roger and Angelica*), c. 1910.
(Museum of Modern Art, New York)

*This pastel's date is not known. It may be portraying Roger rescuing Angelica, or Perseus rescuing Andromeda. Noteworthy are the hero on horseback to the left and the naked heroine to the right.*

62. Gustave Moreau.
*Poète mort porté par un centaure*
(*Dead Poet Borne by a Centaur*), c. 1890.
(Musée Gustave Moreau, Paris)

The examples of symbolist work, which proceeded from Moreau to Chagall, were only exhibited in Paris by exceptional figures, who did not have much in common with each other. On the other hand, Paris was the center for some of the most well-defined, rich, but fleeting artistic movements whose succession formed a major axis of modernity.

### Impressionism

The impressionist movement can only be defined by the intersection of certain criteria. None is sufficient on its own, nor absolutely necessary. As we have already said, it was

63. Henri Rousseau. *La Charmeuse des Serpents* (*The Snake Charmer*), 1907. (Musée d'Orsay, Paris)

about a group of friends that included Monet, Renoir, Alfred Sisley, Camille Pissarro, and Berthe Morisot, but also Manet, Degas, Gauguin, and Cézanne. The period from 1874 to 1886 is assigned to the movement, but these slightly limiting dates do not mark the beginning and end of impressionist artistic production. Rather, they correspond to the first and last of eight joint exhibitions. In the first of these, the painting by Monet that inspired a sarcastic critic to coin the school's name, *Impression, Soleil Levant* (*Impression, Sunrise,* 1873; Musée Marmottan, Paris), was exhibited. The impressionist technique, derived from the chemist Michel Eugène Chevreul's color theories, consisted of distinct brushstrokes (although Pissarro, one of Corot's disciples, did not use distinct brushstrokes except during a short period when he dabbled in pointillism). As original as it may have appeared, this technique already had roots in the work of Joseph Mallard William Turner and Delacroix.

64. Marc Chagall.
*Moi et mon village*
(*Me and My Village*), 1911.
(Museum of Modern
Art, New York)

*Many artists went to Paris during the Belle Epoque, including the Czechs Frantisek Kupka and Alfons Mucha; the Pole Moise Kisling; the Hungarian Joseph Czaky; the Romanian Constantin Brancusi; the Bulgarian Jules Pascin; the Lithuanian Jacques Lipchitz; the Ukranians Alexander Archipenko and Sonia Terk (who married Robert Delaunay); the Russians Jean Pougny and Ossip Zadkine; the Dutch Keesvan Dongen; the Spaniards Pablo Picasso, Juan Gris, and Julio González; the Italians Gino Severini, Amedeo Modigliani, and Giovanni Boldini; and the American Mary Cassatt. Without claiming to be exhaustive, this list must be completed with the names of artists who only passed through Paris before 1914 or who only arrived on the eve of World War I: the Russians Wassily Kandinsky, Kasimir Malevich, Antoine Pevsner, Naum Gabo, Chaïm Soutine, Mikhail Larionov, Natalia Goncharova, Marc Chagall, and Léon Bakst; the Norwegian Edvard Munch; the Netherlanders Vincent van Gogh and Piet Mondrian; the Swiss Paul Klee, the Italians Giorgio de Chirico, Alberto Magnelli, and Medardo Rosso; the Spaniard Pablo Gargallo; and the Japanese Tsugouharu Foujita.*

65. Henri Rousseau.
*La Guerre* (*The War*), 1894.
(Musée d'Orsay, Paris)

66. Claude Monet.
*La Rue Montorgueil.*
*Fête du 30 juin 1878*
(*Rue Montorgueil, Festival*
*on June 30, 1878*), 1878.
(Musée d'Orsay, Paris)

*The June 30, 1878 festival, organized*
*to celebrate the international exposi-*
*tion held in Paris the same year, was*
*the subject of two paintings by Monet*
*and two by Edouard Manet. This*
*work is often wrongly attributed to*
*the celebration of Bastille Day on*
*July 14, but in 1878 that date was*
*not yet an official holiday.*

The unusual charm of impressionist images, their obvious "Frenchness," and their urbanity lies in how they are painted quickly, by visible strokes, as if the brush marks were not even touching.

The landscape, the genre in which most of the group specialized, could be called a distinctive feature of the school. (Limiting movement in this way, however, would practically

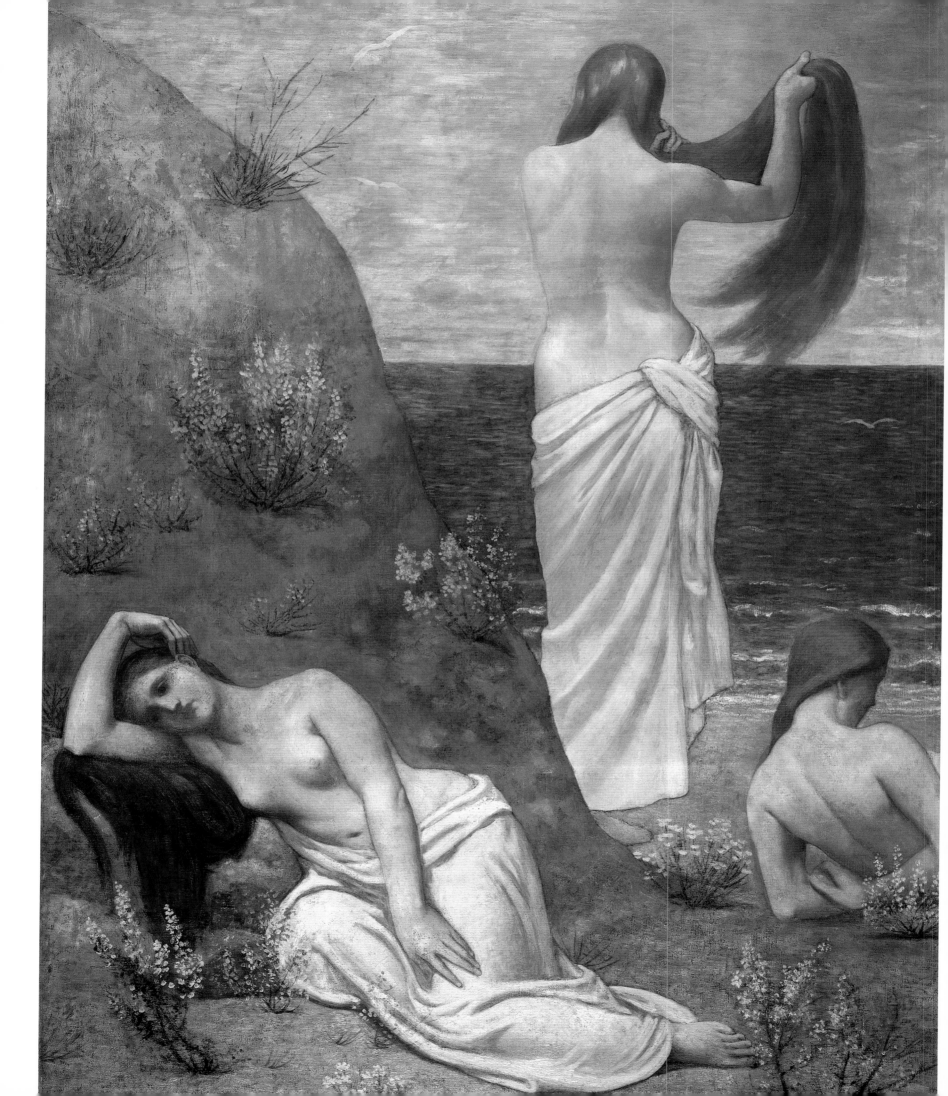

Opposite:

69. Pierre Puvis de Chavannes. *Jeunes Filles au bord de la mer* (*Young Girls at the Seaside*), 1879. (Musée d'Orsay, Paris)

70. Maurice Denis. *Le Soir Trinitaire* (*Trinity Night*), 1891. (Private collection)

*This painting illustrates Adolphe Retté's poem "Soir Trinitaire" (Trinity Night). Denis chose the same female model to portray three different attitudes of the poem's "sole" woman. This work is characteristic of the Nabi style: the composition follows a long contour, the ground is covered with striated grass that looks as if it were a piece of fabric, and the bodies are flat, monotone washes of color. Denis had some of Puvis de Chavannes's figures in mind and also perhaps the tapestry design called "mille fleurs" (a thousand flowers).*

**71. Georges Seurat.**
*Les Poseuses (The Models),*
1886–1888. (Private collection)

*The same model is shown in three different postures here in Seurat's studio on Boulevard de Clichy. A piece of neo-impressionism's famous "founding" painting* Un dimanche après-midi à l'île de la Grande Jatte *(Sunday Afternoon on the Island of La Grande Jatte) is included on the left side of this work.*

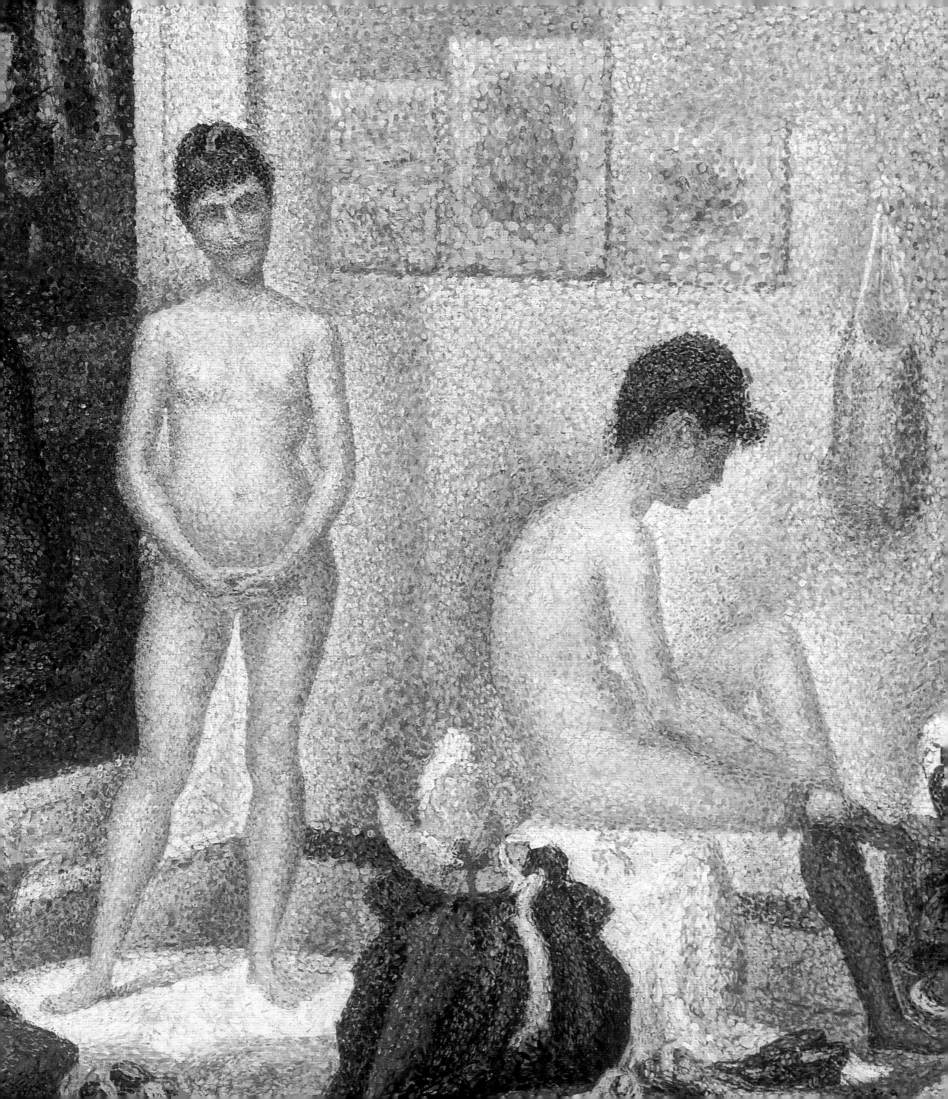

exclude Manet, Degas, and even Renoir's nudes; to a certain extent Renoir's *Le Moulin de la Galette* (fig. 67); and Manet's *Musique aux Tuileries* (*Music in the Tuileries*, 1862; National Gallery, London). The impressionist mission was to capture fleeting effects of various kinds, such as reflections of light on water or puffs of smoke from trains. In fact, the impressionists were the first artists to be interested in trains, that very modern invention. As Zola wrote, "This year [1877] Monet exposed the interiors of some superb train stations. In his paintings, one hears the grinding of the trains as they rush in; one sees the spilling out of smoke that rolls under the vast hangars. That is where painting is today...Our artists must find poetry in the train stations, just as their fathers found it in the forests and rivers."

In the end, the school favored many areas in Paris as subjects for their paintings, such as the Gare Saint-Lazare (Saint Lazare Train Station; fig. 68), which was the launching point for expeditions toward sites downstream along the Seine. They often painted open-air dance floors, pontoon boats, small skiffs and sailboats, and, of course, the Seine flooded with the ancient light of the Ile-de-France. Impressionists advocated *plein-air* painting, or painting

**72. Edouard Vuillard.**
*Jardins Publics (Public Gardens)*, 1894.
(Musée d'Orsay, Paris)

*From left to right, these three panels are entitled "The Nannies," "The Conversation," and "The Red Umbrella." They form part of a nine-panel series that was made to decorate AlexandreNatanson's Avenue de Bois apartment. Today the nine panels are in different collections throughout the world.*

done outdoors. Because of this, they also painted in the areas between Barbizon—the school of the forest—and the Normandy coast, the school of the sea. Barbizon was a favorite site for mid-nineteenth-century landscape painters whose style played a role in the genesis of impressionism. It was known as the "school of the forest" since its sites were around the vast lands surrounding the Fountainebleu Château. An area of the Normandy coast near the little port town of Honfleur made famous by the painters Jongkind and Boudin—also forerunners of impressionism—was the westernmost site.

But as important as locale was, it alone could not serve as the defining factor for impressionism simply because these locations were also favorites of the fauves. Some of Monet's urban views (fig. 66) could be taken for works by a fauvist artist. Besides, the shores of the Oise River, a tributary of the Seine at Pontoise, the domain of Pissaro, and at Auvers, where Cézanne and van Gogh could be seen, are not those of greater Paris (although there was a scattering of artists in the 1880s that marked the end of the great impressionist period). While Monet worked at his home in Giverny, Sisley at Moret-sur-Loing, and Pissaro at Eragny, all three were still located in the Seine basin. But Renoir, one of the first to be

**73. Pierre Bonnard.**
*La Promenade des nourrices ou frise de fiacres (Nursemaids' Promenade or Frieze of Carriages)*, lithograph affixed onto screens, 1897. (Musée d'Orsay, Paris)

*The original composition, painted with tempera, originated in 1894 as a screen decoration. It was later lithographed to make several copies for screen*

struck by the tropical beauty of the Mediterranean, would discover the towns of Estaque in the small Provençal Alps near Marseille and Cagnes-sur-Mer in the Maritime Alps, where he would remain until his death.

### Neo-impressionism

Renoir's saccharine nudes and generic scenes—which could not be distinguished from the clever scenes of Parisian life painted by the "petty masters"—made impressionism a popular movement. In time, impressionist painting became more and more fragmented. They were still portraying similar subjects, but the fresh water lilies of previous years, for example, were now limp and fading. Although these late works may appear to belong to the chaos of

*decoration. The scene portrays a young mother and her children crossing the Place de la Concorde as well as nannies and carriages. The strong influence of Japanese prints on this work is clearly evident, as in many other Nabi paintings.*

**74. Edouard Vuillard.**
*L'Elégante (The Elegant Woman),*
c. 1891–1892. (Private collection)

*This is part of a series of "paintings of doors" in which Vuillard only represents space and figures by means of vertical forms, a framework close to abstraction, but in which several elements of female fashion, which are dear to the Nabis, are figured. This painting is among those executed in Vuillard's apartment on Rue Miromesnil.*

**75.** Corsets fashioned by the Cadolle House, published in the magazine *Les Modes,* 1908.

## ODETTE DE CRÉCY

*…as for her figure, and she was admirably built, it was impossible to make out its continuity (on account of the fashion then prevailing, and in spite of her being one of the best-dressed women in Paris) for the corset, jetting forward in an arch, as though over an imaginary stomach, and ending in a sharp point, beneath which bulged out the balloon of her double skirts, gave a woman, that year, the appearance of being composed of different sections badly fitted together.*

*Marcel Proust,* Du côté de chez Swann *(Swann's Way), 1913, translated by C. K. Scott Moncrieff, 1925.*

the symbolist movement, they should be classified as early neo-impressionist. This disintegration began to become structured, to become systematic in neo-impressionism. Pointillism and the technique of divisionism, both practiced at that time, would have done a better job, but any challenge for a similar appellation for the movement would have been contested. The year that Seurat's "manifesto" painting, *Un dimanche après-midi à l'île de la Grande Jatte* (*Sunday Afternoon on the Island of la Grande Jatte*, 1886; Art Institute of Chicago) appeared, the critics launched, in both name and subject, neo-impressionism.

Seurat had put together a composition on the canvas that was nothing like that of the impressionists. Presented at the last impressionist exhibition, the *Grande Jatte* did give the illusion of continuity, but less through its technique than through its subject matter: a Sunday swim for the general public in the Seine, downstream on the Grande Jatte island. Later, the *Grande Jatte* reappeared as a subject in Seurat's workshop. It acted as a sort of frame for his masterpiece, *Les Poseuses* (*The Models*; fig. 71). The monumental size and color of this painting strongly evoke Puvis de Chavannes's work, especially the representation in triplicate of the same female model in *Jeunes Filles au bord de mer* (*Young Girls at the Seaside*; fig. 69). But the organization of Seurat's painting is more systematic: three axes that divide the painting into

three equal parts situate the model in triplicate. In addition, the axis passing through the main female subject of the *Grande Jatte* defines a golden section. Recourse to mathematical principles as the foundation of classical beauty emphasizes the movement's desire to escape fleeting impressions by entering into a more lasting order. Signac defined the rules of neo-impressionism: color must be obtained by an optic mix of pure prism tones discretely stroked onto the canvas at regular intervals, over which a layer of dots, whose dimension must be in proportion with the painting's dimensions, were applied. This overly systematic reminder to incorporate scientific rigor into painting, in opposition to the impressionist's pragmatism in their use of Chevreul's theories, made Signac's work a bit too conventional. Until his untimely death in 1891 he remained faithful to the basic tenet of divisionism, the technique on which pointillism was based, which involved juxtaposing strokes of pure color on the canvas.

Neo-impressionism was a movement that basically took place in Paris. (Both Seurat and Signac were born in the capital city.) But restlessness propelled Signac toward Normandy, Brittany, and southern France. Newly converted to tropical sunlight, Signac set up shop at Saint-Tropez and made long visits to Antibes, although he also kept a workshop in Paris during that time. After 1900 neo-impressionism became a popular movement, just as impressionism had. Yet the influence of Signac's book, *D'Eugène Delacroix au néo-impressionisme* (*From Eugène to Delacroix on Neo-Impressionism*; 1899), surpassed the limits of the school in significant ways. As contemporary art historian Françoise Cachin has stated "this treatise was able to play a role among the Fauves for its worship of color, among the Cubists for its austerity, with Matisse for its effect of rational analysis, and among the fathers of Abstraction, Delaunay and Kandinsky, for its willful style, its detachment from nature, and its obsession for pure painting and color."

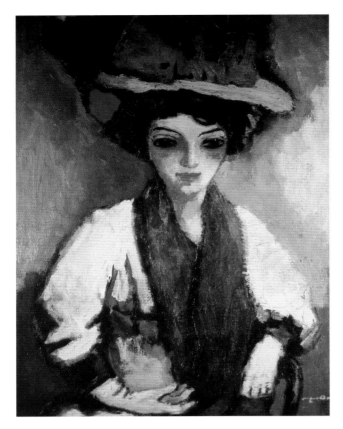

78. Kees van Dongen.
*La Femme au chapeau vert*
(*Woman in a Green Hat*), 1907.
(Fondation Pierre-Gianadda, Martigny)

### The Nabi Movement

Nabi art was nearly contemporary with neo-impressionism and equally rooted in Paris. The "talisman" dates from 1888; the style flourished between 1890 and 1900. *Talisman* is the landscape that Paul Sérusier painted on the lid of a cigar box at Pont-Aven in Brittany, after consulting with Gauguin. It would act as a point of reference for painters back in Paris, to whom Sérusier showed the small painting, who would constitute the Nabi group. When painting the landscape, called "talisman" in fun, Sérusier only used flat, pure colors juxtaposed according to the principles of synthetism, also known as cloissonism, practiced at the Pont-Aven School. As Gauguin said to Sérusier, "If the shadows seem to be blue, paint them in ultramarine; if the leaves appear red to you, make them vermillion." And in 1890 Maurice Denis wrote, "Before becoming a battle horse, a nude woman, or whatever detail, a painting is essentially a flat surface covered in colors put together in a certain way." *L'Hommage à Cézanne* (*Homage to Cézanne*; fig. 33) featured Redon but did not include some of the other Nabi precursors, including Gauguin, Puvis (whom Denis admired), Degas, and Japanese printmakers and calligraphers.

79. Frantisek Kupka.
*Ordonnance sur verticales*
(*Arrangement of Verticals*), 1911–1912.
(Musée National d'Art Moderne,
Centre Georges Pompidou, Paris)

Half jokingly and half seriously, the adepts who gave themselves the name of Nabis (which means "prophets" in Hebrew) met periodically at one of their homes to discuss art, listen to

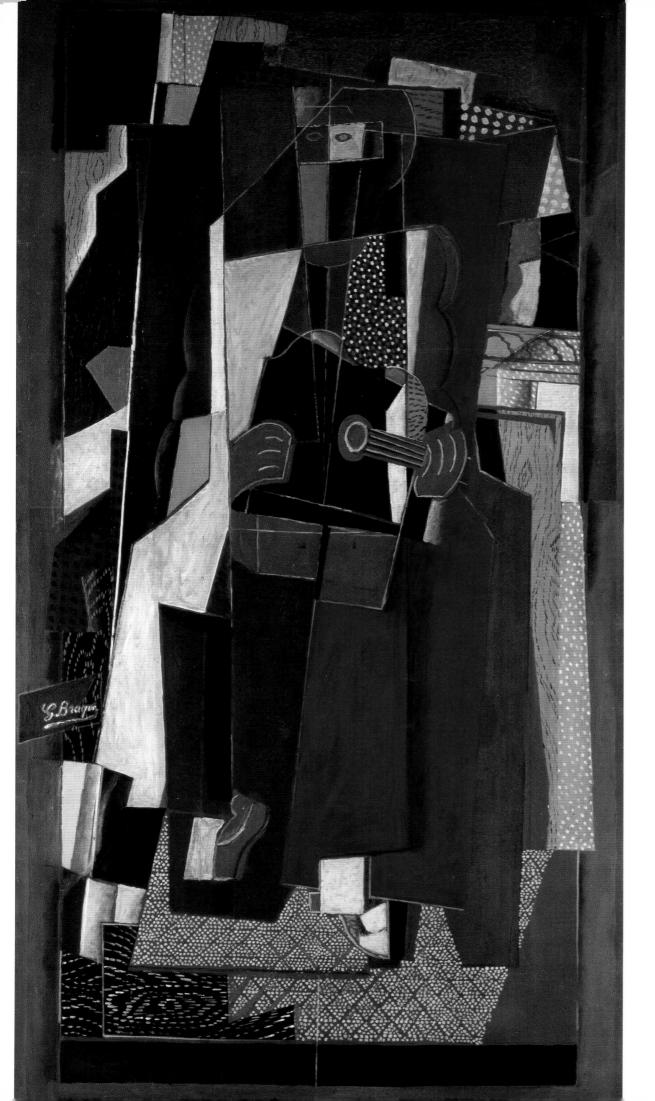

**80. Georges Braque.**
*La Musicienne (The Musician),* 1918.
(Öffentliche Kunstsammlung, Basel)

*This is a sort of parody of Braque's
Femme à la Guitare (Woman with a
Guitar, 1923; Musée National d'Art
Moderne, Centre Georges Pompidou,
Paris). The importance of color shows
the influence of Juan Gris.*

81. Auguste Rodin.
*L'Eternel Printemps*
(*Eternal Spring*), c. 1884.
(Musée Rodin, Paris)

contemporary music, or just to share a good, inexpensive meal together. Paul Ranson's studio on Boulevard Montparnasse was the "Temple" where Madame Ranson, the "light of the Temple" welcomed Bonnard, the "Japanese Nabi"; Georges Lacombe, the "Nabi sculptor"; Denis, the "Nabi of Beautiful Icons;" and the others. Vuillard, Bonnard, and Denis shared the studio of actor-director Aurélien Lugné-Poe for a while. Lugné-Poe was the director of the Oeuvre Theater located in Montmartre on Rue Pigalle. They exhibited their work in the local magazine, *La Revue blanche*, run by the Natanson brothers. Most of their time was spent in Paris, although they sometimes went to the Parisian suburbs: to Roussel's home at Etang-la-Ville, to Denis's home in Saint-Germain-en-Laye, or to Lacombe's at Versailles. Without leaving the basin of the Seine, but going outside of Paris and downstream, they visited Valvins and Villeneuve-sur-Yonne where the beautiful Misia, the muse and wife of Thadée Natanson, entertained them.

Common to the Nabi artists are intimate images of comfortable interiors (figs. 38–39), of gardens (fig. 72), of serenity, and of working life that are reminiscent of subjects approached by old Dutch masters. Some of Vuillard's interiors seem to be penetrated by Vermeer's light, but the style is very different. Rings that limit tinted, seamless backgrounds make twists and turns, as decorative as they are monumental, that run right through the paintings. Such effects are akin to Puvis's art and Asian graphics. The solidity of their compositions and their economy of means drove the Nabi artists to the margins of abstract art (fig. 74). But it also gave them a clarity of vision that allowed them to participate in any decorative scheme, from a small box to a screen or dome decoration. It also earned them a place next to Toulouse-Lautrec as masters of lithography and poster art.

The Nabis also created sculpture. Lacombe, along with Gauguin and Aristide Maillol, returned to direct chiseling. His oeuvre, inspired by Gauguin, was created at Versailles. After 1897 he worked in Normandy, near Alençon. Maillol lived in Villeneuve-Saint-Georges, in Marly-le-Roi, and in greater Paris, but each season he returned to his hometown of Banyuls, in Catalonia. He painted with, and like, the Nabi artists, but is best known for his sculpture. His first sculpted works were bas-reliefs made by direct chiseling. Like Gauguin and Lacombe, Maillol used this technique only on wood. The son of a stone sculptor named Joseph Besnard, he was the only artist to make the transition from soft material to hard, from wood to marble, when using the direct chiseling technique. Although he did not belong to the Nabi family, the decorative and monumental aspect of Maillol's bas-reliefs, not to mention his philosophy of art, belonged to the Nabis. His goal was to "take away a minimum of volume in order to liberate a suspected, rather than projected, presence" and to free the "nymph held prisoner" in marble.

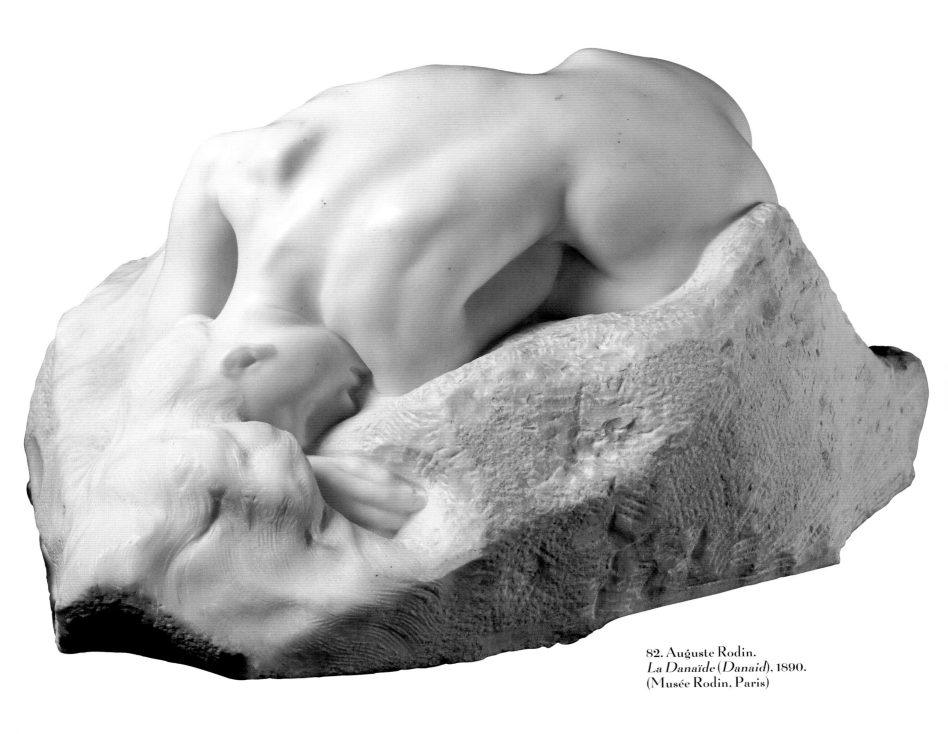

82. Auguste Rodin.
*La Danaïde* (*Danaid*), 1890.
(Musée Rodin, Paris)

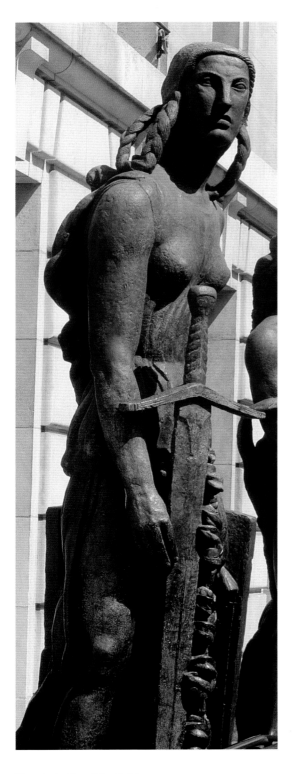

Maillol's art, on the other hand, rapidly moved away from the Nabi School. His high-reliefs (fig. 88) were similar to Bourdelle's (fig. 87). Without leaving Paris, his change in technique (from high-reliefs to *ronde-bosses*, round raised protrusions on a flat surface) was a symbolic return to the womb. His *Méditerranée* (*Mediterranean*) is one of the first examples of a neo-classicism fed by Mediterranean references that would develop during the period between World War I and World War II. Heliotropism had an effect on Roussel, and Bonnard as well. After visiting Cézanne in 1906, Roussel's palette and subjects changed entirely. He no longer painted fauna and bacchanalian women frolicking between the countryside and the leaden sea. From around 1900, Bonnard kept revisiting the theme of bathing nudes without being able to forget Degas. In 1925 he moved to Canet, and without leaving behind his favorite subject, he added a bit of mimosa to his gardens. Denis's evolution was completely different. He never left the region of Paris, but began to move toward a symbolism that would eventually lead him to sacred art. *Le Soir trinitaire* (*Trinity Night*; fig. 70), whose title and subject are drawn from the work of symbolist poet Adolphe Retté, presents three poses of the same woman. This sculpture, of course, was linked to Puvis and Seurat's planned constructions.

### Fauvism

From 1905 to 1907 a major disruption occurred in the art world. At the time, both impressionism and the Nabi movement were tinged with that end-of-the-season melancholy: the shores had changed but the river had followed its course. In 1905 an exhibition of the fauves (a term meaning "wild ones") caused a disturbance; in 1907 it was triggered by a retrospective show of Cézanne's work and Picasso's *Les Demoiselles d'Avignon* (fig. 43). We cannot say definitively that fauvism began during the Fall Salon of 1905 (which was a new Salon established in 1903 by Frantz Jourdain), but that was when the modern painters assembled there were labeled "fauves" by the critics. The origin of fauvism gets lost in the pure color and uniform backgrounds of paintings by Gauguin and van Gogh as well as in Signac's powerful brushstrokes. The fauves adressed the same subjects as the Nabis, but they snatched the last golden days of painting and pulled it kicking and screaming into a world of violence. Transferring the effects of nature to canvas was no longer the task. The essential goal became to show the effects that nature produced on the human soul. In portraiture, fauvism resembled the expressionist painting from the Nordic countries. This was evident in the work of Kees van Dongen, one of van Gogh's countrymen, who arrived in Paris in 1897 (fig. 78). Nonetheless, fauvism was essentially a Mediterranean movement whose major sites were L'Estaque, La Ciotat, Cassis, Cagnes, Cadaquès, Saint-Paul-de-Vence, Martigues, Saint-Tropez, and Collioure. Matisse worked in Saint-Tropez with Signac during the summer of 1904, then worked in Collioure with Derain during the summer of 1905. Fauvism is like isolation, or a forest fire; its color is vermilion. "High noon is made of fire," wrote Paul Valéry in his famous poem *Le Cimetière Marin* (*The Graveyard by the Sea*). It is true that other locales were involved in fauvism—Derain's London, Marquet's Normandy, and, above all, the Chatou of Vlaminck and Derain (figs. 36–37)—but all of them draw us back to greater Paris. At Chatou, the Paris-born Vlaminck and the Chatou-born Derain found themselves on an old impressionist site at Grenouillère. Derain correctly identified it as the locale of Courbet's *Les Demoiselles* (*Demoiselles on the Banks of the Seine*). Matisse, who stood out as the leader of the school, opened an academy in Paris in 1908 that was very popular. From 1910 to 1911, he spent time in Spain and in Morocco, but the French Riviera would draw him back definitively during the time between the two world wars.

### Paul Cézanne

Cézanne's presence in Paris was hardly noticeable. Nonetheless, the artist discovered the work of Delacroix, Géricault, and Daumier there. He went to the Louvre to make copies of the masters' works. At the Café Guerbois and the Café de la Nouvelle Athènes he met impressionists whom he would show his works. He traveled with artists and writers to towns close to Paris: with Zola in Médan; to Pointoise and Auvers-sur-Oise with Pissarro; to La Roche-Guyon with Renoir; and to Hattenville in Normandy, to Victor Choquet's home.

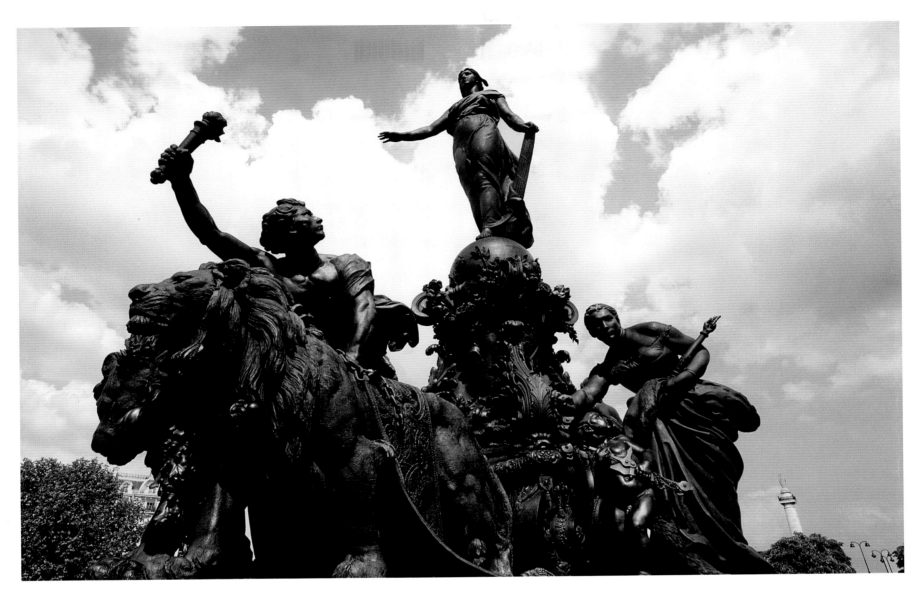

**84–86. Jules Dalou.**
*Triomphe de la République*
(*Triumph of the Republic*), 1879–1884.
Place de la Nation, Paris

*Dalou entered the model for this ensemble in a
competition in 1879. Although he did not win, he
still received the commission in 1880. The
original plaster was finished in 1889 for the
centennial of the French Revolution. The bronze
was not completed and erected until ten years
later. The figure towers above the nation's
chariot pulled by lions: she is accompanied by
Work and Justice, with Liberty leading their
way and Peace following behind them.*

He also went farther away to the Provence region in the south of France: in Marseilles he met Adolphe Monticelli; in L'Estaque he worked with Monet and Renoir; and in the city of his birth, Aix-en-Provence, he lived almost continuously from 1886 onward after inheriting his father's estate. The exact date or location of the creation of the diverse versions of his major series, like the bathing women, cannot always be ascertained, except for those produced in his last twenty productive years in Provence. The landscapes are traceable: the famous *Maison du pendu* (*The Hanged Man's House*, 1873; Musée d'Orsay, Paris) was painted at Auvers. *La Seine à Bercy* (*The Seine at Bercy*) is contemporary and was painted in Paris, but is not very significant. In the end, Parisian exhibitions were what enabled Cézanne, who is regarded as the father of modern art, to stand out among his young peers. Cézanne participated in the first Impressionist Exposition of 1874. At that time he was only known by a few of his contemporaries. Denis exhibited his *Hommage à Cézanne* (*Homage to Cézanne*; fig. 33) at the Salon des Indépendants in 1901. The major exhibitions of this master's works were held at the Fall Salons between 1903 and a posthumous retrospective of 1907.

### Les Demoiselles d'Avignon

*Les Demoiselles d'Avignon* (1907; fig. 43), featuring prostitutes from the Carrer de Avinyo in Barcelona, had been well thought out during one of Picasso's stays in Catalonia, but it was painted in Paris in the artist's Le Bateau-Lavoir studio. Judging by its dominant color, we can say that it belongs to the Rose Period, but this painting was a sort of prelude to his cubist period (although Picasso himself denied it and managed to convince some of his critics that it was not). The facated faces of the women reveal the artist's interest in cubist theories of providing multiple views simultaneously. The sources for this painting have been carefully catalogued, although no list is unanimously agreed upon. First and foremost, two clear sources are the Iberian bas-reliefs from the Osuna province that were exhibited at the Louvre in 1906 and the art of El Greco, whose work Picasso admired. Without a doubt, African art played a role, as did Cézanne, who recommended "rendering nature by cylinders, spheres, and cones." Reactions to *Les Demoiselles* were fairly negative. Matisse believed that Picasso had wanted to make modernism look ridiculous when he unveiled the painting, which was not outside the realm of possibility. Nonetheless, *Les Demoiselles* earned Picasso this friendly endorsement from Henri Rousseau: "We are both the greatest painters of our era. You specialize in the Egyptian genre and I in the modern genre!"

### Cubism

Braque, a native and resident of greater Paris until his death, almost never left the city except for a few stays in Normandy and in the south of France (including La Ciotat,

L'Estaque, and Céret). At the end of his fauve period, he met, became friends with, and collaborated with Picasso. From this association, cubism was born. It was presented as a collective, anonymous project (figs. 40–41); however, Braque was the artist who introduced letters and other trompe l'oeil materials into what we now call synthetic cubism. He also invented the type of collage known as *papiers collés*. The name of the movement came from one of Matisse's comments about Braque's work that was adopted by the critics. Braque and Picasso worked instinct-

ively; theoretical justifications did not move them. Apollinaire wrote the founding doctrine of cubism (*Les Peintres cubistes*, or *The Cubist Painters*, 1913), and in doing so slightly annoyed the founding fathers of the movement. "When we were doing cubist work," Picasso declared, "we had no intention of doing cubist work." (This protest echoes a similar one made by Gustave Courbet about Realism.) Cubism can also be associated with the 1911 exhibition at the Salon des Indépendants, where a number of artists came together in solidarity without really sharing the same convictions and aesthetic ideas. There were many imitators of work by Picasso and Braque, and they managed to use and alter cubism to suit their own personal artistic goals. Juan Gris, however, a painter who arrived in Paris from Madrid in 1906 and set up shop in Le Bateau-Lavoir, should not be counted as an imitator. He was the third most important cubist painter. Gaston Duchamp, known as Jacques Villon, arrived in Paris from Rouen in 1894 and was also inspired by the new movement. He and a group of artists who gathered together in his suburban studio in Puteaux called themselves the Golden Section. His use of guiding lines like those of the Renaissance, which he borrowed from Leonardo da Vinci, brought his work close to that of Seurat.

Contemporary sculpture followed its own path. It was practiced by a generation of foreigners who arrived in Paris before World War I, but who did not come into their own as artists until after the war. The Romanian Constantin Brancusi immigrated in 1904, the

89. Joseph Besnard.
*Danse (The Dance)*, 1911–1913.
(Musée d'Orsay, Paris)
*Executed for the music room of the Hôtel Nocard in Neuilly, this frieze was one of the first examples of the return to direct chiseling in marble. It was reproduced to adorn the Pavillon du Collectionneur (Collector's Pavilion) at the Exposition internationale des arts décoratifs et industriel modernes (International Exhibition of Modern, Decorative, and Industrial Arts) in 1925.*

Ukrainian Alexander Archipenko arrived in 1908, and the Lithuanian Jacques Lipchitz went to Paris in 1909. In 1912 Picasso produced his first works made of cardboard, wood, and metal (fig. 93), and Brancusi completed his famous *Le Baiser* (*The Kiss*; fig. 92), which was a cubist work by virtue of his similar philosophy regarding positive and negative forms in sculpture. Brancusi wrote, "I wanted to remove the hollows that make shadows." The driftings of Fernand Léger, Robert Delaunay, and Marcel Duchamp were those of abstraction and futurism, profuse yet confusing tendencies that are sometimes confounded with cubism.

### Abstraction

Abstraction was born in Munich and Moscow through the German philosophy and Russian spirituality of Wassily Kandinsky and Kasimir Malevich. The theory of "pure visuality" developed by Wilhelm Worringer in *Abstraktion und Einfühlung* (*Abstraction and Empathy*), 1908, led Kandinsky to paint the first non-figurative painting in 1910. It was the result of deliberate abstraction, rather than a non-figurative painting that one might obtain by isolating a fragment of a work by Fragonard or Manet. At its outset, abstraction had little to do with French art. Malevich, who painted *White on White*, had seen cubist work in collections in Moscow.

**90. Aristide Maillol.**
*Danseuse* (*Girl Dancing*),
wooden bas-relief, 1895.
(Musée d'Orsay, Paris)

*Created during the Nabi period, this was one of Maillol's first attempts at sculpture on wood.*

**91. Aristide Maillol.**
*Méditerranée* (*Mediterranean*).
(Jardin des Tuileries, Paris)

*The plaster model for this sculpture was shown in Paris at the Salon of 1905. The state commissioned the marble in 1923 and placed it in the Jardin des Tuileries in 1929, where it was replaced by a bronze in 1965.*

Regarding the development of abstraction, the most important visit to Paris was that of Piet Mondrian in 1912; he would stay for two years. While there he discovered cubism and became convinced he could identify with this "pure painting." It was just what he had been searching for. In Paris he completed his tree series: the progressive metamorphosis of trees in a game of lines. But World War I took Mondrian back to Holland. In Paris abstraction had developed in opposition to cubism, distinguishing itself from the latter by claiming to represent interior life, while cubism was only a technique for representing reality. Cubism was, in the eyes of the abstract artists, the last realism. As such, the futurists treated cubism as a movement that had lost its relevance.

### Futurism and the Cinema

Various movements in the art world began to develop more quickly. The various groups and associations succeeded one another at a lightning speed that the futurists made the soul of their art. The cubists stood for capturing reality stopped in time; the futurists wanted to make it move, to eternally ensure a "dynamic fascination." Artistic, literary, and political futurism based in Rome, Florence, and Milan was, in the beginning, a manifesto machine. The *Futurist Manifesto*, published in *Le Figaro* on February 20, 1909, was purely literary. The *Manifeste des peintres futurists* (*Manifesto of Futurist Painters*) dates from 1910, the same year as the first abstract painting. In 1913, the *Manifeste contre Montmartre* (*Manifesto against Montmartre*) appeared.

92. Constantin Brancusi.
*Le Baiser* (*The Kiss*), 1908
or 1912. (Private collection)

93. Pablo Picasso.
*Mandoline et
clarinette* (*Mandolin
and Clarinet*),
1913. (Musée
Picasso, Paris)

In Paris, the futurists had rivals in Duchamp, Delaunay, Léger, and
Frantisek Kupka. In 1913 Duchamp painted his famous *Nu descendant un
escalier* (*Nude Descending a Staircase*), featuring a wooden mannequin walking down a
staircase. The viewer simultaneously sees all the positions the mannequin must take in
order to descend it. This "cerebral" nude managed to escape the futurists' condemnation,
although they had been campaigning for the end of nude painting for ten years. Painters
who had been obsessed with exhibiting their lover's bodies, they said, had transformed the
Salons into "carnivals of hams." In 1913 Duchamp produced his first "ready-made" (a work
of art created out of everyday objects), a bicycle wheel. Just as some fountains become
petrified by their own water, museums transformed the most banal of objects into a work of
art, claimed the futurists. Yet, what might have happened to ready-mades if the museums
had all been done away with, as many of the radical artists had advocated?

Léger's dislocated volumes (produced from 1909–1910), the verticals of the Czech Kupka,
who came to Paris in 1882 (fig. 79), Delaunay's windows (made in 1912), and other con-
temporary work that was in some way born of cubism would reconcile abstraction and
futurism. They restored contemplation, a form of pleasure, to all the speculation.

In 1882 in Paris, Etienne Jules Marey, a physiologist and professor at the Collège de France,
invented chronophotography as a means for studying the movement of people and animals.
His photographic process captured the continuity of movement through a succession of
images. One can only guess what the futurists, who forbade its use for themselves, and
Duchamp owed to this invention that gave us cinematography. Cinema was born in Lyons in
1895 in the studios of the Lumières brothers. But it was in Paris, in the studios of Georges
Méliès and Charles Pathé, that cinema became an art.

### THE FUTURIST MANIFESTO

*We want to sing our love of danger, the liberation
of energy and darkness ... aggressive movement, fever-
ish insomnia, the gymnast's step, the perilous leap,
the slap and the punch ... We declare that a new
beauty has enriched the glorious world: the beauty
of speed ... A roaring automobile ... is more beauti-
ful than the statue Winged Victory. We want to
glorify war, the world's only hygienic practice ...
beautiful ideas that kill and scorn generosity ...
We want to destroy the museums and libraries ...
We want to sing ... the multi-colored and poly-
phonic undertow of the revolutions occurring in
modern capital cities, the nocturnal rumbling of
the naval dockyards and construction sites beneath
intense electric lights ...*

Le Manifeste du Futurisme (The Futurist
Manifesto) *published in* Le Figaro, *1909.*

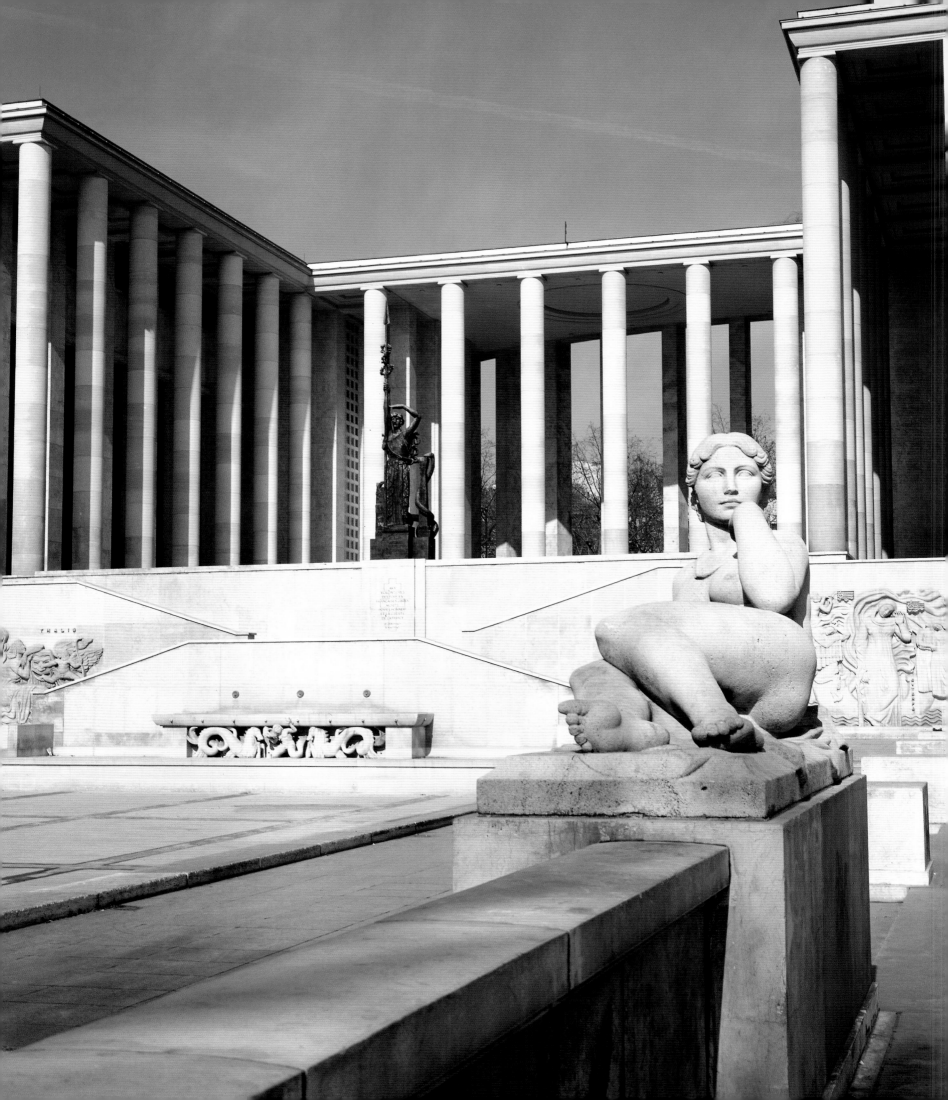

# Chapter XIII
# THE TURBULENT YEARS
## (1914–1940)

The last Chinese lanterns from the gala of 1900 were not extinguished until 1914, when the first conscripts left for the front in World War I. The decade following the conclusion of the Peace Treaty of Versailles (1919) has been called the Turbulent Years. Leaving behind the terror of war meant a return to all things pleasurable and was reminiscent of the response during the month of Thermidor in 1794, which had marked the end of the Reign of Terror and the downfall of Robespierre, and the fanciful fads of the *incroyables* and the *merveilleuses*, the young people who during the Directoire period (1795–1799) were recognizable by their dress—often wearing a red ribbon around their necks at the place where the blade of the guillotine would have struck—and their speech, often repeating "That's incredible!" Women, who in order to participate in the war effort had rejected useless and cumbersome undergarments, refused to don them again once peace returned. Coco Chanel raised skirts to the knee, dropped waistlines, fastened blouses with a man's tie, cut off hair and stuffed it beneath cloche hats pulled down to the eyebrows. Women now rid themselves of floor-length clothing, thereby joining the ranks of men, who had done so in the fourteenth century. Jean Patou invented sports clothes. Victor Marguerite wrote a novel dedicated to this new Eve, *La Garçonne*, 1922, which enjoyed considerable success. The whirlwind of automobiles and the speed of moving objects imposed their rhythms. Everyone wanted to believe that peace was eternal, but the feeling persisted that it was ephemeral and that one must make haste to enjoy it.

With the economic crisis of the 1930s, though, those happy times were once again extinguished. Old beliefs returned in force; various alliances threatened the Republic while Socialists formed the government of the Popular Front. The crisis greatly affected the building industry, whose production diminished by an average of 5 percent annually between 1929 and 1938.

### 1–3. Palais de Tokyo

*This building, which takes its name from the Quai de Tokyo, the former name of Avenue de New York, was built in 1934 on the site formerly occupied by the famous Savonnerie carpet factory. The palace was designed to house two museums of modern art, the city of Paris's, which is still there, and the state's museum, the former Luxembourg Museum, which forms the basis of the Musée d'Orsay. The design by Jean-Claude Dondel, André Aubert, Paul-Jean-Emile Viard, and Marcel Dastugue was selected as the winning entry in a competition in which Le Corbusier and Robert Mallet-Stevens also participated. The decor of the museum is the product of a group of sculptors and craftsmen working in wrought iron (Antoine Bourdelle, Alfred Auguste Janniot, Raymond Subes, and others).*

## United States and Switzerland

The war caused a significant scattering of the Parisian community of artists, some returning to their homeland, others leaving for the United States. Many artists escaped to New York, seduced by the cosmopolitanism and natural dynamism of the young metropolis. Along with the works of American artists, the Armory Show, the international exhibition of modern art held in New York in 1913, had exhibited works by Paul Cézanne, Vincent van Gogh, Paul Gauguin, Picasso, Georges Braque, Robert Delaunay, and other founders of modernism. Its scandal, or rather, its success, had been significant, and had important long term effects. It was at that time that the great American collections of contemporary art began to be assembled. New York readied itself to strip Paris of its title of Capital of the Art World, but the "switch" did not really happen until a second artistic emigration was prompted by World War II. Marcel Duchamp and Francis Picabia were part of the first emigration. A Parisian born of a Cuban father, Picabia had been part of many of the major movements of the period and was one of the precursors of abstract art. The neutrality of Switzerland had also attracted radicals and anarchists whose words would have meant imprisonment for them had they remained in countries who were at war. Following the war, artists returned to Paris, where they were joined by a second wave of immigration, less significant than the first: Victor Brauner was Romanian; Henri Brassaï a Hungarian from Transylvania; Antoine Pevsner from Russia; Alberto Giacometti from Switzerland; Alexander Calder, who was only there briefly, from the United States, like Man Ray, who also settled in Paris. Salvador Dali and Joan Miró were Spanish, or to be more precise, from Catalonia, as was Picasso. Max Ernst was probably the only German artist to make his home in Paris between the wars.

## Montparnasse

Montparnasse was the meeting place of artists in Paris. The popularity of Montparnasse had just barely begun before the first decade of the twentieth century and quietly died after 1930. This neighborhood, so aptly named, took its name from a little hill that seventeenth-century Parisian students mockingly described as Parnassus. The borders of this artistic Parnassus were nebulous: it would have to be connected to the far-off Ruche (The Hive), which was for Amedeo Modigliani, Chaïm Soutine, Marc Chagall, and Fernand Léger what the Bateau-Lavoir had been for Picasso, Juan Gris, Kees van Dongen, and Pablo Gargallo and which, by its name alone, expressed so aptly the tendency of Parisian artists to live in groups. These artists continued to get together at their favorite Paris cafés, Le Dôme and La Rotonde.

## Futurism and Dada

Ideas as well as artists came from abroad. The desire for change, which until then had been able to accommodate a few signs indicating a break with the old world, incited a call to international revolution. The most radical movements came from northern Italy and Switzerland; two of them, futurism and dada, formed a kind of symbolic diptych on either side of World War I. The first proclaimed an ardent confidence in progress, while the second is characterized

### 4. Hangars for Dirigibles at Orly (destroyed)

*These hangars were built from 1921 to 1923 by the engineer Eugène Freyssinet. Each hangar was 295 feet wide, 164 feet high, and 984 feet long. Each consisted of forty "parabolic wave" arches interspersed with openings to provide light. The hangars were destroyed in 1944.*

### 5. Saint-Esprit Church

*This church, built of reinforced concrete between 1928 and 1935 by Paul Tournon, was inspired by the church of Hagia Sophia in Istanbul.*

## 6–7. House at 31, Rue Saint-Guillaume

*This house was rebuilt between 1928 and 1931 for Dr. Dalsace by Pierre Chareau, famous for using facades made of glass, glass blocks, or mirrors. The structures also featured movable ceilings and partitions.*

by a dark pessimism and cynicism. The artistic applications of futurism were limited, all the more so since the principal Italian representatives of the movement were killed on the front during the very war they supported (and even celebrated).

During the course of World War I, the intellectual, literary, and artistic movements that developed in Switzerland, the United States, and in Germany argued in favor of the destruction of social and aesthetic values. Carrying the name of "dada," a term adopted for its total absence of meaning and thus appropriate to cover any use of the arbitrary or the absurd, these movements converged in Paris at the beginning of the 1920s. Dada, created in Zurich in 1916 by the Romanian poet Tristan Tzara, was joined in Lausanne in 1918 by an analogous movement formed in New York around Duchamp, Man Ray, and Picabia. The movement, repressed in wartime Germany, did manage to develop in conquered Germany—in Berlin, Hanover, and Cologne. Cologne was the meeting place of the two Rhinelands—the sculptor, painter, and poet Hans Arp (who was born in Strasbourg, which at that time was occupied by the Germans) and the painter Max Ernst (born in Bruhl, on the outskirts of Cologne) would meet up with Picabia and Tzara during the two or three years of Parisian dada (1920–1922). When dada arrived in Paris after the war, it received the support of André Breton and Louis Aragon. Yet, just after its unification, dada became the victim of a schism perpetrated by Breton, who converted the most important artists to surrealism.

### The Bauhaus, Constructivism, and De Stijl

In 1919 in Weimar, Germany, Walter Gropius founded the famous Bauhaus, a school devoted to an industrial aesthetic in the arts and a new social order: "We must will ourselves to imagine the new building of the future and to work on it together; it will unite architecture, sculpture, and painting in harmony. Like a crystal emblem of new faith in the future, this edifice will rise in the sky of the future through the work of thousands of workers," wrote Gropius in the *Bauhaus Manifesto*, 1919. Eventually, under pressure from the Nazis, the Bauhaus had to abandon Weimar for Dessau, and then fled to England, finally settling in the United States in 1933. The Russian Revolution first produced, then

stifled, constructivism, which, like the Bauhaus, fell victim to the totalitarian state. The influence of this important movement, which advocated simple geometric forms, in France was limited. That was not the case, however, for the De Stijl group founded by Mondrian and Theo van Doesburg in Holland in 1917. The objective of "total art" as conceived of at the Bauhaus assumed that the plastic arts were subservient to architecture. With the same general objective, De Stijl placed painting in the foreground: "Architecture's only goal is to realize in the here and now what the painter has shown in an abstract way in the new plastic art," wrote Mondrian. Two works belonging to this school, dating from 1929, can be found in greater Paris: the Collège néerlandais (or Dutch College, a student residence) at the Cité Universitaire, the student housing complex for the University of Paris, and the van Doesburg house in Meudon. But the influence of De Stijl on the overall architecture of Paris in the period between the two wars is noticeable. So many ideas circulated at this time, and the many groups eventually broke up into innumerable splinter groups. All that was needed was a group of people, a journal, and a healthy dose of innocence combined with outrageousness for another new movement to begin seeking acceptance.

### The CIAM

The only truly international organization was the CIAM (Congrès internationaux d'architecture moderne, or International Congresses of Modern Architecture). The first of these congresses was held in Switzerland in 1928. Le Corbusier was chosen to organize the program. The French section of the CIAM, founded in 1929, included nearly all the French "moderns" from Tony Garnier, to Frantz Jourdain, and from Freyssinet to Henri Sauvage, from André Lurçat to Pierre Chareau, and on to Mallet-Stevens. Auguste Perret was the only great modernist who refused to join the section. Five congresses were held from 1928 until the outbreak of World War II. The first version of the Charter of Athens was drafted in 1933.

### 8. Rue Mallet-Stevens

*This is a private street made up entirely of buildings, private residences, and house/studios built in 1926–1927 by Robert Mallet-Stevens, notably for himself and for the sculptors Joël and Jean Martel.*

### 9. Ozenfant House

*This house was built of concrete by Le Corbusier in 1923 for the painter Amédée Ozenfant at the entrance to Montsouris Square (53, Reille Avenue), a private road divided in 1922. The original primitive shed roof was replaced by a flat roof.*

### 10–11. Villa Savoye at Poissy

*This house was built by Le Corbusier between 1929 and 1931 for Pierre Savoye and his wife.*

## 2 – TECHNICAL AND FUNCTIONAL ARCHITECTURE

### Concrete

The time of pioneers, experimenting, and flashes of brilliance had expired, but construction techniques were constantly being perfected. In the 1930s, the engineer Freyssinet perfected prestressed concrete. Prestressing is a way of impregnating the material with strength prior to its being used. Concrete is compressed so as to better resist stress, which tends to pull concrete apart, as well as reinforced with metal rods or panels. The metal reinforcements within the concrete are themselves placed under tension in order to better withstand the forces that would tend to crush the concrete.

The use of concrete was enough to call buildings using it modern. The beautiful Saint-Esprit Church could be described as a pastiche (fig. 5), but it is built of reinforced concrete and in the aesthetic of reinforced concrete; its model is the church of Hagia Sophia in Istanbul, reference work for the rationalists: "Nowhere else have the principles of a rational architecture been applied with such boldness and assurance," wrote Le Corbusier, echoing many others on the subject of Hagia Sophia. The overall concept of the church at Raincy, the work of Perret, is traditional, but its construction used standardized elements made of reinforced concrete, an internal structure, and non-weightbearing walls.

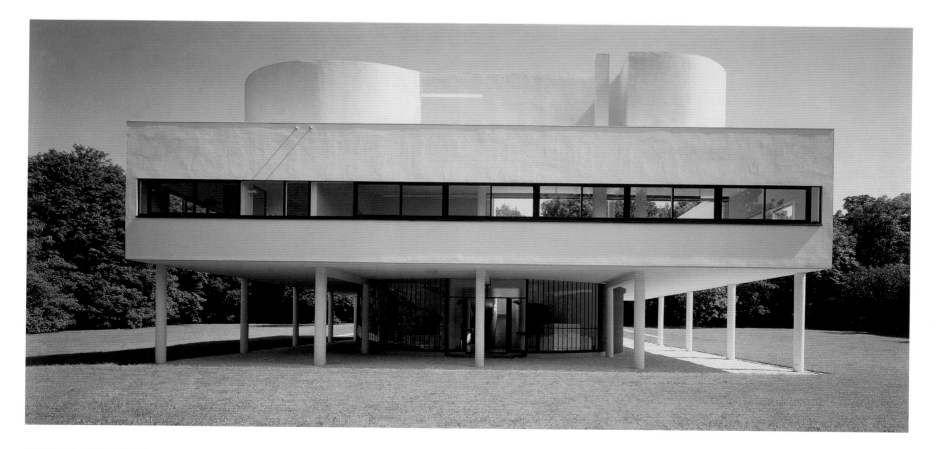

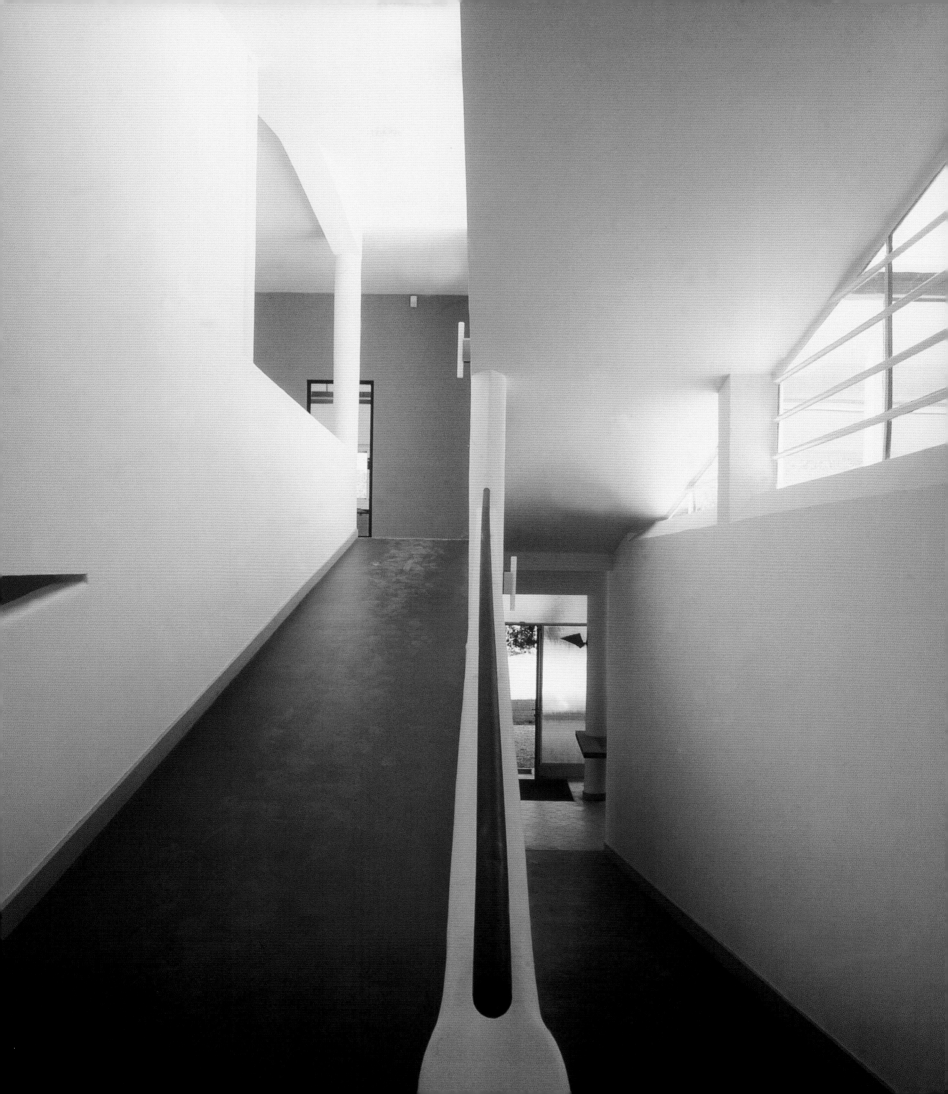

12. Henri Sauvage. Proposal for the
Development of Porte Maillot, 1931.

*In 1931 several architects, among them
Le Corbusier, Perret, Mallet-Stevens, and
Sauvage, submitted proposals for developing
a "Place de la Victoire" at Porte Maillot.*

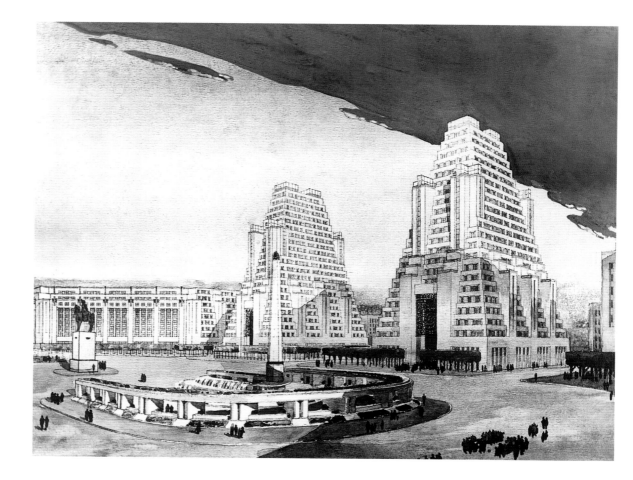

### 13–14. Habitation à Bon Marché (Low-Cost Housing), 13, Rue des Amiraux

*This group of eighty communal housing
units was built between 1921 and 1927 by
Henri Sauvage for the Public Office for
H.B.M. (Habitations à Bon Marché, or
Low-Cost Housing) of the city of Paris.
A swimming pool fills the center space.*

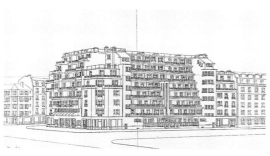

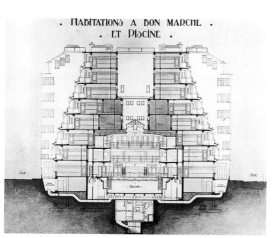

The facings were left in rough concrete, probably in order to save money, but with important stylistic implications. Religious art found its archetype in this "Sainte-Chapelle of concrete." Freyssinet's dirigible hangers at Orly (fig. 4) represented for concrete what the Palais des Machines (Hall of Machines) had represented for metal, and met the same fate: "There wasn't a second when I wasn't thinking about the possible artistic effects; accordingly, they are striking," wrote Freyssinet, unconsciously reproducing Eiffel's commentary on his tower.

### Glass

Since the end of the seventeenth century, when it became possible to replace windows made of blown glass with windows made of pressed glass, glass had progressively taken on a more important role in construction, particularly as glass slabs or blocks set in an iron framework. As a material resistant to compression that was rigid, washable (and thus hygienic), as well as being a conductor of heat and light, glass would have been the ideal material had there been a way to use it without an iron framework that was susceptible to corrosion and allowed leakage at the joints. At the beginning of the century something called "translucent reinforced concrete" appeared, a system of square blocks of glass mounted in cement. The first examples of walls made of glass blocks appeared in the art nouveau of Brussels, which was in so many ways the source of Parisian innovation. The glass block could also be found in Hector Guimard's Béranger Castle and Perret's building on Rue Franklin. The Saint-Gobain company's perfection of a new kind of glass brick in 1928 allowed Chareau to build the glass house (figs. 6–7), a favorite work of the avant-garde because of its open plan, geometric spaces, visible wiring and conduits, its courtyard facade made of glass brick, and its lack of windows, save for the loopholes drilled in the projection of the facade: "I wanted to stretch a veil between the occupant and the outside world," wrote Chareau, an unwitting interpreter of the avant-garde. "Glass alone, with no help from any of [the rest of] us, will end up destroying classical architecture," predicted Frank Lloyd Wright in 1930.

## Urban Buildings and Houses

Despite the Eiffel Tower's 984 feet of riveted iron, the rationalist avant-garde considered technology and functionalism as having the same essential nature. During the period between the wars, through the application of ideas collected at the transition between the nineteenth and twentieth centuries—such as the theory of *cités-jardins* (garden cities), Otto Wagner's urbanism projects in Vienna, and Tony Garnier's *Cité industrielle* (*Industrial City*)—the functioning of the city became the principal field for experimentation in modern architecture. It was during his stay in Rome in 1901 that Garnier, contravening academic rules and being reprimanded by the members of the institute, planned his development, one that paired ingenuity and concrete and foreshadowed a socialist Eden. The *Industrial City (Cité industrielle)*, which was not published until 1917, contributed greatly to the promotion of residential developments made up of individual houses. Rue Mallet-Stevens (fig. 8), the street built entirely by Mallet-Stevens, is a fine example of what the coupling of new techniques and new

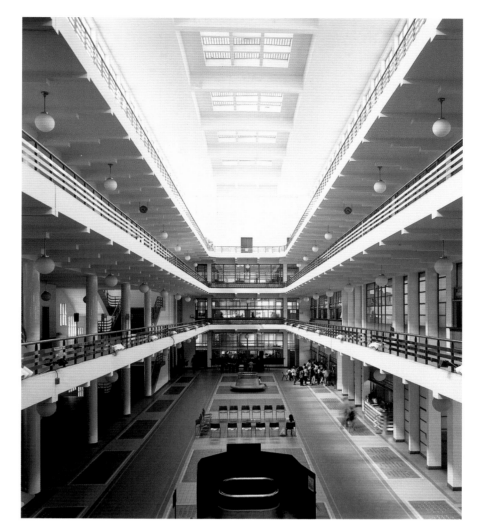

**15. Hôtel de Ville in Boulogne-Billancourt**

*This hôtel de ville (city hall) in Boulogne-Billancourt was built between 1931 and 1934 by Tony Garnier, assisted by Jacques Debat-Ponsan.*

theories made possible. The street was partly private, but was common to all the houses and buildings of the street, which was intended for artists and art lovers. The increase in the number of artist cities (*cités d'artistes*), more or less inherited from the Nouvelle Athènes neighborhood designed by Auguste Constantin, constituted a phenomenon all the more remarkable in that they were inhabited by famous artists. Groups of artists and interconnections among them abounded: André Lurçat built for his brother, the painter Jean Lurçat, at Villa Seurat (a private cul-de-sac); Le Corbusier built for his brother, Albert Jeanneret, in the Dr. Blanche Square and in the Montsouris Square for his friend, the painter Amédée Ozenfant (fig. 9); Perret built for Braque on the street bearing his name, Rue Georges-Braque. In the utilization of interior space, the studio occupied the space that the living room was beginning to occupy in bourgeois apartments.

However, urban houses were the exception rather than the rule in Paris, where the apartment building continued to be the most common type of housing. It was the form that social housing took, seen in both the HBM (Habitations à bon marché, or low-cost housing) and the HLM (Habitations à loyer modéré, or low-rent housing) developments, two types of housing defined by French law on several occasions between 1912 and 1928. The building on Rue des Amiraux, designed by Sauvage (figs. 13–14), brought together the general architectural arrangement of Rue Vavin (chapt. XII, fig. 21) and an integration of functions comparable to that of Rue des Immeubles-Industriels (the Industrial Building Street); it was an HBM (low-cost housing apartment building), but one that contradicted the rules set forth by the Paris municipal HBM Office: the interior courtyard was sacrificed in order to build terraced gardens facing the street level and a swimming pool in the center of the complex.

**16. Maison du Peuple (House of the People) at Clichy**

*This building was built in 1937–1938 by architects Marcel Lods and Eugène Beaudouin and engineers Jean Prouvé and Vladimir Bodiansky.*

## 17–20. Musée des Arts Africains et Océaniens (Museum of African and Oceanic Art)

*This museum, once the Palace of Overseas France, was built between 1928 and 1931 for the Colonial Exhibition by Albert Laprade, a colleague of Louis Lyautey's in Morocco and the exhibition's commissioner, assisted by Léon Jaussely. The bas-reliefs on the facades are by Alfred Janniot. Numerous artists collaborated on the interior design. Pierre Ducos de La Haille painted the enormous frescoes in the Salle des fêtes, called L'Apport de la France à l'outre-mer ("The Contributions of France Overseas"). The furnishings are by Jacques-Emile Ruhlmann.*

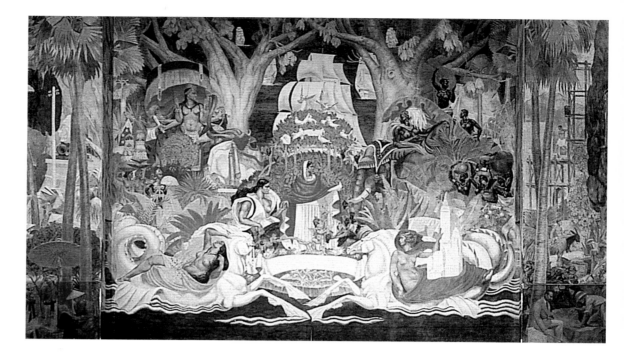

### Low-Rise and High-Rise Buildings

The avant-garde believed it could create happiness for humans in spite of themselves through the combination of modern materials and mass housing. From this idea were born both the low-rise building and the high-rise building. The Pavillon Suisse ("Swiss Pavilion" student residence) at the Cité Universitaire of the University of Paris, designed by Le Corbusier, provided one of the first examples in Paris (1930–1931), and the development at Drancy, a working-class development of low-rise and high-rise buildings, built between 1931 and 1934 by Beaudouin and Lods (and turned into a concentration camp during World War II) provided a more sinister example.

Thus the plan of the ideal city, as old as utopia itself, was filled with low-rise buildings and high-rise towers. Here the model was the *Città nuova* (*New City*), created in 1914 by Antonio Sant'Elia, worthy heir of the theorists of the Renaissance, a futurist whose own future was buried on the battlefield. Sant'Elia's most powerful idea, that of urban traffic flow on several levels, an idea later taken up and developed by avant-garde urbanism, came from Leonardo da Vinci. All these commonplaces were to be found in the proposals entered by Sauvage (fig. 12), Perret, Le Corbusier, and Mallet-Stevens in the 1931 competition for the development of Porte Maillot.

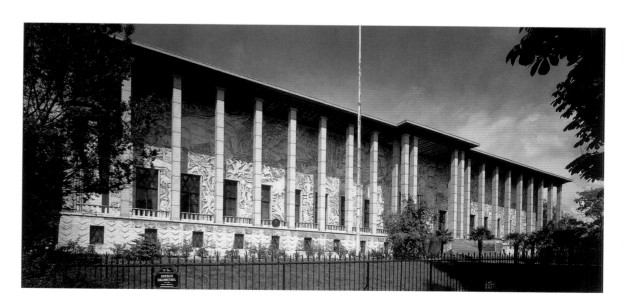

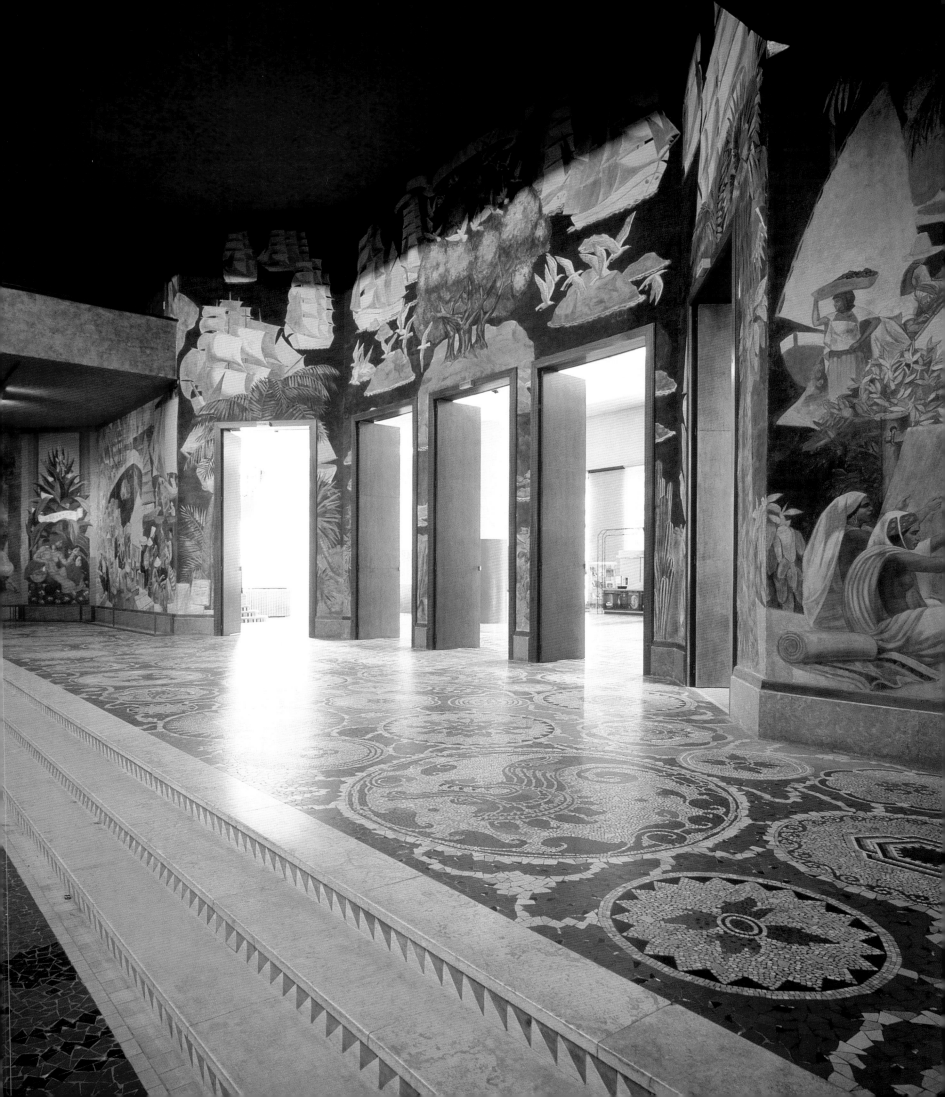

Le Corbusier's project, called the Ville Voisin (1925), which anticipated the razing of all of central Paris, caused the contradictions between functionalism and function to become obvious. The concentration of housing space in high-rise towers was supposed to allow very large public spaces to be opened up, spaces that would be open to natural heat and light. In fact, in summer when the sun was at its zenith, these large spaces would have been scorching hot, and in winter, taken over by the huge shadow of the towers! The immense roadways and public squares of totalitarian urbanism broke cities apart—and it was there that the illusions of new societies were lost.

**21. Robert Delaunay.** *Formes circulaires* (*Cirular Forms*), 1930. (Solomon R. Guggenheim Foundation, New York)

*Schools and City Buildings*

Reflection about social housing went hand in hand with thinking about school buildings, along with legislation and regulations that defined republican teaching. The most original solution was surely the one adopted by Eugène Beaudouin and Marcel Lods for the Ecole de Plein Air (Open Air School) in Suresnes. Here one could see the triumph of modern material and public health, this time through the regeneration by nature, air, and light that characterized the avant-garde. Individual cube-shaped classrooms were spread out along a slope like the individual sections in a beehive; on three sides, the cubes were enclosed only by movable glass partitions; the fourth side, built against the slope, was made of a solid wall.

The tendency was to concentrate complementary functions within a single building, which was treated like a condensed version of an entire city. This produced significant changes to one of the oldest of layouts, that of the *hôtel de ville* (city hall). Boulogne-Billancourt's city hall (fig. 15), the only Parisian building designed by Tony Garnier, whose career developed in Lyons, is characterized by the large central lobby that plays the same role as the lobby in department stores and banks. In Puteaux, the mayor's office, the post office, the tax office, the police station, the justice of the peace, the municipal library, and the fire department are all brought together in the municipal building, which was the work of the brothers Jean and Edouard Niermans (1934). The Maison du Peuple (House of the People) in Clichy, a new work by Beaudouin and Lods, assisted by Vladimir Bodiansky and Jean Prouvé, dates from 1937–1939, the years of the Popular Front. It shows all the characteristics by which the avant-garde, in the service of social and multifunctional programs, wished to be identified: structures made of girders and steel sheets, open plans, movable floors, and sliding walls.

**22. Musée des Travaux Publics (Museum of Public Works)**

*Built by Auguste and Gustave Perret between 1937 and 1939, this building, which was to be the Museum of Public Works, is today occupied by the Economic and Social Council.*

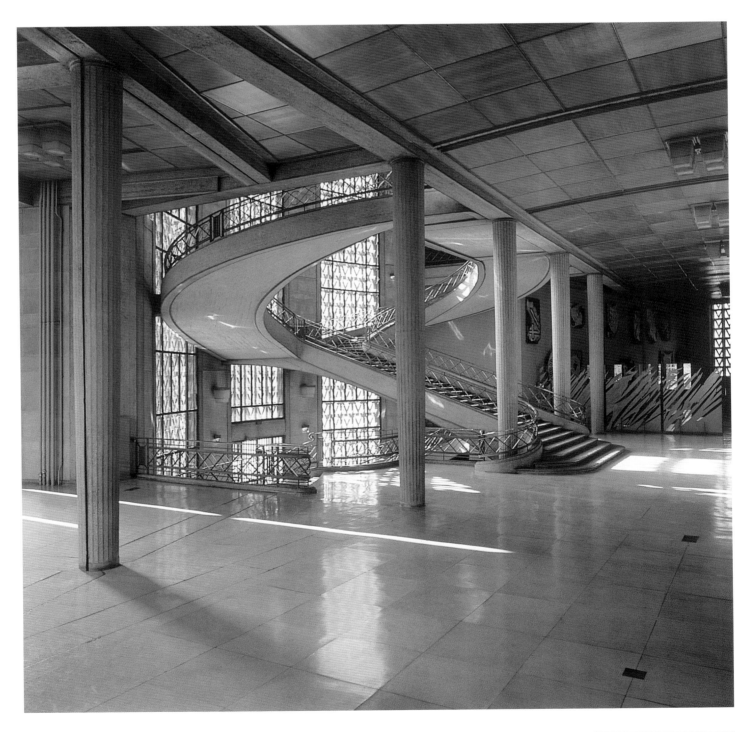

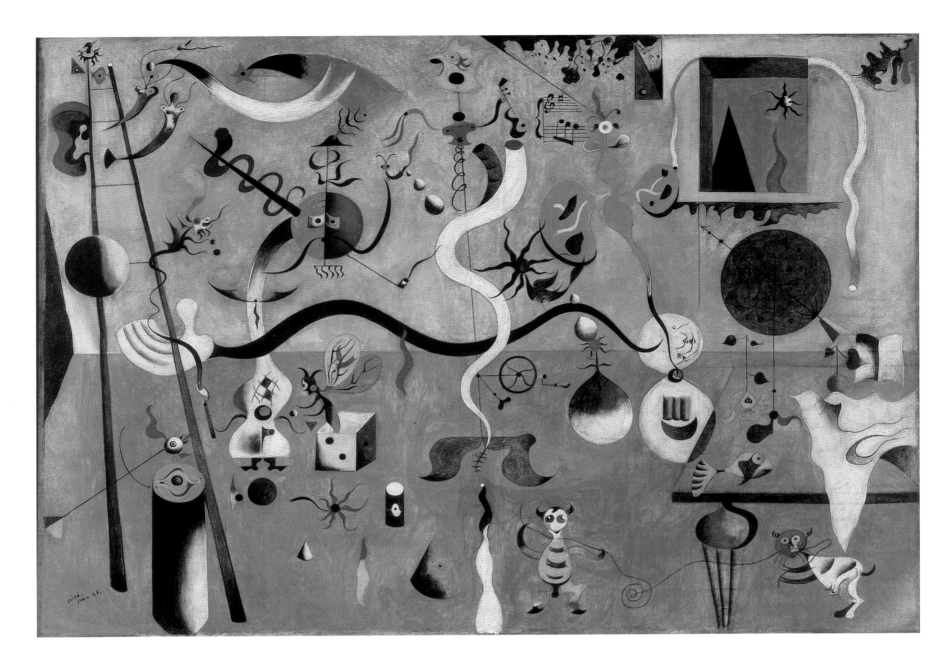

**23. Joan Miró.**
*Carneval d'Arlequin (Harlequin's Carnival)*, winter 1924–1925.
(Albright-Knox Art Gallery, Buffalo)

## 3 – ARCHITECTURE AND THE DECORATIVE ARTS

While art nouveau was tapering off, a "new style" was proclaimed, a style based on the intellectual model of seventeenth-century classicism, on a return to national values, symmetry, and elitism: this "eminently architectural art of organization [will be] of such elevation that it will never be touched by the vulgar or commonplace," wrote André Véra in *L'Art décoratif* (*Decorative Art*) in 1910. Because of the war, these ideas, moving along in concert with ideas about modernity, did not take hold until the time of the *Années folles* (or Roaring Twenties). The Exposition internationale des art décoratifs et industriels modernes (International Exhibition of Modern, Decorative, and Industrial Arts) of 1925 was an exceptional moment of confrontation between this new style, renamed "art deco," and the avant-garde. Art deco was represented at the exhibition only by the Pavillon de l'USSR designed by Konstantin Melnikov, one of the leaders of constructivism, and by the Pavillon de l'Esprit Nouveau designed by Le Corbusier.

### Le Corbusier
*L'Esprit nouveau* was the name of the journal founded by Le Corbusier and the painter Amédée Ozenfant in 1920, which was published until 1925. In the first year's volume, "Ornament and Crime," the important manifesto of Adolph Loos, who in 1926 would build Tzara's house in Paris, appeared in translation. In 1923 Le Corbusier built Ozenfant's house/studio (fig. 9)

as well as the La Roche villa, and published *Vers une Architecture* (literally *Toward an Architecture*, although mistranslated in the 1927 English edition as *Toward a New Architecture*), a book that collected his theories. Le Corbusier, a theorist of rupture, was an artist who was curious about everything, someone who, in the course of his many travels, had assembled the material of what could have been a history of architecture in the style of Viollet-le-Duc. A painter and architect, passionately interested in geometry, Le Corbusier was a Renaissance man who, like Leonardo da Vinci, explored the mechanization of his time. For him the house was a "machine to live in" and its furnishings were "equipment"—everything was to be made up of standardized elements and produced by industry. He summed up his architecture in five points, advocating that architecture should have: [1] an independent skeletal framework, which meant a non-weightbearing "curtain" facade; [2] pilings in order to free the ground level for traffic; [3] an open floor plan; [4] horizontal windows; and [5] a flat roof. These tenets go against the oldest traditions of French architecture with its ritualized distribution of space, vertical spans, and high roofs. It is important to add as well the disappearance of molding, stripped away along with the decor of the facades.

Despite these very functionalist principles, Le Corbusier's theory is only an aesthetic, a painter's aesthetic: "Painting has been the laboratory of forms," he wrote. Its architecture is "picturesque" in the etymological sense of the term: "Architecture is a masterly, correct, and magnificent play of volumes brought together in light...; cubes, cones, spheres, cylinders,

**24–25.** Max Ernst. *Le Père éternel cherche en vain à séparer la lumière des ténèbres* (*The Eternal Father Tries in Vain to Separate Light and Dark*) and *Allons. dansons la ténébreuse* (*Come. Let us Dance the Mystery*).

*These two collages are excerpted respectively from* La Femme 100 têtes (*The Hundred Headless Woman*), 1929, *and* Rêve d'une petite fille qui voulut entrer au Carmel (*The Little Girl Dreams of Taking the Veil*), 1930. *These two novels, with their strong anticlerical tone (the second is linked to the canonization of Thérèse of Lisieux in 1925), were in part devised in the Ardèche region, where Ernst was at the home of his in-laws. The subject of the two pictures is purposefully ambiguous. Levitation, a privilege of gods and mystics, is ridiculed—as is perhaps the state of the surrealist dream as well.*

26. Georges Rouault. *Christ*, 1923.
(Musée d'Art Moderne
de la Ville de Paris)

*This* Christ *is part of a series
of fifty-eight plates engraved
beginning in 1922 and published in
1948 under the title* Miserere.

or pyramids are the great primary forms which light reveals to advantage" (*Toward a New Architecture*, trans. Frederick Etchells, 1927). Such a declaration would be enough to justify Malraux's statement that Cézanne foreshadowed all of twentieth-century architecture. Le Corbusier made of architecture what the sculptor Gianlorenzo Bernini made of it, and like

Bernini he was a mediocre builder. Scarcely were his buildings finished than they began to leak and were threatened to be ruined. Le Corbusier sacrificed the cornice, the very functional dripstone that carried rainwater away from building facades, to his aesthetic as if it were nothing more than a vulgar molding. Ozenfant's house/studio was at first covered with "sheds," the roofs characteristic of factories and equally well suited to a painter's studio, but Ozenfant's shed roof leaked, as did the flat roof of the Villa Savoye. Moreover, the inhabitants of the villa "trickled away" as well, put off by the implacable geometry of "the equipment."

## Steamship Style

Because it was devoted to the decorative arts, the exhibition of 1925 did not deal much with architecture, which was reduced to generally mediocre pavilions. The exceptions were the two avant-garde pavilions, and perhaps the Pavillon d'un Collectionneur (Pavilion of a Collector) designed by Pierre Patout, as well as the Pavillon de l'Ambassade de France (French Embassy Pavilion) designed by Mallet-Stevens; although the latter two were significant mostly because of their interior decoration. Patout, who was also the creator of the main entrance to the exhibition, was a promotor of the "style paquebot" (steamship style). Admiration of the majesty of the great transatlantic ocean liners and the luxuriousness of cruise ships inspired a new streamlining of buildings on dry land: the flat roofs in Sauvage style took the form of ships' bridges, the superstructures were shaped like steamship funnels, and the bays were rounded like portholes. The most prestigious examples of the steamship style presented at the exhibition of 1925 were the ships the *Ile-de-France* (1926), the *Atlantique* (1928–1930), and especially the famous *Normandie* (1934–1935).

## Jacques-Emile Ruhlmann

The Pavillon d'un Collectionneur (Pavilion of a Collector) was devoted to the exceptional renaissance of Parisian cabinetmaking, notably thanks to Jacques-Emile Ruhlmann. Ruhlmann had first opened a furniture store and later he submitted his designs to be manufactured in Faubourg Saint-Antoine, before finally recruiting cabinetmakers and setting up his own workshops. In general, Ruhlmann's furniture was not mass-produced; each piece was made as a one-of-a-kind creation (fig. 38), superbly crafted in exotic woods, with incrustations of mother-of-pearl, tortoiseshell, ivory, metals, lacquer and shagreen, and fish skin, notably sharkskin, then very much in vogue in furniture making.

The decoration of the French Embassy Pavilion, which was to be the embassy of "French taste," was more traditional. Paul Léon, director of the Academy of Fine Arts, had ordered the removal of the Delaunay and Léger paintings that Mallet-Stevens had used to decorate the entrance hall, under the pretext that these works were not representative of French taste.

## Neoclassicism

In the 1930s nationalism emerged once again, particularly in totalitarian countries. Oddly enough, this was manifested by a return to the Greco-Roman International style that neoclassicism had invented in the eighteenth century through a reconciliation of antiquity and modernity. Since that time modernism had touched so many things that artists were continually distinguishing themselves from it, while pretending to owe it nothing. Yet it was, nevertheless, always there. In our view, French neoclassicism of the 1930s was nothing other than the monumental form taken on by modernity in order to adapt itself to the construction of public buildings. The Exposition Coloniale (Colonial Exhibition) of 1931 and the International Exposition of 1937 were the great moments of this new classicism and left behind some remarkable evidence, such as the Musée des Colonies (Museum of the Colonies), the Museums of Modern Art (figs. 1–3), the Palais de Chaillot (fig. 50) and the Musée des Travaux Publics (Museum of Public Works; fig. 22). This last example provided proof that rationalism, classicism, and modern material can co-exist. The Musée des Travaux Publics, which was built of concrete, was the first museum in France to adopt an open floor

27. Chaïm Soutine.
*Le Boeuf écorché* (*Carcass of Beef*). c. 1924.
(Minneapolis Institute of Arts)

plan. The columns were in the shape of spindles (two and a half feet in diameter at the bottom, three and a third feet at the top) since they contained a more substantial framework at the top than at the bottom; in this they evoked aspects of classical vocabulary. The concrete colored by the addition of red sandstone pebbles from the Vosges Mountains and yellow rock from the province of Lorraine; the facings, sometimes rolled with a granular surface, sometimes smooth, were a link to the time when walls were covered in animal skins; the screen walls were derived from the architecture of southern France.

## National Style and Regionalism

In this very international movement of the 1930s, one specifically French tendency can be identified if we return to private architecture. In Paris Michel Roux-Spitz built many bourgeois buildings in a style that earned him the right to be considered the founder of a "Paris School" (Ecole de Paris); but the expression did not appear until 1943. In Roux-Spitz's buildings, with their thoroughly calculated floor plans, the living room formed a frontispiece in three sections in the middle of the facade, as seen in private houses of the eighteenth century; reinforced concrete is covered by interlocking stone tiles; the windows with their metal joinery are horizontal, as in the houses by Le Corbusier; all in all, an architecture of the golden rule ("le juste milieu").

The condemnation of modernity came from a revolt emanating from the rural areas. The principal example of this movement coming from interior France was the Centre Régional (Regional Center) of the 1937 Exposition, whose chief architect was Le Trosne, the creator of regional-type houses adapted to contemporary needs. Under the Vichy government, at the time of the first reconstruction, regionalism gained the status of official architecture.

29. Pablo Picasso.
*Paysans endormis*
(*Sleeping Peasants*), 1919.
(Museum of Modern Art, New York)

30–31. Georges Braque.
*Les Canéphores (Canephores)*, 1922.
(Musée National d'Art Moderne,
Centre Georges Pompidou, Paris)

## Abstract Art

The period between the wars simultaneously saw the triumph of abstract art and the return of representational art (figs. 30–33). Abstract art was brilliantly represented by artists already practicing it in Paris on the eve of the war—such as Frank Kupka and Delaunay; by the adherents of cubism, like Jacques Villon; and by Wassily Kandinsky and Piet Mondrian who moved to the greater Paris region. The Nazis drove Kandinsky away from the Bauhaus, where he had been teaching. He moved to Neuilly-sur-Seine in 1933, when most of his career was already behind him. On the other hand, Mondrian, who returned from Holland to Paris in 1919, did not reach the quintessence of abstract art until that period: it was in Paris that he produced his famous series of grid paintings, consisting of white squares intersected by vertical and horizontal lines in the three primary colors. Robert Delaunay and his wife Sonia (whom he married in 1910) reached that point as well with their circles of pure color (fig. 21). But while Mondrian confined himself to an unchanging universe and easel painting, the Delaunays used color to make their disks turn; they also took over the wall surface itself in order to create large compositions. The Delaunays' abstract art was both dynamic and monumental.

Abstract art was organized in Paris at the beginning of the 1930s with the creation of groups like Abstraction-Création and Cercle-Carré ("Circle-Square"). Support came from all quarters. At the Exposition of 1935, there were four hundred abstract painters and sculptors, more than half of whom were French. The success of abstract art was due in part to the simplicity of its theoretical bases.

## Surrealism

Surrealism was the dominant movement of the period between the wars. It was supported by nearly all the artists active in Paris, even if furtively. Surrealism was above all an ideology; an ideology of a total and political art, which included the modern techniques of art, photography, and cinema; it was an ideology that liberated inspiration from the control of reason and aesthetic precepts and gave it over to the impulses of the unconscious, dreams, and the libido. Surrealism adopted several things from progressive political parties, including writing manifestoes and expelling members whose ideas or actions were deemed contrary to surrealist tenets. In 1924 Breton published his *Surrealist Manifesto*. Expulsions from the surrealist group were motivated by the controversial question of support for the Communist Party. The use of this political practice in the artistic world may appear incongruous; however, it was a response to a pressing necessity. The avant-garde had exhausted all recourse to scandal, and with the ticking of the metronome marking the progress of the arts, expulsion had to be invented. There were no longer any rejected artists, since the number of salons had multiplied; there were henceforth only expelled ones.

The sources of surrealism were symbolism revived by psychoanalysis, the ready-mades of Duchamp, and the art of Giorgio de Chirico. This Italian painter, born in Greece and educated in Germany, spent time in Paris (from 1911 to 1914) before developing his metaphysical style of painting: large neoclassical squares on which a faceless mannequin is placed. The most notable representatives of Parisian surrealism were foreigners: the Catalans Dali and Miró, the American Man Ray, and the German Ernst. Dali spent several long periods in Paris beginning in 1927, particularly in 1929 when he made the famous surrealist film, *Un Chien andalou (An Andalusian Dog)*, with Luis Buñuel; but he never completely left his native Catalonia behind. In 1934 he turned his expulsion by Breton into a very surrealist show. From 1920 on, Miró spent winters in Paris and summers in Catalonia. Man Ray arrived in Paris in 1920; Ernst in 1922. Both of them were former dadaists.

Surrealism was scarcely distinguishable from abstract art except for the place it reserved for representation, notably representation of a figure that gradually takes on human form again. But the human figure was practically absent from the work of Miró (fig. 23), who painted in the same style throughout his lifetime, not without a strain of emotion: when he questioned himself about the value of his art, he said that painting had been continuously on the decline since prehistoric time and saw in the present day of his own time an "assassination of painting." Ernst, on the other hand, made great use of the human form, but it was generally to make it suffer.

Various techniques had an important place in surrealist production: photography, collage, frottage, and sand painting. In *Noire et Blanche* (*Black and White*), the most famous of his photographs, Man Ray juxtaposed the recumbent face of a white woman and an upright African mask (fig. 42), a subversion of the ancient subject of the white mistress and her black slave, but a metaphor as well of photographic technique, of the relationship between black and white. With the collage, heir of cubism, Ernst composed series of hundreds of plates, called *novels* (*romans*), such as *La Femme 100 têtes* (*The Hundred Headless Woman*; fig. 24) and *Rêve d'une petite fille qui voulut entrer au Carmel* (*The Little Girl Dreams of Taking the Veil*; fig. 25). Ernst invented the technique of frottage, which consists of taking the design of the knots in a rustic wood floor, for example, by covering it with a sheet of paper and rubbing over the design with lead pencil or charcoal. André Masson, a Parisian regular, practiced a kind of spontaneous design, inventing the sand painting technique. He would throw glue and scatter sand on a canvas stretched out on the floor; when he lifted the canvas upright, the sand would only remain attached in aleatory fashion on the spaces covered in glue.

### Expressionism

The human figure, almost always the woman's, was the scapegoat of expressionism, always latent in Parisian art. Both Jules Pascin and Brassaï immortalized Parisian prostitutes. Brassaï published *Paris la nuit* (*Paris by Night*) in 1933; Henry Miller devoted an essay to Brassaï, dubbing him *L'Oeil de Paris* (*The Eye of Paris*), 1932. When Brassaï was not photographing prostitutes, he was photographing graffiti, moving from expressionism to surrealism—indeed, to abstract art. Soutine pushed expressionism to its extreme, an extreme attained only in northern Europe, Soutine's home. The portraits of deformed beings (portraits that made Soutine famous) are not where the painter can best be appreciated. Soutine was also a great painter of landscapes and still lifes. In *Le Boeuf écorché* (*Carcass of Beef*; fig. 27) we find all of Soutine's characteristics: his incandescent red, his references to the paintings of the Louvre, which was his school (Chardin's *The Skate* [chapt. IX, fig. 44], for example), and his deathly pale still lifes. To this current was linked the work of Georges Rouault and Chagall and—why not?—the shattered portraits of women by Picasso.

### The Return to Representation

The return to figurative art did not become obvious until the mask dropped, allowing the human being to be associated with surrealism and expressionism. All the moderns began to do it—Léger (fig. 28) and André Derain in 1918, Picasso during the period 1920–1924 (fig. 29), Braque during the period 1922–1926 (figs. 30–31), and Villon around 1935. The canvases were populated by new, strong figures, especially the giants with their big feet and completely virile seduction. One might have said they came from ancient Greece and called their style neoclassical, but that would probably have been wrong. These classically inspired works were the heirs of Aristide Maillol's athletic *Méditerranée* (*Mediterranean Woman*; chapt. XII, fig. 91) and sister of Renoir's gorgeous bathers (*Bathers*, 1918; Barnes Foundation, Marion, PA). The paintings of Picasso most representative of this period were painted outside Paris: *Trois Femmes à la fontaine* (*Three Women at the Spring*, 1921) was painted at Fontainebleau; *Les Baigneuses* (*The Bathers*, 1918; Musée Picasso, Paris) at Biarritz; *Deux Femmes courant sur la plage* (*Frightened Women by the Sea*, 1922; Musée Picasso, Paris) at

32. Pablo Picasso.
*Le sculpteur et son modèle*
(*The Sculptor and his Model*),
etching from the Vollard Suite, 1933.
(Musée National d'Art Moderne,
Centre Georges Pompidou, Paris)

*The Vollard Suite is a group of one hundred
engravings commissioned from Picasso by
the art dealer Ambroise Vollard and
completed between 1930 and 1937.*

Dinard; and *Les Flûtes de Pan* (*The Pipes of Pan*, 1923; Musée Picasso, Paris) at Cap d'Antibes. There was also *Paysans endormis* (*Sleeping Peasants*; fig. 29), one of the most unique works in the artist's diverse oeuvre. Braque's series of *canéphores* (basket bearers), which recall Modigligani's *Caryatid* (1914; Museum of Modern Art, New York), carried the majesty of temple pillars (figs. 30–31).

The etchings by Picasso in the Vollard Suite (fig. 32), which developed the theme of the sculptor and his model, offered the most serene and monumental representations of the classic couple. In the friendly competition which set him against Picasso, Braque also treated the theme of the artist and his model (fig. 33): his figure—shown half fullfrontal, half in profile, half in light, half in shadow—made an original parallel to the portraits of Picasso's women, with one eye seen full face and one in profile. However, Picasso returned to Spain periodically, where he made long visits in 1933 and 1934.

On the condition of being considered modern, artists could henceforth paint figurative works without risking the scorn the avant-garde had previously cast on the academy. *Japonisme*, cubism, and surrealism served as safe modes of expression for wonderful figurative painters like Tsuguharu Foujita, Marcel Gromaire (fig. 34), and Balthus (fig. 35). The academic system continued to function, reserving public commissions for its protégés. But it is the avant-garde, after having won the day within the narrow circles of the intelligentsia, that is remembered by the history of art. Is this a reason for omitting Jean Dupas, creator of *Perruches* (*Budgerigars*; fig. 37) from studies and inventories of the Pavillon du collectionneur (Pavilion of the Collector) at the Exposition of 1925? A reason for ignoring Pierre Ducos de La Haille (fig. 17), decorator of the Palais de la France d'outre-mer (Palace of Overseas France) built for the Colonial Exhibition? Or to leave aside Jean Souverbie, one of the decorators of the Palais de Chaillot for the Exposition of 1937 (fig. 50)? José Maria Sert, decorator of the homes of Prince Edmond de Polignac and Maurice de Wendel (fig. 39), a painter solicited by high society and admired by Paul Claudel, André Gide, and Marcel Proust, was the great forgotten artist among the documented Catalans in Paris even though he had arrived in 1899 and remained in Paris thereafter. It was doubtless his political opinions, rather than his Venetian style (similar to Tiepolo's), that resulted in his exclusion.

## Sculpture: From Cubism to Representational Art

Henri Laurens, Jacques Lipchitz, Alexander Archipenko, Constantin Brancusi, Julio González, Hans Arp, Alberto Giacometti, and Antoine Pevsner, who strove to create cubist, abstract, and surrealist art in Paris, did not know how to completely abstain from representational art. Is Giacometti's *Caresse, Malgré les mains* (*Caress {Despite Hands}*; fig. 40) cubist or surrealist? We could ask the same question about Brancusi's *Muse endormie* (*Sleeping Muse*; fig. 41): the first version (1905) was a marble in the style of Rodin; the second, in gilded bronze, was cubist (1909); and the third, in marble (around 1927), would make a most astonishing surrealist tableau together with Man Ray's *Noire et Blanche* (*Black and White*; fig. 43). Gargallo's *Kiki de Montparnasse* (fig. 42) must also be mentioned. Kiki was one of the main figures of Montparnasse: she was Man Ray's model and mistress; she was the "Blanche" of "Noire et Blanche." Gargallo's Kiki is an odd work of intaglio, a sort of photographic negative. Gargallo, a Spaniard educated in Barcelona and a resident of Paris from 1912, where he was neighbors with Picasso and Gris, produced his first "hollow" intaglio works in 1924. In these works the full was replaced by the empty, what Gargallo called "concave relief," an artifice that he judged to be better than bas-relief at rendering the subtle shadings of shadows and which, surprisingly, worked perfectly. Almost simultaneously, Ossip Zadkine, after a period of sculpting works similar to those of Gauguin, Modigliani, and Brancusi, converted to the intaglio technique

33. Georges Braque.
*Le Peintre et son modèle*
(*The Painter and his Model*), 1939.
(Private collection)

Page at left:

34. Marcel Gromaire.
*Les Lignes de la main* (*Lifelines*), 1935.
(Musée National d'Art Moderne,
Centre Georges Pompidou, Paris)

35. Balthus.
*Thérèse rêvant* (*Thérèse Dreaming*), 1938.
(Private collection)

of Gargallo as well. He created admirable works in this style that must be compared to classically informed work by Braque and Picasso, among them a powerful Ménades celebrating the mysteries of Dionysus and *La Naissance de Venus* (*The Birth of Venus*; fig. 45). *La Leçon de dessin* (*The Drawing Lesson*; fig. 44) was nothing more than the sculpted version of the amorous dialogue between the artist and his model as illustrated by Braque and Picasso. Gargallo and Zadkine were certainly great classicists; but the split seen in painting was also found in sculpture. Thus it is important not to confuse Gargallo and Zadkine with the beneficiaries of public commissions, like Alfred Janniot, who was so brilliantly represented on the facades of the Palais de la France d'outre-mer (Palace of Overseas France; fig. 18) and the Palais de Tokyo (figs. 2–3).

## The Cinema

The mixture of genres that characterized the period between the wars favored the definitive integration of certain industrial or commercial activities into the domain of the plastic arts. French industry of the seventh art was mostly established in the greater Paris region. There were studios at Montreuil, Vincennes, Billancourt, Joinville, Neuilly-sur-Seine, and Courbevoie. The collaboration of artists from diverse disciplines tended to make film a total work

Right: 36. Hôtel d'un collectionneur (*Hôtel* of a Collector), pavilion at the Exposition international des arts décoratifs et industriels modernes of 1925.

Below: 37. French Embassy Pavilion at the Exposition international des arts décoratifs et industriels modernes of 1925.

*The living room fireplace was decorated by Jacques-Emile Ruhlmann with* Perruches (Budgerigars) *by Jean Dupas.*

**38. Jacques-Emile Ruhlmann. Chiffonnier, 1927–1928.**

*This chiffonnier is made of burr amboine. The tooled lock plate was made by Jeannot.*

of art. For example, Léger, Mallet-Stevens, and Darius Milhaud all collaborated to make *L'Inhumaine* (*The Inhuman*, 1924) by Marcel L'Herbier (fig. 48); Dali and Ernst collaborated on Buñuel's *L'Age d'or* (*The Golden Age*). However, it was the American film industry that seized first place during the period between the wars.

*Industry and Fashion*

Airplanes, automobiles, and masterpieces of haute couture entered into the museum of the imagination. After all these were nothing but ready-mades. For Duchamp, who announced the death of painting, nothing could match the beauty of a helicopter's rotor. The work of Léger and Delaunay was very influenced by industrialization (fig. 46). Sonia Delaunay painted automobiles. The French automotive industry was also almost entirely Parisian. In 1903 there were approximately seventy-two workshops in Paris producing automobiles in an artisanal fashion. The prestigious brands—Citroën, Renault, Delage, Delahaye, Panhard and Levasseur, Salmson, Voisin, and Talbot-Lago—built their factories either in Paris or

in the suburbs (Issy-les-Moulineaux, Levallois-Perret, Billancourt, Boulogen, Suresne). And finally the beautiful automobile from Catalan, the Hispano-Suiza, "born" in Barcelona in 1904—the same year Picasso arrived in Paris—eventually was manufactured in France, in Levallois.

Every season the greatest photographers photographed prestigious open touring cars (fig. 47) with beautiful mannequins in front of them modeling the latest fashions. Haute couture had joined the ranks of the liberal arts. In the 1930s there were eighty haute couture houses in Paris, and among them were names known around the world—Elsa Schiaparelli, Balenciaga, Nina Ricci, Lanvin, and Heim (where Sonia Delaunay worked). There were even expressionless mannequins modeling fashions at the Exhibition of Decorative Arts, who took on the look of hieratic statues with red, grey, silver, or gold skin, similar to figures created by Zadkine or Gargallo.

**39. José Maria Sert.**
**Wendel's Salon, 1924.**
**(Musée Carnavalet, Paris)**
*This parlor was designed for the home of Maurice de Wendel, 28, Quai de New York, and reassembled in the Musée Carnavalet.*

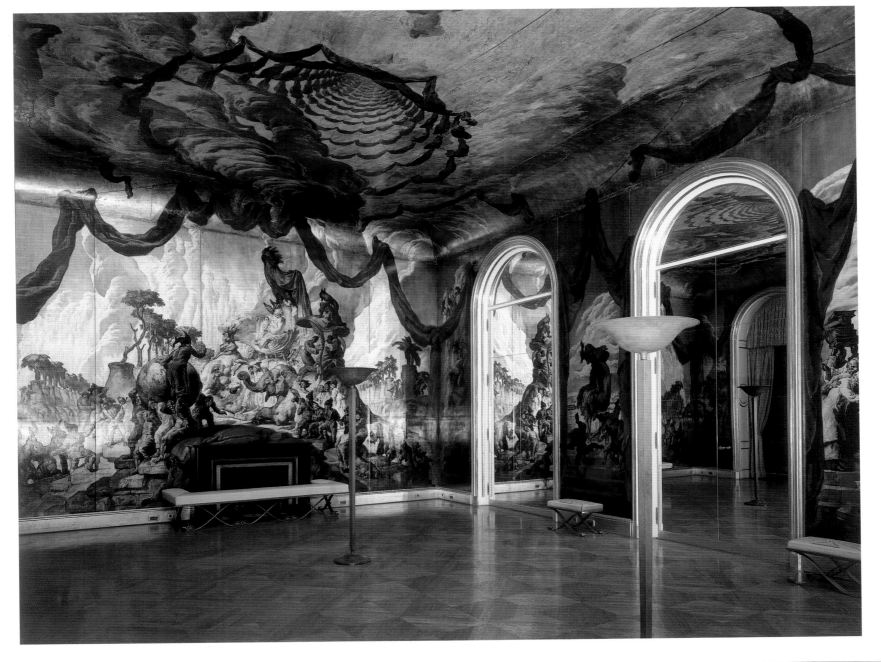

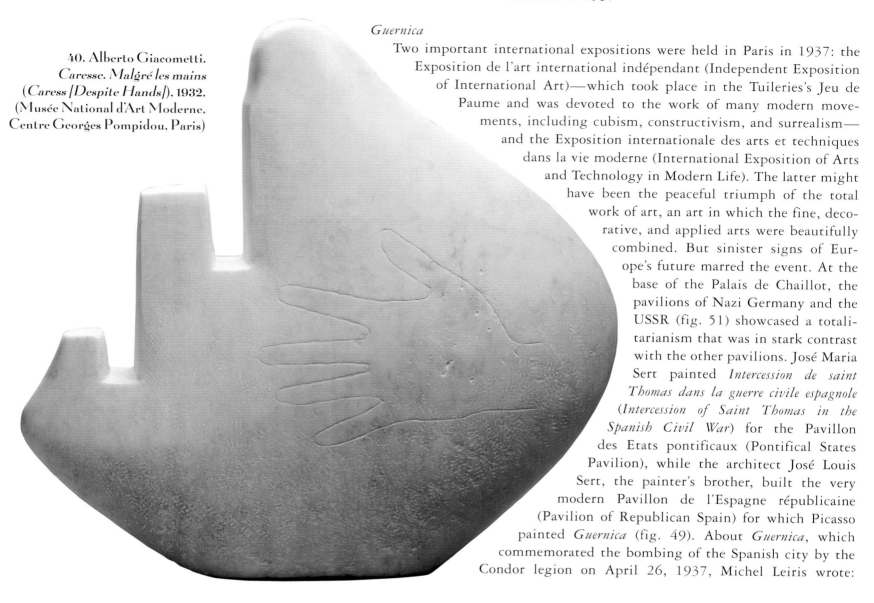

40. Alberto Giacometti. *Caresse. Malgré les mains* (*Caress [Despite Hands]*), 1932. (Musée National d'Art Moderne, Centre Georges Pompidou, Paris)

## Guernica

Two important international expositions were held in Paris in 1937: the Exposition de l'art international indépendant (Independent Exposition of International Art)—which took place in the Tuileries's Jeu de Paume and was devoted to the work of many modern movements, including cubism, constructivism, and surrealism—and the Exposition internationale des arts et techniques dans la vie moderne (International Exposition of Arts and Technology in Modern Life). The latter might have been the peaceful triumph of the total work of art, an art in which the fine, decorative, and applied arts were beautifully combined. But sinister signs of Europe's future marred the event. At the base of the Palais de Chaillot, the pavilions of Nazi Germany and the USSR (fig. 51) showcased a totalitarianism that was in stark contrast with the other pavilions. José Maria Sert painted *Intercession de saint Thomas dans la guerre civile espagnole* (*Intercession of Saint Thomas in the Spanish Civil War*) for the Pavillon des Etats pontificaux (Pontifical States Pavilion), while the architect José Louis Sert, the painter's brother, built the very modern Pavillon de l'Espagne républicaine (Pavilion of Republican Spain) for which Picasso painted *Guernica* (fig. 49). About *Guernica*, which commemorated the bombing of the Spanish city by the Condor legion on April 26, 1937, Michel Leiris wrote:

41. Constantin Brancusi. *Muse endormie* (*Sleeping Muse*), c. 1927. (Private collection)

"Picasso is sending us our letter of mourning. Everything we love is going to die" (*Cahiers d'art*, 1937). At the Pavillon de l'Élégance (Pavilion of Elegance), the pavillon of haute couture, the mannequins were made by the sculptor Couturier, who wrote: "I wanted silhouettes of tragedy, voluntarily stripped of the amiability, the civility that one arbitrarily attributes to elegant women... Their defensive gestures and fear are more reminiscent of the inhabitants of Pompeii surprised by the rain of cinders than a meeting of Faubourg Saint-Honoré regulars."

*Guernica*, with its complex iconography, has many sources: Paolo Uccello's *Rout of San Romano*, 1495 (National Gallery, London); Nicolas Poussin's *Massacre of the Innocents*, 1628–1630 (Musée Condée, Chantilly); Francisco de Goya's *Disasters of War* series; and Auguste Préault's *Slaughter*, 1834 (Musée des Beaux-Arts, Chartres). It should not be surprising that this masterpiece, which makes use of so many diverse sources, was painted in Paris. But it is incongruous that it was painted in a studio in a particular *hôtel* on the Rue des Grands-Augustins that at one time was decorated by the story of Hercules, which was among the first Parisian examples of painting inspired by antiquity.

42. Pablo Gargallo. *Kiki de Montparnasse* (Musée Pablo Gargallo, Saragossa)

Bottom:

43. Man Ray. *Noire et Blanche (Black and White)*, photograph, 1926.

*The woman is Kiki of Montparnasse, who was Man Ray's model, muse, and mistress.*

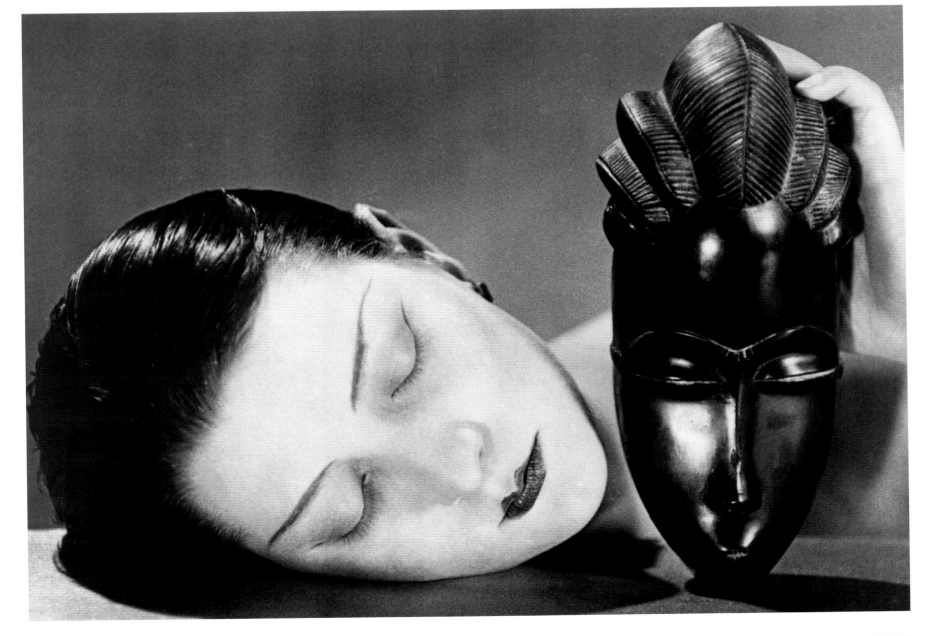

44. Ossip Zadkine. *La Leçon de dessin*
(*The Drawing Lesson*), 1930.
(Musée Zadkine, Paris)

45. Ossip Zadkine.
*La Naissance de Venus*
(*The Birth of Venus*), 1930.
(Musée Zadkine, Paris)

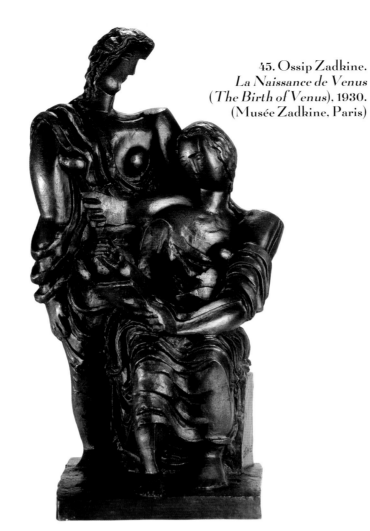

Bottom left:

46. Fernand Léger.
*Eléments mécaniques*
(*Mechanical Elements*), 1929.
(Musée National d'Art Moderne,
Centre Georges Pompidou, Paris)

Bottom right:

47. Jacques-Henri Lartigue.
*Hispano-Suiza 32 HP*,
photograph, 1927.
(Lartigue Collection)

*This open-air touring car, with its long, low carriage and its windshield folded down, belonged to the Lartigue family.*

48.
*L'Inhumaine,*
(*The Inhuman*),
film by Marcel
L'Herbier,
design by
Robert Mallet-
Stevens, 1923.

*Many artists
contributed in
various ways to
the making of
this film:
Fernand Léger
created the sets;
Pierre Chareau,
Lalique, and
Puiforcat did the
furnishings; Paul
Poirot made the
costumes; and
Darius Milhaud
was responsible
for the music.*

**49. Pablo Picasso.**
*Guernica*, 1937.
**(Centro de Arte Reina Sofía, Madrid)**

*This work was painted in Paris in a studio on Rue des Grands-Augustins for the Spanish Pavilion at the International Exposition of 1937.*

Balzac had used this same building as the setting for his short story *Le Chef-d'oeuvre inconnu* (*The Unknown Masterpiece*). Picasso certainly knew about this little novel since he had illustrated it five years prior to renting the house. The story of the novel merits retelling: Pourbus, the court painter of the early seventeenth century, and the young Poussin convince Frenhofer (a creation of Balzac) to unveil for them the portrait of the Belle Noiseuse, which the great master had been working on for several years, but which he had thus far refused to show to anyone. The painting, which no one had seen, is reputed to be the masterpiece of masterpieces. When the painting is unveiled, however, the visitors see nothing but haphazardly applied colors, with the exception of a single, marvelously lifelike foot. Frenhofer accuses his colleagues of being blinded by jealousy; nonetheless, he both destroys the painting and kills himself, while Europe continues to rearm, in preparation for war.

**50. Jean Souverbie.**
*La Musique*, 1937.
**(Palais de Chaillot, Paris)**

*This decorative panel was placed in the stairway leading to the theater inside the Palais de Chaillot; today it is no longer visible.*

## 51. International Exposition of 1937

*In the background we see the Palais de Chaillot, built by Jacques Carlu, Louis-Hippolyte Boileau, and Léon Azéma; and in the foreground the temporary pavilions of the USSR (left) and Nazi Germany (right).*

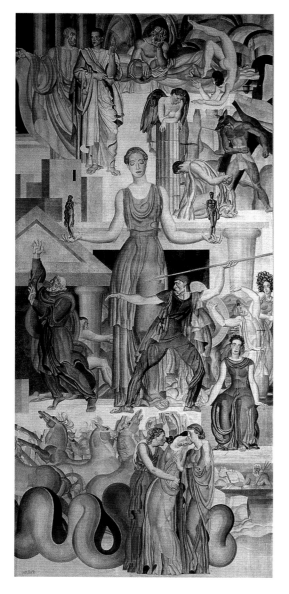

## 52. Louis Billotey. *La Tragédie* (Tragedy), 1937. (Palais de Chaillot, Paris)

*This decorative panel was placed in the stairway leading to the theater.*

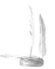

## THE TRIUMPH OF UBIQUITY

*Our fine arts were established, and their types as well as their uses were fixed, in a time very distinct from ours, and by men whose power of action over things was insignificant compared to the power we now possess. But the astonishing growth of our means, the suppleness and precision that they have reached, the ideas and habits they have introduced, ensure that we will see very profound changes in the ancient industry of the Beautiful in the near future. There is a physical aspect in all the arts that can no longer be regarded or dealt with as before, that cannot escape the enterprises of modern knowledge and power. For the past twenty years, neither matter nor space nor time have been what they always were in the past. We must expect such great new things to transform the entire technique of the arts, and through them creation itself, perhaps even going so far as to change our very notion of art.*

*At first it will doubtless be only the reproduction and transmission of works that are affected. We will know how to transport or replicate the system of sensations—or, to be more precise, the system of excitations—that any sort of object or event radiates from one place to another. Works will acquire a sort of ubiquity. Their immediate presence or their reproduction in every era will obey our command. They will no longer be in and of themselves, but anywhere where there is a person, and some sort of apparatus.*

*Paul Valéry,* Pièces sur l'art *(Essays on Art), 1934.*

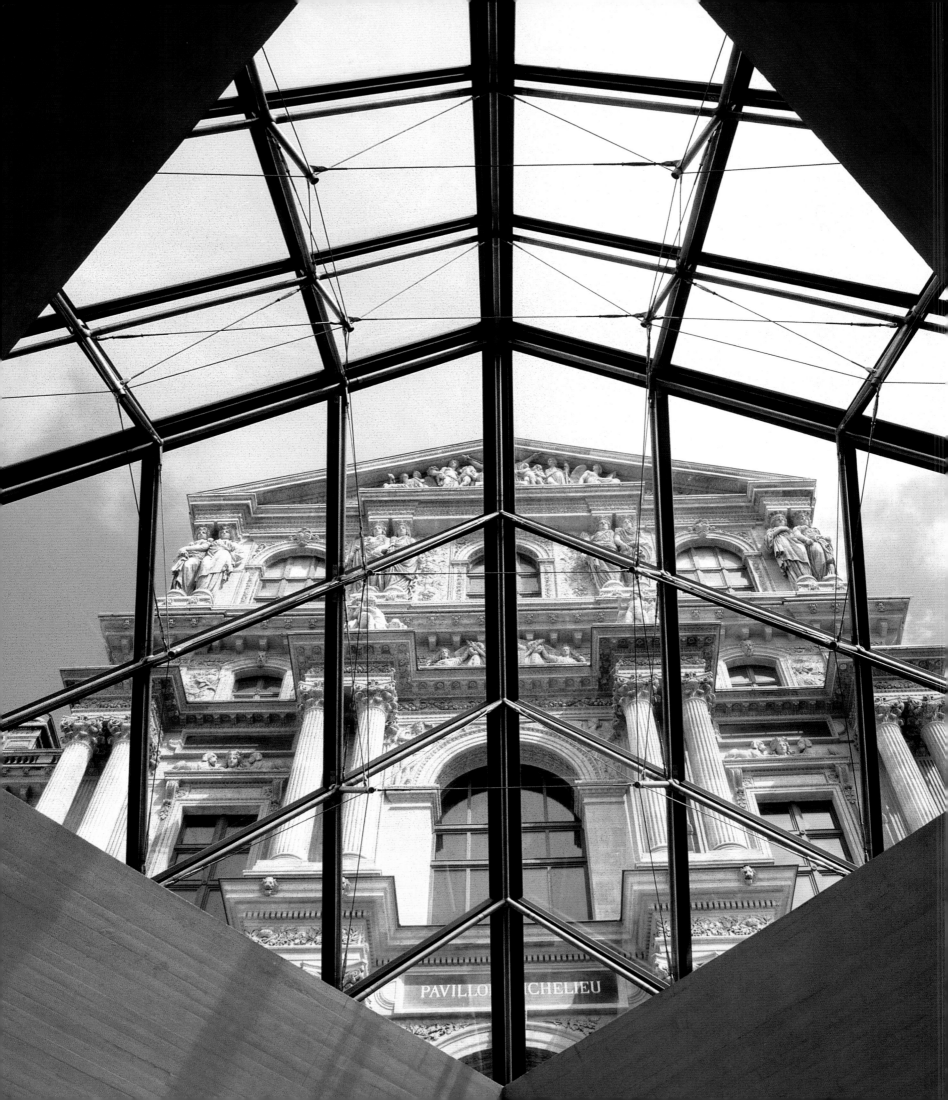

# Epilogue
## LATE MODERNITY

In 1945 the Paris consisting of twenty arrondissements (neighborhoods), whose fame had for so long been based on its size, ranked only ninth in population among the world's metropolitan areas, and fourth—after New York, London, and Tokyo—if suburbs were included. Politics in the name of decentralization tended to challenge Paris's status as "capital city" and its historical role in the arts. Let us assume that all of this would have had but limited effects on the city's prestige, which, at the end of the war, was still fostering great literary activity in Saint-Germain-des-Prés. However, internationalization, population growth, and the increasing mobility of people and images changed Paris and its uniqueness. And if the city's special nature survived or was reborn in any way, it was in other forms than those we have already discussed. The system whose functioning we have described no longer worked. In the first decade following World War II, Paris managed to believe that nothing had changed and that the war was something to be left behind. But for fashion, as well as for painting and sculpture, that illusion did not survive the next two decades.

During the war the Nazis had intended to "move" haute couture to Berlin or Vienna. However, haute couture continued to prosper in occupied Paris. Until the 1950s it enjoyed a golden age. Elsa Schiaparelli had returned from America. The old fashion houses reopened, competing with newer ones. Balenciaga and Fath had reopened as early as 1937, Balmain in 1945, Dior in 1947, Givenchy in 1952, and Cardin in 1953. Their first problems were actually a result of success itself, a success that required greater and greater investments in order to keep their establishments afloat. Efforts to reach agreements with the ready-to-wear industry and the textile industry and the attempt to diversify their products were only palliatives. There were sixty fashion houses in 1952, but only thirty-six in 1958 and twenty-five in 1973. From 1973 to 1990 the number of workers in the fashion industry declined from more than three thousand to fewer than one thousand. Paris resisted international competition fairly well, but the new fact, inconceivable before the war, was that from the 1950s onward genuine competition actually existed in the world of haute couture.

**1–2. The Louvre, Cour Napoléon (Napoleon Courtyard)**

*The glass pyramid designed by I. M. Pei was built beginning in 1983 as the principal entrance to the museum, located in the middle of the Cour Napoléon, built*

*by Hector Lefuel between 1853 and 1880. Pei also had the lead copy of Gianlorenzo Bernini's equestrian statue of Louis XIV moved to the courtyard.*

**3. Georges Rohner.** *Le Musée imaginaire* (*The Imaginary Museum*), 1974–1975.

*All the paintings Rohner depicted are famous, and most of them are in the Louvre: from left to right and top to bottom the works shown are by Jacques-Louis David, Camille Corot, Piet Mondrian, Jean-Auguste-Dominique Ingres, Andrea Mantegna, Philippe de Champaigne, Jean-Baptiste-Siméon Chardin, Evaristo Baschenis, Francisco de Goya, the Fontainebleau School, Paolo Uccello, Eugène Delacroix, David, and Georges de La Tour. On the column we see work by David, Ingres, Rembrandt, Ingres, and Le Nain. On the back wall is another David. At the right is a fragment of a work by Théodore Géricault.*

Without including amateur painters, some three hundred painters active in Paris in the second half of the century have been listed under the name "Paris School." Whereas before the war this label referred to a community bound by common aspirations and the fact that the majority of the group had been immigrants, following the war it no longer conveyed anything but the most disparate of tendencies, and tendencies which were not very Parisian at that. At the end of World War II, foreigners still represented 20 percent of the total number of artists living in Paris (as opposed to 2 percent of the entire adult population); this percentage was as high as 40 percent if only famous artists were accounted for, that is to say, those who had already been "named" prior to the war. The studios of Fernand Léger and Ossip Zadkine were still places that attracted foreigners, especially Americans, who wanted to study in Paris. But Léger died in 1955 and Zadkine in 1967.

**4. Musée d'Orsay**

*The Gare d'Orsay (Orsay Train Station) was built by Victor Laloux for the Exposition of 1900. Beginning in 1980 it was transformed into an art museum devoted to French art of the second half of the nineteenth century. The interior architecture is the work of Gae Aulenti.*

Opposite:

**5. Musée National d'Arts et Métiers (National Museum of Arts and Crafts)**

*This chapel of the former abbey of Saint-Martin-des-Champs was renovated by Andrea Bruno and completed in 2000.*

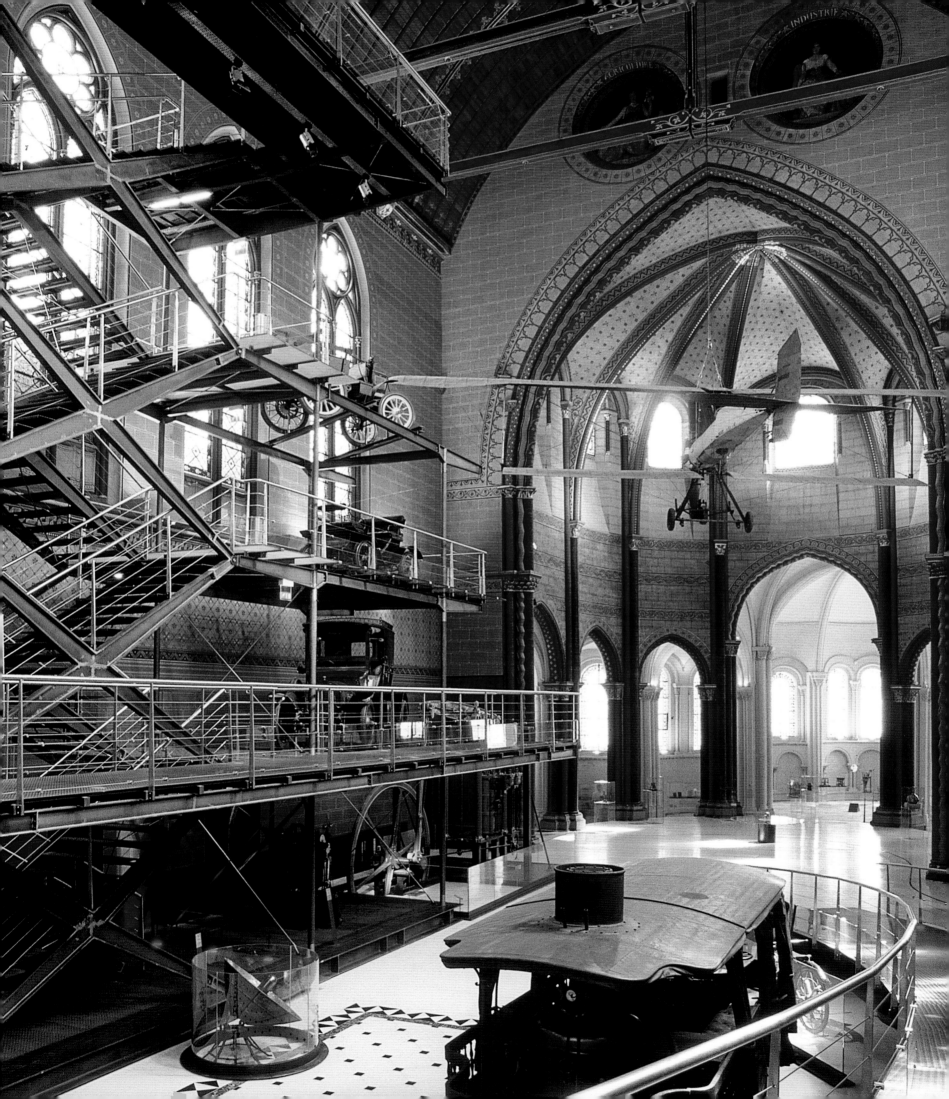

Trying to account for the dissolution of the Ecole de Paris (Paris School) would involve following the career of each artist, for each one claims total autonomy. Abstract art counted remarkable representatives, such as Pierre Soulages, Nicolas de Staël, the Chinese Zao Wou-Ki, the Dutch Bram van Velde, the Russian Serge Poliakoff, and the Portuguese Maria Elena Vieira da Silva. But as early as 1950 the question was asked: is abstract art academic? There were pleas not to confuse geometric abstract art, which was currently being practiced, with the lyrical abstract art represented by Jean-Michel Atlan, Jean Paul Riopelle, and Georges Mathieu; and further pleas not to confuse abstract art with the informalism of the Hungarian Simon Hantaï or with non-representational art. Representational art was being practiced in the Academy of Fine Arts all the way to the Central Committee of the Communist Party, which extolled socialist realism. This committee excommunicated Picasso and admonished Louis Aragon, who had dared praise Picasso's work. It was Aragon, however, who had written in 1937 in *Réalisme socialiste et réalisme français* (*Socialist Realism and French Realism*): "Every time you turn away from reality, you are turning away from France." Did the members of the Forces nouvelles (New Forces) group created in 1935, who—along with Robert Humblot, Georges Rohner, Raymond Legueult, and Roland Oudot—were condemned to carry the infamous brand of "academicism" for having prompted a return to long-standing tradition think otherwise? Other heirs of national tradition, brought up on references to Roman art, included the non-representational artists who exhibited in Paris in 1941 under the title *Vingt jeunes peintres de tradition française* (*Twenty Young Painters of the French Tradition*), among them Jean Bazaine, Alfred Manessier, Jean Le Moal, Roger Bissière, Gustave Singier, and Maurice Estève. Others should be mentioned as well: the survivors of surrealism; Victor Brauner (the Romanian who returned illegally after being banished); the Naïves, along with André Bauchant; and the promoters of kinetic art, such as Victor Vasarely and Nicolas Schöffer.

The surrealists who had left for the United States did not return. Piet Mondrian died in New York in 1944. Marcel Duchamp, Alexander Archipenko, and Yves Tanguy became American citizens. Salvador Dali and Joan Miró went back to their homeland. Max Ernst established himself in Touraine, as did Alexander Calder. The German artist Hans Hartung, who arrived in Paris in 1926 and was one of the principal representatives of lyrical abstrac-

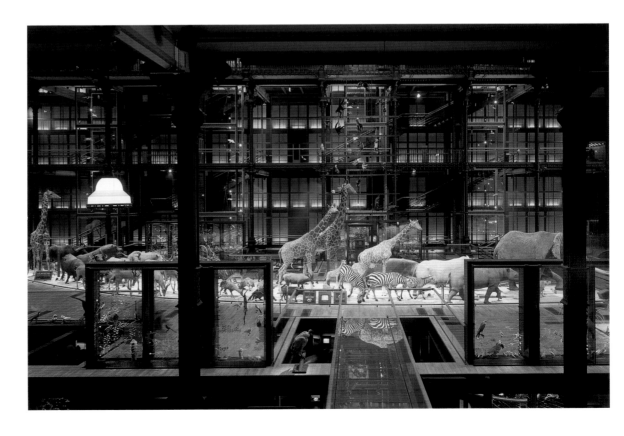

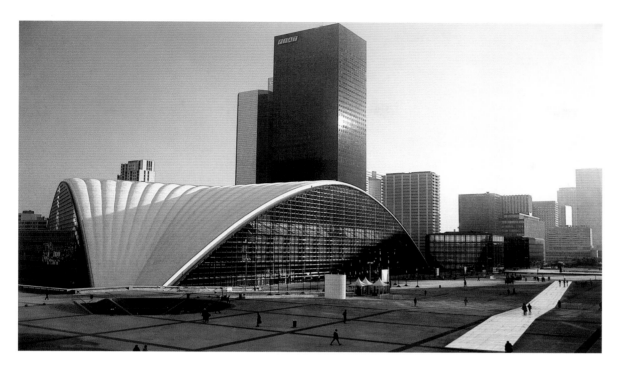

tion, settled in Antibes. The southern part of France, along the Mediterranean coast, attracted the Australian Edouard Goerg (who had come to Paris in 1912), Moïse Kisling, Kees van Dongen, Marc Chagall, Yves Brayer, André Masson, de Staël, Soulages, and Léger, one year before his death. And of course there was Picasso, who after 1948 returned first to Vallauris, then Vauvenargues, and finally settled in Mougins, where he died in 1973. Balthus left Paris in 1953 for the Morvan region. After serving as director of the Villa Medici in Rome (1961–1976), he retired to Switzerland. Everyone went back home—Estève to the Berry region and Bissière to Lot. Georges Braque remained faithful to Paris until his death. The sculptors were always more sedentary than the painters. In Paris itself, there were Zadkine and Alberto Giacometti (who returned to Switzerland only in wartime); Paul Landowski, François Stahly, Jean Dubuffet, and César remained in the greater Paris region. But the studio in the Impasse Ronsin in Montparnasse where Constantin Brancusi died in

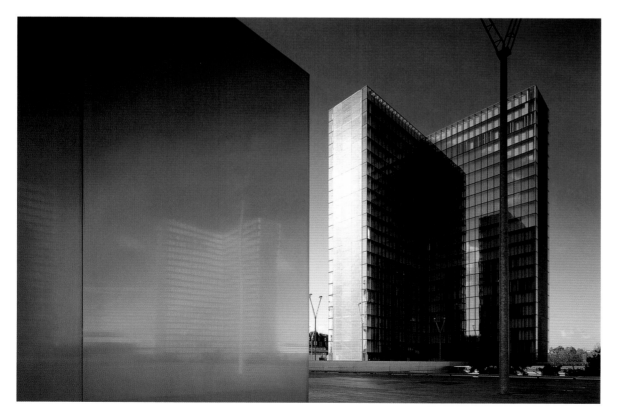

8. Bibliothèque Nationale de France

*The Bibliothèque Nationale was built by Dominique Perrault between 1990 and 1998.*

Following two pages:

9. Beaubourg, Centre national d'art et de culture Georges-Pompidou (Georges Pompidou National Center of Art and Culture)

*Beaubourg was built between 1971 and 1977 by Renzo Piano and Richard Rogers.*

### 10. Palais Omnisport at Bercy

*This building was built by Pierre Parat, Michel Andrault, and Aydin Guvan, and was completed in 1983.*

1957 was razed to make room for a building development. Jean Tinguely, who had a studio in this same cul-de-sac, retired upriver on the Seine, as Vasarely had done upriver on the Marne. From that point on the principal Parisian address of the Ecole de Paris painters became the address of their gallery or their dealer.

The gallery thus replaced the artist's studio, just as the art market replaced the amateur's collection. Reputations were made at the great international fairs like Kassel's Documenta and Venice's Biennale. Paris's position of prominence faded in favor of New York's: "Background Paris. Foreground New York" read one article in 1955 in *Artnews*. Paris was slow to discover the American artists Jackson Pollock, Robert Rauschenberg, and Andy Warhol, as well as American art (abstract expressionism, action painting, and pop art). One of the masters of abstract expressionism, Sam Francis, was tempted by a stay in Paris: he arrived there in 1950, but in 1961 he settled in California. In the art market, only Francis Bacon, the master of the London School, could fetch prices comparable to those of the great Americans. In 1988, at Sotheby's auction house in New York, Jasper Johns' *False Star* fetched the incredible sum of seventeen million dollars.

French officials at the time believed they had been given the mandate to save Paris. They first appealed to the old guard. In 1962 André Malraux, the minister for cultural affairs, handed over the artistic work on the ceiling of the Opéra to Chagall and the ceiling of the Odéon to Masson. These initiatives gained wide acceptance, and from that time on, contemporary artists had more power than ever. The Picasso exhibitions of 1966 in honor of the great artist's eighty-fifth birthday were a triumph. In 1967 ARC (Animation, Research, and Confrontation) and CNAC (Centre national d'art contemporaine, or National Center for Contemporary Art) were founded in order to support the activity of artistic creation with public funds. In May of 1968 Malraux removed the Ecole des Beaux-Arts and the Prix de Rome from the jurisdiction of the Académie des Beaux-Arts (Academy of Fine Arts). A 1969 exhibition at New York's Metropolitan Museum presenting New York painting and sculpture of the postwar period flaunted New York's claim as leader of the art world. The swift response in France was President Pompidou's creation of a center for contemporary art at Beaubourg (now the Centre national d'art et de culture Georges-Pompidou, or Georges Pompidou National Center of Art and Culture), an unquestionable media success. The public, which had long ago lost all capacity to become indignant, convinced itself that contemporary art could be comical. In 1972 French contemporary art was blessed by a very official exhibition, *Twelve Years of Contemporary Art*, held at the Grand Palais. During the opening address by Pompidou, artists who had not been chosen in the selection process, that is to say, those who had not been registered as members of one or another of the movements of the avant-garde, protested loudly.

Pampered by public officials, these movements had lost nothing of their superb rebelliousness; they took advantage of their privileges just like the courtiers of the ancien régime prior to the French Revolution. However, "negations became ritual repetitions, rebellion [became] procedure, criticism [became] rhetoric, and transgression [became] ceremony," noted

Octavio Paz, the great Mexican poet, who himself was a surrealist (*Point de convergence. Du romantisme à l'avant-garde*, or *Point of convergence: From Romanticism to the Avant-Garde*, 1976). Was art dead? From Chateaubriand to Julien Gracq (*Le Monde*, February 5, 2000) everyone said so. In truth it was only the *idea* of the avant-garde that was suffocating beneath layers of discourse, buried as it was beneath a recondite literature on art. The people believed this because the people they elected, very well indoctrinated by their artistic advisors, repeatedly told them so. "No given, no principle appears intangible to them; and the calling into question of the canvas stretched on its frame, of the execution of traditional occupations and of the very nature of artist-authors was going to open up a vast aesthetic field that younger generations would never stop exploring."

When did this artistic revolution and this wonderful urban uplift actually begin? The revolution began in the early 1950s, and the urban uplift started in 1999 with the catalog for the exhibition *La Peinture après l'abstraction* (*Painting After Abstract Art*).

Parisian architecture evolved against the tide of the plastic arts with the lifelessness of the century's first decades followed by a period of intense and brilliant activity. Having been spared during the war, Paris was also spared by reconstruction, the great affair of the first decade. Persistent need for housing kept building activity at a high level during the "glorious thirties," (the thirty years of economic progress between 1945 and 1975) broken by the 1974 OPEC "oil crisis" (the brutal increase in the price of crude oil by its producers); but the proliferation of extensive developments of high-rise towers and low-rise buildings, produced by the forced industrialization of construction, at first affected only the suburbs. At the end of the 1950s, coinciding more or less with the advent of the Fifth Republic, this architecture, whose modernity is recognizable by its disdain for the environment, made its entry into Paris for the purpose of overhauling allegedly unhealthy neighborhoods.

The most significant achievements of the Fourth Republic were essentially provincial—the church at Royan by Guillaume Gillet (1954–1958); the chapel at Ronchamp (1950–1955) and the convent of La Tourette (1956–1959) by Le Corbusier; the church of Assy (1944–1951), built by Maurice Novarina and decorated by the most famous contemporary painters and sculptors. Other significant achievements included hydraulic dams, thermal power stations, factories, and bridges. Paris put up strong resistance to the construction of large buildings on its land, not because the city was complete, but as a result of inertia and weighty administrative and financial procedures, which only presidents elected by the universal suffrage of the Fifth Republic were able to budge. However, three important Parisian buildings, entirely contemporary ones (they were begun in 1955), illustrated the final moments of the Fourth Republic era: the Maison de la Radio (Radio House), the UNESCO headquarters, and the CNIT (Centre national des industries et des techniques, or International Center of Industry and Technology; fig. 7). The Maison de la Radio was built on the banks of the Seine by Henry Bernard. UNESCO headquarters, built at the initiative of the international organization, was the collective work of an American, Marcel Breuer; an Italian, Pier Luigi Nervi; and a Frenchman,

**11. La Villette.**
**Cité des sciences et des techniques**
**(Center for Science and Technology)**

*This former slaughterhouse was transformed in 1979–1980 by Adrien Fainsilber and Peter Rice. In front of the center is the Géode. a movie theater in the form of a sphere. also by Fainsilber.*

Bernard Zehrfuss. They were supervised by a committee of consultants made up of Le Corbusier and Walter Gropius. It was an impressive group, indeed. Since the middle of the century, the realization of large projects had been the work of teams, at the heart of which creative genius became diluted. Zehrfuss, the French member of the UNESCO team, was, like Henry Bernard, a winner of the Prix de Rome, and representative of a generation that was gradually taking over from the generation of the Beaudouins and Le Corbusiers. Zehrfuss's principal share in modernity was his participation in the building of the CNIT, alongwith Robert Camelot and Jean de Mailly, who were also Prix de Rome recipients. However, the technical performance of this concrete shell of exceptional size, with its green facades, was designed mainly by Jean Prouvé and the engineer Nicolas Esquillan. The CNIT was the first building in the Défense area, a business district located at the edge of Paris, in continuation of the axis defined by the Louvre, the Champs-Elysées, and L'Étoile.

Change was primarily implemented in three neighborhoods that, in fact, experienced a surge in population in 1958 (1961 at the very latest) along with the Fifth Republic. These included the Défense area, which developed around the CNIT (International Center of Industry and Technology); the Front-de-Seine, on the Left Bank between the Passy Viaduct and Pont Mirabeau; and Maine-Montparnasse, the former neighborhood of artists. High-rise towers invaded Paris at that time; no matter what their merit, which is still debatable, they awakened the hostility toward modern architecture in Parisians that until then had remained dormant. This hostility was particularly mobilized against the Montparnasse Tower, a project for which cultural affairs minister Malraux had assured a future comparable to the one enjoyed by the Eiffel Tower. In this he was wrong. The discrepancy between public opinion and the authorities became obvious when Pompidou, a stubborn partisan of the modernization of Paris, ordered the destruction of Les Halles at Baltard in 1971, the first act in the renovation of the area; in fact, the destruction and relocation of the market made the neighborhood possible. The international competition for the building at Beaubourg had taken place the year before (for a site adjacent to Les Halles). This building is the one to which the name Pompidou has remained attached. The destruction of Les Halles, a step taken despite an extraordinary mobilization of national and international public opinion against it, was an error from which the neighborhood never really recovered; yet the construction of the Centre Pompidou (fig. 9), as it is called, was an exceptional architectural success, one which has gradually taken its place within the urban landscape. At first it was the object of ridicule, as the Eiffel Tower had been; then finally, like the Eiffel Tower, it came to be treated as a familiar Parisian. This high-tech masterpiece, whose interior space was made completely visible by placing all the mechanical ducts and air shafts in front of the facade, was designed by the British architect Richard Rogers and the Italian Renzo Piano, winners of an international competition that attracted a total of 681 proposals. The first concrete example of the Fifth Republic presidents' interventions in the city's architectural destiny can be seen here. Whereas the jury for the Centre Pompidou was sovereign, in the competitions held during the terms of Giscard d'Estaing and François Mitterrand the juries only proceeded to short-list selections, as the ultimate choice of the winner was determined by the presidents, a fact that unhappy critics irritably referred to as the "imperial fiat." Giscard's selections were somewhat thwarted, or at least reoriented, by the election of Jacques Chirac as mayor of Paris, who reopened the matter of Les Halles, and by the election of Mitterrand to the presidency. Thanks to the advantage of having two successive terms, Mitterrand was able to see through, or at the very least, able to assure the completion of an unprecedented program in terms of its scope (some two thousand proposals were presented in competitions under Mitterrand), making use of sovereign authority that allowed him to go so far as to select the architect of the Louvre's pyramid, I. M. Pei, without holding a competition at all (which was in violation of the regulations). Paris, the work of kings, could not accept the placing of its fertile soil in the service of a great design except by order of an essentially monarchical power, one well served by the essential spirit of the place.

**12. Bastille Opéra**

*The Bastille Opéra was built between 1982 and 1989 according to the plans of Carlos Ott. In the foreground is the Colonne de Juillet (July Column) commemorating the July Revolution of 1830.*

Numerous foreigners were the winners of the competitions and became the favorites of presidents. To the names of Breuer, Nervi, Pei, Rogers, and Piano already mentioned should be added those of Bernard Tschumi (La Villette), Peter Rice (La Villette and the Louvre), Ricardo Bofill (Les Halles), Gae Aulenti (Musée d'Orsay), Carlos Ott (Bastille Opéra), Frank Gehry (the American Center), Otto von Spreckelsen (La Défense arch), Richard Meier (television headquarters of Canal Plus), and several others. It would be tempting to identify this phenomenon with a new outward sign of Paris's international calling. But this would ignore the fact that immigrants have always been present as duly established painters, sculptors, and photographers in Paris and collaborated in the city's greatness. Besides, under what flag does Ott, a Uruguayan with Canadian nationality, work? The Louvre pyramid, designed as a meeting of east and west by an American of Chinese origins, and based on the proportions of the Great Pyramid of Cheops and the golden section, is a fitting proof of the capacity of Paris's internationalism.

Postwar building sites were the training grounds for at least two generations of French architects: the architects of the final Prix de Rome group, who were often members of the Academy of Fine Arts, and the architects belonging to the powerful group known as the Architectes des Bâtiments civils et Palais nationaux (Architects of Public and National Buildings), who were beneficiaries of public commissions.

When the socialists came to power, control of the most prestigious building sites went to the second generation, a generation that been trained on communal housing building sites in the suburbs. The transition from one generation to the next did not go smoothly. Bernard, whom Giscard had chosen as architect for the Institute of the Arab World, was dismissed when Mitterrand came to power. The competition was re-opened, and Jean Nouvel emerged victorious. Even though they are native Frenchmen, these French architects do not represent an architecture that is more "French" than the architecture produced by their foreign competitors. Their fame had rapidly given them access to international commissions.

The stylistic evolution of the architecture in the second half of the twentieth century could be summarized as the passage from the rough or crude to the transparent. The postwar style of Le Corbusier and his disciples has been called Brutalism, a style characterized by the massive and obvious utilization of rough concrete and simple building materials. Even though one can associate the birth of Brutalism with the construction of the Jaoul houses in greater Paris (Neuilly, 1952), the principal examples were found in the provinces (such as Ronchamp and La Tourette) or even abroad, notably in Le Corbusier's Indian Chandigarh. As transparent architecture in glass and steel became an imperative in Paris during Mitterrand's two terms in office, there was a desire to see in this phenomenon a characteristic of Mitterrand style. Enormous greenhouses were tacked on to the building of the Cité des Sciences (Science Center) at La Villette, which had originally been conceived as a meat market. The Institute of the Arab World was a sort of huge architectural lunette allowing Paris to see Mecca. The entrance to the Louvre was designed by Pei around two glass pyramids, one positive and one negative. The towers of the François Mitterrand Library (designed by Perrault) were to be translucent and in this way melt into the Paris skyline. All things considered, one could say that the style of the second half-century reproduced the transition from the massive and provincial Roman to the crystalline, monarchical, and Parisian Gothic. But is this comparison likely to reverse Parisian public opinion, opinion that has remained for the most part reserved, if not hostile, toward the "refinery" of the Beaubourg, the "Assyrian" or "Mussolini-like" renovations at the Musée d'Orsay, and the "Stalinist" low-rise building of the Ministry of Finance by Paul Chemetov?

It must be recognized, however, that the great designs chosen by the presidents of France have served the city's cultural activities very well, and for the most part have respected its heritage. Almost all public buildings built in the second half of the last century had a cultural calling, be it music, literature, or art; and moreover, no matter what their purpose,

**13. Ministère de l'Economie et des Finances (Ministry of the Economy and Finance)**

*This building was built by Paul Chemetov and Borja Huidobro between 1982 and 1988.*

## 15. La Défense Business Park

*In the foreground is Neuilly-sur-Seine: the skyscrapers are part of the Défense area. In the center is the Grande Arche de la Défense (Great Arch of the Défense) built as a counterpart to the triumphal arch in Paris. Otto von Spreckelsen's design was completed in 1989, after the architect's death, by Paul Andreu.*

## 14. Institut du monde arabe (Institute of the Arab World)

*This building was built between 1981 and 1987 by Jean Nouvel, Gilbert Lezenes, Pierre Soria, and Architecture Studio.*

they each house, in whole or in part, a museum. For the first time in its history, the Louvre is entirely used for the exhibition of the state's art collections. The Musée d'Orsay provides a home for French art of the period between 1848 and 1914. The Centre Pompidou and the Fondation Cartier built by Nouvel in 1993 are devoted to contemporary art. Two *hôtels* in the Marais have been renovated to house the Cognacq-Jay collection and the Picasso collection. Gathered together at La Villette are the Cité des sciences et de l'industrie (Center of Science and Industry)—a museum which does not dare to call itself a museum—built by Fainsilber and Rice; the Cité de la musique (Music Center), which contains a museum of musical instruments; and the Zénith, a rock music venue. In Boulogne the Musée des Arts et Traditions populaires (Museum of Popular Arts and Traditions) was built by Dubuisson and Jausserand. The Musée du Jeu de Paume (Tennis Museum), the Musée d'Arts et Métiers (Museum of Arts and Crafts), and the Musée national d'histoire naturelle (Museum of Natural History) have all been renovated. Music is served by the Bastille Opéra (fig. 12) and literature by the François-Mitterrand Library. On the east the library borders the great monumental axis formed by the Seine; and to the west the library faces the Musée des Arts premiers (Museum of Primitive Arts), a construction project that will fill up the last space left vacant on the banks of the Seine, which have been progressively purged of industrial and commercial activity. Grafted on to the river axis at the level of the Louvre is the axis leading to the Louvre's pyramid (figs. 1–2) and to the Grande Arche de la Défense (Great Arch of the Défense; fig. 7). Some have recognized, and certainly with good reason, that these two monuments are derived from two archetypes of commemorative architecture, which was one of the constants of President Mitterrand's architectural program. But a more subtle complicity also exists between the two monuments, one owing nothing to the president's intentions and everything to the odd history of Parisian topography. Since the axis of the Louvre courtyard does not exactly coincide with the large axis passing through the Tuileries Gardens and the Etoile, Pei had to bring the pyramid, which is in the center of the courtyard, alongside Bernini's equestrian statue, which serves as the first boundary marker of the urban axis. Because of a basement already studded by a maze of subterranean passageways, the great arch, a kind of hollow cube, had to be pivoted slightly in order to find firm ground for its foundations. This example perfectly illustrates the complete integration of the pyramid and the arch within the history of monuments of Paris.

The combination of fashion and extraordinary sites makes Paris the top tourist destination in the world. It is a popular city because it resonates with so much beautiful and important history. To aptly describe Paris, one could use the words written by Michel Leiris about the many paintings in the style of the old masters that Picasso painted toward the end of his life: "Taking up in his own way the work of an older painter—is this not treating [the older painter's work] as something integrated to life that cannot be allowed to sleep, something necessarily to be brought to the end of its natural evolution?" The image of Paris proposed by this book participates in this design.

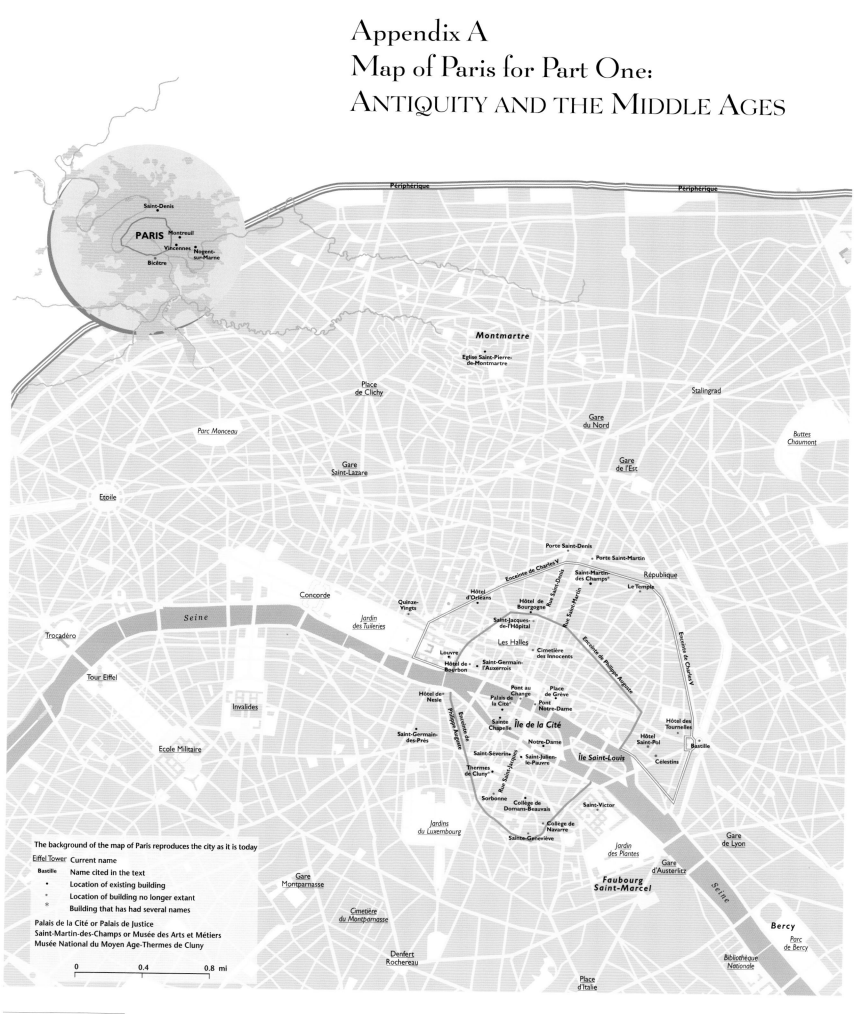

# Appendix A
# Map of Paris for Part One:
# ANTIQUITY AND THE MIDDLE AGES

**Périphérique**

**Périphérique**

Saint-Denis

**PARIS**

Montreuil

Vincennes

Nogent-sur-Marne

Bicêtre

*Montmartre*

Eglise Saint-Pierre-de-Montmartre

Place de Clichy

*Stalingrad*

*Parc Monceau*

Gare du Nord

*Buttes Chaumont*

Gare Saint-Lazare

Gare de l'Est

Etoile

Porte Saint-Denis

Porte Saint-Martin

*Enceinte de Charles V*

Saint-Martin-des-Champs*

*République*

Le Temple

Concorde

Quinze-Vingts

Hôtel d'Orléans

Hôtel de Bourgogne

*Jardin des Tuileries*

Saint-Jacques-de-l'Hôpital*

*Seine*

Les Halles

*Enceinte de Philippe Auguste*

*Enceinte de Charles V*

Trocadéro

Louvre

Cimetière des Innocents

Saint-Germain-l'Auxerrois

Hôtel de Bourbon

Tour Eiffel

Pont au Change

Place de Grève

Hôtel de Nesle

Palais de la Cité*

Pont Notre-Dame

Invalides

Hôtel des Tournelles

Sainte Chapelle

*Île de la Cité*

Hôtel Saint-Pol

Saint-Germain-des-Prés

*Enceinte de Philippe Auguste*

Notre-Dame

*Île Saint-Louis*

Bastille

Ecole Militaire

Saint-Séverin

Saint-Julien-le-Pauvre

Célestins

Thermes de Cluny*

*Rue Saint-Jacques*

Sorbonne

Collège de Domans-Beauvais

Saint-Victor

Gare de Lyon

*Jardins du Luxembourg*

Collège de Navarre

Sainte-Geneviève

*Jardin des Plantes*

Gare d'Austerlitz

The background of the map of Paris reproduces the city as it is today

Gare Montparnasse

*Faubourg Saint-Marcel*

*Seine*

<u>Eiffel Tower</u>   Current name

**Bastille**   Name cited in the text

•   Location of existing building

*   Location of building no longer extant

\*   Building that has had several names

Palais de la Cité or Palais de Justice
Saint-Martin-des-Champs or Musée des Arts et Métiers
Musée National du Moyen Age-Thermes de Cluny

*Cimetière du Montparnasse*

*Bercy*

*Parc de Bercy*

0    0.4    0.8 mi

Denfert Rochereau

*Bibliothèque Nationale*

Place d'Italie

# Appendix B
# Map of Paris for Part Two:
# MODERN TIMES

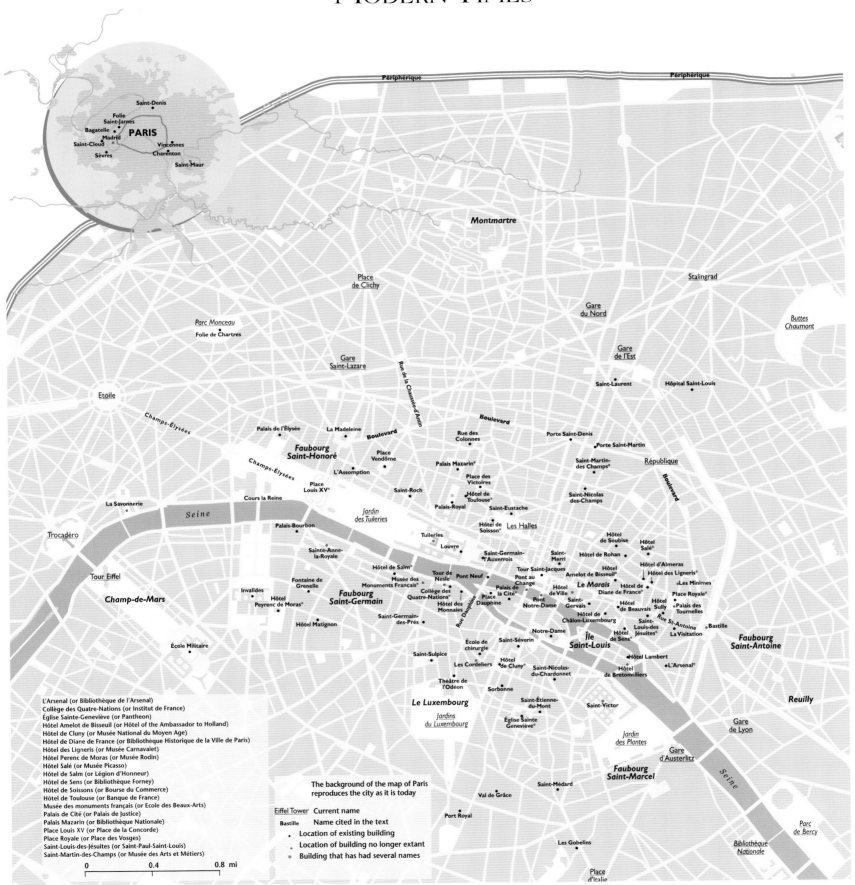

Périphérique    Périphérique

Saint-Denis

Folie
Saint-James
Bagatelle
Madrid  **PARIS**
Saint-Cloud
Vincennes
Charenton
Sèvres
Saint-Maur

*Montmartre*

*Place
de Clichy*

Stalingrad

Gare
du Nord

*Buttes
Chaumont*

*Parc Monceau*
Folie de Chartres

Gare
de l'Est

Gare
Saint-Lazare

Saint-Laurent    Hôpital Saint-Louis

Etoile

*Champs-Élysées*

Palais de l'Élysée    La Madeleine    *Boulevard*

Porte Saint-Denis
Porte Saint-Martin

*Faubourg
Saint-Honoré*

Boulevard

Rue des
Colonnes

Saint-Martin-
des-Champs*

République

*Champs-Élysées*

Place
Vendôme

L'Assomption

Palais Mazarin*

Place des
Victoires

*Boulevard*

Place
Louis XV*

Saint-Roch

Hôtel de
Toulouse*

Saint-Nicolas
des-Champs

La Savonnerie

Cours la Reine

Palais-Royal*

Saint-Eustache

*Seine*    *Jardin
des Tuileries*

Palais-Bourbon

Hôtel de
Soisson*

Les Halles

*Trocadéro*

Tuileries

Louvre

Hôtel
de Soubise

Hôtel
Salé*

Hôtel d'Almeras

Sainte-Anne-
la-Royale*

Saint-Germain-
l'Auxerrois

Saint-
Merri

Hôtel de Rohan

*Tour Eiffel*

Hôtel de Salm*

Musée des
Monuments Français*

Tour de
Nesle*

Pont Neuf

Tour Saint-Jacques

Amelot de Bisseuil*

Hôtel
d'Almeras

Hôtel des Ligneris*

*Les Minimes*

Fontaine de
Grenelle

Pont au
Change

Hôtel
de Ville

*Le Marais*

Hôtel de
Diane de France*

Place Royale*

*Champ-de-Mars*

Invalides

Hôtel
Peyrenc de Moras*

*Faubourg
Saint-Germain*

Collège des
Quatre-Nations*

Palais de
la Cité*

Hôtel
de Beauvais*

Hôtel
Sully

Palais des
Tournelles*

Saint-Germain-
des-Prés

Hôtel des
Monnaies

Place
Dauphine

Pont
Notre-Dame

Saint-
Gervais

Bastille

Hôtel de
Châlon-Luxembourg*

Rue St-Antoine

Hôtel Matignon

*Rue Dauphine*

Hôtel de
Bretonvilliers*

Saint-
Louis-des-
Jésuites*

*Faubourg
Saint-Antoine*

*École Militaire*

École de
chirurgie

Saint-Séverin

Notre-Dame

*Île
Saint-Louis*

Hôtel
de Sens*

La Visitation

Saint-Sulpice

Hôtel
de Cluny*

Les Cordeliers

Saint-Nicolas-
du-Chardonnet

Hôtel Lambert

L'Arsenal

*Reuilly*

Théâtre de
l'Odéon

Sorbonne

*Le Luxembourg*

Saint-Étienne-
du-Mont

Saint-Victor

Gare
de Lyon

*Jardins
du Luxembourg*

Église Sainte
Geneviève*

*Jardin
des Plantes*

Gare
d'Austerlitz

*Faubourg
Saint-Marcel*

L'Arsenal (or Bibliothèque de l'Arsenal)
Collège des Quatre-Nations (or Institut de France)
Église Sainte-Geneviève (or Pantheon)
Hôtel Amelot de Bisseuil (or Hôtel of the Ambassador to Holland)
Hôtel de Cluny (or Musée National du Moyen Age)
Hôtel de Diane de France (or Bibliothèque Historique de la Ville de Paris)
Hôtel des Ligneris (or Musée Carnavalet)
Hôtel Perenc de Moras (or Musée Rodin)
Hôtel Salé (or Musée Picasso)
Hôtel de Salm (or Légion d'Honneur)
Hôtel de Sens (or Bibliothèque Forney)
Hôtel de Soissons (or Bourse du Commerce)
Hôtel de Toulouse (or Banque de France)
Musée des monuments français (or Ecole des Beaux-Arts)
Palais de Cité (or Palais de Justice)
Palais Mazarin (or Bibliothèque Nationale)
Place Louis XV (or Place de la Concorde)
Place Royale (or Place des Vosges)
Saint-Louis-des-Jésuites (or Saint-Paul-Saint-Louis)
Saint-Martin-des-Champs (or Musée des Arts et Métiers)

The background of the map of Paris
reproduces the city as it is today

Val de Grâce

Saint-Médard

Port Royal

Eiffel Tower    Current name

Bastille    Name cited in the text

· Location of existing building

* Location of building no longer extant

* Building that has had several names

Les Gobelins

*Parc
de Bercy*

*Bibliothèque
Nationale*

*Place
d'Italie*

| 0 | 0.4 | 0.8 mi |

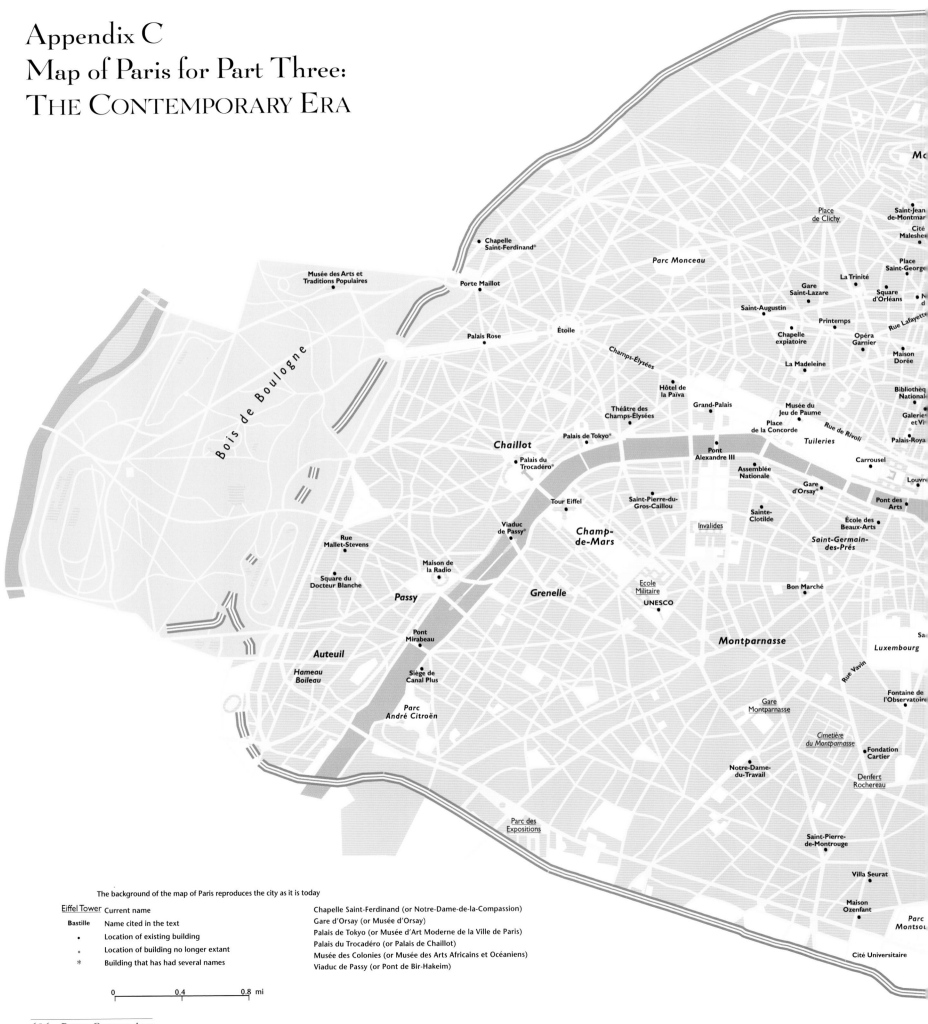

# Appendix C
# Map of Paris for Part Three:
# THE CONTEMPORARY ERA

Mo[...]

Place
de Clichy

Saint-Jean
de-Montmar[...]

Cité
Maleshe[...]

• Chapelle
Saint-Ferdinand*

Parc Monceau

Place
Saint-George[...]

• Musée des Arts et
Traditions Populaires

• Porte Maillot

Gare
Saint-Lazare

La Trinité

Square
d'Orléans

N[...]
d[...]

Saint-Augustin

Rue Lafayette[...]

Printemps

Palais Rose

Étoile

Chapelle
expiatoire

Opéra
Garnier

Maison
Dorée

Champs-Élysées

Bois de Boulogne

La Madeleine

Bibliothèq[...]
National[...]

Hôtel de
la Païva

Grand-Palais

Musée du
Jeu de Paume

Galerie[...]
et Vi[...]

Théâtre des
Champs-Élysées

Place
de la Concorde

Rue de Rivoli

Palais de Tokyo*

Chaillot

Tuileries

Palais-Roya[...]

Pont
Alexandre III

Carrousel

Palais du
Trocadéro*

Assemblée
Nationale

Gare
d'Orsay*

Louvr[...]

Tour Eiffel

Saint-Pierre-du-
Gros-Caillou

Pont des
Arts

Viaduc
de Passy*

Champ-
de-Mars

Invalides

Sainte-
Clotilde

École des
Beaux-Arts

Rue
Mallet-Stevens

Maison de
la Radio

Grenelle

École
Militaire

Saint-Germain-
des-Prés

Bon Marché

Square du
Docteur Blanche

UNESCO

Passy

Montparnasse

Luxembourg

Sa[...]

Auteuil

Pont
Mirabeau

Rue Vavin

Hameau
Boileau

Fontaine de
l'Observatoire

Siège de
Canal Plus

Gare
Montparnasse

Parc
André Citroën

Cimetière
du Montparnasse

Fondation
Cartier

Notre-Dame-
du-Travail

Denfert
Rochereau

Parc des
Expositions

Saint-Pierre-
de-Montrouge

Villa Seurat

Maison
Ozenfant

Parc
Montso[...]

Cité Universitaire

The background of the map of Paris reproduces the city as it is today

Eiffel Tower   Current name

Bastille     Name cited in the text

•          Location of existing building

*          Location of building no longer extant

*          Building that has had several names

Chapelle Saint-Ferdinand (or Notre-Dame-de-la-Compassion)
Gare d'Orsay (or Musée d'Orsay)
Palais de Tokyo (or Musée d'Art Moderne de la Ville de Paris)
Palais du Trocadéro (or Palais de Chaillot)
Musée des Colonies (or Musée des Arts Africains et Océaniens)
Viaduc de Passy (or Pont de Bir-Hakeim)

0          0.4          0.8 mi

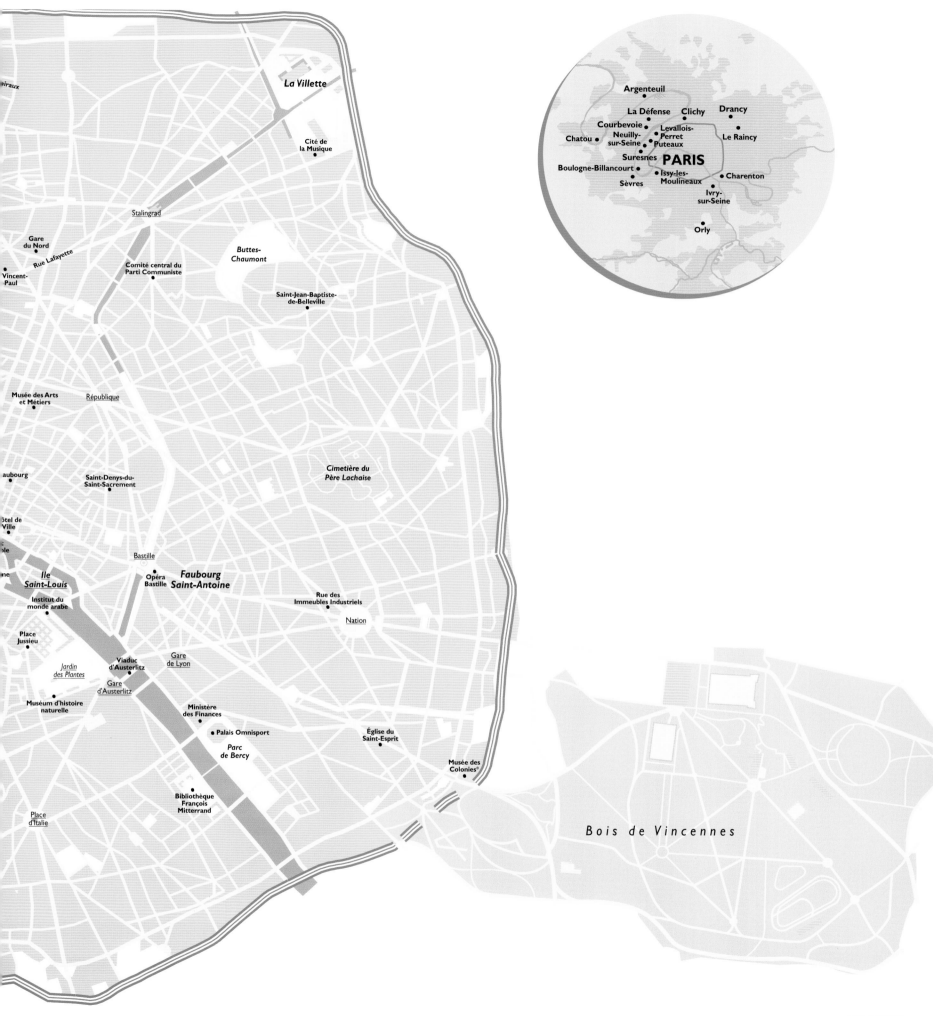

La Villette

Cité de
la Musique

iraux

Stalingrad

Gare
du Nord

Rue Lafayette

Vincent-
Paul

Comité central du
Parti Communiste

Buttes-
Chaumont

Saint-Jean-Baptiste-
de-Belleville

Musée des Arts
et Métiers

République

aubourg

Saint-Denys-du-
Saint-Sacrement

Cimetière du
Père Lachaise

tel de
Ville

Bastille

c
ole

Île
Saint-Louis

Opéra
Bastille

Faubourg
Saint-Antoine

Institut du
monde arabe

ne

Rue des
Immeubles Industriels

Place
Jussieu

Nation

Jardin
des Plantes

Viaduc
d'Austerlitz

Gare
de Lyon

Gare
d'Austerlitz

Muséum d'histoire
naturelle

Ministère
des Finances

Palais Omnisport

Église du
Saint-Esprit

Parc
de Bercy

Musée des
Colonies*

Place
d'Italie

Bibliothèque
François
Mitterrand

Bois de Vincennes

Argenteuil

La Défense    Clichy    Drancy

Courbevoie    Levallois-
Neuilly-    Perret    Le Raincy
sur-Seine    Puteaux

Chatou

Suresnes    PARIS

Boulogne-Billancourt    Issy-les-    Charenton
Moulineaux

Sèvres    Ivry-
sur-Seine

Orly

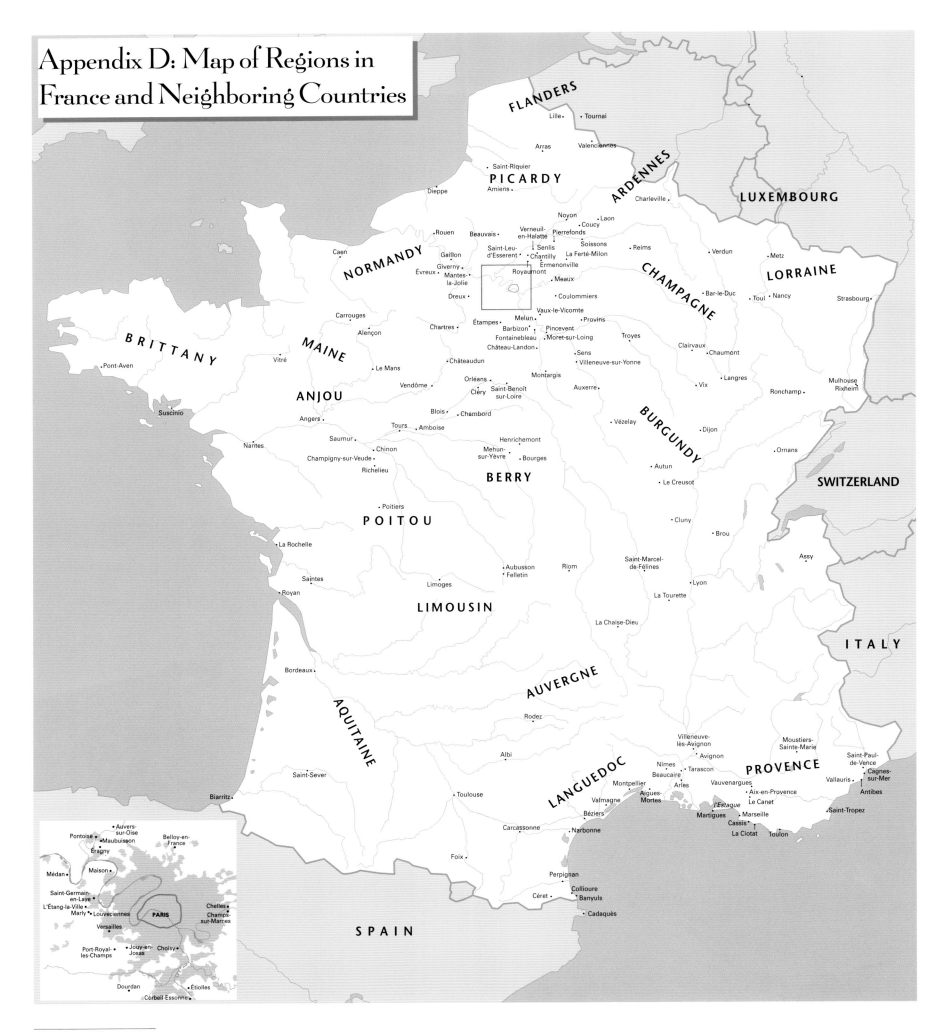

Appendix D: Map of Regions in France and Neighboring Countries

FLANDERS

Lille • Tournai

Arras • Valenciennes

Saint-Riquier •

PICARDY

Dieppe

Amiens •

Charleville •

ARDENNES

LUXEMBOURG

Rouen • Beauvais •

Noyon • Laon

Coucy

Verneuil-
en-Halatte

Pierrefonds

Senlis

Soissons

Reims •

Verdun •

Metz •

LORRAINE

Caen •

Gaillon •

Saint-Leu-
d'Esserent

Chantilly

La Ferté-Milon

NORMANDY

Évreux •

Mantes-
la-Jolie

Ermenonville

Royaumont

Meaux •

Bar-le-Duc •

Toul • Nancy •

Strasbourg •

Dreux •

Giverny •

Coulommiers •

CHAMPAGNE

BRITTANY

Carrouges •

Étampes •

Chartres •

Melun

Vaux-le-Vicomte •

Provins •

Barbizon •

Fontainebleau

Pincevent

Moret-sur-Loing •

Troyes •

Clairvaux •

Chaumont •

Langres •

Mulhouse
Rixheim

Alençon •

Château-Landon •

Sens •

MAINE

Vitré •

Le Mans •

Châteaudun •

Villeneuve-sur-Yonne •

Ronchamp •

Vendôme •

Orléans •

Saint-Benoît
sur-Loire

Montargis •

Auxerre •

Vix •

ANJOU

Pont-Aven •

Cléry •

Vézelay •

Dijon •

Ornans •

Blois •

Chambord •

BURGUNDY

SWITZERLAND

Suscinio •

Angers •

Tours •

Amboise •

Saumur •

Chinon •

Henrichemont •

Nantes •

Champigny-sur-Veude •

Richelieu •

Mehun-
sur-Yèvre

Bourges •

Autun •

Le Creusot •

BERRY

Poitiers •

La Chaise-Dieu •

POITOU

Cluny •

Brou •

La Rochelle •

Saint-Marcel-
de-Félines

Assy •

Aubusson •
Felletin •

Riom •

Lyon •

Saintes •

Limoges •

La Tourette

Royan •

LIMOUSIN

ITALY

Bordeaux •

AUVERGNE

AQUITAINE

Rodez •

Villeneuve-
lès-Avignon

Moustiers-
Sainte-Marie

Saint-Paul-
de-Vence

Albi •

Avignon •

PROVENCE

Nîmes •

Tarascon •

Cagnes-
sur-Mer

Saint-Sever •

Beaucaire

Vauvenargues •

Vallauris •

Montpellier •

Arles •

Aix-en-Provence •

Antibes •

Biarritz •

Toulouse •

LANGUEDOC

Valmagne •

Aigues-
Mortes

l'Estaque

Saint-Tropez •

Béziers •

Le Canet

Martigues •

Marseille •

Carcassonne •

Narbonne •

Cassis •

La Ciotat •

Toulon •

Foix •

Perpignan •

Collioure

Céret •

Banyuls •

SPAIN

Cadaquès •

Auvers-
sur-Oise

Pontoise •

Maubuisson •

Belloy-en-
France

Éragny •

Médan •

Maison •

Saint-Germain-
en-Laye

L'Étang-la-Ville •

Marly • Louveciennes •

Chelles

PARIS

Champs-
sur-Marnes

Versailles •

Port-Royal-
les-Champs

Jouy-en-
Josas

Choisy

Dourdan •

Étiolles •

Corbeil-Essonne •

# BIOGRAPHIES

**ABADIE, PAUL (1812–1884)**
Architect. He restored many Romanesque churches and cathedrals in the southwest of France (for example, Saint-Front de Périgueux), often transforming them; built churches in this region (Sainte-Marie in Bordeaux-Bastide); and above all the Sacré-Cœur Basilica on Montmartre (1876).

**ABÉLARD, PIERRE (1079–1142)**
Philosopher and scholastic theologian. In Paris he was a student and later rival of Guillaume de Champeaux. He opened a school and taught in Melun, Corbeil, and finally in Paris, on Mount Sainte-Geneviéve. His love for Héloïse, the niece of Canon Fulbert, led him to be emasculated by Fulbert's comrades. He withdrew from society and entered Saint-Denis Abbey; Héloise became a nun at the Argenteuil Monastery. He came up against great animosity. His philosophy was an extremely modern, enlightened approach and rational critique of the conventional wisdom.

**ABRAHAM, POL (1891–1966)**
Architect. He was a strong advocate of open prefabrication, though he is better known for his thesis, *Viollet-le-Duc et le rationalisme médiéval* (*Viollet-le-Duc and Medieval Rationalism*), 1935.

**ALCIAT, ANDRÉ (1492–1550)**
Italian humanist. He taught Roman law in Italy and in France. His anthology *Emblematum libellus,* a collection of moral maxims in Latin couplets, was highly successful. It was translated into French as early as 1534.

**ALLAIS, ALPHONSE (1854–1905)**
Writer. Associated with the creation of the Chat Noir cabaret, in 1883 Allais wrote for the newspaper of the same name, and later for the newspapers *Journal*, 1892, and *Sourire* (Smile), 1894. He wrote tales such as *Le Parapluie de l'escouade* (*The Gang's Umbrella*), 1894, novellas, poems, and plays including *L'Innocent* (*The Innocent*), 1896, with Alfred Capus; all his writing expressed his dark humor and strong satirical bent.

**ANDROUET DU CERCEAU**
Family of architects. Jacques I (1510–1585) was well-known as an interior decorator and engraver. He was one of the first theoreticians of classical French architecture. After his journey to Rome, he published several collections of engravings. Baptiste (c. 1545–1590) was the son of Jacques I. He took over from Pierre Lescot as architect of the Louvre in 1548, and became architect to the king. He also designed the Pont Neuf in Paris. Jacques II (c. 1550–1614), brother of Baptiste, was architect to Henri IV, and finished construction of the Grande Galerie (Great Gallery) of the Louvre. Jean I (c. 1590–1649) became the architect to Louis XIII in 1617 and designed the Hôtel de Sully and the Hôtel de Bretonvilliers in Paris (now destroyed).

**ARCHIPENKO, ALEXANDER (1887–1964)**
American sculptor and painter of Russian origin. He arrived in Paris in 1908, and was influenced by art nouveau and cubism. He was a friend of Fernand Léger, and exhibited with the Section d'Or (Golden Section) in 1911. In his sculpture he replaced dense masses with empty areas, arranging open spaces within his works, like *La Boxe* (*Boxing*), 1913.

**ARP, HANS (1887–1966)**
Painter and sculptor. He first exhibited his work with the expressionists. Later he distanced himself from figuration and created glued paper works with Sophie Taeuber. In 1916 he and Tristan Tzara founded the dada movement, which is based on critique of traditional art and bourgeois society. Arp then worked on collages and ink drawings, and wrote poetry. He belonged to the surrealist movement and later to the Abstraction-Création group. He turned to sculpture in the 1930s.

**BAKST, LÉON (1866–1924)**
Russian painter, interior decorator, and illustrator. He was a portrait artist, trained in Moscow and Paris, and helped Sergey Diaghilev found *Mir Iskoustva* (*The World of Art*) in 1898. He then worked as a costume and set designer for Diaghilev's Ballet Russe (*Cleopatra*, 1909, and *The Firebird*, 1910). He continued to paint portraits, nudes, and landscapes in luminous, bright colors, and also illustrated books.

**BALTHUS (BALTHASAR KLOSSOWSKI DE ROLA; 1908–2001)**
Painter. Influenced by the Italian primitives, he painted primarily street scenes and dreamy young women in bare rooms. Touched with eroticism, his works were considered scandalous in the 1930s. His work has remained on the fringe of every movement.

**BARTHOLOMÉ, PAUL ALBERT (1848–1928)**
Sculptor. He was a painter first, and only later devoted himself to sculpture, mostly of elegiac or funerary themes; examples include *Jeune Fille pleurant* (*Young Woman Crying*) and *Jeune Fille priant* (*Young Woman Praying*). He is best known for his *Monument aux morts* (*Monument to the Dead*), 1899, in the Père-Lachaise Cemetery.

**BARYE, ANTOINE LOUIS (1796–1875)**
Sculptor. He was a student of François-Joseph Bosio and Antoine Gros, and made his debut in the 1827 Salon with his busts. He achieved notoriety for his animal subjects with *Le Tigre dévorant un gavial* (*Tiger Devouring a Gavial*). His *Lion écrasant un serpent* (*Lion Crushing a Snake*), 1833, provoked a great deal of controversy, and he did not exhibit in a Salon again until 1850. The state then commissioned him to make *Le Lion au Serpent* (*Lion and Serpent*), *Le Lion en marche* (*Lion Walking*), and *Le Lion assis* (*Lion Seated*). In 1868 he entered the Académie des Beaux-Arts.

**BAUDOT, ANATOLE DE (1834–1915)**
Architect and theoretician. A student of Viollet-le-Duc, he set himself apart through his use of reinforced concrete, in particular at Saint-Jean de Montmartre, the audacious structure of which was inspired by Gothic and even baroque art. He published *L'Architecture: le passé, le présent* (*Architecture: The Past, the Present*) and *L'Architecture et le béton armé* (*Architecture and Reinforced Concrete*).

**BAUDRY, PAUL (1828–1886)**
Painter. He won the Prix de Rome in 1850, designed the decor of the Paris Opéra, and painted the murals in the Château de Chantilly.

**BEAUDOUIN, EUGÈNE (1898–1983)**
Architect and urban planner. Until 1940 he worked with Martin Lods and was interested in designing collective housing and in the industrialization of the housing-construction sector. The team is best known for building the Muette high-rise development in Drancy (1931–1934), the open-air school in Suresnes (1934–1935) and the Maison du Peuple (House of the People) in Clichy (1935–1939). He was subsequently commisioned to build many public buildings including embassies, low-income housing, and secondary schools like the Lycée d'Antony and the Medon Lycée (1960). He also designed urban development plans for several cities.

**BEAUNEVEU, ANDRÉ (c. 1330–c. 1410)**
Painter, sculptor, and miniaturist. Originally from Valenciennes en Hainaut, Beauneveu's presence in Paris was first noted in 1364, when he served as a printmaker and figurine carver to Charles V, whose tombstone he eventually made. Beauneveu then served Duke Jean de Berry. He is thought to have carved the statues in the Gardes de Poitiers hall and those in the Maubergeon Tower.

**BENOIS, ALEXANDRE NIKOLAEVÏTCH (1870–1960)**
Russian painter, interior decorator, and illustrator. After exhibiting his paintings and watercolors, he co-founded *Mir Iskoustva* (*The World of Art*) with Sergey Diaghilev in 1898. Benois then worked for Diaghilev's Ballet Russe designing sets; most notably he painted the scenery for *Giselle* (1910) and *Petrouchka* (1911). He also illustrated a variety of books and magazines.

**BÉRAIN, JEAN (1637–1711)**
Interior decorator and engraver. As designer to the king's court, he created the decor for receptions and performances at Louis XIV's court. He designed interior decoration and tapestry cartoons that ushered in the *rocaille* style, and had a remarkable influence in northern Europe.

**BERNARD, SAINT (1090–1153)**
Founder and first abbot of Clairvaux, doctor of the church. He became a monk at Citeaux Abbey in 1112 and his abbot sent him to found the Clairvaux Abbey in 1115. His success was prodigious, and thanks to him, the considerable influence over church politics that Cluny had held was assumed by the abbey of Citeaux. Bernard had a predominant influence over the advisory circle in the pontifical court.

**BERNINI, GIANLORENZO (1598–1680)**
Italian painter, sculptor, and architect. Trained in sculpture in his father's workshop, Bernini's work was soon noticed and he won the patronage of influential Roman families like the Borgheses and the Barberinis. Cardinal Barberini, later Pope Urban VIII, commissioned Bernini's first large architectural works: the baldachin in Saint Peter's Basilica (1624–1633), the facade of the Collège de Propaganda (1627), and the Palazzo Barberini (1625–1633). He gave up painting and devoted himself to sculpture, making superb statues, busts, and portraits, including a bust of Louis XIV (1665). Between 1644 and 1647 Bernini lost favor with Pope Innocent X, although his masterpiece, the *Ecstasy of Saint Theresa*, was created in 1644 for the Cornaro Chapel of the church of Santa Maria della Vittoria. Later, back in favor with the pope, Bernini achieved fame and glory with his design of city squares (Piazza Barberini with the Triton Fountain, and Piazza Navona). He was a master of baroque sculpture, and won impressive architectural commissions such as the Palazzo Barberini, the church of Sant'Andrea al Quirinale, and Saint Peter's Basilica, for which he designed the colonnade. In 1665 Bernini went to Paris after repeated invitations from King Louis XIV; however, due to sharp criticism from the French classicists his plans for the Louvre were never carried out.

**BING, SAMUEL (1838–1905)**
Art collector and dealer. After his start in the ceramics industry, he moved to Paris and founded the Art Nouveau Gallery in 1895, from which the movement takes its name; there he mainly sold Japanese curios. The Bing Pavilion presented art nouveau in the 1900 World's Fair.

**BODIANSKY, VLADIMIR (1894–1966)**
French engineer, architect, and urban planner of Russian origin. He worked with Eugéne Beaudouin and Martin Lods, then founded ATBAT (Atelier des Batisseurs, or Workshop of Builders) in 1946. Its main project was a housing unit in Marseilles (1945–1952) designed by Le Corbusier. Bodiansky worked toward the industrialization of the construction sector.

**BOFFRAND, GABRIEL-GERMAIN (1667–1754)**
Architect and interior designer. In 1708 Boffrand was a student of François Mansart, the architect of the duke of Lorraine, and incorporated *rocaille* decor into his classical-style buildings, as can be seen in the decoration of the Hôtel Rohan-Soubise (1735–1740) in Paris.

**BOILEAU, ETIENNE (c. 1210–1270)**
Provost to King Saint Louis in Paris in 1261. In 1268, at the king's bidding, he compiled *Le Livre des Métiers* (*The Book of Guilds*), a collection of statutes and rules governing Parisian trade guilds.

**BOILEAU, LOUIS AUGUSTE (1812–1896)**
Architect. He was the first to use iron in the construction of religious monuments, such as his church of Saint-Eugène in Paris (1853).

**BONINGTON, RICHARD PARKES (1801–1828)**
English painter. He was a student of Antoine Gros in Paris, and traveled to Normandy and Venice, where he painted *Piazza San Marco* in 1826. He also painted the well-known *View of the Parterre d'Eau at Versailles*, 1824, and *Rouens Cathedral*, c. 1825, both examples of the Romantic style.

**BONNARD, PIERRE (1867–1947)**
Painter, designer, and poster artist. Bonnard was a great admirer of Gauguin; he was friends with Eduoard Vuillard, Maurice Denis, and Paul Sérusier; and joined the Nabis group. His designs were highly successful, especially his poster for *France Champagne* (1891). His work was influenced by Japanese prints, and Bonnard set himself apart with his unique layouts and his talent with color applied to intimate scenes (*Nu à contre-jour*, or *Backlit Nude*, 1908; and *Nu dans la baignoire*, or *Nude in the Bathtub*, 1937).

**BONNAT, LÉON (1834–1922)**
Painter. His first paintings were influenced by the Spanish School, such as *Adam et Eve découvrant le cadavre d'Abel* (*Adam and Eve Finding Abel's Body*), 1861. A trip Bonnat took to the Far East in 1870 inspired several paintings, and he later devoted himself to portraits. His mastery of technique brought him great success.

**BONTEMPS, PIERRE (1510–1570)**
Sculptor. He worked for Francesco Primaticcio at Fontainebleau and collaborated on the tomb of François I under Philibert de l'Orme. He also created the urn holding François I's heart.

**BOSIO, FRANÇOIS-JOSEPH (1768–1845)**
Sculptor. Originally from Monaco, he studied with Augustin Pajou and Antonio Canova before sculpting bas-reliefs and the statues of Louis XIV on Place des Victoires and of Louis XVI in the Chapelle Expiatoire; as well as busts of Napoleon, Louis XVIII, Charles X; and mythological sculptures.

**BOSSE, ABRAHAM (1602–1676)**
Engraver and author. He collaborated with Jacques Callot on *Jardin de la noblesse française* (*Garden of the French Nobility*) and *Noblesse française à l'église* (*The French Nobility in the Church*), taught perspective at the Parisian academy, and wrote treatises about engraving techniques.

**BOUCHER, FRANÇOIS (1703–1770)**
Painter and engraver. He was accepted into the academy in 1734, and had many commissions from the court and aristocracy. He was appointed First Painter to the king in 1765. Boucher's many works of interior decoration—including cartoons for wallpaper for the Hôtel Beauvais and the Gobelins factory, porcelain objects for Sèvres, and his mythological, pastoral, and libertine scenes—all demonstrate that he was a master of rococo-style painting.

**BOUDIN, EUGÈNE (1824–1898)**
Painter. From Honfleur, he painted mainly seascapes like *Tempête se levant* (*Approaching Storm*), 1864, and *La Jetée à Deauville* (*The Dock at Deauville*), 1869. He influenced impressionists such as Claude Monet, who acknowledged him as a precursor and invited him to exhibit with them in 1874.

**BOUGUEREAU, ADOLPHE-WILLIAM (1825–1905)**
Painter. He won the Prix de Rome in 1850 and, with Léon Gérôme and Alexandre Cabanel, was a leader of academic painting. Bouguereau's mastery of technique is obvious in all his works. Especially impressive are religious paintings, such as *Vierge consolatrice* (*Virgin of Consolation* ) 1877; commissioned works including the decor of the Grand Théâtre in Bordeaux and Saint-Augustin Church in Paris; and his nudes in mythological scenes.

**BOULLE, ANDRÉ CHARLES (1642–1732)**
Cabinetmaker. Patronized by Jean-Baptiste Colbert, Boulle became one of the most important suppliers of furnishing to the king and the court. He was influenced by Jean Bérain at first, then evolved to a more geometric style. His name was used to designate his style of furniture; he was particularly known for pieces in ebony, cabinets, and, above all, commodes encrusted with precious stones.

**BOURDELLE, ANTOINE (1861–1929)**
Sculptor and painter. Trained by Rodin, Bourdelle stood out for his will to simplify, his lyricism, and his expressive power. Especially well-known are his reliefs on the facade of the Champs-Elysées Theater (1912) and several commissioned public works such as the *Monument to Alvear* in Buenos Aires (1914–1919).

**BRANCUSI, CONSTANTIN (1876–1957)**
Romanian sculptor. He first came to Paris in 1904, where he was influenced by Rodin, African and Oceanic sculpture, and cubism. He rejected naturalism and instead sculpted simple, stylized shapes, often ovoid; for example, his different versions of *Mademoiselle Pogagny* (1912–1933). The simplicity he sought gave his works great emotional power.

**BRAQUE, GEORGES (1882–1963)**
Painter and engraver. Braque was first influenced by impressionism and fauvism, and from 1908 adopted a style using quasi-geometric composition

and a somber range of colors. He collaborated with Picasso and initiated the cubist movement with his work *Le Guéridon (Pedestal Table)*, 1911. After World War I he evolved toward a more classical style. He painted nudes; landscapes such as *Falaises (Cliffs)*, 1938; and still lifes, which heralded his series of *Ateliers (Workshops)*, 1950–1956.

**BRASSAÏ, HENRI (1899–1984)**
Hungarian photographer, sculptor, engraver, designer, and painter. He came to Paris in 1923, where he met the surrealists and devoted himself to photography, for example *Paris de nuit (Paris by Night)*, 1933. From 1933—and especially after 1944—encouraged by Picasso, he painted female nudes with lanky, sensual bodies. Later, he wrote and illustrated books, created decors, and made films, engravings, and sculpture.

**BRAUNER, VICTOR (1903–1966)**
French painter of Romanian origin. After exhibiting his works in Bucharest, he moved to Paris in 1930 and joined the surrealists. He was also influenced by German expressionism: *L'étrange Cas de Monsieur K (The Strange Case of Mister K)*, 1934. His paintings portrayed his own inner world of dreams and fantasies, such as *Chimères (Pipedreams)*, 1938–1940.

**BRONGNIART, ALEXANDRE (1770–1847)**
Mineralogist and geologist. Son of Alexandre Théodore, he began working as a mine engineer in 1794 and became director of the Sèvres manufacturing plant in 1800. Brongniart was responsible for the rebirth of the art of painting on glass. He also wrote several treatises on mineralogy and *Description géologique des environs de Paris (A Geological Description of Paris and Its Surroundings)* with Georges Cuvier in 1882.

**BROSSE, SALOMON DE (c. 1571–1626)**
Architect. Appointed royal architect under Henry IV and Marie de Médicis, he designed a homogenous group of buildings in a short period of time, including the Châteaux de Coulomniers and Blérencourt, and the Luxembourg Palace in Paris (1619–1624). A few of his key architectural solutions were later developed by François Mansart.

**BRUANT, LIBÉRAL (c. 1636–1697)**
Architect and engineer. He was appointed architect to the king in 1663 and became a member of the academy in 1671. He represented French classicism, designed the church at the Salpêtrière Hospital (1660–1677), and is best known for the Hôtel des Invalides (1671–1676).

**BRUNETTO, LATINI (c. 1220–c. 1294)**
Italian scholar. Exiled in France, he became known as Brunet Latin. He wrote a book in *langue d'oïl*, a northern medieval-French dialect, entitled *Livre du Trésor (The Book of Treasure)*, a compilation of the science of the time combined with legends. He was one of Dante's teachers.

**BUÑUEL, LUIS (1900–1983)**
Spanish film director. He came to Paris in 1925, became a surrealist, and remained one throughout his life. In 1928 he made the film *Un Chien Andalou (An Andalusian Dog)* with Salvador Dali. He divided his time between France, Spain, and Mexico. His films denounced society's selfishness (*Los Olvidados, or The Forgotten Ones*; 1950) and the oppression of the church (*Nazarin, or Nazarene*; 1958). He also made portraits of women that are touched with eroticism (*Belle de Jour, or Beauty by Day*; 1967).

**CABANEL, ALEXANDRE (1823–1889)**
Painter. He won the Prix de Rome in 1845, entered the institute in 1863, and was later appointed as a professor in the Ecole des Beaux-Arts. He was a favorite painter of the imperial court, and painted historical works such as *La Vie de Saint Louis (The Life of Saint Louis)*.

**CAFFIERI**
A family of artists originally from Naples. Philippe (1634–1716) was a very active cabinetmaker in Paris. Bronze works by his son Jacques (1678–1755) are excellent examples of the *rocaille* style. His son Philippe ran a workshop in the working-class Saint-Germain quarter. Jean-Jacques was a sculptor and portrait painter; in Rome he met Gianlorenzo Bernini, who held him in high esteem, and his loyalty to the baroque style can be seen in his most successful bust.

**CALDER, ALEXANDER (1898–1976)**
American painter, sculptor, and illustrator. He came to Paris in 1926 where he began making small figurines in iron wire, and later created abstract and geometric sculptures in metal. In the 1930s he developed his famous mobiles. He also illustrated many books, created set designs for the theater, and made color prints.

**CALLOT, JACQUES (1592–1635)**
Etcher. As a very young man, his gained his first experience in the circle of Jacques Bellange and the workshop of D. Crocq's. He went to Italy in his teens, where he perfected his technique in Rome. In Florence he made etchings of court receptions and balls for Cosimo de' Medici II, although his interest in the picturesque and ordinary details of daily life persisted throughout his life—the *Caprices* series, 1617, and *Foire de l'Impruneta (Fair at Impruneta)*, 1620, are but two examples. He had a unique knack for combining the natural and the grotesque, evident in works like *Les Bohemiens (The Bohemians)*, c. 1620. In 1628 Cardinal Richelieu ordered a series of engravings commemorating the taking of La Rochelle and the Ile du Roi. These engravings conveyed his sense of drama and foreshadowed the emotional power and perception of his later series of engravings called *Les Grandes misères de la guerre (The Miseries of War)*, 1632–1633.

**CANOVA, ANTONIO (1757–1822)**
Italian sculptor. After his apprenticeship in Venice, he moved to Rome. He is considered the master of neoclassical sculpture. Canova was very active in Italy and France, where he sculpted a bust of *Napoléon* (1803)

and the colossal statue of *Napoléon tenant la Victoire (Napoleon Holding Victory)*, 1811.

**CARON, ANTOINE (1520–1599)**
Master glass artist and designer to the king. Before working with Francesco Primaticcio, he trained with Nicolò dell'Abate. Caron became the painter of Catherine de Médicis in 1559. Part of his role included organizing royal entrances and receptions, and in 1572 he orchestrated the wedding of Henry IV to Marguerite de Valois.

**CARPEAUX, JEAN-BAPTISTE (1827–1875)**
Sculptor, painter, and draftsman. In 1853 Napoleon III commissioned him to make the bas-relief *La Soumission d'Abd el-Kader (The Submission of Abd el-Kader)*. He won the Prix de Rome in 1854 and went to Italy, where he sculpted *Palombella*, 1856, and *Ugolin et ses enfants (Ugolino and His Children)*, 1860. In Paris, his work on the facade of the Opéra, *La Danse (The Dance)*, became a subject of controversy. Thanks to him many effigies of important people of the Second Empire, including *Napoleon III*, the *Empress Eugenie*, and *Jules Grevy*, exist today. He also executed various paintings as well as charcoal and pencil sketches.

**CARRIERA, ROSALBA (1675–1757)**
Italian painter. Carriera was a highly respected portrait artist (and one of the few female artists) of the Venetian aristocracy and high society during the era when pastels were in great demand all over Europe. One example of her work is *Portrait de jeune fille (Portrait of a Young Girl)*, now in the Louvre.

**CARRIER-BELLEUSE, ALBERT ERNEST (1824–1887)**
Sculptor. During his official career, Carrier-Belleuse made many busts (*Ernest Renant, Napoleon III*), and monuments such as the *Massena Monument* in Nice and *La Mort de Desaix (The Death of General Desaix)*, which was exhibited at the Salon of 1859.

**CÉZANNE, PAUL (1839–1906)**
Painter. All his life Cézanne moved back and forth between Paris and Provence. Although he felt close to the impressionists, he preferred color variations to depicting changes in light, and he imposed geometric designs that seemed to presage cubism and twentieth-century art. Cézanne made many landscapes and still lifes in Paris and the surrounding region before moving to Provence permanently in 1862. Thereafter he created *Les Joueurs de cartes (The Card Players)*, early 1890s; *L'Homme à la pipe (Man with a Pipe)*, 1899; and *Les Grandes Baigneuses (Large Bathers)*. From 1885 onward he painted a series of images of *Montagne Sainte-Victoire*.

**CHAGALL, MARC (1887–1985)**
Russian-born painter and engraver. He was a student of Leon Bakst and was influenced by cubism and by Vincent van Gogh. Chagall came to Paris in 1910. His strong, expressive use of colors set his paintings apart. His work was often inspired by his wife, Bella, or the region from which he came, and commonly depicts a fantasy world—*Moi et le Village (I and the Village)*, 1911, and *La Promenade (The Promenade)*, 1917. In 1922 Ambroise Vollard asked him to illustrate the Bible, resulting in a masterpiece. After 1950 his style evolved to give yet more importance to color (*Les amoureux de Vence*, 1957). Toward the end of his life, Chagall became interested in sculpture, ceramics, and especially stained glass.

**CHAMPAIGNE, PHILIPPE DE (1602–1674)**
Painter. Champaigne moved to Paris in 1621, where he made cartoons for tapestries for the cathedral portraying the Life of the Virgin (*La Vie de la Vierge*) and *Portrait de Louis XIII couronné par la Gloire (Louis XIII Crowned by Glory)*, both in the Louvre. Champaigne was one of the founders of the academy. He is also known for the fresco decoration of the church of the Sorbonne (1641–1644). From 1643 on he was close to the Jansenists, which is reflected in his piece *Ex-voto*, 1662, now in the Louvre.

**CHANEL, COCO (1883–1971)**
Dressmaker and fashion designer. Trained first as a hatmaker, Chanel opened her own fashion design company in Paris in 1916. She set the standard for great simplicity of design, offering women comfortable clothes (jerseys, shirtdresses, trousers) accessorized with costume jewelry. She was the first fashion designer to create her own perfume, the famous Chanel Number 5.

**CHARDIN, JEAN-BAPTISTE-SIMÉON (1699–1779)**
Painter and master of the still life. Son of a cabinetmaker and disciple of Charles Le Brun, in 1728 Chardin gained recognition for two paintings—*La Raie (The Ray)* and *Le Buffet (The Buffet)*—which opened the doors of the academy to him. After that he began to include human figures and indoor scenes in his works, which brought him notoriety, the favor of Louis XV, and a European clientele. He was a friend of Denis Diderot, who was also his advisor. Chardin was a prolific artist and his works include portraits, among them three famous pastel self-portraits.

**CHAREAU, PIERRE (1883–1950)**
Architect and interior decorator. Chareau was a decorator first and foremost, and later designed geometric and functional furniture influenced by cubism and surrealism. Starting in 1924 he incorporated wrought iron into his pieces, which was a great success. In 1928 he designed the famous "glass house" on Rue Saint-Guillaume in Paris, the first time that sheets of clear glass were used as the sides of a building.

**CHASSÉRIAU, THÉODORE (1819–1856)**
Painter. A student of Ingres, he debuted at the Salon of 1836. He worked in Rome and Algeria. Chassériau created a new way of portraying women, as can be seen in his portrait *Adèle Chassériau*. He is also known for the paintings *Caïd visitant un douar (Cais Visiting a Village)*, 1849; *Le Tepidarium (The Tepidarium)*, 1853; and *Macbeth*, as well as many drawings.

**CHASTELLAIN, GEORGES (c. 1405–1475)**
Burgundian writer. He was a poet who served two successive dukes of Burgundy, Philippe the Good and Charles the Reckless. He wrote works of poetry that include *Le Miroir de mort (The Mirror of Death)*, and *Le Throne azuré (The Azure Throne)*, as well as ballads, religious poetry, and one of the best chronicles of the period (only parts of which have been preserved).

**CHAUDET, ANTOINE DENIS (1763–1810)**
Sculptor, painter, and designer. A Prix de Rome winner, Chaudet had a very successful career. Among his best-known works are *Bélisaire (Belisaurius)*, 1791, and *L'Amour (Cupid)*, 1817, now in the Louvre. His most monumental work is *La Paix (Peace)*, 1806. He also illustrated the works of Jean-Baptiste Racine, edited by François Didot.

**CHENAVARD, CLAUDE-AIMÉ (1798–1838)**
Painter, designer, and interior decorator. Based at the Sèvres workshop where he worked for Alexandre Brongniart, he is known for *Album de l'ornemaniste (Album of Ornamentation)* and later for *Nouveau Recueil de décorations intérieures (New Anthology of Interior Decoration)*.

**CHENNEVIÈRES-POINTEL, PHILIPPE, MARQUIS DE (1820–1899)**
Art historian. He was named director of the Ecole des Beaux-Arts in 1874, and commissioned the decoration of the Pantheon. He outlined the book *Inventaire général des richesses d'art de France (General Inventory of the Richness of French Art)*. In 1879 he entered the academy. He is known for his numerous monographs and the *Archives de l'art français (Archives of French Art)*, which he founded with Montaignon in 1851.

**CHEVREUL, EUGÈNE (1786–1889)**
Chemist. In Paris he worked in a factory run by Louis-Nicolas Vauquelin and was later appointed professor of chemistry, then director of the dyeworks at the Gobelins factory in 1824. He was accepted into the Academy of Science and then appointed director of the museum in 1864. He developed a color theory that inspired the impressionists.

**CHIRICO, GIORGIO DE (1888–1978)**
Italian painter, sculptor, and writer. His first canvases boldly depicted a dreamlike world, which made him a forerunner of surrealism. He came to Paris in 1911, where he met Pablo Picasso and Guillaume Apollinaire. That was the beginning of de Chirico's metaphysical period: he painted large, deserted city squares with solitary figures such as *Piazza d'Italia*, 1912–1913. After 1919 he began to portray Romantic and mythological themes closely following academic principles.

**CHRISTINE DE PISAN (c. 1364–shortly after 1430)**
Scholar and writer. Daughter of Thomas de Pisan, the Italian astrologer to Charles V, de Pisan was a model of integration. When her husband died, she began to write in order to provide for her three children. Later, when civil war deprived her of her benefactors' protection, she took refuge in a cloister. She was a student of Eustache Deschamps, whom she had met at the royal court. She wrote poetry, prose (*Lamentation sur la guerre civile, or Lament on Civil War*), didactic treatises, and a historical work concerning the reign of Charles V.

**CHRISTOFLE, CHARLES (1805–1863)**
Industrialist and silversmith. He introduced English processes for silver and goldwork in France.

**CHRYSOSTOME, ANTOINE (called QUATREMÈRE DE QUINCY; 1755–1849)**
Archeologist, writer, and politician. He was twice elected representative to the National Assembly (in 1791 and 1820), and was the steward of public arts and monuments in 1816. He compiled a dictionary of architecture, wrote several biographies of artists, and the essays *Jupiter Olympien (Olympian Jupiter)*, *Canova*, and *Michel-Ange (Michelangelo)*.

**CLÉSINGER, JEAN-BAPTISTE "AUGUSTE" (1814–1883)**
Sculptor. After traveling throughout Italy and Switzerland, Clésinger settled in Paris, where he caused a scandal at the 1847 Salon with his sculpture *Femme piquée par un serpent (Woman Bitten by a Snake)*, now in the Musée d'Orsay. The great sculptor of the academy during the Second Empire, he is the creator of allegories such as *La Tragédie (Tragedy)*, *La Littérature (Literature)*, *Cléopâtre et le sphinx (Cleopatra and the Sphinx)*, as well as great historical people (*Louise de Savoie* and *Alexandre Dumas*).

**CLODION, CLAUDE MICHEL (1738–1814)**
Sculptor. He spent nine years in Rome. Most of Clodion's works portray mythological subjects in small dimensions, though he also did some decorative work. He fell out of favor during the French Revolution.

**CLOUET, JEAN (c. 1475–1541)**
Painter and miniaturist of Flemish origin. He spent most of his career in France, where he worked for Louis XII and became an official painter to François I. He worked on miniatures and easel paintings in Paris and in Tours, but his notoriety stems mostly from his work as a portrait painter at the court. His best work is a portrait of François I in the Louvre.

**COENE, JACQUES (fourteenth century)**
Belgian painter and illuminator from Brabant. Coene left Bruges for Paris in 1398, then spent time in Milan, where he helped to build the cathedral. He illustrated the *Bible moralisée (Moralized Bible)* and the *Livre des merveilles du monde (Book of the Wonders of the World)* for King Philip the Bold. He is also believed to be the author of the *Heures du Maréchal de Boucicaut (Hours of Marshall de Boucicant)*, written around 1405–1410.

**COLOMBE, MICHEL (c. 1430–c. 1515)**
Sculptor based in Tours. Between 1502 and 1507, Anne of Brittany commissioned Colombe to sculpt the tomb of François I of Brittany, based on a drawing by Jean Perreal, for the church of Carmes in Nantes. He continued to collaborate with Perreal, but Colombe grew too old and had to

give up their joint project. His works, which tended toward the Italian style, marked the end of Gothic art.

**COROT, CAMILLE (1796–1875)**
Painter. Corot began painting nature in Paris its environs and moved on to Normandy, the Fontainebleau forest, and the Ville d'Avray. He traveled to Italy, where he painted landscapes and figures. He also traveled extensively in France, meeting the artists of the Barbizon School. A prolific painter, Corot's works include *Pont-au-Change à Paris* (*Pont-au-Change in Paris*) and *Cathédrale de Chartres* (*Chartres Cathedral*). He painted several murals for the church at Ville d'Avray and continued to paint in the Paris region, focusing particularly on the play of light in his landscapes.

**CORTONA, DOMENICO DA (also called BOCCADOR; ?–1549)**
Italian architect, engineer, and interior decorator. He worked for King Louis XIII and François I. He is thought to have made the first plans for the castle of Chambord in the Loire Valley and the *Hotel de Ville*, the city hall of Paris (1533).

**CORTOT, JEAN-PIERRE (1787–1843)**
Sculptor. He won the Prix de Rome in 1809, was a member of the institute, and among other works sculpted *L'Apothéose de Napoléon* (*Napoleon's Triumph*) on the Arc de Triumph de l'Etoile and *Marie-Antoinette soutenue par la Religion* (*Marie-Antoinette Sustained by Religion*) in the Chapelle Expiatoire.

**COURBET, GUSTAVE (1819–1877)**
Painter. Before turning to Realism, Courbet copied paintings by Spanish, Flemish, and Dutch masters. He worked in Paris and Ornans, then spent time in Montpellier. By 1855 he was a leader of the realists, yet was denied participation in the Salon with his works *L'Atelier de peinture* (*The Artist's Studio*) and *L'Enterrement à Ornans* (*A Burial at Ornans*), so he displayed his works nearby. He painted numerous masterpieces, including *Les Demoiselles de la Seine* (*Young Ladies on the Bank of the Seine*), 1857, traveled extensively, got rave reviews at subsequent Salons, and opened a studio. An elected member of the Commune, Courbet was sentenced to prison for suggesting that the Vendome Column be moved. He fled to Switzerland in 1873, where he painted his last works in exile.

**COUSIN, THE ELDER, JEAN (1490–1560)**
Painter, sculptor, architect, engraver, mathematician, and writer. Cousin was the most famous painter of the sixteenth century. He published an important paper, *Traité de perspective* (*Treatise on Perspective*), 1560. He was the only French artist honored in Giorgio Vasari's *Lives of the Artists*.

**COUSIN, VICTOR (1792–1867)**
Philosopher. A follower of and then successor to Pierre Paul Royer-Collard at the Ecole Normale and the faculty of literature, Cousin was acquainted with Georg Wilhelm Friedrich Hegel, Friedrich Heinrich Jacobi, and Friedrich Wilhelm Schelling in Germany. He was a government advisor to the July Monarchy, was appointed director of the Ecole Normale, and became a member of the Académie Française in 1830 and of the Academy of Ethics and Political Science in 1832. After the 1851 coup d'état he gave up his chair at the Sorbonne. Cousin invented the history of philosophy in France with his *Histoire de la philosophie du XVIIIᵉ siècle* (*History of Eighteenth-Century Philosophy*).

**COUTURE, THOMAS (1815–1879)**
Painter. Although his *Romains de la décadence* (*Decadence of the Romans*) caused a sensation at the 1847 Salon, Couture never won the coveted Prix de Rome. He had a successful career, particularly as a teacher, and is also known for his many portraits (*George Sand, Michelet,* and *Bruyas,* among others).

**COUTURIER, ROBERT (1905– )**
Sculptor. Influenced by Aristide Maillol in the early stages of his career, Couturier gradually refined and purified his style, sculpting lean, disembodied figures such as *Jeune fille lamelliforme* (*Young Girl in Slivers*), 1950.

**COYPEL**
Family of painters. Noël Coypel (1628–1707) worked for Louis XIV and Cardinal Mazarin, then became director of the Academy of France in Rome. Antoine Coypel (1661–1722), Noël's son, was accepted into the academy in 1681. He was First Painter to the king in 1716 and worked on the Galerie Enée in the Palais Royal and at Versailles. He is also known for his etchings.

**COYSEVOX, ANTOINE (1640–1720)**
Sculptor, painter, and designer. Coysevox came to Paris in 1657 and was named First Sculptor to the king in 1666. He joined the academy where he became a teacher and then director. He is famous for his talent as a portrait painter; indeed, it is thanks to him that so many lively depictions of the famous people of his era still exist. Among his works are also funerary monuments for Jean-Baptiste Colbert (1685–1687), Cardinal Mazarin (1689–1693), and Jules Hardouin-Mansart (1712). Coysevox also contributed to the design of the palace and park of Versailles. As a protégé of Hardouin-Mansart, Coysevox played a primary role in the creation of equestrian statues for royal squares, the Invalides site, and the decoration of Marly's sculpture park. Toward the end of his career he painted a final portrait of Louis XIV and made the first few busts of Louis XV.

**CRESSENT, CHARLES (1685–1768)**
Cabinetmaker and sculptor. Cressent was the official supplier to the duke of Orléans in 1715, and he worked for the most important courts of Europe. His furniture was often decorated with gilt bronze and his work is a fine representation of the *rocaille* style of the period.

**DALI, SALVADOR (1904–1989)**
Spanish painter. He arrived in Paris in 1927, where he met André Breton and established himself as a leader of the surrealist movement thanks to

works like *Le sang est plus doux que le miel* (*Blood Is Sweeter than Honey*), 1927, and collaborated with Luis Buñuel on some films. He was strongly influenced by Freud's psychoanalytical theories and allowed his subconscious to express itself in his paintings. This led to a dominant thread of morbid and sexual themes, and he often associated eclectic, disparate objects. Among his works are *L'Accomodation des désirs* (*Accommodation of Desire*), 1929; *Les Montres molles* (*The Persistence of Time*), 1931; and *La Girafe en feu* (*Giraffe on Fire*), 1935.

**DALOU, JULES (1838–1902)**
Sculptor. As a student of Jean-Baptiste Carpeaux and François-Joseph Duret, Dalou became a naturalist sculptor—*La Brodeuse* (*The Embroiderer*), 1870; and the funerary monument of Victor Noir at the Père-Lachaise cemetery, 1890, are two of his major works. He was an officer in the Foreign Legion, and was commissioned to do several public works. Thus he sculpted monumental compositions such as *Le Triomphe de la République* (*Triumph of the Republic*), 1879–1899, at the Place de la Nation in Paris.

**DAMMARTIN, DROUET AND GUY DE (late fourteenth century)**
Architects and sculptors. Drouet, who died in 1413, worked with Raymond du Temple to build the Louvre under Charles V, then worked for Jean de Berry. In 1383 he became general master of works for the dukes of Burgundy, then built the Charterhouse at Champmol, and the portal of Sainte-Chapelle in Dijon. Upon his return, he carried out numerous construction works for Jean de Berry. Drouet's brother, Guy, who died in 1398, followed a similar career path. He also worked on the Louvre, then as a general contractor for the duke of Berry, and contributed to the castles of Bourges, Concressault, and Poitiers. At Poitiers he built the large clock and restored Jean de Berry's residence.

**DAUBIGNY, CHARLES-FRANÇOIS (1817–1878)**
Painter. Born to a family of painters, he became the student of Paul Delaroche and a friend of Camille Corot's. He traveled in Italy, but painted mostly the Ile-de-France region, on board his floating studio. He later moved to Auvers-sur-Oise.

**DAUMIER, HONORÉ (1808–1879)**
Designer, lithographer, painter, and sculptor. He began his career as an illustrator and cartoonist in 1830, portraying subjects that ranged from social and political satire to scenes from private homes and street scenes, for example, *Un héros de Juillet* (*A July Hero*) and *Le Ventre législatif* (*The Legislative Belly*), 1834. He also did wood engravings, terra-cotta busts, and, in 1848, he did several paintings. His depictions of scenes from daily life were the beginnings of expressionism: *La Laveuse* (*The Laundress*), 1863; *Scène de comédie* (*A Comic Scene*); *Les Joueurs d'échecs* (*Chess Players*), c. 1868; and *L'Attente à la gare de Lyon* (*Waiting at the Gare de Lyons*).

**DAVID D'ANGERS, PIERRE-JEAN (1788–1856)**
Sculptor. He studied at the Ecole Centrale in Angers, moved to Paris, and won the Prix de Rome in 1811 with *La Mort d'Epaminondas* (*The Death of Epaminondas*). He made a statue of Condé, was appointed a member of the institute, and became a professor at the Ecole des Beaux-Arts, where he sculpted many statues including *Chateaubriand, Lamartine,* and *Victor Hugo.*

**DAVID, JACQUES-LOUIS (1748–1825)**
Painter. He studied at the Royal Academy in 1766, won the Prix de Rome, and traveled with his master, Joseph-Marie Vien, to Italy. During a later stay in Rome he painted *Le Serment des Horaces* (*The Oath of the Horatii*), 1784. He also made numerous portraits. David was involved in the political struggles of his time and voted for the death of the king. He was a member of the National Convention, the Jacobins Club, and was superintendent of the Ecole des Beaux-Arts. The Assembly commissioned him to paint *Le Serment du Jeu de paume* (*The Tennis Court Oath*), 1791, which he never finished. He was asked to join the institute, and the empire re-appointed him as official painter. He then painted such works as *Le Couronnement de l'empéreur* (*Coronation of the Emperor*) and *La Distribution des aigles* (*The Distribution of Eagles*), 1810, both commissioned by Napoleon.

**DAVIOUD, GABRIEL (1823–1881)**
Architect. A close associate of Baron Haussmann, he contributed greatly to urbanization projects, but also to the development of the Bois de Boulogne, the creation of Monceau Park, and the design of the Buttes-Chaumont Park. He also designed the two theaters in the Place du Châtelet and, most notably, created the Palais de Trocadéro, which he co-designed with Jules Bourdais for the World's Fair of 1878.

**DEBRET, FRANÇOIS (1777–1850)**
Architect. In 1825 he joined the institute. Debret designed the Louvois Hall of the opera house on Rue Le Peletier, the former Théâtre des Nouveautés (Place de la Bourse), as well as the foundations of the Ecole Normale Supérieure des Beaux-Arts.

**DEGAS, EDGAR (1834–1917)**
Painter and sculptor. Degas traveled in Italy and then America, and participated in his first impressionist show in 1874. He was influenced by Jean-Auguste-Dominique Ingres and Pierre Puvis de Chavannes, felt a kinship with the naturalists, and believed in the importance of portraying everyday life in his era. A prodigious artist, certain themes recur often in his work such as performances: *Le Café-concert des ambassadeurs* (*Café-Concert at the Ambassadeur*), c. 1877; dancers: *La Classe de danse* (*The Dance Lesson*), c. 1879; women at work: *La Repasseuse,* (*A Woman Ironing*), c. 1895; or women bathing and grooming. His last works were pastels.

**DELACROIX, EUGÈNE (1798–1863)**
Painter. Delacroix spent a lot of time in the Louvre and did his first watercolors under the supervision of Théodore Géricault and Raymond Soulier at the Ecole des Beaux-Arts. At the 1822 Salon he exhibited *Dante et*

*Virgile aux Enfers* (*Dante and Virgil in Hell*), which was bought by the state, and showed *La Liberté guidant le peuple* (*Liberty Leading the People*) at the 1831 Salon. He then traveled in Morocco, Spain, and Algeria. He painted numerous other works including still lifes, landscapes, and portraits (*Chopin* and *George Sand,* among others). He had triumphant success at the 1855 World's Fair. A municipal counselor for the city of Paris, he received many commissions including *La Lutte de Jacob avec l'ange* (*Jacob Struggling with the Angel*) and *Héliodore chassé du temple* (*Heliodorus Driven from the Temple*), located in the church of Saint-Sulpice. He also created the decor of the Chamber of Deputies, the Senate library, and the ceiling of the Apollo Gallery in the Louvre.

**DELAROCHE, PAUL HIPPOLYTE (1797–1856)**
History painter. He was a student of Antoine Gros and consulted with Théodore Géricault. Delaroche is best known for *Les Enfants d'Edouard* (*Children of Edward*), 1830, *L'Assassinat du duc de Guise* (*The Assassination of the Duke of Guise*), 1835, and various portraits. He did an enormous decorative painting in the Ecole des Beaux-Arts, where he was appointed as a teacher before becoming a member of the Académie de Beaux-Arts in 1832.

**DELAUNAY, ROBERT (1885–1941)**
Painter. He was influenced first by Georges Seurat, then by Paul Cézanne, whom he opposed, and also went through a cubist period—*La Ville de Paris* (*The City of Paris*), 1909, is one of his major works. Between 1911 and 1913 Delaunay showed his paintings in Munich and Berlin. From then on he painted abstract works in which color is the fundamental component, for example *Fenêtres* (*Windows*), 1912. For the 1937 World's Fair he painted a mural that covered over half an acre.

**DELAUNE, ETIENNE (1518–1595)**
Designer, engraver, and goldsmith. He worked with Benvenuto Cellini during Cellini's time in Paris.

**DELESSERT, BENJAMIN (1773–1847)**
Swiss industrialist and collector. In Passy he founded the first cotton thread factory in 1801, and also built a beet-sugar refinery. He was the director of the Banque de France and an elected representative for the city of Paris who helped establish several institutions, such as the savings banks.

**DELL'ABATE, NICOLÒ (c. 1509–1571)**
Italian painter. Summoned to France in 1552 by Henry II, he worked with Francesco Primaticcio at Fontainebleau.

**DELLA ROBBIA, GIROLAMO (c. 1488–1566)**
Sculptor, son of Andrea. Born to a family of sculptors and ceramic artists in Florence, Girolamo spent his varied career in France, enjoying the favor of François I until the king's death.

**DENIS, MAURICE (1870–1943)**
Symbolist painter. He was the theoretician behind the Nabis movement, and in 1900 painted a group portrait of them entitled *L'Hommage à Cézanne* (*Homage to Cézanne*). He was inspired by art nouveau and Japanese prints. After two trips to Italy, he turned to religious paintings such as *La Mère et l'enfant* (*Mother and Child*), 1895.

**DENIS, SAINT (third century, dates unknown)**
Born in Italy, Denis was the first bishop of Paris (c. AD 250), martyred between 250 and 258 along with his comrades. He is a figure of multiple legends: it is said, for instance, that he was decapitated and carried his own head from the top of Montmartre (the mountain of martyrs) all the way to the plain of Lendit where he was buried. The basilica erected in his honor is located at Catulliacus (now Saint-Denis), formerly a village in the suburbs of Lutèce (the Roman name for Paris).

**DENON, BARON DOMINIQUE VIVANT (1747–1825)**
Engraver and administrator. He was a secretary at the French embassy in Russia, and was later sent with the French ambassador to Naples, where he made a series of illustrations for *Voyage historique et pittoresque de Naples et de Sicile* (*Historical and Picturesque Journey in Naples and Sicily*). Denon became a member of the academy in 1787. Called "the eye of Napoleon," he accompanied Napoleon to Egypt, where he wrote and illustrated a two-volume work chronicling the expedition to Egypt, which gave most Europeans their first glimpse of that exotic culture. An avid collector, he was the first curator of the Louvre and was named general director of museums by Napoleon.

**DERAIN, ANDRÉ (1880–1954)**
Painter and sculptor. A friend of Maurice de Vlaminck, Derain belonged to the fauvist movement. His canvases focused mainly on color, for example *Port de Collioure* (*Boats in the Port of Collioure*), 1905. After meeting Georges Braque and Pablo Picasso his style began to evolve: he used darker colors and began to favor cubist composition, as in *Baigneuse* (*The Bather*), 1908. He also illustrated books and designed sets for the theater.

**DESCHAMPS, EUSTACHE (c. 1346–c. 1406)**
Poet. In the time of Charles V Deschamps traveled throughout Europe as a diplomatic messenger. When he came back to France, he worked for Charles VI and for Louis of Orléans, waging war alongside them. He left behind works that made him the premier poet of medieval France, including a treatise on French verse, *L'Art de dictier.*

**DESJARDINS, MARTIN VAN DEN BOGAERT (1657–1694)**
Dutch sculptor. He moved to Paris around the age of twenty and made his name more "French." At first he was employed to sculpt the building decor on several *hôtels* in the Marais quarter, and later entered the academy, of which he eventually became director. He was one of the sculptors who worked on the king's building projects and who decorated the Collège des Quatre-Nations. Desjardins was best known for the monuments he

sculpted in honor of the king, in particular the equestrian statues for the Place des Victoires in Paris and for the cities of Aix and Lyons.

**DESMARZ, NICOLA DEI MARZI (fourteenth century)**
Italian painter. Born in Rome, he came to France to work for King Philip IV the Fair (c. 1309).

**DEVÉRIA, ACHILLE (1800–1857)**
Lithographer, painter, and engraver. He is known to have painted over four hundred portraits, including *Victor Hugo*, *Alexandre Dumas*, and *Lamartine*. In 1829 he published *Les Heures du jour* (*The Hours of the Day*), and collaborated on the illustrations for *La Mode* (*Fashion*), which made him a witness to the elegant lifestyle of Romanticism.

**DIAGHILEV, SERGEY (1872–1929)**
Russian art critic and impresario. After founding the art magazine *Mir Iskoustva* (*The World of Art*, which was also a movement centered around Diaghilev), he led the Russian public to discover the impressionist movement and French contemporary music (Ravel, Debussy, Dukas). He moved to Paris, where he presented *Boris Godounov* by Moussorgski in 1908 and in 1909 the Ballet Russe, which was a triumphant success. Diaghilev discovered and promoted many new talented artists including painters, musicians, and choreographers.

**DOESBURG, THEO VAN (1883–1931)**
Dutch painter and theoretician. Van Doesburg began as an architect and in 1916, with Piet Mondrian, founded the abstract movement De Stijl, giving a series of lectures to promote their ideas. In 1921 he participated in the dada movement. He worked with Hans Arp and Sophie Taeuber on the decor of the Aubette Brasserie in Strasbourg, where the diagonal that predominates his paintings is also evident.

**DONGEN, KEES VAN (1877–1968)**
Dutch painter. He came to Paris in 1897, where he was first influenced by the impressionists, as seen in *Rue en Hollande* (*Street in Holland*), 1897. He met the fauvists and exhibited with them at the Salon of 1905. His paintings often depicted female figures and typically used intense colors and stylized shapes, for example, *Fille au grand chapeau* (*Girl with a Large Hat*), 1906. By the late 1920s his portraits were in great demand.

**DORÉ, GUSTAVE (1833–1883)**
Painter and illustrator. Doré illustrated numerous books, such as Dante's *Inferno* and Cervante's *Don Quixote*. He issued his first album of lithographs, *Les Travaux d'Hercules* (*The Labours of Hercules*), at the age of fifteen and went on to create numerous illustrations, engravings, and a famous lithograph of the death of Gerard de Nerval. He also did paintings, watercolors, and a few sculptures.

**DOUCET, JACQUES (1853–1929)**
Fashion designer and collector. He took over his grandfather's lace shop and created his own designs, which were inspired by eighteenth-century fashions. He also collected eighteenth-century artworks, rather adding the works of more modern artists to his collection (Edouard Manet, Vincent van Gogh, Paul Cézanne, and Picasso). He donated his collection of art and literary books to the University of Paris in 1918.

**DROCTOVEUS, SAINT (also known as DROCTONIUS; c. 535–576)**
Abbot. A disciple of Saint Germain in Paris, he became the first abbot of Saint-Germain-des-Prés.

**DUBAN, FÉLIX LOUIS JACQUES (1797–1870)**
Architect. He won the Prix de Rome in 1823 and is famous for the restoration of the Portico of Octavia in Rome (1830). He restored Sainte-Chapelle in Paris, the châteaux of Blois and Dampierre, transformed the Cour d'Honneur (Courtyard of Honor) of the Ecole des Beaux-Arts, and built the Quai de Conti edifices. He was named architect of the Louvre in 1848, and joined the institute. He also became Paris's inspector general for civic buildings.

**DUCOS DE LA HAILLE, PIERRE HENRI (1889–1972)**
Painter. He won the Prix de Rome in 1922 and exhibited works at the Salon des Artistes Français, including *Les Rois ages* (*The Three Wise Men*), 1920, and *Oceanides et les bambins* (*Oceanides and the Children*), 1922.

**DUPAS, JEAN THÉODORE (1882–1964)**
Painter and decorator. He painted religious and mythological themes, portraits, and renderings of animals such as *Perruches* (*Parrots*), 1925. He was a professor at the Ecole des Beaux-Arts, and was responsible for the decoration of the *Normandie* oceanliner.

**DURAND, JEAN NICOLAS LOUIS (1760–1834)**
Architect. He was a student of Etienne-Louis Boulée, taking classes at the Academy of Architecture. He explained his vision of architecture in *Précis des leçons d'architecture données à l'Ecole polytechnique* (*Summary of Architecture Classes Given at the Polytechnic School*), 1802–1813.

**EIFFEL, GUSTAVE (1832–1923)**
Engineer. He devoted himself first to metal construction, working on bridges in France and abroad, then on buildings with metal structures (Bon Marché, the Budapest Train Station), and finally the Eiffel Tower, built for the 1889 World's Fair. He then founded an aerodynamics company that contributed to the development of the nascent field of aviation.

**ELOI, SAINT (c. 588–660)**
Bishop of Noyon, patron saint of goldsmiths. He was born near Limoges, and trained locally in enamelwork. He became treasurer and advisor to King Dagobert I, and in 641 became bishop of Noyon. At the Ile de la Cité he founded a goldsmith workshop that developed into a school.

**ERNST, MAX (1891–1976)**
French painter, sculptor, and writer of German origin. He was self-educated, a friend of August Macke's, and painted a few expressionist

---

works before founding the dada movement in Cologne in 1919. He did a series of collages and issued the portfolio *Fiat Modes, Pereat Ars* (1919), a precursor to collage novels like *La Femme à 100 têtes* (*The Woman with 100 Heads*), 1929. In 1922 he settled in Paris and joined the surrealist movement. He experimented with various techniques (scraping, rubbing, printing) to bring out subconscious images in his work. The themes of birds and the forest haunt his works, as in, *Noces d'oiseaux* (*Bird Wedding*), 1928.

**ERRARD, CHARLES (c. 1606–1689)**
Painter. Most of his works have disappeared. He began painting in Rome, where his expenses were paid by the king between 1624 and 1643. Upon his return to Paris, he received the title of court painter to the king, Louis XIV, which was the beginning of a brilliant career. He received as many public commissions as private ones. Jean-Baptiste Colbert preferred Charles Le Brun to Errard, and in 1666 Colbert had Errard "exiled" to the administration of the Academy of France in Rome, which had just been opened. Most of his works have disappeared; his engravings are the best known; for example, *The Breviarium romanum*, 1647.

**ETIENNE D'AUXERRE (end of the thirteenth century)**
Painter. In 1292 he worked for Mahaut d'Artois in Paris, then for King Philip IV the Fair, who sent him to Rome in 1298.

**ETIENNE DE BONNEUIL (end of the thirteenth century)**
Architect. In 1287 he was summoned to build the cathedral of Uppsala in Sweden, modeled after Notre-Dame in Paris.

**EUDES DE MONTREUIL (c. 1220–1289)**
Architect and sculptor. He first accompanied Saint Louis to Palestine, where he built the fortifications of Jaffa. He returned to France in 1254, where he constructed numerous buildings in Paris that have since been destroyed. He was a member of the court of King Philip IV the Fair, and thus accompanied the king on all his journeys.

**EVRARD D'ORLÉANS (c. 1270–c. 1357)**
Painter, sculptor, and architect. He was the first to hold the title "Painter to the King," and he worked on the abbey church of Maubuisson and the Hôtel Artois in Paris.

**FANTIN-LATOUR, HENRI (1836–1904)**
Painter and lithographer. He was a friend of Edouard Manet, James Whistler, and Edgar Degas, and paid tribute to the impressionists in the group portrait *Un atelier aux Batignolles* (*A Studio in Batignolles*), 1870, although his technique was not influenced by them. He was influenced by Eugène Delacroix and Gustave Courbet, and in addition to painting artists' portraits, he did still lifes that display his great mastery of technique, like *Fleurs et Fruits* (*Flowers and Fruit*), 1865.

**FILIPPO RUSUTI (c. 1300)**
Italian painter and mosaicist. Originally from Rome, he made mosaics for the church of Santa Maria Maggiore. In 1308 Philip IV the Fair, invited him to come to France with his son Giovanni.

**FLACHAT, EUGÈNE (1802–1873)**
Engineer. He developed the first train line in France, which ran between Paris and Saint-Germain-en-Laye, and directed the construction of the train lines from Paris to Rouen and to Le Havre. He is also the author of numerous works of scientific value.

**FONTAINE, PIERRE FRANÇOIS LÉONARD (1762–1853)**
Architect. After winning a second Prix de Rome competition, he co-directed the decor of the Opéra with Charles Percier. Together, they had considerable influence over the official art of the imperial period. They were responsible for the plans for clearing the Château des Tuileries, for the Rue de Rivoli, and also designed the Arc de Triomphe du Carrousel. Fontaine was appointed First Architect to the emperor in 1813, and thereafter enjoyed the favor of Louis XVIII, who commissioned him to build the Chapelle Expiatoire. He also designed the Orléans Gallery at the Palais Royal.

**FORTUNAT (c. 530–c. 600)**
Italian poet and bishop of Poitiers. He came to France in 565 on a pilgrimage to the church of Saint-Martin in Tours, then settled in Poitiers where he became the chaplain, and later the bishop (c. 597) of Sainte-Radegonde Church. He wrote a poem dedicated to Lutetia (the Roman name for Paris).

**FOUJITA, LÉONARD (1898–1968)**
Japanese painter. After studying in Tokyo, Korea, and China Foujita settled in Paris. In his paintings of women and cats he used techniques from both Asian and Western art. Toward the end of his life he converted to Christianity and painted religious scenes.

**FOUQUET, GEORGES (1862–1957)**
Jeweler. Born to a family of jewelers, he exhibited pieces he had designed, influenced by art nouveau, at the 1900 World's Fair. Starting in 1901 he made jewelry that is featured in drawings by Alfons Mucha.

**FOUQUET, JEAN (c. 1420–c. 1480)**
Painter and miniaturist. He traveled throughout Italy, and upon his return to France in 1448, he settled in Tours. Fouquet painted the *Diptych of Melun* (c. 1450), for E. Chevalier and a well-known portrait of *Guillaume Jouvenel des Ursins* (c. 1455). His illuminations are of the greatest artistic value, especially *Le Livre d'heures d'Etienne Chevalier* (*Book of Hours of Etienne Chevalier*) and an edition of Boccacio that he illustrated.

**FRÀ GIOCONDO, MONSIGNORI GIOVANNI (1433–1515)**
Italian architect and illustrator. A multi-talented man, Frá Giocondo created the Loggia del Consiglio (Council's Lodge) in Verona, then worked in Naples, Venice, and in France. He published an illustrated edition of Vitruvius in 1511 and executed *126 Drawings* that complete

---

the work of Francesco di Giorgio Martini. From 1514 until his death, he worked with Raphael in the Vatican, directing the work on Saint Peter's.

**FRÉART DE CHAMBRAY, ROLAND (1606–1676) and FRÉART DE CHANTELOU, PAUL (1609–1694)**
Paul and his brother Roland Fréart de Chambray inspired the first movement of French classicism. Roland translated and published many works on art and architecture, including the famous *Parallèle de l'architecture antique avec la moderne* (*Parallels of Ancient Architecture with the Modern*), 1650. Paul lived in Rome from 1640 to 1643, where he met Nicolas Poussin, becoming his friend and patron. He also met Bernini; Paul was appointed his official guide when the Italian visited Paris in 1665, a trip Paul wrote about in *Le Journal de voyage du cavalier Bernin en France* (*Diary of the Cavalier Bernini's Visit to France*), an essential document of the art of their time.

**FRÉMIET, EMMANUEL (1824–1910)**
Sculptor and illustrator. Above all Frémiet was a naturalist illustrator, but also sculpted, working with plaster and making a name for himself through his depictions of animals. He was commissioned to create several public works, most notably an equestrian statue of *Jeanne d'Arc* (*Joan of Arc*), at the Place des Pyramides in Paris. He respected the academic principles of his art and had a knack for portraying details.

**FREYSSINET, EUGÈNE (1879–1962)**
Engineer. A specialist in reinforced concrete, he became technical director of the firm Mercier, Limousin & Compagnie. He built factories, bridges, port facilities, and the hangars for dirigibles at Orly (1921–1923). He successfully made his buildings blend into their natural or urban landscape. In 1917 he invented vibrated concrete and in 1926, prestressed concrete.

**FROMENT-MEURICE, FRANÇOIS DÉSIRÉ (1802–1855)**
Silver- and goldsmith. As the official metalworker of the city of Paris, he introduced the Romantic style into work with fine metals. He created Honoré de Balzac's signature *canne aux singes* (monkey cane). Froment-Meurice's workshops dominated the market, and were continued by his son Emile and his grandson Jacques.

**FULLER, MARIE-LOUISE, "LOÏE" (1862–1928)**
American variety entertainer. She came to Paris in 1891 and presented the Folies-Bergeres's *La Danse serpentine* (*Snake Dance*). Her choreography included brightly projected lighting on the dancer's costumes. She was much admired by Anatole France, Henri de Toulouse-Lautrec, and Auguste Rodin.

**FULRAD, ABBOT (early eighth century–784)**
Abbot of Saint-Denis. A descendant of a powerful Alsatian family, he extended the landholdings of the abbey of Saint-Denis, obtained numerous privileges for the abbey, and had the abbatial church sumptuously rebuilt (768–775). Fulrad was an active participant in bringing down the Merovingian dynasty and in assisting Pippin the Short to the throne. He also helped to orchestrate restoration of papal temporal power in Italy.

**GALLÉ, EMILE (1846–1904)**
Glassmaker, ceramic artist, and cabinetmaker. The driving force in creating the Nancy School, he opened a glass workshop in 1874 and then a cabinetmaking workshop in 1883. He experimented with the effects of transparency and opacity, and created inlaid glass marquetry with motifs directly inspired by nature. He also made furniture. Gallé is considered one of the originators of art nouveau, and gained an international reputation.

**GARGALLO, PABLO (1881–1934)**
Spanish sculptor. He spent time in Madrid, Barcelona, and Paris, creating stone and marble works in the Realist tradition, on the one hand, and more personal and original metal sculptures, on the other. He made masks influenced by African art (1911) and more finely finished works such as *Prophète* (*Prophet*), 1933, with ornamental apertures. As the years went by, his style became freer and more expressive.

**GARNIER, CHARLES (1825–1898)**
Architect. He won the Prix de Rome in 1848, visited Italy and Greece, and studied ancient monuments. In 1860 he became the official architect of the city of Paris. His plan for the Opéra was accepted unanimously. He also designed monuments in Monte Carlo, Nice, and Vittel.

**GARNIER, TONY (1868–1948)**
Architect and urban planner. His plans for a utopian industrialized city, later published as the *Cité industrielle* (*Industrial City*), caused a scandal in Paris in 1904. The city plan reflected his concern for social issues and for functionalism. Garnier applied the principles developed in this study to every building he designed in his capacity as chief architect of the city of Lyons; for example, the Olympic Stadium (1913–1917) and a hospital (1915–1930) there. He incorporated techniques using reinforced concrete and framing concrete, allowing for wider windows and garden terraces.

**GAU, FRANÇOIS CHRÉTIEN (1790–1853)**
German architect. Born in Cologne, Gau settled in Paris where he restored Saint-Julien-le-Pauvre (Saint Julian the Poor) and the presbytery of Saint-Séverin. He also designed the church of Sainte-Clotilde.

**GAUGUIN, PAUL (1848–1903)**
Painter, sculptor, and engraver. He first exhibited his work with the impressionists, and later evolved toward less descriptive painting. In 1886 Gaugin moved to Pont-Aven in Brittany where he met Emile Bernard, with whom he developed syntheticism. It was in Tahiti that he developed his definitive style, characterized by highly expressive shapes and colors, as in *Sur la plage* (*On the Beach*), 1891, and *Ta Matete*, 1892.

**GAUTIER, THÉOPHILE (1811–1872)**
Writer. Leaning toward painting early in his career, he opted for literature. In the preface to his first novel, *Mademoiselle de Maupin* (*Miss Maupin*),

Gautier presented his theory of art for art's sake. He traveled in Spain and oriented his poetry in a new direction, expressing an obsession with death and the nihilism of art, thus making way for Charles Baudelaire, who dedicated his book *Fleurs du Mal* (*Flowers of Evil*) to Gautier.

GAUZLIN, ABBOT (c. 980–1030)
Prelate, son of Hugh Capet. Robert the Pious appointed Gauzlin Abbot of Fleury, then Bishop of Bourges. With his own funds, he rebuilt the abbey of Fleury that had been destroyed by a fire and endowed it generously.

GAVARNI, PAUL (1804–1866)
Designer and illustrator. He contributed to the journals *La Mode* (*Fashion*) and *Charivari*, and in England drew scenes of London for *L'Illustration*. His drawings had a strong influence on society: for example, *Les Partageuses* (*Women Sharing*) and *Histoire de politique* (*The History of Politics*).

GÉRARD, BARON FRANÇOIS (1770–1837)
Painter. He was a student of Augustin Pajou and Jacques-Louis David, and he first became known thanks to his painting *Bataille d'Austerlitz* (*Battle of Austerlitz*). Gerard then became the official portrait artist of the imperial family, and later royal painter for Louis XVIII and Charles X.

GÉRICAULT, THÉODORE (1791–1824)
Painter. He was a disciple of Antoine Gros, and came to the public's attention at the 1812 Salon. He then traveled to Italy where he discovered the work of Michelangelo. Upon Géricault's return to Paris, he undertook his most famous painting, *Le Radeau de la Méduse* (*The Raft of the Medusa*), which was inspired by an 1816 shipwreck and was truly a manifesto of the Romantic school. He went to London in 1820, where his paintings met with great success, and he worked on lithographs, drawings, and a few paintings such as *Derby d'Epsom* (*Derby at Epsom*), 1821.

GÉRÔME, LÉON (1824–1904)
Painter and sculptor. He won great acclaim at the 1847 Salon with *Jeunes Grecs faisant battres des coqs* (*The Cock Fight*). Gérôme was a genre painter, but he also did religious paintings and neoclassical scenes. He became a teacher at the Ecole des Beaux-Arts in 1863 and made several sculptures.

GERVEX, HENRI (1852–1929)
Painter and illustrator. He was a student of Alexandre Cabanel and Fromentin, and began to show his work from the Salon of 1873 onward. Until 1877 Gervex was an academic painter, doing classical works depicting mythological themes. In 1878 he signed his best-known painting, *Rolla*, based on a poem by Alfred de Musset, which was deemed too indecent to show at the Salon. After that Gervex's work evolved toward impressionism and he painted scenes from daily life and female nudes.

GIACOMETTI, ALBERTO (1901–1966)
Swiss sculptor, designer, and painter. He settled in Paris in 1922, studied with Antoine Bourdelle, and took inspiration from Constantin Brancusi and Jacques Lipchitz, but also from African sculpture and Cycladic art. His resulting work was highly stylized. Giacometti belonged to the surrealists from 1930 to 1935—*L'Objet invisible* (*The Invisible Object*), 1934–1935, is an example from this period—then turned to painting. Around 1945 he began to sculpt again, and invented a style of elongated bodies with indistinct contours as seen in *La Forêt* (*The Forest*), 1950.

GILARDONI, FRANÇOIS-XAVIER (1807–1893)
Industrialist. In Atkirch (Upper Rhine region of France), Gilardoni founded his first factory with his brother Joseph in 1835. The Gilardonis manufactured "mechanical tiles," the first machine-made roof tiles. In 1841 he obtained a patent for interlocking tiles, also known as diamond-shaped tiles.

GIRODET-TRIOSON, ANNE-LOUIS (1767–1824)
Painter and designer. He spent five years in Italy, where he was a student of Jacques-Louis David. At the 1792 Salon he exhibited his signature work *Le Sommeil d'Endymion* (*The Sleep of Endymion*), which revealed his Romantic inspiration.

GODDE, ETIENNE HIPPOLYTE (1781–1869)
Architect. Chief architect of the city of Paris from 1813 to 1848, he designed the churches Notre-Dame-de-Bonne-Nouvelle, Saint-Pierre-du-Gros-Caillou and Saint-Denis-du-Saint-Sacrement.

GODEFROID DE CLAIRE (also GODEFROID DE HUY; twelfth century)
Flemish goldsmith and enamelist. He worked in Liege and Maastricht, abroad in England and Germany, and at Saint-Denis. He became a monk in the Neufmoustier Monastery near Huy in 1173. His most famous works are superbly crafted reliquaries.

GOGH, VINCENT VAN (1853–1890)
Dutch painter and draftsman. He took up painting fairly late in life, at first creating somber oils; then in Paris he went through a phase similar to pointillism, painting landscapes of Montmartre, Asnières, and numerous self-portraits (1886–1888). In Arles he worked with Paul Gauguin, and painted, among others, *Les Tournesols* (*The Sunflowers*) and *L'Arlésienne* (*Madame Ginnoux with Books*), both 1888. After a stay in a mental hospital in Saint-Rémy, during which he continued to paint—for example *Deux cyprès* (*Two Cyprus Trees*), 1889—he retreated to Auvers-sur-Oise and lived with Dr. Paul Gachet. Van Gogh continued to paint portraits and famous landscapes, such as *Champ de blé aux corbeaux* (*Wheat Field with Crows*), 1890, until his death by suicide.

GONCOURT, EDMOND (1822–1896) and JULES HUOT DE (1830–1870)
Writers. Together, the Goncourt brothers wrote several Realistic novels such as *Sœur Philomène* (*Sister Philomena*), 1861, and *Germinie Lacerteux*, 1865; in 1851 they founded a newspaper, *Journal*. They were also collectors, especially of eighteenth-century art, and notably of Japanese art, which they in large measure introduced to their contemporaries.

GONZÁLEZ, JULIO (1876–1942)
Spanish sculptor, goldsmith, and painter. Born to a family of art metal-workers, he came to Paris in 1899, but by 1910 turned to sculpture. He was influenced by cubism, created portraits of embossed metal, cut-out masks, and is considered the "father" of iron sculptures. His metal work was very precise and he was adept at using the various qualities of metals.

GOUJON, JEAN (1510–1566)
Sculptor, designer, and architect. Appointed sculptor to the king, he also worked with the architect Pierre Lescot. His works include *Nymphes* in the Fontaine des Innocents (Fountain of Innocents) and some of the allegories on the facade of the Cour Carrée (Square Courtyard) in the Louvre. In 1562 the persecution of the Huguenots forced him to leave France.

GREGORY OF TOURS (c. 538–c. 594)
Bishop and historian. Ordained as a deacon in 563, he succeeded his cousin as the bishop of Tours in 573. He fought to defend the rights of the church against the violence of the time, and to make sure that the right to asylum was respected. Of his many writings, the most significant is *Historia Francorum* (*History of the Franks*), a chronicle in ten volumes.

GREUZE, JEAN-BAPTISTE (1725–1805)
Painter. A master of genre painting, Greuze wanted to elevate it to the level of history painting. At the Salon of 1755 he triumphed with his work *Un père de famille expliquant la Bible à ses enfants* (*Father Reading the Bible to His Children*). Denis Diderot was one of Greuze's most enthusiastic admirers. His sentimental and edifying style of painting has been often imitated.

GRIS, JUAN (1887–1927)
Spanish painter, illustrator, sculptor, and engraver. Highly influenced by art nouveau, Gris illustrated books and magazines in Madrid before he came to Paris in 1906. His first paintings date to around 1910 and belong to the analytical cubism movement. One example is *Bouteille et verre* (*Bottle and Glass*), 1911. Starting in 1913, he painted still lifes that demonstrate his growth toward synthetic cubism, and he also did a series of collages including *Les Tasses à thé* (*Teacups*), 1914.

GROMAIRE, MARCEL (1892–1971)
Painter and engraver. From 1910 onward he spent a lot of time at the free academies of Montparnasse. He painted working-class scenes in an expressive style, using somber colors and simplified shapes as in *La Guerre* (*War*), 1925. He also did nudes, engravings, and decorative panels. Along with Jean Lurçat, he contributed to the renewal of interest in tapestries.

GROS, BARON ANTOINE-JEAN (1771–1835)
Romantic Painter. A student of Jacques-Louis David, he served as an art critic and appraiser for Napoleon's army. His own painting broke with David's tradition and moved toward Romanticism, visible in his painting *Les Pestiférés de Jaffa* (*Napoleon in the Plague House at Jaffa*), 1804. Napoleon commissioned him to decorate the cupola of the Pantheon, which he only finished in 1825, before he painted the ceiling of the Louvre.

GUILLAIN, SIMON (1589–1658)
Sculptor. He was heir to the work of Germain Pilon. After a trip to Italy Guillain began a career as a bronze technician, making effigies of *Louis III*, *Anne of Austria*, and *Louis XIV* as a child, all c. 1643 and in the Louvre. In 1648 Guillain became one of the founding members of the academy, and he became its director in 1657.

GUILLAUME DE CHAMPEAUX (mid-eleventh century–1121)
Scholastic philosopher. In 1108, he developed a small hermitage in Paris into the church of Saint-Victor, and established a set of rules for it that became a model in most regular canons. A close associate of Saint Bernard, de Champeaux became Bishop of Chalons in 1113 at his request.

GUILLAUME DE VOLPIANO (962–1031)
Abbot and monastic reformer. Guillaume entered a monastery as a child and went to the abbey of Cluny in about 985. Robert the Pious appointed him Abbot of Saint-Bénigne in Dijon in order to reform it. He went on to reform over forty monasteries in accordance with the stringent rule of Cluny.

GUILLAUME LE BRETON (c. 1165–1224 or after 1226)
Chronicler and poet. Chaplain to King Philip II, in 1219 he became the canon of Notre-Dame de Senlis. A Latin chronicle authored by Guillaume has survived, entitled *Gesta Philippi Augusti* (*The Deeds of Philip Augustus*), as well as an epic poem, *La Philippide*, an account of the king's reign.

GUIMARD, HECTOR (1867–1942)
Architect and decorator. Inspired by Victor Horta, Guimard designed the Castel Béranger (1897–1898), which established the art nouveau style in Parisian architecture. The laureate of a facade design competition, he also designed the art nouveau wrought-iron entryways to the Métro stations that became a signature feature in Paris.

HAINCELIN DE HAGUENEAU (also HÄNNSLEIN, "LITTLE JOHN"; fifteenth century)
Illuminator from northern Alsace. He worked in France during the reign of Charles VI, then worked for the English between 1420 and 1435 and is thought to have created illuminations for *Les Heures du duc et de la duchesse de Bedford* (*Hours of the Duke and Duchess of Bedford*).

HARDOUIN-MANSART, JULES (1646–1708)
Architect. The nephew and student of François Mansart, he became the preferred architect of Louis XIV, who named him First Architect to the king, superintendant, and director of buildings. Mansart finished the work on Versailles, the symbol of absolutist power (1678–1689); as well as the dome of the Invalides, an example of French classicism; and the Place des Victoires and Place Vendome in Paris, both urban spaces designed specifically to feature equestrian statues in celebration of the king.

HAUSSMANN, BARON GEORGES EUGÈNE (1809–1891)
Politician born in Alsace. He was prefect under Napoleon III and given the title of baron and a Senate seat in 1857. He is largely responsible for the look of Paris as we know it today, making dramatic changes through ambitious public works projects. He planned the boulevards, parks, and gardens—such as the Jardin de Luxembourg, the Parc Monceau, the Parc Montsouris, the Bois de Boulogne and Bois de Vincennes—as well as clearing the areas around the main monuments. He oversaw construction of the central market (Les Halles), churches (La Trinité), theaters (Châtelet), train stations, bridges, barracks, and the whole district west of l'Etoile. He also designed important underground systems including water, sewer, and gas lines.

HENNEBIQUE, FRANÇOIS (1842–1921)
Architect. He was a pioneer in reinforced concrete construction, which he patented in 1892. He built his own home in Bourg-la-Reine, and the apartment buildings at 1 Rue Danton and 140 Rue de Rennes in Paris.

HETZEL, JULES (1814–1886)
Publisher and writer. Active in politics, he was forced into exile in Belgium from 1851 to 1859. In Paris he founded a children's bookstore and published the works of Jules Verne, as well as an edition of Victor Hugo's works. He wrote many books under the pen name Pierre-Jules Stahl, and published *Revue comique à l'usage des gens sérieux* (*Comic Review for the Use of Serious People*).

HILDUIN, ABBOT (c. 775–between 855 and 859)
Abbot, chronicler, and hagiographer. First a monk and later the abbot of Saint-Denis, he imposed the Benedictine rule, then received the abbeys of Saint-Germain-des-Prés and Saint-Medard of Soissons. In his biography of Saint Denis of Paris, *Vita Sancti Dionysii*, he erroneously equated Denis, the apostle of the Gauls, with Denis (Dionysius) the Areopagite, a disciple of the apostle Paul and Bishop of Athens.

HITTORFF, JACQUES (1792–1867)
German architect. Born in Cologne, he settled in Paris and became architect of the city of Paris and the government. He designed the church of Saint-Vincent-de-Paul and the Gare du Nord (train station). He also renewed the decor of the Place de la Concorde, the Champs-Elysées, and l'Etoile, as well as contributed to the designs for the Bois de Boulogne.

HONORÉ, MASTER (late thirteenth century)
Illuminator. He was the first Parisian illumination artist to be identified. He worked under Philip IV the Fair. Positively identified works by Honoré are an illustrated collection of Gratien's decrees and the *Bréviaire de Philippe le Bel* (*Breviary of Philip the Fair*), 1296.

HOREAU, HECTOR (1801–1872)
Architect. A pioneer in the use of iron, he was favored to win the competition for plans to roof the first World's Fair in London in 1851, but in the end Joseph Paxton's project for the Crystal Palace was realized. Horeau built the Jardin d'Hiver (Winter Garden) in Lyons.

HOUDON, JEAN-ANTOINE (1741–1828)
Sculptor. After winning the Prix de Rome in 1761, he spent four years in Italy, taking an interest in the sculptures of antiquity and the Renaissance. His elegant mythological and allegorical statues, as well as his portraits, such as *Voltaire*, show his feeling for grace and proportion.

INGRES, JEAN-AUGUSTE-DOMINIQUE (1780–1867)
Painter. A student of Jacques-Louis David, he won the Prix de Rome in 1801. During his first stay in Rome he painted *Jupiter et Thétis* (*Jupiter and Thetis*), 1811; *La Grande Odalisque*, 1814; and *Le Songe d'Ossian* (*The Songs of Ossian*), 1813. When he returned to Paris, he showed *Le Vœu de Louis XIII* (*The Vow of Louis XIII*), which met with great acclaim and was hung in the Montauban Cathedral. Another work of Ingres's is *L'Apothéose d'Homère* (*The Apotheosis of Homer*), 1827, which is in the Louvre. He was appointed director of the Academy of France in Rome, so returned to Italy from 1834 to 1841. Back in Paris, he began *L'Age d'or* (*The Golden Age*), intended for the château of Dampierre, an enormous composition that he did not complete. His is especially known for his numerous portraits.

IRIBE, PAUL (1883–1935)
Caricaturist and decorator. He was a graphic artist for several magazines and known for unique layouts. He made publicity drawings of the collection of designer Paul Poiret: *Les Robes de Paul Poiret, racontées par Iribe* (*Dresses by Paul Poiret, as Told by Iribe*), 1908. He also designed posters, jewelry, furniture, costumes, and set designs for theater and films.

JACOB, GEORGES (1739–1814)
Master of artistic woodwork. Jacob was designated as a master in Paris in 1765, and produced an enormous variety and quantity of works. He led furniture making under Louis XV, Louis XVI, the Directory, and the empire. He and his younger son, François Honoré, co-founded the Jacob-Desmalter factory, which received orders for furniture from near (Fontainebleau) and far (Holland, Spain, and Russia). The fall of the empire shook the business, which rose again under Louis XVIII but was ultimately sold.

JACQUEMART DE HESDIN (fourteenth century–c. 1411)
Miniaturist painter. He worked at the court of the duke of Berry from 1348 to 1411, where he collaborated with other master artisans such as André Beauneveu, the Limbourg brothers, and Guy de Dammartin. He created some of the most magnificent illuminations, including the *Très riches heures du duc de Berry* and *Les très belles heures* (*The Very Beautiful Hours*).

JACQUES DE CHARTRES (also known as JACQUES THE MASON; fourteenth century)
Sculptor. He was a native of Chartres who later moved to Paris, where he worked on the old Louvre (1365) under Raymond du Temple. He later became the figurine carver to Jean de Berry and settled in Bourges.

**JACQUES DE MOLAY (c. 1243–1314)**
He was the last great master of the Order of the Knights Templar. He entered the order in approximately 1265, gave distinguished service during the Eighth Crusade in Palestine, and was chosen as Grand Master of the Order in 1298. He defended the order to Pope Clement V, but was eventually condemned to burn at the stake by King Philip IV the Fair.

**JACQUET MACI (fourteenth century)**
Illuminator. A disciple and colleague of Jean Pucelle, they worked with Ancian de Cense on a Bible produced by Robert de Billyng in 1327.

**JANNIOT, ALFRED (1889–1969)**
Sculptor. After winning the Prix de Rome in 1919 Janniot was highly sought after, receiving a great number of publicly commissioned works. He is particularly known for having sculpted the decorations on the facades of the Musée des Colonies (1931) and the Palais de Tokyo (1937) in Paris.

**JEAN BONDOL (also JOHN or HENNEQUIN OF BRUGES; 1350–?)**
French painter born in Bruges, Belgium. First Painter to Charles V, he is better known for his illuminations. His most famous work is the design of *Apocalypse*, a series of tapestries made for Duke Louis d'Anjou.

**JEAN D'ARRAS (late thirteenth century–c. 1299)**
Sculptor. He worked on the marble tomb of Philip III, which was continued by Pierre de Chelles (between 1299 and 1307). The recumbent effigy of the king still remains in Saint-Denis, its original intended location.

**JEAN D'ORLÉANS (1350–c. 1418)**
Official painter to John II, Charles V, and Charles VI. He painted part of the decor of the Hôtel Saint-Pol, and possibly the *Parement* at Narbonne.

**JEAN DE BEAUMETZ (died 1396)**
Painter of the French-Flemish School. He was probably a native of the Picardie region, or perhaps from Artois. He worked at Arras for the dukes of Burgundy, came to Paris in 1371, and carried out projects at the various residences of the dukes throughout Burgundy.

**JEAN DE BRECQUESSENT (late thirteenth century–fourteenth century)**
Sculptor. Probably from Brexent in the Artois region, he lived in Hesdin at the end of the thirteenth century, where he worked on the chapel of the château. He then settled in Paris and worked under Pépin de Huy to sculpt the tomb of Otto IV, commissioned by Mahaut d'Artois.

**JEAN DE CHELLES (thirteenth century)**
Architect. He had substantial work done on the Notre-Dame Cathedral, including transcept, chapels, portals, and the northern rose window.

**JEAN DE GAND (fourteenth century)**
Painter and illuminator of the Flemish School. He worked in Paris in 1328 for Mahaut d'Artois.

**JEAN DE JANDUN (c. 1280–1328)**
Theologian. He was a master at the Faculty of Arts of Paris. Apart from his *Traité des louanges de Paris* (*Treatise in Praise of Paris*), written in 1323, he also collaborated with Marsilius of Padua on the writing of *Defensor Pacis* (1324), which presented the thesis of subordination of the church to the state. He then had to flee, taking refuge at the court of Ludwig of Bavaria.

**JEAN DE LIÈGE (or HENNEQUIN; active 1360–1382)**
Sculptor from Liège. He left his native town for Paris in 1361 and became the official sculptor to Charles V. His only works that have survived intact are the posthumous effigies on the joint tomb of Charles VI and his wife, Jeanne d'Evreux. Jean de Liège was one of the most highly reputed artists of the fourteenth century.

**JEAN DE LOUVRES (also JEAN DE LOUBIÈRES; mid-fourteenth century)**
Architect. Pope Clement V gave him responsibility for the construction of a great hall in Avignon similar to the Great Hall of the Palais de la Cité. In 1345 he was placed in charge of the construction of the Palais d'Avignon.

**JEAN DE SAINT ROMAIN (fourteenth century)**
Painter, sculptor, and architect. Although his origins are unknown, we do know that he worked on the Louvre from 1365 to 1370 with Raymond du Temple. He sculpted a statue of Charles le V le Sage (Charles V the Wise) and another of the duke of Anjou, as well as a *Virgin*.

**JEAN DE SOIGNOLLES (fourteenth century)**
Sculptor. He worked in Avignon and sculpted the tomb of Pope Clement VI before moving to Paris around 1358. Later he was invited to Dijon to carve the tombstones of Philippe of Burgundy and his wife.

**JEAN DE THOIRY (also DE THURY; fourteenth–fifteenth century)**
Sculptor. He worked on the cathedral of Arras in 1365, then in Rouen. In 1391, he settled in Paris and sculpted the tombstone of Louis d'Orléans in the church of the Célestins.

**JONGKIND, JOHAN BARTHOLD (1819–1891)**
Dutch painter. He moved to Paris in 1846, where he discovered the shores of the estuary of the Seine, cradle of impressionism, where he made several paintings and watercolors. His precarious financial situation twice forced him to return to Holland, but he returned to Paris, Normandy, and the Nivernais region and spent time in the Dauphiné region (Alps), where he created oil, gouache, and watercolor paintings of mountain landscapes.

**JOURDAIN, FRANTZ (1847–1935)**
Belgian architect and writer. Trained at the Ecole des Beaux-Arts, he was one of the theoreticians behind the art nouveau movement. His main work is the La Samaritaine department store, built in 1905, which artfully integrates technology and decorative art in its metal and glass facade.

**JOUVENET, JEAN (1644–1717)**
Painter. He was a student of Charles Le Brun and a specialist in sacred compositions for the churches of Paris. He is also known for his portraits and frescos in the Palais de Justice in Rennes.

**KANDINSKY, WASSILY (1866–1944)**
Russian-born painter, graphic artist, and theoretician. His first canvases were influenced by impressionism and art nouveau. Around 1910 his work evolved toward a non-figurative style, for example his *Improvisations Impressions,* and *Compositions* series, which used stains of pure color and a nervous graphic style. Kandinsky's 1912 book *Concerning the Spiritual in Art* affirmed his attachment to abstract art grounded in colors and shapes as an expression of the inner world of the artist. He became a teacher and the shapes in his works such as *White Line*, 1920, became more geometrical. He enriched his formal world while giving free reign to fantasy in works like *Composition IX*, 1936.

**KUPKA, FRANK (1871–1957)**
French painter of Czech origin. He came to Paris in 1894, where he met Marcel Duchamp, Robert Delaunay, and Fernand Léger. His first canvases took inspiration from art nouveau, but he moved on to become one of the pioneers of abstract art with works like *Fugue à deux couleurs* (*Fugue in Two Colors*), 1910–1911. He used rhythmical combinations of prisms and stripes of color to represent time and movement. In 1930 he joined the Abstraction-Création movement.

**LABROUSTE, HENRI (1801–1875)**
Architect. Winner of the Prix de Rome in 1824, he worked with Félix Duban on the construction of the Ecole des Beaux-Arts, where he later taught from 1830–1856. As a professor at the Ecole Polytechnique, he organized the ceremony for the transfer of Napoleon's ashes to the Invalides. He headed the reconstruction of the Sainte-Geneviève library, as well as modifications to the Bibliothèque Nationale.

**LACOMBE, GEORGES (1868–1916)**
Painter and sculptor. His first sculptures were inspired by symbolism. In 1892 he joined the Nabi movement and with them exhibited his works influenced by Gauguin and by Japanese prints. He was known as the "Nabi sculptor," but he also did many portraits.

**LA HYRE, LAURENT DE (or LA HIRE; 1606–1656)**
Painter and engraver. His precocious talent, influenced by the art of Fontainebleau, was recognized very early on; he began exhibiting before he was twenty years old. The remarkable compositions of his historical and religious paintings, both solid and realistic, brought him great success. They were clearly influenced by Italian, and particularly Venetian, models—as seen in *Nicolas V au tombeau de Saint François* (*Pope Nicolas V at the Tomb of Saint Francis*), c. 1630; and *Presentation de Jésus au Temple* (*Jesus at the Temple*), 1634—and were even Caravagesque, despite the fact that he had never been to Italy. La Hyre went on to integrate mythological scenes with landscapes and ruins. His last works were even more meticulous, for example, *Les Enfants de Bethel* (*The Children of Bethel Mourned by their Mothers*), 1653. La Hyre was among the group of twelve artists who founded the Royal Academy of Painting and Sculpture in 1648.

**LARGILLIÈRE, NICOLAS DE (1656–1746)**
Painter of Flemish origin. He was educated at Anvers and in England. In 1682 he gained recognition as a portrait painter in Paris, but he also painted still lifes that reflect Flemish inspiration and taste.

**LASSUS, JEAN-BAPTISTE (1807–1857)**
Architect. He restored Sainte-Chapelle and the church of Saint-Séverin, and also built several churches, namely that of Saint-Jean-Baptiste de Belleville in Paris and Saint-Nicolas in Nantes.

**LA TOUR, MAURICE QUENTIN DE (1704–1788)**
Pastel artist. Latour was highly sought after as a portrait artist, especially for the vivacious quality of his pastels. His myriad works include *Voltaire* (1736); *Louis XV* (1748); and *Madame de Pompadour* (1755).

**LAURENS, HENRI (1885–1954)**
Sculptor, painter, and graphic artist. A close friend of Georges Braque, he adapted his sculptures to cubist principles. He sculpted in metal, plaster, and polychrome wood. In the 1930s Laurens's style evolved to become softer and rounder. He was influenced by Maillol, and sculpted mostly female bodies; for example, *Ondines*,1932. He also made paper collages.

**LE BRUN, CHARLES (1619–1690)**
Painter and art theorist. After studying in Paris Le Brun lived in Rome from 1642 to 1646, where he met Nicolas Poussin and discovered the Italian masters, particularly Raphael and Guido Reni. Back in Paris he enjoyed the patronage of Cardinal Richelieu, then Jean-Baptiste Colbert, and became famous for his decorative work in the Château Vaux-le-Vicomte (1658–1661). He was also one of the co-founders of the Royal Academy of Painting and Sculpture. In 1661 Le Brun was appointed First Painter to Louis XIV, and worked at the Louvre, the Tuileries, and especially Versailles, his masterpiece. He became director of the royal Gobelins workshop (1663), and served as master of choreography for official ceremonies. Le Brun was highly influential in contemporary debates of artistic theory.

**LE CORBUSIER (CHARLES-EDOUARD JEANNERET; 1887–1965)**
French architect, city planner, painter, and writer of Swiss origin. After trips to Italy and Asia, from which he brought back drawings, Le Corbusier took up painting, then opened his own architecture studio in 1922. His successive building designs (Villa Stein in Garches, 1927; Swiss Pavilion of the Cité Universitaire, 1932) allowed him to establish the International Style and the principles of the freestyle plan. From 1928 he lobbied with the CIAM (International Congress of Modern Architecture) and acquired an international reputation. He headed numerous urban development projects (though most of his plans were not realized), wrote at length, and designed pieces of furniture that are still being manufactured today.

**LEFUEL, HECTOR (1810–1881)**
Architect. Winner of the Prix de Rome in 1839, he was named architect for the châteaux of Meudon and Fontainebleau, and completed the "new Louvre" (1854–1857). He was also chief architect and builder for the Palais des Beaux-Arts, built for the 1855 World's Fair.

**LÉGER, FERNAND (1881–1955)**
Painter, illustrator, designer, filmmaker. Influenced first by impressionism, then by Paul Cézanne, he began to exhibit with the cubists in 1910. He used bright colors, simplified shapes, and accented volumes—for example, in *Nus dans la forêt* (*Nude in the Forest*), 1909–1910—then evolved toward nonfigurative art. After the shock of World War I, his paintings portrayed the predominant themes of the machine and humans faced with an industrialized world, as in *Eléments mécaniques* (*Mechanical Elements*), 1918–1923. He was also involved in a variety of other arts, from architecture and set design and ceramics.

**LE MERCIER, JACQUES (c. 1585–1645)**
Architect. Trained by his father, Nicolas, he acquired fundamental experience during a lengthy stay in Rome (1607–1614). Upon his return to France, he worked on the expansion of the Louvre for Louis XIII. He also built the Clock Pavilion and part of the Cour Carrée (Square Courtyard). In Paris he also built the churches of the Sorbonne and Saint-Roch, finished the chapel of the Val-de-Grace, and in 1639 constructed the Palais Royal (it was originally the Palais Cardinal built for Cardinal Richelieu). His greatest project was the construction of Richelieu's château and fortified villa, begun in 1625 at the cardinal's behest.

**LEMOYNE, FRANÇOIS (1688–1737)**
Painter. Trained in the grand style, he was influenced by Venetian painting. In addition to the ceilings of the Hercules Salon at Versailles, he decorated the churches of Saint Thomas Aquinas and Saint-Sulpice in Paris.

**LE NAIN**
Family of painters. Three brothers—Antoine, died in 1648; Louis, also died in 1648; and Mathieu, died in 1677—were all born in Laon and moved to Paris around 1629. They are known to have done about sixty paintings, though no one is sure which brother painted which canvases (despite the fact that there are visible differences in style). In contrast to the prevailing classicism, they painted primarily dignified genre scenes and some religious and history pictures. Examples of their works include *Nativité de la Vierge* (*Nativity of the Virgin*); *Notre-Dame de Paris; La Tabagie* (*The Smoke Room*), 1643; *Famille de paysans* (*Peasant Family*), 1640; *Intérieur paysan* (*Peasant Interior*), 1642; *L'Ane* (*The Milkmaid's Family*), c. 1641; and *Paysans devant leur maison* (*Peasants Before Their House*), c. 1641.

**LE NOIR, JEAN (fourteenth century)**
Illuminator. Le Noir was a follower of and later collaborator with Jean Pucelle. He worked for Yolande of Flanders, the duchess of Bar, John II (in 1358), Jean de Berry, and Charles V. His daughter was also an accomplished illuminator.

**LÉON, PAUL (1874–1962)**
Art writer and administrator. He published on art and architecture including *La Vie des monuments français* (*The Life of French Monuments*), 1951. Toward the end of his career he was the director of the Ecole des Beaux-Arts.

**LEPAPE, GEORGES (1887–1971)**
Painter, illustrator, graphic designer, and decorator. He illustrated several fashion magazines, typically creating a fluid, elongated, feminine figure often clothed in the fashions of Paul Poiret, Lucien Lelong, and Jeanne Lanvin. He also illustrated books and designed posters and panels.

**LE PAUTRE (seventeenth and eighteenth centuries)**
A family of architects and interior decorators. Jean (1618–1682) was a designer, prolific engraver, and a highly creative ornamentalist who also wrote clever chronicles such as *Le Sacre de Louis XIV* (*The Coronation of Louis XIV*). His brother Antoine (1621–1691) was an architect, a student of Louis Le Vau, and he built the Hôtel de Beauvais in Paris. Pierre, Jean's son, (c. 1648–1716), was an assistant to Jules Hardouin-Mansart and worked on the châteaux of Marly, Trianon, and Versailles, to which he brought interior *rocaille*-style ornamentations. Pierre, the son of Antoine (1660–1744), was also a Parisian sculptor and engraver.

**LESCOT, PIERRE (1515–1578)**
Architect and painter. He is known for designing the "new" Louvre at the request of François I; construction continued under Henry II. Lescot also designed the Cour Carrée (Square Courtyard), his masterpiece. He collaborated with Jean Goujon on the Fontaine des Innocents (Fountain of Innocents) and the Hôtel des Ligneris (now the Musée Carnavalet).

**LE VAU, LOUIS (1612–1670)**
Architect. He is known to have designed the Hôtel Lambert (1640), the Hôtel de Lyon (1661), the Collège des Quatre-Nations (1662), and the château of Vaux-le-Vicomte (1656–1662). As First Architect to King Louis XIV he was in charge of major building activity at the Louvre throughout the 1660s, and was responsible for the design and construction of the central section of the palace of Versailles, including the facade overlooking the park and the two wings flanking the courtyard.

**L'HERBIER, MARCEL (1888–1979)**
Film director. He first worked as a poet and playwright, then went on to play an important role in the development of the cinema, which he wanted to give a humanistic function. He was attracted to the symbolism of cinematography, and in 1923 made a film entitled *L'Inhumaine* (*The Inhuman*), which was characteristic of the French avant-garde. He founded the IDHEC (Institut des Hautes Etudes Cinématographiques) film school in 1943.

**LIMBOURG BROTHERS (early fifteenth century)**
Illuminators from the Netherlands. Pol was both a sculptor and painter, and Hennequin worked for Duke Philippe the Bold starting in 1402. Hermann joined them when they went to work for Jean de Berry. They are the artists who created the majority of the illuminations for the *Très riches heures du duc de Berry*, a masterpiece that was at least partially made in Paris.

**LIPCHITZ, JACQUES (1891–1973)**
French sculptor of Lithuanian origin. A friend of Amedeo Modigliani and Pablo Picasso, Lipchitz gave up classical principles in favor of cubism early on. He sculpted geometric, contrasting forms and evolved toward abstraction, as in *Homme à la mandoline* (*Man with Mandolin*), 1917. In the latter part of his life, during which he spent many years in the United States, he created softer, more supple shapes, which were more expressionist.

**LODS, MARTIN (1891–1978)**
Architect and city planner. Lods worked with Eugène Beaudouin until 1940 and also took an interest in collective housing and in the industrialization of construction. Together they built the Cité de la Muette in Drancy (1931–1934), the open-air school of Suresnes (1934–1935), and the Maison du Peuple (House of the People) in Clichy (1935–1939). After World War II, Lods worked on some very large projects, for example housing developments in Marly le Roi (1957–1959) and Rouen (1968–1970).

**LURÇAT, ANDRÉ (1894–1970)**
Architect, city planner, and writer. Linked to the modernist movement, he was one of the representatives of the International Style. After building homes for several artists, such as Villa Seurat (1925–1928), Lurçat became interested in social welfare programs. Subsequently commissioned by working-class communities and suburbs of Paris, he designed, for example, the Karl Marx School in Villejuif. He worked in the USSR, and after World War II headed the rebuilding of the town of Maubeuge.

**MAILLOL, ARISTIDE (1861–1944)**
Sculptor, designer, and painter. Trained by Léon Gérôme and Alexandre Cabanel, a friend of the Nabis group, he established a tapestry workshop before devoting himself entirely to sculpture. He sculpted successively in wood, terra-cotta, stone, and bronze, portraying almost exclusively female nudes. He developed a unique female body type in sculptures like *Ile-de-France* and *La Rivière* (*The River*). He also illustrated books.

**MAJORELLE, LOUIS (1859–1926)**
Painter and cabinetmaker. Majorelle trained as a painter but soon turned to the family business of furniture making. Along with Emile Gallé and Jean Prouvé, he was a member of the Nancy School. He experienced great success at the 1900 World's Fair and again at the 1925 Exposition d'Arts Décoratifs. He was influenced by art nouveau and by Japanese art, and his furniture pieces are ornamented with motifs directly inspired by nature.

**MALLET-STEVENS, ROBERT (1886–1945)**
Architect and decorator. Along with Le Corbusier, he represented the International Style. He used reinforced concrete to build spare, geometrical buildings with bare walls, bay windows, and cubic volumes of space. He built a wide range of projects in many places, from single-family homes to government buildings, casinos to designers' stores, and is particularly known for the Villa Paul Poiret in Mézy-sur-Oise (1924) and the design of the houses on Rue Mallet-Stevens in Auteuil (1926–1927).

**MANET, EDOUARD (1832–1883)**
Painter and printmaker. After traveling to Brazil with the French navy Manet worked in Thomas Couture's studio, then copied works in the Louvre and made several more trips, especially to Spain. *Le Déjeuner sur l'herbe* (*Luncheon on the Grass*) was not accepted for the 1863 Salon; Manet exhibited it at the alternative Salon des Refusés, the first of the scandals surrounding his work. He achieved success after the war of 1870 (*Bon Bock* was a triumph at the Salon of 1873). Because he portrayed scenes of daily life such as *Un Bar des Folies Bergère* (*A Bar at the Folies Bergère*), 1882, he is considered to be one of the founders of modern art.

**MANSART, FRANÇOIS (1598–1666)**
Architect. A student of Salomon de Brosse, he actively served the aristocracy and rich Parisian middle class. He was appointed First Architect to the king in 1636, and was a rigorous innovator whose works mark the transition from Renaissance to classicism. Among his best-known works are the Val-de-Grâce and renovation of the Hôtel Carnavalet.

**MARCEL, ETIENNE (c. 1316–1358)**
Politician. A merchant and Provost of Paris (1355–1358), he represented the aspirations of the Parisian merchant middle class, who wanted to govern themselves within a constitutional monarchy. Marcel wanted Paris to be run like the Flemish cities. The heir apparent, Charles (later Charles V), fled and initiated the blockade of Paris. Marcel headed the defense of the city, where he reigned as a dictator, and called in dukes allied with the English, whom he allowed to enter the city. However, public outcry forced him to expel them almost immediately. This tactical mistake lent strength to the heir apparent, who had Marcel assassinated.

**MAREY, ETIENNE JULES (1830–1904)**
Doctor. As a physiologist, he studied cardiac activity. Marey devised a system of chronophotography that was able to divide human and animal movements into minute actions by taking photographs at very close intervals. This was an important step toward cinematography.

**MAROCHETTI, CARLO (1805–1867)**
Italian-born sculptor. In Paris he participated in the Salons of 1827 and 1831, and created many public and church statues including *Ravissement*

*de sainte Madeleine* (*Ravishment of Saint Madeleine*) for the high altar of the church of La Madeleine. He retired to England, where he completed several monuments after 1848.

**MARQUET, ALBERT (1875–1947)**
Painter and draftsman. A friend of Henri Matisse and student of Gustave Moreau at the Ecole des Beaux-Arts, he exhibited with the fauvists in 1905. He painted landscapes and cities using pure, bright colors as in *La Plage de Fécamp* (*The Beach at Fécamp*), 1906. Over time his work evolved and he began to use less intense coloring than other fauvists.

**MARTIN, SAINT (c. 316–397)**
Bishop of Tours. Born in Italy, he served as a Roman soldier and converted to Christianity as a youth. He was the first to evangelize northern Gaul; due to his successful efforts he was chosen to fill the Episcopal seat in Tours in 373. The patron saint of France, no other saint was more popular in ancient France.

**MASSON, ANDRÉ (1896–1987)**
Painter and draftsman. Influenced by cubism at first, Masson joined the surrealist movement in 1923 and made automatic drawings such as *Les quatres éléments* (*The Four Elements*), 1923–1924. Around 1927 he invented the sand technique, in which he projected sand onto a canvas dabbed with glue. He later developed an idiosyncratic style, showing expressionist tendencies and using bright colors to deal with violent and erotic themes, for example in *Massacres*, 1931. Toward the end of his life Masson moved closer to abstraction.

**MATISSE, HENRI (1869–1954)**
Painter. His first canvases were influenced by the impressionists, especially Cézanne. However, by the Salon in the fall of 1905, his paintings such as *Fenêtre ouverte à Collioure* (*Open Window at Collioure*) established a new style dubbed "*fauve*" (meaning wild animal) by the critics. His paintings became increasingly simple; he abandoned central perspective and used a limited range of colors, for example in *La Danse et la Musique* (*Dance and Music*), 1909; and *La Danse* (*Dance*), 1931. Later in his long and productive career Matisse developed these principles through other media and techniques, in particular a series of paper cutouts.

**MATTEO GIOVANETTI (c. 1300–1368 or 1369)**
Italian painter. The prior of San Martino, in about 1343 he was chosen by Pope Clement VI to direct the decoration of the Palais d'Avignon. He himself painted the chapels of Saint-Martial and Saint-Jean, as well as a series of *Prophets* in the Grand Hall of Justice, all in the Palais d'Avignon. He also painted the Charterhouse Chapel in Villeneuve-lès-Avignon. He worked primarily in service of the French papal court.

**MAURICE DE SULLY (c. 1120–1196)**
Bishop of Paris. He became a canon first in Bourges and then in Paris, where he was appointed bishop in 1160. De Sully made the decision to build Notre-Dame Cathedral. He was one of the most eminent masters of the cathedral school, among the most learned and eloquent.

**MAZZONI, GUIDO (also called IL MODANINO or MASTER PAGAIN; c. 1450–1518)**
Italian sculptor. Early in his career he created decors and staged events for the court of the powerful Este family, as well as polychrome terra-cotta statue groups. In Paris he worked on the Château Gaillon and Hôtel Cluny, created the tomb of Charles VIII, and possibly designed that of Louis XII.

**MEISSONIER, ERNEST (1815–1891)**
Painter. He debuted his work at the 1834 Salon with his painting *Une visite chez le bourgmestre* (*A Visit to the Burgomaster*), and participated in the annual Salons for the next thirty years. In 1859 he went to Italy with the army staff of Napoleon III. Already very successful with his small-format, detailed history and genre paintings, after his return from Italy Meissonier often portrayed military themes. In the years 1870–1871 he produced several well-known sketches including *Les Ruines des Tuileries* (*Ruins of the Tuileries*) and *Le Siège de Paris* (*The Siege of Paris*).

**MÉLIÈS, GEORGES (1861–1938)**
Screenwriter and film director. Méliès began as an illusionist and designer, but became known as the pioneer of cinematography. As a designer of cinematographic sets he dealt with three main themes: magical fantasy, science fiction, and news. Examples of each of those themes, respectively, are *Cendrillon* (*Cinderella*), 1899; *Le Voyage dans la Lune* (*A Trip to the Moon*), 1902; and *L'Affaire Dreyfus* (*The Dreyfus Affair*), 1899. He transformed cinematography into art.

**MICHALLON, ACHILLE-ETNA (1796–1822)**
Painter. He was a student of Pierre Henri Valenciennes, an advisor to Jean-Baptiste Corot, exhibited in his first Salon at the age of sixteen, and won the grand prize for landscape paintings at twenty-one. He is known for *La Mort de Roland* (*The Death of Roland*) and *Vue du Colisée de Rome* (*View of the Roman Coliseum*).

**MICHEL, GEORGES (1763–1843)**
Painter. He accomplished a great number of paintings and drawings, mostly depicting Paris and the surrounding area, such as *Entrée de forêt* (*Child Herders*, or *Forest at Fontainebleau*), 1795; and *Moulin de Montmartre avant l'orage* (*The Mill of Montmartre*), c. 1820. He was one of the forerunners of the great nineteenth-century French landscape painters.

**MIGNARD, PIERRE (1612–1668)**
Painter, brother of Nicolas. He spent many years in Italy (1634–1657), where he was influenced by the painting style of the Bologna School. When he returned to Paris he received several important commissions, including the frescos in the dome of Val-de-Grace in 1663. Although he

was a rival of the influential Charles Le Brun, he knew how to stay in favor, in particular through his portraits of the court.

**MILHAUD, DARIUS (1892–1974)**
Composer. His works are based on polytonality. Milhaud was embassy secretary under Paul Claudel in Brazil from 1917 to 1919, where he was inspired by South American folklore, and in New Orleans he discovered jazz. He composed in many genres from operas like *Christopher Columbus*, 1928, to ballets, stage and orchestral music, and religious music. He was a professor at the Conservatoire and gained an international reputation.

**MILLET, JEAN-FRANÇOIS (1814–1875)**
Painter. He came from the Cotentin region of France, studied with Jacques-Louis David, and moved to Paris. He soon turned to painting rustic country scenes with figures in a Realist style. Examples include *La Laiterie* (*The Dairy*) and *Le Vanneur* (*The Basketweaver*). In 1849 Millet settled in Barbizon, where he lived for the rest of his life. For the most part he painted scenes of farm life such as *Le Semeur* (*The Sower*); *Les Glaneuses* (*The Gleaners*), 1857; and *L'Angelus* (*The Angelus*), 1857–1859. Especially in his later years, Millet also painted numerous landscapes, like the well known *Le Printemps* (*Spring*), 1868–1873.

**MIRÓ, JOAN (1893–1983)**
Spanish painter and sculptor. His first canvases were influenced by fauvism and cubism, and display an uncanny knack for detail, as in *Nu debout* (*Standing Nude*), 1918. After moving to Paris in 1920 Miró leaned toward surrealism, letting loose a world of fantasy and varied symbols in his paintings, for example *Terre labourée* (*The Tilled Field*), 1923–1924. He also made collages and lithographs. Miró was shaken by the Spanish Civil War and his paintings became more anguished, filled with deformed figures. In the latter part of his career he took up ceramics and sculpture.

**MODIGLIANI, AMEDEO (1884–1920)**
Italian painter and sculptor. His first paintings were influenced by Henri de Toulouse-Lautrec, Pablo Picasso, and Paul Cézanne, for example *Le Joueur de violoncelle* (*The Cello Player*), 1909. He painted mostly portraits and nudes, rendering elongated faces with ochre tones and melancholy expressions inspired by African art, as in *Soutine*, 1917; and *Nu couché* (*Reclining Nude*), 1920. His taste for elongated figures is also evident in the sculptures he made after 1909, inspired by Constantin Brancusi.

**MOLESMES, ROBERT DE (c. 1029–1111)**
Benedictine abbot. Prior in several different Benedictine monasteries and then abbot, Robert founded the Molesmes monastery in 1075. Desiring stricter adherence to the monastic rule, in 1098 he moved to Cîteaux with a small group of monks and founded a new community. The Cistercian Order spread throughout Europe and became a center of monastic reform under the leadership of Saint Bernard, Abbot of Clairvaux.

**MONDRIAN, PIET (1872–1944)**
Dutch painter and theoretician. After an early expressionist phase, his encounter with cubism around 1910 led him to paint more abstract works, such as *Pommier en fleurs* (*Flowering Apple Tree*), 1912. In Holland he founded a movement inspired by theosophy that believed artistic creation should be separate from nature. From the 1920s Mondrian painted grids of black lines interspersed with geometric shapes of pure color, and gradually diversified this composition, for example in *Composition avec deux lignes* (*Composition with Two Lines*), 1931.

**MONET, CLAUDE (1840–1926)**
Painter. Monet began his career in Normandy, but soon came to Paris where he met Camille Pissaro, Pierre Auguste Renoir, Alfred Sisley, and Frédéric Bazille. In 1863 he began painting outdoors in the forest of Fontainebleau. Among his early works are *Le Déjeuner sur l'herbe* (*Luncheon on the Grass*), 1865; and *Femmes au jardin* (*Women in the Garden*). He painted many landscapes, especially in Bougival and Argenteuil, experimenting with new techniques. During the war of 1870 he went to London, where he admired Joseph Turner's work. In 1874 Monet showed *Impression, soleil levant* (*Impression, Sunrise*) at an exhibition held in the studio of Nadar. Monet joined the group, which derived its name from his painting: the impressionists. His paintings increasingly conveyed a sense of color, for example *Gare Saint-Lazare*, 1877, and *La Berge à Lavacourt* (*Banks of the Seine at Lavacourt*), 1878. In 1883 Monet settled in Giverny, where he lived for more than forty years and painted along the Mediterranean shore. In the latter part of his career he explored variations of light and color, including many paintings of the same subject. He painted the Rouen Cathedral forty times, for example; Monet also painted series of *Haystacks* (from 1891) and his renowned *Water Lilies* (1916–1926).

**MONTICELLI, ADOLPHE (1824–1886)**
Painter. He moved back and forth between Paris and Marseilles, painting landscapes and scenes of gallantry. In 1870 Monticelli settled in Marseilles and his paintings evolved toward impressionism, depicting a dream-like fairy world. Paul Cézanne and Vincent van Gogh were inspired by his work.

**MOREAU, GUSTAVE (1826–1898)**
Painter. He greatly admired Théodore Chassériau and portrayed mostly biblical and mythological themes. He exhibited *Oedipe et le Sphinx* (*Oedipus and the Sphinx*) at the Salon of 1864 to great acclaim. Moreau also did sketches and watercolors. All his work demonstrates a refined aesthetic sense and talent in the use of color. Moreau taught at the Ecole des Beaux-Arts from 1892, training Georges Rouault, Henri Matisse, and Albert Marquet.

**MOREAU, JEAN-MICHEL (MOREAU THE YOUNGER; 1741–1814)**
Designer, illustrator, and engraver. Designer to Louis XV in 1770 and Designer and Engraver to Louis XVI, he enjoyed a long, successful career.

**MORISOT, BERTHE (1841–1895)**
Painter, designer, and printmaker. She admired Camille Corot and modeled for Edouard Manet, and showed her own works with the impressionists starting in 1874. After 1880 she distanced herself from the impressionists to paint works that were typically soft-toned and freestyle in technique, including *Jour d'été* (*Summer's Day*), 1879, and an 1885 *Self-Portrait*. In her later works, influenced by Renoir, a more precise line appeared, as in *La Petite Marcelle* (*Young Marcelle*), 1895.

**MORRIS, WILLIAM (1834–1896)**
British artist, writer, and politician. He was first and foremost a painter, and in 1861 opened an interior decoration workshop. In 1886 it became the Arts and Crafts Exhibition Society, which extolled a return to hand-made crafts in interior decoration and contributed to the development of art nouveau and a new aesthetic for objects in daily life.

**MUCHA, ALFONS (1860–1939)**
Czech painter and poster artist. He is considered one of the main representatives of art nouveau. He began his career illustrating books and designing posters for theater and industry. He also designed jewelry and made decorative panels. His works, often focusing on female figures and inspired by Japanese prints, were very popular in his lifetime.

**MURGER, HENRI (1822–1861)**
Author. He studied painting, then became a secretary to Count Tolstoy. He barely made a living until his *Les Scènes de la vie de bohème* (*Scenes of Bohemian Life*) were published, first as a series of short stories in the newspaper *Le Corsaire*, then as a play and a novel. He then collaborated on the *Revue des Deux Mondes* (*Journal of Two Worlds*).

**NADAR (GASPARD-FÉLIX TOURNACHON; 1820–1910)**
Photographer, illustrator, and writer. Founder of the *Revue comique* (*Comic Review*) in 1849, Nadar also opened a photography studio and in 1854 published the *Panthéon Nadar*, an extensive collection of lithographs caricaturizing contemporary celebrities. His photographic studio quickly became known for its insightful portraits. Always innovative, in 1868 Nadar took the first aerial photographs—of Paris, from a hot-air balloon. He also drew caricatures and published several books.

**NATANSON, ALEXANDRE (1867–1936) and THADÉE (1868–1951)**
Brothers; the former was a publisher and the latter a journalist. Together they established the art and literary review *La Revue blanche*; contributors included Stéphane Mallarmé, Jules Renard, and Marcel Proust. They published the art of Nabi painters and Henri de Toulouse-Lautrec. Thadée was a founder of the Human Rights League.

**NEUVILLE, ALPHONSE DE (1836–1885)**
Painter. Neuville's forte was military paintings, and he debuted at the 1859 Salon with *Le Cinquième Bataillon de chasseurs à la batterie Gervais* (*The Fifth Battalion of Chausseurs at the Gervais Battery*). He painted many works based on his experience as an officer in the war of 1870, the most renowned being *Les Dernières cartouches* (*The Last Cartridge*), 1873; and *Le Cimetière de Saint-Privat* (*Cemetery of Saint-Privat*), 1881.

**NICOLAS DE VERDUN (twelfth century)**
Metalworker. A student of Godefroid de Claire, Nicolas was the most illustrious Mosan (enamel) and metalworker of his time, creator of the Klosterneuburg altarpiece (1181) and the reliquary of the Three Kings in Cologne.

**NIERMANS, JEAN (1897–1989) and EDOUARD (1904–1984)**
Architects and urban planners. The Niermans brothers built the Hôtel de Ville of Puteaux (1931–1934) in the neoclassical style. From 1935 to 1937 they renovated the Trocadéro Theater in a classically academic style but with art deco influences. Jean Niermans later directed the reconstruction of the city of Dunkirk.

**NODIER, CHARLES (1780–1844)**
Writer. Born in Besançon, he wrote about natural history before turning to literature. He made his royalist views known in a satirical ode, and later in novels likened to *"romans noirs"* ("black novels"). In 1813 Nodier was named head of the Arsenal (library of the duke of Artois) in Paris, where he gathered young Romantic Movement writers for famous soirées. A prolific writer, he published everything from humor and fantasy writing to volumes of memoirs, historical essays, critiques, and bibliographies.

**OBERKAMPF, CHRISTOPHE PHILIPPE (1738–1815)**
Industrialist. He worked first as an engraver in Mulhouse, then became a colorist at the Arsenal factory in Paris. In 1760 he founded the first factory to print upholstery fabric in Jouy-en-Josas, for which Napoleon gave him the Legion d'Honneur cross.

**OPPENORD, GILLES-MARIE (1672–1742)**
Architect. He studied under Jules Hardouin Mansart, was named First Architect to the duke of Orléans in 1712, and worked on the Palais Royal. He played an important role in developing the taste for the *rocaille* style during the Regency period.

**ORESME, NICOLE (c. 1320–1382)**
Philosopher, economist, and scholar. He began his prodigious academic career in theology and became bishop of Lisieux in 1377; he was also a trusted associate of King Charles V. Oresme translated several of Aristotle's works into French, wrote about mathematics and economics, and in *De caelo et mundo* established that the earth might rotate on its own axis, thus laying the foundation for modern science.

**OZENFANT, AMEDÉE (1886–1966)**
Painter and theoretician. Along with Le Corbusier, Ozenfant denounced the decorative style of late cubism and wrote a purist manifesto defending a stricter form of art. In his paintings, he standardized and geometricized shapes and used muted colors.

**PASCIN, JULES (1885–1930)**
American illustrator and painter of Bulgarian origin. He trained in Vienna and Munich, where he was influenced by Jugendstil (the German art nouveau movement). In 1905 Pascin came to Paris, where he led a turbulent life. He tended toward fauvism, then cubism, painting nudes and portraits of women, such as *Femmes aux botines jaunes* (*Woman with Yellow Boots*), 1908. In the next decade he traveled extensively and had shows in Paris, Berlin, and New York. His drawings and watercolors were often satirical.

**PATHÉ, CHARLES (1863–1957)**
Cinematographer and industrialist. He and his brother Emile produced the "Pathé Frères" (Pathé Brothers) phonogram, which gradually improved on Edison's. Charles Pathé was the first to manufacture rolls of film and opened the first photo development lab. He produced films in his Vincennes studio, and introduced the newsreel (called the *"Pathé journal"*)in 1909.

**PATOU, JEAN (1887–1936)**
Fashion designer. Established in 1919, his fashion design company was Chanel's main competitor between World Wars I and II. Patou lengthened clothing and launched the boyish style for women. His perfumes were highly successful, especially *Joy*, created in 1935.

**PATOUT, PIERRE (1879–1965)**
Architect, city planner, and decorator. He represented moderation in modern architecture, avoiding the trends of the day. His buildings focused on space and imposing volumes. He designed the interiors of the ocean liners *Ile-de-France* (1926) and *Normandie* (1934–1935), introducing port-holes, passageways, and gangways that gave birth to the ocean-liner style. He also headed reconstruction of the city of Tours after World War II.

**PÉPIN DE HUY (late thirteenth century–mid-fourteenth century)**
Flemish sculptor. He worked for Mahaut d'Artois in Hesdin, and sculpted the tomb of her son, Robert d'Artois, who died at the age of nineteen.

**PERCIER, CHARLES (1764–1838)**
Architect and decorator. In partnership with Pierre François Léonard Fontaine he was the official architect of the empire style under Napoleon. He was responsible for the Arc de Triomphe du Carrousel, and founded the Ecole des Beaux-Arts in 1812.

**PERRAULT, CLAUDE (1613–1688)**
Architect, physician, theoretician, and member of the Royal Academy of Science. Perrault participated in the design process for the west facade of the Louvre, and was chosen to implement the final plans with François d'Orbay. He also worked on the restoration of Sainte-Geneviève (1670–1680) and the Château de Sceaux. At Colbert's request, he translated and annotated Vitruvius's monumental work *On Architecture*.

**PERRET, AUGUSTE (1874–1954)**
Architect. He worked with his brothers, Gustave (1876–1952) and Claude (1880–1960), and specialized in building with reinforced concrete. He designed the Champs-Elysées Theater (1911–1913), an example of his distinctive style, which was generally inspired by classical architecture.

**PEVSNER, ANTOINE (1886–1962)**
French painter and sculptor of Russian origin. He came to Paris in 1910, and became interested in the avant-garde. In 1920 he and his brother, Naum Gabo, issued the *Manifeste réaliste* (*Realist Manifesto*), which advanced non-figurative art based on rational and technical principles (constructivism). His geometrical sculptures were often built with welded metal rods.

**PICABIA, FRANCIS (1879–1953)**
Painter and writer. A friend of Alfred Sisley and Camille Pissaro, he painted impressionist landscapes, then took interest in cubism, and finally in abstract art, for example *Udine*, 1913. He exhibited at the Armory Show in New York in 1913, with great success. He met Marcel Duchamp and Man Ray and joined the dadaists for four years.

**PICASSO, PABLO (1881–1973)**
Spanish painter, sculptor, and printmaker. He came to Paris to paint in 1900 and settled there permanently in 1904. He invented cubism—of which *Les Demoiselles d'Avignon*, 1907, is a good example—and collage, like *Nature Morte à la chaise cannée* (*Still Life with Chair Caning*), 1912. He also explored the pure abstraction from 1929–1935. The high point of his expressionist phase was *Guernica* (1937), with its violent, dismembered figures. He retired to the south of France, where he devoted himself to painting and sculpture.

**PIERRE DE CHELLES (fourteenth century)**
Architect. Probably the son of Jean de Chelles, Pierre was in charge of the construction of Notre-Dame Cathedral.

**PIERRE DE MONTREUIL (c. 1200–1266)**
Architect. He was likely the greatest architect working during the reign of Saint Louis. He built the refectory and Chapel of the Virgin of Saint-Germain-des-Prés and finished the south facade of the transept of Notre-Dame, begun by Jean de Chelles. He may have also designed the refectory of Saint-Martin-des-Champs.

**PIERRE DE THOIRY (fifteenth century)**
Sculptor. Possibly related to Jean de Thoiry, he worked in Paris sculpting recumbent effigies for the tombs of Charles VI and Isabeau of Bavaria at the basilica of Saint-Denis.

**PILON, GERMAIN (c. 1528–1590)**
Sculptor. The favorite sculptor of Catherine de Médicis, he was a key sculptor of the French Renaissance. He worked with Francesco Primaticcio and contributed to the tombs of Henri II and Catherine de Médicis.

**PISSARO, CAMILLE (1830–1903)**
Painter and lithographer. Influenced by Camille Corot, he was part of the impressionist circle including Claude Monet, Pierre Auguste Renoir, and Paul Cézanne. He painted landscapes of the Ile-de-France, such as *Jardins de l'Ermitage à Pontoise* (*Gardens of the Ermitage in Pontoise*), 1867–1869; but also portraits and still lifes. Pissaro struggled to make impressionism known and influenced many artists. Around 1885 his work became more pointillist. His last canvases depict Paris, for example *Boulevard Montmartre, effet du nuit* (*Boulevard Montmartre at Night*), 1897, and towns in Normandy.

**POIRET, PAUL (1879–1944)**
Fashion designer and decorator. He changed fashion forever by eliminating the corset, proposing instead a more feminine form, for example the empire waistline. Maurice de Vlaminck, Raoul Dufy, and Man Ray worked for him, and he presented his collections at sumptuous parties.

**POLONCEAU, BARTHÉLEMY CAMILLE (1813–1859)**
Engineer. He designed the railroad from Paris to Versailles, then became director of the Alsation railroad company Chemins de Fer d'Alsace.

**PRADIER, JEAN-JACQUES "JAMES" (1792–1852)**
Sculptor. He won the Prix de Rome in 1813, became a teacher at the Ecole des Beaux-Arts as early as 1827, and won multiple commissions, including sculpting twelve *Victories* for the tomb of Napoleon I and figures for the Arc de Triomphe at l'Etoile. Pradier is also known for *Satyr and Baccant*, 1834, and numerous statues of women such as *Les Trois Graces* (*The Three Graces*), 1825; *Louise Colet*, 1846; and *Sappho*, 1852.

**PRÉAULT, AUGUSTE (1809–1879)**
Romantic and revolutionary sculptor. He gained fame thanks to his work *La Tuerie* (*The Slaughter*), 1834, a bas-relief that denounced crimes against humanity. He is also known for *Dante et Virgile* (*Dante and Virgil*), *Christ en croix* (*Christ on the Cross*) in Saint-Gervais in Paris, and *Clémence Isaure* in the Luxembourg Gardens.

**PRIMATICCIO, FRANCESCO (1504–1570)**
Italian painter and sculptor. He was an assistant to Jules Romain in Mantua before coming to France as early as 1532 to serve François I, working with Rosso Fiorentino at Fontainebleau. Most of his works have been either destroyed or disfigured; however, there are still numerous and beautiful preliminary sketches by him.

**PROUDHON, PIERRE JOSEPH (1809–1865)**
Socialist and journalist. In 1848 he was elected representative to the Constituent Assembly. He founded the People's Bank, which failed, and started three newspapers, as well. He was forced to flee to Belgium in 1858 after being convicted for violating laws governing the press. When he later returned to France, he had given up politics and begun to write. He is known for *Du Principe de l'art* (*On the Principles of Art*), 1865, and he wrote several political works that influenced the working class.

**PROUVÉ, JEAN (1901–1984)**
Architect. He worked with Eugène Beaudouin and Martin Lods on the Buc aeroclub in 1935, then on the Maison du Peuple (House of the People) in Clichy (1937–1939), where he created room dividers of foldable steel panels. He built his own home in Nancy in 1953, then contributed to the design of the CNIT (National Center for Industry and Technology) at La Defense in 1958. He was a professor at the Conservatoire National d'Arts et Métiers, and advocated the use of light alloys.

**PRUD'HON, PIERRE PAUL (1758–1823)**
Painter. He studied sculpture, miniatures, and allegories in Burgundy and Paris before moving to Rome in 1785. In France he did engravings and interior decor, for example, the *hôtel* of Josephine de Beauharnais, a ceiling in the palace of Saint-Cloud, and two ceilings in the Louvre. He enjoyed the favor of the Bonapartes and painted a portrait of Empress Josephine, which further fueled his career. Prud'hon's best works are allegorical and mythological subjects, such as *L'enlèvement de Psyche* (*The Abduction of Psyche*), as well as charcoal and chalk drawings, which made him a precursor of the Romantic movement.

**PUGET, PIERRE (1620–1694)**
Painter and sculptor. He was greatly influenced by the Italian painters Pietro da Cortona, his master, and Guido Reni. He developed a baroque style in which he spectacularly demonstrated his virtuosity of technique.

**PUVIS DE CHAVANNES, PIERRE (1824–1898)**
Painter. As an apprentice in Ary Scheffer's studio, he received advice from Eugène Delacroix and Thomas Couture. His *Pietà* was shown at the 1850 Salon, though his works were not always accepted in following years. He painted several oil compositions for the cities of Lyons, Marseilles, Poitiers, and Rouen before winning his first major commission for large-scale scenes depicting the life of Saint Genevieve in the Pantheon (1876–1880), which won him an international reputation. Thereafter he decorated the grand amphitheater of the Sorbonne and the Hôtel de Ville (City Hall).

**RAINALDI, CARLO (1611–1691)**
Italian architect. Rainaldi worked extensively in Rome, where he built the church of Santa Maria in Campitelli and the facade of Sant'Andrea della Valle, and designed the two churches in Piazza del Popolo. He participated in the bids for construction of the Louvre in 1664.

**RAMBUTEAU, CLAUDE PHILIBERT BARTHELOT, COUNT OF (1781–1869)**
Administrator. As chamberlain to Napoleon, he organized the resistance to the invasion of 1814. As prefect of the Seine *arrondissement* from 1833 to 1848, he strove to transform Paris. During his tenure the street that bears his name was created, sewers were built, gas streetlights installed, trees planted, and over 4,000 houses were built. He also arranged for the fountains

and obelisk on Place de la Concorde, erected the Colonne de Juillet (July Column), and oversaw completion of the Arc de Triomphe and the Madeleine.

**RANSON, PAUL (1864–1909)**
Painter and writer. He was one of the Nabis group, which regularly met in his studio. His paintings incorporate warm colors and are infused with a touch of mysticism, for example *Christ jaune* (*The Yellow Christ*), 1889. In 1908 he founded a painting academy in Paris.

**RAY, MAN (1890–1976)**
American painter and photographer. His first paintings were influenced by cubism. He was subsequently inspired by dadaism and made paper collages such as *Revolving Doors*, 1917, and unusual objects like an iron covered with nails (*Gift*, 1921). He experimented with a process he called the *Rayogram*, which uses light-sensitive paper to make images without a camera. Man Ray belonged to the surrealist movement, and decided to devote all his energy to photography, through which he gained greater notoriety. He also made experimental films, such as *L'Etoile de mer* (*The Starfish*), 1928.

**RAYMOND DU TEMPLE (fourteenth century–1405?)**
Architect. He worked with Jean le Bouteiller on Notre-Dame and took leadership of that project in 1363. He was Master Mason to the king and sergeant at arms. His major work was the transformation and enlargement of the Louvre, ordered by Charles V (1362–1380). He also worked with the Dammartin brothers for the dukes of Burgundy and the duke of Berry, designing the tomb of Du Guesclin for the abbey of Saint-Denis (1397), then built the upper floor of the keep of Château de Vincennes; he may also have designed the fortified walls around it. He is also thought to have built the small Château de Beauté in Nogent-sur-Marne, the Célestins church in Paris, and the chapel at the Collège de Beauvais.

**REDON, ODILON (1840–1916)**
Illustrator, engraver, and painter. Greatly influenced by the engraver Rodolphe Bresdin, Redon began with drawings, but soon turned to engraving himself. His first album of lithographs, *Dans le rêve* (*In the Dream*), 1879, revealed a fantastic world peopled with monsters and visions. From 1890 he focused on pastels and mythological and floral oil paintings.

**RÉMI, SAINT (c. 437–c. 533)**
Bishop. Rémi was named Bishop of Reims in 459; in 496 he baptized Clovis there and became his advisor. He organized the Christian missions to evangelize the Franks, and founded the seats of Therouanne, Laon, and Arras.

**RENOIR, PIERRE AUGUSTE (1841–1919)**
Painter. He was trained in Charles Gleyre's studio, where he met Eduoard Monet, Alfred Sisley, and Frédéric Bazille, with whom he painted in the forest of Fontainebleau. In 1868 *Lise au parasol* (*Lise with a Parasol*) was accepted at the Salon. He participated in impressionist exhibitions from 1874, and painted great works like *Le Moulin de la Galette* (*Dance near the Mill of Galette*), 1876, before drifting away from the impressionist movement. After a trip to Italy he adopted a new style, clearly evident in *Les Parapluies* (*The Umbrellas*), 1879–1880. Toward the end of his life he painted mostly portraits and nudes, for example, *Après le bain* (*After the Bath*), 1910.

**RETTÉ, ADOLPHE (1863–1930)**
Writer. An ardent adherent of symbolism, one of Retté's works was *Du Diable à Dieu* (*From the Devil to God*), 1907, in which he described his conversion to Catholicism.

**REVOIL, PIERRE HENRI (1776–1842)**
Painter. A member of the Lyons School, he preferred subjects from antiquity to those from the Middle Ages. He is known for history scenes, including *Tancrède prend possession de Bethlem 6. Juin 1099* (*Tancred of Hauteville, Prince of Antioch, Takes Possession of Bethlehem, June 6, 1099*), 1839.

**RICCI, SEBASTIANO (1659–1734)**
Italian painter. He worked in Lombardy and Venice painting commissioned works for individuals, as well as for the San Giorgio Maggiore Church and the chapel of Santa Maria dei Carmini. He also worked in England (1712–1716). After that Ricci had prestigious patrons throughout Europe, among them the court of Turin (the royal palace and the castle of Rivoli). Later in his life he painted several altarpieces in Venice.

**ROBERT, HUBERT (1733–1808)**
Painter, engraver, and decorator. His work was influenced by Giovanni Paolo Pannini and Giovanni Battista Piranesi, whom he met during a long stay in Italy. He also traveled with Jean-Honoré Fragonard and the abbot of Saint-Non during those years. When he returned to France he launched the trend of painting ruins, for example the *Pont du Gard*, 1787. He was one of the first curators at the Louvre.

**RODIN, AUGUSTE (1840–1917)**
Sculptor. Rodin only experienced success after many difficulties. In 1875 he went to Italy, and upon his return *L'Age d'airain* (*The Age of Bronze*) was accepted into the 1877 Salon. A major commission for a bronze door for the Museum of Decorative Arts (*La Porte de l'enfer*, or *The Gates of Hell*) followed—which he worked on the rest of his life—then *Les Bourgeois de Calais* (*The Burghers of Calais*), 1884. Rodin had a productive career and made masterpieces such as *Le Penseur* (*The Thinker*), 1880; *Eve*, 1881; and *Le Baiser* (*The Kiss*), 1886; as well as numerous busts and exquisite drawings.

**ROSSO FIORENTINO (GIOVANNI BATTISTA DI JACOPO; 1495–1540)**
Italian painter. A great admirer of Michelangelo, he was born and worked actively in Florence until 1523, then in Rome—where he discovered Raphael—and later he went to Paris. He became the painter to François I and canon of Sainte-Chapelle and Notre-Dame. He was in charge of the interior decoration of Fontainebleau, where he painted the Gallery of François I. Rossos's style was formative for the School of Fontainebleau.

**ROUAULT, GEORGES (1871–1958)**
Painter, printmaker, and stained-glass artist. He admired Rembrandt, but was trained by Gustave Moreau. A devout Catholic, Roualt painted out of his social conscience, often representing people on the margins of society—such as *La fille au miroir* (*Prostitute at Her Mirror*), 1906—and later more religious themes; for example, *Christ et les pêcheurs* (*Christ and the Fishermen*), c. 1932. He felt drawn to expressionism, but his marked black contours and aggressive colors stood out. Later he painted stained-glass windows and made engravings, notably a series presented under the title *Miserere* (1917–1927), a response to the horror of World War I.

**ROUSSEAU, HENRI (1844–1910)**
Painter. The first of the naïve painters, Rousseau taught himself to paint while working in the Paris customs office (hence his nickname "Le Douanier"). He started exhibiting his work at the Salon des Indépendants in 1886, and did not find great acclaim in his lifetime. He painted portraits and many landscapes, particularly jungle scenes, for example *La Charmeuse de serpents* (*The Snake Charmer*), 1907; and *Le Rêve* (*The Dream*), 1910. His keen eye for composition and color gave his works great poetic strength.

**ROUSSEL, KER XAVIER (1867–1944)**
Painter. A friend of Edouard Vuillard, he belonged to the Nabis group. He used bright, luminous tones to paint still lifes, portraits, landscapes, and mythological scenes like *Venus et l'Amour au bord de la mer* (*Venus and Cupid by the Sea*), 1908. He also painted interior decorations.

**ROUX-SPITZ, MICHEL (1888–1957)**
Architect. He studied under Tony Garnier, and his buildings integrated a certain traditionalism with a concern for functionality and the use of new materials such as reinforced concrete. Roux-Spitz designed numerous bourgeois apartment buildings as well as public buildings; for example, a central post office in Paris in 1932. He directed the rebuilding of the city of Nantes after World War II.

**RUDE, FRANÇOIS (1784–1855)**
Sculptor. Winner of the Prix de Rome in 1812 and strong supporter of Napoleon, he lived in exile in Brussels until 1827. At the Salon of 1828 he exhibited a *Virgin* that had been commissioned for Saint-Gervais. In 1842 he went to Italy and replaced David of Angers, who was forced to resign from the academy in Rome. Rude made numerous marble busts (for example *Jacques-Louis David, Perugia, and Gaspard Monge*) and sculpted the tombstone of Cavaignac (in Montmartre Cemetery). His signature work is the ornamentation of and a high-relief group on the Arc de Triomphe, *Départ des volontaires* (*Departure of the Volunteers*).

**RUHLMANN, EMILE JACQUES (1879–1933)**
Interior decorator. Starting in 1910 he created interiors for high-society homes and was commissioned to do public buildings; for example, the interior of the Palais d'Elysée. His classical and elegant furniture pieces were hand-made of exotic wood and inlaid with rare materials such as mother-of-pearl, ivory, shell, bronze, and galuchat.

**SANSON, ERNEST (1836–1919)**
Architect. At the turn of the century, he was in great demand among Parisian high society. He was commissioned to design their *hôtel* in a very academic, classical style. One example is the Palais Rose (1896–1902); made in imitation of the Trianon, it was torn down in 1969.

**SARRAZIN, JACQUES (1588–1660)**
Sculptor. He studied in Rome (c. 1610–1627) and oriented his work toward strict imitations of ancient Roman and Greek works, as can be seen in the caryatids in the Clock Pavilion of the Louvre (1636) and the decoration of Château de Maisons (done with François Mansart, 1642–1650). This structure loosened in his later works, giving over to a more tormented, theatrical style; for example, in the monument of Henri de Bourbon, Prince of Condé, rebuilt today in Chantilly.

**SAUVAGE, HENRI (1873–1932)**
Architect. Trained at the Ecole des Beaux-Arts of Paris, in 1898 he designed Louis Majorelle's villa in Nancy. He was inspired by art nouveau, and designed buildings that were exemplary in their functionality. In 1921, for example, he built number 26, Rue Vavin in Paris with terraced storys that allow more light into the interior.

**SAUVAL, HENRI (1623–1676)**
Historian. He was a parliamentarian lawyer, and studied and wrote about the history of Paris. His works, however, were not published until 1724, under the title *Histoire et recherches des antiquités de Paris* (*History and Research of the Antiquities of Paris*).

**SCHEFFER, ARY (1795–1858)**
Dutch painter. He studied under Pierre-Narcisse Guérin at the Ecole des Beaux-Arts, and painted in a classical academic style. Scheffer took particular inspiration from the Romanticism of the works of Goethe and Byron, painting history and genre scenes, portraits, and religious paintings. Well-known is his *La Mort de Géricault* (*The Death of Géricault*), 1824.

**SEDILLE, PAUL (1836–1900)**
Architect. He is known for his design of the basilica at Domrémy (1881) and the Printemps department store in Paris.

**SENEFELDER, ALOYS (1771–1834)**
German inventor of the lithography technique. Although he was too poor to publish his own works, he discovered a technique for printing on stone as a young man, thus giving commercial lithography its launch.

**SERT, JOSÉ-LUIS (1902–1983)**
Spanish architect. He came to Paris in 1929 to work with Le Corbusier. In Barcelona he founded the GATEPAC, a group of Spanish architects affiliated with the CIAM (International Congress of Modern Architecture). Sert's building designs reflect his goals of functionality and for structures to blend into their environment; one example is the Maeght Foundation (a museum of modern art) in Saint-Paul de Vence (1962–1964).

**SERT, JOSÉ-MARIA (1874–1945)**
Spanish painter. After spending time in Italy, he moved to Paris in 1899. Influenced by the great masters, like Tiepolo, his use of color is brilliant, often working in tempera. Sert's vast murals are in prominent places all over Europe and the United States; for example the Vich Cathedral in Catalonia, the Palais des Nations in Geneva, and *America's Progress* in the Rockefeller Center. Sert also illustrated books by André Gide and Paul Claudel.

**SÉRUSIER, PAUL (1864–1927)**
Painter. He studied with Paul Gauguin in Pont-Aven, and in 1888 painted *Talisman*, a landscape painted with areas of juxtaposed flat colors. Strong reaction to this work led Sérusier to found the Nabis group when he returned to Paris in 1889. He continued to work with Gauguin and created set designs for the Théâtre de l'Oeuvre. After a trip to Italy in 1899, he turned to painting religious themes.

**SERVANDONI, GIOVANNI NICOLÒ (1695–1766)**
Italian architect, painter, and decorator, and naturalized French citizen. He settled in Paris in 1724 and worked successfully for the theater of the Opéra in Paris, as well as the royal courts in London (1749) and Dresden (1760). His most famous architectural work is the facade of Saint-Sulpice in Paris (1732–1745).

**SEURAT, GEORGES (1859–1891)**
Painter and theorist. Seurat observed that colors change with distance, and made research on color and vision his life's work. Between 1880 and 1883 he made numerous drawings. In 1884 Seurat painted *Une baignade à Asnières* (*Bathing at Asnières*), the first pointillist (or divisionist) painting. He also studied movement, separating an action into its individual steps, as seen in *Le Chahut*, 1889–1890, and *Le Cirque* (*The Circus*), 1891. His painting influenced the fauvists, the futurists, and the cubists.

**SIGNAC, PAUL (1863–1935)**
Painter. Self-trained, he was an admirer of Claude Monet, and with other painters founded the Salon des Indépendants in 1884. He worked with Georges Seurat to define the principles of neoimpressionism, especially trying to obtain the greatest possible luminosity, from 1908–1934.

**SIMART, PIERRE CHARLES (1806–1857)**
Sculptor. Winner of the Prix de Rome in 1833, he sculpted *Architecture et la sculpture* (*Architecture and Sculpture*) on the facade of the Hôtel de Ville in Paris, and *La Justice et l'abondance* (*Justice and Abundance*), both of which were commissioned by the state in 1840. He also sculpted the reliefs on Napoleon's tomb in the Invalides.

**SISLEY, ALFRED (1839–1899)**
British painter. He painted alongside Frédéric Bazille, Edouard Monet, and Pierre Auguste Renoir in the forest of Fontainebleau; for example, *La Rue de village à Marlotte* (*Village Street in Marlotte*), 1866. Moving toward impressionism, he made many Ile-de-France landscapes, conveying changes in the atmosphere according to weather and time of day, as in *Louveciennes*, 1878. He is an important representative of the French impressionist movement.

**SLUTER, CLAUS (c. 1350–1406)**
Master sculptor of Dutch origin. He trained in Flanders and from 1385 served Philippe II, duke of Burgundy. Sluter did much of the sculpture for the Charterhouse at Champmol, including *Les Donateurs* (*The Donors*) and other portal figures, and the *Well of Moses*. In 1404 he began the tomb of Philippe the Bold, also at Champmol. A master of Burgundian sculpture, his influence spread, especially in Flanders and in Germany. He was a main source of the realist tendency in fifteenth-century sculpture and painting.

**SORBON, ROBERT DE (1201–1274)**
Theologian. He was the canon of Cambrai, a master in theology, and personal chaplain of Saint Louis. He used his influence with the king to found the college bearing his name, La Sorbonne (1253–1257), and was its first director. Sorbon was renowned as a preacher and later became canon of Notre-Dame.

**SOUTINE, CHAÏM (1893–1943)**
Painter of Lithuanian origin. Soutine came to Paris in 1913. During stays in Ceret (1919–1922) and Cagnes (1923–1925) he painted many apocalyptic landscapes, such as *Arbres couchés* (*Fallen Trees*), 1923. After he returned to Paris in 1925, he painted a series of skinned animals; he also painted deformed figures, still lifes, and portraits that reveal his malaise. In the 1930s he discovered Gustave Courbet, who inspired him to paint more serene works like *Siesta*, 1934.

**SOUVERBIE, JEAN (1891–1981)**
Painter and designer. He was first influenced by the Nabis group and the fauvist palette of colors, but around 1920 he discovered cubism through the work of Georges Braque. Most of Souverbie's paintings are portraits of women, nudes, and still lifes. He also decorated the Palais de Chaillot in Paris in 1937, and later designed decor for ocean liners (1945–1951).

**SUGER, ABBOT (c. 1081–1151)**
Monk. He was a clever diplomat who entered the Abbey of Saint-Denis and became its abbot in 1122. He was a fellow student of Louis VI's and became his advisor for ecclesiastical affairs, thus having a predominant influence on the government. He quadrupled the abbey's revenues, founded new towns such as Vaucresson (1146), and erected the superb church of Saint-Denis. Suger took over the regency when Louis VII went on crusade (1147–1149) and ensured public order, overcoming the intrigues of the nobility

and the insubordination of some of the clergy. The king conferred upon him the title of "Father of the Nation."

**TAYLOR, ISIDORE JUSTIN SÉVERIN, BARON (1789–1879)**
Writer and printmaker. He traveled in Spain and Algeria before being named inspector of the Beaux-Arts in 1838. He became a senator in 1869, and with Charles Nodier coauthored *Voyages pittoresques et romantiques de l'ancienne France* (*Picturesque and Romantic Travels in Old France*), 1820.

**TIFFANY, LOUIS COMFORT (1848–1933)**
American interior decorator and glass artist. He was inspired by Japanese prints, and in 1892 began to make art nouveau lamps, vases, and stained glass that brought him international acclaim. He also created interiors, including rooms in the White House.

**TOULOUSE-LAUTREC, HENRI DE (1864–1901)**
Painter and lithographer. He lived in Montmartre, and the Moulin Rouge and its stars are the main theme of his paintings, for example *Au Moulin Rouge* (*At the Moulin Rouge*), 1890; *Jane Avril sortant du Moulin Rouge* (*Jane Avril in the Entrance of the Moulin Rouge*), 1892; and *Yvette Guilbert*, 1894. He was inspired by Edgar Degas and by Japanese prints. His works combine concise lines with decorative elements, and provide a psychological study of society.

**TURNER, JOSEPH MALLORD WILLIAM (1775–1851)**
English painter, watercolor artist, and engraver. He was first and foremost an engraver, but during a visit to Wales painted his first landscapes, including *Moonlight, a Study at Millbank*, 1797. In 1820 he traveled to France and Switzerland, and thereafter continued to travel all over the continent. During his travels he made a series of watercolors and sketches that strove to portray variations in atmosphere, moving farther and farther from the object.

**TZARA, TRISTAN (1896–1963)**
French writer of Romanian origin. In 1916 he founded the dada movement in Zurich. Tzara came to Paris in 1920, left the dada movement, and became interested in surrealism. He joined the communist party but rejected the idea of politicized poetry. Throughout his life he wrote poetry, plays, essays, and articles that expressed his ideological evolution and the preoccupations of his era.

**VALENCIENNES, PIERRE HENRI (1750–1819)**
Painter. He was the main figure working in the genre that combined history painting and landscapes. In Rome he studied the works of Claude Lorrain and Nicolas Poussin.

**VELDE, HENRY VAN DE (1863–1957)**
Belgian painter, architect, decorator, and theoretician. In around 1893, after training as a painter, he took an interest in architecture and decorative arts, in particular William Morris's Arts and Crafts movement. He represented art nouveau in his various decorative and architectural designs in Europe. In 1906 he founded the Weimar School of Applied Arts, which later became the Bauhaus.

**VERNET, CLAUDE-JOSEPH (1714–1789)**
Painter, draftsman, and engraver. Vernet's views of Rome, Naples, and their surroundings, made while he lived in Italy (1734–1753) and greatly influenced by Nicolas Poussin and Claude Lorrain, foreshadowed the Italian landscapes of Camille Corot and reveal an almost Romantic sentiment about nature. In 1753 Louis XV commissioned him to paint a series of the seaports of France (now in the Louvre).

**VERNET, HORACE (1789–1863)**
Painter. A supporter of Napoleon, Vernet painted large-scale military scenes, horses, and sailors. He was rejected by the Salon in 1822, though he exhibited his works in his own studio with success. He also painted a portrait of *Charles X*, a ceiling in the Louvre, and various picturesque scenes. He became director of the Academy of France in Rome and traveled widely in Algeria and Russia, where he painted *La Prise de Varsovie* (*The Capture of Warsaw*). Among his works are *La Prise de la Smala* (*The Capture of Smalah*) and *La Bataille du pont d'Arcole* (*Battle of the Bridge of Arcole*).

**VIEN, JOSEPH-MARIE (1716–1809)**
Painter and engraver. Jacques-Louis David was one of his students. Vien stayed in Rome from 1743 to 1750 and again from 1771 to 1780, living in the artistic environment engendered by his discovery of the sites of Herculaneum and Pompeii. This led to his enthusiasm for the neoclassical movement, which he actively promoted.

**VIGÉE-LEBRUN, ELISABETH (1755–1842)**
Painter. Influenced by Jean-Baptiste Greuze, she specialized in portraits and became the official portrait painter of Marie-Antoinette; see *La Reine et ses enfants* (*Queen Marie-Antoinette with Her Children*), 1787. When the Revolution began she emigrated, and for many years traveled throughout Europe. She returned to France in 1802, and from 1810 painted landscapes.

**VIGNON, CLAUDE (1593–1670)**
Painter and engraver. He almost certainly studied painting under Georges Lallemant. During a stay in Rome (1616–1620) Vignon encountered the Caravaggisti, a loose group of artists influenced by Caravaggio. He also studied Venetian art of cinquecento, but remained closely tied to mannerism, as seen in *Joueurs de flute* (*Flute Players*) and *Chanteur* (*Young Singer*). He achieved marvelous results in his mystical works.

**VILLARD DE HONNECOURT (mid-thirteenth century)**
Draftsman. He was a contemporary of Saint Louis and a witness to the epoch of rayonnant architecture. He is famous for his *Portfolio*, a collection of sketches that includes building plans, designs for war machines, and combat and religious scenes. He traveled throughout Europe, and may have contributed to the construction of the Cambrai Cathedral.

**VILLON, JACQUES (GASTON DUCHAMP; 1875–1963)**
Painter and engraver. He was first and foremost an engraver and draftsman, publishing his sketches in different magazines. His first paintings were influenced by impressionism and fauvism, then later by cubism. Around 1911 Villon organized regular meetings of a group of cubist artists, called the *Section d'or* (*Golden Section*), in his studio. His paintings used sparing, light colors to depict abstract compositions of lines and planes; for example, *Soldats en marche* (*Marching Soldiers*), 1913.

**VIOLLET-LE-DUC, EUGÈNE EMMANUEL (1814–1879)**
Architect and writer. He traveled in Italy, Sicily, and France, then joined the restoration work on the Sainte-Chapelle in Paris. He participated in the restoration of Notre-Dame with Jean-Baptiste Lassus in 1845, and became architect of Saint-Denis in 1846. He worked in several cities in France before being elected city councilor for the Montmartre district.

**VLAMINCK, MAURICE DE (1876–1958)**
Painter, illustrator, engraver, and writer. He was an admirer of Vincent van Gogh and one of the founders of fauvism. Vlaminck painted canvases dominated by pure colors and contrasting effects, as in *Les Arbres rouges* (*Red Trees*), 1906. As his style evolved, he was influenced by Paul Cézanne and began using milder colors and a more precise touch, as in *La Maison à l'auvent* (*The Painter's House*), 1920. Vlaminck also wrote several novels.

**VOLLARD, AMBROISE (1868–1939)**
Art merchant, editor, and writer. A great collector, Vollard discovered and supported many talented artists—Paul Cézanne, Paul Gauguin, Odilon Redon, and Pablo Picasso—and held exhibitions of their works. Auguste Renoir, Picasso, and Pierre Bonnard all painted him. Vollard published works on some of the artists he became close to, including *Renoir*, 1920.

**VOUET, SIMON (1590–1649)**
Painter. In 1611 he accompanied the French ambassador to Turkey on a trip to Constantinople, where Vouet painted a portrait of Sultan Mustafa I, then spent fifteen years in Italy, where he enjoyed the patronage of Cardinal Barberini in Rome and of the Dorias in Genoa. He became Prince of the Academy of Saint Luke in 1624, and painted genre scenes and religious subjects. In 1627 Vouet was called back to France and named First Painter to the king, for whom he painted decorations in the châteaux Chilly, Saint-Germain, and Wideville as well as Hôtel Bullion and Hôtel Seguier. His status declined when Nicolas Poussin arrived in Paris.

**VUILLARD, EDOUARD (1868–1940)**
Painter and printmaker. He was a member of the Nabis group, and drew inspiration from the symbolist movement and Japanese prints. He painted interior scenes like *Femme balayant* (*Woman Sweeping*), 1892–1893; as well as street scenes, portraits, and gardens, such as *Jardins publics, la conversation* (*The Conversation*), 1894.

**WATTEAU, JEAN-ANTOINE (1684–1721)**
Painter. He was accepted into the academy in 1717 with his painting *L'Embarquement pour Cytère* (*Embarkment for Cythera*). He launched a new pictorial style influenced by the works of Peter Paul Rubens, called *fêtes gallantes*: genre scenes of romantic parties, society life, and the world of theater. This style had a lasting impact on European painting; well known examples include *Pierrot* and *Les Charmes de la vie* (*Delights of Life*).

**WINTERHALTER, FRANZ XAVER (1805–1873)**
German painter. He painted a portrait of the Grand Duke Leopold of Baden (c. 1830), who named him painter to his court. Winterhalter came to Paris in 1834, where he became the nobility's fashionable portrait painter. Well-known among his many portraits are *Empress Eugénie*, c. 1852 and 1854; *Mademoiselle Rimsky-Korsakova*, 1864; as well as L'*Impératrice entourée des dames du palais* (*The Empress Eugénie Surrounded by Her Maids of Honor*), 1855.

**WORTH, CHARLES-FRÉDÉRIC (1825–1895)**
English-born couturier. He worked in the fabric trade in Paris and in 1860 opened his own business. Worth was the first to present his designs in an annual show with live models. Later he served as Empress Eugénie's personal couturier, giving him immense influence over French society. Worth is considered the founder of *haute couture* (high fashion).

**ZADKINE, OSSIP (1890–1967)**
French sculptor and engraver of Russian origin. Zadkine settled in Paris in 1909 and joined the cubist movement, applying its principles to sculpture. Influenced by African art, he sculpted wood, stone, and bronze, playing with convex and concave, empty and full spaces. World War II inspired him to create *La Ville détruite* (*The Destroyed City*), 1947–1954.

# BIBLIOGRAPHY

This bibliography, which could have consisted of a bibliography of Paris and a bibliography of French art, only contains works consulted by the author of the present volume, from which he drew directly, or which in his estimation are worthy of citation. The bibliography was compiled with the assistance of Eglantine Reymond.

GENERAL WORKS AND WORKS PARTICULARLY APPLICABLE TO MORE THAN THREE CHAPTERS
ALCOUFFE, D., A. DION-TENENBAUM, A. LEFEBURE, et al. *Le Mobilier du musée du Louvre*. Dijon, 1993, 2 vol. / *L'Art de vivre. Decorative arts and design in France 1789–1989*. Multiple authors. New York, 1989. / AUBERT, M., and M. BEAULIEU. *Musée du Louvre. Description raisonnée des sculptures du Moyen Age et de la Renaissance*. 1950. / AUBERT, M., A. CHASTEL, L. GRODECKI, J. GRUBER, J. LAFOND, F. MATHEY, J. TERACON, and J. VERRIER. *Le Vitrail français*. 1958. / AULANIER, C. *Histoire du palais et du musée du Louvre*. 1948–71, 11 vol. / BABELON, J.-P. "D'un fossé à l'autre. Vingt ans de recherches sur le Louvre," in *revue de l'art*, nr. 78 (1987), pp. 5–25. / BABELON, J.-P., M. FLEURY, and J.-S. SACY. *Richesses d'art du quartier des Halles, maison par maison*. 1968. / BAUCHAL, C. *Nouveau Dictionnaire biographique et critique des architectes français*. 1887. / BAULANT, M. "Le Salaire des ouvriers du bâtiment à Paris de 1400 à 1726," in *Annales, Economies, Sociétés, Civilisations*. 1971, pp. 463–481. / BEAULIEU, M., and V. BEYER. *Dictionnaire des sculpteurs français du Moyen Age*. 1992. / BEAUNE, C. *Les Manuscrits des rois de France au Moyen Age. Le miroir du pouvoir*. 1997. / BELLIER DE LA CHAVIGNERIE, E., and L. AUVRAY. *Dictionnaire général des artistes de l'Ecole française depuis l'origine jusqu'à nos jours*. 1882–85, 3 vol. / BERGERON, L., ed. *Paris, naissance d'un paysage*. 1989. / BERTY, A., H. LEGRAND, L.-M. TISSERAND, and C. PLATON. *Topographie historique du Vieux Paris*. 1885–97, 6 vol. / BEZOMBES, D., ed. *Le Grand Louvre: histoire d'un projet*. 1994. / BIVER, P. and M.-L. *Abbayes, monastères et couvents de Paris, des origines à la fin du XVIII*ᵉ *siècle*. 1970. / —. *Abbayes, monastères et couvents de femmes à Paris, des origines à la fin du XVIII*ᵉ *siècle*. 1975. / BLUNT, A. *Art and Architecture in France 1500–1700*. Harmondsworth, 1980. / BOINET, A. *Les Eglises parisiennes*. 1958–64. / BONNARDOT, A. *Dissertations archéologiques sur les anciennes enceintes de Paris, suivies de recherches sur les portes fortifiées qui dépendaient de ces enceintes*. 1852–53. / BOUCHER, F. *Histoire du costume en Occident, de l'Antiquité à nos jours*. 1983. / BOUDON, F., A. CHASTEL, H. COUZY, and F. HAMON. *Système de l'architecture urbaine. Le Quartier des Halles à Paris*. 1977, 2 vol. / BOUILLART, Dom J. *Histoire de l'abbaye royale de Saint-Germain des Prés*. 1724. / BOUILLON, J.-P. *Journal de l'Art déco*. Geneva, 1988. / BROCHARD, L. *Saint-Gervais*. 1938–50, 2 vol. / BRUNEL, G., M.-L. DESCHAMPS-BOURGEON, and Y. GAGNEUX. *Dictionnaire des églises de Paris*. 1995. / BUSSON, D. *Carte archéologique de la Gaule*. 1998. / CHARTIER, R., and H.-J. MARTIN, ed. *Histoire de l'édition française*. 1983–86, 4 vol. / CHASTEL, A. *L'Art français*. 1993–96, 4 vol. / CHÂTELET, A., and J. THUILLIER. *La Peinture française*. Vol. I *De Fouquet à Poussin*. Vol. II *De Le Nain à Fragonard*. Geneva, 1963–64. / *Les Cisterciens à Paris*, exh. cat. Paris: Musée Carnavalet, 1986. / COHEN, J.-L., and B. FORTIER. *Paris, la ville et ses projets*. 1992 (new edition). / DELALAIN, P. *Etude sur le libraire parisien du XIII*ᵉ *au XV*ᵉ *siècle, d'après les documents publiés dans le "Cartulaire de l'Université de Paris."* 1891. / DELPIERRE, M. *Le Costume. De la Restauration à la Belle Epoque. De 1914 aux années folles*. 1990. / DÉRENS, J. *A la découverte des plans de Paris du XVI*ᵉ *au XVIII*ᵉ *siècle*. 1994. / DUBY, G., ed. *Histoire de la France urbaine*. 1980. / —, ed. *L'Histoire de Paris par la peinture*. 1988. / DU COLOMBIER, P. *Notre-Dame de Paris. Mémorial de la France*. 1966. / DUFOUR, V. *Collection d'anciennes descriptions de Paris*. 1878–83, 10 vol. / DUFOURCQ, N. *Le Livre de l'orgue français*. 1971–82, 6 vol. / ERLANDE-BRANDENBURG, A., and A.-B. MEREL-BRANDENBURG. *Histoire de l'architecture française. Du Moyen Age à la Renaissance IV–début XVI*ᵉ. 1995. / *L'Europe gothique, XII*ᵉ*–XIV*ᵉ *siècles*, exh. cat. Paris: Louvre, 1968. / *Evolution de la Géographie industrielle de Paris et sa proche banlieue*. Multiple authors. 1976. / FABRE, G. "Les monnaies des Parisii," in *L'Histoire de Paris depuis 200 ans*, exh. cat. Monnaie de Paris, 1950. / FARÉ, M. *La Nature morte en France. Son histoire et son évolution du XVII*ᵉ *au XX*ᵉ *siècle*. Geneva, 1962–63, 2 vol. / FAVIER, J. *Paris, deux mille ans d'histoire*. 1997. / FÉLIBIEN, Dom M. *Histoire de l'abbaye royale de Saint-Denys en France*. 1706. / FÉLIBIEN, Dom M. *Histoire de la Ville de Paris*. 1725, 5 vol. / FENAILLE, M. *Etat général des tapisseries de la manufacture des Gobelins depuis son origine jusqu'à nos jours 1600–1900*. 1904–07. / FERAY, J. *Architecture intérieure et décoration en France des origines à 1875*. 1988. / FIERRO, A. *Paris, Histoire et Dictionnaire*. 1996. / FLEURY, M., A. ERLANDE-BRANDENBURG, and J.-P. BABELON. *Paris monumental*. 1973. / FLEURY, M., and V. KRUTA. *Le Château du Louvre*. 1989. / FLEURY, M., and G.-M. LEPROUX, ed. *Les Saints Innocents*. 1990. / FRANKLIN, A. *Dictionnaire historique des arts, métiers et professions exercés dans Paris*. 1906, 2 vol. / GADY, A. *Le Marais, guide historique et architectural*. 1994. / GAUDRIAUET, R. *La Gravure de mode féminine en France*. 1983. / GAUTHIER, M.-M. *Emaux du Moyen Age occidental*. Fribourg, 1972. / GERARDS, E. *Paris souterrain*. 1908, ed. of 1991. / GUÉROUT, J. "Le Palais de la Cité à Paris, des origines à 1417," in *Mémoires de la Fédération des Sociétés historiques et archéologiques de Paris et de l'Ile-de-France*. 1949, vol. I, pp. 57–212, vol. II, pp. 21–204, vol. III, pp. 7–101. / GRILLERAU, A. *Bâtir la ville. Révolutions industrielles*

dans les matériaux de construction; France-Grande Bretagne. Champ Valle, 1995. / GRODECKI, L. Ivoires français. 1947. / —. Le Moyen Age retrouvé. I De l'an mil à l'an 1200. II De Saint-Louis à Viollet-le-Duc. 1986, 1990. / —. Le Vitrail français. 1958. / GUIFFREY, J. Les Manufactures nationales de tapisserie. Les Gobelins et Beauvais. 1905. / —. Artistes parisiens du XVIᵉ et du XVIIᵉ siècle. 1915. / —. Histoire de l'Académie de Saint-Luc. 1915. / GUILMARD, D. Les Maîtres ornemanistes, Dessinateurs, Peintres, Architectes, Sculpteurs et Graveurs. 1880–81, 3 vol. / HAUTECOEUR, L. Histoire de l'architecture classique en France. 1943–57, 9 vol. / —. Paris. 1972, 2 vol. / HÉNARD, E. Etude sur les transformations de Paris. 1903–09. / HOPKINS, J. Paris in the Age of Absolutism. 1968. / JOBÉ, J. Le Grand livre de la tapisserie. Lausanne, Paris, 1965. / JURGENS, M., and P. COUPERIE. "Le Logement à Paris aux XVIᵉ et XVIIᵉ siècles: Une source, les inventaires après décès" in Annales, Economies, Sociétés, Civilisations. 1962. / KOECHLIN, R. Ivoires gothiques français. 1924, 3 vol. / LACLOTTE, M., and J.-P. CUZIN, ed. Petit Larousse de la peinture. 1979, 2 vol. / LAMBEAU, L. L'hôtel de ville de Paris des origines jusqu'à 1871. 1920. / LAMI, S. Dictionnaire des sculpteurs de l'Ecole française au XIXᵉ siècle. 1914–21. / LANDAU, B., C. MONOD, and E. LOHR, editors. Les Grands Boulevards. 2000. / LAVEDAN, P. "Histoire de l'urbanisme à Paris," in Nouvelle Histoire de Paris. 1993 (2nd ed.). / LEHOUX, F. Le Bourg Saint-Germain-des-Prés depuis ses origines jusqu'à la fin de la guerre de Cent Ans. 1951. / LE MOËL, M., and J. DÉRENS. La Place de Grève. 1991. / LE MOËL, M., and R. SAINT-PAUL. Le Conservatoire national des Arts et Métiers. 1994. / LEMOINE, B. Les Halles de Paris. 1980. / LE QUÉRÉ, A. Orfèvres et Changeurs d'après les registres du Parlement. 1973. / LE ROUX DE LINCY, A.-J.-V., and L.-M. TISSERAND. Paris et ses historiens, documents et écrits aux XIVᵉ et XVᵉ siècles. 1867. / LE ROY LADURIE, E., and P. COUPERIE. "Le Mouvement des loyers parisiens de la fin du Moyen Age au XVIIIᵉ siècle" in Annales E.S.C., 1970 (4th ed.), pp. 1002–23. / LESPINASSE, R. de. Les Métiers et Corporations de la Ville de Paris. Recueil, statuts, règlements depuis le XIIIᵉ siècle jusqu'à la fin du XVIII. 1886–97, 3 vol. / LORTIE, A. Paris s'exporte. Modèle d'architecture ou architectures modèles. 1995. / MABILLE, G. Orfèvrerie française du XVIᵉ, XVIIᵉ et XVIIIᵉ siècles. Catalogue raisonné des collections du musée des Arts décoratifs et du musée Nissim de Camondo. 1984. / MAHIEU, B. L'Eglise Saint-Etienne du Mont de Paris. 1985. / Les Manuscrits à peintures en France du VIIᵉ au XIIᵉ siècle, exh. cat. Paris: Bibliothèque nationale, 1954. / Les Manuscrits à peintures en France du XIIIᵉ au XVIᵉ siècle, exh. cat. Paris: Bibliothèque nationale, 1955. / Le Marais, mythe et réalité, exh. cat. Paris: Hôtel de Sully, 1987, contributions by J.-P. Babelon, J.-M. Léri, and D. Lavalle. / MARREY, B., and M.-J. DUMONT. La Brique à Paris. 1991. / MESQUI, J. Ile-de-France gothique. II. Les Demeures seigneuriales. 1988. / MOLLAT, M., ed. Histoire de l'Ile-de-France et de Paris. Toulouse, 1971. / MONTESQUIOU-FEZENSAC, B. de, and D. GABORIT-CHOPIN. Le Trésor de Saint-Denis. 1973–77, 3 vol. / Musée du Louvre. Département des sculptures. Sculptures françaises. I Moyen Age II Renaissance et Temps modernes, edited by J.-R. Gaborit. 1996. / NOCQ, H. Le Poinçon de Paris; Répertoire des maîtres orfèvres de la juridiction de Paris depuis le Moyen Age jusqu'à la fin du XVIII. 1926–31, 5 vol. / Orfèvrerie civile française du XVIᵉ au début du XIXᵉ siècle. 1926, 2 vol. / NORA, P., ed. Les Lieux de mémoire. 1984, 1986, 1992. / Les Ordres mendiants à Paris, cat. edited by J.-P. Willesme. 1992. / Les Orgues de Paris, texts collected by M. Le Noël. 1992. / Le Palais-Royal, exh. cat. Paris: Musée Carnavalet, 1988. / PARDAILHÉ-GALABRUN, A. La Naissance de l'intime: 3000 foyers parisiens, XVIIᵉ–XVIIIᵉ siècles. 1988. / PARENT-DUCHATELET, A. Paris. Genèse d'un paysage. 1989. / Paris Guide, par les principaux écrivains et artistes de la France. 1867, 2 vol. / PÉROUSE DE MONTCLOS, J.-M. Histoire de l'architecture française: de la Renaissance à la Révolution. 1989. / —, ed. Le Guide du patrimoine. Paris. 1994. / PERROT, M., ed. Histoire de la vie privée. 1987. / PINON, P. Paris, biographie d'une capitale. 1999. / POISSON, G. Histoire de l'Elysée. 1997 (3rd ed.). / —. "Histoire de l'architecture à Paris" in Nouvelle Histoire de Paris. 1997. / POMIAN, K. Collectionneurs, amateurs et curieux: Paris, Venise: XVIᵉ–XVIIIᵉ siècles. 1987. / PONS, B. Grands décors français 1650–1800. 1995. / PRADÈRE, A. Les Ebénistes français de Louis XIV à la Révolution. 1989. / PRÉAUD, M., P. CASSELLE, M. GRIVEL, and C. LE BITOUZÉ. Dictionnaire des éditeurs d'estampes à Paris sous l'Ancien Régime. 1987. / PRÉAUD, M., et al. Dictionnaire des éditeurs d'estampes à Paris sous l'Ancien Régime. 1987. / PRIS, C. La Manufacture royale des glaces de Saint-Gobain, 1665–1830, une grande entreprise sous l'Ancien Régime. Lille, 1975, 3 vol. / Procès-verbaux de l'Académie Royale de Peinture et de Sculpture, 1648–1793, published by the Société d'histoire de l'art français following the national registers conserved at the Ecole des Beaux-Arts. 1875–92, 10 vol. / QUONIAM, P., and L. GUINAMARD. Le Palais du Louvre. 1988. / Recensement des vitraux anciens de la France; CNRS-Ministère de la Culture: Paris, Région parisienne, Picardie, Nord-Pas-de-Calais. 1978. / RIGAULT, J. "Document sur les hôtels particuliers des ducs de Bourgogne" in Comité des travaux historiques et scientifiques, section de philologie et d'histoire, Actes du 100ᵉ Congrès national des sociétés savantes. 1975, vol. II, pp. 129–133. / ROCHE, D. La Culture des apparences. Une histoire du vêtement. XVIIᵉ–XVIIIᵉ siècles. 1989. / Le Roi, la Sculpture et la Mort, gisants et tombeaux de la basilique de Saint-Denis, exh. cat. Saint-Denis: Archives de la Seine-Saint-Denis, 1975, contributions by A. Erlande-Brandenbourg, J.-P. Babelon, F. Jenn, and J.-M. Jenn. 1975. / ROSENFELD, M.-N. "La Distribution des palais et des hôtels à Paris: du XIVᵉ au XVIᵉ siècle" in Architecture et vie sociale. Actes du colloque du Centre d'Etudes supérieures de la Renaissance. Tours, 1988, 1994, pp. 207–220. / ROUX, S. "La Construction courante à Paris du milieu du XIVᵉ siècle à la fin du XVᵉ siècle," in La Construction au Moyen Age, histoire et archéologie. 1973, pp. 175–198. / —. "Le quartier de l'Université à Paris du XIIIᵉ au XVᵉ siècle: étude urbaine" in Les Cahiers de l'Institut de recherches marxistes, nr. 38 (1989), pp. 125–131. / SAINTE-FARE GARNOT, N. L'Hôpital Saint-Louis. 1986. / SAINTE-FARE GARNOT, N., and E. JACQUIN. Le Château des Tuileries. 1988. / Saint-Germain des Prés, exh. cat. Archives nationales. 1958. / SAUERLÄNDER, W. Die Académie Royale d'Architecture, 1671–1793: Anatomie einer Institution. Cologne, Weimar, Vienna, 1993. / STEIN, H. Le Palais de Justice et la Sainte-Chapelle de Paris. Historical and archeological note. 1972 (new ed.). / STERLING, C. La peinture médiévale à Paris, 1300–1500. 1987–90, 2 vol. / THORNTON, P. L'Epoque et son style: la décoration intérieure: 1620–1920. 1986. / Le Trésor de Saint-Denis, exh. cat. (with contributions by D. Alcouffe, F. Avril, and D. Gaborit-Chopin). Paris: Louvre, 1991. / VERLET H. "Les Bâtiments monastiques de l'abbaye de Saint-Germain des Prés" in Paris et Ile-de-France, Mémoires, vol. IX. 1957–58, pp. 9–68. / VERLET, P. Le Mobilier royal français. 1900–94, 4 vol. / VIDAL, P., and L. DURU. Histoire de la corporation des marchands merciers, grossiers, joailliers […]. 1911. / VIEILLARD-TROIEKOUROFF, M., D. FOSSARD, E. CHATEL, and LAMY-LASSALE. "Les Anciennes églises suburbaines de Paris (IVᵉ–Xᵉ siècles)" in Paris et Ile-de-France, Mémoires, vol. XI. 1960. / Les Vitraux de Paris, de la région parisienne, de la Picardie et du Nord Pas de Calais, volume of the corpus vitrearum medii aevi, established under the direction of L. Grodecki, J. Tabalon, and F. Perrot, 1978. / WILHELM, J. Les Peintres du paysage parisien du XVᵉ siècle à nos jours. 1944.

CHAPTER I

BOUSSARD, J. Paris, de la fin du siège de 885–886 à la mort de Philippe Auguste in Nouvelle Histoire de Paris. 1976. / COLBERT DE BEAULIEU, J.-B. Les Monnaies gauloises des Parisii. 1970. / DION, R. Paris dans les récits historiques et légendaires, du IXᵉ au XIIᵉ siècle. Tours, 1949. / DUVAL, P.-M. De Lutèce oppidum à Paris capitale de la France in Nouvelle Histoire de Paris. 1993. / FLEURY, M. "La cathédrale mérovingienne Saint-Etienne" in Si le roi m'avait donné […]. 1995, pp. 161–174. / —, and A. FRANCE-LANORD. "Les bijoux mérovingiens d'Arnegonde" in Art de France, vol. I, 1961, pp. 7–17. / HATT, J.-J. Les monuments gallo-romains de Paris, et les origines de la sculpture votive en Gaule romaine. 1952. / LOMBARD-JOURDAN, A. Montjoie et Saint-Denis: le centre de la Gaule aux origines de Paris et de Saint-Denis. 1989. / Lutèce: Paris de César à Clovis, exh. cat. Paris: Musée Carnavalet, 1984. / MOHEN, J.-P. L'Age de bronze dans la région de Paris; catalogue synthétique des collections conservées au Musée des Antiquités nationales. 1977. / Paris mérovingien, exh. cat. Paris: Musée Carnavalet, 1981–82. / PÉRIN, P., L. RENOU, and VELAY. Collections mérovingiennes et du haut Moyen Age du musée Carnavalet. 1985. / Recueil général des monuments sculptés en France pendant le haut Moyen Age (IVᵉ–Xᵉ siècles). I. Paris et son département. 1978, 4 vol. / SANDRON, D. "Saint-Germain-des-Prés, les ambitions de la sculpture de la nef romane" in Bulletin monumental, 1995 (4th ed.), pp. 333–350. / SEMMLER, J. "Die Residenzen der Fürsten und Prälaten im mittelalterlichen Paris (12.–14. Jahrhundert)" in Mélanges offerts à René Crozet. 1966, vol. II, pp. 1217–36. / VELAY, P., ed. Les bronzes antiques de Paris. 1989. / —. De Lutèce à Paris. 1992.

CHAPTER II

BOUSSARD, J. op. cit. / CROSBY, S. Mck. L'Abbaye royale de Saint-Denis. 1953. / CURZON, H. de La Maison du Temple de Paris. Histoire et description. 1888. / DION, R. Paris dans les récits historiques et légendaires, du IXᵉ au XIIᵉ siècle. Tours, 1949. / ERLANDE-BRANDENBURG, A. Notre-Dame de Paris. 1991. / FLEURY, M. "Paris du Bas-Empire au début du XIIIᵉ siècle" in Paris croissance d'une capitale. Colloques, Cahiers de civilisation. 1961, pp. 73–96. / GRODECKI, L. Etude sur les vitraux de Suger à Saint-Denis: XIIᵉ siècle. 1995. / KIMPEL, D., and R. SUCKALE. L'Architecture gothique en France, 1130–1270. Munich, 1985. / SEMMLER, J. op. cit.

CHAPTER III

L'Art au temps des rois maudits Philippe le Bel et ses fils, 1285–1328, exh. cat. Paris: Grand Palais, 1998. / AUBERT, M., L. GRODECKI, J. LAFOND, and J. VERRIER. Les Vitraux de Notre-Dame et de la Sainte-Chapelle. 1959. / BARON, F. "Enlumineurs, peintres et sculpteurs parisiens des XIIIᵉ et XIVᵉ siècles d'après le rôle de la taille" in Bulletin archéologique du Comité des travaux historiques et scientifiques. 1968, pp. 37–121. / BENNERT, V. "Art et propagande sous Philippe IV le Bel: le cycle des rois de France dans la Grande Salle du Palais de la Cité" in revue de l'art, nr. 97 (1992), pp. 46–59. / BRANNER, R. Saint-Louis and the Court Style in Gothic Architecture. London, 1965. / —. Manuscript Painting in Paris During the Reign of Saint-Louis. Berkeley, 1977. / CAZELLES, R. Paris, de la fin du règne de Philippe Auguste à la mort de Charles V, 1223–1380 in Nouvelle Histoire de Paris. 1972. / CURZON, H. de. op. cit. / ERLANDE-BRANDENBURG, A. op. cit. / ERLANDE-BRANDENBURG, A. Le Roi est mort. Etude sur les funérailles, les sépultures et les tombeaux des rois de France jusqu'à la fin du XIIIᵉ siècle. 1975. / La France de Saint-Louis. Septième centenaire de la mort de Saint-Louis, exh. cat. Paris: Salle des Gens d'armes du Palais, 1970–71. / FREIGANG, G. Imitare ecclesias nobiles. Die Kathedralen von Narbonne, Toulouse und Rodez und die nordfranzösische Rayonnant-Gotik in Languedoc. Worms, 1992. / KIMPEL, D., and R. SUCKALE. op. cit. / LENIAUD, J.-M., and F. PERROT. La Sainte-Chapelle; 1991. / MORAND, K. Jean Pucelle. Oxford, 1962. / SEMMLER, J. op. cit.

CHAPTER IV

L'Art européen vers 1400, exh. cat. Vienna: Kunsthistorisches Museum, 1962. / AVRIL, F. L'Enluminure à la cour de France au XIVᵉ siècle. 1978. / BARON, F. op. cit. / —. "Enlumineurs, peintres et sculpteurs parisiens des XIVᵉ et XVᵉ siècles d'après les archives de l'hôpital Saint-Jacques-aux-Pélerins" in Bulletin archéologique du Comité des travaux historiques et scientifiques. 1970, pp. 77–115. / —. "Les arts précieux à Paris aux XIVᵉ et XVᵉ siècles d'après les archives de l'hôpital Saint-Jacques-aux-Pélerins. Répertoire des artistes et des travaux" in Bulletin archéologique du Comité des travaux historiques et scientifiques. 1984–85, pp. 59–141. / BOS, H. "L'architecture religieuse flamboyante à Paris (1436–vers 1500)" in Positions des thèses de l'Ecole des Chartes. 1997, pp. 63–71. / CAZELLES, R. Paris, de la fin du règne de Philippe Auguste à la mort de Charles V, 1223–1380 in Nouvelle Histoire de Paris. 1972. / CHAPELOT, J. Le Château de Vincennes. Une résidence royale au Moyen Age. 1994. / —. La Peinture française, XVᵉ et XVIᵉ siècles. Geneva, 1962. / Les Fastes du gothique: le siècle de Charles V, exh. cat. Paris: Galeries nationales du Grand Palais, 1981–82. / GABORIT-CHOPIN, D. Ivoires du Moyen Age. Fribourg, 1978. / GUÉNÉE, B., and F. LEHOUX. Les Entrées royales françaises de 1328 à 1515. 1968. / HEINRICHS-SCHREIBER, U. Vincennes und die höfische Skulptur: die Bildhauerkunst in Paris 1360–1420. Berlin, 1997. / La Librairie de Charles V, exh. cat. Paris: Bibliothèque nationale, 1968. / Les Manuscrits à peintures en France, 1430–1515, exh. cat. Paris: Bibliothèque nationale, 1993. / MEISS, M. French Painting in the Time of Jean de Berry. London, New York, 1967–76, 5 vol. / MIROT, L. "La Formation et le démembrement de l'hôtel Saint-Pol" in Bulletin de la Société historique et archéologique du IVᵉ arrondissement de Paris. La Cité. 1916, pp. 269–319. / —. "Paiements et quittances de travaux exécutés sous le règne de Charles VI, 1380–1422" in Bibliothèque de l'Ecole des Chartes, nr. 81 (1920), pp. 183–304. / POGNON, E. Les Très riches heures du duc de Berry. Manuscrit enluminé du XVᵉ siècle. Fribourg, Geneva, 1979–83. / REYNAUD, N. "Les heures du chancelier Guillaume Jouvenel des Ursins et la miniature parisienne autour de 1440" in revue de l'art, nr. 126 (1999), pp. 23–35. / ROBIN, F. "Louis d'Anjou et le rayonnement de l'art parisien (1360–1380)" in Journal of Medieval History. 1986, pp. 55–80. / Sous les pavés, la Bastille. Archéologie d'un mythe révolutionnaire, exh. cat. Paris, 1989–90, contributions by C. Corvisier, A. Erlande-Brandenburg, N. Faucherre, J. Mesqui, and M. Whiteley. / La Tenture de l'Apocalypse d'Angers in Cahier de l'Inventaire nr. 4. Nantes, 1987 (2nd ed.). / WHITELEY, M. "Le Louvre de Charles V: disposition et fonction d'une résidence royale" in revue de l'art, nr. 97 (1992), pp. 60–71.

CHAPTER V

L'Ancien Hôtel de Ville de Paris et la place de Grève, exh. cat. Paris: Musée Carnavalet. 1975. / AVRIL, F., and N. REYNAUD. Manuscrits à peintures en France 1440–1520. 1993. / BABELON, J.-P. Paris au XVIᵉ siècle in Nouvelle Histoire de Paris. 1986. / BARON, F. op. cit. / BIMBENET-PRIVAT, M. "L'orfèvrerie parisienne de la Renaissance: trésors dispersés" in Estampille, L'Objet d'art, nr. 294 (1995), pp. 50–59. / —. Les Orfèvres parisiens de la Renaissance (1506–1620). 1992. / Bos, H. op. cit. / BOUDON, F., and M. CHATENET. "Les logis des rois de France au XVIᵉ siècle" in Architecture et vie sociale à la Renaissance, acts of the colloquium of the Centre d'Etudes supérieures de la Renaissance. Tours, 1988, 1994, pp. 65–82. / CHARTROU, J. Les Entrées solennelles et triomphales à la Renaissance (1484–1551). 1928. / CHÂTELET, A. La Peinture française. XVᵉ et XVIᵉ siècles. Geneva, 1962. / FAVIER, J. Paris au XVᵉ siècle, 1380–1500, in Nouvelle Histoire de Paris. 1996 (2nd ed.). / FONTANA, V. Fra Giovanni Giocondo architetto, 1433–1515. Vicenza, 1988. / Jean Fouquet, exh. cat. Paris: Louvre, "Dossier du département des peintures," nr. 22 (1981), contribution by N. Reynaud. / GUÉNÉE, B., and F. LEHOUX. op. cit. / LEPROUX, G.-M. Recherches sur les peintres-verriers parisiens de la Renaissance 1540–1620. Geneva, 1988. / LESUEUR, P. Dominique de Cortone dit Le Boccador: du château de Chambord à l'hôtel de ville de Paris. 1928. / LESUEUR, P. "Fra Giocondo en France" in Bulletin de la Société de l'histoire de l'art français. 1931, pp. 115–144. / Les Manuscrits à peintures en France, 1430–1515, exh. cat. Paris: Bibliothèque nationale, 1993, contributions by F. Avril and N. Reynaud. / MELLEN, P. Jean Clouet, catalogue raisonné de son oeuvre complet: dessins, miniatures et peintures. 1971. / PARENT, A. Les Métiers du livre à Paris au XVIᵉ siècle (1535–1560). 1974. / POGNON, E. Les Très riches heures du duc de Berry. Manuscrit enluminé du XVᵉ siècle. Fribourg, Geneva, 1979–1983. / RENOUARD, P. Répertoire des imprimeurs parisiens, libraires, fondeurs de caractères et correcteurs d'imprimerie depuis l'introduction de l'imprimerie à Paris (1470) jusqu'à la fin du XVIᵉ siècle. 1965 (2nd ed.). / —. Imprimeurs et libraires parisiens du XVIᵉ siècle. 1964–82, 3 vol. (2 vol. publ.). / REYNAUD, N. "Les vitraux du choeur de Saint-Séverin" in Bulletin monumental 1985, pp. 25–40. / SANKOVITCH, A.-M. "A Reconsideration of French Renaissance Church Architecture" in L'Eglise et l'architecture de la Renaissance, acts of the colloquium of the Centre d'Etudes supérieures de la Renaissance, Tours, 1996, pp. 161–180. / SCHAEFER, C. Les Heures d'Etienne Chevalier de Jean Fouquet. 1971. / THOMSON, D. Renaissance Paris, Architecture and Growth 1475–1600. London, 1984. / VERDON, T. The Art of Guido Mazzoni. New York, 1978. / Vitraux de la Renaissance, exh. cat. Paris: Mayorate of the VIᵉ arrondissement, contributions by G.-M. Leproux. 1993. / WHITELEY, M. "Royal and ducal palaces in France in the Fourteenth and Fifteenth Centuries: Interior, Ceremony and Function" in Architecture et vie sociale à la Renaissance, acts of the colloquium of the Centre d'Etudes supérieures de la Renaissance, Tours, 1988, Paris, 1994, pp. 47–64. / ZERNER, H. L'Art de la Renaissance en France. L'invention du classicisme. 1996.

CHAPTER VI

BABELON, J.-P. "Du 'Grand Ferrare,' à Carnavalet, naissance de l'hôtel classique" in revue de l'art, nr. 40–41 (1978), pp. 83–108. / —. Paris au XVIᵉ siècle, in Nouvelle Histoire de Paris. 1986. / BIMBENET-PRIVAT, M. op. cit. / BOUDON, F. "Paris. Architecture mineure et lotissements du milieu du XVIᵉ siècle" in La Maison de ville à la Renaissance. Recherches sur l'habitat urbain en Europe aux XVᵉ et XVIᵉ siècles, acts of the colloquium of the Centre d'Etudes supérieures de la

Renaissance. Tours, 1977. Paris, 1983, pp. 25–30. / BOUDON, F., and M. CHATENET. "Les logis des rois de France au XVI<sup>e</sup> siècle" in *Architecture et vie sociale à la Renaissance*, acts of the colloquium of the Centre d'Etudes supérieures de la Renaissance. Tours, 1988, Paris 1994, pp. 65–82. / CHARTROU, J. op. cit. / CHÂTELET, A. op. cit. / *Les Clouet et la cour des rois de France*. 1900. / DU COLOMBIER, P. *Jean Goujon*. 1949. / *L'Ecole de Fontainebleau*, exh. cat. Paris: Grand Palais, 1972–73, edited by S. Béguin and M. Laclotte. / EHRMANN, J. *Antoine Caron, peintre à la Cour de Valois*. Geneva-Lille, 1955. / GARGIANI, R. *Idea e Costruzione del Louvre*. Florence, 1998. / GEYMÜLLER, H. von. *Les Du Cerceau, leur vie et leur oeuvre*. 1887. / GRAHAM, V.-E., and W. MACALLISTER JOHNSON. *The Paris Entries of Charles IX and Elizabeth of Austria. 1571*. Toronto, 1974. / GRODECKI, C. *Documents du Minutier central des notaires de Paris. Histoire de l'art au XVI<sup>e</sup> siècle (1540–1600)*. 1985–86, 2 vol. / LEPROUX, G.-M. op. cit. / MACFARLANE, I. D. *The Entry of Henry II into Paris, 16 June 1549*. New York, 1982. / MELLEN, P. *Jean Clouet, catalogue raisonné de son oeuvre complet: dessins, miniatures et peintures*. 1971. / *Paris et Catherine de Médicis*, and J.-P. Babelon). Paris: Mayorate of the I<sup>er</sup> arrondissement, 1989. / *La peinture de manuscrits à la cour de France au temps d'Henri II. Livres d'Heures royaux*, exh. cat. (with contributions by T. Crépin-Leblond and M. Dickmann Orth). Ecouen: Musée national de la Renaissance. 1993. / PÉROUSE DE MONTCLOS, J.-M. *Philibert De l'Orme, architecte du roi (1514–1570)*. 2000. / *Germain Pilon et les sculpteurs français de la Renaissance*, acts of the colloquium, Paris: Louvre. 1990, 1993. / *Reliures royales de la Renaissance. La librairie de Fontainebleau 1544–1560*, exh. cat. Paris: Bibliothèque nationale, 1999. / RENOUARD, P. op. cit. / SANKOVITCH, A.-M. op. cit. / THOMSON, D. op. cit. / *Vitraux parisiens de la Renaissance*, exh. cat. (with contributions by G.-M. Leproux). Paris: Mayorate of the VI<sup>e</sup> arrondissement, 1993. / WHITELEY, M. op. cit. / ZERNER, H. op. cit.

CHAPTER VII

ANDIA, B. de, and N. COURTIN, ed. *l'Ile Saint-Louis*. 1997. / ANDIA, B. de, and A. GADY, ed. *La Rue des Francs-Bourgeois*. 1992. / ARGAN, G. C. *L'Europe des capitales. 1600–1700*. Geneva, 1964. / BABELON, J.-P. *Demeures parisiennes sous Henri IV et Louis XIII*. 1991 (2nd ed.). / BABELON, J.-P., A. MÉROT, C. MIGNOT, et al. "L'Hôtel parisien au XVII<sup>e</sup> siècle" in XVII<sup>e</sup> siècle, nr. 162 (1989). / BABELON, J.-P., and C. MIGNOT, ed. *François Mansart. Le génie de l'architecture*. 1998. / BLUM, A.-S. *Abraham Bosse et la société française du XVII<sup>e</sup> siècle*. 1924. / BLUNT, A. *The Paintings of Nicolas Poussin. A Critical Catalogue*. London, 1966. / BOUCHER, F. *Le Pont Neuf*. 1925–26, 2 vol. / *Jacques Callot, 1592–1635*, exh. cat. (with contributions by P. Behar, A. Brejon de Lavergnée, et al.). Nancy: Musée historique Lorrain, 1992. / COOPE, R. *Salomon de Brosse and the Development of the Classical Style in French Architecture*. London, 1972. / *De la place Royale à la place des Vosges*, exh. cat. 1996. / DORIVAL, B. *Art et politique en France au XVII<sup>e</sup> siècle: la Galerie des Hommes illustres du Palais-Cardinal*. 1973. / ——. *Philippe de Champaigne. 1602–1674: la vie, l'oeuvre et le catalogue raisonné de l'oeuvre*. 1976, 2 vol. / ——. *Supplément au catalogue raisonné de l'oeuvre de Philippe de Champaigne*. 1992. / FARÉ, M. *Le Grand Siècle de la nature morte en France: le XVII<sup>e</sup> siècle*. Fribourg, 1974. / FERAULT, M.-A. "Charles Chamois architecte parisien (vers 1610–après 1684)" in *Bulletin monumental*, vol. 148 (1990), pp. 117–153. / FLEURY, M. *Documents du Minutier central concernant les peintres, les sculpteurs et les graveurs au XVII<sup>e</sup> siècle (1600–1650)*. 1969. / GARGIANI, R. op. cit. / GEYMÜLLER, H. von. op. cit. / GODARD DE DONVILLE, L. *Signification de la mode sous Louis XIII*. Aix-en-Provence, 1978. / GRIVEL, M. *Le Commerce de l'estampe à Paris au XVII<sup>e</sup> siècle*. Geneva, 1986. / LEPROUX, G.-M. "La Participation de Clément Métezeau à la construction de la façade de Saint-Gervais" in *Documents d'histoire parisienne*. 1992 (1st ed.), pp. 25–32. / *Marie de Médicis et le palais du Luxembourg*, exh. cat. (with contributions by B. de Andia, B. Barbiche, and M.-N. Baudouin-Matuszek). Paris: Mayorate of the XV<sup>e</sup> arrondissement, 1991. / MAZEROLLE, F. *Jean Varin, conducteur de la Monnaie du Moulin tailleur général des monnaies*. 1932. / MÉROT, A. *Eustache Le Sueur. 1616–1655*. 1987. / ——. *La Peinture française au XVII<sup>e</sup> siècle*. 1994. / ——. *Retraites mondaines. Aspects de la décoration intérieure à Paris au XVII<sup>e</sup> siècle*. 1990. / MIGNOT, C. *Le Val de Grâce*. 1984. / ——. *Pierre Le Muet architecte*, dissertation, Paris IV, 1991. Microfilm, Université de Lille III. / MONTAIGLON, A. de. *Catalogue raisonné de l'oeuvre de Claude Mellan*. Abbeville, 1856. / PACHT-BASSANI, P. *Claude Vignon (1593–1670)*. 1993. / *La Peinture française du XVII<sup>e</sup> siècle dans les collections américaines*, exh. cat. (with contributions by M. Fumaroli and P. Rosenberg). Paris: Grand Palais, 1982. / PETITJEAN, C., and C. WICKERT. *Catalogue de l'oeuvre gravée de Robert Nanteuil*. 1925. / PILLORGET, R. *Paris sous les premiers Bourbons 1594–1661* in *Nouvelle Histoire de Paris*. 1988. / *Plafonds parisiens du XVII<sup>e</sup> siècle*, extra edition of the *revue de l'art*, nr. 122 (1998). / *Poussin*, exh. cat. (with contributions by P. Rosenberg and L.-A. Prat). Paris: Grand Palais, 1994–95. / *Actes du colloque international Nicolas Poussin (1958)*, directed by A. Chastel. 1960, 2 vol. / RANUM, O. *Les Parisiens du XVII<sup>e</sup> siècle*. 1968–73. / *Richelieu et le monde de l'Esprit*, exh. cat. Paris: Sorbonne, 1985. / *Robert Nanteuil. 1623–1678*, exh. cat. Reims: Bibliothèque municipale, 1978. / ROSENBERG, P. *Tout l'oeuvre des Le Nain*. 1993. / ——, and F. MACÉ DE LÉPINAY. *Georges de La Tour. Vie et oeuvre*. Fribourg, 1973. / *Saint-Paul-Saint-Louis. Les Jésuites à Paris*, exh. cat. (with contributions by J.-P. Willesme). Paris: Musée Carnavalet, 1985. / *Jacques Sarrazin, sculpteur du Roi*, exh. cat. (with notes by B. Brejon de Lavergnée, G. Bresc-Bautier, and F. de La Moureyre). Noyon: Musée du Noyonnais, 1992. / SAUVEL, T. "De l'hôtel de Rambouillet au Palais-Cardinal" in *Bulletin monumental*. 1960, pp. 160–190. / SCHNAPPER, A. "La Cour de France au XVII<sup>e</sup> siècle et la peinture italienne contemporaine" in *Seicento: la peinture italienne du XVII<sup>e</sup> siècle et la France*. 1990, pp. 423–497. / ——. *Curieux du grand siècle. Les collections d'art en France au XVII<sup>e</sup> siècle*. 1994. / SILVESTRE, I. (with an introduction and commentaries by J.-P. BABELON). *Vues de Paris*. 1977. / TERNOIS, D. *Jacques Callot. Catalogue complet de son oeuvre dessiné*. 1962–98, 2 vol. / THUILLIER, J. *La "Galerie de Médicis" de Rubens et sa genèse*. 1969. / ——. *Georges de La Tour*. 1992. / ——. *Nicolas Poussin*. 1994. / *Vouet*, exh. cat. (with contributions by J. Thuillier, A. Brejon de Lavergnée, and D. Lavalle). Paris: Grand Palais, 1990–91. / *Simon Vouet*, acts of the colloquium. Paris, 1991, 1992.

CHAPTER VIII

ALCOUFFE, D. *Le Meuble d'ébéniste parisien aux XVII<sup>e</sup> et XVIII<sup>e</sup> siècles*, in *Métiers d'art. Art du meuble*. 1984. / BERGER, R. W. *Antoine Le Pautre, A French Architect of the Era of Louis XIV*. New York, 1969. / ——. *The Palace of the Sun: the Louvre of Louis XIV*. Philadelphia, 1993. / BOISLISLE, A. de. *La Place des Victoires et la place Vendôme*. Paris, Nogent-le-Rotrou, 1889. / *Colbert 1619–1683*, exh. cat. Paris: La Monnaie. 1983. / *Les Collections de Louis XIV. Dessins, albums, manuscrits*, exh. cat. Paris, 1977. / DETHAN, G. *Paris au temps de Louis XIV* in *Nouvelle Histoire de Paris*. 1990. / FARÉ, M. op. cit. / FERAULT, M.-A. op. cit. / GOULD, C. *Bernini in France [...]*. London, 1981. / GRIVEL, M. op. cit. / HAUTECOEUR, L. *Le Louvre et les Tuileries de Louis XIV*. 1927. / JESTAZ, B. *L'Hôtel et l'église des Invalides*. 1990. / *Charles Le Brun (1619–1690) peintre et dessinateur*, exh. cat. (with contributions by J. Montagu and J. Thuillier). Château de Versailles, 1963. / LE MOËL, M. *L'Architecture privée à Paris au Grand siècle*. 1990. / *Louis XIV, faste et décors*, exh. cat. Paris: Musée des arts décoratifs, 1960. / MAUBAN, A. *Jean Marot, architecte et graveur parisien*. 1944. / MAZEROLLE, F. op. cit. / MÉROT, A. op. cit. / MIGNOT, C. op. cit. / MONTAIGLON, A. de. op. cit. / MONTCLOS, B. de. *Almanachs parisiens 1661–1716*. 1997. / PACHT-BASSANI, P. op. cit. / *La Peinture française du XVII<sup>e</sup> siècle dans les collections américaines*, exh. cat. (with contributions by M. Fumaroli and P. Rosenberg). Paris: Grand Palais, 1982. / PETITJEAN, C., and C. WICKERT. op. cit. / PICON, A. *Claude Perrault ou la curiosité d'un classique*. 1988. / *Plafonds parisiens du XVII<sup>e</sup> siècle*, special edition of the *revue de l'art*, nr. 122 (1998). / PONS, B. *De Paris à Versailles, les sculpteurs ornemanistes parisiens*. Strasbourg, 1986. / RANUM, O. op. cit. / SAMOYAULT, J.-P. *André-Charles Boulle et sa famille*. Geneva, 1979. / SCHNAPPER, A. op. cit. / ——. *Jean Jouvenet (1644–1717) et la peinture d'histoire à Paris*. 1974. / SILVESTRE, I. op. cit. / SOUCHAL, F., F. DE LA MOUREYRE, and DUMUIS, H. *French Sculptors of the XVII<sup>th</sup> and XVIII<sup>th</sup> Centuries. The Reign of Louis XIV. Illustrated catalogue*. Oxford and London, 1977–87, 3 vol.

CHAPTER IX

ADHÉMAR, J. *La Gravure originale au XVIII<sup>e</sup> siècle*. 1963. / ALBIS, A. d', and T. PRÉAUD. *La Porcelaine de Vincennes*. 1991. / ALCOUFFE, D. op. cit. / ANANOFF, A. and D. WILDENSTEIN. *François Boucher, Peintures, catalogue raisonné*. Geneva, 1976, 2 vol. / ANDIA, B. de and D. FERNANDES, ed. *Rue du faubourg Saint-Honoré*. 1994. / *Germain Boffrand, 1664–1754, l'aventure d'un architecte indépendant*, exh. cat. (with contributions by M. Gallet and J. Garms). Paris-Lunéville, 1986. / *François Boucher, 1703–1770*, exh. cat. New York: The Metropolitan Museum, 1986; Detroit Institute of Arts, 1986; Paris, Grand Palais, 1986–87. / BOUDRIOT, P.-D. "La Maison à louer: étude du bâtiment à Paris sous Louis XV" in *Histoire, Economie et Société*. 1982. / BRUNEL, G. *Boucher*. 1986. / CHAGNIOT, J. *Paris au XVIII<sup>e</sup> siècle*, in *Nouvelle Histoire de Paris*. 1988. / *Chardin, 1699–1779*, exh. cat. (with a contribution by P. Rosenberg). Paris: Grand Palais, 1999. / COQUERY, N. *L'Hôtel aristocratique. Le marché du luxe à Paris au XVIII<sup>e</sup> siècle*. 1998. / *De la place Louis XV à la place de la Concorde*, exh. cat. Paris: Musée Carnavalet. 1982. / DETHAN, G. *Paris au temps de Louis XIV* in *Nouvelle Histoire de Paris*. 1990. / ERIKSEN, S., and G. DE BELLAIGUE. *Sèvres Porcelain. Vincennes and Sèvres, 1740–1800*. London, 1987. / FARÉ, M. and F. *La Vie silencieuse en France. La nature morte au XVIII<sup>e</sup> siècle*. Fribourg, 1976. / GALLET, M. *Stately Mansions. Eighteenth-Century Paris Architecture*. London, 1972. / ——. *Les Architectes parisiens du XVIII<sup>e</sup> siècle*. 1995. / GALLET, M., and X. BOTTINEAU, ed. *Le Gabriel*. 1982. / GARNIER, N. *Antoine Coypel (1661–1722)*. 1989. / HAMON, F. "Les Eglises parisiennes du XVIII<sup>e</sup> siècle. Théorie et pratique de l'architecture cultuelle" in *revue de l'art*, nr. 32 (1976), pp. 7–14. / *Jean Baptiste Oudry (1686–1755)*, exh. cat. Galeries nationales du Grand Palais, 1982–83. / *Jean Jouvenet, 1644–1717*, exh. cat. (with contributions by A. Schnapper). Rouen: Musée des Beaux-Arts, 1966. / JESTAZ, B. op. cit. / KIMBALL, F. *Le Style Louis XV, origine et évolution du rococo*. 1949. / KJELLBERG, P. *Le Mobilier français du XVIII<sup>e</sup> siècle. Dictionnaire des ébénistes et des menuisiers*. 1989. / KRETZSCHMAR, F. J. *Pierre Contant d'Ivry*. Cologne, 1981. / LA GORCE, J. de. *Bérain, dessinateur du Roi-Soleil*. 1986. / LA MOUREYRE, F. de. *Thomas Gobert (v. 1640–1708), architecte des Bâtiments du Roi*. 1990. / LANGENSKJÖLD, E. *Pierre Bullet the Royal Architect*. Stockholm, 1959. / *Largillierre, peintre du XVIII<sup>e</sup> siècle*, exh. cat. Montreal: Musée des Beaux-Arts, 1981. / *Louis XIV et l'urbanisme royal parisien*, exh. cat. Archives nationales. 1984. / *Louis XIV, faste et décors*, exh. cat. Paris: Musée des arts décoratifs, 1960. / *Louis XV, un moment de perfection de l'art français*, exh. cat. Paris: La Monnaie. 1959–61, 2 vol. / "La maison parisienne au siècle des Lumières" in *Cahiers du Centre de recherches et d'études de Paris et de l'Ile-de-France*, nr. 92 (Sept. 1985). / MATHIEU, M. *Pierre Patte, sa vie et son oeuvre*. 1940. / MAUBAN, A. op. cit. / MEUVRET, J. *Les Ebénistes du XVIII<sup>e</sup> siècle français*. 1963. / MONTCLOS, B. de. *Charles-Joseph Natoire*, exh. cat. Troyes, Nimes, Rome, 1977. / NEUMAN, R. *Robert de Cotte and the Perfection of Architecture in Eighteenth-Century France*. Chicago, London, 1994. / OPPERMAN, H. "François Desportes et le paysage: modernisme ou modernité" in *Paysage en Europe du XVI<sup>e</sup> au XVIII<sup>e</sup> siècle*. 1995, pp. 171–189. / ——. *Jean-Baptiste Oudry*. New York, London, 1977, 2 vol. / PÉROUSE DE MONTCLOS, J.-M. *Les Prix de Rome. Concours de l'académie d'architecture au XVIII<sup>e</sup> siècle*. 1984. / PERRIN, C. *Pierre Mignard le Romain*, acts of the colloquium of the Louvre, directed by J.-C. Boyer. Paris, 1995, 1997. / PLINVAL DE GUILLEBON, R. de. *Faïence et porcelaine de Paris. XVIII<sup>e</sup>–XIX<sup>e</sup> siècles*. Dijon, 1995. / PONS, B. op. cit. / POULOT, D. *Musée, Nation, Patrimoine, 1789–1815*. 1997. / RAMBAUD, M. *Documents du minutier central intéressant l'histoire de l'art, 1700–1750*. 1964 and 1971, 2 vol. / RÉAU, L. *Le Rayonnement de Paris au XVIII<sup>e</sup> siècle*. 1946. / ROLAND MICHEL, M. *Watteau, un artiste au XVIII<sup>e</sup> siècle*. 1984. / ——. *Chardin*. 1994. / ROSENBERG, P. *Tout l'oeuvre de Chardin*. 1983. / ——. *Tout l'oeuvre de Fragonard*. 1989. / ROSENBERG, P., and E. CAMESASCA. *Tout l'oeuvre peint de Watteau*. 1982. / ——, and L.-A. PRAT. *Antoine Watteau, 1684–1721. Catalogue raisonné des dessins*. 1996, 3 vol. / SAMOYAULT, J.-P. op. cit. / SCHNAPPER, A. "Antoine Coypel: la galerie d'Enée au Palais Royal" in *revue de l'art*, nr. 5 (1969), pp. 33–42. / ——. op. cit. / SCOTT, K. *The Rococo Interior. Decoration and Social Spaces in Early Eighteenth-Century Paris*. New Haven, London, 1995. / SOUCHAL, F. *Les Slodtz, sculpteurs et décorateurs du Roi 1685–1764*. 1967. / ——. "Jean Aubert, architecte des Bourbons" in *revue de l'art*, nr. 6 (1969), pp. 29–38. / ——. *Les Frères Coustou, Nicolas (1658–1733), Guillaume (1677–1746) et l'évolution de la sculpture française du Dôme des Invalides aux Chevaux de Marly*. 1980. / SOUCHAL, F., F. DE LA MOUREYRE, and H. DUMUIS. op. cit. / *Soufflot et son temps*, exh. cat. Paris: Caisse des Monuments historiques, 1980. / STRANDBERG, R. *Pierre Bullet et J.-B. Bullet de Chamblain à la lumière des dessins de la collection Tessin*. Stockholm, 1971. / TADGELL, C. *Ange-Jacques Gabriel*. London, 1978. / TEYSSEDRE, B. *Roger de Piles et les débats sur le coloris au siècle de Louis XIV*. 1957. / VERLET, P. *Les Meubles français du XVIII<sup>e</sup> siècle*. Fribourg, 1966. / VERLET, P. *Les Bronzes dorés français du XVIII<sup>e</sup> siècle*. 1987; reprint edition 1998. / *Watteau 1684–1721*, exh. cat. Washington, D. C.: National Gallery; Paris: Grand Palais; Berlin: Schloss Charlottenburg. 1984–1985. / ——. "Le Commerce des objets d'art et les marchands merciers de Paris au XVIII<sup>e</sup> siècle" in *Annales, Economies, Sociétés, Civilisations*. 1958 (Jan.–March), pp. 10–29. / ——. *La Maison du XVIII<sup>e</sup> siècle en France;*

CHAPTER X

ADHÉMAR, J. op. cit. / ALCOUFFE, D. op. cit. / ALCOUFFE, D., C. BAULEZ, J. P. MOUILLESEAUX, et al. *Bagatelle, la folie d'Artois*. 1988. / ANANOFF, A. *L'oeuvre dessiné de Jean Honoré Fragonard*. 1961, 4 vol. / *Les Architectes de la liberté, 1789–1799*, exh. cat. Paris: Grand Palais. 1989. / ARNASSON, H. H. *The Sculptures of Houdon*. 1975. / *Aux armes et aux arts. Les arts de la Révolution, 1789–1799*. Multiple authors. 1989. / *Bagatelle dans ses jardins*, edited by M. Constans. 1997. / BECKER, W. "Paris und die deutsche Malerei 1750–1840" in *Studien zur Kunst der 19. Jahrhunderts*. Munich, 1971, 2 vol. / BIVER, M.-L. *Fêtes révolutionnaires à Paris*. 1979. / ——. *Le Paris de Napoléon*. 1963. / ——. *Pierre Fontaine*. 1964. / BOUDRIOT, P.-D. op. cit. / BRAHAM, A. *L'Architecture des lumières de Soufflot à Ledoux*. 1982. / BRETTE, A. *Histoire des édifices où ont siégé les assemblées parlementaires de la Révolution française et de la Première République*. 1902. / *Brongniart*, exh. cat. Paris: Musée Carnavalet, 1986. / BRUNET, M., and T. PRÉAUD. *Sèvres, des origines à nos jours*. Fribourg, 1978. / CHAGNIOT, J. op. cit. / *Charles-Joseph Natoire*, exh. cat. Troyes, Nimes, Rome, 1977. / *Clodion*, exh. cat. (with contributions by A.-L. Poulet and G. Scherf). Paris: Louvre, 1992. / COQUERY, N. op. cit. / COURAJOD, L. *Alexandre Lenoir et le musée des Monuments français*. 1878–87, 3 vol. / CUZIN, J.-P. *Fragonard*. Fribourg, 1987. / *Jacques-Louis David 1748–1825*, exh. cat. Paris: Louvre, 1989–90, edited by A. Schnapper and A. Sérullaz. / *De David à Delacroix. La peinture française de 1774 à 1830*, exh. cat. Paris: Grand Palais, 1974–75, edited by P. Rosenberg. / DEMING, M. K. *La Halle au blé de Paris*. Brussels, 1984. / *Diderot et l'art de Boucher à David. Les Salons: 1759–1781*, exh. cat. Paris: La Monnaie, 1984–85. / ERIKSEN, S. *Early Neo-Classicism in France*. London, 1974. / ERIKSEN, S., and G. de BELLAIGUE. op. cit. / ETLIN, R. A. *The Architecture of Death, the Transformation of the Cemetery in Eighteenth-Century Paris*. Cambridge, 1984. / *Fragonard*, exh. cat. Paris: Grand Palais, 1987–88; New York: The Metropolitan Museum or Art, 1988. / *French Painting 1774–1830. The Age of Revolution*, exh. cat. Detroit: Detroit Institute of Arts; New York: The Metropolitan Museum of Art. 1975. / GABORIT, J.-R. *Jean-Baptiste Pigalle, 1714–1785*. 1985. / GAEHTGENS, T.-W., and J. LUGAND. *Joseph-Marie Vien (1716–1809)*. 1993. / GALLET, M. op. cit. / ——. *Demeures parisiennes, l'époque de Louis XVI*. 1964. / ——. *Claude-Nicolas Ledoux*. 1980. / GALLET, M., and X. BOTTINEAU. op. cit. / GRUBER, A. *Les Grandes Fêtes et leurs décors à l'époque de Louis XVI*. Geneva, 1972. / GRUNCKER, P. *Le Grand prix de peinture: le concours des Prix de Rome de 1797 à 1863*. 1983. / HONOUR, H. *Neo-Classicism*. Hardmondsworth, 1968. / KJELLBERG, P. *Le Mobilier français du XVIII<sup>e</sup> siècle. Dictionnaire des ébénistes et des menuisiers*. 1989. / KRETZSCHMAR, F. J. op. cit. / LAULAN, R. *L'Ecole militaire*. 1950. / LEBEN, U. "La fondation de l'Ecole Royale Gratuite de Dessin et son rôle (1767–1815). Modèle pour l'Europe et prédécesseur pour le développement des écoles professionnelles et d'arts décoratifs au XIX<sup>e</sup> siècle" in *Francia*, 21, nr. 2 (1994), pp. 217–240. / LOCQUIN, J. *La Peinture d'Histoire en France de 1747 à 1785*. 1912. / *Louis XV, un moment de perfection de l'art français*, exh. cat. Paris: La Monnaie. 1959–61, 2 vol. / "La maison parisienne au siècle des Lumières" in *Cahiers du Centre de recherches et d'études de Paris et l'Ile-de-France*, nr. 92 (Sept. 1985). / MATHIEU, M. op. cit. / MEUVRET, J. op. cit. / MONVAL, J. *Soufflot, sa vie, son oeuvre*. 1918. / *Le Néo-classicisme. Dessins français de 1750 à 1825 dans les collections du musée du Louvre*, exh. cat. Paris: Louvre; Copenhagen:

Thornvaldsens Museum, 1972. / *Le Néo-classicisme français. Dessins des musées de province,* exh. cat. Paris: Grand Palais; Copenhagen: Thornvaldsens Museum, 1975. / OZOUF, M. *La Fête révolutionnaire, 1789–1799.* 1976. / *Pajou sculpteur du roi 1730– 1809,* exh. cat. (with contributions by J.-D. Draper and G. Scherf). Paris: Louvre, 1997–98. / *Le Panthéon, symbole des révolutions: de l'Eglise de la nation au temple des grands hommes,* exh. cat. Paris: Hôtel de Sully; Montreal: Centre canadien d'architecture. 1989. / PÉROUSE DE MONTCLOS, J.-M. op. cit. / ———. *Etienne-Louis Boullée;* 1994. / PERRIN, C. op. cit. / PETZET, M. *Soufflots Sainte-Geneviève und der französische Kirchenbau des 18. Jahrhunderts.* Berlin, 1961. / PLINVAL DE GUILLEBON, R. de. op. cit. / ———. *Porcelaine de Paris 1770–1850.* Fribourg, 1972. / POISSON, G. *L'Architecture de la Révolution à Paris.* 1970. / POMMIER, E. *L'Art de la liberté. Doctrines et débats de la Révolution française.* 1991. / POULOT, D. op. cit. / RABREAU, D., and M. STEINHAUSER. "Le théâtre de l'Odéon de Charles de Wailly et Marie-Joseph Peyre (1767–1782)" in *revue de l'art,* nr. 19 (1973), pp. 9–49. / RÉAU, L. op. cit. / RICE, H.C. Jr. *Thomas Jefferson's Paris.* Princeton, 1976. / ROSENBLUM, R. *Transformations in Late Eighteenth-Century Art.* Princeton, 1967. / SAHUT, M.-C. *Le Louvre d'Hubert Robert* in *Les dossiers du département des peintures,* nr. 18 (1979). / *Soufflot et l'architecture des Lumières,* acts of the colloquium of Lyon, 1986. / *Soufflot et son temps,* exh. cat. Paris: Caisse des Monuments historiques, 1980. / STERN, J. *A l'ombre de Sophie Arnould: François-Joseph Bélanger. 1930,* 2 vol. / SZAMBIEN, W. *J. N. L. Durand, 1760–1834. De l'imitation à la norme.* 1984. / ———. *Les Projets de l'an II. Concours d'architecture de la période révolutionnaire.* 1986. / ———. "Les architectes de l'époque révolutionnaire" in *revue de l'art,* nr. 83 (1988), pp. 36–50. / ———. *De la rue des Colonnes à la rue de Rivoli.* 1992. / TADGELL, C. op. cit. / THUILLIER, J. *Fragonard.* Geneva, 1967. / TULARD, J. *La Révolution* in *Nouvelle Histoire de Paris.* 1989. / VAUGHAN, W. *L'Art du XIXᵉ siècle. 1780–1850.* 1989. / VERLET, P. op. cit. / VIDLER, A. *Ledoux.* 1987. / *Charles de Wailly, peintre-architecte dans l'Europe des Lumières,* exh. cat. (with contributions by M. Mosser and D. Rabreau). Paris, 1979.

## CHAPTER XI

ADHÉMAR, J. et al. *La Lithographie: deux cents ans d'histoire, de technique, d'art.* 1983. / *Un Age d'or des arts décoratifs (1815–1844),* exh. cat. Paris: Grand Palais, 1991. / *The Architecture of the Ecole des Beaux-Arts,* exh. cat. Museum of Modern Art, New York, 1978. / ARMINJON, C. "Les fabricants orfèvres parisiens au début du XIXᵉ siècle" in *L'Orfèvrerie au XIXᵉ siècle: actes du colloque international galeries nationales du Grand Palais.* 1991, pp. 11–16. / ARMINJON, C., J. BEAUPUIS, and M. BILIMOFF. *Dictionnaire des poinçons de fabricants d'ouvrages d'or et d'argent de Paris et de la Seine 1838–1875.* 1994. / *L'Art en France sous le Second Empire,* exh. cat. Paris: Grand Palais, 1979. / *L'art français sous le Second Empire,* exh. cat. Paris: Grand Palais. 1979. / BECKER, W. "Paris und die deutsche Malerei 1750–1840" in *Studien zur Kunst des 19. Jahrhunderts.* Munich, 1971. / BENJAMIN, W. *Paris, Capital of the Nineteenth Century.* 1935. / BERTIER DE SAUVIGNY, G. de. *La Restauration* in *Nouvelle Histoire de Paris.* 1977. / BOWIE, K., ed. *Les Grandes gares parisiennes au XIXᵉ siècle.* 1987. / BRUNET, M., and T. PRÉAUD. op. cit. / CARS, J. DES, and P. PINON. *Paris-Haussmann, le pari d'Haussmann.* 1991. / CASO, J. de. *David d'Angers: l'avenir de la mémoire: étude sur l'art signalétique à l'époque romantique.* 1988. / *Cézanne,* exh. cat. Paris: Grand Palais. 1995–96. / CHEMETOV, P., and B. MARREY. *Architectures, Paris 1848–1914.* 1976. / COMMENT, B. *Le XIXᵉ siècle des panoramas.* 1993. / COURAJOD, L. op. cit. / DARRAGON, E. *Manet.* 1991. / DAUMARD, A. *Maisons de Paris et propriétaires parisiens au XIXᵉ siècle, 1809–1880.* 1965. / *Jacques-Louis David 1748–1825,* exh. cat. Paris: Louvre, 1989–90. / *De David à Delacroix. La peinture française de 1774 à 1830,* exh. cat. Paris: Grand Palais, 1974–75. / *Gabriel Davioud architecte de Paris,* exh. cat. (with contributions by D. Rabreau, D. Jarrasse, C. de Vaulchier, and T. von Joëst). Paris: Mayorates of the XVIᵉ and XIXᵉ arrondissements, 1981. / *Degas,* exh. cat. (with contributions by H. Loyrette, M. Pantazzi, G. Tinterow, and J.-S. Boggs). Paris: Grand Palais, 1988–89. / *Paul Delaroche. Un peintre dans l'histoire,* exh. cat. Nantes: Musée des Beaux-Arts, 1999–2000. / *Gustave Doré,* exh. cat. Strasbourg, 1983. / *Félix Duban 1798–1870,* exh. cat. (with contributions by S. Bellenger and F. Hamon). Blois, 1996. / DUMONT, J.-M. *Le Logement social à Paris (1850–1930). Les habitations à bon marché.* Liège, 1991. / EARLS, I.-A. *Napoléon III, l'architecte et l'urbaniste de Paris.* 1991. / EGBERT, D. D. *The Beaux-Arts Tradition in French Architecture.* Princeton, 1980. / EITNER, L. *Géricault, sa vie, son oeuvre.* 1991. / EITNER, L. *La Peinture du XIXᵉ siècle en Europe,* French transl. 1993. / FARGUELL, M., and V. GRANDVAL. *Hameaux, villas et cités de Paris.* 1998. / *Le Faubourg Saint-Antoine. Architecture et métiers d'art,* exh. cat. 1998. / *Le Faubourg Saint-Antoine. Un double usage.* 1998. / *Les frères Flandrin,* exh. cat. Paris: Musée du Luxembourg, Lyons: Musée des Beaux-Arts, 1985. / FOUCART, B. "La 'Cathédrale synthétique' de L. A. Boileau: Saint-Eugène et le problème de l'application du fer à l'architecture religieuse" in *revue de l'art* nr. 3 (1969), pp. 18–66. / ———. *Le Renouveau de la peinture religieuse en France, 1800–1860.* 1987. / GAILLARD, J. *Paris, la Ville: 1852–1870. L'urbanisme parisien à l'heure d'Haussmann.* 1976. / GAUDIBERT, P. "Paris romantique vu par les aquarellistes anglais" in *Bulletin du musée Carnavalet.* 1957, pp. 2–15. / GEIST, J.-F. *Le Passage, un type architectural du XIXᵉ siècle.* Liège, 1989. / GEORGEL, P., and L. ROSSI BORTOLATTO. *Tout l'oeuvre peint de Delacroix.* 1975. / *Géricault,* exh. cat. (with contributions by S. Laveissière and R. Michel). Paris: Grand Palais, 1991–92. / *Ingres,* exh. cat. Paris: Petit Palais, 1967. / LEDOUX-LEBARD, D. *Les Ebénistes parisiens, 1795–1870.* 1965. / LEDOUX-LEBARD, D. *Le Mobilier français du XIXᵉ siècle.* 1984. / LEFUEL, H. *François-Honoré-Georges. Jacob-Desmalter.* 1925. / LEMOINE, B. *Les passages couverts en France.* 1989. / LENIAUD, J.-M. *Lassus.* 1980. / ———. *Viollet le Duc ou les délices du système.* 1994. / LOYER, F. *Histoire de l'architecture française, XIXᵉ–XXᵉ siècles.* 1999. / LOYER, F. *Paris, XIXᵉ siècle. L'immeuble et la rue.* 1987. / *Manet 1832–1883,* exh. cat. Paris: Grand Palais, 1983. / MARREY, B. *Les Grands Magasins, des origines à 1939.* 1979. / ———. *Le Fer à Paris: architectures.* 1989. / MARTIN-FUGIER, A. *La Vie élégante ou la formation du Tout-Paris. 1815–1848.* 1990. / MIDDLETON, R., ed. *The Beaux-Arts and Nineteenth-Century French Architecture.* Cambridge, 1982. / MIGNOT, C. *L'Architecture au XIXᵉ siècle.* Fribourg, 1983. / *Modernity and Modernism: French Painting in the Nineteenth Century.* New Haven, London, 1993. / *Le Néo-classicisme. Dessins français de 1750 à 1825 dans les collections du musée du Louvre,* exh. cat. Paris: Louvre; Copenhagen: Thornvaldsens Museum, 1972. / *Le Néo-classicisme français. Dessins des musées de province,* exh. cat. Paris: Grand Palais; Copenhagen; Thornvaldsens Museum, 1975. / *Noisiel. La chocolaterie Menier. Inventaire général des monuments et des richesses artistiques de la France.* 1994. / NOUVEL-KAMMERER, O., ed. *Les Papiers peints panoramiques, 1790–1865.* 1990. / *La Nouvelle Athène. Le quartier de Saint-Georges de Louis XV à Napoléon III,* exh. cat. Paris: Musée Renan-Scheffer, 1984. / OETTERMANN, S. *The Panorama. History of a Mass Medium.* New York, 1997. / *Le Panthéon, symbole des révolutions: de l'Eglise de la nation au temple des grands hommes,* exh. cat. Paris: Hôtel de Sully; Montreal: Centre canadien d'architecture. 1989. / PINKNEY, D. H. *Napoléon III and the Rebuilding of Paris.* Princeton, 1972. / PINON, P. *L'Hôpital de Charenton. Temple de la raison ou folie de l'archéologie.* Brussels, 1989. / PLINVAL DE GUILLEBON, R. de. op. cit. / POISSON, G. *Napoléon et Paris.* 1964. / *Auguste Préault, sculpteur romantique 1809–1879,* exh. cat. Paris: Musée d'Orsay, 1997. / *Puvis de Chavannes,* exh. cat. Paris: Grand Palais; Ottawa: Galeries nationales du Canada, 1976–77. / ROBERT, H., ed. *Le Mécénat du duc d'Orléans: 1830–1842.* 1993. / ROSENTHAL, L. *Du romantisme au réalisme, la peinture en France de 1830 à 1848.* 1987. / ROZEN, C., and H. ZERNER. *Romantisme et réalisme, mythes de l'art du XIXᵉ siècle.* 1986. / SADDY, P. *Henri Labrouste architecte. 1801–1875.* 1977. / *La Sculpture française au XIXᵉ siècle,* exh. cat. Paris: Grand Palais, 1986. / SIEGFRIED, S. L. *The Art of Louis-Léopold Boilly. Modern Life in Napoleonic France.* New Haven, London, 1995. / *Statues de chair. Sculptures de James Pradier, 1790–1852,* exh. cat. Geneva: Musée d'Art et d'Histoire, 1984; Paris: Musée du Luxembourg, 1985. / STEINHAUSER, M. *Die Architektur der Pariser Oper.* Munich, 1969. / SZAMBIEN, W. op. cit. / TERNOIS, D., and H. NAEF. *Tout l'oeuvre peint d'Ingres.* 1984. / TEXIER, S., ed. *Eglises parisiennes du XXᵉ siècle, architecture et décor.* 1996. / TULARD, J. *Le Consulat et l'Empire* in *Nouvelle Histoire de Paris.* 1970. / VANIER, H. *La Mode et ses métiers. Frivolités et luttes des classes. 1830–1870.* 1960. / VAUGHAN, W. *L'Art du XIXᵉ siècle. 1780–1850.* 1989. / VIGIER, P. *Paris pendant la Monarchie de Juillet,* in *Nouvelle Histoire de Paris.* 1991. / *Viollet-le-Duc,* exh. cat. Paris: Galeries nationales du Grand Palais, 1980. / *Louis Visconti 1791–1853,* exh. cat. (with contributions by F. Hamon and C. Maccalum). Paris: Musée du Luxembourg, 1991. / *Franz Xaver Winterhalter et les cours d'Europe de 1830 à 1870,* exh. cat. Paris: Petit Palais, 1988. / ZANTEN, D. VAN. *Building Paris: Architectural Institutions and the Transformation of the French Capital, 1830–1870.* Cambridge, 1996.

## CHAPTER XII

*Paul Abadie,* exh. cat. Musée d'Angoulême, 1984–85. / *The Architecture of the Ecole des Beaux-Arts,* exh. cat. (with a contribution by A. Drexler). New York: The Museum of Modern Art, 1978. / BASTIÉ, J., and R. PILLORGET. *Paris de 1914 à 1940,* in *La Nouvelle histoire de Paris.* 1997. / BENOIST, J. *Le Sacré-Coeur de Montmartre: de 1870 à nos jours.* 1992. / *Bonnard,* exh. cat. Paris: Centre Georges-Pompidou, 1984. / *Pierre Bonnard, 1867–1947,* exh. cat. Lausanne: Fondation de l'Hermitage. 1991. / BORSI, F., and E. GODOLI. *Paris. Art nouveau, architecture et décoration.* 1989. / BOUILLON, J.-P. *Journal de l'Art nouveau: 1870–1914.* Geneva, 1985. / BOUILLON, J.-P., P.-L. RINUY, and A. BAUDIN. *L'Art du XXᵉ siècle: 1900–1939.* 1996. / BRUNET, M., and T. PRÉAUD. op. cit. / BRUNHAMMER, Y., and S. TISE. *Les Artistes décorateurs 1900–1942.* 1990. / CACHIN, F. *Gauguin.* 1989. / CAMARD, F. *Ruhlmann.* 1983. / CHEMETOV, P., and B. MARREY. op. cit. / COHEN, J.-L., and A. LORTIE. *Des Fortifs au périf.* 1991. / DAIX, P. *Dictionnaire Picasso.* 1995. / ———. *Journal du cubisme.* Geneva, 1982. / DARRAGON, E. op. cit. / *André Derain, le peintre du "trouble moderne,"* exh. cat. Paris: Musée d'art moderne de la ville de Paris, 1994–95. / *Le Douanier Rousseau,* exh. cat. Paris: Grand Palais; New York: The Museum of Modern Art, 1984–85. / DUMAS, A. and G. COGEVAL. *Vuillard.* 1990. / DUMONT, J.-M. op. cit. / DUNCAN, A., and G. de BARTHA. *La Reliure en France: Art nouveau, Art Déco 1880–1940.* 1989. / EGBERT, D.D. op. cit. / FARGUELL, M., and V. GRANDVAL. op. cit. / *Fauvisme,* exh. cat. Paris: Musée d'art moderne de la ville de Paris, 1999–2000. / FLEURY, M., ed. *Dictionnaire par noms d'architectes des constructions élevées à Paris aux XIXᵉ et XXᵉ siècles. Première période 1876–1899.* 1990–94, 4 vol. / GARGALLO-ANGERA, P. *Pablo Gargallo. Catalogue raisonné.* 1998. / GRUMBACH, D. *Histoires de la mode.* 1993. / HITCHCOCK, H.-R. op. cit. / *Hommage à Claude Monet,* exh. cat. Paris: Grand Palais, 1980. / *Hommage à Pablo Picasso,* exh. cat. Paris: Grand Palais and Petit Palais, 1966–67. / *L'Impressionnisme et le paysage français,* exh. cat. Los Angeles: County Museum of Art; Chicago: The Art Institute; Paris: Grand Palais, 1984–85. / *Fernand Léger,* exh. cat. (with contributions by I. Monod-Fontaine and C. Laugier). Paris: Musée national d'art moderne, 1997. / LENORMAND-ROMAIN, A. *Rodin.* 1997. / LOUPIAC, C., and C. MENGIN. *L'Architecture moderne en France.* Vol. I *1889–1940.* 1997. / LOYER, F. op. cit. / ———. *Henri Sauvage, les immeubles à gradins.* Liège, 1987. / LOYRETTE, H. *Gustave Eiffel.* 1986. / ———. *Degas.* 1990. / *Manet 1832–1883,* exh. cat. Paris: Grand Palais, 1983. / MARREY, B., and F. HAMMOUTÈRE. *Le Béton à Paris.* 1999. / MIDANT, J.-P., ed. *Dictionnaire de l'architecture du XXᵉ siècle.* 1996. / MIDDLETON, R., ed. op. cit. / MOLINARI, D. *Sonia et Robert Delaunay.* 1987. / *Paris 1937. L'art indépendant,* exh. cat. Paris: Musée d'art moderne de la ville de Paris, 1987. / *Paris: Belle Epoque: 1880–1914,* exh. cat. Essen: Villa Hügel, 1994. / PARISOT, C. *Modigliani.* 1991. / PLUM, G. *Le Grand-Palais: l'aventure du palais des beaux-arts.* 1993. / *Puvis de Chavannes,* exh. cat. Paris: Grand Palais; Ottawa: Galeries nationales du Canada, 1976–77. / RAGON, M. *Histoire de l'architecture et de l'urbanisme modernes.* Tournai, 1971, 3 vol. / *Renoir,* exh. cat. Paris: Grand Palais, 1985. / REWALD, J. *Cézanne.* 1986. / RIALS, S. *De Trochu à Thiers 1870–1873* in *Nouvelle Histoire de Paris.* 1985. / ROUSSAUD, A. *Dictionnaire des peintres à Montmartre.* 1999. / ROUSSET-CHARNY, G. *Les Palais parisiens de la Belle Epoque.* 1990. / *Seurat,* exh. cat. Paris: Grand Palais, 1991. / SILVER, K.-E. *Vers le retour à l'ordre: l'avant-garde parisienne et la Première guerre mondiale: 1914–1925,* French transl. 1991. / SILVERMAN, D.L. *Art nouveau in Fin-de-siècle France. Politics, Psychology and Style.* The Hague, 1989. / *Sisley,* exh. cat. Paris: Musée d'Orsay, 1993. / TEXIER, S., ed. op. cit. / *Le Triomphe des mairies,* exh. cat. Paris: Petit Palais, 1987. / VAISSE, P. *La Troisième République et les peintres.* 1995. / VALLIER, D. *L'Art abstrait.* 1967. / *Van Gogh à Paris,* exh. cat. Paris: Musée d'Orsay, 1988. / *Viollet-le-Duc,* exh. cat. Paris: Galeries nationales du Grand Palais, 1980. / WARNOD, J. *Les Artistes de Montparnasse.* 1988.

## CHAPTER XIII

ABRAM, J. *L'architecture moderne en France, tome II, 1940–1966.* 1999. / ACHE, J., and A. PROTHIN. *André Lurçat architecte.* 1967. / *Les Années folles,* text of M. Collomb. 1986. / *Balthus,* exh. cat. Paris: Centre Georges-Pompidou, 1984. / BASTIÉ, J., and R. PILLORGET. *Paris de 1914 à 1940* in *La Nouvelle histoire de Paris.* 1997. / *Bonnard,* exh. cat. Paris: Centre Georges-Pompidou, 1984. / *Pierre Bonnard, 1867–1947,* exh. cat. Lausanne: Fondation de l'Hermitage. 1991. / BOUILLON, J.-P. *Journal de l'Art déco (1903–1940).* Geneva, 1988. / BRUNHAMMER, Y., and S. TISE. *Les Artistes Décorateurs 1900–1942.* 1990. / CHEMETOV, P., M.-J. DUMONT, and B. MARREY. *Paris-banlieue 1919–1939.* 1989. / CHEVREFILS DESBIOLLES, Y. *Les Revues d'art à Paris: 1905–1940.* 1993. / CLAIR, J. *Balthus.* 1999. / DAGEN, P. *L'Art français. Le XXᵉ siècle.* 1998. / DAIX, P. op. cit. / DAY, S. *Louis Süe, architecte des années folles.* Bruxelles, 1986. / *Dictionnaire général du Surréalisme.* 1982. / DUMONT, J.-M. op. cit. / DUNCAN, A., and G. de BARTHA. op. cit. / EGBERT, D.D. op. cit. / *Eglises parisiennes du XXᵉ siècle: architecture et décor.* 1996. / FRAMPTON, K., and M. VELLAY. *Pierre Chareau.* 1984. / GARGIANI, R. *Auguste Perret, (1874–1954). La théorie et l'oeuvre.* Milan, Paris, 1993. / GRUMBACH, D. op. cit. / *Guimard,* exh. cat. Paris: Musée d'Orsay, 1992. / HODEIR, C., and M. PIERRE. *1931 l'exposition coloniale.* Bruxelles, 1991. / HOEGES, D. *Picasso und Balzac: das unbekannte Meisterwerk.* 1992. / *Hommage à Claude Monet,* exh. cat. Paris: Grand Palais, 1980. / JOLY, P., B. DE ANDIA, J.-L. AVRIL, et al. *Le Corbusier à Paris.* 1987. / LAROQUE, D., M. REYNAUD, and S. RÉMY, ed. *Michel Roux-Spitz architecte 1888–1957.* Bruxelles, 1983. / *Fernand Léger,* exh. cat. Paris: Musée national d'art moderne, 1997. / LEMOINE, B., and P. RIVOIRARD. *L'Architecture des années Trente.* 1987. / LOUPIAC, C., and C. MENGIN. *L'Architecture moderne en France.* Vol. I *1889–1940.* 1997. / LOYER, F. *Henri Sauvage, les immeubles à gradins.* Liège, 1987. / LOYER, F. *Histoire de l'architecture française, XIXᵉ–XXᵉ siècles.* 1999. / MARREY, B. *Paris de verre. La ville et ses reflets.* 1997. / MARREY, B., and J. FERRIER. *Paris sous verre: la ville et ses reflets.* 1997. / MARREY, B., and F. HAMMOUTÈRE. *Le Béton à Paris.* 1999. / *Max Ernst,* exh. cat. Paris: Grand-Palais. 1975. / *Meubles 1920–1937,* exh. cat. Paris: Musée d'art moderne de la ville de Paris, 1986. / MIDANT, J.-P., ed. *Dictionnaire de l'architecture du XXᵉ siècle.* 1996. / *Le Mobilier national et les manufactures nationales des Gobelins et de Beauvais sous la IVᵉ République: commandes et achats,* exh. cat. Beauvais: Galerie nationale de la tapisserie. 1997. / MOULIN, R. *L'Artiste, l'institution et le marché.* 1992. / *Paris-Paris,* exh. cat. Paris: Centre Georges-Pompidou, 1981. / PINCHON, J.-F., ed. *Robert Mallet-Stevens: architecture, mobilier, décoration.* 1986. / ———. *Edouard Niermans, architecte de la café society.* 1991. / *Le Primitivisme dans l'art du XXᵉ siècle,* exh. cat. New York, Paris, 1987. / *Qu'est-ce que la sculpture moderne?,* exh. cat. Paris: Centre Georges-Pompidou, 1986. / RAGON, M. op. cit. / RISPAIL, J.-L. *Les Surréalistes, une génération entre le rêve et l'action.* 1991. / SCHNEIDER, P. op. cit. / SILVER, K.-E. op. cit. / *Sisley,* exh. cat. Paris: Musée d'Orsay, 1993. / TABART, M. *Brancusi, l'inventeur de la sculpture moderne.* 1995. / VAISSE, P. op. cit. / VALLIER, D. op. cit. / WARNOD, J. op. cit.

## EPILOGUE

ABRAM, J. op. cit. / CHASLIN, F. *Les Paris de François Mitterrand. Histoire des grands projets architecturaux.* 1985. / CLAIR, J. op. cit. / ———. *Considérations sur l'état des Beaux Arts, critique de la modernité.* 1989. / DAGEN, P. op. cit. / *Eglises parisiennes du XXᵉ siècle: architecture et décor.* 1996. / FUMAROLI, M. *L'Etat culturel. Essai sur une religion moderne.* 1991. / GARGIANI, R. op. cit. / GRUMBACH, D. op. cit. / *Guimard,* exh. cat. Paris: Musée d'Orsay, 1992. / HARAMBOURG, L. *L'Ecole de Paris 1945–1965: dictionnaire des peintres.* Neuchâtel, 1993. / LOYER, F. op. cit. / MARREY, B. *Paris de verre. La ville et ses reflets.* 1997. / MIDANT, J.-P., ed. op. cit. / MILLET, C. *L'Art contemporain en France.* 1987. / MONNIER, G. *L'Architecture moderne en France, tome III, 1967–1999.* 1999. / MOULIN, R. *L'Artiste, l'institution et le marché.* 1992. / *Paris-Paris,* exh. cat. Paris: Centre Georges-Pompidou, 1981. / *Paris Post War. Art and Existentialism, 1945–55.* London: The Tate Gallery, 1993. / *Le Primitivisme dans l'art du XXᵉ siècle,* exh. cat. New York, Paris, 1987. / *Qu'est-ce que la sculpture moderne?,* exh. cat. Paris: Centre Georges-Pompidou, 1986. / RAGON, M. op. cit. / SCHNEIDER, P. op. cit. / SUNER, B. *Ieoh Ming Pei.* 1988.

# INDEX

Numbers in italics refer to illustrations.

ABADIE, Paul 586
ABELARD, Pierre 37
ALBERTI, Leon Battista 210, 284
ALCIAT, André 196
ALLAIS, Alphonse 596
ALPHONSE DE POITOU 61
AMBOIS, Georges d', archbishop 143, 149, 182
AMBOIS, Jacques d', abbot of Cluny 143
AMBOIS, Louis d', bishop 143, 180
AMBOIS, Pierre d' 143
AMBOISE (town) 135, 149, 151
AMBOISE, Georges d' 149
AMBOISE, Jacques d' 174
AMBOISE-CHAUMONT family 143
AMERICAN CENTER 681
AMIENS 87, 90, 96, 148
AMIENS, Colin d' 148
ANDROUET DU CERCEAU family 235, 243
ANDROUET DU CERCEAU, Baptiste 189, 226, 243, 266
ANDROUET DU CERCEAU, Jacques I 189, 199, 204, 207, 210, 215, 226, 234, 243
ANDROUET DU CERCEAU, Jacques II 204, 243, 269
ANDROUET DU CERCEAU, Jean 243, 289, 290, 314
ANGÉLIQUE, Mother (see Arnauld)
ANGUIER family 262
ANGUIER, Michel 262, 304, 476
ANNE OF AUSTRIA 255, 268, 276, 277, 280, 300, 304, 476
ANNE OF BRITTANY 149, 150, 160
ANNE OF KIEV 33
ANNE DE MONTMORENCY 150, 159
ANTOINE, Jacques Denis 412
APOLLINAIRE, Guillaume 580, 611, 631
ARAGON, Louis 638, 672
ARAGON, Yolande d' 126
ARC DE TRIOMPHE DE L'ETOILE 486, 515, 534, 560, 560
ARC DE TRIOMPHE DU CARROUSEL 486, 490, 515
ARCHE DE LA DEFENSE 681, 682, 682
ARCHIPENKO, Alexander 657, 672
AREGONDE, Queen 27
ARGENSON, marquis d' 408
ARMAGNAC family 101, 102
ARNAULD, Mother Angélique 281
ARNOULD, Sophie 460, 464
ARP, Hans 638, 657
ARRAS 125, 127, 133
ARSENAL 311, 376
ART NOUVEAU GALLERY 589
ARTOIS, count of (future Charles X) 440, 483
ARTOIS, county 99, 100, 108, 126, 127, 133
ARTOIS Folly 440
ASSEMBLÉE NATIONALE (see CHAMBRE DES DÉPUTÉS)
ASSUMPTION, church of the 378
ASTRUC, Jules 579
ATTILA 26
AUGUSTINE, Saint 38
AUSTERLITZ, viaduct 580
AUTEUIL 500
AUTUN 35
AUVERS 606, 621, 628, 630
BACON, Francis 676
BAGATELLE 440
BAJENOV, Vassili Ivanovitch 451
BAKST, Léon 573, 597, 598, 613
BALBIANI, Valentine 234, 235
BALDACCHINO (see Bernini, Gianlorenzo)
BALENCIAGA, Cristobal 661, 669
BALLU, Théodore 515
BALMAIN, Pierre 669
BALTARD, Victor 504, 514
BALTHUS, Baltasar Klossowski, called 657, 659, 673
BALZAC, Honoré de 485, 521, 567, 609, 666
BARBEDIENNE, manufacturer 563
BARBERINO, Francesco da 97
BARBIZON 524, 540, 546
BARTHES, Roland 578
BARTHOLOMÉ, Paul Albert 558
BARYE, Antoine 558, 559, 560, 563
BASTILLE, château 106, 112, 115, 128, 136, 147

BATAILLE, Nicolas 124, 125, 133
BATEAU-LAVOIR studios 570, 606, 611, 630, 631, 637
BAUCHANT, André 672
BAUDELAIRE, Charles 493, 494, 521, 543, 550, 560, 565, 567, 596
BAUDOT, Anatole de 573, 581, 582
BAUDRY, Paul 501, 552
BAYLE, Pierre 405
BAZAINE, Jean 672
BAZAR NAPOLEON (bazar de l'Hôtel de Ville) 567
BEARDSLEY, Aubrey 572
BEAUBOURG (Centre Pompidou) 673, 674, 675, 676, 678, 682
BEAUDOUIN, Eugène 643, 644, 646, 678
BEAUJOYEUX, Balthazar de 190
BEAUNEVEU, André 121, 126, 136
BEAURAIN, Nicolas 202, 203
BEAUTÉ, château de 115, 125
BEAUVAIS 53
BEAUVAIS, Pierre 298
BEDFORD, duke of 101, 103, 115, 132, 133
BEER, Jan de 152
BELANGER, François 440, 445, 464
BELLANGE 244, 249
BELLEVILLE 11
BELLIER, Catherine 298, 300
BENEDETTI, Abbot Elciopio 325, 333
BENJAMIN, Walter 9, 567
BENNEMAN, Guillaume 448
BENOIS, Alexandre 573, 597
BERAIN, Jean 332, 335, 344, 345, 359, 403
BERCY 19, 676
BERGERE 513
BERNARD, Charles 273
BERNARD, Henry 677, 678, 681
BERNARD, Saint 33, 38
BERNINI, Gianlorenzo (Baldacchino) 262, 305, 318, 319, 320, 322, 324, 325, 326, 327, 328, 333, 335, 347, 348, 352, 359, 363, 404, 475, 682
BERRY, Jean de, duke of 100, 107, 108, 109, 111, 115, 128, 131, 132, 135, 136, 137, 149
BERTIN, Rose 413
BERTON, Pierre 208
BERULLE, Pierre de 277
BESNARD, Joseph 626, 631
BIBLIOTHEQUE NATIONALE, old 502, 504
BICETRE, château 109, 115, 128, 137
BIETTE, Louis 575
BIGOT, Antoine 582
BILLOTEY, Louis 667
BING, Samuel 589, 606
BIRAGO (see Birague)
BIRAGUE, chapel 234, 235
BIRAGUE, René de 234, 235
BISSIERE, Roger 672, 673
BLANCHARD, Jacques 255
BLANCHE de Castille 91
BLOIS (town) 135
BLONDEL, Jacques-François 238, 333, 338, 350, 353, 358, 364, 393, 398, 399, 402, 404, 409, 412, 417, 418, 429, 468, 514
BLUNT, Alain 255
BOCCADOR (see Cortona)
BODIANSKY, Vladimir 643, 647
BOFFRAND, Gabriel-Germain 357, 360, 361, 396, 397, 402
BOFILL, Ricardo 681
BOILEAU, Etienne 64
BOILEAU HAMEAU (village) 497, 514
BOILEAU, Louis Auguste 504, 507, 508, 575
BOILEAU, Louis Charles 578
BOILLY, Louis-Léopold 540
BOIZOT, Simon-Louis 449, 457
BON MARCHE, department store 567, 578, 583
BONAPARTE (see Napoleon I)
BONCHAMPS, Charles, marquis de 556
BONDOL OF BRUGES (see Jean Bondol)
BONNARD, Pierre 590, 595, 621, 626, 628
BONNAT, Léon 598, 601
BONTEMPS, Pierre 221, 223
BORROMEO, Saint Charles 278

BOSIO, François-Joseph 558
BOSSE, Abraham 306, 312, 314, 315
BOSSUET, Jacques Bénigne 237, 332, 334, 462, 469
BOUCHARDON, Edmé 393
BOUCHER, François 388, 288, 391, 408, 413, 442, 452, 453, 542
BOUCHER, Madame 391
BOUDIN, Eugène 620
BOULENGER, Hippolyte 582, 589
BOULIER DE BOURGES, Jean 300
BOULLE, André-Charles 355, 371, 448
BOULLÉE, Etienne Louis 413, 422, 423, 425, 434, 440, 473, 474
BOULOGNE 682
BOULOGNE, Bois de 147, 176, 177, 183, 515, 519
BOULOGNE-BILLANCOURT 643, 647
BOURBON-ARTOIS, Louise-Marie-Thérèse de, duchess of Parma 566, 567
BOURDELLE, Antoine 581, 597, 628, 630
BOURDON, Sébastien 255
BOURET DE VÉZELAY 429, 432
BOURG-LA-REINE 581
BOURGES 53, 101, 136, 137, 148, 153
BOYCEAU, Jacques 292
BRABANT, Marie de 132
BRANCUSI, Constantin 631, 632, 633, 657, 662, 673
BRANTÔME, Pierre de Bourdeille, called de 194
BRAQUE, Georges 387, 595, 597, 625, 630, 631, 637, 643, 654, 655, 656, 657, 659, 673
BRASSAI, Henri 637, 655
BRAUNER, Victor 637, 672
BRAYER, Yves 673
BRETEZ, Louis 321
BRETON, André 638, 654
BREZE, Louis de 208
BREUER, Marcel 677, 678
BRICE, Germain 282, 322
BRIÇONNET, Charlotte 145
BRIÇONNET, Guillaume 145, 147
BRIOT, Isaac 314
BRISEUX, Charles-Etienne 398, 404
BRONGNIART, Alexandre 429, 432, 449, 562, 564
BROSSE, Salomon de 238, 240, 243, 285, 289
BROU, church of 150, 160, 180
BRUANT, Libéral 348
BRUNELLESCHI, Filippo 281, 290
BRUNO, Andrea 670
BRUNO, Saint 33
BURIDAN, Jean 99
BUTTES-CHAUMONT, quarries 11, 488
BUTTES-CHAUMONT, Parc des 488, 519
BUYSTER Philippe de 262
BYRON, George Gordon Noel, Lord 536
CABOCHE, Simon 101
CACHIN, François 624
CAFFIERI family 402
CAFFIERI, Jacques 371, 372
CAFFIERI, Philippe 344, 372
CAIL, Jean-François 562
CAIRE, Passage du 496, 512
CALDER, Alexander 637, 672
CALLOT, Jacques 244, 247, 264, 315
CALVIN, John 285
CAMELOT, Robert 673, 678
CAMPBELL, Colin 399
CAMPIN, Robert 148
CANAL PLUS, headquarters 678
CANALE, Martino de 97
CANDIANI 324
CANOVA, Antonio 475, 491, 558, 559
CAPUCINES CONVENT, church of the 378
CARAVAGGIO, Michelangelo Merisi da 247, 249, 251
CARLIN, Martin 448
CARLOMAN, son of Pepin the Short, king of the Franks 30
CARLU, Jacques 667
CARMELITE CONVENT 92

CARMELITES, church of the, Institut Catholique 281
CARON, Antoine 194, 196, 203
CARPEAUX, Jean-Baptiste 556, 559, 560, 610
CARPI, Alberto Pio, count of 145, 152, 161
CARRACCI, Agostino and Anibal 247, 249, 305
CARRIER-BELLEUSE, Albert-Ernest 556, 560
CARRIERA, Rosalba 388
CARTIER, foundation 682
CASANOVA, Giacomo 391
CASSAS, Louis-François 484, 498
CASTEL BÉRANGER 586, 588, 589
CASTELLANE, Boniface de 585
CATHERINE DE MEDICIS, queen 204, 223, 228, 228, 230, 232, 234, 235, 267, 268, 272, 273
CATHERINOT, Nicolas 404
CAYLUS, Anne Claude de 413, 465
CELESTINES, convent of the 128, 133, 206, 207, 519
CENDRARS, Blaise 611
CENTRE POMPIDOU (see Beaubourg)
CENTRE REGIONAL 653
CAESAR, Gaius Julius 20, 21
CESAR, César BALDACCINI, called 673
CEZANNE, Paul 387, 526, 590, 594, 612, 620, 621, 628, 630, 637, 650
CHAGALL, Marc 501, 612, 613, 637, 655, 673, 676
CHAILLOT, hill 344, 515, 587
CHAMBERS, William 449
CHAMBIGES, Martin 150, 171
CHAMBIGES, Pierre 150, 178
CHAMBRAY (see Fréart de Chambray)
CHAMBRE DES COMPTES (Counting House) 149, 172, 176
CHAMBRE DES DEPUTES or ASSEMBLEE NATIONALE 515, 537
CHAMOIS, Charles 306
CHAMPAGNE, Marie de, countess of 37
CHAMPAIGNE, Philippe de 238, 244, 247, 249, 250, 251, 252, 255, 263, 281, 528
CHAMP-DE-MARS 566
CHAMPEAUX, market 59, 64
CHAMPS-ELYSÉES 272, 341, 440, 512, 518, 562, 566, 678
CHAMPS-ELYSEES Theater 581, 597, 601
CHAMPS-SUR-MARNE 398
CHANEL, Coco 635
CHANTAL, Jeanne de 279
CHANTELOU (see Fréart de Chantelou)
CHANTILLY 150, 376
CHAPELLE EXPIATOIRE (Chapel of Atonement) 507, 508 558
CHARDIN, Jean-Baptiste-Siméon 378, 383, 387, 497, 655
CHAREAU, Pierre 638, 639, 642
CHARENTON, asylum 500, 540
CHARENTON TEMPLE 285, 285
CHARLES I, called CHARLEMAGNE, emperor of the Franks 30, 69, 118
CHARLES II THE BALD, king of the Franks 30
CHARLES IV THE FAIR, king of France 63, 69, 128
CHARLES V, Roman emperor 100, 118
CHARLES V THE WISE, king of France 100, 101, 102, 103, 106, 106, 107, 109, 111, 112, 115, 116, 116, 118, 124, 125, 126, 126, 128, 130, 131, 132, 135, 136, 145, 147, 148, 151, 179, 216
CHARLES VI THE MAD, king of France 100, 101, 102, 103, 115, 124, 125, 126, 127, 127, 128, 130, 132, 133, 145, 146, 148, 228
CHARLES VII, king of France 101, 102, 103, 130, 139, 144, 145, 146, 148, 160
CHARLES VIII, king of France 135, 139, 146, 149, 149, 150, 159, 160, 180
CHARLES IX, king of France 189, 190, 193, 234

CHARLES X, king of France (formerly count of Artois) 440
CHARLES D'ANJOU, duke, brother of Saint Louis IX, king of France 61, 97
CHARLES DE BOURBON, cardinal-abbot 228
CHARLES DE FRANCE, duke of Berry, brother of Louis XI 148
CHARLES D'ORLÉANS, duke 101, 146
CHARLES MARTEL 30
CHARLES DE LUXEMBURG, king of Bohemia 130
CHARLES THE BAD, king of Navarre 99, 100
CHERPITEL, Mathurin 400
CHARTIER, Alain 137
CHARTRES 11, 53, 55, 92, 96
CHARTRES, Folly of 440
CHASSERIAU, Théodore 526, 533, 537, 539, 547, 547, 598, 601, 606
CHASTEL, André 20, 38
CHASTELLAIN, Georges 130
CHASTELLAIN, Jean 152, 167, 203
CHASTILLON, Claude 266, 268, 269, 272, 273
CHAT NOIR, cabaret 570
CHATAIGNER, Alexis 476
CHATEAU-LANDON, quarry 11
CHATEAUBRIAND, François René de 541, 542, 546
CHATEAUVILAIN, Gallery Count of 194
CHATELET, theater 597
CHATOU 595, 628
CHAUDET, Antoine Denis 559
CHAUSSARD, Jean-Baptiste 445
CHAUSSEE-D'ANTIN 432, 434, 465
CHEDANNE, Georges 579
CHEMETOV, Paul 672, 581, 681
CHENAVARD, Claude-Aimé 562, 564
CHENNEVIERES-POINTEL, Philippe 542
CHESTERFIELD, Lord Philip Dormer Stanhope, Fourth Earl of 355
CHEVALIER, Etienne 145, 151, 153, 184
CHEVALIER family 145
CHEVALIER, Pierre 145
CHEVREUL, Michel Eugène 565, 612
CHILDEBERT I, Merovingian king 25, 26, 27, 56
CHINESE BATHS 446
CHINON 101
CHIRAC, Jacques 678
CHIRICO, Giorgio de 654
CHOISY-LE-ROI 398
CHRISTINE DE PISAN 102, 106, 107, 111
CHRISTOFLE, Charles 563
CITE BERGERE 513
CITE DE LA MUSIQUE 682
CITE DES ITALIENS 514
CITE DES SCIENCES ET DE L'INDUSTRIE 677, 681, 682
CITE MALESHERBES 514
CITE NAPOLEON 514
CITE TREVISE 513
CITÉ UNIVERSITAIRE 639, 644
CITY HALL OF THE Xᵉ ARRONDISSEMENT 583, 585
CLAUDEL, Paul 657
CLERISSEAU, Charles Louis 417, 442, 448
CLESS, Jean-Henri 485
CLICHY, Maison du Peuple (House of the People) 643, 647
CLICQUOT, family 363
CLICQUOT, François Henri 363
CLODION, Claude Michel 432, 460, 464, 465, 610
CLOTAIRE I, king of Paris 27
CLOTILDE, wife of Clovis 26
CLOUET, François 193, 194, 204
CLOUET, Jean 148, 159, 160
CLOVIS, Merovingian king 26, 27, 30, 35, 93
CLUNY 20, 21, 33, 35
CNIT 673, 677, 678
COCHIN, Charles Nicolas 399, 402, 403, 405, 408
COENE, Jacques 131
COEUR, Jacques 144, 153
COLBERT GALLERY 513, 520

COLBERT, Jean-Baptiste 191, 239, 317, 318, 319, 323, 324, 325, 326, 327, 328, 335, 338, 341, 344, 345, 347, 350, 351, 352, 353, 393, 402, 403, 408, 514
COLINES, Simon de 145, 161, 162
COLLEGE DE FRANCE 147, 484, 633
COLLIGNON, Jean 334
COLOMBE, Michel 151, 160, 180
COLONNA, Francesco 196, 198
COMANS, Marc de 313
COMEDIE-FRANÇAISE 421
COMMINES, chapel 182
COMMINES, Philippe de 149, 161
COMPTOIR NATIONAL D'ESCOMPTE (National Discount Trading Post) 582
CONFLANS 118, 124
CONSTANCE OF PROVENCE 33
CONSTANT, Pierre, called Constant (Contant) d'Ivry 420
CONSTANTIN THE GREAT, Roman emperor 25, 26, 27, 30, 35, 52, 94
CONSTANTIN, Auguste 513, 517
CONVENTION HALL 471, 473
CONVENT OF LOURCINES 92
COQUERET, college 187
CORBEIL 33, 54, 54
CORDEMOY, Abbot Jean-Louis de 401
CORMONT, Thomas de 90
CORNEILLE, Pierre 272
COROT, Camille 387, 524, 526, 543, 544, 546, 546, 567, 598, 612
CORROYER, Edouard-Jules 582
CORROZET, Gilles 147, 196, 221
CORTONA, Domenico da, called Boccador 149, 166, 173, 174, 178
CORTONA, Pietro da 255, 298, 305
CORTOT, Jean-Pierre 558
COTTARD, Pierre 309
COTTE, Robert de 348, 357, 363, 404
COULOMMIERS, château 290
COURBET, Gustave 12, 13, 492, 493, 496, 497, 525, 540, 541, 551, 556, 585, 594, 601, 628, 631
COURBEVOIE 659
COURS-LA-REINE 272
COURTONNE, Jean de 397
COUSIN THE ELDER, Jean 194, 196, 198, 199, 203, 204, 210, 211
COUSIN, Victor 496, 550
COUSTOU, Guillaume I 365
COUSTOU, Thomas 533, 534, 535, 536, 537
COUTURIER, Robert 663
COYPEL, Antoine 358, 358, 378
COYSEVOX, Antoine 262, 333, 335, 336
CRESSENT, Charles 370, 372
CRISSE, Turpin 508
CUCCI, Domenico 341, 371, 402
D'ANGIVILLER, Charles Claude de Flahaut de la Billarderie, count 409, 417, 424, 460
DAGOBERT I, Merovingian king 28, 29, 93
DAGUERRE, Louis Jacques Mandé 490
DALI, Salvador 589, 637, 654, 660, 672
DALOU, Jules 597, 629
DAMMARTIN, Drouet de 114, 126, 136, 137
DAMMARTIN, Guy de 126, 128, 136, 137
DAMPIERRE, château de 559
DANTE ALEGHIERI 66, 97, 560, 610
DAUBIGNY, Charles-François 524, 546
DAUDET, Alphonse 551
DAUMESNIL, workers' cité 514
DAUMIER, Honoré 525, 541, 564
DAVENT, Léon 193
DAVID D'ANGERS, Pierre-Jean 556, 558
DAVID, Gérard 148
DAVID, Jacques-Louis 409, 410, 449, 457, 460, 468, 469, 470, 470, 473, 474, 475, 524, 528, 534, 535, 536, 541, 556, 597
DAVIOUD, Gabriel 587
DE BAIF, Jean Antoine 187
DE LA FOND, family 243

DE L'ORME, Philibert 187, 191, 192, 203, 205, 206, 208, 210, 211, 220, 221, 221, 223, 223, 226, 228, 234, 235, 302, 326, 353, 426, 504
DEBRET, François 498
DEBUSSY, Claude 597
DECAMPS, Alexandre 542
DEFENSE, district 673, 678, 681, 682
DEGAS, Edgar 569, 594, 596, 601, 604, 605, 605, 606, 608, 609, 612, 620, 624, 628
DEGOULLONS, family 357
DELACROIX, Eugène 471, 493, 496, 497, 525, 526, 533, 534, 535, 536, 537, 541, 542, 543, 546, 550, 560, 567, 585, 606, 611, 612, 628
DELAMARRE, Jean 150, 151
DELAROCHE, Paul Hippolyte 524, 541
DELAUNAY, Robert 611, 624, 633, 637, 646, 651, 654, 660
DELAUNAY, Sonia 654, 660, 661
DELAUNE, Etienne 189, 204
DELESSERT, Benjamin 500
DELL'ABATE, Nicolò 192, 204, 205
DE MACHY, Pierre-Antoine 418
DEMARTEAU, Gilles 442, 452
DENIS, Maurice 590, 594, 601, 617, 624, 626, 628, 630
DENIS, Saint 24, 25, 28, 30, 37, 38, 62
DENON, Baron Dominique Vivant 563
DERAIN, André 592, 595, 596, 628, 655
DERAND, François 244, 278, 282
DESAIX, Louis 558
DESCAMP, Jean 96, 97
DESCARTES, René 264
DESCHAMPS, Eustache 102, 103, 107
DESGODETS, Antoine 353
DESJARDINS, Martin van den Bogaert 333, 335
DESMARZ, Nicola dei Marzi 97
DESPORTES, Alexandre-François 383, 387, 388, 465
DESPREZ, François 189, 315
DEVERIA, Achille 567
DE WAILLY, Charles 397, 405, 409, 417
DIAGHILEV, Sergey 573, 597
DIANE DE POITIERS 189, 203
DIDEROT, Denis 387, 391, 412, 413, 457, 459, 464, 474
DIEHL, Charles-Guillaume 564
DIONYSIUS THE AREOPAGITE 30
DIOR, Christian 669
DOESBURG, Theo van 639
DONGEN, Kees van 624, 628, 637, 673
DORAT, Jean Dinemandi called 187
DORÉ, Gustave 492, 521, 540, 542, 543, 560, 606
DORIGNY, Charles 194, 195, 210, 211, 255
DORMANS, Jean de, bishop of Beauvais 115
DORMANS-BEAUVAIS, college 115, 116
DOUCET, Jacques 590, 592
DOURDAN 59
DOURDIN, Jacques 133
DRANCY 644
DROCTOVEUS, Saint 27
DROUET, André 126
DROUET, Juliette 559
DUBAN, Jacques-Félix 559
DU BARRY, Marie Jeanne Bécu 456
DU BELLAY, Joachim 187, 188, 206
DUBOIS, Ambroise 244
DUBOIT, Maurice 312
DU BREUIL, Jehan 153
DUBREUIL, Toussaint 244
DUBUFFET, Jean 673
DUBUISSON, Walter 682
DU BUS, Gervais 69
DUCHAMP, Marcel 632, 633, 637, 638, 654, 660
DUCHAMPS, Gaston, see Villon, Jacques
DUCHESNE-DUPARC, Louis-Victor 565
DUCHESNOIS, Catherine Raffin 514
DUCOS DE LA HAILLE, Pierre 657
DU FAUR, Jacques 193
DUFOUR, manufacturer 566
DU GUESCLIN, Bertrand 100
DUMAS, Alexandre 541
DUPAS, Jean 657
DUPRAT, Antoine 159
DURAND, Jean-Nicolas 474, 475, 500

DU RY, family 243
DU TILLET, Jean 193
DU VIVIER, Hennequin 130
DYCK, Anthony van 387, 388
EBERTS, Jean-Henri 448, 449
ECOLE DES BEAUX-ARTS 176, 193, 217, 281, 484, 491, 498, 502, 521, 551, 552, 575, 584, 588, 597, 598, 607
ECOLE MILITAIRE 395, 414, 420, 421, 424, 512, 515
ECOLE ROYALE DE CHIRURGIE 420, 442
EDWARD III, king of England 99, 128
EIFFEL, Gustave 570, 575, 578, 579, 642
EIFFEL TOWER 569, 570, 575, 578, 579, 586, 642, 643, 678
ELEANOR, duchess of Aquitaine 37
ELEUTHERIUS 25
ELIGIUS, Saint 27, 28
ELSHEIMER, Adam 247
EMERY, Michel Particelli d' 288
ERMENONVILLE 500
ERNST, Max 637, 638, 649, 654, 655, 660, 672
ERRARD, Charles 345
ESQUILLAN, Nicolas 678
ESTEVE, Maurice 672, 673
ESTIENNE, family 161
ESTIENNE, Gomar 199
ESTIENNE, Henri 162
ESTIENNE, Robert 162
ETAMPES 33, 55, 59
ETIENNE DE BONNEUIL 97
EUDES DE MONTREUIL 190
EUGENE IV, pope 160
EVRARD D'ORLEANS 96
EVELYN, John 272
EYCK, Jan van 131, 153
FAINSILBER, Adrien 682
FANTIN-LATOUR, Henri 594
FATH, Jacques 669
FELIBIEN, André 350, 401
FELIN, Didier de 150, 176
FELIN, Jehan de 150, 172
FELS, count of 585
FERDINAND I DE MEDICI, grand duke 267
FERDINAND, duke of Orléans, heir to the throne of France 564
FERMIERS GENERAUX, wall of the 427, 427
FERRIERES, royal abbey church 52
FEYDEAU ARCADE 472
FLACHAT, Eugène 504
FLANDRIN, Hippolyte 514, 559
FLANDRIN, Paul 547, 559
FLEURY, Michel 27
FLEURY RICHARD, Montaigne de 542
FONTAINE, Pierre-François-Léonard 442, 451, 486, 514, 515, 562
FONTAINEBLEAU 9, 149, 150, 151, 188, 192, 193, 194, 196, 199, 204, 206
FONTAINE DES INNOCENTS (Fountain of the Innocents) 211, 216, 462
FONTENELLE, Bernard de 403
FORTUNATUS, bishop of Poitiers 25
FOUJITA, Tsuguharu 657
FOULON, Abel 221
FOUQUET, boutique 589, 589
FOUQUET, Georges 588, 589
FOUQUET, Jean 143, 145, 151, 152, 153, 160, 166, 180, 182, 184, 528
FOUQUET, Nicolas 319
FOY, Maximilien 556
FRA GIOCONDO (Monsignore Giovanni) 149, 172
FRAGONARD, Evariste 525, 542, 632
FRAGONARD, Jean-Honoré 442, 452, 452, 453, 455, 456, 457, 459, 460
FRANCINI, Alexander 290
FRANCINI, Tommaso 290
FRANCIS, Sam 676
FRANCKEN, Jérôme 244
FRANÇOIS I, king of France 59, 135, 145, 146, 147, 148, 149, 150, 159, 160, 166, 174, 176, 177, 179, 182, 187, 188, 193, 196, 199, 204, 206, 210, 221, 223
FRANÇOIS I, neighborhood 513
FRANÇOIS II, king of France 189
FRANÇOIS DE SALES 279
FRANÇOIS MITTERRAND LIBRARY 681, 682
FREART DE CHAMBRAY, Roland 237, 250, 281, 403

FREART DE CHANTELOU, Paul 250, 251, 282, 318, 326, 327, 328, 333
FREDERICK II, king of Prussia 407
FREMIET, Emmanuel 601
FREMIN, Michel 401
FREMINET, Martin 244
FREUDENBERGER, Sigmund 414
FREYSSINET, Eugène 637, 639, 640, 642
FROMENT-MEURICE, workshops 566
FULLER, Marie-Louise, called Loïe 589
FULRAD, abbot 30
FURETIERE, Antoine 315
GABRIEL, Ange-Jacques 357, 395, 397, 399, 404, 407, 408, 414, 420, 421, 422, 424
GALLE, Emile 588
GARAMOND, Claude 199
GARE DE L'OUEST (see Gare Saint-Lazare)
GARE D'ORSAY 580
GARE DU NORD 562
GARE SAINT-LAZARE 504
GARGALLO, Pablo 637, 657, 659, 661, 663
GARLANDE, Etienne de 54, 55
GARNIER, Charles 498, 500, 501, 575
GARNIER, Tony 639, 643, 647
GAU, Chrétien François 486, 507, 562
GAUDREAUX, Antoine 371, 372
GAUGUIN, Paul 594, 596, 601, 606, 608, 610, 612, 624, 626, 628, 637, 657
GAUSSEL, Jean 169
GAUTIER, Théophile 493, 547, 556, 567
GAUZLIN, Abbot 35
GAVARNI, Paul 564, 567
GEHRY, Frank O. 681
GENEVIEVE, Saint 19, 24, 26, 28, 33
GENTILESCHI, Orazio 247
GERARD, François 465, 471, 475, 541, 551, 559
GERICAULT, Théodore 524, 526, 536, 540, 540
GERMAIN, bishop of Paris 27
GERMAIN, François-Thomas 376, 376, 377, 387
GEROME, Jean-Léon 551, 598, 611
GERSAINT, Edmé-François 377, 384
GERVEX, Henri 601, 604, 604
GIACOMETTI, Alberto 637, 657, 662, 673
GIDE, André 610, 657
GILARDONI, François-Xavier 582
GILLY, Friedrich 449
GIRARD, Bernard de 234
GIRARD, Laurens 152, 166
GIRARDIN, Emile de 567
GIRARDON, François 262, 347
GIRODET-TRIOSON, Anne-Louis 474, 475, 527, 533, 535, 541, 542
GISCARD D'ESTAING, Valéry 678, 681
GIVENCHY, Hubert 669
GIVERNY 621
GLUCK, Christoph Willibald 464
GOBELIN, family 341
GOBELINS 313, 341, 459, 566
GODEFROID DE CLAIRE (also Godefroid de Huy) 38
GOERG, Edouard 673
GOES, Hugo van der 148
GOETHE, Johann Wolfgang von 547
GOGH, Vincent van 590, 596, 599, 606, 610, 621, 628, 637
GOMBERT, Thomas 404
GOMBOUST, Jacques 264
GONCOURT, Edmond Huot de 585
GONCOURT, Jules Huot de 585
GONDOUIN, Jacques 413
GONZAGUE, Louis de 189, 190
GONZALES, Julio 657
GOUJON, Jean 188, 194, 196, 206, 207, 208, 209, 210, 211, 215, 216, 217, 220, 235, 261, 462
GOULD, Anna 585
GOUTHIERE, Pierre 449, 456
GOYA, Francisco de 493, 663
GRAND PALAIS 577, 580, 676
GRANDS AUGUSTINS, convent of the 149, 264, 512
GRANT, Catherine Noël Worlée 462
GRATIANUS 64
GREBAN, Arnould d' 146
GREGORY, Abbot 476
GREGORY of Tours 24, 25, 26

GRENELLE'S FOUNTAIN 393, 395
GRENOUILLERE, pontoon 591, 595, 628
GREUZE, Jean-Baptiste 457, 462
GRIMM, Baron Friedrich Melchior 388, 412, 457, 464
GRIS, Juan 631, 637, 657
GROLIER, Jean 199
GROMAIRE, Marcel 657, 659
GROPIUS, Walter 638, 678
GROS, Antoine-Jean 524, 533, 534, 535, 536, 541, 542
GUARINI, Guarino 320, 322, 324, 402, 504
GUERIN, Claude 287
GUERIN, Pierre Narcisse 527, 528, 533
GUILBERT, Yvette 587, 589
GUILLAIN, Simon 255, 261
GUILLAUME DE CHAMPEAUX 33
GUILLAUME DE VOLPIANO 33
GUILLAUME LE BRETON 58
GUILLAUME, Jean 182
GUIMARD, Hector 586, 588, 589, 642
GUIMARD, Marie-Madeleine 442, 464
HAINCELIN de Haguenau 132
HALLES DE BALTARD 504, 563, 678
HALLEWIN, Louis de 159
HANNON, Jean 207
HANTAI, Simon 672
HARDOUIN-MANSART, Jules 336, 346, 347, 348, 393, 395, 397, 404, 434, 442
HARTUNG, Hans 672
HAUSSMANN, Baron Georges Eugène 191, 486, 518, 519, 520, 565, 567
HEIM, Ambrosius 661
HEINE, Heinrich 486
HENNEBIQUE, François 581
HENRIET, Isaac 247
HENRY I, king of England 37
HENRY I, king of France 33, 35
HENRY II, king of England 37
HENRY II, king of France 187, 188, 189, 190, 191, 193, 194, 198, 199, 203, 204, 204, 209, 210, 211, 212, 221, 223, 230, 232, 234, 267, 273, 312, 335
HENRY III, king of England 97
HENRY III, king of France 189, 194, 223, 243, 267
HENRY IV, king of France 26, 190, 228, 235, 237, 238, 243, 244, 247, 248, 261, 263, 264, 266, 267, 267, 268, 269, 273, 288, 290, 311, 312, 313, 344, 347
HENRY V, king of England 101
HENRY V, Roman emperor 37
HENRY VI, king of England 101
HILDUIN, Abbot 30
HITCHCOCK, Henry Russel 501
HITTORFF, Jacques 486, 498, 507, 514, 562
HONORE, Master 64, 66, 69
HOOCH, Pieter de 387
HOREAU, Hector 504
HORTA, Victor 572, 588
HOSTEN Houses 472, 473
HOTEL AMELOT DE GOURNAY, called Hôtel des Ambassadeurs d'Hollande 302, 309, 397, 398
HOTEL BEAUVAIS 298, 298, 305
HOTEL BIRON (see Hôtel Peyrenc de Moras)
HOTEL BONY 514, 517
HOTEL BOTTEREL-QUINTIN 449
HOTEL BOURBON (or Petit Bourbon) 115, 228
HOTEL BOURET DE VEZELAY 429, 432, 583
HOTEL CARNAVALET (see Hôtel des Ligneris)
HOTEL CHÂLON-LUXEMBOURG 302
HOTEL COLBERT DE VILLACERF 390
HOTEL D'ALMERAS 302
HOTEL D'ARTOIS (or Hôtel de Bourgogne) 108, 115, 118, 137
HOTEL DE BEAUHARNAIS 496, 500
HOTEL DE BOURBON 115
HOTEL DE BOURGOGNE (see Hôtel d'Artois)
HOTEL DE BRUNOY 434, 440
HOTEL DE CHABANNES 407, 432, 442
HOTEL DE CLUNY 153, 174, 176, 180

HOTEL DE CONDÉ 440
HOTEL DE DIANE DE FRANCE 219, 228, 235
HOTEL DE GRIMOD DE LA REYNIERE 442, 448
HOTEL DE GUISE 192, 520
HOTEL DE LA PAÏVA 518, 523, 534
HOTEL DE LAW 378
HOTEL DE MADEMOISELLE DUCHESNOIS 514, 517, 583
HOTEL DE MAILLY 345, 345
HOTEL DE MARSILLY 375, 376
HOTEL DE MONTMORENCY 432, 434
HOTEL DE NESLE 115, 149
HOTEL DE NEVERS 189, 228
HOTEL DE RAMBOUILLET 306, 311
HOTEL DE ROHAN 360, 362, 365
HOTEL DE ROUGON 587
HOTEL DE SALM 436, 440
HOTEL DES AMBASSADEURS D'HOLLANDE (see Hôtel Amelot de Gournay)
HOTEL DE SENS 150, 176, 179
HOTEL DES INVALIDES 348, 348, 421, 512
HOTEL DES LIGNERIS (Carnavalet) 218, 220, 235, 295, 311
HOTEL DES MONNAIES 412, 418
HOTEL DE SOUBISE 360, 361, 362, 396, 397, 402
HOTEL DES PILIERS 103
HOTEL DES SOISSONS 228
HOTEL DES TOURNELLES 115, 228, 313, 512
HOTEL DES URSINS 109
HOTEL DE THELUSSON 432, 434, 440, 520
HOTEL DE TOULOUSE 359
HOTEL DE VILLE 166, 174, 178, 182, 521, 567, 597, 598
HOTEL DE VILLE, BOULOGNE-BILLANCOURT 643
HOTEL D'HERCULE 153, 228
HOTEL-DIEU 48
HOTEL D'UZES 428, 429, 442
HOTEL GAILLARD 587
HOTEL HEUSCH DE JANVRY, also called Boisgelin Hôtel) 399
HOTEL LAMBERT 261, 292, 293, 295, 297, 298, 300, 302, 304, 305, 311
HOTEL LA RIVIERE 261, 304, 305
HOTEL LA TREMOILLE (see Hôtel Legendre)
HOTEL LAUZUN, also called Hôtel Gruyn) 306
HOTEL LEGENDRE, called La Tremoille 176, 182, 182, 520, 521
HOTEL MATIGNON 397, 398
HOTEL MENIER 582, 587
HOTEL PEYRENC DE MORAS, also called Hôtel Biron 398, 398, 608
HOTEL SAINT-POL 103, 112, 115, 118, 124, 128, 147, 176, 442, 512
HOTEL SALE (Hôtel Aubert de Fontenay) 300, 300, 302
HOTEL SULLY (Hôtel Mesme Gallet) 290, 295
HOTEL URBAIN 383
HOTEL YVETTE GUIBERT 587
HOUDIN, Antoine-Léonor 323
HOUDON, Jean-Antoine 460, 460, 464, 465
HOYAU, Germain 174, 221
HUET, Jean-Baptiste 403, 442, 452
HUGH, Abbot of Saint-Germain 45
HUGH CAPET 33, 59, 61, 69, 97
HUGO, Victor 473, 483, 519, 521, 537, 540, 556, 560
HUMBLOT, Robert 672
HUNT, Richard M. 502
HURET, Grégoire 275
HUYSMANS, Joris-Karl 569, 580, 596, 607
ILE DE LA CITE 11, 12, 20, 27, 29, 30, 59, 63, 76, 103, 266
ILE-SAINT-LOUIS 272, 298
INGELARD, monk 35
INGRES, Jean-Auguste-Dominique 258, 391, 524, 526, 528, 532, 533, 535, 536, 539, 541, 547, 547, 550, 551, 559, 560, 563, 565
INNOCENTS, cemetery of the 59, 132
INNOCENTS, Fountain (see Fontaine des Innocents)
INSTITUT CATHOLIQUE (see Carmelites, church of the)
INSTITUT DU MONDE ARABE (Institute of the Arab World) 681, 683

INVALIDES, dome of the (or les Invalides) 348, 378, 395, 397, 424, 515
IRIBE, Paul 592
ISABEAU OF BAVARIA 101, 126, 127, 127, 132, 133
ISABELLE D'ARAGON, queen 94, 95
IVRY-SUR-SEINE 579, 582
JABACH, Everhard 240
JACOB, Georges 449, 566
JACOB-DESMALTER, François Honoré, manufacturer 566
JACOPO, Giovanni Battista (see Rosso)
JACQUEMART DE HESDIN 136
JACQUES, abbot of Cluny 139
JACQUES DE CHARTRES 127, 128
JACQUES DE MOLAY 99
JACQUIOT, Ponce 218, 223
JAL, Edmé-Anatole 521
JANEQUIN, Clément 188
JANNIOT, Alfred Auguste 659
JAOUL, houses 681
JAQUET MACI 118
JAUSSERAND, Michel 682
JEAN IV LE VISTE 144, 153
JEAN BONDOL (John or Hennequin of Bruges) 124, 125, 126
JEAN D'ARRAS 95, 96
JEAN DE BEAUMETZ 127
JEAN DE BRECQUESSENT 126
JEAN DE BROISSELLES 96
JEAN DE CHELLES 87, 90, 96
JEAN DE DOUAI 96
JEAN DE JANDUN 64
JEAN DE JOINVILLE 76
JEAN DE LANNOY 126, 128
JEAN DE LIEGE (or Hennequin) 126, 128
JEAN DE LOUVRE 97
JEAN DE SAINT-ROMAIN 127, 128
JEAN DE SOIGNOLLES (or de Sanholis) 126
JEAN DE THOIRY 127
JEAN D'ORLEANS 124, 125, 126
JEAN DU PRE 135
JEAN LE SCELLEUR 71
JEANNE DE BOURBON 128
JEANNE DE NAVARRE 63, 94
JEANNE D'EVREUX 63, 69, 70, 92, 126, 127
JEANNERET, Albert 643
JEANNERET, Charles Edouard (see Le Corbusier)
JEAN-SANS-PEUR (John the Fearless), duke of Burgundy 101, 102, 115, 131
JEFFERSON, Thomas 451, 501
JESUIT NOVITIATE, church of 251, 281, 285
JESUIT HOUSE OF THE PROFESSED 249
JESUIT SEMINARY (church of Saint-Paul-Saint-Louis) 278, 281, 282
JOAN OF ARC 101
JOHN II THE GOOD, king of France 99, 100, 102, 124, 128, 130
JOHN OF LUXEMBURG, king of Bohemia 100
JOHN OF GHENT 124
JOHNS, Jasper 676
JOINVILLE 659
JOLY, Jules-Jean-Baptiste de 517
JONGKIND, Johan Barthold 546, 620
JOSEPHINE, empress 535
JOUBERT, Gilles 372
JOURDAIN, Frantz 582, 589, 628, 639
JOUVENEL, Guillaume 139, 148, 153, 159, 160
JOUVENEL, Jean 102, 103
JOUVENEL DES URSINS also JUVENAL family 139, 144, 145, 151, 159, 534
JOUVENET, Jean-Baptiste 378
JOYEUSE, Marguerite de 190, 194
JULIAN, Roman emperor 21, 22, 23, 25
JUSTE, Antoine and Jean 160
KANDINSKY, Wassily 624, 632, 654
KELLER, foundry owner 376
KIKI DE MONTPARNASSE 657, 663
KISLING, Moïse 673
KOECHLIN, Maurice 578
KUPKA, Frank 624, 633, 654
L'HERBIER, Marcel 660, 665
LA BODERIE, Lefèvre de 191
LABROUSTE, Henri 502, 504, 575
LA BRUYERE, Jean de 317

LACOMBE, Georges 626
LA DRIESCHE, Jean de 153
LA FAYETTE, Madame de 189
LA FERTE-MILON 136
LA FEUILLADE, François d'Aubusson, count of 347
LAFONT DE SAINT-YENNE 352, 391, 393, 403, 412, 424, 493
LA HAMEE, Jean de 152
LA HYRE, Laurent de 240, 244, 247, 255, 263
LALANNE, Maxime 493
LALIVE DE JULLY, Ange-Laurent de 448
LALLEMANT, Georges 244
LALOUX, Victor 670
LAMBERT, abbot 350
LA MESANGERE, Pierre A. de 567
LANDON, Charles Paul 417
LANDOWSKI, Paul 673
LANFRANC, abbot 41
LA NOUE, François de 234
LANVIN, Jeanne 661
LAON 52, 53
LAPIN AGILE, cabaret 570
LA PLANCHE, François de 313
LA RUCHE 611
LAPRADE, Albert 644
LARGILLIERE, Nicolas de 387, 388
LARTIGUE, Jacques-Henri 664
LASSUS, Jean-Baptiste 498, 508
LATIN QUARTER 161
LA TOUR, Georges de 240, 244
LA TRINITE, church of 508, 515
LA TRINITE, workshop 199, 203
LAUGIER, abbot 401, 432
LAURENS, Henri 657
LAURENS, Jean-Paul 600
LAURENT, Girard 312
LA VILLETTE 677, 681, 682
LAVIROTTE, Jules 589
LEBAS, Hippolyte 510
LEBLANC, abbot 403, 408
LE BRUN, Charles 255, 256, 260, 261, 262, 263, 293, 304, 305, 313, 327, 334, 335, 341, 344, 345, 346, 353, 378, 388, 460, 465, 535
VIGEE-LEBRUN, Elisabeth 459, 460, 462, 464
LE CORBUSIER (Charles Edouard Jeanneret) 639, 640, 640, 643, 644, 646, 648, 649, 650, 651, 653, 677, 678, 681
LEDOUX, Claude-Nicolas 407, 413, 427, 428, 429, 432, 433, 434, 435, 442, 451, 464, 468, 472, 473, 514
LE DUC, Gabriel 328, 335
LE DUC, Louis 148
LEFEVRE D'ETAPLES, Jacques 145
LEFUEL, Hector 500, 501
LEGENDRE family 145
LEGENDRE, Jean 145
LEGENDRE, Pierre 145, 176
LEGER, Fernand 632, 363, 637, 651, 652, 655, 660, 664, 670, 673
LEGRAND, J.-G. 417, 420, 421
LEGUEULT, Raymond 672
LEIBNIZ, Gottfried Wilhelm von 22
LEIRIS, Michel 662, 682
LE LORRAIN, Louis-Joseph 448, 449
LE LYS, royal abbey 91
LE MERCIER, family 235
LE MERCIER, Jacques 235, 243, 256, 262, 274, 276, 277, 280, 293, 295, 323
LE MERCIER, Pierre 150, 151, 173
LE MOAL, Jean 672
LEMOYNE, François 378
LE MUET, Pierre 243, 289, 289, 305, 315, 328, 335
LE NAIN, Antoine 251, 260, 261
LE NAIN, brothers 247, 251, 255, 263, 387
LE NAIN, Louis 251
LE NAIN, Mathieu 251
LENDIT, plain 19, 24, 25, 37, 90
LENOIR, Alexandre 446, 476
LENOIR, Jean 118
LEON, Paul 651
LENORMANT DE TOURNEHEM, Charles-François-Paul 391
LE NOTRE, André 292
LEPAPE, Georges 592
LEPAUTRE, Antoine 237, 238, 281, 295, 298, 298, 305, 328
LEPAUTRE, Jean 305, 313, 325, 328, 335
LE PAUTRE, Pierre 357
LE PRETRE DE NEUBOURG FOLLY 440, 444
LEQUEU, Jean-Jacques 468, 468, 474, 475
LEROY, David 417

LESCOT, Pierre 187, 188, 191, 192, 194, 206, 207, 208, 209, 210, 211, 215, 216, 217, 220, 235, 273, 290, 302, 304, 323, 325, 347, 352
LE SUEUR, Eustache 240, 252, 255, 258, 258, 295, 297, 304, 391, 547
LE TROSNE, architect 653
LE VAU, Louis 243, 292, 293, 295, 298, 304, 318, 319, 320, 322, 323, 324, 327, 348, 398, 403, 432, 434
LIBERGIER, Hugues 87, 88
LIBERTY, Arthur Lasenby 572
LIMBOURG brothers, Herman, Hennequin (Jean) and Pol de 108, 131, 132, 136
LIMOUSIN, Léonard 204
LIPCHITZ, Jacques 632, 657
LIPPOMANO, Luigi 174
LODS, Marcel 643, 644, 646, 647
LOOS, Adolf 648
LORRAIN 239, 240, 546
LOUIS D'AMBOISE, bishop of Albi 143, 180
LOUIS I, duke of Anjou 100, 118, 125
LOUIS I, duke of Orléans 101, 133, 136, 146
LOUIS II, duke of Anjou 126
LOUIS II, duke of Bourbon 115
LOUIS VI THE FAT, king of France 37, 48, 59
LOUIS VII, king of France 37, 48
LOUIS IX (saint Louis), king of France 61, 63, 66, 69, 76, 77, 87, 90, 91, 92, 95, 96, 97, 99, 102, 106, 111, 128, 136, 190, 279
LOUIS XI, king of France 143, 144, 146, 148, 160, 166, 180
LOUIS XII, king of France 135, 143, 146, 149, 150, 150, 159, 160, 161, 172, 180, 204, 221
LOUIS XIII, king of France 228, 237, 239, 247, 249, 250, 255, 261, 268, 272, 273, 277, 278, 292, 323, 344, 347
LOUIS XIV, king of France 96, 237, 239, 247, 255, 255, 262, 280, 300, 311, 317, 322, 335, 338, 341, 344, 347, 355, 357, 359, 370, 371, 372, 376, 387, 393, 397, 402, 403, 412, 417, 423, 448
LOUIS XV, king of France 357, 359, 362, 370, 372, 391, 393, 395, 399, 403, 405, 407, 417, 420, 423, 424, 456
LOUIS XVI, king of France 372, 395, 399, 407, 418, 423, 448, 471
LOUIS, Nicolas, called Victor 413, 422
LOUIS-NAPOLEON, prince (see Napoléon III)
LOUIS-PHILIP, king of France 483, 484, 493, 513, 514, 564, 566
LOUVECIENNES, château 455, 456
LOUVET, Albert 577
LOUVOIS, François-Michel Le Tellier, marquis de 344, 345, 404
LOUVRE, Clock Pavilion 243, 262
LOUVRE, Colonnade 327, 351, 352, 352, 393, 396, 422, 424
LOUVRE, Cour Carrée 273, 323, 324, 327, 352, 393, 424
LOUVRE, Grande Galerie (Great Gallery) 251, 263, 312, 344, 420, 425, 476
LOUVRE, Grande Salle 188
LOUVRE, Musée du (see Musée du Louvre)
LOUVRE, Palais (see Palais du Louvre)
LOUVRE, Hall of the Caryatids 216, 217
LUCAS-CARTON, restaurant 588
LUGNE-POE, Aurélien Marie 626
LUMIERE, Auguste 633
LUMIERE, Louis and André, brothers 633
LURÇAT, Jean 639, 643
LUXEMBOURG, palace gardens 240, 292, 556
LUXEMBOURG Palace 238, 239, 240, 247, 289, 290, 292, 328, 346, 398, 456
LUZARCHES, Robert de 87, 88, 90
MAC KIM, Ch. F. 502
MADELEINE, church of the 420, 507, 515
MADRID, château 147, 149, 176, 177, 183, 311
MAHAUT D'ARTOIS 99, 118, 124, 125, 126
MAILLOL, Aristide 626, 628, 631, 632, 655
MAILLOT, Porte 642, 644

MAILLY, Jean de 673, 678
MAINE-MONTPARNASSE district 678
MAINNEVILLE Château 94
MAISON DE LA RADIO 677
MAISON DOREE 514, 518
MAISON GOUTHIERE 436, 440, 440
MAISON JOLLIVET 514, 521
MAISON, Château de 328
MALEVICH, Kasimir 596, 632
MALHERBE, François de 238
MALLARME, Stéphane 590
MALLET-STEVENS, Robert 592, 639, 642, 643, 644, 651, 660
MALRAUX, André 387, 650, 676, 678
MANESSIER, Alfred 672
MANET, Edouard 493, 497, 525, 539, 546, 552, 553, 567, 567, 594, 596, 601, 604, 605, 606, 607, 612, 620, 632
MANGIN, Pierre 523
MANSART DE JOUY 348
MANSART DE LEVY 348
MANSART, family 348, 350, 393, 423
MANSART, François 238, 243, 278, 279, 280, 287, 302, 318, 319, 323, 323, 324, 325, 331, 333, 335, 348, 353, 357, 409
MANSART, Jules 348
MANUTIUS, Aldus 199
MARAIS 147, 221, 235, 267, 278, 295, 317, 348
MARCEL, Etienne 100, 102, 103, 107
MARCHAND, Guyot 135
MAREY, Etienne Jules 633
MARGUERITE DE PROVENCE 128
MARGUERITE DE VALOIS, called Queen Margot 190, 194
MARGUERITE OF AUSTRIA 150, 180
MARGUERITE, Victor 635
MARIA THERESA, empress of Austria 300
MARIE-ANTOINETTE, queen 462
MARIE DE MEDICIS 239, 244, 267, 272, 290
MARIE D'ANJOU 148
MARIGNY, Enguerrand de 94
MARIGNY, Abel François Poisson, marquis de 408, 409, 421, 422, 424
MARIVAUX, Pierre 384, 387
MARLY 357
MARLY, horses of 362, 365
MARLY-LE-ROI 626
MAROCHETTI, Carlo 558
MAROT, Jean 230, 275, 277, 285, 302, 326
MARQUET, Albert 628
MARS, Mademoiselle 514
MARTELLANGE, Brother Etienne 277, 278, 281, 285
MARTIN, family 372
MARTIN, Jean 196, 198, 206, 208, 210, 211
MARTIN, Saint 25
MARVILLE, Charles 494, 521, 565
MARY OF ENGLAND, queen 149
MASSON, André 655, 673, 676
MASTER OF BEDFORD 132
MASTER OF BOUCICAUT 131, 132
MASTER OF COËTIVY or Master of the Hours of Olivier de Coëtivy 148, 152, 153, 157, 160
MASTER OF GUILLAUME JUVENAL DES URSINS 148
MASTER OF ROHAN 132, 134
MASTER OF SAINT-GILLES 30, 148
MASTER OF SAINT JOHN THE BAPTIST 148
MASTER OF THE HOURS OF ANNE OF BRITTANY 148, 152, 153, 162, 165
MASTER OF THE HOURS OF CHARLES III DE NAVARRE 124
MASTER OF THE HUNT OF THE UNICORN 148
MASTER OF THE PIETA OF SAINT-GERMAIN-DES-PRES 148
MASTER L. D. (possibly Léon Davent) 193
MASTER PAGAIN (see Mazzoni)
MATHIEU, Georges 672
MATISSE, Henri 387, 590, 596, 607, 611, 624, 628, 630, 631
MATTEO GIOVANNETTI 124
MAUBUISSON, royal abbey 91
MAURICE DE SULLY 48, 53, 54

MAUSOLEUM-CHURCH OF THE BOURBONS 331, 335, 348
MAZARIN, Jules, cardinal 237, 239, 255, 272, 293, 295, 300, 317, 318, 320, 322, 323, 324, 325, 335, 341, 344
MAZZONI, Guido (Master Pagain) 149, 149, 153, 160, 161, 182
MEDICI, family 290
MEIER, Richard 681
MEISSONIER, family 535
MEISSONNIER, Juste-Aurèle 375, 376, 393, 402
MELIES, Georges 633
MELNIKOV, Konstantin 648
MENGS, Anton Raffael 457, 490
MENIER CHOCOLATE FACTORY 572, 579, 587
MENIER, Emile 587
MERCER GALLERY 64, 314, 315
MERCIER, Louis-Sébastien 432, 434
MERIAN, Mathieu 264, 273
MERIMEE, Prosper 507, 521
MEROVAEUS, Merovingian king 26, 30
MERYON, Charles 491
METEZEAU, Clément 243, 277
METEZEAU, Louis 243, 269, 302
METEZEAU, Thibaut 219, 228, 235, 243
METIVIER, Antoine 243
METIVIER, Joseph 440
MEUDON 608
MICHALLON, Achille-Etna 544, 546
MICHEL, Claude (see Clodion)
MICHEL, Georges 543
MICHELANGELO BUONARROTI 191, 194, 223, 228, 237, 244, 280, 290, 328, 536, 540, 541, 547, 556
MICHELET, Jules 484, 486, 556
MIGNARD, Pierre 255, 333, 335, 345, 388
MIGNON, Jean 191, 193
MILAN, Pierre 193
MILHAUD, Darius 660
MILITAIRE, café 442, 451
MILLER, Henry 655
MILLET, Jean-François 524, 525, 540
MILVIUS bridge 26
MINIMES, church of the 279, 280, 287, 348
MINISTERE DE L'ECONOMIE ET DES FINANCES (Ministry of the Economy and Finances) 681, 681
MIRBEAU, Octave 569
MIRO, Joan 637, 648, 654, 655, 672
MITTERRAND, François 678, 681, 682
MODIGLIANI, Amedeo 596, 599, 637, 656, 657
MOISANT, Armand 579
MOLIERE (Jean-Baptiste Poquelin) 295, 317, 345
MOMUS, café 525
MONCEAU PARK 440, 519
MONDRIAN, Piet 632, 639, 654, 672
MONET, Claude 546, 566, 591, 594, 595, 612, 614, 615, 620, 621, 630
MONTAGNE SAINTE-GENEVIEVE 21, 22, 63
MONTESQUIEU, Charles de 397, 405
MONTEVERDI, Claudio 190
MONTMARTRE 11, 21, 25, 29, 513, 570, 586, 606, 611, 626
MONTPARNASSE 626, 637, 657, 673, 678
MONTREUIL 659
MONTSOURIS 519, 643
MOREAU, Edme 282
MOREAU, Gustave 526, 606, 607, 611, 611, 612
MOREAU, Jean-Michel (the Younger) 414, 417
MORISOT, Berthe 612
MORRIS, William 572
MOULIN DE LA GALETTE 570
MOULIN ROUGE 570
MUCHA, Alfons 588, 589, 589
MULLER, Emile 582
MURET, Etienne de 33
MUSEE CASSAS 484
MUSEE DELACROIX 525
MUSEE DE LA VIE ROMANTIQUE 525
MUSEE DES ANTIQUES 476
MUSEE DES ARTS AFRICAINS ET OCÉANIENS 644, 651
MUSEE D'ARTS ET METIERS 670, 682
MUSEE DES ARTS ET TRADITIONS POPULAIRES 682
MUSEE DES ARTS PREMIERS 682

MUSEE DES COLONIES (see Musée des Arts Africains et Océaniens)
MUSEE DES MONUMENTS FRANÇAIS 424, 476, 498, 518
MUSEE DES TRAVAUX PUBLICS 647, 651
MUSEE D'ORSAY 670, 681, 682
MUSEE DU JEU DE PAUME (Tuileries) 682
MUSEE DU LOUVRE 412
MUSEE NATIONAL D'HISTOIRE NATURELLE 672, 682
MUSEUM OF MODERN ART 651
NADAR, Félix 564, 565, 566, 567
NANTEUIL, Robert 256
NAPOLEON I Bonaparte 483, 484, 486, 498, 500, 514, 515, 518, 534, 535, 536, 556, 558, 559, 560, 562, 563
NAPOLEON III 484, 486, 493, 500, 501, 508, 514, 518, 519, 537, 552, 563, 566, 567
NAPOLEON family 551, 560
NATANSON brothers 626
NATIORE, Charles 361
NATTIER, Jean-Marc 391
NAUTES, pillar of the 22, 23, 35
NAVARRE, college 93, 94, 128
NEGRE, Charles 565
NERVI, Pier Luigi 677, 681
NESLE Tower 99, 318, 476
NEUFVILLE DE VILLEROY family 145
NEUFVILLE, Nicolas de 145
NEUILLY-SUR-SEINE 654, 659, 681
NEUVILLE, Alphonse-Marie de 535
NEWTON, Isaac 473, 474
NICOLAS DE VERDUN 38
NIEPCE, Joseph Nicéphore 490
NIERMANS, Jean and Edouard, brothers 647
NIJINSKY, Vaslav 597
NIVELLE, Henri le 133
NODIER, Charles 565, 567
NORBERT, Saint 33
NOTRE-DAME Cathedral 44, 47, 47, 48, 50, 53, 55, 58, 61, 63, 78, 87, 89, 90, 92, 93, 95, 96, 97, 149, 150, 190, 252, 312, 332, 356, 357, 363, 378, 498, 564
NOTRE-DAME-DE-LORETTE, church of 507, 508, 510, 514, 524, 564
NOTRE-DAME-DU-TRAVAIL, church of 579, 580
NOUGUIER, Emile 578
NOUVEL, Jean 681, 682, 682
NOUVELLE ATHENES, café 525, 628
NOUVELLE ATHENES, neighborhood 513, 514, 643
NOYERS (see Sublet de Noyers, François)
NOYON, cathedral 53
OBERKAMPF, Christophe Philippe 566
OBSERVATORY Foutain (Fountain in the Jardins de l'Observatoire) 559, 560
ODEON, theater 417, 421, 422, 676
OEBEN, Jean-François 372, 402
OEUVRE, theater 626
OLIER, Jean-Jacques 277
OLIVIER, Fernande 606
OPERA BASTILLE 681, 682
OPERA DES TUILERIES 471, 473
OPERA GARNIER 483, 498, 500, 501, 559, 575, 597, 676
OPPENORD, Gilles-Marie 357, 358, 393, 395, 402
OPSTAL, Gerard van 262
ORATOIRE, church of the 277
ORESME, Nicolas 116
ORLEANS (city) 11, 23, 27, 33
ORLEANS, square 513
ORLY 637, 642
OTT, Carlos 681
OUDOT, Roland 672
OUDRY, Jean-Baptiste 382, 387, 388
OURCQ, canal 517
OZENFANT, Amédée 640, 643, 648, 651
PAILLOT DE MONTABERT, Jacques Nicolas 547
PAJOU, Augustin 459, 460, 460, 462, 464, 464, 610
PALAIS BOURBON 398, 399, 440
PALAIS CARDINAL (see Palais Royal)
PALAIS CHAILLOT 651, 657, 662, 667
PALAIS DE LA CITE 59, 64, 87, 88, 90, 91, 97, 144, 177, 266, 274, 314, 315

PALAIS DE LA CITE, Counting House 97, 149, 172
PALAIS DE LA CITE, Great Hall 97, 163, 172
PALAIS DE LA FRANCE D'OUTRE-MER (Palace of Overseas France) 657
PALAIS DE L'ELYSEE 397
PALAIS DES ARTS ET DE L'INDUSTRIE 562
PALAIS DES MACHINES (Hall of Machines) 569, 570, 579, 642
PALAIS DES TUILERIES 189, 206, 226, 228, 234, 272, 273, 290, 295, 302, 328, 341, 501, 515, 518, 521
PALAIS DE TOKYO 635, 659
PALAIS DU CARDINAL MAZARIN 255, 256, 293, 295
PALAIS DU LOUVRE 54, 59, 99, 103, 107, 107, 109, 115, 116, 118, 127, 128, 136, 137, 146, 147, 161, 176, 187, 188, 194, 204, 206, 207, 210, 213, 215, 216, 216, 217, 220, 228, 235, 238, 239, 243, 251, 255, 262, 263, 272, 273, 274, 277, 290, 293, 300, 302, 304, 312, 323, 323, 324, 324, 325, 326, 327, 335, 341, 344, 347, 351, 351, 352, 359, 387, 393, 396, 402, 407, 409, 412, 420, 422, 424, 476, 493, 500, 501, 512, 515, 567, 628, 655, 669, 678, 681, 682
PALAIS DU LUXEMBOURG (see Luxembourg Palace)
PALAIS DU TROCADERO 587, 596
PALAIS ROSE 585
PALAIS ROYAL (formerly Palais Cardinal) 239, 247, 251, 255, 256, 293, 295, 358, 358, 359, 378, 397, 422, 440, 442, 513, 540
PALAIS STOCLET 572
PALISSY, Bernard 204
PALLADIO, Andrea 237
PANNINI, Giovanni Paolo 393
PANTHEON (see also Sainte-Genevieve [ex Saints-Apôtres], abbey church) 407, 418, 597, 598
PARENT, Henry 582
PARLIAMENT, Great Chamber 63, 144, 159, 172
PASCIN, Jules 655
PASSY, viaduct (also Pont de Bir-Hakeim) 575, 580, 678
PATHE, Charles 633
PATOU, Jean 635
PATOUT, Pierre 651
PATTE, Pierre 395, 404
PAZ, Octavio 677
PEI, Ioh-Ming 669, 678, 681, 682
PELERIN, Jean, also known as Viator 163
PELLEGRINI, Gian Antonio 378
PENNI, Luca 191, 193, 194, 196, 203
PEPIN DE HUY, Jean 96, 126
PEPIN THE SHORT, king of the Franks 30, 33
PERCIER, Charles 425, 442, 451, 486
PERE-LACHAISE Cemetery 485, 518, 556, 558
PEROTIN THE GREAT 64
PERRAULT, Dominique 673, 681
PERRAULT, Charles 324, 326, 327, 328, 341, 352, 395, 396, 403
PERRAULT, Claude 290, 327, 350, 351, 352, 353, 395, 402, 422
PERREAL, Jean 150, 160, 180
PERRET, Auguste 581, 585, 639, 640, 642, 643, 644, 647
PERRET, Claude 581, 585
PERRET, Gustave 581, 585, 647
PERRIER, François 255, 297
PETIT BOURBON 190, 226
PETRARCH, Francesco 128, 146, 182
PEVSNER, Antoine 637, 657
PEYRE, Marie-Joseph 417, 440, 442, 444
PHARAMOND 93
PHELIPPIN, Jean 161
PHELYPEAUX DE LA VRILLIERE, Louis 288
PHILIP I, king of France 35
PHILIP II AUGUSTUS, king of France 58, 59, 61, 62, 63, 91, 112, 115, 176
PHILIP III THE BOLD, king of France 61, 71, 94, 95, 95, 96, 97
PHILIP IV THE FAIR, king of France 61, 63, 66, 69, 87, 91, 93, 93, 94, 95, 97, 99, 102, 103, 128

PHILIP VI, king of France 99
PHILIPPE II D'ORLEANS, regent 358, 359
PHILIPPE II THE BOLD (PHILIPPE-LE-HARDI), duke of Burgundy 100, 101, 132, 133, 136
PHILIPPE III THE GOOD (PHILIPPE-LE-BON), duke of Burgundy 102, 136, 153
PHILIP AUGUSTUS Fortifications 58, 58, 107, 112, 115, 176
PHILIPPE EGALITE, Louis Philippe Joseph, duke of Orléans, known as 440, 483
PICABIA, Francis 637, 638
PICASSO, Pablo 12, 13, 526, 528, 560, 569, 570, 585, 590, 595, 596, 596, 599, 606, 611, 628, 630, 631, 633, 637, 653, 655, 656, 656, 657, 659, 661, 662, 663, 666, 666, 672, 673, 676, 682
PICQUE, Claude 199
PIERRE DE BROISSELLES 118
PIERRE DE CHELLES 61, 87, 89, 96
PIERRE DE MONTREUIL 61, 76, 79, 87, 88, 90, 96
PIERRE DE THOIRY 127, 132
PIERREFONDS, castle 136
PILES, Roger de 345, 346
PILON, Germain 204, 223, 232, 234, 235, 261
PINAIGRIER family 203, 312
PINAIGRIER, Nicolas 203
PINAIGRIER, Robert 203
PINEAU, Nicolas 357, 364, 375, 376, 402
PIRANESI, Francesco 563
PIRANESI, Giovanni Battista 417, 423, 435, 436, 500, 518
PISANELLO (Antonio Pisano) 204
PISSARRO, Camille 612, 628
PLACE DAUPHINE 266, 266, 347
PLACE DE FRANCE 268, 272
PLACE DE LA BASTILLE 469
PLACE DE LA CONCORDE 394, 500, 515, 518
PLACE DE L'ETOILE 515, 518, 560, 682
PLACE DES VICTOIRES 346, 347
PLACE DES VOSGES (or Place Royale) 228, 267, 268, 269, 279, 295, 302, 313, 347, 440
PLACE DU CAIRE 496, 500, 513
PLACE JUSSIEU 514, 519
PLACE LOUIS XV (later Place de la Concorde) 362, 394, 395, 397
PLACE ROYALE (see Place des Vosges)
PLACE VENDOME 346, 347, 347
POERSON, Charles 255, 309, 311
POIRET, Paul 592
POL, Abraham 575
POLIAKOFF, Sergey 672
POLLOCK, Jackson 676
POLONCEAU, Barthélemy Camille 504, 563
POMPADOUR, Jeanne Antoinette Poisson, marquise de 357, 388, 388, 391, 397, 399, 403
POMPIDOU, Georges 676, 678
PONCHER, Etienne, archbishop 145
PONCHER, Louis 145, 161
PONT ALEXANDRE III 577, 580
PONT-AU-CHANGE 152, 262, 314
PONT-AVEN 624
PONT D'ARCOLE 563
PONT DE BIR-HAKEIM (see Passy, viaduct)
PONT DE LA CONCORDE 556
PONT DES ARTS 323, 562, 563
PONT DU CARROUSEL 563
PONT MIRABEAU 580, 678
PONT-NEUF 235, 266, 266, 267, 267, 323, 418
PONT NOTRE-DAME 149, 150, 172, 176, 266
PORT-ROYAL-DES-CHAMPS, abbey 249, 281
POTEMONT, Adolphe 493
POURBUS, Franz 244, 247
POUSSIELGUE-RUSAND, Placide 564, 566
POUSSIN, Nicolas 238, 239, 240, 244, 247, 247, 250, 251, 255, 260, 261, 285, 318, 345, 346, 460, 465, 546, 608, 663, 666
PRADIER, Jean-Jacques (or James) 556, 558, 559, 560
PRAXITELES 22, 559
PREAULT, Antoine-Auguste 533, 556, 560, 610, 663
PRIEUR, Jean-Louis 426, 470
PRIMATICCIO, Francesco 150, 192, 192, 193, 194, 223, 232, 235, 346

PRINTEMPS, Department store 567
PROUDHON, Pierre Joseph 547
PROUST, Marcel 657
PROUVE, Jean 643, 647, 678
PRUD'HON, Pierre Paul 465, 475, 533
PUCELLE, Jean 66, 69, 70, 71, 96, 97, 118, 124
PUGET, Pierre 402, 404
PUMP OF THE SAMARITAN WOMAN 266
PUTEAUX 631, 647
PUVIS DE CHAVANNES, Pierre 526, 598, 601, 601, 606, 617, 623, 624, 626, 628
QUATRE-NATIONS, Collège des 317, 318, 318, 319, 323, 395, 418
QUATREMERE DE QUINCY, Antoine-Chrysostome Quatremère, called 417, 476, 559
QUENTIN DE LA TOUR, Maurice 388
QUINAULT, Philippe 317
QUINZE-VINGTS, home for the poor 128
RABELAIS, François 182, 187, 206
RACINE, Jean 317
RAIMONDI, Marcantonio 163
RAINALDI, Carlo 324, 324, 325
RAINCY, church of 640
RAMBOUILLET, Madame de 311
RAMBUTEAU, Claude Philibert de 508, 518
RAMPARTS OF CHARLES V 106, 107, 216, 273
RANSON, Madame 626
RANSON, Paul 626
RAUSCHENBERG, Robert 676
RAVEL, Maurice 597
RAY, MAN 592, 637, 638, 654, 655, 657, 663
RAYMOND DU TEMPLE 107, 111, 115
RECAMIER, Madame de 551
REDON, Odilon 606, 607, 608, 611, 611, 624
REGNAULT, Guillaume 151, 160, 161
REMBRANDT HARMENSZOON VAN RIJN 247
REMI, Saint 30
RENARD, E. 520
RENAUDIN, Laurent 208
RENEE DE FRANCE, duchess of Ferrara 189
RENOIR, Pierre Auguste 591, 595, 612, 615, 620, 621, 628, 630, 655
RENWICK, James 502
RESAL, Jean 580
RESTIF DE LA BRETONNE, Nicolas 414, 486
REUILLY 344
REVEILLON, Jean-Baptiste 566
REVOIL, Pierre Henri 542
RICCI, Nina 661
RICCI, Sebastiano 378
RICE, Peter 681, 682
RICHELIEU, Armand Jean de Plessis de, cardinal 238, 239, 247, 255, 260, 268, 272, 280, 282, 293, 295
RIDING SCHOOL 471, 475
RIESENER, Jean-Henri 372, 402, 448
RIGAUD, Hyacinthe 384, 388, 404
RISENBURGH family 372
RISENBURGH, Bernard II van 372, 391, 402
ROBERT I D'ARTOIS 61
ROBERT I THE STRONG 31, 33
ROBERT II D'ARTOIS 118
ROBERT II THE PIOUS 33, 35
ROBERT III D'ARTOIS 99, 100
ROBERT BRUCE, king of Scotland 97
ROBERT DE LANNOY 126
ROBERT DE MOLESME 33
ROBERT DE VERDUN 66
ROBERT, Hubert 420, 424, 425, 453, 464, 476
ROBESPIERRE, Maximilien de 469, 471, 535
RODIN, Auguste 560, 608, 609, 610, 611, 626, 627
ROENTGEN, David 448
ROFFET, Etienne 199
ROGERS, Richard 678, 681
ROHNER, Georges 670, 672
ROISSY-EN-FRANCE 12
ROMANELLI, Giovanni Francesco 239, 255, 262, 304, 476
ROME 24, 25, 30, 61, 93, 97, 103, 124, 146, 147, 149, 151, 160, 180, 182, 239, 247, 249, 250, 252, 260, 261, 262, 263, 277, 278, 280, 281,

294, 295, 298, 318, 322, 324, 325, 326, 335, 345, 347, 348, 350, 353, 363, 376, 395, 397, 402, 407, 408, 409, 412, 417, 423, 442, 456, 457, 460, 462, 474, 490, 491, 494, 524, 528, 533, 556, 558, 560, 566, 632, 643, 673
RONSARD, Pierre de 182, 187, 188, 190, 207, 220
ROSENBERG, P. 260
ROSSO FIORENTINO (Giovanni Battista di Jacopo) 149, 152, 193, 194, 208
ROUAULT, Georges 606, 607, 610, 650, 655
ROUSSEAU, Henri (called "Le Douanier") 590, 611, 612, 613, 630
ROUSSEAU, Jean-Jacques 440, 500
ROUSSEAU, P. 436
ROUSSEAU, Théodore 524, 546
ROUSSEL, Ker Xavier 623, 626, 628
ROUX-SPITZ, Michel 653
ROUYER, Eugène 583
ROYAL BANK 378
ROYAL BASILICA 221, 221, 228
ROYAUMONT, royal abbey of 91
RUBENS, Peter Paul 247, 249, 255, 290, 313, 378, 387, 388, 456, 534, 535
RUDE, François 534, 559, 560, 563
RUE DE LA PAIX, house on the 567
RUE DE REAUMUR, building on 579, 582
RUE DES AMIRAUX 642, 643
RUE DES COLONNES 472, 472
RUE DES IMMEUBLES-INDUSTRIELS 583
RUE FRANKLIN, building on 583, 585, 642
RUE GEORGES-BRAQUE 643
RUE LAFAYETTE 488, 518
RUE MALLET-STEVENS 639, 643
RUE SAINT-ANTOINE 145, 188, 210
RUE SAINT-GUILLAUME 638
RUE VAVIN, building on 582, 583, 584, 643
RUHLMANN, Jacques-Emile 651, 660
RUNGIS 21
RUSTICUS 25
RUSUTI, Filippo 97
RUSUTI, Giovanni 97

SABATIER, Madame 560
SACRE-COEUR, basilica 586
SACRE-COEUR, school of 589
SAINT-ANTOINE, abbey 371
SAINT-ANTOINE, porte 112
SAINT-AUBIN, Gabriel de 408
SAINT-AUGUSTIN, church of 508, 514
SAINT-CLOUD 328, 328, 376
SAINT-CUCUFA 500
SAINT-DENIS, basilica and monastery 27, 28, 29, 30, 37, 38, 41, 41, 42, 44, 45, 48, 53, 54, 55, 56, 59, 69, 80, 87, 88, 90, 92, 93, 94, 95, 95, 126, 127, 131, 132, 150, 160, 223, 232, 328, 335, 348, 498
SAINT-DENIS, gare 353
SAINT-DENIS, porte 210, 338
SAINT-DENIS, town 9, 19, 25, 37, 90, 230, 348, 581
SAINT-DENYS-DU-SAINT-SACREMENT, church of 507
SAINT-ESPRIT, church of 637, 640
SAINT-ETIENNE-DU-MONT, church of 152, 165, 166, 187, 208, 282, 287, 312, 422, 491
SAINT-EUGENE AND SAINTE-CECILE, church of 507, 508
SAINT-EUSTACHE, church of 147, 151, 166, 173, 174, 182
SAINT-FERDINAND Chapel 558
SAINT-GEORGES, district 513, 514, 520
SAINT-GERMAIN, château 315
SAINT-GERMAIN-DES-PRES Abbey 9, 25, 27, 33, 35, 45, 53, 54, 55, 59, 76, 109, 145, 147, 159, 160, 263, 520
SAINT-GERMAIN-DES-PRES, Chapel of the Virgin 87, 90, 92
SAINT-GERMAIN-DES-PRES, district 493, 669
SAINT-GERMAIN-DES-PRES, doorway 93
SAINT-GERMAIN-DES-PRES, palace of the abbey 228
SAINT-GERMAIN-DES-PRES, refectory 87, 90, 93, 520
SAINT-GERMAIN-EN-LAYE 87, 90, 147, 150, 290

SAINT-GERMAIN-L'AUXERROIS, church of 35, 115, 145, 161, 166, 169, 207, 208, 235, 274, 323, 324, 401
SAINT-GERVAIS-SAINT-PROTAIS, church of 150, 166, 167, 171, 179, 282, 285, 312, 368
SAINT-GOBAIN COMPANY 642
SAINT-IGNY, Jean de 256, 314, 315
SAINT JACQUES TOWER 150
SAINT-JACQUES-DE-L'HÔPITAL, church of 93
SAINT-JACQUES-DE-LA-BOUCHERIE, church of 166, 172
SAINT JAMES FOLLY 440, 445
SAINT-JEAN-DE-MONTMARTRE, church of 573, 575, 581, 582
SAINT-JEAN-BAPTISTE-DE-BELLEVILLE 508
SAINT-JULIEN-LE-PAUVRE, church of 55, 56
SAINT-LANDRY, church of 22
SAINT-LANDRY, pillar 19, 22
SAINT-LAURENT, church of 166
SAINT-LEU-D'ESSERENT, quarry 11
SAINT-LEU-SAINT-GILLES, church of 159, 244
SAINT LOUIS OF THE JESUITS, church of 244, 278, 281, 282
SAINT-LOUIS Hospital 268, 273
SAINT-MACLOU 208
SAINT-MARTIN, porte 338
SAINT-MARTIN-DES-CHAMPS 9, 29, 33, 35, 44, 44, 45, 53, 55, 56, 57, 59, 79, 87, 91, 91, 378, 504
SAINT-MAUR 206, 207
SAINT-MEDARD, church of 166
SAINT-MERRI, or Saint-Merry, church of 145, 166, 179, 199, 208, 401, 547
SAINT-NICOLAS-DES-CHAMPS, church of 247, 249, 251, 262, 401
SAINT-NICOLAS-DU-CHARDONNET, church of 274, 335
SAINT-NON, Abbey 453
SAINT-PAUL-SAINT-LOUIS, church of (see Jesuit Seminary)
SAINT-PHILIPPE-DU-ROULE, church of 424, 507
SAINT-PIERRE-DE-MONTMARTRE, church of 29, 32, 53
SAINT-PIERRE, Abbey 405
SAINT-PIERRE-DE-MONTROUGE, church of 508
SAINT-PIERRE-DU-GROS-CAILLOU, church of 507
SAINT-POL, chapel of the royal lodging 127
SAINT-ROCH, church of 274, 368
SAINT-SEVERIN, church of 66, 116, 152, 163, 166, 168, 179, 401
SAINT-SIMON 344
SAINT-SULPICE, church of 274, 277, 375, 376, 393, 547
SAINT-SULPICE, district 566
SAINT-VICTOR Abbey 33, 59, 151, 166, 520
SAINT-VINCENT-DE-PAUL, church of 507, 512, 514, 547, 562, 564
SAINTE-ANNE-LA-ROYALE, church of 320
SAINTE-CATHERINE, region 220, 228
SAINTE-CATHERINE-DES-ECOLIERS convent 221, 235
SAINTE-CHAPELLE 72, 76, 82, 84, 85, 87, 90, 92, 92, 93, 96, 97, 116, 124, 127, 136, 137, 149, 152, 162, 205, 274
SAINTE-CLOTILDE, church of 507
SAINTE-CROIX-SAINT-VINCENT, church of 27
SAINTE-GENEVIEVE (ex SAINTS-APOTRES), abbey church of; see also PANTHEON 420, 422, 423, 520
SAINTE-GENEVIEVE Library 502, 504
SAMARITAINE department store 567, 582
SANSON, Ernest 585
SANT'ELIA, Antonio 644
SARRAZIN, Jacques 247, 249, 262
SARTO, Andrea 151
SAULNIER, Jules 572, 579
SAUMUR 128, 136
SAUVAGE, Henri 583, 584, 588, 589, 639, 642, 643, 644, 651
SAUVAL, HENRI 118, 153, 207
SAUVESTRE, Stephen 570
SAVONNERIE 344, 344, 345

SCELLEUR, Jean le 71
SCHEFFER, Ary 525
SCHIAPARELLI, Elsa 661, 669
SCHINKEL, Karl Friedrich 449
SCHNEIDER, company 579
SCHOELLKOPF, Xavier 587, 589
SCHÖFFER, Nicolas 672
SCHWERDFEGER, Ferdinand 448
SECHELLES, Hérault de 469
SEDILLE, Paul 585, 587
SEILER-MULHEMAN COMPANY 563
SEMBLANÇAY, Jacques de Beaune, baron de 147
SENEFELDER, Aloys 564
SENLIS 33, 53, 55, 59
SENS 53, 55
SENS, archbishop of 145, 174
SAINTE-GENEVIEVE, new church of (see Pantheon)
SEQUANA, river goddess 22
SERLIO, Sebastiano 188, 206, 206, 210, 211, 213, 216, 228, 234, 273, 289, 323, 352, 496
SERT, José Maria 657, 661
SERUSIER, Paul 624
SERVANDONI, Giovanni 393, 395, 547
SEURAT, Georges 601, 618, 623, 624
SEVRES 377, 449, 450, 457, 564, 566
SIGNAC, Paul 588, 606, 624, 628
SILVESTRE, Isaac 177, 230, 247
SIMART, Pierre Charles 559
SINGIER, Gustave 672
SISLEY, Alfred 612, 621
SOANE, Sir John 449
SORBIN, Robert de 63
SORBONNE, church of 237, 274, 275, 280, 281, 282, 328
SORBONNE, university 63, 274, 275, 597, 598
SOREL, Agnès 130
SOUFFLOT, Jacques-Germain 403, 408, 417, 420, 421, 422, 423, 424, 496
SOULAGES, Pierre 672, 673
SOUTINE, Chaïm 387, 606, 637, 651, 655
SOUVERBIE, Jean 657
SPRECKELSEN, Otto von 681
STAËL, Anne Louise Germaine Necker, Madame de Staël-Holstein 486
STAËL, Nicolas de 672
STAHLY, François 673
STRAVINSKY, Igor 597
SUBLET DE NOYERS, François 237, 281, 318, 408
SUE, Eugène 540
SUGER, Abbot 37, 38, 41, 53, 54, 55, 69, 87, 285
SULLY, Henri de 53
SULLY, Maximilien de Belhune, duke of 272, 312
SUVEE, Joseph Benoît 459, 463, 475
TALMA, François Joseph 514
TANGUY, Yves 672
TAYLOR, Isidor Justin Séverin, Baron 565
TEMPLE, studio of Paul Ranson 626
TEMPLE, church of the 52, 59, 90, 91, 520
THEATINES Monastery 320
THEVET, André 190
THIERRY family 363
THOMAS, Sidney Gilchrist 579
THOMAS DE PISAN 107
THOMIRE, Pierre-Philippe 449, 457
THUILLIER, Jacques 252
TINGUELY, Jean 676
TOEPFFER, Rodolphe 564
TORY, Geoffroy 162, 163, 182, 196, 199
TOULOUSE, Louis-Alexandre, count of 359, 402
TOULOUSE-LAUTREC, Henri de 589, 604, 605, 606, 626
TOURNELLES 115, 210, 228, 267, 313, 512
TOURNON, Paul 637
TRISTANO, Giovanni 277, 278
TRUSCHET, Olivier 174, 221
TSCHUMI, Bernard 681
TUBY, Jean-Baptiste 344
TUILERIES (see Opéra and Palais)
TUILERIES, Jeu de Paume 662
TURGOT, Michel 321
TURNON, Paul 637
TZARA, Tristan 638, 643
UCCELLO, Paolo 663
UNESCO headquarters 677
URBAN II, pope 33
VAL-DE-GRACE, convent of 276, 277, 278, 280, 324, 328, 335, 345, 348

VALENCIENNES, Pierre-Henri de 463, 465, 546
VALENTIN DE BOULOGNE 239, 240
VALENTINIAN, Roman emperor 21
VALERY, Paul 9, 628
VALLOTTON, Félix 623
VALOIS ROTUNDA 223, 230
VALPERGA, Antonio Maurizio 320
VASARELY, Victor 672, 676
VASCOSAN, Michel de 161
VASSE, François Antoine 357, 359
VAUBAN, Sébastien Le Prestre de 317, 338
VAUGELAS, Claude Favre, seigneur de 238
VAUX-LE-VICOMTE, castle 304, 305, 319, 323
VELDE, Bram van 672
VELDE, Henry van de 572, 573, 581
VERA, André 648
VERBERCKT, Jacques 357, 361
VERCINGETORIX, Gallic chieftain 20, 21
VERKADE, Jan 573
VERMEER, Johannes 387
VERNEILH, Félix de 508
VERNET family 535
VERNET, Joseph 465
VERNET, Horace 514, 524
VERNEUIL, château 289
VERSAILLES 9, 260, 292, 295, 315, 317, 338, 341, 355, 357, 359, 363, 371, 372, 376, 378, 391, 393, 399, 400, 402, 413, 418, 421, 422, 501
VERSAILLES Cathedral 558
VERSAILLES, GRAND TRIANON 398, 580
VIEIRA DA SILVA, Maria Elena 672
VIEN, Joseph-Marie 449, 456, 456, 457, 460, 474
VIGEE-LEBRUN, Elisabeth 462, 464
VIGNON, Claude 247, 258
VILLA LA ROCHE 649
VILLARD DE HONNECOURT 66, 97
VILLA SAVOYE (Poissy) 640, 651
VILLA SEURAT 643
VILLE-D'AVRAY 543, 546
VILLON, François 99, 182
VILLON, Jacques 631, 654, 655
VINCENNES 9, 99, 111, 111, 112, 112, 115, 116, 127, 128, 147, 202, 203, 203, 295, 328, 376, 519, 520, 659
VIOLLET-LE-DUC, Eugène 182, 498, 500, 501, 521, 566, 575, 586, 587, 589, 649
VISCONTI, Gian Galeazzo 161
VISITATION DE SAINTE-MARIE, church of the 279, 287
VIVIENNE GALLERY 513, 520
VLAMINCK, Maurice de 592, 595, 596, 628
VOLLARD, Ambroise 656
VOLTAIRE (François Marie Arouet) 355, 393, 396, 397, 407
VOLTERRA, Daniel de 228, 267
VOLVIC 564
VOUET, Simon 244, 247, 249, 250, 251, 255, 258, 260, 261, 262, 263, 285, 303, 313
VUILLARD, Edouard 590, 594, 595, 620, 622, 626
VULCOP, Conrad de 148
VULCOP, Henri de 148
WACHEL, Chrétien 161
WAGNER, Richard 490
WATTEAU, Jean-Antoine 377, 378, 379, 384, 387, 404, 405, 452, 453
WEBER, villa 582, 585
WEISWEILER, Adam 448
WEYDEN, Rogier van der 148
WINCKELMANN, Johann Joachim 475, 490, 558
WINTERHALTER, Franz Xaver 551, 552, 567
WORRINGER, Wilhelm 632
WORTH, Charles-Frédéric 567, 592
WOU-KI, Zao 672
WREN, Christopher 395, 399, 423
WRIGHT, Frank-Lloyd 642
YVER, Etienne 161
ZADKINE, Ossip 657, 659, 661, 664, 670, 673
ZAKHAROV, Andrei 451
ZEHRFUSS, Bernard 673, 678
ZENITH, rock music venue 682
ZERNER, Henri 182
ZOLA, Emile 493, 497, 567, 583, 587, 620

# Photo Credits

A. K. G., Paris 13 b, 27, 70 r, 116 l, 193, 254, 260, 261, 264 t, 380–381, 410, 411, 462, 470, 568, 599 t and bl, 608 ; E. Lessing 611 r, 614

Albright-Knox Art Gallery, Buffalo 648

N. d'Archimbaud 11, 138–139, 140–141, 183 r, 216 r, 217, 218, 219, 229, 267, 268, 285 t r, 305, 306 l and b, 319 r, 336, 337, 347 b, 397 l, 398 c, 427 r, 428 r and tl, 442 l, 445, 449, 450, 451 t, 459 tr, 460 b, 478, 479, 480, 481, 498 t, 500, 502, 518 b, 519 r, 520 b, 571, 583, 587 r, 629, 635, 644 b, 668–669

Archipress 270, 271, 412 r, 517 b, 570 b, 579 r, 586 l, 640 t, 671, 672, 674–675, 677, 679

Archives Albert-Khan, Boulogne 636

Archives nationales, Paris 320

Archives photo, Paris 226 b, 566, 567 t, 573 t

Artephot 548–549, 604, 623 r, 654, 655, 659 ; Babey 72 r, 528 t, 529 ; Held 539 r, 596 ; Varga 617

Arthotek 389, 540 b, 593, 597, 618–619, 624 b, 652

Y. Arthus-Bertrand/Altitude 318, 348

The Art Institute of Chicago 606

Bildarchiv Berlin 484 t, 510–511

BHVP/J.-J. Hautefeuille 494

Bibliothèque municipale, Grenoble 135 l

Bibliothèque municipale, Tours 65

BnF, Paris 12, 28, 52, 62, 66, 67, 68, 71, 80 b, 87, 90, 93, 100, 101, 106 r, 109 r, 117, 121, 132, 134, 135 r, 137, 149, 159 l, 165 r, 177, 178 t, 183 b, 191, 196, 198 l, 200, 201, 212, 230 b, 234 r, 235 b, 237, 256 b, 264 b, 266, 285 br, 287 tl, 313, 314, 315, 323, 331 r, 332, 352, 353 b, 360 b, 375, 393 tr, 394 t, 412 b, 422 r, 423, 428 bl, 429 c, 433, 434, 444 b, 468 b, 473 t, 474, 475, 476, 485 t, 492, 493 t, 495 t, 497, 501 b, 543 b, 567 b, 569, 588 t

BIFI, Paris 665

C. Bony 634, 682

Bridgeman Art Library, London 382, 554–555

British Library, London 133

British Museum, London 29

Calouste Gulbenkian Foundation, Lisbon 387

Centre Georges-Pompidou 662 t, 663 ; G. Meguerditchian 638 ; Ph. Migeat 610 l

J.-L. Charmet 275 t

Chevojon 574, 578

The Cleveland Museum of Art 119

The Cloisters, New York 48 l, 155

C. M. N. 57, 83, 84, 85, 114, 231, 419 b, 600, 647

C. M. N./J.-C. Ballot 640 b, 641

C. M. N./Th. Beghin 643 b

C. M. N./D. Bordes 88, 162 r

C. M. N./J. Feuillie 162 l

C. M. N./L. Gueneau 584

C. M. N./J. J. Hautefeuille 108 r, 302 l

C. M. N./P. Léger 40, 41 r, 95, 127 l, 151 l, 223, 232 r, 233

C. M. N./P. Lemaître 26 l, 41 l, 42, 94, 126, 150 b, 222, 224, 225, 252 l, 356 b

C. M. N./Longchamp 295

C. M. N./J.-P. Muller 291

C. M. N./Pons 508 t

C. M. N./C. Rose 111 l, 124, 150 t, 151 r, 300, 310, 406, 499, 501 t, 546 b, 601 l

Collection Sydney and Frances Lewis 588 b

Columbia University Avery Library, New York 213 t

The Courtauld Institute, London 607

Dagli-Orti 506, 528 b, 536 b, 586 r, 620, 631 t

J. Darblay 108 l, 299, 308, 639 l

J.-C. Dartoux 10, 58, 374, 561, 579 l, 582 t, 680

M. Daspet 73g

Dominique Delaunay 573 b

Documentation française 345 b, 488

J.-C. Doerr 293, 294

Ecole nationale supérieure des beaux-arts, Paris 198 r, 199, 205, 208, 400, 401, 405, 459 b, 544 b

Edimedia/Guillot 357 b

Editions du Regard 660 b

G. Fessy 2, 414 r, 482

The Fine Arts Museum, San Francisco 258 b

Fondation Dina Vierny, Paris 632 b

Fondation Pierre-Gianadda, Martigny 624 t

The Frick Collection, New York 454, 455

P. Gargallo Anguerra 663 t

H. Gaud 56, 113, 115, 163, 168 t, 170, 171 b, 172, 174, 175, 179 l, 186–187, 202, 203, 241, 242, 280 t, 286, 302 r, 316, 334, 338, 339, 346 b, 347 t, 362, 363 b, 364 r, 365 b, 368 t, 369, 392, 395, 398 t, 399 t, 427 l, 477, 487, 489, 496 t, 509, 515 l, 520 r, 576–577, 673 t

D. Genêt 43, 81, 311, 361, 365 t, 487, 503, 507, 522–523, 534 b

Giraudon 13 t, 23, 86, 98, 107 l, 109, 110, 125, 129, 131, 159 r, 184, 185, 205 c, 209, 232 l, 249, 253, 257, 259 l, 342–343, 383 t, 524, 526, 533, 537, 538, 541, 542 b, 544 l, 546, 550, 551, 552, 556, 558 t, 594, 598, 599 t, 633 l, 652, 658, 664 bl, 666 b, 670 t

J.-L. Godard 20, 21, 167

Solomon R. Guggenheim Museum, New York 599 r, 646

J.-J. Hautefeuille 32, 41 c, 44 t, 45 b, 46, 47 l, 48 tr, 76, 77, 80 t, 82, 88 b, 89 r, 91, 96, 99, 109 tr, 111 r, 112, 168 b, 173, 176, 178 b, 179 r, 180, 182, 183 tl and c, 207 b, 211 t l, 215 r, 216 l, 226 r and c, 228, 230 t, 238, 239, 272, 273, 275 b, 276 b, 277, 285 l, 287 tr, 289, 290, 292, 298, 317, 319 l, 321, 327 t, 346 t, 349, 350 b, 356 r, 357 t, 358 t, 359, 368 b, 393 l, 394 l, 396 b, 397 r, 398 b, 399 b, 413 br, 414 l, 418 t, 419 t, 422 l, 424, 432, 435, 437 r and tl, 444 r, 472, 483, 484 b, 498 r and b, 504, 505, 514 b, 515 r, 570 l, 585 b

I. F. A. 486 b, 585 r, 639 b, 642

Inventaire général Alsace/adagp 250 b

Inventaire général Ile-de-France/adagp 643 t

H. Josse 589 b

The J. Paul Getty Museum, Los Angeles 465 l

Keystone 519 b, 660 r

J. H. Lartigue. © Ministère de la Culture-France/AAJHL 664 br

Magnum E. Lessing 30, 31, 245, 256 t, 262, 301, 366, 464 l

K. Maucotel 585 tl

R. Mazin 79, 211 r, 306 tr, 441, 516, 517 t

The Metropolitan Museum of Art, New York 70 bl, 461, 591 t

The Minneapolis Institute of Arts 651

J.-M. Pérouse de Montclos 97, 206, 207 t, 220, 221, 274, 280 r, 282, 413 t and bl, 473 b, 622 l

M.-A. de Montclos 227, 518 t

Musée Antoine Vivenel, Compiègne 425

Musée des Arts décoratifs, Paris/L.-S. Jaulmes 490–491 t

Musée des Augustins, Toulouse 623 l

Musée des Beaux-Arts, Angers 358 b

Musée des Beaux-Arts, Arras 250 t

Musée des Beaux-Arts, Bern 595 t

Musée des Beaux-Arts, Rennes 189

Musée du Berry, Bourges 303

Musée Bourdelle, Paris 628, 630

Musée départemental de Rouen 197

Musée de l'Oise, Beauvais/photo Bernard 535

Musée des Beaux-Arts, Strasbourg 456 l

Musée Fabre, Montpellier 385

Musée Granet, Aix-en-Provence 384

Musée Rodin, Paris/B. Jarret, adagp 626 ; A. Rzepko 627

Musée Sainte-Croix, Poitiers 463 b

Musée Sandelin, Saint-Omer/C. Theriez 39

Musées de Metz/J. Munin 545

Museo Reina Sofia, Madrid 666 t

The Museum of Modern Art, New York 611 l, 613 t, 653

The National Gallery, London 263

Nationalmuseet, Copenhagen 70 tl,

Nationalmuseum, Stockholm 287 b, 326

National Museum of Fine Arts, Stockholm 591 b

Öffentliche Kunstsammlung Basel/M. Bühler 625

Österreichische Nationalbibliothek, Vienna 265

Philadelphia Museum of Art 605

Photothèque des Musées de la Ville de Paris 22, 24, 45 t, 106 l, 188, 244, 248, 288, 296 b, 297 b, 309, 378, 394 r, 407, 416, 417, 418 b, 426, 438, 439, 443 b, 446, 447, 452, 453, 468 t, 469, 471 b, 485 b, 490 b, 491 b, 493 b, 495 b, 508, 512 r, 540 r, 650, 656, 661, 664 t

Private collection, Paris 622 r

Private collection, Paris 649

Private collection, Paris 657

Private collection, New York 204 t

Private collections 269, 393 br, 637, 639 b, 660 l

Rapho 328

Rijksmuseum, Amsterdam 610 r

R. M. N., Paris 6, 8, 18, 19, 26 r, 34, 36, 54, 55, 72 l, 73 r, 74, 75 r and l, 92, 120, 122–123, 127 r and c, 130, 142, 143, 144, 145, 146, 147, 152, 154, 156–157, 158, 166, 181, 192, 204 b, 211 c and b, 234 b, 235 t, 243, 247, 251, 252 r, 255, 258 t, 296 t, 297 t, 304, 312, 322, 324, 325, 327 b, 333, 340, 341, 344, 345 r, 354, 355, 367, 372, 373, 376, 377, 379, 383 br and l, 386, 388, 390, 391, 408, 409, 420, 421, 429 t, 430, 431, 448 br, 457, 458, 459 l, 460 t, 463 r, 465 r, 466, 467, 471 r, 514 r, 525, 527, 530–531, 532, 534 r, 536 r, 539 b, 543 r, 547, 553, 557, 558 b, 560, 562, 563, 564 r, 565, 590, 592, 602 r, 609 b, 613 b, 615, 616, 621, 631 b, 632 r, 633 r, 670 b

Roger-Viollet 542 t, 575, 580, 581, 587 r, 667 t

C. Rose 44 b, 47 r, 48 br, 49, 50, 51, 60, 61, 78, 89 l, 169, 171 t, 213 b, 214, 215 l, 236, 240, 276 t, 278, 279, 283, 284, 302 c, 307, 329, 330, 331 l, 350 t, 351, 353 t, 360 t, 363 t, 364 l, 375 t, 396 t, 415, 436, 437 bl, 442 r, 443 t, 496 b, 582 b, 600, 602–603, 667 b

Saint John's College, Oxford 116 r

Staatliche Museen zu Berlin 512 tl

Statens Museum for Kunst, Copenhagen 429 b

Thyssen-Bornemisza Collection, Madrid 609 t

Universitätsbibliothek, Basel 104–105

Urba Images Paris 676, 683

Vatican Library, Rome 210

Victoria and Albert Museum, London 161, 448 l and c, 464 r

Ville de Paris/C. O. A. R. C. 164, 165 l, 195, 246

The Wallace Collection, London 370, 371, 456 r

Wallraf Richartz Museum, Cologne 512 b, 513 t

The Walters Art Gallery, Baltimore 559

Pages I to XIV

I l RMN ; I r Dagli-Orti ; II l Pix-Giraudon ; II tr Nicolas d'Archimbaud ; II br Henri Gaud, III tl Caroline Rose ; III r C. M. N. ; IV t Henri Gaud, IV b C. M. N. ; V l C. M. N. ; V r Dominique Genêt ; VI Nicolas d'Archimbaud ; VII Nicolas d'Archimbaud ; VIII t Caroline Rose, VIII b Giraudon ; IX t Rapho ; IX b Nicolas d'Archimbaud ; X l Nicolas d'Archimbaud ; X r Archipress ; XI t C. M. N. ; XI b Nicolas d'Archimbaud ; XII l Rapho ; XII r C. M. N. ; XIII C. M. N. ; XIV t Archipress/Georges Fessy ; XIV b Caroline Rose

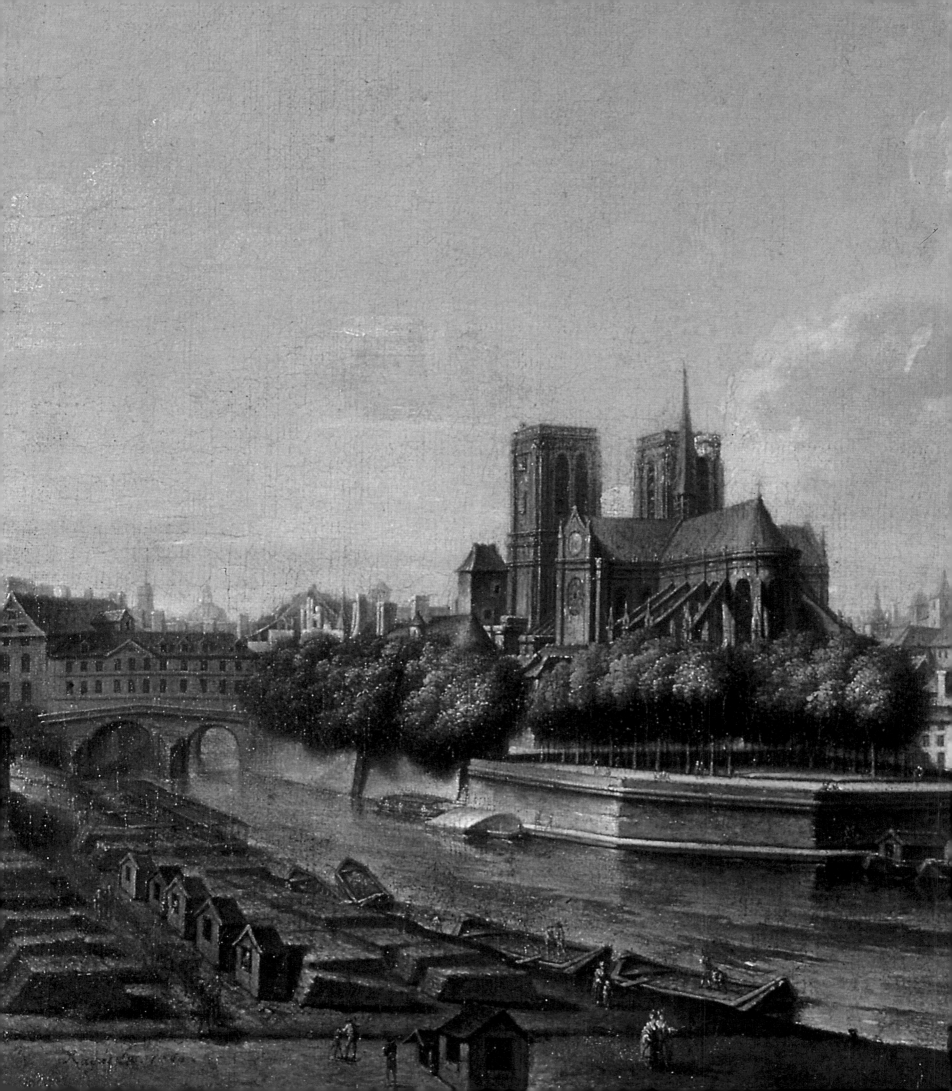